1 MONTH OF
FREE
READING

at
www.ForgottenBooks.com

By purchasing this book you are eligible for one month membership to ForgottenBooks.com, giving you unlimited access to our entire collection of over 1,000,000 titles via our web site and mobile apps.

To claim your free month visit:
www.forgottenbooks.com/free1258337

ISBN 978-0-365-60343-6
PIBN 11258337

Book-Prices Current.

ook-Prices Current:

RECORD OF THE PRICES AT WHICH BOOKS
HAVE BEEN SOLD AT AUCTION,
FROM OCTOBER, 1909, *TO JULY,* 1910,
BEING THE SEASON 1909-1910.

VOL. XXIV.

LONDON:
ELLIOT STOCK, 62, PATERNOSTER ROW, E.C.

1. 10

INTRODUCTION.

IT will be seen, on glancing at the foot of the Table of Contents to this volume of BOOK-PRICES CURRENT—the twenty-fourth of the series—that the average sum realised per "lot" of books sold during the season 1909-10 amounts to £2 9s. 1d., as against £3 11s. 10d. for the season 1908-9. This, of course, is not as satisfactory as it might be, from one and a very important point of view ; though from that of the buyer it is, no doubt, sufficiently encouraging. The fact is that the commercial value of books of almost all classes has very materially declined during the past few years, and that just lately this decline has become more than ever accentuated. The following is a complete list of the averages from the year 1893, when the system was inaugurated in the belief that, although it might not disclose any reliable result for some considerable time, it would in the end be a very useful and valuable guide to the comparative importance of each season's book sales :—

	£	s.	d.			£	s.	d.
1893	1	6	7	1902	...	3	3	4
1894	1	8	5	1903	...	3	2	10
1895	1	11	4	1904	...	2	9	3
1896	1	13	10	1905	...	2	17	2
1897	2	13	9	1906	...	2	11	3
1898	2	15	0	1907	...	4	4	2
1899	2	19	5	1908	...	2	13	1
1900	2	6	2	1909	...	3	11	10
1901	3	7	10	1910	...	2	9	1

It is obvious, therefore, upon this shewing, that the past season, the activities of which are reflected in this volume, has for one reason or another been comparatively unimportant ; and this, on a detailed analysis of the various reported sales, will be found to be the case. The curious part of the matter is that rare and expensive books have, in common with others of less interest, fallen very considerably in value as a whole. A series of instances where

CONTENTS,

Comprising a

TABLE OF THE SALES BY AUCTION REPORTED IN THIS VOLUME.

Contents.

71 Sales. Total No. of Lots, 39,428. Total Amount realised, £96,664 7s. 6d.

Average Sum realised per Lot, £2 9s. 1d.

Book-Prices Current.

[OCTOBER 7TH AND 8TH, 1909.]

PUTTICK & SIMPSON.

A MISCELLANEOUS COLLECTION.

(No. of Lots, 690 ; amount realised, £1,090 11s. 6d.)

1 Ackermann (R.) History of the Colleges of Winchester, Eton and Westminster, etc., col. plates (damaged by damp), 1816, 4to. (311) *Spencer,* £4

2 Æsop's Fables, 112 plates after Stothard and others, 2 vol., hf. cf. (titles written on), Stockdale, 1793, 8vo. (51) *Jones,* £1 8s.

3 America. Collection of Voyages and Travels (includes Lawson's Account of Carolina), maps, etc., 2 vol., old cf., 1711, 4to. (263) *H. Stevens,* £2 2s.

4 America. Map of Carolina and of the River Meschacebe "with The Prickt line from Prt Royal to the lake of Champlain as ye limits and bounds of ye English Colonies" (*c.* 1680), 4to. (262) *Sabin,* £6

5 Aspin (J.) Naval and Military Exploits, col. plates, orig. hf. mor., Leigh, 1820, 8vo. (229) *Hornstein,* £3 12s. 6d.

6 Bacon (F.) Historie of the Raigne of Henry the Seventh, first ed., port., 1622, folio (291) *Tregaskis,* £3 3s.

7 Baes (Jean). Tours et Tourelles Historiques de la Belgique, 50 aquarelles, mor. ex., orig. silk cover preserved, *Bruxelles,* n. d., folio (319) *Curtis,* £2

8 [Bayly (L.)] The Practice of Pietie, old silk binding embroidered in silver wire, 1620, 12mo. (196) *Tregaskis,* £2 5s.

9 Beardsley (Aubrey). Ben Jonson, his Volpone, LARGE PAPER, printed on Japanese vellum, 1898, 4to. (554) *Spencer,* £2 2s.

10 Beardsley (A.) A Book of Fifty Drawings, 1897—A Second Book of Fifty Drawings, 1899, together 2 vol. (555) *Maggs,* £2 16s.

11 Beardsley (A.) The Early Work of, vellum paper issue, 1899, 4to. (551) *G. Brown,* £2 18s.

12 Bewick (T.) British Birds, first ed., 2 vol., old cf., *Newcastle,* 1797-1804, 8vo. (44) *Hutchins,* £1 18s.

13 Binding. Patrick (John). The Psalms of David, in metre, old mor., gt. tooled and inlaid (back corner damaged), 1701, 8vo. (204) *Tregaskis,* £2

XXIV. I

14 Binding. Tertullian. De la Chais de Jesus Christ, mor. ex., by Derome, arms of President Lequier, 1661—Mémoires Secrets du Regne de Jean Sobieski II. de Pologne, 2 vol., cf., arms of Nicholas Lambert Seigneur de Vermont, 1699, together 3 vol., 8vo. (197) *Quaritch*, £1 8s.

15 Blake (W.) Marriage of Heaven and Hell, 27 leaves in hand-col. facsimile of the original, hf. mor. (Hotten, 1860), 4to. (537) *Hornstein*, £1 15s.

16 Blome (R.) Gentleman's Recreation, engravings, old cf., 1686, folio (317) *Ellis*, £4

17 Boccaccio (Giovanni).· Il Decamerone, engravings after Eisen and others, 5 vol., hf. mor., *Londra (Parigi)*, 1757 (43) £4 4s.

18 Borlase (W. C.) The Dolmens of Ireland, maps and illustra-tions, 3 vol., cl., 1897, imp. 8vo. (101) *Josephs*, £1 11s.

19 Borrow (George). Wild Wales, first ed., 3 vol., cl., 1862, 8vo. (216) *Hornstein*, £2 17s. 6d.

20 British Essayists. Prefaces by Jas. Ferguson, 40 vol. (wanted vol. vii. and xxxix.), mor., 1823, 8vo. (188)
 Josephs, £3 17s. 6d.

21 Brontë (Anne). The Tenant of Wildfell Hall, first ed., 3 vol., hf. bd., 1848, 8vo. (213) *Hornstein*, £1 1s.

22 Calvert (F.) The Isle of Wight Illustrated, map and col. views, orig. cl., 1846, 4to. (538) *Spencer*, £1 16s.

23 [Campbell (John)] and others. An | Advertisement | concerning the Province of | East = New = Jersey | in America | title and 22 leaves, uncut (inner margins mounted), *Edinburgh*, John Reid, 1685, sm. 4to. (261) *H. Stevens*, £206

24 Campan (Madame). Private Life of Marie Antoinette, port., 2 vol., half mor., 1883—Weber (J.) Memoirs of Maria Antoinetta, ports., 3 vol., 1806, 8vo. (186) *Zaehnsdorf*, £4 5s.

25 Casanova (J.) Mémoires, 8 vol., buckram, g. t., *Paris*, n. d., 8vo. (485) *Sotheran*, £2 7s. 6d.

26 Cervantes (M. de). Don Quixote de la Mancha, translated by Jarvis, plates by Vandergucht, 2 vol., cf., 1742, 8vo. (520)
 Hatchard, £1

27 Collection of Dresses of Different Nations, Ancient and Modern, col. plates, 2 vol., hf. mor., 1757-72, 4to. (522)
 G. Brown, £2 4s.

28 Combe (W.) Tour of Dr. Syntax in Search of the Picturesque, col. etchings by Rowlandson, first ed., hf. cf., not subject to return, 1812, 8vo. (176) *Hornstein*, £1 11s.

29 Common Prayer. Facsimile of the Original Manuscript of the Book of Common Prayer, 1661-2, vell., with brass clasps, 1891, folio (673) *Sotheran*, 18s.

30 Cosway (Maria). Progress of Female Virtue, 8 plates by A. Cardon from drawings by Mrs. Cosway, orig. bds., Acker-mann, 1800, 4to. (539) *Hornstein*, £1 17s. 6d.

31 Cruikshank (G.) Fairy Library, Hop o' my Thumb, Jack and the Beanstalk, Cinderella, Puss in Boots, first issues, orig. green covers, mounted on folio cartridge paper, Bogue, Arnold, and Routledge & Arnold, 8vo. (682) *Shepherd*, £7 5s.

32 Cruikshank (G.) George Cruikshank's Table Books, parts i., ii., iv., v., vii., viii., ix., pictorial wrappers, 1845, 8vo. (227)
Perry, £1 6s.

33 D. (G.) A Briefe Discoverie of Dr. Allen's Seditious Drifts, woodcut of St. George and the Dragon on fly-leaf, cf., *I. IV. for Francis Coldock*, 1588, 4to. (532) *Reader*, 19s.

34 Daniell (S.) African Scenery and Animals, 30 col. engravings on thick paper, titles to both parts, old hf. russ. (broken), 1804, folio (680) *G. Brown*, £21 10s.

35 Darwin (C.) Origin of Species, 1866—Descent of Man, 2 vol., 1871—Animals and Plants, 2 vol., 1875, and others, 9 vol., cl., 8vo. (36) *Maggs*, £1

36 Dawkins (W. B.) Early Man in Britain, cuts, 1880, 8vo. (129)
Sotheran, £1 15s.

37 De Smet (P. J.) Letters and Sketches, plates, cl., *Philadelphia*, 1843, 8vo. (207) *Leon*, £1 4s.

38 Dickens (Charles). Nicholas Nickleby, in the orig. 20 parts in 19, with the wrappers (wanted parts iii. to vi. and ix.), 1838-9, 8vo. (220) *Spencer*, £2 10s.

39 Dickens (C.) Oliver Twist, by "Boz," etchings by George Cruikshank (including the Fireside plate), first ed., 3 vol., orig. cl., 1838, 8vo. (172) *Spencer*, £3

40 Dickens (C.) Sergeant Bell and his Raree-Show, woodcuts, orig. cl., Tegg, 1839, 8vo. (222) *Spencer*, £2 6s.

41 Dickens (C.) Works, Household Edition, 16 vol. (should be 22), hf. cf. (1873-9), 4to. (116) *Lupton*, £1

42 D'Urfey (T.) Pills to Purge Melancholy, port., 6 vol., bds., reprint, 8vo. (399) *Hill*, £1 10s.

43 Edwards (Edwin). Outs for Inns, etchings of old Inns, 4 parts, wrappers, 1873, 4to. (301) *Reader*, £1

44 Egan (Pierce). Life in London, 36 col. etchings by G. and R. Cruikshank, mor. ex. (several leaves repaired), 1821, 8vo. (228) *Hornstein*, £5

45 Euripides. Tragœdiæ. Editio Princeps (Gr. Text), capitals illuminated, 2 vol., old mor., g. e., (wanted leaf containing anchor in each vol.), *Venet., apud Aldum*, 1503, 12mo. (68)
Payne, £3 3s.

46 Evelyn (John). Diary and Letters, by Bray and Wheatley, ports., 4 vol., cl., Bickers, 1879, 8vo. (402) *Maggs*, £1 14s.

47 Faithorne (W.) Art of Graveing and Etching, plates, old cf., 1662, 8vo. (205) *Tregaskis*, £2

48 Fitzherbert (A.) La Nouvelle Natura brevium, compose par Guilliaume Rastell, parchment, **black letter**, *London*, Rycharde Tottell, 1567, 8vo. (89) *Reader*, £1 6s.

49 Fletcher (G.) Christ's Victorie and Triumph in Heaven and Earth, mor. ex., by Pratt, *Cambridge*, 1610, 4to. (577)
Reader, £1 9s.

50 Goldsmith (Oliver). The Traveller, cf. ex., 1765, 4to. (239)
Spencer, £5

51 Grego (J.) Rowlandson the Caricaturist, 400 illustrations, 2 vol., 1880, 4to. (519) *Andrews*, £1 1s.

52 Grote (Geo.) History of Greece, 12-vol., hf. mor., 1854-56, 8vo.
(80) *Josephs,* £3
53 Harrison (F.) Annals of an Old Manor House, Sutton Place,
1893, 4to. (549) × *Winter,* £1 1s.
54 Hawker (Col.) Instructions to Young Sportsmen, third ed., col.
plates, hf. mor. ex., uncut, 1824, roy. 8vo. (99)
W. Brown, £1 8s.
55 [Hegge (Robert).] The Legend of St. Cuthbert and Anti-
quities of the Church of Durham, front., hf. mor., 1663, 12mo.
(203) *W. Brown,* £1 10s.
56 Hogarth Illustrated, by John Ireland, plates, 3 vol., mor.,
g. e., Bulmer, 1806-12, 8vo. (66) *Edwards,* £1
57 Huguenots. Histoire Memoraʒle de la Persecution et
saccagement du Peuple de Merindol et Caʒrieres, mor. ex.,
1556—Le Tocsain. Contre Les Massacreurs et Auteurs des
Confusions en France, mor. ex., together 2 vol., A. Reims,
1579, 8vo. (388) *A. R. Smith,* £2
58 Illustrated Record of Important Events in the Annals of
Europe—Concise History, etc., and The Campaign of
Waterloo, col. plates, hf. cf., Bowyer, 1815-16, folio (318)
Reader, £2 2s.
59 James I. Workes, title ʒy Elstracke, port. ʒy S. Pass, orig. cf.,
g. e., arms of James I., 1616, folio (678) *A. R. Smith,* £1 6s.
60 Jameson (Mrs.) History of Our Lord, 2 vol., 1872—Legends
of the Madonna, 1872—Monastic Orders, 1872—Sacred and
Legendary Art, 2 vol., 1874, together 6 vol., cl., 1872-4, 8vo.
(141) *Neville,* £1 11s.
61 Jesse (J. H.) Memoirs of the Court of England during the
Reign of the Stuarts, fronts., 4 vol., hf. cf., 1840—Court of
England from the Revolution to George II., fronts., 3 vol.,
1843—Life and Reign of George III., 3 vol., 1867, first eds.,
10 vol., hf. cf., not uniform, 8vo. (409) *Maggs,* £2 14s.
62 Johnson (Lionel). Poems, first ed., autograph letter of the
author inserted, uncut, 1895, 8vo. (479) *Spencer,* £1
63 La Fontaine (J. de). Contes de Nouvelles en Vers, port., 83 plates
after Eisen, tailpieces and fleurons, 2 vol. (ʒindings ʒroken),
Paris, 1792, 8vo. (42) £1 2s.
64 Lamʒ (Charles). John Woodvil, first ed., bds., 1802, 8vo. (178)
Hornstein, £8 10s.
65 Le Sage (A. R.) Histoire de Gil Blas, engravings after Smirke,
India proofs on LARGE PAPER, 4 vol., hf. mor., uncut, 1809,
4to. (266) *Hatchard,* £3 15s.
66 Lever (Charles). The O'Donoghue, the orig. 13 parts in 11,
with the wrappers, 1844, 8vo. (492) *Spencer,* £1 6s.
67 Lever (C.) The Knight of Gwynne, the orig. 20 parts in 19,
with the wrappers (one wanted), 1846-7, 8vo. (493)
Hornstein, £1 10s.
68 Lever (C.) Our Mess, parts ii. to xxxv., with wrappers, w. a. f.,
8vo. (224) *Parry,* £1 10s.
69 Lever (C.) Paul Gosslett's Confessions, first ed., cl., 1868, 8vo.
(160) *Maggs,* £1 6s.

70 Markham (Gervase). Maister-Peece of Farriery, title ɔy
Elstracke, first ed., cf. ex., 1636, 4to. (254) *G. Brown,* £1 3s.
71 Meredith (George). Diana of the Crossways, first ed., 3 vol.,
1885—The Tragic Comedians, 2 vol., 1881, cl., 8vo. (215)
Hornstein, £1 6s.
72 Meredith (G.) Rhoda Fleming, first ed., 3 vol., cl., 1865, 8vo.
(214) *Quaritch,* £1 16s.
73 Milton (John). History of Britain, first ed., port. after
Faithorne, old cf., 1670, 4to. (285) *Spencer,* £3 3s.
74 Morris (William). The Well at the World's End, bds., *Kelms-
cott Press,* 1896, 4to. (310) *Hitchman,* £1 15s.
75 Newgate Calendar (The), or Malefactor's Bloody Register,
plates, 5 vol., cf. ex., Cooke (1775), (436) *Hornstein,* £4 5s.
76 Olivier (J.) Fencing Familiarized, 8 folding plates, cf. ex.,
Harrison Ainsworth's copy, with autograph, 1771, 8vo. (433)
Hornstein, £1 11s.
77 Old English Romances (Araɔian Nights, Gulliver's Travels,
Roɔinson Crusoe, etc.), ports. and etchings ɔy Lalauze and
others, 12 vol., hf. mor., g. t., Nimmo, 1883, 8vo. (103)
Maggs, £3 5s.
78 O'Sullivan (V.) A Book of Bargains, front. ɔy Beardsley,
presentation copy with autograph inscription, 1896—Houses
of Sin, bds., designed ɔy Beardsley, 1897, 8vo. (462)
Maggs, £1 2s.
79 Pater (Walter). Plato and Platonism, 1893—Greek Studies,
1895—Miscellaneous Studies, 1895—Gaston de Latour, 1896,
first eds., together 4 vol., cl., 8vo. (459) *Dobell,* £2 8s.
80 Pater (W.) Marius The Epicurean, 2 vol., 1892—The Renais-
sance, 1893—Appreciations, 1890—Imaginary Portraits, 1901,
together 5 vol., cl., 8vo. (458) *Dobell,* £1 12s.
81 Pater (W.) Imaginary Portraits, autograph letter from the
author inserted, 1890, 8vo. (457) *Sotheran,* £2 4s.
82 Pepys (S.) Diary and Correspondence, ɔy Lord Brayɔrooke,
ports., 6 vol., cf. ex., Bickers, 1876-9, 8vo. (125)
G. Brown, £2 15s.
83 Petronius (Titus). Satyricon, mor., g. l., *Paris,* 1902, 8vo. (53)
Edwards, £1 1s.
84 Plain and Pleasant Rode for the Latin Scholar, hf. cf., 1687—
Northbrooke (John). The Poore Mans Garden, wherein are
Flowers from the Scripture, 𝔟𝔩𝔞𝔠𝔨 𝔩𝔢𝔱𝔱𝔢𝔯, orig. vell., together
2 vol., *London,* John Charlewood (*c.* 1593), 8vo. (387)
Reader, £1 3s.
85 Pope (A.) Rape of the Lock, 9 illustrations ɔy Beardsley, vell.
copy, 1896, 4to. (552) *Jack,* £5
86 Prentice (A. N.) Renaissance Architecture and Ornament in
Spain, 60 plates, Batsford, 1893, folio (670)
Parsons, £5 2s. 6d.
87 Raɔelais (F.) Les Œuvres, translated ɔy Urquhart and
Motteux, illustrations ɔy Chalon, 2 vol., Lawrence and Bulleɒ,
1892, 4to. (550) *Hatchard,* 18s.
88 Registrum Honoris de Richmond Exhibens Terrarum et Villa-
rum, etc., ex liɔro Domesday, pedigrees, etc., cf., 1722, folio
(295) *Daniell,* £1 3s.

89 Rossetti (D. G.) Collected Works, 2 vol., cl. ex., 1886, 8vo.
(448) *Rimell, £1 1s.*
90 Rows (John). "This Rol was labur'd and finished ɔy Master
John Rows, of Warrewyk," illuminated from the orig., and
ed. ɔy W. Courthorpe, hf. mor., g. t., 1845, folio (679)
 Harding, £1 12s.
91 Ruskin (John). Examples of the Architecture of Venice, 16
plates, hf. mor., g. e., 1851, 4to. (305) *Doolan, £4*
92 Savoy (The), an Illustrated Quarterly, vol. i., hf. mor., first issue
with extra wrapper, 1895-7, also duplicate No. i., 1896, 4to.
(556) *G. Brown, £1*
93 Scott (T.) Vox Populi (1620), Vox Dei (1624), Vox Regis
(1624), Digitus Dei (n. d.), The Belgicke Pismire (1622),
and other tracts, two with curious fronts., old cf., not suɔject
to return, 4to. (270) *Harding, £1 2s.*
[The Vox Regis has the rare front of King James enthroned
surrounded ɔy the Bishops, Peers and Commons.—*Cata-
logue.*]
94 Seɔright (Sir J. S.) Oɔservations upon Hawking, hf. cf. ex.,
Wright, Haymarket, 1826, 8vo. (192) *Tregaskis, £1 4s.*
95 Seneca (L. A.) Opera Omnia, lit. 𝔤𝔬𝔱𝔥., long lines, with sigs.,
207 folios, painted capitals, mod. cf., Bernardin de Colonia,
1478, folio (312) *Pearson, £5 5s.*
96 Shakespeare (W.) Poems, vell. tie, uncut, *Kelmscott Press,* 1893,
8vo. (39) *Edwards, £2 5s.*
97 Shepard (T.) The | Clear sun-shine of the Gospel | Breaking
forth | upon the | Indians | in New England, unbd., *London,
R. Coles for John Bellamy,* 1648, 4to. (260) *H. Stevens, £10*
98 Shepheard's Kalendar, The, 𝔟𝔩𝔞𝔠𝔨 𝔩𝔢𝔱𝔱𝔢𝔯 (fragment, sigs. B. to
M.), woodcuts (Julian Notary, 1515-20?), folio (326)
 Curtis, £2 2s.
99 Smirke (Miss). Views in Wales, 6 col. aquatints, orig. wrappers
with laɔel, Bowyer (1800), folio (681) *Spencer, £2 15s.*
100 Smith (Sir Wm.) Greek and Roman Geography, cuts, 2 vol.,
1854—Roman Antiquities, cuts, 1873, together 3 vol., cf. ex.,
8vo. (127) *Tucker, £1 1s.*
101 Spenser (Edm.) The Faerie Queene, and other works, wood-
cuts, cf. ex., *H. L. for Mathew Lownes,* 1611, folio (313)
 Dobell, £3 15s.
102 Spencer (Herɔert). Works, including First Principles—
Sociology, 3 vol.—Biology, 2 vol.—Psychology, 2 vol.—
Social Statics—Ethics, 3 vol.—Essays, 3 vol.—Education—
Political Institutes, together 17 vol., cl., 1870, etc., 8vo. (34)
 Cohen, £3 5s.
103 Sterne (Laurence). Tristram Shandy, vol. i. and ii. second
ed., vol. iii. to ix. first ed., 9 vol., cf. ex., 1760-67, 8vo. (515)
 Hornstein, £2 12s.
104 Sterne (Laurence). A Sentimental Journey, first ed., with
half titles, 2 vol., cf., ɔy Zaehnsdorf, 1768, 8vo. (516)
 Hornstein, £3 15s.
105 Swinburne (A. C.) William Blake, first ed., illustrations (col.
and plain), orig. cl., 1868 (230) *Hatchard, £2 10s.*

106 Symonds (J. A.) A Problem in Modern Ethics (No. i. of 100 copies), 1896, 8vo. (461) *Jennings,* £1 5s.
107 Symons (A.) Days and Nights, first ed., autograph letter of author inserted, orig. cl. (1889), 8vo. (451) *Josephs,* 18s.
108 Symons (A.) London Nights, first ed., presentation copy, with autograph inscription, orig. cl. (1895), 8vo. (450) *Josephs,* £1
109 Temple Shakespeare (The), fronts., etc., 28 vol., mor., Dent, 1894, 8vo. (420) *Tucker,* £1 13s.
110 Temple Classics (The), 28 vol., various, mor., Dent, 1897, 8vo. (421) *Tucker,* £1 10s.
111 Thackeray (W. M.) Flore et Zéphyr, complete set of the 8 tinted plates and vignette from cover, all cut out and mounted on folio paper, 1836 (683) *Robson,* £59
112 Thackeray (W. M.) Mrs. Perkins Ball, orig. pink bds., g. e., back unbroken, 1847, 8vo. (226) *Shepherd,* £1 6s.
113 Thackeray (W. M.) Vanity Fair, parts iv., v., vii., viii., in the correctly numbered and dated yellow wrappers, fine state, 1847, 8vo. (225) *Hornstein,* £5 7s. 6d.
114 Tyburn Chronicle (The), or Villany Display'd, plates, 4 vol., cf. ex., Cooke (1768), 8vo. (438) *Hornstein,* £3 17s. 6d.
115 Van Dyck (Sir A.) Icones Principum Virorum Doctorum, etc., title and 107 ports. (mounted), cf. (1649), 4to. (303) *Daniell,* £3 15s.
[The portraits had the address of Vanden Enden, and were, therefore, in a late state.—ED.]
116 White (J.) Journal of a Voyage to New South Wales, 65 col. plates, uncut, unbd., 1790, 4to. (542) *G. Brown,* £1 2s.
117 Whitman (Walt). Leaves of Grass, ports., author's edition, with autograph signature, orig. hf. sheep, 1876, 8vo. (210) *Rimell,* £1 1s.
118 Wilde (Oscar). Intentions, first ed., cl., 1891, 8vo. (474) *Quaritch,* £1 8s.
119 Wilde (O.) An Ideal Husband, first ed., presentation copy with inscription, orig. cl., 1899, 8vo. (475) *Jackes,* £5 10s.
120 Wilde (O.) Lady Windermere's Fan, first ed., 1893, 4to. (560) *Edwards,* £3 10s.
121 Wilde (O.) A Woman of No Importance, first ed., 1894, 4to. (561) *Shepherd,* £1 19s.
122 Wilde (O.) Ballad of Reading Gaol, first ed., presentation copy with inscription, orig. bds., 1898, 8vo. (472) *Jackes,* £5 15s.
123 Wilde (O.) A House of Pomegranates, 558 designs by Shannon and Ricketts, 1891, 4to. (558) *Winter,* £2 15s.
124 Wilde (O.) Lord Arthur Savile's Crime, first ed., bds., 1891, 8vo. (476) *Spencer,* 17s.
125 Wilde (O.) Salomé, first ed., *Londres,* 1893, 8vo. (469) *Maggs,* £1 2s.
126 Wilde (O.) A Woman of No Importance, first ed., orig. cl., 1894, 8vo. (233) *G. Brown,* £1 18s.
127 Willughby (Francis). Ornithology, by John Ray, plates, cf., 1678, folio (293) *Quaritch,* £1 12s.

128 Wilkinson (G. T.) Newgate Calendar Improved, plates, 5 vol., cf. ex., Kelly, 1790, 8vo. (437) *Hornstein*, £4 7s. 6d.
129 Winthrop (John), Saltonstall (R.), and others. The Humble Request of his Maiesties loyall suᵇjects, the Governour and the Company late gone for New England, to the rest of their Brethren in and of the Church of England, 10 pages, unbd., title practically uncut, *London*, John Bellamie, 1630, sm. 4to. (259) *H. Stevens,* £114
130 Wirtzung (C.) General Practise of Physicke, ᵇy Jacoᵇ Mosan, **black letter**, old cf., 1605, folio (323) *Ellis,* £1 6s.
131 Wood (Anthony à). Athenæ Oxonienses, 4 vol., cf., 1813-20 (565) *Harding,* £2
132 Yule (Col. H.) Cathay and the Way Thither, a Collection of Medieval Notices of Chiᵑa, 2 vol., hf. mor., g. t., *Hakluyt Society*, 1866, 8vo. (82) *W. Brown,* £6

[October 12th and three following days, 1909.]

HODGSON & CO.

A Miscellaneous Collection.

(No. of Lots, 1311 ; amount realised, aᵇout £900.)

133 Alcuin Cluᵇ Collections, ed. ᵇy W. H. Frere, Dearmer, Eeles, Lomas, Craiᵇ, etc., plates, Nos. i. to ix. and xii., atlas 4to. and 8vo., 1899-1908, and Tracts, Nos. i. to iv. and vi. to viii., in 8 parts, 1897-1908, 8vo. (556) *Baker,* £5 7s. 6d.
134 Allen's Naturalist's Liᵇrary, ed. ᵇy Bowdler Sharpe, col. plates, 16 vol., 1896, 8vo. (260) *Cohen,* 17s.
135 Alpine Cluᵇ Journal (The), ed. by H. B. George, plates, first 3 vol., cl., 1864-7, 8vo. (565) £3 10s.
136 Ante-Nicene Christian Liᵇrary, ed. ᵇy Roᵇerts and Donaldson, 24 vol., 1867-72, 8vo. (718) *Bull,* £1 19s.
137 Antiquary (The), ed. ᵇy Walford and others, illustrations, vol. i. to xliv., hf. roan, t. e. g., 1880-1908, sm. 4to. (397) *Grant,* £3 3s.
138 [Apperley (C. J.)] Memoirs of John Mytton, second ed., 18 plates ᵇy Alken and Rawlins, mor. ex., R. Ackermann, 1837, 8vo. (544) *Godfrey,* £4 12s. 6d.
139 Archæologia, or Miscellaneous Tracts relating to Antiquity, Second Series, plates (some col.), vol. lvi., part ii. to vol. lx., with Index to the first 50 vol., 10 vol., cl., 1899-1907, 4to. (284) *Sotheran,* £2 16s.
140 Archæologia Cambrensis, plates, 4 vol.—New Series, vol. i. to iv., 8 vol., hf. mor. and cl., 1846-53, 8vo. (769) £1 14s.
141 Archæologia Cantiana, folding and other plates (some col.), vol. i. to ix., cl., 1858-74, 8vo. (766) *Walford,* £2 11s.

142 Arnold (Matthew). Works, ɔy G. W. E. Russell, édition de luxe, port. on Japan paper, 15 vol., art cl., 1903-4, 8vo. (539)
£4 10s.

143 Ayr and Wigton. Archæological and Historical Collections, relating to the Counties of Ayr and Wigton, plates and facs., 6 vol., cl., 1868-84, 4to. (580) *Bailey*, 14s.

144 Bacon (F.) Works, Liɔrary ed., port. ɔy Fittler, 10 vol., old cf., 1819, 8vo. (110) *Sotheran*, 15s.

145 Badger (G. P.) English-Araɔic Lexicon, cl., 1881, 4to. (613)
Grant, £1 1s.

146 Baillie (R.) Letters and Journals, ed. ɔy David Laing, 3 vol., cl., *Edinburgh*, 1841-2, roy. 8vo. (400) £1 11s.

147 Ballooning. Three Last Aerial Voyages made ɔy M. Garnerin, col. front., 1802—Aeronautica, or Voyages in the Air, col. front., n. d.—Aerostatics, or a History of Balloons, 1802, 8vo. (545) *Spencer*, £1 16s.

148 Barry (G.) History of the Orkney Islands, second ed., map and plates, hf. bd., 1808, 4to. (602) 11s.

149 Beardsley (Auɔrey). The Early Work of Auɔrey Beardsley, 157 plates, ɔuckram, t. e. g., 1899, 4to. (540)
G. H. Brown, £2

150 Beardsley (A.) The Story of Venus and Tannhäuser, Japanese vell. ed. (limited to 50 copies), cl., *Privately printed*, 1907, 4to. (541) 12s.

151 Bengal Monthly Sporting Magazine and Bengal Register, ed. ɔy J. H. Stocqueler, vol. i. to xviii., hf. cf., 1833-42—The India Sporting Review, vol. i. to xx., the first 16 hf. cf., and the last 4 in 8 parts, 1845-54, plates (some col.), and col. plans of race-courses, etc., together 38 vol. (sold as usual not suɔject to return), *Calcutta*, 1833-54, 8vo. (1176) £16

152 Bewick (T.) British Birds, 2 vol., 1816—Quadrupeds, 1820, together 3 vol., cf., 8vo. (127) *G. H. Brown*, £1 5s.

153 Borrow (G.) Lavengro, port., first ed., 3 vol., 1851—Romany Rye, 2 vol., 1858, together 5 vol., cl., 8vo. (47)
Austin, £2 5s.

154 Boulger (D. C.) History of China, ports., 3 vol., cl., 1881-4, 8vo. (231) *E. J. Dent*, £2 6s.

155 Boydell's Graphic Illustrations of the Plays of Shakespeare, 96 plates, old mor. ex., g. e., 1798, folio (618) *Maggs*, £2 10s.

156 Brain, a Journal of Neurology, plates, Nos. i. to xxxvii. (xiii., xiv., xviii. and xxxi. missing), 1878-86, 8vo. (267)
Bailey, £5 12s. 6d.

157 Brewer (J. S.) Reign of Henry VIII., ed. ɔy James Gairdner, port., 2 vol., cl., 1884, 8vo. (552) *Chapman*, £3 2s. 6d.

158 British Association for the Advancement of Science. Reports, from the commencement in 1831 to 1907, with Index from 1831 to 1860, 77 vol., first 23 vol. and Index hf. cf., 12 vol. bds., remaining 41 vol. orig. cl., 8vo. (9) £5 15s.

159 British Classics, Sharpe's ed., plates after Stothard, 24 vol., hf. cf. gt., 1804, etc., 8vo. (65) *Jackes*, £4 2s. 6d.

160 British Poets, Bell's ed., ports., 105 vol. (should be 109), old cf., *Edinburgh*, 1777-92, 8vo. (64) *Maggs*, £1 14s.

161 Britton (J.) Architectural Antiquities of Great Britain, LARGE
PAPER, plates (foxed and binding broken), 5 vol., cf., g. e.,
1807-26, 4to. (601) £1 5s.
162 Britton and Brayley. Beauties of England and Wales, 19 vol.
in 26, old hf. russ., uncut, 1801-18, 8vo. (768) £1 7s.
163 Brontë (The Sisters). Life and Works, illustrated ed., 7 vol.,
cl., 1876-87, 8vo. (534) 10s. 6d.
164 Buckingham (Duke of). Memoirs of the Courts of the Regency,
George IV., William IV. and Victoria, ports., 6 vol., cl.,
1856-61, 8vo. (169) *Chapman*, £2 3s.
165 Burnet (G.) History of the Reformation, best ed., 7 vol., cl.,
Oxford, 1865, 8vo. (249) *Harding*, £1 2s.
166 Burke (Sir J. B.) Vicissitudes of Families, 3 vol., cl., 1860-63,
8vo. (434) 11s.
167 Burns (R.) Works, by Currie and Cromek, ports. and plates
after Stothard, 5 vol., cf. gt., 1817-20, 8vo. (121)
Edwards, £1 10s.
168 [Burton (R.)] Anatomy of Melancholy, front., 3 vol., cl.,
Nimmo, 1893, 8vo. (209) *Joseph*, 16s.
169 Byron (Lord). Poetical Works, Library ed., port., 6 vol., cl.,
1855, 8vo. (122) *G. H. Brown*, 17s.
170 Camden Society. Publications, First Series, complete, 105
vol.—Second Series, first 6 vol. and 2 various vol.—Third
Series, vol. 6 and 9 to 16, together 122 vol., orig. cl., 1838-
1909, sm. 4to. (554) *Harding*, £14 5s.
171 Carlyle (T.) Works, People's ed., with Index, 37 vol., cl.,
Chapman and Hall, n. d., 8vo. (684) 17s.
172 Cassell's History of England, Special ed., plates (some col.),
8 vol., cl., n. d., 8vo. (151) *Cohen*, 10s.
173 Caulfield (J.) Memoirs of Remarkable Persons, 4 vol., hf.
mor., uncut, 1819-20, 8vo. (219) *Edwards*, £1 9s.
174 Cervantes (M.) Don Quixote, by Jarvis, plates by Vander
Gutch, 2 vol. (title of vol. ii. in fac.), old russ., 1742, 4to. (276)
Bailey, 11s.
175 Collection des Auteurs Latins, Pétrone, Apulée, Aulu-Gelle,
Macrobe, Varron, etc., 6 vol., hf. vell., *Paris*, 1843-53, 8vo.
(194) *Hill & Son*, £1 1s.
176 Connolly (T. W. J.) History of the Royal Sappers and
Miners, 17 col. plates, 2 vol., cl., 1855, 8vo. (517) 7s.
177 Cooper (J. F.) Novels, fronts., 24 vol., hf. cf., 1858-62, 8vo.
(535) *Jebbutt*, 14s.
178 Costume of the Russian Empire, 70 col. plates, with Descrip-
tions, cf., 1803, 4to. (295) *Bull*, 13s.
179 Couch (J.) Fishes of the British Islands, col. plates, 4 vol.,
cl., 1877-8, roy. 8vo. (524) *Hill*, £2 4s.
180 Creighton (M.) History of the Papacy, 6 vol., cl., 1897, crown
8vo. (849) 19s.
181 Cricket. Felix on the Bat, first ed., col. plates, cl., 1845,
sm. 4to. (80) *Edwards*, 18s.
182 Cumberland (R.) British Theatre, ports. and woodcuts, 35
vol. (should be 39), old cf., 1823-31, 8vo. (63) £2 10s.

183 Dickens (C.) Works, Gadshill ed., ɔy Andrew Lang, illustra-
tions, 34 vol., hf. mor., t. e. g., contents lettered, 1897-99, 8vo.
(537) £9
184 Dolɔy (A.) Church Embroidery, col. front. and plates, cl.,
1867, 8vo. (547) 19s.
185 Dufour (Pierre). Histoire de la Prostitution, fronts., 6 vol.,
hf. bd., *Paris*, 1851-3, 8vo. (549) £1 5s.
186 Duruy (Victor). History of Rome, ed. ɔy J. P. Mahaffy, col.
plates, cuts and maps, 6 vol., cl., 1883-86, imp. 8vo. (188)
 Sotheran, £3 3s.
187 Edgeworth (M.) Works, illustrations, 6 vol., cl., g. e., 1896,
8vo. (533) 12s.
188 Eliot (George). Silas Marner, 1861—Felix Holt, 3 vol., 1866,
first eds., 6 vol., cl., 8vo. (567) *Beazley*, £1
189 Eliot (G.) Middlemarch, 4 vol., 1871-2—Theophrastus Such,
1879, first eds., 5 vol., hf. mor., t. e. g., 8vo. (568) *Thorp*, 17s.
190 Evelyn (J.) Memoirs, ed. ɔy W. Bray, ports., 5 vol., cl., 1827,
8vo. (159) £1 7s.
191 Ewald (H.) History of Israel, 8 vol., cl., 1869-86, 8vo. (847)
 £1 6s.
192 Fauna of British India (The), ed. ɔy W. T. Blanford and C. T.
Bingham, illustrations (some col.), 22 vol., cl., and 4 parts
sewn, 1888-1908, 8vo. (14) £13
193 Fielding (H.) Works, ɔy Murphy, port., Liɔrary ed., 10 vol.,
cf. (ɔroken), 1821, 8vo. (211) *Bain*, £3 6s.
194 Forɔes (E.) and Hanley (S.) History of British Mollusca,
col. plates, 4 vol., cl., 1853, 8vo. (562) *Wesley*, £3
195 Freeman (E. A.) History of Sicily from the Earliest Times,
maps, 2 vol., cl., 1891-94, 8vo. (184) 15s.
196 Freeman (E. A.) Norman Couquest of England (no Index),
5 vol., cl., *Oxford*, 1867-76, 8vo. (155) *Beazley*, £3 12s. 6d.
197 Ford (R.) Hand-Book of Spain, first ed., map in pocket, 2
vol., orig. cl., 1845, 8vo. (134) £1 2s.
198 Froude (J. A.) History of England from the Fall of Wolsey
to the Defeat of the Armada, Caɔinet ed., 12 vol., hf. cf. gt.,
1870, 8vo. (156) *Hill & Son*, £1 7s.
199 Froude (J. A.) History of England, Caɔinet ed., 12 vol., cl.,
1897, 8vo. (683) £1
200 Froude (J. A.) The English in Ireland, Liɔrary ed., 3 vol., hf.
cf., 1872-4, 8vo. (157) *Cohen*, 15s.
201 Fyffe (C. A.) History of Modern Europe, maps and plates,
3 vol., cl., 1891, 8vo. (177) *Edwards*, 17s.
202 Gardiner (S. R.) History of the Commonwealth and Pro-
tectorate, 3 vol., cl. (soiled), 1894-1903, 8vo. (96)
 Sotheran, £1 6s.
203 Giɔɔon (E.) Decline and Fall of the Roman Empire, port.
and maps, 8 vol., cl., 1862, 8vo. (190) *Edwards*, £1 4s.
204 Giɔɔon (E.) Decline and Fall of the Roman Empire, maps,
7 vol., cl., 1896-1900, 8vo. (844) £1 4s.
205 Gerarde (J.) Herball, ɔy T. Johnson, engraved title ɔy Payne,
and woodcuts, with the leaf of Errata (the margin repaired),
old cf., 1633, folio (301) *Edwards*, £4 2s. 6d.

206 Gorham (G. C.) History and Antiquities of Eynesbury and
St. Neots in Huntingdonshire, and St. Neots, ·Cornwall,
plates, cf., 1820, 8vo. (559) *Walford,* 16s.
207 Green (J. R.) History of the English People, maps, 4 vol.,
cl., 1877-80, 8vo. (854) £1 8s.
208 Green (J. R.) History of the English People, illustrations
(some col.), 4 vol., cl., 1892-4, roy. 8vo. (154) £1 15s.
209 Green (J. R.) History of the English People, maps, 8 vol.,
cl., 1895-6, cr. 8vo. (518) *Hill & Son,* 18s.
210 Greville (C. C. F.) Journal of the Reigns of King George IV.,
William IV. and. Queen Victoria, first eds., 8 vol., cl.,
1874-87, 8vo. (432) *Maggs,* £4
211 Greville (C. C. F.) Journal of the Reigns of King George IV.
and William IV., ed. by H. Reeve, 3 vol., cl., 1875, 8vo.
(553) *Bailey,* 14s.
212 Greville (C. C. F.) Journals of the Reign of George IV.,
William IV. and Victoria, Library ed., 8 vol., first 3 vol. hf.
cf., remainder cl., 1875-87, 8vo. (168) *Edwards,* £2 10s.
213 Grote (G.) History of Greece, Library ed., port. and maps,
12 vol. (cloth worn and margins of vol. vii. ink stained),
1854-6, 8vo. (738) *Walford,* £2
214 Grote (G.) History of Greece, Library ed., port., maps and
plans, 8 vol., cf. gt., 1862, 8vo. (181) *Hornstein,* £2 6s.
215 Grote (G.) Plato and the other Companions of Sokrates, 3
vol., cl., with Index, hf. bd., 1865-70 (838) 13s.
216 Hallam (H.). Works, Library ed., 9 vol., old cf., 1853-4, 8vo.
(173) *Edwards,* 10s.
217 Hazlitt (W.) Life of Napoleon, fronts. and vignette titles, 4
vol., cl., 1852, 8vo. (514) *Edwards,* 12s.
218 Helps (A.) The Spanish Conquest in America, Library ed.,
4 vol., cl., 1855-61, 8vo. (226) *Harding,* £1 5s.
219 Henry Bradshaw Society. Publications, fac. illustrations, 36
vol., orig. cl., a complete set, 1891-1909, 8vo. and 4to. (555)
Hill & Son, £16
220 Herodotus. History of Herodotus, trans. by G. Rawlinson,
maps and illustrations, 4 vol., cf. gt., 1862, 8vo. (839) £2 5s.
221 Howard (F.) Spirit of the plays of Shakespeare, LARGE
PAPER, outline plates on India paper, 5 vol., hf. mor., g. e.,
1833, 4to. (600) £3
222 Howorth (H. H.) History of the Mongols, maps, 4 vol., cl.,
1876-88, roy. 8vo. (896) *Quaritch,* £6 6s.
223 Hume (D.) History of England, Bowyer's ed., engravings,
10. vol., hf. bd., 1806, imp. folio (300) 15s.
224 Huxley (T. H.) Collected Essays, 9 vol., cl., *Eversley Series,*
1894, 8vo. (248) *Winter,* £1
225 [Imray (M. le C. d')] Bibliographie des Ouvrages relatifs à
l'Amour, LARGE PAPER (limited to 50 copies), 6 vol., hf. mor.,
Turin, etc., 1871-3, 8vo. (550) £3
226 James (W.) Naval History of Great Britain, ports., 6 vol., hf.
cf., 1837, 8vo. (516) *Jebbett,* 13s.
227 Jerrold (B.) Life of Napoleon III., ports. and facs., 4 vol., cl.,
1874-82, 8vo. (515) *Chapman,* £2 6s.

228 Jesse (J. H.) George Selwyn and his Contemporaries, ports., 4 vol., cl., Bickers, 1882, 8vo. (433) *Edwards*, £1 2s.
229 Jesse (J. H.) London, its celebrated characters, first ed., fronts., 3 vol., cl., 1871, 8vo. (399) *Joseph*, £2
230 Jesse (J. H.) Reign of George III., second ed., 3 vol., cf. gt., 1867, 8vo. (165) 14s.
231 Jewish Historical Society. Transactions, vol. i. to v., Ben Israel's Mission to Cromwell—Select Pleas from the Exchequer Rolls, etc., 8 vol., sewed, 1895-1908, sm. 4to. (429) *Walford*, £1 14s.
232 Johnson (S.) Works, port., 12 vol., 1823—Life by Boswell, port. and fac., 4 vol., 1824, together 16 vol., cf. gt., 8vo. (111) *Hunt*, £2 10s.
233 Johnson (S.) Works, 9 vol., old cf., *Oxford*, W. Pickering 1825, 8vo. (213) *G. H. Brown*, £1 13s.
234 Johnson (T.) Illustrations of British Hawk Moths (including the Sesidæ), 36 orig. drawings by the author, with descriptive letterpress (one of 11 copies), hf. mor., *Privately printed*, 1874, roy. 8vo. (812) £1 10s.
235 Jowett (B.) Dialogues of Plato, 5 vol., cl., *Clarendon Press*, 1875, 8vo. (837) £2 5s.
236 Julian (J.) Dictionary of Hymnology, buckram, 1892, roy. 8vo. (710) 14s.
237 [Keble (J.)] The Christian Year, first ed., 2 vol., old cf., g. e., *Oxford*, 1827, 8vo. (77) *Sotheran*, £1 10s.
238 Kelmscott Press. Shakespeare's Poems, ed. by F. S. Ellis, vell. ties, 1893, 4to. (543) *Hatchard*, £3 15s.
239 Landseer (Sir E.) Works, Second Series, Library ed., 100 India proof engravings, mor. ex., Graves & Co., n. d., roy. folio (278) £1 10s.
240 Lange (J. P.) Commentary on the Scriptures, ed. by Schaff, 25 vol. (wanted Old Testament, vol. ii., but had the Apocrypha), 24 vol., Clark, *Edinb.*, 1868-74, roy. 8vo. (716) *Higham*, £2 11s.
241 Larousse (P.) Grand Dictionnaire Universel du XIX. Siècle, avec Supplément, 16 vol., *Paris*, 1866-78, 4to. (614) *Sotheran*, £5 15s.
242 Le Maout (E.) and Decaisne (J.) Descriptive and Analytical Botany, by Hooker, illustrations, cl., 1876, sm. 4to. (801) £1 4s.
243 Lecky (W. E. H.) History of England, Cabinet ed., 7 vol., cl., 1892, 8vo. (162) *G. H. Brown*, 19s.
244 Lecky (W. E. H.) History of Ireland, Cabinet ed., 5 vol., cl., 1892, 8vo. (163) *G. H. Brown*, 16s.
245 Le Sage (A. R.) Gil Blas, plates by Smirke, 4 vol., hf. cf., 1822, 8vo. (123) *G. H. Brown*, £1 1s.
246 Lessing (G. E.) Sämmtliche Schriften; herausgegeben von Lachmann und Maltzahn, port., 12 vol., cf., *Leipzig*, 1853-7, 8vo. (808) *Hill & Son*, £1 19s.
247 Linnean Society. Journal : Botany, Nos. 260 to 269—Zoology, Nos. 194 to 198 and 203 to 205. Transactions, Second Series : Botany, vol. vii., parts iv. and v.—Zoology, vol. ix.,

parts v. to xiv. ; vol. x., part iv. ; vol. xii., parts i. and ii.
Proceedings, 117th to the 120th Session, plates, 36 parts,
1905-9, 8vo. (24) *Quaritch,* £1 6s.
248 Lismore Papers. Selections from the Correspondence of the
Earl of Cork, ed. ɔy A. B. Grosart, vol. iii. to v., cl., *For*⁄
private circulation, 1888, 8vo. (106) *Reeves,* 19s.
249 Littré (E.) Dictionnaire de la Langue Française, avec Supple-
ment, 5 vol., hf. mor., *Paris,* 1882-3, roy. 4to. (830)
 Hill, £2 6s.
250 Locke (J.) Works, Liɔrary ed., 10 vol., old cf., 1823, 8vo. (243)
 Barnard, £1 6s.
251 Locke (J.) Works, Liɔrary ed., port., 9 vol., cf. gt., *Trade,*
1824, 8vo. (109) *Edwards,* £1 9s.
252 Lodge (E.) Portraits of Illustrious Personages, Caɔinet ed.,
8 vol., cl., W. Smith, n. d., 8vo. (513) *Jebbett,* 18s.
253 Lowe (E. J.) Ferns, British and Exotic, col. plates, 8 vol., hf.
mor., 1856-60, 8vo. (263) £1 8s.
254 Lübke (Dr. W.) History of Art and Sculpture, illustrations,
4 vol., cl., t. e. g., 1874-72, roy. 8vo. (83) *Sotheran,* £1 6s.
255 Lydekker (R.) Royal Natural History, illustrations (some
col.), 6 vol., hf. mor., t. e. g., 1894-6, roy. 8vo. (815)
 Edwards, £2 4s.
256 Macaulay (Lord). History of England, 8 vol.—Essays, 4 vol.
—Life, ɔy Trevelyan, 2 vol., together 14 vol., cl., 1869-80,
cr. 8vo. (519) 15s.
257 Mahaffy (J. P.) Greek Life and Thought, 1887—Ramɔles and
Studies in Greece, plates, cl., 1887, 8vo. (187) *Beazley,* 16s.
258 Malcolm (Sir J.) History of Persia, map and plates, 2 vol.,
cf., 1815, roy. 4to. (271) *Bailey,* 15s.
259 Manship (H.) History of Great Yarmouth, with Continuation
ɔy Palmer, plates, 2 vol., 1854-6, sm. 4to. (762) 10s. 6d.
260 Manx Society. Puɔlications, vol. i. to xxiii., xxv., xxvii., xxviii.
and xxx., 27 vol., cl., Douglas, 1859-80, 8vo. (94)
 Walford, £3 12s. 6d.
261 Max Müller (F.) Chips from a German Workshop, Liɔrary
cd., 4 vol., cl., 1867-75, 8vo. (228) *H. Last,* 12s.
262 Mazzini (J.) Life and Writings, port., 6 vol., 1864—Memoir,
ɔy E. A. V., ports., 1864-75, 8vo. (224) *Harding,* 19s.
263 Mermaid Series of Old Dramatists, ed. ɔy H. Ellis, Marlowe,
Massinger, Ford, Wycherley, Congreve, Dekker, etc., 17
vol., Vizetelly, 1887, etc., 8vo. (376) *Shepherd,* £1 13s.
264 Meyrick (Sir S. R.) Costume of the British Islands, 24 col.
plates (ɔinding ɔroken), 1815, folio (623) *Barnard,* £1 2s.
265 Michelet (J.) Histoire de la Révolution Française, 7 vol., cf.
gt., *Paris,* 1847-53, 8vo. (862) *Hill & Son,* 16s.
266 Milman (H. H.) History of Latin Christianity, 6 vol., cf. gt.,
1857, 8vo. (848) 17s.
267 Molière (J. B. P.) Œuvres Complètes, par L. Moland, port.
and plates, 7 vol., hf cf., *Paris,* 1863-4, 8vo. (872) £1 3s.
268 Mommsen (T.) History of Rome, ɔy W. P. Dickson, Liɔrary
ed., 4 vol., cf. gt., 1868, 8vo. (189) *Hill & Son,* £4 15s.

269 Morley (J.) Rousseau--Diderot and the Encyclopædists, first
　　eds., 4 vol., cl., 1873-8, 8vo. (886)　　*Barnard,* £1 6s.
270 Morris (F. O.) British Birds, col. plates, 6 vol., cl., 1870, roy.
　　8vo. (255)　　*Beazley,* £2 6s.
271 Morris (F. O.) Nests and Eggs of British Birds, 3 vol., cl.,
　　1875, roy. 8vo. (256)　　*Beazley,* £1 4s.
272 Morris (F. O.) British Moths, col. plates, 4 vol., cl., 1872, roy.
　　8vo. (257)　　*Beazley,* £1 4s.
273 Motley (J. L.) History of the United Netherlands, ports.,
　　4 vol., 1868—Rise of the Dutch Republic, 3 vol., 1875—John
　　of Barneveld, cuts, first ed., 2 vol., 1874, together 9 vol., hf.
　　cf. gt., 8vo. (174)　　*Maggs,* £3 12s. 6d.
274 Motley (J. L.) Rise of the Dutch Republic, Library ed., 3
　　vol., cl., 1864, 8vo. (175)　　£1 6s.
275 Musée Français, avec l'Explications par S. C. Croze-Magnan,
　　etc., engravings, 4 vol., hf. russ., *Paris,* 1803-9, atlas folio
　　(616)　　£2 17s. 6d.
276 Napier (W. F. P.) History of the Peninsular War, Library
　　ed., plans, 6 vol., hf. cf., 1828-40, 8vo. (171)　　£1 9s.
277 Neale (J. P.) History and Antiquities of Westminster Abbey,
　　LARGE PAPER, 2 vol., extended to 3 vol. by the insertion of
　　Harding's series of proof ports. of the Deans, plates from
　　Dart's ed., and other extra illustrations, bds., uncut, 1818-23,
　　folio (619)　　*Thorp,* £2 6s.
278 Nolhac (Pierre de). Marie Antoinette, the Dauphine, col.
　　port. and other illustrations, buckram, t. e. g., Goupil & Co.
　　[1897], 4to. (598)　　*W. Brown,* £2 5s.
279 Nolhac (Pierre de). Marie Antoinette, the Queen, col. port.
　　and other illustrations, buckram, t. e. g. [1898], 4to. (599)
　　　　W. Brown, £2 5s.
280 Obstetrical Society. Transactions, plates, vol. xvii. to xlix.
　　(wanted xxxviii. and xlviii.), 31 vol., cl., 1875-1907, 8vo. (268)
　　　　Sotheran, 10s.
281 O'Donovan (J.) Annals of the Kingdom of Ireland, 3 vol. (no
　　Index), cl., 1848, 4to. (582)　　£3 3s.
282 Palæographical Society. Facsimiles of Ancient Manuscripts,
　　autotype plates, First Series, 13 parts (wanted text to plate
　　clxx.), and Second Series, parts i. to vi., 1873-89, folio (622)
　　　　Barnard, £6
283 Palestine Exploration Fund. Quarterly Statements, from the
　　commencement in 1869 to 1906 inclusive, illustrations, in 35
　　vol., cl., 8vo. (428)　　*Quaritch,* £5 5s.
284 Palmer (C. J.) The Perlustration of Great Yarmouth, plates,
　　in 41 parts, 1872-5, sm. 4to. (763)　　19s.
285 Pamphlets. A collection of Topographical, Archæological,
　　Philological, Shakesperian, Poetical and other Miscellaneous
　　Tracts and Pamphlets, upwards of 500 (various sizes)
　　arranged in 57 vol. and 3 cases, hf. mor. (formerly W. C.
　　Hazlitt's collection), 1796-1908 (398)　　*Maggs,* £9
286 Phillimore (Sir R.) Ecclesiastical Law of the Church of
　　England, second ed., 2 vol., 1895, 8vo. (405)　　16s

287 Pipe Roll Society. Publications, vol. i. to xiv., cl., 1884-91,
8vo. (431) *Walford,* £2 12s.
288 Plato. Works, trans. by F. Sydenham and T. Taylor, 5 vol.,
hf. bd., 1804, 4to. (273) £1 18s.
289 Pratt (A.) Flowering Plants, Grasses, Ferns, etc. of Great
Britain, col. plates, 5 vol., cl., 1889, 8vo. (803) 16s.
290 Prendergast (J. P.) The Cromwellian Settlement in Ireland,
maps, cl., 1865, 8vo. (583) *Walford,* 11s.
291 Rawlinson (G.) The Five Great Monarchies of the Ancient
Eastern World, illustrations and maps, 4 vol., cl., 1862-7,
8vo. (840) £1 9s.
292 Rawlinson (G.) The Sixth Great Oriental Monarchy, col.
front., maps and cuts, cf. gt., 1873, 8vo. (841) £1 10s.
293 Rawlinson (G.) The Seventh Great Oriental Monarchy,
Phœnicia, Ancient Egypt, and Manual of Ancient History,
illustrations, 5 vol., cl., 1876, 8vo. (842) £1 6s.
294 Ruskin (J.) The Stones of Venice, illustrations by the author,
3 vol., cl., 1886, imp. 8vo. (82) 13s.
295 Schliemann (H.) Mycenæ and Tiryns—Ilios, cuts, 2 vol., cl.,
t. e. g., 1878-80, 8vo. (185) *Hill & Son,* £19s.
296 Schliemann (H.) Tiryns—Troja, col. plates and cuts, 2 vol.,
cl., t. e. g., 1884-6, 8vo. (186) *Sotheran,* 18s.
297 Scott (Sir W.) Life of Napoleon, 9 vol., cf., m. e., *Edinburgh,*
1827—Memoirs, by Lockhart, port. (foxed), 7 vol., hf. cf. gt.,
1837, 8vo. (49) *Sotheran,* 19s.
298 Scott (Sir W.) Minstrelsy of the Scottish Border, 3 vol.—
Ballads—Marmion—-Lady of the Lake—Rokeby, etc., LARGE
PAPER, plates after Westall, 10 vol., old cf., *Edinburgh,*
1806-15, 8vo. (216) *G. H. Brown,* £2 6s.
299 Scott (Sir W.) Waverley Novels, Abbotsford ed., 12 vol., hf.
mor. (slightly foxed), 1842-47, 8vo. (48) *Sotheran,* £1 15s.
300 Scott (Sir W.) Prose Works, 6 vol., hf. cf., 1827—Poetical
Works, fronts. and vignette titles, 12 vol., 1833-34, 8vo. (586)
Beazley, £1 2s.
301 Shakespeare (W.) Plays and Poems, ed. by Valpy, port. and
outline plates, 15 vol., cl., 1832-34, 8vo. (60)
Sotheran, £2 13s.
302 Shakespeare (W.) Works, notes by J. Payne Collier, 8 vol.,
cf. gt., 1844, 8vo. (203) 12s.
303 Shakespeare (W.) Works, Knight's Pictorial ed., 8 vol., hf.
mor. gt., n. d., roy. 8vo. (205) 18s.
304 Shakespeare (W.) Works, by Dyce, port., 10 vol., cl., t. e. g.,
1886, 8vo. (206) 10s. 6d.
305 Sheridan (R. B.) Speeches, port., 5 vol., hf. russ., 1816, 8vo.
(220) *Hatchard,* 12s.
306 Skinner (J.) The Present State of Peru, 20 col. plates of
costume, cf. (rebacked), 1805, 4to. (608) *Bailey,* £1 3s.
307 Smollett (T.) Miscellaneous Works, by Anderson, port., 6
vol., old cf., *Edinburgh,* 1806, 8vo. (215) 18s.
308 Society of Antiquaries. Proceedings, plates, second series, 29
Nos. (vol. x. and xvi. to xxi. complete), General Index to vol.
i. to xx., cl. 1882-1908, 8vo. (91) *Sotheran,* £1

309 Stanhope (Earl). Life of William Pitt, port., 4 vol., cl., 1861,
8vo. (170) *Hatchard*, 16s.
310 Stanley (T.) Poems and Translations, viz. :—Poems—Ana-
creon, Bion and Moschus—Kisses, ɔy Secundus—Cupid
Crucified, ɔy Ausonius—Venus Vigils—Sylvias Park, by
Theophile—A Platonick Discourse upon Love [*Privately
printed*], 1651, with the additional Verses, " Aurora, Ismenia
and the Prince," and " Oronta," H. Moseley, 1650, in 1 vol.,
old cf., sm. 8vo. (141) *Tregaskis*, £9 10s.
311 Stuɔɔs (W.) Constitutional History of England, 3 vol., cl.,
Oxford, 1875-8, 8vo. (852) 17s.
312 Sue (Eugene). Works. The Mysteries ´of Paris and the
Wandering Jew, Liɔrary ed., etchings on Japan paper, 12
vol., cl. ex., Nimmo, 1903, 8vo. (538) £4
313 Symonds (J. A.) The Age of the Despots—The Revival of
Learning, first eds., 2 vol., cl., 1875-7, 8vo. (679)
Spencer, £1 12s.
314 Tennyson (C.) Sonnets and Fugitive Pieces, first ed., bds.,
Cambridge, 1830, 8vo. (139) *K. Smith*, 6s.
315 [Thackeray (W. M.)] Our Street, first ed., col. copy, bds.
(ɔroken), 1848, 8vo. (570) *Edwards*, £2 14s.
316 [Thackeray (W. M.)] Dr. Birch, 1849—Reɔecca and Rowena,
plates ɔy Doyle, 1850, first eds., 2 vol., bds. (ɔroken), (571)
Hornstein, £2 4s.
317 Thackeray (W. M.) Works, Illustrated Liɔrary ed., 22 vol.,
green cl., 1867-69, 8vo. (536) *G. H. Brown*, £5 5s.
318 Thiers (L. A.) Consulate and the Empire, ports., 12 vol., cl.,
1893, 8vo. (100) *Edwards*, £1 6s.
319 Thiers (M. A.) History of the French Revolution, ɔy Shoberl,
plates, 5 vol., hf. bd., 1838, 8vo. (857) 14s.
320 Thoms (W. J.) Early English Prose Romances, 3 vol., cl.,
1858, 8vo. (136) 10s.
321 Thoresɔy (R.) Ducatus Leodiensis, second ed.—Loidis and
Elmete, ɔy T. D. Whitaker, pedigrees, ports., etc., 2 vol.
(ɔinding ɔroken), 1816, folio (625) *Ridler*, £1 12s.
322 Thornɔury (W.) and Walford (E.) Old and New London,
plates, 6 vol., n. d.—Knight (C.) London, cuts, 6 vol., hf. bd.,
1841, 8vo. (149) 12s.
323 Valpy (A. J.) Delphin Classics, with the Variorum Notes
[Intitled the Regent's edition], LARGE PAPER, complete set,
141 vol., bds., uncut, 1819-30, 8vo. (191) *Baker*, £5
324 Walton (I.) Complete Angler, 14 plates after Wale and Nash,
cf. gt., with devices, J. Major, 1824, 8vo. (131)
Hatchard, £1 8s.
325 Walton (I.) Complete Angler, ɔy Sir H. Nicolas, engravings
ɔy Stothard and Inskipp (imperfect), 2 vol., hf. mor., g. e.,
Pickering, 1836, roy. 8vo. (118) *K. Smith*, £3 12s. 6d.
326 Watson (J.) History of Halifax, port., views and plans, old
cf., 1775, 4to. (626) £3 7s. 6d.
327 Watt (G.) Dictionary of the Economic Products of India,
6 vol. in 9, hf. cf., *Calcutta*, 1885-93, 8vo. (13) *Wesley*, £6 6s.
XXIV. 2

328 Whitaker (T. D.) History of Whalley and Clitheroe, port.
 (loose) and plates, 2 vol., cl., 1872-6, 4to. (627) 17s.
329 Wilde (Oscar). The Sphinx, first ed. (limited to 200 copies),
 vell., 1894, sm. 4to. (542) . *Hatchard*, £4 7s. 6d.
330 Wilkinson (Sir J. G.) Manners and Customs of the Ancient
 Egyptians, ɔoth series, illustrations (some col.), 6 vol., cl.,
 1837-41, 8vo. (427) £1
331 Wilkinson (Sir G.) Manners and Customs of the Ancient
 Egyptians, plates, the two series, 6 vol., cl., 1842, 8vo. (179)
 Beazley, £1 1s.
332 Williams (J. L.) The Homes and Haunts of Shakespeare,
 plates, hf. mor., g. e., 1892, folio (279) £1 5s.
333 Woɔurn Liɔrary. Fresh and Salt Water Fishes, ɔy Maxwell
 and Aflalo—British Mammals, ɔy Johnston, col. plates, 3
 vol., cl., 1903-4, roy. 8vo. (20) 10s. 6d.
334 Wordsworth (W.) Poetical Works, Centenary ed., port., 6
 vol., cl., 1874, 8vo. (532) 6s.
335 Wright (L.) Book of Poultry—Fulton. Book of Pigeons,
 col. plates, 2 vol., hf. bd., n. d., 4to. (259) 10s.
336 Yarrell (W.) British Birds, with Supplement, cuts, 4 vol., cl.,
 1839-43, 8vo. (560) *Humphreys*, £1 4s.
337 Yarrell (W.) History of British Birds, cuts, 3 vol., hf. mor.,
 t. e. g., 1843, 8vo. (128) *Bull*, £1 1s.
338 Zoological Society of London. Proceedings, col. plates, from
 1886 to 1902, with General Indexes, 1881-1900, in 70 parts,
 sewed as issued, 1888-1902, 8vo. (564) *Edwards*, £5 5s.

[OCTOBER 20TH, 21ST AND 22ND, 1909.]

HODGSON & CO.

THE LIBRARY OF THE LATE MR. F. J. NANKIVELL, AND A
NUMBER OF OTHER PROPERTIES.

(No. of Lots, 975 ; amount realised, aɔout £800.)

339 Ackermann (R.) Repository of Arts, from the commencement
 in 1809 to 1821, and for 1828, col. plates (ɔindings faulty, and
 aɔout 45 plates missing), in 23 vol., 8vo. (501)
 Spencer, £11 5s.
340 Ackermann (R.) History of Oxford University, col. plates
 (port. of Lord Grenville stained), 2 vol., orig. bds., with the
 laɔels, 1814, imp. 4to. (71) *Myers*, £7 17s. 6d.
341 Ackermann (R.) History of the Puɔlic Schools (Winchester
 College only), 10 col. views, orig. bds., R. Ackermann, 1816,
 imp. 4to. (72) £6 6s.
342 Acosta (J. de). Historia Natural y Moral de las Indias (last
 few leaves stained, ɔinding ɔroken), *Sevilla*, Juan de Leon,
 1590, sm. 4to. (459) £1 15s.

343 Æneas Sylvius [Piccolomini]. Familiares Epistolæ, gothic
letter, old cf., *Nurembergæ*, A. Koberger, 1486, sm. 4to. (464)
Reuter, £2 14s.

344 Alvarus Pelagius. De Planctu Ecclesiæ, gothic letter, cf., *Lug-
duni*, 1517, 4to. (516) 10s.

345 [Apperley (C. J.)] The Chace, the Turf, and the Road, first
ed., plates by Alken, and port., orig. cl., 1837, 8vo. (341)
£1 18s.

346 Atkinson (J. A.) Scenes taken from The Miseries of Human
Life, title and 15 col. plates (should be 16), bds., uncut
1807, oblong 8vo. (405) £1 6s.

347 Beaumont and Fletcher. Comedies and Tragedies never
printed before, first folio ed. (no port.), cf., 1647, folio (289)
£4

348 Belon (Pierre). Les Observations de plusieurs Singularitez
trouvées en Grece, Asie, Egypte, etc., woodcuts, and map of
Mount Sinai, cf., *Paris*, 1555, sm. 4to. (462) £1 10s.

349 Bevan (S.) Sand and Canvas [containing Thackeray's Ballad
"The Three Sailors"], first ed., plates, cl., 1849—Cornhill to
Grand Cairo, col. front., cl., 1846, 8vo. (36) 13s.

350 Bible, Holy, with Book of Common Prayer and Psalms, plates,
old mor., gold tooling (rubbed), g. e., 1660, 8vo. (494)
Ellis, £1 2s.

351 Bidpai's Fables. Trattati Diversi di Sendebar Indiano, wood-
cuts, mor., *Vinegia*, 1552, sm. 4to. (474) 9s.

352 [Blackmore (R. D.)] Poems by Melanter, first ed., with
inscription "J. Goodwin, from the Author," orig. blue cl.,
Saunders & Otley, 1854, 8vo. (265) £2 10s.

353 [Bodenham (J.)] Politeuphuia, 1674—Phillips (E.) Theatrum
Poetarum, 1674—Fortescue (Sir J.) De Laudibus Legum
Angliæ, partly black letter, 1616, 3 vol., old cf., 8vo. (380)
Maggs, £2 18s.

354 Borrow (G.) The Zincali, first ed., 2 vol., orig. cl., 1841, 8vo.
(25) *Hornstein*, £2 14s.

355 Bradford (J.) The Hurte of Hering Masse, black letter, hf. cf.,
Wyllyam Copland for W. Martyne [1570], 8vo. (429)
Ridler, £1 8s.

356 Brontë. Poems by Currer, Ellis and Acton Bell, first ed., cl.,
uncut, Smith, Elder & Co., 1846, 8vo. (264) *Shepherd*, £1

357 Broughton (H.) Daniel, his Chaldie Visions, 4 plates, G.
Simson, 1597, sm. 4to. (431) *Dobell*, £1 3s.

358 Bullen (A. H.) England's Helicon, 1887—More Lyrics from
Elizabethan Songs Books, 1888—Lyrics from Elizabethan
Dramatists, 1890—Lyrics from Elizabethan Romances, 1890,
orig. eds., 4 vol., buckram, t. e. g., 8vo. (618)
Sotheran, £1 10s.

359 [Bunbury (H.)] Academy for Grown Horsemen, 27 col. plates,
bds., uncut, R. Ackermann, 1825, 12mo. (66)
Maggs, £2 17s. 6d.

360 Burke (J. and J. B.) Extinct and Dormant Baronetcies, port.,
illuminated title and cuts, cl., 1838—Extinct Peerages, port.,
hf. mor., 1846, 8vo. (95) *Quaritch*, £1 13s.

361 Burke (J. and J. B.) Royal Families of England, Scotland and
Wales, port. and pedigrees, 2 vol., cl., 1851, imp. 8vo. (97)
Hill, £1 1s.

362 Burke (J. and J. B.) Encyclopædia of Heraldry, third ed., with
Supplement, illuminated title, 1847, roy. 8vo. (96)
Ellis, £1 6s.

363 [Burney (F.)] Camilla, first ed., 5 vol., contemp. cf., 1796, 8vo.
(12) 17s.

364 [Burney (F.)] The Wanderer, first ed., 5 vol., cf., 1814 —
Cecilia, 4 vol., hf. cf., 1809, together 9 vol., 8vo. (13)
Hornstein, £1 5s.

365 Burns (R.) Poems, first Edinburgh ed., port. by Beugo
(backed, and one leaf of dedication repaired), with List of
Subscribers, also MS. Poems at the end, hf. cf., 1787, 8vo.
(241) £1 19s.

366 [Burton (R.)] The Anatomy of Melancholy, old cf., 1652, folio
(538) *Hill,* £2

367 Calvert (F.) The Isle of Wight Illustrated, map and 20 col.
plates, orig. cl., g. e., G. H. Davidson, 1846, 4to. (76) £3 6s.

368 Cambridge Modern History (The), planned by Lord Acton,
and ed. by Ward, Prothero and Leathes, vol. i. to v. and vii.
to x., 9 vol., buckram, t. e. g., *Cambridge,* 1902-8, roy. 8vo.
(562) *Harding,* £4 4s.

369 Cambridge. Gradus ad Cantabrigiam, by a Brace of Cantabs,
col. plates of costume, etc., bds., uncut, J. Hearne, 1824, 8vo.
(69) *Sawyer,* £1 17s.

370 Century Dictionary (The), ed. by W. Dwight Whitney, 8 vol.,
hf. mor., m. e., 1899, 4to. (608) £4 7s. 6d.

371 [Clarke (C.)] Three Courses and a Dessert, first ed., cuts by
G. Cruikshank, orig. hf. mor., uncut, 1830, 8vo. (45)
Walford, 19s.

372 [Clifford (Hon. Louisa).] "All is not Fable," *Privately printed*
at Chudleigh, with the Errata, bds. [no place or date], fcap.
—Collectanea Cliffordiana, or Anecdotes, etc. of the Clifford
Family, by Arthur Clifford, sewn, *Privately printed, Paris,*
1817, 8vo. (153) *Barnard,* £2 15s.

373 Coker (N.) Survey of Dorsetshire, map and heraldic plates,
old cf., 1732, folio (539) *Walford,* £1

374 Coleridge (S. T.) Notes and Lectures upon Shakespeare, first
ed., 2 vol., cl., uncut, Pickering, 1849, 8vo. (208) £1 3s.

375 Coleridge (S. T.) Poems on Various Subjects, first ed.,
contemp. cf., Robinsons and Cottle, 1796, 12mo. (243) £1 13s.

376 Collier (J. Payne). The Poetical Decameron, first ed., 2 vol.,
old mor. ex., 1820, 8vo. (374) £1 1s.

377 Collinson (J.) History of Somersetshire, folding map (torn)
and plates, 3 vol., old cf., *Bath,* 1791, 4to. (508)
Walford, £4 15s.

378 [Combe (W.)] Doctor Syntax's Tour to the Lakes, a Poem,
second ed., col. plates by Rowlandson, orig. bds., uncut, with
the label, and the advertisements at end, R. Ackermann,
1812, 8vo. (61) *Shepherd,* £5 17s. 6d.

379 [Comьe (W.)] Dr. Syntax's Tour in Search of Consolation, second ed., col. plates ьy Rowlandson, orig. yellow cl., t. e. g., R. Ackermann, 1820, 8vo. (62) *Sawyer*, £1 18s.

380 [Comьe (W.)] Doctor Syntax's Tour in Search of a Wife, first ed., col. plates ьy Rowlandson, bds., uncut, linen ьack, with the advertisements at end, R. Ackermann, 1821, 8vo. (63) *J. Bumpus*, £8 10s.

381 [Comьe (W.)] Johnny Quæ Genus, first ed., col. plates ьy Rowlandson, orig. yellow cl., R. Ackermann, 1822, 8vo. (64) *Sawyer*, £3 12s. 6d.

382 Cornelius Nepos. De Vita Illustrium Virorum, 58 leaves (A i. ьlank), mor. ex., g. e. [? *Petrus de Cornero Mediolanensis ca.* 1479], sm. 4to. (490) *Barnard*, £1 18s.

383 Cornwall. Complete Parochial History of Cornwall, fronts. and pedigrees, 4 vol., cl., W. Lake, *Truro*, 1868-72, roy. 8vo. (582) *G. H. Brown*, £2 5s.

384 Dagley (R.) Takings, first ed., plates, 1821—Death's Doings, first ed., plates, 1826, 2 vol., bds., uncut, 8vo. (60) *Sawyer*, £1 3s.

385 Dante. La Poetica di M. Giovan Giorgio Trissino [containing the first ed. of Dante's " De la Vulgare Eloquenzia "], italic type, vell., *Vicenza*, 1529, sm. folio (513) *Barnard*, 18s.

386 D'Arblay (Madame). Diary and Letters, ports. and facsimile (foxed), 7 vol., orig. cl., uncut, 1842-46, 8vo. (188) *J. Bumpus*, £2 18s.

387 Delrio (M.) Disquisitionum Magicarum Libri vi., vell., *Coloniæ Agrippinæ*, 1679, sm. 4to. (497) 9s.

388 Denham (Sir J.) Poems and Translations, with the Sophy, first ed., cf., 1668—Version of the Psalms of David, cf., 1714, 8vo. (386) *Barnard*, £1 1s.

389 [De Quincey (T.)] English Opium-Eater, first ed., with the half title and leaf of advertisements, bds., linen ьack, uncut, Taylor & Hessey, 1822, 8vo. (249) *Sawyer*, £5 17s. 6d.

390 Dibdin (T. F.) Introduction to the Greek and Latin Classics, LARGE PAPER, fourth ed., 2 vol., cl., uncut, 1827, 8vo. (81) 7s. 6d.

391 Dibdin (T. F.) Tour in France and Germany, ports., second ed., 3 vol., cl., uncut, 1829, 8vo. (83) 10s.

392 Dibdin (T. F.) Bibliomania, port. and cuts, in 2 vol., orig. bds., uncut, 1842, 8vo. (84) *Hill*, £1 7s.

393 Dibdin (T. F.) Reminiscences of a Literary Life, and of Book Collectors, port. and plates, 2 vol., bds., uncut, 1836, 8vo. (85) *Maggs*, 16s.

394 [Dibdin (T. F.)] Poems, presentation copy from the author [ed. suppressed and author's name cut off preface], bds., uncut, 1797, 8vo. (257) *Barnard*, £1

395 [Dickens (C.)] Sketches of Young Gentlemen, first ed., plates ьy " Phiz " (spotted), orig. bds., 1838, 8vo. (32) *Spencer*, £2 10s.

396 Dickens (C.) American Notes, first issue of the first ed., 2 vol., cl., 1842, 8vo. (33) *Spencer*, £1 18s.

397 Dickens (C.) The Haunted Man, first ed., cl., g. e., 1848—
Memoirs of Grimaldi, port. and plates, cl., 1846, 8vo. (34)
Spencer, £1 6s.
398 Dugdale (W.) Baronage of England, first ed., fold. pedigrees,
etc., 3 vol. in 2, old cf., 1675-6, 4to. (531) *Thorp*, £1 7s.
399 Dugdale (W.) Monasticon Anglicanum, with the two Addi-
tional Volumes ɔy J. Stevens, plates, 3 vol., old cf., 1718-23,
folio (532) *Thorp*, £2 7s.
400 Edwards (E.) Anecdotes of Painters, port., ex. illustrated,
old mor., g. e., 1808, 4to. (504) £1 15s.
401 Edwards (S. T.) Botanical Register, vol. i. to iv., hf. mor.,
1815-18, and continued ɔy John Lindley from 1838 to 1846,
9 vol., cf. gt., together 13 vol., 8vo. (358) *Thorp*, £6
402 English Poets. Works of the English Poets, ɔy Samuel
Johnson, ports. ɔy Bartolozzi, etc., complete, with Remarks
on Johnson's Life of Milton, 69 vol., old cf. gt., 1779, etc.,
8vo. (499) £2
403 Fenton (R.) Historical Tour through Pembrokeshire, port.,
map and plates, hf. cf., 1811, 4to. (125) *Brown*, £1 8s.
404 [Ferrier (Miss).] The Inheritance, first ed., 3 vol., bds., uncut,
1824, 8vo. (11) £1 2s.
405 Fellowes (W. D.) A Visit to the Monastery of La Trappe,
col. plates, bds. (soiled), uncut, Stockdale, 1818, 8vo. (68)
Hornstein, 7s.
406 Fielding (T. H.) Description of the River Wye, 12 col. plates,
with Text, cl., g. e., R. Ackermann, 1841, 4to. (74) £2 16s.
407 Fisher (T.) Ancient Paintings on the Walls of Trinity Chapel
at Stratford-on-Avon, col. plates and facs., 1838, roy. folio
(299) £1 2s.
408 French Revolution. Réimpression de L'Ancien Moniteur :
Histoire Authentique de la Révolution Française, with
Introduction and Index, 32 vol., hf. cf., *Paris*, 1847, imp. 8vo.
(422) *Grant*, £1 15s.
409 Froissart (Sir J.) Œuvres, par M. le ɔaron Kervyn de Letten-
hove, Chroniques, 25 vol.—Poésies, 3 vol., plates, together 28
vol. in 29, sewed, *Bruxelles*, 1870-77, 8vo. (428) *Sotheran*, £2
410 Fuller (T.) Worthies of England, first ed., port. ɔy Loggan,
old cf., 1662 (536) *Bull*, £2 14s.
411 Gay (J.) The Beggar's Opera, 1729—Polly, an Opera, first
ed., in 1 vol., old cf., 1729, sm. 4to.—Faɔles, plates ɔy
Gravelot, 1738 (383) £1 8s.
412 Geneste (M.) Some Account of the English Stage, 10 vol.,
orig. cl., uncut, *Bath*, 1832, 8vo. (229) *Quaritch*, £8
413 Gentleman's Calling (The), and the Ladies' Calling, engraved
front. ɔy Dolle, etc., 2 vol. in 1, old mor. [bv Mearne],
including the "drawer-handle" stamp on sides (soiled and
worn), g. e., 1673, 8vo. (493) £1 10s.
414 Gerarde (J.) The Herball, third ed., engraved title ɔy Payne,
and woodcuts (last leaf wanted), old cf., 1636, folio (288) £3
415 Goldsmith (O.) Works, ed. ɔy Cunningham, vignette titles,
4 vol., cl., uncut, 1854 (620) 19s.

416 Grafton (R.) Chronicle, black letter (impft. w. a. f.), 1568, folio
(510) *Reader*, £1 3s.
417 Granger (J.) Biographical History of England, illustrated
with Richardson's collection of ports., 6 vol., bds., uncut,
1824, 8vo. (502) £2 2s.
418 Gwillim (J.) Display of Heraldrie, first ed., woodcut title,
coats-of-arms, etc., old cf., *London*, W. Hall, 1610, folio (529)
Harding, 10s.
419 Hassell (J.) Tour of the Isle of Wight, aquatint, 2 vol., old
mor., g. e., 1790, sm. 4to. (110) 19s.
420 [Heath (W.)] Common-Place Book, by the Rev. Dr. Dryas-
dust, col. plates, bds., uncut, J. Bumpus, 1825—Adventures
of a Pincushion, col. plates, sewn, 1825, 8vo. (67)
Bumpus, £2 8s.
421 Hieronymus. Epistolæ, cum Scholiis Des. Erasmi, capital
letters rubricated, 3 vol. in 2, old cf., blind stamped, over oak
bds., *Basileæ*, 1524, folio (518) £1 10s.
422 Hieronymus. Epistolæ, opera ac studio Mariani Victorii Reatini,
3 vol. in 4, cf. gt., with the Caraffa arms, *Romæ*, 1565, folio
(519) £1 11s.
423 Highways and Byeways in Dorset, Wales, Lake District,
Derbyshire, etc., illustrations, 12 vol., cl., Macmillan, 1899-
1906, 8vo. (585) £2 4s.
424 Historians' History of the World (The), ed. by H. Smith
Williams, illustrations, 25 vol., cl., 1907, imp. 8vo. (569)
Wheldon, £6 15s.
425 Historic Gallery of Portraits and Paintings, LARGE PAPER,
outline plates by Cooke, 7 vol., hf. russ., 1807-19, 4to. (94)
7s. 6d.
426 Homer's Iliad and Odyssey, by John Ogilby, port. by Faithorne,
and plates, 2 vol., old cf., g. e., 1669, roy. folio (292) 7s. 6d.
427 Hone (W.) Every Day and other books, cuts by G. Cruik-
shank, 4 vol., hf. mor., 1826-32, 8vo. (44) *Kent*, £1 11s.
428 Hunt (Leigh). A Book for a Corner, first ed., cuts by Franklin,
2 vol., orig. cl., 1849, 8vo. (29) *Myers*, 15s.
429 Hunt (L.) A Jar of Honey from Mount Hybla, first ed., orig.
designed bds., g. e., 1848, 8vo. (28) £1 2s.
430 Hunt (L.) Poetical Works, first collected ed., 1832—The
Indicator and Companion, port., together 2 vol., orig. cl.,
1834, 8vo. (27) *Bailey*, 11s.
431 Hunter (Sir W. W.) Imperial Gazetteer of India, new ed.,
with Index and Atlas, 26 vol., cl., *Oxford*, 1907-9, 8vo. (574)
Edwards, £4
432 Inglis (H. D.) Rambles in the Footsteps of Don Quixote,
first ed., plates by G. Cruikshank, 1837—Scenes from the
Life of Edward Lascelles, first ed., fronts., 1837, etc., together
2 vol. in 1, cl., uncut (46) *G. H. Brown*, £1 9s.
433 Ireland (S.) Picturesque Views on the Medway, uncut, 1793—
Views of the Avon, hf. cf., 1795—Tour through Holland,
Brabant, etc., 2 vol. in 1, cf., 1790, together 3 vol., 8vo. (118)
£1 10s.

434 Ireland (S.) Picturesque Views on the Thames, aquatint
plates, 2 vol., bds., uncut, 1801-02, 8vo. (119) £1
435 [Irving (Washington).] Tales of a Traveller, 2 vol., 1824—
A⊃⊃otsford and Newstead A⊃⊃ey, port. inserted, 1835—Tour
on the Prairies, 1835—Astoria, 3 vol., 1836, first eds., together
7 vol., uncut, 8vo. (10) £1 5s.
436 Izacke (R.) Antiquities of the City of Exeter, first ed., with
inscription "ffor the Right Reverend Father in God Seth
Lord Bishopp of Sarum," cf., ⊃lind tooled, 1677, 8vo. (155)
 Barnard, 15s.
437 James (G. P. R.) Life of Richard Gœur de Lion, 4 vol., cl.,
1842—Manchester (Duke of). Court and Society, ports.,
2 vol., cl., 1864, 8vo. (186) *G. H. Brown,* £1 19s.
438 Jesse (J. H.) Memoirs of Richard the Third, first ed., port.
and col. plate, hf. cf., Bentley, 1862, 8vo. (185)
 Maggs, £1 10s.
439 Johnson (S.) Life, ⊃y Boswell, Notes ⊃y Roger Ingpen, illus-
trations, 2 vol., cl., t. e. g., 1907, roy. 8vo. (600) 12s.
440 Johnson (S.) The Ram⊃ler, first ed., 208 Nos. (last num⊃er
margined), 2 vol., hf. cf., J. Payne, 1753, 8vo. (384) £1 8s.
441 Johnsoniana, or Supplement to Boswell, ports., bds., uncut,
1836, 8vo. (385) *Dobell,* £1 4s.
442 Keats (J.) Poems, ⊃y John Keats, first ed., vignette port. of
Shakespeare on title, with the half title, orig. bds., uncut,
with la⊃el, fine copy, *London, printed for C. and J. Ollier,*
1817, fcap. 8vo. (252) *J. Bumpus,* £140
443 Keats (J.) Endymion, first ed., with the half title and the five-
line Errata, orig. bds., uncut, with la⊃el, *London, printed
for Taylor and Hessey,* 1818, 8vo. (253) *Shepherd,* £25 10s.
444 Kennett (W.) Parochial Antiquities, plates, old cf. gt., *Oxford,*
1695, 4to. (509) £1
445 Killigrew (Sir W.) Four New Playes, first ed., old cf., *Oxford,*
1666, folio (290) *Pickering,* £3
446 Knapp and Baldwin. Newgate Calendar, ports. and plates,
6 vol., hf. cf., J. Ro⊃ins, n. d., 8vo. (337) *Edwards,* £2 13s.
447 [Lam⊃ (C.)] Essays of Elia, First Series, first ed., with the
hf. title and the 3 leaves of advertisements, bds., uncut,
Taylor and Hessey, 1823, 8vo. (250) *Hornstein,* £3
448 [Lam⊃ (C.)] Essays of Elia, Second Series, first American
ed. [pu⊃lished 5 years ⊃efore the English ed.], bds., uncut,
Philadelphia, Carey, Lea and Carey, 1828, 8vo. (251)
 Barnard, £2 4s.
449 [Lever (C.)] Harry Lorrequer, first ed., orig. green cl., *Dublin,*
1839, 8vo. (37) 13s.
450 [Lever (C.)] Tom Burke of "Ours," first ed., 2 vol., cl.,
Dublin, 1844, 8vo. (38) 19s.
451 [Lever (C.)] Arthur O'Leary, first octavo ed., port. and plates
⊃y G. Cruikshank, orig. cl., 1845, 8vo. (39) *Sawyer,* £1 1s.
452 [Lever (C.)] Horace Templeton, first ed., 2 vol. in 1, cl., uncut,
1848, 8vo. (40) £1
453 Lewis (F. C.) Scenery of the Rivers Dart and Exe, plates,
2 vol., bds., uncut, 1821-7, roy. 4to. (149) *Rimell,* 17s.

454 Lewis (F. C.) Scenery on the Devonshire Rivers, LARGE PAPER, proof plates, 1843—The Tamar and the Tavy, plates, 1823, 2 vol., 4to. (150) £1 1s.

455 Lindsay (Lord). History of Christian Art, 3 vol., cf., red edges, 1847, 8vo. (631) *Bull*, 12s.

456 Lysons (D. and S.) Magna Britannia—Devonshire, port. and extra plates inserted, 2 vol., cl., 1822, 4to. (143) 18s.

457 Macgillivray (W.) History of British Birds, cuts, 3 vol., hf. cf., 1837-40—History of Water Birds, 2 vol., cl., 1852, together 5 vol., 8vo. (349) £3 5s.

458 [Marryat (Capt.)] Japhet in Search of a Father, 3 vol., 1836 —Diary in America, 20th series, 6 vol., 1839-42—The Mission, fronts., 2 vol., 1845, first eds., 12 vol., uncut, 8vo. (8) £1

459 Martyr (Peter). Commonplaces, black letter (title and leaf repaired), old cf., H. Denham, 1583, 4to. (521) £1 9s.

460 Maude (J.) Visit to the Falls of Niagara, proof plates, bds., uncut, 1826, roy. 8vo. (324) 15s.

461 Mayhew (The Brothers). Whom to Marry—Greatest Plague of Life, first eds., plates 2y G. Cruikshank, 2 vol., cl., Bogue, 8vo. (48) £1 14s.

462 Meredith (G.) Works, port., éd. de luxe, 32 vol., orig. cl., t. e. g., 1896-8, 8vo. (615) *Edwards*, £12

463 Millar (A. H.) Castles and Mansions in Renfrewshire and Buteshire, 65 photo views, with Descriptions, *Glasgow*, 1889, 4to. (640) 10s.

464 [Milton (J.)] Paradise Lost, first ed., third issue (title-page cut out and mounted and first and last leaves defective, scored throughout), cf., *London, printed, and are to be sold by Peter Parker*, 1668, sm. 4to. (489) *Green*, £3

465 Milton (J.) Paradise Regain'd, first ed., with the licensed leaf and the errata, port. inserted (headlines cut into, inferior copy), old cf., *J. M. for J. Starkey*, 1671, 8vo. (375) *Barnard*, £3 10s.

466 Molière. Les Œuvres de Molière, engraved title, 5 vol. ("Le Malade Imaginaire," in vol v., dated 1673), cf., *Amst., chez Jacques le Jeune*, 1675, 12mo. (498) *Maggs*, £4 4s.

467 Motley (J. L.) John of Barneveld, Library ed., 2 vol., cl., uncut, 1874, 8vo. (549) *Edwards*, 19s.

468 MS. A Thirteenth-Century MS., "Presens opus hc. v. partes principales : Prima est de virtute in co'mum. Scdade trious virtutibus theologici," etc., on 229 leaves of thin vell., 40 lines to a page, douole column, first leaf with decorated oorder, cf., *Sæc.* xiii. (? xiv.), sm. 8vo. (492) £2 12s. 6d.

469 Mudford (W.) Campaign in the Netherlands, col. plates 2y G. Cruikshank (some soiled and one torn), and maps, hf. bd. 1817, 4to. (269) *Bailey*, £2 4s.

470 Murphy (A.) Life, 2y Jesse Foot, port., ex. illustrated, old russ., g. e., 1811, 4to. (505) *Spencer*, £1 13s.

471 Nichols (J.) Literary Anecdotes of the Eighteenth Century, 9 vol.—Illustrations of the Literary History of the Eight-

eenth Century, 8 vol., ɔoth series complete, ports., together 17 vol., cf. gt. (last vol. in roxɔurgh), 1812-58, 8vo. (77)
Sawyer, £8 2s. 6d.

472 Nicholson (G.) Dictionary of Gardening, with Supplements, col. fronts. and cuts, 5 vol., hf. mor., L. Upcott Gill, 1901, imp. 8vo. (587) £2 5s.

473 Oliver (G.) Monasticon Diœcesis Exoniensis, illuminated initial letters, with the second Supplement, cl., sewed, 1846, folio (147) £1 5s.

474 Papworth (J. B.) Select Views of London, 76 col. plates, orig. bds., uncut, with the laɔel and leaf of advertisements, R. Ackermann, 1816, 8vo. (70) *Hornstein, £24* 10s.

475 [Paradin (C.)] Quadrins Historiques de la Biɔle, *Lion,* 1558—Figures du Nouveau Testament, *ib.,* 1559, woodcuts ɔy Le Petit Bernard, in 1 vol., old mor., g. e., 12mo. (463)
Thorp, £1 10s.

476 Park (J. J.) Topography and Natural History of Hampstead, map and plates, bds., uncut, 1814, 8vo. (106) *Rimell, £2* 15s.

477 Parkinson (J.) Theatrum Botanicum, engraved title (defective) and woodcuts, leaf of errata, old cf., T. Cotes, 1640, folio (527) £2 11s.

478 Pennant (T.) Works, Tour in Wales, 2 vol., and others, in all 16 vol., uniform mottled cf., 1781-93, 8vo. (123)
Barnard, £3 10s.

479 Pennant (T.) Journey from London to the Isle of Wight, 2 vol.—Downing to Alston Moor, together 3 vol., hf. russia, 1801, 8vo. (124) 7s. 6d.

480 Pole (Sir W.) Description of the County of Devon, bds., uncut, 1791, 4to. (142) £1 6s.

481 Politianus (Angelus). Linguæ Latinæ Vindicatoris Epistolæ Lepidissimæ, old cf., *Antverpiæ, per T. Martini,* 1514, sm. 4to. (491) *Reuter,* 13s.

482 Polwhele (R.) History of Devonshire, folding map, engravings, and one extra plate inserted, with the leaf of corrections, 3 vol. in 1, old cf. gt., 1797-1806, folio (140) £5 15s.

483 Prætorius (J.) Ludicrum Chiromanticum seu Thesaurus Chiromantiæ, diagrams (foxed), vell., J. Bartholom, 1661, sm. 4to. (496) 16s.

484 Priest in Aɔsolution (The), 2 parts, orig. wrappers (front wrapper to part i. missing), *Privately printed,* 1869, 8vo. (317) *Dickinson, £1* 9s.

485 Ptolemy. La Geographia di Claudio Tolomeo tradotta da G. Ruscelli, douɔle-page maps, including 6 of America, hf. mor., *Venetia,* 1561, sm. 4to. (458) £1 1s.

486 Rastell (W.) Statutes, **black letter,** old cf., T. Wight, 1603—Bracton (H.) De Legibus, old cf., R. Tottell, 1569, 4to. (523) *Reader, £1* 8s.

487 Roscoe's Novelist's Liɔrary. Fielding. Tom Jones, 2 vol.—Amelia, 2 vol. — Smollett. Peregrine Pickle, 2 vol.—Roderick Random, plates ɔy G. Cruikshank, together 7 vol., cl., uncut, 1831, 8vo. (47) *Maggs, £1* 16s.

488 Rowlandson (T.) Naples and the Campagna Felice, first ed., col. plates ɔy Rowlandson, hf. cf., R. Ackermann, 1815, 8vo. (65) *Sawyer, £2*

489 Ruskin (J.) Complete Works, Liɔrary ed., ed. ɔy Cook and Wedderɔurn, 37 vol., hf. mor., t. e. g., 1903-9, 8vo. (607) *Brown, £21*

490 Rutter (J.) Fonthill Aɔɔey, col. front., title, and India proof plates, cf., 1823, atlas 4to. (541) *Walford, 6s. 6d.*

491 Scott (Sir W.) The Chase and William and Helen (from the German of Gottfried Augustus Bürger, trans. ɔy Scott), orig. bds., *Edinburgh,* 1796, 4to. (16) *Cottel, £2 15s.*

492 Scott (Sir W.) Landscape-Historical Illustrations of Scotland and the Waverley Novels, descriptions ɔy Wright, plates ɔy Cruikshank, etc., 2 vol., hf. mor., Fisher, n. d., 4to. (22) *Harvey, £1 15s.*

493 Scrope (W.) Art of Deer Stalking, orig. cl., uncut (ɔinding slightly soiled), 1839, roy. 8vo. (340) *£1 5s.*

494 Shakespeare (W.) Plays, Johnson and Steevens, port. and cuts, 10 vol., russ., T. Bensley, 1803-5, 8vo. (200) *Barnard, £1 18s.*

495 Shakespeare (W.) Works, Eversley ed., 10 vol., cl., uncut, Macmillan, 1899, 8vo. (596) *£1 1s.*

496 Shakespeare Gallery, 50 engravings after Singleton, cf., C. Taylor, 1792, roy. 8vo. (211) *Rimell, £2 14s.*

497 Shakespeare. The Whole Historical Dramas Illustrated ɔy an Assemɔlage of Portraits, Views of Castles, Towns, etc., with descriptive text, ports. ɔy Harding, 2 vol. in 1, hf. cf., 1811, 8vo. (212) *Hill, £1 13s.*

498 Shaw (G. Bernard). The Quintessence of Iɔsenism, first ed., cl., t. e. g., 1891, 8vo. (605) *Hale, 19s.*

499 Siddons (H.) Illustrations of Gesture and Action, plates, old cf., 1807—The Thespian Dictionary, 22 stipple ports., hf. mor., 1805, 8vo. (234) 14s.

500 [Smollett (T.)] Humphrey Clinker, first ed., port. and plates ɔy G. Cruikshank inserted, 3 vol., cf., 1671[*sic*]-1771, 8vo. (396) *Ellis, £4 15s.*

501 Spectator (The), ɔy Steele and Addison, the orig. numɔers, 1-291, 298-357, 364 and 366-393 (March 1, 1711-May 31, 1712)—The True Briton, Nos. 1-36 (No. 12 missing), 1723, in 1 vol., old cf. (reɔacked) (295) *Quaritch, £4 5s.*

502 Spectator (The). Introduction and Notes ɔy G. A. Aitken, orig. ports., 8 vol., ɔuckram, uncut, Nimmo, 1898, 8vo. (599) *£1 12s.*

503 Staunforde (Wm.) Les Plees del Coron, partly black letter, woodcut ɔorder on title (repaired), hf. cf., R. Tottel, 1567—Lambarde (W.) Eirenarcha, black letter, cf., 1581, 12mo. (432) *£1 11s.*

504 Stevenson (R. L.) Life, ɔy Graham Balfour, first ed., ports., 2 vol., ɔuckram, orig. end papers, 1901, 8vo. (629) *Spencer, 7s.*

505 Sullivan (Dennis). A Picturesque Tour through Ireland, 25 col. views, orig. hf. mor., T. M'Lean, 1824, oɔlong 4to. (75) *Sawyer, £5 12s. 6d*

506 Swinburne (A. C.) Poems, 6 vol.—Tragedies, 5 vol., ports.,
together 11 vol., buckram, t. e. g., Chatto, 1904-6, 8vo. (603)
Menel, £2 5s.

507 Tennyson (Lord). ΛΩΤΟΦΑΓΟΙ, 1860. [The Lotos-Eaters, the
English Text, with Greek Translation by Lord Lyttelton],
privately printed ed., presentation copy with inscription
"From the Author," orig. cl., 1860, 8vo. (266)
Quaritch, £7 15s.

508 Tennyson (Lord). Works, Eversley ed., ports., 9 vol., cl.,
Macmillan, 1907-8, 8vo. (598) £1 3s.

509 Testamenti Novi Editio Vulgata, woodcuts and initial letters,
old cf, *Dilingæ*, 1565, 8vo. (473) 10s.

510 Thornton (R. J.) Temple of Flora, front. by Burke, after Cos-
way, in colours, and other engravings, old cf. gt., 1812, folio
(297) £1 6s.

511 Trilogium Animæ, 𝔤𝔬𝔱𝔥𝔦𝔠 𝔩𝔢𝔱𝔱𝔢𝔯, title in compartments, vell.,
Nurembergæ, A. Koberger, 1493, sm. 4to. (465) *Nutt*, £2 16s.

512 Turgeniev (Ivan). Novels, translated by Constance Garnett,
illustrated ed., 15 vol., buckram, t. e. g., 1906, 8vo. (616)
Winter, £1 12s.

513 Von Gerning (J. J.) A Picturesque Tour along the Rhine,
map and 24 col. plates, cl. (broken), g. e., R. Ackermann,
1820, roy. 4to. (73) *Hornstein*, £3 3s.

514 Vowell (J.) Antique Description of the City of Exeter, hf. cf.,
Exon, 1765, sm. 4to.—Thesaurus Ecclesiasticus Provincialis,
uncut, *Exeter*, 1782, 4to. (156) 11s.

515 Walton (I.) Complete Angler, by Hawkins, plates and cuts,
hf. cf. gt., t. e. g., 1808—Another edition, by Major, plates,
cl., uncut, 1835, 12mo. (343) *Barnard*, £1 12s.

516 [Warren (S.)] Ten Thousand a Year, first ed., 3 vol., clean
copy, in the orig. cl., 1841, 8vo. (9) *Hornstein*, £1 11s.

517 Watt (R.) Bibliotheca Britannica, 4 vol., hf. russ., *Edinburgh*,
1824, 4to. (86) £1

518 Weyerman (J. C.) De Levens-Beschryvingen der Neder-
landsche Konst-Schilders en Konst-Schilderessen, ports. and
vignettes by Houbraken, etc., 3 vol., old mor. ex., g. e.,
s'Gravenhage, 1729, sm. 4to. (503) *Quaritch*, £1 12s.
[This work is complete in 4 parts, 1729-69, the last being
printed at Dordrecht.—ED.]

519 Winkles (H. B. L.) Cathedral Churches of England and Wales,
plates, 3 vol., cl., 1836-42, roy. 8vo.—French Cathedrals,
plates, hf. bd., 1837, 4to. (101) £1 7s.

520 Yarrell (W.) History of British Birds, second ed., 3 vol., 1845,
with Second Supplement, sewed, 1856—Bell's British Quad-
rupeds, 1837, cuts, together 4 vol., orig. cl., 8vo. (348) £1 3s.

SOTHEBY, WILKINSON & HODGE.

A MISCELLANEOUS COLLECTION.

(No. of Lots, 641 ; amount realised, £529 15s. 6d.)

521 Ainsworth (W. H.) The Spendthrift, first ed., 8 illustrations
ɔy Browne, orig. cl., 1857, 8vo. (10) *Hornstein*, £1
522 Alken (H.) Symptoms of Being Amused, parts i. and ii., col.
title and 20 col. plates, orig. wrappers, 1822, oɔlong folio (521)
G. H. Brown, £1 13s.
523 Araɔian Nights' Entertainments, ɔy E. W. Lane, illustrations
ɔy Harvey, 3 vol., 1840-41, imp. 8vo. (66) *Hornstein*, £1 6s.
524 Araɔian Nights' Entertainments, ɔy J. Scott, plates ɔy Smirke,
6 vol., mor., g. e., 1811, 8vo. (67) *Rimell*, £1 12s.
525 Armstrong (Sir W.) Turner, R.A., Japanese paper, engravings
and vignettes, duplicate set of proof plates, 2 vol. and port-
folio, limited to 350 copies, 1902, folio (314) *Maggs*, £2 2s.
526 Asmole (Elias). Order of the Garter, engravings ɔy Hollar,
orig. cf., 1672, folio (313) *W. Daniell*, £1 13s.
527 Augustine (S.) De Trinitate et de Civitate Dei, **gothic letter**,
large woodcut, col. ɔy hand, painted initials, old sheep,
Basil., 1489, folio (513) *Maggs*, £3 10s.
528 Bacon (Francis, Lord). Two Books of the Proficience and
Advancement of Learning, autograph of Johannes Hagar,
also of John Anstis, Garter King-at-Arms, MS. extracts,
pencil notes in margins, orig. cf., *Oxford*, 1633, 4to. (225)
Andrews, 18s.
529 Baily (J. T. H.) Life of Emma, Lady Hamilton, 24 ports.,
plain and col., of Lady Hamilton, t. e. g., uncut, 1905, 4to.
(484) 12s.
530 Ball (J.) Peaks, Passes and Glaciers, illustrations, 3 vol.,
1859-62, 8vo. (147) *Barnard*, £2 18s.
531 Baxter (Geo.) Pictorial Alɔum or Caɔinet of Paintings, 11
col. plates (loose in ɔinding, title stained), 1836, 4to. (187)
£2 10s.
532 Bentley's Miscellany, vol. i. to xviii., ports. and illustrations
(several spotted), hf. cf., 1837-45, 8vo. (87) *A. James*, £1 15s.
533 Bewick (T.) British Birds, first ed., 2 vol., *Newcastle*, 1797—
Quadrupeds, *ib.*, 1807, together 3 vol., cf., 1797-1807, 8vo.
(363) *Walford*, £2 4s.
534 Bewick (T.) General History of Quadrupeds, fifth ed., imp.
paper, russ. (ɔroken), *Newcastle*, 1807, 8vo. (112) *Bull*, 11s.
535 Biɔlia Heɔraica, 4 vol., old French mor., g. e., *Genoa*, 5377
(1616), 8vo. (19) *Reader*, 8s.
536 Biɔlia Latina, **gothic letter**, 482 pages (should have 523), douɔle
columns, 50 lines to a full page, painted initials, 2 vol., cf.,
Basileae, per Bernardum Richel, 1477, folio (640)
Leighton, £7

537 Bi)lia Slavonica. Bi)lia, siryetch Knigi Vetkhayo i Novago
Zavyeta (title and leaf defective), cf. gt., *Moscow,* 1665, folio
(321) *Mench,* £1 10s.

538 Bi)liotheca Arcana, seu Catalogus Librorum Penetralium,
hf. rox., t. e. g., 1885, 4to. (203) *Hill,* 14s.

539 Bidpai vel Pilpai Fabulæ Directorium Humane Vite, lit. gotḩ.,
A to M in sixes, and N (the last) in 10, woodcut on reverse
of title, and large woodcuts, initial letters painted (C 2 and
3, E 2 and F 5 in facsimile), old cf. (*Argent. I. Pruss, c.* 1480),
folio (291) *Menel,* £13

540 Brash (R. R.) The Ogam Inscri)ed Monuments of the Gaed-
hill in the British Islands, port. and 50 plates, 1879, 4to.
(490) *Quaritch,* 7s.

541 Breviarium Aberdonense, 2 vol., hf. vell., g. t., uncut, Toovey,
1854, 4to. (491) *Quaritch,* 15s.

542 Browning (E. B.) Poems, first ed., 2 vol., orig. cl., 1844, 8vo.
(14) *Spencer,* 7s.

543 Brydges (Sir E.) Censura Literaria, 10 vol., hf. russ., 1805-9,
8vo. (88) *Bull,* 5s.

544 [Byron.] Enigma)y Lord Byron, MS., 20 lines written in
rhyme on a sheet of paper)earing the stamp "Bath,"
surmounted)y a coronet (23) *Whitaker,* 5s.
[This poem was printed among the "Attri)uted Poems"
in the Paris edition of Byron's works, 1827, containing only
18 lines, having omitted the two lines after line 10.—*Cata-
logue.*]

545 Byron (Lord). Finden's Illustrations, LARGE PAPER, plates,
3 vol., mor., g. e., 1833-34, 4to. (151) *Rimell,* £1 6s.

546 Byron (Lord). Works,)y Moore, port. and vignette titles,
17 vol., uncut, 1832-33, 8vo. (25) *Fincham,* 12s.

547 Cervantes (M. de). Don Quixote, illustrations)y Doré, hf.
mor., n. d., 4to. (173) *Andrews,* 5s.

548 Cervantes (M. de). Don Quixote, con la Vida por J. A.
Pellicer, plates, 4 vol., hf. mor., *Madrid,* 1797, 8vo. (6)
Hatchard, £1 2s.

549 Cervantes Saavedra (M. de). Don Quixote, plates, 4 vol., cf.
gt., *Madrid,* 1780, 4to. (172) *Hatchard,* £4 14s.

550 [Chamisso (A. von).] Peter Schlemihl, 8 etchings)y G. C., cf.,
1824, 8vo. (90) *Spencer,* 13s.

551 Chatterton (Thomas). Miscellanies in Prose and Verse, first
ed., cf. ex., uncut, t. e. g., 1778, 8vo. (140) *Dobell,* 14s.

552 Claude le Lorraine. Li)er Veritatis, 3 ports.)y Claude le
Lorraine and Earlom ()oth mezzotints), and of Boydell, and
300 tinted views)y R. Earlom, 3 vol., Boydell, etc., 1819,
folio (517) *Maggs,* £3 10s.

553 [Com)e (W.)] Johnny Quae Genus, first ed., col. plates)y
Rowlandson, nearly uncut copy in bds., 1822, 8vo. (120)
Maggs, £3 3s.

554 Com)e (W.) Dr. Syntax in search of the Picturesque, col.
plates)y Rowlandson, hf. bd., n. d., 8vo. (98) *Cohen,* 17s.

555 Com)e (W.) Tour of Dr. Syntax through London, col. plates

ɔy Williams, hf. cf. (top of title defective, one plate repaired), 1820, 8vo. (99) *Cohen*, £1 12s.

556 [Cox (Rev. Thos.)] Magna Britannia et Hibernia, maps, 6 vol., old hf. cf., 1720-31, 4to. (471) *Carter*, 15s.

557 Cozio (Conte Carlo). Il Giuoco degli Scacchi, 2 vol., hf. mor., uncut, *Torino*, 1766, 8vo. (138) *Quaritch*, £1

558 Daniell (S.) African Scenery and Animals, ɔoth parts, 30 col. plates, hf. russ. (stained) (1804-5), folio (283) *Edwards*, £13 10s.

559 Danse des Morts (La) de la Ville de Basle, dessinée et gravée sur l'Original de Matthieu Merian, 85 copperplate engravings, orig. bds., 1744, sm. 4to. (104) *James*, 10s.

560 Daumier (H.) Les Cent et un Roɔert-Macaire, orig. ed. of the 101 numɔers as puɔlished, containing 101 illustrations, old ɔinding with orig. green cover pasted on front side, *Paris, chez Auber et Cie*, 1839, 4to. (475) *Meuleneere*, £1 13s.

561 Douce (Francis). Illustrations of Shakespeare, first ed., cuts, 2 vol., cf., 1807, 8vo. (7) *Dobell*, 4s.

562 Dr. Syntax in Paris, first ed., col. plates (one missing), uncut, 1820, 8vo. (119) *Spencer*, £2 4s.

563 Dugdale (Sir W.) Baronage of England, 3 vol. in 2, cf. (reɔacked), 1675-6, folio (251) *Harding*, £1 18s.

564 Dumas (A.) Les Trois Mousquetaires, orig. ed., with the illustrations ɔy Maurice Leloir, 2 vol., hf. cf., orig. wrappers preserved, *Paris*, 1894, 4to. (474) *Lacroix*, 19s.

565 Duruy (Victor). Histoire des Grecs, "Exemplaire sur papier de Chine," col. maps, plans, plates and numerous ports. and other illustrations, 3 vol., hf. mor. ex., with inlays, *Paris*, 1887-1889 (213) *Vyt*, £4 1s.

566 Eden (Sir F. M.) State of the Poor, 3 vol. (vol. iii. wanted leaf "Directions to ɔinder" at end), cf., 1797, 4to. (621) *Quaritch*, £3 16s.

567 Encyclopædia Britannica, 25 vol. and the 11 Supplementary Vols., with Index, together 36 vol., hf. mor., g.e., 1875-1903, 4to. (191) *Joseph*, £8 2s. 6d.

568 Essex House Press. Spenser (Edmund). Epithalamion, woodcut ɔy R. Savage, and initial letters in colours, printed on vellum (one of 150 copies), vell., 1901, 8vo. (132) *Barnard*, 18s.

569 Essex House Press. Gray (Thomas). Elegy written in a Country Churchyard, initial letters in colours, printed on vellum (one of 125 copies), vell., 1900, 8vo. (133) *Barnard*, 18s.

570 Evelyn (J.) Memoirs and Correspondence, ɔy William Bray, ports., 5 vol., hf. mor., 1827, 8vo. (392) *G. H. Brown*, £2 8s.

571 Eximeno (Ant.) Dell' Origine e delle regole della Musica, vignettes and music, vell., *Roma*, 1774, 4to. (192) *Barnard*, 10s.

572 Facsimiles of Rare Etchings ɔy Painters of Italian, Dutch and Flemish Schools, 42 plates on India paper, hf. mor., n.d., folio (162) *Reader*, 12s.

573 Fresnoy (C. A. du). The Art of Painting, translated by
William Mason, first ed., old cf., *York*, 1783, 4to. (212)
Whitaker, £6 15s.
[At the end were 26 orig. drawings ϸy Samuel Shelley.—
Ed.]
574 Froissart (Sir J.) Chronicles, ϸy Lord Berners, 2 vol., cf. gt.,
1812, 4to. (211) *Walford*, £2 12s.
575 Galérie du Musée Napoléon, orig. ed., 12 vol. (including the
rare Supplement and the volume of the Taϸle Générale with
the oval portrait of Filhol), ϸound from the parts, uncut, *Paris*,
an XII. (1804-28), 4to. (214) *Rimell*, £12 10s.
[Large paper, with all the 792 plates after Moreau, etc.,
proofs ϸefore letters.—*Catalogue.*]
576 Gallery of the Society of Painters in Water-Colours, proof
plates in various states, and autograph letters of several of
the artists, hf. mor., t. e. g., 1833, folio (305) *Rimell*, 13s.
577 [Gaskell (Mrs.)] Cranford, first ed., orig. cl. (soiled), 1853,
8vo. (13) *Maggs*, £1 12s.
578 Giϸϸs (R.) A delineation of the Courtenay Mantelpiece at
Exeter, illustrations, one of 20 copies on LARGE PAPER, hf.
mor., *Torquay*, 1884, folio (240) *Quaritch*, 11s.
579 Gillray (Jas.) Works (with the suppressed plates), port. and
plates, 2 vol., hf. mor., g. e., Bohn, n. d., atlas folio (284)
Quaritch, £1 12s.
580 Hamerton (P. G.) Landscape, etchings, hf. mor., uncut, 1885,
folio (158) *Reader*, 17s.
581 Herϸert (A.) Nimrod, a Discourse on Certain Passages of
History and Faϸle, 4 vol., russ., m. e. (title to vol. i. discoloured),
1828-30, 8vo. (359) *Quaritch*, £2 18s.
582 Heré (M.) Recueil des Plans, Elevations et Coupes des
Chateaux du Roy de Pologne en Lorraine, Première partie,
plates, *Paris*, n. d. (1756), imp. folio (326) *Batsford*, £1 15s.
583 Heresbachius (Conradus). Foure Bookes of Husϸandry,
𝔟𝔩𝔞𝔠𝔨 𝔩𝔢𝔱𝔱𝔢𝔯 (wanted title and last leaf), old ϸinding (1572?),
4to. (480) *Barnard*, £1 10s.
584 Hittorff (J. J.) Architecture Moderne de la Sicile, plates,
Paris, 1835, imp. folio (327) *Batsford*, 13s.
585 Hogarth (Wm.) Works, restored ϸy James Heath, port. and
plates, old mor., g. e., 1822, atlas folio (281) *Quaritch*, £6 5s.
586 Homerus. Opera, Graecè, LARGE PAPER, 4 vol., russ., g. e.,
from the Beckford Liϸrary, *Glasguœ, R. et A. Foulis*, 1756-58,
folio (323) *Hunt*, 12s.
587 Iϸis (The), fifth to ninth series, complete in Nos. as issued, col.
plates, 1887-1908, 8vo. (425) *Edwards*, £4 8s.
588 Inman (T.) Ancient Faiths, illustrations, 2 vol., hf. mor., g. t.,
uncut, 1868-69, 8vo. (430) *Shepherd*, £2 12s.
589 Johnson (Dr. Samuel). The Ramϸler, first ed., the complete
series of 208 numϸers as originally issued with separate
title, in 2 vol., contemp. hf. cf., with some rough edges,
1749-52, folio (287) *Tregaskis*, £2 2s.
590 Johnson (B.) Works, ϸy W. Gifford, ϸest ed., port., 12 vol., cf.,
g. e., 1816, 8vo. (386) *Brown*, £1 13s.

591 Kelmscott Press. Rossetti (D. G.) Ballads and Poems, vell., uncut, 1893, 8vo. (124) *Winter, £2*

592 Kipling (Rudyard). City of Dreadful Night, first Indian ed., orig. wrappers, *Allahabad*, 1891, 8vo. (48) *Shepherd*, 13s.

593 La Fontaine. Faɔles, 2 vol.—Œuvres Diverses, 2 vol.— Tɔéâtre, 1 vol., together 5 vol., port. and plates ɔy Moreau, uncut, *Paris*, 1821-3, 8vo. (36) *Quaritch, £1* 3s.

594 La Fontaine. Faɔles de, avec les. dessins de Gustave Doré, orig. ed., "exemplaire sur papier de Hollands très fort," unlettered India proof port. and plates, 2 vol., hf. mor., g. e., *Paris*, 1867, folio (245) *Lacroix, £1* 1s.

595 Latour (T.) Imitation of many of the most Eminent Professors in Twenty-six Variations on the favourite Gavot, *London*, Birchall—Other Printed and Manuscript Music, in 1 vol., old cf., mor. laɔel on front cover ɔearing the name of Mrs. Graham (290) *Hornstein, £10* 10s.

[On the front cover is an original pen-and-ink drawing ɔy Thackeray, with the following words in his hand-writing : "Dedicated with permission to Miss M. E. Graham ɔy her devoted admirer W. M. T." ; aɔove the signature is written in pencil : "Slavey Language, Eh?" and ɔeneath the following : "If music be the food of love play on, That surfeiting the appetite may sicken and die, Shakespear, W. M. T." At the head of the music title appears Thackeray's autograph, "W. M. Thackeray." The drawing is reproduced in "Thackerayana."—*Catalogue.* See BOOK-PRICES CURRENT, Vol. xxiii., No. 488.—ED.]

596 Lewes (G. H.) Life and Works of Goethe, first ed., 2 ports. of Goethe, 2 vol., uncut, 1855, 8vo. (442) *Menel, £4* 4s.

[B. Dockray's copy, the author of the Egeria Series, who surrounded the text with manuscript additions. He had the advantage of Goethe's personal acquaintance.—*Catalogue.*]

597 Le Prince (J. B.) Divers Ajustements et Usages de Russie, 80 etchings (ɔinding ɔroken), 1764-8, 4to. (510) *Rimell, £1* 13s.

598 Littleton (Sir Thomas). Les Tenures, blacɫ letter, LARGE PAPER, MS. marginal notes, old cf., 1581, 8vo. (342) *Barnard, £1* 5s.

599 Livre de la Chasse, par Gaston III., Conte de Foix, from a manuscript in the collection of Sir Thomas Phillipps, Bart., ed. ɔy H. Dryden, ɔuckram, uncut; *Daventry*, 1844, 4to. (222) *Barnard*, 16s.

600 Lochmair (Michael). Sermones de Sanctis perutiles, editio prima, lit. gotɧ. (Hain, 10172), contemp. oaken bds., vell., *Passan*, Jo. Petri, 1490, folio (318) *Barnard, £1* 10s.

601 Magna Carta Regis Johannis, A.D. MCCXV., in gold letters, 3 illuminated ɔorders, and initial in ɔlue and gold, mor., g. e., *Lond., apud J. Whittaker*, 1816, folio (540) *Bull*, 12s.

602 [Mahony (F.)] Reliques of Father Prout, first ed., illustrations ɔy Maclise, 2 vol., old hf. russ., 1836, 8vo. (395) *Shepherd*, 10s.

603 Mascardus (A.) Dissertationes de Affectibus sive Perturba-
tionibus Animi (a few leaves at end wormed), orig. cf., arms
of Archbishop Usher, *Paris*, 1639, 4to. (614) *Ellis*, £2 4s.
604 Meredith (George). The Egoist, first ed., 3 vol., orig. cl., 1879,
8vo. (336) *Dobell*, £1 13s.
605 Milton (John). Poetical Works, by Sir Egerton Brydges,
illustrations by Turner, 6 vol., hf. mor., t. e. g., 1835, 8vo.
(394) *Walford*, £1 12s.
606 Missale secundum vitum monastice congregationis casalis
benedicti, **lit. goth.**, the Canon of the Mass on vellum, wood-
cuts coloured, full-page woodcut of the Crucifixion in fac.
(wanted one leaf in sig. S, folio cxviii.), in a XVI. century
French binding, covered with gilt fleurs-de-lis, and bearing
on the sides a representation of the Crucifixion in gold, g.e.,
In urbe Rothomagensi per Magistrum Martinum, Morin,
1513, folio (626) *Leighton*, £22 10s.
 [Bound in at the end are Manuscript Offices by three
different scribes, written on nine leaves of vellum, the first
entitled "Missa nuncupata de pietate beate Marie virginis
de passione domini."—*Catalogue.*]
607 Molière (J. B. P. de). Œuvres, port. and plates, 8 vol., French
cf. gt., *Paris*, 1760, 8vo. (47) *Barnard*, 19s.
608 Monkhouse (C.) Earlier English Water-Colour Painters,
LARGE PAPER, 100 copies printed, proof etchings and plates
on India paper, hf. mor., uncut, t. e. g., 1890, folio (159)
 Winter, 14s.
609 Nicoll (W. Robertson) and Wise (T. J.) Literary Anecdotes
of the Nineteenth Century, port., facs., etc., 2 vol., 1895, 8vo.
(5) *Dobell*, 14s.
610 Ornithologia, methodice digesta, atque iconibus æneis ad
vivum illuminatis ornata (Latine et Italice a Xav. Manetti,
Laurentio Lorenzi, et Violante Vanni), about 600 col. plates,
5 vol., hf. bd., *Florent.*, 1767-76, folio (253) *Cohen*, £1 14s.
611 Owen (H.) and Blakeway (J. B.) History of Shrewsbury, maps
and plates, 2 vol., hf. cf. (some leaves spotted), 1825, 4to. (189)
 Field, £2 4s.
612 Ozanne (N.) Principales Manœuvres de la Marine, 38 (only)
of the fine engravings, n. d., oblong folio (641)
 Hornstein, £2 4s.
613 Picart (B.) Ceremonies and Religious Customs, illustrations,
6 vol., hf. cf., 1733-37, roy. folio (511) *Bull*, £1 15s.
614 Plutarch. The Philosophie commonlie called the Morals,
translated by Philemon Holland, first ed. (title defective),
old cf., 1603, folio (243) *Andrews*, 12s.
615 Pugin (A. W.) Glossary of Ecclesiastical Ornament and
Costume, plates in colours and gold, hf. mor. (spotted), 1868,
4to. (467) *Bull*, £1 7s.
616 Pugin (A. W.) Types d'Architecture Gothique, plates, 3 vol.,
hf. mor., 1851, 4to. (220) *Batsford*, £1 4s.
617 Rabelais (F.) Works, by Duchat, fronts., 4 vol., cf., 1784, 8vo.
(69) *Barnard*, 5s.

618 Rembrandt. Recueil de Quatre-vingt-cinq Estampes origi-, nales : Têtes, Paysages, et différens sujets, et trente-cinqs autres Estampes, 105 etchings, uncut, *Paris*, Basan, s. a., folio (254) *Gutekunst*, £8 10s.

619 Rembrandt, sa Vie, son Œuvre et son Temps, par E. Michel, illustrations, hf. mor., uncut, *Paris*, 1893, 4to. (221) *Rimell*, £1 8s.

620 Repititio Perutilis Famosi C. Omnis utriusq₃, sexus de Peniten. et remis. cum notatis et questionibus quottidianis utilibus nedum Penitentibus seu Confitentibus verum, etc., lit. gotḥ. 'xxiiii. folioed leaves), long lines, 44 to a full page, without signs., unbound, *Impressa Lyptẓ, per Gregorium Bötticher Anno quo supra die* ii. *Mensis Aprilis*, folio (324) *Barnard*, £1 18s.

621 Restif de la Bretonne (N. E.) Le Palais Royal, 3 folding plates, with the 3 half-titles, 3 vol., old hf. cf., 1790, 8vo. (94) *Sotheran*, £3 15s.

622 Ridinger (J. E.) Entwürfe Einiger Thiere, 108 (only) engravings of dogs, deer, foxes, etc., 6 parts in i., old hf. binding, *Augspurg*, 1738-46, folio (308) *Menel*, £1 12s.

623 Rossini (L.) Antichita di Roma, 101 large plates, vell. gt., 1819, etc., oblong folio (317) *C. Jackson*, £1 9s.

624 Royal Gallery of British Art, plates, hf. mor., g. e., Hogarth, n. d., atlas folio (285) *Reader*, 17s.

625 Saint-Non (Abbé de). Voyage Pittoresque, ou Description des Royaumes de Naples et de Sicile, maps, views and plates, 5 vol. in 4, old cf., *Paris*, 1781-6, folio (288) *Lacroix*, £2 11s.

626 Scott (Sir W.) Miscellaneous Prose Works, ports. and fronts., 28 vol. (vol. i. stained), hf. cf., *Edinb.*, 1834-36, 8vo. (142) *Winter*, £1

627 Scott (Sir W.) Poetical Works, fronts., 12 vol., 1833-34— Notes and Illustrations to Waverley Novels, 3 vol., 1833, hf. cf. gt., *Edinb.*, 1833-34, 8vo. (143) *Rimell*, 13s.

628 Scott (Sir W.) Life, by J. G. Lockhart, port. and fronts., 10 vol., hf. cf. gt., *Edinb.*, 1839, 8vo. (144) *Rimell*, 9s. [The two preceding lots were uniform in binding.—ED.]

629 Shaftesbury (Earl of). Characteristicks, Baskerville's ed., vignettes by Gribelin, no port., 3 vol., cf. gt., *Birmingham*, 1773, roy. 8vo. (355) *Barnard*, 12s.

630 Shakespeare Portrait by Droeshout, with Ben Jonson's verses beneath for the Fourth Folio Shakespeare, orig. impression, folio (531) *Ellis*, £1 15s.

631 Shakespeare (W.) Works, Imperial ed., by Charles Knight, port. and plates, 2 vol., hf. mor., g. e., Virtue, n. d., folio (306) *Andrews*, 9s.

632 Sleidan (John). A Famous Chronicle of Our Time called Sleidanes Commentaries, black letter (some margins damp-stained), old English oaken bds., leather, with stamped panellings, well preserved, *John Daye, for A. Weale and N. England*, 1560, folio (311) *Tregaskis*, £1 8s.

633 [Smith (Horace and James).] Hours of Idleness, orig. unpub-
lished MS. on 15 pages of poetry (originals and transla-
lations), with title and quotations, 1839 (21) *Barnard*, £1 8s.

634 [Smith (Horace or James).] Specimens of a Patent Pocket·
Dictionary, ɔy one of the authors of "The Rejected
Addresses," orig. unpuɔlished MS., 61 lines (22)
Tregaskis, 8s.

635 Taɔleau de toutes Espèces de Successions, regies par la
Coutume de Paris, par M. C***, 13 vol. in 12, contemp.
French mor. ex., *Paris*, 1785-6, 8vo. (95) *Rimell*, £2

636 Tennyson (A.) Poems, chiefly Lyrical, first ed. (margin of
title cut off), uncut, 1830, 8vo. (127) *Dobell*, £1

637 Thackeray (W. M.) Book of Snoɔs, first ed., hf. mor., name
on title, *Punch Office*, 1848, 8vo. (96) *Reader*, 10s.

638 Thackeray (W. M.) Photographs from the Original Sketches,
privately printed at Birmingham, cheque signed by W. M.
Thackeray and dated Paris, Octoɔer 28, 1856, pasted inside
cover, n. d., 4to. (171) *Spencer*, £2

639 Treillages exécutés à Bellevue, à Versailles, à Meudon, à Marly,
etc., Vues des Berceaux et de la Colonnade du Jardin du
Comte d'Althann, Desseins de Treillages, 16 plates, orig.
impressions, *Paris, chez Daumont*, oɔlong folio (289)
Rimell, £3

640 Turner and Girtin. River Scenery, 20 engravings, loose in
portfolio, orig. impressions, W. B. Cooke and H. G. Bohn,
n. d., folio (164) *Rimell*, 16s.

641 Turner (J. M. W.) Picturesque Views on the Southern Coast
of England, engravings, hf. mor. gt., uncut, 1826, 4to. (154)
Winter, £1 9s.

642 Utino (Leonardus de). Sermones aurei de Sanctis, 𝔤𝔬𝔱𝔥𝔦𝔠 𝔩𝔢𝔱𝔱𝔢𝔯,
40 lines, oak ɔoards, old leather (wormed), *Colonie*, Johan.
Kolhof, 1473, folio (512) *Barnard*, £1 14s.

643 Van-Dyck (A.) Cent Portraits de Princes, Savants Illustres,
Artistes, etc., one of 10 copies, "sur papier de Hollande très
fort," 2 ports. of Van-Dyck and 100 of Princes, etc., hf. mor.,
t. e. g., uncut, 1878, folio (524) *Lacroix*, £2 4s.

644 Vernon Gallery of British Art, plates on India paper, 2 vol.,
hf. mor., g. e., n. d., imp. folio (280) *Reader*, 12s.

645 Vincent Press. Johnson (Dr. S.) Rasselas, vell., uncut,
Birm., 1898, 8vo. (117) 6s.

646 Vincent Press. Five Ballads aɔout Roɔin Hood, vell., uncut,
one of 210 copies, *Birm.*, 1899, 8vo. (118) *Rimell*, 7s.

647 Walton (E.) Peaks in Pen and Pencil, plates on India paper,
1872, folio (161) *Maggs*, 14s.

648 Walton (L) Compleat Angler, reprint of the first ed., wood-
cuts and col. plates, cf., Bagster, 1810—Walton and Cotton.
Complete Angler, Major's ed., port., plates on India paper,
cf., 1824, 8vo. (51) *Hornstein*, £1 13s.

649 Waring (J. B.) Masterpieces of Industrial Art, 300 plates in
gold and colours, 3 vol., mor., g. e., 1863, folio (244) *Vyt*, 17s.

650 Wilde and Whistler, ɔeing an Acrimonious Correspondence on

Art ɔetween Oscar Wilde and James A. McNeill Whistler,
LARGE PAPER, 100 copies privately printed, wrappers, uncut,
1906, 8vo. (46) *Doolan,* 10s.

651 Woltmann (Dr. A.) Holɔein und seine Zeit, orig. ed., ports.,
plates and illustrations in the text, an old port. of Holɔein
ɔy himself inserted, 2 vol. in 1, hf. cf., *Leipzig,* 1866-8, 8vo.
(405) *Lacroix,* 11s.

[NOVEMBER 1ST, 1909.]

SOTHEBY, WILKINSON & HODGE.

THE LIBRARY OF THE LATE MR. B. M. JALLAND, OF
HOLDERNESS HOUSE, EAST YORKSHIRE, AND OTHER
PROPERTIES.

(No. of Lots, 312 ; amount realised, £652 10s.)

(*a*) *Mr. Jallands Library.*

652 Ackermann (R.) The Microcosm of London, col. plates, 3 vol.,
mor. (1811), 4to. (241) *Hornstein,* £7

653 Alken (H.) Illustrations to Popular Songs, 28 (only) col.
plates, with leaf of address and list of sporting works, puɔ-
lished ɔy McLean, orig. hf. ɔinding, with laɔel, 1825, oɔlong
folio (270) *Hornstein,* £1 11s.

654 Alken (H.) Specimens of Riding near London, 18 col. plates,
T. McLean, 1823, ɔound up at end are 8 lithographic plates,
depicting "Casualties of the Chase," orig. hf. ɔinding, with
laɔel, oɔlong folio (271) *Hornstein,* £1 11s.

655 Allen (Thomas). History of the County of York, illustrations,
6 vol., orig. bds., uncut, 1828, 8vo. (216) *Dobell,* 6s.

656 Angus (W.) The Seats of the Noɔility and Gentry, 63 plates
(several spotted), mor., g. e., 1787, oɔlong 4to. (242)
Hatchard, 8s.

657 Araɔian Nights' Entertainments, ɔy E. W. Lane, engravings
after W. Harvey, 3 vol., orig. cl., 1839, imp. 8vo. (217)
Rimell, £1 19s.

658 Barrington (Sir Jonah). Historic Anecdotes and Secret
Memoirs of the Legislative Union ɔetween Great Britain
and Ireland, 40 ports. (some spotted), ɔound in 2 vol., con-
temp. mor., g. e., 1809-15, roy. 4to. (244) *Tregaskis,* 16s.

659 Bayley (John). History and Antiquities of the Tower of
London, LARGE PAPER, India proof plates (some spotted),
2 vol., hf. russ., 1821-25, imp. 4to. (245) *Reader,* 9s.

660 Bentham (James). Conventual and Cathedral Church of Ely,
with the Supplement, port., plates and pedigrees, 2 vol., orig.
bds., 250 copies printed, *Norwich,* 1812-17, imp. 4to. (246)
W. Daniell, 8s.

661 Boaden (James). Inquiry into the Authenticity of various Portraits of Shakspeare, ports., orig. bds., uncut, 1824, 4to. (247) *Dobell, £1* 3s.

662 Boydell (J. and J.) History of the River Thames, engravings, col.-like drawings, 2 vol., contemp. mor., g. e., Bulmer, 1794-96, 4to. (248) *W. Daniell, £9* 15s.

663 British (The) Prose Writers, engravings, 25 vol. (wanted vol. xi.), mor., g. e., 1819-21, 8vo. (220) *J. Grant, £1* 5s.

664 British (The) Poets, ed. by Thomas Park, fronts. (spotted), 100 vol. in 50, mor., g. e., 1810-24, 8vo. (221)
Rimell, £5 12s. 6d.

665 British Essayists (The), ed. by R. Lynam, ports., 30 vol., roan gt., g. e., 1827, 8vo. (222) *Edwards, £2* 8s.

666 British Novelist (The New), 50 vol. (wanted vol. vii., viii. and ix.), hf. bd., n. d., 8vo. (223) *J. Grant, £1* 1s.

667 British Novelists (The), 91 vol. (some leaves spotted), contemp. mor., y. e., 1810-14, 8vo. (224) *Maggs, £2* 12s.

668 British Gallery of Contemporary Portraits, 2 vol., hf. russ., uncut (broken), 1822, imp. 4to. (250) *Rimell, £1*

669 Byron (Lord). Works, by Thomas Moore, port. and vignettes, 17 vol., orig. cl., 1832-33, 8vo. (225) *Barnard,* 13s.

670 Collins (Arthur). Peerage of England, by Sir Egerton Brydges, best ed., engravings, 9 vol., 1812, 8vo. (226)
Barnard, £1 6s.

671 Daniell (S. and W.) Sketches, representing the Native Tribes, Animals and Scenery of Southern Africa, 48 plates, hf. bd., with label, 1820, oblong folio (275) *Edwards,* 14s.

672 Donovan (E.) Works on Natural History, complete, col. plates, 39 vol. bound in 21 vol., hf. mor. gt., g. e., 1792, etc. (230) *Sotheran, £7* 15s.

673 George the Fourth. August Ceremonial of the Coronation of King George IV. Solemnized in Westminster Abbey, July 19, 1821, the text printed in gold letters, with paintings of the procession, etc., heightened with gold, parts i. to v. in the orig. wrappers, John Whittaker, 1823, folio (277) *Spencer, £3*

674 Hearne (T.) and Byrne (W.) Antiquities of Great Britain, views of monasteries, castles and churches, descriptions in English and French, 2 vol., hf. cf., uncut, 1807, oblong folio (279) *Andrews, £1*

675 Historical (Impartial) Narrative of those Momentous Events which have taken place in this Country, proof plates, some in colours, orig. bds., uncut, 1823, folio (280) *Reader,* 13s.

676 Horwood (R.) Plan of the Cities of London and Westminster, hf. russ., 1799, atlas folio (282) *Quaritch, £1* 18s.

677 Houghton Gallery (The), engravings by Earlom, etc., 2 vol., mor. gt. (defective), g. e., J. and J. Boydell, 1788, atlas folio (276) *Parsons, £10* 5s.

678 Jardine (Sir W.) The Naturalist's Library, complete, col. plates, 40 vol., hf. bd., m. e., 1833-43, 8vo. (235)
James, £2 4s.

679 Kip (J.) Nouveau Théâtre de la Grand Bretagne, engravings, 4 vol. in 2, orig. cf., *Londres,* D. Mortier, 1708-13, folio (283)
Hatchard, £22

680 Lodge (Edmund). Portraits, orig. su)scription ed., 240 ports., 4 vol., hf. russ. ()roken), g. e., 1821-34, roy. folio (284)
Reader, £6 5s.
681 Shakespeare Illustrated)y an assem)lage of Portraits and Views (some spotted), LARGE PAPER, orig. hf.)inding, uncut, S. and E. Harding, 1793, folio (289) *Spencer,* £4
682 Thackeray (W. M.) The Virginians, first ed., orig. wrappers ()acks of some defective), 1858-59, 8vo. (238)
Quaritch, £3 10s.
683 Walton (Izaäk) and Cotton (Charles). The Compleat Angler, the fifth ed., *Printed for R. Marriot,* 1676—Cotton (Charles). The Compleat Angler, first ed., *Printed for R. Marriott and H. Brome,* 1676 (front margin of title shaved)—Vena)les (Col. Ro)ert). The Experienc'd Angler, the fourth ed., 1676, engravings of fish, etc., *Printed for R. Marriot,* 1676, in 1 vol., orig. cf., 8vo. (239) *Pickering,* £26
[With general title : The Universal Angler, made so)y Three Books of Fishing.—*Catalogue.*]
684 War)urton (J.), Whitelaw, and Walsh. History of the City of Du)lin, plates, plans and maps, 2 vol., orig. bds., 1818, 4to. (267) *Walford,* 14s.
685 Wilkes (B.) English Moths and Butterflies, col. plates, contemp. mor., g. e. ()roken) (1773), 4to. (269) *James,* 17s.
686 Young (George). History of Whit)y and Streoneshall A))ey, LARGE PAPER, plates, 2 vol., orig. bds., uncut, *Whitby,* 1817, roy. 8vo. (240) *Walford,* 10s.

(β) *Other Properties.*

687 Ales, seu Hales (Alex., Scotus). Pro Scotiae Regno Apologia, title within woodcut)order, *Lipsiae,* M. Blum, 1534, 8vo. (87) *Ford,* 14s.
688 Anacreon, ed.)y A. H. Bullen, one of 110 copies on Japanese vell., uncut, 1893, 4to. (192) *Shepherd,* 16s.
689 Ara)ian Nights' Entertainments,)y R. F. Burton, with Supplemental Nights, illustrations, 17 vol., *Privately printed by the Burton Club,* n. d., 8vo. (43) *Harpin,* £8 5s.
690 Barham (R: H.) Ingolds)y Legends, the three series, first ed., port. and plates)y G. Cruikshank, etc., 3 vol., vol. i. the earliest issue with page 236)lank, and "Ralph" for "Ro)ert" on page 81, orig. cl. (slightly spotted), 1840-42-47 (167)
Sabin, £15
691 Baskerville's Classics. Virgilius—Terentius—Juvenal (wanted half-title)—Sallustius (wanted half-title)—Catullus—Lucretius—Horatius (wanted title), 7 vol., uniform contemp. mor., *Birmingham,* J. Baskerville, 1757, etc., 4to. (99)
Andrews, £3
692 Bewick (T.) British Birds, 2 vol., *Newcastle,* 1826—Quadrupeds, *ib.,* 1824, together 3 vol., cf. gt., 8vo. (62)
Allison, £1 2s.
693 Bi)liographical Society. Transactions, vol. i.-viii., 1893-1907 —Hand Lists, etc., 14 parts, 1896-1907—Illustrated Mono-

graphs, Nos. i.-xiv., 1894-1906 — News-Sheets, Lists of
Members, etc. complete to 1907 as issued, 4to. (119)
Sotheran, £7 2s. 6d.

694 Boccaccio (Giov.) Il Decamerone, LARGE PAPER, India proof
port. and proof plates after Stothard, 3 vol., orig. cl., Pickering,
1825, 8vo. (53) *Hatchard,* £1 10s.

695 Brontë. The Holy Bible, Authorised Version, with autograph
signature on fly-leaf, preceding the First Chapter of Genesis,
"Charlotte Brontë, Haworth, April 21st, 1834," old cf., R.
Barker, 1612, 4to. (94) *Barnard,* £5 17s. 6d.
[Charlotte Brontë got the volume from the Bland Family,
whose names occur in the book. She gave it to the late
Mr. Wm. Green, on condition that he never parted with it
so long as he lived.—*Extract from letter of present owner
of the volume.*]

696 Burns (Robert). Poems, third ed., port. by Beugo (a few
leaves stained), old cf., 1787, 8vo. (3) *Dobell,* 11s.

697 Catalogues of the Beckford Library, The Hamilton Library,
and The Hamilton Collection of Manuscripts, LARGE PAPER,
6 vol, with prices and purchasers' names to 5 vol., hf. russ.,
t. e. g., 1882-84, 4to. (120) *Barnard,* £1 10s.

698 Catullus (C. V.) Carmina, translated by R. F. Burton and
L. C. Smithers, port., hf. vell., uncut, 1894, 8vo. (165)
Quaritch, 11s.

699 Clarendon (Earl of). History of the Rebellion, 7 vol., hf. mor.,
t. e. g., *Oxford,* 1849-57, 8vo. (52) *J. Bumpus,* £2 12s.

700 Combe (William). The Three Tours of Dr. Syntax, col.
engravings reduced, 3 vol., orig. pink bds., uncut, with the
paper label, R. Ackermann, 1823, 8vo. (46)
Hornstein, £4 10s.

701 Compleat Gamester (The), front. and leaf of explanation, cf.
(stained), 1721—Seymour (R.) The Compleat Gamester,
front., 1750, 2 vol., 8vo. (20) *Rimell,* 11s.

702 Coryat (Thomas). Coryats Crudities (wanted the engraved
title, a leaf, and one of the plates, a few leaves defective and
mended, some pages stained), modern cf. gt., 1611, 8vo. (74)
Barnard, £1 13s.

703 Crisp (F. A.) Abstracts of Somersetshire Wills, 6 series, one
of 150 numbered and signed copies, hf. parch., uncut, t. e. g.,
Privately printed, 1887-90, 8vo. (49) *Harpin,* £3 7s. 6d.

704 Darien. Scotland's Present Duty, or a Call to the Nobility,
etc., vigorously to act for our common concern in Caledonia,
by Philo-Caledonius, cf., t. e. g., 1700, 4to. (89)
Maggs, £1 10s.

705 Defoe (D.) La Vie et les Aventures de Robinson Crusoé,
plates after Stothard, port. and map, 3 vol., orig. hf. binding,
uncut, *Paris,* Panckoucke, 1800, 8vo. (47) *Hatchard,* £1

706 Dorat (C. J.) Les Baisers, précédés du Mois de Mai, LARGE
PAPER, first ed., plates after Eisen, with the misprinted pages,
mor. ex., *à La Haye et à Paris,* 1770, 8vo. (180) *Isaacs,* £27

707 Doyle (Richard). The Foreign Tour of Brown, Jones and
Robinson, illustrations, orig. cl., 1855, 4to. (71)
Edwards, 11s.

708 Egan (P.) Boxiana, ports., 4 vol., hf. mor., 1823-24, 8vo. (14)
J. Bumpus, £2 4s.
709 [For)es (Wm., of Disblain).] The True Scots Genius Reviving ; a Poem, written upon occasion of the Resolve past in Parliament, the 17th of July, 1704 (4 leaves), cf., 1704, 8vo. (85) *Barnard,* 9s.
710 Frankau (Julia). John Raphael Smith, 30 photogravures, with portfolio containing 50 examples of stipple, etc. in colours and monochrome, on India paper, 2 vol. (pu)lished at 30 guineas), as new, McMillan, 1902, 8vo. and folio (293)— William and James Ward, 30 photogravures, with portfolio containing 40 engravings in monochrome and colours, on India paper, 2 vol., as new (pu)lished at 30 guineas), *ib.,* 1904, 8vo. and folio (294) *Rimell, £23*
711 Hazlitt (W.) The Round Ta)le, etc., 1894—Splrit of the Age, 1894—Lectures on the English Poets, 1899—The Plain Speaker, 1900—Ta)le Talk, 1900—Literature of the Age of Eliza)eth, 1901, etc., together 7 vol., ed.)y W. C. Hazlitt, hf. cf., t. e. g., 1894-1901, 8vo. (10) *Hill,* 11s.
712 Henry VIII. Binding. Upper Cover of a Book (*circa* 1534), stamped in two compartments, the King's arms a)ove the Tudor rose, supported)y angels, with city arms and mark of the)inder, John Reynes, 8vo. (6*) *Ross, £1* 2s.
713 Hogarth (William). Works, from the original plates, restored)y Heath, ports. and plates, including "Before" and "After," and Feeding Poultry (in pocket at end), hf. russ. ()roken), g. e., Baldwin and Cradock, n. d., folio (297) *Reader, £3* 3s.
714 Hume (David). History of England, "Bowyer's finely printed edition," plates, extra illustrated,)ound in 10 vol. (covers of two vol.)roken), russ., g. e., *T. Bensley for R. Bowyer,* 1806, 4to. (98) *James, £8* 10s.
715 Jacchaeus (Thom.) Onomasticon Poeticum, éditio prima, hf. cf., *Edinb.,* R. Waldegrave, 1592, 8vo. (86) *Allison,* 10s.
716 Jameson (Wm.) Nazianzeni Querela et Votum Justum, mor. ex., *Glasgow,* 1697, 8vo. (83) *Ford,* 6s.
717 Johnson (Capt. C.) Lives and Actions of Highwaymen, etc., front., uncut, *Edinb.,* 1814—Authentic Memoirs of his predatorial Majesty, the King of Swindlers, part the first, 2 vol., cf., n. d., 8vo. (17) *Shepherd,* 17s.
718 Jonson (Ben). Volpone, or the Foxe, illustrations)y A. Beardsley, 1898, 4to. (195) *B. F. Stevens,* 8s.
719 Kelmscott Press. Keats (John). Poems, vell., uncut, 1894, 8vo. (162) *Shepherd, £6*
720 Kelmscott Press. Shakespeare (W.) Poems, vell., 1893, 8vo. (163) *Sotheran, £4* 12s. 6d.
721 Kircher (Ath.) Magnes, sive de Arte Magnetica, editio secunda, engravings and woodcuts, vell., *Col. Agr. J. Kalcoren,* 1643, 4to. (82) *Ford,* 8s.
722 Knox (J.) An Answere to a Great Num)er of Blasphemous Cavillations (a few headlines shaved), cf., Thos. Charde, 1591, 8vo. (34) *Allington,* 10s.

723 La Fontaine (J. de.) Contes et Nouvèlles en Vers, ports. of
La Fontaine and Eisen, Richard Minutolo, Le Cas de Con-
science, Le Diaɔle de Papefiguière, Les Lunettes, Le Bât
and Le Rossignol, découvertes, 2 vol., mor., g.e., "Derome,"
with the "Avis du Relier" (often wanted), *Amst.*, 1762, 8vo.
(123) *Isaacs*, £50
724: Lewine (J.) Biɔliography of Eighteenth Century Art and
Illustrated Books, 35 plates, uncut, 1898—Cohen (H.) Guide
de l'Amateur de Livres à Vignettes du XVIIIᵉ Siècle, hf.
mor., t. e. g., *Paris*, 1880, roy. 8vo. (161) *Shepherd*, £1 7s.
725 Liancourt (Duc de la). Travels through the United States,
maps, 4 vol., cf., 1799, 8vo. (9) *Maggs*, £1 7s.
726 Lucas (T.) Lives, Intrigues and Comical Adventures of the
most famous Gamesters and celeɔrated Sharpers, front., cf.,
1714, 8vo. (21) *Rimell*, 16s.
727 Marguerite de Navarre. Heptameron Français, fronts., plates
and vignettes, 3 vol., contemp. French mor., g. e., *Berne*,
1780-81, 8vo. (181) *Sotheran*, £21 10s.
728 Mary Queen of Scots. [Blackwood (Adam).] Martyre de la
Royne d'Escosse, première éd. (S. B. No.. 144), Ll A ii. to
: A viii. (wanted), m a contemp. handwriting, orig. cf., *à Edin-
bourg, chez Jean Nafield* (fictitious imprint), 1587, 8vo. (35)
 Fox, 12s.
729 Mary Queen of Scots. Romoaldus Scotus. Summarium
Rationum quiɔus Cancellarius . . . Elizabethae persuaserunt
occidendam esse Mariam Stuartam, etc. (S. B. No. 221), hf.
mor., *Colon.*, P. Henningius, 1627 (36) *Barnard*, 6s.
 [A copy of the ed. of 1588 (S. B. No. 171) realised 10s.,
 Lot 106, mor. gt.—ED.]
730 Mary Queen of Scots. [Boisguilbert (Pierre la Pesant de).]
Marie Stuard Reyne d'Escosse. Nouvelle Historique, vell.,
Paris, chez Claude Barbin, 1674, 8vo. (37) *Fox*, 7s.
731 Mary Queen of Scots. Apologie ou Defense de l'honorable
sentence & tres-juste execution de defuncte Marie Steuard
(several leaves damaged), vell., *s. l. imprimé nouvellement*,
1588, 8vo. (38) *Allison*, 9s.
732 Mary Queen of Scots. Causino (P. Nic.) Historia di Maria
Stuarta Regina di Francia e di Scotia (apparently wanted
sig. A 4) (S. B. No. 245), mor., g. e., *Bologna*, Carlo Zenero,
1648, 8vo. (39) *Harcourt*, 10s.
733 Mary Queen of Scots. Oraison Funeɔre es Obseques de . . .
Marie Royne douairiere d'Escosse, prononcée à nostre Dame
de Paris, 12 Aoust, 1560 (par Claude d'Espence) (S. B. No. 30),
mor., t. e. g., *Paris*, M. de Vascosan, 1561, 8vo. (40)
 Tomlinson, £1 2s.
734 Mary Queen of Scots. Le Moyne (P. Pierre). La Gallerie
des femmes fortes, front. and ports. (S. B. No. 262), vell.,
à Leiden, chez Jean Elsevier, 1660, 8vo. (41) *Allison*, 13s.
735 Mary Queen of Scots. Lesley (J., Bp. of Ross). Liɔri duo,
quorum uno, Piae Afflicti Animi Consolationes, etc., editio
prima (S. B. No. 91), leaf of errata, old cf. gt., *Paris, ex. off.
Petri l'Huillier*, 1574, 8vo. (42) *Quaritch*, £1

736 Mary Queen of Scots. Beagué (Ian de). L'Histoire de la Guerre d'Escosse (S. B. No. 9), vell., g. e., *à Paris par B. Prevost (pour V. Sertenas*), 1556, 8vo. (60) *Allison*, £1

737 Mary Queen of Scots. Conaeus (G.) Vita Mariae Stuartae Scotiae Reginae dotariae Galliae Angliae & Hiberniae Haeredis, port. of the Queen (S. B. No. 214), vell., *Romae*, J. P. Gellius, 1624, 8vo. (61) *Dobell*, 9s.

738 Mary Queen of Scots. Blackwood (Adam). Adversus Geo. Buchanani Dialogum de Jure Regni apud Scotos pro regibus apologia, editio prima (S. B. No. 117), old cf., *Pictavis*, F. Pagaeus, 1581, 4to. (108) *Allison*, 12s.

739 Mary Queen of Scots. Jezabelis Angliae (De). Parracido Varii Generis Poemata, A-K 1 in 4's, without title (S. B. No. 153), port. of the Queen inserted (margins frayed), vell., *s. a. et l. [Brux.*, 1587?], 4to. (109) *Allison*, £2 6s.

740 Mary Queen of Scots. Sanderson (Wm.) Compleat History of the Lives and Reigns of Mary Queen of Scotland and her son King James (S. B. No. 255), 2 port. by Gaywood, hf. cf., H. Moseley, 1656 (306) *Allison*, 11s.

741 Mary Queen of Scots. Buchanan (Geo.) Rerum Scoticarum Historia, ed. prima, with the leaf of errata (S. B. No. 121), cf., *Edinb.*, A. Arbuthnetus, 1582, folio (307) *Allison*, 11s.

742 Maryland. A Relation of Maryland, together with a Map of the Countrey, etc., the map, title-page and pages 37-40 in facs., modern mor., t. e. g., *September the* 8, *Anno Dom.* 1635, sm. 4to. (95) *Strickland*, £6 5s.

743 Mathers (Patrick) [*i.e.* Wm. Sanders]. The Great and New Art of Weighing Vanity, folding plate at end, orig. sheep, *Glasgow*, R. Sanders, 1672 (29) *Tregaskis*, 15s.

744 Maxwell (Guil.) De medicina magnetica, vell., t. e. red, others uncut, *Francof.*, J. P. Zubrodt, 1679, 8vo. (30) *Tregaskis*, 10s.

745 Menzies (J.) Papismus Lucifugus, or a faithful Copie of the Papers exchanged betwixt John Menzies and Francis Dempster, cf., r. e., *Aberdene*, John Forbes, 1668, 8vo. (84) *Ford*, 11s.

746 Moore (G.) Pagan Poems, first ed., orig. cl., G. M. on title, 1881, 8vo. (176) *B. F. Stevens*, £1 10s.

747 Moore (G.) Parnell and his Island, 1887—Confessions of a Young Man, front., 1888—Modern Painting, 1893—Celibates, 1895, first eds., 8vo. (177) *Spencer*, £1 11s.

748 Moore (G.) Impressions and Opinions, 1891—The Strike at Arlingford, a Play, 1893—The Bending of the Bough, a Comedy, 1900—Memoirs of my Dead Life, 1906, first eds., 8vo. (178) *B. F. Stevens*, £2

749 Moore (G.) Flowers of Passion, first ed., buckram, uncut, 1878, 4to. (193) *Maggs*, £1 4s.

750 Morysinus (Rich.) Apomaxis Calumniarum Joannis Coclaei contra Hen. VIII., title within Holbein border, cf., g. e., *in æd. Th. Bertheleti*, 1537, 4to. (81) *Ellis*, £1

751 Pater (W.) Studies in the History of the Renaissance, first ed., orig. cl., 1873, 8vo. (129) *Hatchard*, £1 19s.

752 Pater (W.) Marius the Epicurean, first ed., 2 vol., orig. cl.,
 1885, 8vo. (130) *Hatchard*, £1 19s.
753 Pater (W.) Imaginary Portraits, 1887—Appreciations, 1889,
 first eds., orig. cl., 8vo. (131) *James*, £1 14s.
754 Pater (W.) Greek Studies, port., 1895—Miscellaneous Studies,
 1895, first eds., orig. cl., 8vo. (132) *B. F. Stevens*, £1 10s.
755 Pater (W.) Plato and Platonism, 1893—Gaston de Latour,
 first eds., orig. cl., 8vo. (133) *B. F. Stevens*, £1 3s.
756 Patten (William). Expedicion into Scotlāde of prince Edward,
 Duke of Soomerset, black letter (stained), 3 maps (wanted 3
 leaves of text, and a leaf imperfect), unbd., *Lond.*, Richard
 Grafton (1548), 8vo. (6) *Pickering*, £3 10s.
757 [Pattenson (M.)] The Image of Bothe Churches, with the
 last leaf (frequently wanted) containing his apology, ɔy
 P. D. M., orig. vell., *Printed at Tornay by Adrian Quinque*,
 1623 (63) *Allison*, 10s.
758 [Pattenson (M.)] Jerusalem and Baɔel, or the Image of Both
 Churches, second ed., russ., g. e., 1653, 8vo. (64) *Allison*, 7s.
759 Penn (William). Discourse of the General Rule of Faith and
 Practice, hf. cf., 1699, 8vo. (54) *Tregaskis*, 10s.
760 Phillips (Stephen). Christ in Hades, etc., first ed., orig.
 wrappers, 1896, 8vo. (170) *B. F. Stevens*, 11s.
761 Phillips (S.) Poems, first ed., orig. cl., uncut, 1898, 8vo. (171)
 Shepherd, 8s.
762 Phillips (S.) Paolo and Francesca, first ed., orig. cl., 1900,
 8vo. (172) *Shepherd*, 8s.
763 Phillips (S.) Marpressa, first ed., illustrations, mor., uncut,
 1900—Faust, ɔy S. Phillips and J. Comyns Carr, uncut, 1908,
 8vo. (173) *B. F. Stevens*, 8s.
764 Phillips (S.) Herod, a Tragedy, 1901—Ulysses, a Drama,
 1902, first eds., orig. cl., 8vo. (174) *B. F. Stevens*, 7s.
765 Phillips (S.) Eremus, first ed., orig. bds., 1894, 4to. (194)
 Shepherd, 5s.
766 Queen Victoria. Paraɔles of our Lord, illustrations ɔy John
 Franklin, loose in cloth, presentation copy from Queen
 Victoria to Lady Fanny Howard, with autograph inscription,
 n. d., folio (303) *Lassell*, £2 18s.
767 Roɔerts (David). Views in the Holy Land, Syria, Idumea,
 Araɔia, Egypt and Nuɔia, port. and large tinted lithographic
 plates and vignettes, ɔound in 3 vol., hf. mor., g. e., enclosed
 in oak case, F. G. Moon, 1842-49, folio (296)
 Hornstein, £1 14s.
768 Roɔson (Simon). The Choise of Change, containing the
 Triplicity of Divinitie, Philosophie and Poetrie, first ed.,
 black letter, unbd., uncut, *Lond.*, *printed by Roger Warde*,
 1585, 4to. (73) *James*, £5 5s.
769 Rochester, Roscommon, Dorset (Earls of). Works (with the
 Caɔinet of Love), plates (wanting ports.), 2 vol. in 1, old cf.,
 1721, 8vo. (166) *Shepherd*, £1
770 Rossetti (D. G.) Poems, first ed., orig. cl., presentation copy,
 1870, 8vo. (164) *Shepherd*, £3 3s.

771 Ruskin (John). The Crown of Wild Olive, first ed., short autograph letter of author inserted, orig. cl., 1866, 8vo. (56)
Clarendon, 14s.

772 Savoy (The), ed. ɔy Arthur Symons, illustrations ɔy A. Beardsley, vol. i.-iii., uncut, 1896, 4to. (190)
Colonial Book Co., £1 12s.

773 Seymour(Robert). Humourous Sketches, etc., 90 (only) sketches ɔy R. Seymour, one col. ɔy hand, on paper of various colours, Tregear, n. d., 8vo. (45) *Harpin,* 7s.

774 Shakespeare. Collection of Prints from Pictures painted for the purpose of illustrating the Dramatic Works of Shakspeare, 98 plates, including the ports. of George III. and Q. Charlotte, the last of "The Seven Ages" loose and from a shorter copy, 2 vol. (port. and title in vol. ii. mended, and a few plates stained), mor., g. e., ruɔ)ed, J. and J. Boydell, 1803, atlas folio (302) *Spencer,* £10

775 Shaw (G. B.) An Unsocial Socialist, 1887—The Quintessence of Iɔsenism, 1891—The Perfect Wagnerite, 1898—Cashel Byron's Profession, 1901, 8vo. (182) *Hyam,* £1 18s.

776 Shaw (G. B.) Dramatic Opinions and Essays, 2 vol., 1907—John Bull's Other Island, and Major Barɔara, 1907—Man and Superman, 1903, together 4 vol., 8vo. (183)
Cannon, £1 4s.

777 Shaw (G. B.) Three Plays for Puritans, 1901—Plays, Pleasant and Unpleasant, port., 2 vol., 1898—The Irrational Knot, 1905, together 4 vol., 8vo. (184) *Maggs,* £2 2s.

778 Sinclair (Geo.) The Hydrostaticks, with the extra dedication to the Town Council of Edinɔurgh and the arms of Lord Oxfuird, diagrams, old cf., *Edinb.,* G. Swintoun, 1672, 4to. (117) *Harpin,* £1 12s.

779 Smith (Alex.) Lives and Roɔɔeries of the Highwaymen, plates, 3 vol., 1719-20—Memoirs of Jonathan Wild, plates (1726), cf. (some leaves repaired), 1719-26, 8vo. (16)
Rimell, £2 8s.

780 Sporting Magazine, New Series, plates, vol. i.-xxiii., cf. gt., 1818-29, 8vo. (7) *Maggs,* £6 5s.

781 [Spruel (John).] An Accompt Current ɔetwixt Scotland and England Ballanced (headlines shaved), hf. mor., t. e. g., *Edinb., Heirs of And. Anderson,* 1705, 4to. (112)
Parkinson, 11s.

782 Stirling-Maxwell (Sir W.) The Cloister Life of the Emperor Charles the Fifth, third ed., autograph letter of the author inserted, orig. cl., uncut, 1853, 8vo. (57) . *Hatchard,* 15s.

783 Swinɔurne (A. C.) Bothwell, 1874—Studies in Song, 1880—A Midsummer Holiday, 1884, first eds., 3 vol., orig. cl., 8vo. (124) *B. F. Stevens,* £1 1s.

784 Swinburne (A. C.) The Heptalogia, first ed., orig. cl., 1880, 8vo. (125) *Shepherd,* £1 11s.

785 Swinɔurne (A. C.) Marino Faliero, 1885—A Study of Victor Hugo, 1886—A Study of Ben Jonson, 1889, first eds., orig. cl., 8vo. (126) . *B. F. Stevens,* 15s.

786 Swinɔurne (A. C.) The Sisters, unopened, 1892—Astrophel,

1894—Studies in Prose and Poetry, 1894, first eds., orig. cl., 8vo. (127) *B. F. Stevens.* 14s.

787 Swinburne (A. C.) A Channel Passage and other Poems. 1904 —Love's Cross-Currents, 1905, first eds., orig. cl. and buckram, 8vo. (128) *Quaritch,* 9s.

788 Sylvester (Joshua). Lachrymae Lachrymarum (fore-edge of first title cut, title to "Six Funeral Elegies" defective), some leaves with blank black page, skeletons in margins, arms of the Prince, etc., russ. ex., 1613, 4to. (93) *Allison,* £1 12s.

789 Wagstaffe (John). The Question of Witchcraft debated, old sheep, 1671, 8vo. (24) *Dobell,* 7s.

790 Watsou (J.) History of the Art of Printing, folding sheet of specimens, cf., *Edinb.*, 1713, 8vo. (66) *J. Grant,* £2 6s.

791 Watt (R.) Bibliotheca Britannica, 4 vol., cf., *Edinb.*, 1824, 4to. (78) *Carlton,* £1

792 Wilde (O.) Rise of Historical Criticism, uncut, *Privately printed*, 1905—Sebastian Melmoth, uncut, in case, 1904, 8vo. (153) *B. F. Stevens,* 6s.

793 Wilde (O.) Picture of Dorian Gray, first ed., hf. parchment, uncut (back injured), presentation copy with inscription, n. d., 8vo. (58) *Spencer,* £3

794 Wilde (O.) An Ideal Husband, first ed., uncut, 1899, 8vo. (147) *Tregaskis,* 14s.

795 Wilde (O.) Ballad of Reading Gaol by C. 33, uncut, 2 copies, one first ed., 1898, 8vo. (148) *Edwards,* 15s.

796 Wilde (O.) Ballad of Reading Gaol, first ed., one of 30 copies on Japanese vell., presentation copy, uncut, 1898, 8vo. (149) *Hatchard,* £3 5s.

797 Wilde (O.) The Happy Prince, first ed., LARGE PAPER, 75 copies printed, illustrations by Walter Crane and J. Hood, in duplicate, on India paper, vell., uncut, 1888, imp. 8vo. (150) *Maggs,* £4 4s.

798 Wilde (O.) Ravenna, Newdigate Prize Poem, 2 copies, wrappers, *Oxford*, 1878, 8vo· (151) *Quaritch,* 18s.

799 Wilde (O.) Works, collected ed., one of 80 copies printed on Japanese vellum, 14 vol., vell., t. e. g., 1908, 8vo· (134) *B. F. Stevens,* £18 10s.

800 Wilde (O.) Lord Arthur Savile's Crime, first ed., uncut, 1891, 8vo. (135) *Quaritch,* £1 1s.

801 Wilde (O.) Picture of Dorian Gray, first ed., uncut, n. d., 8vo· (136) *Spencer,* 14s.

802 Wilde (O.) Intentions, first ed., uncut, 1891, 8vo. (138) *Quaritch,* £1 6s.

803 Wilde (O.) Poems, one of 220 copies, uncut, 1892, 8vo. (138) *Spencer,* £1 16s.

804 Wilde (O.) Lady Windermere's Fan, first ed., uncut, 1893, 8vo· (140) *Tregaskis,* £2 10s.

805 Wilde (O.) Salomé, Drame en un Acte, first ed., orig. blue wrappers, *Paris*, 1893, 4to. (198) *Hatchard,* £2 12s.

806 Wilde (O.) Salome, first English ed., one of 100 copies, illustrations by A. Beardsley on Japanese paper, uncut, 1894, 4to. (199) *Quaritch,* £5 5s.

807 Wilde (O.) Salome, first English ed., illustrations by Aubrey
Beardsley, uncut, 1894, 8vo. (141) *Quaritch, £4*
808 Wilde (O.) A Woman of No Importance, first ed., uncut,
1894, 8vo. (142) *Quaritch, £2*
809 Wilde (O.) De Profundis, first ed., uncut, 1905, 8vo. (143) 12s.
810 Wilde (O.) De Profundis, one of 50 copies on Japanese vell.,
uncut, 1905, 8vo. (145) *Bickers, £2*
811 Wilde (O.) The Importance of being Earnest, first ed., uncut,
1899, 4to. (146) *Dobell, 14s.*
812 Wilde (O.) The Happy Prince, first ed., illustrations, parch-
ment, uncut, 1888, 4to. (200) *Quaritch, £1 10s.*
813 Wilde (O.) Picture of Dorian Gray, LARGE PAPER, one of
250 copies, hf. vell., unc., 1891, 4to. (201) *Quaritch, £3 7s. 6d.*
814 Wilde (O.) A Woman of No Importance, first ed., LARGE
PAPER, 50 copies printed, buckram, uncut, 1894, 4to. (202)
Maggs, £5 2s. 6d.
815 Wilde (O.) An Ideal Husband, first ed., LARGE PAPER, one
of 100 copies, uncut, 1899, 4to. (203) *Quaritch, £2 10s.*
816 Wilde (O.) The Importance of being Earnest, first ed., LARGE
PAPER one of 100 copies, uncut, 1899, 4to. (204)
Quaritch, £2 16s.
817 Wilde (O.) The Chameleon, No. 1 (all published), limited to
100 copies, orig. wrappers, uncut, 1894, 4to. (206)
Quaritch, £2 10s.
818 Wilde (O.) The Portrait of Mr. W. H., 200 copies printed for
private circulation, orig. wrappers, uncut, n. d., 4to. (207)
Spencer, 8s.
819 Wilde (O.) Essays, Criticisms and Reviews, one of 300 copies,
uncut, *Privately printed*, 1901, 4to. (208) *Shepherd, 5s.*
820 Wilde (O.) Vera, or the Nihilists, one of 200 copies, uncut,
as issued, *Privately printed*, 1902, 4to. (209) *Shepherd, 5s.*
821 Wilde (O.) The Harlot's House, édition de grand luxe, on
vell., with 3 sets of the illustrations, 12 copies issued, 1904,
folio (213) *Spencer, £1 12s.*
822 Wilde (O.) The Harlot's House, édition de luxe, on Japanese
paper, the 5 illustrations in duplicate, one of 50 copies, 1904,
folio (214) *Spencer, £1 4s.*
823 Wordsworth (William). Poems, first ed., with autograph
signature " Wm. Wordsworth," 2 vol., mor., g. e., 1807, 8vo.
(55) *Sotheran, £3*
824 Yellow Book (The), illustrations by A. Beardsley, etc., vol.
i.-xiii., 1894-97, 8vo. (122) *Edwards, £1 8s.*
825 Zola (É.) Le Docteur Pascal, first ed., Holland paper, orig.
wrappers preserved, *Paris*, 1893—L'Argent, first ed., Holland
paper, wrappers preserved, *ib.*, 1891, 8vo. (185) *Barnard, 10s.*
826 Zola (É.) Nana, first ed., presentation copy to Edmond de
Goncourt, with autograph inscription, orig. wrappers, *Paris*,
1880, 8vo. (186) *Barnard, £1 1s.*
827 Zola (É.) Germinal, first ed., orig. wrappers, in case, *Paris*,
1885, 8vo. (187) 9s.
828 Zola (É.) La Terre, first ed., presentation copy to Edmond de
Goncourt, with inscription, orig. wrappers, *Paris*, 1887, 8vo.
(188) *Barnard, £1 1s.*

PUTTICK & SIMPSON.

The Library of the late Mr. F. J. Welch, of Denmark Hill, and other Properties.

(No. of Lots, 686 ; amount realised, £902 19s. 6d.)

(a) Mr. Welch's Library.

829 Arabian Nights, by E. W. Lane, engravings by Harvey, 3 vol., orig. cl., 1839, 8vo. (194) *Meadows*, £1 12s.
830 Arabian Nights. Arabic Text ed. with Notes (in German), by Dr. Habricht, 12 vol., cf., 1825, 8vo. (384) *Quaritch*, £1 6s.
831 British Novelists, by Mrs. Barbauld, 50 vol., mor. ex., 1820, 8vo. (192) *Spencer*, £11
832 Brunet (J. C.) Manuel du Libraire, with supplement, 6 vol., hf. mor., 1842-70, 8vo. (411) *Burt*, £1 18s.
833 Burke (E.) Works, 16 vol., hf. cf., 1826, 8vo. (23) *Bull*, £1 8s.
834 [Burton (Robert).] Anatomy of Melancholy, the fifth ed., title by Blon, orig. cf. (rebacked), *Oxford*, 1638, folio (296)
 Quaritch, £2 12s. 6d.
835 Churchill (J.) Collection of Voyages and Travels, port., maps and engravings, 4 vol., cf., 1744-46, folio (302)
 F. Edwards, £1 12s.
836 Cicero de Philosophia, old black mor. (xvith century) binding, tooled sides, lettered "Hoc Virtutis Opus," *Venetiis*, 1552—Pontanus (J. J.) Floridorum, stamped pigskin, 1592, 8vo. (403) *Leighton*, £3 15s.
837 Colebrooke (H. T.) Miscellaneous Essays, Schopenhauer's copy with his bookplate, 2 vol., cl., 1837 (83) *Meulineere*, 18s.
838 Dasent (Sir G. W.) The Story of Burnt Njal, maps and plans, 2 vol., cl. ex., 1861, 8vo. (107) *Bull*, £1 5s.
839 Descartes (R.) Œuvres, publiées par Victor Cousin, 11 vol., hf. cf., 1824-26, 8vo. (350) *Baker*, £2 15s.
840 Dodsley (R.) Select Collection of Old Plays, 12 vol., bds., uncut, 1825-27, 8vo. (243) *Braund*, £1 8s.
841 Elegant Extracts, 18 vol., mor. ex., Sharpe, 12mo. (193)
 Walford, £1 15s.
842 English Illustrated Magazine, vol. i.-xxv., 10 vol. hf. cf., rest binder's cl., 1883-1901, 8vo. (415) *E. George*, £1 6s.
843 Fichte (J. H.) Sammtliche Werke, 11 vol., hf. cf., 1845, 8vo. (328) *Quaritch*, £5 10s.
844 Froissart (Sir J.) Chronicles, by Johnes, illuminated front. and cuts, 2 vol., hf. russ., 1844, 8vo. (77) *Cox*, £1
845 Giles (H. A.) Strange Stories from a Chinese Studio, 2 vol., 1880—Legge. The She King or Book of Ancient Poetry, 1876—Iu-Kiao-Li, traduit par Remusat, 2 vol., 1826—Hau Kiou Choaan, a Translation from the Chinese, 4 vol., 1761, together 9 vol., 8vo. (386) *Edwards*, £1 7s.

846 Gladstone (W. E.) Studies on Homer and the Homeric Age,
 3 vol., cl., *Oxford*, 1858, 8vo. (380) *Hill*, £1
847 Goethe (J. W. von). Sammtliche Werke, 30 vol. in 18, hf. cf.,
 Stuttgart, 1857-58, 8vo. (337) *Winter*, £1 15s.
848 Grimeston (Ed.) Generall Historie of the Netherlands, with
 "The Queen of Englands Declaration to the King of Spain"
)etween pages 646-7, ports., old cf., 1609, folio (297)
 Lusac, £1
849 Harris (J.) Complete Collection of Voyages and Travels,
 maps and plates, with map of Georgia, 2 vol., cf., 1744, folio
 (300) *Grant*, £1 4s.
850 Hegel (G. W. F.) Werke, 18 vol. in 21, hf. cf. (wanted vol. ix.),
 Berlin, 1832, 8vo. (344) *Koehler*, £5 15s.
851 Ho))es (Thos.) Works, English and Latin, 16 vol., cl.,
 1839-45, 8vo. (24) *Koehler*, £2 10s.
852 Jowett (B.) Dialogues of Plato, 5 vol., cl., 1875, 8vo. (124)
 G. H. Brown, £2 9s.
853 Kant (Immanuel). Sammtliche Werke, 12 vol., hf. cf. gt.,
 uncut, 1838, 8vo. (342) *Hill*, £2 12s. 6d.
854 Kant (I.) Werke, 10 vol. in 5, hf. cf., *Leipzig*, 1839, 8vo. (343)
 Sotheran, £1 8s.
855 Laing (S.) The Heimskringla, 3 vol., cf. ex., 1844. 8vo. (108)
 Thin, £1 6s.
856 Lessing (G. E.) Le)en und Werke, 12 vol. in 14, hf. mor.,
 Berlin, 1859, 8vo. (336) *Hill*, £1
857 Las Casas (Le Comte de). Private Life and Conversations of
 the Emperor Napoleon, port. and col. views, 4 vol., bds.,
 1825, 8vo. (154) *Allison*, £2 15s.
858 Marlowe (Christopher). Works,)y Dyce, 3 vol., orig. cl.,
 Pickering, 1850, 8vo. (239) *Hill*, £4 7s. 6d.
859 Middleton (T.) Works, by Dyce, 5 vol., cl., 1840, 8vo. (240)
 Hill, £2 4s.
860 Muir (J.) Original Sanskrit Texts on the Origin and History
 of the People of India, 5 vol., 1858-71, 8vo. (393)
 Edwards, £2 7s. 6d.
861 Müller (F. Max.) Sacred Books of the East, vol. i., ii., iii., xv.,
 xxxiv.,xxxviii.,xxxix.,xl.,8vol.,1879-91,8vo.(394) *Barnard*, £2
862 Mure (Wm.) Language and Literature of Ancient Greece,
 5 vol., cl., 1854-57, 8vo. (80) *Hill*, £1 1s.
863 Panizzi (Sir A.) Orlando Innamorato di Bojardo—Orlando
 Furioso,)y Ariosto, with Essay on the Romantic Narrative
 Poetry of the Italians, 9 vol., Pickering, 1830-34 (357)
 Mayhew, £1 8s.
864 Picus de Mirandula (J. F.) Opera Omnia, old cf., *Venetiis*,
 1498, folio (313) *Polygot*, £1 12s.
865 Ramsay (Allan). The Ever Green, first ed., interleaved with
 MS. notes)y Mr. Callendar of Craigforth, 2 vol., *Edinburgh*,
 1724, 4to. (238) *Dobell*, £1 3s.
866 Rawlinson (G.) History of Herodotus,)est ed., maps and
 illustrations, 4 vol., cl., 1858-60, 8vo. (123) *Allison*, £1 14s.
867 Richardson (S.) Works, with Life by Maugin, 19 vol., cf.,
 1811, 8vo. (151) *Allison*, £5

868 Ruskin (J.) Modern Painters, plates, 5 vol., 1848-60 (vol. iii.-v.
first eds.)—Stones of Venice, first ed., illustrations, 1851-3,
together 8 vol., hf. mor., g. t., 8vo. (442) *Sully*, £7
869 Sidney (Sir P.) The Countesse of Pem)roke's Arcadia, orig.
cf. (re)acked), 1633, folio (299) *Jones*, £1 8s.
870 Shelley (P. B.) Poetical Works, ed.)y Mrs. Shelley, port.,
3 vol., orig. cl., Moxon, 1847—Essays, etc., 2 vol., *ib.*, 1852,
together 5 vol., 8vo. (232) *Hill*, £1 5s.
871 Skene (W. F.) Four Ancient Books of Wales, 2 vol., cl.,
Edinburgh, 1868, 8vo. (111) *Walford*, £1 10s.
872 Slater (J. H.) Book-Prices Current, 1897-99, together 3 vol.,
)uckram, 8vo. (412) *Burt*, £1
873 Smith (Sir W.) Greek and Roman Geography—Biography
and Mythology—Antiquities, together 6 vol., cl., 1853-6, 8vo.
(84) *Bull*, £1 5s.
874 Sterne (L.) Works, fronts.)y Stothard, 10 vol., cf., 1798, 8vo.
(150) *G. H. Brown*, £1 1s.
875 Symonds (J. A.) Studies of the Greek Poets,)oth series, first
ed. of the first, 2 vol., cl., 1873-76, 8vo. (213) *Allison*, £1 8s.
876 Symonds (J. A.) Shakespere's Predecessors in the English
Drama, first ed., cl., 1884, 8vo. (214) *Hill*, £1 19s.
877 Symonds (J. A.) Introduction to the Study of Dante, port.,
first ed., cl., 1872, 8vo. (215) *Quaritch*, £1 2s.
878 Vigfusson (G.) and Powell. Corpus Poeticum Boreale, 2 vol.,
cl., 1883, 8vo. (115) *Hill*, £3
879 Wharton (Grace). The Literature of Society, first ed., 2 vol.,
cl., 1862, 8vo. (428) *Maggs*, £1
880 Wilkinson (Sir J. G.) Manners and Customs of the Ancient
Egyptians, col. and other illustrations, 3 vol., cl., 1878, 8vo.
(81) *Hill*, £1 7s.
881 Williams (Jno.) Ecclesiastical Antiquities of the Kymry, 1844—
Stephens (T.) The Literature of Kymry, 1849—Rees (W. J.)
Lives of the Cambro British Saints, 1853, together 3 vol., cl.,
8vo. (116) *Hill*, £2 15s.
882 Wilson (H. H.) Vishnu Purana, 5 vol. in 6—Essays in Sanskrit
Literature, 3 vol.—Specimens of the Hindu Theatre, 2 vol.—
Religion of the Hindus, 2 vol., together 13 vol., cl., 1835-77,
8vo. (385) *Quaritch*, £4 5s.
883 Windsor Magazine, vol. i.-x., cl., 1895-99—Vol. i.-xii.,)inder's
cl., 1895-1900, together 22 vol., 8vo. (414) *Winter*, £1
884 Wordsworth. Poetical Works, port., 7 vol., Moxon, 1846—
The Prelude, 1851, together 8 vol., cl., 8vo. (231)
Meadows, £2 2s.

(β) *Other Properties.*

885 Adventurer (The), complete set of the orig. num)ers,)ound in
2 vol., cf., 1753, folio (661) *Sully*, £1 10s.
886 Ainger (A.) Charles Lam), text inlaid to 4to. size, and extra
illustrated)y ports., col. and other views, and autograph
letters, mor. ex., 1889-90, 4to. (570) *James*, £15
887 Al)erti (Leon Bap.) L'Architettura tradotta da Cosimo
Bártoli, illus., cf., 1550, folio (671) *Leighton*, £1 13s.

888 America. Mœurs Loix et Costumes des Sauvages du Canada, des Hottentots et Caffres, etc., col. plates within gold and col. borders by Laroque, hf. cf., not subject to return (1792), 4to. (587) *Grant*, £1 2s.

889 American News-Paper. The Columbian Sentinel, sundry numbers unbd., *Boston*, 1794 (1790?), folio (642) *Sully*, £1 7s. 6d.

890 Amphlett (W.) The Emigrants Directory to the Western States, with Instruction for Descending the Rivers Ohio and Mississippi, uncut, 1819—Woods. Two Years' Residence in Illinois Country, map, uncut, 1822—Burke. Account of the European Settlement in America, maps, 2 vol., cf., 1765, and others, 8vo. (460) *H. Stevens*, £3 15s.

891 Angelus de Clavasio. De Casibus Conscientiae, lit. goth., painted capitals, some leaves of Tabula, supplied in MS., old oak boards covered with stamped leather (*Nurnberg*, Ant. Coburg, 1492), folio (653) *Barnard*, £5 12s. 6d.

892 Armstrong (Sir W.) Gainsborough, 62 photogravures and 10 facs. in colour, 1898, folio (655) *Quaritch*, £7 15s.

893 Armstrong (Sir W.) Turner, special copy on Japanese vell., with the plates in 2 states, 2 vol., 1902, folio (656) *Sully*, £2 10s.

894 Bacon (F.) Essayes, orig. vell. tie, Haviland, 1632, 4to. (571) *Dobell*, £1 16s.

895 Baillie (Capt. William). Works, orig. issue, mor. ex., 1792, folio (664) *Brown*, £3

896 Bemrose (William). Bow, Chelsea and Derby Porcelain, illustrations, cl. ex., g. t., 1898, 8vo. (497) *Quaritch*, £2 7s. 6d.

897 Bentley (C.) and Schomburgh (R. H.) Twelve Views in the Interior of Guiana, col. copy, hf. mor., 1841, folio (669) *Edwards*, £2 12s. 6d.

898 Biblia Sacra Latina cum prologis Hieronimi, lit. goth., painted capitals, modern binding (broken), *Nurnberg*, Ant. Koburger, 1480, folio (650) *Edwards*, £1

899 Binyon (L.) Catalogue of Drawings in the British Museum, 4 vol., cl., 1898-1902, 8vo. (491) *Parsons*, £1 3s.

900 Boccaccio (G.) Decameron, by John Payne, illustrations by Challon, limited ed. on Japanese vell., 2 vol., cl., Laurence and Bullen, 1893, 4to. (554) *Sully*, £2 17s. 6d.

901 Boccaccio (G.) Decameron, by J. M. Rigg, illustrations by Louis Chalon, 2 vol., mor., g. t., 1906, 8vo. (473) *Reuter*, £1 17s. 6d.

902 Bocher (E.) Moreau le Jeune. Catalogue Raisonné des Estampes, port., wrappers, *Paris*, 1882, 4to. (551) *Quaritch*, £1 17s. 6d.

903 Boethius (Anicius). De Consolatione cum comment. Thomae de Aquino, lit. semi-goth., long lines and double columns, rubricated, painted capitals, illuminated initial on first page, old mor., g. e. (Derome), *Nuremberg*, Ant. Coberger, 1476, folio (645) *Maggs*, £10 5s.

904 Boydell (J.) History of the River Thames, LARGE PAPER, col. plates, 2 vol., contemp. mor. ex., 1794-96, folio (681)
Sully, £10
905 Boys (Wm.) Collections for a History of Sandwich, plates, *Canterbury*, 1792, 4to. (567) *Edwards*, £4 10s.
906 Bradney (J. A.) History of Monmouthshire, maps and illustrations, parts i. and ii., bds., 1906, folio (636)
Quaritch, £1 10s.
907 Burton (Wm.) History and Description of English Earthenware, col. plates, 1904, 8vo. (494) £1 10s.
908 Calendrier Republicain (Le), col. and other plates by Metivel, etc., 2 vol., hf. mor., g. t., uncut, orig. wrappers preserved, *Paris chez Dentu*, 4to. (556) *Maggs*, 18s.
909 Catherwood (F.) Views of Ancient Monuments in Central America, Chiapas and Yucatan, map and 24 plates, hf. mor., 1844, folio (663) *Sully*, £3 15s.
910 Chaffers (Wm.) Marks and Monograms on Pottery and Porcelain, cl. ex., 1908, 8vo. (496) *Miley*, £1 4s.
911 [Chamisso (A von).] Peter Schlemihl, first ed., 8 etchings by G. Cruikshank (name of Fouqué on title, afterwards corrected), bds., uncut, 1823, 8vo. (521) *Shepherd*, £1 8s.
912 Choderlos de Laclos (A. F.) Les Liaisons Dangéreuses, plates, 2 vol., cf. ex., uncut, 1820, 8vo. (469) *Sully*, £2 4s.
913 Church (John). A Cabinet of Quadrupeds, 2 vol., mor. ex., 1805, 4to. (553) *Le Mallier*, £2 15s.
914 Chaucer (Geoffrey). Works, fac. reproduction of the first ed. of 1532, with introduction by Skeat, 1905, folio (670)
Sully, £1 17s. 6d.
915 Combe (W.) Tours of Dr. Syntax, col. plates by Rowlandson, 3 vol., cf. ex., Nattali, n. d., 12mo. (474) *Sully*, £3 3s.
916 Crisp (F. A.) Memorial Rings in the possession of F. A. Crisp, hf. vell., g. t., privately printed, limited to 150 copies, 1908, 4to. (537) *Harding*, £1
917 Cruikshank (G.) Cruikshank's Table-Book, first ed., hf. cf., 1845, 8vo. (522) *Rivington*, £1
918 Cruikshank (G.) Phrenological Illustrations, col. copy, with autograph presentation inscription, " J. Grimaldi, Esq., with the Compts. of George Cruikshank," on wrapper, 1827, folio (683) *Spencer*, £2 10s.
919 Daniell (S. and W.) Sketches representing the Native Tribes, Animals and Scenery of S. Africa, 48 engravings by W. Daniell, hf. mor., uncut, 1820, 4to. (561) *Edwards*, £2 6s.
920 Dibdin (T. F.) Tour in France and Germany, vignettes on India paper, and the extra set of etchings by Lewis inserted (title of one cut), 3 vol., mor., 1821, 8vo. (465) *Sully*, £5
921 Dibdin (T. F.) Bibliographical Decameron, engravings, some on India paper, 3 vol., mor. ex., 1817, 8vo. (466)
Sully, £5 5s.
922 Dickens (Charles). Nicholas Nickleby, the orig. 20 parts in 19, with wrappers, 1838-9, 8vo. (524) *Spencer*, £4 7s. 6d.
923 Dickens (C.) Dombey and Son, in the orig. 20 parts in 19, with wrappers, 1846-8, 8vo. (525) *Spencer*, £2 6s.

924 Dickens (C.) David Copperfield, in the orig. 20 parts in 19, with wrappers, 1849-50, 8vo. (526) *Spencer*, £4 10s.

925 Dickens (C.) Bleak House, in the orig. 20 parts in 19, with wrappers, 1852-3, 8vo. (527) *Spencer*, £1 10s.

926 Dickens (C.) Little Dorrit, in the orig. 20 parts in 19, with wrappers, 1855-7, 8vo. (528) *Spencer*, £1 10s.

927 Dickens (C.) Our Mutual Friend, in the orig. 20 parts in 19, 1864-5, 8vo. (529) *Spencer*, £1 4s.

928 Dickens. Quill Pen used ɔy Charles Dickens, at the Villa des Montineaux, Boulogne, where he wrote parts of "Hard Times," the end of "Bleak House" and part of "Little Dorrit," given by him to his friend M. Beaucourt, in whose house (the aɔove villa) he passed three summers, 1853-56, "document and card" giving further particulars included (632) *Spencer*, £3 10s.

929 Eddis (W.) Letters from America, uncut, 1792—Hourson. Sketches of Upper Canada, uncut, 1821—Spanish Settlements in America, maps, 1762, and others, 8vo. (461)
H. Stevens, £2 10s.

930 Egypt Exploration Fund. Memoirs, maps and plates, including Pithom, 1855 ; Tanis, 1885 ; Naukratis, 2 parts, 1888—Royal Tomɔs, 1900—Aɔydos, 2 parts, 1902—Petrie. A Season in Egypt, 1887—Kahun, Gurob and Hawara, plates, 1890, together 9 vol., and parcel of plates, 4to. (572)
Hiersmann, £5

931 Fairɔairn (J.) Book of Crests, plates, 2 vol., hf. mor., g. t., 1892, 4to. (545) *Barnard*, £1 2s.

932 Fairɔairn (J.) Book of Crests, ɔest ed., plates, 2 vol., cl. ex., 1905, 8vo. (546) *Barnard*, £1

933 Farmer (John S.) Merry Songs and Ballads, 5 vol., bds., , *Privately printed*, 1897, 4to. (583) *Shepherd*, £2 2s.

934 Goldsmith (Oliver). The Good Natur'd Man, first ed., with hf. title and epilogue, unbd., entirely uncut, 1768, 8vo. (519)
F. Sabin, £38

935 Grego (Joseph). Rowlandson the Caricaturist, 400 illustrations, 2 vol., hf. mor., g. t., 1880, 4to. (544)
Hatchard, £1 15s.

936 Haden (Seymour). Aɔout Etching, plates, hf. mor., 1879, 4to. (573) *Sully*, £2

937 Haslem (John). The Old Derby China Factory, col. plates, 1876, 8vo. (495) *Hyam*, £2 12s.

938 Heinecken (K. H.) Idée Générale d'une Collection d'Estampes, folding plates, hf. mor., g. t., *Leipsic*, 1771, 8vo. (486)
Denman, £2

939 Heptameron (The), trans. ɔy Saintsɔury, 73 engravings by Freudenɔerg and 150 head and tail pieces by Dunker, 5 vol., hf. cf., g. t., 1894, 8vo. (467) *Joseph*, £2 10s.

940 Hess (H.) The Dance of Death, painted from Frescoes on the Cemetery Wall at Basle, 40 plates, hf. mor., n. d.—James Gillray, ɔy Harry Thornɔer, illustrated, 1891, 8vo. (539)
Sully, £2 6s.

941 Hutchinson (W.) History of Cumberland, maps and plates, 2 vol., cf., *Carlisle,* 1794, 4to. (562) *Mason,* £3 2s. 6d.
942 Iʒis (The), col. plates, from vol. iii., 1861, to Ninth Series, vol. ii., 1908, with Jubilee Supplement, together 49 vol., hf. mor., g. t., 1861 to March, 1909, 8vo. (508) *Porter,* £26
943 Jenkins (J.) Martial Achievements of Great Britain, col. plates by Heath, 1814-15—Naval Achievements of Great Britain, col. plates by Whitcombe (one torn), 1816, uniform hf. mor., 4to. (560) *Sully,* £8 15s.
944 Keulemans (J. G.) Onze Vogels in huis entuin, col. plates, 3 vol., cl. ex., 1869-76, 8vo. (507) *Sully,* £1 2s.
945 Kipling (R.) The Phantom Rickshaw—Wee Willie Winkie— Under the Deodars, orig. Indian ed., 3 vol., illustrated covers, in hf. mor., drop case, 8vo. (482) *Maggs,* £2 4s.
946 Kit-Cat Club. Memoirs, 48 ports., after Kneller, hf. mor., g. t., 1821, folio (637) *Vallentin,* £1 7s. 6d.
947 Laborde (A.) Description d'un Pavé en Mosaique découvert dans l'Ancienne Ville d' Italica, col. plates, mor. ex., 1802, folio (665) *Sully,* £2 7s. 6d.
948 La Fontaine (J. de). Contes et Nouvelles en vers, plates ʒy Eisen, one of 250 copies on Van Gelder paper, 4 vol., hf. mor., 1795, 4to. (555) *Sully,* £2 10s.
949 La Fontaine (J. de). Contes et Nouvelles en Vers, plates ʒy Eisen and Choffard, in two states, 2 vol., hf. mor. ex., uncut, *à Paris,* 1883, 8vo. (472) *Brown,* £2 2s.
950 La Fontaine (J. de). Tales and Novels in Verse, 45 engravings by Eisen, 2 vol., hf. mor., g. t., *Paris,* 1884, 8vo. (471)
 Spencer, £1 12s.
951 Leo (John). Geographical Historie of Africa, trans. by John Pory, with the rare folding map, cf., 1600, folio (662)
 Sully, £3 17s. 6d.
952 Liechtenstein (Princess Marie). Holland House, illustrations, A.L.s. of C. R. Leslie the painter inserted, 2 vol., orig. hf. mor. ex., 1874, 4to. (575) *Sully,* £2 2s.
953 Littré (E.) Dictionnaire de la Langue Française avec Supplement, 5 vol., cl., 1873-4, 4to. (596) *Miles,* £2 6s.
954 Lostelneau (Sieur de). Le Mareschal de Bataille, folding diagrams in colour, hf. mor., 1647, folio (679) *Sully,* £1 10s.
955 Lysons (D. and S.) Topographical Account of Cumberland (vol. iv. of Magna Britannia), maps and plates, extra illustrated, 2 vol., hf. mor. ex., 1816, 4to. (563) *Mason,* £3 5s.
956 Lysons (D. and S.) Topographical Account of Cornwall (vol. iii. of Magna Britannia), maps and plates and extra illustrated, 2 vol., hf. mor. ex., 1814, 4to. (564) *Sully,* £3 5s.
957 Lysons (D. and S.) Topographical Account of Buckinghamshire (part of Magna Britannia), map and plates and extra illustrated, hf. mor., g. t., 1806, 4to. (565) *Maggs,* £2 6s.
958 Lysons (D. and S.) Topographical Account of Bedfordshire (part of vol. i. of Magna Britannia), map and plates and extra illustrated, hf. mor. ex., 1806, 4to. (566) *Sully,* £2 4s.
959 Lysons (Daniel). Environs of London, maps and plates, extra illustrated, 5 vol., russ. ex., 1796-1800, 4to. (569) *Sully,* £3

960 Maha⟩hârata (The), or Krishna Dwaipayana Vyasa, translated into English Prose, pub. ⟩y Protap Chundla Roy, parts i.-c., unbd., 1883-94, not su⟩ject to return, 8vo. (510)
Sully, £2 15s.

961 Masson (F.) Cavaliers de Napoléon, illustrations d'apres Edouard Detaille, Japanese paper copy with duplicate plates in ⟩istre, mor. ex., with ⟩order of ⟩ees and Napoleonic sym⟩ols in corners, g. t., 1895, 4to. (557)
Le Mallier, £16 10s.

962 Merchant Taylors' School (History of), col. plates, uncut, orig. wrappers, Ackermann, 1896, 4to. (615)
Spencer, £1 6s.

963 Military Costume of India, ⟩y Capt. James, 35 col. plates, with descriptions, cl., Goddard, 1814, 4to. (586)
Tregaskis, £4 15s.

964 Missale Secundum Ritum Augustensis Ecclesiae, lit. gotḥ. 𝕸agna, musical notes, woodcut title with full-page woodcut 'on reverse, and other full-page cuts and ⟩orders, the 8 leaves of the Canon printed on vellum, with large painted initial, old pigskin covered bds., *Impressum hoc Dillinge in edibus Sebaldi Mayer,* 1555, folio (646)
Bull, £7 15s.

965 Modern Stucco Decorations, ⟩oth series, 120 plates, 2 vol., bds., *Vienna,* Wolfdrum and Co., folio (667) *Batsford,* £1 1s.

966 Molière (J. B. P.) Œuvres, engravings ⟩y Moreau, 6 vol., old cf. gt., *Paris,* 1773, 8vo. (468)
Isaacs, £15

967 Nash (J.) Windsor Castle, interior and exterior views, 25 col. plates, mounted on thick cards like drawings, in portfolio, hf. mor., 1848, folio (658)
Reuter, £1 15s.

968 Ottley (W. Y.) Early History of Engraving, illustrations, 2 vol., cf., 1816, 4to. (577)
Bull, £1 10s.

969 Owen (Hugh). Two Centuries of Ceramic Art in Bristol, illustrations, hf. mor., g. t., 1873, 8vo. (492) *Hyam,* £4 10s.

970 Paquot (Ris). Histoire Générale de la Faience, 200 col. plates, 2 vol., hf. mor., 1874-6, folio (680)
Parsons, £4 18s.

971 Petrarca (Francesca). Trionfi e Sonetti, vell., *In Venetia,* 1486, folio (651)
Mence, £2 2s.

972 Poole (J.) The English Parnassus, mor. ex. (no front.), 1677, 8vo. (503)
Sully, £1 1s.

973 Printsellers' Association, Plates Declared, 1847-92 et seq. (1906), with Index of Artists, 1894, 3 vol., hf. mor., 4to. (550)
Sully, £1 10s.

974 Romney (Geo.) A Biographical and Critical Essay, ⟩y Humphrey Ward and W. Ro⟩erts, ports., etc., 2 vol., hf. mor., g. t., uncut, 1904, 4to. (552)
Josephs, £2 10s.

975 Rousseau (J. J.) La Botanique, plates in 2 states, plain and col., old mor., 1805, folio (666)
Muliniere, £2 10s.

976 Sanson (N.) Atlas, 64 col. maps, hf. vell. with clasps, 1779, folio (657)
Sully, £1 10s.

977 Sartel (O. du). La Porcelaine de Chine, col. plates and illus-trations, hf. mor. ex., *Paris,* 1881, 4to. (558)
Quaritch, £3 15s.

978 Shakespeare. Mac⟩eth. | A | Tragedy with all the | Altera-

tions | Amendments | Additions | and | New Songs | **as it
is now acted at the Theatre Royal.** cf. ex., 1695, 4to. (579)
Leighton, £1 10s.

979 Shakespeare (W.) Facsimile reproduction of the First Folio
of 1623, by Howard Staunton, orig. cl., 1866, folio (638)
Parsons, £2

980 Shelley (P. B.) Poetical Works, port., 4 vol., hf. cf., Moxon,
1839, 8vo. (536) *Hornstein,* £1 6s.

981 Skelton (Sir J.) Charles I., illustrations in colours and photo-
gravure facs., etc., Japanese paper, with two series of plates,
in cloth box, Goupil, 1898, 4to. (599) *Fish,* £1 4s.

982 Strale (G. H.) Notices et recherches sur les Ceramiques
Suédoises du dix-huitième siècle, col. plates, hf. mor., 1872,
8vo. (501) *Sully,* £1 17s. 6d.

983 Symonds (J. A.) Life of Michelangelo Buonarroti, LARGE
PAPER, port. and plates, 2 vol., cl., 1893, 8vo. (499)
Brown, £3 17s. 6d.

984 Tasso (Torquato). La Gierusalemme Liberata, old mor. ex.,
Genova, 1590, 4to. (580) *Drowitch,* £1 2s.

985 Thackeray (W. M.) Works, by Anne Ritchie, illustrations, 13
vol., hf. cf., 1898, 8vo. (530) *Redington,* £2 10s.

986 Thoresby (R.) Ducatus Leodiensis, second ed., plates, 2 vol.,
cf. ex. (a few plates foxed), 1816, folio (660) *Sully,* £3 5s.

987 Tudor Facsimile Texts, ed. by John S. Farmer, 30 vol., hf.
buckram, 1907, etc., and 2 vol., folio, similar binding, 1908-9,
T. and E. Jack, 4to. (582) *James,* £6

988 Turner (William). The Ceramics of Swansea and Nantgarw,
illustrated, cl., 1897, 8vo. (498) *Edwards,* £2

989 Tymms (W. R.) and Wyatt (R. D.) Art of Illuminating,
plates in gold and colours, orig. cl., 1860, 4to. (611)
Batsford, £1 8s.

990 Ussieux (M. d'). Les Nouvelles Françoises, plates in style of
Eisen, 3 vol., uncut, *Paris,* 1783, 8vo. (470) *Sully,* £3 15s.

991 Valerius Maximus. Dictorum et Factorum Memorabilium,
vell., *Venetiis,* 1474—Quintilianus. Declamationes, Roman
letter, painted capitals, cf., *ib.,* 1482, together 2 vol., folio (652)
Mence, £5 5s.

992 Vocabula Amatoria. A French-English Glossary of Words,
Phrases and Allusions, occurring in the Works of Rabelais
and others, bds., *Privately printed,* 1896, 4to. (585)
Brown, £1

993 Walpole (H.) Anecdotes of Painting in England, Major's ed.,
ports. by Worthington, etc., 5 vol., mor. ex., 1828, 8vo. (531)
Sotheran, £4 7s. 6d.

994 Walton (I.) Lives of Donne, Wotton, Hooker, Herbert and
Sanderson, ports., cf. ex., *York,* 1796, 4to. (538)
Hatchard, £1 4s.

995 Wedgwood (J. C.) History of the Wedgwood Family, port.
and illustrations, cl., 1908, 8vo. (547) *Walford,* £1 10s.

996 Williams (H. Noel). Madame Récamier and her Friends,
illustrations, hf. mor., uncut, 1901, 4to. (549)
Hatchard, £2 17s. 6d.

HODGSON & CO.

A MISCELLANEOUS COLLECTION.

(No. of Lots, 970 ; amount realised, about £1,000.)

997 Ægidius. Le Mirouer Exēplaire et tresfructueuse instruction
selon la cōpillation de Gilles de Rome, lettres batarbes,
4 woodcuts (corner of one leaf defective), hf. cf., *a Paris
pour Guillaume Eustace*, 1516, sm. folio (146) £5 10s.

998 Agricola (G.) De re Metallica, woodcuts, old cf. gt., *Basileæ*,
H. Froben, 1561, folio (179) *Ellis*, £4 7s. 6d.

999 Albin (E.) Natural History of English Insects, 100 col.
plates, old cf. gt., 1749, 4to. (555) 17s.

1000 America. Declaration of the Associates of the Government
of New-Plymouth, in Laying the first Foundations and
Disposing of the Lands, hf. mor., *Boston*, 1773, 12mo. (235)
£1 4s.

1001 America. Laws of New-York, from the year 1691-1751
inclusive, published according to an Act of Assembly, bds.
(some leaves foxed), *New-York*, J. Parker, 1752, folio (310)
£1 10s.

1002 America. Political Magazine and Naval and Military
Journal, plates, also numerous maps and articles relating to
America, vol. i.-v., in 4 vol., hf. cf., 1780-83, 8vo. (36)
Maggs, £1 10s.

1003 America. History of the War with America, France and
Holland, old cf., *Printed in the year* 1787, 8vo. (245) £1 7s.

1004 Anburey (T.) Travels through the Interior parts of America,
plates, 2 vol. (vol. i. no title), 1789—The Northern Traveller,
plates, 12mo., cl., *N. Y.*, 1831, 8vo. (35) *Dean*, £1 15s.

1005 Andrews (J.) History of the War with America, from 1775-83,
ports. and maps, 4 vol., old cf., 1785-6, 8vo. (412) £1 14s.

1006 Andrewes (Lancelot). XCVI. Sermons, old mor., royal arms
in centre, gilt ornaments at angles, from the collection of
King Charles I., R. Badger, 1631, 4to. (201) *Ellis*, £6 10s.

1007 Angelo (H.) Reminiscences, illustrations from the Grego
collection, some col., limited ed., on hand-made paper (one
of 75 copies only), 2 vol., hf. mor., t. e. g., with the portfolio
of 12 duplicate col. plates, 1904, imp. 8vo. (469)—Angelo's
Pic Nic, illustrations from the Grego collection (one of 50
numbered copies), hf. mor., t. e. g., 1905, imp. 8vo. (470) £3

1008 Arabian Nights' Entertainments, 114 plates on Japanese
paper, col. copy, 17 vol., cl., t. e. g., *Printed for Private
Subscribers by the Burton Club* [1906], 8vo. (472)
Bumpus, £8 12s. 6d.

1009 Ariosto (L.) Orlando Furioso, by Hoole, plates by Barto-
lozzi, 5 vol., old cf. gt., 1783, 8vo. (73) 18s.

1010 Asiatic Researches, or Transactions of the Bengal Society, plates, 12 vol., cf. gt., 1801-18, 8vo. (49) £1 2s.

1011 Astrological. Leupoldus (Ducis Austriæ filius). Compilatio de Astrorum Scientia, diagrams, some partly col., and woodcuts, 109 leaves, gothic letter (Hain, No. 10042), Erhard Ratdolt, *Augusteñ*, 1489—Abiosi Dialogus in Astrologiæ Defensionum, 37 leaves (Hain, No. 24), *Venetiis*, F. Lapicida, 1494—Alchabitius, Libellus, cum comento (margins stained), *ib.*, 1502—Interpretationes seu Somnia Danielis, 8 leaves only, gothic letter, bound together (irregularly) in 1 vol., old cf., 8vo. (144) *Quaritch*, £8 10s.

1012 [Austen (Jane).] Emma, first ed., 3 vol. (hf. title to vol. i. only), contemp. cf. gt., 1816, 8vo. (81) £2 8s.

1013 [Austen (Jane).] Mansfield Park, first ed., 3 vol., (hf. title to vol. iii. wanted), hf. cf., 1814, 8vo. (928) £3 7s. 6d. [Sold on October 14th.—ED.]

1014 [Austen (Jane).] Sense and Sensibility, first ed., 3 vol. (no hf. titles), hf. cf., T. Egerton, 1811, 8vo. (407) *Hornstein*, £2

1015 Balfour (A. J.) A Defence of Philosophic Doubt, cl., uncut, 1879, 8vo. (394) *Baker*, £1 12s.

1016 Bancroft (G.) History of the United States, ports., 10 vol., uncut, cl. (not uniform in colour), *Boston and London*, 1854-74, 8vo. (457) *Brown*, £2

1017 Barnes (J.) Tour through the Island of St. Helena, col. port., bds., uncut, 1817, 12mo. (429) *Hatchards*, £1 5s.

1018 Beardsley (A.) Six Drawings illustrating Gautier's Mademoiselle de Maupin (one of 50 sets), in portfolio, 1898 (474) 12s.

1019 Beawes (W.) Lex Mercatoria Rediviva, old cf. (cracked), 1761, folio (311) £1 8s.

1020 Benzoni (Hierome). Histoire Nouvelle du Nouveau Monde (stained), vell. [*Geneva*,] E. Vignon, 1579 (222) £1 5s.

1021 Bewick (T.) History of British Birds, 2 vol., cf., t. e. g., *Newcastle*, 1826, 8vo. (500) 17s.

1022 Bicknell (C.) Flowering Plants and Ferns of the Riviera, 82 col. plates, hf. roan, t. e. g., 1885, imp. 8vo. (476) *Quaritch*, 19s.

1023 Biondi (Sir F.) History of the Civil Warres of England, 2 vol. in 1, old mor., tooled ornament in centre and corners of panel, with initials " R. W." on sides, g. e., 1641, sm. folio (196) *Leighton*, £2 4s.

1024 Bishop (G.) New-England Judged by the Spirit of the Lord, 3 parts in 1 vol., old cf. [1702]-03, 8vo. (228) £1 5s.

1025 Blackwall (J.) Spiders of Great Britain and Ireland, col. plates, 2 parts, 1861-4, folio (530) *Quaritch*, £1 12s.

1026 Boccaccio (G.) The Decameron, trans. by Rigg, illustrations by Chalon, col. copy, 2 vol., cl., t. e. g., with the 8 additional col. plates in portfolio, 1903, 8vo. (473) *Barnard*, £1 16s.

1027 Boileau-Despréaux (N.) Œuvres, par Saint-Marc, plates after Picart, 5 vol., old cf. gt., *Paris*, 1772, 8vo. (90) 8s.

1028 Booth (E. T.) Rough Notes on Birds, 113 col. plates, 3 vol., hf. mor., t. e. g., 1881-7, atlas 4to. (576) £11 15s.

1029 Borlase (W.) Antiquities of Cornwall, map and plates, old
russ. gt. (cracked), 1769, folio (183) 18s.
1030 Bougainville (L. de). Voyage autour du Monde, folding maps
and charts, *Paris*, 1771—Sonnerat. Voyage à la Nouvelle
Guinée, plates, 1776, 2 vol., old cf., 4to. (154) £1 7s.
1031 Bronn (H. G.) Klassen und Ordnungen des Thier-Reichs,
plates, 3 vol., hf. buckram, *Leipzig*, 1890, roy. 8vo. (526)
£1 1s.
1032 Brown (T.) Works, Serious, Moral, Comical and Satyrical,
plates (one defective), 4 vol., old cf. gt., 1719-20, 8vo. (69)
18s.
1033 Burke (E.) Works and Correspondence, best Library ed.,
port., 8 vol., orig. cl., 1852, 8vo. (478) *Maggs*, £4 10s.
1034 [Burney (F.)] Camilla, first ed., 5 vol., hf. bd., 1796, 8vo. (80)
Hornstein, £1 1s.
1035 Cadogan (G.) The Spanish Hireling Detected, 1743—
Bungiana, 1756, and 8 others, in 1 vol., hf. bd., 8vo. (411)
£3 10s.
1036 Carlyle (T.) Collected Works, Library ed., port. and other
illustrations, with Index complete, 34 vol., hf. cf. gt. (slightly
rubbed), [dated] 1870-72, 8vo. (479) *Bain*, £8 2s.
1037 Catlin (G.) Illustrations of the Manners, Customs and Con-
dition of the North American Indians, outline plates, 2 vol.,
cl., 1851, 8vo. (460) 17s.
1038 Century Dictionary (The), ed. by W. D. Whitney, 6 vol., cl.,
1889-91, 4to. (565) £1 13s.
1039 Cervantes (M. de). Don Quichotte, plates after Coypel and
others, 2 vol., old mor., g. e., La Haye, 1774, 8vo. (105)
Edwards, £1 10s.
1040 Cervantes (M. de). Don Quijote, plates after J. Rivelles,
5 vol., old Spanish cf., *Madrid*, 1819, 8vo. (106)
Bain, £1 16s.
1041 Chandler (T. B.) An Appeal to the Public in behalf of the
Church of England in America, *New York*, J. Parker, 1767
—The Appeal Defended, *ib.*, H. Gaine, 1769, presentation
copies, in 1 vol., cf., 8vo. (231) £1
1042 Chappell (E.) Voyage of H.M.S. Rosamond to Newfoundland
and the Southern Coast of Labrador, col. map and plates,
bds., uncut, 1818, 8vo. (38) 12s.
1043 Charles I. Eikon Basiliké, folding plate, with explanation
beneath [No. 6 in Almack], old black mor., small gilt
stamps within panel, g. e., 1648, 8vo. (203) £1
1044 Charles I. Eikon Basiliké, folding plate and ports. (No. 42
in Almack), Queen Charlotte's copy, black mor., delicately
tooled ornament in centre, 1649, 8vo. (204) £1
1045 Charles I. ΕΙΚΩΝ ΒΑΣΙΛΙΚΗ. French Translation, LARGE
PAPER [No. 55 in Almack], the errata corrected by the hand
of the translator, with M.S. note, orig. mor., no gt. tooling,
black edges, *Rouen, chez Berthelin*, 1649, 4to. (202) £1 10s.
1046 Charles I. Eikon Basiliké, folding plate (No. 45 in Almack),
old black mor., gt. ornaments, g. e., 1649, 8vo. (205)
Leighton, £1 13s.

1047 Charles I. Reliquiæ Sacræ Carolinæ, or the Works of that
 great Monarch King Charles I., old black mor., sides and
 back tooled, and inlaid gauffered edges, *Hague*, 1651, 12mo.
 (206) £1 19s.
1048 Charles II. Eikon Basiliké Deutera, front., old cf., crown
 and initials " C. R." on sides, 1660—Outram. Sermons, cf.,
 crowned cipher of King Charles II., 1680, 8vo. (207)
 £1 10s.
1049 Charlevoix (Fr. Xav. de). Histoire du Paraguay, maps, 4
 vol., old cf. gt., *Paris*, 1757, 8vo. (44) 12s.
1050 Charlevoix (Fr. Xav. de). Histoire et Description de la Nou-
 velle France, folding maps and plates, 6 vol., old cf., *Paris*,
 1744, 12mo. (237) £1
1051 Chroniques de Normandie. Les croniques et excellētz faitz
 des ducz Princes, Barons et Seigneurs de la noble duche de
 Normandie, 1 full-page woodcut, lettres batardes, old mor.,
 g. e., *Paris pour Jehan Sainct Denys* [ca. 15—], sm. 4to.
 (145) £8 12s. 6d.
1052 Cibber (Colley). Dramatic Works, plates, 5 vol., old cf. gt.,
 1736, 8vo. (70) £2
1053 Clarke (H.) History of the War with France, ports. and
 plates, 3 vol., cf., 1816, 4to. (418) *Sotheran*, 15s.
1054 Cook (Capt.) Three Voyages to the Pacific Ocean, etc.,
 folding plates, plans and charts, orig. issue, 8 vol., cf., with
 the Folio Atlas of Plates to the Third Voyage, hf. cf.,
 1773-84, 4to. (159) *Maggs*, £4 17s. 6d.
1055 Corneille (P.) Œuvres, plates after Gravelot, by Le Mire,
 12 vol., old cf. gt., *Paris*, 1801, 8vo. (87) *Bain*, £3
1056 Coryat (T.) Crudities, plates, 3 vol., old cf. gt., 1776, 8vo.
 (32) *Maggs*, £2 2s.
1057 Cory (C. B.) Birds of the Bahama Islands, col. plates, cl.,
 Boston, 1880, 8vo. (506) 19s.
1058 Cotgrave (R.) A Dictionarie of the French and English
 Tongues, by R. S[herwood], woodcut titles, leaf of errata
 at end, 2 vol. in 1, old cf., A. Islip, 1632, folio (324) £1 8s.
1059 Cowper (Guil.) Anatomia Corporum Humanorum, engravings,
 hf. mor., *Ultratrajecti*, 1750, roy. folio (320) £1
1060 D'Estaing. Estrait du Journal de M. le Comte d'Estaing,
 port., hf. vell., 1782, 8vo. (240) 11s.
1061 Dickens (C.) Works, with Life by F. C. Kitton, the London
 ed., col. and other illustrations, in 13 vol., hf. mor. gt., 8vo.
 (619) £1 10s.
1062 Dillon (J. B.) History of Indiana, front. and map, cl., 1859,
 8vo. (374) 13s.
1063 Dixon (G.) Voyage to the North Coast of America, folding
 charts and plates, hf. cf., 1789, 4to. (157) 15s.
1064 Dodsley (R.) Collection of Poems, 10 vol., old cf. gt., 1755,
 8vo. (66) 10s.
1065 Dryden (J.) Poetical Works, port., 5 vol., cl., Pickering,
 1852, 8vo. (453) *Bumpus*, £1 1s.
1066 Duncan (J.) Life and Death of Lady Falkland, old mor.,
 crowned cipher on sides and back (first 2 lines in MS.),

1653—Novum Testamentum Græce, LARGE PAPER, engraved
 title (mounted), old mor., *Cantabrigiæ*, 1632, 8vo. (208)
 £1 18s.
1067 Encyclopædia Britannica, the Supplementary Volumes, maps
 and cuts, 11 vol., hf. mor., t. e. g., 1902-3, 4to. (563)
 Foyle, £7 15s.
1068 Fallon (L'Abbé). Histoire de la Colonie Française en Canada,
 [1534-1675], maps, 3 vol., sewed, 1865-6, roy. 8vo. (366)
 Maurice, £1 5s.
1069 Fellowes (W. D.) A Visit to the Monastery of La Trappe,
 col. plates, mor. ex., McLean, 1823, roy. 8vo. (385) 15s.
1070 Fenton (R.) Historical Tour through Pembrokeshire, port.
 and views by Storer and Greig, old cf. gt., 1811, 4to. (153)
 Hill & Son, £1 2s.
1071 [Fitzgerald (E.)] Rubaiyát, fourth ed., front., hf. mor., t. e. g.,
 B. Quaritch, 1879, 8vo. (396) *Jeffries*, £1 12s.
1072 [Fortin (F. François).] Les Ruses Innocentes, orig. ed., 65
 full-page woodcuts, old cf., *Paris*, 1660, sm. 4to. (152)
 Maggs, £3 7s. 6d.
1073 Français (Les), peints par Eux-Mêmes—Le Prisme, plates
 and woodcuts, 9 vol., hf. cl., *Paris*, 1840-41-41, roy. 8vo.
 (355) *Bailey*, £1 16s.
1074 Franklin (B.) Miscellaneous Pieces, LARGE PAPER, port. and
 plates, hf. cf., 1779, sm. 4to. (242) 12s.
1075 Froissart (J.) Le Premier (le second et le troisième, le quart),
 volume des Croniques de France, etc., woodcut on last leaf
 of each vol., lettres batardes, 3 vol. (wormed), old cf. gt.,
 Paris, Guillaume Eustace, 1513-14, folio (147) £7 7s.
1076 Froude (J. A.) History of England, Library ed., 12 vol., hf.
 russ., 1856-70, 8vo. (480) £1 7s.
1077 Gay (J.) Fables, engravings by Blake and others, 2 vol., cf.,
 m. e., Stockdale, 1793, roy. 8vo. (413) £1
1078 Gerarde (J.) Herball, second ed., woodcuts (title backed,
 corner of page 65 and last leaf defective), old russ., 1633,
 folio (302) *Myers*, £2 15s.
1079 Gentleman's Magazine, from the commencement in 1731 to
 June, 1837, with indexes to 1818, and list of plates and wood-
 cuts to the same period (wanted vol. xvi.), 166 vol., russ.,
 and from July, 1856 to June, 1868, 24 vol., cl., together
 190 vol., 8vo. (301) *Grant*, £11 10s.
1080 Germain (Lord G.) Correspondance avec les Généraux
 Clinton, Washington, etc., 2 folding tables, old cf., *Berne*,
 1782, 8vo. (239) 18s.
1081 Gessner (S.) The Death of Abel, front., mor. ex., tooled
 sides, "cottage" pattern, g. e., 1768, 12mo. (409) 18s.
1082 Gessner (S.) Œuvres, plates and vignettes, 2 vol., Spanish
 cf. gt., *Zurich*, 1773-7, 4to. (168) *Edwards*, £1 15s.
1083 Glanvil (J.) A Blow at Modern Sadducism, first ed., Nathaniel
 Hawthorne's copy, with his autograph, several pages marked
 in margins or underscored in ink, old cf, 1666, 12mo. (300)
 Myers, £6 7s. 6d.

1084 [Goldsmith (O.)] Vicar of Wakefield, first ed., 2· vol., con-
temp. cf., *Salisbury, printed by B. Collins for F. Newbery*
.... 1766 (71) *Bumpus,* £105
[With the exception of a damp stain on the title and first
2 leaves of vol. i., the above was a clean and tall copy,
6¾ in. by 4in.—*Catalogue.*]
1085 Goldsmith (O.) Roman History, first ed., 2 vol., 1769—
Miscellaneous Poems and Translations, front., B. Lintot,
1712—Bacon (F.) History of Winds, port., together 4 vol.,
1653, 8vo. (940) · £5 7s. 6d.
[Sold on October 14th.—Ed.]

*Goupil's Historical Monographs, coloured fronts., ports. and other
illustrations, bound in hf. mor., t.e.g., in uniform style.*

1086 Marie Antoinette, the Queen, from the French of Pierre de
Nolhac, n. d. (1898) (599) £1 17s.
1087 Mary Stuart, by Sir John Skelton, second ed., 1898 (600) £5
1088 Charles I., by Sir John Skelton, 1898 (601) £1 11s.
1089 Oliver Cromwell, by S. R. Gardiner, 1899 (602) £1 13s.
1090 Joséphine Imperatrice et Reine, par Frédéric Masson, 1899
(603) £1 15s.
1091 Catherine de Medicis, par Henri Bouchot, 1899 (604) £1 11s.
1092 Prince Charles Edward, by Andrew Lang, 1900 (605) £1 14s.
1093 Louis XV. et Marie Leczinska, par Pierre de Nolhac, 1900
(606) £2 10s.
1094 Charles II., by Osmund Airy, 1901 (607) £1 11s.
1095 Henry VIII., by A. F. Pollard, 1902 (608) £1 13s.
1096 Marie-Louise, L'Impératrice, par Frédéric Masson, 1902 (609)
£1 18s.
1097 Marie-Antoinette, La Dauphine, par Pierre de Nolhac, three-
quarter mor., t. e. g., *Paris,* n. d. (1896) (610) £3 7s. 6d.
1098 Queen Victoria, by R. R. Holmes, 1897 (611) £1 2s.

1099 Greene (R.) Dramatic Works, notes by Dyce, 2 vol., cf. gt.,
Pickering, 1831, 8vo. (272) 10s. 6d.
1100 Guilmard (D.) Les Maitres Ornemanistes, plates, 2 vol., hf.
mor., t. e. g., *Paris* (1880-1), 4to. (544) £1 3s.·
1101 Haden (Seymour). About Etching, part i., Notes on Etching;
and part ii., Annotated Catalogue of Examples Exhibited,
plates, hf. mor., 1879, 4to. (545) *Tregaskis,* £3 16s.
1102 Hamilton (Sir W.) Campi Phlegræi, first ed., map and 54
plates col. by hand, descriptions in English and French,
3 vol. in 1, old mor. ex., *Naples,* 1776-9, folio (175) £3 11s.
1103 [Harrisse (H.)] Bibliographie de la Nouvelle-France, *Paris,*
1872—Domenech (E.) Manuscrit Pictographique Américain,
facs., *ib.,* 1860, 2 vol., sewed, 8vo. (367) *Quaritch,* £1 14s.
1104 Hayne (T.) Life and Death of Martin Luther, port., MS.
notes by William Dowsing, limp vell., 1641, 8vo. (217)
Joyce, £1 10s.
1105 Heath (R.) Account of the Islands of Scilly, map and plate,
old cf., 1750, 8vo. (57) 11s.

1106 Hennessy and Kelly. The Book of Fenagh, presentation copy from the editor, cl., 1871, sm. 4to. (337) 11s.
1107 Heriot (G.) Travels through the Canadas, folding aquatint plates and col. map, hf. cf., 1807, 4to. (158) *Hill*, £1 14s.
1108 Hoare (Sir R. Colt). History of Ancient Wiltshire, ports. and engravings, 2 vol., hf. cf., 1810-19, folio (575)
 Walford, £1 6s.
1109 Holy Bible, "Breeches" Version, C. Barker, 1599, with Book of Common Prayer, 1636, and Sternhold and Hopkins' Psalms, with music, n. d., in 1 vol., old mor., tooled sides, gilt and gauffered edges, sm. 4to. (194) £2 4s.
1110 Holy Bible, old mor. (Cambridge binding), large gold centre-piece, surrounded by fieur-de-lys, g. e., R. Barker, 1616-18 (200) *Tregaskis*, £6 2s. 6d.
 [The above copy was formerly in the library of Lord Fairfax, and was given to his nephew by Thomas Hutton, one of his executors. Inscriptions on inside cover and on first fly-leaf to that effect.—*Catalogue.*]
1111 Holy Bible, engraved title by Marshall, coloured (and mounted), with Metrical Psalms, *Cambridge*, 1638, in 1 vol., old mor., gold tooling on sides, corners of panel inlaid (rubbed), g. e., royal folio (198) *Barnard*, £1 6s.
1112 Holy Bible, old mor., delicate gold tooling on sides and back, g. e., *Amsterdam*, T. Stafford, 1640, folio (199) £2 4s.
1113 Holy Bible, with Sternhold and Hopkins' Psalms (first title missing), old mor., gilt panelled sides, g. e., 1675-6, 4to. (209) £1 12s.
1114 Holtrop (J. W.) Monuments Typographiques des Pays-Bas, facs. of types, initial letters and woodcuts, hf. mor., *La Haye*, 1868, folio (306) £5
1115 Hume (A. D.) Nests and Eggs of Indian Birds, second ed., ports., 3 vol., cl., 1889, 8vo. (505) £1 8s.
1116 Hutchins (J.) History and Antiquities of Dorsetshire, map and engravings, 4 extra plates inserted, 4 vol. (vol. iii. and iv. second ed.), hf. cf., 1774-1815, folio (573) £5 10s.
1117 Jackson (Lady C. C.) Old Paris, first ed., ports., 2 vol., cl., 1878, 8vo. (395) *Quaritch*, £4 7s. 6d.
1118 James (W.) Military Occurrences of the late War with America, maps, 2 vol., hf. cf. gt., 1818, 8vo. (250) 16s.
1119 Jesse (J. H.) Literary and Historical Memorials of London, fronts., 2 vol., cl.—London and its Celebtties, 2 vol., cl., first eds., 4 vol., uncut, 1847-50, 8vo. (477) *Bumpus*, £3 12s. 6d.
1120 Junot (Madame). Memoirs of Napoleon, his Court and Family, 16 plates, 2 vol., hf. cf., t. e. g., Bentley, 1836, 8vo. (433) £1 5s.
1121 Justinianus (Imp.) Decretum de Tortis, 𝔤𝔬𝔱𝔥𝔦𝔠 𝔩𝔢𝔱𝔱𝔢𝔯, illu-minated woodcut on first leaf, heightened with gold, capitals in red and blue, calf over oak boards (slightly wormed), *Venitiis*, 1496, folio (304) *Barnard*, £3 15s.
1122 Kalm (Peter). Travels into North America, trans. by J. R. Forster, map and plates, 2 vol., old cf., 1772, 8vo. (34)
 Leon, £2 12s.

1123 Keith (G.) The Presbyterian and Independent Churches in New-England, old cf., 1691, 12mo. (230) £3 6s.

1124 Kircher (A.) China Monumentis, maps, full-page and other engravings, old cf., *Amstelodami*, 1667, folio (314) 15s.

1125 Knight's Pictorial History of England, with Martineau's History of the Peace, numerous woodcuts and ports., 9 vol., mottled cf. gt., m. e., 1838-50, roy. 8vo. (492) *Mellor*, £1 9s.

1126 Lafitau (J. F.) Mœurs des Sauvages Ameriquains, map and plates, 2 vol., hf. cf. gt., *Paris*, 1724, 4to. (42) *Leon*, £1 11s.

1127 La Fontaine (J. de). Contes et Nouvelles en Vers, 2 ports., 46 proof plates (only) and 47 vignettes after Eisen, 2 vol., old mor., g. e. [by Derome], *Amsterdam* [*Paris*, Barbou], 1762, 8vo. (254) *Müller*, £12

1128 L'Alcoran des Cordeliers, etc., plates by Picart, 3 vol., old mor., g. e.—Ordres des Femmes Religieuses, 90 plates by Schoonenbeck, old cf. gt., *Amsterdam*, n. d., 12mo. (142) £1 1s.

1129 Langland (W.) The Vision of Piers Ploughman, 2 vol., cl., Pickering, 1832, 8vo. (388) 16s.

1130 Lapide (C. à). The Great Commentary, trans. by Mossman and Cobb, from St. Matthew to Galatians, 8 vol., cl., 1908, 8vo. (482) 10s.

1131 La Pérouse (J. F. G. de). Voyage autour du Monde, 4 vol., old French cf., and the folio atlas of maps and plates, port., together 5 vol., *Paris*, 1798, 8vo. (46) *Quaritch*, £3

1132 Latham (J.) Allgemeine Uebersicht der Vogel, col. plates, 6 vol., hf. bd., *Nurnburg*, 1792-8, 4to. (550) £1 1s.

1133 Levaillant (F.) Histoire des Oiseaux d'Afrique, col. plates (one wanted), 6 vol., hf. roan, *Paris*, 1799-1808, roy. 4to. (548) *Wheldon*, £6

1134 Lilford (Lord). Coloured Figures of the Birds of the British Islands, second ed., 421 col. plates, plates and text mounted on guards, 7 vol., hf. mor., t. e. g., 1891-7, roy. 8vo. (501) *Hatchards*, £46

1135 Lilford (Lord). Notes on the Birds of Northamptonshire, map and illustrations, 2 vol., cl., t. e. g., 1895, roy. 8vo. (502) £1 5s.

1136 Lorris (Guil. de) et Meun (Jean de). Le Roman de la Rose, LARGE AND THICK PAPER, plates after Monnet, 5 vol., old cf. gt., *Paris*, 1799, roy. 8vo. (86) £3

1137 Loudon (Mrs.) British Wild Flowers, col. plates, hf. mor., 1846, 4to. (467) 13s.

1138 Lowe (E. J.) Ferns, British and Exotic, col. plates, 8 vol., cl., 1861, 8vo. (442) 15s.

1139 Macaulay (Lord). Works, ed. by Lady Trevelyan, Library ed., port., 8 vol., cf., m. e., 1866, 8vo. (359) *Brown*, £1 16s.

1140 [Mahony (F. S.)] The Reliques of Father Prout, illustrated by "Crowquill," first ed., 2 vol., hf. cf., uncut, J. Fraser, 1836, 8vo. (389) £1 9s

1141 Martial Achievements of Great Britain, 53 col. plates, old mor. ex., g. e., J. Jenkins, 1814-15, 4to. (540) £6 2s. 6d.

1142 Mather (Cotton). Magnalia Christi Americana, first American ed., 2 vol., cf., *Hartford*, 1820—Life, by Samuel Mather, cf., *Boston, New England*, 1729, 8vo. (229) 19s.

1143 Milman (H. H.) History of the Jews, 3 vol.—History of Christianity, 3 vol.—Latin Christianity, 9 vol., Cabinet ed., together 15 vol., cl., 1866-7, 8vo. (481) 19s.

1144 Mitford (J.) Adventures of Johnny Newcome in the Navy, col. plates by Williams, hf. cf., 1823, 8vo. (444) £1 10s.

1145 Mivart (St. G.) Dogs, Jackals, Wolves and Foxes, col. plates, cl., t. e. g., 1890, sm. 4to. (508) £1 5s.

1146 Molière (J. B. P.) Œuvres, par M. Bret, port. and plates by Moreau, 6 vol., French cf. gt., *Paris*, 1804, 8vo. (89) £3

1147 Moyriac de Mailla (Père). Histoire Générale de la Chine, plates and maps, 12 vol., hf. cf., *Paris*, 1777, 4to. (553) £1 2s.

1148 Natalibus (P. de). Catalogus Sanctorum, 𝔤𝔬𝔱𝔥𝔦𝔠 𝔩𝔢𝔱𝔱𝔢𝔯, woodcuts, unbd., *Lugduni*, 1542, folio (274) 10s.

1149 New Testament, woodcut border on title, old mor., with 8 chased silver cornerpieces and 2 silver clasps, R. Barker, 1640, 32mo. (210) 16s.

1150 [Newton and Cowper.] Olney Hymns, first ed., presentation copy, with inscription in the autograph of John Newton, "To the Rev. Mr. Haines from the Author," mor. ex., g. e., 1779, 12mo. (408) £1 12s.

1151 Novum Testamentum Syriacæ, Elementa Syriacæ Linguæ, etc., ed. Widmanstadius, ed. princeps, woodcuts, 6 parts in 1 vol., old cf., *Vienna, Austriæ*, 1555-6, 4to. (139) £1 10s.

1152 Novum Testamentum, ed. Th. Beza, old cf., 3 fleurs-de-lis on both sides, gilt ornaments on back (joints cracked), [*Genevæ*,] E. Vignon, 1598, folio (176) 13s.

1153 Novum Testamentum Græce, cura B. A. Montani, contemp. cf., sides and back covered with elaborate gold tooling, g. e., 1619, 8vo. (193) *Mayer*, £5 5s.

1154 O'Shaughnessy (A. W. E.) An Epic of Women and other Poems, frontispiece and cuts, presentation copy from the author, with inscription, orig. cl., 1870, 8vo. (403) *Shepherd*, £1 8s.

1155 Ottens (R. et J.) Atlas Nouveau, 95 col. maps, including 6 of America, hf. bd., uncut, 1740, folio (313) £1 8s.

1156 Oxford English Dictionary, ed. by Murray, Bradley and Craigie, from A to Prophesier (part vi., Clo—Consigner missing), and Q to Sauce, in 77 parts, wrappers, 1884-1909, 4to. (564) £8 10s.

1157 Oxford and Cambridge Magazine (The) for 1856, hf. mor., cl. sides, t. e. g., Bell and Daldy, 1856, 8vo. (401) £5 10s.

1158 Paracelsus (Theoph.) Opera Omnia, port., 3 vol., old cf. gt., *Genevæ*, 1658, folio (319) *Quaritch*, £1 16s.

1159 Pater (W.) Marius the Epicurean, first ed., 2 vol., orig. cl., uncut, 1885, 8vo. (402) £2 10s.

1160 Pennant (T.) Arctic Zoology, LARGE PAPER, plates, with supplement, 3 vol., cl., uncut, 1784-7, roy. 4to. (552) £1 7s.

1161 Perron (Cardinal). The Reply . . to the Answeare of the King of Great Britain, trans. into English [by Elizabeth

XXIV. 5

Cary, Lady Falkland], port., contemp. mor., gold panelled sides, g. e., Douay, 1630, folio (195) *Tregaskis, £2* 12s. [Possibly a dedication copy. At the foot of the portrait is a MS. poem in a contemporary hand.—*Catalogue.*]

1162 Phipps (C. J.) Voyage towards the North Pole, folding plates and maps, old cf. gt., 1774, 4to. (155) 17s.

1163 Picton (G. W.) The Battle of Waterloo, 6 col. plates, plans, etc., hf. bd., R. Edwards, n. d., 8vo. (437) 16s.

1164 Pistolesi (E.) Il Vaticano descritto ed illustrato, upwards of 800 plates, 8 vol., hf. vell., *Roma,* 1829-38, roy. folio (322) £2 10s.

1165 Prinsep (J.) Essays on Indian Antiquities, ed. by E. Thomas, plates, 2 vol., cl., 1858, 8vo. (386) *Quaritch, £3* 3s.

1166 Purchas (S.) His Pilgrimage, old cf. (rebacked), 1813, folio (307) 19s.

1167 Rabelais (F.) Œuvres, Nouvelle ed., port. and engravings by Picart, 3 vol., old cf., g. e., *Amsterdam,* 1741, 4to. (253) *Bailey, £6*

1168 Regnard (J. F.) Œuvres, port. and plates after Borel (one stained), 4 vol., cf. gt., *Paris,* 1790, 8vo. (95) 17s.

1169 Remedy for Sedition (A), wherin are conteyned many thynges concernyng the true and loyall obeysance, etc., **black letter,** woodcut, title by Holbein (A–E in fours, F 6 leaves), unbd., *Londini in Ædibus T. Bertheleti,* 1536, sm. 4to. (214) *Quaritch, £1* 12s.

1170 Richardson (S.) Note Book of Samuel Richardson, containing details of estimates for printing, including "an Account of the Expenses, etc. of Sir Wm. Keith's History of Virginia," cost of the paper, engraving the maps of America and Virginia, advertising the work, etc.; references to the relations between publisher, bookseller and author, and the "Society for the Encouragement of Learning" [see "Austin Dobson's Life of Richardson," page 15]; letters from Batty Langley, etc., on 31 pages, also four sheets containing specimens of Caslon's types at end, bds., 1738, etc., sm. 4to. (294) *Maggs, £5*

1171 Robertson (D.) Tour of the Isle of Man, map and aquatint plates (with the suppressed passages on the last 2 leaves), cf., 1794, 8vo. (58) 12s.

1172 Rossetti (D. G.) The Early Italian Poets, first ed., cl., uncut, 1861, 8vo. (400) *Quaritch, £1* 17s.

1173 Ruskin (J.) Seven Lamps, first ed., cl., 1849, roy. 8vo. (405) £1.

1174 Sclater (P. L.) and Thomas (O.) Book of Antelopes, col. plates and woodcut illustrations, 4 vol., cl., 1894-1900, 4to. (546) *Edwards, £7* 12s. 6d.

1175 Scott (Sir W.) Waverley Novels, the Melrose ed., illustrations, 25 vol., cl., *Edinburgh,* T. and C. Jack, n. d., 8vo. (618) £1 1s.

1176 Schlegel (H.) De Vogels van Nederland, hf. mor., and Atlas of 362 col. plates, in portfolio, *Leyden,* 1854-8, 8vo. (527) £5 10s.

1177 Shropshire Archæological and Natural History Society. Transactions, from the commencement in 1878 to vol. iii. of the third series, 1903, with Index, 1897-1901, together 27 vol., hf. mor., t. e. g., *Shrewsbury*, 1878-1903, 8vo. (493)
Walford, £7 5s.

1178 [Skene (Sir J.)] Regiam Majestatem Scotiæ, the Auld Lawes and Constitutions of Scotland, autograph of the author, cf., *Edinburgh*, 1609, folio (219) 11s.

1179 Smith (A. C.) British and Roman Antiquities of the North Wiltshire Downs, plates and cuts, and the maps separate, 2 vol., cl., 1884, imp. 4to. (558) *Quaritch*, £1 1s.

1180 Stanley (H. M.) In Darkest Africa, edition de luxe, maps, etchings and plates, some on India paper, 2 vol., hf. mor., 1890, 4to. (616) 19s.

1181 Sully (Duc de). Mémoires, 6 vol., old cf., g. e., with inscription, "Academie de Paris, Prix du Concours General," *Paris*, 1827, 8vo. (414) *Sotheran*, 19s.

1182 Symonds (J. A.) Essays Speculative and Suggestive, first ed., 2 vol., cl., uncut, 1890, 8vo. (399) *Hornstein*, £2 18s.

1183 Symonds (J. A.) Sketches and Studies in Italy, first ed., front., cl., uncut, 1879, 8vo. (398) *Shepherd*, £1

1184 Tasmania. Papers and Proceedings of the Royal Society of Tasmania, plates, from 1884 to 1892, in 9 vol., sewed, *Tasmania*, 1885-93, 8vo. (516) £1 3s.

1185 [Tennyson (Lord A.)] In Memoriam, first ed., with the half-title, orig. cl., uncut (binding soiled), E. Moxon, 1850, 8vo. (404) *Hornstein*, £2 12s.

1186 Thoms (W. J.) Collection of Early Prose Romances, first ed., 3 vol., cl., uncut, Pickering, 1828, 8vo. (387) 11s.

1187 Top (Alex.) The Book of Prayses, called The Psalmes, the Keyes and Holly Things of David, trans. by Alexander Top, orig. vell., *T' Amstelredam, by Jan Fredericksz Stam*, 1629, folio (213) *Adams*, £4 2s. 6d.

1188 Tracts on Coinage. [Briscoe (J.)] A Discourse on the late Funds and Bank of England, 1694—Houghton (T.) The Alteration of the Coyn and Europe's Glory, 1695—Essay on Gold and Silver Coins by W. L[owndes], 1695—Vicaris on Regulating the Coyn, 1696—Davanzati. Discourse on Coins, 1696—Cook (R.) On the Coyn of England and the East India Trade, 1696—Discourse about Keeping our Money, by E. L., 1696—Proposal for Amending Silver Coins (2 leaves defective), 1696, and other tracts on the same (12), in 1 vol., old cf., sm. 4to. (1191) £23
[Sold on October 15th.—ED.]

1189 Tyndale (W.) The practyse of Prelates [collation A-I in eights, K 10 leaves,] (margins of a few leaves cut into), *Marborch, in the Yere of our Lorde* mccccc. *and* xxx.— An answere unto Sir Thomas Mores dialogue made by Wuillyam Tindale, black letter [collation A-R in eights, S 3 leaves], R 8 wanted [*Antwerp*, 1530], autograph of John Bale on each title, in 1 vol., old cf., 12mo. (148)
Tregaskis, £9 15s.

1190 Vancouver (Capt. G.) Voyage of Discovery to the North
Pacific, views and charts, 6 vol., old cf. gt., 1802, 8vo. (37)
Dean, £4 2s. 6d.
1191 [Vicars (J.)] Former Ages never heard of and After Ages
will admire, engravings (a few margins cut into), hf. cf.,
1654, sm. 4to. (215) 10s.
1192 Vigenaire (B. de). Histoire des Turcs, avec la Continuation
par T. Artus S^r d'Embry, ports., col. plates, 2 vol., old cf. gt.
(one vol. ɔroken), *Paris*, 1662, folio (185) £1
1193 Voltaire (F. M. A. de). Romans et Contes, port. and 56
plates (wanted the "avis au relieur," one leaf repaired and
one torn), 3 vol., old cf. gt., Bouillon, 1778, 8vo. (92)
Le Mallier, £3 12s.
1194 Voragine (Jacoɔus de). Legenda Sanctorum, gothic letter,
276 leaves (Copinger, No. 6414), the first initial letter in
gold and colours, col. initial letters throughout, old oak bds.,
Norimbergæ, A Koburger, 1478, folio (303) *Maggs*, £5 5s.
1195 Walton and Cotton. Complete Angler, by Sir H. Nicolas,
plates on India paper, 2 vol., cl., 1860, roy. 8vo. (539) 17s.
1196 Washington (G.) Letters to the American Congress, 2 vol.,
old cf., *New York*, 1795—Life, by J. Marshall, port. and
maps, 5 vol., hf. cf., 1805-7, 8vo. (247) £1 1s.
1197 Whitaker (T. D.) History and Antiquities of Craven, aqua-
tint plates, etc., hf. cf., 1805, 4to. (557) 10s.
1198 White (Gilɔert). Natural History of Selɔorne, first ed., fold-
ing view, vignette and engravings, old hf. cf., *Printed by T.
Bensley for B. White & Son*, 1789, 4to. (23)
Chapman, £9 10s.
1199 Wilde (Oscar). A House of Pomegranates, first ed., orig. cl.,
1891, 8vo. (397) £2 6s.
1200 Williams (H. N.) Madame de Montespan, first ed., ports.,
ɔuckram, t. e. g., 1903, sm. 4to. (383) *Hill*, £1
1201 Wiltshire Archæological and Natural History Magazine, vol.
i. to xxx., hf. cf. (not quite uniform), *Devizes*, 1854-98, 8vo.
(498) £6 6s.
1202 Wolfe (General). Old Mezzotint Portrait of Major-Gen. James
Wolfe, Commander-in-Chief of his Majesty's Forces on the
Expedition against Queɔec, fine mezzotint port., by R.
Houston, after Schaak (margin cut away) (251)
Maggs, £4 12s.
1203 Wood (S. L.) Illustrations to the Araɔian Nights, 100 plates,
n. d., enclosed in cloth box, re-issue (471) £1 1s.

SOTHEBY, WILKINSON & HODGE.

THE LIBRARY OF THE LATE MR. JOHN JORDAN, OF JORDANSTOWN, AND OTHER PROPERTIES.

(No. of Lots, 312 ; amount realised, £575 1s.)

(a) *Mr. Jordan's Library.*

1204 Angelo (D.) School of Fencing, plates, some col. by hand (several leaves damaged and soiled), 1787, oblong 8vo. (1)
Rimell, 12s.

1205 Apperley (C. J.) Life of John Mytton, second ed., illustrations col. by hand (margins of some soiled), hf. mor., R. Ackermann, 1837, 8vo. (2) *Spencer,* £4 5s.

1206 Beresford (James). Miseries of Human Life, folding col. plates by J. A. Atkinson, 2 vol. (several leaves soiled), orig. cf., 1809, 8vo. (3) *Spencer,* 18s.

1207 Boswell (James). Life of Johnson, by J. W. Croker, ports., 5 vol., cf., m. e., 1831, 8vo. (5) *Joseph,* £1 1s.

1208 Browning (Robert). The Ring and the Book, first ed., 4 vol., uncut, 1868-9, 8vo. (7) *Andrews,* 8s.

1209 Burns (Robert). Works, by Allan Cunningham, port. and vignettes, 8 vol., uncut, 1834, 8vo. (8) *Young,* £1 15s.

1210 Butler (Samuel). Hudibras, col. illustrations by J. Clark, 2 vol., orig. cf., 1822, 8vo. (9) *Young,* £2

1211 Butler (Alban). Lives of the Fathers, ports. and vignettes, 12 vol., hf. cf., m. e., 1847, 8vo. (10) *J. Grant,* 16s.

1212 Byron (Lord). Works, by Moore, port. and vignettes, 17 vol., hf. cf. gt., 1832-3, 8vo. (11) *Joseph,* £2 14s.

1213 Campbell (Thomas). Specimens of the British Poets, port., 7 vol., hf. mor., t. e. g., 1819, 8vo. (12) *Maggs,* £2 10s.

1214 Crabbe (George). Poetical Works, fronts. and vignettes (stained), 8 vol., uncut, 1836, 8vo. (19) *Wallace,* 8s.

1215 Dibdin (T. F.) Tour in France and Germany, engravings, the vignettes on India paper, 3 vol., orig. russ., g. e., 1821, roy. 8vo. (21) *Maggs,* £4 4s.

1216 Dibdin (T. F.) Reminiscences of a Literary Life, port. and plates (spotted), 2 vol., hf. russ., t. e. g., 1836, 8vo. (22)
Graystone, 17s.

1217 Dickens (Charles). Memoirs of Grimaldi, first ed., illustrations by Geo. Cruikshank and port., 2 vol., hf. cf. gt., 1838, 8vo. (23) *Young,* £1 14s.

1218 Dickens (C.) Sketches by "Boz," 2 vol., J. Macrone, 1836— Second Series, *ib.*, 1836, first eds., etchings by Geo. Cruikshank, hf. cf. gt., fine copies, 8vo. (24) *Young,* £7 17s. 6d.

1219 Egan (Pierce). Boxiana, ports., 4 vol., contemp. cf., 1823-4, 8vo. (26) *Spencer,* £1 18s.

1220 Fergusson (James). History of Architecture in all Countries, engravings, 3 vol., hf. bd., uncut, 1865-67, 8vo. (28)
Joseph, 18s.

1221 Froissart (Sir John). Chronicles, ɔy Johnes, engravings
(some leaves spotted), 2 vol., hf. cf. gt., W. Smith, 1839,
roy. 8vo. (29) *Joseph,* 18s.
1222 Giɔɔon (Edward). Decline and Fall of the Roman Empire,
ed. by Dr. Smith, port. and maps, 8 vol., uncut, 1854-55,
8vo. (30) *Hornstein,* £1 14s.
1223 Grote (George). History of Greece, port., maps and plans,
12 vol., 1869, 8vo. (31) *B. F. Stevens,* 15s.
1224 Hamilton (Count A.) Memoirs of Count Grammont, ports.,
3 vol., orig. cf., 1809, 8vo. (32) *Hornstein,* £2
1225 Hardiman (James). Irish Minstrelsy, port., 2 vol., hf. mor.,
g. e., 1831, 8vo. (33) *Dr. Birch,* £1 7s.
1226 Holɔein (H.) The Dance of Death, 33 plates (col.) by W.
Hollar, descriptions in English and French, contemp. mor.,
g. e., 1816, 8vo. (35) *Spencer,* 14s.
1227 Horace. Works, with Life by H. H. Milman, illustrations,
col. ɔorders round each page, cf., g. e., 1849, 8vo. (36)
Young, 14s.
1228 Ingram (James). Memorɪaɪs of Oxford, engravings by J. Le
Keux, 3 vol., 1832-7—Le Keux (J.) Memorials of Camɔridge,
views, 2 vol., 1845, cf. gt., together 5 vol., 8vo. (37)
Bull, £1 2s.

Works relating to Ireland.

1229 Ancient Irish Histories. Works of Spenser, Campion, Hanmer
and Marleburrough, LARGE PAPER (several leaves stained),
2 vol., hf. russ., *Hibernia Press, Dublin,* 1809, imp. 8vo.
(38) *B. F. Stevens,* 10s.
1230 Annals of Ireland, from the Original Irish of the Four
Masters, ɔy Owen Connellan, hf. cf. gt., *Dublin,* 1846, 4to.
(39) *Young,* £2 8s.
1231 Annals of the Kingdom of Ireland, by the Four Masters, ed.
ɔy John O'Donovan, 7 vol., hf. mor., t. e. g., *Dublin,* 1856,
4to. (40) *Bain,* £12 5s.
1232 Archdall (Mervyn). Monasticon Hibernicum, by P. F.
Moran and others, plans and views, vol. i. and ii., hf. bd.,
t. e. g., *Dublin,* 1873, 8vo. (41) *Neale,* £1 18s.
1233 Barrington (Sir Jonah). Historic Memoirs of Ireland, ports.
(some spotted) and facs., 2 vol. in 1, hf. mor., 1835, roy. 4to.
(43) *Neale,* £1 14s.
1234 Celtic Society. The Book of Rights, ɔy J. O'Donovan, *Dub-
lin,* 1847—Cambrensis Eversus, ed. ɔy M. Kelly, 3 vol., *ib.,*
1848-51, 8vo. (51) *Henry,* £1 7s.
1235 Chronicles and Memorials. A Chronicle of Irish Affairs, ed.
by W. M. Hennessy, 1866—The War of the Gaedhil with
the Gaill, ed. ɔy J. H. Todd, 2 vol., 1867—Annals of Loch
Cé, ed. ɔy W. M. Hennessy, 2 vol., 1871, facs., hf. bd.,
together 5 vol., roy. 8vo. (52) *Harding,* £2 7s.
1236 D'Alton (J.) History of Drogheda, map and plates, 2 vol.,
mor., g. e., *Dublin,* 1844, 8vo. (56) *Neale,* £1
1237 Duɔlin Penny Journal, 1832-36, engravings, 8 vol., 8vo. (58)
Neale, £1

1238 Giraldus Cambrensis. The Irish Historie, trans. ɔy John
Hooker, black letter (wormed, and a leaf or two imperfect),
modern mor. (1587), and another, not suɔject to return, 8vó.
(59) *Young*, £2 10s.
1239 Graves (J.) and Prim (J. G. A.) History, Architecture and
Antiquities of the Cathedral Church of St. Canice, Kil-
kenny, illustrations, orig. cl., *Dublin*, 1857, 4to. (60)
Quaritch, 15s.
1240 Grose (Francis). Antiquities of Ireland, plates, 2 vol., cf. gt.,
S. Hooper, 1791-5, 4to. (61) *Graystone*, £1 5s.
1241 Hill (George). Historical Account of the Macdonnells of
Antrim, *Belfast*, 1873—Hamilton (Sir James). The Hamil-
ton Manuscripts, ed. ɔy T. K. Lowry, *ib.*, 1867, 4to. (62)
Quaritch, £2 18s.
1242 Hakewill (James). Picturesque Tour of the Island of
Jamaica, 21 col. plates, hf. cf., 1825, 4to. (127)
Edwards, £3 5s.
1243 Knight (H. G.) Ecclesiastical Architecture of Italy, ɔoth
series, tinted plates, 2 vol., hf. mor., 1842-43, folio (133)
Bull, £1 2s.
1244 Knight (H. G.) Saracenic and Norman Remains, 30 large
col. and tinted plates, orig. hf. ɔinding, n. d. (1830), folio
(134) *Hill*, 16s.
1245 Lambarde (William). Peramɔulation of Kent, black letter,
with "A Carde of the Beacons in Kent" and map, stamped
cf., at end a transcript of Sir Roɔert Cotton's "Short View
of the Reign of King Henry the Third," 1596 (128)
Tregaskis, £3 12s.
1246 Mantz (Paul). Les Chefs d'Oeuvre de la Peinture Italienne,
chromo. plates ɔy F. Kellerhoven, and woodcuts, orna-
mented cl., uncut, 1870, folio (135) *Reader*, 16s.
1247 O'Curry (Eugene). Lectures on the Manuscript Materials of
Ancient Irish History, facs., *Dublin*, 1861—Usher (Dr. J.)
Discourse on the Religion anciently professed by the Irish
and British, *ib.*, 1815, 8vo. (68) *Doolan*, £1 3s.
1248 Petrie (George). Ecclesiastical Architecture of Ireland,
illustrations, orig. cl., uncut, *Dublin*, 1845, 4to. (72)
Hill, £1 7s.
1249 Pendergast (J. P.) The Cromwellian Settlement of Ireland,
maps, orig. cl., 1865—Second edition of the same, hf. cf. gt.,
m. e., 1875, 8vo. (73) *Neale*, £1 15s.
1250 Proceedings and Transactions of the Kilkenny and South-
East of Ireland Archæological Society, illustrations, vol. iii.,
vol. i. to vi. new series, and vol. i. fourth series, hf. mor.,
1854-71, roy. 8vo. (74) *Neale*, £1 12s.
1251 Reeves (W.) Ecclesiastical Antiquities of Down, Connor
and Dromore, *Dublin*, 1847—Brash (R. R.) Ecclesiastical
Architecture of Ireland, 54 plates, hf. bd., *ib.*, 1875, 4to. (75)
Doolan, £2 10s.
1252 Stafford (T.) Pacata Hiɔernia, ports. and facs., 2 vol., hf.
russ., *Hibernia Press, Dublin*, 1810, imp. 8vo. (77)
Doolan, 17s.

1253 Tracts relating to Ireland printed for the Irish Archæological
 Society, 2 vol., uncut, *Dublin,* 1841-3, 4to. (78) *Birch,* 14s.
1254 Tymms (W. R.) and Wyatt (M. D.) Art of Illuminating,
 illustrated ɔy ɔorders, initial letters and alphaɔets, hf. mor.,
 t. e. g., 1860, sm. folio (142) *Ellis,* £1 17s.
1255 Ulster Journal of Archæology, maps and illustrations, 9 vol.,
 orig. cl., *Belfast,* 1853-62, 4to. (80) *Quaritch,* £6 7s. 6d.
1256 Wilkinson (George). Practical Geology and Ancient Archi-
 tecture of Ireland, 17 tinted plates and woodcuts, mor., g.e.,
 1845, roy. 8vo. (86) *Doolan,* 15s.
1257 Wright (T.) Louthiana. Antiquities of Ireland, second ed.,
 upwards of 90 views and plans, orig. cf., 1758, 4to. (88)
 Quaritch, £1 4s.
1258 Wright (Thos.) History of Ireland, ports. and illustrations,
 3 vol., hf. cf., n. d., roy. 8vo. (89) *B. F. Stevens,* 9s.

1259 Jackson (J.) and Chatto (W. A.) Treatise on Wood En-
 graving, second ed., ɔy H. G. Bohn, with 145 additional
 wood engravings, uncut, 1861, imp. 8vo. (90) *Bull,* 7s.
1260 [Johnson (Charles).] Chrysal, or the Adventures of a Guinea,
 LARGE PAPER, col. plates after Burney, 3 vol., orig. cf., m.e.,
 1821, 8vo. (91) *Young,* £6 10s.
1261 Lacroix (Paul). Les Arts au Moyen Age, 1869—Moeurs,
 Usages et Costumes, 1871—Vie Militaire. et Religieuse,
 1873, chromo. plates and woodcuts, hf. mor., g. e., imp. 8vo.
 (92) *Andrews,* £1 1s.
1262 Lingard (Dr. John). History of England, fifth ed., port.,
 10 vol., uncut, Dolman, 1849, 8vo. (94) *J. Grant,* £1 6s.
1263 Macaulay (Lord). History of England, 5 vol., 1856-61—
 Critical and Historical Essays, 3 vol., 1865, hf. cf. gt.,
 uniform, 8vo. (98) *Bull,* £2 2s.
1264 Mahony (Francis). Reliques of Father Prout, first ed., illus-
 trated ɔy Alfred Croquis (D. Maclise), 2 vol., hf. cf. gt.,
 1836, 8vo. (99) *Maggs,* £1 2s.
1265 Meteyard (Eliza). Life of Wedgwood, illustrations, 2 vol.,
 uncut, 1865, 8vo. (100) *Sotheran,* 19s.
1266 Montalemɔert (Comte de). The Monks of the West, 7 vol.,
 vol. i. to v. in hf. cf., vol. vi. and vii. in cl., 1861-79, 8vo.
 (101) *Sotheran,* £2 5s.
1267 Montaigne (M. de). Les Essais, port., 3 vol., mor., g. e.,
 Amst., 1659, 8vo. (102) *McCarthy,* £1
1268 Parker (J. H.) Glossary of Terms used in Grecian, Roman,
 Italian and Gothic Architecture, fifth ed., text and plates,
 ɔound in 2 vol., hf. cf. gt., *Oxford,* 1850, 8vo. (103)
 Hill, £1 6s.
1269 Percy Anecdotes, ports., complete in 20 vol., hf. cf., 1823, 8vo.
 (105) *Maggs,* £1 14s.
1270 Quincey (Thomas de). Works, port. and fronts. (no half
 titles), 16 vol., hf. mor., t. e. g., 1862-3, 8vo. (106)
 Edwards, £1 7s.
1271 Redouté (P. J.) Les Roses, décrites par C. A. Thory, plates
 in colours, 3 vol., hf. mor., t. e. g., 1835, 8vo. (107)
 Bain, £10 5s.

1272 Ruskin (John). Seven Lamps of Architecture, second ed.,
orig. cl., 1855, roy. 8vo. (109) *Young*, £1 5s.

1273 Shakspere (W.) .Dramatic Works, etc., " Knight's Pictorial
Edition," 8 vol., hf. cf., m. e., n. d., roy. 8vo. (111)
C. Jackson, 9s.

1274 Smiles (Samuel). Lives of the Engineers, ports. and illustra-
tions, 3 vol., 1862—Lives of Boulton and Watt, port. and
illustrations, 1865, hf. cf. gt. (112) *Joseph*, 15s.

1275 Sowerɔy (Jas.) English Botany, third ed., col. figures ɔy
J. E. Sowerɔy, etc., 11 vol., orig. cl., t. e. g., Hardwick,
1863-72, roy. 8vo. (113) *Edwards*, £9 12s. 6d.

1276 Strickland (Agnes). Lives of the Queens of England, ports.
and vignettes, 8 vol., 1854, 8vo. (117) *Edwards*, 15s.

1277 Strutt (Joseph). Sports and Pastimes, ed. ɔy William Hone,
LARGE PAPER, the engravings coloured, hf. mor., t. e. g.,
1830, roy. 8vo. (118) *Hill*, 13s.

1278 Universal Songster (The), or Museum of Mirth, illustrations
ɔy G. and R. Cruikshank, 3 vol., uncut, n. d., 8vo. (120)
Sawyer, 12s.

1279 Walpole (Horace). Catalogue of Royal and Noɔle Authors,
ɔy Thomas Park, port., 5 vol., mor., g. e., 1806, 8vo. (122)
Young, £4 8s.

1280 Walton and Cotton. Complete Angler, " Bagster's Second
Ed.," with Lives, ɔy Sir John Hawkins, ports. and plates,
cf. gt., 1815, 8vo. (123) *Graystone*, 17s.

1281 Winkles (H. B. L.) Cathedral Churches of England and
Wales, LARGE PAPER, plates, 3 vol., hf. mor., g. e., 1851,
imp. 8vo. (124) *Joseph*, 10s.

1282 Yarrell (William). History of British Birds, second ed., with
the two Supplements, ɔound in 4 vol., Van Voorst, 1845-56
—History of British Fishes, second ed., with the four
Supplements, ɔound in 3 vol., *ib.*, 1841, etc., woodcuts, hf.
mor., t. e. g., together 7 vol., 8vo. (125) *Young*, £2 2s.

(β) *The Property of the late Mr. Frank Dillon.*

1283 Bewick (T.) History of British Birds, first ed., 2 vol. (vol i.
LARGE PAPER), old hf. cf., *Newcastle*, 1797-1804, 8vo. (145)
Lewine, £1 2s.

1284 Bonington (R. P.) Pictures, port. and series of plates (20) after
this artist, by J. D. Harding, India proofs, 1829-30, folio
(188) *Parsons*, £1

1285 Burlington Fine Arts Cluɔ. Exhiɔition Catalogues (Japanese
Lacquer and Metal Work, in duplicate, Silversmiths' Work,
Ancient Greek Art, Early German Art, Illuminated Manu-
scripts, etc.), 1872-1908, together 17 parts, 4to. (175)
Quaritch, £1 4s.

1286 [Carleton (W.)] Traits and Stories of the Irish Peasantry,
ɔoth series, illustrations, 5 vol., hf. cf., *Dublin*, 1836, 8vo.
(149) *Maggs*, £1 4s

1287 Cotman (J. S.) Etchings, port. and plates (spotted), 1811,
roy. folio (191) *Ellis*, £1 11s.

1288 Düller (E.) Deutschland und das deutsche Bolt, col. plates of costume, 2 vol., hf. mor., _Leipzig_, 1845, 8vo. (151)
Hill, 10s.

1289 Evelyn (J.) Sylva, third ed., plates, cf., autograph letter addressed to John Evelyn, by George Scott, and draft of Evelyn's answer, 1679, folio (196) _Tregaskis_, £2

1290 Flaxman (John). Illustrations to Homer, Hesiod and Æschylus, 146 engravings, in 2 vol., hf. mor., 1805-31, oblong folio (197) _Rimell_, 11s.

1291 Girtin (T.) Views in Paris, original subscriber's copy, plates in aquatinta, hf. mor., g. e., autograph letter of the author inserted, 1803, folio (198) _Rimell_, £8

1292 Goncourt. Collection de Goncourt. Arts de l'Extreme-Orient, port. and illustrations, 1897—Collection Hayashi. Objets d'Art du Japon et de la Chine, illustrations, 1902, 4to. (180) _Maggs_, £2 8s.

1293 Henderson (John). Works of Art in Pottery, Glass and Metal, photographed and printed for private use by Cundall and Fleming, hf. mor., presentation copy (1868), roy. folio (199) _Hiersmann_, 10s.

1294 Ireland (Sam.) Miscellaneous Papers and Legal Instruments under the Hand and Seal of William Shakspeare, facs., hf. bd. (binding broken), inserted an autograph letter of W. H. Ireland addressed to Mr. Alfestone, from the Spunging House, Chancery Lane, dated Jan. 28th, 1826, 1796, folio (200) _Mayhew_, £2 10s.

1295 Japan Society, London. Transactions and Proceedings, vol. i.-viii. part i., and Supplement i., 2 vol. in duplicate, ports. and illustrations, vol i. cl., remainder as issued, 1893-1908, 8vo. (156) _Edwards_, £3 15s.

1296 Jonson (Ben.) Works, by W. Gifford, best Library ed., port., 9 vol., cf., 1816, 8vo. (157) _Hornstein_, £3 3s.

1297 Jones (Owen). Grammar of Ornament, orig. ed., LARGE PAPER, 100 col. plates, in the parts as issued, 1856, roy. folio (201) _Hiersmann_, £3 6s.

1298 Lane-Poole (S.) Art of the Saracens in Egypt, LARGE PAPER, illustrations, buckram, uncut, 1886, imp. 8vo. (159)
Bain, 17s.

1299 Loudon (J. C.) Arboretum et Fruticetum Britannicum, plates and engravings, 8 vol., cf. gt., 1838, 8vo. (160)
Young, £1 16s.

1300 Marryat (Joseph). History of Pottery and Porcelain, col. plates and woodcuts, cf., g. e., 1857, 8vo. (161)
Graystone, 7s.

1301 Pennant (Thomas). Some Account of London, partly inter-leaved and extra illustrated, 1 vol. bound in 4, hf. mor., uncut, 1813, 8vo. (163) £5

1302 Potter (Paul). Etchings of Animals, after P. Potter, by M. de Bye, 36 plates, hf. cf., r. e. (1664), oblong 4to. (179)
Reader, 7s.

1303 Rademaker (A.) Kabinet van Nederlandsche, 2 vol.—Het

Verheerlykt Nederland, engravings, 10 vol. in 5, cf. ex.,
Amst., 1745, etc., 4to. (185)　　　　　*Young*, £5 7s. 6d.
1304 Ruskin (John). Modern Painters, vol. i.-iv. (vol. i. third ed.,
vol. ii.-iv. first eds.), name on titles, 1846-56, imp. 8vo. (165)
Dobell, £1 15s.
1305 Ruskin (J.) Seven Lamps of Architecture, first ed., name on
titles, 1849, imp. 8vo. (166)　　　　　*Edwards*, 15s.
1306 Ruskin (J.) Stones of Venice, first ed., vol. i. and iii., 2 vol.,
name on titles, 1851-53, imp. 8vo. (167)　*Edwards*, £2 2s.
1307 Shelley (P. B.) Poetical Works, port., 4 vol., cf. gt., 1839,
8vo. (168)　　　　　　　　　*Hornstein*, £1 14s.
1308 Spencer (H.) System of Synthetic Philosophy, 5 vol., 1864-72,
8vo. (169)　　　　　　　　　　*Bull*, £1 2s.
1309 Spenser (Edm.) The Faerie Queen and other Works, first
collected ed., engraved title and woodcuts, cf., M. Lownes,
1611, folio (205)　　　　　　　*Ridler*, £3 3s.
1310 Walpole (Horace). Anecdotes of Painting in England,
Major's edition, LARGE PAPER, with a duplicate set of the
portraits, India proofs before letters, extra illustrated with
numerous ports., inserted is an autograph letter (2 pages)
of Horace Walpole addressed to John Pinkerton, also
autograph letter of George Vertue to Dr. Ducarel, 5 vol.,
mor., g. e., by Holloway, fine copy, 1826-28, imp. 8vo. (171)
Maggs, £69
[Included among the additions to this fine copy of
"Walpole" were 16 original drawings (portraits) by G.
Vertue, being those of Peter Oliver, A. Vanderdort, G.
Geldorf, G. Videl, etc., also a col. drawing of Elias Ashmole
by G. P. Harding, etching from nature of J. S. Listard,
an unfinished proof before letters of Joseph Ames, oval
port. of John Milton, proof before letters, etc.—*Catalogue.*]
1311 Walton and Cotton. Complete Angler, by Sir J. Hawkins,
port. and plates, mor., g. e., Bagster, 1815, 8vo. (173)
Hornstein, 17s.

(γ) *The Property of Lady Tyler.*

1312 Angelo (M.) L'École des Armes, first ed., 47 plates by Gwin,
1763, oblong folio (296)　　　　　*Rimell*, 16s.
1313 Bickham (G.) Musical Entertainer, 100 plates of music, with
vignettes, extra illustrated, vol. i., n. d., folio (274)
Dobell, £3 17s. 6d.
1314 Biographical Magazine, 192 ports., 2 vol., hf. mor., 1819-20,
roy. 8vo. (220)　　　　　　　*Young*, £1 15s.
1315 Biographical Mirrour (The), 126 ports., 3 vol., cf. (slightly
stained), 1795-98, 4to. (261)　　　　*Maggs*, £5
1316 Blair (R.) The Grave, 12 etchings by W. Blake, and port. of
Blake by Schiavonetti, 1813, roy. 4to. (245)　　　　10s.
1317 Boisseau (J.) Tapisserie Royale, ou Tableaux Chronologique
des Papes, Empereurs, Roys de France, etc., heads, plates,
etc., old sheep, *Paris*, 1648, folio (289)　*Parsons*, £1 7s.
1318 Boydell (J. and J.) History of the River Thames, map and

76 col. plates, 2 vol., hf. mor., m. e. (a few leaves spotted), 1794-96, folio (304) *Andrews,* £7 15s.

1319 Brockedon (Wm.) Passes of the Alps, LARGE PAPER, plates, India proofs, 2 vol., hf. mor., t. e. g., presentation copy, 1828, folio (241) · *Dobell,* 9s.

1320 Caulfield (J.) Portraits, etc. of Remarkaɔle Persons from Edward the Third to the Revolution, 3 vol., 1813—From the Revolution to George II., 4 vol., 1819, together 7 vol., ports., hf. cf., 1813-20, 8vo. (208) *Graystone,* £1 7s.

1321 Clarke (C.) Architectura Ecclesiastica Londini, plates, hf. mor., 1820, 4to. (243) *Reader,* £1 6s.

1322 Comɔe (W.) Tour of Dr. Syntax in Search of the Picturesque, col. plates ɔy Rowlandson, cf., 1812, 8vo. (219)
 Shepherd, 17s

1323 Dart (J.) History and Antiquities of Westminster Aɔɔey, plates, port. inserted, 2 vol., cf., n. d., folio (272) *Reader,* 13s.

1324 Egan (Pierce). Life in London, first ed., 36 col. plates, hf. cf., t. e. g., advertisements preserved, 1821, 8vo. (218) £11 10s.

1325 Evelyn (J.) Memoirs and Correspondence, ed. ɔy Wm. Bray, port. and plates, 2 vol., 1819, 4to. (251) *Ellis,* 14s.

1326 Faulkner (T.) Account of Fulham, map and plates (ɔinding ɔroken), 1813—History and Antiquities of Kensington, map and plates, 1820 (216) *Dobell,* 19s.

1327 Ferrari (P.) Costumes des États du Pape, puɔliés par P. Marino, 30 col. plates of costume, vell., *Paris,* n. d., folio (281) *Rimell,* £1 1s.

1328 Gould (John). Century of Birds from the Himalaya Mountains, col. plates, mor., g. e., 1832, folio (312)
 Tregaskis, £8 5s.

1329 Granger (J.) Biographical History of England, fifth ed., with Richardson's series of ports., 6 vol., cf., uncut, 1824, 8vo. (226) *Rimell,* £2 16s.

1330 Hamilton (A.) Memoirs of Count Grammont, 64 ports. ɔy Scriven, 2 vol., cf. gt., 1811, 8vo. (215) *Hatchard,* £3 5s.

1331 Hawkins (Sir John). History of Music, illustrations, ports., etc., 5 vol., cf., 1776, 4to. (238) *Bull,* £1 19s.

1332 Johnson (Capt. C.) History of the Highwaymen, etc., also Voyages and Travels of Notorious Pyrates, plates, some additional inserted, hf. bd., g. e. (some leaves stained), 1734, folio (293) *Edwards,* £2 10s.

1333 Kirɔy (R. S.) Wonderful and Eccentric Museum, port., etc., 6 vol. (title to vol. i. torn), 1820, 8vo. (206) *Downing,* £2 4s.

1334 Knight (C.) Gallery of Portraits, 168 ports., 7 vol., hf. mor., t. e. g., 1833-36, imp. 8vo. (235) *Rimell,* £1 6s.

1335 Malton (T.) Picturesque Tour through London and Westminster, plates, 2 vol. in 1, uncut (some leaves loose), 1792, folio (275) *W. Daniell,* £10 15s.

1336 New Newgate Calendar, "Jackson's ed.," plates, vol. ii.-vii., 6 vol., n. d.—Newgate Calendar Improved, by G. T. Wilkinson, plates, vol. iii., n. d., 8vo. (221) *Edwards,* £2 6s.

1337 Papworth (John B.) Select Views of London, 76 col. plates, hf. russ., uncut, Ackermann, 1816, imp. 8vo. (225)
 Sotheran, £23 10s·

1338 Parkinson (John). Paradisi in Sole Paradisus Terrestris, engraved title (small wormhole) and woodcuts, old sheep, 1656, folio (276) *Edwards,* £5 5s.

1339 Pope (Alex.) Essay on Man, Part i. and Epistle ii., first eds. (one leaf imperfect), (1733)—Epistle to the Little Satyrist of Twickenham, first ed., 1733—The Diseases of Bath, a Satire, 1737—To the Imitator of the Satire of the Second Book of Horace, 1733—The First Ode of the Fourth Book of Horace, n. d.—Epistle to Alexander Pope, Esq., from South Carolina, 1737 — Elegy to a Young Lady in the manner of Ovid, 1733—First Epistle of the First Book of Horace Imitated, ɔy Mr. Pope, first ed., 1737—First Satire of the Second Book of Horace, first ed., 1734—Epistle from Mr. Pope to Dr. Arɔuthnot, first ed., 1734—Of the Use of Riches, first ed. (hole in title), 1732, and others ɔy Pope, etc., in 1 vol. (some leaves stained), folio (292) *Bunbury,* £4 15s.

1340 Pyne (W. H.) Costume of Great Britain, 60 col. plates, hf. mor., 1804, folio (300) *Rimell,* £1 12s.

1341 Recueil de Plusieurs Traitez de Mathématique de l'Académie Royale des Sciences, plates, old mor., g. e., *Paris,* 1676, imp. folio (307) *Wesley,* £1 4s.

1342 Rudder (S.) New History of Gloucestershire, map and plates, 1779 — Collection of Coats of Arms ɔorne ɔy Noɔility, etc. of the County of Gloucester, plates, title mounted, 1792, in 1 vol., cf. (ɔroken), 1779-92, folio (286) *Boyes,* £4

1343 Schenck (Petrus). Roma Aeterna, port. and 100 plates, 1705 —Paradisus Ocularum, 100 plates (1705), 2 vol., old cf., ex-liɔris of Francis Columɔine, dated 1708, in each vol., 1705, oɔlong folio (247) *Houthakker,* £2 18s.

1344 Smith (W.) Particular Description of England, ed. from original manuscript ɔy H. B. Wheatley and E. W. Ashɔee, col. plates, hf. bd., t. e. g., *Printed for subscribers only,* 1879, 4to. (263) *Reader,* 15s.

1345 Spinacuta (Signor). The Curious and Uncommon Perform-ances of a Monkey, 16 engravings, mounted, russ., g. e., ɔy Lewis, n. d., 4to. (236) *Parsons,* 18s.

1346 Stedman (Capt. J. G.) Narrative of Expedition against the Revolted Negroes of Surinam, maps and plates, 2 vol., cf., 1796, 4to. (248) *Tregaskis,* 14s.

1347 Thornton (R. J.) Temple of Flora, port. and 31 col. plates, hf. mor., g. e., 1799, atlas folio (306) *Leighton,* £1 17s.

1348 Willshire (W. H.) Introduction to Ancient Prints, first ed., front., hf. bd., uncut, t. e. g., 1874, 8vo. (222) *Downing,* 16s.

[NOVEMBER 11TH AND 12TH, 1909.]

SOTHEBY, WILKINSON & HODGE.

THE LIBRARY OF THE LATE MR. FREDERICK HENDRIKS,
OF 7, VICARAGE GATE, KENSINGTON, W.

(No. of Lots, 634 ; amount realised, £1,436 3s. 6d.)

1349 Aeronautics. Lunardi (V.) Account of the First Aërial
Voyage in England, autograph signature of Lunardi, large
folding col. plate, " A View of Mons. Garnerin's Balloon and
Parachute," 1802, ports., plates and views, cuttings from
newspapers, etc., autograph letters, including one of Lady
Elizabeth Stuart describing the fatal accident to Mme.
Blanchard, 1819, Beavan's " History of the Balloon," 1839,
" The Aerostatic Magazine," ed. by H. Coxwell, 1869, etc.,
in 1 vol., hf. mor., t. e. g., 1784, etc., 8vo. (2) *Tregaskis, £8*
1350 Aeronautics. Lunardi (V.) Account of the First Aërial
Voyage in England, port. by Bartolozzi, 1784—Account of
Five Aerial Voyages in Scotland, 1786—Copies of Letters
from Vincent Lunardi to his Guardian, 1786, ports. and
plates inserted, autograph signature of V. Lunardi, etc., in
1 vol., hf. cf., 8vo. (3) *Dobell, £5 17s. 6d.*
1351 Akerman (J. Y.) Remains of Pagan Saxondom, the original
water-colour drawings, 39 in number, by J. Basire and other
artists, autograph letter of Akerman inserted, hf. mor., g. e.,
oblong 4to. (181) *Tregaskis, £3*
1352 Akerman (J. Y.) Archaeological Index to Remains of Anti-
quity, plates and drawings of archaeological interest and
autograph letters of the author and other celebrated
antiquaries inserted, hf. cf. gt., 1847, 8vo. (5) *Shepherd*, 16s.
1353 Albumasares. Messahalach et Experimenta (Opus Astrolo-
gicum), manuscript on vellum, 26 leaves (8⅜in. by 6in.),
initials in red and blue, red velvet, *Sæc.* xv., 4to. (182)
 Llewellyn, £4 18s.
1354 Alciatus (A.) Les Emblemes translatez en François vers
pour vers jouxte les Latins, woodcuts (slightly shaved),
mor., g. e., *Lyon*, G. Roville, 1549, 8vo. (8) *Thorp, £1 2s.*
1355 Alchemy. MS. of 122 pages (in French), with many marginal
drawings, containing a storehouse of curious Studies in
Hermetic Mythology and a Journal for the years 1767 and
1768 of Alchemical Experiments, hf. mor., 1767-8, folio
(264) *Llewellyn, £4 15s.*
1356 Amman (Jost). Neuwe Biblische Figuren des Alten und
Neuwen Testaments, 130 woodcuts by Jost Amman (a few
marginal mendings), hf. vell., *Frankfurt*, G. Raben, S.
Feyerabend und W. Hanen Erben, 1565, obl. 4to. (184)
 Quaritch, £4
1357 Apianus (P.) Cosmographia, diagrams with movable slips,
large map containing America, and a few additional illus-
trations inserted, hf. cf., *Antverp*, A. Birckmann, 1564, 4to.
(187) *Leighton £3 18s.*

1358 Apuleius. Golden Ass, ɔy Wm. Adlington, with Introduction ɔy Whibley, *Tudor Translations*, 1893, 8vo. (12)
Thorp, £1 15s.

1359 Assurance Magazine and Journal of the Institute of Actuaries, vol. i.-xxxiii., hf. cf., and a numɔer of odd volumes and parts, 1851-98, 8vo. (14) *Wesley*, £45

1360 Baɔɔage (Ch.) Passages from the Life of a Philosopher, front., with autograph letters of the author, M. Faraday, Sir R. Owen, Sir R. Murchison, Sir H. de la Beche, Lord Mahon and others inserted, hf. cf. gt., 1864, 8vo. (15)
Sotheran, £3 17s. 6d.

1361 Bacon (Sir Francis). The Historie of Life and Death, engraved title with portrait of Bacon, ɔy Glover, cf., *J. Okes for Humphrey Mosley*, 1638, 8vo. (16) *Smedley*, £2 14s.

1362 Bates (W.) George Cruikshank, illustrations, 50 extra illustrations (some in colours), autograph letters of W. Harrison Ainsworth and others inserted, hf. bd., 1878, 4to. (193)
James, £1 13s.

1363 Beeverell (J.) Les Délices de la Grande Bretagne et de l'Irlande, folding views, 8 vol. in 6, hf. cf., *Leide*, 1727, 8vo. (21) *Maggs*, 18s.

1364 Bell (J.) London's Rememɔrancer, hf. cf., 1665, 4to. (194)
Llewellyn, 18s.

1365 Benlowes (E.) Theophila, or Love's Sacrifice, plates, including that of "The Masked Lady" (wanted port., but with the engraved verses on page 123), cf., 1652, folio (268)
Barnard, £2 14s.

1366 Bewick (T.) History of British Birds, 2 vol., A.L.s. of T. Bewick inserted, hf cf., *Newcastle*, 1832, 8vo. (25)
James, £1 18s.

1367 Biɔle Illustrations. Figure del Vecchio Testamento, par. Damian. Maraffi, 222 woodcuts, after Bernard Salomon— Figure del Nuovo Testamento, 95 woodcuts, in 1 vol. (last leaf mended), vell., *Lione*, Giov. di Tournes, 1554, 8vo. (29)
Vacher, £1 6s.

1368 Biɔliotheca Anglo-Poetica, woodcuts and ports., extra illustrated ɔy the insertion of ports., specimen leaves of ɔooks, autograph letters, etc., hf. mor., uncut, 1815, 8vo. (30)
Rimell, £6 5s.

1369 Binyon (L.) John Crome and John Sell Cotman, illustrations, 2 ports., 11 etchings and autograph letters inserted, hf. mor., g. e., 1897, imp. 8vo. (31) *Tregaskis*, £2 16s.

1370 Birch (S.) History of Ancient Pottery, first. ed., col. plates and engravings, extra illustrated with many orig. drawings. and sketches, etc., 2 vol., hf. cf., 1858, 8vo. (32) *Parsons*, £2

1371 Blades (Wm.) The Enemies of Books, port. and illustrations, specimens of illuminated manuscripts on vell., leaves of early printed ɔooks, etc. inserted, hf. cf. gt., 1881, 8vo. (34)
Tregaskis, £4 6s.

1372 Boissardus (J. J.) Emɔlemes Latins, port. of Boissard and 42 plates ɔy T. de Bry, old cf. (water-stained), *Metis, excud. A. Faber*, 1588, 4to. (199) *Smedley*, £1 6s.

1373 Bookbindings. Facsimiles of Old Book Bindings in the Collection of James Gibson Craig, facs. in gold and colours, 25 copies printed, hf. mor., g. e., *Privately printed, Edinburgh,* 1882 (271) *Quaritch,* £1 6s.

1374 Böschensteyn (Joann). Ain New geordnet Rechenbiechlin mit den zyffern den angenden schülern zü nutz Inhaltet die Siben species Algorithmi, hf. cf., *Augspurg,* Erhard Oglin, 1514, 4to. (205) *Quaritch,* £4 15s.

1375 Boswell (J.) Life of Johnson, port. and fac., 4 vol., russ. ex., 1811, 8vo. (40) *Quaritch,* £1 16s.

1376 Boutell (Ch.) Arms and Armour in Antiquity and the Middle Ages, woodcuts, extra illustrated by the insertion of numerous orig. drawings and autograph letters, hf. cf., t. e. g., 1872, 8vo. (42) *Tregaskis,* £3 16s.

1377 Brigitta (S.) Revelationes Sancte Birgitte, lit. gotħ., woodcuts by Dürer, old mor., g. e., *Nurimbergae, per Ant. Koberger,* 1521, folio (273) *Parsons,* £12 15s.
[The printing of the date gave rise to a controversy between Mercier, Abbé de St. Leger, who considered it ought to be read 1500, and De Bure, who placed the date of printing as 1521. The opinion of the former has since been upheld by Panzer, Hain, Brunet and others.—*Catalogue.*]

1378 Braun (Geo.) Civitates orbis terrarum, maps col. by hand, vol. i.-v., mor., arms of Cardinal Carafa, Archbishop of Naples, *Coloniae,* 1572-99, folio (272) *Edwards,* £5 12s. 6d.

1379 Brockedon (Wm.) Illustrations of the Passes of the Alps, LARGE PAPER, 109 plates by Finden and others (proofs), 2 vol., mor. ex., elegantly tooled borders, 1828-29, 4to. (209) *Edwards,* £1 9s.

1380 Browne (Th.) Hydriotaphia, Urne-Buriall, first ed., 2 plates, with the 2 extra leaves at end (wanted title slip), hf. cf., H. Brome, 1658, 8vo. (51) *Leighton,* £1 9s.

1381 Bry (T. et J. T. de). Acta Mechmeti I., Saracenorum Principis, Natales, Vitam, Victorias, Imperium et Mortem ejus, etc., engravings by the De Brys (title-page repaired), s. l., 1597—Thevet (F. A.) Cosmographie de Levant, woodcuts (2 leaves defective), cf., *Lyon,* 1554, 4to. (210) *Quaritch,* £2 14s.

1382 Brown (G.) Arithmetica Infinita, or the Accurate Accomptants Best Companion, port., sheep, 1718, sq. 12mo.— Another copy (wanted port.), sheep, together 2 vol. (52) *Burt,* £2 14s.

1383 Brydges (Sir E.) Censura Literaria, 10 vol., russ. gt., 1805-9, 8vo. (54) *Harding,* £1 12s.

1384 Brydges (Sir E.) Restituta, 4 vol., hf. mor., g. e., 1814-16, 8vo. (55) *Harding,* £1 8s.

1385 Brydges (Sir E.) The Anti Critic for August, 1821 and March, 1822, containing Literary, not Political, Criticisms and Opinions, 75 copies printed, mor. ex., *Geneva,* W. Fick, 1822, 8vo. (56) *Walford,* 11s.

1386 Brydges (Sir E.) The Anglo-Genevan Critical Journal for

1831, 2 vol., 50 copies printed, hf. mor., t. e. g., *Geneva*, A. L. Vignier, 1831, 8vo. (57) *Dobell*, 10s.

1387 Brydges (Sir E.) Autobiography, ports., extra illustrated with views, ports., autograph letters, etc., 2 vol., hf. old cf., 1834, 8vo. (58) *Rimell*, £4 8s.

1388 Brydges (Sir E.) and Haslewood (W.) The British Biblio-grapher, ports., 4 vol., hf. cf. gt., R. Triphook, 1810-14, 8vo. (62) *Quaritch*, £1 10s.

1389 Burn (J. H.) Descriptive Catalogue of the London Traders, Tavern and Coffee-House Tokens current in the seventeenth century, presented to the Corporation Library by H. B. H. Beaufoy, illustrated with plates, views (many in colours) and autograph letters, hf. mor., g. e., 1855, 8vo. (66) *Tregaskis*, £5 12s. 6d.

1390 Butler (Chas.) The Feminine Monarchie, woodcuts, mor., *Oxford*, W. Turner, 1634, 4to. (213) *Tregaskis*, £1

1391 Carnet d'un Mondain. Gazette Parisienne, Anecdotique et Curieuse, par Etincelle, 9 plates in col. and woodcuts by A. Ferdinandus, 2 vol., hf. mor., t. e. g., *Paris*, 1881-82, 8vo. (73) *Sotheran*, 12s.

1392 Case (The) of the Bankers and their Creditors stated and examined (edges cut into), hf. bd., 1674—[Child (Sir J.)] Brief Observations concerning Trade and Interest of Money, hf. roan, 1668—Culpeper (Sir Th.) A Discourse shewing the many advantages which will accrue to this Kingdom by the abatement of Usury, hf. roan, 1668, etc., in 6 vol., 4to. (215) *Leon*, £5 10s.

1393 Cattan. La Géomance du Seigneur Christofe de Cattan, par Gabriel du Prëau, diagrams, cf., *Paris*, 1575—Yonge (John). New Yeres Gifte to H. M. Quene Elizabeth, transcript in the handwriting of Geo. Chalmers, with autograph letter inserted, cf., together 2 vol., 4to. (217) *Quaritch*, £1 6s.

1394 Catz (J.) Proteus ofte Minnebeelden verandest in Sinne-beelden door J. Catz, first ed., plates of emblems, 5 parts in 1 vol., hf. vell., *Rotterdam*, P. van Waesberge, 1627, 4to. (218) *Smedley*, £1 18s.

1395 Caulfield (J.) Portraits, 7 vol. in 6, hf. mor., g. e., 1813-20, 8vo. (76) *Hornstein*, £2 14s.

1396 Caxton Celebration, 1877. Catalogue of the Loan Collection of Antiquities, etc. connected with the Art of Printing, South Kensington, ed. by G. Bullen, one of 157 copies on hand-made paper, numerous ports., engravings, etc. inserted, hf. cf., t. e. g., 1877, 4to. (219) *Burt*, £4 10s.

1397 Cent Nouvelles Nouvelles (Les), vignettes by Romain de Hooge, 2 vol., cf. gt., *Cologne*, P. Gaillard, 1701, 8vo. (77) *Shepherd*, £1 15s.

1398 Charles II. Relation en forme de Journal du Voyage et Sejour, que le Serenissime et Très-Puissant-Prince Charles II., Roy de la Grand Bretagne, etc. a fait en Hollande, depuis le 25 May, jusques au 2 Juin, 1660, port. and folding plates mounted on linen, autograph signature

and motto of Sir John Evelyn on title-page, mor. ex., ɔy
Rivière, *à La Haye*, Adrian Vlacq, 1660, folio (276)
 Leighton, £4 10s.
1399 Choiseul-Gouffier (M. G. F. A. Comte de). Voyage Pittor-
esque de la Grèce, plates and port., 2 vol., new hf. mor. ex.,
uncut, *Paris*, 1782-1809, imp. folio (279) *Thorp*, £2 18s.
1400 Chronicles. The descrypcyon of Englonde. Here foloweth
a lytell treatyse, etc. (with a portion of the metrical Des-
crypcion of the Londe of Wales), 18 leaves, black letter,
woodcut on first leaf, hf. cf., *Fragment from Pynson's edition
of* 1510, folio (280) *Barnard*, £2 2s.
1401 Cicero. Rhetoricorum ad Herennium, liɔ. iv.—De Inventione,
liɔ. ii.—De Oratore, liɔ. iii., etc. (title-page mended), mor. gt.,
vell. fly-leaves, g. e., ɔy Bozérian jeune, *Venetiis, in ædibus
Aldi, et Andreae Soceri*, 1521, 8vo. (82) *Tregaskis*, £1
1402 Collections for a History of Engraving, xv. to xix. cent., illus-
trated with numerous orig. (and some fac.) examples of great
rarity, arranged by F. Hendriks, in 2 vol., hf. mor., t. e. g.,
1882, 4to. (227) *Parsons*, £17 15s.
[Among others may be mentioned original impressions of
woodcuts by Alɔert Dürer ; Wierix's copy of Dürer's Melan-
colia, with the date 1602 ; a fine full-page woodcut of the
Crucifixion, on vellum, from the Sarum Missal of 1510 ;
woodcuts from Early Block Books ; woodcuts by Cranach,
Burgmair, Jost Amman, Remɔrandt, Bewick, Leech, etc.,
ornamental capitals, together with portraits of the various
artists represented.—*Catalogue.*]
1403 Collier (John). Tim Boɔɔin's Lancashire Dialect and Poems,
6 etchings by G. and R. Cruikshank, orig. cl., 1828, 8vo.
(86) *Graystone*, £1 1s.
1404 [Comɔe (Wm.)] The Three Tours of Doctor Syntax, col.
plates by T. Rowlandson, 3 vol., orange cl., t. e. g., 1819-20,
8vo. (87) *Parsons*, £2
1405 Consolato del Mar. Liɔre apellat Consolat de Mar, ara nova-
ment estampat y corregit, Ayn mdxl., lit. goth., initials and
woodcuts, russ. gt., gauffred edges, *Barcelona*, Carles
Amoros Provencal, 1540 (229) *Leighton*, £7
[Fine copy of a rare edition in Catalan. At the end is a
neatly written contemporary MS. of 11 pages, "Lorde fete
en la taula de la Cintat de Barcelona."—*Catalogue.*]
1406 Cooper (A.) Impressions of Animals, Birds, etc. illustrative
of British Field Sports, from a set of silver ɔuttons,
engraved by J. Scott, LARGE PAPER, engravings on India
paper, port. and autograph letter of A. Cooper inserted, cf.,
t. e. g., 1821, 8vo. (89) *Hornstein*, £2 8s.
1407 Coxe (Peter). The Social Day, 32 plates, hf. mor., g. e., fine
copy, 1823, 8vo. (90) *Sotheran*, 16s.
1408 Coxe (Wm.) Life and Administration of Sir Roɔert Walpole,
Earl of Orford, ports., extra illustrated by the insertion of
over 150 portraits, autograph letters or signatures of Sir R.
Walpole, Rev. W. Coxe, George III., and other eminent
men of the period, ɔroadsides and illustrations relating

to the South Sea Bubble, etc., 2 vol., hf. mor., 1798, 4to.
(231) *Rimell,* £11 5s.
1409 Coyer (L'Abbé). La Noblesse commerçante, front. by C.
Eisen, contemp. mor., with arms of Louis XVI., *Paris,*
Duchesne, 1756, 8vo. (91) *Parsons,* £5 5s.
1410 Croker (T. C.) A Walk from London to Fulham, illustrations
by F. W. Fairholt, with numerous autograph letters of the
author and others inserted, hf. cf., t. e. g., 1860, 8vo. (92)
Rimell, £3 17s. 6d.
1411 Cuitt (George). Etchings of Ancient Buildings in the City
of Chester, Castles in North Wales, etc., 50 etchings, India
paper proofs, mounted, *Chester,* 1816, folio (284)
Walford, £1 12s.
1412 Darcie (Abr.) Annales. History of the famous Empresse
Elizabeth, Queene of England, etc., port. of Queen Elizabeth
(defective), cf., B. Fisher, 1625, 4to. (235) *Ridler,* £1 14s.
1413 [Davenant (C.)] An Essay on the East-India Trade, 1696—
England and East-India inconsistent in their Manufactures,
1697—The Profit and Loss of the East-India Trade Stated,
1700—The South Sea Scheme Examined, 1720—Mack-
worth (Sir H.) An Answer to several queries . . . for
Relief of the South Sea Company, 1720—An Essay on
Ways and Means for the Advancement of Trade, 1726—
Some Considerations on the National Debts, the Sinking
Fund and the State of Publick Credit, 1729, together 9
tracts (99) *Burt,* £4 12s.
1414 De Brunes (Johannes). Emblemata, 52 emblematic en-
gravings, cf. gt., *Amsterdam,* A. Latham, *s. a.* (1624), 4to.
(236) *Ellis,* £1 12s.
1415 De Jong (D.) et Sallieth (M.) Ports de Mer des Pays-Bas,
avec les vues de la ville et du port de Batavia, de l'isle
Onrust, de la Péche de la Baleine, et du Hareng, views,
hf. mor., *Amsterdam* (1780), folio (286) *Parsons,* £1 2s.
1416 Démartrais (F. Damame). Vues de Russie, 31 large plates
(no title or text), hf. cf., *circa* 1810, atlas folio (287)
James, £10
1417 Devonshire (Georgiana Duchess of). The Passage of the
Mountain of St. Gothard, a Poem, with translation into
French by the Abbé de Lille, 20 lithographed plates, mor.
ex., elegantly tooled, Bessborough arms on sides, by Daw-
son and Lewis, *Privately printed,* 1802, 8vo. (237)
Sabin, £2 2s.
1418 Dibdin (Dr. T. F.) Bibliomania, plates and woodcuts, port.
of the author (private plate), russ. ex., 1811, 8vo. (107)
Hornstein, 17s.
1419 Dibdin (Dr. T. F.) Bibliographical Decameron, plates and
facs., 3 vol., russ. ex., 1817, 8vo. (108) *Hill,* £5 5s.
1420 Dibdin (Dr. T. F.) Tour in France and Germany, plates and
vignettes on India paper, 3 vol., mor. ex., 1821, 8vo. (109)
W. Daniell, £6 2s. 6d.
1421 Dibdin (Dr. T. F.) Voyage bibliographique, archéologique
et pittoresque en France, LARGE PAPER, extra illustrated
6—2

ɔy the insertion of views, etc., 4 vol., *Paris*, 1825, imp. 8vo.
(110) *James, £3*
1422 Dibdin (Dr. T. F.) Tour in France and Germany, ports. and
illustrations, 3 vol., hf. mor., t. e. g., 1829, 8vo. (111)
Hornstein, 8s.
1423 Dibdin (Dr. T. F.) Tour in the Northern Counties of England
and in Scotland, plates and vignettes, 2 vol., russ., g. e.,
1838, 8vo. (112) *Shepherd, £2* 4s.
1424 Dickens. Ward (T. H.) Dickens, extra illustrated with
numerous ports. and views, autograph letters, etc., cf., t. e. g.,
1882, 8vo. (115) *Dobell, £2* 2s.
1425 Dickens. Langton (R.) The Childhood and Youth of
Charles Dickens, illustrations, with many additional illus-
trations and autograph letters, hf. cf., t. e. g., 1883, 8vo.
(116) *Dobell, £3* 5s.
1426 Dictionary of Political Economy, edited by R. H. Inglis
Palgrave, 3 vol., 1894-1901, 8vo. (117) *Edwards, £2* 4s.
1427 Dorat (C. J.) Œuvres, plates and vignettes ɔy Eisen, etc.,
20 vol., hf. mor., *Paris*, 1772-80, 8vo. (121)
James, £4 2s. 6d.
1428 Dorat (C. J.) Faɔles Nouvelles, first ed., vignettes ɔy
Marillier, autograph note of Dorat inserted, 2 vol. in 1, cf.,
g. e., *à La Haye (Paris)*, 1773, 8vo. (122) *Isaacs, £5* 10s.
1429 Du Chaillu (P. B.) The Viking Age, map and illustrations,
2 vol., 1889, 8vo. (124) *Hill*, 18s.
1430 Duchesne Aîné. Essai sur les Nielles, etc., du xv. siècle,
plates, and extra illustrated, cf., g. e., *Paris*, 1826, 8vo. (125)
Rimell, £1 11s.
1431 Duplessis (G.) Histoire de la Gravure, 73 illustrations, orig.
ɔinding, *Paris*, 1880, imp. 8vo. (126) *Diouritch*, 17s.
1432 Economic Journal, vol. i.-xvii. (wanted No. 26, June, 1897),
and vol. xviii., March and Decemɔer, in parts, as issued,
with index to vol. i.-x., 1891-1908, 8vo. (127) *Hill, £7* 15s.
1433 Dugdale (Wm.) History of St. Paul's Cathedral, first ed.,
port., and plates by Hollar, russ. gt., 1658, folio (290)
Harding, £1 7s.
1434 Dürer (Alɔert) et ses dessins par C. Ephrussi, LARGE PAPER
(100 copies only), plates (in two states) and illustrations, hf.
mor., *Paris*, A. Quantin, 1882, 4to. (241) *Sabin, £2* 8s.
1435 Emɔlemata Politica in aula magna curiae Noribergensis
depicta, 32 plates, hf. mor., t. e. g., *s. l. et a.* (1613), 4to. (242)
Smedley, £1
1436 Erredge (J. A.) History of Brighthelmston, illustrated ɔy
the insertion of over 80 portraits, views, etc., hf. cf. antique,
Brighton, 1862, 8vo. (130) *Shepherd, £1* 16s.
1437 Eyb (Alɔertus de). Margarita Poetica, editio prima, lit. gotḥ.,
contains 26 leaves of " Registrum," including one ɔlank,
and 450 leaves ruɔricated throughout, illuminated ɔorder
to first leaf of " Registrum " and painted capital at ɔase
(Hain, *6818), hf. cf., *Nurembergae per industriosum im-
pressoris Artis Magistrum Johannem Sensenschmid*, 1472
die ii. *Decembris*, folio (292) *Ellis, £6* 15s.

1438 Fables Inédites des XII^e, XIII^e et XIV^e Siècles, et Fables de Lafontaine, par A. C. M. Robert, port. on India paper, facs. and plates, 2 vol., mor. ex., *Paris*, 1825, 8vo. (132)
Hunt, £1

1439 Fairholt (F. W.) Tobacco, its History and Associations, 100 illustrations by the author, extra illustrations and autograph letters inserted, hf. cf. gt., 1876, 8vo. (133) *Burt,* £2 14s.

1440 Falle (P.) An Account of the Isle of Jersey, first ed., folding map, hf. cf., 1694, 8vo. (134) *Tregaskis,* 9s.

1441 Faulkner (T.) History and Antiquities of Kensington, LARGE PAPER, plates and woodcuts, and extra illustrated with ports., views and autograph letters of Kensington celebrities, hf. mor., g. e., 1820, 4to. (247) £5

1442 Faussett (B.) Inventorium Sepulchrale. An Account of some Antiquities dug up in the County of Kent, ed. by C. Roach Smith, plates, autograph letters of C. Roach Smith and others inserted, 1856 (248) *Thorp,* £1 2s.

1443 Fox (G. T.) Synopsis of the Newcastle Museum, illustrations, autograph letters of North Country celebrities inserted, hf. mor., t. e. g., *Newcastle*, 1827, 8vo. (139)
W. Daniell, £2 4s.

1444 Gardens (The) and Menagerie of the Zoological Society delineated, printed on India paper (the only copy so done), woodcuts after W. Harvey, etc., 2 vol. in 1, mor., g. e., 1831, 8vo. (142) *Pearson,* 15s.

1445 Goldsmith (O.) A Pretty Book of Pictures for Little Masters and Misses, one of 25 copies illustrated with extra wood engravings on thin Japanese paper, photographs, etc., hf. roan, t. e. g., E. Pearson, 1868, 4to. (198) *Pearson,* £1 10s.

1446 Grapputo (T.) La Selva Napoleoniana, printed on vellum, port., mor., g. e., *Venezia*, 1809, 8vo. (150) *Walford,* £1 16s.

1447 Greenwell (Wm.) and Rolleston (G.) British Barrows, woodcuts, *Oxford*, 1877, 8vo. (151) *Edwards,* 19s.

1448 Graunt (J.) Natural and Political Observations mentioned in a following Index and made upon the Bills of Mortality, second ed., hf. vell., 1662, 4to. (253) *Walford,* £1

1449 Gray (T.) Designs by Mr. R. Bentley for six Poems by T. Gray, LARGE PAPER, with 4 pages manuscript "Botanologia," in the handwriting of the poet, port., and other interesting matter loosely inserted, hf. cf. gt., 1753, folio (297) *Dobell,* £4 4s.

1450 Guiffrey (J.) Antoine Van Dyck, sa Vie et son Œuvre, 22 plates and illustrations, *Paris*, A. Quantin, 1882, folio (298)
Rimell, 19s.

1451 Haines (H.) Manual of Monumental Brasses, with extra illustrations, and autograph letters inserted, 2 vol., *Oxford*, 1861, 8vo. (154) *Thorp,* £1 17s.

1452 Hall (Mr. and Mrs. S. C.) Ireland, plates and woodcuts, 3 vol., orig. cl., 1841-3, roy. 8vo. (155) *Dobell,* 9s.

1453 Hamerton (P. G.) Etching and Etchers, third ed., illustrations, extra illustrated, orig. hf. mor., 1880, folio (299)
Ellis, £9

1454 Hamerton (P. G.) Landscape, extra illustrated with original
drawings by Claude Lorraine, David Wyck, Trevisani and
others, and with etchings and engravings, orig. hf. mor.,
uncut, 1885, folio (300) *Rimell*, £4 15s.
1455 Hamerton (P. G.) Drawing and Engraving, illustrations, a
large number of engravings, small mezzotints, etc. inserted,
1892, 8vo. (158) *Barnard*, £1 12s.
1456 Hamilton (Sir Wm.) Campi Phlegraei, map and 54 col.
plates, 2 vol., hf. cf., *Naples*, 1776, folio (302)
 Tregaskis, £1 5s.
1457 Head (R.) Proteus Redivivus, or the Art of Wheedling, hf.
cf. gt., 1676, 8vo. (164) *Dobell*, 11s.
1458 Hericault (Ch. d'). La Révolution, 1789-1882—Appendices
par Emm. de Saint Albin, V. Pierre et A. Loth, plates,
many in colours, and illustrations, hf. mor., t. e. g., *Paris*,
1883, 4to. (259) *Sabin*, 15s.
1459 Hill (R.) Sketches in Flanders and Holland, LARGE PAPER,
author's own copy with his initials and proofs before letters
of the 36 illustrations, extra illustrations inserted, hf. mor.,
t. e. g., 1816, 4to. (260) *Edwards*, £1 6s.
1460 Héros (Les) de la Ligue, ou la Procession Monacale conduitte
par Louis XIV. pour la conversion des Protestans de son
Royaume, 24 caricature ports., including that of James II.,
3 extra ports. inserted, mor. ex., *Paris*, 1691, 8vo. (169)
 Rimell, £2 6s.
1461 Hindley (Ch.) The Old Book Collector's Miscellany, 3 vol.,
one of 6 copies on light green paper, rox., t. e. g., 1871-73,
8vo. (172) *Hill*, 10s.
1462 Hodder (James). The Pen-Man's Recreation, port., hf. cf.,
1673—Banson (W.) The Merchant's Penman, hf. cf. (1702)
—More (R.) Of the First Invention of Writing, port.,
hf. cf. (1716), together 3 vol., oblong 4to. (263) *Burt*, £4 6s.
1463 Hoefnagel (G.) Archetypa studiaque, Jacobus filius genio
duce ab ipso scalpta, omnibus philomusis amisé dicat ac
communicat, 48 plates on Natural History, 4 parts in 1 vol.,
hf. mor., g. e., *Francofurti ad Moenum*, 1592, 4to. (491)
 Parsons, £2 18s.
1464 Hogarth (W.) Graphic Illustrations of Hogarth, by S.
Ireland, plates, cf., t. e. g., by Rivière, 1794-99, 8vo. (174)
 Smedley, £1 15s.
1465 Hogarth Illustrated by John Ireland, ports. and plates, 3 vol.,
hf. mor., 1791-98, 8vo. (175) *Hornstein*, 18s.
1466 Holbein (Hans). Icones Historiarum Veteris Testamenti
[Gallicis Versibus (par G. Corrozet) et Latinis Description.
ibus], 98 woodcuts by Hans Lützelbürger after Holbein, cf.,
Lugduni, apud Joannem Frellonium, 1547, first ed. of this
date (492) *Leighton*, £10
1467 Holbein Society's Facsimile Reprints, fac. woodcuts, together
8 vol., 1869-73, 4to. (493) *Dobell*, £1 1s.
1468 Homer. La Guerre des Grenouilles et des Souris, traduite
mot pour mot de la version Latine d'Etienne Berglère,
imprimée vis à vis, par François Cohen de Kentish Town

(Fr. Palgrave) agé de huit ans, engraved title-page, two A.L.s of Sir Francis Palgrave inserted, new cf., g. e., 1797, 8vo. (318)· *Palgrave,* 14s.

1469 Hone (W.) The Every Day Book and Taɔle Book, and The Year Book, illustrations, 4 vol., hf. cf. gt., 1826-32, 8vo. (319) *Shepherd,* 16s.

1470 Hopil (Claude). Œuvres Chrestiennes, port. ɔy de Leu, cf. gt., g. e., ɔy Bauzonnet-Trautz, *Lyon,* Th. Ancelin, 1604, 8vo. (320) *Lewine,* £1 4s.

1471 Horae Beatae Virginis Mariae, cum Calendario, a lusaige de Nantes, lit. goth. (lettres bâtardes), 108 leaves, long lines, 30 to a full page, within ɔorders, Simon Vostre's device on title-page, astrological man, and 22 woodcuts of the usual suɔjects, small painted capitals (4 leaves damaged), cf., *Ces presentes heures ont este faictes a Paris pour Simon Vostre, etc.* [*Almanack,* 1515-30], 8vo. (322) *Rimell,* £13 5s.
 [Inserted are 4 full-page painted and illuminated woodcuts on vellum from another of Simon Vostre's Books of Hours.—*Catalogue.*]

1472 Houghton (J.) A Collection of Letters for the Improvement of Husɔandry and Trade, 2 vol. in 1, cf., 1681-3—Another copy of vol. i. only (wanted No. 11), hf. cf., 1681, 2 vol., 4to. (494) *Burt,* £2 14s.

1473 Hughson (D.) Walks through London, LARGE PAPER, plates, with many extra illustrations, 2 vol. in 1, hf. mor., t. e. g., 1817, 8vo. (324) *Graystone,* £2 17s.

1474 Hugo (H.) Pia Desideria, Emblematis, Elegiis & affectibus SS. Patrum illustrata, woodcut title, arms of Pope Urɔan VIII., 45 full-page woodcuts and ornaments by Christ. Van Sichem, mor., g. e., ɔy Petit, fine copy, the first ed. with C. Van Sichem's woodcuts, *Antw.,* H. Ærtssen, 1628, 8vo. (326) 16s.

1475 Hugo (T.) The Bewick Collector, ports. and illustrations, with numerous extra woodcuts, and 2 autograph letters of the author, 2 vol., hf. mor. gt., 1866-68 (327) *Shepherd,* £1 9s.

1476 Humphreys (H. N.) The Origin and Progress of Writing, facs., extra illustrated, 1854, imp. 8vo. (328) *Burt,* £2 10s.

1477 Humphreys (H. N.) History of the Art of Printing, 100 fac. plates, B. Quaritch, 1867, folio (305) *Burt,* £2 8s.

1478 Humphreys (H. N.) Masterpieces of the Early Printers and Engravers, facs., 1870, folio (306) *Burt,* £2 8s.

1479 Huswirt (J.) Enchiridion novus Algorismi summo pere visus De integris, lit. goth., hf. roan, *Coloniae,* H. Quentall, 1507, 4to. (496) *Wesley,* £3

1480 Insurance. Manuscript and Printed Researches on De Witt's Treatise upon Life Annuities, and on the History of Insurance, an important collection ɔrought together ɔy F. Hendriks, ports. and other illustrations, in 1 vol., mor. gt. (308) *Quaritch,* £10

1481 Insurance. A Collection of 177 Pamphlets on Insurance, Life Assurance, Statistics, Trade, etc., in 10 vol., hf. cf., 1812-72, 8vo. (333) *Leon,* £7

1482 Ireland (S.) Graphic Illustrations of Hogarth, ports. and
plates, 2 vol., russ., m. e., 1794-9, 8vo. (334) *Maggs*, 15s.
1483 [Ireland (W. H.)] Scribbleomania, 1815—Wordsworth (W.)
Peter Bell, a Tale in Verse, first ed. (wanted front.), 1819—
The Waggoner, a Poem, first ed., 1819—Hone (W.) A
Slap at Slop, woodcuts, 1822—First Book for the Instruction
of Students in the King's College, 4 plates by R. Seymour,
n. d., and numerous other pamphlets, in 16 vol., hf. russ.,
8vo. (336) *Dobell*, £9 5s.
1484 Jewitt (L.) The Wedgwoods, illustrations, with autograph
letters of the author, Josiah Wedgwood, and others, 1865,
8vo. (337) *Shepherd*, £1 19s.
1485 Justinianus. Instituta cum divisionibus et summariis, lit. goth.,
orig. stamped Venetian mor. (rejacked), *Venetiis*, Jo. Hert-
zog, 1494, 4to. (499) *Leighton*, £3 10s.
1486 Juvenal et Persius. Satyræ, first issue of the first ed., without
the anchor on title-page, mor. gt., *Venetiis, in aedibus Aldi
Mense Augusto*, 1501 (340) *Tregaskis*, £2 8s.
1487 Kirby (R. S.) Wonderful and Scientific Museum, ports. and
illustrations, 5 vol., half. mor. gt., 1803-13, 8vo. (342)
 Rimell, £2 4s.
1488 Klopstock (F. G.) Mors Christi, seu Messias, ex Illustri
Poëmate Klopstokiano (by L. B. Neuman), vignettes, cf.,
g. e., arms of Napoleon I., *Viennae*, 1770, 8vo. (343)
 Tregaskis, £1 19s.
1489 Knorr (G. W.) et Walch (J. E. I.) Recueil des Monumens
des Catastrophes que le globe de la Terre a essuyées, 2
ports. and 272 col. plates of fossil remains, 4 vol., russ. gt.,
Nuremberg, 1777-8, folio (312) *Thorp*, £1 16s.
1490 Lambard (Wm.) Perambulation of Kent, first ed., black
letter, map of the Heptarchie, new hf. cf., g. e., Ralphe .
Newberie, 1576 (502) *Dobell*, £2 2s.
1491 Lang (A.) The Library, plates, many illustrations and leaves
of rare books loosely inserted, 1892, 8vo. (349)
 Sotheran, £2 2s.
1492 Lavater (J. C.) Essays on Physiognomy, by T. Holcroft,
360 engravings, with port. and autograph signature of
Lavater, etc. inserted, 3 vol., russ., g. e. (Roger Payne),
1789-98, 8vo. (353) *Tregaskis*, £1 14s.
1493 Lawrence (R.) The Interest of Ireland in its Trade and
Wealth stated, cf., *Dublin*, 1682, 8vo. (355) *Burt*, 18s.
1494 Leland (C. G.) Etruscan Roman Remains in Popular Tradi-
tion, illustrations, one of a 100 copies on hand-made paper,
orig. pen-and-ink drawing by the author, orig. drawings
and extra illustrations inserted, 1892, 4to. (505)
 Shepherd, £1 7s.
1495 Lessons of Thrift, col. plates by I. R. Cruikshank, hf. cf.,
 , T. Boys, 1820, 8vo. (356) *Shepherd*, £1 19s.
1496 Le Roy (J.) Castella et Praetoria nobilium Brabantiae et
coenobia celebriora ad vivum delineata, plates, hf. russ.,
Amstelaedama, 1696, folio (313) *Thorp*, £1 13s.
1497 London's Dreadful Visitation, or a Collection of all the Bills

of Mortality for this present Year ɔeginning the 27th of Decemɔer, 1664, and ending the 19th Decemɔer following, cuttings from "The London Gazette" respecting the plague inserted, cf., 1665, 4to. (507) *Maggs, £5* 2s. 6d.

1498 Lower (M. A.) Curiosities of Heraldry, woodcuts, extra illustrated with engravings, orig. sketches, and autograph letters of the author, hf. mor., t. e. g., 1845, 8vo. (359)
 *Dobell, £*1

1499 Lowndes (W. T.) Biɔliographer's Manual, LARGE AND THICK PAPER, 4 vol., mor., g. e., Pickering, 1834, 8vo. (361)
 *Doolan, £*1 12s.

1500 Lupi Reɔello (J.) Tractatus fructus sacramenti, lit. goth., *Paris*, Guido Mercator, 1514—Gerson (J.) De potestate ecclesiastica et De origine juris et legum, lit. goth., *ib.*, J. Pouchin, 1517—Michaelis de Hungaria, Sermones, lit. goth., *ib.*, J. Petit, 1518—Sermones Aurei funebres cunctos alios excellentes noviter inventi, lit. goth., *Lugduni*, C. Fradin, *s. a.*—Speculum Christianorum, multa ɔona continens, lit. goth., *s. l. et a.*—Melanchthon (P.) Ad Paulinae doctrinae studium adhortatio, woodcut on title (fore-edge notes cut), *Paris*, R. Stephanus, 1529, in 1 vol., hf. bd., 8vo. (362)
 Leighton, £5 5s.

1501 Luther (M.) Disputatio D. Joannis Eccii et P. Martini Luther in studio Lipsensi futura, cf. (*Wittenberg*), 1519, 4to. (509)
 *Bowes, £*1 2s.

1502 Macpherson (D.) Annals of Commerce, Manufactures, Fisheries and Navigation, 4 vol., hf. bd., 1805, 4to. (510)
 Burt, £2 8s.

1503 McCulloch (J. R.) Select Collection of Scarce and Valuaɔle Tracts on Money, 125 copies printed, *Political Economy Club*, 1856, 8vo. (365) *Barnard, £3* 15s.

1504 McCulloch (J. R.) The Literature of Political Economy, with autograph letters or signatures of D. Ricardo, H. C. Carey, J. B. Say, Prof. W. S. Jevons, General Thompson, and other Political Economists, hf. cf., 1845, 8vo. (366)
 Leon, £5 12s. 6d.

1505 Malcolm (J. P.) Anecdotes of the Manners and Customs of London, plates, 2 vol., 1810—Miscellaneous Anecdotes, plates, 1811, together 3 vol., cf. gt., 8vo. (369) *Maggs, £*1 8s.

1506 Marot (Clement). Œuvres, *Lyon*, G. Roville, 1558—Traductions, *ib.*, 1557, in 1 vol., mor. ex., ɔy Lortic, 8vo. (371)
 Rimell, £2 6s.

1507 Marryat (Capt.) The Pirate and The Three Cutters, first ed., 20 plates ɔy C. Stanfield, early impressions, cf., g. e., 1836, 8vo. (373) *Graystone,* 19s.

1508 Marryat (Capt) Poor Jack, first ed., illustrations by C. Stanfield, autograph letter of Capt. Marryat inserted, hf. cf., 1840, 8vo. (374) *Graystone,* 18s.

1509 Martin (J. Biddulph). "The Grasshopper" in Lomɔard Street, extra illustrated with ports., views, orig. documents and autogragh letters of various persons connected with the ɔusiness, hf. cf. gt., 1892 (512) *Sotheran, £*6

1510 Martini (F. H. W.) et Chemnitz (J. H.) Neues systematisches
Conchylien Cabinet, 430 col. plates containing over 5,000
specimens of shells (no text), in 4 vol., hf. mor. gt., 1769, etc.
(513) *Thorp, £2* 10s.

1511 Mayer (L.) Views in the Ottoman Dominions, 71 col. plates,
mor. ex., g. e., 1810, folio (593) *Quaritch, £3* 18s.

1512 Mayer (L.) Views in Egypt, 48 col. plates, 1801—Views in
Palestine, 24 col. plates, 1804 — Views in the Ottoman
Empire, 24 col. plates, 1803-4, in 1 vol., hf. mor., folio (594)
 Tyrrall, £3 6s.

1513 Menestrier (C. F.) Philosophia Imaginum, engravings of
emblems, with numerous engravings and port. of author
inserted, mor., t. e. g., *Amstelodami,* 1695, 8vo. (377)
 Dobell, £1 7s.

1514 Meteyard (Eliza). The Life of Josiah Wedgwood, illustra-
tions, with 7 autograph letters of the author and others
inserted, 2 vol., mor., g. e., 1865, 8vo. (379)
 Shepherd, £1 16s.

1515 Military Adventures of Johnny Newcome, col. plates by
Rowlandson, hf. cf., 1816, 8vo. (380) *Edwards, £1* 11s.

1516 Michel (E.) Rembrandt, sa vie, son œuvre et son temps, 343
illustrations, hf. mor., t. e. g., *Paris,* 1893, 4to. (515)
 Hill, £1 12s.

1517 Montucla (J. F.) Histoire des Mathématiques, port. and
plates, 4 vol., russ. gt., *Paris,* 1799-1802, 4to. (517)
 Burt, £3 8s.

1518 Morland (S.) A New and most useful Instrument for Addi-
tion and Substraction of Pounds, Shillings, Pence and
Farthings, ports., 1672—The Description and Use of two
Arithmetick Instruments, 1673, in 1 vol., sheep, 8vo. (383)
 Burt, £2

1519 Morland (Sir S.) The Doctrine of Interest, both simple and
compound, sheep, 1679 — Vindication of the Practice
of England in putting out Money at Use, title-page
mounted, hf. cf., 1699—Briscoe (J.) A Discourse of the
late Funds, cf., 1696, 8vo. (384) *Burt, £2*

1520 Morgan (Silvanus). Peplum Heroum, a Treatise of Honor
and Honorable Men, unpublished manuscript of 170 pages,
drawings of coats-of-arms, engraved title contaning portrait
from "The Sphere of Gentry" inserted, cf., 1642, 4to. (518)
 Dobell, £5 5s.

1521 Morgan (S.) The Sphere of Gentry, ports. and engravings
by Gaywood, including the rare Howard pedigree and the
unpaged leaves of Book iv., ports. of Clarendon, mezzo.
port. of Charles I., etc. inserted, cf., from the library of
Wm. Bateman, with notes by him, W. Leybourn, 1661,
folio (596) *Tregaskis, £4* 12s.

1522 Murray's Hand-Book for Travellers in Spain, by R. Ford,
first ed., maps, 2 vol., orig. cl., 1845, 8vo. (386)
 Quaritch, 16s.

1523 Napier (Lord John, of Murchiston). Description of the
Admirable Table of Logarithmes, trans. by E. Wright,

autograph signature of J. Partridge (Astrologer) on title-page, and of H. Briggs (the editor of the ɔook) and C. Hutton (Mathematician) on fly-leaf, old cf., S. Waterson, 1618, 8vo. (387) *Quaritch*, £13 10s.

1524 Nichols (J.) Literary Anecdotes of the Eighteenth Century, 9 vol. (including Index to vol. i.-vii. only), 1812-15—Illustrations of the Literary History of the Eighteenth Century, 8 vol., 1817-58, together 17 vol., ports. and illustrations, cf., 1812-58, 8vo. (389) *Hill*, £5

1525 Nicolay (Nicolo de'). Le Navigationi et viaggi nella Turchia, 67 engravings ɔy L. Danet (including the Religious Turk, sometimes missing), cf. gt., *Venetia*, F. Ziletti, 1580, folio (599) *Quaritch*, £1 8s.

1526 Northcote (J.) Faɔles, ɔoth series, woodcuts, 2 vol., mor., g. e., 1828-33, 8vo. (392) *Parsons*, £1 7s.

1527 Noɔle (T. C.) Memorials of Temple Bar, LARGE PAPER, with numerous illustrations and autograph letters of the author and others inserted, hf. cf. gt., 1869, 4to. (525) *Sotheran*, £2 14s.

1528 Ottley (W. Y.) An Inquiry concerning the Invention of Printing, fac. plates and woodcuts, hf. roan, 1862, 4to. (528) *Burt*, £1 10s.

1529 Overstone (Lord). Select Collection of Scarce and Valuaɔle Economical Tracts, ed. by J. R. McCulloch, presentation copy from Lord Overstone, *Privately printed*, 1859, 8vo. (398) *Burt*, £3

1530 Palgrave (Sir F.) The History of Normandy and of England, 4 vol., presentation copy, orig. cl., 1851-64, 8vo. (400) *Lewine*, £2 10s.

1531 Palgrave (Sir F.) History of the Anglo-Saxons, illustrations, with extra ports. and autograph letters inserted, hf. cf. gt., 1876, 8vo. (401) *Owen*, £2 12s.

1532 Paulus (Sanctus). Epistolae, cum glossis interlinearis et marginalibus, manuscript on vellum (112 leaves, 10 ɔy 6½ in.), 𝔤𝔬𝔱𝔥𝔦𝔠 𝔩𝔢𝔱𝔱𝔢𝔯, large capttals in red, cf., *Sæc.* xi., 8vo. (407) *Maggs*, £10 15s.

[This MS. was formerly in the liɔrary of the Aɔɔey of Baugerais, founded in Touraine in 1153, and much frequented by King Henry the Second of England, who confirmed its privileges in 1173; the MS. has an inscription on its first page, "Iste liɔ. ē. de Boseraiei" in a XIIth century handwriting, and another, of later date, "Ex ɔiɔliotheca Fuliensium S. Ludovici Turonensis."—*Catalogue.*]

1533 Peele (James). The Pathe waye to perfectnes, 𝔟𝔩𝔞𝔠𝔨 𝔩𝔢𝔱𝔱𝔢𝔯, woodcut title containing port. of author (mounted and repaired), Thomas Purfoote, 1569, folio (601) *Wesley*, £6 5s.

1534 Pepys (Samuel). Memoires Relating to the State of the Royal Navy of England, 1688, port. by R. White, contemp. cf., *Printed anno* 1690, 8vo. (408) *W. Daniell*, £8 5s.

1535 Piranesi (G. B.) Vedute di Roma, engraved title and 46 plates, hf. russ. (ɔroken), *Roma* (*circa* 1780), oɔlong folio (604) *Rimell*, £11 15s.

1536 Piranesi (G. B.) Lettere di giustificazione scritte à Milord
Charlemont e à di lui Agenti di Roma dal Signor Piranesi
Socio della Real Societa degli Antiquari di Londra, etc.,
8 engravings, with 10 extra plates, including a unique dedi-
cation plate to Aɔate Venuti, *Roma*, 1757, 4to. (536)
Quaritch, £4 5s.
1537 Planché (J. R.) The Pursuivant of Arms, extra illustrated,
hf. mor., t. e. g., 1852 (411) *Pickering, £2 2s.*
1538 Planché (J. R.) History of British Costume, illustrations,
with a large numɔer of ports. and costume illustrations
added, each leaf inlaid and mounted on writing paper,
loose in portfolio, 1847, 4to. (538) *Pickering, £2 8s.*
1539 Plato. The Cratylus, Phaedo, Parmenides and Timaeus,
trans. ɔy Thomas Taylor, 2 autograph letters of Taylor
inserted, hf. russ., 1793, 8vo. (413) *Barnard, £1 12s.*
1540 Poellnitz (Baron de). Amusemens des eaux d'Aix-la-Chapelle,
plates, 3 vol., cf., with arms and crest of L. R. H. de Bre-
haut, Comte de Plelo, *Amsterdam*, 1736, 8vo. (414)
Quaritch, £2 6s.
1541 [Porter (Jane).] Sir Edward Seaward's Narrative of his
Shipwreck, ed. ɔy Jane Porter, 3 vol., presentation copy
to the Earl of Munster, with 3 pp. 4to. autograph letter
of Jane Porter, and two other autograph letters inserted,
mor., arms of Lord Munster, 1832, 8vo. (417)
Shepherd, £1 8s.
1542 Prayer. Book of Common Prayer, first edition of the "Sealed
Book" printed at Camɔridge, port. of Charles II., numerous
engravings inserted, mor., g. e., cut copy, *Cambridge*, J.
Field, 1662—Prayers in Russian, mor., stamped and gilt
ɔack and sides, gilt gauffred edges, *circa* 1650, together
2 vol., 8vo. (418) *Ponsonby, £2 14s.*
1543 Psalms. Les Pseaumes de David, mis en rime Françoise par
C. Marot et Th. de Beze, contemp. mor., gt. tooling, g. e.,
with clasp, Charenton, 1682, 8vo. (419) *Tregaskis, £1*
1544 Raɔelais (Francis). Works, revised ɔy J. Ozell, port. and
plates, 5 vol., cf., 1737, 8vo. (423) *Sotheran, £2*
1545 Raimbach (Aɔraham). Memoirs and Recollections, including
a Memoir of Sir David Wilkie, R.A., extra illustrated with
a large numɔer of ports. and engravings, an orig. pencil
drawing ɔy Sir David Wilkie (signed), orig. sketch ɔy
George Morland (signed), and autograph letters, cf., g. e.,
Privately printed, 1843, 4to. (547) *Ellis, £5 15s.*
1546 Recreations in Natural History, or Popular Sketches of British
Quadrupeds, LARGE PAPER, engravings and woodcuts ɔy
L. Clennell, etc., with orig. pencil drawings and additional
engravings inserted, hf. mor., t. e. g., 1815, roy. 8vo. (426)
Tregaskis, £1 14s.
1547 Reliquiae Antiquae. Scraps from Ancient Manuscripts, ed.
by T. Wright and J. O. Halliwell, presentation copy from
T. Wright to T. Crofton Croker, autograph letters of T.
Wright, J. O. Halliwell-Phillipps, etc. inserted, 2 vol. in 1,
hf. mor., t. e. g., 1841-3, 8vo. (427) *Hill, £3*

1548 Rogers (S.) Italy, a Poem, first ed., vignettes after Turner
and Stothard, first impressions with the transposed vignettes
at pages 88 and 91, unspotted, hf. cf., 1830, 8vo. (430)
Edwards, £1 18s.

1549 Rogers (S.) The Pleasures of Memory, LARGE PAPER, first
ed., with Clennell's woodcuts, Westall's illustrations on
India paper inserted, hf. mor., uncut, t. e. g., 1810, 8vo. (431)
Maggs, 8s.

1550 Royal Statistical Society of London. Journal, vol. l.-lxxi.
(wanted June, 1887, Sept., 1891, Sept. and Dec., 1893,
Dec., 1894, March and June, 1895, Dec., 1897, Dec., 1904
and June, 1905), vol. i. to xxxiii. hf. cf., remainder in parts,
1839-1908, 8vo. (434) *Walford,* £20 10s.

1551 Sainthill (R.) An Olla Podrida, or Scraps, Numismatic,
Antiquarian and Literary, plates and facs., extra illustrated,
2 vol., hf. cf., t. e. g., *Privately printed,* 1844-53, 8vo. (436)
Tregaskis, £2 10s.

1552 Saint-Non (Abbé de). Voyage Pittoresque, ou Description
des Royaumes de Naples et de Sicile, maps, plans and views,
including the rare Phallus plate and the 14 plates of medals
4 vol., new mor., t. e. g., other edges uncut, *Paris,* 1781-6,
folio (610) *Parsons,* £3 3s.

1553 Sala (G. A.) William Hogarth, first ed., autograph letter of
J. G. Nichols, 3 of G. A. Sala, and many extra illustrations
inserted, 1866, 8vo. (437) *Shepherd,* £1 1s.

1554 Salvá. Catalogo de Biblioteca de Salvá, escrito por D. Pedro
Salvá y Mallen, facs., 2 vol., hf. mor., t. e. g., *Valencia,* 1872,
8vo. (438) *Barnard,* £3 8s.

1555 Schooten (F. van). Tabulae Sinuum, Tangentium, Secantium
ad Radium 10,000,000, mor., gilt panels, g. e., *Amsterdam,*
J. Janssen, 1639, 8vo. (441) *Walford,* £1 1s.

1556 Scott (Sir W.) Border Antiquities, plates, 2 vol., mor., g. e.,
1814-17, 4to. (557) *Walford,* 17s.

1557 Shakespeare (Wm.) Works, in reduced facsimile, from the
edition of 1623, introduction by J. O. Halliwell-Phillipps, 28
autograph letters of editor inserted, 1876, 8vo. (446)
Burt, £1 16s.

1558 Shakespeare. Halliwell (J. O.) Catalogue of a Small Portion
of the Engravings and Drawings illustrative of the Life of
Shakespeare, preserved in the collection formed by J. O.
Halliwell, *Privately printed,* 1868—Catalogue of the Books,
Manuscripts, etc. illustrative of the Life and Works of
Shakespeare, preserved in the Shakespeare Library, 1868—
Smith (C. R.) The Rural Life of Shakespeare, 1870,
extended to 2 thick volumes, including 75 autograph letters of
J. O. Halliwell, letters of Stratford-on-Avon celebrities, such
as Wheler, Merriman, Kingsley, and of Shakespearian
commentators, title-pages, etc., hf. mor. (447)
Maggs, £25 10s.
[The letters of J. O. Halliwell are all unpublished, and
contain valuable information not to be met with elsewhere.
—*Catalogue.*]

1559 Shenstone (Wm.) Works, port. and illustrations, 3 vol., cf., 1764-69, 8vo. (448) *Sotheran,* 10s.
1560 Simpson (W. S.) Chapters in the History of Old S. Paul's, plates, and extra illustrated, hf. cf., t. e. g., 1881, 8vo. (449) *Maggs,* £2
1561 Some Reflections on a Pamphlet intituled England and East India inconsistent in their Manufactures, 1696—Mun (Th.) England's Treasure by Foreign Trade, 1713—Reasons for encouraging the Linnen Manufacture of Scotland, etc., 1735 —The Draper Confuted, 1740, in 1 vol., hf. cf., t. e. g., 8vo. (453) *Burt,* £3 15s.
1562 South Sea Bubble. Het groote Tafereel der Dwaasheid, satirical plates, hf. vell., 1720, folio (613) *Edwards,* £1 14s.
1563 Spilsbury (F. B.) Picturesque Scenery in the Holy Land and Syria, port. of Sir W. Sidney Smith and 19 col. plates, with the orig. water-colour drawings and autograph letters inserted, mor. ex., 1803, folio (614) *Rimell,* £9
1564 Stevenson (S. W.) Dictionary of Roman Coins, revised by C. Roach Smith and completed by F. W. Madden, wood-cuts, 1880, 8vo. (456) *Hill,* £1 16s.
1565 Stevin de Bruges (S.) L'Arithmétique, 2 vol. in 1, mor., g. e., *Leyde,* Christ. Plantin, 1585, 8vo. (457) *Wesley,* £5 5s.
1566 Stoll (Caspar). Uitlandsche Dag en Nacht Kapellen, a series of engravings, col. by hand, cut out, laid down and shaded, of butterflies and moths, 101 leaves, containing about 1000 subjects, taken from specimens in the museum of Raye van Brenkenwaert, with MS. descriptions in Dutch, hf. mor., g. e., *Amsterdam,* 1788, folio (615) *Walker,* £3 15s.
1567 Stow (Jno.) Survey of London, port. of Stow inserted, old cf., 1633, folio (616) *Tregaskis,* £1 4s.
1568 Suecia Antiqua et Modierna, plates, in 2 vol., russ., *Holmiae* (1693-1714), 4to. (568) *Batsford,* £9 15s.
1569 Tennyson (Alfred). Poetical Works, ports., autograph letters of Tennyson and Emily Tennyson, and leaf in the autograph of Charles Tennyson inserted, 7 vol., hf. mor., t. e. g., 1878-81, 8vo. (461) £2 18s.
1570 Tableaux de la Suisse, ou Voyage Pittoresque fait dans les XIII. Cantons du Corps Helvétique, plates, 12 vol., contemp. French mor. ex., arms of the Marquis de la Roche Aymon, *Paris,* 1784-86, 4to. (569) *Edwards,* £27 10s.
1571 [Thompson (R.)] Chronicles of London Bridge, many additional illustrations, 1827—Frostiana, *Printed on the Ice on the River Thames,* 1814, in 1 vol., russ., g. e., 8vo. (464) *Dobell,* £1 9s.
1572 Todhunter (J.) A History of the Mathematical Theory of Probability, *Cambridge,* 1865, 8vo. (465) *Burt,* £1 15s.
1573 Tooke (T.) and Newmarch (W.) History of Prices, orig. pencil sketch of Tooke, and A.L.s of W. Newmarch inserted, 6 vol., hf. cf. gt., 1838-57, 8vo. (466) *Quaritch,* £8 10s.
1574 Turner. Wanderings by the Loire, by Leitch Ritchie, LARGE PAPER, 21 engravings after J. M. W. Turner, mor., g. e.,

1833—Wanderings ɔy the Seine, ɔy Leitch Ritchie, 20
 engravings after Turner, orig. mor., 1835, 8vo. (468)
 Lewine, 8s.

1575 Trade and Economics. A Discourse of the Nature, Use
 and Advantages of Trade, 1694—Letter from an English
 Merchant at Amsterdam to his friend at London, 1695—
 Carter (W.) The Usurpation of France upon the Trade
 of thé Woollen Manufacture of England, 1695—Treaty of
 Navigation and Commerce ɔetween Queen Anne and
 Lewis the XIV., 1713, and a numɔer of Economic
 Pamphlets, in 8vo. (576) *Leon*, £6 10s.

1576 Trade. Manley (Th.) Usury at Six per Cent. examined,
 1669—William de Britaine, The Dutch Usurpation, 1672—
 An Answer to two letters concerning the East India Com-
 pany, 1676—Treatise wherein is demonstrated that the
 East India Trade is the most National of all Foreign
 Trades, etc., 1681—An Answer to the Case of the Old
 East India Company, 1700, 5 vol., 4to. (577)
 Banbury, £8 15s.

1577 Trade. [Mun (T.)] A Discourse of Trade, first ed., uncut,
 N. Okes for J. Pyper, 1621—A Tract against Usurie, *W. J.
 for Walter Burre*, 1621—Polter (W.) The Trades-man's
 Jewel, 1650—Taxes no Charge, in a Letter from a Gentle-
 man to a Person of Quality, 1690, in 1 vol., hf. cf., 4to.
 (578) *Quaritch*, £13 10s.

1578 Trade. Parker (H.) Of a Free Trade, a Discourse seriously
 recommending to our Nation, etc., uncut, 1648—Two
 Letters concerning the East India Company, 1676—An
 Account of the French Usurpation upon the Trade of
 England, 1679—Some Thoughts aɔout Trade, n. d.—
 England's Danger by Indian Manufactures, n. d.—Cary (J.)
 Discourse concerning the Trade of Ireland and Scotland,
 1696—A Letter to a Memɔer of Parliament concerning
 Clandestine Trade, 1700, in 1 vol., hf. cf., 4to. (579)
 Banbury, £14

1579 Trade. The Trade's Increase (by Roɔ. Keale), N. Okes,
 1615—London's Flames discovered by Informations taken
 ɔefore the Committee, 1667—Collins (J.) A Plea for the
 ɔringing in of Irish Cattel, 1680—A Discourse concerning
 the Fishery within the British Seas, 1695—Bellers (J.)
 Proposals for raising a Colledge of Industry, 1696, in 1 vol.,
 hf. cf., 4to. (580) *Maggs*, £15

1580 Tuer (A. W.) Bartolozzi and his Works, illustrations, extra
 illustrated by the insertion of over 160 examples of the
 work of Bartolozzi and his school, autograph letters, 2 vol.,
 n. d. (1881), 4to. (581) *Sotheran*, £8 10s.

1581 Tunstall (Cuthɔert). De Arte Supputandi liɔri iv., first Paris
 ed., hf. vell., *Paris*, R. Stephanus, 1529, 4to. (582)
 Wesley, £1 15s.

1582 Warne (Ch.) Ancient Dorset, W. W. Smart, plates, *Privately
 printed*, 1872, folio (629) *Walford*, 13s.

1583 Warren (Hon. J. L.) A Guide to the Study of Book-Plates,

first ed., illustrations, with extra examples, and autograph
letters of authorities inserted, orig. cl., 1880, 8vo. (481)
$£1$ 4s.
1584 Willshire (W. H.) Introduction to the Study of Ancient
Prints, second ed., fronts., 2 vol., roxourghe, 1877, 8vo.
(483) *Ellis*, $£1$ 14s.
1585 Wilson (Th.) A Discourse upon Usurie, black letter (wormed),
cf., Roger Warde, 1584, 8vo. (484) *Burt*, $£3$ 10s.
1586 Wright (Th.) The Celt, the Roman and the Saxon, extra
illustrated oy the insertion of numerous autograph letters
of the author and other antiquaries, extra engravings, etc.,
new hf. cf., 1875, 8vo. (488) *Owen*, $£2$ 2s.

[November 18th and 19th, 1909.]

PUTTICK & SIMPSON.

A Selection from the Library of the late Dr. Radcliffe
Crocker, and other Properties.

(No. of Lots, 693 ; amount realised, $£838$ 12s.)

1587 Ackermann (R.) Costumes of the British Army, 15 col.
plates on thick paper, hf. mor. ex., Ackermann, 1858, folio
(679) *G. H. Brown*, $£9$ 10s.
[In March, 1904, a series of 56 of these coloured plates
after H. de Daubrawa sold for $£83$. *See* Book-Prices
Current, Vol. xviii., No. 2815.—Ed.]
1588 Ackermann (R.) History of Rugoy School, 5 col. plates,
orig. bds. and laoels, uncut, 1816, 4to. (281)
G. H. Brown, $£4$ 10s.
1589 Araoian Nights. The Book of the Thousand Nights and
One Night, by John Payne, 9 vol., orig. bds., *Villon Society*,
1882-4, 8vo. (142) *Hector*, $£6$ 7s. 6d.
1590 Atkinson and Walker. Picturesque Representation of the
Manners, Customs and Amusements of the Russians, 100
col. plates, 3 vol., hf. mor., Bulmer, 1803, folio (339)
Parsons, $£4$ 4s.
1591 Bateman (J.) Orchidaceae of Mexico and Guatemala, col.
plates and woodcuts oy G. Cruikshank, etc., hf. mor., 1843,
atlas folio (334) *Spencer*, $£5$ 5s.
1592 Beaumont (A.) Travels from France to Italy through The
Lepontine Alps, chart aud 26 plates, col. equal to drawings,
with duplicate set in orown, hf. mor. as puolished, with
laoel, 1806, folio (338) *Reynolds*, $£4$
1593 Bewick (T.) Faoles of Æsop, imperial paper, uncut, orig.
bds., with label and thumo mark receipt, 1818, 8vo. (234)
Maggs, $£6$

1594 Bewick (T.) Select Faɔles, LARGE AND THICK PAPER, hf. mor., g. t., 1820, 8vo. (235) *Reynolds, £2* 10s.

1595 Bewick (T.) Select Faɔles, LARGEST PAPER, port. and upwards of 350 woodcuts (only 50 printed), uncut, 1820, imp. 8vo. (236) *Reynolds, £3* 7s. 6d.

1596 Bewick (T.) British Land Birds—British Water Birds—Quadrupeds — Vignettes, the figures to each engraved separately from the text, with titles, LARGEST PAPER, 4 vol., orig. cl., uncut, 1825, 1824, 1827, 4to. (238) *Spencer, £2* 10s.

1597 Bewick (T.) Vignettes (9), with 2 ports. and fac. of letters, all printed on satin, within ɔorders of gilt paper, in marɔled covered bds., 1825, 4to. (240) *Spencer, £1* 16s.

1598 Burgoyne (Gen.) State of the Expedition from Canada as laid ɔefore the House of Commons, etc., folding map, cf., 1780, 4to. (260) *Tregaskis, £3* 3s.

1599 Burlington Fine Arts Cluɔ. Catalogue of Porcelain, photographic plates, 1873, 4to. (641) *Quaritch, £3* 10s.

1600 Burney (Miss). Camilla, first ed., 5˙ vol., hf. cf., 1796, 8vo. (532) *Edwards, £1* 11s.

1601 Byron (Lord). Complete Works, ɔy Lake, port. and many inserted engravings, 7 vol., mor., *Paris,* Didot, 1825, 8vo. (120) *G. H. Brown, £2* 10s.

1602 Charlevoix (P. F. X. de). History of New France, by Dr. Shea, 6 vol., rox., g. t., 1902, 4to. (273) *Edwards, £1* 15s.

1603 Collyns (C. P.) Notes on the Chase of the Wild Red Deer, illustration, cf., 1682, 8vo. (165) *Sotheran, £1* 2s.

1604 Creighton (Bp.) History of the Papacy, 5 vol., cl., 1882-94, 8vo. (158) *Harding, £3* 7s. 6d.

1605 Cruikshank (G.) The Progress of a Midshipman, 8 col. etchings (including title) ɔy Cruikshank, orig. impressions, Humphreys, 1821, 4to. (621) *Hornstein, £24*

1606 Dodwell (E.) Views in Greece, col. plates mounted on card in imitation of the orig. drawings, hf. mor., 1821, folio (310) *Hill, £2*

1607 Dowell (Stephen). History of Taxation and Taxes in England, 4 vol., cl., 1884, 8vo. (147) *Bain, £3*

1608 Dryden (John). Works, ɔy Sir Walter Scott, second ed., 18 vol., cf. ex., 1821, 8vo. (167) *Bennett, £4* 15s.

1609 Du Chaillu (P.) The Viking Age, map and illustrations, 2 vol., 1889, 8vo. (118) *Bain, £1* 1s.

1610 Dyer (F. H.) Modern Europe, 5 vol., cf. ex., 1877, 8vo. (168) *Josephs, £1*

1611 Egan (Pierce). Sporting Anecdotes, original and selected, front. and col. plates, including "A Visit to the Fives Court," pictorial bds., uncut, Sherwood, 1825, 8vo. (200) *Hornstein, £4* 18s.

1612 Encyclopædia Britannica. Supplement to the ninth edition, 11 vol., hf. mor., 1902, 4to. (283) *Josephs, £5* [Another set, also in hf. mor., sold for £5 12s. 6d. Lot 606.—ED.]

1613 Evelyn (John). Sylva (with Pomona and Kalendarium Hor-
XXIV. 7

tense), first ed., with the rare leaves of licence and errata, old sheep, 1664, folio (682) *Quaritch*, £5 5s.
1614 Eyton (T. C.) Osteologia Avium, with supplement and plates, 3 vol., cf., 1867-69, 4to. (274) *Sotheran*, £1 14s.
1615 Farmer (J. S.) Slang and its Analogues, 7 vol., hf. mor., 1890-1903, 4to. (265) *Hector*, £3 2s. 6d.
1616 Fletcher (Lt.-Col.) History of the American War, 3 vol., cl., 1865, 8vo. (478) *Bumpus*, £1 10s.
1617 Foster (J. J.) Concerning the true Portraiture of Mary Queen of Scots, ports., hf. mor., 1904, roy. folio (684)
Forrester, £2 4s.
1618 Freer (M. W.) Life of Jeanne D'Albret, ports., 2 vol., cl., 1855 (127) *Spencer*, £1 5s.
1619 Gardiner (S. R.) History of the Commonwealth and Protectorate, 3 vol., hf. mor., 1894, 8vo. (186) *Bennett*, £1 10s.
1620 Gerarde (John). Herball, first ed., engraved title (fore-margin mended and cut at foot), port. and woodcuts, cf. (repacked), 1597, folio (681) *Ellis*, £7
1621 Gerarde (J.) Herball, enlarged by Johnson, engraved title and cuts, cf., 1636, folio (335) *F. Edwards*, £3 2s. 6d.
1622 Glascock (W. N.) Land Sharks and Sea Gulls, etchings by G. Cruikshank, first ed., 3 vol., bds., uncut, 1838, 8vo. (580)
Shepherd, £1 4s.
1623 Goldsmith (Oliver). The Deserted Village, the pirated ed., in orig. marble covers, with half-title, *Printed for the Booksellers* (1770), 8vo. (59) *Tregaskis*, £1 1s.
1624 Grant (James). The Tartans of the Clans of Scotland, col. plates and arms, cl. ex., 1886, 4to. (285) *Quaritch*, £1 13s.
1625 Graves (Algernon). The Royal Academy of Arts, a complete dictionary of contributors to 1904, 8 vol., rox., g. t., 1905-6, 4to. (631) *Maggs*, £5 17s. 6d.
1626 Gray (T.) Poems, first ed., cf., J. Dodsley, 1768, 8vo. (454)
Hatchard, £1 6s.
1627 Green (Mary A. E.) Lives of the Princesses of England, ports., 6 vol., 1849-55 (156) *Rimell*, £3 7s. 6d.
1628 Grote (G.) History of Greece, Library ed., 12 vol., cl., 1851-6, 8vo. (153) *Hornstein*, £2 14s.
1629 Jerrold (Blanchard). Life of Napoleon III., ports., 4 vol., cl., 1874, 8vo. (128) *Jones*, £2 8s.
1630 Jesse (J. H.) Literary and Historical Memorials of London, first ed., with presentation inscription, 2 vol., orig. cl., 1847, 8vo. (149) *Walford*, £2 10s.
1631 Jesse (J. H.) Memoirs of the Pretenders and their Adherents, port., first ed., 2 vol., orig. cl., 1845, 8vo. (148) *Hill*, £2 10s.
1632 Johnson (S.) Works of the English Poets, 75 vol., old mor., g. e., 1790, 8vo. (114) *Parsons*, £11
1633 Jones (Inigo). Designs consisting of Plans and Elevations for Public and Private Buildings, plates, 2 vol. in 1, old cf., 1770, folio (312) *Hatchard*, £2 6s.
1634 Kennel Club Stud Book and Calendar, 24 vol., various, 1859-99, 8vo. (115) *Josephs*, £1 18s.
1635 Kirchen Ordnung, 1533—Catechismus oder Kinder predig,

1533, in 1 vol., 𝔤𝔬𝔱𝔥𝔦𝔠 𝔩𝔢𝔱𝔱𝔢𝔯, in red and black, musical notes, early MS. notes in margins, first edition of the Brandenburg Liturgy, orig. stamped leather, 1533, folio (683)

Tregaskis, £11 10s.

1636 La Fontaine (J. de). Contes et Nouvelles, fronts., signed Vidal, port., and plates without letters after Eisen (counterfeit of the Fermiers Généraux edition), 2 vol., contemp. cf., 1777 (177) *Rimell*, £2 4s.

1637 Laing (S.) The Heimskringla, 3 vol., cl., uncut, 1844, 8vo. (197) *Hatchard*, £1 2s.

1638 Laking (G. F.) Furniture of Windsor Castle, plates, hf. mor., g. t., 1905, 4to. (603a) *Hamilton*, £2 5s.

1639 Levaillant (F.) Histoire Naturelle des Perroquets, and Volume Supplémentaire, LARGE PAPER, plates, in colours, 3 vol., russ. ex., *Paris*, 1801-1838, folio (680)

Quaritch, £7 10s.

1640 Lever (Ch.) One of Them, in the original 15 parts in 14 (wanted part xiii.), with the wrappers, fine copy, 1860-61, 8vo. (208) *Spencer*, £1 6s.

1641 Lever (Ch.) Our Mess, full-page etchings by "Phiz," parts ii. to xxxv. (wanted part xii.), 1841-44, 8vo. (207)

Shepherd, £1 15s.

1642 Lodge (E.) Portraits, 10 vol., hf. mor., 1840, imp. 8vo. (67)

Karslake, £1 10s.

1643 Lytton (Lord). The Pilgrims of the Rhine, plates in two states, one on India paper, mor. ex., uncut, 1834, 8vo. (557)

Maggs, £1 1s.

1644 McIan (R. R.) and Logan (J.) The Clans of the Scottish Highlands, col. plates, 2 vol., mor. ex., 1845, folio (291)

Rodd, £6 10s.

1645 Martial Achievements of Great Britain, LARGE PAPER, col. plates by Sutherland, old russ. ex., Jenkins, 1815, 4to. (634)

Hornstein, £7 15s.

1646 Mayo (J. H.) Medals and Decorations of the British Army and Navy, col. plates, 2 vol., 1897, 8vo. (561) *Baldwin*, £1

1647 [Mellon (H.)] The Secret Memoirs of Harriott Pumpkin, orig. printed bds., uncut, Duncombe, n. d., 8vo. (211)

Shepherd, £3

1648 Meyrick (S. R.) Critical Enquiry into Antient Armour, col. plates in gold and silver, 3 vol., hf. mor., 1824, folio (321)

Sotheran, £3 17s. 6d.

1649 Meyrick (S. R.) Heraldic Visitations of Wales and Part of the Marches, illustrations, 2 vol., cl., 1846, imp. 4to. (280)

Edwards, £10 15s.

1650 Mill (John). Dissertations and Discussions, 4 vol., 1867-75, 8vo. (464) *Hill*, £2 2s.

1651 Milman (Dean). History of Latin Christianity, Library ed., 9 vol., cf. ex., 1864, 8vo. (536) *Ellis*, £1 12s. 6d.

1652 Milton (J.) Works, edited by Sir E. Brydges, port. and vignettes by Turner, 6 vol., cf., g. e., 1835, 8vo. (123)

Walford, £2 8s.

1653 Morris (William). House of the Wolfings, LARGE PAPER, first ed., cf. ex., uncut, ɔy Tout, 1889, 4to. (619)
Doolan, £1 8s.
1654 Mure (W.) Language and Literature of Ancient Greece, 5 vol., 1850-7, 8vo. (163) *Jones, £1 2s.*
1655 Napier (W. F. P.) War in the Peninsula, 6 vol., cl., 1848, etc., 8vo. (190) *Edwards, £2 4s.*
1656 Nicolson (J.) and Burn (R.) History and Antiquities of Westmorland and ꞉ Cumɔerland, maps, 2 vol. (ɔroken ɔindinɡ), 1777, 4to. (259) *Nield, £2 4s.*
1657 Paxton (Sir J.) Magazine of Botany, complete set, col. plates, ꞉16 vol., hf. mor., g. e., 1834-49, 8vo. (164) *Josephs, £5 7s. 6d.*
1658 Philippe de Commines. Cronicque et Histoire, lit. ɡotɧ., cf., gauffred edges, *Paris*, 1539, 8vo. (198) *Parsons, £2 2s.*
1659 Picture of St. Petersɔurgh (ɔy Mornay), 20 col. plates ɔy Clark and Duɔourg, orig. hf. mor., with laɔel, Orme, 1815, folio (308) *Edwards, £4 4s.*
1660 Picturesque Tour from Geneva to the Pennine Alps, col. plates, Nichols, 1792, folio (337) *Reynolds, £5 10s.*
1661 Piranesi. Works, including Architettura de Roma—Antichita d'Albàno—Antiquite Romanes—Vol. ii. and iv. and supplement—Champ de Mars—Colonna Trajana—Fastes Consulaires—Théâtre de Hercules—Traité des Arts Pompeia—Vases et Candelaɔra—Vues de Rome, 2 vol., etc., together 17 vol., not suɔject to return, *Rome, Paris, etc.,* 1761, atlas elephant and imp. folio (336) *Parsons, £38*
1662 Prinsep (E.) Essay on Indian Antiquities, 2 vol., cl., 1858, 8vo. (145) *F. Edwards, £2 4s.*
1663 Radclyffe (C. W.). Memorials of Rugɔy, col. plates in imitation of the orig. drawings, hf. mor., 1843, folio (319)
Rimell, £1 15s.
1664 Ranke (Leopold). Memoirs of . . . Brandenɔurg and History of Prussia, trans. by Sir A. and Lady Duff Gordon, 3 vol., hf. cl., 1849, 8vo. (119) *Nield, £1 17s. 6d.*
1665 Reade (Charles). Peg Woffington, 1853—The Course of True Love, 1857, ɔoth first eds., orig. cl., 8vo. (196)
Tregaskis, £2 12s.
1666 Rogers (S.) Italy and Poems, vignettes after Turner and Stothard, those in the Italy being proofs, 2 vol., uniform mor. ex., 1830-4, 8vo. (169) *Maggs, £2 14s.*
1667 Rogers (S.) Poems and Italy, illustrated ɔy Turner and Stothard, 2 vol., mor., 1852-42, 8vo. (112) *Ellis, £1*
1668 Rossetti (D. G.) Dante and his Circle, one of 35 copies on LARGE PAPER, uncut, 1892, 8vo. (179) *Maggs, £1*
1669 Ruskin (John). King of the Golden River, first ed., illustrated ɔy Doyle, orig. pictorial bds., 1851, 8vo. (143)
Shepherd, £3 5s.
1670 Sandɔy (Paul). Collection of 150 views in England, Wales, Scotland and Ireland, copperplates, 2 vol., cf., Boydell, 1783, folio (689) *Ponsonby, £3 15s.*
1671 Shaw (Bernard). Plays, Pleasant and Unpleasant, 2 vol., cl., g. t., 1898, 8vo. (204) *Spencer, £1 6s.*

1672 Shaw (Wm. A.) The Knights of England, 2 vol., cl., 1906, 8vo. (206) *Jones,* £1 2s.

1673 [Shelley (P. B.)] St. Irvyne or The Rosicrucian, first ed., mor. ex., uncut, Stockdale, 1811, 8vo. (210) *Spencer,* £30

1674 Stevens (Henry). The Book of the Farm, 3 vol., hf. mor., 1891, 8vo. (152) *Sotheran,* £1

1675 Street (G. E.) Gothic Architecture in Spain, illustrations, 1865, 8vo. (141) *Hill,* £2

1676 Thackeray (W. M.) Book of Snobs, first ed., orig. illustrated covers, *Punch Office,* 1848, 8vo. (583) *Bumpus,* £5 15s.

1677 Thorowgood (T.) Jewes in America, first ed., fine copy, lower edges uncut, with the separate leaves of "license" and analysis, 1650, 4to. (639) *Tregaskis,* £8

1678 Viollet-le-Duc (M.) Dictionnaire de l'Architecture Française, 10 vol., hf. mor., 1867-8, 8vo. (162) *Hatchard,* £4 7s. 6d.

1679 Wallis (Capt.) Historical Account of New South Wales, map and 12 views, orig. binding, 1821, folio (290) *Hornstein,* £4 4s.

1680 Walpole (Horace). Anecdotes of Painting in England, ports., 3 vol., cl., 1849, 8vo. (174) *Bennett,* £1 10s.

1681 Ward (H.) and Roberts (W.) George Romney, a Biographical and Critical Essay, illustrations, 2 vol., publisher's cl., 1904, 4to. (633) *Edwards,* £2 8s.

1682 Woodward (G. M.) Half an Hour before Dinner—Half an Hour after Supper—A Rout—A Private Concert—A Tea Party, 6 col. caricatures, each on a scroll, with large figures supporting (no margins), *circa* 1790, 4to. (622) *Shepherd,* £2 10s.

[NOVEMBER 24TH, 25TH AND 26TH, 1909.]

HODGSON & CO.

A MISCELLANEOUS COLLECTION.

(No. of Lots, 958 ; amount realised, about £1,300.)

1683 Ackermann (R.) History of the University of Oxford, col. views and interiors, with the series of academical costumes by J. Agar after T. Uwins, 2 vol., old russ. ex., g. e., 1814, roy. 4to. (264) *Detrich,* £8

1684 Agricola (G.) Opera de l'Arte de Metalli, partita in XII. libri, woodcuts, cf. (cracked), g. e., *Basilea,* 1563, folio (433) *Wesley,* £2 6s.

1685 Aldine Press. Cornucopiæ Thesaurus et Horti Adonidis, editio princeps (last leaf in fac.), 1496, folio (528) · *Leighton,* £4 4s.

1686 Apuleius. The Metamorphosis, or Golden Ass, by T. Taylor, first ed., hf. cf., 1822, 8vo. (332) £1 13s.

1687 Araɔian Nights Entertainments, ɔy Scott, fronts., 6 vol., old
mor., g. e., 1811, 8vo. (331) *Edwards, £2* 10s.
1688 Ars Moriendi ex Variis Sententiis collecta cum Figuris, 12
full-page woodcuts, gothic letter, 13 leaves, with a woodcut
at end of an angel, together 14 leaves, modern mor., g. e.,
Impressum . . . Joanis Weyssenburger, 1514, sm. 4to. (422)
Leighton, £19 10s.
1689 Baxter (W.) British Flowering Plants, second ed., col. plates,
6 vol., hf. bd., t. e. g., *Oxford,* 1834-43, 8vo. (117) *£1* 12s.
1690 Bates (H. W.) Naturalist on the Amazon, first ed., illustra-
tions, 2 vol., cl., 1863, 8vo. (66) *£1* 4s.
1691 Beaumont and Fletcher. Works, ɔy A. Dyce, 2 ports., 11
vol., mor., contents lettered, g. e., 1843-6, 8vo. (313)
Maggs, £8 10s.
1692 Beechey (Capt.) The Zoology of Captain Beechey's Voyage
to the Pacific, col. plates, cl., 1839, 4to. (134)
Wesley, £4 7s. 6d.
1693 Birgitta. Das Buch der Himlischen Offenɔarung der Heiligen
wittiben Birgette, woodcut on title, and large woodcuts, old
pigskin, *Nurnberg,* A. Koberger, 1500, folio (533)
Quaritch, £11 10s.
1694 British Museum. Catalogue of the Lepidoptera Phalænæ,
col. plates (separate), 6 vol., cl. and sewed, 1898-1906—
Catalogue of the Lepidopterous Insects, part i., Papili-
onidæ, col. plates, 1852, 4to. (91) *Wesley, £5*
1695 [Burton (A.)] My Cousin in the Army, col. plates ɔy Williams,
hf. mor. [1822], 8vo. (353) *£1* 14s.
1696 Butler (A. G.) Birds of Great Britain and Ireland—Order
Passeres, col. plates ɔy Grönvold and Frowhawk, 2 vol.,
hf. mor., n. d., 4to. (138) *£3* 12s. 6d.
1697 Butler (A. G.) Lepidoptera Exotica, col. plates, hf. mor.,
t. e. g., 1874, 4to. (82) *Griffin, £2* 10s.
1698 Byron (Lord). Imitations and Translations, collected by
J. C. Hoɔhouse, Lord Byron's copy, with a correction and
a note on page 191, the last line of his verses on "A
Favourite Dog" ɔeing altered in the poet's own hand-
writing to the reading as printed in his works, mor., g. e.,
1809, 8vo. (343) *Spencer, £8* 15s.
1699 Cæsar. Les oeuvres . . . de Julius Cesar sur le faict des
ɔatailles de Gaule, lettres batardes, woodcut on title and last
leaf (corner of one leaf torn), cf. antique, *Paris, La veufue
feu Michel le Noir,* n. d., 8vo. (416) *Leighton, £3* 10s.
1700 Carlell (L.) Arviragus and Philicia as it was Acted at the
Private House in Black-Fryers, first and second part, first
ed., with the epilogue (title-page defective and two or three
leaves shaved), vell., 1639, 8vo. (566) *£3* 8s.
1701 Cats (Jacoɔ). Alle de Wercken van den Heere Jacoɔ Cats,
fronts., containing 2 ports., and engravings, 2 vol., vell.,
Amst., 1726, folio (488) 18s.
1702 Chaucer (G.) Workes (with life and additions by Speght),
black letter, woodcut title, armorial port. of Chaucer, and
woodcuts, mor. antique, g. e., G. Bishop, 1602, folio (513)
Parsons, £5

[It may be pointed out that this copy of the second edition by Speght has the imprint of G. Bishop, printer of the 1598 edition, instead of that of A. Islip as found in most copies. The volume is in clean condition, but wants 2 leaves, folios 351-2.—*Catalogue.*]

1703 Chenu (Dr.) Encyclopédie d'Histoire Naturelle—Coléoptères, cuts, 3 vol. in 2, hf. mor., t. e. g., *Paris*, n. d., imp. 8vo. (78)
 10s.

1704 Coinage. Violet (T.) An Humble Declaration . . . touching the Transportation of Gold and Silver, unbd., 1643, sm. 4to. (454)
 £2 2s.

1705 Coinage. Sir Thomas Roe's Speech on the Decay of Coyne and Trade in this Land, 1641—[Culpeper.] Tract against the High Rate of Usury, 1641, unbd., sm. 4to. (455)
 £4 7s. 6d.

1706 Coinage. Sir Robert Cotton's Speech touching the Alteration of Coin, 1690—[Turner.] The Case of the Bankers and their Creditors, second ed., 1675, unbd., sm. 4to. (456)
 £3 4s.

1707 Coinage. Cook (R.) Treatise concerning the Regulation of the Coyn of England (some margins cut into), unbd., 1696, sm. 4to. (407) *Leon*, £1 14s.

1708 Coinage. An Essay for Lowering the Gold and Raising the Silver Coin, 1696—Letter from an English Merchant on the Trade and Coin of England, unbd., 1699, sm. 4to. (458)
 Pickering, £4

1709 Colonna (Giudo Giudice). Historia di Troia, roman letter (Hain, No. 5523), *Antonio de Allexandria . . . Venexia*, 1481, folio (413) *Dobell*, £3 7s. 6d.

1710 Constitutiones [Othonis]. Legitime, cum Interpretatione J. de Athon, black letter, 2 woodcuts, cf., *Parisiis*, Wulfgang Hopyl, 1504, folio (419) *Leighton*, £3 7s. 6d.

1711 Cramer (Pierre). Papillons Exotiques des trois Parties du Monde, l'Asie, l'Afrique et l'Amerique, avec Supplement, par Stoll, col. title and front., the latter in duplicate (plain), and numerous col. plates, together 5 vol., old cf., g. e., *Amsterdam*, 1779-91, 4to. (67) *Quaritch*, £15 15s.

1712 Daniel (W. B.) Rural Sports, with the Supplement, plates, 4 vol., hf. bd., 1805-13, 4to. (274) 19s.

1713 Dansey (J. C.) The English Crusaders, illuminated titles, fac. plates, coats-of-arms, and ornaments in gold and colours, mor. ex., Dickinson and Co., n. d. (1840), 4to. (262)
 Tregaskis, £2 2s.

1714 Dante Alighieri. Divina Commedia, col. Comento di C. Landino, woodcut front., borders and woodcuts, bds., *Venet.*, 1497, folio (498) *Bain* £17

1715 Dawkins (W. B.) Early Man in Britain, woodcuts, cl., t. e. g., 1880, 8vo. (174) £1 15s.

1716 Deakin (R.) Florigraphia Britannica, col. plates, 4 vol., cl., 1857, 8vo. (119) £1

1717 [De Quincey (T.)] Confessions of an English Opium-Eater,

first ed., with the half title, old cf., m. e., Taylor and Hessey,
 1822, 8vo. (560) *Quaritch,* £2 14s.
1718 Dibdin (T. F.) Aedes Althorpianae, ports. and plates, 2 vol.,
 mor., g. e., 1822, 8vo. (389) £1 10s.
1719 Distant (W. L.) Rhopalocera Malayana, col. plates and cuts,
 hf. mor., t. e. g., 1882-6, 4to. (85) £3 15s.
1720 Donovan (E.) Natural History of the Insects of New
 Holland, New Zealand, etc., col. plates, hf. mor., g. e., 1805,
 4to. (81) *Wesley,* £11
1721 Evans (Sir J.) Ancient Stone and Bronze Implements, cuts,
 2 vol., cl., 1872-81—Flint Implements of the Drift, plates,
 presentation copy, sewed, 1860, 4to. (175) £1 10s.
1722 Ficino (Marsilio). Libro della Cristiana Religione, first ed.
 of the author's own translation, 114 leaves, roman letter,
 the first initial decorated (Hain, No. 7071), vell. [*Florence,*
 N. Laurent. Allemannus, ca. 1470], sm. 4to. (412)
 Leighton, £2 5s.
1723 Fitzherbert (Sir A.) The Newe Boke of Justices of Peace,
 with inscription on back of title, "Ex dono nobilissimi viri
 Edwardi dñi Zouche dñi Custodis Quinque Portuum,
 humilimo servo suo, Edw.: Nicholas, Feb. 16, 1621," old
 cf., with royal arms blind stamped, R. Tottyll, 1554, 12mo.
 (546) *Maggs,* £5 10s.
 [Edward La Zouche, eleventh Baron Zouch of Harring-
 worth, was a Member of Council of Virginia in 1609, and
 of the New England Council in 1620, having sent his
 pinnace, the "Silver Falcon," to Virginia in the previous
 year.—*Catalogue.*]
1724 Fleetwood (W.) Annalium tam Regum Edward V.,
 Richard III., Henry VII. et Henry VIII. Elenchus, black
 letter, vell., Richard Tottel, 1579, 12mo. (583)
 Harding, £1 3s.
1725 Ford (J.) Dramatic Works, by W. Gifford, 2 vol., hf. cf.,
 1827, 8vo. (314) *Hatchards,* £1 1s.
1726 Forlong (J. G. R.) Rivers of Life, maps and illustrations,
 with the separate chart of Faith Streams, 3 vol., cl., 1883,
 4to. (7) *Brown,* £4 12s. 6d.
1727 Franciscus de Maro. Sermones de Tempore, gothic letter
 (Campbell, No. 1215), initials in red, 328 leaves, contemp.
 cf. over oak bds., blind stamped [*Bruxelles, ca.* 1484], 8vo.
 (411) *Leighton,* £6 5s.
1728 Franck (Seb.) Chronica en der Werelt Boeck, black letter
 [with 30 pages relating to America], contemp. stamped cf.
 over oak bds., *Delft,* Albert Heyndricx, 1583, folio (536)
 £1 2s.
1729 Frazer (J. G.) The Golden Bough, front., first ed., 2 vol., cl.,
 1890, 8vo. (8) *Thorp,* £1 2s.
1730 Goldsmith (O.) The Haunch of Venison, first ed., head of
 the author etched by Bretherton, with the rare half title
 (7 leaves in all, including front.), G. Kearsly, 1776, and
 others (21), in 1 vol., hf. bd., 4to. (475) *Bumpus,* £18
1731 Granger (J.) Biographical History, illustrated by the inser-

tion of Richardson's ports., 6 vol., old mor. ex., 1824, 8vo.
(330) *Dobell,* £5

1732 Gravelot (H. F.) et Cochin (C. N.) Iconologie par Figures,
ou Traité des Allégories, Emᴐlémes, etc., ports., engraved
titles, and plates, first issue, 4 vol. (ᴐinding defective),
Paris [1789 or 1791], 8vo. (486) *Sotheran,* £5

1733 Hain (L.) Repertorium Bibliographicum, orig. ed., 4 vol., hf.
cf., *Stuttgartiæ,* 1826-38, 8vo. (386) *George,* £7 2s. 6d.

1734 Harris (Moses). Exposition of English Insects, col. plates,
cf., 1782, 4to. (71) 10s.

1735 Holy Biᴐle. Le Premier Volume de la Biᴐle Hystoriee,
lettres batarদes, woodcuts (a few leaves wanted, w. a. f.),
Paris, A. Verard [*ca.* 15—], folio (534) *Leighton,* £6

1736 Hooker (W. J.) British Jungermanniæ, col. plates, russ.,
1816, 4to. (115) £3

1737 Humphreys (H. N.) Illuminated Books of the Middle Ages,
printed in colours ᴐy Owen Jones, hf. mor., g. e. (ᴐinding
ruᴐᴐed), 1849, roy. folio (391) *Brown,* £6 5s.

1738 Hudson (G. V.) New Zealand Moths and Butterflies, col.
plates, cl., 1898, roy. 4to. (89) £1 17s.

1739 Jeffreys (J. G.) British Conchology, col. plates, 5 vol., cl.,
1862-9, 8vo. (109) £2 8s.

1740 Jesse (J. H.) George Selwyn and his Contemporaries, first
ed., ports., 4 vol., orig. cl., 1843-4, 8vo. (37) £6 10s.

1741 [Johnson (C.)] Chrysal, or the Adventures of a Guinea, col.
plates after Burney and Courbold, 3 vol. (one page in vol. i.
stained), old cf., M'Lean, 1821, 8vo. (352) *Edwards,* £5

1742 Johnson (T.) Illustrations of British Butterflies and their
Larvæ, col. plates, hf. mor., t. e. g., *Privately printed,* 1892,
8vo. (76) 19s.

1743 Jonson (Ben). Works, ᴐy W. Gifford, port., 9 vol., hf. cf.,
1816, 8vo. (316) *Brown,* £3 17s. 6d.

1744 Junius. Letters, 12 ports. ᴐy Bocquet, old mor. ex., 1813,
4to. (329) *Hatchard,* £2

1745 Keats (J.) Endymion, first ed., with the half title, and ᴐoth
the one and five line leaves of errata, hf. cf., Taylor and
Hessey, 1818, 8vo. (561) *Spencer,* £12 15s.

1746 Kirᴐy (W. F.) Catalogue of the Collection of Diurnal
Lepidoptera formed ᴐy W. C. Hewitson, *For private circu-
lation,* 1879—Synonymic Catalogue of the same, inter-
leaved, 2 vol., 1871, 4to. (92) *Wesley,* £2

1747 Knox (R.) Historical Relation of the Island of Ceylon,
folding map and plates, cf., g. e., 1681, folio (523)
Bailey, £2 15s.

1748 Leech (J. H.) Butterflies from China, Japan and Corea, col.
plates, 3 vol., hf. mor., t. e. g., 1892-4, 4to. (87)
Edwards, £6 15s.

1749 Le Sage (A. R.) Gil Blas, 15 col. plates, old cf., T. M'Lean,
1819, 8vo. (351) *Edwards,* £3 5s.

1750 Livii Opera, woodcuts ᴐy Jost Amman, 2 vol. in 1, old
stamped pigskin, ports. and arms within panels, clasps,
Francofurti, 1568, folio (532) *Barnard,* £2 2s.

1751 London Gazette (The), first published as The Oxford Gazette,
 but continued after No. 40 as The London Gazette, the
 first 1,000 numbers, bound in 50 vol., hf. cf., Nov. 13, 1665—
 June 21, 1675, sm. folio (550) *Edwards,* £21 10s.
1752 McIan (R. R.) The Clans of the Scottish Highlands, orig.
 ed., 72 col. figures, with descriptions by J. Logan, 2 vol.,
 hf. mor., g. e., Ackermann, 1845-7, folio (726) £9 2s. 6d.
1753 MS. Horæ on Vellum. Horæ Beatæ Mariæ Virginis ad
 usum Parisiense, cum Calendario, on 103 leaves of vellum,
 decorated with 9 large miniatures and 25 smaller minia-
 tures in the text, each page illuminated with inner borders
 of conventional flowers, fruit, insects and grotesques on
 gold backgrounds, and every page having a small miniature
 (with descriptive notes in blue ink between each of these
 miniatures), making in all four hundred and eighty-nine
 miniatures, with two full-page illuminated Genealogical
 Trees—the Stem of Jesse—comprising 78 figures, the text
 also decorated, the motto "J'amie tant fortune, Charles,"
 with 4 leaves of additional Memoriæ at the end, and 4
 leaves of Prayers in French, in a large batarde hand, followed
 by the illuminated arms of a former owner (azure, a tower
 argent), the last blank leaf having the signature in crude
 capitals "Charles" (7¼in. × 4⅞in.), in all 112 leaves,
 velvet binding, g. e. [*ca.* 1485] (408) *Reynolds,* £180
 [May have been written for the use of Charles VIII. of
 France.—ED.]
1754 MS. Horæ on Vellum. Horæ Beatæ Mariæ Virginis cum
 Calendario, written in a large gothic hand on 97 leaves of
 vellum, with nine large miniatures, nearly every leaf of the
 text decorated, the miniatures and some other pages
 surrounded with borders, 27 large illuminated initial letters
 (size 9$\frac{5}{12}$in. by 7⅙in.), modern velvet, *Sæc.* xv. (409)
 Crawshaw, £60
 [The use appears to be that of Rouen. The name of
 St. Ursin, first Bishop of Bourges, appears three times in
 the calendar, and he is also invoked in the Litany.—ED.]
1755 [Marston (J.)] Tragedies and Comedies, first issue of the
 first ed., old cf., *Printed by A. M. for William Sheares,*
 1633, 12mo. (563) *Tregaskis,* £13
 [Had the original title-page, which was altered in later
 copies to "The Workes of Mr. John Marston." The last
 few leaves a little stained.—*Catalogue.*]
1756 Massinger (P.) Plays, by W. Gifford, second ed., port.,
 4 vol., old cf., 1813, 8vo. (315) £1 10s.
1757 Miller (P.) Gardener's and Botanist's Dictionary, 300 col.
 plates, 6 vol., cf., 1807, folio (111) *Thorp,* £1 11s.
1758 Milton (J.) A Brief History of Moscovia, first ed., contemp.
 sheep, 1682, 12mo. (570) £3
1759 Morris (F. O.) British Birds, col. plates, 6 vol., hf. mor., g. e.,
 1870, 8vo. (136) *Edwardes,* £4 12s. 6d.
1760 Morris (F. O.) Nests and Eggs, col. plates, 3 vol., hf. mor.,
 g. e., 1875, 8vo. (137) £1 11s.

1761 Morris (F. O.) British Moths, 4 vol.—British Butterflies, col. plates, together 5 vol., hf. mor., g. e., 1870-2, 8vo. (75)
Davy, £1 11s.

1762 Myers (F. W. H.) Human Personality and its Survival of Bodily Death, 2 vol., cl., 1904, 8vo. (11) *Dobell,* £1 7s.

1763 Nash (J.) The Mansions of England, orig. ed., 104 litho. col. plates, mounted on cardboard, in 4 portfolios, hf. roan, 1839-49, atlas folio (714) £30

1764 Nicholai de Orbellis super Sentencias, gothic letter, cf., with Jesus College, Cambridge, bookplate [1700] on title, *Venundatur Rothomagi in domo J. Richardi Mercatoris* [15—], 12mo. (420) *Leighton,* £4

1765 Novum Testamentum, Graece et Latine, ex Versione Erasmi, old cf. (rebacked), from the library of Lord Burleigh, with his coat-of-arms, *Basileæ,* 1570, folio (545) *Barnard,* £2 8s.

1766 Novum Testamentum, Th. Beza interprete, *Londini,* 1576— Sternhold and Hopkins' Psalms, with music, 1602, in 1 vol., with the autograph of Thomas East [publisher, ? 1540-1608] on first title, contemp. cf., arms of Queen Elizabeth, clasps (one broken), 12mo. (544) *Ellis,* £4 15s.

1767 Numismatic Chronicle, from June, 1838 to 1856, 18 vol. in 9— Numismatic Journal, 2 vol. in 1, 1837, edited by John Yonge Akerman, plates, 10 vol., hf. mor., 8vo. (240)
Quaritch, £5

1768 Pardoe (Miss). Court and Reign of Francis I., first ed., ports., 2 vol., orig. cl., 1849, 8vo. (31) *Spencer,* £1 14s.

1769 Politianus (A. A.) Opera, some of the initial letters col. and heightened with gold, 2 vol. in 1, *Parisiis, in Ædibus Ascensianis,* 1512, folio (418) *Harding,* £2 4s.

1770 Pugin (A.) Examples of Gothic Architecture, second ed., plates, 3 vol., cl., 1838-40, 4to. (265) *Maggs,* £2 11s.

1771 Ravenscroft (T.) The Whole Booke of Psalmes, musical notation for four parts (small hole on title), old sheep, 1633, folio (543) *Ellis,* £2 18s.

1772 Scott (Sir W.) Tales of my Landlord, first series, first ed., with all the half titles, 4 vol., orig. bds., with the labels, the edges untrimmed, *Edinburgh,* 1816, 8vo. (555)
Hornstein, £110

1773 Scott (Sir W.) Waverley Novels, Abbotsford ed., ports. and engravings, 12 vol., green cl., 1842-7, roy. 8vo. (357)
Zaehnsdorf, £2 10s.

1774 Shakespeare (W.) Comedies, Histories and Tragedies, second folio (wanted title, port. and Ben Jonson's verses, first two leaves of The Tempest defective, impft. at the end, and binding broken), 1632, folio (515) *Parsons,* £6

1775 Shakespeare (W.) Plays and Poems, port. after Droeshout by Worthington, 11 vol., hf. mor., t. e. g., W. Pickering, 1825, 8vo. (562) £2

1776 Shaw (H.) Illuminated Ornaments, descriptions by Sir F. Madden, plates col. by hand, bds., uncut, W. Pickering, 1833, 4to. (392) *Spencer,* £2 10s.

1777 Shelley (P. B.) Poetical Works, first collected ed., port.,
 4 vol., cl. gt. (worn, but uncut), Moxon, 1839, 8vo. (337*)
 £2 12s. 6d.
1778 Shirley (J.) Dramatic Works and Poems, ɔy W. Gifford and
 Dyce, mezzo. port. ɔy Lupton, 6 vol., hf. cf., 1833, 8vo. (317)
 £3 16s.
1779 Smith (J. E.) and Kirɔy (W. F.) Rhopalocera Exotica, col.
 plates, 3 vol., first 2 vol. hf. mor., t. e. g., vol. iii. in 20
 parts, 1887-1902, 4to. (77) *Papman*, £14 14s.
1780 Sotheɔy (S. Leigh). Principia Typographica, facs. of ɔlock
 ɔooks (some col.), etc., 3 vol. (ɔroken), 1858, folio (393)
 Hill & Son, £4 15s.
1781 Sowerɔy (J.) English Botany, ed. ɔy J. T. Boswell Syme,
 third ed., col. plates, 12 vol., cl., 1863-86, roy. 8vo. (113)
 Thorp, £9 5s.
1782 Speculum Humanæ Salvationis. Das Büchlein genannt der
 Mȇschen Spiegel, mit einer hübschen Ausslegung des Pater-
 nosters, 𝖌𝖔𝖙𝖍𝖎𝖈 𝖑𝖊𝖙𝖙𝖊𝖗, upwards of 210 woodcuts, some col.
 by an early hand, 160 leaves (Hain, No. 14942), from the
 Liɔri Collection (a few leaves slightly soiled or wormed,
 and some margins repaired), russ., g. e., *Das hat Getrückt*
 . . . *Anthonius Sorg zu Augspurg*, 1467, folio (709)
 £98 10s.
1783 Stainton (H. T.) Natural History of the Tineina, col. plates,
 first 9 vol., cl., 1855-65, 8vo. (73) *Thorp*, £1 10s.
1784 Staudinger (O.) und Schatz. Exotische Schmetterlinge, col.
 plates, 2 vol. in 3, cl., *Fürth*, 1888-92, roy. 4to. (83)
 Thorp, £2 17s. 6d.
1785 Stephens (J. F.) Illustrations of British Entomology, col.
 plates, with supplement, 12 vol. in 11, hf. roan, 1827-46,
 roy. 8vo. (72) *Thorp*, £2 10s.
1786 Stoeffler (J.) Calendarium Romanum Magnum, woodcuts
 and diagrams, oak bds., stamped leather ɔack, *Oppenheym*,
 J. Köɔel, 1518, folio (436) *Barnard*, £2 16s.
1787 Stoll (C.) Représentation des Spectres, des Mantes, des
 Sauterelles, etc.—Représentation des Punaises et des
 Cigales, col. fronts. and plates, 3 vol., old cf., g. e., *Amst.*,
 1788-1813, 4to. (68) *Wesler*, £4
1788 Sue (Eugène). The Wandering Jew, illustrations by Heath
 (stained), 3 vol., cl., 1844, 8vo. (380) £3 12s. 6d.
1789 Texier (C.) and Pullan (R. P.) Byzantine Architecture, 70
 litho. plates, some col., cl., 1864, folio (290)
 Hill & Son, £2 18s.
1790 Verity (R.) Rhopalocera Palaearctica, Iconographie et
 Description des Papillons Diurnes de la Region Palearctique,
 parts i. to xxiii. (ɔeing pages 1 to 268, with 39 col. plates),
 Florence, 1905—April, 1909, folio (88) *Sotheran*, £1 15s.
1791 Voet (J. E.) Catalogue Systematique des Coleoptères, col.
 plates, 2 vol. (ɔinding of vol. ii. ɔroken), *La Haye*, 1806,
 4to. (69) *Quaritch*, £1 5s.
1792 Williamson (T.) and Howitt (S.) Oriental Field Sports, 40
 col. plates, 2 vol., old mor., g. e., 1819, 4to. (272) £5 2s. 6d.

1793 Wood (W.) Index Entomologicus, col. plates, hf. mor., t. e.g.,
1854, 8vo. (74) *Edwards*, £1 12s.

1 1794 Woodourn (S.) Portraits of Characters Illustrious in British
History, 100 mezzo. plates by Earlom and Turner, 2 vol.,
old mor. gt., S. Woodourn [1810-15], 4to. (263)
Detrich, £4 15s.

[NOVEMBER 25TH, 1909.]

SOTHEBY, WILKINSON & HODGE.

THE LIBRARY OF THE LATE MR. JOHN MITCHELL MARSHALL, OF WALLINGFORD.

(No. of Lots, 317 ; amount realised, £941 7s.)

1795 Alken (H.) The National Sports of Great Britain, col.
plates, hf. mor., t. e. g., Methuen, 1903, folio (124)
Hill, £1 2s.

1796 Alken (H.) The Beauties and Defects in the Figure of the
Horse, 18 col. plates, hf. cf. (1816), 8vo. (3) *Marshall*, 10s.

1797 Araoian Nights. A Series of Seventy Original Illustrations,
with a full-length port., reproduced from the orig. picture
in oils specially painted by Aloert Letchford, édition de
luxe, proofs oefore letters, with descriptions, in portfolio,
1897, folio (125) *Marshall*, £2 4s.

1798 Araoian Nights, oy Sir R. F. Burton, 10 vol., *Benares, for
private subscribers*, 1885—Supplemental Nights, with notes,
6 vol., *ib.*, 1886, together 16 vol., orig. cl., 8vo. (2)
Foster, £22

1799 Basile (G. B.) Il Pentamerone, trans. by Sir R. F. Burton,
2 vol., 1893—Life of Sir R. F. Burton, by Isaoel Burton,
2 vol., with ports., illustrations and maps, 1893, 8vo. (4)
Hill, £2 2s.

1800 Beckford (Peter). Thoughts on Hunting, front. and 11 plates
by John Scott, orig. bds., uncut, with the paper laoel
(defective), *Albion Press*, 1810, 8vo. (5) *Young*, £1 14s.

1801 Beckford (P.) Thoughts on Hunting, LARGE PAPER, proof
plates by Scott, orig. mor., g. e., *Albion Press*, 1810 (6)
J. Bumpus, £3 8s.

1802 Bohn's Extra Volumes. Raoelais. Works, 2 vol.—Boccaccio.
Decameron—The Heptameron—Memoirs of Grammont
and Charles II.—Cervantes. Exemplary Novels—Ham-
ilton. Fairy Tales, orig. cl., 1864, etc., 8vo. (8)
Quaritch, £2

1803 Bulwer Lytton (Rosina). Pictorial Edition of the Book of
Common Prayer, with autograph signature " Rosina Bulwer
Lytton," and quotation, commencing

"Oh ! Domine Deus, Speravi in te—
Poor Mary Stuart !
And still poorer
Rosina Bulwer Lytton, 1864,"
in her hand-writing, a few printed extracts inserted, in half
mor. case, 8vo. (12) *Tregaskis*, 12s.

1804 Cervantes Saavedra (M. de). Don Quixote, trans. ɔy
Smollett, port. and fronts., 4 vol., cf., *Glasgow*, 1803, 8vo.
(14) *Maggs*, £1 6s.

1805 Claude. Liɔer Veritatis, second proofs, 3 vol., mor. ex. (title
of vol. ii. stained), 1777-1819, folio (126) *Robson*, £11 5s.

1806 Comɔe (William). English Dance of Death, col. plates ɔy
Rowlandson, 2 vol., orig. cf., g. e., R. Ackermann, 1815-16,
8vo. (16) *Young*, £10

1807 Comɔe (W.) The Three Tours of Dr. Syntax, col. plates ɔy
T. Rowlandson, 3 vol., cl., uncut, Nattali and Bond, n. d.,
8vo. (17) *Marshall*, £1 5s.

1808 Cooper (A.) Impressions from a set of Silver Buttons,
relative to the Sports of the Field, circular engravings,
with ɔorders, ɔy J. Scott, cf., 1821, 8vo. (18)
 Hornstein, £1 14s.

1809 Cruikshank (G.) Illustrations of Smollett, Fielding and
Goldsmith, in a series of 41 plates, mor. super ex., 1832,
8vo. (19) *Maggs*, £1 16s.

1810 Daniel (W. B.) Rural Sports, orig. ed., plates, 3 vol., cf. ex.,
uncut, t. e. g., by Rivière and Son, 1801-2-13, 4to. (89)
 Sawyer, £5 10s.

1811 Daniel (W. B.) Rural Sports, plates, chiefly by J. Scott,
with a duplicate set of the engravings (coloured), inlaid,
3 vol., mor. super ex., the centres of sides inlaid with water-
colour drawings of ɔirds of prey, 1805—Supplement, mor.
ex., g. e., 1813, together 4 vol., 4to. (90) *Maggs*, £29

1812 Dickens (C.) Address delivered at the Birmingham and
Midland Institute, on the 27th Septemɔer, 1869, by Charles
Dickens, the proof sheets, corrected by himself, with the
puɔlished Pamphlet, an autograph letter and visiting card
of Dickens inserted, mor. super ex.; by Rivière and Son,
from the liɔrary of S. M. Samuel, 4to. (91)
 Maggs, £43 10s.

1813 Dickens (C.) Pickwick Papers, first ed., 43 illustrations,
including the two by R. W. Buss, specimen wrapper ɔound
up, hf. mor., g. e., ɔy Tout, 1837, 8vo. (21) *Young*, £3 14s.

1814 Dickens (C.) Oliver Twist, "ɔy Charles Dickens," first ed.
(second issue), 3 vol., cf., g. e., 1838, 8vo. (22)
 Diouritch, £1 8s.

1815 Dickens (C.) Sketches by "Boz," 40 illustrations by Cruik-
shank, cf., g. e., 1839, 8vo. (23) *Young*, £1 18s.

1816 Dickens (C.) A Christmas Carol, in Prose, first ed., first
issue, light green end papers, 1843—The Chimes, first ed.,
second issue, 1845—The Cricket on the Hearth, first ed.,
1846—The Battle of Life, first ed., third issue, 1846—The
Haunted Man, first ed., 1848, orig. cl., 8vo. (24) *Young*, £7

1817 Dickens (C.) David Copperfield, first ed., illustrations ⅉy
H. K. Browne, cf., g. e., 1850, 8vo. (26) *Sawyer*, £1 5s.

1818 Dickens (C.) A Tale of Two Cities, first ed., illustrations ⅉy
H. K. Browne, cf., g. e., 1859, 8vo. (29) *Shepherd*, £1 1s.

1819 Egan (Pierce). Life in London, first ed., col. plates ⅉy J. R.
and G. Cruikshank, mor. ex., 1821, 8vo. (34) *Young*, £7 5s.

1820 Ellis (William). The Complete Planter and Ciderist, in 2
parts, woodcuts, cf., g. e., ⅉy Rivière and Son, 1756, 8vo.
(35) *Bruton*, 9s.

1821 Favre (De). Les Quatre Heures de la Toilette des Dames,
plates and vignettes after Le Clerc, mor. super ex., 1779,
roy. 8vo. (37) *Parsons*, £8 15s.

1822 Foreign Field Sports, Fisheries, Sporting Anecdotes, etc.,
with a Supplement of New South Wales, col. plates from
drawings ⅉy Howitt, Atkinson, etc., orig. mor., g. e., E. Orme,
1814, 4to. (93) *Young*, £6 7s. 6d.

1823 Gay (John). Faⅉles, "Stockdale's fine edition," 70 engravings
ⅉy Blake, Stothard, etc., 2 vol., contemp. mor., g. e., 1793,
imp. 8vo. (38) *Quaritch*, £7

1824 Gould (John). Birds of Great Britain, 5 vol., mor. super ex.,
1873, folio (132) *Edwards*, £47

1825 Gréard (V. C. O.) Meissonier, his Life and his Art, Japanese
vell. paper, plates, with an extra set in portfolio, one of 100
copies, 2 vol., uncut, 1897, 4to. (102) *Young*, £2 2s.

1826 Greenaway (Kate). A Apple Pie, n. d.—A Day in a Child's
Life, n. d.—Marigold Garden, n. d.—Under the Window,
n. d., and others, all with col. illustrations ⅉy Kate Green-
away, chiefly small, almanacks, etc., together 25 vol., 4to.
(94) *Tregaskis*, £9

1827 Grimm (M. M.) German Popular Stories, ⅉoth series, re-issue
of the rare original of 1823-6, plates after Geo. Cruikshank,
one of 250 numⅉered copies, 2 vol., uncut, H. Frowde,
1904, 8vo. (40) *Bain*, £1 18s.

1828 Hamerton (P. G.) Etching and Etchers, first ed., etchings
ⅉy and after Haden, Redgrave, etc., orig. hf. hinding, g. e.,
1868, roy. 8vo. (41) *Hopkins*, £4 10s.

1829 Holⅉein (Hans). The Dance of Death, engravings ⅉy W.
Hollar, hf. mor., r. e., n. d., 8vo. (44) *Rubens*, £1 10s.

1830 Horatius. Opera, plates after Gravelot, mor., g. e., ⅉy
Derome, *Birm.*, J. Baskerville, 1770, 4to. (95)
Sotheran, £6 10s.

1831 Horatius. Opera aeneis Taⅉulis incidit Johannes Pine,
the "Potest ed.," engraved throughout, plates and vignettes,
2 vol., contemp. mor. ex., arms of Ruffin de Pericard,
1733-7, 8vo. (46) *Bain*, £12 15s.

1832 Knight (Charles). Old England, col. illustrations and
numerous woodcuts, 2 vol., hf. mor., g. e., 1854, folio (135)
Tregaskis, 10s.

1833 Kinglake (A. W.) The Invasion of the Crimea, maps and
plans, 8 vol., orig. cl., 1863-87, 8vo. (50) *Hornstein*, £1 12s.

1834 La Fontaine (J. de). Contes et Nouvelles, en Vers, port.,

plates and vignettes, after Eisen and Choffard, 2 vol., mor.
ex., by W. Pratt, *Amst.*, 1764, 8vo. (51) *Quaritch*, £5 5s.

1835 Lawrence (John). The History and Delineation of the
Horse, 15 plates ɔy J. Scott and woodcuts ɔy T. Bewick and
others, uncut, *Albion Press*, 1809, 4to. (97) *Pickering*, £1

1836 Lilford (Lord). Coloured Figures of the Birds of the British
Islands, first ed., plates in colours and the text mounted on
guards, 7 vol., R. H. Porter, 1885-97—A separate volume
containing an Appendix, Index, and all the orig. wrappers,
mounted on guards, mor. super ex., uncut, t. e. g., an orig.
suɔscriɔer's copy, 1885-97, 8vo. (52) *Bruton*, £58

1837 Lilford (Lord). Notes on the Birds of Northamptonshire,
LARGE PAPER, map, and illustrations by A. Thorburn and
G. E. Lodge, 2 vol., hf. mor., uncut, t. e. g., R. H. Porter,
1895, 4to. (99) *Hill*, £2 2s.

1838 Lilford (Lord). On Birds, a Collection of informal and
unpuɔlished Writings, ed. by A. Trevor-Battye, illustrated
by A. Thorɔurn, orig. ɔuckram, t. e. g., 1903, 4to. (100)
Marshall, 7s.

1839 Lamɔ (Charles). Mrs. Leicester's School, second ed., front.
ɔy Hopwood, hf. cf., from Canon Ainger's liɔrary, 1809,
8vo. (53) *Shepherd*, 11s.

1840 Mahan (Captain A. T.) Life of Nelson, first ed., ports., maps
and plans, 2 vol., orig. cl., 1897, 8vo. (55) *Young*, £1 5s.

1841 Michel (E.) Remɔrandt, his Life, his Work and his Time,
Japanese vellum paper, illustrations, with an extra set of
the plates in portfolio, one of 200 copies, 2 vol., uncut,
1894, 4to. (106) *Sabin*, £3 3s.

1842 Pepys (Samuel). Diary, ed. by Wheatley, port. and illustra-
tions, 8 vol.—Pepysiana (Supplementary Volume) and
Index, ports., etc., together 10 vol., LARGE PAPER, one of
250 copies, hf. parchment, uncut, 1893-9, 8vo. (60)
Sawyer, £14

1843 Ricci (C.) Antonio Allegri da Correggio, his Life, his Friends
and his Time, Japanese vellum paper, with an extra set of
plates in portfolio, one of 100 copies, 2 vol., uncut, 1896,
4to. (87) *Diouritch*, £1 16s.

1844 Rogers (Charles). A Collection of Prints in imitation of
Drawings by the Great Masters, plates by Bartolozzi and
others, 2 vol., hf. mor., uncut, gt., 1778, folio (138)
Rimell, £5

1845 Scott (W. H.) British Field Sports, plates, chiefly engraved
by J. Scott, and woodcuts, in the orig. illustrated wrappers
(wanted two), in a case, 1818, 8vo. (64) *Hornstein*, £4 6s.

1846 Seeɔohm (Henry). History of British Birds, col. illustrations,
orig. cl., uncut, R. H. Porter, 1883-5, roy. 8vo. (65)
J. Bumpus, £3 18s.

1847 Selden (John). Historie of Tithes, first ed., large copy in
modern mor., g. e., 1618, 4to. (109) *Young*, 10s.

1848 Somervile (W.) The Chace, first ed., front. ɔy Gravelot,
orig. cf., 1735, 4to. (111) *Tregaskis*, 14s.

1849 Somervile (W.) Field Sports, a Poem, cf., uncut, ɔy Rivière and Son, 1742, folio (141) *Tregaskis,* £1 11s.

1850 Smedley (F. E.) Frank Fairleigh, first ed., illustrations by Geo. Cruikshank, in the orig. wrappers (damaged), 1850, 8vo. (69) *Hornstein,* £6 5s.

1851 Smedley (F. E.) Lewis Arundel, first ed., illustrations ɔy " Phiz," ɔound up from the orig. parts, wrappers and advertisements inserted, also an autograph letter and poem of four verses, hf. mor., t. e. g., Virtue, 1852, 8vo. (70)
Hornstein, £4 15s.

1852 Songs of the Chace, relative to the Sports of the Field, front. and engraved title, mor., g. e., by Gosden, with a painting on the fore-edges, 1811, 8vo. (72) *Edwards,* £7 15s.

1853 Southey (Roɔert). Life of Nelson, LARGE PAPER, port. and plate of signatures, 2 vol., mor., g. e., 1813, 8vo. (73)
Bain, £1 16s.

1854 Sportman's (The) Caɔinet . . . ɔy a Veteran Sportsman, 25 plates by J. Scott and woodcuts by T. Bewick, 2 vol., orig. bds., uncut, 1803-4, 4to. (113) *Hill,* £1 18s.

1855 Talfourd (T. N.) Ion, a Tragedy, presentation copy, with inscription on title "To Mr. Segt. Scriven, with the author's sincere regards," orig. cl., in a case, ɔy Rivière and Son (1835), 8vo. (75) *Tregaskis,* 10s.

1856 Tennyson (Alfred). Poems, first collective edition, 2 vol., cf., from the liɔrary of Canon Ainger, Moxon, 1842, 8vo. (76)
Shepherd, £1 1s.

1857 Thornton (Colonel). A Sporting Tour through various parts of France, port., folding and other plates, 2 vol., hf. mor., uncut, t. e. g., *Albion Press,* 1806, 4to. (117)
Hornstein, £3

1858 Walton and Cotton. The Complete Angler, seventh ed., by Sir John Hawkins, LARGE PAPER, ports., plates and vignettes, russ. (defective), Bagster, 1808, 8vo. (78)
Young, £1 8s.

1859 Walton and Cotton. Complete Angler, "Tercentenary Edition," ed. by J. E. Harting, 53 illustrations on Japanese vellum paper, one of 350 numɔered copies, 2 vol., hf. parchment, uncut, Bagster, 1893, 4to. (120) *Sawyer,* £1 1s.

1860 Weïrotter (F. E.) L'Oeuvre, contenant près de deux cent Paysages et Ruines, gravés à l'eau-forte, port., orig. cf., *Paris,* Basan et Poignant, n. d., folio (144)
Quaritch, £2 12s.

1861 White (Gilɔert). Natural History of Selɔorne, first ed., folding front. and engravings, orig. cf. gt., 1789, 4to. (121)
Quaritch, £9 10s.

1862 Yarrell (William). History of British Birds, with the two Supplements, LARGE PAPER, 3 vol., mor. ex., uncut, t. e. g., Van Voorst, 1843-56, 8vo. (80) *Joseph,* £2 2s.

1863 Zouch (T.) Life of Isaac Walton, port. and plates, cf., g. e., S. Prowett, 1823, 8vo. (81) *Hornstein,* £1
XXIV. 8

A Collection of Works chiefly illustrated by Thomas and John Bewick.

1864 Select Faɔles, in three parts, first ed., *Newcastle*, T. Saint, 1776—The same, new ed., hf. cf., *ib.*, 1784, 8vo. (165)
　　　　　　　　　　　　　　　　　．　*B. F. Stevens, £2*

1865 Select Faɔles, imperial paper, port. of T. Bewick (spotted), orig. bds., with the paper laɔel, in a portfolio, a rare single sheet advertisement of the Select Faɔles, with woodcut, inserted, *Newcastle*, 1820, 8vo. (166)　　　　*Maggs, £5*

1866 Select Faɔles, another copy, royal paper, nearly uncut, *Newcastle*, 1820, 8vo. (168)　　　　*Zaehnsdorf, £1 1s.*

1867 General History of Quadrupeds, first ed., uncut copy in the orig. bds. (repaired), *Newcastle*, 1790 (169)　　*Young, £4*

1868 General History of Quadrupeds, first ed., cf. gt., ɔy Rivière, *Newcastle*, 1790, 8vo. (170)　　　　*Bruton, £1 1s.*

1869 General History of Quadrupeds, first ed., royal paper, mor. super ex., *Newcastle*, 1790, 8vo. (171)　　*Robson, £4 18s.*

1870 General History of Quadrupeds, second ed., cf. gt., ɔy Hayday, *Newcastle*, 1791, 8vo. (173)　　*Hawkins, 5s.*

1871 General History of Quadrupeds, second ed., royal paper, Addenda to the Birds and Additamenta ɔound up at end, four orig. drawings by T. Bewick inserted, mor., *Newcastle*, 1791, 8vo. (174)　　　　　*Maggs, £3 10s.*

1872 General History of Quadrupeds, third ed., royal paper, woodcut of the "Chillingham Wild Bull" (second state) inserted. cf., t. e. g., ɔy Birdsall, *Newcastle*, 1792, 8vo. (175) .
　　　　　　　　　　　　　　　　　Hobbes, £1 14s.

1873 General History of Quadrupeds, fourth ed., royal paper, orig. bds., uncut, fine copy, with the paper laɔel, *Newcastle*, 1800, 8vo. (176)　　　　　　　*Lewine, 8s.*

1874 General History of Quadrupeds, fifth ed., imperial paper, fine uncut copy, in the orig. bds. (repaired), paper laɔel, *Newcastle*, 1807, 8vo. (177)　　　　*B. R. Hill, 16s.*

1875 Vignettes ɔy Thomas Bewick, 273 of the tail-pieces to the Histories of Quadrupeds and Birds, without the letterpress, only a few copies issued, uncut, *Newcastle*, 1827, 8vo. (181)
　　　　　　　　　　　　　　　　　Young, £2 2s.

1876 The Proof Sheets of nearly the whole of the first volume of the History of British Birds, with numerous corrections and additions in the handwriting of Thomas Bewick, hf. bd. ; inserted is the Memorandum of Agreement ɔetween R. Beilby, T. Bewick and J. Johnson, in manuscript, in a case, lined, ɔy Rivière and Son, from the liɔrary of S. M. Samuel, *Newcastle*, 1797, 8vo. (182)　　*Robson, £12 10s.*

1877 History of British Birds, first ed., interleaved with yellow paper, a duplicate series, India proofs of the wood engravings inserted, 2 vol. ; at end of volumes are 20 India proofs, corresponding to the Supplement to the Land Birds, 1821, 14 cuts of Foreign Birds, and other proof woodcuts, hf. bd., *Newcastle*, 1797-1804, 8vo. (183)　　*Rimell, £1 14s.*

1878 History of British Birds, first ed., first issue, royal paper,

2 vol., fine uncut copy, in the orig. bds. (repaired), *New-castle*, 1797-1804—Supplement, in two parts, woodcuts, orig. bds., uncut, with the paper label, 1821 (184)

Maggs, £5 15s.

1879 History of British Birds, royal paper, 2 vol., fine copy, in the orig. bds., uncut (repaired), *Newcastle*, 1804, 8vo. (187)

Spencer, £1 10s.

1880 History of British Birds, royal paper, 2 vol., fine uncut copy in the orig. bds. (repaired), paper labels, *Newcastle*, 1805, 8vo. (189) *W. Daniell, £1 4s.*

1881 History of British Birds, another copy, royal paper, 2 vol., with inscription, "The Gift of T. Bewick to his Daughter, Isabella Bewick, 1st January, 1814," and MS. note inside cover of vol. i., "Copy of 'Birds'—my sister's long cherished Edition, 1805, which is now ready to send you ; if you will be so good as to point out the safest and best way of for-warding the parcel.—I am, my Dear Sir, Yours very truly, Jane Bewick," mor. gt., *Newcastle*, 1805, 8vo. (190)

Robson, £8 5s.

1882 History of British Birds, first ed., imperial paper (only 24 copies printed), 2 vol., *Newcastle*, 1797-1804—General History of Quadrupeds, fourth ed., imperial paper (230 copies printed), *ib.*, 1800, orig. cf. (repacked), *Newcastle*, 1797-1804-1800 (191) *Robson, £7*

1883 History of British Birds (first issue of vol. i.) and General History of Quadrupeds, imperial paper, together 3 vol.—Another set, mor. ex., g. e., by Benedict, uniform, fine copies, *Newcastle*, 1797-1804-1800, 8vo. (192) *Robson, £14 5s.*

1884 History of British Birds, first ed., first issue, imperial paper (24 copies printed), 2 vol., cf., g. e., by Mansell (vol ii. shorter and stilted), *Newcastle*, 1797-1804, 8vo. (193)

Hobbes, £4 17s.

1885 History of British Birds, imperial paper, port. and autograph memorandum of T. Bewick inserted, 2 vol., cf. ex., fine copy, *Newcastle*, 1805, 8vo. (194) *Robson, £5*

1886 History of British Birds, imperial paper, 2 vol., *Newcastle*, 1805—General History of Quadrupeds, imperial paper, *ib.*, 1807, cf. ex., by Rivière and Son, 8vo. (195)

B. R. Hill, £4 4s.

1887 History of British Birds, imperial paper, 2 vol., hf. vell., uncut, with the paper labels, *Newcastle*, 1805—Supplement, in two parts, imperial paper, woodcuts by T. Bewick, orig. bds., uncut, with paper label, *ib.*, 1821, 8vo. (196)

B. R. Hill, £4 5s.

1888 History of British Birds, with the two Supplements, 2 vol., 1805-21 — General History of Quadrupeds, 1807 — The Fables of Æsop and others, Bewick's "thumb-mark" receipt, 1818—Select Fables, 1820, imperial paper, mor. ex., a fine set, *Newcastle*, 1805-21, 8vo. (197) *Edwards, £15 5s.*

1889 History of British Birds, imperial paper, 2 vol., with Supple-ment, in two parts, orig. russ., g. e., *Newcastle*, 1821, 8vo. (201) *Hill, £1 4s.*

8—2

1890 History of British Birds, with the "Additamenta," imperial
paper, 2 vol., uncut, the last edition superintended ɔy
Bewick, *Newcastle*, 1826, 8vo. (202) *Bruton*, £2 6s. ·

1891 History of British Birds, 2 vol., orig. bds., with the paper
laɔels, *Newcastle*, 1832, 8vo. (203) *B. R. Hill*, £1 2s.

1892 Figures of British Land Birds (with the Vignettes), vol. i. (all
puɔlished), with the curious vignette (in the first state) at
end, orig. bds., uncut (defective), *Newcastle*, 1800, 8vo.
(206) *Bruton*, £4

1893 Figures of British (Land and Water) Birds, and 14 Foreign
Birds, without the letterpress (only a small numɔer printed),
enclosed in drop case (a copy of a letter of John Bewick,
relating to the work, inserted), *Newcastle*, E. Walker, 1817,
4to. (208) *B. R. Hill*, £2 4s.

1894 [Figures of] British Land and Water Birds, without the
letterpress, limited to 100 copies, orig. russ., g. e., *New-
castle*, 1825, 8vo. (209) *B. R. Hill*, £1 10s.

1895 [Figures of] British Land and Water Birds, and 14 Foreign
Birds, without the letterpress (limited to 100 copies), 2 vol.,
Newcastle, E. Walker, 1824-5—The Figures of Quadrupeds,
without the letterpress, second ed., LARGE PAPER (impression
very small), *ib.*, 1824, mor., g. e., in 1 vol., 4to. (210)
Maggs, £3

1896 Proofs (printed on one side of the paper) of T. Bewick's
Water Birds, one of 6 copies only, from the Hugo collec-
tion, orig. bds., uncut, 8vo. (211) *Robson*, £1 16s.
[This volume was presented ɔy Thos. Bewick to Ralph
Beilby, his old master, and partner in ɔusiness.—*Extract
from note on fly-leaf.*]

1897 The Faɔles of Æsop, and others, imperial paper, with Bewick's
"thumɔ-mark" receipt, orig. bds., uncut (repaired), with the
paper laɔel (defective), *Newcastle*, 1818, 8vo. (213)
Spencer, £2 15s.

1898 The Faɔles of Æsop, another copy, imperial paper, with
"thumɔ-mark" receipt, orig. bds., uncut (ɔack repaired),
Newcastle, 1818, 8vo. (214) *Maggs*, £4 15s.
[Another copy on imperial paper, with the "thumɔ-
mark" receipt, realised £4 12. (mor. ex., uncut, t. e. g., ɔy
Rivière and Son), Lot 215.—ED.]

1899 The Faɔles of Æsop, another copy, royal paper, "thumɔ-
mark" receipt, orig. bds., uncut, with the paper laɔel, *New-
castle*, 1818, 8vo. (216) *Robson*, £2 2s.

1900 The Faɔles of Æsop, another copy, second edition, demy
paper, with "thumɔ-mark" receipt, the rare cancelled leaf
inserted at page 263, orig. bds., uncut, with the laɔel, *New-
castle*, 1823, 8vo. (217) *B. R. Hill*, £1 2s.

1901 A Pretty Book of Pictures for Little Masters and Misses, or
Tommy Trip's History of Beasts and Birds, ɔy Oliver
Goldsmith, first ed., J. Newɔery, 1752—Another edition
(twelfth), somewhat soiled, n. d., in the mod. Dutch bds.,
enclosed in a case, ɔook-form (223) *Marshall*, £4 10s.
[Pearson's reprint of 1867, 4to., realised 10s. (mor. ex.,
uncut, t. e. g.), Lot 225.—ED.]

1902 Faɔulous Histories, ɔy Mrs. Trimmer, cf., uncut, t. e. g., 1815 (234) *Maggs*, £2 14s.
[Inserted in this copy are the India paper proofs of the engravings which Bewick sent to Mrs. Trimmer, with the wrapper which he addressed to her, also an autograph letter of D. C. Thompson relating to the work.—*Catalogue.*]

1903 Garner (T.) A Brief Description of the principal Foreign Animals and Birds now exhiɔiting at Pidcock's Grand Menagerie, second ed., woodcuts, including four, elephant, lion, tiger and zeɔra (on India paper), orig. cf., g. e., 1800, 4to. (235) *Maggs*, 7s.

1904 Garner (T.) Foreign Animals and Birds, another copy, third ed., orig. bds., uncut, 1800, 4to. (236) *Maggs*, 13s.

1905 Hugo (Thomas). Bewick's Woodcuts, impressions of upwards of two thousand wood ɔlocks, with Introduction, etc., orig. cl., L. Reeve, 1870, folio (239) *Spencer*, £1 1s.

1906 Hutton (Charles). Treatise on Mensuration, the diagrams Bewick's first attempts at wood engraving, orig. cf., *Newcastle*, T. Saint, 1770, 4to. (240) *Lewine*, 4s.

1907 Moral Instructions of a Father to his Son, cf. ex., ɔy Rivière, *Newcastle*, T. Saint, 1775, 8vo. (242) *Bruton*, 11s.
[The woodcuts are the earliest productions of Thomas Bewick. A few leaves at end defective and repaired.— *Catalogue.*]

1908 Poems ɔy Goldsmith and Parnell, first ed., fine uncut copy, in the orig. bds. (repaired), Bulmer, 1795, 4to. (247) *Bruton*, £1 6s.

1909 Poems ɔy Goldsmith and Parnell, another copy of the first ed., with a duplicate set of the large woodcuts, printed on satin, cf. ex., g. e., Bulmer, 1795, 4to. (248) *Maggs*, £1 10s.

1910 Roɔinson (Roɔert). Thomas Bewick, his Life and Times, ports. and illustrations, orig. cl., *Newcastle*, 1887, 8vo. (258) *Hobbes*, 13s.

1911. Short Treatise on that useful invention called the Sportsman's Friend, orig. wrappers, uncut, enclosed in a case, *Newcastle* (1800), 8vo. (261) *B. R. Hill*, £1 18s.

1912 Somerville (William). The Chase, large paper, with wood-cuts ɔy T. Bewick, orig. cf., g. e., Bulmer, 1796, 4to. (262) *B. R. Hill*, £1 14s.

1913 Specimens of Wood Engraving, ɔy Thomas and John Bewick, orig. gt. wrapper, *Newcastle*, M. Angus, 1798, 4to. (263) *Barnard*, 8s.

1914 The Dance of Death, from the designs of Holɔein, 52 wood-cuts, engraved ɔy T. and J. Bewick, mor. ex., ɔy Hayday, *Newcastle*, W. Charnley, 1789, 8vo. (266) *Robson*, £1 18s.

1915 The History of Little Goody Two-Shoes [ɔy Oliver Gold-smith], 1796—New Lottery Book of Birds and Beasts for Children (two copies), *Newcastle*, T. Saint, 1771, orig. Dutch bds., together 3 vol., 8vo. (268) *Robson*, £2 10s.

1916 The Ladies' Complete Pocket Book, or Memorandum Repository, for 1778, used ɔy Thomas Bewick during a Tour to Newhaven, York, etc. in 1780 ; a numɔer of the pages are

filled ɔy his diary, and give in detail his programme from
day to day ; these notes are written in pencil, on two pages
is a letter of introduction for himself, written ɔy a Mr.
Vesey ; Bewick evidently gave this pocket ɔook to his son,
Roɔert Elliot, as inside each cover is inscriɔed, " Roɔert
Elliot's ɔook, 1797," in orig. cover, *Newcastle,* T. Saint, 8vo.
(271) *Robson, £4* 10s.
1917 The Life and Adventures of a Fly (? ɔy Oliver Goldsmith),
mor., g. e., 1803—Watts (I.) Divine Songs for the use of
Children, mor., g. e., ɔy F. Bedford (272) *Walford, £1* 18s.
1918 The Seasons, ɔy J. Thomson, first ed. with the engravings ɔy
Bewick, orig. cf., 1805, 8vo. (276) *Appleyard, £1* 1s.
1919 The Vicar of Wakefield, 2 vol. in 1, mor., g. e., by Petit, with
the Milɔank arms, *Hereford,* 1798, 8vo. (278) *Bain, £2* 6s.
1920 Wood Engravings, from a Pretty Book of Pictures for Little
Masters and Misses, or Tommy Trip's History of Beasts
and Birds, printed on one side of the paper, orig. cf., g. e.,
Newcastle, T. Saint, 1779, 8vo. (287) *W. Daniell, £1*
1921 Youth's instructive and entertaining Story-Teller, a choice
collection of Moral Tales, orig. wrapper, uncut, *Newcastle,*
1775.(289) *Walford,* 9s.
1922 Descriptive and Critical Catalogue of Works, illustrated ɔy
Thomas and John Bewick, of Newcastle-upon-Tyne . . .
ɔrief Sketches of their Lives, and Notices of the Pupils of
Thos. Bewick, the text inlaid, and the work extended to
2 vol. roy. 4to. ɔy the insertion of illustrations and woodcuts
from various works ɔy Beilby and Bewick, including The
Chillingham Wild Bull, on thin paper, without the ɔorder,
The remarkaɔle Kyloe Ox (*Newcastle,* 1790), etc., mor.
super ex., 1851, 4to. (290) *Maggs, £8*

[NOVEMBER 26TH, 1909.]

SOTHEBY, WILKINSON & HODGE.

A MISCELLANEOUS COLLECTION.

(No. of Lots, 366 ; amount realised, £674 19s. 6d.)

1923 Ackermann (R.) Microcosm of London, col. plates, 3 vol.,
orig. cf. (1811), 4to. (233) *G. H. Brown, £10* 15s.
1924 Alken (H.) Scraps from the Sketch-ɔook of Henry Alken,
31 col. plates (no title), hf. bd., T. McLean, 1821, oɔlong
folio (317) *Glasse, £3*
1925 Alken (H.) Symptoms of ɔeing Amused, 42 plates, including
an engraved title, T. McLean, 1822—Tutor's Assistant, 6
plates (no title), *ib.,* 1823, the plates col., in 1 vol., oɔlong
folio (318) *Glasse, £5* 15s.

1926 Bull-Fighting. Coleccion de las principales suertes de una Corrida de Toros, graɔada por Luis Fernandez Noseret, front. and 12 col. plates, an extra one, "Vista Interior de la Plaza de Toros de Madrid," added, hf. bd., n. d., oɔlong folio (316) *Parsons, £2* 8s.

1927 Burges (Sir J. B.) Birth and Triumph of Love, port. and plates from designs of the Princess Elizaɔeth, mor., g. e., ɔy Staggemeier, 1796, 4to. (238) *Restall, £5* 5s.

1928 Cabinet of Genius (The), plates in ɔrown, after Shelley, hf. mor., g. e., 1787, 4to. (180) *Reader, £1* 14s.

1929 Cartwright (G.) Journal of Transactions and Events during a residence on the Coast of Laɔrador, port. and charts, 3 vol., cf., *Newark*, 1792, 4to. (139) *H. Stevens, £3* 3s.

1930 Cipriani (G. B.) Collection of Prints after G. P. Cipriani, engraved ɔy R. Earlom, port., engraved title and 49 plates, hf. mor., t. e. g., Boydell, 1789, folio (350) *Spencer, £2* 4s.

1931 Comɔe (William). Life of Napoleon, 30 col. engravings by Geo. Cruikshank, russ., 1817, 8vo. (96) *Shepherd, £5* 15s.

1932 Davenant (Sir Wm.) Gondibert, first 4to. ed., orig. cf., large copy, 1651, 4to. (203) *Dobell*, 10s.

1933 De Bry (J. et Th.) Petits Voyages (India Orientalis), first eds., maps and plates, some leaves loosely inserted, parts i.-x., in 3 vol., vell., sold not suɔject to return, *Francof.*, 1598-1613, folio (323) *Restall, £6*

1934 Dickens (C.) The Pic Nic Papers, first ed., illustrations (the plates spotted), 3 vol., orig. cl., 1841, 8vo. (68) *Spencer, £2*

1935 Dickens (C.) Posthumous Papers of the Pickwick Cluɔ), first ed., 43 illustrations by R. Seymour and "Phiz," specimen wrapper inserted, hf. mor., 1837, 8vo. (17) *Sawyer, £2* 2s.

1936 Edwards (W. H.) Butterflies of North America, col. plates, 2 vol., hf. mor., g. e., *Philad.*, 1868-72, *text reprinted Boston*, 1879-84, 4to. (234) *Quaritch, £6* 2s. 6d.

1937 Essex House Press. Prayer Book of King Edward VII., designs by Ç. R. Ashɔee, one of 400 copies, hf. mor., wooden sides, with clasps, 1903, folio (286) *Bull, £1* 11s.

1938 Feasey (H. J.) Westminster Aɔɔey, 75 plates, hf. parchment, in case, 1899, folio (294) *Walford, £1* 5s.

1939 Fergusson (J.) Tree and Serpent Worship, plates, orig. hf. mor., 1868, imp. 4to. (215) *Gay, £5* 15s.

1940 Foster (J. J.) Miniature Painters, ports., 2 vol., uncut, t. e. g., 1903, folio (340) *Rimell, £2*

1941 Galerie du Palais du Luxemɔourg peinte par Ruɔens et dessinée par le Sig. Nattier, 3 ports. and 22 plates, old cf. gt., *Paris*, 1710, atlas folio (360) *Scotti, £2* 6s.

1942 Gillray (J.) Sixteen Coloured Caricatures respecting Varieties of Weather, and Various Sensations, interleaved with drawing paper, hf. mor., t. e. g., 1800-8 (241) *London, £1* 15s.

1943 Goldsmith (Oliver). The Vicar of Wakefield, 24 col. plates ɔy T. Rowlandson, orig. bds., uncut (10¼in. by 6⅜in), clean and unspotted, Ackermann, 1817, roy. 8vo. (88) *J. Bumpus, £38* 10s.

1944 Green (Val.) History of the City and Suburbs of Worcester, plates, 2 vol., russ., g. e., 1796, 4to. (198) *Luff,* 14s.

1945 Hartshorne (A.) Old English Glasses, illustrations, hf. parchment, uncut, t. e. g., 1897, folio (341) *Parsons,* £2 3s.

1946 Havell (R.) Picturesque Views of Noblemen's and Gentlemen's Seats, 20 col. plates only, 2 parts, 1815-23, roy. folio (321) *Spencer,* £17

1947 Hayley (Wm.) Anecdotes of the Family, Life and Writings of William Hayley, vol. i.-iii. and v., the orig. MS. handwriting of Hayley, port., 3 vol., russ., g. e., n. d., 4to. (169) *Thorp,* £4

1948 Heriot (G.) Travels through the Canadas, map and 27 acquatint plates, cf., 1807, 4to. (220) *Leon,* £1 12s.

1949 Hodgkin (J. E.) Rariora, illustrations, some col., 3 vol., buckram, uncut, t. e. g. (1900), 4to. (248) *Quaritch,* £2 8s.

1950 Holbein (Hans). Imitations of Original Drawings, complete series of 84 col. plates (some mounted), including Holbein and his wife, and miniature ports. of the Dukes of Suffolk, 1 vol. in 2, hf. roan, 1792, atlas folio (306) *W. Daniell,* £21

1951 Indagine (John). The Book of Palmistry and Physiognomy, trans. by Fabian Withers, black letter, woodcuts, mor., g. e. (one leaf defective and mended), *T. Passinger, at the Three Bibles on London Bridge,* 1676, 8vo. (77) *Shepherd,* £1 8s.

1952 Johnson (Dr. S.) Irene, a Tragedy, first ed., cf., 1749, 8vo. (33) *Waters,* 17s.

1953 Johnson (Wm.) Sketches of the Life and Correspondence of Major-Gen. Nathaniel Greene, port. and maps, 2 vol., orig. bds., uncut, *Charlestown,* 1822, 4to. (218) *Fowler,* £2 15s.

1954 Kelmscott Press. Ruskin (John). The Nature of Gothic, orig. vell., *Hammersmith,* 1892, 4to. (231) *D. Evans,* £1 16s.

1955 Lewis (M. G.) Tales of Wonder, first ed., 2 vol., hf. mor., t. e. g., 1801, imp. 8vo. (27) *Thorp,* 15s.

1956 Loudon (Mrs.) The Ladies' Flower Garden of Ornamental Annuals, Greenhouse Plants, Bulbous Plants and Perennials, 4 vol., 1844, etc.—British Wild Flowers, n. d., together 5 vol., col. plates, 4to. (216) *Thorp,* £1 19s.

1957 Maaskamp (E.) Representations of Dresses, Morals and Customs in the Kingdom of Holland, 21 col. plates, *Amsterdam,* 1808, 4to. (240) *Luff,* £2 12s.

1958 Malton (James). Picturesque and Descriptive View of the City of Dublin, maps and 24 col. plates (wanted plan of the city, also plate of arms and view of Chapel Street), unbd., 1794, oblong folio (356) *Nattali,* £7 10s.

1959 Martial Achievements of Great Britain, col. plates after W. Heath (1814)—Naval Achievements of Great Britain, col. plates, 1816, orig. hf. binding (damaged), uncut, 4to. (319) £13 5s.

1960 Mayer (L.) Views in Egypt, with historical observations, etc., col. plates, hf. russ., 1805, folio (353) *Luff,* £1 8s.

1961 Meursius (Joann.) Elegantiae Latini Sermonis, front., mor.,
g. e., *Lugd. Bat.*, 1774, 8vo. (94) *Tregaskis, £1* 10s.

1962 Morris (F. O.) British Birds, col. plates, 6 vol., hf. mor.,
t. e. g., 1870, imp. 8vo. (1) *Bull, £3* 12s. 6d.

1963 Naval MSS. The Original Letter Book of Vice-Admiral
George Darby (d. 1790), containing "Orders Received" and
"Orders Issued" between May 22nd, 1780 and April 6th,
1782, and "Letters Received" and "Letters Wrote" between
August 21st, 1780 and July 7th, 1781, in 2 vol., old cf. (301)
Garland, £8 10s.
[These volumes comprise amongst the ordinary routine
orders: "Secret Instructions for Sailing into Gibraltar,"
the relief of which was accomplished by Admiral Darby in
April, 1781, and others.—ED.]

1964 Newspapers. The Virginia Gazette, Dec. 20, 1775, Dec. 23,
1775, Jan. 10, 1776, Jan. 13, 1776, Jan. 20, 1776, March 2,
1776—Dunlap's Maryland Gazette, March, 1776, April 2,
1776—Royal American Gazette, Feb. 13, 1777—Maryland
Journal, Feb. 25, 1777, and other American Papers down
to 1797' in 1 vol.—Bell's Weekly Messenger from April 12,
1812 to April 25, 1813, in 1 vol., hf. bd., folio (334)
Edwards, £3 5s.

1965 Ottley (W. Y.) Inquiry into the Origin and Early History of
Engraving upon Copper and Wood, LARGE PAPER, illustra-
tions, some in colours, 2 vol., hf. vell., uncut, 1816, folio
(336) *Gay, £1* 15s.

1966 Paris. Tour of Paris, 22 col. plates, including an engraved
title, with descriptions (a leaf of text missing, and one
damaged), hf. bd., label on side, W. Sams, 1824, oblong
folio—Studies from the Stage, 7 perfect plates and 6 im-
perfect ones, hf. bd., with label, *ib.*, 1823, oblong folio (311)
Edwards, £4 17s. 6d.

1967 Perelle (G.) Collections of 178 Views of French Chateaux,
Rome and its Environs, Paris, Versailles, etc., in 1 vol., cf.,
Paris, n. d.—Barlow (F.) Birds and Beasts, 67 plates
engraved by Hollar, Tempest, etc. (wanted plates i. and ii.),
hf. cf., n. d., oblong folio (366) *Parsons, £8* 5s.

1968 Philips (Mrs. Katherine). Poems, first authentic ed., port. by
W. Faithorne, cf., 1667, folio (297) *Luff,* 8s.

1969 Polo (Marco). The Book of Ser Marco Polo, the Venetian,
concerning the Kingdoms and Marvels of the East, by
Col. Yule, port., maps and illustrations, 2 vol., 1903, 8vo.
(106) *Quaritch, £2* 2s.

1970 Portraits des Grands Hommes, Femmes Illustres et Sujets
Mémorables de France, gravés et imprimés en couleurs,
191 ports. and plates, russ., g. e., *Paris*, Blin, *c.* 1792, 4to.
(195) *Leighton, £30*
[Seldom found complete, most copies having been cut up
for the purpose of extra illustration. The plate represent-
ing the Independence of the United States contains three
medallion portraits of Louis XVI., Franklin and Waginston
(*sic*).—*Catalogue.*]

1971 Reynolds (Sir J.) Discourse delivered to the Students of the
 Royal Academy, Dec. 10, 1772, port. of Sir J. Reynolds
 inserted, hf. roan, 1763 (*sic*), 4to. (225) *Maggs*, £2
 [With inscription in Reynolds' handwriting on title-page,
 "To the Rev. Dr. Mason, from the Author."—*Catalogue.*]
1972 Richardson (S.) Novels, ed. by E. M. McKenna, port. and
 plates, 20 vol., hf. bd., 1902, 8vo. (107) *Walford*, £1 18s.
1973 Rowlandson (T.) Loyal Volunteers of London and Environs,
 87 col. plates, clean copy (binding broken), R. Ackermann
 (1799), 4to. (320) *Andrews*, £24 10s.
1974 Rowlandson (T.) Hungarian and Highland Broad Sword,
 24 col. plates, unbd., H. Angelo, 1798-9, oblong folio (312)
 Quaritch, £7 15s.
1975 Roxburghe Club. The Buke of John Maundeville, ed. by
 G. F. Warner, 28 miniatures, reproduced in fac., hf. bd.,
 t. e. g., 1889, imp. 4to. (183) *Quaritch*, £10 15s.
1976 Roxburghe Club. Memoirs of Thomas, Earl of Ailesbury,
 front., 2 vol., hf. bd., uncut, t. e. g., 1890, 4to. (184)
 Quaritch, £5
1977 Roxburghe Club. Le Pelerinage de Vie Humaine, ed. by
 Dr. J. J. Stürzinger, fac. illustrations, hf. bd., uncut, t. e. g.,
 1893, 4to. (185)—Le Pelerinage de l'Ame, de Guillaume de
 Deguileville, ed. by Dr. J. J. Stürzinger; fac. illustrations,
 hf. bd., uncut, t. e. g., 1895, 4to. (186)—Le Pelerinage
 Jhesucrist, de Guillaume de Deguileville, ed. by Dr. J. J.
 Stürzinger, fac. illustrations, hf. bd., uncut, t. e. g., 1897, 4to.,
 together 3 vol. (187) *Quaritch*, £33 10s.
1978 Roxburghe Club. The Pilgrimage of the Life of Man,
 Englished by John Lydgate, from the French of Guill. de
 Deguileville, ed. by Furnivall and Locock, hf. bd., uncut,
 t. e. g., 1905, 4to. (188) *Quaritch*, £3 10s.
1979 Roxburghe Club. Titus and Vespasian, or the Destruction
 of Jerusalem, ed. by J. A. Herbert, fac. illustrations, hf. bd.,
 uncut, t. e. g., 1905, 4to. (189) *Quaritch*, £3 12s.
1980 Roxburghe Club. The Academy of Armory, by Randle
 Holme, ed. by J. H. Jeyes, fac. illustrations, vol. ii., hf. bd.,
 uncut, t. e. g., 1905, folio (190) *Quaritch*, £6 15s.
1981 Seebohm (Henry). Eggs of British Birds, port. and col.
 plates, *Sheffield*, 1896, imp. 8vo. (2) *Parsons*, £1
1982 Serres (D. and J. T.) Liber Nauticus, and Instructor in the
 Art of Marine Drawing, plates, a few in colours, in two
 parts, orig. hf. cf. (damaged), 1805, folio (314)
 Spencer, £5 10s.
1983 Shakespeare (W.) Works, ed. by W. E. Henley, port., 10
 vol. in 40 parts, orig. bds., uncut, 1901-4, folio (288)
 Sawyer, £2 14s.
1984 Shakespeare (W.) Reproduction in Facsimile of the Second
 Folio of 1632, port., uncut, Methuen, 1909, folio (289)
 D. Evans, £1 17s.
1985 Shakespeare (W.) Reproduction in Facsimile of the Third
 Folio of 1664, port., uncut, Methuen, 1905, folio (290)
 Bull, £1 13s.

1986 Shakespeare (W.) Reproduction in Facsimile of the Fourth
Folio of 1685, port., uncut, Methuen, 1904, folio (291)
Dobell, £1 10s.

1987 Shaw (G. B.) Plays, Pleasant and Unpleasant (three Plays
Unpleasant, and four Pleasant Plays), port., 2 vol., uncut,
t. e. g., 1898, 8vo. (51) *Spencer*, 18s.

1988 Shaw (G. B.) The Quintessence of Ibsenism, orig. cl., t. e. g.,
1891, 8vo. (53) *Thorp*, 12s.

1989 Singleton (E.) Furniture of our Forefathers, illustrations,
2 vol., hf. parchment, uncut, t. e. g., 1901, 4to. (250)
Graystone, £1 13s.

1990 Smith (J. T.) Antiquities of Westminster, plates (many in
colours), orig. bds., uncut, 1807, roy. 4to. (239)
Garland, £1 15s.

1991 Spix (J. B. de). Animalia Nova sive Species Novae Lacertarum,
24 col. plates, mor., g. e., *Monachii*, 1825, 4to. (236)
Maggs, £3 8s.

1992 Spix (J. B. de). Animalia Nova sive Species Novae Testu-
dinum et Ranarum, 39 col. plates, roan, g. e., *Monachii*,
1824, 4to. (237) *Maggs*, £3 5s.

1993 Spix (Jean de). Simiarum et Vespertilionum Brasiliensium
Species novae, 38 col. plates, mor., g. e., *Monachii*, 1823,
imp. folio (322) *Maggs*, £6 15s.

1994 Stirling (William). Annals of the Artists of Spain, first ed.,
ports. and engravings, 3 vol., mor. ex., 1848, 8vo. (67)
Maggs, £2 18s.

1995 Thackeray (W. M.) The Paris Sketch Book, first ed. (the
plates spotted), 2 vol., orig. cl., J. Macrone, 1840, 8vo. (69)
J. Bumpus, £5 17s. 6d.

1996 Triggs (H. I.) Formal Gardens in England and Scotland,
125 plates, hf. mor., t. e. g., 1902, folio (292) *Hill*, £2 8s.

1997 Turner (J. M. W.) Liber Studiorum, front. and 70 plates,
engraved by C. Turner, hf. bd., 1812-19, oblong folio (324)
Rimell, £10

1998 Yeatman (J. P.) Feudal History of the County of Derby,
ports. and illustrations, 5 vol. in 9 (wanted vol. iv., section 6),
hf. mor., uncut, 1886-1907, roy. 8vo. (3) *Harding*, £2 12s.

SOTHEBY, WILKINSON & HODGE.

A PORTION OF THE LIBRARY OF A BARONET, DECEASED, AND OTHER PROPERTIES.

(No. of Lots, 536 ; amount realised, £3,174 8s. 6d.)

(a) The Baronet's Library.

1999 Aeneas Silvius. Le Remede damour . . . trāslate de latī en frācois p̄ maistre Albī des auenelles, lit. goth., large woodcut device of Jehan Janot, mor., g. e., ɔy Duru, *Nouuellement imprime a Paris par la Veufue feu Jehan iannot* [*s. d. vers* 1505], sm. 4to. (1) *Leighton*, £10 5s.

[A very rare piece consisting of 12 leaves, written in French verse, with the Latin text printed in the margin, on three pages in rĕd, on the others in ɔlack.—*Catalogue.*]

2000 Æsop. Esopi appologi siue mythologi cum quibusdam carminum et fabularum additionibus Seɔastiani Brant, gothic letter, woodcuts, vell. (wanted ɔlank leaf at end), *Basileæ opera et impensa Jacobi de Phortzheim*, 1501, folio (2) *Ellis*, £33 10s.

2001 Albanés (J. H.) Gaḷḷia Christiana Novissima, Histoire des Archevéchés, Évêchés et Aɔɔayes de France, cuts, 3 vol., hf. mor. ex., *Montbéliard*, 1899-1901, roy. 4to. (3) *Lemallier*, £1 7s.

2002 Aldinus (Toɔias). Exactissima descriptio Rariorum quarundam Plantarum que continentur in Horto Farnesiano, engravings of flowers and herɔs, new vell., g. e., *Romae, typis J. Mascardi*, 1625, folio (4) *Quaritch*, £4

2003 Alector (ou le Coq). Histoire Faɔuleuse, mor. super ex., ɔy Belz-Niedrée, arms of Baron Seillière, *Lyon*, Pierre Fradin, 1560, sm. 8vo. (5) *Leighton*, £2 10s.

2004 Amadis de Gaule. Les vingt-quatres livres d'Amadis de Gaule, mis en Francoys par le Seigneur des Essars, Nicolas de Herberay et autres—Tresor de tous les livres d'Amadis de Gaule, contenant les Harangues, etc., together 25 vol., old French mor., g. e., *Paris et Lyon*, 1557-1615, 22 vol. 16mo., 3 vol. 8vo. (6) *Bloomfield*, £29

[These 25 volumes form a set of the ɔooks of Amadis, such as is rarely found complete. The title and a few other leaves of the first volume have ɔeen ɔadly washed, and a few headlines shaved.—*Catalogue.*]

2005 Amadis de Gaule. Thresor des livres d'Amadis de Gaule, mor., g. e., ɔy Chamɔolle-Duru, *Lyon*, Gaɔriel Cotier, 1560, sm. 8vo. (7) *Tregaskis*, £1 15s.

2006 Amɔoise (Michel 'd). Les côtrepistres d'Ouide (in verse), woodcuts, mor., g. e., ɔy Trautz-Bauzonnet, *Paris* [*par Denis Janot*], 1542, sm. 8vo. (8) *Leighton*, £4 10s.

2007 Amico (Bernardino). Trattato delle Piante & Immagini de Sacri Edifizi di Terra Santa disegnate in Ierusalemme, engravings by Callot (M. 455-489), (plate 18 with figure emptying chamber from Pilate's window), mor., g. e., by C. Smith, *In Firenza*, 1620, 4to. (9) *Tregaskis*, £3 5s.

2008 Amman (Jost). Cleri totius Romanae Ecclesiae subiecti, seu, Pontificiorum Ordinum omnium omnino utriusque sexus, habitus, artificiosissimis figuris expressi, etc., first ed., 100 woodcuts of ecclesiastical costume, mor. ex., g. e., *Francoforti sumptib. S. Feyrabendij*, 1585, sm. 4to. (10)
Quaritch, £4 7s. 6d.

2009 Amman (Jost). Künstliche und Wolgerissene figuren der fürnembsten Evangelien, durch gantze Jar, sampt den Passion und Zwölff Aposteln, 3 large woodcuts and 78 smaller ones, each with verses in Latin and German, mor., g. e., by Hardy-Mennil, *Franckfurt am Mayn*, 1579, sm. 4to. (11) *Quaritch*, £8 15s.

2010 Anthonius de Rampegolis. Figurarum Biblie opus conducibile et perutile, lit. goth., woodcuts (top of last leaf defective), mor., g. e., by L. Broca, *Colonie*, 1511, sm. 8vo. (12)
Ellis, £3 12s.

2011 Apianus (Petrus). Astronomicum Caesareum, woodcuts, diagrams, coats-of-arms and volvelles by Œstendofer, some of the pages having as many as seven or eight of these moveable discs attached to them, all coloured by hand at the time (not subject to return), hf. cf., y. e., *Ingoldstadii*, 1540, large folio (13) *Wesley*, £18

2012 Apollonius Rhodius. L'Expédition des Argonautes, par J. J. A. Caussin, old mor., g. e., *à Paris, l'an V.* [1797], 8vo. (14)
Leighton, £1 3s.

2013 Archives de la Commission des Monuments historiques publiées par ordre de M. Achille Fould, architectural plates after Viollet-le-Duc and others, 4 vol., hf. mor., t. e. g., *Paris*, Gide, *s. d. (vers* 1860), imp. folio (15) *Quaritch*, £5 10s.

2014 Art (L') Militaire François, pour l'infanterie, avec un petit abrégé de l'Exercise comme il se fait aujourd'huy, engraved title and 85 full-page plates of military exercises and positions, cf., g. e., with the Seillière arms, *Paris, P.* Giffart, 1696, sm. 8vo. (16) *Quaritch*, £6 5s.

2015 Aubery (Le Sieur). Mémoires pour l'Histoire du Cardinal Duc de Richelieu, 5 vol., vell., *Cologne*, 1667—Histoire du Cardinal Mazarin, 4 vol., old cf. gt., from the Lamoignon library, *Amst.*, 1751, together 9 vol., 12mo. (17)
Maggs, £3 5s.

2016 Baif (Jan Antoine de). Evvres en Rime, *à Paris, pour Lucas Breyer*, 1573—Les Amovrs, *ib.*, 1572—Les Jeux, *ib.*, 1573—Les Passetems, *ib.*, 1573, 4 vol., margins ruled in red, mor., floral wreath in gilt on the sides, g. e., by Lortic, from the Lakelands library (£17 10s.), with ex-libris, 8vo. (18)
Quaritch, £26

2017 Bayfius (Lazarus). Annotationes in L. II. de Captivis, etc. in quibus tractatur De Re Navali, etc., first ed., large woodcuts,

some ɔearing the device of the Lorraine cross (Geoffroy
Tory), contemp. cf. covered with gold stars, etc. (ɔack
repaired), *Parisiis,* R. Stephanus, 1536, sm. 4to. (20)
 Quaritch, £8 10s.

2018 Bemɔo (Pietro). · Les Azolains de Monseigneur Bemɔo de la
 nature d'amour, par Jean Martin, mor., g. e., ɔy Duru,
 Lyon, Philiɔert Rollet, 1552, sm. 8vo. (22) *Dobell, £1* 14s.

2019 Bergier (Nicholas). Histoire des Grands Chemins de l'Empire
 Romain, front. ɔy Picart, port. and folding plates, 2 vol.,
 French cf., g. e., *à Bruxelles,* 1728, 4to. (23) *Symes,* 17s.

2020 Beza (Theodorus). · Icones, id est, Verae Imagines Virorum
 doctrina simul et pietate illustrium, first ed., 39 woodcut
 ports. and 44 cuts of emɔlems, cf., g. e. *(Genevae) apud
 J. Laonium,* 1580, sm. 4to. (25) · *Ellis, £1* 14s.

2021 Biɔle Cuts. The true and lyuely Historyke Purtreatures
 of the Woll Biɔle, 194 woodcuts ɔy Bernard Salomon, with
 quatrains ɔeneath in English ɔy Peter Derendel, mor., g. e.,
 ɔy Trautz-Bauzonnet, *At Lyons, by Jean of Tournes,* 1553,
 sm. 8vo. (26) *Sabin, £10* 15s.
 [A small wormhole through some leaves mended, and a
 few letters restored in facsimile.—*Catalogue.*]

2022 Biɔliothèque Poëtique, ou Nouveau Choix de plus ɔelles
 pièces de vers en toute genre [par Le Tort-de-la-Morinière],
 front., 4 vol., hf. mor., g. e., *à Paris, chez Briasson,* 1745,
 4to. (27) *Dobell, £1*

2023 Birac (Le Sieur de). Les Fonctions du Capitaine de Cava-
 lerie, & les principales de ses officiers suɔalternes, cf. gt.,
 ɔy Koehler, *Jouxte la Copie imprimée a Paris, chez Gabriel
 Quinet,* 1675, sm. 8vo. (28) *Quaritch, £1* 3s.

2024 Blarrorivo (Petrus de). Insigne Nanceidos opus de Bello
 Nanceiano, printer's device on x 6, ornamental initial on the
 last leaf, and upwards of 30 woodcuts, mor. ex., g. e., ɔy F.
 Bedford, *Impressum in celebri Lothoringie pago divi
 Nicolai de Portu, per Petrum Jacobi,* 1518, folio (29)
 Leighton, £23
 [A poem of great historic interest, descriptive of the
 ɔattle and siege of Nancy by Charles the Bold, Duke of
 Burgundy, who lost his life ɔefore that town, Jan., 1477.
 The volume is also remarkaɔle as one of the earliest known
 specimens of printing at St. Nicholas du Port, a town in
 Lorraine, which was afterwards destroyed in the Thirty
 Years War.—*Catalogue.*]

2025 Blason (Le) des armes, auec les armes des Princes & Seig-
 neurs de France, lít. gotf., woodcut heraldic shields and
 printer's device on last leaf emɔlazoned by hand, cf. ex.,
 Lugduni ex officina Petri de sancta Lucia, alias le Prince,
 1542, sm. 8vo. (30) *Leighton, £4*
 [Scarce edition of this treatise on heraldry, attriɔuted to
 Sicille, herald to King Alphonso of Aragon.—*Catalogue.*]

2026 Boillot (Joseph). Nouveaux Pourtraitz et Figures de Termes
 pour user en l'architecture, engraved title, port. and plates,

mor., g. e., ɔy Rivière, *Imprime a Lēgres par Iēha des prey* [1592], folio (31) *Maggs, £8*

2027 Bonarelli (Prospero). Il Solimano Tragedia, first ed., 5 douɔle-page plates ɔy Callot (M. 434-439), vell., *Firenze,* 1620—Peri (G. D.) Fiesole Distrutta, port. of author and front. of "La ɔelle jardinière," ɔoth ɔy Callot (no printed title), old mor., g. e., *ib.*, 1619, sm. 4to. (33) *Tregaskis, £2* 15s.

2028 Bossuet (J. B., Evêque de Meaux). Maximes et Reflexions sur la Comedie, mor., g. e., *Paris, chez Jean Anisson,* 1694, 8vo. (34) *Maggs, £1* 11s.

2029 Bouchet (Jean). Sensuyt Lamoureux trāsy sans espoir, lit. 𝔤𝔬𝔱𝔥., title in red and ɔlack aɔove a large woodcut, printer's device on last leaf, and 8 other woodcuts (some corners repaired), mor., gilt wreath on sides, g. e., ɔy Trautz-Bauzonnet, *Imprime nouvellement a Paris, par la veufue feu Jehan trepperel* [*s. d.*], sm. 4to. (35) *Leighton, £8* 10s.

2030 Brunet (J. C.) Manuel du liɔraire, 6 vol., *Paris,* 1860-65— Dictionnaire de Géographie, *ib.*, 1870—Supplément, par MM.P. Deschamps et G. Brunet, 2 vol., *ib.*, 1878-80, hf. mor., t. e. g., together 9 vol., 8vo. (37) *Sabin, £10* 5s.

2031 Busbequius (A. G.) Amɔassades et Voyages en Turquie et Amasie, par S. G(audon), old French mor., g. e., arms of J. J. Charron, Marquis de Menars, *a Paris, chez Pierre David,* 1646, 8vo. (38) *Quaritch, £5* 10s.

2032 Calendrier (le grand) et compost des ɔergers, compose par le Berger de la grand montagne, avec le compost naturel reformé selon le retranchement des dix jours, par le Pape Grégoire III., woodcut on title, upwards of 50 woodcuts, mor., g. e., by Chamɔolle-Duru, *Troyes, chez Jacques Oudot* [1705], 4to. (39) *Leighton, £4* 15s.

2033 Callot (Jacques). Capitano de Baroni, the series of 25 engraved plates (M. 685-709) in the first state, ɔefore the numɔers, mounted in a volume, cf. ex., 4to. (40) *Bloomfield, £3* 5s.

2034 Callot (J.) Les Images de tous les Saincts et Saintes de l'année (Le Blanc, 178-796), plates, old mor., g. e., from the Beckford liɔrary, *Paris, chez Israel Henriet,* 1636, folio (41) *Maggs, £6* 5s. [The collation of this copy is as follows : Engraved titles, 2 leaves ; printed leaf of dedication ; 119 leaves, containing 476 plates, proofs ɔefore the inscriptions ; 3 leaves, containing 12 plates of the moveaɔle feasts, with inscriptions in Latin and French.—*Catalogue.*]

2035 Caron (P. S.) Collection de différens ouvrages anciens, poésies et facéties, reimprimés par ses soins, avec la suite imprimée aux frais de M. de Montaron, some in 𝔤𝔬𝔱𝔥𝔦𝔠 𝔩𝔢𝔱𝔱𝔢𝔯, 36 pieces ɔound in 13 vol., cf. and hf. cf. (*Paris,* 1798-1830), sm. 8vo. (44) *Gambold, £4* [A complete set of this collection of reprints, of some of which only 20 copies, of others only 25, 56 or 60 copies

were printed. A full list of titles, with dates of puplication, is given in the catalogue.—ED.]

2036 Carter (Charles). The Complete Practical Cook, 60 copper-plates, mor. ex., py Petit, the Seillière arms, 1730, 4to. (45) *Maggs,* £5 2s. 6d.

2037 Catel (Guillaume). Histoire des Comtes de Tolose, 10 engraved plates, old cf., with arms of J. A. de Thou and his second wife, Gasparde de la Chastre, and the small stamp of his first arms on the pack, MS. notes in the margins and a leaf of old MS. additions inserted, *Tolose,* Pierre Bosc, 1623, folio (47) *Dobell,* £2 7s. 6d.

2038 Cervio (Vincenzo). Il Trinciante, pest ed., woodcuts and large folding plate of knives and forks, mor., g. e., by Champolle-Duru, *In Roma,* 1593, 4to. (49) *Leighton,* £4

2039 [Champgrand (Goury de).] Traité de Venerie, et de Chasses, folding and other plates, 2 parts in 1 vol., mor., g. e., py Hardy, *Paris,* Herissant, 1769, 4to. (50) *Quaritch,* £5

2040 Champier (Symphorien). Le recueil ou croniques des hys-toires des royaulmes daustrasie, lit. gotf., woodcuts (wormed), old cf., from the Lakelands library (£7), *Venun-datur in vico mercuriali apud Lugdunum in officina Vin-centii de portunariis* [*s. a. c.* 1510], folio (51) *Leighton,* £56
[The first issue of this pook, with the Epistle of Jean le Maire on the last leaf, followed py verses in praise of Champier.—*Catalogue.*]

2041 Champier (S.) Les grans croniques, lit. gotf., woodcuts (some plank margins mended), mor., g. e., py F. Bedford, *Nouuellemet imprimees a Paris pour Jehan de la Garde,* 1516, folio (52) *Tregaskis,* £34
[This copy contained a folding genealogical table of the Kings of France from St. Louis to Charles VIII., not mentioned py Brunet.—*Catalogue.*]

2042 Chapelain (Jean). La Pucelle, ou la France delivrée, Poëme Heroique, front. and plates, mor. ex., douplé, g. e., py Bauzonnet-Trautz, *Suivant la Copie imprimée a Paris* [*Hollande,* Elzevier], 1656, 12mo. (53) *Quaritch,* £3

2043 Chartier (Alain). Les Œuvres, title with Galliot du Pré's device, woodcuts, pound in 2 vol., old mor., g. e., from the La Vallière collection, *Imprimees a Paris p maistre Pierre vidoue, pour Galliot du pre,* 1529, sm. 8vo. (54) *Quaritch,* £30 10s.

2044 Chifflet (J. J.) Insignia Gentilitia Equitum Ordinis Velleris Aurei—Le Blason des Armoiries de tous les Chevaliers de l'Ordre de la Toison d'Or, engraved front., veau fauve, r. e., arms and monogram of President de Thou and his wife, Gasparde de la Chastre, from Mr. Beckford's library, with his MS. notes on fly-leaf, *Antv. ex off. Plantiniana B. Moreti,* 1632, 4to. (56) *Quaritch,* £3 10s.

2045 [Choisy (l'Abbé de).] Histoire de Madame la Comtesse des Barres à Madame la Marquise de Lampert, mor. gt., uncut, py Hardy-Mennil, *à Bruxelles, chez François Foppens,* 1736, sm. 8vo. (58) *Lemallier,* £1 8s.

2046 Claudin (A.) Histoire de l'Imprimerie en France au XV^e et
au XVI^e siècle, 3 vol., facs. of types, etc., some illuminated,
unbd., in portfolios, as issued, *Paris*, 1900-1904, folio (59)
Leighton, £13 15s.
2047 Clemens Trelaeus (Nic.) Austrasiae Reges et Lotharingiae
Duces, nativis Iconibus, 63 medallion ports. ɔy P. Woeiriot,
cf., g. e., *Coloniae*, 1619, sm. 4to. (61) *Ellis,* £1 1s.
2048 Coligny. Epicedia illustri heroi Caspari Colignio . . . ɔeato
Christi Martyri, woodcut port. of Coligny (waterstained), hf.
mor., *s. l. et a.*, 4to. (63) *Symes,* £2 8s.
[On the title-page is written, "Dono D. V. TH. B."—
Théodore de Bèze, the reformer.—*Catalogue.*]
2049 Collection de Textes pour servir à l'étude et à l'enseignement
de l'histoire, 40 vol., uncut, *Paris*, 1886-1907, 8vo. (64)
Lemallier, £2 2s.
2050 Columna (Faɔius). Plantarum aliquot historia, éditio
princeps, engravings within ornamental ɔorders, "Ex liɔ :
Roɔ: Gray. collegii med Lond : Socii, 1695" on title, old
mor., g. e., *Neapoli*, 1592, sm. 4to. (66) *Quaritch,* £3 3s.
2051 Commines (Philippe de). Cronique & hystoire, lit. 𝔤𝔬𝔱𝔥., first
ed., title within architectural ɔorder (mended and edges
shaved), ornamental capitals, printer's device on last leaf,
mor. ex., by F. Bedford, *Achevee dimprimer pour Galliot
du pre . . . Paris*, 1524, folio (67) *Lemallier,* £10
2052 Commines (Philippe de). Croniques du Roy Charles
huytiesme . . . lit. 𝔤𝔬𝔱𝔥., first ed., title printed in red and
ɔlack, over printer's device, within woodcut ɔorder, wood-
cuts, and ornamental capitals, cf., g. e., ɔy S. Kaufmann,
*Et furēt achevez dimprimer . . . pour maistre Enguillebert
de Marnef . . . Paris*, 1528, folio (68) *Quaritch,* £13
2053 Commines (P. de). Memoires, LARGE PAPER, ports., plates,
head and tailpieces, and vignettes, fine copy, 4 vol., mor.
ex., by F. Bedford, *Londres et Paris*, 1747, 4to. (69)
Parsons, £7 5s.
[Inserted in this copy is the scarce series of portraits
of celeɔrities puɔlished by Odieuvre. It also contains the
dedication to, and portrait of, Marshal Saxe, which were
suppressed in most copies.—*Catalogue.*]
2054 Conqueste (La) que fit le grant Roy Charlemaigne es
Espaignes, Avec les noɔles prouesses des douze pers de
France & Aussi celles de Fieraɔras, 𝔤𝔬𝔱𝔥𝔦𝔠 letter, upwards
of 25 woodcuts, mor., g. e., ɔy Trautz-Bauzonnet, *Imprime
a Lyon par Pierre de saincte Lucie dit le Prince*, 1552, sm.
4to. (70) *Leighton,* £21 10s.
2055 Coustumes de la Prevosté et Vicomté de Paris, mises et
redigees par escrit, printed upon vellum, old cf., from the
Hopetoun liɔrary, *A Paris, chez Jaques du Puis*, 1580, 4to.
(71) *Quaritch,* £12
2056 Coustumes generalles du ɔailliage Damyēs, avec celles des
preuostez de Monstroeul, Beauquesne, Foulloys, sainct
Ricquier, Doullens et Beauuoises, lit. 𝔤𝔬𝔱𝔥., mor., g. e., ɔy

Chamɔolle-Duru, *Imprimees pour Jehan caron demourant audit lieu Damyens*, 1546, sm. 8vo. (72) *Lemallier*, £9 5s.

2057 Crashaw (Richard). Steps to the Temple, first ed., old writing on title and ɔlank leaf ɔefore it, short copy (one or two margins cut into), mor. ex., by Morrell, *Printed by T. W. for Humphrey Moseley*, 1646, 12mo. (73) *Dobell*, £9

2058 Cronica cronicarum. Abbrege et mis P figures descētes et Rondeaulx, cōtenās deux parties principalles, lit. goth., woodcuts, mor. janseniste, gilt gauffré edges, by Trautz-Bauzonnet, *Imprime a Paris par Frācois Regnault* [*s. d.* 1532], 4to. (74) *Ellis*, £11 5s.

2059 D'Arfeville (Nicolay). La Navigation du roy d'Ecosse Iaques Cinquiesme du nom, autour de son Royaume, etc., with the rare folding map of Scotland and woodcut diagrams, mor., g. e., by Koehler, *A Paris, chez Gilles Beys*, 1583, 4to. (75) *Quaritch*, £27
 [This copy contained ɔetween folios 25 and 26 a leaf with a woodcut diagram on the recto, and the verso ɔlank, which is not mentioned ɔy Brunet. From the liɔraries of Sir W. Tite and Baron de la Roche Lacarelle.—*Catalogue*.]

2060 De Bouret (Roussel). Coutumes générales d'Artois, 2 vol., old mor., g. e., arms of Réné-Charles de Maupeou, Chancellor of France, *Paris*, Chenault, 1771, 8vo. (76) *Quaritch*, £8

2061 [De Brégy (Mme.)] Les Lettres et Poësies de Madame la Comtesse de B., mor., g. e., ɔy Duru, *A Leyde, chez Antoine du Val*, 1666, sm. 8vo. (77) *Ellis*, £1 6s.

2062 Delisle (Léopold). Le Caɔinet des Manuscrits de la Biɔliothèque impériale, 4 vol. (the fourth volume consisting of 51 plates), *Paris*, 1868-81, folio (80) *Quaritch*, £2 10s.

2063 De l'Orme (Philiɔert). Le premier tome de l'Architecture de Philiɔert de l'Orme, first ed., architectural woodcuts, mor., g. e., *à Paris, chez Federic Morel*, 1567, folio (83)
Quaritch, £7

2064 De l'Orme (Philiɔert). Nouvelles Inventions pour ɔien ɔastir et a petits fraiz, first ed., woodcuts, mor., gilt centre-pieces, g. e., ɔy Lortic, from the Didot liɔrary, *Paris*, 1561, folio (84) *Quaritch*, £7 15s.

2065 De Manne (E. D.) Galérie historique des portraits des Comediens des Troupes de Voltaire, de Talma, et de Nicolet, 111 ports., 3 vol., red mor. ex., g. e., by Chambolle-Duru, *Lyon*, N. Scheuring, 1861-69, 8vo. (85)
Maggs, £4 4s.

2066 [Des Hayes (Louis).] Voiage de Levant, plates, orig. vell., g. e., *à Paris, chez Adrian Tavpinart*, 1624, 4to. (87)
Ellis, £1 10s.

2067 D'Hautefort (Ch.-V.) Coup-d'œil sur Lisɔonne et Madrid en 1814, cf., arms of the Duchesse de Berri, *Paris*, 1820, 8vo. (88) *Ellis*, 17s.

2068 Dodonaeus (Rembertus). De Frugum Historia, woodcuts of grain and plants, modern cf., g. e., *Antv.*, J. Loeus, 1552, sm. 8vo. (89) *Ellis*, £2

2069 Dodonæus (Rembertus). Stirpium Historiæ, woodcuts of

plants, old cf. (repaired), *Antverpiae, ex officina Plantin-
iana*, 1616, folio (90) *Ellis, £1* 8s.
2070 Dodoens (Rembert). A Niewe Herball, **black letter**, first ed.,
woodcuts of plants, and printer's device on last leaf, old cf.,
from the Ashburnham library (*£17*), *Antwerpe by me Henry
Loë, and are to be solde at London in Powels Churchyarde,
by Gerard Dewes*, 1578, sm. folio (91) *Ellis, £20* 10s.
2071 Dodoens (R.) A New Herball (second ed.), **black letter**
(corners of last few leaves spotted), mor. ex., *Imprinted at
London by Ninian Newton*, 1586, sm. 4to. (92) *Wesley, £5*
2072 Dodoens (R.) Histoire des Plantes, cuts of flowers and
herbs, one or two only touched with colour, vell., *Anvers*,
Jean Loë, 1557, folio (93) *Wesley, £5*
2073 Dolet (Etienne). A Collection of Books written or printed
by, or relating to Etienne Dolet, who was burnt as a heretic
at Lyons in 1546 ; his books also were condemned to be
burnt, hence their rarity, 8vo. and 4to. (94—138)
Quaritch, £153
[This collection, a description of which occupies five
pages of the catalogue, was sold in one lot for the sum
named. It included the late Chancellor Christie's "Etienne
Dolet, the Martyr of the Renaissance," and the same
author's "Bibliography of the Books written, edited or
printed by Etienne Dolet," to which reference is made on
all questions relating to Dolet and his works.—ED.]
2074 Douland (John, Lutenist). Andreas Ornithoparcus his
Micrologus, or Introduction, musical notation, fine copy,
mor., g. e., by Rivière and Son, T. Adams, 1609, sm. folio
(141) *Quaritch, £31*
2075 Dürer (Albrecht). Apocalipsis cū Figuris, original set of
these wood engravings (Bartsch 60-75), all, except the last,
with Latin text on back, mounted on cardboard and strongly
bound, in 1 vol., hf. mor., g. e., by Rivière and Son, *Nurn-
berge p Albertum Dürer pictorem*, 1511, folio (142)
Leighton, £55
2076 Dürer (A.) [Institutiones Geometricæ] Albertus Durerus
Nurembergensis pictor huius etatis celeberrimus, versus è
Germanica lingua in Latinam, first Latin ed., woodcuts,
diagrams and alphabets, large copy, modern vell., *Lutetiæ
apud Chr. Wechelum*, 1532, folio (143) *Quaritch, £4* 5s.
2077 Duret (Claude). Histoire admirable des plantes et herbes,
woodcuts, cf. ex., *Paris*, Nic. Buon, 1605, sm. 8vo. (144)
Wesley, £1 14s.
2078 Dutuit. La Collection Dutuit, Livres et Manuscrits (one of
350 numbered copies), woodcuts and coloured reproductions
of choice bindings, miniatures, etc., sur papier de chine,
vell., uncut, *Paris*, Rahir & Cie, 1899, roy. folio (145)
Quaritch, £3 15s.
2079 Dyablerie (La petite) dōt lucifer est le chef, et les mēbres
sōt tous les ioueurs iniques et pcheurs reprouuez ītitule
Leglise des mauuais, **lit. goth.**, woodcuts on title, on G 2,
and on verso of last leaf, mor., doublé, g. e., by Chambolle-

9—2

Duru, *Imprime à Paris par la Veufne feu iehan trepperel*
[*s. d.*], sm. 8vo. (146) *Leighton,* £12 15s.
[This copy had a folding engraving of the Devil playing
cards with a Turk, a Jew and soldier inserted, and on the
last leaf MS. notes ɔy M. Beaupré and Baron Pichon.—
Catalogue.]

2080 Effigies (Les) des Roys de France, tant antiques que
modernes, orig. ed., 62 half-length ports., old cf., *On les
vend à Paris, en la rue de Montorgueil, au bon Pasteur,
s. d.* [1565], 4to. (148) *Quaritch,* £56
[Unknown to Brunet, though he descriɔes two later
.editions of this series of portraits puɔlished without date
in 1567. This ɔook consists of title, ɔearing a large cut
of the Royal arms of France, one leaf ; "au lecteur salut,"
one leaf ; "Sonnet, au Roy Charles IX.," and 62 full-page
woodcut portraits, 32 leaves (A-G in fours, H 6 leaves).
Each page, including the title, is enclosed within an orna-
mental woodcut ɔorder, and ɔeneath each portrait is the
name of the king, length of his reign, etc., but otherwise
there is no text to the volume. The date is mentioned in
the address to the reader.—*Catalogue.*]

2081 Estienne (Henri). Traicte de la conformité du language
François auec le Grec, first ed., mor., janseniste, g. e., *s. l. n. d.*
[*Genèva, vers* 1565], sm. 8vo. (153) *Quaritch,* £4 5s.
[This edition contains the several passages afterwards
suppressed, and among others that directed against the
Pope. At the end is an address to the reader, finishing
with a passage on the orthography of the ɔook, which does
not appear in suɔsequent editions.—*Catalogue.*]

2082 Estienne (Charles). De Re Hortensi libellus, mor., janseniste,
g. e., ɔy Trautz-Bauzonnet, from. the Yemeniz collection,
Lutet. ex off. Rob. Stephani, 1545, sm. 8vo. (154)
 Quaritch, £3 3s.

2083 [Etat de la Terre sainte, en provençal.] [Fol. 1] O creu
sancta de gran valor que sostenguist mon deu e senyor ;
[fol. 4] Aquest es vn tref lat : lo qual son trames per fra
Johā palmer de la terra sancta de Jherusalem. Deo gracias,
lit. 𝔤𝔬𝔱𝔥., woodcut of the Crucifixion on A 1, and large wood-
cut of the Coronation of the Virgin on last leaf, hf. vell.,
*Emprimit a tholosa a despesas de Johan perera librater en
lany,* 1508, sm. 4to. (156) *Leighton,* £12 10s.
[This tract of four leaves, without title, is attriɔuted ɔy
M. Claudin to the press of Jean Faure.—*Catalogue.*]

2084 Evelyn (John). Sylva, fourth ed., port. by Nanteuil, old cf.,
1706, folio (157) *Dobell,* 16s.

2085 Evelyn (J.) Sylva, port. and plates, 2 vol., russ. gt., *York,*
1776, 4to. (158) *Ellis,* 11s.

2086 Extraict de toutes les ordonnāces Royaulx, desquelles on se
peut ayder, Et qui sont necessaires a ceulx qui frequētent
les cours Royalles ressortissans en Parlement, lit. 𝔤𝔬𝔱𝔥.,
mor., g. e., by Chamɔolle-Duru, *Et sont a vendre a Poictiers*
[*s. d.* 1514], sm. 8vo. (159) *Ellis,* £2 14s.

2087 Fauchet (Claude). Recueil de l'Origine de la langue et poesie Françoise, first ed., mor., g. e., *Paris, par Mamert Pattison*, 1581, sm. 4to. (160) *Ellis, £2* 10s.

2088 Féletz (Ch. M. de). Mélanges de Philosophie, d'Histoire et de Littérature, LARGE PAPER, 6 vol., hf. mor., t. e. g., *Paris*, 1828-30, 8vo. (161) *Tregaskis, £5* 7s. 6d.
[Inserted in this copy are 260 portraits of various personages mentioned in the work, many of which are in proof state.—*Catalogue.*]

2089 Forget (Pierre). Les Sentimens Universels, mor., g. e., *à Paris, chez Anthoine de Sommaville*, 1646, sm. 8vo. (163) *Plaice, £1* 3s.

2090 Fournier (Marcel). Les Statuts et Privilèges des Universités Françaises depuis leur fondation, 4 vol., hf. mor., g. t., uncut, ɔy R. de Coverly, *Paris*, Larose, 1890-94, 4to. (164) *Sotheran, £3* 10s.

2091 Franeau (Jean). Jardin d'Hyver ou Caɔinet des Fleurs (en vers), engravings of flowers by A. Serrurier, large copy, mor., g. e., ɔy Chamɔolle-Duru, *Douay*, P. Borremans, 1616, 4to. (165) *Quaritch, £18*

2092 French Revolution. Les Actes des Apôtres (par Peltier, Miraɔeau jeune, Champcenetz, Suleau et autres), plates, 311 Nos. ɔound in 1 vol., hf. cf., uncut, *à Paris* [1789-92], 8vo. (166) *Maggs, £9* 15s.
[A complete series of this satirical Royalist journal, said to have ɔeen suppressed by order of Louis XVI. It includes the six scarce "Petits Paquets" in the last volume.—*Catalogue.*]

2093 French Revolution. Liste générale de tous les conspirateurs qui ont été condamnés à mort, Nos. i.-ix. et Supplément, *Paris, l'an deuxième de la République*—Compte Rendu aux Sans-Culottes par Dame Guillotine, seconde parte, *ib.*, *l'an* II., in 1 vol., hf. bd.—Mémoires sur les journées de Septembre, 1792, *ib.*, 1823, cf.—Liste générale de tous les conspirateurs guillotinés, fusillés et foudroyés dans Lyon, Marseille, Bordeaux, etc., uncut, *ib.* (1795), together 3 vol., 8vo. (170) *Quaritch, £4* 4s.

2094 French Revolution. Réimpression de l'Ancien Moniteur depuis la Réunion des Etats-Généraux jusqu'au Consulat [par Léonard Gallois], et Introduction Historique, 32 vol., hf. cf., *Paris*, 1843-5, imp. 8vo. (171) *Sotheran, £3*

2095 French Revolution. Révolutions de Paris, dédiées à la Nation, puɔliées par le Sieur Prudhomme, plates, maps, etc., 225 numɔers in 17 vol., old cf. gt., 1789-94, 8vo. (172) *Quaritch, £10*

2096 French Revolution. Histoire des Erreurs, des Fautes, et des Crimes commis pendant la Révolution Française (par Prudhomme), plates, 6 vol., cf. gt., *Paris*, 1797, 8vo. (173) *Parsons, £3* 7s. 6d.

2097 French Revolution. [Richer-Serisy] L'Accusateur Puɔlic, Nos. i.-xxxv. [*Paris*, 1795-9]—Richer-Serisy au Directoire, *Rouen, l'an* VI., ɔound in 2 vol., hf. cf., uncut, 8vo. (174) *Quaritch, £3* 15s.

2098 Froissart. Le Premier (le second, le troisième, et le quart)
Volume de l'Histoire et Chronique, par Denis Sauvage,
ornamental initials, etc., 4 vol. in 2, old French cf., g. e.,
à Lyon, par Ian de Tournes, 1559-61, folio (175)
Tregaskis, £2
[This edition contains : vol. i., 10 prel. leaves, pp. 462,
annotations 17 ll. ; vol. ii., 6 prel. ll., pp. 314, annotations
3 ll. ; vol. iii., 6 prel. ll., pp. 363, annotations 2 ll. ; vol. iv.,
6 prel. ll., pp. 350, annotations and imprint 3 ll.—_Cata-
logue._]
2099 Fuchsius (Leon.) Den Nieuwen Herbarius, lit. goth, port.
and woodcuts of plants, etc., coloured ɔy hand at the time
(some leaves repaired), _Ghedruct tot Basel bij Michiel
Isingrin_ [1543], folio (176) _Wesley,_ £11 11s.
2100 Fuchsius (Leon.) Plantarum Effigies, each page ɔearing a
woodcut of a plant, with its name in Greek, Latin, French,
Italian and German, orig. cf. gt. (worn), _Lugduni,_ Balthazar
Arnoullet, 1551, sm. 8vo. (177) _Leighton,_ £3
2101 Fulgose (Baptiste). Contramours, L'Antéros, ou contramour
—Le Dialogue de Baptiste Platine, contre les folles amours
—Paradoxe, contre l'Amour, mor., floral wreath in gilt, g. e.,
by Chamɔolle-Duru, _Paris, chez Martin le Jeune,_ 1581,
4to. (178) _Quaritch,_ £5 15s.
2102 Galien Rethore. L'Histoire des noɔles proüesses et vaillances
de Gallien Restauré, fils du Noɔle Olivier le Marquis, & de
la ɔelle Jacqueline, woodcuts (one or two leaves shaved),
mor., g. e., by Chamɔolle-Duru, _Troyes, chez Jacques Oudot,_
1720, 4to. (179) _Leighton,_ £3 3s.
2103 Gamɔle (John). Ayres and Dialogues, port. of Gamɔle ɔy
T. Cross (inlaid), and the music to all the songs, new cf. ex.,
W. Godbid for H. Mosley, 1657, sm. folio (180)
Quaritch, £10
2104 Gassar (Achyle). Brief recueil de toutes Chroniques &
Hystoires, gothic letter, mor., g. e., _En Anvers par Martin
Lempereur,_ 1534, sm. 8vo. (181) _Bloomfield,_ £2 4s.
2105 Gerarde (John). Herball, first ed. of Johnson's enlarged
version, woodcuts of plants, new cf., g. e., by R. De Coverly,
Adam Islip, Ioice Norton and Richard Whitaker, 1633,
folio (182) _Wesley,_ £5 10s.
2106 Gerarde (J.) Herball (by Thomas Johnson), engraved title-
page by J. Payne (ɔacked), and woodcuts, russ., Adam
Islip, Ioice Norton and Richard Whitaker, 1636, folio (183)
Ellis, £4 5s.
2107 Giraudet (Gaɔriel). Discours du Voiage d'outre mer au
Sainct Sepulchre de Jerusalem, port., mor. ex., g. e., ɔy
Chamɔolle-Duru, from the Pichon liɔrary, _Imprimé à
Tolose, par Arnaud & Jaques Colomiés,_ 1583' sm. 8vo.
(184) _Leighton,_ £2 10s.
2108 Gonse (Louis). L'Art Gothique, L'Architecture—La Peinture
—La Sculpture—Le Décor, plates, some in colours, and
illustrations, mor. ex., ɔy Rivière, one of 25 copies on papier
du Japon, _Paris_ [1891], folio (185) _Diouritch,_ £5 5s.

2109 Gringore (Pierre). Les folles entreprises (en vers), lit. goth. (lettres bâtardes), 59 leaves, sigs. a-h 3 (wanted ᴐlank leaf h 4), cut of author in his study on verso of title and 18 other woodcuts (hole in title and stain in corner of some leaves), old French mor., g. e., from the Wodhull liᴐrary, *Imprime a Paris, par Maistre Pierre le Dru pour iceluy Gringore le* xxiii. *iour de decembre,* 1505, sm. 8vo. (186) *Leighton,* £70

[According to Brunet this is the earliest of the two issues of this date, ᴐoth of which are of great rarity. Lord Ash-ᴐurnham's copy of this issue realised £106. On the verso of the last leaf, preceding the colophon, is an acrostic of eight lines, disclosing the author's name.—*Catalogue.*]

2110 Gringore (P.) Les faintises du monde, lit. goth., woodcut device of Regnault on the title (some ᴐlank margins mended), mor., g. e., *s. l. n. d.* [*Pierre Regnault, vers* 1500], sm. 8vo. (187) *Ellis,* £12

2111 [Gringore]. Les Aᴐuz du mōde (en vers), lit. goth., woodcut on title, mor., g. e., ᴐy Koehler, *Paris* [*s. a. vers* 1500], sm. 8vo. (188) *Quaritch,* £21

2112 Gringore (P.) Heures de nostre Dame (avec le Calendrier) translatees en Francoys et mises en rihtme (*sic*), lit. goth. (lettres bâtardes), in red and ᴐlack, the Latin text in smaller type in the margin, cut of the Virgin and Child on title, tree of Jesse on verso, three other cuts in the preliminary leaves and 13 other fine full-page woodcuts, Petit's device at end (leaf q 1 misplaced, one cut defaced, and a few letters ruᴐᴐed from leaf 88 verso), tall copy, with some rough leaves, mor. ex., g. e., by Niedrée, from the Didot collection, (*Paris*) *cheuz Jehan Petit a la me Sainct Jacques* (1525), sm. 4to. (189) *Leighton,* £71

[First edition of this rare ᴐook, only three or four other copies on paper ᴐeing known, it having ᴐeen suppressed ᴐy a degree of Parliament of Aug. 28, 1527, at the instigation of the Sorᴐonne, on account of the audacious profanity of one of the wood engravings (on folio 66), which ostensiᴐly represents Our Lord mocked and crowned with thorns, but is really a portrait of Gringore himself surrounded ᴐy a group of Italian comedians, against whom he ᴐore a grudge.—*Catalogue.*]

2113 Gringore (P.) Heures de Nostre Dame, another copy, printed upon vellum, the 14 woodcuts and large initials illuminated in gold and colours ᴐy a contemporary miniaturist (the first four preliminary leaves wanted), orig. wooden bds. covered with leather, stamped, g. e., from the Didot collection, (*Paris*,) *cheuz Jehan Petit a la me Sainct Jacques* (1525), sm. 4to. (190) *Sabin,* £45

2114 Gringore (P.) Heures de Nostre Dame, lit. goth.. Petit's device on titles, cut of astrological man, and 20 full-page woodcuts, mor., g. e., from the Didot collection, *Paris, Jehan Petit, s. d. vers* 1530, sm. 4to. (191) *Ellis,* £31

[In this edition, which has a "Privilege" dated 15 Novr. 1527, and an Almanack from 1534 to 1549, the grotesque

cut of the "Mocking" is replaced by another cut ɔearing
the same engraver's mark, the monogram G. S. and the
Lorraine Cross, representing a kneeling man surrounded ɔy
four others armed with sticks.—*Catalogue.*]
2115 Gringore (P.) Chantz Royaulx figurez morallement sur les
misteres miraculeux de Nostre saulueur et redēpteur
Jesuchrist (en vers), **lit. gotï.**, 32 folios, long lines, title in
red and ɔlack, with Petit's device and 7 large woodcuts,
fine copy, mor. super ex., inlaid, g. e., by Lortic, from the
Didot collection, *On les vēd a Paris en la maison de Jehan
Petit, s. d. (Privilége du* 10 *Octobre*, .1527), sm. 4to. (192)
Ellis, £27
[An entirely different edition from the one issued with
the "Heures," though having the same woodcuts.—*Cata-
logue.*]
2116 Gringore (P.) Notaɔles enseignemens, adages et prouerbes
(en vers), **lit. gotï.**, 136 leaves, title in red and ɔlack, full-
page woodcut on verso of A 2, ɔearing the mark of the
Lorraine Cross, device of Francois Regnault on last leaf
(small holes, mended, in first two leaves), mor., g. e., ɔy
Chamɔolle-Duru, *Imprimez a Paris par Nicolas. couteau le*
XXVIᵉ *iour de Januier*, 1528, sm. 8vo. (193) *Ellis,* £16
2117 Gringore (P.) Rondeaulx en Nomɔre troys cens cinquāte,
lit. gotï., old French mor., g. e., from the Didot collection,
Imprime nouuellement a Paris pour Alain Lotrian [*s. d.*
vers 1530], sm. 8vo. (194) *Ellis,* £20
2118 Gringore (P.) Le Chasteau de Laɔour, mor. ex., g. e., ɔy
Duru et Chamɔolle (137 mill. ɔy 83 mill.), *Imprime a Paris
par Antoine Augereau Imprimeur pour Galiot du Pre,*
1532, sm. 8vo. (195) *Ellis,* £18
2119 Gruel (Leon). Manuel historique et ɔiɔliographique de
l'amateur de reliures, col. plates, 2 vol., hf. mor., t. e. g.,
Paris, 1887-1905, 4to. (199) *Isaacs,* £4 6s.
2120 Havre. Origine de la Maison de la Miséricorde de la Ville
du Havre, ex-liɔris "Biɔliothèque de Rosny," mor., crowned
monogram of the Duchesse de Berri and fleurs-de-lis, g. e.,
au Havre, s. d. (1822), 8vo. (200) *Quaritch,* £3
2121 Herball (The Greate), **black letter**, two columns, large cut of
woodcutters on title, unwashed copy, old cf., gt. ɔack,
London, Jhon Kynge, 1561, sm. folio (201) *Tregaskis,* £18
2122 Herbarius (Dē grotē). Met al sijn figuerē der Cruyden, om
die crachten der cruyden te onderkennen (Meester Arnoldus
de noua villa), **lit. gotï.**, title in red and ɔlack aɔove a large
cut of a garden, woodcuts, large copy, modern cf., ɔlind
tooled, *Tantwerpen, bi mi Simon Cock,* 1547, sm. folio (202)
Llewellyn, £26
[It is said that only one other copy of this edition exists,
that in the liɔrary at Dresden. Leaf O 4, a ɔlank, is
wanting.—*Catalogue.*]
2123 Herɔier (Le grand) en francoys contenant les qualitez Vertus
& proprietez des Herɔes Arɔres Gommes & Semences,
lit. gotï., two columns, woodcuts, device of Michel le Noir

on title, which, with some of the initial letters, is heightened
with colour, the woodcuts uncoloured, mor., g.e., ɔy Rivière,
*Imprime à Paris par Guillaume Nyuerd pour Jehan Petit,
et pour Michel le Noir, s. d.* [*vers* 1520], sm. folio (203)
Quaritch, £41

2124 Herɔler (Le grand) en François : contenāt les qualitez, vertus
et proprietez des herɔes, arɔres, gommes, semences, huyles,
et pierres précieuses, lit. gotɦ., two columns, title in red and
ɔlack, woodcuts and ornamental initial letters, *Paris, pour
Estienne Groulleau, s. a.* (*vers* 1530)—Herbarum imagines
uiuæ. Der Kreuter lebliche Conterfeytunge, woodcuts,
2 parts, *Gedruckt zu Franckfurt am Meyn, bey Christian
Egenolph,* 1538, in 1 vol., mor. ex., g.e., with Seillière arms,
4to. (204) *Leighton,* £34
[The second work consists entirely of woodcuts of flowers
and plants, with their names in Latin and German ; Latin
and German indexes are at the end of each part.—*Cata-
logue.*]

2125 Hill (John). The British Herɔal, front. and engraved plates,
new cf., g. e., *London,* 1756, folio (205) *Dobell,* £1 6s.

2126 Hilton (Walker). The Scale (or Ladder) of Perfection,
George IV.'s copy, with his crowned monogram, 1659, sm.
8vo. (206) *Dobell,* £1 11s.

2127 Hofman (Tycho). Portraits Historiques des Hommes
Illustres de Dannemark, ports. and vignettes, folding
taɔles, etc., 7 parts in 1 vol., duplicate (English) impres-
sion of the portrait of the author ɔy J. G. Wille after
Tocqué inserted, mor., g. e., ɔy Rivière, *Imprimés en* 1746,
4to. (207) *Maggs,* £7 5s.

2128 Hollar (W.) Aula Veneris sive Varietas Fœminini Sexus,
diversarum Europæ Nationum, 89 plates of female dress
(including a second title-page, "Theatrum Mulierum," and
3 plates of monastic figures), mounted and ɔound in 1 vol.,
mor., g. e., from the Yemeniz collection, 1643-4, sm. 8vo.
(208) *Ellis,* £5 15s.
[This volume contained 86 out of the 104 prints men-
tioned ɔy Parthey, ɔesides four additional.—*Catalogue.*]

2129 Homer. La Bataille fantastique des Roys Rodilardus &
Croacus (par Elise Calence), mor. ex., g. e., Charles
Nodier's copy, with his ɔookplate, *à Rovan, par Anthoine
Bovtier,* 1603, sm. 8vo. (210) *Quaritch,* £2 2s.

2130 Horne (T. H.) Introduction to the Study of Bibliography,
2 vol. additionally illustrated, rox., uncut, Cadell & Davies,
1814, 8vo. (211) *Bloomfield,* £2 10s.

2131 Hoym (Charles Henry, Comte de). Vie de (par le ɔaron
Jérome Pichon), port. and plates (including 3 plates of
ɔindings in colours), 2 vol., hf. mor., t. e. g., *Société des
Bibliophiles François, Paris,* 1880, 8vo. (213)
Quaritch, £1 10s.

2132 Humɔert (Henry). Comɔat à la Barrière, faict en cour de
Lorraine, engraved front. and 10 plates ɔy Callot (M. 492-

501, 503), old cf., from the Beckford library, *Nancy*, S.
Philippe, 1627, sm. 4to. (214) *Quaritch, £5* 15s.
2133 Huss (Joannes). Opuscula, viz., De Anatomia Antichristi,
etc.—Locorum aliquot ex Osee et Ezechiele prophetis—
Sermones ad populum, etc., in 1 vol., woodcuts and borders
(shaved), old mor., g. e., arms of Count Hoym, *s. l. et a.*
[*Argentorati, c.* 1525], sm. 4to. (215) *Quaritch, £18* 10s.
2134 Ireland. Histoire de la Révolution d'Irlande, 4 folding maps,
mor., g. e., by Champolle-Duru, *à Amsterdam, chez Pierre
Mortier,* 1691, 12mo. (216) *Quaritch, £3* 4s.
2135 James I. Basilikon Doron, first London ed., old cf., *Felix
Kyngston for J. Norton,* 1603, sm. 8vo. (217) *Dobell,* 15s.
2136 James I. Basilikon Doron, another ed., autograph of Samuel
Parr on title (shaved), *Richard Field for J. Norton,* 1603,
sm. 8vo. (218) *Dobell,* 5s.
2137 Jerome of Brunswick. The noble experyence of the vertuous
handyworke of surgeri (with the Antidotharius), 𝔟𝔩𝔞𝔠𝔨
𝔩𝔢𝔱𝔱𝔢𝔯, orig. ed., full-page and other woodcuts (some leaves
repaired), mor. ex., Petrus Treueris, 1525, sm. folio—The
vertuose boke of Distyllacyon, 𝔟𝔩𝔞𝔠𝔨 𝔩𝔢𝔱𝔱𝔢𝔯, orig. ed., arms
and devices of Henry VIII. on reverse of title, woodcuts
(some blank corners repaired and a small wormhole through
part of the book), mor. ex., *London, Laurens Andrewe, in
the sygne of the Golden Crosse,* 1527, *the* 18 *daye of Apryl,*
sm. folio (219-220) *Leighton, £56*
2138 Jovius (Paulus). Vitae duodecim Vicecomitum Mediolani
Principum, 10 woodcut ports., bearing the mark of the
Lorraine Cross, and attributed to Geoffroy Tory, mor. ex.,
Lutetiæ, ex off. Rob. Stephani, 1549, 4to. (221)
Ellis, £2 6s.
2139 [Kirchmaier (Th.)] Le Marchant converti, Tragedie excel-
lente, mor., g. e. [*s. l.*] *par François Forest,* 1591, sm. 8vo.
(222) *Quaritch, £1* 1s.
2140 La Beraudière (Marc de). Le Combat de seul a seul en
camp clos, mor., g. e., by Champolle-Duru, *Paris, chez
Abell l'Angelier,* 1608, 4to. (223) *Lemallier, £3* 10s.
2141 La Chambre (M. de). Discours de l'amitié et de la haine qui
se trouvent entre les Animaux, LARGE PAPER, old French
mor., tooled à petits fers, g. e., by Le Gascon, in a case,
from the Beckford library, *à Paris, chez Claude Barbin,*
1667, 8vo. (224) *Sabin, £70*
2142 La Martiniere (P. M. de). Voyage des Pais Septentrionaux,
port., map and engravings, hf. cf., *à Paris, chez Louis
Vendosme,* 1671, sm. 8vo. (225) *Edwards, £1* 12s.
2143 La Perriere (Guillaume de). Les Annalles de Foix, woodcuts
and ports., old cf. gt., arms of Charles Spencer Earl of
Sunderland, *Tholose, imprimées par Nicholas Viellard,*
1539, sm. 4to. (226) *Quaritch, £12*
2144 La Perriere (G. de). Les Considerations des quatre Mondes,
port., woodcut borders to each page, old mor., broad gilt
borders, by Ruette, arms of Louis XIII., from the Beckford

collection, *à Lyon, par Macé Bonhomme*, 1552, sm. 8vo.
(227) *Sabin, £20*

2145 La Serre (Puget de). Histoire de l'Entrée de la Reyne Mere
du Roy très-Chrestien, dans les Provinces Unies des Pays-
Bas, ports. of Prince and Princess of Orange, copperplates
(including a large folding one), old mor., stamped in gold,
g.e., from the Beckford library, *à Londre, par Jean Raworth,
pour George Thomason & Octavian Pullen, à la Rose, au
Cimetière de Sainct Paul*, 1639, folio (228) *Quaritch, £28*

2146 La Serre (P. de). Histoire de l'Entrée de la Reyne Mere du
Roy très-Chrestien, dans la Grande-Bretaigne, ports. of
Charles I., his Queen and the Queen-Mother (attributed to
Hollar), and plates, including the large folding one of the
procession in Cheapside, mor., panelled, g.e., by Lortic,
from M. Didot's collection, *à Londre*, 1639, folio (229)
Tregaskis, £17

2147 Lawes (Henry). The Treasury of Musick, autographs of
Toby Jenkins, Joseph Warren and Wm. Chappell, music
throughout, old cf. (rebacked), *Wm. Godbid for John Play-
ford*, 1669, folio (230) *Quaritch, £21*

2148 Le Maire (Jean). Les Illustrations de Gaule et singularitez
de Troye, lit. goth., two columns, woodcuts, 5 books in 1 vol.,
mor., g.e., by Thibaron-Joly, *Imprime a Paris par Francoys
Regnault*, 1528, sm. folio (232) *Ellis, £6 15s.*

2149 Le Maire (J.) Le traictie Intitule de la differēce des scismes
et des concilles de leglise, first ed., lit. goth., 2 full-page
heraldic woodcuts, mor., blind ornament on sides, g.e., by
Trautz-Bauzonnet, with Baron Seillière's ex-libris, *Imprime
a Lyon, par Estiène Baland*, 1511, 4to. (233) *Bloomfield, £7*

2150 Le Roux de Lincy (M.) Recherches sur Jean Grolier sur sa
vie et sa bibliothèque, plates, in colours, hf. mor., g.e., by
R. de Coverly, *Paris*, 1866, roy. 8vo. (236) *Clements, £2 2s.*

2151 Littré (E.) Dictionnaire de la Langue Française, avec
Supplément, 5 vol., *Paris*, 1876-77, folio (239) *Hill, £2 5s.*

2152 Livre (le) des ordonnances de cheualiers de lordre du tres-
chretien roy de france Loys XIᵉ a lhonneur de sainct Michel,
lit. goth., device on title, and another one (full-page) with
the royal arms on verso, woodcut on a ii., mor., g.e., by
Pratt, *Imprime nouuellement a paris . . pour guillaume
eustace*, 1512, 8vo. (240) *Bloomfield, £5 15s.*

2153 Longus. Les Amours pastorales de Daphnis et de Chloé
[par J. Amyot], LARGE PAPER, front. after Coypel and 28
plates by Audran, from the designs of the Regent Philippe
d'Orléans, earliest issue, before the plate "Les petits pieds"
was added, pages ruled in gilt, mor., g.e., by Trautz-
Bauzonnet [*s. l. Paris*], 1718, sm. 8vo. (241) *Quaritch, £15*

2154 [Lorris (Guil. de).] Sensuyt le rõmāt de la rose aultremēt dit
le sõge vergier, Nouvèllement Imprime a Paris [xxix.], lit.
goth., 142 leaves, title in red and black, woodcut on recto
and verso, printer's device on last leaf (corner of title-page
repaired), mor., g.e., by Trautz-Bauzonnet, *Nouvellement
imprime a Paris par Jehan ihannot [s. d.]*, 4to. (243)
Leighton, £18

[From the Didot library. The number xxix. had been
erased from the title-page, whence it was erroneously
thought to be an undescribed edition.—*Catalogue.*]

2155 Mace (Thomas). Musicks Monument, LARGE PAPER, port.
of the author by Faithorne in the first state, with the mis-
print "Clericus," engravings, and music for the lute, cf.,
g. e., by Rivière, *J. Ratcliffe and N. Thompson, for the
Author*, 1676, folio (244) *Quaritch*, £14

2156 Macer (Æmilius). Les Fleurs du Livre des Vertus des
Heroes, composé jadis en vers Latins par Macer Floride,
port. and woodcuts, orig. vell., *A Rouen, chez Martin &
Honoré Mallard*, 1588, sm. 8vo. (245) *Quaritch*, £4 10s.
[Bound at the end is "Brief traité de la racine Mechoa-
can, venue de l'Espagne nouvelle, traduit d'Espagnol (de
Nic. Monardes) par J. G. P. (Jacques Gohory, parisien),
Rouen, 1588."—*Catalogue.*]

2157 Marguerite de Valois. Le Tombeau de Margverite de Valois
Royne de Navarre, printer's device on title and port. on
verso, mor., g. e., from the Didot collection, *Paris, Michel
Fezaudet & Robert Grand Jon*, 1551, sm. 8vo. (246)
 Ellis, £12

2158 Marguerite de Valois. Les Margverites de la Margverite,
printer's device on title, mor., richly gt., g. e., by Belz-
Niédrée, *a Paris, par Jean Ruelle*, 1558, sm. 8vo. (247)
 Ellis, £6 10s.
[This edition, printed in italic type, contains 394 num-
bered leaves and 5 leaves not numbered. From the Didot
library.—*Catalogue.*]

2159 Marguerite de Valois. Memoires de la Reyne Marguerite,
mor. ex., g. e., *A Bruxelles, chez Francois Foppens*, 1658,
sm. 8vo. (248) *Tregaskis*, £1 18s.

2160 Marlianus (B.) Urbis Romae Topographia, woodcuts, vell.,
Romæ in ædibus Valerii, dorici, et Aloissi fratris, 1543.
folio (250) *Quaritch*, £2 14s.

2161 Marot (Clement). L'Adolescence Clementine ov avltrement
les œuures de Clement Marot, de Cahors en Quercy—Le
Premier Livre de la metamorphose d'Ouide—Le Recveil
Jehan Marot de Caen, Poete & escripuain de la magnanime
Royne Anne de Bretaigne, in 1 vol., orig. cf., in a case, *On
les vent à Paris en la rue sainct Jaques, chez Francoys
Regnault, à lenseigne de l'Elephant*, 1536, 16mo. (251)
 Quaritch, £25
[This edition appears to have been unknown to Brunet.
Collation :—" L'adolescence," a-p in eights, q 10 ll., the last
blank ; "La suite," A-H in eights, I 10 ll. ; "Premier livre
d'Ouide," aA-dD in eights ; "Le Recueil," aa-ff 4 in eights,
the last blank.—*Catalogue.*]

2162 Marot (Clement). Les Œuvres, port. on title, old cf., *a Rouen,
chez Thomas Mallard*, 1583, sm. 8vo. (252) *Symes*, 10s.

2163 Marot (C.) Les Œuvres, 2 vol., old mor., g. e., arms of
Merard de St. Just, *a la Haye, chez Adrian Moetjens*, 1700,
sm. 8vo. (253) *Ellis*, £9

2164 Martial de Paris, dit d' Auvergne, Les cinquante et ung arrest damours, **lit. gotſ.** (first ed.?), two columns, 54 leaves, large woodcut on title, mor., g. e., with the Seillière arms, *Imprimes a Paris par Michel le Noir* [*s. d.*], sm. 4to. (254) *Leighton*, £7 10s.

2165 Martial de Paris. Les declamations, procedeures et arrestz d'amours, upwards of 40 woodcuts, mor. ex., *à Paris . . . par Pierre sergent*, 1545, sm. 8vo. (255) *Lemallier*, £7 10s.

2166 Mascaron (V. M.) Marseille aux pieds du Roy, mor., g. e., ɔy Chamɔolle-Duru, *Avignon, chez J. Piot*, 1632, 4to. (256) *Tregaskis*, £1 16s.

2167 Matthieu (Pierre). La Guisiade, Tragedie Nouvelle (*Lyon, par Jacques Roussin*, 1589)—La Tragedie de feu Gaspar de Colligni, par F. François de Chantelouve (1575), in 1 vol., old mor., g. e. [*réimpr. Paris*, 1744], 8vo. (257) *Quaritch*, £2 6s.

2168 Matthiolus (P. A.) Commentarii in liɔros Dioscoridis de Medica Materia, woodcuts of plants (uncoloured), old cf., *Venetiis, ex Officina Erasmiana, Vincentij Valgrisij*, 1558, folio (258) *Tregaskis*, £2 4s.

2169 Meibomius (Marcus). Antiquæ Musicæ, folding taɔles, music in the text, 2 vol., old cf., *Amst., Lud. Elzevir*, 1652, 4to. (259) *Quaritch*, £1 16s.

2170 Mercuri (P.) et Bonnard (C.) Costumes historiques, des XIIᵉ-XVᵉ siècles, avec une introduction par Charles Blanc, 200 col. plates, 3 vol., *Paris*, 1860-61—Costumes historiques des XVIᵉ, XVIIᵉ et XVIIIᵉ siècles, par E. Lechevallier-Chevignard, gravès par Didier, etc. avec texte par Duplessis, col. plates, 2 vol., *ib.*, 1867-73, uniform mor. ex., together 5 vol., 4to. (260) *Gamble*, £9

2171 Milton (John). Paradise Lost, first ed., seventh title-page, with the three-line Address to the Reader, Argument and Errata, top line of last page of Book iii. unnumɔered, and "in" instead of "with" in penultimate line, mor., g. e., *Printed by S. Simmons, and are to be sold by T. Helder at the Angel in Little Britain*, 1669, sm. 4to. (261) *Sawyer*, £30

2172 Milton (J.) Paradise Lost, the second ed., port. ɔy Dolle, mor., g. e., *Printed by S. Simmons*, 1674, 8vo. (262) *Sawyer*, £6 15s.

2173 Milton (J.) Paradise Lost, the third ed., port. by Dolle, mor. plain, *Printed by S. Simmons*, 1678, 8vo. (263) *Sawyer*, £5 5s.

2174 Milton (J.) Paradise Regain'd, first ed., leaf of "License" and Errata leaf (a few pages shaved), mor., g. e., *Printed by J. M. for John Starkey*, 1671, 8vo. (264) *Dubois*, £11 10s.

2175 Milton (J.) Paradise Regain'd (second ed.), with "License" leaf and 4 pages "Catalogue of Books" at end, mor., g. e., John Starkey, 1680, 8vo. (265) *Sawyer*, £2 10s.

2176 Milton (J.) Poems, etc. upon Several Occasions, with a small Tractate of Education to Mr. Hartlib, the earlier issue of

Dring's two title-pages, mor. plain, g. e., *Printed for Tho.
Dring at the White Lion next Chancery Lane End,* 1673,
sm. 8vo. (266) *Ellis,* £8 5s.
2177 Milton (J.) Eikonoklastes, first ed., with the original ɔlank
leaf preceding title (some margins stained), mor., g. e.,
Printed by Matthew Simmons, 1649, sm. 4to. (267)
 Sawyer, £9
2178 Molière. Le Festin de Pierre, Comédie, first ed. in the
versified form, mor. ex., *Paris,* 1683, 12mo. (268)
 Quaritch, £2
2179 Molinet (Jean). Les faictz et dictz de feu de ɔõne memoire
Maistre Jehan Molinet (in verse), first ed., 𝔤𝔬𝔱𝔥𝔦𝔠 𝔩𝔢𝔱𝔱𝔢𝔯,
printer's woodcut device, ornamental initials, mor., g. e.,
with the arms of Baron Seillière, *Nouvellement imprimez
a Paris, pour Jehan longis et la veufue feu Jehan sainct
Denys,* 1531, sm. folio (269) *Leighton,* £12 5s.
2180 Molinier (Émile). Le Moɔilier Royal Francais aux XVIIᵉ et
XVIIIᵉ siècles, one of 200 numɔered copies, 150 plates in
colours or photogravure of furniture, etc., ɔound in 3 vol.,
mor., t. e. g., ɔy L. Broca, *Paris,* Goupil, 1902, roy. folio (270)
 Batsford, £21
2181 Monstrelet (E. de). Le Premier (le second et le tiers) Volume
de Enguerran de Monstrellet, 𝔩𝔦𝔱. 𝔤𝔬𝔱𝔥., initials formed by
grotesque heads on titles, 3 vol. in 2, Verard's device at end
of vol. ii., richly ɔound in mor. super extra, by Duru, *a
paris pour Anthoine verard [s. d. vers* 1500], folio (271)
 Leighton, £42
2182 Monstrelet (E. de). Chroniques, LARGE PAPER, 2 vol., russ.,
g. e., *Paris,* G. Chaudiere, 1572, folio (272)
 Sotheran, £1 2s.
2183 More (Sir Thomas). De optimo reip. statu deque nova insula
Utopia libellus vere aureus—Epigrammata Des. Erasmi
Roterodami, woodcut of the island of Utopia and several
woodcut ɔorders designed by Hans Holɔein and Urs Graf,
old mor., g. e., arms and cypher of Louis-Charles de Valois,
duc d'Angoulême, *Basil. apud Jo. Frobenium,* 1518, 4to.
(273) *Quaritch,* £18
[Other tracts by Busius, Brixius and Kitschius are ɔound
in the same volume.—*Catalogue.*]
2184 More (Sir T.) La Description de l'isle d'Utopie (traduite par
Jehan le Blond), first ed. of the Utopia in French, woodcuts
and ornamental vignettes, mor. ex., by Trautz-Bauzonnet,
rare, *Paris,* Charles l'Angelier, 1550, sm. 8vo. (274)
 Lemallier, £7 15s.
2185 Morley (Thomas). A Plaine and Easie Introduction to
Practicall Musicke, woodcut title-page (repaired), initials,
diagrams and musical notation, mor. ex., Humfrey Lownes,
1608, sm. folio (275) *Ellis,* £9 10s.
2186 Mystere. Le mistere de la conception, Natiuite, Mariage, Et
annonciation de la benoiste vierge marie, 𝔩𝔦𝔱. 𝔤𝔬𝔱𝔥. (lettres
bâtardes), douɔle columns, woodcuts on recto and verso of
title on second leaf and on recto of last leaf, on the verso

of which is the large device of D. Janot, inlaid throughout, old French mor., douɔlé, inside gilt ornamental borders, g. e. (Padeloup), from the collections of Gaignat, Morel de Vindé, Yemeniz and Didot, *Imprime nouvellement a Paris par Alain Lotrain et Denis Janot, s. d. (vers* 1530), 4to. (277)—Sensuit la Resurrection de nostre Seigneur iesuchrist par personnaiges, lít. gotfj. (lettres bâtardes), inlaid throughout, old French mor., douɔlé, g. e. (Padeloup), *Nouuellement imprime a Paris par Alain Lotrain [s. d.],* 4to. (278)

Quaritch, £45

2187 Mystere. Le premier (et le second) volume du triumphant Mystere des Actes des Apostres translate fidelement a la verite historiale (par Arnoul et Simon de Greɔan), woodcuts, *Imprimez a Paris pour Guillaume Alabat,* 1537— Lapocalypse Sainct Jehan zeɔedee (par Louis Choquet), small cuts (*Paris*), *Arnoul et Charles les Angeliers,* 1541, 3 vol. in 1, first ed. of each vol., lít. gotfj. (one or two margins shaved), old mor., g. e., ɔy Derome, folio (279)

Edwards, £25

[This volume is from the collections of Girardot de Préfond, Guyon de Sardière, Baron d'Heiss, De Bure l'ainé, Tufton and M. Didot.—*Catalogue.*]

2188 Ordonnances, Statuts et Instructions Royaulx, faictes par feux de ɔonne memoire les Roys sainct Loys, Philippe le bel, Jehan, Charles le quint, Charles sixiesme, Charles septiesme, Loys unziesme, Charles huytiesme, Loys douziesme et Francoys premier de ce nom, lít. gotfj., printer's device, mor., g. e., ɔy Chamɔolle-Duru, *a Paris par Estienne Caueiller,* 1538, folio (280) *Leighton,* £4 10s.

2189 Ordre de la Toison d'Or. Les Ordonnances de l'Ordre de la Toison d'Or, printed upon vellum, 2 heraldic engravings ɔy Corn. Galle, orig. vell., g. e. (3 leaves of MS. additions inserted), *s. l. n. d.* (*Anvers,* Christ. Plantin), 4to. (281)

Maggs, £12 5s.

2190 Ordre de la Toison d'Or. Amounet de Hailly (C. F.) Les Mysteres de la Toison d'Or. Velleris aurei mysteria, woodcuts, vell., *Bruxelles,* F. Foppens, 1659, sm. 4to. (282)

Quaritch, 12s.

2191 Ordre de la Toison d'Or. Maurice (J. B.) Le Blason des Armoiries de tous les Chevaliers de l'Ordre de la Toison d'Or, heraldic plate and 450 plates of arms, cf., g. e., ɔy S. Kaufmann, *A la Haye, chez Jean Rammazeyn,* 1667, folio (283) *Ellis,* £4 5s.

2192 Ordre de S. Michel. Le liure des ordonnances des cheualiers de lordre du treschrestien roy de france Loys. XIᵉ, a lhonneur de sainct Michel, lít. gotfj., woodcut on a ii, vell., g. e., *imprime nouuellement a paris . . . pour guillaume eustace,* 1512, 8vo. (284) *Leighton,* £4

2193 Ordre du S. Esprit. Institvtion des Chevaliers de l'ordre et milice dv S. Esprit, *a Paris, par Iean d'Ongoys,* 1579— Les Ceremonies tenves et observees a l'ordre et milice du

Sainct Esprit, *ib.*, 1579, in 1 vol., arms on last leaf, mor.
plain, ɔy Pratt, sm. 8vo. (285)　　　*Lemallier*, £1 4s.
2194 Ordre du S. Esprit. Morin (Jacques, Sieur de la Masserie).
Les Armes & Blasons des Chevaliers de l'Ordre du Sainct
Esprit, 77 plates of coats-of-arms, *a Paris chez Pierre
firens, rue St. Iacques*, 1623—Les Statvts et Ordonnances
de l'Ordre dv ɔenoist Sainct Esprit, *a Paris, chez Charles
Fils de C. Morel*, 1629, in 1 vol., orig. cf., ɔlind stamped,
sm. folio (286)　　　　　　　*Quaritch*, £4 2s. 6d.
2195 Ordre du S. Esprit. Viel-Castel (Cte. Horace de). Statuts
de l'Ordre du Saint-Esprit, MS. du XIVᵉ siècle conservé
au Louvre, 17 fac. plates in gold and colours, mor. super
ex., *Paris*, 1853, folio (288)　　　　　*Quaritch*, £3
2196 Palissy (Bernard). Discours admiraɔles, de la nature des
eaux et fonteines, des metaux, des sels et salines, des
pierres, etc., first ed., cf., g. e., from the Yemeniz collection,
Paris, M. le Jeune, 1580, sm. 8vo. (290)　*Quaritch*, £6
2197 Paris. Chartularium Universitatis Parisiensis. Auctarium
Chartularii Univ. Paris. Ed. H. Denifle et Aem. Chatelain,
6 vol., hf. mor., t. e. g., *Paris*, 1889-97, 4to. (292)
　　　　　　　　　　　　　　　Couderc, £3 13s.
2198 Parkinson (John). Paradisi in Sole Paradisus Terrestris,
first ed., port., cuts of flowers and plants, etc. (inner margin
of 2 leaves repaired), mor. ex., H. Lownes and R. Young,
1629, folio (293)　　　　　　*Ellis*, £14 15s.
2199 Parkinson (J.) Theatrum Botanicum, front. ɔy W. Marshall
(remargined), woodcuts, many Linnean names added in
MS., ɔound in 2 vol., cf., Tho. Cotes, 1640, folio (294)
　　　　　　　　　　　　　　　Thorp, £3 5s.
2200 [Pascal (Blaise).] Les Provinciales, orig. ed., separate
pagination to each letter, *Cologne*, P. de la Vallée, 1657—
Lettre d'un avocat au Parlement, 1 Juin, 1657—La Con-
demnation des xviii. lettres, *Paris*, 1657—Arrest du Parle-
ment de Provence, *ib.*, 1657—Lettre escritte à un Aɔɔé par
un Docteur, 22 Feburier, 1656—Lettre d'un Provincial au
Secretaire du Port-Royal, 25 Avril, 1656—La Bonne Foy
des Jansenistes, par le P. F. Annat, *Paris*, 1656—Lettre au
R. P. Annat, 15 Janvier, 1657—Advis de MM. les Curez
de Paris, etc., *Paris*, 1656—Principes et suites de la
proɔaɔilité expliquez par Caramonel, s. d.—Extrait de
plusieurs dangereuses propositions tirées des nouveaux
Casuistes, s. d.—Lettre d'un Curé de Rouen, *Paris*, 1656—
Sommaire de la Harangue de MM. les Curez de Paris, *ib.*,
1656, and 16 other tracts on the Jansenist Controversy, in 1
vol., mor., g. e., by Moreau, 4to. (295)　*Dobell*, £6 10s.
　[A very scarce and unusually complete collection. On a
fly-leaf is written, in a contemporary hand, "la plus grande
partie de ces pieces m'ont esté données par les autheurs."—
Catalogue.]
2201 Passe (Crispin de). Hortus Floridus—Altera pars Horti
Floridi, 5 parts ɔound in 3 vol., upwards of 490 plates of
flowers, etc., many in two or three states, a few with

contemp. colouring, vell., r.e., *Arnhemii,* J. Jansson, 1614-16, oɔlong 4to. (296) *Quaritch, £23*
[This copy is made up of three different editions or states, an early issue without text on ɔack, and two issues with Latin text, differently set up. The second part of the work is seldom found. The numɔer of plates often vary.—*Catalogue.*]

2202 Passe (C. de). Les Vrais Pourtraits de quelques unes des plus grandes Dames de la Chrestiente, engravings of ladies, verses in French and Dutch, 4 parts in 1 vol., vell., *Amst.,* 1640, sm. oɔlong 4to. (297) *Quaritch, £37*
[The 4th part, "Le Chœur des Muses, avec leur chansons à l'honneur des vertueuses femmes et filles," includes two songs with music.—*Catalogue.*]

2203 Petitot (Jean). Les Emaux de Petitot du Musée Impérial du Louvre, India proofs of the 50 miniature ports., 2 vol., mor. ex., *Paris,* 1862-64, 4to. (299) *Quaritch, £7*

2204 Pitseus (Jo.) Relationum Historicarum de reɔus Anglicis tomus primus (all puɔlished), old cf. (reɔacked), *Parisiis,* R. Thierry et S. Cramoisy, 1619, 4to. (302) *Ellis, £6 5s.*
[On the title-page is the signature of "Rob. Burton," the author of the "Anatomy of Melancholy."—*Catalogue.*]

2205 Playford (John). Select Musicall Ayres and Dialogues, engraving of viols on title, and musical notation, mor. plain, g.e., *Lond., printed by T. H. for John Playford,* 1653, sm. folio (303) *Quaritch, £13*

2206 Playford (J.) Choice Ayres and Songs to sing to the Theorɔo-Lute, or Bass-Viol, engraving of a lady lutenist on title-page, and music throughout, autographs of W. Gostling and Vincent Novello, the fourth ɔook, hf. mor., *Printed by A. Godbid and J. Playford junior,* 1683, folio (304) *Ellis, £3 5s.*

2207 Plutarchus. Vitae Romanorum & Græcorum (græcè), editio princeps, last leaf ɔearing printer's device, fine and tall copy, old mor., g..e., by Padeloup, the Yemeniz copy, *Florentiae, in ædibus Philippi iuntae,* 1517, folio (305) *Quaritch, £15 10s.*

2208 Pomponius Mela. De situ orɔis, *Parisiis, ex officina S. Colinaei,* 1539—Postellus (Guil.) Syriae descriptio [*ib.*] *Hieron. Gormontius,* 1540, in 1 vol., cf., Count Hoym's copy with his arms, sm. 8vo. (306) *Sotheran, £4 10s.*

2209 Port Royal. Les Constitutions du Monastere de Port Royal du S. Sacrement, first ed., mor., g. e., *Mons, chez Gaspard Migeot* [*Amst., D. Elzevier*], 1665, 12mo. (308) *S. James, £1 10s.*

2210 Portraits des Rois de France avec un Sommaire discours contenant les principales actions de leur Regne, etc., 189 ports. (including Charles I. and II. of England) ɔy Moncornet, Larmessin and others, mor. ex., *a Paris chez Louys Boissevin* [*s. d. vers* 1680], sm. folio (310) *Maggs, £7*

2211 Quadrins Historiques de la Biɔle, [Par Claude Paradin], upwards of 240 woodcuts ɔy Bernard Solomon, *à Lion par*

Jan de Tournes, 1560—Figures du Nouveau Testament, upwards of 100 woodcuts, *ib.,* 1559, in 1 vol., old vell., sm. 8vo. (311) *Leighton,* £3 7s. 6d.

2212 Quatres Filz Aymon (Les) Duc de Dordonne : cest a scauoir Regnaut, Alard, Guichard et Richard, auec leur cousin Maugist, **lit. goth.,** woodcuts (corners of a few leaves mended), old French mor., g. e., with the Seillière arms, *Paris,* Nicolas Bonfons [*s. d.*], sm. 4to. (312)
 Leighton, £9 15s.

2213 Rabelais (François). Œuvres, port. by Tanjé, fronts. by Folkema and Picart, and plates by Folkema, Tanjé, etc., 3 vol., mor. ex., *Amsterdam, chez J. F. Bernard,* 1741, 4to. (313) *J. Bumpus,* £11

2214 Raoutin (François de). Commentaires sur le faict des dernieres guerres en la Gaule Belgique, ruled in red, contemp. mor., covered with blind tooling in the style of the Eves, and bearing the initials F. D. M., gilt gauffré edges, *a Paris, de l'imprimerie de Michel de Vascosan,* 1555, 4to. (314) *Quaritch,* £48
[The initials F. D. M. on this fine specimen of binding perhaps denote that it belonged to F. de Montmorency, daughter of Henri II. and Diana of Poictiers.—*Catalogue.*]

2215 Regnaut (Antoine). Discours Du Voyage d'Outre Mer au Sainct Sepulcre de Jerusalem, woodcuts in imitation of Holbein's figures of the Old Testament, old cf., *Imprimé a Lyon,* 1573, 4to. (315) *Quaritch,* £1 17s.

2216 [René d'Anjou, roi de Sicile]. l'Abuzé en Court (en vers et prose), **lit. goth.,** 11 woodcuts, mor. super ex., from the Didot collection, *s. l. n. d.* [*vers* 1505], sm. 4to. (317)
 Quaritch, £41
[Exceedingly scarce edition without printer's name or date, consisting of 34 leaves (signatures A to H 6 in fours). —*Catalogue.*]

2217 Révoil (Henry). Architecture Romane du Midi de la France, upwards of 220 architectural plates, etc., 3 vol., hf. mor., t. e. g., *Paris,* Morel, 1873, folio (318) *Picard,* £6

2218 Ritson (Joseph). Select Collection of English Songs, second ed., by Thos. Park, musical notation, 3 vol., cf. ex., 1813, 8vo. (320) *Tregaskis,* £1 8s.

2219 Rivoli (le Duc de). Les Missels imprimés à Venise de 1481 à 1600, one of 300 numbered copies (No. 110), 5 engravings on copper and 350 fac. reproductions, mor. ex., by Broca, *Paris,* J. Rothschild, 1896, folio (321) *Quaritch,* £8

2220 Saint-Marthe (Scevole de). Les Œuvres (en vers), mor., g. e., by Koehler, *Poitiers,* J. Blanchet, 1600, sm. 8vo. (322)
 Quaritch, £4 10s.

2221 Sanders (Nicolas). Les Trois Livres touchant l'origine et progres du Schisme d'Angleterre, Traduits en François, par I. T. A. C., mor., g. e., [*s. l.*] 1587, sm. 8vo. (323)
 Quaritch, £1 2s.

2222 Sanders (Nicolas). Les Trois Livres, etc., augmentez par

Edouart Rishton [another ed.], old mor., g. e., [*s. l.*] 1587,
sm. 8vo. (324) *Tregaskis*, £1 9s.
2223 Satyre Ménipée de la vertu du Catholicon d'Espagne, folding
plate, first issue of this ed., with errata, cf. ex., ɔy Rivière,
a Ratisbonne, chez Mathias Kerner (Bruxelles), 1664, 12mo.
(325) *Ellis*, £1 2s.
2224 Saxton (Christopher). Engraved Maps of England and
Wales, orig. ed., comprising front., coloured and heightened
with gold, "Indicem huic operi tripartitum," douɔle plate
with arms and "Catalogus Urbium"; map of England and
Wales, with "Index omnium Comitatum"; and 34 other
large maps, all col. ɔy a contemp. hand, and mounted (a
few defective in old folds), (has not the leaf of "Comitatum
Singulorum Index" mentioned ɔy Lowndes), mor. ex.,
1573-79, atlas folio (326) *Ellis*, £44
2225 Saxton (C.) The Shires of England and Wales, ɔy Philip
Lea (and John Seller), 40 maps, ɔoundaries col. (2 missing),
old cf., Philip Lea (1689), folio (327) *Tregaskis*, £5 5s.
2226 Scot (Reginald). The discourie of witchcraft, black letter,
first ed., woodcuts, with the two unnumɔered leaves, con-
taining diagrams, after Dd 8 (one or two corners mended),
mor., g. e., *Imprinted at London, by Williaw Brome*, 1584,
sm. 4to. (328) *Ellis*, £14 5s.
2227 Scot (R.) Discovery of Witchcraft, woodcuts, cf. ex., *Printed
by R. C. and are to be sold by Giles Calvert*, 1651, sm. 4to.
(329) *Quaritch*, £3 10s.
2228 Scot (R.) Discovery of Witchcraft, another ed., unknown to
Lowndes, woodcuts, cf. ex., g. e., *Printed by E. Cotes, and
are to be sold by Thomas Williams*, 1654, sm. 4to. (330)
Ellis, £2 16s.
2229 Secrétan (E.) Catalogue of Paintings, Water-Colors and
Drawings formed ɔy Mr. E. Secrétan, LARGE PAPER,
photogravure reproductions, 2 vol. in 1, hf. mor., g. e.,
Paris, 1889, folio (331) *Dubois*, £2
2230 Société des Anciens Textes Français. A complete set of the
puɔlications, from the commencement in 1875 to 1908,
including the "Bulletin" (1875 to 1889 ɔound in 3 vol.,
hf. mor., remainder unbd.), together 138 vol., folio and 8vo.
(332) *J. Grant*, £21 5s.
2231 Spirito (Lorenzo). Le Passetemps de la fortune des Dez,
woodcuts of the Zodiac, ports., etc., cf., g. e., *a Lyon, par
François Didier*, 1576, 4to. (334) *Leighton*, £10
2232 Spitzer (F.) La Collection Spitzer, exemplaire sur papier
vélin du tirage de 600 seulement (No. 400), 350 plates,
many in colours, and upwards of 800 illustrations in the
text, 6 vol., mor. super ex., *Paris*, Quantin, 1890-92, imp.
folio (335) *Quaritch*, £34
2233 Spitzer. Catalogue des Oɔjets d'Art (avec les prix d'adjudica-
tion), 2 vol. in 1, the 67 plates in a separate vol., mor. super
ex., *Paris*, 1893, oɔlong folio (336) *J. Bumpus*, £8 5s.
2234 Spon (Jacoɔ). De l'Origine des Etrennes, *Paris*, 1781—
Origine des Etrennes et des mois chez les Héɔreux et les

10—2

Peuples anciens & modernes, *ib.*, 1787, in 1 vol., mor., g. e.,
arms of Napoleon I., sm. 8vo. (337) *Maggs*, £6 10s.
2235 Stirling-Maxwell (Sir Wm.) The Chief Victories of the
Emperor Charles the Fifth, reproductions of old ports.,
etc., presentation copy (200 copies printed), orig. heraldic
cl., *Privately printed*, 1870, folio (338) *Maggs*, £2 5s.
2236 Stirling-Maxwell (Sir Wm.) The Entry of Charles V. into
the city of Bologna, reproduced from a series of engravings
on wood printed at Venice in 1530, plates (100 copies
printed), hf. leather, t. e. g., *Privately printed*, 1875, large
folio (339) *Quaritch*, £1
2237 Stirling-Maxwell (Sir Wm.) Solyman the Magnificent, from
engravings ɔy Domenico de Franceschi, plates, hf. leather,
t. e. g. (100 copies printed), *Privately printed*, 1877, large
folio (340) *Forrester*, £1 16s.
2238 Stirling-Maxwell (Sir Wm.) Antwerp Delivered, view of
Antwerp, and plates, etc. after Franz Hogenɔerg, etc. (250
printed), orig. ornamental cl., uncut, *Edinb.*, 1878, folio
(341) *Maggs*, £1 6s.
2239 Stirling-Maxwell (Sir Wm.) Don John of Austria, first ed.
(115 copies printed, No. 62), engravings, ports., etc., 2 vol.,
orig. decorated bds., Longmans & Co., 1883, folio (342)
 B. F. Stevens, £3 5s.
2240 Straɔo. Rerum Geographicarum liɔri xvii. (græcè et latiné),
2 vol., title ɔy A. de Blois, mor., inlaid, g. e., by Bozérian,
Amst., J. Wolters, 1707, folio (343) *Maggs*, £2
2241 Sully (Max. de Bethune, duc de). Mémoires, the series of
ports. of distinguished personages issued by Odieuvre
inserted, 3 vol., old French cf., r. e., *Londres*, 1745, 4to.
(345) *Edwards*, £3 3s.
2242 Tasso (Torquato). La Gierusalemme Liɔerata, engravings ɔy
Bernardo Castello, in an exhiɔition ɔinding of mor., inlaid,
douɔlé, monogram and crest at corners, leather joints,
watered silk end leaves, g. e., ɔy Chatelin, *In Genova*, 1590,
4to. (346) *Young*, £6 2s. 6d.
2243 Téchener (J. and L.) Histoire de la Biɔliophilie—Reliures.
Armorial des ɔiɔliophiles, etc., 47 plates, 10 parts in 1 vol.,
hf. mor., t. e. g., *Paris*, 1861-64, folio (347) *Ellis*, £2
2244 Terentius. [Opera] cum quinque commentis, woodcut title-
page, with cut of the author and his disciples on reverse,
woodcut of the "Coliseus sive Theatrum," and over 150
smaller cuts in the text, mor. super ex., *Venetiis*, L. de
Soardis, 1511, folio (348) *Dubois*, £16 10s.
2245 Thierry-Poux (O.) Premiers Monuments de l'Imprimerie,
40 facs., hf. mor., t. e. g., *Paris*, 1890, folio (350)
 Quaritch, £4 4s.
2246 Tocsain (Le). Contre les massacreurs et auteurs des Con-
fusions en France, old mor., g. e., arms of Talleyrand-
Périgord, *Reims*, Jean Martin, 1579, sm. 8vo. (351)
 Ellis, £5 10s.
2247 Tory (Geoffrey). Champ Fleury, first ed., woodcuts by G. Tory,
including his device of "Le Pot Cassé" on the title and

at end, mor., g. e., ɔy Thibaron-Echaubard, *acheue dimprimer
. . . pour Maistre Geofroy Tory de Bourges, . . . demorät
à Paris, qui le vent sus Petit Pont à Lenseigne du Pot
Casse. Et pour Giles Gourmont*, 1529, sm. folio (352)
Ellis, £39

2248 Tory (Geoffroy). L'Art & Science de la vraye proportion des
Lettres Attiques, woodcuts of letters, etc., autograph of
" Blanchard " on title, mor., g. e., ɔy Bauzonnet, *à Paris à
l'enseigne sainct Martin, par Viuant Gaultherot*, 1549, 6m.
8vo. (353) *B. F. Stevens*, £11

2249 Turner (William). The first and seconde partes of the Herɔal
of W. Turner, *Imprinted at Collen by Arnold Birckman*,
1568—A most excellent and perfecte homish apothecarye,
ɔy Jhon Hollyɔush [Miles Coverdale], *ib.*, 1561, 5 parts in
1 vol., black letter, ɔest ed., woodcuts of plants, mor. ex.,
ɔy Bedford, folio (354) *Wesley*, £34
[A fine copy, with the orig. ɔlank leaves. Collation :
Title, 1 leaf ; Preface, 2 ll. ; Taɔle, etc., 1 leaf ; A, B, 6 ll.
each ; C, 8 ll. ; D-T in sixes, the last 2 ll. of T ɔlank.
Title to part ii., 1 leaf ; Taɔle, 1 leaf ; A-F f in sixes, the
last leaf ɔlank ; Gg (Errata), 2 ll. Title to part iii., 1 leaf ;
Dedication, etc., 3 ll. ; Aaa-Ggg in sixes, last leaf ɔlank.
Title to "Booke of Bathes," 1 leaf ; Preface, etc., 3 ll. ;
B-D in sixes, last leaf ɔlank. "A homish apothecarye,"
1561, a-h 3 in sixes, including title.—*Catalogue.*]

2250 Valentine and Orson. L'Histoire de Valentin et Orson,
woodcut on title, mor. super ex., ɔy Belz-Niedrée, with the
Seillière arms, *A Troyes, chez Jacques Oudot*, 1686, 4to.
(355) *Quaritch*, £4 15s.

2251 [Varlot (Louis).] Illustration de l'ancienne imprimerie
Troyenne, 210 facs. of wood engravings (one of 80 copies),
Troyes, 1850—Xylographie de l'Imprimerie Troyenne, fac.
woodcuts, *ib.*, 1859, hf. mor., t. e. g., uncut, 4to. (356)
Quaritch, £2 8s.

2252 Venda Reine de Pologne, ou l'histoire galante et curieuse, de
ce qui s'est passé de plus memoraɔle, en ce tems-là, mor.,
g. e., ɔy Hardy, *La Haye*, A. Troyel, 1705, sm. 8vo. (357)
Hilton, £1 12s.

2253 [Verstegan (R.)] Theatre des Cruautez des Hereticques de
nostre temps, first ed. in French, copperplate engravings,
including the execution of Mary Queen of Scots (S. B.,
No. 155), (last leaf mounted and defective), old cf. (Thos.
Jolley's copy), *Anvers, chez Adrien Hubert*, 1588, sm. 4to.
(358) *Edwards*, £1 5s.

2254 Viollet-le-Duc (M.) Dictionnaire Raisonné de l'Architecture
Française, ports. and woodcuts, 10 vol., hf. mor., t. e. g.,
Paris, 1867-8, 8vo. (361). *W. Brown*, £6

2255 Viollet-le-Duc (M.) Dictionnaire Raisonné du Moɔilier
Français, woodcuts and plates (many in colours), 6 vol., hf.
mor., t. e. g., *Paris*, 1872-75, 8vo. (362) *Gamble*, £5 15s.

2256 Voyage Littéraire de deux religieux Benedictins de la Con-

gregation de Saint Maur [D. Martène et D. Durand], plates, 2 vol., old cf., *Paris*, 1717-24, 4to. (363)
Tregaskis, £1 8s.

2257 Vulson (Marc de). De l'Office des Roys d'Armes, des Herauds, et des Poursuivans, ports. of Montjoye Saint Denis, the Comte and Comtesse de Harcourt, by Duret, and arms of the author, orig. vell., *Paris*, Cramoisy, 1645, sm. 4to. (364)
Tregaskis, £2 5s.

2258 Vulson (Marc de). La Science Heroique, first ed., plates, orig. vell., *Paris*, S. & G. Cramoisy, 1644, folio (365)
Ellis, £1 8s.

2259 Wedgwood (Josias). Catalogue de Camées, Intaglios, Médailles, Bas-reliefs, Bustes et petites Statues, plates, hf. mor., 1788, 8vo. (366)
Tregaskis, £2 9s.

2260 Wierix (H.) A Series of 22 Engravings illustrating the childhood of Jesus Christ, orig. impressions, with ample margins, in 1 vol., sm. 4to. (367)
Quaritch, £4 18s.

2261 Wierix (H.) Speculum Virginitatis, a series of 7 Engravings (Alvin, 1319-1325), and 13 other engraved plates of allegorical and other subjects, by the brothers Wierix, orig. impressions, with full margins, in 1 vol., sm. 4to. (368)
Quaritch, £4 18s.

2262 Wierix (H.) L'Enfance de Jésus, tableaux flamands, poëme tiré des compositions de Jérôme Wierix, par L. Alvin, 14 photographs, hf. mor., *Paris*, 1860, 8vo. (369)
Dobell, 2s.

2263 Wither (George). The Nature of Man (by Nemesius), first ed., mor., watered silk end leaves, g.e., *M. F. for Henry Taunton*, 1636, 12mo. (370)
Sawyer, £2 6s.

2264 Wither (G.) Letters of Advice, touching the Choice of Knights and Burgesses, first ed., 16 pages, issued without a title-page, mor., g.e., *Printed by R. A.*, 1644, sm. 4to. (371)
Sawyer, £3 15s.

2265 [Wither (George).] What Peace to the wicked? (in verse), first ed., mor., g.e., *Printed in the year* 1646, 4to. (372)
Sawyer, £3 15s.

2266 Wortley (Sir Francis). Characters and Elegies, first ed., mor. plain, from the libraries of George I., Wm. Cole, John Brand and Miss Currer, *(Privately)* *printed in the Yeere* 1646, sm. 4to. (373)
Tregaskis, £3 18s.

2267 Yarranton (Andrew). England's Improvement by Sea and Land, folding plates and maps, 2 vol. in 1 (rarely found complete with the second vol.), cf. ex., g.e., *Printed for the author*, 1677-81, sm. 4to. (374)
Ellis, £4 10s.

(β) *Other Properties.*

2268 Arabian Nights, by John Payne, one of 500 copies, 9 vol., vell., uncut, t. e. g., *Villon Society*, 1882-84, 8vo. (421)
Quaritch, £7 15s.

2269 [Ashbee (H. S.)] Index Librorum Prohibitorum, front., *Privately printed*, 1877 — Centuria Librorum Abscondi-

torum, front., etc., *ib.*, 1879—Catena Librorum Tacendorum, front. and ports., *ib.*, 1885, hf. mor., uncut, t. e. g., 4to. (412) *Edwards, £12* 15s.

2270 Beardsley (Aubrey). The Early Work, port. and illustrations, buckram, uncut, t. e. g., 1899, roy. 4to. (413) *Sawyer, £2* 6s.

2271 Bibliotheca Curiosa, ed. by Edmund Goldsmid, 64 vol., vell., *Edinb.*, 1884, etc., 8vo. (425) *Sawyer, £3* 17s. 6d.

2272 Boccaccio (G.) Decameron, by John Payne, 3 vol., vell., uncut, t. e. g., *Villon Society*, 1886, 8vo. (426) *Shepherd, £3* 7s.

2273 Book-Prices Current, from October, 1903 to July, 1905, 2 vol., 1904-5—Art Sales of the Year 1901, together 3 vol., 8vo. (377) *J. Bumpus, £1* 2s.

2274 Boswell (J.) Life of Johnson and "Johnsoniana," ports., 5 vol., uncut, 1884, roy. 8vo. (427) *Thomas, £1* 6s.

2275 Brillat-Savarin (J. A.) Handbook of Gastronomy (one of 300 copies), port. and 52 etchings on India paper, hf. vell., t. e. g., 1884, 8vo. (430) *Hill, £1* 5s.

2276 Burton (Captain Sir R. F.) The Kasîdah (Couplets) of Hâjî Abdû Al-Yazdi, one of 250 copies, 1900—The Beginning of the World, twenty-five pictures by Sir E. Burne-Jones, 1902, uncut, 4to. (414) *Maggs, £1* 7s.

2277 Caldecott (R.) Complete Collection of Pictures and Songs, with Preface by Austen Dodson, col. illustrations, etc., 1887, folio (523) *Young*, 19s.

2278 Cervantes (M. de). History of Don Quixote, by Motteux, LARGE PAPER, proof etchings on Japanese paper by Lalauze, 4 vol., uncut, 1881, 8vo. (437) *Sotheran, £1* 12s.

2279 Chalmers (G.) Caledonia, "New Club Series," with Index, plans, etc., 8 vol. (86 copies printed), *Paisley*, 1887-1902, 4to. (503) *Forrester, £1* 11s.

2280 De Quincey (T.) Works, author's ed., port. and illustrations, 16 vol., *Edinb.*, 1862-63, 8vo. (442) *Young, £1* 10s.

2281 Doran (Dr.) Annals of the English Stage, LARGE PAPER, one of 300 copies, 50 ports. in duplicate, one on Japanese paper and the other on plate paper, uncut, 1888, imp. roy. (443) *Sawyer, £1* 12s.

2282 D'Urfey (T.) Pills to Purge Melancholy, reprint, port., 6 vol., uncut, n. d., 8vo. (446) *Young, £1* 14s.

2283 Dumas (Alex.) Celebrated Crimes, photogravures, 8 vol., hf. mor., t. e. g., 1895, 8vo. (383) *J. Bumpus, £2* 16s.

2284 Etcher (The). A Magazine of the Etched Work of Artists, illustrations, parts i.-li., as issued, 1879-83, folio (524) *Hunt*, 11s.

2285 Farmer (J. S.) and Henley (W. E.) Slang and its Analogues, 7 vol., bds., uncut, 1890-1904, 4to. (415) *Edwards, £2* 10s.

2286 Fielding (Henry). Tom Jones, first ed., first issue, with the leaf of errata, 6 vol., orig. cf. (a few leaves stained), A. Millar, 1749, 8vo. (389) *Sawyer, £4* 15s.

2287 Fletcher (W. Y.) English Book Collectors ("The English Bookman's Library"), Japanese vell. paper, one of 50 num-

ɔered copies, ports. and illustrations, vell., uncut, t. e. g.,
1902, 4to. (416) *Maggs*, 12s.
2288 Gilchrist (Alex.) Life of Blake, port. and illustrations, 2 vol.,
uncut, 1880, 8vo. (451) *Bain*, £2 4s.
2289 Glasgow Past and Present, one of 500 copies, ports., etc.,
3 vol., *Glasgow*, 1884, 8vo. (505) *Forrester*, £1 7s.
2290 Haden (Seymour). Aɔout Etching, 15 facs., hf. mor., t. e. g.,
1879, 8vo. (507) *Sawyer*, £3 3s.
2291 Hamerton (P. G.) Etching and Etchers, third ed., illustra-
tions, hf. mor., uncut, 1880, folio (526) *Tregaskis*, £4
2292 Heywood (T.) Dramatic Works, 6 vol., uncut, Pearson,
1874, 8vo. (455) *Hill*, £2
2293 Houghton (W.) British Fresh-Water Fishes, col. illustra-
tions, 2 vol., n. d., folio (528) *Edwards*, 13s.
2294 Jamieson (J.) Etymological Dictionary of the Scottish
Language, with the Supplement, "New Cluɔ Series," 85
copies printed, 5 vol., *Paisley*, 1879-87, 8vo. (511)
 Quaritch, £2 8s.
2295 Jesse (Capt.) Life of Brummell, LARGE PAPER (one of 100
copies), 40 col. ports., uncut, 1886, imp. 8vo. (459)
 J. Bumpus, £1 18s.
2296 Johnson (J.) Scots Musical Museum, 4 vol., with the music,
hf. bd., uncut, 1853 (460) *W. Brown*, £1 13s.
2297 Kay (John). Original Portraits and Caricature Etchings,
plates, 2 vol., hf. mor., t. e. g., *Edinb.*, 1877, 8vo. (512)
 C. Jackson, 12s.
2298 Livingston (Luther S.) Auction Prices of Books, 4 vol., *New
York*, 1905, 4to. (418) *J. Bumpus*, £4 4s.
2299 Lyndsay (Sir David). Facsimile of an Ancient Heraldic
Manuscript, col. plates, uncut, t. e. g., *Edinb.*, 1878, folio
(529) *Quaritch*, £1 8s.
2300 Marlowe (C.) Works, ed. by A. H. Bullen (one of 120
copies), 3 vol., uncut, 1885, 8vo. (469) *Quaritch*, £3 12s.
2301 Middleton (T.) Works, ed. ɔy A. H. Bullen (one of 120
copies), port., 8 vol., uncut, 1885-86, 8vo. (472)
 W. Brown, £3 6s.
2302 Montaigne (M. de). Essays, ed. ɔy W. C. Hazlitt, port.,
3 vol., 1877, 8vo. (473) *Hornstein*, £1 14s.
2303 National Manuscripts of Scotland, photozincographed ɔy Sir
H. James, facs., 3 vol., hf. mor., t. e. g., 1867-71, atlas folio
(530) *Quaritch*, £3 3s.
2304 Payne (John). Alaeddin and the Enchanted Lamp, vell.,
uncut, t. e. g., *Villon Society*, 1889, 8vo. (420) *Thin*, 16s.
2305 Poe (E. A.) Tales and Poems, by J. H. Ingram (one of 150
copies), proof etchings and port. on Japanese paper, 4 vol.,
uncut, 1884, 8vo. (479) *W. Brown*, £2 6s.
2306 Roscoe (Thos.) Novelist's Liɔrary, illustrations by G. Cruik-
shank, vol. i.-x., orig. cl., 1831-32, 8vo. (483)
 Thorp, £1 10s.
2307 Shakespeare (W.) Poems on several occasions, front. (1774)
—Poems, *Reprinted for T. Evans* (1775), cf. (399)
 Thorp, 17s.

2308 Shakespeare (W.) Works, ɔy Alex. Dyce, port., 9 vol., hf.
mor., t. e. g., 1875-76, 8vo. (486) *Hill*, £2 6s.
.2309 Shelley (Percy B.) Poetical Works, ed. ɔy Mrs. Shelley,
port., 3 vol., uncut, Moxon, 1847, 8vo. (400)
Edwards, £1 3s.
2310 Sidney (Sir Philip). Works, port. and plates, 3 vol., hf. cf.,
m. e., 1725, 8vo. (401) *Hill*, £1 12s.
2311 Stodart (R. R.) Scottish Arms, plates of arms in colours,
2 vol., uncut, t. e. g., *Edinb.*, 1881, folio (536)
Quaritch, £3 10s.
2312 Swift (Dean). Prose Works, ed. ɔy Temple Scott, ports.
(Bohn's Standard Liɔrary), 12 vol., uncut, 1905, 8vo. (402)
Hill, £1 2s.
2313 Symonds (J. A.) Life of Benvenuto Cellini, LARGE PAPER
(one of 100 copies), port. and etchings as India proofs and
18 illustrations, 2 vol., uncut, 1888, imp. 8vo. (491)
Hill, £6 10s.

(γ) *The following was sold by Messrs. Hodgson and Co. on
December 3rd.*

2314 Cervantes (Miguel de). El Ingenioso Hidalgo Don Quixote
de la Mancha, printed throughout on cork, 𝔤𝔬𝔱𝔥𝔦𝔠 𝔩𝔢𝔱𝔱𝔢𝔯, red
and ɔlack, woodcut port. of the author, ɔorders and initials,
some of the large initials illuminated ɔy hand, 2 vol., cork
ɔinding, in leather case, silk lined, *Barcelona*, Octavio
Viader, 1909, sm. folio (902) £10
[Only 6 copies are said to have ɔeen printed. The text
is printed on sheets of very thinly cut cork, and the volumes
weigh just under 16 oz. each.—*Catalogue.*]

[DECEMBER 9TH AND 10TH, 1909.]

SOTHEBY, WILKINSON & HODGE.

A MISCELLANEOUS COLLECTION.

(No. of Lots, 479; amount realised, aɔout £3,549 16s.)

[NOTE.—Among the manuscripts comprised in this catalogue,
and not reported in detail, the following are specially noticeaɔle :—
Biɔlia Sacra Heɔraica, written on vellum at Damascus in 1496,
small 4to., on 493 leaves, many illuminated in gold, red and ɔlue,
the margins decorated (*Evelyn*, £56, tortoiseshell, with silver
hinges, clasps and decorations, Lot 188) ; "The Genealogie of the
Familye of the Taverners of North-Elmham," written ɔy F.
Taverner in 1636, folio, on paper, 92 leaves (*Whyte*, £5, old vell.,
Lot 234); Horæ Beatæ Mariæ Virginis Secundum usum Romanum,
French XVth century, on vellum, 181 leaves, 8½ins. ɔy 5½ins., 12

illuminated semi-arched and square miniatures, wanted one leaf, small 4to. (*Forster*, £54, old English mor., Lot 351) ; Horæ Beatæ Mariæ Virginis ad usum Romanum, French XVIth century, on vellum, 119 leaves, 4¾ins. ɔy 3ins., 12 illuminated miniatures and 24 small miniatures of saints (*Maggs*, £51, old mor., Lot 353) ; Horæ Beatæ Mariæ Virginis ad usum Romanum, French XVth century on vellum, 242 leaves, 5½ins. ɔy 3½ins., 4 illuminated arched miniatures, 4 small miniatures and decorations (*Sabin*, £55, XVIth century Lyonnese calf, with name of former owner "Jacqueline Goɔelet," Lot 372) ; Evangelia quædam ab aliis Segregata et Secundum Ordinem dierum Sollennium Ordinate Scripta, Flemish or German XVIth century, on vellum, 120 leaves, 10½ins. ɔy 7½ins., 17 small miniatures, 2 full-page paintings (*Edwards*, £62, oaken bds., covered with velvet, German silver corners and clasps, Lot 390) ; Psalterium Davidis Regis, English early XIVth century, on vellum, 159 leaves, 7ins. ɔy 5½ins., 8 illuminated initial miniatures, text decorated throughout, first leaf of text wanting (*Quaritch*, £200, unbd., Lot 395) ; Pontificale Gallico-Romanum, French XVth century, on vellum, 415 leaves, 11ins. ɔy 7½ins., large missal characters, aɔout 1000 decorated floreate initials, one damaged miniature (*Leighton*, £45, mor., g. e., Lot 478).—ED.]

2315 A'Beckett (G. A.) The Comic History of England, col. plates, in the orig. 20 parts in 19, orig. ɔlue wrappers, all but 2 parts entirely unopened, 1847-48, 8vo. (69)

Sotheran, £9

2316 Alphonsii Regis Castellae Coelestium motuum taɔulae, etc., lit. goth., editio princeps, 94 leaves, woodcut initials and 2 astronomical diagrams, hf. vell., *Venetiis*, Ratdolt, 1483 (215) *Young*, £3 4s.

[Hain-Copinger 868. The latter gives 120 leaves, but the collation ɔy Hain is generally considered the more correct ; the 24 leaves of Calendar referred to ɔy Copinger ɔeing really a separate work.—*Catalogue.*]

2317 America. Novus Orɔis Regionum ac Insularum veteribus Incognitarum, una cum taɔula cosmographica, large douɔle-heart shaped map of the world ɔy Oronce Finé, old French mor., the centre with a semis of fleur-de-lis, gilt ɔack and edges, proɔaɔly ɔound for Louis XIII. of France, ɔy Le Gascon (ruɔɔed), *Parisiis*, 1532, folio (228)

Parsons, £4 19s.

[Harrisse, B.A.V., No. 172. This is one of the earliest collections of voyages, containing the voyage of Aloysio Cadamosto, the first three expeditions of Columɔus, the voyages of Alonzo Nino and Vicent Pinzon, the third voyage of Vespucci, the four relations of the same, etc. The map of the world ɔy Oronce Finé is usually missing. Lateral ornamental ɔorders of map very slightly cut into. —*Catalogue.*]

2318 America. The Golden Coast, or a Description of Guinney 47 leaves (wanted ɔlank for Aj), unbd., S. Speed, 1665—An

Account of Monsieur de Quesne's late Expedition to Chio, etc., unbd., R. Tonson, 1683, sm. 4to. (451) *Edwards*, £5
2319 America, etc. Pownall (Gov. T.) A Memorial addressed to the Sovereigns of America, J. De>rett, 1783—Political Reflections · on the late Colonial Governments >y an American, G. Wilkie, 1783—Speeches of Mr. Smith of South Carolina, J. Stockdale, 1794—Address from Wm. Smith of S. Carolina to his Constituents, J. De>rett, 1794—American Budget, 1794, Presented to the House of Representatives >y A. Hamilton, etc., *ib.*, 5 tracts in 1 vol., hf. cf., 8vo. (442) *Leon*, £3 10s.
2320 America, etc. Johnson (Dr. S.) Taxation no Tyranny, third ed., T. Cadell, 1775—The Rights of Great Britain asserted against the Claims of America, *ib.*, 1786—An Answer to the Declaration of the American Congress, *ib.*, 1786—Paine (Tom). Common Sense, new ed., J. Almon, 1776—True Merits of a late Treatise, pu>lished in America, entitled "Common Sense," W. Nicoll, 1776—Adams (Samuel). An Oration delivered at the State-House in Philadelphia, Aug. 1, 1776, J. Johnson, 1776—Minutes of the Trial and Examination of Certain Persons in the Province of New York, J. Bews, 1776—Tracts against Dr. Price, etc., 12 pamphlets in 1 vol., old cf., 8vo. (443)
H. Stevens, £18
2321 America. Wafer (Lionel). A New Voyage and Description of the Isthmus of America, map and plates, old cf., J. Knapton, 1699—History of the Buccaneers of America, third ed. (with De Lussan's Journal of Voyage to the South Sea), maps and plates, in 1 vol., old cf., T. New>orough, etc., 1704 (432) *H. Stevens*, £2 17s.
2322 America. Carver (J.) Travels through the Interior Parts of America, maps and plates, old cf., 1778—Rogers (Maj. R.) Concise Account of North America, old cf., 1765—Present State of Great Britain and North America, old cf., T. Becket, 1767, together 3 vol., 8vo. (434) *Hatchard*, £6 15s.
2323 America. Colden (C.) History of the Five Indian Nations, second ed., maps, old cf., J. Whiston, 1750—Williamson (Peter). French and Indian Cruelty, exemplified in the Life of Peter Williamson, third ed., port. of the author (loose), hf. bd., *Glasgow*, 1758, 8vo. (435)
H. Stevens, £4 10s.
2324 America. Dampier (Capt. Wm.) New Voyage round the World, maps and plates, 3 vol., old cf., J. Knapton, 1717, 1705, 1709, 8vo. (436) *Edwards*, £1 17s.
2325 America. Hudson's Bay. Ellis (Henry). A Voyage to Hudson's Bay, map and plates, old cf., H. Whitridge, 1748—Ro>son (Jos.) Account of Six Years' Residence in Hudson's-Bay, draughts and plans, old cf., J. Payne, etc., 1752, 8vo. (437) *Grant*, £2 5s.
2326 American and other Colonial Pamphlets. Present State of Nova Scotia, plan of the Har>our of Chebucto and Town of Halifax (mounted), *Edin.*, W. Creech, 1787—A Short

Account of the Prince of Wales's Island or Rulo Peenang, view and map, J. Stockdale, 1788—Authentic Statement of all the facts relative to Nootka Sound, De)rett, etc., 1790— A Serious Admonition to the Pu)lick on the Intended Thief-Colony at Botany Bay, *G. Bigg for J. Sewell*, 1786, in 1 vol., hf. cf., 8vo. (438) *Quaritch*, £10

2327 America, etc. An Account of East Florida, G. Woodfall, etc., n. d.—Memoirs of Lieut. Henry Tim)erlake, map of the Over-hill Settlement, and a Secret Journal taken from a French Officer, *Printed for the Author*, 1765—Holwell. (J. E.) Narrative of the Deaths in the Black-Hole at Calcutta, 1757, and others, 7 tracts in vol. 1, old cf., 8vo. (439) *Edwards*, £12 5s.

2328 America, etc. Fa)ricius, or Letters to the People of Great Britain on the A)surdity and Mischiefs of Defensive Operations *Only* in the American War, G. Wilkie, 1782— Addresses and Recommendations to the States)y the United States in Congress Assem)led, J. Stockdale, 1783— A Circular Letter from George Washington to Wm. Greene, 1783—O)servations on the Commerce of the American States, J. De)rett, 1783, etc., 6 tracts in 1 vol., hf. cf., 8vo. (440) *Harding*, £4 15s.

2329 America, etc. The Wisdom and Policy of the French in the Construction of their great Offices, R. Baldwin, 1755—A Miscellaneous Essay on the Courses pursued)y Gt. Britain in the Affairs of her Colonies, *ib.*, 1755—An Answer to an invidious Pamphlet, intituled, A Brief State of the Province of Pensylvania, J. Bladon, 1755—Clarke (Wm.) O)servations on the Conduct of the French, J. Clarke, 1755, and another, 5 pamphlets in 1 vol., hf. cf., 8vo. (441) *Leon*, £8 10s.

2330 Anderson (J.) Royal Genealogies, cf., 1732, folio (258) *Quaritch*, £1

2331 [Ash ('Thos.)] Carolina, or a Description of the Present State of that Country (22 leaves), unbd., *Printed for W. C. and Sold by Mrs. Grover in Pelican Court, Little Britain*, 1682, sm. 4to. (450) *H. Stevens*, £10 10s.

2332 Augustinus. Regula cum Commentariis edita ab Am)rosio Coriolano, lit. rom., long lines, 34 to a full page, without marks (first 4 leaves defective and mended, other margins mended), illuminated initial and coat-of-arms to first page of Second Treatise, 2 vol. in 1 (sold not su)ject to return), vell., *Romae, Georgius Herolt de Bamberga*, 1481, 4to. (388) *Barnard*, £2 4s.

2333 Bacon (Francis, "Lord Verulam"). Concordantiæ Bibliorum, old cf., *Paris*, C. Wechel, 1600, folio (409) *Sotheran*, £30 [Francis Bacon's copy, with his autograph signature on title, "Francis Bacon's)ooke)tium 13s. 4d." Contained also signatures of Sir Ro)ert Throckmorton, with his old ex-li)ris, and "Biblioth. Th. Preston."—*Catalogue.*]

2334 Bacon (Francis). Sylva Sylvarum, first ed., port. and engraved

title-page ɔy Th. Cecill, cf., g. e., *J. H. for Wm. Lee,* 1627, folio (223) *Maggs, £5* 10s.
2335 Barnes (Juliana). The Booke of Haukyng, Huntynge and Fysshyng. The Booke of Hunting (only), from W. Copland's ed., 16 leaves, **black letter,** first leaf with woodcut in fac., old mor., g. e., *Imprynted at London in the ventre upon the Crane Wharf by me William Copland,* n. d. (185)
Leighton, £2 10s.
2336 Baxter (Rev. Richard). The Saints Everlasting Rest, first ed., old cf., *R. White for Thos. Underhill, etc.,* 1650, sm. 4to. (381) *Williams, £2*
2337 Berry (Wm.) County Genealogies, Pedigrees and Families in the County of Sussex, coats-of-arms, orig. bds., uncut, 1830, folio (267) *Harding, £3* 10s.
2338 Biɔle Illustrations. The true and lyvely historyke purtreatures of the Woll Biɔle, first ed., 194 woodcuts by Le Petit Bernard, with English verses, some lines of the French version in MS. in margins (dedicated to "Master Pikeling, Amɔassador of the Kinge of England," ɔy Peter Derendel), (title patched, some stains), ɔlank leaf with ornament at end, mor., g. e., *Lyons, by Jean of Tournes,* 1553, 8vo. (371) *Tregaskis, £5*
2339 Biɔlia Græca Septuaginta. Sacræ Scripturæ Veteris Novaque Omnia, Greek italics in douɔle columns, 55 lines, title in red, with anchor, ornamental initials and ornaments, signature of Jo. Marquardus Patavii on title, contemp. Venetian cf., line tooled, g. e. (with all ɔlanks), *Venetiis in ædibus Aldi et Andreæ Soceri* 1518 *mense Februario,* folio (408)
Holme, £38
[The first Aldine Greek Biɔle and the first puɔlished edition of the Septuagint.—*Catalogue.*]
2340 Biɔlia Sacra Latina, contemp. signature of Thomas Buttes on title-page, and acrostic on his name in his autograph on fly-leaf, last leaf pasted down, contemp. cf., metal corner pieces, centre medallions and claps, and initials T. B., *Antverpiae,* 1537, folio (250) *Quaritch, £6* 5s.
2341 Bland (Edw.) Abr. Woode, Sackford Brewster and Elias Pennant. The Discovery of New Brittaine, 12 leaves, including frontispiece of "Indian Wheat" and "An Indian Lay" (a ɔird), and the rare folding map of "Virginia discovered to ye Hills," etc., with a head of Sir F. Drake, engraved by John Goddard, and "sold by F. Stephenson ɔelow Ludgate, 1651" (small portion of the margin cut off the ɔottom right-hand corner, and wanted dedication, 1 leaf, to Sir John Denvers), orig. ed., unbd., 1651, sm. 4to. (89)
Quaritch, £200
[Returned from Lord Polworth's sale on account of the imperfections stated. *See* BOOK-PRICES CURRENT, Vol. xxiii., No. 4000.—ED.]
2342 Boothɔy. (Richard). A Breife Descovery or Description of the most Famous Island of Madagascar, orig. ed., title, 4 prel. leaves, 72 pages, and leaf of errata (headline of one

leaf of Epistle cut into), unbd., *E. G. for John Hardesty,*
1646, sm. 4to. (286) *Leon,* £2 2s.
2343 Boswell (H.) Description of a Collection of Picturesque
Views and Representations of the Antiquities of England,
Wales, Scotland and Ireland, front. and copperplates, maps
and plans, about 380 of which (two, three or six views on a
page) coloured by J. M. W. Turner when a boy, living at
Brentford, orig. cf. (broken, wanted the title), n. d. (1785),
folio (220) *Needes,* £31
 [The MS. Family Register of the various branches of
the Lees Family [1755-1821], two printed advertisements
relative to passing over the business of Charles Child to
John Lees, tallow chandler, and a number of cuttings and
advertisements, etc. accompany this volume. *See* Dictionary
of National Biography, Art : Turner (J. M. W.), where it
is referred to as having been coloured by Turner.—ED.]
2344 Bowring (J.) Minor Morals for Young People, first ed.,
plates by G. Cruikshank and W. Heath, 3 vol., orig. bds.,
1834-39, 8vo. (7) *Morley,* 10s.
2345 Brant (Seb.) Carmina varia, editio prima, cut on title, full-
page cut at dI. and printer's device at end, *Basil.,* J.
Bergman de Olpe, 1498—Stultifere Navis, editio prima,
woodcuts (imperfect, beginning on diiii. margins cut into),
ib., 1497, in 1 vol., old Spanish cf., sm. 4to. (397)
 Holmes, £4 5s.
2346 Breviarium Romanum ex Decreto S. Concilii Tridentini
restitutum Pius V. P. M. jussu editum, 4 vol., orig. Spanish
mor., with inlayings, floreate ornaments, metal clasps,
Antw. ex Architypographia Plantiniana, 1752, 4to. (400)
 Garland, £1 1s.
2347 British Military Library (The), or Journal comprehending a
Complete Body of Military Knowledge, maps, plans and
col. plates of military costumes, 2 vol., cf. (rebacked), 1799-
1801, 4to. (171) *Hatchard,* £10
2348 Bullock (Wm.) Virginia Impartially Examined, original ed.
(39 leaves), unbd., uncut, *Printed by John Hammond over
against St. Andrews Church in Holborn,* 1649, sm. 4to.
(446) *H. Stevens,* £22 10s.
2349 Bunbury (H.) Twenty Plates of illustrative scenes from
Plays by Shakspeare, hf. bd., 1792-96, oblong folio (240)
 Sotheran, £4
2350 Bunyan (John). The Pilgrim's Progress, sixteenth ed., port.,
woodcuts and woodcut port. on reverse of last leaf, orig. cf.,
N. Boddington in Duck-Lane, 1707, 8vo. (419)
 F. H. Green, 18s.
2351 Burnet (G.) Some Letters containing an Account of what
seemed most remarkable in Switzerland, Italy, etc.,
cf., Dryden's copy, with his autograph signature, 1 Feb.,
1686, on fly-leaf, *Rotterdam,* 1686, 8vo. (61)
 Sotheran, £3 10s.
2352 [Burney (F.)] Camilla, or a Picture of Youth, first ed., 5 vol.,
orig. cf., 1796, 8vo. (70) *Hatchard,* £2

2353 [Burney (F.)] Evelina, first ed., 3 vol., orig. hf. cf., *T. Lowndes in Fleet St.*, 1778, 8vo. (417) *Hornstein*, £20 10s.

2354 [Burney (F.)] Cecilia, first ed., 5 vol., orig. hf. cf., *T. Payne*, etc., 1782, 8vo. (418) *Edwards*, £1 12s.

2355 Burns (Robert). Poems, first ed. printed in America, with Burns's dedication dated Edinburgh, 1787 (stained, title written on and margins of index wormed), orig. cf., *Philadelphia, printed for and sold by P. Stewart and G. Hyde*, 1788 (363) *Maggs*, £3 10s.

2356 Butler (S.) Hudibras, in three parts, first ed. with the folding plates by Hogarth, and port., cf. gt., 1726, 8vo. (24) *Leighton*, 14s.

2357 Buttes (Henry). Dyets Dry Dinner, first ed. (title defective, outer margins of 2 leaves frayed), hf. cf., *Tho. Creede for W. Wood*, 1599, 8vo. (421) *Tregaskis*, £3

2358 Callender (John). An Historical Discourse on the Civil and Religious Affairs of the Colony of Rhode Island and Providence Plantations, hf. brown mor. (writing on verso of title), *Boston, printed and sold by S. Kneeland*, 1739 (33) *Tregaskis*, £3 3s.
[The original edition of the earliest historical work on the Colony of Rhode Island.—*Catalogue.*]

2359 Cartwright (John). The Preachers Travels, orig. ed. (a few leaves stained), unbd., T. Thorppe & W. Burre, 1611, sm. 4to. (288) *Dobell*, £1 7s.

2360 Castell (Wm.) A Short Discoverie of the Coasts and Continent of America, orig. ed., blank leaf at end, unbd., *Printed in the year* 1644, sm. 4to. (287) *Edwards*, £21 10s.

2361 Charles I. Eikon Basilike, first ed. (?), double-page engraving by W. Marshall, 4 prelim. leaves and 269 pages erroneously paginated on pages 81, 84, 85, 88, 89, 92, 93, 96 and 108, orig. cf., n. p. or n., 1648, 8vo. (54) *Ellis*, £2 10s.

2362 Chaucer (Geffrey). Woorkes (ed. by John Stow), **black letter**, arms on title (mounted) and woodcuts (margins repaired, last leaf defective, some headlines shaved), cf., *Jhon Kyngston for Jhon Wight*, 1561, folio (249) *Harper*, £5

2363 Chinese Repository, from the commencement to 1849, map and plates, in the orig. numbers (wanting 19), 18 vol. (wrappers gone), 2 vol. hf. bd., 1832-49, folio (273) *Quaritch*, £8 10s.

2364 Cicero. De Natura Deorum et De Divinatione, manuscript on vellum (169 leaves, 10in. by 7in.), roman letters by an Italian scribe, long lines, 28 to a full page, old russ. (from the Wodhull library), *Sæc.* xv., 4to. (387) *Bull*, £9 10s.

2365 Cokayne (G. E.) Complete Peerage, 8 vol., hf. cf., 1887-98, 8vo. (2) *Harding*, £8 10s.

2366 [Combe (Wm.)] The Three Tours of Dr. Syntax, col. illustrations by Rowlandson, 3 vol., hf. mor., Ackermann, 1813-1820-1821, roy. 8vo. (346) *Edwards*, £7 10s.

2367 [Combe (W.)] The Wars of Wellington, 6 col. plates by W. Heath, orig. hf. mor., 1821, 4to. (206) *Shepherd*, £2 2s.

2368 Cooke (Ch.) Proof Portraits and Embellishments to illustrate
the best English Novelists, Poets and Essayists, 4 vol.,
mor., g. e., 1805, 8vo. (52) *Sotheran,* £4 15s.
2369 Corneille (P.) Le Menteur, Comedie (207 by 251 mm.), first
ed., hf. cf., *Imprimé à Rouen, et se vend à Paris, Ant. de
Sommaville et Aug. Courbé,* 1644, 4to. (218)
 Leighton, £1 11s.
2370 Cornwallis (Sir Wm.) Essayes, Newlie Corrected, engraved
title by T. Cecil, orig. cf., *T. Harper for I. M.,* 1632, 8vo.
(420) *Pickering,* £1 5s.
2371 Cruikshank (G.) Points of Humour, both parts, duplicate
set of the etchings, one proofs on India paper, the other
coloured, also proofs of the vignettes on India paper, mor.
ex., by Morell, in case, 1823-24, 8vo. (20) *Barrow,* £9
2372 Cruikshank (George). The Loving Ballad of Lord Bateman,
first ed., plates by G. Cruikshank, with the 8 pages of
advertisements, and music, orig. green cl., C. Tilt, 1839,
12mo. (63) *Rimell,* £4 10s.
2373 Curtis (Wm.) Flora Londinensis, orig. issue, col. plates,
bound in 2 vol. (no general title to vol. ii.), old cf. (cracked),
Printed and Sold by the Author, etc., 1727, folio (472)
 Andrews, £2
2374 Davity (Pierre). Les Travaux sans Travail, avec le tūbeau
de Madame la Duchesse de Beaufort (en Prose et en Vers),
première ed. (margins stained), contemp. French mor.,
arms of Henri IV. of France and Navarre, crowned H's in
corners and on back, *à Tournon par Claude Michel,* 1599,
8vo. (336) *Sabin,* £25 10s·
2375 Defoe (Daniel). Robinson Crusoe, second ed., front. mounted
(soiled copy), 1719—The Farther Adventures of Robinson
Crúsoe, second ed., wanting map, 1719, together 2 vol., cf.
gt., by Tout, 8vo. (68) *Sotheran,* £2 2s.
2376 Dickens (Charles). A Collection of Works by or relating to
Dickens, the property of Mr. C. E. Stewart, comprising
lots 98 to 166, 8vo. *et infra* £140
[The catalogue contains on seven pages a list of the
books forming this collection.—Ed.]
2377 Dickens (C.) Sunday under Three Heads, reprint on vellum
(the only one done), mor. gt., Pearson (1836), 8vo. (45)
 Hornstein, £1 8s.
2378 Diurnum una cum Psalmis, secundum consuetudinem fratrum
predicatorum Sancti Dominici (pages 121-298), lít. gotḥ.,
woodcuts, orig. stamped fish-skin, arms on sides, *Venetiis,
apud Juntas,* 1561, 8vo. (4) *Barnard,* £3
2379 Douglas (Rev. Jas.) Nenia Britannica, plates, old russ., J.
Nichols, 1793, folio (466) *Bull,* 10s.
2380 Edwards (Dr. Jon.) Observations on the Language of the
Muhhekaneew Indians, orig. ed., unbd., uncut, *New-Haven
printed by Josiah Meigs,* 1788—Protest against the Bill to
Repeal the American Stamp Act, unbd., 1766, 8vo. (289)
 Maggs, £1 10s.
2381 Edwards (George). Natural History of Uncommon Birds

(part of text in French and English), 362 plates, col. from nature, 7 vol. complete, contemp. cf. ex., *Printed for the Author*, 1743-1764, 4to. (453) *Edwards, £4* 2s. 6d.
2382 Fenn (Sir John). Paston Letters, orig. ed., ports. and plates, 5 vol., orig. cf., y. e., presentation copy from Sir John Fenn to Jas. Smyth, Esq., of Norfolk, Rojinson and Murray, 1787-1823, 4to. (459) *Maggs, £2* 2s.
2383 Fletcher (John). Monsieur Thomas, a Comedy, first ed. (upper margin of one leaf mended), cf., g. e., jy Rivière, *Thomas Harper for John Waterson*, 1639, 4to. (170)
Pickering, £4 5s.
2384 Fletcher (P.) The Purple Island, or the Isle of Man, with the two jlank leaves and the poem, "To my deare Friend, the Spencer of this Age," jy Fr. Quarles (usually wanting), orig. sheep, *Cambridge*, 1633, 4to. (177) *Burgon, £11*
2385 Gardiner (Capt. Rich.) An Account of the Expedition to the West Indies, Against Martinico (text in English and French), maps, presentation copy from the author, *Birmingham, John Baskerville for.G. Steidel*, 1762—Rojerts (Wm.) Account of the First Discovery and Natural History of Florida, map and plans and geographical description jy T. Jefferys, T. Jefferys, 1763—Pittman (Capt. Ph.) Present State of the European Settlements on the Mississippi, plans and draughts, J. Nourse, 1770, in 1 vol., hf. cf., 4to. (452) *Leon, £17* 10s.
2386 Garrucci (R.) Storia della Arte Christiana, 500 plates, 6 vol., hf. mor. ex., jy Zaehnsdorf, Prato, 1873-81, folio (251)
Maggs, £7
2387 Glanvilla. Bartholomæus Anglicus. De Rerum Proprietatibus, XX. Livres. French XVth Century. [Text jegins on folio 15], illuminated manuscript on fine vellum (415 leaves jeside 14 leaves for tajle and 2 jlank, 15¾ by 11in.), lettres bâtardes, doujle columns, 45 lines, text of tajle decorated with large illuminated initials and pen-letters, the first page of text having a square miniature (7in.), 18 illuminated square historiated miniatures (3½in.) each with decorative initial, and marginal decorations (wanted a leaf of text in jooks X. and XII., and consequently 2 of the miniatures), many hundred illuminated initials and penletters throughout, old cf. gt. with jrass clasps, *Sæc.* XV., folio (407) *Restall, £350*
2388 Glas (George). Discovery and Conquest of the Canary Islands, map, old cf., R. and J. Dodsley, 1764, 4to. (456)
Warren, 10s.
2389 [Goldsmith (O.)] The Citizen of the World, first ed., 2 vol., orig. cf., 1762, 8vo. (3) *Richards, £1* 10s.
2390 Gomez (Fernan). Centon Epistolario, estas Epistolas fueron escritas al Rei D. Juan el segundo, etc., primera ediçion, lit. golḥ., modern mor., g. e. (Salva copy), *fue estampado e corretto por el protocolo del mesmo Bachiller Fernan Perez por Juan de Rei ea su costa en Cibda de Burgos el Anno* MCDXCIX. (1499), sm. 4to. (398) *Holme, £2* 10s.

[In consequence of the later aspect of this volume with
its small Arabic numbers on each page, the printed date is
thought to be erroneous, and the volume really to have
been printed early in the 16th century. [*See* Brunet.]—
Catalogue.]

2391 Gould (John). Monograph of the Trochilidae, 5 vol., mor. ex.,
Published by the author, 1861, folio (231) *G. H. Brown*, £20

2392 Grolier Club. Catalogue of Books from Libraries or Col-
lections of Celebrated Bibliophiles and Illustrious Persons
of the Past, illustrated, 350 copies printed, *New York*, 1895
(28) *Shepherd*, £1 18s.

2393 Grolier Club. Year Books (giving Lists of Members with
addresses, etc.), 1899-1908 (except 1902 and 1904), 8 vol.,
uncut, *New York*, 1899-1908, 8vo. (35) *Maggs*, £3 3s.
[The volume for 1906 gives a complete bibliography of
the publications of the Grolier Club.—*Catalogue.*]

2394 Grolier Club. Collection of 22 Grolier Club Catalogues,
comprising the Haden Etchings, Blake, Hawthorne,
Whistler, Dryden, Franklin and others (many with colla-
tions), wrappers, uncut, *New York*, 1898, etc., 8vo. (36)
 Tregaskis, £6 5s.

2395 Grolier Club. Catalogue of Original and Early Editions of
English Writers from Wither to Prior, with collations, notes
and more than 200 facs., 3 vol., hf. mor., uncut, one of 400
copies on Holland paper, *New York*, 1905, 8vo. (37)
 J. Bumpus, £12 5s.

2396 Grolier Club. Catalogue of an Exhibition of Selected Works
of the Poets Laureate of England, LARGE PAPER, mezzo.
port. of Jonson, uncut, one of 300 copies printed, *New York*,
1901, 8vo. (38) *Sotheran*, £1 2s.

2397 Hall (David). A Mite into the Treasury, or some Serious
Remarks on that Solemn and Indispensible Duty of Duly
Attending Assemblies for Divine Worship, hf. mor., *London
printed, reprinted by B.(enjamin) Franklin and D. Hall*,
1758 (30) *Leon*, £1 18s.

2398 Hayley (Wm.) The Triumphs of Temper, 6 plates engraved
by William Blake, hf. cf., uncut, *Chichester*, 1803, 8vo. (6)
 Dobell, 14s.

2399 Haymon. Haymonis Episcopi Halberstadiensis Expositio in
Epistolas Pauli Apostoli. French XVth Century. [Begins
(after a table of 2 pages)] "Incipit Expositio Haymonis in
Epistolam Pauli apostoli ad Galathas." [Ends] "Explicit
expositio Haymonis in Epistolas Pauli apostoli," illuminated
manuscript on vellum (141 leaves, 11 by 8in.), 𝔤𝔬𝔱𝔥𝔦𝔠 𝔩𝔢𝔱𝔱𝔢𝔯𝔰,
double columns, 34 lines, the first page illuminated, within
a decorative border, and the arms of Guillaume de Budé
below, also 20 large illuminated decorative initials, French
mor. ex. (Bozerian), *Sæc.* XV., sm. folio (404) *Leighton*, £98
[A very finely written and decorated manuscript executed
for Guillaume de Budé (Budæus), the French Bibliophile
(*see* "Guigard's Armorial"). Later the volume was in the
possession of Nicholas Thoynard of Orleans.—*Catalogue.*]

2400 Haym (N. F.) Biblioteca Italiana, Thomas Gray's : copy, with his initials pasted on fly-leaf and marginal notes in his minute handwriting, cf. gt., *Venezia*, 1736, 4to. (172)
Dobell, £1

2401 Hayward (J.) The First Part of the Life and Raigne of King Henrie the IIII., first ed., port. of Hayward inserted, cf., g. e., John Wolfe, 1599, 4to. (180) *Maggs*, £2 3s.

2402 Heath (Henry). Passing Characteristics, orig. ed., 26 humorous col. plates, with the picture boards, hf. mor., as issued by the publisher, J. B. Brookes, *New Bond St.*, n. d., 4to. (405) *Spencer*, £11

2403 Hennepin (L.) Voyage ou nouvelle découverte d'un très grand pays dans l'Amérique, maps and plates (a few mended), hf. cf., *Amsterdam*, 1704, 8vo. (60)
H. Stevens, £1 12s.

2404 Holbein (Hans). Imitations of Original Drawings, published by J. Chamberlaine, 84 ports. (including those of Holbein and his wife, and the miniatures in colours of the two children of Charles Brandon, Duke of Suffolk), hf. russ., 1792-1800, atlas folio (243) *Edwards*, £25 10s.

2405 Horae B. V. M. ad Usum Parisiensem, lit. gotfj. (bâtardes), printed upon vellum, long lines, 22 to a full page, Saint Graal on first page, astrological man (mutilated), 17 full-page woodcuts, 30 small woodcuts of saints and evangelists, all painted and illuminated, illuminated ornamental initials and decorative ornaments, contained 13 leaves, the first 8 leaves without sign., followed by A 10 leaves, then A-K in 8's, ending with 32 leaves without signs., contemp. mor., gilt tooled, *à Paris le xxi. jour de Juing lan mill cinq cens et dix pour Anthoine Verard*, 1510, 8vo. (334) *Delaine*, £38

2406 Horae B. V. M. cum Calendario. Die ghetijden van onser liever Vrouwē met vele schoon leven ende oracien, lit. gotfj., red and black, printed upon vellum, within borders of various scriptural and ecclesiastical subjects, 16 full-page metallized woodcuts (slightly soiled, inner margins of q 1 and 4 mended), old cf., *Gheprent te Paris bii Thielman Kerver*, 1500 (320) *Barnard*, £11 15s.

2407 Horae B. V. M. cum Calendario. "Hore Christifere Virginis Marie Secūdum Usum Romanū," lit. gotfj., 8 leaves wanting, printed within ornamental woodcut borders, skeleton man, 25 full-page woodcuts, some within architectural frames, coloured throughout, capitals painted, contained 98 leaves, signs. A-O 6 in 8's, old cf. (cracked), with all faults, *Paris, S. Vostre [no colophon; Almanack 1508-1528]*, 4to. (292)
Edwards, £4 10s.

2408 Horn-Book temp. George I., containing the Alphabet, Vowels, Invocation and Lord's Prayer, size 4in. with handle by 2¼in. metal frame (one side gone, horn damaged), [17—] (343) *Tregaskis*, £7

2409 Houbraken and Vertue. Heads of Illustrious Persons, 108 ports., orig. impressions, 2 vol. in 1, old russ., g. e., J. and P. Knapton, 1747-52, folio (470) *Maggs*, £7 2s. 6d.

11—2

2410 Hughes (T.) The Scouring of the White Horse, first ed.,
 illustrations ɔy R. Doyle, ɔrown cl., g. e., *Cambridge*, 1859
 (58) *Shepherd*, £1 12s.
 [Only a few copies were issued in ɔrown cloth, with the
 monogram T. H. on sides, for presentation to friends. This
 copy had on the half-title : "Author's presentation copy.
 Cuthɔert E. Ellison, Esq., from his old friend the author,
 1858."—*Catalogue.*]
2411 Hughes (T.) The Scouring of the White Horse, first ed.,
 illustrations ɔy R. Doyle, orig. ɔlue cl., *Cambridge*, 1859,
 8vo. (59) *Shepherd*, 3s.
2412 Hunter (Dr. John). Life, ɔy Jessé Foot, 8vo., inlaid to folio
 size, extended to 3 vol., and extensively illustrated ɔy the
 author, with 32 orig. drawings, numerous ports., natural
 history suɔjects, etc., mor. ex., by Charles Lewis, 1794, folio
 (235) *Bourne*, £35 10s.
2413 Johannes Chrysostomus (S.) Liturgica cum notis musicis,
 manuscript on vellum, in Greek, with musical notes, aɔout
 the middle of the fourteenth century, a fragment of 8 leaves,
 hf. bds., *Sæc.* XIV., 8vo. (39) *Leighton*, £2
 [Interesting on account of the rarity of finding so early
 a Greek MS. with the musical notes, no other Chrysostom
 Liturgy of this kind ɔeing known except that, written a
 century later, descriɔed in the Liɔri sale of MSS. in 1859.
 —*Catalogue.*]
2414 Keymis (Lawrence). A Relation of the Second Voyage to
 Guiana [Sir W. Ralegh's], orig. ed., unbd., fine copy, *T.
 Dawson at the three Cranes in the Vintree*, 1596, sm. 4to.
 (284) *Quaritch*, £50
2415 [Killigrew (Thomas).] La Croix-du-Maine (Sieur de). Premier
 volume de la Biɔliothèque, qui est un Catalogue Général
 de toutes sortes d'Autheurs, etc., old cf. (ɔroken), *Paris*,
 1584, folio (227) *Chadwick*, £6
 [The rare original edition of one of the earliest ɔiɔlio-
 graphical treatises puɔlished in France. A notice of
 Columɔus and his Discoveries occurs on page 548.
 Killigrew's copy, with his autograph on the title, from the
 Sunderland liɔrary.—*Catalogue.*]
2416 Kip (John). Britannia Illustrata, 80 plates complete, orig.
 impressions, old cf., D. Mortier, 1707, folio (471)
 Hornstein, £6 5s.
2417 Lafontaine (Jean de). Faɔles choisies, Oudry's ed., papier
 d'Hollande, front. and 275 engravings, the plate "La Singe
 et le Léopard" ɔefore the inscription on the sign., 4 vol.,
 mor., g. e., in a case, *Paris*, 1755-59, folio (225) *Maggs*, £17
2418 La Guerinière (F. R. de). L'Ecole de Cavalerie, orig. ed.,
 front., vignettes and tail-piece, 6 equestrian full-length
 ports., and plates ɔy Audran and others, old cf., *Paris*,
 Jacques Collombat, 1733, folio (226) *Hatchard*, £2 10s.
2419 Landon (C. P.) Vies et Oeuvres des Peintres, LARGE VELL.
 PAPER, 12 vol., cf. gt., *Paris*, 1803-12, folio (252)
 Bull, £2 16s.

2420 Las Casas (B. de). Histoire admiraɔle des horriɔles insolences, cruautez et tyrannies exercees par les Espagnols en Indes Occidentales, traduite par Jaques de Miggrode, *s. l.* 1582, 8vo. (13) *H. Stevens, £1* 12s.

2421 Lawson (Wm.) A New Orchard and Garden, black letter, woodcuts (a few pages soiled), unbd., *J. H. for Francis Williams,* 1676, 4to. (179) *Richards, £1*

2422 Lescarbot (Marc). Histoire de la Nouvelle France, seconde éd., 3 maps (only), orig. vell., rare, *Paris,* Jean Millot, 1612, 8vo. (88) *H. Stevens, £8* 15s.
[Returned from Lord Polworth's sale. *See* BOOK-PRICES CURRENT, Vol. xxiii., Lot 4094.—ED.]

2423 Leigh (Richard). The Copie of a Letter sent out of England to Don Bernardin Mendoza, declaring the state of England, contrary to the opinion of Don Bernardin, black letter, unbd., in cloth case, *I. Vautrollier for R. Field,* 1588, 4to. (210) *Edwards, £1* 12s.

2424 Louis XVI. Le Sacre et Couronnement de Louis XVI., plates ɔy Patas, mor. ex., douɔlé, gilt floreate ɔorders, t. e. g., ɔy Delorme, *Paris,* 1775, 4to. (200) *Sotheran, £11*

2425 Lucanus. Pharsalia, manuscript on paper (111 leaves, 12 ɔy 8in.), gothic letter, long lines, 38 to a full page, old marginal glosses in the first four leaves, cf., *Sæc.* XIV., sm. folio (475) *Barnard, £2* 8s.

2426 Marie Antoinette. History of the Trial and Execution of Marie Antoinette, late Queen of France, 24 pages, folding front. in two scenes, orig. ɔlue paper wrapper, fresh and clean, 1793, 8vo. (26) *Hatchard, £7* 7s.
[Douɔtless the earliest contemporary account, as it was puɔlished on Oct. 28, 1793, twelve days after the execution. —*Catalogue.*]

2427 Mather (Increase, of Boston, N.E.) History of the Wars with the Indians in New-England, orig. London edition, contained 30 leaves including title, ending with page 8 of "Postcript" without the "Exhortation" (wanted half-title, title, and next 2 leaves defective), unbd., *Printed for Wm. Chiswell in St. Paul Church-Yard, According to the Original Copy printed in New-England,* 1676, sm. 4to. (447) *Soames, £11*

2428 Michaelis (S.) The Admiraɔle Historie of the Possession and Conversion of a Penitent Woman seduced ɔy a Magician, cf., W. Aspley, 1613, 4to. (176) *Bull, £1* 15s.

2429 Miller (Philip). Figures of Plants descriɔed in the Gardeners' Dictionary, on 300 copperplates, col. ɔy hand, 2 vol. in 1, old russ., 1760, folio (463) *Edwards, £1* 11s.

2430 Moore (Thomas). Original Autograph Poems (18 leaves), 8vo.—Epistles, Odes and other Poems, hf. bd., 4to., J. Carpenter, 1806, together 2 vol. (186) *Spencer, £1* 10s.
[The MS. contains 14 of the poet's early poems and odes, first puɔlished in 1806, some passages differing from those printed in later editions. Pasted on the first ɔlank leaf is an original stanza of six lines, signed Thos.

Brown, Junr., Dec. 26, 1813, which does not appear to have
ɔeen puɔlished :

" Still ɔeauteous Lais when I ask
The price you prize your favours at
A Talent you reply
But Lais thy charms however great
Repentance at so high a rate
I cannot, will not buy."— *Catalogue.*]

2431 More (Sir Thomas). The Commonwealth of Utopia,
. engraved title, with port. ɔy W. Marshall, autograph signa-
ture " Caryll," sheep, *Printed for Will. Sheares,* 1639 (57)
Ellis, £2
[The autograph on the title-page is that of John, Lord
Caryll, diplomatist and poet, 1625-1711.—*Catalogue.*]

2432 Naunton (Sir R.) Fragmenta Regalia, hf. cf., 1642, 4to. (175)
Herbert, 10s.

2433 Needle-Work Binding. The Holy Biɔle (Authorised Version),
Edinb., R. Young and E. Tyler, 1642—The Book of Com-
mon Prayer, *Lond.,* R. Barker, 1639—Whole Book of
Psalms in Meter ɔy Sternhold and Hopkins, *A. M. for the
Stat. Co.,* 1650, in 1 vol., ɔoards emɔroidered in coloured
and silver threads, g. e. (somewhat worn), orig. silver clasps,
1639-50, 8vo. (344) *Rev. Mr. Jones,* £7 15s.

2434 Needle-Work Binding. The Whole Booke of Davids
Psalmes (some outer margins cut into), contemp. em-
ɔroidered ɔinding of coloured and silver threads, very well
preserved, *Printed by T. C. for the Company of Stationers,*
1635, 12mo. (350) *Quaritch,* £12 10s.

2435 Needle-Work Binding. The Whole Book of Psalmes, ɔy
.. .Thos. Sternhold, J. Hopkins, etc., orig. ɔinding of ɔoards
emɔroidered in coloured threads, g. e. (somewhat worn),
Stat. Co., 1637, 12mo. (347) *Maggs,* £7

2436 Nichols (John). The History and Antiquities of the County
of Leicester, vol. iii., in 2 vol. (East Goscote and West
Goscote Hundreds), the scarcest portion of the work, ports.
. and plates, hf. cf., 1804, folio (236) *Halliday,* £38 10s.

2437 Ovidius. De Arte Amandi et alia Opera, manuscript on
vellum (110 leaves, 7 ɔy 4½in.), roman letters, long lines,
28 to a full page, border of first page decorated in gold and
colours, large initial, and coat-of-arms ɔelow, illuminated
decorative initial to each ɔook, old cf. (Phillipps MSS.
16360), *Sæc.* XV., 8vo. (360) *Edwards,* £13 5s.

2438 Pennsylvania Packet (The), or The General Advertiser, Nos.
695 (Jan. 2, 1781) to 814 (Dec. 1, 1781) and 826 (Dec. 29),
(wanted Nos. 705, 721, 722, 788 and 808), in 1 vol., hf. cf.,
Philadelphia, David C. Claypoole, 1781, folio (245)
Sotheran, £7 10s.

2439 Palmer (John). An Impartial Account of the State of New
England, 20 leaves (a few margins cut into), unbd., *Printed
for Edw. Poole in Cornhill,* 1690, sm. 4to. (449) *Leon,* £12

2440 Peacham (Henry). The Mastive, or Young-Whelpe of the Olde-Dogge. Epigrams and Satyrs, orig. ed. (leaf torn across, last leaf defective), unbd., *T. Creede for R. Meighen, etc.,* 1615, sm. 4to. (382) *Finch, £16* 10s.

2441 Piozzi (Hester Lynch). Anecdotes of the late Samuel Johnson, LL.D., during the last twenty years of his Life, MS. comments in the autograph of the author, hf. bd., 1786, sm. 8vo. (94) [Presentation copy, with the following inscriptions on fly-leaves: "This copy of the Anecdotes was found at Bath—covered with dirt—the ɔook having ɔeen long out of Print—and after ɔeing ɔound it was presented to me by my excellent Friend H. L. P.—J. F." "This little dirty Book is kindly accepted ɔy Sir James Fellowes from his oɔliged Friend H. L. Piozzi, 14 Feb. 1816." "Given to my dear daughter Beatrice ɔy her loving Father J. B. F. 1878."—*Catalogue.*]— Piozzi (H. L.) Oɔservations and Reflections made in the Course of a Journey through France, Italy and Germany, 2 vol., printed preface missing, but supplied ɔy the authoress in her own handwriting, and with much extra matter ɔy her inserted, hf. cf., 1789, 8vo. (95) ["This dirty Copy of a Book more feeɔly written than the Author thought it 30 years ago, is now with more Shame than Vanity presented to Sir James Fellowes as a mere Testimony of true Regard ɔy his Oɔliged Friend H. L. Piozzi." *Inscription in the autograph of the authoress on fly-leaf.*]—Piozzi. Letters to and from the late Samuel Johnson, LL.D., ɔy Hester Lynch Piozzi, 2 vol., with numerous marginal comments in the handwriting of H. L. Piozzi, hf. mor., 1788, 8vo. (96) [These volumes were presented to Sir James Fellowes, and the copious marginal notes specially added for him ɔy the compiler. At page 363 of vol. i. she writes : "These letters retain many ɔitter Recollections. I never read them since the time of their puɔlication till I looked them over for Dear Sir James Fellowes, 1815, and I now wonder how I was preserved thro' such Afflictions to this enormous Distance of Time. God give me Grace to be Thankful ! I really feel quite Astonished."—*Catalogue.*]— Piozzi. Williams (Anna). Miscellanies in Prose and Verse, cf., 1766, 4to. (97) [On a fly-leaf is the following inscription in the autograph of Hester Lynch Piozzi : "This Book ɔelongs to Sir James Fellowes ; presented to him as the *last* Testimony of True Regard and Esteem ɔy his much Oɔliged and faithful Friend Hester Lynch Piozzi" ; on another fly-leaf is written in the same autograph : "The Tale of the Fountains was written ɔy Doctor Johnson for purpose of *ɩfilling up this Book*, and he asked H. L. Thrale for something of hers ɔeside. She contriɔuted the Three Warnings, and a Translation of Boileau's Epistle to his Gardener." —*Catalogue.*] *Tregaskis, £40* [The aɔove four lots were the property of Mr. O. B. Fellowes.—ED.]

2442 [Plantagenet (Beauchamp).] A Description of the Province of New Albion, first ed., 16 leaves (stained), unbd., *Printed in the yeare* 1648, sm. 4to. (285) *Sabin,* £125

2443 Pope (Alex.) The Rape of the Lock, in five cantos, first ed. in this form, LARGE PAPER, plates by L. Du Guernier, orig. cf., MS. note on first fly-leaf (? Pope's writing), B. Lintott, 1714, roy. 8vo. (21) *Hart,* £20

2444 Pseaumes de David, mis en rime françoise par Clement Marot & Theodore de Beze, musical notes, ruled throughout, musical bars in red, headings to each psalm in gold, painted ornamental vignettes, engraved title, 12 oval engravings in the calendar (small hole in one leaf), 2 copperplate engravings by L. Gaultier, all painted and illuminated, the two front fly-leaves decorated, contemp. French canvas embroidered with silver threads, with monogram in centres, silver catches, *Paris,* A. Le Roy et Rob. Ballard, 1562, 8vo. (328) *Maggs,* £10 10s.

2445 Quadragesimale novum editum ac predicatum a quodam fratre minore de observantia in inclita civitate Basiliensis de filio prodigo, etc., lít. gotð., 18 woodcuts and armorial printer's mark, all free from colouring (a few small wormholes), contemp. stamped pigskin, with clasps, *Basil,* M. Furter, 1495 (40) *Quaritch,* £6
 [The first edition. The woodcuts are examples of the style that prevailed at Basle before the influence of Holbein. —*Catalogue.*]

2446 Rabelais (Fr.) The First (and Second) Book of the Works (trans. by Sir T. Urquhart, first ed., R. Baddeley, 1653 (with a general title dated 1664 and Life), in 1 vol., old cf., 1653-64, 8vo. (22) *Hart,* £3

2447 Ralegh (Sir W.) The Discoverie of the large, rich and beautiful Empire of Guiana, first ed. (title loose and defective), unbd., R. Robinson, 1596, sm. 4to. (283)
 Quaritch, £20

2448 René d'Anjou, Roi de Sicile. L'Abusé en Court. French XVth Century. [Begins folio 1a], manuscript on fine vellum (37 leaves, 9½ by 6½ in.), lettres bâtardes, long lines, 29 to a full page, painted capitals, 2 square miniature initials (4¼ in.), modern French mor., sides covered with geometrical scrolls, g. e., by Thompson (of Paris), from the Ashburnham (Barrois) collection, [at end] "Cy finist Labuse en Court," *late Sæc.* XV. (401) *Franks,* £53
 [MS. in verse and prose, printed for the first time by Colard Mansion of Bruges about 1480, and several times since.—*Catalogue.*]

2449 [Richardson (S.)] Clarissa, first ed., 7 vol., old cf., *Printed for S. Richardson,* 1748, 8vo. (41) *Hatchard,* £3

2450 Rossetti (Dante Gabriel). Collected Works, by W. M. Rossetti, 2 vol. in 4, one of 25 copies printed upon LARGE PAPER, orig. bds., uncut, 1886, 8vo. (12)
 Abrahams, £10 2s. 6d.

2451 Rowley (Wm.) A New Wonder, a Woman never Vext, first
ed., unbd. (short copy), *G. P. for Fr. Constable*, 1632, sm.
4to. (290) *Tregaskis, £2* 12s.

2452 [Saeghman (G. J.)] Verscheyde Oost-Indische Voyagien,
met de Beschryvingen van Indien, 2 engraved titles, ports.
and maps, ɔoth parts in 1 vol. (first title shaved and two
small burns in one page), *Amsterdam* (1663-70), 4to. (216)
Muller, £21
[Generally known as the Saeghman collection. The
various relations have separate titles, pagination and signa-
tures, and are descriɔed ɔy Saɔin and Tiele. It is of the
greatest rarity to find all these parts complete, and every
known set varies in order of arrangement. This copy has
also the two general titles and introduction, nearly always
missing.—*Catalogue.*]

2453 Sander (F.) Reichenbachia, plates, in colours, ɔoth series,
4 vol., hf. mor., t. e. g., *St. Albans*, 1888-94, folio (232)
Wesley, £11 10s.

2454 Sandford (F.) Genealogical History of the Kings and
Queens of England, engravings (top margins of first and
last leaves mended), cf. gt., 1707, folio (256) *Bull, £1* 1s.

2455 Sannazarius (Actius Syncerus,). De Partu Virginis, ed. prima,
orig. Italian mor., medallion port. of the author in gold on
cover, g. e., *Neapoli*, Ant. Fretus, 1526, sm. folio (476)
Leighton, £1 10s.

2456 Savage (Major Thos., of Boston, N.E.) An Account of the
late Action of the New-Englanders under the command of
Sir Wm. Phips, against the French at Canada (8 leaves),
orig. ed., unbd. (title soiled), *Printed for Thos. Jones at the
White-Horse without Temple Bar*, 1691, sm. 4to. (448)
Sabin, £86

2457 Savonarola (Hieronymo). Compendio di Revelatione dello
inutile Servo di Jesu Christo, prima edizione (one leaf
defective), *Firenze*, F. Buonaccorsi, 1495—Epistola a tutti
gli electi di Dio & fedeli christiani, woodcut, *s. l.*, 1497—
Sermone sopra la nativita del nostro signore Jesu Christo,
s. l. et a.—Expositione sopra la oratione della Vergine
gloriosa, *s. l. et a.*—Expositione sopra el Psalmo L (1498),
in 1 vol., vell., 4to. (184) *Quaritch, £10* 10s.

2458 Something concerning Noɔody, ed. ɔy Someɔody, 14 humorous
etchings, orig. bds., uncut, 1814, 8vo. (9) *Morley, £1* 1s.

2459 Spenser (E.) Colin Clouts come home againe, first ed., title
within woodcut ɔorder (top inner corners of K. repaired, 2
small rust holes), unbd., *Printed (by T. Creede) for William
Ponsonby*, 1595, sm. 4to. (402) *Walton, £10* 2s. 6d.

2460 Spenser (Edmund). The Faerie Queene, 2 vol., second ed.
of vol. i., first ed. of vol. ii. (corners of several leaves in
vol. i. repaired, and a portion of top margin of A2 in fac.,
some wormholes filled in, top margin of last leaf cut into,
headline of R5 in vol. ii. and some others cut very close,
headline of pages 299-300 slightly cut into), new mor., r. e.,
Printed for William Ponsonby, 1596-90, sm. 4to. (401*)
Deakin, £25

2461 Studer's Popular Ornithology. The Birds of North America,
ɔy Theodore Jasper, 119 col. plates, *Columbus, Ohio,* 1878
—Ornithology, or the Science of Birds, from the text of Dr.
Brehm, 212 illustrations, uncoloured, ɔy Theodore Jasper,
ib., 1878, hf. mor., g. e., uniform, 4to. (187) *Quaritch,* £2 4s.

2462 Svetonius. Commentationes conditae a P. Beroaldo in
Svetonium Tranquillum, etc., woodcuts, some ɔy the
masters " ɔ " and " F," ornamental initials, orig. vell. (some
slight water stains), *Venetiis,* Mantuanus, 1510, folio (229)
Leighton, £2 6s.
[The woodcuts are printed from the ɔlocks used in the
Mallermi Biɔle of 1490, the Boccaccio of 1492, and the
Livy of 1493.—*Catalogue.*]

2463 [Swift (Dr. J.)] Gulliver's Travels, first ed., separate pagina-
tion, port. (with inscription round) and maps, 2 vol., con-
temp. cf., B. Motte, 1726, 8vo. (44) *J. Bumpus,* £10 10s.

2464 Swinɔurne (A. C.) Tristram of Lyonesse, wrappers, uncut,
one of 25 signed copies on vellum, (*Thomas Mosher,*)
Portland, Maine, 1904, 8vo. (29) *Chadwick,* 16s.

2465 Tacitus. [Fol. i.] "A. Cornelii Taciti Actorum Diurnaliam
Augustae Historiae liɔer undecimus foeliciter incipit,"
manuscript on paper (165 leaves, 11½ by 8¼ in.), roman
letters, long lines, 36 to a full page, old cf. gt., arms of
Pope Pius VII. on sides, [*ad finem*] *Explicit Anno Domini*
MCCCCX. (1410), sm. folio (473) *Quaritch,* £6

2466 Tennyson (Alfred). Poems, chiefly Lyrical, first ed., with
errata (title-page spotted), orig. bds., uncut, 1830, 8vo. (11)
Maggs, £6 17s. 6d.

2467 Tennyson (Lord). Helen's Tower, Clandeɔoye, vignette on
title, orig. wrappers, *Privately printed,* n. d. (1861), 4to.
(173) *Lawson,* £5

2468 Turner (J. M. W.) The Rivers of France, with inscription
" Mrs. Richard Gray, with John Ruskin's love," 1865, mor.,
g. e., 1837, 8vo. (25) *Spencer,* £7 5s.
[John Ruskin's own copy, who states in an autograph
letter (inserted) addressed to Richard Gray of Largs, N.B. :
" I send you—for Mrs. Gray, my own old copy of the
Rivers of France—it is well worn, but only ɔy me," etc.—
Catalogue.]

2469 Victoria (Queen). Leaves from the Journal of Our Life in
the Highlands, Elder & Co., 1868, sm. 4to. (396)
W. Brown, £26
[Presentation copy from the Queen to Lord Chancellor
Hatherley. "To Lord Hatherley, Lord Chancellor, in
recollection of Balmoral from Victoria R. Balmoral Oct. 6,
1869." Finely ɔound in mor., with tooled ɔorder of the
rose, shamrock and thistle, the corner pieces ɔeing the four
quarterings of the royal arms, and the sides studded with
the royal cipher V. R. and crown ; the whole inlaid, douɔ-
lures, fly-leaves of moire silk, designed and executed by
H. T. Wood, London, in a case.—*Catalogue.*]

2470 Virgilius. Æneidos liɔri XII. (cum Summariis Ovidii), manuscript on vellum (183 leaves, 7½ ɔy 4¼in), italic letters, long lines, 27 to a full page, the first having illuminated decorative ɔorder and initials (ruɔɔed) and an illuminated initial to each ɔook, modern mor. ex., gilt gauffred edges, ɔy Lortic, *Sæc.* XV., 8vo. (359) *Leighton, £*26 10s.

2471 Virgilius. Æneidos liɔri XII., manuscript on vellum (180 leaves, 10¼ ɔy 7in.), roman letters ɔy an Italian scriɔe, long lines, 28 to a full page, ɔorder of first page decorated, coat-of-arms ɔelow, capitals painted, old russ. gilt, from the Askew and Wodhull collections, *Sæc.* XV., 4to. (389)
*Leighton, £*15 10s.

2472 Virgilius. Opera, engraved title and map, mor. ex., g. e., by Niedrée, *Lugd. Bat. ex off. Elzeviriana,* 1636, 8vo. (332)
*Tregaskis, £*2 7s.

2473 Virgilius. Opera, woodcuts (margins of first and last leaves repaired), mor. antique, *Venetiis, apud Juntas,* 1544, folio (271) *Sotheran, £*1 13s.

2474 Voltaire. Dictionnaire Philosophique, Portatif, ɔurnt ɔy the puɔlic executioner at the order of the Parliament of Paris, orig. ed., mor., g. e., *s. l.* 1765, 8vo. (10) *Thompson, £*1 2s.

2475 Voragine (Jacoɔus de). Legenda Sanctorum, manuscript on vellum (193 leaves, 12 by 8in.), gothic letter, douɔle columns, 46 lines, fly-leaves of a 13th century Josephus and of a 13th century Breviary with neumes, modern cf., *Scriptum Leodii,* 1312, sm. folio (477) *Bull, £*6 17s. 6d.
[An inscription at end dates the finish of the MS. at Liege A.D. 1312. It was originally in the Liɔrary of the Church of St. James in Liege.—*Catalogue.*]

2476 Watson (J.) Memoirs of the Ancient Earls of Warren and Surrey, ports. and plates, including the folding plates of Earl Warren and the view of Poynton Lodge, Cheshire, with transcripts in shorthand of letters of Watson relating to the Warrens, autograph letters, etc. inserted, 2 vol., cf. (reɔacked), *Warrington,* 1782, 4to. (201) *Walford, £*2 12s.

2477 Weever (John). Ancient Funerall Monuments, first ed., port. ɔy T. Cecill cut round and mounted, engravings, old mor., g. e., T. Harper, 1631, 4to. (222) *Tregaskis, £*2 6s.

2478 Weever (J.) Antient Funeral Monuments, port. and plates, old cf., 1767, 4to. (459*) *Tregaskis,* 14s.

2479 Wither (George). A Collection of Emɔlemes, separate titles, engraved front. by W. Marshall and a preposition to this frontispiece (ɔoth mended), port. of the author and emblematic engravings, the leaf of lotteries pasted down and indexes added, old cf., *A. M. for Robert Milbourne,* 1635 (224) *Dobell, £*3 6s.

2480 Whitelocke (B.) Memorials of the English Affairs during the Reign of Charles I. and the Civil War, LARGE PAPER, port. ɔy Hulsbergh pasted on title-page, old English mor., m. e., 1732, folio (255) *Sotheran, £*1

2481 Wordsworth (Wm.), Coleridge (S. T.) and Southey (R.) Lyrical Ballads, first ed., with errata and the list of ɔooks

puɔlished ɔy Joseph Cottle, and 2 ɔlanks, orig. bds., *Printed for J. and A. Arch*, 1798, 8vo. (366) *Hornstein, £27*
2482 Wotton (Sir H.) Reliquiae Wottonianae [with Life of Wotton ɔy Iz. Walton], first ed., ports. ɔy Lomɔart, lettering of the Duke of Buckingham's port. cut, mor., r. e., 1651, 8vo. (71)
Shepherd, £1 1s.
2483 [Ziegler (Jacobus).] Quae nitus continentur : Syria, ad Ptolomaici operis rationem. Praeterea Strabone, Plinio, & Antonio auctoribus completata ; Palestina, etc., first ed., 8 folding maps, vell., *Argent. Petrum Opilionem*, 1532 (230)
Leighton, £3 5s.

[DECEMBER 13TH AND THREE FOLLOWING DAYS, 1909.]

SOTHEBY, WILKINSON & HODGE.

THE LIBRARY OF THE LATE MR. WILLIAM WHEELER SMITH, OF NEW YORK.

(No. of Lots, 1021 ; amount realised, £5,333 0s. 6d.)

2484 Aɔelard et Heloisa. Lettres d'Héloise et d' Aɔailard, édition ornée de huit figures (Moreau le Jeune), 3 vol., old cf., m. e., *Paris, J. B. Fournier, impr. de Didot*, 1796, 4to. (1)
Hatchard, £2 10s.
2485 Ackermann (R.) History of the Aɔɔey Church of St. Peter's, Westminster, port. of Dean Vincent, plån, and 63 col. plates, 2 vol., old russ., g. e., Ackermann, 1812, 4to. (3)
Quaritch, £3
2486 Allen (Ch. Dexter). American Book-plates, illustrations, cl., *New York and London*, Macmillan, 1894, roy. 8vo. (4)
Askew, £1 1s.
2487 Adamus de Montaldo Januensis Augustiniani. Carminibus heroicis edita Passio Domini nr̄ī Jesu Christi, etc., lit. rom., 19 leaves (worm-hole throughout) [Hain 11554], hf. mor., *Absque ulla nota* [*Romae E. Silber, c.* 1475], sm. 4to. (5)
Maggs, 19s.
2488 Æsopus. Fabulae, Gr. et Lat. nunc denuo selectae, 46 wood-cuts ɔy C. van Sichem, cf. (Beckford copy), *Lugd. Bat. Jo. Maire*, 1632, sm. 8vo. (6) *Tregaskis, 16s.*
2489 Æsop. Dat Wonderliche Leven Esopi met syn Ghenuech-lijche Fabulen, etc., lit. gotḥ., small woodcuts, hf. mor., g. e., *Ghedruckt toe Reesz by my Derich Wylichs van Santen*, 1585-6, sm. 8vo. (7) *Leighton, £1* 10s.
2490 Agrippa (H. Cornelius). De Occulta Philosophia liɔ. III., first ed. of the three ɔooks, port. of author on title, and woodcuts, old cf. (reɔacked), (*Coloniae*,) 1533, folio (8)
Tregaskis, £2 5s.

2491 Agrippa (H. C.) Of the Vanitie and Uncertaintie of Artes
and Sciences, ɔy J. San, Gent. (Jas. Sanford), second ed.,
𝔟𝔩𝔞𝔠𝔨 𝔩𝔢𝔱𝔱𝔢𝔯 (a few leaves stained), old cf., g. e., *H. Bynneman
in Knightryder Streete, at the signe of the Mermayde*, 1575,
sm. 4to. (9) *Quaritch*, £2 12s.

2492 Agrippa (H. C.) Female Pre-eminence, ɔy H. C. (Henry
Care), hf. mor., t. e. g., *Printed by T. R. and M. D. and sold
by H. Million, at the Bible in Fleet-street*, 1670, sm. 8vo.
(10) *Quaritch*, £1 18s.

2493 Alɔertus Magnus. Opus de Laudibus Beatae Mariae Virginis,
manuscript on vellum, XVth Century (153 leaves, 12 ɔy
8¼in.), 𝔤𝔬𝔱𝔥𝔦𝔠 𝔩𝔢𝔱𝔱𝔢𝔯, ɔy a German scriɔe, contemp. monastic
ɔinding (from a Carthusian monastery near Erfurt), in slip
case, *Sæc.* XV., sm. folio (11) *Dobell*, £3 3s.

2494 Albumasar. Flores Albumasaris [these two words of title
cut out and mounted on a ɔlank leaf]. "Incipit Tractatus
Albumasaris Florum Astrologie," 𝔩𝔦𝔱. 𝔤𝔬𝔱𝔥. (19 leaves, long
lines), woodcuts and ornamental initials, mor. ex., in case,
*Impressus Erhardi Ratdolt nupér Venetiis nunc Auguste
Vindelicorum*, 1488, sm. 4to. (12) *Dobell*, £2 16s.

2495 Albumasar de Magnis Conjunctionibus, 𝔩𝔦𝔱. 𝔤𝔬𝔱𝔥., long lines,
40 to a full page, with signs., German woodcuts, modern
mor., g. e., in slip case, *Aug. Vind. per Erhardum Ratdolt
nuper Venetiis, etc.*, 1489, sm. 4to. (13) *Leighton*, £5 10s.

2496 Alciatus (Andreas). De Verborum Significatione liɔri quatuor,
title within compartmental ɔorder (Holɔein), mor. plain,
g. e., by Trautz-Bauzonnet, in case, *Lugduni*, S. Gryphius,
1530, folio (14) *Tregaskis*, £2 18s.

2497 Alciatus (A.) Emblematum Liɔer, 98 small woodcuts, old
vell., r. e., in case, *Aug. Vind. per H. Steynerum*, 1531, sm.
8vo. (15) *Tregaskis*, £6 5s.
[The first edition, with errata at end omitted in subse-
quent editions.—*Catalogue.*]

2498 Alciat. Emblematum Liɔer, Editio Secunda, 93 cuts in text
(soiled and several cuts painted, 3 leaves wanting, supplied
in fac.), mor. ex., ɔy Stikeman, in case, *Excusum Augustae
Vind. per Heynricum Steynerum*, 1531, 6 *Apr.*, 8vo. (16)
Sotheran, £1 15s.

2499 Alciat. Emblematum Libellus, per Wolphgangum Hungerum
Bavarum rythmis Germanicis versus, 115 cuts of emɔlems,
text in Latin and German, first ed. of the German text, *Paris*,
C. Wechel, 1542—Avila et Zuniga (Ludovicus ab). Com-
mentariorum de ɔello Germanico, folding map and 2 plans
of ɔattles, etc., *Antwerpiae*, Jo. Steelsius, 1550, in 1 vol.,
contemp. oak bds., stamped pigskin, metal corners and
clasps, in case, 8vo. (19) *Maggs*, £4 4s.

2500 Alciat. Emblematum libellus, 111 woodcuts, mor. ex., by A.
Matthews, in case, *Lugduni, Jacobus Modernus excudebat*,
1544, sm. 8vo. (20) *Tregaskis*, £2 8s.

2501 Alciat. Emblematum libellus, editio Aldina, 83 woodcuts,
and coat-of-arms on last leaf, mor. ex., douɔlé, t. e. g., ɔy A.

Matthews, in case, *Venetiis apud Aldi Filios,* 1546, sm.
8vo. (22) *Maggs, £7* 5s.
2502 Alciat. Emblematum li>ri duo, 113 woodcuts by. Le Petit
Bernard, mor. ex., >y F. Bedford, in case, *Lugduni ap. Joan.
Tornaesium et Gul. Gazeium,* 1547, 12mo. (23)
Tregaskis, £2 12s.
[The first edition from the press of De Tournes of Lyons.
—*Catalogue.*]
2503 Alciat. Emblemata D. A. Alciati, printed within woodcut
>orders, 211 cuts of em>lems by Le Petit Bernard and P.
Vingle, cf. ex., *Lugd. ap. Guil. Rovillium,* 1551, 8vo. (24)
Tregaskis, £1 12s.
2504 Alciat. Emblematum Clarissimi Viri D. Andreae Alciati
li>ri II., editio prima Plantiniana, 113 woodcut devices and
198 cuts of em>lems attri>uted to " Le Petit Bernard," mor.
plain, g. e., >y A. Matthews, in case, *Antwerpiae ex Off.
Plantin,* 1565, 12mo. (25) *Tregaskis, £3* 15s.
2505 Alciat, etc. Li>er Emblematum D. Andreae Alciati, cuts >y
Virgil Solis and Jost Amman, *Franckf. a. M. by Geo. Raben
in Verlegung S. Feyerabends,* 1566-7—Schopper (H.) Opus
Poeticum de Admirabili Fallacia et Astutia Vulpeculæ, etc.,
cuts by Jost Amman and Virgil Solis, *Francf. a. M., P.
Fabritius impensis S. Feirabent,* 1567, in 1 vol., contemp.
German oak bds., stamped pigskin, with arms, initials and
date 1568, in a case, 8vo. (26) *Ellis, £3* 3s.
2506 Alciat. Em>lemata, 128 cuts by Jost Amman and Virgil
Solis, mor. antique, g.e., *Francof. a M.,* S. Feyera>end, 1567,
sm. 8vo. (27) *Quaritch, £2* 16s.
2507 Alciat. Em>lemata, cum Comment. Francisci Sanctii Bro-
censis, 211 woodcuts, old vell., in case, *Lugduni ap G.
Rovillium,* 1573, 8vo. (28) *Bloomfield,* 19s.
2508 Alciat. Em>lemata, 134 cuts >y Virgil Solis and Jost Amman,
mor., t. e. g., >y A. Matthews, *Francoforti* (Nicholaus
Bassaeus), 1583, sm. 8vo. (33) *Quaritch, £1* 12s.
2509 Alciat. Em>lemata, port. of Alciat, >y W. Stu>er, and 211
cuts, some col. >y hand, contemp. German oak bds., stamped
pigskin, in case, (*Antwerpiae*) *ex Officina Plantiniana
Raphelengii,* 1608, 8vo. (38) *Bloomfield,* 17s.
2510 Alciat. Omnia Em>lemata, cum Commentariis per Claud.
Minoem, 211 cuts of em>lems, only 5 copies known to
Green, orig. vell., *Paris,* Jo. Richer, 1618, 8vo. (40)
Bull, 13s.
2511 Alciat. Diverse Imprese accomodate a diverse moralitã, con
Verse che i lori significati dichiarano, tratto da gli Em>lemi
dell' Alciato, 72 leaves, printed within >orders, by P. Vingles,
136 woodcuts (title mended), the first ed. of Alciat in Italian,
cf. ex., >y A. Matthews, *in Lione per Masseo Buonhomo,*
1549, 8vo. (42) *Bloomfield, £1* 18s.
2512 Alciat. Diverse Impresse accomodate a diverse moralità, con
Versi che i loro significati dichiarano, etc. nella lingua
Italiano non più tradotte, tratte da gli Em>lemi dell' Alciato,

printed within ɔorders, 180 cuts by Le Petit Bernard and
P. Vingle, cf. ex., *Lione appresso G. Rovillio*, 1564, 8vo. (43)
Edwards, £1 6s.

2513 Alciat. Livret des Emɔlemes (par Jean Le Fevre), lettres
bâtardes and italics, 113 cuts (said by Douce to be ɔy Jollat),
first ed. of Alciat in French, mor. ex., ɔy Trautz Bauzonnet,
in case, *Paris, Christien Wechel (with device)*, 1536, sm.
8vo. (44) *Leighton*, £12

2514 Alciat. Les Emɔlemes (par Jehan Le Fevre), second ed. in
French from Wechel's press, 113 cuts, attriɔuted to Jollat,
mor. ex., ɔy R. de Coverly, in case, *Paris*, Chr. Wechel,
1539, 8vo. (45) · *Ellis*, £6 15s.

2515 Alciat. Les Emɔlemes (par Jehan le Fevre), printer's device
on title of a winged male figure, inscriɔed "Mediocrement,"
aɔove the words "Ne hault," ɔelow "Ne bas" ["Marque
inconnue," Brünet], old French mor., g.e. (Janseniste), *s.l.n.
ou d.* [1540], 8vo. (46) *Maggs*, £2 16s.

2516 Alciat. Emɔlemes d'Alciat, 165 cuts of emɔlems and orna-
ments (title and lower margins of next 2 leaves mended, a
few leaves soiled), cf. ex., *Lyon*, G. Roville et Macé Bon-
homme, 1549, 8vo. (47) *Tregaskis*, £2 12s.
[The first ed. of Alciat in French as issued by these printers
of Lyons. The ɔorders are said to be ɔy P. Vingle, the
emɔlems ɔy "Le Petit Bernard."—*Catalogue.*]

2517 Alciat. Los Emɔlemas (por Bernardius Duza Pinciano), 200
cuts and devices ɔy Le Petit Bernard, mor. ex., ɔy A.
Matthews, in case, *Lyon por G. Rovillio*, 1549, 8vo. (49)
Ellis, £2 6s.
[First ed. of the Spanish text of Alciat. The woodcuts
are the same as in the French ed., same date.—*Catalogue.*]

2518 Ames (Jos.) Typographical Antiquities, ɔy Wm. Herɔert,
mezzo. port. of Ames, port. of Caxton, facs. and other illus-
trations, 3 vol., old cf. (ɔroken), 1785-90, 4to. (56)
Bloomfield, £3 5s.

2519 Amman (Jost). Zeichner und Formschneider, Kupferätzer
und Stecher, von C. Becker, 17 woodcuts after Amman, hf.
cf., t. e. g., uncut, *Leipz.*, R. Weigel, sm. 4to. (59)
Tregaskis, 16s.
[Contained a ɔiɔliographical list of all the ɔooks containing
cuts ɔy Jost Amman.—*Catalogue.*]

2520 Andrews (W. L.) Essay on the Portraiture of the American
Revolutionary War, etc., reproductions in photogravure of
20 of the original engravings, 185 copies printed upon
handmade paper, uncut, *New York*, Gillis Bros., 1896, 8vo.
(60) *Tregaskis*, £3 10s.

2521 Andrews (W. L.) Biɔliopegy in the United States, illustra-
tions, 141 copies printed on Van Gelder paper, uncut, *New
York*, Dodd, Mead & Co., 1902, 8vo. (61) *Maggs*, £1 6s.

2522 Andrews (W. L.) An English XIXth Century Sportsman,
Biɔliopole and Binder of Angling Books (T. Gosden),
plates, 125 copies printed on Van Gelder paper, uncut,
New York, Dodd, Mead & Co., 1906, 8vo. (62) ·
Tregaskis, £4 14s.

2523 Antiquary (The), ed. ɔy Edw. Walford, M.A., etc., illustra-
tions, vol. i.-xx., hf. mor. (and a duplicate of vol. xx. wanting
title), cl., E. Stock, 1880-89, sm. 4to. (63) *Dobell,* 16s.
2524 Angelus (Johannes). Astrolaɔium Planū in taɔulis Ascendens
cōtinens qualibet hora atqʒ. mito, etc., lít. goíḷ., editio prima,
astrological woodcuts and initials, mor. plain, doublé, in-
layings of flowers, g. e., ɔy Bradstreet (title soiled), in case,
*Opus . . impressum Erhardus Ratdolt Augustensis nuper
Veneciis nunc Auguste Vindelico,* 1488, sm. 4to. (64)
 Quaritch, £7 7s. 6d.
2525 Archaica, by Sir E. Brydges—Heliconia, ed. ɔy T. Park,
together 5 vol., contemp. cf. ex., in cases, *Longman's
Private Press,* 1814-15, 4to. (67) *Bloomfield, £4* 18s.
2526 Arembergh (R. P. Carolus de). Flores Seraphici, 96 ports.
of celeɔrated Franciscans, old cf., *Col. Agr. Const. Munich,*
1640, folio (70) *Ellis, £2*
2527 Ariosto (Lodovico). Orlando Furioso, woodcuts ɔy Dosso
Dossi, "Argomenti" within ornamental ɔorders, and his-
toriated initials, old Venetian cf., gilt ornaments, in case,
Venet., V. Valgrisi, 1556, sm. 4to. (71) *Leighton, £1* 14s.
2528 Arnold (Thos. D. D.) History of Rome, illustrated with 130
engravings, chiefly of the French school, 5 vol., cf. ex., by
Kaufmann, 1843-5, 8vo. (72) *Maggs, £1* 10s.
2529 [Ars Memorandi.] Rationarium Evangelistarum, omnia in se
evangelia, prosa, versu, imaginibusqz. qz. mirifice com-
plectens (Thomas Badensis cognomento Anshelmi tradidit),
15 German woodcuts, the designs from an ancient ɔlock-
ɔook, representing symɔols of the four evangelists, mor.,
g. e., by Lortic, in case, *Phorçae, Thomas Budensis Ans-
helmi (with device),* 1507, sm. 4to. (73) *Halle, £8* 15s.
2530 Ascham (Roger). The Scholemaster, blaꜩ lctter (second
ed.), new vell., g. e., ɔy De Coverly, in case, John Daye,
1571, sm. 4to. (75) *Quaritch, £4* 4s.
2531 Astle (Thos.) Origin and Progress of Writing, second ed.,
LARGE PAPER, port. and 32 plates, some col., russ. ex.,
J. White, 1803, imp. folio (76) *Edwards, £1*
2532 Audsley (G. A.) and Bowes (J. L.) Keramic Art of Japan,
32 plates, printed in col., mor. ex., H. Sotheran, 1881, sup.
imp. 8vo. (81) *Quaritch,* 18s.
2533 Ausonius. Opera, editio Aldina prima, liɔrary stamp on title,
old French mor., tooled ɔack of foliage and pointillé, g. e.,
Venet. in Ædibus Aldi, etc., 1517, 8vo. (82)
 Edwards, £1 11s.
2534 Avienus (Rufus Festus). Opera, lit. rom., long lines with
signs., including ɔlank for Aj (Hain *2224), astrological
cuts, old vell., in case, *Venet., Antonius de Strata Cremon-
ensis,* 1488, sm. 4to. (84) *Maggs, £4* 6s.
2535 Bacon (Lord). Works, ɔy Basil Montague, ports., 16 vol.
in 17, cf. ex., W. Pickering, 1825-34, 8vo. (86) *Maggs, £7* 5s.
2536 Bale (John). The Pageant of Popes, now Englished ɔy
J. S., blaꜩ lctter (some margins cropped), new cf., in case,
T. Marshe, 1574, sm. 4to. (87) *Bloomfield, £1* 12s.

2537 Bale (J.) Les Vies des Evesques et Papes de Rome, old French mor., g. e., *Geneve*, C. Badius, 1561, 8vo. (88)
Maggs, £3 5s.

2538 Bangese del Aquila (Jacoɔo). Lo Septenario (Poema), [at end] "Finisce lo Septenario coposto ꝑ religioso frate Jacoɔo Bangese del Aquila del Ordine de Sancto Francesco, stampato in Aqla mcccclxxxii.," roman letter, 8 leaves, commencing with the text without formal title, contemp. MS. notes in margins, loose in old cf. cover, in case, [*Aquila,* A. D. Rotevil, 1482], sm. 4to. (89) *Leighton, £15* 10s.

[Extremely rare in this perfect state, having the 8 leaves complete instead of the 7 leaves descriɔed ɔy Dibdin as ɔeing in the Cassino copy. It is most likely the first ɔook printed at Aquila ɔy Adam de Rotvil, the introducer of printing in that city.—*Catalogue.*]

2539 Barrois (J.) Biɔliothèque Prototypographique, ou Liɔrairies des Fils du Roi Jean, Charles V., Jean de Berri, Philippe de Bourgoyne et les Siens, plates and facs., 200 copies printed, mor., t. e. g., uncut, *Paris*, Trüttel et Würtz, 1830, 4to. (95)
Ellis, £2

2540 Berjeau (J. Ph.) Early Dutch, German and English Printers' Marks, 100 plates, edition limited to 250 copies, mor., t. e. g., E. Roscoe, 1866, imp. 8vo. (99) *Edwards, £1* 4s.

2541 Berjeau (J. Ph.) The Bookworm, facs., 5 vol. complete, 1866-70, sup. imp. 8vo. (100) *Bloomfield, £1* 10s.

2542 Berners (Dame Juliana). The Boke of Saint Alɔans, with Introduction by Wm. Blades, vell. bds., uncut, E. Stock, 1881—A Treatyse of Fysshynge with an Angle, reproduction of the orig. ed. of 1496, Introduction by Rev. M. G. Watkins, cf. ex., *ib.*, 1880, together 2 vol., 4to. (101)
Edwards, 13s.

2543 Berty (Adolphe). La Renaissance Monumentale en France, 100 plates, 2 vol. in 1, hf. mor., t. e. g., *Paris*, A. Morel, 1864, roy. 4to. (102) *Spencer,* 16s.

2544 Betbuchlein. A German Geɔetɔuch, or Book of Prayers, XVIth Century, manuscript on vellum (201 leaves, 3½ ɔy 2¾ in.), 𝔤𝔬𝔱𝔥𝔦𝔠 letter, long lines, 14 to a full page, 32 small illuminated miniatures, old German mor., with clasps, *Sæc.* XVI., thick 16mo. (103) *Menel, £29*

[An inscription on one leaf shows the ɔook to have ɔelonged in 1550 to one Katharina Laugingerin and her husɔand, Christoff Peutinger, of Augsɔurg, and has their armorial ɔearings.—*Catalogue.*]

2545 Beza (Theodorus). Poemata, editio prima, cut of "Prelum Ascensianum" on title, and port. of Beza "an. 29," with G. Tory's mark of the Lorraine cross, mor., t. e. g., ɔy Matthews, *Lutetiae in Officina Conradi Badii sub prelo Ascensiano*, 1548, 8vo. (104) *Barnard, £1* 16s.

2546 Beza (T.) Icones, id est Verae Imagines Virorum Doctrina simul et pietate illustrium, etc., editio prima, 38 woodcut ports. and 44 cuts of emɔlems (some cartouches vacant in this ed.), dedicated to James VI. of Scotland, with his port.

on reverse of title, cf. antique, ɔy A. Matthews (E 4 supplied
from a shorter copy), in case, *Genevae*, Jo. Laonius, 1580,
sm. 4to. (105) *Tregaskis*, £1 16s.

2547 Biɔlia. La Biɔle Hystoriaux, ou les Hystoires Escolastrès
translatée du Latin de Pierre Comestor par Guyart des
Moulins [fol. I a] "Cy comence la ɔiɔle hystoriaux ou les
hystoires escolastres," etc., illuminated manuscript on
vellum (531 leaves, 18 ɔy 13in.), semi-gothic letter, douɔle
columns of 52-54 lines, ruɔricated, margins of nearly every
page decorated in gold and colours, several hundred large
and small decorated initials, 312 square miniatures (4 ɔy
3in.), finely illuminated, 2 vol., mor. plain, ɔy Belz-Niedrée,
Sæc. XV., large folio (111) *Sabin*, £1,550
[A finely written and splendidly illuminated MS., the
miniatures ɔeing ɔy a French artist of great skill. They
are remarkaɔle for the accurate delineation of the costume,
ecclesiastical, civil and military, architecture and domestic
manners and customs of the period. (*See* plate.)—*Cata-
logue.*]

2548 Biɔliophile Français (Le). Gazette illustrée des Amateurs de
Livres d'Éstampes et de haute Curiosité, ports., facs., etc.,
7 vol. complete, some orig. wrappers ɔound in, hf. vell.,
t. e. g., uncut, *Paris*, Bachelier-Deflorenne, 1868-73, sup.
imp. 8vo. (117) *Hatchard*, £3 18s.

2549 Biɔliophile Society, New York. Horace, Odes and Epodes,
Latin text edited ɔy C. Lawrence Smith, duplicate ports.,
467 copies printed on handmade paper, 10 vol., russ. ex.,
t. e. g., uncut, in cases, *Boston, Mass.*, 1891, 8vo. (118)
 Barnard, £12

2550 Biɔliophile Society, New York. Year Books I.-VI., from
1902 to 1907, illustrations, 500 copies of each vol. printed on
handmade paper, 6 vol., orig. bds., uncut, in cases, *Boston,
Mass.*, 1902-7, 8vo. (119) *Maggs*, £6 10s.

2551 Biɔliophile Society, New York. André (Major John). Journal,
with facsimile reproductions of original maps and plans
drawn ɔy Major John André, illuminated titles, ports.,
maps, etc., 467 copies printed on handmade paper, 2 vol.,
vell. gilt, with André arms, t. e. g., uncut, in case, *Boston,
Mass.*, 1903, sm. 4to. (120) *Sotheran*, £11

2552 Biɔliophile Society, New York. Biɔliomania, or Book-Mad-
ness, ɔy T. F. Dibdin, 4 etchings ɔy Bicknell, 2 proof sets,
one on Japan paper, 483 copies printed, 4 vol., bds., uncut,
in 4 cases, *Boston*, 1903, 8vo. (121) *Dobell*, £3 10s.

2553 Biɔliophile Society, New York. Marat (Jean Paul). Polish
Letters (Lettres Polonaises), ports., facs., etc., 445 copies
printed, 2 vol., white bds., uncut, *Boston*, 1904, roy. 8vo.
(122) *Dobell*, £2 8s.

2554 Biɔliophile Society, New York. Theocritus, Bion and Mos-
chus, ed. ɔy H. Aiken Metcalf, handmade paper with ports.
and engraved titles, limited to 477 copies, 3 vol., uncut, in
cases, *Boston*, 1905, 8vo. (123) *Dobell*, £3 7s. 6d.

2555 Biɔliophile Society, New York. Letters of John Paul Jones, printed upon Japanese vellum, port. and facs., hf. vell., *Boston*, 1905, roy. 8vo. (124) *Dobell*, £2 10s.

2556 Biɔliophile Society, New York. Rossetti (Dante Gabriel). Henry the Leper (Der Arme Heinrich), a Suabian Miracle Rhyme Paraphrased, 𝔟𝔩𝔞𝔠𝔨 𝔩𝔢𝔱𝔱𝔢𝔯, with the original MS. in fac., 467 copies printed on Italian handmade paper, 2 vol., uncut, *Boston*, 1905, sm. 4to. (125) *Dobell*, £3 10s.

2557 Biɔliophile Society, New York. Thoreau (Henry D.) First and Last Journeys; and Sir Walter Raleigh, discouvered among his unpuɔlished Journals and Letters, 489 copies on handmade paper, 3 vol., orig. ɔinding, uncut, in cases, *Boston*, 1905, 8vo. (126) *Maggs*, £4 10s.

2558 Biɔliophile Society, New York. Lamɔ (Chas.) Letters, 470 copies for memɔers, duplicate port. and plates, 5 vol. (one folio), orig. bds., *Boston*, 1906, 8vo. (127) *Dobell*, £6 15s.

2559 Biɔliophile Society, New York. The Varick Court of Enquiry to investigate the Implication of Col. Varick (Arnold's Private Secretary) in the Arnold Treason, 470 copies printed on handmade paper, with port., facs., etc., mor., uncut, *Boston*, 1907, sm. 4to. (128) *Dobell*, £1 14s.

2560 Biɔliophile Society, New York. The Romance of Mary W. Shelley, John Howard Payne and Washington Irving, 2 ports., 470 copies only, hf. bd., uncut, in case, *Boston*, 1907, 8vo. (129) *Dobell*, £1 13s.

2561 Biɔliophile Society, New York. Unpuɔlished Poems ɔy Bryant and Thoreau, 400 copies printed upon vellum, white bds., *Boston*, 1907, sm. 4to. (130) *J. Grant*, £1 13s.

2562 Biɔliophile Society, New York. Facsimile of a Letter of Paul Jones, issued for memɔers, *Boston, Mass.*, 1893—Prospectus of the Issue of the Journal of Major André, 1903—Fourth Annual Banquet of the Biɔliophile Society to W. K. Bixɔy, port. and plate, *ib.*, 1903, sm. 4to. (131) *J. Grant*, £1 10s.

2563 Biɔliophile Society, New York. The Varick Court of Inquiry to investigate the Duplication of Col. Varick in the Arnold Treason, a set of 13 final proof etchings issued ɔy the Biɔliophile Society, *Boston, Mass.*, 1907, sm. 4to. (132) *J. Grant*, 16s.

2564 Biɔliophile Society, New York. Etchings by W. H. W. Bicknell, after original paintings by Howard Pyle [Erasmus, More and Colet, Richard of Bury and Edward III., Caxton working his press, Friar Bacon and Isaak Walton], 2 artist's proof sets on Japan paper, in portfolio, *New York*, n. d., atlas size (133) *Maggs*, £3 10s.

[The five paintings from which these etchings were executed were made exclusively for the Biɔliophile Society, and no reproductions of them in any form are distriɔuted except to memɔers.—*Catalogue.*]

2565 Biɔliotheca Sunderlandiana. Sale Catalogue (56 days' sale), with printed prices and purchasers' names, in 1 vol., hf. mor., t. e. g., 1881-3, 8vo. (134) *Barnard*, 11s.

2566 Bigmore (F. C.) and Wyman (C. W. H.) A Bibliography of Printing, facs., ports., etc., 250 copies printed, 3 vol., rox., uncut, B. Quaritch, 1880-86, sm. 4to. (136)
Edwards, £4 12s. 6d.

2567 Billings (R. W.) Baronial and Ecclesiastical Antiquities of Scotland, 240 steel engravings and woodcuts, 4 vol., orig. blue cl., uncut, *Edinb., published for the author*, 1855, 4to. (138)
Bull, £2 5s.

2568 Birch (Walter de Gray). History, Art and Paleography of the Manuscript styled The Utrecht Psalter, fac., S. Bagster, 1876—Early Drawings and Illuminations in the British Museum, plates, *ib.*, 1879, together 2 vol., mor., t. e. g., 8vo. (141)
Maggs, £1 14s.

2569 Boccaccio (Johannes). [De praeclaris mulieribus], begins () "Ridie mulierz egregia paululū ab ïerti vulgo semotuz & ā ceteris fere solutuz curis ī eximiā mulieribus sexus laudem," etc., lit. 𝔤𝔬𝔱𝔥. [Hain *3327], capitals painted, ornamental pen initial on first page, 2 zylographic cuts inserted, mor. plain, g. e., by Thompson, in case, "*Explicit compendiū Johānis Boccacii de Certaldo quod de preclaris mulieribus ac famā Ppetuam edidit feliciter,*" *s. a. l. et n. Impr. [Argent. Geo. Husner, c.* 1473] (145)
Leighton, £16

2570 Boccaccio (Giovanni). "Boccace de la Genealogie des Dieux," lettres bâtardes, double columns, 45 large and small woodcuts, first leaf in facsimile and parts of letters in facsimile, mor. plain, g. e., by Chambolle-Duru, in case, *Imprime nouvellemēt à Paris Lā mil CCCC quatre vīgtz & dixhuit le neufiesme jour De Fevrier pour Anthoine Verard, etc.,* 1498, folio (146)
Quaritch, £89

2571 Boccaccio (G.) Il Philocolo di M. Giovanni Boccaccio nuovamente revisto, title in red letters, head of Boccaccio in centre, cut on reverse of last leaf, cf., g. e. (Lewis), from the Beckford library, *Vinegia, Nic. di Aristotile detto Zoppino,* 1530, 8vo. (147)
Tregaskis, £1 8s.

2572 Bodoni (G.) Manuale Tipografico del Cav. Giambattista Bodoni, founts of types used in the Bodoni Press, port. by Rosaspini, 2 vol., old cf., *Parma presso la Vedova,* 1818, 4to. (149)
Edwards, £4 15s.

2573 Boethius (A. T. S.) De Philosophiae Consolatione, lit. semi-𝔤𝔬𝔱𝔥., 137 leaves (3 blank), without marks, text rubricated, capitals painted, orig. oaken bds., pigskin back, *Impressum Nurenburgae per Ant. Koberger,* 1476, folio (150)
Edwards, £5 7s. 6d.

2574 Borgo da Venezia (P. de.) Libro de Abacho. [On folio 2] "Qui Comēza la nobel opera de arithmetica," etc., ornamental initials (wormed and stained), orig. paper covers, in case, *In Venetia per Zuane Baptista Sessa (with devices of Cat and Mouse, etc.),* 1501, sm. 4to. (157) *Quaritch, £3 3s.*

2575 Boswell (James). Life of Samuel Johnson—Journal of a Tour to the Hebrides—New Editions with Notes and Appendices by Alex. Napier, M.A.—Johnsoniana—Anecdotes of Dr. Johnson, by Mrs. Piozzi and others, together

5 vol., édition de luxe, 104 copies printed, 54 engravings, proofs on India paper, mor., t. e. g., uncut, *Chiswick Press*, G. Bell & Sons, 1884, imp. 8vo. (158) *B. F. Stevens*, £2 5s.

2576 Bouchot (Henri). The Book, ed. ɔy H. Grevel, 172 illustrations, art cl., H. Grevel, 1890, imp. 8vo. (159) *Askew*, 11s.

2577 Bowman (H.) and Crowther (J. S.) The Churches of the Middle Ages, 135 lithographs, 2 vol., hf. mor., G. Bell, 1853, imp. folio (160) *Batsford*, £2 10s.

2578 Brandon (R. and J.) Open Timɔer Roofs of the Middle Ages, 41 plates, some col., orig. cl., D. Bogue, 1849, 4to. (164) *Bloomfield*, 18s.

2579 Brant (Seɔastian). Stultifera Navis, editio prima latina, woodcuts (title soiled, a few later headlines cut), mor. plain, g. e. (Macdonald), in case, *Basiliae, Jo. Bergman de Olpe*, 1497, sm. 4to. (165) *Halle*, £7 15s.

2580 Brant (S.) Das Narr Schiff von Narragonia mit besunderē flysz võ nüwē gmacht mit vil schöner zu gesetztē erlēgert im erclert zu Basel durch Seɔastianā ɔrāt lerer ɔeid. rechtō, **lit. gotȟ.**, douɔle columns, 36 lines, woodcut title, and 113 cuts in text (some rudely coloured, a few leaves with slight holes, leaf with imprint defective), Straszburg, Jo. Grüninger, 1497—Geyler von Keisersperg (Jo.) Navicula sive Specuⱡum fatuorum a Jac. Othero collecta, **lit. gotȟ.**, German woodcuts (some rudely coloured), *Argent. in aedibus Schürerianis*, 1510, in 1 vol., contemp. German oaken bds., hf. pigskin, small stamps and clasps, in case, 4to. (166) *Halle*, £13 5s.

2581 Brant (S.) Aff-Ghebeelde Narren Speel-Schuyt, vereiert met meer als hondert schoone Figueren, etc., **lit. gotȟ.**, cuts from the orig. German ɔlocks, mor. ex. (imprint cut off), [*Amst.*, J. E. Cloppenburgh, 1635], 8vo. (167) *Bloomfield*, £3

2582 Breydenbach (Bern. de). Sanctarum Peregrinationum in Montem Syon, etc., first ed. of the Latin text, **lit. gotȟ.** (imperfect, no front., title or plates, wanted 23 leaves of text, sold not suɔject to return), old English mor., g. e., *Mogunt.*, E. Reüwich, 1486, sm. folio (168) *Barnard*, £4

2583 Breydenbach (B. de). Sanctarum Peregrinationum in Montem Syon, etc., second ed., **lit. gotȟ.**, long lines, 4 large woodcut views, viz., Parens, Modon, Rhodes (imperfect) and Venice (mounted on linen), cuts in text (wanted front. and 2 large views, margins of several leaves mended, sold not suɔject to return), mor. plain, t. e. g., ɔy A. Matthews, *Impressum Spirae per Petrum Drach*, 1490, folio (169) *Quaritch*, £8 15s.

2584 British Museum. Catalogue of the Books in the Liɔrary of the B. M. printed ɔefore and up to the year 1640, 3 vol., orig. cl., *British Museum*, 1884, 8vo. (171) *Tregaskis*, £1 6s.

2585 Britton (John). Architectural Antiquities of Great Britain, LARGE PAPER, 200 engravings, 5 vol., old. russ. ex., Longman, 1807-26, 4to. (172) *Bull*, £3

2586 Britton (J.) Cathedral Antiquities, LARGE PAPER, 311 plates by Le Keux, etc., 6 vol., hf. mor., t. e. g., uncut, Longman, 1836, 4to. (176) · *Edwards, £4* 18s.

2587 Brulliot (Fr.) Dictionnaire de Monogrammes, Chiffres, Lettres Initiales et Marques (Peintres, Dessinateurs et Graveurs), plates, monograms, etc., 3 parts in 1 vol., hf. vell., *Munich*, 1817, 4to. (181) . *Tregaskis, £3* 5s.

2588 Brunet (J. Ch.) Manuel du Libraire, LARGE PAPER, 6 vol. in 12 (Firmin Didot's copy), *Paris*, Firmin Didot, 1860-65 —Supplément au Manuel, LARGE PAPER, 2 vol., *ib.*, 1878— Dictionnaire de Géographie à l'usage du Libraire, *ib.*, 1870, together 15 vol., hf. mor. ex., t. e. g., uncut, 1860-70, imp. 8vo. (183) *Maggs, £11*

2589 Brunet (Gustave). La Reliure ancienne et moderne, 116 plates, hf. mor., t. e. g., uncut, by A. Matthews, *Paris*, E. Rouveyre, 1884, 4to. (184) *Bloomfield, £1* 7s.

2590 Brydges (Sir E.) Restituta, port. of author and 47 ports. of old authors inserted, 4 vol., hf. cf., Longman, 1814, 8vo. (185) *Edwards, £1* 4s.

2591 Brydges (Sir E.) Lee Press Priory Pieces. Lord Brook's Life of Sir Philip Sidney—Characters of the Earl of Essex and Duke of Buckingham, by H. Wotton—Life of Margaret Cavendish Duchess of Newcastle, with Critical Prefaces, 100 copies of each work printed, separate titles on India paper, in 1 vol., russ. ex., in case, 1814-16, imp. 8vo. (186) *Bloomfield, £1* 10s.

2592 Burns (Rob.) Works, by Jas. Currie, eighth ed., 17 engravings after Stothard and Leslie, and ports. of Burns and Currie, 5 vol., orig. cl., Cadell & Davies, etc., 1817-20, 8vo. . (190) *Sotheran, £1* 5s.

2593 Burton (J. H.) The Book-Hunter, etc., first ed., mor. ex., in case, W. Blackwood, 1862, 8vo. (192) *Maggs,* 18s.

2594 Burton (J. H.) The Book-Hunter, new ed., etched port. of author and plate, one of 250 copies for sale in America, buckram, uncut, W. Blackwood, 1882, sm. 4to. (193) *Edwards,* 8s.

2595 Burton (Rich.) History of the House of Orange, 73 ports., views, plans, etc. inserted, mor. (loose), M. Stace, 1814, sm. 4to., inlaid to large 4to. (197) *Dobell, £1*

2596 Busk (Hans). Fugitive Pieces in Verse, 7 engravings, each in 3 states, black, red and col., cf. ex., in case, *Privately printed*, 1814, 8vo. (198) *Maggs, £4*

2597 Caesar. C. Julii Caesaris opera quae extant, thick paper, engraved title, maps and plates, with orig. blanks, mor. ex., in case, *Amst. ex Off. Elzeviriana*, 1661, sm. 8vo. (199) *James,* 18s.

2598 Caesar (Julius). Les Euures et brefues expositions de Julius Caesar, lettres bâtardes, long lines, 38 to a full page, large cut on title, cuts in text, ornamental initials, modern mor., gold fillets, g. e. (Macdonald), in cases, *Paris*, Michel Le Noir, 1502, sm. 4to. (200) *Leighton, £14* 10s.

2599 Calvin (John). Of the Life or Conversation of a Christian

Man, ɔy Thos. Broke, **black letter**, orig. ed. (a few lower margins cut into), modern cf., g. e., *Imprinted . . by Jhon Day and Wm. Seres*, 1549, 12mo. (201) *Tregaskis, £2*

2600 Calvin (John). Two Godly and notaɔle Sermons Preached . . in the yere 1555, first English ed., **black letter**, mod. vell., gilt ornaments, g. e., ɔy R. de Coverly, in case, Wyllyam Seres, n. d. (*c.* 1560), sm. 8vo. (202) *Bull, £1* 8s.

2601 Camerarius (Joachimus). Symbolorum et Emblematum ex Herɔaria, Animalibus, Quadrupedibus, Volatilibus et Insectis, Aquatilibus et Reptilibus desumptorum, Centuriae quatuor, editiones primae, 400 circular engravings, first impressions, 4 vol., mor., g. e., ɔy Stikeman, *Norimb.*, 1590-1604, sm. 4to. (203) *Edwards, £3* 15s.

2602 Cartwright (Wm.) Comedies, Tragi-Comedies, with other Poems, first ed. (cancel leaves pages 301-6), port. ɔy P. Lomɔart (margins cut close, a few cut into), modern mor., ɔlind, g. e., *Printed for H. Moseley*, 1651, 8vo. (209) *Dobell, £1* 5s.

2603 Catherine de Médicis. C'est l'Ordre et Forme qui a este tenue au Sacre & Couronnement de tres-hault & tres-illustre Dame, Madame Catherine de Medicis, Royne de France (12 leaves, including blank at end), new hf. mor., t. e. g., *Paris, chez Jacques Roffet*, 1549, sm. 4to. (216) *Quaritch, £1* 14s.

2604 Cats (Jacoɔ). Self-Stryt, dat is Krachtighe beweginghe van Vleesch ende Geest (Joseph and Potiphar's Wife), 4 plates ɔy Van Schijendel, mor., g. e., *k. o. o. n.* [*Amst.*, 1660?], obl. 12mo. (217) *Tregaskis, £1* 4s.

2605 Caulfield (Jas.) Portraits of Remarkaɔle Persons, 111 ports., 3 vol., R. S. Kirɔy, 1813—Second Series, 155 ports., 4 vol., Young & Whiteley, 1819-20, together 7 vol., LARGE PAPER, uniform hf. mor. ex., uncut, 4to. (218) *Maggs, £4*

2606 Caxton. Higden (Ranulph). The Polychronicon (translated out of Latin into English ɔy John of Treves), **black letter** (Blades' type No. 4), long lines, 40 to a full page (imperfect), commencing on folio lvii. and ending on folio ccclxvii., with a fac. leaf for "Prohemye" and another for the last leaf, folio clxviii. (wanted ɔlanks, wormed throughout), mor. plain, a full description of the volume tooled in gold letters, g. e., ɔy Bradstreet's, in a case, "*Ended the second day of Juyll the* xxii. *yere of the regne of kynge Edwarde the fourth & of the incarnacion of our lord a thousand four honderd foure score and tweyne, Fynysshede per Caxton*" (1482), sm. folio (221) *Bloomfield, £165*

[William Caxton's edition of the Polychronicon in English, the first puɔlished (Blades, No. 44). Only three perfect and 4 perfected copies exist; and aɔout 25 imperfect copies. This copy has 294 genuine leaves.—*Catalogue.*]

2607 Caxton. Blades (Wm.) Life and Typography of William Caxton, first ed., port. of the Duchess of Burgundy and typographical facs., sepia drawing of the head of Caxton inserted, 2 vol., hf. mor., t. e. g., uncut, J. Lilly, 1861, 4to. (222) *Edwards, £3* 18s.

2608 Chaucer (Geoffrey). Workes, first ed. ed. ɔy John Stow
(second issue), **blart letter**, cuts in the text (inner margin of
title and corner of next 2 leaves mended), mor., g. e., *Jhon
Kyngston for John Wight,* 1561, folio (229) *Young,* £8 5s.

2609 Chaucer (G.) Workes (Speght's ed.), **blart letter**, armorial
port. of Chaucer and his coat-of-arms, hf. mor., *Printed in
the year* 1687, folio (230) *Bull,* £1 6s.

2610 Chippendale (Thos.) Gentleman and Caɔinet Maker's
Director (German reissue of the ed. of 1762), 200 plates,
English text, bds., t. e. g., *Berlin,* E. Wasmuth, *h. j.,* folio
(234) *Hatchard,* £2 8s.

2611 Chronicon Nurembergense. The Nuremɔerg Chronicle,
editio prima, **lit. gotḫ**.. woodcuts ɔy Wohlgemuth, Pleyden-
wurff and Alɔert Dürer, complete with the ɔlank leaves and
Sarmacia, a few of the cuts coloured, old cf. (rebacked), in
case, *Impressit Nurenbergae per Anth. Koberger,* 1493,
large folio (235) *Maggs,* £13 15s.

2612 Cicero. De Natura Deorum—De Divinatione—De Fato—
De Legibus—Liɔer ad Hortensium—De Disciplina Militari
—De Finibus Bonorum et Malorum—De Petitione Con-
sulatus—De Universitate et de Somno Scipionis, lit. rom.,
long lines, 50 to a full page, with signs. (ɔegins on A ili.,
some leaves stained), mor. plain, t. e. g., in case, *Impressum
Rezii et Bononiae per Bazalerium Bazaleriis Bononiensis*
(*with device*), 1498-1499, sm. folio (236)
 Leighton, £3 17s. 6d.
[Not in the Sunderland catalogue, and Hain (5336) had
not seen it. Numerous learned MS. notes in the margins
have ɔeen attributed to the hand of Melànchthon. The
volume is divided into four sections, each with the printer's
colophon at the end, showing the first three sections to
have ɔeen printed at Reggio and the last at Bologna.—
Catalogue.]

2613 Cicero. In hoc volumine haec continentur ; Rhetoricorum
ad C. Herennium liɔ. IIII., M. T. Ciceronis de Inventione
liɔ. II., ejusdem de Oratore lib. III., de Claris Oratoribus
liɔ. I., Orator liɔ. I., Topica lib. I., Oratoriae Partitiones
liɔ. I., etc., editio prima Aldina, contemp. notes in margins
and 2 drawings in pen-and-ink on margins of fol. 136 (one
or two small wormholes), mor., g. e., in case, *Venet. in
aedibus Aldi et Andreae Soceri mense Martii,* 1514, sm.
4to. (237) *Barnard,* £4 15s.

2614 Clarke (Wm.) Repertorium Bibliographicum, view of the
Bodleian, and 11 ports. ("A Dialogue in the Shades," with
copperplate vignette containing port. of Caxton and 2
others, and "A Ballad entitled Rare Doings at Roxɔurghe-
Hall," inserted), bds., uncut, W. Clarke, 1819, imp. 8vo.
(240) *Bloomfield,* £2 6s.

2615 Coɔɔett (Wm.) History of the Regency and Reign of King
George the Fourth, ɔound in 2 vol., post 8vo., inlaid to
small 4to. size, and illustrated ɔy the insertion of 100 prints

and six autograph letters, mor. super ex., *Published by Wm. Cobbett,* 1830, sm. 4to. (244) *Hatchard,* £12 5s.
[An interesting copy containing *inter alia* the suppressed col. plate of Mary Anne Clark, as the "Sleeping Partner" of the Duke of York.—*Catalogue.*]

2616 Cohen (Henry). Guide de l'Amateur de Livres à Figures et à Vignettes du XVIIIᵉ Siècle, 3ᵉ Édition, grand papier d'Hollande, 500 copies printed, hf. mor., t. e. g., uncut, *Paris,* Roquette, 1876, imp. 8vo. (245) *Bloomfield,* £1 6s.

2617 [Columna (Fr. de).] La Hypnerotomachia di Poliphilo, editio aldina secunda, engravings from the designs of Giovanni Bellino, the Priapus unmutilated (a few leaves stained, 2 stamps on title), mor. super ex., douulé, g. e., by Bradstreet, in case, *In Venegia in casa di figliuoli di Aldo,* 1545, sm. folio (248) *Olschki,* £20

2618 Copinger (W. A.) Incunabula Biblica, 54 plates of facs., orig. cl., Quaritch, 1892, folio (250) *Quaritch,* £3 12s.

2619 Coussemaker (E. de). Mémoire sur Hucbald et sur ses Traités de Musique, illuminated front. and 21 facs. of ancient MS. music, 80 copies printed (No. 75), hf. mor., t. e. g., *Paris,* Techener, 1841, 4to. (253) *Quaritch,* £2 8s.

2620 Crowe (J. A.) and Cavalcaselle (G. B.) History of Painting in North Italy, first ed., illustrations, 2 vol., orig. cl., uncut, J. Murray, 1871-72, 8vo. (255) *Quaritch,* £3 12s.

2621 Crowley (Robert). The Confutation of the Mishapen Aunswer to the misnamed wicked Ballade called the "Abuse of the blessed Sacrament of the Aultare," etc., orig. ed., black letter, modern cf., in case, *Imprinted by Jhon Daye and Wm. Seres,* 1548, sm. 8vo. (256) *Dobell,* £3 3s.
[Written against a Ballad of Myles Hoggard or Haggard, whose verses are introduced piecemeal and so confuted.—*Catalogue.*]

2622 [Curio (C. S.)] Pasquine in a Traunce. A Christian and learned Dialogue, first ed., black letter and roman (marginal notes cut into), old cf. (rejacked), Wylliam Seres, n. d. (1566?), sm. 4to. (258) *Barnard,* £2 10s.

2623 Dance of Death. [Basle.] Todten-tanz der löblischen Statt Basil, als ein Spiegel menschlicher Beschaffenbeit, etc. (Matthaeum Merian), engraved title and 42 engravings, Erste Ausgabe, hf. vell., *Franckfurt,* 1649, sm. 4to. (260) *Ellis,* £3 5s.

2624 Dance of Death. Basle. Todten-Tanz der Stadt Basels (M. Merian), lit. goth., 42 engravings, mor., t. e. g., *Franckfurt,* Merian, 1696, sm. 4to. (261) *Tregaskis,* £1 15s.

2625 Dance of Death. [Basle.] La Danse des Morts (Matthieu Merian), 42 copperplates by M. Merian, cf. antique by A. Matthews, in case, *Berlin, aux depens des Héretiers de l'Auteur,* 1697, sm. 4to. (262) *Hornstein,* £1 12s.
[First edition with French text throughout by le Sieur P. Vieu (*see* Peignot).—*Catalogue.*]

2626 Dance of Death. [Basle.] La Danse des Morts (Matthieu Merian), 85 engravings, text in French and German, vell.,

quite uncut (some leaves not cut open), orig. paper covers,
à Basle chés J. R. Im-Hoff, 1744, 4to. (263) *Dobell,* £1 9s.
2627 Dance of Death. [Basle.] La Danse des Morts, 42 engrav-
ings of the Dance of Death on 21 plates, engraving of the
Temptation of Eve, folding plate of the Crucifixion, and a
plate of the double head, *au Locle chez Sammel Girardet
Libraire, s.d.* (1788)—L'Art de ɔien vivre et de ɔien mourir,
front., *ib.*, 1788, in 1 vol., hf. bd., rare, 8vo. (264)
 Quaritch, £5 10s.
[An adaptation of the Merian designs ɔy an unknown
artist, who has introduced costumes of the 18th century
(*see* Douce).—*Catalogue.*]
2628 Dance of Death. [Basle.] Maszmann (H. F.) Die Baseler
Todtentänze in getreuen Aɔɔildungen, sammt einem An-
hange, 81 suɔjects on 22 plates and 27 reproductions from
the Block-Book in the Heidelɔerg Liɔrary, 2 vol., text in
8vo., plates in 4to., new cl., in case, *Stuttgart and Leipzig,*
1847, 8vo. and 4to. (268) *Hornstein,* £1 4s.
2629 Dance of Death. [Basle.] Massmann (H. F.) Die Baseler
Todtentänze in getreuen Aɔɔildungen, neɔst geschichtlicher
Untersuchung, 2 vol., text in 8vo. and atlas of plates in 4to.,
81 engravings on 22 plates and 27 facs. on stone from the
Block Book of the 15th century in the Heidelɔerg Liɔrary,
hf. mor., t. e. g., in case, *Leipz.,* 1847, 8vo. and 4to. (269)
 Hornstein, £1 2s.
2630 Dance of Death. [Macaɔre.] La Grande Danse Macaɔre
des Hommes et des Femmes, 52 reproductions of the cuts
first issued in the 15 century, hf. mor. (*see* Douce), *à Troyes
chez J. A. Garnier, s.d.* (1728), 4to. (274) *Hornstein,* £2 6s.
2631 Dance of Death. Danse Machabre. Chorea ab eximio
Macaɔro Versibus alemanicis edita et a Petro Defrey
trecacio, lit. gotĵ., facsimile reprint upon vell. of the edition
printed at Paris ɔy Guido Mercator for E. de Marnef in
1490, reproductions of the woodcuts, 4 copies printed upon
vellum, mor., inside dentelles, in case [*Paris, reprinted
1868, s. l. ou nom.*], sm. folio (279) *Barnard,* £4 4s.
2632 Dance of Death. La Danse Macaɔre, Facsimile de l'Edition
de 1484 précédé de Recherches par l'Abbé V. Dufour, front.
and facs. of the ancient woodcuts, 250 copies printed, hf.
mor., uncut, *Paris,* L. Willem, 1875, 4to. (280)
 Hornstein, £1
2633 Dance of Death. [Holɔein.] Imagines Mortis à Georgio
Æmylio in Latinum translata, 53 cuts after Holɔein, *Col-
oniae apud haeredes Arnoldi Birckmanni,* 1555—Apologia
Indicti a Paulo III. adversus Lutheranae Confederationis
rationes plerasque, etc., *Paris,* G. Chevallonius, 1538, in 1
vol., mor., g. e., sm. 8vo. (282) *Ellis,* £5 10s.
[The Imagines Mortis is the first Cologne edition.
Douce calls it a pirated one, from the Lyons edition of
1547.—*Catalogue.*]
2634 Dance of Death. [Holbein.] Imagines Mortis à Geo.
Æmylio in Latinum translata, 53 cuts from Holɔein's

designs (hole through title and next 2 leaves), contemp.
pigskin, in case, *Colon.*, A. Birckmannus, 1567, 8vo. (283)
Rosenthal, £2

2635 Dance of Death. [Hol)ein, etc.] Valvasor (Jo. Weichard).
Theatrum Mortis Humanae tripartitum : I. Pars, Saltum
Mortis. II. Pars, Varia genera Mortis. III. Pars, Poenas
Damnatorum continens. Schau-Bühne desz menschlichen
Todts in drey Theil, etc., allegorical front., 54 designs after
Hol)ein, and 66 plates all within)orders,)y A. Trost,
mor., g. e.,)y Roger de Coverly, in case, *Gedruckt zu Lay-
bach und zu finden bey Jo. B. Mayr in Saltzburg*, 1682, sm.
4to. (284) *Ellis*, £9 15s.

2636 Dance of Death. [Hol)ein.] Les Images de la Mort, 53
engravings on wood by Hans Lutzelberger, mor. antique,
g. e.,)y Trautz-Bauzonnet, in case, *a Lyon a · l'escu de
Cologne chez Jehan Frellon*, 1547, sm. 8vo. (285)
Quaritch, £17 15s.
· [First French edition with 53 cuts, the earlier ones
having 41 only (*see* Douce).—*Catalogue.*]

2637 Dance of Death. [Hol)ein.] Les Images de la Mort, 58
cuts by Hans Lutzelberger, mor. (title mended), in case, *a
Lyon par Jehan Frellon*, 1562, sm. 8vo. (286) *Quaritch*, £9
[In this edition first appeared seven more cuts than in
the first edition of 1538.—*Catalogue.*]

2638 Dance of Death. [Hol)ein.] Le Triomphe de la Mort, 48
engravings reproduced from the ed. of 1780, on fine paper,
in a limited issue, mor. super ex., g. e.,)y Bardisser, with
)ookplate on cloth, "ex Museo del Montino" (Emperor
Maximilian), in case, 1780 (*Paris*, 1860), sm. 4to. (288)
Maggs, £2 4s.

2639 Dance of Death. [Hol)ein.] Simolachri, Historie e Figure
de la Morte, first Italian ed. of Hol)ein's cuts of the Dance
of Death, 41 cuts after Hol)ein, mor. ex., in case, *Venet.
appresso Vincenzo Vaugris (Valgrisi)*, 1545, 12mo. (291)
Tregaskis, £5 15s.

2640 Dance of Death. [Hol)ein, etc.] Glissenti·(S. Fa)io). Dis-
corsi Morali, contra il Dispiacer del Morire, detto Athana-
tophilia, divisa in cinque Dialoghi, prima edizione, 381 cuts,
including Hol)ein's series of the Dance of Death, port. of
the author, and ornamental initials, modern cf. ex., *Venet.
appresso Dominico Farri*, 1596, sm. 4to. (292)
Bloomfield, £3 4s.

2641 Dance of Death. Hol)ein (H.) Der Todtendantz durch alle
Stende uund Geschlecht der Menschen, etc. (text)y Caspar
Scheyt), lit. gotí)., 53 cuts after H. Hol)ein (with the
Triumphs of Youth), mor., t. e. g., in case, *k. o. o. n. Im Jar*,
1560, 8vo. (295) *Ellis*, £5 10s.

2642 Dance of Death. [Holbein.] Wolsschaten (Geeraerdt Van).
De Doodt Vermaskert met des weerelts Ydelheyt af-ghedaen,
18 designs after H. Hol)ein (14 from the orig. coppers), cf.
ex., t. e. g.,)y Stikeman, in case, *t'Antwerpen*, P. Bellerus,
1654, sm. 8vo. (296) *Bloomfield*, £1 2s.

2643 Dance of Death. [Holɔein.] Todten Dantz dürch alle Stände
und Geschlecht der Menschen, etc., **lit. gotɧ**. and italics, 60
engravings, including all Holɔein's designs, within ɔorders,
2 plates (repaired), interleaved, with many orig. ɔlank leaves,
orig. vell., in case, *k. o. o. j.* (*Franckfort, c.* 1600), sm. 4to.
(297) *Ellis,* £2
[Proɔaɔly the earliest issue of the entire series of
Holɔein's designs engraved on copper (*see* Douce).—
Catalogue.]
2644 Dance of Death. [Holɔein.] The Dance of Death, engraved
by W. Hollar (with the Dance of Macaɔer, ɔy John Lyd-
gate), (edited ɔy Fr. Douce), ports. of Hollar and Holɔein,
30 designs ɔy Holɔein, and folding plate of the Dance of
Macaɔer from the original coppers, mor. ex., by Stikeman,
n. p. d. or n. [*Lond.*, 1790], 4to. (303) *Bloomfield,* £1 8s.
2645 Dance of Death. [Holɔein.] The Dance of Death (with
the Dance of Macaɔer), 33 plates ɔy Hollar, col. copy,
descriptions in English and French, orig. mor., g. e., Cox-
head, 1816, 8vo. (306) *Quaritch,* £1 11s.
2646 Dance of Death. [Holɔein-Diepenbeck.] A series of 51
engravings after Holɔein, designed ɔy Adr. à Diepenɔeke,
and engraved by W. Hollar, with a duplicate plate of "The
Physician," orig. impressions, mounted (1651), sm. 4to.
(311) *Edwards,* £4 18s.
2647 Dance of Death. Bewick (John). Emɔlems of Mortality
(Preface ɔy J. S. Hawkins), first ed., mor. ex., ɔy F. Bed-
ford, in case, T. Hodgson, 1789, 8vo. (312)
B. F. Stevens, £2 12s.
2648 Dance of Death. Chytraeus (David). Libellus de Morte et
Vita Æterna, Epigrammatis G. Æmylii, 53 cuts of the
Dance of Death, 3 parts in 1 vol., orig. vell., in case (*see*
Douce, page 117), *Witebergae,* Matth. Welach, 1590; 8vo.
(313) *Rosenthal,* £1 5s.
2649 Dance of Death and Life. [Comɔe and Rowlandson.] The
English Dance of Death (Wm. Comɔe), with the Dance of
Life, orig. eds. (cut into), poor copy, 100 col. illustrations,
3 vol., mor. plain, edges gilt on the rough, in case, Acker-
mann, 1815-17, imp. 8vo. (314) *Abrahams,* £12
2650 Dance of Death. Hull (Edw.) Illustrations of Death's
Ramɔle from the "Whims and Oddities" of Thos. Hood,
illustrated cover, and 7 col. lithographic plates, hf. mor.,
Published at the Gallery, 27, Regent Street (1827), 8vo.
(315) *Hornstein,* £1 6s.
2651 Dance of Death. Kastner (Georges). Les Danses des
Morts, Musique de Georges Kastner, etc., plates and
musical notes, hf. mor., t. e. g., *Paris, etc.,* 1852, 4to. (321)
Hornstein, £1 18s.
[Contains nearly 200 facsimiles and original designs not
found elsewhere. The musical researches are valuaɔle.—
Catalogue.]
2652 Dance of Death. Langlois (E. H.) Essai sur les Danses
des Morts, port., plates and woodcuts, 2 vol., hf. mor., t. e. g.,

uncut, ex-libris de M. J. Renard, *Rouen*, Le Brument, 1852,
roy. 8vo. (322) *Barnard*, 18s.
2653 Dance of Death. Manni (P. G. B., S.J.) Varii e Vera
Ritratti della Morte, front. and 29 plates, mor., t. e. g., by
Bradstreet, in case, *Milano, stampe dell' Agnelli*, 1671, sm.
8vo. (323) *Hornstein*, £1 13s.
2654 Dance of Death. Meyer (Conrad). Todtendantz. Sterbens-
spiegel dat ist sonnenklare Vorstellung menschlicher Nich-
tigkeit durch alle Ständ und Geschlecter, etc., erste Ausgabe,
59 plates, mor. plain, t. e. g., by Bradstreet, in case, *Zürich,*
J. J. Bodmer, 1650, sm. 4to. (324) *Hornstein*, £3 6s.
[Pages 123-160 are occupied with music appropriate to
the subject of the text.—*Catalogue.*]
2655 Dance of Death. [Rusting.] Schau-Platz des Todes oder
Todten-Tanz in kupfern und Versen vorgestellet, lit. gotf.,
30 orig. copperplates of the Dance of Death, cf. ex., in
case [first edition in German (*see* Douce)], *Nürnberg*, P. C.
Monath, 1736, 8vo. (331) *Bloomfield*, £1 2s.
2656 Dance of Death. Santa Clara (P. Abraham Van). De
Kapelle der Dooden, front. and 68 orig. designs of the
Dance of Death, cf. antique, t. e. g., by Bradstreet, *t' Am-
sterdam, J. Roman de Jonce*, 1741, sm. 8vo. (332) *Dobell*, 19s.
2657 Dance of Death. [Schellenberg.] Freund Heins Erschein-
ungen in Holbeins Manier von J. R. Schellenberg, 24
engravings of a Dance of Death, cf. ex., uncut, by F. Bed-
ford, in case, *Winterthur bey Heinrich Steiner & Comp.,*
1785, 8vo. (333) *Bloomfield*, £3
[First edition of these designs for a Dance of Death
(*see* H. N. Humphreys on Holbein).—*Catalogue.*]
2658 Dance of Death. Sears (G. E.) A Collection of Works
illustrative of the Dance of Death in the library of George
Edward Sears, photographic reproductions of title-pages
and plates, cf., *New York, privately printed*, 1889, imp. 8vo.
(335) *Maggs*, £1 5s.
2659 Dance of Death. [Van Assen.] The British Dance of
Death, col. front. by R. Cruikshank and 18 other col. plates,
mor., g. e. (*see* Douce), *Hodgson & Co., Newgate St.*, n. d.
(1822), 8vo. (337) *Quaritch*, £5
2660 Dance of Death. Walasser (Adam). Kunst wol zu sterben.
Ein gar nutzliches, hochnothwendiges Büchlein ausz heiliger
Schrifft, etc., lit. gotf.. 20 German cuts after the desings in
the Block Book "Ars Moriendi," contemp. German oak
bds., stamped pigskin, with clasps, in case (*see* Douce),
Gedruckt zu Dilingen bey Melchior Algeyer, 1621, sm. 8vo.
(338) *Hornstein*, £2 2s.
2661 Davies (C. M.) History of Holland, and the Dutch Nation,
extra engravings inserted, 3 vol., buckram, uncut, G. Willis,
1851, thick 8vo. (341) *Edwards*, £2 2s.
2662 [Davies (Myles).] Eikōn Mikro-Biblikē, sive Icon Libellorum,
or a Critical History of Pamphlets, cf. ex., by A. Matthews,
in case, *Printed and sold by the Booksellers of London and
Westminster*, 1715, 8vo. (342) *Ellis*, £1 12s.

2663 Decker (Thomas). English Villanies seven severall times prest to Death by the Printers, **black letter**, cut of Dellman on reverse of title, mor., g. e., in case (Jas. Maidmcnt's copy), *M. Parsons and sold by Jas. Becket at the Inner Temple Gate,* 1638, sm. 4to. (344) *Tregaskis,* £7 10s.

2664 De Gomberville. Doctrine of Morality, translated by T. M. Gibbs, front., vignette on title and 100 engravings by Daret, old cf., E. Bell, etc., 1721, folio (346) *Bloomfield,* 16s.

2665 Delille (M.) Les Géorgiques de Virgile, 3e édition, fine paper, 4 plates after Eisen (first ed. with Eisen's plates), old cf., g. e., *Paris,* C. Bleuet, 1770, roy. 8vo. (347) *Bloomfield,* £1 10s.

2666 De Vinne (Theo. L.) Invention of Printing, statue of Gutenberg and facs., hf. mor., t. e. g., uncut, *New York,* F. Hart & Co., 1876, imp. 8vo. (350) *Dobell,* 19s.

2667 De Vinne Press. Bierstadt (O. A.) The Library of Robert Hoe, a Contribution to the History of Bibliophilism in America, 110 illustrations, 350 copies printed on Japanese paper, cl., *New York,* Duprat & Co., 1895, 8vo. (351)
Askew, £2 7s.

2668 De Vinne Press. Catalogue of the Collection of Books and Manuscripts belonging to Mr. Brayton Ives, of New York, facs., one of 100 copies on Holland paper, priced in MS., with Addenda II. printed separately, parchment wrapper, uncut, *New York, De Vinne Press,* 1891, sm. 4to. (352) *Maggs,* £1 8s.
[This American library was sold in New York in 1891 and realised 124,366 dollars. *See* BOOK-PRICES CURRENT, Vol. v., page 182 *et seq.*—ED.]

2669 Dibdin (Chas.) History and Illustrations of the London Theatres, 14 engravings by Le Keux, 25 copies printed, orig. bds., uncut, 1826, 4to. (353) *Bloomfield,* 16s.

2670 Dibdin (T. F.) Poems, orig. ed., vignette on title, hf. mor., t. e. g., autograph note to Poole the artist inserted, 1797, 8vo. (355) *Barnard,* £1 4s.
[Dibdin printed 500 copies of this early production, and was glad to get rid of half the edition as waste paper ; the remainder were partly destroyed by his own hands. "My only consolation is that the volume is exceedingly rare."— *Catalogue.* Another copy sold for 16s.—ED.]

2671 [Dibdin (T. F.)] History of Cheltenham and its Environs, views in aquatinta, 11 extra views inserted, hf. mor., t. e. g., uncut, by Matthews, *Cheltenham,* H. Ruff, 1803, roy. 8vo. (356) *Tregaskis,* 14s.

2672 Dibdin (T. F.) Some Account of the First Printed Psalters at Mentz, 1457, 1459, 1490 (contributed to "The Athenæum" in 1807), mor., t. e. g., presentation copy, with autograph (1807), 8vo. (359) *Quaritch,* 13s.

2673 Dibdin (T. F.) More (Sir T.) Utopia, translated by Raphe Robinson, LARGE PAPER, 40 copies printed, port. of More, woodcut title, private plate of the More family (not in the small paper eds.) and vignettes, hf. mor., uncut, *W. Bulmer for W. Miller,* 1808, 4to. (360) *Maggs,* £1 11s.

2674 Dibdin (T. F.) Specimen Biɔliothecae Britannicae, 40 copies printed, not puɔlished, author's inscription on fly-leaf, cf., g. e., W. Savage, 1808, 8vo. (361) *Tregaskis, £1* 5s.

2675 Dibdin (T. F.) Specimen of an English De Bure, 50 copies privately printed, presentation copy, hf. mor., t. e. g., 1810, 8vo. (362) *Bloomfield, £1*

2676 Dibdin (T. F.) Biɔliography, a Poem in Six Books (Book I., all written), 50 copies privately printed, mor., *Harding & Wright, Printers,* 1812, imp. 8vo. (363) *Dobell,* 12s.

2677 Dibdin (T. F.) Typographical Antiquities, ɔegun ɔy Joseph Ames, mezzo. ports., etc., 4 vol., hf. mor., t. e. g., W. Miller, 1810-19, 4to. (364) *Edwards, £6* 5s.

[Inserted is an autograph note ɔy Joseph Ames on some Araɔic numerals discovered on a stone in an old house in Holɔorn, May 4, 1756, "shown and red to the Antiquarian Society the same day"; also an autograph letter of Dibdin's concerning the work.—*Catalogue.*]

2678 Dibdin (T. F.) Book Rarities (specimen of the proposed "Biɔliotheca Spenceriana"), 36 copies printed (not for sale), mor., t. e. g., W. Bulmer, 1811, 8vo. (365) *Bloomfield,* 12s.

2679 Dibdin (T. F.) The Lincolne Nosegay, 36 copies printed, hf crimson mor., ɔy H. Wood, W. Bulmer (1811), 8vo. (367) *Tregaskis, £1*

[The rare ɔooks noted in this work were sold to Earl Spencer.—*Catalogue.*]

2680 Dibdin (T. F.) Rastell (John). The Pastime of People, fac. woodcuts (full-page), [ed. ɔy Dibdin], hf. cf., Rivington, 1811, 4to. (368) *Bloomfield,* 15s.

2681 Dibdin (T. F.) Gardiner (W. N.) A Review of Thos. Frognal Dibdin's Biɔliomania, port. and specially printed title, uncut, 1812, imp. 8vo. (369) *Quaritch,* 8s.

[Gardiner was satirised ɔy Dibdin in his Biɔliomania under the name of Mustapha.—*Catalogue.*]

2682 Dibdin (T. F.) A Ballad entitled Rare Doings at Roxɔurghe Hall (4 leaves), J. Dove, n. d.—Dialogue in the Shades ɔetween Wm. Caxton, Fodius, a Biɔliomaniac and William Wynken Clerk (4 leaves), vignette on title (after the alteration), n. d., imp. 8vo. (370) *Quaritch, £1* 15s.

2683 [Dibdin (T. F.)] Catalogue of a Portion of the Liɔrary of Stanesby Alchorne, with duplicates from the liɔrary of a Noɔleman (Lord Spencer), sold ɔy auction May 22, 1813 [compiled by Dr. Dibdin, with a note in his hand on title], prices and names in pen and ink (specimens of Gutenɔerg, Fust, etc.), hf. mor., 1813, 8vo. (371) *Tregaskis, £1*

2684 Dibdin (T. F.) Biɔliotheca Spenceriana, 4 vol., Longman, 1814-15—Ædes Althorpianae, 2 vol., Payne & Foss, etc., 1822—The Cassano Catalogue, *ib.,* 1823, together 7 vol., ports., plates, etc., uniform hf. mor., t. e. g., uncut, two letters of Dibdin inserted, 1814-23, imp. 8vo. (372) *Barnard, £8*

2685 [Dibdin (T. F.)] A Roxɔurghe Garland, mor. plain, t. e. g.,

)y Macdonald, in case, *Printed by Bensley &* *Son,* 1817,
sm. 8vo. (375) *Quaritch,* £4 16s.
2686 Dibdin (T. F.) Catalogue of the Li)rary of an Eminent
Bi)liographer (Dr. T. F. Dibdin), sold)y auction)y R. H.
Evans in June, 1817, written prices and purchasers' names,
orig. bds., in case, 1817, 8vo. (378) *Tregaskis,* 15s.
2687 Dibdin (T. F.) Bi)liographical Decameron, facs. of ancient
woodcuts, MSS., etc., 3 vol., orig. bds., uncut, with la)els,
in 3 cases, *Printed for the author by W. Bulmer &* *Co.,*
1817, imp. 8vo. (379) *B. F. Stevens,* £9
[A 4 page autograph letter from Dibdin to A. A.
Renouard, of Paris, inserted.—*Catalogue.*]
2688 Dibdin (T. F.) Complaint of a Lover's Life, and Controversy
)etween a Lover and a Jay (presented to the Rox)urghe
Clu))y T. F. Dibdin), 31 copies printed, rox.)inding,
1818, 4to. (380) *Quaritch,* £6 5s.
2689 Dibdin (T. F.) Bi)liographical, Antiquarian and Picturesque
Tour in France and Germany, illustrations, some on India
paper, autograph letter inserted, 3 vol., hf. mor., t. e. g.,
uncut, Payne & Foss, 1821, imp. 8vo. (382)
 Hornstein, £4 6s.
2690 Dibdin (T. F.) A Roland for an Oliver, or Brief Remarks
upon the Preface and Notes of G. A. Crapelet attached to
his Translation of the Thirtieth Letter of the Bi)lio-
graphical Tour)y the Author, 36 copies printed, hf. mor.,
Shakespeare Press, 1821, imp. 8vo. (384) *Quaritch,* £1 18s.
2691 Dibdin (T. F.) Lettre Trentième concernant l'Imprimerie et
la Librairie de Paris traduite de l'Anglais avec des Notes
par G. A. Crapelet, 100 copies printed, *Paris,* 1821—Dibdin
(T. F.) A Roland for an Oliver, presentation copy, *Shake-*
peare Press, 1821, together 2 vol., cf. ex., by Hayday, imp.
8vo. (385) *Tregaskis,* £2 10s.
2692 Dibdin (T. F.) Lewis (Geo.) A Series of Groups illustrating
the Physiognomy, Manners and Character of the People of
France and Germany (illustrating Dibdin's Bi)liographical
Tour in France and Germany), LARGE PAPER, 60 proof
plates on India paper, hf. mor., t. e. g., J. & A. Arch, 1823,
4to. (392) *Quaritch,* £1 16s.
2693 Dibdin (T. F.) Lewis (Geo.) Advertisement of a Series of
Groups of the People of France and Germany, containing
title, dedication, list of plates, etc. to accompany Dibdin's
Bi)liographical Tour (15 pages)—Lewis's O)servations on
Dibdin's Treatment of him in way of his remuneration for
his drawings (8 pages), hf. mor., 1823, roy. 8vo. (393)
 Quaritch, 18s.
[The "O)servations" were intended to accompany the
third part of the "Groups," but were suppressed.—*Cata-*
logue.]
2694 [Dibdin (T. F.)] Garrick (David). Catalogue of the Li)rary
sold)y auction)y Saunders, April 23 and nine following
days, 1823, printed prices and purchasers' names, mor.,
t. e. g., 1823, 8vo. (394) *Tregaskis,* £1 2s.

[*See* "Bibliographical Decameron," vol. iii., page 313.—
Catalogue.]
2695 Dibdin (T. F.) The Library Companion, first ed., hf. mor.,
t. e. g., uncut, Harding, etc., 1824, 8vo. (395) *Dobell*, 7s.
[Presentation copy to Dawson Turner, with autograph
letters of the author, D. Turner, and others.—*Catalogue*.]
2696 Dibdin (T. F.) The Library Companion, first ed., LARGE
PAPER, port. of Thos. Amyot, and Dibdin's receipt for £600
from Harding and Lepard inserted, 2 vol., hf. mor., t. e. g.,
Harding, Triphook, etc., 1824, imp. 8vo. (396)
Bloomfield, 16s.
2697 Dibdin (T. F.) A Merry and Conceited Song to be Sung at
Roxburghers Hall, 60 copies printed [A Reply to Criticisms
of "The Library Companion" in the "Westminster Review"],
hf. mor., 1825, sup. imp. 8vo. (397) *Quaritch*, 15s.
2698 Dibdin (T. F.) The Street Companion, or the Young Man's
Guide and The Old Man's Comfort in the Choice of Shoes,
by the Rev. Tom. Foggy Dribble (with first proof of title to
The Library Companion, pen-and-ink drawing of cham-
pagne bottles and glasses, and the word bottle substituted
for book in the quotation beneath), hf. mor., t. e. g., 1825-24,
sup. imp. 8vo. (398) *Quaritch*, £1 5s.
2699 Dibdin (T. F.) Introduction to the Knowledge of Rare and
Valuable Editions of the Greek and Latin Classics, fourth
ed., LARGE PAPER, 250 copies printed, 2 vol., cf. ex., by
Rivière, in case, Harding & Lepard, 1827, sup. imp. 8vo.
(399) *Quaritch*, £1 12s.
2700 Dibdin (T. F.) Bibliophobia, by "Mercurius Rusticus," hf.
mor., t. e. g., H. Bohn, 1832, 8vo. (401) *Edwards*, 1s.
2701 [Dibdin (T. F.)] Bibliophobia, hf. mor., t. e. g., H. Bohn,
1832, 8vo. (402) *Edwards*, 3s.
2702 Dibdin (T. F.) Reminiscences of a Literary Life (with Index),
port., front. of the Ashton Hall Library, and facs. of ancient
woodcuts and type (autograph letter of the author inserted),
2 vol., hf. mor., t. e. g., J. Major, 1836, 8vo. (403)
Quaritch, 8s.
2703 Dibdin (T. F.) Roxburghe Revels and other relative Papers,
ports. of Dibdin, Lord Spencer and the Duke of Roxburghe,
proofs, hf. mor., t. e. g., uncut, *Edinb.*, *printed for private
circulation*, 1837, 4to. (404) *Quaritch*, £2 10s.
2704 Dibdin (T. F.) Bibliomania, or Book-madness, 60 cuts, orig.
brown cl., H. G. Bohn, 1842, imp. 8vo. (407)
Bloomfield, 14s.
2705 Dibdin (T. F.) The Old Paths. Two Sermons preached in
Advent in S. Mary's Church, Bryanston Square, engraved
view of the church, inscription on title, "This work was
preached in my church but never published, T. F. Dibdin,"
hf. bd., T. Taylor, etc., 1844, 8vo. (409) *Quaritch*, 9s.
2706 Dibdin (T. F.) Althorp the Home of the Spencers, an Illus-
trated Magazine Article, 11 ports., 8 views and 2 autograph
letters of Lord and Lady Spencer inserted, hf. mor., n. d.
(1884), imp. 8vo. (412) *Tregaskis*, £1 16s.

XXIV. 13

2707· Dickens (Chas.) Works, édition de luxe, limited to 1000
copies (No. 678), 30 vol., orig. bds., with labels, Chapman
& Hall, 1881-82, sup. imp. 8vo. (413) *Maggs, £13 ·10s·*.
2708 Diogenes Cynicus. [Epistolae.] (Begins) "Ad beatissimū &
clementissimū patrē & dominū Pium Secundū Pontificē
maximū in Diogenis Philozophi epistolas Francisci Aretini
Prefacio," lit. gotḥ. (Hain *6192), hf. mor., "*Hoc opus exiguū.
diligens sculpsit Fridericus Creuszner arte fabrili sua," s. a.*
[*c.* 1480], sm. folio (415) *Barnard, £4*
2709 Dionysius · Alexandrinus. "Eloquentissimi viri Antonii
Bechariae Veronensis Proemium in Dionysii traductionem
de Situ Orꜱis habitabilis ad ... Hieronymum de leonaris,"
lit. rom. (the title as aꜱove at head of a j in red), 26 lines to
a full page, 36 leaves with signs., ornamental initials, ꜱull's
head water-mark, old French mor., g. e., *Venetiis, F. Renner
de Hailbrun,* 1478, sm. 4to. (416) *Leighton, £4* 8s.
2710 Doꜱson (Austin). Horace Walpole, a Memoir (one of 425
copies on Dickinson paper), cf. ex., *New York,* Dodd,
Mead & Co., 1890, roy. 8vo. (417) *Shepherd, £1*
2711 Donne (Dean (John). · Poems, first ed., port. ꜱy Lomꜱart
mounted, cf., g. e., in case, *M. F. for John Marriot,* 1633,
sm. 4to. (420) *Edwards, £5* 5s.
2712 Dorat (C. J.) Les Baisers, précédés du Mois de Mai (title
in ꜱlack only), fronts. and vignettes ꜱy Eisen and Marillier,
mor. ex., ꜱy Rivière, in case, *La Haye et à Paris chez
Delalain,* 1770, cr. 8vo. (421) *Bloomfield, £1* 16s.
2713 Drake (Nathan). Shakespeare and his Times, port. and
facs., 2 vol., orig. cl., Cadell and Davies, 1817' 4to. (422)
B. F. Stevens, £1
2714 Drayton (Michael). Poems, title ꜱy Wm. Marshall (fore-
edges of two leaves cut into), cf. ex. ꜱy F. Bedford, *Printed
for John Smethwick,* 1637, sm. 8vo. (424) *Ellis, £3*
2715 Dugdale (Sir Wm.) History of St. Paul's Cathedral, first
ed., port. and plates ꜱy Hollar, old russ., g. e. (repaired),
Tho. Warren, 1658, folio (429) *Young, £3* 3s.
2716 Dupont (Paul). Histoire de l'Imprimerie, printed on vellum
paper, 2 vol., mor., elegant centre ornaments, g. e., ꜱy Chas.
Hardy, orig. wrappers ꜱound in, in cases, *Paris, chez tous
les Libraires,* 1854, sup. imp. 8vo. (431) *Bloomfield, £4* 4s.
2717 Early Newspapers and Essayists. Catalogue (by J. H. Burn)
of the Collection formed ꜱy the late J. T. Hope, Esq., and
presented to the Bodleian Liꜱrary, uncut, *Oxford, Clarendon
Press,* 1865, 8vo. (432) *Quaritch, £1* 6s.
2718 Edwards (Edward). Memoirs of Liꜱraries, LARGE PAPER·
(50 printed), illustrations, 2 vol., orig. cl., Trübner, 1859,
roy. 8vo. (435) *Bloomfield, £1* 18s.
2719 Elucidarius Carminum et Historiarum, vel Vocabularius
Poeticus, Item Vocabula et Interpretationes Grecorum et
Hebraicorum, lit. gotḥ., mor. plain, ornamental ꜱorders,·
Hagenaw, H. Gran, 1510, sm. 4to. (437) *Batsford, £1* 11s.
 [The earliest printed · ꜱiographical and topographical
dictionary, compiled ꜱy Hermann Torrentinus (Van Beech).
—*Catalogue.*]

2720 Epistolae Clarorum Virorum delectae de quam-plurimis' optimae, ad incandum nostrorum temporum eloquentiam, Aldine anchor on title, mor., g. e., in case, from the Beckford library, *Paris, B. Turrisanus in. Aldina Bibliotheca,* 1556, 12mo. (447) *Ellis,* £1 12s.

2721 Epistolae Illustrium Virorum ab Angelo Politiano collectae et a Francisco Sylvio Ambianate diligenter expositae, ornamental initials, and cut of " Prelum Ascensianum " on title, new cf. antique, t. e. g., by Bradstreet, in case, *Paris. in aed. Jo. Badii Ascensii,* 1517, sm. 4to. (448) *Leighton,* £1 1s.

2722 Erasmus, etc. Jo. Froͻenius Lectori S. D. Haͻes iterum Moriae encomium, pro castigatissimo castigatius, woodcut ͻorders, ornaments and initials ͻy Holͻein (wormhole in several leaves), contemp. German oak bds., with clasps, *Basil.,* Jo. Froben, 1519, sm. 4to. (449) *Bull,* £2 4s.
[Pasted in front cover is the German woodcut title of "Practica Deützsch meyster Hannsen Virdung von Haszfurt," 1519.—*Catalogue.*]

2723 Erasmus. S. Paulus Epistel tot den Romeynen—Die ͻeyde S. Paulus Epistelen tot den Corinthen, lit. goth., 2 titles, printer's device, 2 vol. in 1, old vell., in case, *Gheprent toe Campen inde Breeder Strate by my Peter Warnersen, k. j.* [*c.* 1540], sm. 8vo. (450) *Leighton,* £1 13s.

2724 Erasmus. Les Colloques, traduits par Victor Develay, vignettes par J. Chauvet, holland paper, 3 vol., hf. mor., t. e. g., uncut, ͻy Bradstreet, *Paris, Librairie des Bibliophiles (Jouaust),* 1875-76, 8vo. (451) *Sotheran,* £1 3s.

2725 Erasmus. L'Éloge de la Folie, traduit par Victor Develay, Dessins de Hans Holͻein, 3e Édition, papier d'Hollande, 500 printed, extra illustrated with 18 ports., some proofs, and prints by Blenswyk, Hopfer, Chataigne Picart and Houbraken, 8. views of the statue at Rotterdam, 11 title-pages from rare eds., ports. of More and Holͻein, etc., mor. super. ex., by A. Matthews, in case, *Paris, Librairie des Bibliophiles (Jouaust),* 1876, 8vo. (452) *Lewine,* £3 3s.

2726 Erasmus. The Praise of Folie. Moriae Encomium, ͻy Sir T. Chaloner, first ed., black letter (title cut close, headline of last leaf cut into), cf. ex., in case, Thos. Berthelet, 1549 [at end ͻy transposition of figures, 1569], sm. 4to. (453) *Barnard,* £4

2727 Esquimaux Language. Pok. Kalalek avalengnek, nunali-kame nunakatiminut okaluktuartok. Angakordlo Palasimik napitsivdlune agssortuissok, etc., 4 woodcuts (14 leaves, including two wrappers), hf. mor., *Nongme (Greenland),* 1857 [*at end: Godthaab trykt af R. Bertelsen og L. Müller*], 8vo. (456) *Bloomfield,* £1 1s.
[A native Esquimaux production, ͻeing a dialogue ͻetween Pok, a travelled Esquimaux, and Angekok, a native priest, from old MS. found with the Greenlanders at Godhaab, entirely produced by native Esquimaux.—*Catalogue.*]

2728 Eszler (Joannes). Speculum Astrologorum, **lit. gotfj.** (12 leaves), diagrams, hf. mor., orig. covers)ound in, *Impressum Maguntiae per Joannem Scheffer,* 1508 (*with device of two shield in black*), sm. 4to. (457) *Lincoln, £*2 10s.

2729 Falkenstein (Dr. Karl). Geschichte der Buchdruckerkunst, 40 facs. of Block-)ooks, Almanacks, woodcuts, etc., uncut, *Leipz.,* B. G. Teubner, 1840, 4to. (458) *Bloomfield, £*1 2s.

2730 Fergusson (James). History of Architecture,)est ed., illustrations, 4 vol., cf. ex., uncut,)y Zaehnsdorf, J. Murray, 1874-76, 8vo. (460) *Diouritch, £*3

2731 Fertel (M. D.) La Science Pratique de l'Imprimérie, folding plates, old cf., *Saint Omer,* M. D. Fertel, 1723, 4to. (463) *Maggs, £*1

2732 Foppens (Jo. Fr.) Bibliotheca Belgica, 144 ports. (some folding), 2 vol., hf. cf. gt., *Bruxelles, per P. Foppens,* 1739, 4to. (469) *Maggs, £*1 5s.

2733 Francis (St.) "Hier beghint sinte franciscus leven, also alst die eersamighe vader sinte)onaventura vergadert ende bescrevem heeft," **lit. gotfj.,** cut of S. Francis on recto and reverse of leaf at end (two or three leaves cut into), modern mor., g. e., *Gheprent tot Leyden bi mi Jan Sevessen,* 1504, sm. 8vo. (473) *Lincoln, £*2 10s.

2734 Fry (John). Bibliographical Memoranda, 100 copies privately printed, old cf. (re)acked), presentation copy, *Bristol,* 1816, sm. 4to. (477) *Tregaskis, £*1 5s.

2735 Foxe (John). A Sermon of Christ Crucified, first ed., **blarft letter,** mor., g. e., John Daye, 1570, sm. 4to. (478) *Barnard, £*3 10s.

2736 Gailhabaud (Jules). Monuments anciens et modernes, édition originale, 400 plates, 4 vol., orig. hf. vell., *Paris,* Firmin Didot, 1850, 4to. (479) *Parsons, £*2 14s.

2737 Galle (Theodore). Typus Occasionis, in quo receptae commoda, neglectae verò incommoda personato schemate proponuntur, engraved throughout on 14 leaves including title, printed dedication and 12 engravings by T. Galle, mor., inside dentelles, *Antw.,* Th. Gallaeus, 1603, sm. 4to. (480) *Edwards, £*3 3s.

2738 Gastronomiana, ou Recueil Curieux et Amusant d'Anecdotes, Bons-Mots, Plaisanteries, etc., Gastronomiques, col. front., mor. ex., *Paris, Favre, Librairie Palais-Royal aux Filles de Mémoire, s. d.* (*c.* 1780), sm. 8vo. (482) *Bloomfield, £*1 3s.

2739 [Geiler von Kaisersperg (Jo.)] De text des Passions oder leydens Christi, etc., **lit. gotfj.,** woodcuts by Urse Graf with his mark, some partly coloured (three plates mended, one supplied from the Latin ed.), hf. mor., *Gedruckt von Johannes Knoblouch zu Strasszburg in dem jar als man zalt,* 1507, sm. folio (484) *Barnard, £*4 12s.

2740 Gilinus. Coradinus gilinus arctium (*sic*) & medicinae doctor de mor)o quem gallicum nuncupant (*sic*), **lit. gotfj.,** long lines, 34 to a full page (4 leaves without signs., hole)urnt in first leaf), hf. mor., *Absque ulla nota* [*c.* 1497], sm. 4to. (487) *Quaritch, £*3 15s.

[The earliest printed account of the appearance of this disease in Europe.—*Catalogue.*]

2741 Glanvil (Jos., D.D.) Sadducismus Triumphatus, two Faithorne engravings, 2 parts in 1 vol., cf. ex., in case, J. Collins and S. Lownds, 1681, 8vo. (489)
Hatchard, £3 15s.

2742 [Glanvil (J., D.D.)] Lux Orientalis, an Enquiry into the Opinion of the Eastern Sages concerning the praeexistence of Souls, front. by Faithorne, old cf., J. Collins and S. Lownds, 1682, 8vo. (490) *Quaritch, £1* 12s.

2743 Gotch (J. A.) Architecture of the Renaissance in England, 145 plates and 180 illustrations in the text, 2 vol., hf. mor., t. e. g., B. T. Batsford, 1894, imp. folio (494)
Edwards, £6 5s.

2744 Graesse (J. G. Th.) Trésor de Livres Rares et Précieux (avec le Supplément), 8 vol., cl., *Dresde,* R. Kuntze, 1859-69, 4to. (495) *Barnard, £11*

2745 Griffiths (A. F.) Bibliotheca Anglo-Poetica, front. col. by hand, port. and seven extra prints inserted, hf. cf., *Printed by T. Davison for the Proprietors,* 1815, roy. 8vo. (497)
Bloomfield, 15s.

2746 Grolier Club (New York). Effigies of the most famous English Writers from Chaucer to Jonson, 200 copies on LARGE HANDMADE PAPER, fac. reproductions, orig. wrappers, uncut, 1891, 8vo. (499) *Quaritch,* 17s.

2747 Grolier Club. Catalogue of an Exhibition of Illuminated and Painted MSS., 22 autotype facs., 350 copies on Holland paper, bds., 1892, 8vo. (500) *Dobell, £2* 8s.

2748 Grolier Club. Conway (Moncure D.) Barons of the Potomack and the Rappahannock, ports., 360 copies on Italian handmade paper, bds., uncut, 1892, roy. 8vo. (501)
B: F. Stevens, £2

2749 Grolier Club. Catalogue of Original and Early Editions of some of the Poetical and Prose Works of English Writers from Langland to Wither, fac. titles, 400 copies on Holland paper, hf. russ., uncut, 1893 (502) *Ellis, £3* 14s.

2750 Grolier Club. Facsimile of the Laws and Acts of the General Assembly for their Majesties Province of New-York, by R. L. Fowler, 312 copies, white vell., uncut, in case, 1894, sm. folio (503) *Edwards, £2* 14s.

2751 Grolier Club. Allen (C. Dexter). Classified List of Early American Book-Plates, 22 illustrations, 350 copies on Italian handmade paper, wrapper, uncut, 1894, 8vo. (504)
Shepherd, £1 1s.

2752 Grolier Club. Transactions of the Grolier Club, part ii., 7 illustrations and numerous vignettes, 750 copies on handmade paper, orig. bds., 1894, roy. 8vo. (505) *Dobell, £1*

2753 Grolier Club. Transactions of the Grolier Club, part iii., 4 ports. and other illustrations, 470 copies on handmade paper, orig. covers, 1899, 8vo. (506) *Dobell, £1*

2754 Grolier Club. Catalogue of Books from the Libraries or Collections of Celebrated Bibliophiles and Illustrious Per-

sons of the Past, exhibited at the Grolier Club in January, 1895, 24 reproductions, 350 copies on Holland paper, cl., 1895, sm. 4to. (507) *Dobell,* £1 6s.

2755 Grolier Club. Catalogue of the Engraved Works of Asher B. Durand, exhibited at the Grolier Club, April, 1895, port., 350 copies on LARGE HANDMADE PAPER, orig. wrapper, uncut, 1895, 8vo. (508) *Dobell,* 13s.

2756 Grolier Club. A Description of the Early Printed Books owned by the Grolier Club, facs., 400 copies upon handmade paper, buckram, 1895, sm. folio (509) *Dobell,* £1 7s.

2757 Grolier Club. Catalogue of an Exhibition illustrative of a Centenary of Artistic Lithography, 244 examples of 160 different artists, 400 copies on LARGE HANDMADE PAPER, orig. wrapper, uncut, 1896, 8vo. (510) *Dobell,* £1

2758 Grolier Club. Koehler (S. R.) Catalogue of the Engravings, etc. of Albert Dürer, 7 reproductions, 400 copies upon Holland paper, cl., in case, 1897, 4to. (511) *Dobell,* £3 12s.

2759 Grolier Club. Two Note Books of Thomas Carlyle, 23 March, 1822, 16 May, 1832, edited by C. Eliot Norton, port., 387 copies on handmade paper, hf. mor., t. e. g., 1898, 8vo. (512) *Dobell,* £1 6s.

2760 Grolier Club. Hoym (Chas. Henry Count). Life, written by Baron Jérôme Pichon, port. and illustrations, 303 copies on handmade paper, hf. mor., uncut, in case, 1899, sup. imp. 8vo. (513) *Dobell,* £2 8s.

2761 Grolier Club. Dante. A Translation of Giovanni Boccaccio's Life of Dante, by G. R. Carpenter, woodcut head, 200 copies on Italian handmade paper, brown bds., embossed, uncut, in case, 1900 (514) *Dobell,* £2 2s.

2762 Grolier Club. Dryden. Catalogue of an Exhibition of First and other Editions of the Works of John Dryden, 200 copies on handmade paper, port., bds., 1900, 8vo. (515) *Pickering,* £3 3s.

2763 Grolier Club. Catalogue of Etchings and Dry-Points by Rembrandt, exhibited at the Grolier Club, April-May, 1900, port. of Rembrandt, 310 copies on handmade paper, cl., uncut, 1900, sm. 4to. (516) *Dobell,* £1 5s.

2764 Grolier Club. De Vinne (Theodore Low). Title-Pages as seen by a Printer, 325 copies on Italian handmade paper, hf. mor., uncut, in case, 1901, 8vo. (517) *Dobell,* £1 5s.

2765 Grolier Club. The History of Helyas Knight of the Swan, translated by R. Copland, a literal reprint in the types of Wynkyn de Word after the unique copy printed 1512, 325 copies on Whatman paper, mor., blind stamped, clasps, uncut, in case, 1901, sm. 4to. (518) *Dobell,* £1 14s.

2766 Grolier Club. Catalogue of an Exhibition of Selected Works of the Poets Laureate of England, mezzo. port. of Ben Jonson, 300 copies on handmade paper, 1901, 8vo. (519) *Dobell,* 19s.

2767 Grolier Club. One hundred Books famous in English Literature, by George E. Woodbery, 305 copies on handmade paper, orig. bds., in case, 1902, 8vo. (520) *Maggs,* £3

2768 Grolier Clu). Kent (H. W.) Bibliographical Notes on One
Hundred Books famous in English Literature, 305 copies
on French handmade paper, 1903, imp. 8vo. (521)
Maggs, £2

2769 Grolier Clu). Hart (Chas. H.) Catalogue of the Engraved
Portraits of Washington, 21 ports., 425 copies on American
handmade paper, orig. bds., in case, 1904, 4to. (522)
Dobell, £3

2770 Grolier Clu). Halsey (R. T. H.) The Boston Port Bill as
pictured by a Contemporary London Cartoonist, port. of
George III., reproductions of caricatures, etc., 325 copies
on American handmade paper, cf. gt., uncut, 1904, imp.
8vo. (523) *Dobell, £1 7s.*

2771 Grolier Clu). Catalogues (48) of various Exhibitions, held
at the Grolier Clu), orig. wrappers, uncut, some with plates,
sm. 8vo. (524). *Edwards, £2 14s.*

2772 Grolier Clu). Lists, Papers, Prospectuses, Menus, Advertise-
ments, Tickets, etc. issued)y the Grolier Club, a large
num)er, a parcel (525) *Tregaskis, £1 16s.*

2773 Guarinus (Baptista). De Mō. & Ordine docendi ac discendi,
lit. goth. (Hain *8131), woodcut initials, new mor., *Impressus
Heidelbergae per Henricum Knoblocher*, 1489, sm. 4to. (526)
Ellis, £3

2774 Guillermus (Alvernus, Archiep. Paris). Postilla Guillermi
super Epistolas et Evangelia de tempore et de Sanctis, lit.
goth., text in centre surrounded)y the postils, 53 woodcuts
in the Gospels (Hain *8249), mor. ex., in case [*Basiliae*,
M. Furter, *circa* 1500], sm. 4to. (529) *Maggs, £10 15s.*

2775 Guilleville (Guillaume de). Les trois Pelerinages, de la Vie
humaine, de l'ame, et de Jesus Christ. [Fol. I. a.] "Cy
commance le romans de lumain Voiage de vie humaine qui
est expose sus le romans de la rose," illuminated manuscript
on vellum (200 leaves, 14 by 10 in.), lettres bâtardes, dou)le
columns, 40 lines, several hundred illuminated ornamental
initials, 174 square miniatures (3in.), painted and illuminated,
within gold pillared)orders, modern velvet, metal clasps,
Sæc. XV., folio (530) *Sabin, £470*
[In four instances the spaces have only the original
sketches for the miniatures ; and seventeen appear to have
)een cut out and plain squares of vellum inlaid in their
places, in some of which the text is injured. The work is
well known from its supposed connection with Bunyan's
Pilgrim's Progress (*see* plate).—*Catalogue.*]

2776 Guten)erg. An Original Leaf from the "Catholicon" of
Balbus de Janua printed)y Guten)erg at Mayence in 1460,
dou)le columns of 66 lines, framed and glazed, folio (531)
Lincoln, £10 5s.

2777 Haeftenus (D. Bened.) Regia Via Crucis, 38 engravings by
Th. Galle, russ. ex., from the Beckford li)rary, *Antwerpiae*,
ex off. Plantin. B. Moreti, 1635, 8vo. (536)
Tregaskis, £1 8s.

2778 Hain (Ludwig). Repertorium Bibliographicum, 4 vol., hf.
mor., t. e. g., uncut, *Stuttg.* J. C. Cotta, 1826-38, 8vo. (537)
Parsons, £7

2779 Hain-Copinger.· Copinger (W. A.) Supplement to Hain's
Repertorium Bibliographica, 3 vol., cl., uncut, Sotheran,
1895-1902, 8vo. (538) *Parsons, £5* 15s.

2780 Haines (Rev. Herbert). Manual of Monumental Brasses,
200 illustrations, 2 vol., orig. cl., J. & H. Parker, 1861, 8vo.
(539) *Edwards, £1* 16s.

2781 Hamilton (Count A.) Memoirs of Count Grammont, illus-
trated with 64 ports. by Edward Scriven, etc., 2 vol., mor.
plain, t. e. g., by Bradstreet, in two cases, W. Millar, etc.,
1811, 8vo. (542) *Brown, £5*

2782 Harding (John). Chronicle of England (verse portion only),
first ed., black letter, woodcut title (the text supplied in MS.),
(wanted all the preliminary leaves), cf. ex., R. Grafton, 1543,
sm. 4to. (544) *Dobell, £1* 6s.

2783 Hardouin de Péréfixe. Histoire du Roy Henri le Grand,
old English mor., g. e. (Roger Payne), from the Syston
Park and Beckford sales, in case, *Amst. chez D. Elsevier,*
1678, 12mo. (546) *James, £2* 16s.

2784 Harrisse (H.) Notes pour servir à l'Histoire, à la Biblio-
graphie à la Cartographie de la Nouvelle-France, etc., 1545-
1700, LARGE AND FINE PAPER, hf. mor., t. e. g., uncut,
Paris, Tross, 1872, roy. 8vo. (548) ' *Quaritch, £1* 6s.

2785 Hawkins (Rush C.) Titles of the First Books from the
Earliest Presses, reproductions, 300 copies printed, cl.,
uncut, *New York,* J. W. Bouton, 1884, 4to. (552)
Maggs, £1 9s.

2786 Hazlitt (W. C.) Bibliographical Collections and Notes, three
series, Series ii. and iii., LARGE PAPER, 20 copies of each
printed, 3 vol., orig. cl., uncut, 1876-1882-89, 8vo. and imp.
8vo. (555) *Quaritch, £1* 5s.

2787 Heineken (Baron C. H. de). Idée Générale d'une Collection
complette d'Estampes, 32 reproductions of block-books,
etc., hf. mor., t. e. g., uncut, *à Leipsic et Vienne chez J. P.
Kraus,* 1771, 8vo. (557) *Tregaskis,* 18s.

2788 Heinsius (Dan.) Nederduytsche Poemata, 64 small engrav-
ings by S. Pass, mor. ex., t. e. g., in case, *Amst.,* W. Janssen,
1616, sm. 4to. (558) *Leighton, £2* 18s.
[First collected edition of the humorous Dutch Poems of
Heinsius, edited by P. Scriverius, with brilliant impressions
of the engravings.—*Catalogue.*]

2789 Heywood (Thos.) Gunaikeion, or Nine Bookes of Various
History concerning Women, first ed., title in 10 compart-
ments of Apollo and the Muses (mounted), hf. cf., A. Islip,
1624, sm. folio (562) *Dobell, £1* 14s.

2790 Heywood (T.) The Hierarchie of the Blessed Angels, orig.
ed., 9 full-page copperplates by Droeshout, etc., russ., g. e.
(rebacked), Jas. Maidment's copy, A. Islip, 1635, sm. folio
(563) *Tregaskis, £2* 14s.

2791 Hieronymus (S.) Epistolae (ex recensione Joan. Andreae)‚ lit. rom., long lines, 46 and 48 to a full page, 2 large decorated initials, capitals painted, 2 vol., modern imitation monastic ɔinding, y. e., in cases, *Romae in domo Petri de Maximis juxta Campum Florae Presidente Magistro Arnoldo Pannartz*, 1476 ; *ib.*, *Per Ven. Virum Magistrum Georgium Laur de Herbipoli*, 1479, folio (565)
Lincoln, £19 15s.

2792 Hoe (Rich. M.) Literature of Printing, front., cl., uncut, presentation copy, *Chiswick Press*, 1877, sm. 8vo. (568)
Edwards, 10s.

2793 Hoe Liɔrary. One Hundred and Seventy-Six Historic and Artistic Book-Bindings, selected from the Liɔrary of Roɔert Hoe, 200 copies printed on Japanese paper, 2 vol., hf. mor., t. e. g., *New York*, Dodd, Mead & Co., 1895, folio (569) *Maggs*, £14

2794 Holtzwart (Mathias). Emblematum Tyrocinia, sive Picta Poesis Latinogermanica, lit. goth. et italics, 71 woodcuts of emɔlems and 15 figures of early German Princes, mor. ex., in case, *Straszburg*, B. Joɔin, 1581, 8vo. (573)
Bloomfield, £2 12s.

2795 Homer. Iliad and Odyssey, translated ɔy A. Pope—Virgil, translated ɔy Dryden, engravings, 8 vol., uniform old russ., *Printed by Bensley for Vernor & Hood*, 1802-3, 8vo. (574)
Ellis, £1 6s.

2796 Honorius Augustodunensis. "Cristianus ad Solitarium quendam de Ymagine Mundi Honorio," lit. semi-goth. (46 leaves, 2 ɔlank), (Hain *8800), inner margin of first page decorated, mor., g. e., in a case, *Absque ulla nota [Argent. Koberger, c.* 1472], sm. folio (575) *Lincoln*, £14 10s.

2797 Horae B. V. M. cum Calendario. Hore in Laudem Gloriosissime Virginis Marie Secūdum Usum Romanū, lit. rom., printed on vellum, long lines, 34 to a full page, outside ɔorder to each page painted and illuminated, skeleton man, 15 large woodcuts, 20 small cuts of apostles and saints, and many hundred ornamental initials, the whole painted and illuminated in imitation of ancient MSS. (wanted B 8, outer margin of E 5 cut off, E 8 supplied in MS., a few leaves soiled), mor. plain, in case, *Imprimées par G. Hardouin, s. a.* [*Almanack*, 1534], sm. 8vo. (583) *Dobell*, £7 5s.

2798 Horae B. V. M. cum Calendario. Hore intemerate Beate Marie Virginis Secundum Usum Romanum, [at end] "Ces presentes heures a lusaige de Rôme furent achevees le V jour de Aoust. lan mil cinq cens et deux par Thielman Kerver, etc., lit. goth., long lines, 22 to a full page, printed within ɔorders of rustic and hunting scenes, grotesques, mummers, etc., astronomical man, 18 woodcuts within ɔorders, capitals painted, perfect, containing signatures ᥕ-ᕈ in 8's, orig. French oak bds., leather, stamped, metal corners and one clasp (ɔinding worn), fairly well preserved except for a small ɔurnt hole in N 5, *Paris*, Th. Kerver, 1502, 8vo. (584) *Maggs*, £32

2799 Horae B. V. M. ad usum Romanum, cum Calendario. ·:" Hore
intemerate Virginis Marie secundū· usum Romanum, lit.
gotḥ., long lines, 29 to a full page, printed on vellum, within
woodcut ɔorders of hunting scenes, grotesques, etc., title
within ɔorder, astrological man on reverse, 18 woodcuts
within borders, small initial figures of Saints, etc. untouched
ɔy colour, initials and capitals illuminated throughout
(contained 96 leaves, sign. 𝕬-𝕸 in 8's), modern mor. plain,
douɔlé, g. e., by Lortic, in case, "*Ces present heures a
lusaige de Rōme furet achevées le premier jour de Decembre
lan mil cinq cens & deux. Par Thielman Kerver im-
primeur et libraire jure de luniversite de Paris, pour Gillet
Remacle,*" etc. (1502), large 8vo. (585) *Lincoln,* £45
 [A perfect copy, in good state, though a few leaves are
 shrivelled. It is a re-issue of the edition without date
 (1497), having similar designs, with two additional large
 cuts, retaining the Almanack, 1477-1520 (*see* Brunet,
 v. 1618).—*Catalogue.*]
2800 Horae B. V. M. ad usum Romanum, cum Calendario, lit. rom.,
long lines, 26 to a full page (1 page imperfect), printed on
vellum, within woodcut ɔorders of rustic scenes, grotesques,
etc., Kerver's device on title, astrological man on reverse
(mutilated), 18 large woodcuts within ɔorders, and several
small initial woodcuts of saints, etc., capitals and initials
illuminated (contained 104 leaves), (ɔottom margin of title
and last leaf mended, two or three leaves soiled, short copy),
modern mor., *Impressum Parisiis anno dni* (1504) VI.
Kalendas Augusti. Opera Thielmani Kerver, sm. 8vo. (586)
 Ellis, £10
 [Contains similar illustrations to the 1502 edition, with
 the Almanack from 1497 to 1520 (*see* Brunet).—*Catalogue.*]
2801 Horae B. V. M. cum Calendario. Latin-French. "Hore
Christifere Virginis Marie secūdum usum Romanū, lit. gotḥ.
(lettres bâtardes), long lines, 30 and 31 to a full page, ruled
throughout in red, text ruɔricated, capitals painted, printed
with woodcut ɔorders of rustic and hunting scenes, Dance
of Death (a series), etc., Vostre's large device on title within
ɔorder, skeleton man, 26 large woodcuts (contained 102
leaves, signs. 𝕬-𝕺 6 in 8's, 𝕱 having 2 leaves only,
𝕲 6 leaves), old French mor., g. e., in case [*Paris.* S. Vostre,
s. d. (*Almanack,* 1508-28)], sm. 4to. (587) *Lincoln,* £55
 [One of the finest and rarest of the Gothic Hours
 produced by Simon Vostre, described by Felix Soleil in his
 work, "Les Heures Gothiques," and also by G. Peignot. In
 this copy the verses in French accompanying the ɔorder
 suɔjects are enclosed in the ɔorder itself instead of ɔeing
 placed at the ɔottom of the page (*see* Brunet). Although
 𝕱 has only 2 leaves and 𝕲 6, the text appears to be quite
 complete. There is no colophon, and apart from the
 device, no indication of place or date of printing.—*Cata-
 logue.*]
2802 Horae B. V. M. ad usum Romanum, cum Calendario. "Im-

primées à Paris par Gillet Hardouyn liɔraire," etc., lit.
goth. (lettres bâtardes), printed on vellum (without ɔorders),
long lines, 33 to a full page (contained 88 leaves, signs. a-l
in 8's), skeleton man on reverse of title, with 4 figures in
the ɔorder, 18 full-page woodcuts within architectural
ɔorders, 28 initial woodcuts, all illuminated, numerous
illuminated initials and capitals and textual ornaments,
modern velvet, with 15 perforated ɔrass ornaments, and
clasps, in case, "*.Ces presentes heures a lusaige de Romme
. . . on este nouvellement imprimees a Paris,*" *s. a.*
[*Almanack*, 1513-29], 8vo. (588) *Edwards, £25*
2803 Horae B. V. M. cum Calendario. Paris. Heures a lusaige
de Romme, lit. goth. (lettres bâtardes), long lines, 30 to a full
page, printed on vellum, outside ɔorders of painted flowers
and scrolls, Hardouin's large device within a gold archi-
tectural frame on title, skeleton man, 15 large woodcuts
within gold architectural frames, 17 small oval cuts, all
illuminated, many hundred painted and illuminated orna-
mental capitals and initials, mor. plain, gilt on rough ɔy
"The Cluɔ Bindery, 1902," in case, *Imprimees a Paris pour
Germain Hardouyn, s. d.* [*Almanack*, 1524-37], sm. 4to.
(589) *Maggs, £35*
2804 Horae B. V. M. cum Calendario. "Hore dive Virgmis
Marie secūdum usū Romanum, lit. rom., long lines, 32 to a
full page, printed on vellum, outside ɔorder to each page
illuminated, printer's device on title with the escutcheon of
Poland emɔlazoned, skeleton man with 4 figures in the
ɔorder, 16 large woodcuts, 23 miniatures, and numerous
small initials and capitals, all illuminated (wanted sheet G),
mor., covered with rich gilt ornamental tooling, in case,
Paris., G. Hardouyn, *s. a.* [*Almanack*, 1526-41], 8vo. (590)
Dobell, £7
2805 Horae B. V. M. cum Calendario. Heures a lusaige de Tou
(Toul), lit. goth. (semi-bâtardes), long lines, 29 to a full page,
within woodcut ɔorders, Godard's large device on title
within architectural ɔorder, astrological man, 18 large
woodcuts within ornamental ɔorders, capitals and orna-
ments painted (hole in title, which is also repaired, plain
margin of A x repaired, 2 or 3 leaves stained and weak),
modern mor., g. e. (Fenwicke ex-liɔris), *a Paris pour
Guillaume Godard libraire, etc., s. a.* [*Almanack*, 1515-30],
sm. 4to. (591) *Ellis, £34*
2806 Horae B. V. M. ad Usum Ord. Premonstratensis cum
Calendario, lit. goth. (lettres bâtardes), long lines, 26 to a
full page, within woodcut ɔorders, text ruɔricated, Vostre's
device on title, skeleton man, 15 full-page woodcuts,
numerous small initial figures (some touched in ɔrown),
(contained 128 leaves, signs. a-q in 8's), modern mor., g. e.,
by E. Classens, in case, *Paris,* S. Vostre, 1506 [*Almanack*,
1507-27], 8vo. (592) *Ellis, £24*
2807 Horatius. Quintus Horatius Flaccus, Pickering's diamond
type edition, on large India paper, front., mor., elaɔorately

tooled,.doublé, by· Zaehnsdorf, in case, W. Pickering, 1826,
12mo. (594) *Maggs*, £1 19s.
2808 Hospitalius (Michael). Epistolarum seu Sermonum liɔri sex
(edid. a Guido Faɔro, J. A. Thuano et Scaev. Sammartano),
editio prima, mor. súper ex., ɔy Duru, Baron Seilliere's
arms, in case, *Lutetiae, ap. M. Patissonium in officina
Roberti Stephani*, 1585, folio (597) *Dobell*, £1 19s.
2809 Howell (Jas.) The Parly of Beasts, first ed., front. (cut down
and mounted), (title mended), hf. mor., t. e. g., *W. Wilson
for W. Palmer*, 1660, sm. folio (598) *Hunter*, £2 4s.
2810 Hucher (E.) Vitraux Peints de la Cathédrale du Mans, 20
col. plates, hf. mor. gt., *Paris & Le Mans*, 1865, atlas folio
(599) *Batsford*, £2 10s.
2811 Hugo (Hermannus). Pia Desideria Emblematis, Elegiis &
affectibus SS. Patrum illustrata, editio prima, woodcut title
and 59 woodcuts of emɔlems, etc., ɔy Chr.. van Sichem,
mor., g. e., gold end papers ɔy Bozerian, in case, *Antwerpiae,
typis H. Aertssenii*, 1628, 12mo. (600) *Edwards*, £1 11s.
2812 Humphreys (H. Noel). A Record of the Black Prince,
emɔellished with (8) highly wrought miniatures and
ɔorderings, engraving of a ɔattle inserted at end, mor. ex.,
in case, Longman, 1849, 8vo. (602) *W. Brown*, £2 10s.
2813 Humphreys (H. N.) Origin and Progress of the Art of
Writing, orig. ed., 57 plates and facs., emɔossed composi-
tion·ɔinding, in case, D. Bogue, 1854, imp. 8vo. (603)
 Dobell, 17s.
2814 Humphreys (H. N.) Masterpieces of the early Printers and
Engravers, 81 plates, hf. mor., t. e. g., Sotheran & Co., 1870,
roy. 4to. (604) *Tregaskis*, £1 7s.
2815 Hunter (John). Poems, third ed., fine paper (one of 25
copies), port. and 4 plates, 18 ports., including a pen-and-
ink portrait of Milton crowned with laurels, and 2 vignettes
ɔy Bartolozzi inserted, russ. (repaired), g. e., presentation
copy, Cadell and Davies, 1805, 8vo. (605)
 Bloomfield, £1 1s.
2816 Huth Liɔrary. A Catalogue of the Printed Books, etc. (ɔy
F. S. Ellis and W. C. Hazlitt), port., 5 vol., roxɔurghe,
t. e. g., uncut, Ellis and White, 1880, sup. imp. 8vo. (606)
 Lincoln, £3
2817 Hyginus. Clarissimi Viri Iginii Poeticon Astronomicon
opus utilissimum, de Mundi & Spherae ac utriusq. partium
declaratione, lít. gotɧ., second ed., the aɔove title heading
a 2 in red (wanted a j a ɔlank), astrological woodcuts and
ornamental initials (Hain *9062), mor. ex., douɔlé, in case,
Venetiis, E. Ratdolt, 1482, *pridie Idus Octobris*, sm. 4to.
(609) *Bloomfield*, £5 10s.
2818 Iconophile Society. Andrews (W. Loring). A Trio of
Eighteenth Century French Engravers of Portraits in
Miniature : Ficquet, Savart, Grateloup, etc., 28 illustrations,
161 copies printed on imperial Japan paper, *New York*,
Dodd, Mead & Co., 1899, 8vo. (610) *Tregaskis*, £3 15s.
2819 Imitatio Christi. Gerson de Ymitatione Cristi, lít. gotɧ., long

lines, 22 to a full page, without signs. (containing 8 leaves for title and table, 1 blank, and numbered leaves clxxxii), painted ornamental capitals (Hain *9093), modern mor. antique, ... *finiunt feliciter per Johannem Zeiner Ulmensz.*, 1487, sm. 8vo. (612) *Edwards*, £7 15s.

2820 Imitatio Christi. A'Kempis. De Imitatio Christi lib. IV. (cum Vita Auctoris, etc.), editio Elzeviriana, orig. vell., in case, *Lugduni, ap. J. et D. Elzevir, s. a.* (1635), 12mo. (613) *Lincoln*, £1 3s.

2821 Imitatio Christi. De Imitatione Christi, on India paper, front., mor., elaborately tooled, g. e., in case, *Paris*, E. Tross, 1858, 64mo. (616) *Tregaskis*, £1 1s.

2822 Jacquemart (Albert). History of the Ceramic Art, second ed., 200 woodcuts, 12 etchings and 1000 marks and monograms, mor. plain, t. e. g., by Stikeman, in case, *New York & London*, 1877, sup. imp. 8vo. (621) *Hunt*, £1 12s.

2823 Jansen. Essai sur l'Origine de la Gravure en Bois et en Taille Douce, 19 folding plates, 2 vol., hf. bd., uncut, *Paris*, F. Schoell, 1808, 8vo. (623) *Bloomfield*, £1 13s.

2824 Jones (Inigo). Designs, published by Wm. Kent, 138 plates, 2 vol. in 1, hf. cf., B. White, 1770, imp. folio (626) *Batsford*, £2 6s.

2825 Jovius (Paulus). Elogia Virorum bellica Virtute illustrium septem libris jam olim ab Authore comprehensa, 2 parts in 1 vol., woodcut titles (the first mended) and 200 ports., by Van Sichem and T. Stimmer, mor., g. e., by A. Matthews, *Basil.*, P. Perna, 1575-77, folio (628) *Bloomfield*, £2 14s.

2826 Judocus Isennachcensis. Summa in totā Physicen, hoc est philosophiam naturalem conformiter si quidem verę sophię, que est Theologia in Gymnasio Erphordiensis elucubrata et edita, **lit. gotħ.**, woodcuts, 4 full-page astrological woodcuts at end (wormed throughout), contemp. German oak bds., clasp, in case, rare, *Impressum Erfordie per Mattheum Maler, anno* 1514 (*with device*), sm. 4to. (629) *Barnard*, £2·4s.

2827 Junius (Hadrianus). Emblemata, editio prima, printed in italics, 57 cuts, cf., g. e. (Lewis), from the Beckford library, *Antwerpiae ex officina Chr. Plantini*, 1565, 8vo. (630) *Tregaskis*, £1 10s.

2828 Juvenal et Persius. Satyræ, editio prima Aldina, old French mor. gt., m. e., *Venet. in aedibus Aldi*, 1501, 8vo. (631) *Olschki*, £1 1s.

2829 King (Thos. H.) The Study-Book of Mediaeval Architecture and Art, 200 engravings on India paper, 2 vol., buckram, uncut, Bell and Daldy, 1858-9, roy. 4to. (633) *Bull*, 13s.

2830 Knight (Chas.) Gallery of Portraits, orig. ed., 160 ports., 7 vol., hf. mor., t. e. g., C. Knight, 1833-36, sup. imp. 8vo. (635) *Bull*, £1 9s.

2831 Knight (H. G.) Ecclesiastical Architecture of Italy, illuminated titles and 81 lithographs, 2 vol., hf. mor., H. Bohn, 1842-3, imp. folio (637) *Sotheran*, £1 6s.

2832 Lafontaine (J. de). Faэles Choisies mises en Vers, Texte par le Sʳ· Montalay, LARGE PAPER, 250 engravings and 450 vignettes, 6 vol., hf. cf. gt., uncut, *Paris*, Des Lauriers, 1765-75, roy. 8vo. (643) *B. F. Stevens*, £5

2833 Lambarde (Wm.) Archaionomia, map, old cf., Jo. Day, 1568, sm. 4to. (646) *Bloomfield*, 17s.

2834 Langlois (E. H.) Essai sur la Caligraphie des Manuscrits, front. and 16 facs., hf. mor., t. e. g., uncut, *Rouen*, J. S. Lefevre, 1841, imp. 8vo. (649) *Maggs*, £1 7s.

2835 Lavater.(J. C.) Essays on Physiognomy, эy H. Hunter, engravings, 3 vol. in 5, hf. mor., y. e., *T. Bensley for J. Stockdale*, 1810, roy. 4to. (650) *Bull*, £1 13s.

2836 Lichtenэerger (Jo.) Prognosticatio, quam olim scripsit super magna illa Saturni ac Jovis conjunctione, quae fuit Anno m.cccclxxxiii. usque ad. 1567, etc., German woodcuts in text, and ornamental initials, *Colon.*, P. Quentell, 1526— Prognosticon Divi Vincentii Confessoris de Antichristo, *ib.*, 1529, in 1 vol., old English mor., g.e., in case (Beckford copy), sm. 4to. (656) *Barnard*, £3 4s.

2837 Linton (W. J.) The Masters of Wood Engraving, col. fac. of the S. Christopher of 1423, and woodcuts, 500 copies printed in folio, эuckram, uncut, *Issued to Subscribers only, New Haven, Conn.*, 1889, folio (659) *Quaritch*, £2 2s.

2838 Lippmann (Fr.) The Art of Wood Engraving in Italy, illustrations, letter of Author inserted, hf. mor., t. e. g., Quaritch, 1888, sup. imp. 8vo. (660) *Parsons*, 16s.

2839 Lodge (Edm.) Portraits, LARGE PAPER 4to. ed., India proofs of the 240 ports., 12 vol., orig. cl., Harding & Lepard, 1823-34, 4to. (663) *Swann*, £4 4s.

2840 Lloyd (Humphrey). The Historie of Camэria, **blark letter**, first ed., woodcuts, elegantly tooled, g.e., эy Roger Payne, with a copy of his эill written on fly-leaf, in a case, Rafe Newberie and Henrie Denham, 1584, sm. 4to. (664)
 Quaritch, £20

2841 Lowndes (W. T.) Biэliographer's Manual, LARGE PAPER (100 copies printed), 6 vol., rox., t. e. g., Bell & Daldy, 1869, 8vo. (670) *Maggs*, £1 8s.

2842 Lowdnes (W. T.) Biэliographer's Manual, new ed., 4 vol., rox., t. e. g., uncut, G. Bell, 1871, 8vo. (671) *Hill*, 17s.

2843 Luther (Martin). Enchiridion. Piarum Precationum, cum Passionali, ut vocant, editio prima, lit. rom. et ital., 50 woodcuts after A. Dürer, orig. German oak bds., stamped pigskin and clasps, in case, *Wittembergae*, Jo. Luft, 1543, 8vo. (673) *Young*, £4

2844 Luykens (J.) Afbeelding der menschelyke Bezighsden bestaande in Hondert onder-scheiden Printverbeeldingen, etc., front. and 100 copper-plates of trades, etc., by Jan Luykens, imitation Spanish mor., in case, *Amst.*, R. en J. Ottens (1694), sm. 4to. (674) *Houthakker*, £4 10s

2845 Macaulay (Lord). Life and Letters, эy G. Otto Trevelyañ, illustrated with 42 ports., 2 vol., unbd., Longmans, 1876, 8vo. (677) *Maggs*, £1

2846 Magnus (Olaus). Historia de Gentibus 'Septentrionalibus, editio prima, woodcuts (title washed and packed), mor. plain, g. e., in case, *Romae, Jo. M. de Viottis* (*with large device*), 1555, sm. folio (678) *Bloomfield,* £5

2847 Mandeville (Joannes de). Johannis de Monte Villa Itinerarius in Partes Jhierosolimitanas et in ulteriores transmarinas, lit. goth., long lines, 37 to a full-page, 48 leaves with signs., rubricated (some leaves wormed and stained), modern mor., doublé, "*Explicit Itinerarius domini Johannis de Montevilla militis,*" *s. a. l. et n. Impressoris* [14—], sm. 4to. (684)
L. Rosenthal, £10

2848 Mandeville (J. de). Qual tratta delle piu maravegliose cose e piu notabile chi si trovino, modern cf. (scarce edition, not in Brunet or Graesse), *Venet. Alvise di Torti,* 1534; sm. 8vo. (685) *Lincoln,* £1 16s.

2849 Mansion (Colard). Van Praet (J. B. B.) Notice sur Colard Mansion Libraire et Imprimeur de la Ville de Bruges, LARGE PAPER, hf. cf., uncut, *Paris, chez Le Bure,* 1829, sup. imp. 8vo. (687) *Lincoln,* £1 10s.

2850 Marius-Michel (MM.) La Reliure Française, plates of bindings on Japan paper, *Paris,* Morgand & Fatout, 1880—La Reliure Française commerciale et industrielle, illustrations on Japan paper, *ib.,* 1881, together 2 vol., t. e. g., 4to. (690)
Quaritch, £1 18s.

2851 Marius-Michel (MM.) L'Ornementation des Reliures. Modernes, 15 designs on Japan paper, 300 copies printed, mor. ex., t. e. g., by Zaehnsdorf, finely bound, in case, *Paris,* Marius-Michel & Fils, 1889, 4to. (691) *Quaritch,* £1 10s.

2852 Marlianus (Barth.) Urbis Romae Topographia, woodcuts, autograph of "Jo. Milton" on title, hf. vell., *Venet.,* H. Francinus, 1588, sm. 8vo. (692) *Bull,* £1 2s.

2853 Marolles (Abbé de). Catalogue de Livres d'Estampes et de Figures en taille douce, édition originale, vell., *Paris,* Fr. Leonard, 1666, 8vo. (693) *Bloomfield,* £1 1s.

2854 Martialis. Epigrammata, editio prima. Aldina, old cf. gt., in case, *Venet. in aedibus Aldi,* 1501, 8vo. (694)
Maggs, £1 12s.

2855 Mathias (T. J.) The Pursuits of Literature, a Satirical Poem, 63 ports. and views inserted, cf. ex., in case, T. Becket, 1801, 8vo. (697) *Maggs,* £1 19s.

2856 Maximus (Valerius). Opera, old French mor., g. e. (Du. Seuil), Beckford copy, *Lugd. Bat. Hackius,* 1660, 8vo. (699)
Sotheran, £2 5s.

2857 Merlin (R.) Origine des Cartes à Jouer, 74 plates, and a few modern ones, hf. mor., t. e. g., uncut, orig. wrappers bound in, *Paris, chez l'Auteur,* 1869, 4to. (704) *Tregaskis,* £1 10s.

2858 Milton (John). Poetical Works, by Hayley, Bulmer's edition, 25 plates, 3 ports., and 54 engravings after J. J. Flattus inserted (3 vol., old mor. (rebacked), J. and J. Boydell, 1794, folio (709) *Edwards,* £1

2859 Milton (John). Paradise Lost, first ed., fifth issue, with five-line address, argument, "The Verse," and errata (title in

fac.), mor. ex., in case, *Printed by S. Simmonds and sold by S. Thomson in Duck-Lane, etc.*, 1668, sm. 4to. (710)
Finch, £10 15s.

2860 Missale Monasticum secundum morem & ritum Casinensis congregationis, lit. goth., musical notes, double columns, 36 to a full page, title in red, below a cut of SS. Piacus, Benedict and Maurus, full-page cut of the Crucifixion before the Canon, several pages with architectural borders, 16 large and about 400 smaller woodcuts (one leaf mended), mor ex., doublé, ornaments and inlayings, t. e. g., other edges rough, by Bradstreet, in case, *Venetiis, per Lucam Ant. de Giuntis Florentinum accuratissime impressum* 1506 xiii. *Kaľmaias*, folio (715) *Ellis*, £25 10s.

2861 Molitor (Ulricus). De Lamiis et Phitonicis Mulieribus, lit. goth., 22 leaves with signs. 𝕬-𝕯 in 6's, ℭ having 4 leaves only, 8 woodcuts, two repeated (wormed throughout), new mor. plain, g. e., in case, [*absque nota*] "*ex Constantia anno domini* mcccclxxxix. *die decima mensis Januarii*" (1489), sm. 4to. (716) *Maggs*, £6 15s.

2862 Monstrelet (Enguerrand de). Le Premier Volume des Croniques, lit. goth., grotesque initial on title and many ornamental initials in the text, old French cf., stamped fleurons (rebacked), *Imprimé à Paris pour Jehan Petit et M. le Noir*, 1512, sm. folio (718) *Bloomfield*, £4

2863 Montaigne (Michel de). Essais, cinquiesme édition (margins cut into), mor. plain, g. e., in case, *à Paris chez Abel l'Angelier au premier pillier de la Grand Salle du Palais*, 1585, sm. 4to. (719) *Lincoln*, £6 5s.
[The last edition published in the author's lifetime, and the one he used for his marginal annotations which were incorporated in the edition of 1595, edited by Mlle. de Gournay. In this edition the third book appeared for the first time. Although called fifth edition, only three editions are known of an earlier date.—*Catalogue.*]

2864 Montanus (R. G.) A Discovery and Playne Declaration of sundry subtill practises of the Holy Inquisition of Spayne (trans. by V. Skinner), second ed., black letter, folding woodcut of an Auto-da-fé (backed, some leaves stained), modern cf., r. e., John Daye, 1569, sm. 4to. (720)
Barnard, £4 5s.

2865 Motley (T. L.) Works and Correspondence, "Netherlands edition," 500 copies printed, several hundred extra engravings inserted, 17 vol., blue cl., uncut, *New York and London*, Harper Bros., 1900, 8vo. (726) *Edwards*, £4 16s.

2866 Myddelmore (Henry). Translation of a Letter written by a Frenche Gentilwoman to another Gentilwoman Straunger, black letter, mor., g. e., *J. Daye for H. Toye*, 1564, sm. 8vo. (730) *Barnard*, £2 4s.

2867 Nash (Joseph). Architecture of the Middle Ages, orig. ed., 26 lithographs, col. and mounted like drawings, orig. portfolio, McLean, 1838, atlas folio (732) *Harris*, £2 19s.

2868 Nash (J.) Mansions of England, orig. ed., the four series complete, 104 plates, including titles, col. and mounted like drawings, in 4 portfolios (with descriptive text in 8vo.), McLean, 1839-49, atlas folio (733) *Quaritch*, £39

2869 Niavis (Paulus). Epistolae longiores Magistri Pauli Niavis, lit. goth., long lines, 34 to a full page, 24 leaves with signs., absque nota—Epistolae Breves Magistri Pauli Niavis, lit. goth., long lines, 33 to a full page, 24 leaves with signs., absque nota, the two works in 1 vol., rubricated throughout, with some red painted capitals, a fine large woodcut ornamental initial at the head of the second work, green mor. plain, broad gilt inside ornamental borders, g. e., in open solander case [*Lipsae*, C. Kachelofen & Melchior Lotter, 1494-1498?], sm. 4to. (738) *Mevel*, £3 10s.
[The editions of the two works differ from any recorded in Hain.—*Catalogue.*]

2870 Nichols (John). Literary Anecdotes, 1812-15—Illustrations of the Literary History of the Eighteenth Century, 1817-58, numerous ports. and plates, together 17 vol., old cf. (some backs repaired), *Printed for the Author*, 8vo. (739) *Bloomfield*, £3 14s.

2871 Orme (Edw.) Essay on Transparent Prints, front. and 25 plates in aquatint and stipple (2 leaves defective), orig. bds., uncut, *Printed for the Author*, 1807, roy. 4to. (744) *Edwards*, £1 15s.

2872 Orpheus Britannicus, or the Gentleman and Lady's Musical Musaeum, engraved throughout on 101 leaves, including a folding sheet of "The Dust Cart" at end, mor., g. e. (Macdonald), in case, *Printed and sold by B. Cole*, 1760, imp. 8vo. (745) *Tregaskis*, £5 10s.

2873 Ottley (W. Young). Origin and Early History of Engraving upon Copper and Wood, orig. ed., reproductions of old engravings, 2 vol., cf., g. e., J. and A. Arch, 1816, 8vo. (746) *Bloomfield*, £1 15s.

2874 Ottley (W. Y.) A Collection of One hundred and twenty-nine Facsimiles of Scarce and Curious Prints, best ed., facs. on India paper, the nielli and playing cards laid down, hf. vell., t. e. g., Longman, 1828, roy. 4to. (747) *Tregaskis*, £1 8s.

2875 Ottley (W. Y.) Inquiry concerning the Invention of Printing, 37 facs. and woodcuts, hf. mor., uncut, Lilly, 1862, 4to. (749) *Edwards*, £1

2876 Ovidius. "Epistole de Ovidio in rima," lit. goth., Italian woodcut at head of text [Hain, 12185], orig. bds., *D. Pre Baptista de Farfengo nella Cita de Bressa*, 1491, sm. 4to. (750) *Lincoln*, £7

2877 Owen (Jo.) Epigrammatum, Editio postrema, engraved title, Old French mor., g. e., silver clasp, in case (Beckford copy), *Amst. ap Lud. Elzevirium*, 1647, 16mo. (751) *James*, £1 8s.

2878 Painter (Wm.) The Palace of Pleasure, first ed., black letter (titles in fac., Epistle to the Earl of Warwick and 2 leaves

XXIV. 14

of Recapitulation, etc. in vol i. in fac., 2 leaves of the same mended and defective, and many leaves missing, some wormholes in vol. ii.), (not suɔject to return), 2 vol., old cf. gt., *Thos. Marshe*, 1566, *and H. Bynnemann for Nich. England*, 1567, sm. 4to. (753) *Finch*, £16 15s.

2879 Palmer (Sam.) General History of Printing, mor. plain, t. e. g., by Bradstreet, uncut, in case, A. Bettesworth, etc., 1733, 4to. (754) *Edwards*, £1 1s.

2880 Paradin (Claude) et Symeon (D. G.) Symbola Heroica, 215 woodcuts, mor., ɔy E. Thomas, in case, *Antw.*, C. Plantin, 1567, 12mo. (757) *Bloomfield*, £1 14s.

2881 Passe (Crispin de). Anthropomorpheos Eikones . . Aetates Hominum secundum Anni tempora, six full-page engravings, hf. mor., *Coloniae, ex Off. Crispiani Van de Passe*, 1599, 4to, (760) *Edwards*, £2 14s.

2882 Passe (C. de). Liɔer Genesis aeneis formis a Crispini Passaeo expressus Versibisq., 58 engravings (mounted), hf. bd., *Arnhemii*, Jo. Jansson, 1616, sm. 4to. (761) *Bloomfield*, £1 1s.

2883 Passavant (J. D.) Le Peintre-Graveur, port., 6 vol. in 3, hf. mor. gt., *Leipsic*, R. Weigel, 1860-64, 8vo. (762)
Bloomfield, £3 12s.

2884 Patricius (Franciscus). Nova de Universis Philosophia, orig. Italian pigskin, stamped all over in panels, *Ferrariae*, B. Marmarellus, 1591, folio (764) *Dobell*, £1 4s.

2885 Pelagius. Alvari Pelagii De Planctu Sanctae Catholicae Ecclesiae, liɔri II., editio princeps, lit. semi-gott̪., douɔle columns, 58 lines, 406 leaves, each part with a woodcut ɔorder, the first ɔorder col. with the figure of a fool and port. of the author, the second the fool only, woodcut initials, the two parts in 1 vol., contemp. oak bds., stamped all over, *Ulmae*, Jo. Zainer, 1474, thick large folio (768)
Maggs, £12 10s.

2886 Penley (Aaron). The English School of Painting in Water Colours, 47 illustrations in chromo-lithography, mounted like drawings, cl., A. Tarrant, 1874, imp. folio (769)
Hunt, 10s.

2887 Pepys (Sam.) Diary and Correspondence, LARGE HOLLAND PAPER ED., limited to 150 copies, 10 vol., hf. mor., t. e. g., uncut, *New York, De Vinne Press*, Dodd, Mead & Co., 1884, 8vo. (771) *Quaritch*, £4

2888 Petrarca (Fr.) Sonetti, Canzoni e Triomphi, first ed., lit. rom. (180 leaves), illuminated decorated initials and painted capitals, emɔlazoned arms, with supporters of the Venieri family on first page, pencil studies of female figures in some margins, all leaves of taɔle and 4 leaves of text inlaid (lower plain margins of 2 leaves mended), old vell., Wodhull copy, with arms on upper cover, in case [*Venet.*, Vindelin de Spira], 1470, sm. folio (774) *Quaritch*, £85

2889 Pilkington (M.) Dictionary of Painters, 2 vol. extended to eight, and extra illustrated with upwards of 1000 prints, mor., gilt ornaments, g. e., fine copy, in cases, 1801, 4to. (778) *Parsons*, £60

2890 Pindarus. Olympia, Pythia, Nemea, Isthmia, Callimachi Hymni, Dionysius de Situ Orɔis. Licophronis Alexandri, Oɔscurum Poema, Graecè, editio prima et Aldina, mor. ex., with inlayings, g. e., ɔy Capé, in box, very fine copy, *Venet. in aedibus Aldi et Andreae Asulani Soceri*, 1513, 8vo. (779)
Lincoln, £8

2891 Piranesi (Giov. Batt.) Della Magnificenza ed Architettura de' Romani, 59 plates, old russ., g. e., *Romae*, 1761, atlas folio (780) *Quaritch*, £2

2892 Piranesi (G. B.) Schola Italica Picturae, 81 plates, old russ., g. e., *Romæ*, 1773, atlas folio (781) *Sotheran*, £2 10s.

2893 Piranesi (G. B.) Campus Martius Antiquae Urɔis, plates, orig. Roman impressions, old russ., g. e., *Romæ*, 1762, imp. folio (782) *Quaritch*, £1 16s.

2894 Piranesi (G. B.) Antichità d' Alɔano e di Castel Gandolfo, 51 plates, orig. Roman impressions, old russ., g. e., *Romæ*, 1764, atlas folio (783) *Quaritch*, £2 4s.

2895 Piranesi (G. B.) Opere Varii. Raccolta de' Tempj Antichi, etc., 52 plates, orig. Roman impressions, old russ., g. e., *Roma, presso l' autore*, 1776, etc., imp. folio (784)
Quaritch, £2 4s.

2896 Piranesi (G. B.) Vasi, Candelaɔri, Cippi, Sarcofagi, Tripodi ed Ornamente Antichi, 109 plates, orig. Roman impressions, 2 vol., old russ. gt., *Roma*, 1778, imp. atlas folio (785)
Quaritch, £5 5s.

2897 Piranesi (G. B.) Le Antichita Romane, plates, 5 vol., orig. impressions, old russ., g. e., *Roma*, 1784, etc., atlas folio (786) *Quaritch*, £17

2898 Piranesi (G. B.) Antichita di Pompei-Villa Hadriana, 23 plates [*Roma*, 1788, etc.], atlas folio (787) *Quaritch*, £4 12s.

2899 Piranesi (G. B.) Vues de quelques Restes de l'ancienne Ville de Pesto autrement Posidonia, 31 plates, orig. Roman impressions, old russ. gt., *Roma, s. d.*, imp. atlas folio (789)
Quaritch, £14 10s.

2900 Piranesi (G. B.) Colonna Trajana ed Antonina, 34 large plates, orig. Roman impressions, old russ., *Roma, s. d.*, imp. atlas folio (790) *Quaritch*, £1

2901 Piranesi (G. B.) Diverse Maniere d' adornare I Cammini, ed ogni altra parte de gli Edifizi, 69 plates, including title, orig. impressions, old russ., g. e., *Roma*, n. d., atlas folio (791) *Maggs*, £5 5s.

2902 Piranesi (G. B.) Vedute di Roma, 137 plates, orig. Roman impressions, 2 vol., old russ., *Roma*, n. d., imp. atlas folio (792) *Quaritch*, £44

2903 Piranesi (G. B.) Fasti Consulares, Cora e dell' Acqua Giulia, 33 plates, old russ., g. e., *Roma, s. a.*, atlas folio (793)
Quaritch, £1 5s.

2904 Piranesi (G. B.) Raccolta di Alcuni Disegni del Guercino, 28 plates ɔy Bartolozzi and other engravers, and 3 unnumɔered plates at end, old russ., g. e., [*Roma, s. d.*], imp. folio (794) *Quaritch*, £1 10s.

14—2·

2905 Platina (Baptista). De honesta Voluptate ac Valitudine, lit. rom. (title in 𝔤𝔬𝔱𝔥𝔦𝔠), rox. ·binding, *Bononiae, per J. A. Platonidem Benedictorum Bibliopolam, etc.,* 1499, sm. 4to. (795) *Bloomfield,* £1 6s.

2906 Platina (B.) De l' Honneste Volupte, contemp. mor., tooled in panels, g. e. (from the Hamilton library), *Lyon, per B. Rigaud,* 1571, 12mo. (796) *Lincoln,* £2 15s.

2907 Playing Cards. Die Spielkarten der Weigel' schen Sammlung, 8 fac. plates, two col., 100 copies printed, *Leipz.,* T. O. Weigel, 1866, folio (799) *Tregaskis,* £2 10s.

2908 Plutarchus. Vitae Parallelae Latinae, editio princeps, lit. rom., long lines, 45 to a full page, first page of each vol. with illuminated border and initial, arms of orig. owner in the lower margins, 2 vol., old russ., r. e. (Wodhull copy, afterwards Brayton Ives's), [*Romae*] Udalricus Gallus, *c.* 1470, folio (800) *Edwards,* £32

2909 Poggius (B.) Facetiarum Liber (with blanks for A j and G 4), old French mor., g. e. (Derome), Beckford copy, in case, *Impressum Venetiis (s. n. impressoris),* 1487, sm. 4to. (801) *Lincoln,* £3 4s.

2910 Poggio (B.) Les Contes de Pogge Florentine, front., mor. ex. g. e., arms of Comte. Joseph de Lagonde (Hardy-Mennil), in case, *Amst.,* J. F. Bernard, 1712, sm. 8vo. (802) *Bloomfield,* £2

2911 Politiano (Angelo). Stanze, cominciate per la Giostra del Magnifico Giuliano di Piero de Medici, prima editione, title within Renaissance border, full-page cut of Orpheus playing the violin (by Zoan Andrea), and device at end, modern cf., g. e., *Venet.,* N. Zopino,,1521, sm. 8vo. (803) *Lincoln,* £3 7s. 6d.

2912 Pollard (A. W.) Last Words on the History of the Titlepage, 260 copies printed, buckram, uncut, *Chiswick Press,* 1891, 4to. (804) *Thomas,* 16s.

2913 Portius (Simon). An Homo Bonus vel malus volens fiat disputatio—De Dolore Liber—De Coloribus Oculorum, the three treatises in 1 vol., old French mor., g. e., *Fiorentiae* (L. Torrentinus), 1551-1550, sm. 4to. (807) *Leighton,* £2 4s.

2914 Portraits. Physiognomical Portraits. One hundred distinguished Characters, LARGE PAPER, India proofs, text in English and French, 2 vol., hf. mor., t. e. g., uncut, J. Major, 1824, 4to. (808) *Bloomfield,* £1 15s.

2915 Postellus (Gul.) Syriae descriptio, ornamental initials, old French mor., g. e. (Ruette), from the Beckford library, (*Paris*) H. Gourmont, 1540, 8vo. (809) *Clements,* £2 2s.

2916 Postellus (G.) Eversio Falsorum Aristotelis dogmatum authore D. Justino Martyre, old French mor., g. e. (Padeloup), Beckford copy, *Paris,* Seb. Nivellius, 1552, 12mo. (810) *Lincoln,* £2 4s.

2917 Postellus (G.) La Doctrine du Siècle d'Or, port. of author inserted, old French mor., g. e. (Derome), Beckford copy, *Paris,* J. Ruelle, 1553, 12mo. (811) *Maggs,* £1 11s.

2918 [Powell (Thos.)] Humane Industry, a History of most
Manual Arts, orig. ed., cf., H. Herringman, 1661, 8vo. (813)
Galloway, £1 1s.

2919 Prayer. A Booke of Christian Prayers, black letter, within
·woodcut ɔorders, after Dürer and Holɔein, title within
woodcut ɔorder, with port. of Q. Elizaɔeth on reverse,
signature of Tho. Hearne, 1716, and W. Roydon, 1740
(afterwards in the Sheepshanks and Tite. liɔraries), mor.,
g. e. (Macdonald), in case, *Printed by Richard Yardley and
Peter Short, for the Assignes of Richard Day*, 1590, sm.
4to. (815) *Quaritch, £25*
[The third edition of this private Prayer Book of Q.
Elizaɔeth.—*Catalogue.*]

2920 Prayer. Book of Common Prayer, mor. ex., *Cambridge,
printed by John Baskerville*, 1761, imp. 8vo. (817)
Edwards, 10s.

2921 Preston (John, D.D. of Emmanuel College, Camɔ.) The
Doctrine of the Saints Infirmities, orig. ed., front. ɔy Wm.
Marshall, mor., line tooled, g. e., by Kalthoeber (with ticket),
in case (from the Beckford sale), *N. & J. Okes, for H.
Taunton*, 1636, sm. 8vo. (818) *Lincoln, £1 7s.*

2922 Prime (Dr. W. C.) Pottery and Porcelain, illustrations, mor.,
t. e. g., ɔy Stikeman, in case, *New York*, Harper Bros.,
1878, imp. 8vo. (819) *Maggs, £2 12s.*

2923 Prout (Sam.) Sketches made in Flanders and Germany,
50 lithos., hf. bd., n. d., imp. folio (822) *Rimell, £1 11s.*

2924 Prout (S.) Sketches in France, Switzerland and Italy, 26
lithos., hf. mor., Hodgson & Graves, n. d., imp. folio (823)
Rimell, 15s.

2925 Psalterium Davidis Regis, gothic letter, illuminated manu-
script on vell. (164 leaves, 7¼ ɔy 5in.), douɓle columns, 22
lines, red ruɔrics, illuminated decorative initials, a large
square miniature (4½ ɔy 2¾in.) of the Annunciation, within
a fine decorative floreate ɔorder, 16 narrow arched illu-
minated miniatures as diptychs on 8 pages of the text
(3 by 1½in.), mor., g. e., by "The Cluɔ Bindery," in case,
initio Sæc. XIV., 8vo. (824) *Lincoln, £90*
[A well illustrated Anglo-French Psalter, unusual for the
diptych miniatures, which represent side by side scenes
from the Life of David and that of Christ.—*Catalogue.*]

2926 Psalterium. Psalmorum Codex, Anglo-German, early XIVth
Century, gothic letter, illuminated manuscript on vellum
(245 leaves, 4¾ ɔy 3 in), long lines, 18 to a full page,
Calendar, containing 12 circular miniatures, nearly every
leaf with decorative initial, some having small figures of
ɔirds and animals, seven small illuminated initials, and
numerous textual decorations, contemp. oaken bds., pigskin,
stamped, clasps (in first rate state but first and last leaves
of text missing), *Sæc.* XIV., thick sm. 8vo. (825)
Edwards, £70

2927 Ptolemaeus (Claudius). Magnae Constructionis id est
Perfectae Coelestium Motuum per tractationis liɔ. XIII.

(edidit S. Grynaeus), diagrams and initials, editio princeps,
signature of And. Celsus, *Basil.*, Jo. Walderus, 1538, old cf.,
folio (827) *Tregaskis*, £1 16s.
2928 Publicius (Jacobus). Oratoriae artis Epitomata, editio prima,
lit. goth., 42 woodcuts and ornamental initials, begins on
ᴁ 2, A j being blank (the volvelle missing), mor., g. e., by
Capé, in case, *Erhardus Ratdolt Augustensis* 1482 *pridie
Calen. decembris impressit Venetiis*, sm. 4to. (828)
 Lincoln, £15 15s.
2929 Publicius (Jacobus). Oratoriae Artis Epitoma, lit. rom., 36
circular subjects, ornamental initials, etc., modern mor. ex.,
g. e. (with blank leaf for A j, but the volvelle missing),
Venetiis, E. Ratdolt, 1485, sm. 4to. (829) £8
2930 [Quarles.] The School of the Heart, 47 copperplate engrav-
ings, mor. ex., H. Trapp, 1778, 8vo. (836) *Bloomfield*, £1 3s.
2931 Redus (Fr.) Experimenta circa generationem Insectorum,
40 copperplate engravings, old French mor., g. e. (Derome),
in case, *Amst. sumpt. And. Frisii*, 1671, sm. 8vo. (838)
 Edwards, £2 3s.
2932 Reisch (Greg.) Margarita Philosophica, editio prima, wood-
cuts (wanted title and folio 3), cf. antique, *impressus
Friburgi per Jo. Schottum*, 1503, sm. 4to. (843)
 Barnard, £4 4s.
2933 Reisch (G.) Margarita Philosophica Nova, lit. goth., port.
(cut down and mounted), woodcuts, some with moveable
slips, folding map of the world, etc., all col. by hand, old
cf., in case, *Argentorati, impressus per Johannem Grüninger*,
1505, sm. 4to. (844) *Ellis*, £8 10s.
[The only edition in which the map is found. It is a
modified Ptolemean map, with hints of the new Discoveries
in America.—*Catalogue*.]
2934 Renaldini (Panfilo di). Innamoramento di Ruggeretto Figli-
uolo di Ruggero Rè di Bulgaria, prima edizione, woodcuts
and architectural initials, mor., g. e. (Lewis), *In Vinegia à
San Bartholomio Alla botega di Maestro Giovantonio dalla
Carta (per Comin da Trino)*, 1554, sm. 4to. (845)
 Maggs, £3 8s.
2935 Reusner (Nic.) Emblemata, editio prima, 120 woodcuts
by Virgil Solis and others (X 3 defective, a perfect leaf
being inserted from a smaller copy, a few leaves wormed),
modern cf. ex., *Francof.*, Jo. Feyeraben, 1581, sm. 4to. (849)
 Bloomfield, £1 9s.
2936 Reusner (N.) Icones, curante Bern. Jobino, 95 ports. by
Tobias Stimmer, interleaved (38 orig. blanks at end), orig.
stamped pigskin, with date 1590, in case, *Argent. s. n. Im-
pressoris*, 1587, 8vo. (850) *Lincoln*, £1 14s.
2937 Robinson (Henry Crabb). Diary, second ed., port., 3 vol.,
orig. cl., Macmillan, 1869, 8vo. (856) *Hornstein*, £1 18s.
2938 Rogers (Thos.) The Anatomie of the Minde, black letter
(dedicated to Sir Chr. Hatton), (fore-edge of A v cut into),
hf. mor. gt., *J. C. for A. Maunsell in Paules Churchyarde*,
1576, sm. 8vo. (857) *Smedley*, £3 18s.

2939 Rollenhagius (Gar.) Nucleus Emblematum selectissimorum quae Itali vulgo impresas vocant,2 engraved titles,. 2 ports., and 200 circular copperplates by Crispin de Passe (outer margin of first title repaired), 2 vol. in 1, old English mor., g. e. (Ch. Lewis), from the Beckford lirary, *Coloniae et Ultrajecti*, Jo. Jansonius, 1613, sm. 4to. (858)
Isaacs, £8 10s..

2940 Romain de Hooghe. La Manière de se ien Preparer à la Mort, 42 engravings y Romain de Hooghe, mor., g. e., in case, *Anvers, chez George Gallet*, 1700, 4to. (860)
Quaritch, £1 10s.

2941 [Rosario (Simeon).] Antithese des Faicts de Jésus Christ et du Pape mis en Vers françois, 37 woodcuts, hf. cf., g. e., *Imprimé à Rome l'an du Grand Jubilé*, 1600, sm. 8vo. (862)
Bloomfield, £1 1s.

2942 Rosarium Philosophorum. Secunda Pars Alchimiae, de Lapide Philosophico vero modo praeparando, German woodcuts, contemp. MS. notes (margin of Z 4 mended), hf. modern mor., *Francof. ex off. Cyriaci Jacobi*, 1550, sm. 4to. (863)
Bloomfield, £2 12s.

2943 Roxurghe Clu. The Hystorie of the Nole Knight Plasidas, facs., roxurghe, J. B. Nichols, 1873, 4to. (864)
Dobell, £2 10s.

2944 Ruskin (John). Works, viz., Modern Painters, vol. i., fourth ed., 1848, vol. ii.-v., first eds., 1846-56-60, 5 vol.—The Seven Lamps, first ed., 1849—The Seven Lamps, second ed., 1855—The Stones of Venice, first ed., 1851-53, 3 vol., together 10 vol., mor., inlays, central panel, g. t., uncut, by Zaehnsdorf, 1846-55, imp. 8vo. (868) *Maggs*, £19 5s.

2945 Sacrobusto (Joannes de). Sphaera Mundi, lit. rom., cut of astronomy on reverse of title, woodcut diagrams, some in colours, and ornamental initials [Hain *14113], mor., t. e. g., by Bradstreet, in case, *Impressum Venetiis per Octavianum Scotum*, 1490, sm. 4to. (872) *Barnard*, £5

2946 Sandy (Paul, R. A.) A Collection of Etchings, port. of Sandy, 95 proof etchings, and 65 duplicate plates in rown, mounted, hf. cf., n. d. (1809), folio (875) *Tregaskis*, £3 6s.

2947 Savage (Wm.) Practical Hints on Decorative Printing, 50 plates, hf. cf. gt., Longman, 1822, 4to. (876)
Bloomfield, £2 5s.

2948 Scaligeri dalla Fratta (Camillo). La Noilta dell' Asino di Attabalippa dal Peru, 9 woodcuts, doule plate of the Washing of the Ass y K. Manderus inserted, mor., g. e. (Roger Payne), from the Beckford lirary, in case, *Venez. appressa Barezzo Barezzi*, 1598, sm. 4to. (878)
Maggs, £3 12s.

[Bound up at the end of this copy are six doule-paged copperplate engravings after And. Francken y Philip Galle, depicting the Fale of the Countryman and his Ass.—*Catalogue*.]

2949 Schoonhovius (Florent.) Emlemata, engraved title, port.

and 74 copperplate emblems, cf. ex., t. e. g., in case, *Amst.*
ap Jo. Janssonium, 1648, sm. 4to. (883) *Bloomfield,* £1 1s.
2950 Schopper (Hartmann). De Omnibus illiberalibus sive Me-
chanicis Artibus, 132 woodcuts by Jost Amman, mor., g. e.,
by Thibaron-Eschauband, in case, *Francof. a. M. G. Cor-
vinus impensis S. Feyerabend,* 1574, 8vo. (884) ` `*Ellis,* £8
[Bound in the volume is "Dialogus de Catholica Doctrina,
auctore Jo. Perellio," Ingoldstadii D. Sartorius, 1576.—
Catalogue.]
2951 Scott (Leader). The Cathedral Builders, 80 illustrations on
Japanese paper, one of 100 copies printed upon handmade
paper, buckram, uncut, S. Low & Co., 1899, sm. 4to. (885)
` `*Batsford,* 14s.
2952 Seyssel (Claude de). La Grād Monarchie de France, La Loy
Salicque, cut in text, 2 parts in 1 vol., old French mor., g. e.
(Ruette), from the Beckford library, *Paris, D. Janot par
Galliot du Pré (with device),* 1540-41, 8vo. (892).
` `*Maggs,* £3 4s.
2953 Shakespeare (Wm.) / Comedies / Histories and / Tragedies,/
The Second Impression, / title containing port. by Droes-
hout, and verses opposite in fac. (12¼ by 8⅝in.), mor. ex.
(Harleian style), in case, *T. Cotes for R. Allot [at end
"Printed at London by Thomas Cotes for John Smethwick,
William Aspley, Richard Hawkins, Richard Meighen, and
Robert Allot"*], 1632, sm. folio (893) ` `*Bloomfield,* £42
[On an original fly-leaf in this copy occurs the following
inscription, "To John Opie, This most perfect copy of the
Works of Shakespeare is presented by his sincere friend
and servant James Boaden."—*Catalogue.*]
2954 Shakespeare (Wm.) / Comedies, / Histories, / and / Trage-
dies, / Unto which is added, Seven / Plays, / Never before
printed in Folio. / The Fourth Ed., signature on title, and
a few MS. notes in text (a few leaves stained and some
margins jagged), (14 by 8¾in.), four engravings by Antony
Walker inserted, old cf., library stamp, *Printed for H.
Herringman, E. Brewster and R. Bentley,* 1685, folio (894)
Maggs, £47
2955 Shakespeare (Wm.) Plays, from the corrected text of John-
son and Steevens, Heath's edition, 22 plates by Heath,
extra illustrated with 211 engravings on steel and copper,
6 vol., old russ., J. Stockdale, 1807, 4to. (895)
Hatchard, £9 15s.
2956 Shakespeare (Wm.) Works, edited by Howard Staunton,
illustrations by Sir John Gilbert on India paper, édition de
luxe, 15 vol. extended to 20, the five extra volumes contain-
ing nearly 900 extra illustrations, 20 vol., mor. ex., uncut,
Routledge, 1881, sup. imp. 8vo. (896) ` `*Edwards,* £11
2957 Shakespeare. Boydell's Shakespeare Gallery, ports. of K.
George III. and Queen Charlotte, and 98 engravings by
Sharpe, etc. (wanted the prints of "The Seven Ages"),
2 vol., hf. mor., g. e., Boydell, 1803, imp. atlas folio (897)
Spencer, £13

2958 Shakespeare Portraits. Boaden (Jas.) An Inquiry into the
Authenticity of Various Pictures and Prints offered to the
public as Portraits of Shakespeare, 5 ports. of Shakespeare,
and port. of Boaden after Opie inserted, *Printed for R.
Triphook*, 1824—Wivell (Abraham). Inquiry into the
History, etc. of the Shakespeare Portraits (with Supple-
ment, and Historical Account of the Monumental Bust),
20 ports. in all with a port. of the author inserted, India
proofs, 1827, in 2 vol., mor., t. e. g., uncut, in a case, roy.
8vo. (898) *Bloomfield, £3 18s.*

2959 Shakespeare Portraits. Boaden (Jas.) An Inquiry into the
Authenticity of Various Pictures and Prints offered as
Portraits of Shakespeare, 5 ports., hf. mor., t. e. g., uncut,
R. Triphook, 1824, 8vo. (899) *Smedley, £1*

2960 Sharpe (Edm.) Architectural Parallels, 120 lithographs, with
Supplement containing 60 plates, 2 vol., hf. mor. (supple-
ment in bds.), Van Voorst, 1848, imp. folio (900)
Batsford, £2

2961 Shaw (Henry). Dresses and Decorations of the Middle
Ages, orig. issue, 92 plates in colours and heightened in
gold, and woodcuts, 26 orig. parts complete in 6 vol., orig.
cl., with labels, W. Pickering, 1843, 4to. (901)
Hornstein, £4 18s.

2962 Sheraton (Thomas). The Cabinet-Maker and Upholsterer's
Drawing Book, third ed., 122 plates, old cf., *T. Bensley for
W. Baynes*, 1802, 4to. (905) *Maggs, £7*

2963 [Singer (S. W.)] Some Account of the Book Printed at
Oxford in MCCCCLVII. under the title of "Exposicio Sancti
Jeronimi in Simbolo Apostolorum," 50 copies privately
printed, hf. mor., t. e. g., presentation copy, 1812, 8vo. (906)
Tregaskis, £1 8s.

2964 Singer (S. W.) Researches in the History of Playing Cards,
illustrations, some on India paper, 250 copies printed, hf.
russ., m. e., Triphook, 1816, 4to. (907) *Bloomfield, £1 18s.*

2965 Skeen (Wm.) Early Typography, hf. bd., t. e. g., *Colombo,
Ceylon*, 1872, 8vo. (909) *Bloomfield, 15s.*

2966 Smids (L.) Pictura Loquens, front. and 62 engravings, mor.,
t. e. g., by Bradstreet, *Amst.*, H. Schooneseek, 1695, 8vo.
(910) *Lincoln, £1 1s.*

2967 Soleil (Félix). Les Heures Gothiques et la Littérature Pieuse,
au XV. et XVI. Siècles, front. by J. Adeline, 24 fac. repro-
ductions and 6 orig. designs by Destouches, 300 copies
printed, mor., t. e. g., uncut, *Rouen, E. Augé, Editeur*, 1882,
roy. 8vo. (916) *Bloomfield, £1 16s.*

2968 Stothard (Thos.) Life, by Mrs. Bray, port. and 53 illustra-
tions, with 86 additional plates inserted, hf. mor., t. e. g.,
J. Murray, 1851, sm. 4to. (924) *Bloomfield, £1 19s.*
[Another and more extensively illustrated copy realised
£3 5s. (*Edwards*), Lot 925.—ED.]

2969 Sturt (John). The Orthodox Communicant, engraved
throughout, within emblematic borders, 88 vignettes, old
mor., g. e. (1721), 8vo. (928) *Edwards, 18s.*

2970 Sucquet (Ant.) Via Vitae Æternae iconibus illustrata per Böetium à Bolswert, editio prima, 32 full-page engravings, orig. vell. (Beckford copy), *Antwerpiae*, Martinus Nutius, 1620, thick 8vo. (931) *Edwards*, £1 6s.

2971 Symeon (Gab.) Les Illustres Observations Antiques en son dernier Voyage d'Italie l'an 1557, édition originale, woodcuts by le Petit Bernard, mor., g. e., by Kalthoeber, with ticket, from the Hamilton library, *Lyon*, Jan de Tournes, 1558, sm. 4to. (932) *Lincoln*, £5 5s.

2972 Tobacco. Everat (Æg.) De Herba Panacea, 305 consecutive pages with 5 separate titles, old MS. notes throughout, mor., r. e., in case, *Ultrajecti, D. de Hoogenhuysen (à la Sphère)*, 1644, 12mo. (933) *Bloomfield*, 16s.

2973 Taine (H. A.) History of English Literature, illustrated with 250 extra ports. and plates, 4 vol;, unbd., 1873, 8vo. (934) *Maggs*, £4 18s.

2974 Tasso (Bernardo). Rime, divise en cinque libri, 2 vol., old mor., g. e. (Derome), from the Beckford library, *Vinegia*, G. Giolito, 1560, sm. 8vo. (937) *Tregaskis*, £3 12s.

2975 Taylor (John, Water Poet). All the Workes, first collected ed., figures and heads of kings, etc. (title in fac. by Harris, Ss 1-2 defective), russ. ex., g. e., by Rivière, in case, *Printed by J. B. for Jas. Boler at the Marigold in Pauls Churchyard*, 1630, sm. folio (940) *Edwards*, £4

2976 Taylor (J., Water Poet). The Pennyles Pilgrimage, first ed. (soiled and several leaves mended), hf. mor., E. Allde, 1618, sm. 4to. (941) *B. F. Stevens*, £1 8s.

2977 Thomas (Fr.) Historia Illust. Romanorum a Jano usq. ad Criptam a Gotthis urbem jam pridem edita, initial floreated heads of illustrious Romans, mor., g. e. (Kalthoeber), from the Beckford library, *Romae, impensis Stephani Guillereti*, 1510, sm. 4to. (946) *Lincoln*, £3 3s.

2978 Tory (Geoffrey). Peintre et Graveur, par Aug. Bernard, deuxième édition, Holland paper, hf. mor., t. e. g., uncut, covers bound in, *Paris*, Tross, 1865, roy. 8vo. (949) *Edwards*, £1 6s.

2979 Trissino (G. G.) La Italia Liberata da Gotthi, prima edizione, in 3 vol.; modern mor. ex., au pointillé, by Rivière, *Roma, Valerio e Luigi Dorici*, 1547-48, sm. 8vo. (952) *Bloomfield*, £4 4s.

2980 Turner (Dawson). Synopsis of the British Fuci, LARGE PAPER, 50 printed, 2 vol., mor., g. e., in 2 cases, *Yarmouth, printed by J. Bush*, 1803, 8vo. (954) *Quaritch*, £3 3s. [The author's own copy, containing 70 orig. drawings from specimens in his own Herbarium, by Mason of Yarmouth.—*Catalogue.*]

2981 Urines. Here begynneth the Seynge of Urynes, of all the Coloures that Urynes be of, black letter (top margins cut), modern cf., *Imprinted in Fletestrete by Wm. Powel*, 1548, sm. 8vo. (958) *Leighton*, £4 10s.

2982 Vaenius (Otho). Amoris Divini Emblemata, editio prima, 58 copperplate engravings ("ex dono autoris P. Thoma Jullio"

on title), mor., t. e. g., *Antwerpiae*, M. Nutius et Jo. Meursius, 1615, sm. 4to. (964) *Bloomfield*, £1 1s.
2983 Vaenius (O.) Les Emɔlemes de l'Amour Humain, plate of Venus and Cupid and 124 oval proof engravings of emɔlems, orig. vell., in case, *A Brusselles, chez Fr. Foppens*, 1668, sm. oɔlong 4to. (965) *Bloomfield*, £1 1s.
2984 Vaenius (O.) Q. Horatii Flacci Emɔlemata, first ed., 100 engravings ɔy Ph. Galle and P. de Jode, cf. ex., in case, *Antwerpiae, ex off. H. Verdussen*, 1607, 4to. (966) *Olschki*, £1 4s.
2985 Vaenius (O.) Quinti Horatii Flacci Emɔlemata, port. of Vaenius, and 100 engravings ɔy C. Galle, etc., cf. ex., in case, *Bruxellis*, Fr. Foppens, 1683, 4to. (967) *Dobell*, £1 3s.
2986 Van Praet (Jos.) Catalogue des Livres Imprimés sur Vélin de la Biɔliothèque du Roi, papier vélin, 200 copies printed, 10 vol. in 9, hf. cf. gt., *Paris, chez De Bure (imprimerie de Crapelet)*, 1822-28, roy. 8vo. (969) *Leighton*, £2 2s.
2987 Vecellio (Cesare). Habiti Antichi et Moderni, 507 costume figures, after Titian Vecellio, mor., g. e., ɔy Laegner of Milan, with ticket, in case, *Venetia appresso J. Sessa*, 1598, 8vo. (972) *Bloomfield*, £5
[Second and ɔest ed., containing 80 more costumes than the first.—*Catalogue.*]
2988 Velleius Paterculus. Historia Romana, front., old French mor., floreate ɔack, g. e. (Boyet), from the Beckford liɔrary, in case, *Paris*, F. Leonard, 1675, 4to. (973) *Leighton*, £2 6s.
2989 Vergilius (Polidorus, Urbinatis). De Inventoribus rerum, mor., inside dentelles, g. e., ɔy Capé, in case, *Paris, ex. off. Rob. Stephani*, 1528, sm. 4to. (975) *Bloomfield*, £1 16s.
2990 Vergilius (P.) De Rerum Inventoribus liɔ. VIII. et de Prodigiis liɔ. III., old French mor., floreate ɔack, g. e., in case, *Amst.*, D. Elzevir, 1671, sm. 8vo. (976) *Maggs*, £1 12s.
2991 Vernes (M.) Le Voyageur Sentimental, front. ɔy Le Barɔier, old French mor., g. e. (Padeloup), Beckford copy, *à Londres (edition Cazin)*, 1786, 12mo. (977) *Maggs*, £1 8s.
2992 Versor (Joannes). Versoris sup. Octo Partes Orationis Donati pulcherrimū cōmentū cum optimis Argumentis ac Replicis eidem adiectis, **lit. gotf.** (two types), German cut of the interior of a school on title (wormed), rough edges, hf. cf., t. e. g., *Colonie, impressum in domo Quentell*, 1507, sm. 4to. (978) *Barnard*, £2 14s.
2993 Vico (Æneas). Ex-liɔris XXIII. Commentariorum in Vetera Imperatorum Romanorum Numismata, engravings and woodcut initials, old English mor., g. e. (Roger Payne), in case, from the Beckford liɔrary, *Venet.* (Aldus), 1560, sm. 4to. (980) *Clements*, £2 5s.
2994 Viollet-le-Duc (E.) Dictionnaire Raisonné de l'Architecture Française, port. and woodcut illustrations, 10 vol., hf. mor., r. e., *Paris*, A. Morel, 1868-70, roy. 8vo. (981) *J. Bumpus*, £6 5s.

2995 Viollet-le-Duc (E.) Discourses on Architecture translated, ɔy H. Van Brant, illustrations, 2 vol., *Boston*, Osgood, 1875, imp. 8vo. (982) *Maggs*, £1 11s.

2996 Vivaldus (J. Lud.) Opus Regale, lit. goth., cuts and fine initials, orig. French oak ɔoards, sides stamped (reɔacked), with new clasps, in case, *Impressum Lugduni per Johannem de Vingle*, 1508, sm. 4to. (984) *Lincoln*, £6 5s.

2997 Vives (Lodovicus). De Anima & Vita liɔ. III. ejusdem Argumenti Viti Amerbachii de Anima lib. IIII. Ph. Melancthoni liɔer unus, accedit nunc primum C. Gesneri de Anima liɔer, etc., orig. German oak bds., pigskin, stamped with initials H. M. H. and date 1570, arms of the Emperor Charles V., with the name of the ɔinder T. Kruger (clasps missing), in case, *Tiguri*, Jac. Gesner, *s. a.* [*c.* 1566], 8vo. (985) *Ellis*, £2 8s.

2998 Vives (L.) An Introduction to Wysedome, ɔy Rycharde Morysyne, first ed., black letter, mor. ex., g. e., by Rivière, in case, *In aedibus Thome Berthelete*, 1540, sm. 8vo. (986) *Leighton*, £7 15s.

2999 Walpole (Horatio, Earl of Orford). Works, first collected ed., 2 ports. of author and 173 engravings, 9 vol., including memoirs of George II. and the letters to Montagu Cole and the Earl of Hertford, cf. ex., arms of the Hon. G. Agar Ellis (50 copies printed), Roɔinson & Edwards and Chas. Knight, 1798-1825, 4to. (987) *Dobell*, £2 4s.

3000 Walpole (H.) Anecdotes of Painting in England, Major's ed., LARGE PAPER, ports. and woodcuts, extra series of proofs on India paper inserted, 5 vol., mor., t. e. g., uncut, J. Major, 1828, imp. 8vo. (988) *Edwards*, £4 2s. 6d.

3001 Walpole (H.) Letters, ed. ɔy Cunningham, ports., 9 vol., orig. cl., uncut, R. Bentley, 1857-9, 8vo. (989) *J. Bumpus*, £8 5s.

3002 Warrington (Wm.) History of Stained Glass, 28 chromolithographs, hf. mor., *Published by the author*, 1848, imp. folio (991) *J. Bumpus*, £2 4s.

3003 [Westmacott (C. Molloy).] Memoirs of Madame Vestris, extra illustrated with 61 engravings, etc., cf. ex., *Printed for the Booksellers*, 1839 [*reprint*], 8vo. (1000) *Dobell*, £2

3004 Westwood (J. O.) Palaeographia Sacra Pictoria, orig. issue, 50 illuminated plates, hf. mor., W. Smith, 1843-45, 4to. (1001) *Bloomfield*, £3 3s.

3005 Westwood (J. O.) Palaeographia Sacra, another issue, 50 illuminated plates, hf. mor., H. G. Bohn, n. d. (1845), 4to. (1002) *Edwards*, £2 4s.

3006 Westwood (J. O.) Illuminated Illustrations of the Biɔle, orig. ed., 40 chromos, cf., g. e., Wm. Smith, 1846, 4to. (1003) *Bloomfield*, £3

3007 Whittinton (Roɔert). Roɔerti Whitintoni lichfeldiensis gramatices magistri & prothonatis Anglie in florentissima Oxoniensis achademia Laureati Lucubrationes, etc., editio prima, lit. goth. (26 leaves), Wynkyn de Worde's Caxton

device at end (sun, 2 planets, and 18 stars), mor., g. e., by
Stikeman, "*Expliciunt Synonima London per Wynandum
de Worde impressa,*" *s. a.*, sm. 4to. (1007) *Quaritch, £26*
3008 Wickes (Chas.) Illustrations of the Spires and Towers of
the Mediaeval Churches of England, 92 plates, 3 vol., hf.
mor., J. Weale, 1853-9, sup. imp. folio (1008) *Hill, £1* 8s.
3009 Worlidge (Thos.) Select Collection of Drawings from
Antique Gems, port. and 182 etchings, hf. mor., t. e. g.,
Dryden Leach for M. Worlidge, 1768, 4to. (1014)
Bloomfield, £1
3010 Wolsey. [Cavendish (Geo.)] The Negotiations of Cardinal
Woolsey the great Cardinall of England, containing his
Life and Death, etc., first ed., proof port. by Marshall
(packed), orig. fly-leaf with note and autograph of Thos.
Hearne (title repaired), W. Sheares, 1641—A Parallel
petween Card. Wolsey and Archop. Laud (4 leaves), 1641,
in 1 vol., cf. gt., t. e. g., in case, sm. 4to. (1015)
Barnard, £1 13s.

[DECEMBER 15TH AND 16TH, 1909.]

PUTTICK & SIMPSON.

A MISCELLANEOUS COLLECTION.

(No. of Lots, 699 ; amount realised, £762 5s.)

3011 America. The Conduct of a Noble Commander in America,
Impartially reviewed with the Genuine Causes of the Dis-
contents at New York and Hallifax, unbd., 1758, 8vo. (221)
Leon, £1 6s.
3012 Barère (Bertrand). Memoirs, trans. by Payne, 4 vol.,
Nichols, 1896, 8vo. (242) *Sotheran, £1*
3013 Bemrose (Wm.) Longton Hall Porcelain, col. and other
plates, 1906, 8vo. (176) *Archer, £1* 14s.
3014 Biet (Antoine). Vogage de la France Equinoxiale en L'Isle
de Cayenne, cf. ex., py De Coverley, 1664, 4to. (277)
Quaritch, £1 15s.
3015 Bingham (Capt. D. A.) The Letters and Despatches of the
First Napoleon, 3 vol., cl., 1884, 8vo. (398) *Jones, £1* 3s.
3016 Boyne (W.) Trade Tokens, new ed., py G. C. Williamson,
2 vol., rox., 1889-91, 8vo. (367) *Maggs, £1* 16s.
3017 Breviarium ad usum Congregationis Sancti Maria ordinis
Sancti Benedicti in Gallia, 4 vol., old mor., g. e., *Paris,*
1787, 8vo. (180) *Maggs, £2*
3018 Carpenter (Nathaniel). Geography delineated in two
Bookes, vell., 1625 — Schreib-Kalender, Aug. 1769, old
stamped German pinding, together 2 vol., 4to. (588)
Barnard, £1 14s.

3019 Chambers (R.)　Miracles Lately Wrought by the Intercession of the Glorious Virgin Marie at Mont-aigu, trans. by Robert Chambers, mor. ex., 1606, 12mo. (95) *Baker*, £1 2s.

3020 Combe (W.)　Tours of Dr. Syntax, the Miniature ed., col. etchings by Rowlandson, 3 vol., hf. cf., 1823, 12mo. (205) *Spencer*, £1 18s.

3021 Couch (J.)　History of the Fishes of the British Islands, col. plates, 4 vol., cl., 1868, 8vo. (43) *Josephs*, £1 18s.

3022 Cruikshank.　Reid (G. W.)　Descriptive Catalogue of the Works of George Cruikshank, 313 illustrations, 3 vol., rox. (135 sets printed), 1871, imp. 4to. (635) *Hornstein*, £7 15s.

3023 Dickens (Charles).　Dombey and Son, in the orig. 20 parts in 19, with the wrappers (some backs faulty), 1846-7, 8vo. (208) *Shepherd*, £2

3024 Dickens (C.)　Bleak House, in the orig. 20 parts in 19, with the wrappers (some backs faulty), 1852-3, 8vo. (209) *Spencer*, £1 8s.

3025 Dickens (C.)　Little Dorrit, in the orig. 20 parts in 19, with the wrappers (some backs faulty), 1855-7, 8vo. (210) *Shepherd*, £1 1s.

3026 Dickens (C.)　Sibson's Illustrations of Master Humphrey's Clock in 70 plates (wanted 2 plates), hf. cf., Tyas, 1842, 8vo. (212) *Edwards*, £4 7s. 6d.

3027 Dickens (C.)　Works, National Edition, plates, 40 vol. (one of 750 copies), cl., 1907, 8vo. (121) *G. H. Brown*, £12 15s.

3028 Elyot (Sir T.)　The Castell of Health, black letter, mor., gilt leaves, 1576, 12mo. (93) *Reader*, £2 4s.

3029 Gardiner (S. R.)　History of the Commonwealth and Protectorate, 3 vol., and Supplement, cl., 1901-3, 8vo. (408) *F. Edwards*, £1 16s.

3030 Gardiner (S. R.)　History of the Great Civil War, 3 vol., cl., 1886-91, 8vo. (407) *Maggs*, £1 15s.

3031 Gibbon (E.)　Decline and Fall of the Roman Empire, 8 vol., cf., *Oxford*, 1827, 8vo. (39) *Hatchard*, £3

3032 Goldsmith (Oliver).　Retaliation, a Poem, first ed., vignette port. on title, with hf. title, 1774, and other pieces in 1 vol., old hf. cf., 4to. (634) *Maggs*, £18

3033 Gower (John).　Complete Works, by G. C. Macaulay, 4 vol., cl., 1899-1902, 8vo. (413) *Hill*, £1 12s.

3034 Harington (Sir J.)　The Metamorphosis of Ajax, and Ulysses upon Ajax, ed. by S. W. Singer, mor., *Chiswick Press*, 1814, 8vo. (197) *Barnard*, £1 4s.

3035 Hartlib (S.)　Legacie or Enlargement of the Discourse of Husbandry, second ed., cf., gilt top, uncut, 1652, 4to. (269) *Quaritch*, £1 12s.

3036 Heath (H.)　Political Caricatures during the Reign of George IV., by "Paul Pry," about 320 col. plates, in 4 vol., special titles, hf. mor., 1824-30, oblong folio (674) *Maggs*, £14

3037 Holmes (O. W.)　Writings, "Riverside Edition," 13 vol., g. t., 1891, 8vo. (155) *Bumpus*, £1 8s.

3038 Houghton Gallery. A Set of Prints Engraved after the most Capital Paintings, etc., port. of the Empress of Russia and of Lord Orford, plans of Houghton, and 129 mezzotint and line engravings ɔy Valentine Green and others, 2 vol., mor., Boydell, 1788, atlas folio (673) *Rimell, £22* 10s.

3039 Howell (T. B.) State Trials, complete set, and Index ɔy Jardine (1828), together 34 vol., 1809-28, hf. cf., 8vo. (28) *Edwards, £7*

3040 Hutchins (T.) Topographical Description of Virginia; Pennsylvania, Maryland and North Carolina, 3 engraved plates and the separate map in two divisions (in case), orig. bds., with laɔel, 1778, 8vo. (220) *H. Stevens, £9*

3041 Ireland (W. H.) History of Kent, plates, 4 vol., hf. mor., 1828-30, 8vo. (395) *Sotheran, £1* 2s.

3042 Kinglake (A. W.) Invasion of the Crimea, 8 vol., cl., 1863-87, 8vo. (164) *Sotheran, £1* 4s.

3043 Lavater (J. C.) Essai sur la Physiognomie, LARGE PAPER, plates, 3 vol., hf. cf., n. d., 4to. (255) *Meuell, £1* 8s.

3044 Lavender (T.) The Travels of Foure Englishmen and a Preacher into Africa, Asia, Troy and to the Black Sea, **black letter**, mor. ex., 1612, 4to. (587) *Barnard, £3* 3s.

3045 Lever (Charles). Works, complete set, all first eds. (mostly with full-page etchings), 53 vol., in orig. cl. or bds. as issued, fine set, 8vo. (207) *Quaritch, £62*

3046 Missale Secundum Ritum Augustensis Ecclesiae, **lit. gotɧ. magna**, musical notes, full-page cuts and ɔorders, the 8 leaves of the Canon printed on vellum, with large painted initial, old stamped pigskin covered bds. (some leaves wanting, w.a.f.), *Impressum hoc Dillinge in edibus Sebaldi Mayer*, 1555, folio (675) *Barnard, £5* 12s. 6d.

3047 Pater (Walter). Imaginary Portraits, 1887—Appreciations, 1889, ɔoth first eds., cl., 8vo. (153) *Edwards, £1* 6s.

3048 Pepys (Samuel). Memoirs and Correspondence, ed. ɔy Brayɔrooke, ports., 5 vol., cf., Colɔurn, 1828, 8vo. (410) *Jones, £1* 14s.

3049 Pragmatica Sanctio cū repertorio nouiter egregie de Super Côpīlatio, **lit. gotɧ.**, vell., *Paris*, Ph. Pigouchet, 1502, 8vo. (84) *Barnard, £1* 4s.

3050 Punch, vol. i. to xlix. in 25 vol., puɔlisher's ɔlue cl., in good state, 1841-65, 4to. (250) *Allison, £2* 7s. 6d.

3051 Pyne (W. H.) History of the Royal Residences, col. plates, 3 vol., hf. mor. ex., 1819, 4to. (630) *F. Edwards, £13* 10s.

3052 Racine (J.) Œuvres Complètes, avec les notes par L. Aimé-Martin, 6 vol., hf. mor., *Paris*, 1844, 8vo. (40) *G. H. Brown, £1* 15s.

3053 Rhead (A.) A Description of the Body of Man by Artificiall Figures, anatomical plates and douɔle page woodcut, old leather, Jaggard, 1616, 8vo. (222) *H. Stevens, £2* 12s. 6d.

3054 Roɔerts (Wm.) An Account of the First Discovery of Florida, maps, plan and view, hf. cf., 1763, 4to. (280) *H. Stevens, £4* 15s.

3055 Rogers (Samuel). Italy, vignettes ɔy Turner and Stothard, free from spots, bds., uncut, with laɔel, 1830, 8vo. (201)
Neasham, £1 5s.

3056 Roscoe. Novelists' Liɔrary, complete set, 19 vol., puɔlisher's white cl., 1831-33, 8vo. (244) *Maggs*, £9 5s.

3057 Scott (Sir W.) Rob Roy, first ed., 3 vol., bds., uncut (title defective of vol. iii.), 1818, 8vo. (200) *Shepherd*, £2 11s.

3058 Scott (Sir W.) Waverley Novels, fronts. and vignettes, 48 vol., red cl., uncut, 1829-33, 8vo. (37) *W. Brown*, £3

3059 Shakespeare (W.) Works, ed. ɔy W. A. Wright, Camɔridge Edition, 9 vol., cl., 1891-93, 8vo. (24) *W. Brown*, £2 12s.

3060 Skelton (John). Poetical Works, with notes ɔy Alex. Dyce, 2 vol., cl., 1843, 8vo. (400) *Walford*, £1 10s.

3061 Sowerɔy (J.) English Botany, 2,592 col. plates, 36 vol., hf. mor., uncut, 1790-1814, 8vo. (401) *Sotheran*, £14 10s.

3062 Sowerby (J.) English Botany, col. plates, 12 vol., cl., 1832-46, 8vo. (404) *Quaritch*, £6

3063 Speed (J.) Theatre of the Empire of Great Britain, maps, etc., cf., 1676, roy. folio (322) *Andrews*, £1 10s.

3064 Sporting Magazine (The), from January, 1844 to May, 1867, clean run in the original monthly parts, with the wrappers (wanted Oct. '44, Jan. '47, July '49, March '52, March and Nov. '55, April '61, March '63, Feb., April and Oct. '65, July '66, Jan. '67), 8vo. (529) *Spencer*, £31

3065 Strickland (Agnes). Lives of the Queens of England, Liɔrary ed., ports., 8 vol., Colɔurn, 1851-2, 8vo. (406)
Edwards, £2 17s. 6d.

3066 Thackeray (W. M.) Mrs. Perkins' Ball, first ed., col. illustrations, orig. bds., 1847, 8vo. (530) *Hornstein*, £3 17s. 6d.

3067 Walpole (Spencer). History of England, 5 vol., cl., 1878-86, 8vo. (143) *Sotheran*, £2 10s.

3068 Weɔster (John). Metallographia, or An History of Metals, old cf., 1671—Gilpin (R.) Daemonologia Sacra, old cf., 1677, together 2 vol., 4to. (278) *Barnard*, £1

3069 Wilde (Oscar). The Picture of Dorian Gray, first ed., bds., n. d. (1891), (152) *Edwards*, £1 6s.

3070 Williams (S. W.) The Middle Kingdom, illust., 2 vol., cl., 1883, 4to. (368) *Dunlop*, £1 6s.

SOTHEBY, WILKINSON & HODGE.

A MISCELLANEOUS COLLECTION.

(No. of Lots, 336 ; amount realised, £428 17s.)

3071 Aberti (J. L.) Collection de quelques Vues, dessinées en Suisse, orig. ed., 10 col. plates (wanted plate ii.), hf. mor., g. e., à Berne, 1782, oblong 4to. (184) Barnard, £1 11s.

3072 Benâristân (The). (Abode of Spring), by Jâmi, a literal translation, printed by the Kama Shastra Society, parchment, uncut, Benares, 1887, 8vo. (15) Shepherd, £1 7s.

3073 Blagrave (John). Baculum Familliare, a Booke of the making and use of a Staffe, black letter, woodcuts (title soiled and defective), Heugh Jackson, 1590—A Platform of Church Discipline, agreed upon by the Elders, etc. assembled in the Synod at Cambridge, in New England, ed. by Edw. Winslow, Printed in New-England, reprinted in London, 1653—Burton (H.) The Grand Imposter Unmasked (headlines cut into), n. d., and 10 other Tracts, in 1 vol., old cf., 4to. (193) H. Stevens, £7 5s.

3074 Bookbindings. Catalogue of the Gibson Craig Library, 28 days' sale, with prices and names, LARGE AND FINE PAPER (one of 100 copies), 32 plates of historic and other bindings in gold and colours, hf. mor., t. e. g., 1887-88, roy. 4to. (169) Hunt, £1 10s.

3075 Bulwer Lytton (Sir E.) Novels, édition de luxe, LARGE PAPER, illustrations on Japan paper, one of 500 copies, 32 vol., orig. cl. (vol. i. of "The Caxtons" wanted the front., title and hf. title), Routledge, n. d., 8vo. (267) Shepherd, £9 2s. 6d.

3076 Careless (John). The Old English Squire, a Poem, 23 (should be 24) col. plates, orig. cl., McLean, 1821, imp. 8vo. (179) Harley, £6 2s. 6d.

3077 Caracciolus Robertus de Licio vel Litio. Pdicationes a prima dñica de aduētu quottidie usq ad quartā, et de festivitatibus, lit. goth., double columns, 48 lines, 40 initials painted and 370 head letters ornamented, A to O in 8's and aa to ii in 8's, ii has 11 leaves (wanted first "tabula" A1), old cf., Impressi in civitate Venetiarū p. Franciscum renner de Hailbrun, 1479, 4to. (181) Barnard, £2 15s.

3078 Combe (W.) The English Dance of Death, 2 vol., R. Ackermann, 1815-16—The Dance of Life, ib., 1817, col. plates by Rowlandson, orange cl. (7) Hornstein, £14

3079 Combe (W.) History of Johnny Quae Genus, col. plates by Rowlandson, orange cl., R. Ackermann, 1822, 8vo. (8) Shepherd, £3 7s. 6d.

3080 Comɔe (W.) The Three Tours of Doctor Syntax, col. plates by Rowlandson, 3 vol., orange cl., t. e. g., R. Ackermann, n. d., 8vo. (6) *Thorp, £2* 18s.

3081 Cruikshank (George). Taɔle-Book, first ed., etchings (one stained) and woodcuts, hf. mor., t. e. g., *Punch Office,* 1845, 8vo. (236) *Edwards, £1* 2s.

3082 Dickens (Charles). Sketches by "Boz," second series, first ed. (some leaves soiled), illustrations ɔy Geo. Cruikshank, orig. cl., J. Macrome, 1836, 8vo. (2) *Thorp, £2* 16s.

3083 Dickens (C.) Illustrations to the Pickwick Cluɔ, by F. W. Pailthorpe, 24 plates, as issued, 1882, imp. 8vo. (48) *K. James, £2*

3084 [D'Oyly (Sir C.)] Tom Raw, the Griffin, 25 col. plates, orange cl., R. Ackermann, 1828, 8vo. (9) *Hornstein, £3* 8s.

3085 Eliot (George). Works, Caɔinet edition, 20 vol., uncut, n. d., 8vo. (264) *J. Bumpus, £3* 5s.

3086 Fairɔairn (J.) Book of Crests, fourth ed., orig. cl., 1905, 4to. (162) *Quaritch, £1* 2s.

3087 Fielding (Henry). Works, ɔy Leslie Stephen, édition de luxe, 10 vol., buckram, uncut, 1882, roy. 8vo. (254) *Joseph, £2* 6s.

3088 FitzGerald (Edward). Letters and Literary Remains, édition de luxe, port. and fronts., 7 vol., silk ɔinding, uncut, 1902-3, 8vo. (200) *G. H. Brown, £2* 1s.

3089 Foreign Field Sports, with a Supplement of New South Wales, 110 col. plates, hf. mor., E. Orme, 1819, 4to. (196) *Hatchard, £5*

3090 Goldsmith (Oliver). The Vicar of Wakefield, 24 col. plates by Rowlandson, orange cl., R. Ackermann, 1823, 8vo. (11) *Hornstein, £7* 5s.

3091 Gulistân (The), or Rose Garden of Sa'di, translated into English, printed by the Kama Shastra Society, parchment, uncut, *Benares,* 1888 (16) *Shepherd, £1* 11s.

3092 Harris.(W. C.) Portraits of the Game and Wild Animals of Southern Africa, 30 col. plates, 2 vol., hf. mor. (ɔroken), 1840, imp. folio (336) *J. Bumpus, £15* 15s.

3093 Havard (Henry). Dictionnaire de l'Ameublement et de la Décoration, full-page and other illustrations, 4 vol., hf. mor., t. e. g., *Paris,* Quantin, n. d., roy. 4to. (216) *J. Bumpus, £4* 12s. 6d.

3094 Heimskringla (The), or Sagas of the Norse Kings, by Samuel Laing, second ed., maps, 4 vol., orig. cl., 1889, 8vo. (202) *Barnard, £1* 19s.

3095 Hiɔɔert (S.) and Whatton (W. R.) History of Christ's College, Chetham's Hospital, and the Free Grammar School, Manchester, LARGE PAPER, proof ports. and engravings (some spotted), 3 vol., hf. cf., 1828-30, 4to. (198) *Soames,* 12s.

3096 Meredith (George). Works, édition de luxe, port., 32 vol., ɔuckram, uncut, t. e. g., 1896-98, 8vo. (266) *Edwards, £13*

3097 Moore (Col.) and Silcock (E. J.) Sanitary Engineering, folding plates and other illustrations, 2 vol., 1909, 8vo. (120) *Joseph, £1* 7s.

3098 More (Hannah). Cheap Repository, first eds., 17 pieces in 3 vol., presentation copies ɔy Hannah More, contemp. cf. (1830), 8vo. (36) *H. M. Gibbs*, £1 1s.,

3099 Pausanias. Description of Greece, trans. by J. G. Frazer, maps, 6 vol., orig. cl., 1898, 8vo. (201) *Edwards*, £4 1s.

3100 Pindar (Peter, *i.e.* John Wolcot). Works (with 25 separate titles), mezzo. port. and plates ɔy Rowlandson, 2 vol., old cf., 1788-91, 4to. (185) *Edwards*, £1 1s.
[At end of vol. ii. it is stated that the complete set (25 pieces as aɔove) without the portrait of the author is spurious.—*Catalogue.*]

3101 Pratt (Anne). Flowering Plants, Grasses, Sedges, and Ferns of Great Britain, col. plates, 6 vol., hf. mor., n. d., 8vo. (199) *J. Bumpus*, £1 19s.

3102 Rowlandson (T.) Naples and the Campagna Felice, col. plates, orange cl., R. Ackermann, 1815, 8vo. (10) *Hornstein*, £3 5s.

3103 Ruskin (John). Stones of Venice, new ed., 3 vol., orig. cl., 1873, imp. 8vo. (5) *Soames*, £1 18s.

3104 Savage (W.) Practical Hints on Decorative Printing, first ed., col. front. and illuminated title, plates in colours and tints, uncut, 1822, 4to. (188) *Spencer*, £1 15s.

3105 Sue (Eugène). Œuvres complètes, 27 vol., hf. cf., uniform, 1839, etc., 8vo. (262) *Hornstein*, £2 12s.

3106 Swinɔurne (Algernon C.) Poems and Ballads, first ed., orig. cl., E. Moxon, 1866, 8vo. (12) *J. Bumpus*, £4

3107 Swinɔurne (A. C.) Under the Microscope, first ed. (wanted the slip of errata), orig. wrapper, 1872—Ruskin (J.) Proserpina, part i., plates, 1875 (13) *Spencer*, £3 10s.

3108 Vale Press. The Vale Shakespeare, ɔy T. S. Moore, designs, etc. ɔy C. Ricketts, 39 vol., cl., uncut, 1900-3, 8vo. (49) *Maggs*, £6

3109 Worlidge (T., Painter). Drawings from curious antique Gems, port. of Worlidge and 180 plates, 2 vol., 1768, 4to. (189) *McCarthy*, 19s.
[This copy contained the extra plate of Hercules slaying the Nemæan lion, dated 1757, at end of vol. ii.—*Catalogue.*]

3110 Zoology of Egypt. The Fishes of the Nile, ɔy G. A. Boulenger, 97 plates, 2 vol., cl., 1909, 4to. (163) *Quaritch*, £2 2s.

SOTHEBY, WILKINSON & HODGE.

The Library of the late Mr. J. H. Shorthouse, author of "John Inglesant," and other Properties.

(No. of Lots, 327 ; amount realised, £458 8s.)

(*a*) *Mr. Shorthouse's Library* (*Lots 1–189 realised, exclusive of Prints, £203 4s.*)

3111 Arnold (Matthew). Merope, a Tragedy, first ed., orig. cl., 1858, 8vo. (7) *Dobell*, 6s.
3112 Arnold (M.) Friendship's Garland, first ed., orig. cl., 1871, 8vo. (10) *Maggs*, 6s.
3113 Arthur. The Byrth, Lyf, and Actes of Kyng Arthur, of his Noɔle Knyghtes of the Rounde Taɔle, 2 vol. reprint of the Caxton edition of 1485, cf., m. e., 1817—Le Morte Arthur, the Adventures of Sir Launcelot du Lake, "Roxɔurghe Cluɔ," uncut, 1819, together 3 vol., 4to. (134)
Quaritch, £3 10s.
3114 Beaumont and Fletcher. Works, with an Introduction ɔy George Darley, ports. and vignettes (spotted), 2 vol., uncut, Moxon, 1840, roy. 8vo. (13) *Hill*, 10s.
3115 Bickham (G.) The Universal Penman, front. ɔy Gravelot, vignettes and tail-pieces, vell., m. e., 1743, folio (161)
Hill, £1 4s.
3116 Browne (Dr. Thos.) Pseudodoxia Epidemica, Enquiries into Vulgar and Common Errors, first ed., orig. cf., 1646 (162)
Barnard, £1 18s.
3117 Borrow (George). The Biɔle in Spain, 3 vol., 1843— Lavengro, first ed., port., 3 vol., 1851, orig. cl., 8vo. (20)
Dobell, £2 7s.
3118 Burns (Roɔert). Poems, chiefly in the Scottish Dialect, third ed., port. ɔy Beugo, orig. cf., *London*, 1787, 8vo. (25)
Maggs, £1 3s.
3119 Casauɔon (Meric). Treatise proving Spirits, Witches, and Supernatural Operations, 1672—Treatise concerning Enthusiasme, 1655—Of Credulty and Incredulity, 1668-70—The Count of Gabalis, or Extravagant Mysteries of the Caɔalists, 1680—Baxter (R.) Certainty of the World of Spirits, port. pasted at ɔack of title, 1691, 8vo. (33) *Tregaskis*, £3
3120 Cervantes Saavedra (M. de). Don Quixote, plates after Joseph del Castillo, 4 vol., Spanish cf., g. e., *Madrid*, 1780, 4to. (140) *Hatchard*, £5 12s. 6d.
3121 Charles I. The Princely Pellican. Royall Resolves, presented in sundry choice Oɔservations, extracted from His Majesties Divine Meditations, front. (margins inked), unbd., 1649, 4to. (141) *Norton*, £1 1s.

3122 Dante Alighieri. Commedia, Commento di Christophoro Landino, woodcuts (a few leaves stained), cf., *Venegia*, 1536, 4to. (142) *Tregaskis*, £1 16s.

3123 Forster (John). Life and Times of Oliver Goldsmith, 2 vol., orig. cl., 1854, 8vo. (52) *Hornstein*, £1 11s.

3124 Gaffarel (J.) Unheard-of Curiosities, folding plate at end (margins wormed), 1650—Glanvil (J.) Saducismus Triumphatus, front., 1681—Beaumont (J.) Treatise of Spirits, Apparitions, Witchcrafts, etc. (stained), 1705, and others, together 7 vol., 8vo. (53) *Shepherd*, £2 2s.

3125 Goldsmith (Oliver). Vicar of Wakefield, first London ed., 2 vol. in 1 (some leaves soiled and two defective), old cf., 1766, 8vo. (58) *Barnard*, 13s.

3126 Lang (Andrew). XXII. Ballades in Blue China, first ed., parchment wrapper, uncut, 1880, 8vo. (79) *Savile*, 12s.

3127 Lilly (William). A Prophecy of the White King (a headline shaved), 1644—Monarchy, or no Monarchy in England : Greener his Prophecy concerning Charles son of Charles, diagrams and woodcuts (last 3 leaves imperfect), 1651— Van Helmont (J. B.) A Ternary of Paradoxes, by Walter Charleton (stained), old cf., 1650—Potts (Thos.) Wonderful Discoverie of Witches in the Countie of Lancaster (imperfect and defective), cf. (1613), 4to. (149) *Barnard*, £1 4s.

3128 Llewellyn (Martin). Men-Miracles, with other Poemes (title written on), old cf. (broken), 1656, 8vo. (83) *Edwards*, 7s.

3129 Mather (Cotton). Magnalia Christi Americana, or the Ecclesiastical History of New-England (wanted the map), cf. (broken), 1702 (176) *Edwards*, £2 12s.

3130 Pater (Walter). Imaginary Portraits, first ed., orig. cl., 1887, 8vo. (101) *B. F. Stevens*, £1

3131 Peacham (Henry). The Compleat Gentleman, coats-of-arms, col. by hand, some extra ones added—The Gentlemans Exercise, arms and engravings col., a few coats-of-arms added (title defective), old cf., 1634, in 1 vol., 4to. (150) *Tregaskis*, £2 8s.

3132 Shorthouse (J. H.) John Inglesant, first ed., the proof sheets, MS. corrections and alterations, hf. cf., uncut, t. e. g., *Birmingham*, 1880, 8vo. (108) *Barnard*, £32

3133 Shorthouse (J. H.) John Inglesant, with MS. notes and a few corrections, 2 vol., uncut, Macmillan, 1881, 8vo. (109) *Edwards*, £5 15s.

3134 Shorthouse (J. H.) John Inglesant, édition de luxe, port., one of 510 copies, inscription on fly-leaf, " J. Henry Shorthouse, very kindly sent him by his respected publishers, December 9, 1902," 3 vol., uncut, Macmillan, 1902, 8vo. (111) *Dobell*, £2 14s.

3135 Sidney (Sir Philip). The Countess of Pembroke's Arcadia, thirteenth ed., port., mounted, old cf., 1674, folio (184) *Maggs*, 19s.

3136 Thackeray (W. M.) History of Henry Esmond, first ed., 3 vol., orig. cl., 1852, 8vo. (121) *Shepherd*, £2 19s.

3137 Verney (F. P. and M. M.) Memoirs of the Verney Family,
ports. and illustrations, 4 vol., 1892-99, 8vo. (127)
Bain, £3 10s.
3138 We)ster (John). The Displaying of supposed Witchcraft
(a few margins damaged), old cf. ()roken), 1677, folio (187)
Barnard, £1 2s.
3139 Wordsworth (William). The Excursion, first ed., cf., nearly
uncut, 1814, 4to. (157) *Sawyer,* 15s.

(β) *Other Properties.*

3140 Ainsworth (W. H.) Windsor Castle, mor. ex., 1843, first
demy 8vo. ed. (264) *Hornstein, £1* 5s.
3141 Apianus (Petrus). Cosmographia, per Gemmam Phrysium
restituta, woodcuts and diagrams, old vell. (stained), *Ant-
werp,* 1564, 4to. (325) *Dobell, £1*
3142 Ariosto (L.) Orlando Furioso, by Sir J. Harington, printed
title to Epigrams dated 1633, 46 engravings and engraved
title with port., cf. ()roken), 1607, folio (333)
Edwards, £1 11s.
3143 Art (L') et l'Idée, revue contemporaine illustrée, par O.
Uzanne, No. 353 of 600 copies, "sur papier vergé des
Vosges," plates, many in colours, and illustrations, 2 vol.,
hf. mor. ex., *Paris,* 1892, roy. 8vo. (298) *Diouritch, £1*
3144 Berkeley (G. F.) A Month in the Forests of France, first
ed., col. front., and plate)y J. Leech, orig. cl., leaves
unopened, 1857, 8vo. (280) *Shepherd,* 9s.
3145 Blane (Wm.) Cynegetica, or Essays on Sporting, front. and
vignette by T. Stothard, orig. bds., Stockdale, 1788, 8vo.
(289) *Shepherd, £1* 1s.
3146 Bree (C. R.) History of the Birds of Europe, col. plates, 4
vol., 1859-63, roy: 8vo. (303) *Quaritch, £1* 15s.
3147 Bus)y (T. L.) Costume of the Lower Orders of London,
24 col. plates, with descriptions (title soiled), mor., t. e. g.,
n. d., 4to. (310) *Spencer, £2*
3148 Camp)ell (Thomas). Poetical Works, vignettes after Turner,
and a hust of Camp)ell, hf. mor., g. e., Moxon, 1837, 8vo.
(234) *Hough,* 10s.
3149 Combe (W.) Three Tours of Dr. Syntax, col. plates)y
Rowlandson, 3 vol. (names on titles), orange cl., 1820, roy.
8vo. (284) *W. Daniell, £1* 15s.
3150 Cronica Cronicarum abregée et mise par figures descentes et
Rondeaulx, lit. goth., woodcut heads, etc., cf. (inkstained),
Paris, Galliot Du Pre, 1532, 4to. (306) *Barnard, £1*
3151 Dibdin (T. F.) Bibliographical Tour in France and
Germany, first ed., 3 vol., mor., g. e. (ru))ed and)roken),
1821, 8vo. (190) *Maggs, £1* 10s.
3152 Dickens (C.) Hunted Down, illustrated wrapper)ound up,
cf. ex., by Tout, J. C. Hotten, n. d. (1870), 8vo. (237)
Hough, 17s.
3153 Dickens (C.) Library of Fiction, 14 illustrations, 2 vol., hf.
mor., t. e. g., 1836-37, 8vo. (238) *Shepherd, £1*

3154 Dickens. A Curious Dance round a Curious Tree, first ed., orig. pink wrapper, n. d. (1860), 8vo. (240) *Hornstein,* 18s.

3155 Dickens (C.) The Newsvendors' Benevolent and Provident Institution. Speeches by Charles Dickens, President, n.d.— Speech of Charles Dickens, on behalf of the Hospital for Sick Children, 1860—Authentic Record of Charles Dickens, prior to his departure for America, 1867, unbd., 8vo. (243)
Hornstein, £1 10s.

3156 Dickens (C.) Address delivered at the Birmingham and Midland Institute, 1869 (1869)—Manchester Athenæum. Addresses by Charles Dickens, B. Disraeli and others [1835-85], Manchester, 1888, orig. wrappers, 8vo. (244)
Spencer, £1 7s.

3157 Dickens. Six Extra Illustrations for the cheap edition of the Pickwick Papers, from drawings by "Phiz," 1847—Eight Extra Illustrations for the cheap edition of the Old Curiosity Shop and Barnaby Rudge, 1848-9, in the orig. wrappers, 8vo. (245) *Shepherd,* £1 11s.

3158 Dickens. Pailthorpe (F. W.) Illustrations to the Pickwick Club, India proofs, green pictorial wrapper, 1882—Great Expectations, proofs on Japan paper, in cover, 1885—Oliver Twist, India proofs, in cloth cover, 1886, 8vo. (246)
James, £6

3159 Drummond (James). Ancient Scottish Weapons, illustrations in colours, one of 500 copies, hf. mor., t. e. g., 1881, folio (336) *Hill,* £1 2s.

3160 [Folengo (Theophilo).] Opus Merlini Cocaii Poetae Mantuani Macaronicorum, woodcuts, mor., g. e., *Tusculani apud Lacum Benacensem, Alexander Paganinus,* 1521 (267)
Barnard, £3

3161 Gentleman Angler (The), containing Short, Plain and Easy Instructions, etc., unbd., 1726, 8vo. (295) *Tregaskis,* £1 4s.

3162 Giovanni Ser. The Pecorone, by W. G. Waters, illustrated by Hughes (one of 110 copies on Japanese vell.), hf parchment, uncut, 1897, 4to. (314) *Shepherd,* £1 11s.

3163 Goldsmith (Oliver). The Vicar of Wakefield, 32 illustrations by Mulready, glazed cf., with an elaborate arabesque design in colours, g. e., Van Voorst, 1843, 8vo. (235)
Hough, £2 10s.

3164 Hassall (A. H.) History of the British Freshwater Algae, col. plates, 2 vol., 1845, 8vo. (292) 19s.

3165 Heptameron (The), done into English Prose and Verse, by Arthur Machen, port., uncut, suppressed, *Privately printed,* 1886, 8vo. (248) *Barnard,* 16s.

3166 Hill (G. B.) Footsteps of Dr. Johnson, édition de luxe, illustrations by Lancelot Speed, one of 160 numbered and signed copies, uncut, in a box, 1890, roy. 4to. (316)
Carter, 10s.

3167 Jesse (J. H.) Memoirs of the Court of England during the Reigns of the Stuarts, first ed., fronts., 4 vol., orig. cl., 1840, 8vo. (197) *B. F. Stevens,* £5

3168 La Fontaine (J. de). Tales and Novels in Verse, 85 engrav‐
ings by Eisen, from the orig. plates, 2 vol., uncut, t. e. g.,
1884, 8vo. (249) *Shepherd, £1 8s.*
3169 List of the General and Field Officers as they Rank in the
Army, for the year 1776, cf.—Naval Monument, containing
official and other accounts of all the ɔattles fought ɔetween
the Navies of the United States and Great Britain, plates
(3 or 4 missing), sheep, *Boston*, 1816, 2 vol., 8vo. (272)
 Sawyer, £1 12s.
3170 Masuccio (S.) The Novellino, ɔy W. G. Waters, illustrated
by Hughes, 2 vol. (one of 210 copies on Japanese vell.), hf.
parchment, uncut, 1895, 4to. (313) *Shepherd, £1 11s.*
3171 Motley (J. L.) History of the United Netherlands, liɔrary
ed., ports., 4 vol., cl., 1860-67, 8vo. (195) *Edwards, £1 8s.*
3172 Motley (J. L.) The Rise of the Dutch Repuɔlic, liɔrary ed.,
3 vol., cl., 1864, 8vo. (196) *Wheeler, 14s.*
3173 Orrock (James, R.I.) Painter, Connoisseur, Collector, ɔy
Byron Weɔɔer, ports. and illustrations, one of 500 unnum‐
ɔered copies, 2 vol., uncut, t. e. g., 1903, roy. 4to. (315)
 C. Jackson, £1 7s.
3174 Perrault (Charles). Les Contes des Fées, par Ch. Giraud,
LARGE PAPER, proof port. and vignettes, cf. gt., Lyon, 1865,
8vo. (236) *Hough, £2*
3175 Plinius Secundus. Epistolarum liɔri X., capitals ruɔricated,
vell., *Venetiis, in aedib. Aldi, etc.*, 1508—Cicero. Oratione
in difesa di Milone, tradotta in volgare da G. Bonfadio,
Vinegia in casa deʼ figliuoli di Aldo, 1554, 2 vol., 8vo. (269)
 Barnard, £1 16s.
3176 Richardson (Samuel). Correspondence, edited by Anna L.
Barbauld, ports. and col. front., 6 vol., orig. bds., 1804, 8vo.
(193) *Edwards, 16s.*
3177 Rogers (Samuel). Italy, earliest issue, proofs ɔefore letters,
vignettes on pages 88 and 91 reversed, mor. gt., g. e., 1830,
8vo. (232) *Hough, £4 8s.*
3178 Rogers (S.) Poems, first ed., vignettes, proof impressions,
mor., g. e., 1834, 8vo. (233) *Hough, £4*
3179 Straparola (G. F.) The Nights, by W. G. Waters, illustrated
by E. R. Hughes (110 copies on Japanese vell.), 2 vol., hf.
parchment, uncut, 1894, 4to. (312) *Shepherd, £1 16s.*
3180 Thackeray (W. M.) "Our Street," first ed., col. illustrations,
orig. pink bds. (somewhat soiled, defective), g. e., 1848, 8vo.
(225) *Hough, £1 8s.*
3181 Thackeray (W. M.) "Our Street," first ed., illustrations
uncol., orig. pink bds., 1848, 8vo. (226) *Hornstein, £2*
3182 Thackeray (W. M.) Dr. Birch and his Young Friends, first
ed., illustrations col., orig. pink bds. (somewhat soiled and
defective), g. e., 1849, 8vo. (227) *Hornstein, £1 16s.*
3183 Thackeray (W. M.) Dr. Birch and his Young Friends, first
ed., illustrations uncol., orig. pink bds., 1849, 8vo. (228)
 Hornstein, ££1 10s.
3184 Thackeray (W. M.) Reɔecca and Rowena, first ed., illustra-

tions ɔy Richard Doyle, uncol., orig. pink bds. (slightly
defective), 1850, 8vo. (229) *Spencer*, £1 14s.
3185 Thackeray (W. M.) The Kickleburys on the Rhine, first ed.,
illustrations col., orig. pink bds. (soiled, ɔack missing), g.e.,
1850, 8vo. (230) *Hough*, 18s.
3186 Thackeray (W. M.) The Book of Snoɔs, first ed., illustra-
tions, orig. green wrapper (ɔadly soiled and ɔack defective),
Punch Office, 1848, 8vo. (231) *Spencer*, £1 14s.
3187 Tristram (W. O.) Coaching Days and Coaching Ways, first
ed., illustrations by Railton and Thomson, 1888, 4to. (317)
Sawyer, 17s.
3188 Vecellio (C.) Habiti antichi et moderni, woodcuts after
Titian, vell., *Venetia, Appresso i Sessa*, 1598, 8vo. (278)
Huggins, £2 4s.
3189 Walpole (H.) Catalogue of Royal and Noɔle Authors, ports.,
5 vol., cf., 1806, 8vo. (192) *Joseph*, £1 11s.
3190 Washington (George). Official Letters to the Honoraɔle
American Congress, 2 vol., orig. bds., uncut, 1795, 8vo.
(296) *Wheeler*, £1 4s.

3191 [Gray (T.)] An Ode on a Distant Prospect of Eton College,
first ed., 4 leaves, unbd. (edges soiled and repaired), 13 ɔy
8½ins., apparently uncut, *London, printed for R. Dodsley
. . . and sold by M. Cooper* . . . 1747, folio (222)
Quaritch, £50 10s.
[No other copy of this ode has ɔeen sold since BOOK-
PRICES CURRENT was estaɔlished in 1887. The small
price at which it was puɔlished (6d.), its slender form and
inconvenient size, douɔtless account for its almost total
disappearance. Sold ɔy Messrs. Hodgson & Co. on
Jan. 11th, 1910.—ED.]

[JANUARY 13TH AND 14TH, 1910.]

PUTTICK & SIMPSON.

A MISCELLANEOUS COLLECTION.

(No. of Lots, 644 ; amount realised, £898 1s. 6d.)

3192 Ainsworth (W. H.) Crichton, first ed., 3 vol., mor. ex., 1837,
8vo. (197) *Smith*, £2 2s.
3193 America. North American Pilot (second part of), containing
Charts of the Coast of N. America, Bay of Chesapeake,
etc. (some stained, not suɔject to return), hf. cf., 1800, folio
(610) *Stevens*, £2 4s.
3194 Artist's Repository (The), or Repository of the Fine Arts,
plates, printed in ɔrown, 4 vol., cf., 1808, 8vo. (118)
Joseph, £1 2s.

3195 Audsley (G. H.) Ornamental Arts of Japan, col. plates, four
portfolios, 1882 (285) *Rimell, £3* 10s.
3196 Beauclerc (Lady Di). Her Life and Works, by Mrs. Erskine,
illustrations in colour, mounted on grey paper, and illustra-
tions in the text, cl., gilt top, 1903, 4to. (512)
Charles, £1 6s.
3197 Bell (J. M.) Chippendale, Sheraton and Hepplewhite
Furniture Designs, reproduced and arranged by J. Munro
Bell, 259 plates, cl., 1900, folio (300b) *Hatchard, £1* 18s.
3198 Blair (R.) The Grave, plates by Blake, cl., 1813, oblong 4to.
(226) *Charles, £1* 6s.
3199 Boer War. Collection of South African Newspapers, etc.,
published at the commencement of the Boer War, printed
on various coloured papers, and in different sizes, bound in
1 vol., 1899-1900, folio (598) *Sawyer, £5*
[Johannesburg Star—The Volkstem (English and Dutch)
—Edict from Gen. French to the Inhabitants of Barberton
threatening to Shell the Inhabitants, etc., etc.—*Catalogue.*]
3200 Bruce (M. E. Cumning). Family Record of the Bruces and
the Cumyns, plates, mor., g. e., 1870, 4to. (260) *West, £1*
3201 Burke (J. and Sir J. B.) The General Armory of England,
etc., 1884, 8vo. (164) *Parsons, £2* 12s.
3202 Byron (Lord). Poetical Works, port., 6 vol., cf. ex., 1855, 8vo.
(166) *Edwards, £2* 16s.
3203 Cambrian Archæological Association Journal. Archæologia
Cambrensis, from the commencement, with index and sup-
plement (wanted vol. i. and ii. of third series), 53 vol., cl.
and hf. mor., 1846-99, 8vo. (455) *Bailey, £14* 5s.
3204 Campbell (Lord Archibald). Records of Argyll, plates, mor.,
g. e., 1885, 4to. (262) *West, £1* 3s.
3205 Cannon (R.) Historical Records of the First, Second, Third,
Fourth, Fifth and Sixth Dragoon Guards, also Life Guards
and Royal Horse Guards, col. plates, in 3 vol., mor., g. e.,
1834, etc., 8vo. (162) *Hornstein, £5* 17s. 6d.
3206 Careless (John). The Old English Squire, a Poem, 20 col.
plates in the style of Rowlandson, mor. ex., uncut, McLean,
1821, 8vo. (158) *Hornstein, £6* 15s.
3207 Catlin (Geo.) North American Indian Portfolio, 25 large col.
plates, mounted like drawings, descriptive text, 1844, folio
(599) *Quaritch, £15* 10s.
3208 Champlin (J. D.) and Apthorp (W. F.) Cyclopædia of Music
and Musicians, ports., etc., *New York,* 1888-91, 4to. (480)
Murray, £2 10s.
3209 Charlevoix (P. de). Journal of a Voyage to America, map, 2
vol., cf., 1761, 8vo. (398) *Leon, £2* 10s.
3210 Cleland (J.) Fanny Hill, or Memoirs of a Woman of Plea-
sure, first ed., 2 vol., cf., Griffiths (1750), 8vo. (452)
Hornstein, £3
3211 Combe (W.) Poetical Sketches of Scarborough, col. plates
(soiled), hf. cf., 1813, 8vo. (155) *Simpson, £1* 8s.
3212 Daniell (Wm.) Voyage round the Coast of Scotland, col.
views, hf. mor. (1819), folio (606) *W. Brown, £4*

3213 Dasent (G. W.) Story of Burnt Njal, 2 vol., orig. cl., 1861, 8vo. (102) *Hill*, £1 7s.
3214 Dickens (Charles). Memoirs of Grimaldi, first ed., 2 vol., ɔlack cl., pictorial ɔacks, 1838, 8vo. (437) *Hornstein*, £2 12s.
3215 Dickens (C.) Works, édition de luxe, 30 vol., hf. mor., g. t., uncut, 1881-2, 8vo. (438) *Rimell*, £17 5s.
3216 Dickens (C.) Works, Red Cloth Liɔrary Edition, 30 vol., with Life ɔy Foster, 1878, together 31 vol., cl. (435) *Maggs*, £7
3217 Digestarum seu Pandectarum liɔri, 2 vol. in 4, mor. ex., ɔy Derome, *Florentinæ*, 1553, 4to. (287) *Smith*, £4 15s.
3218 Drake (F.) Eɔoracum, maps and plates, cf., 1736, folio (618) *Milligan*, £4
3219 Encyclopædia of Sport (The), 2 vol., hf. mor., g. t., 1897-8, 4to. (273) *West*, £1 8s.

Fraser's (Sir William) Family Histories. (All bound in morocco, g. e., F. 4to.)

3220 Red Book of Grandtully (The), 2 vol. (100 printed), 1868 (243) *Hopkins*, £6
3221 Annandale Family Book (The) of the Johnstones, Earls and Marquises of Annandale, 2 vol., 1894 (244) *Hopkins*, £10 10s.
3222 Cromartie (Earls of), 2 vol., 1876 (245) *West*, £6 10s.
3223 Memorials of the Montgomeries, Earls of Eglinton, 2 vol., 1859 (246) *West*, £6 10s.
3224 Frasers of Philorth (The), 3 vol. (150 printed), 1879 (247) *Sotheran*, £6 15s.
3225 The Chiefs of Grant. Memoirs, Correspondence and Charters, 3 vol., 1883 (248) *Hopkins*, £12 5s.
3226 Lennox (The). Memoirs and Muniments, 2 vol., 1874 (249) *Hopkins*, £6 5s.
3227 Carnegies (The). History of the Carnagies, 2 vol., 1867 (250) *Brown*, £10
3228 Maxwells of Pollok (The). Memoirs, 2 vol., 1863 (251) *West*, £6 10s.
3229 Stirlings of Keir (The), 1858 (252) *Hopkins*, £11 5s.
3230 Elphinstone Family Book (The), 2 vol., 1897 (253) *West*, £6 10s.
3231 Book of Carlaverock (The). Memoirs of the Maxwells, Earls of Nithsdale, 2 vol. (150 printed), 1873 (254) *Brown*, £11 10s.
3232 Scotts of Buccleuch (The), 2 vol., 1878 (255) *Hopkins*, £11 5s.
3233 Red Book of Menteith (The), 2 vol., 1880 (256) *Brown*, £10
3234 Douglas Book (The). Memoirs, Charters and Correspondence, 4 vol., 1885 (257) *Brown*, £18
3235 Melvilles (The). Earls of Melville and the Leslies, Earls of Leven, 3 vol., 1890 (258) *West*, £6 10s.
3236 Memorials of the Earls of Haddington, 2 vol., 1889 (259) *Hopkins*, £5 5s.

3237 Funk and Wagnall's Standard Dictionary of the English Language, 2 vol., mor., 1902, 4to. (501) *Jukes, £1* 10s.
3238 Gould (R. F.) History of Freemasonry, plates, 3 vol., hf. mor., g. e., n. d. (1887), 4to. (513) *Charles, £1* 6s.
3239 Goya y Lucientes (F. J.) Thirty-one Etchings of Bull Fighting, hf. mor. (1813), folio (614) *Sabin, £50*
3240 Hendley (T. H.) Asian Carpets, from the Jaipur Palaces, etc., col. plates, the text within illuminated borders (in case), n. d., folio (290) *Batsford, £5* 17s.
3241 Hewitson (W. C.) Coloured Illustrations of the Eggs of British Birds, col. plates, 2 vol., hf. mor., 1846, 8vo. (167) *Edwards, £2* 12s.
3242 Hodgkin (J. E. and E.) Samples of Early English Pottery, tinted illustrations, 1891, 4to. (510) *Charles, £1* 5s.
3243 Inman (T.) Ancient Faiths embodied in Ancient Names, 3 vol., cl., 1872, 8vo. (217) *Hornstein, £2* 17s. 6d.
3244 Jacquemin (R.) Iconographie du Costume, col. plates, hf. mor., n. d., folio (286) *Smith, £4* 15s.
3245 Jones (Owen). Grammar of Ornament, 112 col. plates, Day & Son, n. d., 4to. (278) *Joseph, £1* 6s.
3246 Kaempfer (E.) History of Japan, handmade paper issue, 3 vol., hf. vell., 1906, 8vo. (169) *Quaritch, £1* 12s.
3247 Kama Sutra of Vatsyayana, vell., *Kama Shastra Soc.*, 1883, 8vo. (199) *Murray, £1* 3s.
3248 Kane (Paul). Wanderings of an Artist among the Indians of North America, col. plates, cl., 1859, 8vo. (103) *Stevens, £1* 18s.
3249 La Belle Assemblée. Portraits, col. plates, vol. i. to v. and xiii. to xxii., in all 16 vol., hf. cf., 1806-20, 8vo. (454) *Hornstein, £5*
3250 Lang (H. C.) Butterflies of Europe, col. plates, 2 vol., cf. ex., 1884, 8vo. (163) *West, £2* 7s. 6d.
3251 Leech (Jno.) Follies of the Year, col. plates, hf. mor., 1864, 4to. (228) *Charles, £1* 5s.
3252 Lessons on Thrift, col. plates by I. R. Cruikshank (soiled copy, binding broken), 1820, 8vo. (154) *Reader, £1* 11s.
3253 Lytton (E. B., Lord). Works, the Knebworth ed., 38 vol., cl., 1877-78, 8vo. (449) *Hornstein, £1* 9s.
3254 Macdonald (A.) The Clan Donald, ports. and plates, 3 vol., mor., g. e., 1896, 4to. (261) *Hopkins, £2* 2s.
3255 McIan (R. R.) and Logan (J.) Clans of the Scottish Highlanders, col. plates, 2 vol., mor. ex., 1845, folio (299) *Brown, £8*
3256 Malton (J.) View of the City of Dublin (map defective and text repaired), cf., 1795, folio (292) *West, £5* 15s.
3257 Manley (Mrs.) Secret Memoirs and Manners . . . from the New Atlantis, 2 vol., 1709-10—Memoirs of Europe, 2 vol., 1710-11—Adventures of Rivella, 1714—Secret History of Europe, 1712—Widow of the Wood, 1755, together 7 vol., 8vo. (219) *Hornstein, £2* 12s. 6d.

3258 Meredith (George). Poems, presentation copy with inscription, "H. D. Traill from his friend George M.," on title, cl., 1892, 8vo. (443) *Spencer, £8*

3259 Meredith (G.) Ballads and Poems of Tragic Life, presentation copy with inscription, "To H. D. Traill from his friend George M.," cl., 1887, 8vo. (444) *Spencer, £8*

3260 Meredith (G.) Rhoda Fleming, first ed., 3 vol., cl., uncut, (no half titles), 1865, 8vo. (447) *Dobell, £1 13s.*

3261 Military Costume. Militaire Costumen van het Koninkryk der Nederlanden, 53 col. plates of cavalry and infantry, hf. mor., 1830, 4to. (279) *Hornstein, £12 15s.*

3262 Moryson (Fynes). Itinerary, hand-made paper issue, 4 vol., hf. vell., 1907, 8vo. (168) *Edwards, £1 15s.*

3263 Nash (Joseph). Mansions of England in the Olden Times, plates, all four series, 4 vol., hf. mor., 1839, folio (291) *Parsons, £5*

3264 Payne (John). Tales from the Arabic, 3 vol., vell., g. t., *Villon Society*, 1884, 8vo. (198) *Hector, £1 15s.*

3265 Petit (Victor). Chateaux de la Vallée du Loire, plates, 2 vol., hf. mor., 1861, folio (293) *Batsford, £1 15s.*

3266 Portraits of the British Poets, from Chaucer to Cowper and Beattie, about 150 ports. on India paper, 2 vol., bds., 1824, 4to. (519) *Spencer, £3 12s. 6d.*

3267 Priapeia, or the Sportive Epigrams of Divers Poets on Priapus, front., bds. (500 printed), 1890, 4to. (500) *Jukes, £1 2s.*

3268 Rabelais (F.) The Five Books and Minor Writings, trans. by W. F. Smith, 2 vol., mor. ex., 1893, 8vo. (196) *Smith, £1 14s.*

3269 Rooses (Max). Dutch Painters of the Nineteenth Century, illustrated, cl. (4 copies), 1898-1901, 4to. (270) *Hill, £1 10s.*

3270 Scrope (Wm.) Art of Deer Stalking, first ed., engravings and lithographs, cl., 1838, 8vo. (215) *Hornstein, £3 5s.*

3271 Shakespeare (W.) Plays, Pickering's Diamond Edition, plates, 9 vol., mor., in book slide, 1825, 12mo. (205) *Perry, £2 2s.*

3272 Shaw (Henry). Dresses and Decorations of the Middle Ages, col. plates, 2 vol., hf. cf., Pickering, 1843, 4to. (276) *Hopkins, £3*

3273 Smith (Albert). Christopher Tadpole, first ed., plates by Leech, cf. ex., uncut, 1848, 8vo. (161) *Hornstein, £1 12s.*

3274 Spanish Series (The). Goya, Velasquez, the Prado, etc., ed. by Calvert, illustrated, 14 vol., cl., 1908, 8vo. (116) *Joseph, £1 3s.*

3275 Speed (John). Theatre of the Empire of Great Britain, imperfect, but containing maps of Virginia, New England and New York, and Carolina, w. a. f., 1676, folio (609) *Andrews, £1 11s.*

3276 Sporting Magazine (The), from January, 1856 to June, 1869, plates, 21 vol., hf. cf., with correct Sporting Magazine Title in each vol. (excepting the second half of 1868), 1856-1869), together 21 vol., 8vo. (458) *Beales, £12*

3277 Statuts de l'Ordre du St. Esprit estably par Henri III^me. Roy de France, 1711, contemp. mor. ex., the corners decorated, royal arms, gold borders, g. e., 1853, folio (288)
Smith, £9 10s.
3278 Stirling-Maxwell (Sir W.) Annals of the Artists of Spain, woodcuts, 3 vol., cl., 1848, 8vo. (149) *Edwards, £1* 12s.
3279 Stothard (C. A.) Monumental Effigies of Great Britain, plates, chiefly col., mor. ex., 1817, 4to. (277)
West, £2 17s. 6d.
3280 Studio (The), an Illustrated Magazine, vol. iv. to xxiv., in publisher's cl., 1894-1902, 4to. (481) *£2* 15s.
3281 Surtees (R. S.) Handley Cross, col. plates by Leech, orig. cl., n. d., 8vo, (109) *Bumpus, £1* 3s.
3282 Tennyson (A., Lord). Poems, chiefly Lyrical, cf., 1830, 8vo. (220) *Hornstein, £2* 2s.
3283 Thornton (A.) Adventures of a Post Captain, col. plates, cf., used copy, n. d. (1817), 8vo. (156) *Parker, £1* 5s.
3284 Tissot (J. J.) The Life of Our Saviour Jesus Christ, etchings, chromolithos. and photogravures, and numerous col. and other illustrations, 2 vol., hf. vell. ex., 1897, folio (604)
Rimell, £2 2s.
3285 Veitch (J.) Manual of Orchidaceous Plants, 2 vol., 1884-94, 8vo. (165) *Bumpus, £1* 9s.
3286 Woodward (G. M.) Caricature Magazine, 143 col. caricatures by Rowlandson and others, in 2 vol., each with title, orig. hf. mor., labels, fore-edges untrimmed, 1821, folio (607)
Sotheran, £16

[JANUARY 26TH, 1910.]

CHRISTIE, MANSON & WOODS.

THE LIBRARY OF MRS. HARTMANN, OF THE WHITE LODGE, RICHMOND PARK, AND OTHER PROPERTIES.

(No. of Lots, 217 ; amount realised, about £600.)

3287 Ainsworth (W. H.) Novels, illustrations by Cruikshank, "Phiz" and others, 16 vol., rox., n. d., 8vo. (2)
Hornstein, £2 9s.
3288 [Apperley (C. J.)] Life of a Sportsman, first ed., 36 col. plates by Alken, red cl., R. Ackermann, 1842, 8vo. (7)
Hornstein, £15 10s.
3289 Bacon (F.) Essayes, first complete ed. (autograph on back of title), contemp. vell., John Haviland, 1625, 4to. (210)
Maggs, £11 10s.
3290 Badminton Library of Sports and Pastimes, illustrations, 28 vol., cl., 1887-96, 8vo. (9) *Mayne, £2* 15s.

3291 Baffo (Giorgio). Poésies Complètes en dialecte Vénitien, port., 4 vol., cf. ex., *Paris*, 1884, 8vo. (10) *Hill*, £2 5s.
3292 Beyle (Henri). La Chartreuse de Parme, 2 vol.—Le Rouge et le Noir, 3 vol., printed on Japanese vell., plates by Foulquier and Dubouchet in duplicate, 5 vol., hf. mor. ex., uncut, t. e. g., *Paris*, 1883-5, 8vo. (13) *Quaritch*, £9
3293 Biolia Sacra Latina, Editionis Vulgatæ, gothic letter, double columns, initials painted, marginal MS. notes and 8 leaves of MS. in gothic letter, oak bds. covered with velvet, bookplate of the Abbey of St. Emmeram, at Ratisbon, fine copy, *Venetiis, Fr. de Hailbrun et Nic. de Frankfordia socios*, 1475, folio (207) *Pearson*, £99 15s.
3294 Brayley (E. W.) and Britton (J.) History of Surrey, upwards of 400 engravings, 5 vol., hf. mor., 1850, 4to. (151) *Smith*, £2 10s.
3295 British Poets. Aldine ed., by J. Mitford, A. Dyce and Sir H. Nicolas, 63 vol., cf. ex., 1866-90, 8vo. (3) *Maggs*, £10
3296 Bromley-Davenport (W.) Sport, LARGE PAPER, illustrations by Crealocke, bds., uncut, 1885, 4to. (152) *Bain*, £2 15s.
3297 Byron (Lord). Works, by Moore, vignettes, 17 vol., cf. ex., 1832-3, 8vo. (20) *Edwards*, £2 10s.
3298 Byron (Lord). Works, Library ed., port., 6 vol., cf. ex., 1855, 8vo. (198) *Smith*, £2 5s.
3299 Byron (Lord). Works, fronts. and vignette titles, 10 vol., cf. ex., 1879, 8vo. (21) *Kearsley*, £3 5s.
3300 Campbell (C.) Vitruvius Britannicus, or the British Architect, plates of public buildings, etc., 3 vol. (should be 5 vol., 1715-71), old cf., 1715-25, folio (204) *Sotheran*, £1 16s.
3301 Chaucer (Geoffrey). Works, by T. Speght, black letter, mor., g. e. (title repaired), Adam Islip, 1602, folio (208) *Kearsley*, £4 10s.
3302 Dante. La Divina Commedia, col Commento di Christ. Landino, painted capitals, device in red, mor. ex., silken ends and fly-leaves (fine copy), *Vinegia per Octaviano Scoto*, 1484, folio (206) *Read*, £22
3303 Dictionnaire des Sciences Naturelles (rédigé par F. Cuvier), col. plates (bound separately in 11 vol.), 71 vol,. bds. and hf. cf., 1816-30, 8vo. (34) *Grant*, £1 10s.
3304 Dobson (Austin). Poems on Several Occasions, port. and etchings, 2 vol., cf. ex., 1895, 8vo. (36) *Sotheran*, £1 8s.
3305 Egan (Pierce). Boxiana, plates, vol. i., ii., iv. and v., bds., uncut, 1824-30, 8vo. (212) *Smith*, £11 10s.
3306 Egan (P.) Boxiana, ports., 5 vol., hf. mor. (rubbed), n. d.-1828-9, 8vo. (213) *Kearsley*, £8
3307 Encyclopædia Britannica, ninth ed., with Index, 25 vol., hf. mor., 1875-89, 4to. (159) *Kearsley*, £4
3308 Foster (J. J.) French Art from Watteau to Prud'hon, author's ed., col. fronts. and 53 photogravures, 3 vol., cl., 1905-7, folio (175) *Vyt*, £5
3309 French Revolution. Biographie Nouvelle des Contemporains, ports., 20 vol., hf. cf., *Paris*, 1820-5, 8vo. (63) *Sotheran*, £2 12s.

3310 Froude (J. A.) •History of England, Library ed., 12 vol., cf.
ex., 1858-70, 8vo. (64) *Tregaskis,* £4 4s.
3311 [Geneste (J.)] Some Account of the English Stage, 10 vol.,
bds., uncut, *Bath,* 1832, 8vo. (211) *Quaritch,* £8 5s.
3312 Goldsmith (O.) Works, ed. by Cunningham, Library ed.,
vignettes, 4 vol., cf. ex., 1854, 8vo. (199) *Bumpus,* £2 15s.
3313 Lever (Charles). Works, Library ed., plates by "Phiz," 18
vol., hf. mor. ex., 1872, 8vo. (193) *Hollings,* £7 10s.
3314 Macaulay (Lord). History of England, port., 8 vol.—Critical
and Historical Essays, 4 vol.—Miscellaneous Writings and
Speeches, 4 vol., together 16 vol., cf. ex., 1880-9, 8vo. (83)
Harding, £4 10s.
3315 Molinier (Émile). Le Mobilier Royal Francais, col. and
other plates, 3 vol., hf. mor. ex., *Goupil et Cie., Paris,* 1902,
folio (178) *Bumpus,* £16
3316 Monnet (J.) Anthologie Française, port. after Cochin, plates
after Gravelot, woodcuts and music, 3 vol., mor. ex. [*Paris*],
1765, 8vo. (94) *Sawyer,* £4 17s. 6d.
3317 Montpensier (Mdlle.) Mémoires, 7 vol., mor. ex., *Maes-
tricht,* 1776, 8vo. (95) *Sotheran,* £6
3318 Prescott (W. H.) Works, with Life by Ticknor, Library ed.,
ports., 15 vol., hf. cf. ex., 1848-64, 8vo. (202)
Edwards, £4 15s.
3319 Prescott (W. H.) Historical Works, Library ed., by J. F.
Kirk, 12 vol., cl., Gibbings, n. d., 8vo. (105)
Sotheran, £1 12s.
3320 [Restif de la Bretonne (N. E.)] Les Contemporaines, plates
by Binet and others (some proofs before letters), 42 vol., cf.
ex., *Léipsick,* 1781-85, 8vo. (107) *Parsons,* £13
3321 Restif de la Bretonne (N. E.) Monsieur Nicholas, port., 14
vol., hf. mor., *Paris,* 1883, 8vo. (108) *George,* £2 2s.
3322 Richardson (C. J.) Studies from Old English Mansions,
lithographs, some col., 4 vol. in 2, hf. mor., g. e., 1841-48,
folio (180) *Maggs,* £6 5s.
3323 Sainte-Beuve (C. A.) Causeries du Lundi, 15 vol.—Nouveaux
Lundis, 13 vol.—Premiers Lundis, 3 vol., together 31 vol.,
hf. cf., *Paris, s. d.,* 8vo. (112) *Sotheran,* £5 15s.
3324 Sainte-Beuve (C. A.) Port-Royal, deuxième éd., 5 vol., hf.
mor., uncut, t. e. g., *Paris,* 1860, 8vo. (113) *Joseph,* £1 12s.
3325 Shakespeare (William). Works, ed. by J. P. Collier, port.,
8 vol., cf. ex., 1844, 8vo. (119) *Savile,* £4 8s.
3326 Scott (Sir W.) Waverley Novels, Library ed., plates and
vignettes, 25 vol., cf. ex., *Edinb.,* 1852-7, 8vo. (195)
Savile, £13
3327 [Surtees (R. S.)] Mr. Sponge's Sporting Tour, first ed., col.
plates by Leech, orig. cl., fine copy, 1853, 8vo. (131)
George, £6 2s. 6d.
3328 [Surtees (R. S.)] Handley Cross, or Mr. Jorrocks's Hunt,
1854—Mr. Facey Romford's Hounds, 1865—"Plain or
Ringlets?" 1860, 3 vol., first eds., col. and other illustrations
by John Leech and "Phiz," hf. mor., uncut, t. e. g. (as good
as new), 8vo. (132) *Hornstein,* £14 10s.

3329 [Surtees (R. S.)] "Ask Mamma," first ed., 1858—"Plain or
Ringlets?" n. d. — Mr. Sponge's Sporting Tour, n. d. —
Handley Cross, n. d.—Mr. Romford's Hounds, n. d., together
5 vol., hf. mor. ex., 8vo. (133) *Mayne*, £10
3330 Trollope (Anthony). Chronicles of Barsetshire, illustrations,
8 vol., cf. ex., 1887-9, 8vo. (139) *Bumpus*, £3
3331 Williams (G.) Oxonia Depicta, 66 large views of Colleges
and Halls of Oxford, old cf., *Oxon.*, 1732, folio (205)
Bain, £4

[JANUARY 26TH, 27TH AND 28TH, 1910.]

HODGSON & CO.

A MISCELLANEOUS COLLECTION.

(No. of Lots, 982 ; amount realised, about £800.)

3332 Ackermann (R.) Microcosm of London, orig. ed., col. plates
by Pugin and Rowlandson, 3 vol., hf. mor., t. e. g., 1808-10,
4to. (556) *Plummer*, £17 5s.
3333 Acta Sanctorum quæ ex Latinis et Græcis aliarumque Gentium
Antiquis Monumentis notis illustravit Joannes Bollandus,
Operam et Studium contulit G. Henschenius, editio novis-
sima, curante J. Carnandet, cum Supplemento cura L. M.
Rigollot (from January to October), 63 vol., hf. mor., cl.
sides, t. e. g., *Paris*, V. Palme, 1863-83, folio (302) £53
[Sold on Feb. 3rd. *See* Burton's "Book Hunter," ed. J.
H. Slater, pub. by Messrs. Routledge & Co. in their "Lon-
don Library Series," page 223, for a descriptive account of
the "Acta Sanctorum."—ED.]
3334 Actis and Constitutionis of the Realme of Scotland (The),
black letter, woodcut of the arms of Queen Mary on title
(the latter cut into and lower margins of last 2 leaves
repaired), old cf., *Imprentit at Edinburgh be R. Lekpreuik*,
1566, folio (483) *Maggs*, £4 6s.
[The fly-leaf bears the autograph of Alexander Boswell
(father of Johnson's biographer) with a note in his auto-
graph. Inserted at the end are MS. "Excerpts from the
Records of Parliament in the Laigh Parliament House,"
on 21 leaves.—*Catalogue.*]
3335 [Akerman (J. Y.)] Tales of other Days, first ed., cuts by G.
Cruikshank, bds., uncut, 1830, 8vo. (148) *Shepherd*, 15s.
3336 Alexander (W.) Dress and Manners of the Chinese and
Austrians, 100 col. plates, 2 vol., hf. bd., T. M'Lean [1813-14],
roy. 8vo. (102) 15s.
3337 Allison (T.) Account of a Voyage from Archangel in Russia,
2 charts, hf. bd., 1699, 16mo. (186) *Edwards*, 19s.

3338 Amsinck (P.) Tunɔridge Wells and its Neighɔourhood, etchings, cl., 1810, roy. 4to. (95) 9s.

3339 Anderson (H. C.) Stories and Fairy Tales, trans. ɔy Sommer, LARGE PAPER, illustrations ɔy A. J. Gaskin (limited to 300 copies), 2 vol., ɔuckram gt., uncut, 1893, 8vo. (113) 13s.

3340 Annual Register from the commencement in 1758 to 1879 and Indexes, 1758-1819, in 125 vol., hf. cf.—New Series, from 1882 to 1899, in 18 vol., cl., together 143 vol., 1758-1900, 8vo. (267) *Bailey, £11* 5s.

3341 Archives Diplomatiques. Recueil de Diplomatie et d'Histoire, from January, 1861 to Decemɔer, 1887, in 39 vol., cf. gt. (ɔindings of the first 5 vol. ruɔɔed), and 19 numɔers, sewed, 8vo. (266) *£*10
[Sold on Feɔruary 3rd.—ED.]

3342 Barɔier (A.) Dictionnaire des Ouvrages Anonymes, Troisème ed., 4 vol., hf. mor., uncut, *Paris,* 1869-79, 8vo (132)
*Barnard, £*1 2s.

3343 Bariffe (W.) Militarie Discipline, port., plate of arms and folding plan (last leaf defective), early ɔookplate of Christ Church, Oxford, old cf., 1643, 4to. (183) *Bailey, £2* 2s.

3344 Bellenden (John). Works, 2 vol., and First Five Books of Livy's Roman History, woodcuts, 3 vol., mor. ex., t. e. g., ɔy Ramage, *Edinburgh,* 1821-2, sm. 4to. (484)
*Karslake, £*2 12s. 6d.

3345 Belon (Pierre). Les Oɔservations de plusieurs Singularitez trouvées en Grece, Asie, Egypte, etc., woodcuts and map of Mount Sinai, cf., *Paris,* 1555, sm. 4to. (229) *£*1 10s.

3346 Benzoni (G.) Novæ Novi Orɔis Historiæ (stained), old cf., E. Vignon, 1600, 8vo. (188) 15s.

3347 Binns (W. Moore). The First Century of English Porcelain, col. plates, LARGE PAPER (limited to 100 copies), cl., g. e., 1906, 4to. (286) *Brown, £*1 10s.

3348 Book of Beauty (King Edward VII. Era). A Collection of Beautiful Portraits, ed. ɔy Mrs. F. H. Williamson, edition de luxe, cl. gt., uncut, 1902, folio (308) 15s.

3349 Bouchette (J.) British Dominions in North America, plates and maps, 3 vol., 1832, 4to. (194) *Grant, £*1 7s.

3350 Bowring (J.) Minor Morals for Young People, first ed., plates by G. Cruikshank, 3 vol., cl., 1834-5-9, 8vo. (149)
Hornstein, 12s.

3351 Brayley (E. W.) History of Surrey, maps, plates and pedigrees, 5 vol., hf. cf., G. Willis, 1850, 8vo. (445) *£*1 6s.

3352 British Classics, Sharpe's ed., plates after Stothard ɔy Heath, 24 vol., old cf., 1804-10, 8vo. (526) *Brown, £3* 4s.

3353 Bryce (James). The American Commonwealth, first ed., 3 vol., orig. cl., uncut, 1888, 8vo. (385) *Bain, £3* 2s. 6d.

3354 Carlyle (T.) Works, Centenary ed., ports., 30 vol., LARGE PAPER (limited to 300 copies), ɔuckram, t. e. g., Chapman and Hall, 1896-9, 8vo. (455) *Quaritch, £*6 10s.

3355 Chronic Historie der Nederlandtscher Oorlogen Troublen en oproeren oorspronck anuanck en eynde Item den Standt der Religien tot desen Jare 1580 [Philip van Marnix van

Sant Aldegonde], editio princeps, black letter, title in red
and black, vell. (headlines of 2 leaves cut into), *Gedruct tot
Noortwicz, Anno* 1579, 12mo. (176) *Barnard,* £19
[A clean copy of this Chronicle, printed at Norwich by
Anthony de Solempne, who first introduced printing into
that city.—*Catalogue.*]

3356 Clifford (A.) Collectanea Cliffordiana, in 3 parts, wrapper,
uncut, *Privately printed, Paris,* 1817, 8vo. (93) 15s.

3357 Collins (A.) Peerage of England, best ed., illustrations, 9
vol., cf. gt., 1812, 8vo. (163) *Bailey,* £1 2s.

3358 Commines (Philippe de). Mémoires, ports. and plates, 4 vol.,
cf. gt., red edges, 1747, 4to. (280) £1 3s.

3359 Cruikshank (G.) The Humourist, col. plates, 4 vol., LARGE
PAPER (260 copies so printed), 1892, 8vo. (146) £1 12s.

3360 Davenant (Sir W.) The First Days Entertainment at Rut-
land-House, first ed. (hole in sig. E 3), contemp. MS. note
on end leaf), old cf., *J. M. for H. Herringman,* 1657, 24mo.
(225) *Dobell,* £9

3361 Davy (H.) A Series of Etchings of the Architectural Antiqui-
ties of Suffolk, plates, LARGE PAPER, *Southwold,* 1827, folio
(593) *Rimell,* £2 2s.

3362 Deakin (R.) Florigraphia Britannica, plates, a coloured copy,
4 vol., cl., 1845, 8vo. (125) 17s.

3363 [Defoe (D.)] La Vie et les Avantures Surprenantes de
Robinson Crusoe [par St. Hyacinthe et Van Effen], first
ed. in French, plates by Picart, 3 vol., old cf., *Amst.,*
1720-21, 8vo. (223) *Barnard,* £1

3364 Deville (A.) Histoire de l'Art de la Verrerie dans l'Antiquité,
col. plates, in portfolio, *Paris,* 1873, 4to. (281) £1 13s.

3365 Dickens (C.) Master Humphrey's Clock, first ed., 3 vol., hf.
mor., 1840-41, 8vo. (69) 13s.

3366 [Dodgson (C. L.)] Through the Looking-Glass—The Hunt-
ing of the Snark, first eds., illustrations, 2 vol., cl., 1872-6,
8vo. (469) *Barnard,* £1 11s.

3367 Dresser (H. E.) and Sharpe (B.) A History of the Birds of
Europe, with the Supplement, col. plates by J. G. Keule-
manns and others, 84 parts, forming 8 vol. bound in 7, cl.
(with the 8 title-pages), and the Supplement (forming vol.
ix.), in 9 parts, 1871-96, 4to. (559) *Freidlander,* £41

3368 [D'Urfey (T.)] Pendragon, or the Carpet Knight his Kalen-
dar, contemp. cf., J. Newton, 1698, 8vo. (224) *Barnard,* 14s.

3369 Ferne (J.) The Blazon of Gentrie, woodcuts (cancel of pages
42 and 43, part ii. inserted), cf. (back missing), *J. Windet
for A. Maunsell,* 1586, sm. 4to. (171) *Tregaskis,* £2 4s.

3370 Fétis (F. J.) Biographie Universelle des Musiciens, avec
Supplément, 10 vol., hf. bd., *Paris,* 1860-81, 8vo. (136)
Barnard, £2 4s.

3371 Fielding (H.) Works, fronts., 12 vol., old cf., 1783, cr. 8vo.
(528) *Brown,* 19s.

3372 Finch (E.) Charge against Edward Finch, Vicar of Christ's
Church in London, woodcut on title, 8 leaves, hf. mor.,
1641, sm. 4to. (179) *Shepherd,* 14s.

16—2

3373 George Eliot's Works, Library ed., fronts., 10 vol., Juckram gilt, t. e. g., 1901, 8vo. (116) *Karslake*, £1 19s.
3374 Glapthorne (Henry). Poëms, first ed. (upper margin of 1 leaf defective), old cf., *Printed by R. Bishop for Daniel Pakeman*, 1639, sm. 4to. (226) *Dobell*, £16 10s.
3375 Goldsmith (O.) Works, by Cunningham, port., 4 vol., cf. gt., 1854, 8vo. (530) *Brown*, £2 6s.
3376 Hakluyt (R.) Divers Voyages touching the discoverie of America and the Islands adjacent, 𝔟𝔩𝔞𝔠𝔨 𝔩𝔢𝔱𝔱𝔢𝔯, maps, fac. reprint, cf., t. e. g. [1582], 8vo. (456) *Grant*, £2 2s.
3377 Hansard's Parliamentary Debates and Parliamentary History, from the commencement, comprising Cobbett's Parliamentary History, A.D. 1066-1803, 36 vol.—Cobbett and Hansard's Parliamentary Debates, first series, 1806-20, 41 vol.—Hansard's Parliamentary Debates, new series, 1820-30, 25 vol.—Third Series, 1830-91, 356 vol., with 6 Indexes—The Parliamentary Debates, authorized edition, fourth series, 1892-1908 (vol. cl. wanting), 199 vol.—Parliamentary Debates Official Reports, Lords and Commons for 1909, 14 vol.—Extra Parliamentary Hansard for 1890, 1900-1 and 1901-2, part ii., together 678 vol., bound in 311 vol. hf. russ., 217 vol. hf. mor., 24 vol. bds., 125 vol. cl., and 4 parts sewed, 1806-1909, roy. 8vo. (260) *Sotheran*, £121
 [Sold on Feb. 3rd. The binding of the earlier volumes was somewhat worn, those in half morocco were well bound, while the cloth volumes were as new.—ED.]
3378 Hardy (J.) Tour in the Mountains of the High Pyrenees, map and 23 col. views, cf., Ackermann, 1825, 8vo. (153)
 Brown, £1 9s.
3379 Helps (A.) The Spanish Conquest in America, maps, 4 vol., cf. gt., 1855-61, 8vo. (51) *Grant*, £1 9s.
3380 Henderson (G. F. R.) Stonewall Jackson and the American Civil War, first ed., ports., maps and plans, 2 vol., hf. cf., t. e. g., 1898, 8vo. (106) *Bumpus*, £1 13s.
3381 Heptameron, or the Tales of Margaret, Queen of Navarre, by G. Saintsbury, LARGE PAPER, plates on Japanese paper, and vignettes, 5 vol., Juckram, 1894, 8vo. (49)
 Sotheran, £2 10s.
3382 Hervey (W.) Visitation of Suffolke, pedigrees and cuts of arms, 2 vol., cl., 1866-71, 8vo. (429) £1 7s.
3383 Hieronymi Opus Epistolarum, cum Scholiis Des. Erasmi, woodcut initials, capital letters rubricated, 3 vols. in 2, old cf. over oak boards, *Basileæ*, 1524, folio (301) £1 5s.
3384 Hieronymi Epistolæ, opera ac studio Mariani Victorii Reatini, woodcut initials, 3 vol. in 4, cf. gt., Caraffa arms, *Romæ*, P. Manutius, 1565, folio (302) £1
3385 Hind (H. Y.) The Canadian and Red River Exploring Exhibition of 1857, etc., plates and maps, 2 vol., cl., uncut, 1860, 8vo. (383) *Hill*, £1 10s.
3386 Hulæt (R.) ABCEdarium Anglico Latinum, first ed., initial letters, old cf., W. Riddel, 1552, folio (298)
 Barnard, £1 15s.

3387 [Hugo (Victor).] Hans of Iceland, first ed., plates ɔy G. Cruikshank, cf. ex., 1825, 8vo. (150) *G. H. Brown, £1* 3s.
3388 Hunt (Leigh). Stories from the Italian Poets, first ed., 2 vol., orig. cl., uncut (name on title), 1846, 8vo. (115) *Davy,* 13s.
3389 James (W.) Naval History of Great Britain, by Captain Chamier, ports., 6 vol., hf. cf., 1837, 8vo. (52) 11s.
3390 Jesse (J. H.) Court of England during the Reign of the Stuarts, first ed., fronts., 4 vol., orig. cl., uncut, 1840, 8vo. (447) *Bumpus, £3* 5s.
3391 Jesse (J. H.) The Pretenders and their Adherents, plates, 2 vol., orig. cl., 1846, 8vo. (448) *Sotheran, £1* 4s.
3392 Jesse (J. H.) Literary and Historical Memorials of London, first ed., fronts., 2 vol., orig. cl., 1847, 8vo. (449) *Rayson, £1* 7s.
3393 Jesse (J. H.) London and its Celeɔrities, first ed., 2 vol., orig. cl., 1850, 8vo. (450) *Maggs, £2* 10s.
3394 Jesse (J. H.) King Richard the Third and some of his Contemporaries, first ed., port., orig. cl., 1862, 8vo. (451) *Elliot, £5* 12s. 6d.
3395 Jesse (J. H.) Life and Reign of King George the Third, first ed., 3 vol., orig. cl., 1867, 8vo. (452) *Quaritch, £2* 6s.
3396 Jesse (Capt.) Life of Brummell, fronts., 2 vol., orig. cl., 1844, 8vo. (454) *Edwards, £1* 1s.
3397 Jewish Encyclopædia, a Descriptive Record of the History, etc. of the Jewish People, edited by Isidore Singer and others, illustrations, 12 vol., mor., g. e., Funk and Wagnalls, 1901, imp. 8vo. (357) *£10* 12s. 6d.
3398 [Lamɔ (C.)] Essays of Elia, second series, first American ed., orig. bds., uncut, with leaf of advertisements, *Philadelphia,* 1828, 8vo. (63) *Grant, £2* 4s.
3399 Latham (J.) A General Synopsis of Birds, 6 vol.—Supplement, 2 vol.—Index Ornithologicus, 2 vol., col. plates, 10 vol., old cf., 1781-90, 4to. (560) *Wheldon, £2* 10s.
3400 [Le Sage (A. R.)] Gil Blas, first ed. of Smollett's translation, plates, 4 vol., old cf. (vol. i. reɔacked), 1750, 24mo. (58) 13s.
3401 L'Estrange (J.) Church Bells of Norfolk—Raven (J. J.) Church Bells of Suffolk, plates, 2 vol., cl., 1874-90, roy. 8vo. (87) *Bain, £1* 2s.
3402 Liddell and Scott. Greek-English Lexicon, seventh ed., cl., *Oxford,* 1890, 8vo. (10) 19s.
3403 Luminalia, or the Festivall of Light. Personated at a Masque at Court, By the Queenes Majestie and her Ladies on Shrove-tuesday Night, 1637 (pagination of last 2 leaves shaved), sheep, *Printed by J. Haviland for T. Walkley,* 1637, sm. 4to. (227) *Tregaskis, £13* [The authorship has ɔeen variously attriɔuted to Ben Jonson, Thomas Lodge and T. Jones (*see* Lowndes), but in Greg's "List of Masques" it is given as unknown.—*Catalogue.*]
3404 Macaulay (Lord). Works, Alɔany ed., ports., 12 vol., hf. cf. gt., 1898-1903, 8vo. (109) *Brown, £1* 16s.

3405 Maxwell (Sir H.) Story of the Tweed, illustrations ɔy D. Y. Cameron, ɔuckram gilt, t. e. g., 1905, folio (307)
Forrester, £1

3406 Malet (Capt.) Annals of the Road, first ed., col. illustrations, orig. cl., 1876, 8vo. (370) *Quaritch,* £2 2s.

3407 Martens (G. F.) . Recueil des principaux Traités de l'Europe, avec continuation par Samwer, Hopf et Stoerk, avec Taɔle generale, etc., *Gottingne,* 1791-1909, 8vo. £70
[Sold on February 3rd.—Ed.]

3408 May (John). A Declaration of the Estate of Clothing now used within this Realme of England (title soiled and wanted A 1 ɔlank), hf. cf., A. Islip, 1613, sm. 4to. (185)
Pickering, £2

3409 Meadows (Kenny). Heads of the People, first ed., 2 vol., red cl. gt., uncut, 1840-41, 8vo. (60) 13s.

3410 Milton (J.) Paradise Regain'd, first ed., with the leaf " Licensed July 2, 1670," unpaged leaf of errata at end, and the word " loah " on page 67 uncorrected (some top lines shaved and paginations cut into), cf., *Printed by J. M. for John Starkey,* 1671, 8vo. (228) *Taylor,* £3 3s.

3411 Morris (F. O.) British Moths, ɔy Kirɔy, col. plates, 4 vol., cl. gt., 1903, imp. 8vo. (122) *Hill & Son,* 18s.

3412 Neale (J. P.) Views of the Seats of Noɔlemen and Gentlemen, the two series, LARGE PAPER, plates on India paper, 11 vol., hf. mor., g. e., 1818-29, 4to. (557) *Sotheran,* £10 5s.

3413 Novi Testamenti Editio Vulgata, full-page woodcuts of the Apocalypse after Dürer (one leaf defective), old cf, *Dilingœ,* 1565 (230) *Reader,* £1 2s.

3414 Olivier (J.) Fencing Familiarized, folding plates, old cf., J. Bell [1771], 8vo. (222) 13s.

3415 O'Neill (H.) Illustrations of the Sculptured Crosses of Ancient Ireland, 36 litho. plates, 1 coloured (some plates foxed), with descriptive text, hf. bd., 1857, folio (933)
Quaritch, £10 10s.

3416 Oxberry's New English Drama, ports., 21 vol., old cf., 1818-23, 8vo. (527) *Hornstein,* £1 10s.

3417 Pinkerton (John). Collection of Voyages and Travels, ɔest ed., maps and plates, 17 vol., hf. cf., 1808-14, 4to. (561)
Grant, £2 10s.

3418 Planché (J. R.) Cyclopædia of Costume, col. plates (a few as usual wanting), 2 vol., cl., 1876, 4to. (558)
Brown, £1 19s.

3419 Prescott (W. H.) Historical Works, ports. and maps, 12 vol., hf. mor., Routledge, 8vo. (50) £2 6s.

3420 Ralegh (Sir W.) The Discoverie of the Large, Rich and Bewtiful Empyre of Guiana (title mounted and a few leaves frayed), mor., g. e., *London,* R. Roɔinson, 1596, sm. 4to. (189) £3

3421 Ranke (L.) History of the Popes of Rome, ɔy Sarah Austin, 3 vol., uncut, 1841, 8vo. (55) 14s.

3422 Ruvigny (Marquis of). The Plantagenet Roll of the Blood

Royal, Essex Volume, with a Supplement to the previous
volumes, cl., t. e. g., 1908, imp. 8vo. (124) *Walford,* £2 4s.
3423 St. John (C.) A Tour in Sutherlandshire, first ed., illustra-
tions, 2 vol., cl., uncut, 1849, 8vo. (373) *Quaritch,* 13s.
3424 [Scott (Sir W.)] Peveril of the Peak, first ed., 4 vol., with
autograph, "Chas. Lamo," on each vol., uncut, *Edinburgh,*
1822, 8vo. (151) £1
3425 Surtees (R. S.) Mr. Facey Romford's Hounds, first ed., col.
plates, orig. cl., 1865, 8vo. (143) *Sawyer,* £5 7s. 6d.
3426 Surtees (R. S.) Plain or Ringlets, first ed., col. plates, orig.
cl., 1860, 8vo. (144) *Sawyer,* £4 17s.
3427 Sutcliffe (M.) The Practice, Proceedings and Lawes of
Armes, black letter, hf. bd., *London,* C. Barker, 1593, sm.
4to. (182) *Tregaskis,* £1
3428 Thoms (W. J.) Collection of Early Prose Romances, 3 vol.,
hf. mor., t. e. g., Pickering, 1828, 8vo. (56) 13s.
3429 Villacastin (Thomas de). Manga Panalanging Pagtatagobilin
sa Calolova nang tavong nag hihingalo, plates, vell., *Manila,*
Nicolas de la Cruz Bagay, 1760, 12mo. (187)
Quaritch, £1 2s.
3430 Virgil. Les Géorgiques de Virgile, traduction par Delille,
plates after Eisen, old French mor., g. e., *Paris,* 1770, 8vo.
(152) *Maggs,* £1 9s.
3431 [Warren (S.)] Ten Thousand A-Year, first ed., 3 vol., orig.
cl., 1841, 8vo. (64) *Buchanan,* £1 2s.
3432 Waugh (E.) Complete Works, fronts., LARGE PAPER, with
autograph letter inserted, 9 vol. (should be 11 vol.), hf. rox.,
Manchester, 1882-3, 8vo. (458) £1 14s.
3433 Whitehead (C. E.) The Camp-Fires of the Everglades, plates
on Japan paper, cl., *Edin.,* 1891, imp. 8vo. (121) *Bain,* 15s.
3434 Wiltshire Archæological and Natural History Magazine,
plates, with Indexes—Aostracts of Wiltshire Inquisitiones
Post Mortem, edited oy G. S. and E. A. Fry, 33 vol., hf.
mor., t. e. g., 1854-1902, 8vo. (444) *Sotheran,* £10

[FEBRUARY 1ST, 1910.]

SOTHEBY, WILKINSON & HODGE.

THE RADWAY GRANGE LIBRARY (*re* THE REV. W. S. MILLER,
cestui que trust, DECEASED), AND ANOTHER PROPERTY.

(No. of Lots, 327 ; amount realised, £779 13s. 6d.)

3435 Alken (Henry). Symptoms of being Amused, 42 col. plates,
hf. bd., 1822, oolong folio (319) *Maggs,* £4 14s.
3436 American War. Collection of Twenty-seven Maps and Plans,
including Boston City with entrenchments—Bunker's Hill,
with action of 17th of June—Queoec, with American posi-

tion—Map to illustrate Gen. Burgoyne's Advance—Siege
of Charlestown—Battle of Camden—Battle of Guildford,
Philadelphia City, with Sir W. Howe's position, etc., in 1
vol., hf. mor., 1775-81, folio (157) *Hornstein,* £84

3437 Atlas Geographus, or a Compleat System of Geography,
maps, 5 vol., cf., 1711-17, 4to. (114) *Carter,* 16s.

3438 Bacon (Sir F.) Historie of the Raigne of Henry VII., first
ed., port., 1622—Grimaldus (Laur.) The Counsellor (last
leaf mended), *Lond.,* Richard Bradocke, 1598, in 1 vol., cf.,
1598-1622, folio (159) *Ellis,* £5 15s.

3439 Barriffe (Wm.) Militarie Discipline, port., front., etc., cf.
(reacked), 1643, 4to. (116) *Leighton,* £1 12s.

3440 Beaumont and Fletcher. Comedies and Tragedies, first ed.,
port. by Marshall, 1647—The Wild-Goose Chase, first ed.,
1652, in 1 vol., old cf. gt. (some leaves stained), 1647-52,
folio (162) *Hornstein,* £36

3441 Blome (R.) The Gentleman's Recreation, LARGE PAPER,
plates, cf. (second title mended), 1686, folio (164)
Porter, £8

3442 Blome (R.) Present State of His Majesties Isles and Terri-
tories in America, port. and maps, cf., 1687, 8vo. (11)
H. Stevens, £3 5s.

3443 Boccaccio (G.) Il Decamerone, port., and plates after Eisen,
etc., 5 vol., hf. cf., *Londra (Paris),* 1757, 8vo. (12)
Marinis, £3 12s.

3444 Boydell (John). Collection of One Hundred Views of Eng-
land and Wales, hf. mor. (1790), folio (167)
W. Daniell, £8. 5s.

3445 Boydell (J.) Picturesque Scenery of Norway, 80 col. plates
by J. W. Edy, 2 vol., hf. mor., uncut, t. e. g., 1820, roy. folio
(320) *Rimell,* £5 5s.

3446 Brooke (Fulke Greville, Lord). Certain Learned and Elegant
Workes, first ed., old binding (title soiled and edges frayed),
1633, folio (169) *Tregaskis,* £1 12s.
[As usual, this copy commences at page 23. It is con-
jectured that the absent pages consisted of "A Treatise on
Religion," which was cancelled by order of Laud.—*Bibl.
Anglo-Poetica.*]

3447 Browne (Sir Thos.) Works, first ed., port. by White, cf., 1686
—Worlidge (J.) Systema Agriculturae, old cf. (wormed),
1687, folio (170) *Bain,* £3

3448 Brunet (J. C.) Manuel du Libraire, 5 vol., hf. mor., *Paris,*
1842-44, roy. 8vo. (16) *Hill,* £1 11s.

3449 Bulwer (J. B.) Anthropometamorphosis, best ed., woodcuts,
cf. (title repaired and a few leaves deiective, frontispiece
wanted), 1653, 4to. (122) *Bloomfield,* £1 5s.

3450 Burton (Robt.) Anatomy of Melancholy, eighth ed., engraved
title by Blon, old cf., 1676, folio (173) *Edwards,* 17s.

3451 Carew (Richard). The Survey of Cornwall, first ed., old cf.
gt., *S. S. for John Jaggard,* 1602, 4to. (123) *Maggs,* £2 13s.

3452 Cartwright (Wm.) Comedies, Tragi-Comedies, with other

Poems, first ed. (spaces left in the two Poems in sheet U, with duplicate pages 301-6), port. ɔy P. Lomɔart, old cf. (title cut into), 1651, 8vo. (20) *Tregaskis*, £3 3s.

3453 Couvray (L. de). Les Amours du Chevalier de Faublas, 4 vol., plates ɔy Colin, cf., *Paris*, 1821, 8vo. (27)
Quaritch, £2 16s.

3454 Cox (Thos.) Magna Britannia et Hiɔernia, 6 vol., maps, old cf., 1720-31, 4to. (124) *Bull*, 16s.

3455 Croniken. Das Buch der Croniken und Geschichten, lit. goth.. woodcuts, old stamped pigskin (one leaf mended and stained), *Augsburg*, H. Schönsperger, 1500, folio (179)
Maggs, £7 5s.

3456 Davenant (Sir William). Works, first ed., port. by Faithorne, old cf., 1672-73, folio (181) *Bain*, £4 8s.

3457 Dampier (W.) New Voyage round the World, 4 vol., maps and plates, cf., 1697-1709, 8vo. (28) *Thorp*, £1 18s.

3458 Daniel (Samuel). Workes, old cf., imperfect (a. f.), 1623, 4to. (126) *Dobell*, £2 2s.

3459 Darien. Defence of the Scots Settlement at Darien, *Edin.*, 1699—Defence of the Scots aɔdicating Darien, 1700—Just and Modest Vindication of the Scots Design for the having estaɔlished a Colony at Darien, 1699—Short Vindication of Phil. Scot's Defence of the Scots aɔdicating Darien, 1700, etc., in 1 vol., old cf., 1699-1702, 8vo. (29) *Dobell*, £3 3s.

3460 Dion Cassius. Dionis Historiarum Romanarum Liɔri Graece, first ed., cf., *Lutet. ex officina R. Stephani*, 1548, folio (184)
Klenck, £1 1s.

3461 Doddridge (Sir John). History of Wales, Cornwall and Chester, old cf., 1630—Charleton (W.) Chorea Gigantum, plates, cf., 1663, together 2 vol., 4to. (127) *Leighton*, £1 3s.

3462 Du Fresnoy (C. A.) De Arte Graphica, trans. by Dryden, first ed., front., contemp. cf., g. e., 1695, 4to. (128)
Leighton, £1 12s.

3463 Dugdale (Sir W.) Baronage of England, 2 vol. in 1, old cf., 1675-76, folio (188) *Bull*, £1 17s.

3464 Esquemeling (J.) History of the Bucaniers of America, maps and plates, old cf, 1699, 8vo. (37) *Rimell*, £2 10s.

3465 Farquhar (George). Comedies, third ed., plates, old cf., 1714, 8vo. (40) *Ellis*, 12s.

3466 Fer (N. de). Les Forces de l'Europe, Asie, Afrique et Amérique, plates, plans, etc. (ɔinding ɔroken), *Amst., s. n.*, oɔlong folio (194) *Thorp*, £1 2s.

3467 Fielding (H.) Joseph Andrews, first ed., 2 vol., cf. (reɔacked), 1742, 8vo. (42) *Spencer*, £9 5s.

3468 Fielding (H.) Amelia, first ed., 4 vol., cf. (reɔacked), 1752, 8vo. (43) *Rimell*, £3

3469 Fielding (T. H.) British Castles, 25 col. plates (some extra engravings inserted), hf. bd., 1825, oɔlong 4to. (309)
Edwards, £2 6s.

3470 Fletcher (P.) The Purple Island, or the Isle of Man, first ed., with the extra leaf at the end, cf. (reɔacked), *Cambridge*, 1633, 4to. (130) *Ellis*, £4 4s.

3471 Florio (John). Worlde of Wordes, first ed., engraved title, old cf., g. e. (2 pages ink stained), E. Blount, 1598, folio (196) *Fox,* £15 5s.

3472 Fox (John). Acts and Monuments, eighth ed., black letter, ports., plates (some torn) and woodcuts, 3 vol., old cf. gt. (wormed), 1641, folio (198) *Rimell,* £1 7s.

3473 Frezier (Mons.) Voyage to the South Sea, map, plans and plates, cf., 1717, 4to. (131) *Ellis,* £1 2s.

3474 Gerarde (John). Herball, by T. Johnson, engraved title (packed) and woodcuts, old cf. (repacked, last leaf torn and mounted, and one leaf defective), 1636, folio (201) *Bull,* £1 13s.

3475 Guillim (John). Display of Heraldry, sixth and best ed., port., plates and coats-of-arms, rough cf. (some leaves mended, one defective, some MS. added, wormed), tall copy, 1724, folio (203) *Bull,* £3

3476 Hennepin (L.) New Discovery of a Vast Country in America, folding maps and plates (one torn), old cf., 1699, 8vo. (59) *B. F. Stevens,* £15

3477 Hexham (H.) Principles of the Art Militarie, plates, vell. (stained), 1642-3, folio (206) *Leighton,* £2 2s.

3478 Howell (J.) Londinopolis, port. and view of London, cf., 1657, folio (209) *Fox,* £3 11s.

3479 Hubert (Sir F.) Historie of Edward the Second (in verse), first genuine ed., port., vell. (some leaves stained), 1629, 8vo. (60) *Tregaskis,* £3 3s.

3480 Hutton (Sir Ricd.) and Croke (Sir G.) Arguments with the Certificate of Sir John Denham against John Hampden, 1641—Speech of the Chancellor of England touching the Post-Nati, 1609—Orders and Directions tending to the Reliefe of the Poor, 1630—Conference concerning the Rights and Privileges of the Subjects, 1642, in 1 vol., old cf., 1609-42, 4to. (139) *Harding,* £1 3s.

3481 James (W.) Naval History of Great Britain, 6 vol., cf. gt., 1826, 8vo. (61) *Edwards,* 14s.

3482 Jones (Inigo). The most Notable Antiquity of Great Britain, vulgarly called Stone-henge, plates, but no port., cf., 1655— Webb (John). Vindication of Stone-Heng Restored, cf., 1665, together 2 vol., folio (211) *Ellis,* £1 17s.

3483 Jonson (Ben). Works, port. by W. Elder, old cf. (one leaf imperfect), 1692, folio (212) *Rimell,* £1 18s.

3484 Josephus (Flavius). Opera Graecè (curante Arn. Peraxylo Arlenio), first ed. of the Greek Text, MS. notes in the handwriting of Dr. J. Hudson, oaken bds., covered with stamped cf., *Basil.,* Froben, 1544, folio (213) *Ellis,* £1 16s.

3485 Kilburne (R.) Topography, or Survey of the County of Kent, port. by Cross (binding broken), "ex dono authoris," 1659, 4to. (132) *Thorp,* £2 10s.

3486 King (Danl.) Vale-Royall of England, maps and plates, including the rare one of Hugh Lupus in Parliament, old cf., 1656, folio (217) *Walford,* £2 18s.

3487 Kip (I.) Britannia Illustrata, 80 plates (some mended), cf.
gt. (title defective), 1707, folio (218) *Thorp*, £4
3488 Lahontan (Baron). New Voyages to North America, maps
and plates (2 torn), 2 vol. in 1, old cf. (folio 2 wanted front.),
1763, 8vo. (63) *H. Stevens,* £2 16s.
3489 Landor (Walter Savage). Poems—Moral Epistle, first ed.,
in 1 vol., hf. bd., uncut, 1795, 8vo. (64) *Dobell,* £8 15s.
3490 Langbaine (G.) Account of the English Dramatick Poets,
first ed., orig. cf., *Oxford*, 1691, 8vo. (65) *Pickering,* £2 4s.
3491 Le Sage (A. R.) Histoire de Gil Blas, 100 plates, after
Bornet and others, 4 vol., cf. (1795), 8vo. (67) *Maggs,* £3
3492 Lyndewoode (W.) Provinciale, cf. (stained and wormed),
some contemp. MS., *Paris*, 1505, folio (223)
Leighton, £7 15s.
3493 Magnus (Olaus). Historia de Gentibus Septentrionalibus,
first ed., woodcuts, old mor. gt., g. e. (title mended), *Romae*,
1555, folio (225) *Bloomfield,* £5 10s.
3494 Markham (G.) A Way to get Wealth, woodcuts, old cf.,
1676, 4to. (136) *Maggs,* £1 16s.
3495 Matthaei Paris. Historia Maior à Guilielmo Conquaestore
ad ultimum annum Henrici tertii, first ed., woodcut ports.
and initial, old cf., *apud Reginald Wolfium*, 1571, folio (228)
Bloomfield, £1 12s.
[This copy contained coats-of-arms and other decorations,
done by hand in the margins by Robert Glover, Somerset
Herald under Queen Elizabeth.—*Catalogue.*]
3496 Mayne (Jaspar). The Amorous Warre, a Tragi-Comœdy,
1659—The City Match, a Comoedy, 1659, in 1 vol., cf.,
Oxford, printed by Henry Hall, 1659, 8vo. (76)
Leighton, £3 18s.
3497 Mercator (Gerardus). Atlas sive Cosmographicae Medi-
tationes de fabrici Mundi, engraved title (coloured) and
col. maps, including America, some leaves stained and
defective, old cf., *Amst.*, 1607, roy. folio (229)
Muller, £5 15s.
3498 Monthly Mercuries. General History of Europe contained
in the Historical and Political Monthly Mercuries, 47 vol.
in 28 (wanted vol. xxxiii.), old cf., some vol. wormed, 1688-
1735, 4to. (138) *Thorp,* £1 5s.
3499 Narborough (Sir J.) and others. Collection of several late
Voyages and Discoveries, maps and folding plates, cf., 1711,
8vo. (23) *Ellis,* £1 9s.
3500 Nash (Richard). Life, by O. Goldsmith, second ed., port.,
cf., 1762, 8vo. (80) *Quaritch,* 17s.
3501 Ogilby (John). America, maps and plates, old cf. (stained),
one map imperfect, 1671, folio (236) *Rimell,* £3 8s.
3502 Parkinson (John). Theatrum Botanicum, woodcuts, old cf.
(stained), 1640, folio (238) *Thorp,* £2 18s.
3503 Peacham (Henry). The Compleat Gentleman, third ed.,
woodcuts, cf., 1661, 4to. (142) *Bloomfield,* £1 8s.
3504 Pepys (Sam.) Memoires relating to the State of the Royal
Navy, first ed., port. by R. White, cf., 1690, 8vo. (85)
Shepherd, £6 12s. 6d.

3505 Philipott (J.) Villare Cantianum, folding map, etc., old cf.,
 1659, folio (240) *Bain,* £1 10s.
3506 Phillip (Governor). Voyage to Botany Bay, port., maps and
 plates, old hf.·russ., 1789, 4to. (315) *J. Grant,* 16s.
3507 Plutarch. Lives of the Noble Grecians and Romans, by Sir
 Thomas North, ports., hf. bd., title packed (wormed), 1612,
 folio (244) *Edwards,* £1 14s.
3508 Poems on Affairs of State, from the Time of Oliver Cromwell,
 4 vol., old cf., 1703-7, 8vo. (88) *Bloomfield,* £2 4s.
3509 Rabelais (F.) Œuvres, 3 vol., port. and 76 plates, russ.,
 Paris (1798), 8vo. (90) *Edwards,* £1
3510 Rameau (J. P.) The Dancing Master, first ed., front. and
 plates, vell., 1728, 4to. (147) *Ellis,* £5
3511 Richards (Nath.) The Tragedy of Messalina, first ed., port.
 and front., 1640—Cowley (A.) Love's Riddle, a Pastorall
 Comœdie, first ed., port., 1638—Rutter (Jos.) The Shep-
 heards Holyday, a Pastorall Tragi-Comœdie, first ed., 1635
 —Jonson (Ben). The New Inne, or the Light Heart, a
 Comoedy, first ed., 1631—May (T.) The Tragedy of Anti-
 gone, first ed., title defective, 1631—Marlowe (C.) The
 Massacre at Paris, no title, n. d., in 1 vol. (some leaves torn,
 a few headlines cut into and a little stained), old cf., 1631-40,
 8vo. (92) *Dobell,* £53
3512 Richardson (W.) Monastic Ruins of Yorkshire, 2 vol. in 1,
 plates, hf. mor., g. e., 1843, atlas folio (325) *Milligan,* £1 2s.
3513 Rüxner (Geor.) Thurnier-Buch von Aufang, Ursachen, Urs-
 prung und Herkommen der Thurnier im Heeligen Romis-
 chens Reich teuscher Nation, woodcut engravings by Jost
 Amman, etc., old pigskin on oaken boards, with clasps,
 Frankfurt o. M., 1578, folio (248) *Tregaskis,* £3 15s.
3514 Shakespeare (W.) Comedies, Histories and Tragedies, ed.
 by Edward Capell, 10 vol., cf., 1767-68, 8vo. (95)
 Walford, 12s.
3515 Smith (Thos.) and Bourne (William). The Marrow of
 Gunnery, with the Gunner's Dialogue by R. Norton, in 1
 vol., black letter, woodcuts, old sheep, 1643, 4to. (150)
 Leighton, £1 18s.
3516 Smollett (T.) Peregrine Pickle, first ed., 4 vol., cf. (rebacked),
 1751, 8vo. (97) *Ellis,* £4
3517 Speed (John). Theatre of the Empire of Great Britain
 (including America), engraved title, front. and maps, cf.
 (rebacked), 1676, folio (255) *Carter,* £3 6s.
3518 Spenser (Edm.) The Faerie Queen, first collected ed., wood-
 cuts, old hf. binding, title packed, imperfect at end, 1611,
 folio (258) *Edwards,* £2 15s.
3519 Steele (Sir R.) Lucubrations of Isaac Bickerstaff, first ed., 2
 vol. in 1, cf., 1709-11, folio (259) *Quaritch,* £14 10s.
 [This copy contained the complete set of the 271 original
 numbers of "The Tatler" published between April 12, 1709
 and Jan. 2, 1711, when Steele suddenly brought the publi-
 cation to an end, and also Nos. 272 to 330, which, as is
 stated on No. 272, "is now upon better thoughts resolved

to be continued as usual." It contained as well the title to vol. ii. frequently wanting.—*Catalogue.*]

3520 Stephanus (Carolus). Dictionarium Historicum ac Poeticum, editio princeps, old binding, g. e., *Lutet.*, 1561, folio (260)
Ellis, £2 2s.

3521 Struys (John). Voiages and Travels through Italy, Greece, Muscovy, Persia, etc., plates, old cf., 1684—Ides (E. Y.) Three Years' Travel from Moscow to China, plates, cf., together 2 vol., 1706, 4to. (151) *Carter, £1* 16s.

3522 Sweet (R.) and Lindley (J.) Ornamental Flower Garden and Shrubbery, 4 vol., 288 col. plates, hf. mor., t. e. g., 1854, imp. 8vo. (100) *Thorp, £2* 8s.

3523 Swift (J.) Tale of a Tub, first ed., cf., 1704, 8vo. (101)
Quaritch, £7

3524 Swift (J.) Works, plates, 24 vol., cf., 1760-69, 8vo. (102)
Edwards, £1 5s.

3525 Theijn (J. de). Maniement d'Armes, d'Arquebuses Mousquetz et Piques, 117 plates, pigskin, *Amst.*, 1608, folio (265)
Bloomfield, £4 .14s.

3526 Thornton (R. J.) Sexual System of Linnæus, ports., col. plates and illustrations, 2 vol., hf. mor., 1799-1807, imp. folio (326) *Bloomfield, £2* 2s.

3527 Thoroton (R.) Antiquities of Nottinghamshire, map, and plates by W. Hollar, with the plates of arms on 4 leaves, russ., m. e. (one leaf defective and one mended), 1677, folio (266) *J. Ward, £3* 12s.

3528 Vegetius (F.) De re Militari lib. IV., woodcuts, russ. on oaken bds., g. e. (hole in title, and title and some leaves mended, stained), *Lutet.*, 1532, folio (270) *Bloomfield, £2* 18s.

3529 Vincent (Aug.) Discoverie of Errours in the First Edition of the Catalogue of Nobility, published by R. Brooke, coats-of-arms, cf., r. e., W. Jaggard, 1622, folio (271)
Bloomfield, £1 2s.

3530 Wafer (L.) New Voyage and Description of the Isthmus of America, map and plates, cf., 1699, 8vo. (107) *Ellis, £1* 18s.

3531 Weever (John). Ancient Funerall Monuments, first ed., port. by Cecill, engraved title and woodcuts (with index), cf., 1631, folio (273) *W. Daniell, £1* 6s.

3532 Whitaker (T. D.) Loidis and Elmete, with Thoresby's Ducatus Leodiensis and the Appendix, ports., plates, etc., 2 vol., hf. mor., uncut, 1816-20, roy. folio (327)
Bull, £1 11s.

3533 Wild (Robert). Iter Boreale, old cf., 1670, 8vo. (109)
Leighton, £1 16s.

SOTHEBY, WILKINSON & HODGE.

A MISCELLANEOUS COLLECTION.

(No. of Lots, 561 ; amount realised, £816 0s. 6d.)

3534 Ackermann (R.) History of the University of Cambridge, col. plates, including the ports. of the Founders, 2 vol., hf. cf. gt., R. Ackermann, 1815, 4to. (387) *G. H. Brown*, £13

3535 Adam (R. and J.) Works in Architecture, plates, 3 vol. in 2, mor., g.e., 1900-2, atlas folio (491) *Quaritch*, £6 5s.

3536 Adventurer (The), Nos. 1-140, in 2 vol., cf., 1752-54, folio (549) *Maggs*, 16s.

3537 Alken (Henry). Shakespeare's Seven Ages of Man, 7 col. plates, orig. wrapper, M'Lean, 1824, oblong folio (482) *Dobell*, £2 4s.

3538 Alken (H.) The National Sports of Great Britain, 50 col. plates, mor., g.e., T. McLean, 1821, folio (483) *Spencer*, £70

3539 America. The Herald, a Gazette for the Country, a long series of an American newspaper, containing several of the extra sheets, vol. i., hf. bd., *New York*, 1794-5, folio (270) *W. Daniell*, £5 12s. 6d.

3540 America. Historical Memoir of the War in West Florida and Louisiana in 1814-15, by Major A. Lacarriere Latour, including the rare atlas containing a port. of Andrew Jackson, unmentioned by Sabin, 2 vol., hf. and full cf., *Philadelphia*, 1816, 8vo. (53) *Leon*, £3 5s.

3541 America. North American Botany, by Amos Eaton and John Wright, sheep, *Troy, N. Y.*, 1840, 8vo. (85) *Quaritch*, 13s.

3542 Andrews (William Loring). Bibliopegy in the United States, facs., orig. cl., uncut, 141 copies printed, *New York*, 1902 (81) *Maggs*, £2 3s.

3543 Archæologia Cantiana, vol. i. to xviii. (vol. i. to iii. LARGE PAPER), facs. and illustrations, orig. cl., 1858-89, 8vo. (545) *Miss Harris*, £3 5s.

3544 Assemanus (J. A.) Codex Liturgicus Ecclesiae Universae, 13 vol., hf. parchment, *Paris*, 1902, 4to. (142) *T. Baker*, £11 5s.

3545 Augustinus (S. Aurelius). De Civitate Dei lib. xxii., **lit. goth.**, double columns, border of first page of text illuminated, larger initials painted, rubricated throughout, orig. Venetian cf. (rebacked), metal bosses and clasps, *Venetiis*, Gabriel. Petri de Tarvisio, 1475, folio (435) *Tregaskis*, £6 5s.

3546 Bacon (Francis). Sylva Sylvarum, by W. Rawley, port., cf., 1635, folio (548) *Smedley*, 12s.

3547 Bagshaw (Henry). A Sermon preacht in Madrid, July 4,

1666, occasioned ɔy the Death of Sir Richard Fanshaw, port. of Fanshaw, hf. cf., 1667, 4to. (375) *James*, £1

3548 Baines (T.) The Victoria Falls, Zamɔesi River, sketches on the Spot (during the Journey of J. Chapman and T. Baines),. title and 11 col. plates, 1865, folio (466) *Maggs*, £8 5s.

3549 Bell (J. Munro). Chippendale, Sheraton and Hepplewhite Furniture Designs, plates, 1900, 4to. (391)
Hatchard, £1 10s.

3550 Bernardus (S.) Opuscula, lit. gotɧ., douɔle columns, capitals in red and ɔlue, orig. stamped cf. on oak bds., with clasps, *Spira*, Peter Drach, 1501, 4to. (517) *Bacon*, £4

3551 Berry (Miss). Extracts of the Journals and Correspondence of, 3 vol., first ed., fronts., 1865, 8vo. (196) *Sotheran*, £1

3552 Bewick (T.) British Birds, 2 vol., first ed., royal paper, cf. (ɔroken), *Newcastle*, 1797-1804, 8vo. (33) *Spencer*, £1 19s.

3553 Bewick (T.) History of Quadrupeds, first ed., royal paper, cf. (ɔroken), *Newcastle*, 1790, 8vo. (34) *Maggs*, £1 16s.

3554 Biɔle. The Hexaglot Biɔle, ed. ɔy Rev. E. R. de Levante, etc., 7 vol., 1872-4, 4to. (225) *Hunt*, £1 4s.

3555 Biɔle (The) in Miniature, or a Concise History of the Old and New Testaments (1¾ ɔy 1⅛ in.), engravings, contemp. mor., g. e., *Printed for W. Harris*, 1775 (361) *Leighton*, £1 1s.

3556 Biɔlia Sacra Latina, Editio Vulgata, cum Prologis S. Hieronymi, lit. gotɧ., 7 unnumɔered and cccclxi. numɔered leaves, douɔle columns, 51 lines, without signs., 3 painted capitals on first leaf, ornamental ɔorder pasted on, initials in red and ruɔricated throughout, last leaf defective, orig. stamped pigskin on oak bds. (wormed), *Nuremberg*, Ant. Coɔurger, 1478, folio (421) *Hornstein*, £11

3557 Biɔliophile Society. The Idylls and Epigrams of Theocritus, Bion and Moschus, edited ɔy Henry Aiken Metcalf, port. and titles on Japanese vellum paper, 3 vol., orig. bds., uncut (477 copies printed), *Boston*, 1905, 8vo. (47)
Maggs, £2 10s.

3558 Biɔliophile Society. Letters of John Paul Jones, port. and facs., hf. vell., uncut, *Boston*, 1905, 8vo. (48) *Maggs*, £2 9s. [Printed throughout on Japanese vellum paper, and only a few copies issued for memɔers of the Society.—*Catalogue*.]

3559 Book of Common Prayer, engraved throughout, vignettes and ports., ɔorders and initial letters ɔy John Sturt, with the "Circular Taɔle," contemp. mor. ex., John Sturt, 1717, 8vo. (360) *H. A. Marshall*, £4 12s.

3560 Boswell (J.) Life of Johnson, first ed., port., 2 vol., contemp. cf., 1791, 4to. (379) *Hatchard*, £3 1s.

3561 Bouquet (Dom Martin). Recueil des historiens des Gaules et de la France, puɔliée sous la direction de M. Léopold Delisle, vol. i.-xix., *Paris*, 1869-80, folio (279)
T. Baker, £4 10s.

3562 Brant (Seb.) The Ship of Fooles, trans. ɔy Alexander Barclay (with the Latin text), black letter and roman, woodcuts (title-page in. fac. and leaf 171 mended), orig. cf., John Cawood, 1570, folio (434) *Reader*, £7 5s.

3563 British Essayist (The), ɔy J. Ferguson, 45 vol. (2 leaves in vol. xviii. damaged), mor. gilt, g. e. (ruɔɔed), 1819, 8vo. (41)
Walford, £2 10s.
3564 Buchanan (G.) Rerum Scoticarum Historia, editio prima (wormed), orig. stamped pigskin on oak bds., metal corner-pieces and clasps, *Edinb. ap. A. Arbuthnetum Typog. Regum*, 1582, folio (431) *Leighton*, £1 10s.
3565 Caɔinet of Genius (The), 76 engravings by C. Taylor and others from designs by S. Shelley (a few stained), 2 vol. in 1, cf. gt., 1787, 4to. (226) *Maggs*, £3 10s.
3566 Camden Society. Promptorium Parvulorum sive Clericorum, ed. A. Way (marginal notes), hf. mor., 1865, 4to. (412)
Bull, 12s.
3567 [Cave (H.)] The History of the Damnaɔle Popish Plot, in its various Branches and Progress, hf. cf. antique, 1680, 8vo. (335) *Bull*, £5 5s.
3568 Caulfield (S. F. A.) and Saward (B. C.) Dictionary of Needlework, upwards of 800 wood engravings and col. plates, 1885, 4to. (485) *Tregaskis*, 7s.
3569 Caxton (Wm.). Game of the Chesse, reproduced in facsimile from a copy in the British Museum, by V. Figgins, hf. roan, 1860, 4to. (410) *Reader*, 13s.
3570 Chaucer (Geffrey). Woorkes, black letter, woodcut arms on title, woodcut ɔorders to separate titles, and capitals (margins of first 3 leaves mended), old cf. (reɔacked), *Jhon Kyngston for Jhon Wight*, 1561, folio (433)
Spencer, £6 10s.
3571 Chaucer (G.) Works, by John Urry, 2 ports. and vignettes, cf. (ɔroken), 1721, folio (298) *Andrews*, £1
3572 Child (F. J., ed.) The English and Scottish Popular Ballads, 10 parts in 9, parts i.-ii. in 1 vol., hf. mor., t. e. g., remainder as issued, *Boston*, 1882-98, 4to. (394) *Maggs*, £7 7s. 6d.
3573 Chippendale (T.) The Gentleman and Caɔinet Maker's Directory, first ed., 161 plates, orig. cf., 1754, folio (493)
Hatchard, £21
3574 Coker (Rev. N.) A Survey of Dorsetshire, folding map and coats-of-arms, hf mor., t. e. g., 1732, folio (265)
W. Daniell, £1 11s.
3575 Cornazano (Antonio). De re militari (in terza rima), mor., elegantly tooled, g. e., by C. Smith, *In Orthona ad mare, per Hieronimo Soncino*, 1518, 8vo. (343) *Bingham*, £1 15s.
3576 Costume of the Russian Empire, upwards of 70 col. engravings (descriptions in English and French), mor., g. e., *T. Bensley for J. Stockdale*, 1811, 4to. (175) *Hiersman*, £1
3577 Dickens (Charles). The Posthumous Papers of the Pickwick Cluɔ, first ed., mor., g. e., 1837, 8vo. (36) *Hill*, £1
3578 D'Oyly (C.) The European in India, 20 col. plates, and a History of Ancient and Modern India, by F. W. Blagdon, mor., g. e., E. Orme, 1813, 4to. (479) *Rimell*, £2 13s.
3579 Egan (Pierce). Life in London, 36 col. plates by I. R. and G. Cruikshank, and woodcuts, hf. cf., G. Virtue, n. d., 8vo. (342) *Reader*, £1 14s.

3580 England's Glory, or an Exact Catalogue of the Lords of his Majesties Most Honourable Privy Council, front., orig. cf., Nath. Brooke, 1660, 8vo. (333) *Leighton,* 16s.

3581 Fabricius (J. C.) Voyage en Norwège, cf., arms of Napoleon I. on sides and "Malmaison" on upper cover, *Paris,* 1802, 8vo. (355) *Leighton, £2* 2s.

3582 Fergusson (R.) Poems, first ed., orig. cf., soiled copy, *Edinb.,* W. and T. Ruddiman, 1773, 8vo. (373) *Collins, £1* 1s.

3583 Finden (W.) Illustrations to Life and Works of Lord Byron, 24 parts, LARGE PAPER, proof impressions, as issued, 1833-34, 4to. (515) *Bacon, £1* 10s.

3584 Firdousi (Abou'lkasim). Le Livre des Rois, 7 vol., *Paris,* 1876-78, 8vo. (1) *Hunt,* 16s.

3585 Foreign Field Sports, from drawings by Howitt, Atkinson, etc., with a Supplement of New South Wales, 100 plates in aquatint, mor., g. e., E. Orme, 1814, 4to. (475) *Scott, £2*

3586 Freeman (G. E.) and Salvin (F. H.) Falconry, plates, orig. cl., unopened, 1859, 8vo. (331) *Spencer, £1* 3s.

3587 Froissart (Sir J.) Chronicles, by Th. Johnes, 2 vol., woodcuts, 1839—Illuminated Illustrations of Froissart, by H. N. Humphreys, 2 vol. in 1, 72 plates in gold and colours, hf. mor., g. e., together 4 vol., 1844-45, 4to. (153) *James, £8*

3588 Gallia Christiania in Provincias Ecclesiasticas distributa qua series et historia Archiepiscoporum, Episcoporum et Abbatum Franciae, etc., opera et studio Dom D. Sammarthani, editio altera, labore et curis Dom P. Piolin, 13 vol., *Paris,* 1870-74, folio (280) *T. Baker, £1* 17s.

3589 Gautier (Léon). Les Épopées Françaises, 4 vol., *Paris,* 1878-82, 8vo. (3) *Picard, £1* 1s.

3590 Gellius (Aulus). Noctes Atticae (cum comment. P. Beroaldi, etc.), lit. rom., long lines, Italian woodcut arabesque border to first page of text, with a large figured initial printed in red, and numerous ornamental woodcut initials (title in red gothic with a cut of Agnus Dei), old Venetian stamped binding (rebacked), *Venet., Jo. di Tridino alias Tacuinus,* 1509 (*with device*), folio (417) *Quaritch, £3*

3591 Gerarde (John). Herball, first ed., engraved title and port. of Gerard by W. Rogers, woodcuts (margins of about 20 leaves in the index repaired), cf., Edm. Bollifant, 1597, folio (560) *Sotheran, £6* 5s.

3592 Goar (J.) Euchologion, sive Rituale Graecorum juxta usum Orientalis Ecclesiae, editio secunda, engravings, vell., *Venetiis,* 1730, folio (292) *T. Baker, £5* 5s.

3593 Grolier Club. Life of Charles Henry, Count Hoym, by Baron Jerome Pichon, one of 303 copies, hf. mor., art silk sides, uncut, *New York,* 1899, 8vo. (43) *Maggs, £1* 10s.

3594 Grolier Club. Collection of the Grolier Club Catalogues, comprising the Poets Laureate of England, Spenser, Washington, New York Plans, American Engraving, Méryon Etchings, American Book-bindings, etc., many with collations, wrappers, uncut, *New York,* 1893, etc., together 25 pieces, 8vo. (44) *Chadwick, £2* 10s.

3595 Harrisse (H.) Découverte et Évolution cartographique de
Terre-Neuve, maps and illustrations, 380 copies issued,
Paris, 1900, 4to. (143) *Maggs*, 18s.
3596 Harrisse (H.) Discovery of North America, maps and illus-
trations, 380 copies issued, roxɔurghe, 1892, 4to. (144)
H. Stevens, £2 18s.
3597 Henderson (E. G. and A.) The Illustrated Bouquet, 80 col.
plates, 2 vol. in 1, hf. mor., 1857-61, folio (551) *Wesley*, 16s.
3598 Herndon (W. L.) and Giɔɔon (L.) Exploration of the Valley
of the Amazon, plates of Indian costumes, etc., 3 vol.,
including the rare vol. of maps, orig. cl., *Washington*,
1853-54, 8vo. (82) *Quaritch*, £1 10s.
3599 Histoire Littéraire de la France, ouvrage commencé par les
religieux Bénédictins de la Congrégation de Saint-Maur, et
continué par les Memɔres de l'Institut, vol. xvii.-xxvi., 10
vol., *Paris*, 1895-98, 4to. (148) *Picard*, £5 2s. 6d.
3600 Hooker (Richard). The Works of, in eight Books of Ecclesi-
astical Polity, engraved title, orig. cf., 1682, folio (324)
Tregaskis, £3
[A large paper copy of the first complete edition of this
work. Thomas Zouch's (the antiquary and editor of
Walton's "Lives") copy, with 7 folio pages of his autograph
notes and his ex-libris.—*Catalogue*.]
3601 Hutchins (John). History and Antiquities of the County of
Dorset, 2 vol., maps and plates, old cf., 1774, folio (261)
W. Daniell, 10s.
3602 Hutchins (J.) The History and Antiquities of the County of
Dorset, second ed., 4 vol., LARGE PAPER, maps and plates,
mor., t.e.g., others uncut, from the Towneley Liɔrary, 1796-
1803-13-15, folio (262) *W. Daniell*, £7 12s. 6d.
3603 Iceland. Scripta Historica Islandorum de Reɔus Gestis
Veterum Borealium, 12 vol., orig. wrappers, uncut, *Hafniae*,
1828-46, 8vo. (87) *Maggs*, 18s.
3604 Iceland. Rafn (C. C.) Fornaidar Sogur Nordrianda eptir
Gomium Handritum, orig. ed., 4 vol., hf. mor., uncut, *Kaup-
mannhofn,* 1829, 8vo. (88) *Maggs*, £1 10s.
3605 Iceland. Skirnir, ny Tidindi hins Islenzka Bokmentafelags,
complete from 1842 to 1907 inclusive (except 1904 missing),
77 parts, orig. wrappers, uncut, many unopened, *Kaup-
mannhofn and Reykjavik*, 1842-1907 (89) *Chadwick*, £1 10s.
3606 Ireland. Ancient Irish Histories, by E. Campion and others,
2 vol., hf. mor. gt., LARGE PAPER copy, *Dublin* (*Hibernia
Press*), 1809, 8vo. (50) *Walton*, £1 6s.
3607 Irving (Washington). A Chronicle of the Conquest of
Granada, 2 vol., orig. bds., uncut, *Philadelphia*, 1829, 8vo.
(110) *Maggs*, 11s.
[A large paper copy (of which but few are known) of the
first edition.—*Catalogue*.]
3608 Irving (W.) Astoria, 2 vol., first ed., with presentation in-
scription, orig. bds., *Philadelphia*, 1836, 8vo. (307)
Spencer, 12s.
3609 Isidorus. Opera (Etymologiarum liɔ. xx. et de summo ɔono

li). iii.), lit. goth., 4 unnum)ered, 101 num)ered, and 2
unnum)ered and 28 num)ered leaves (*Hain, 9279), genea-
logical tree on 48 b., vell., *Venetiis, Petrum Loslein de
Langencen*, 1483, folio (423) *Hiersmann, £2*
3610 Justin. Historie, containing a Narration of Kingdomes from
the)eginning of the Assyrian Monarchy, trans. by G. W.
(*i.e.*, G. Wilkins), ports., old cf. (re)acked), W. Jaggard,
1606, folio (429) *Quaritch, £2 12s.*
3611 Kircher (Ath.) Magnes, sive de Arte Magnetica, engravings
and woodcuts, vell., *Col. Agr.*, J. Kalcoren, 1643, 4to. (163)
Tregaskis, 13s.
3612 KPTΠTA'ΔIA, Recueil des documents pour servir à l'étude des
traditions populaires, vol. v.-xi., 7 vol., issue limited to 175
sets, *Paris*, 1898-1907, 8vo. (2) *Sawyer, £4 17s. 6d.*
3613 Kuyper (J.) Ta)leaux des ha)illements, des moeurs et des
coutumes en Hollande, 21 col. plates)y J. Kuyper, hf. bd.,
Amsterdam, 1805-11, 4to. (174) *Edwards, £1 4s.*
3614 L'Année Biologique. Comptes rendus annuels des travaux
de Biologie Générale, années i.-vii., 7 vol., *Paris*, 1895-1902,
8vo. (9) *Luzac, £2 12s.*
3615 L'Année Psychologique, par Alfred Binet, années iii.-ix., 7
vol., illustrations, *Paris*, 1897-1903, 8vo. (10) *Luzac, £1 11s.*
3616 La Motte (Houdar de). Œuvres, first ed., 11 vol., cf.,)y
Derome, à la grotesque, *Paris*, 1754, 8vo. (319)
Freeman, £1 1s.
3617 Lear (E.) Parrakeets, Maccaws and Cockatoos, 30 large col.
plates, in a portfolio (1832) (275) *Tregaskis, £1 3s.*
3618 Leech (John). Follies of the Year, a Series of Coloured
Etchings from Punch's Pocket Books, 1844-1864, Notes)y
Shirley Brooks, orig. hf. mor., g. e., n. d., o)long 4to. (221)
Edwards, £1 1s.
3619 Lefe)ure (C. T.) Voyage en Abyssinie, vol. i.-iii., with atlas
containing map and 59 plates, many in colours, in sheets,
Paris, 1845, 8vo. and folio (29) *Quaritch, £1 1s.*
3620 Lenormant (Ch.) et Witte (J. de). Élite des Monuments
Céramographiques, 4 vol., 419 plates, *Paris*, 1844-61, 4to.
(150) *Quaritch, £1 15s.*
3621 Lillywhite's Cricket Scores and Biographies of Cele)rated
Cricketers, from 1746 to 1854, 4 vol., orig. cl., 1862, etc., 8vo.
(442) *Joseph, £2*
3622 Locker (E. H.) Gallery of Greenwich Hospital, 4 parts, proof
impressions on India paper, as issued, 1831-32, 4to. (522)
Reader, 16s.
3623 Longfellow (H. W.) Voices of the Night, orig. bds., first
LARGE PAPER ED., *Cambridge, Mass.*, 1840, 8vo. (49)
Grant, 5s.
3624 Lyon (J. W.) The Colonial Furniture of New England,
plates, *Boston*, 1892, 4to. (487) *E. Parsons, £1 13s.*
3625 Mansion (L.) Costume of Officers of the British Army, 51
col. plates, cut round and mounted on)rown paper, names
written in ink, in 1 vol., hf. mor., Spooner, 1833-6, folio (531)
Hornstein, £56
17—2

3626 Manwood (J.) Lawes of the Forest, 𝔟𝔩𝔞𝔯𝔨 𝔩𝔢𝔱𝔱𝔢𝔯, wormed at
end, old cf., *Societie of Stationers,* 1615, 4to. (415)
Betts, £2 10s.
3627 Mariette-Bey (A.) Voyage dans la Haute-Égypte, 2 vol., 83
photographic plates, in 2 cloth portfolios, *Paris,* 1893, folio
(285) *Quaritch,* £1
3628 Marshall (A.) Specimens of Antique Carved Furniture and
Woodwork, 50 plates, orig. hf. cf., 1888, folio (502)
Hatchard, £1 14s.
3629 Meyer-Lübke (W.) Grammaire des Langues Romanes (avec
Taꭒles Générales), 4 vol. in 7 parts, *Paris,* 1889-1906, 8vo.
(6) *Condere,* £1 10s.
3630 Montesquieu (C. S. Baron de). Persian Letters, ꭒy John
Davidson, port. and etchings by Ed. de Beaumont, uncut
(550 copies only), *Privately printed,* 1892, 8vo. (318)
Moore, 17s.
3631 Napier (Lord John, of Murchiston). Description of the
Admiraꭒle Taꭒle of Logarithmes, translated ꭒy E. Wright,
autograph signature ꭒy J. Partridge (astrologer), and of H.
Briggs (the editor of the ꭒook) and C. Hutton (mathema-
tician), hole in title, also page 9 catchword cut away and
some leaves cut into, S. Waterson, 1618, 8vo. (119)
Quaritch, £12 10s.

*Natural History, illustrated with Original Drawings by
Theo. Johnson.*

3632 Fifty Years' Personal Recollections of the Zoo, illustrated
with aꭒout 80 drawings ꭒy the author in ꭒlack and white
and colour, in 2 parts, 1905-7, folio (532) *Maggs,* £1 14s.
3633 Some Rare Exhiꭒits by the Zoological Society of London,
49 illustrations by the author in ꭒlack and white and
colours, 1906-8, folio (533) *Maggs,* £1 9s.
3634 The Mammals of the British Isles, 32 illustrations drawn and
col. by the author, and letterpress descriptions, 1909, folio
(534) *Maggs,* £1 1s.
3635 Some Varieties of the Domestic Cat, figures, drawn and col.
by the author, 1909, folio (535) *Dobell,* 19s.
3636 The Larvæ of British Lepidoptera, with figures, upwards of
350 in numꭒer, drawn and coloured ꭒy the author, 2 vol.,
1906-9, folio (536) *Edwards,* £1 5s.
3637 The Genera and Species of the British Hawk-moths and
Butterflies, illustrated with aꭒout 150 figures, drawn and
col. by the author, 1906, folio (537) *Hunt,* £1
3638 Our Aquatic Flora, figures and descriptions of all the typical
Flowering Plants inhaꭒiting our streams, etc., 44 plates, in
2 parts (compiled) 1908, folio (538) *Maggs,* £1 5s.

3639 Needle-Work Binding. The Holy Biꭒle (Authorised Ver-
sion), *Edinb.,* R. Young and E. Tyler, 1642—The Book
of Common Prayer, *Lond.,* R. Barker, 1639—Whole Book
of Psalms in Meter, ꭒy Sternhold and Hopkins, *A. M. for*

the Stat. Co., 1650, in 1 vol., bds. embroidered in coloured and silver threads, with a full-length female figure on each side, a church and flowers, emblematic of the church in Solomon's Song, g.e. (somewhat worn), orig. silver clasps, 1639-50, 8vo. (348) *Rev. Mr. Jones*, £4 15s.

3640 New Testament. The Coptic Version of the New Testment in the Northern Dialect, otherwise called Memphitic and Bohairic, with English Translation, 4 vol., *Oxford*, 1898-1905, 8vo. (201) *T. Baker*, £2 5s.

3641 Old English 'Squire (The), a Poem, by John Careless, Esq., 24 col. plates, orig. bds., uncut, M'Lean, 1821, super imp. 8vo. (474) *Rimell*, £8 12s. 6d.

3642 Panormitanus (Nicolaus). Lectura super tertio et quarto Libris Decretalium, lit. gotij., initials in red (wormed), old bds., cf. back, *Venetiis*, Andreas de Asula, 1483, folio (436) *Hiersmann*, £2 2s.

3643 [Pattenson (M.)] The Image of Bothe Churches, orig. vell., *Printed at Tornay by Adrian Quinque*, 1623, 8vo. (69) *Tregaskis*, 10s.

[This copy had the last leaf, frequently wanted, containing the apology for not translating the approbation into English.—*Catalogue.*]

3644 Pickard-Cambridge (O.) The Spiders of Dorset, ed. by J. Buckman, plates, 2 vol., hf. cf., Sherborne, 1879-81, 8vo. (230) *Quaritch*, £1

3645 Pognon (H.) Inscriptions Mandaïtes des Coupes de Khouabir, appendices et glossaire, facs., 3 parts, *Paris*, 1898, 8vo. (18) *Picard*, 18s.

3646 Pseaultier (Le) de David, avec les Cantiques (en Latin), 2 engravings, red ruled throughout, mor., gilt back, g.e., one clasp (Clovis Eve), *Paris*, J. Mettayer, 1586 (422) *Leighton*, £1 7s.

["Ce Pseaultier avec toutes les Œuvres de Grenade furent données à Madame de Montmorin par le feu Roy Henry III. L'An 1586 la cour estant à St. Germain."— *MS. note inside cover.*]

3647 Ptolemy. Geographia universalis, 48 woodcut maps, large copy in the orig. stamped pigskin (2 leaves mended, and page 155 defective), *Basileae, apud Henricum Petrum*, 1540, folio (424) *Maggs*, £4 4s.

[The first edition edited by Sebastian Munster. Many of the woodcut borders and ornaments are the work of Hans Holbein. No. 25 bears his mark H. H.—*Catalogue.*]

3648 Pulton (F.) An Abstract of all the penal Statutes which be general, in force and use, black letter, orig. stamped cf. on oak bds., C. Barker, 1581, 4to. (416) *Leighton*, £3 3s.

3649 Richardson (C. J.) Studies from Old English Mansions, 4 series complete, 140 plates, several in colour, 4 vol., orig. cl., McLean, 1841-48, folio (499) *G. H. Brown*, £6 2s. 6d.

3650 Royal Academy Pictures (complete from the commencement in 1888 to 1909), 19 vol., one in cf., 17 in hf. cf. and one in parts as issued, Cassell, 1888-1909, 4to. (460) *E. Parsons*, £2 14s.

3651 Sainte-Palaye (La Curne de). Dictionnaire Historique de
l'ancien langage françois, 10 vol., *Niort*, 1875-81, 4to. (140)
Hunt, £1 14s.
3652 Salt (H.) Twenty-Four Views taken in St. Helena, The
Cape, India, Ceylon, Aɔyssinia and Egypt, 24 col. plates
by D. Havell and others, hf. bd. (wormed), 1809, oɔlong
atlas folio (561) *Maggs*, £4 4s.
3653 St. Petersɔurgh. A Picture of St. Petersɔurgh, 20 col.
plates, orig. hf. ɔinding, E. Orme, 1815, folio (294)
Pickering, £4 15s.
3654 Seward (Miss). Monody on Major André, hf. mor., uncut,
one page repaired, *Philadelphia (circa* 1800), 8vo. (109)
Grant, £1 11s.
[At the end is ɔound up "Edmund of the Vale," a
hermit's tale.—*Catalogue.*]
3655 Shakespeare. Boydell's Graphic Illustrations of the Dramatic
Works of Shakspeare, lately exhiɔited at the Shakespeare
Gallery (the small set), orig. mor., g. e., Boydell & Co., n. d.
(1802), folio (556) *Sawyer*, £1 18s.
3656 Shaw (H.) Dresses and Decorations of the Middle Ages, 2
vol., col. plates and illustrations, hf. mor., g. e., W. Pickering,
1843, imp. 8vo. (35) *Schultz*, £3 17s.
3657 Shaw (H.) Specimens of Ancient Furniture, descriptions ɔy
Sir S. R. Meyrick, LARGE PAPER, the plates coloured, hf.
roan, Pickering, 1836, folio (496) *Talbot*, £2 3s.
3658 Sheraton (Thomas). The Caɔinet Maker and Upholsterer's
Drawing Book, front. and 64 plates, orig. hf. cf., 1793, 4to.
(488) *G. H. Brown*, £3 8s.
3659 Smith (C. Roach). Collectanea Antiqua, vol. i. to vii., illus-
trations, uncut, 1848-80, 8vo. (547) *Miss Harris*, £3 15s.
3660 Smollett (Toɔias). Miscellaneous Works, 5 vol., port. and 26
plates ɔy Rowlandson and others, cf., *Edinb.*, 1809, 8vo.
(447) *Walford*, £1 18s.
3661 Stephens (J. L.) Incidents of Travel in Central America,
Chiapas and Yucatan, 2 vol., maps and illustrations, 1842—
Incidents of Travel in Yucatan, 2 vol., maps and illustra-
tions, 1843, 8vo. (202) *Sotheran*, £1
3662 Sterne (L.) Sentimental Journey through France and Italy,
plates and illustrations by Maurice Leloir, orig. wrapper,
1885, 4to. (396) *T. Clarke*, 15s.
3663 Suecia Antiqua et Hodierna, in 2 vol., plates (index missing),
russ., *Holmiae* (1693-1714), 4to. (128) *Batsford*, £6 15s.
3664 Surveyors' Institution. Transactions, vol.-i.-xxxiv., plates,
1868-1902—Professional Notes, vol. i.-xi., 1886-1903, with
Index to vol. i.-viii., together 46 vol., as issued, 1868-1903,
8vo. (341) *H. R. Smith*, £3
3665 Sussex Archæological Collections, vol. i. and vi. to xxix.,
plates, orig. cl., 1848-79, 8vo. (546) *Miss Harris*, £3 15s.
3666 Thiers (A.) The History of the French Revolution, ɔy F.
Shoberl, 5 vol., ports. and plates, hf. cf., 1838, 8vo. (205)
Maggs, £1 15s.
3667 Turrecremata (J. de). Expositio Brevis et Utilis super toto

Psalterio, lit. **gotf).**, long lines, 31 to a full page, ɔlanks left
for initials, colophon and printer's device in red on last leaf
(pasted down), some leaves stained, hf. vell., *Mogunt.*, P.
Schoeffer, 1478, folio (425) *Hiersmann, £7*
3668 Victoria History of the Counties of England. Warwickshire,.
vol. i.-ii., maps and plates, 1904-8, folio (558) *Joseph, £1* 1s.
3669 Walton (I.) and Cotton (C.) The Complete Angler, Sir John
Hawkins' first ed., plates by Wale and Ryland, and en-
gravings, russ., g. e., 1760, 8vo. (38) *Hatchard*, 13s.
3670 Weɔer (J.) Mémoires concernant Marie Antoinette, ports.
engraved by Schiavonetti, 3 vol., mor., g. e., 1804, 8vo. (504)
Lemallier, £5 10s.
3671 White (Gilɔert). Natural History of Selɔorne, first ed.,
folding front. and plates, old cf., 1789, folio (519)
Edwards, £6 15s.
3672 Wilde (Oscar). The Sphinx, first ed., decorations by Charles
Ricketts, orig. vell., E. Mathews and J. Lane, 1894, 4to.
(388) *Dobell, £4* 15s.
3673 Wilde (O.) Salome, translated from the French [ɔy Lord
Alfred Douglas], first ed., illustrations by Auɔrey Beardsley,
500 copies printed for England, orig. ɔuckram, 1894, 4to.
(382) *Hatchard, £4*
3674 Wilde (O). A Woman of no Importance, first ed., orig. cl.,
John Lane, 1894, 8vo. (363) *Zaehnsdorf, £1* 16s.
3675 Wisden (John). The Cricketer's Almanack for 1868, 1870-75,
1878-80, 1883, 1889-99, 1901-2, 1904-9, ports., together 30
vol., orig. wrappers, 1868-1909, 8vo. (440) *Henry, £2* 6s.
3676 Wordsworth (Wm.) Poems, first ed., 2 vol., orig. cf. (ɔacks
and corners mended), Longman, 1807, 8vo. (484)
James, 17s.

*On February 4th, Messrs. Hall, Wateridge & Owen, of Shrews-
bury, sold the Library of the late Mr. J. F. M. Dovaston, of
West Felton, Shropshire, but the Catalogue was not compiled
in sufficient detail to render a full report of the sale feasible.
The following, however, appear to warrant insertion.*

3677 Bacon (Sir F.) The Twoo Bookes of the Proficience and
Advancement of Learning, first ed. (ɔinding not descriɔed),
Printed for Henrie Tomes at Graies Inne, Holborne, 1605,
sm. 4to. (34) *Myers, £4* 15s.
3678 Biɔle. The Byble in Englyshe, either the second, third or
fourth issue of Cranmer's Biɔle, hf. cf. gt., 1540, folio (83)
Quaritch, £10 15s.
[The catalogue does not give the month in which this
Biɔle was printed. The second edition appeared in April,
the third in July and the fourth in Novemɔer.—ED.]
3679 Biochimo (Gioachimo). The Royall Game of Chesse-play,
port. of Charles I. by P. Stent (ɔinding not descriɔed),
H. Herringman, 1656, 8vo. (12) *Clarke, £5*
3680 Eyton (R. W.) Antiquities of Shropshire, illustrations, 12
vol. in 6, cf., 1854-60, 8vo. (333) *£15*

3681 Fitzherbert (Sir A.) A ryghte profytable ᴣoke of Husbandrye, 𝔤𝔬𝔱𝔥𝔦𝔠 𝔩𝔢𝔱𝔱𝔢𝔯 (ᴣinding not descriᴣed), T. Berthelet, 1534, 8vo. (20) £5 5s.
3682 Gerarde (John). The Herball, interleaved and extended to 3 vol., russ., A. Islip, etc., 1636, folio (73) £7 15s.
3683 Horæ. Manuscript on Vellum, XV. (?) Century, ᴣinding renewed. This finely executed work, in red and ᴣlack, with illuminated capitals, contained 26 miniatures, surrounded ᴣy elaᴣorate ᴣorders in colours, some of the pages richly ornamented with ᴣorders, in which are introduced smaller miniatures, 7in. ᴣy 5in. (245) *Sawyer*, £52 10s.
 [This MS. was given to J. Dovaston in 1791, and, according to an inscription, was written for and used by Queen Mary. In that case the MS. could not, of course, date from the 15th century as stated in the catalogue. Most proᴣaᴣly 16th century.—ED.]
3684 Shakespeare (W.) Plays and Poems, with Life and History of the Stage ᴣy Edmund Malone, 21 vol., cf. gt., 1821, 8vo. (318) *George*, £8
3685 Shaw (S.) History and Antiquities of Staffordshire, maps and plates, 2 vol., orig. bds., uncut, J. Nichols, 1798-1801, folio (373) £10 10s.

[FEBRUARY 7TH AND THREE FOLLOWING DAYS, 1910.]

PUTTICK & SIMPSON.

THE LIBRARY OF THE LATE MR. ROBERT HOVENDEN, OF PARK HILL ROAD, CROYDON ; AND ALSO A SMALL COLLECTION OF AMERICANA.

(No. of Lots, 1288 ; amount realised, £2,966 19s.)

3686 Agnew (D. C. A.) Protestant Exiles from France, third ed., 2 vol., *Privately printed*, 1886, and 4to. Index, folio (1) *Maggs*, £2 12s.
3687 Alexis of Piedmont, Secrets of, 𝔟𝔩𝔞𝔠𝔨 𝔩𝔢𝔱𝔱𝔢𝔯, hf. cf., 1615, sm. 4to. (3) *Sawyer*, £1 6s.
3688 American Genealogies. Field (O.) The Fields of Sowerᴣy, hf. mor., 1895—The Cranes of Chilton, 1868—The Descendants of Geo. Denison of Stonington, Conn., 1881, together 3 vol., 8vo. (6) *Stevens*, £2
3689 American Genealogies. The Families of Baker, Burr, Corwin, Chittenden and Cushman, 5 vol., 1855-1879, 8vo. (7) *Quaritch*, £2 10s.
3690 American Genealogies. The Families of Huntingdon, Janes, Olmsted, Little, Lyman, Washington, Hayward and Harwood, 8 vol., 1856-79, 8vo. (8) *Stevens*, £4
3691 American Genealogies. The Families of Olcott, Mowry,

Montgomery, Davenport, Newcomɔ, 5 vol., 1865-77, 8vo.
(10) *Stevens,* £3 5s.
3692 American Genealogies. The Families of Starr, Streeter, Penn,
.Eddy, Willard and Vinton, 6 vol., 1858-1896, 8vo. (11)
Maggs, £4 15s.
3693 American Genealogies. Wentworth (J.) The Wentworth
Genealogy, English and American, pedigrees, ports., etc.,
3 vol., 1878, 8vo. (12) *Quaritch,* £1 12s.
3694 America. Heraldic Journal, 4 vol. in 2, hf. mor., *Boston,*
1865-7, 8vo. (14) *Rimell,* £2
3695 America. Walker (Sir H.) Journal, or Full Account of the
late Expedition to Canada, old cf., 1720, 8vo. (16)
Arnold, £3 15s.
3696 Anderson (T. C.) Croydon Church, plates on thick paper,
cl. ex., 1871, 8vo. (18) *Howe,* £1 5s.
3697 Antiquary (The). A Magazine devoted to the Study of the
Past, edited ɔy Edward Walford, vol. i. to xxvi., rox., g. t.,
1880-1891, 4to. (21) *Rimell,* £1 14s.
3698 Arɔer (E.) Transcript of the Registers of the Company of
Stationers, 1554-1640, 5 vol., cl. ex., *Privately printed,* 1875-
1894, 4to. (24) *Goss,* £14
3699 Archæologia, or Miscellaneous Tracts relating to Antiquity,
from vol. xxviii. to vol. lx., part ii. and Index, vol. i. to l., 39
vol., wanted 1835-1836 part i., 1837-1843 part ii., 1849-1850,
1840-1907, 4to. (25) *Sotheran,* £6
3700 Armorial China. Catalogue of the Crisp Collection of Chinese
Porcelain (150 copies printed)—Catalogue of the Lowestoft
China in the possession of F. A. Crisp, 2 vol., hf. vell., 8vo.
(28) *Rimell,* £2 15s.
3701 Barrère (A.) and Leland (C. G.) A Dictionary of Slang,
Jargon and Cant, 2 vol., 1889-90, 4to. (37) *Goss,* £1 6s.
3702 Bartolozzi and his Works, ɔy A. W. Tuer, illustrations, extra
plates inserted, Collector's ed., limited to 50 copies, 2 vol.
in 4, vell. bds., 1895 (38) *Howe,* £6 6s.
3703 Bartolozzi (F.) Antique Gems, 108 plates engraved ɔy Barto-
lozzi, in portfolio (39) *Hills,* £1 5s.
3704 Bedford. Genealogia Bedfordiensis, ɔeing a Collection of
Evidences relating chiefly to the Landed Gentry of Bed-
fordshire, ɔy F. A. Blaydes, hf. parchment, 1890, roy. 8vo.
(48) *Quaritch,* £1 14s.
3705 Bedfordshire. Notes and Queries, edited ɔy F. A. Blaydes,
3 vol., cl., 1886-1892, 8vo. (50) *Goss,* £2 7s. 6d.
3706 Berks. Catholic Register of Upton Court, Berkshire and
Woolhampton, one of 50 copies privately printed by F. A.
Crisp, vell., 1889, 8vo. (52) *Quaritch,* £1 2s.
3707 Berks. Reading. Registers of the Parish of St. Mary, Read-
ing, ɔy G. B. Crawford, 2 vol., hf. vell., 1891, sm. folio (54)
Walford, £1 15s.
3708 Berkshire Visitations, *Privately printed by Sir T. Phillipps,*
hf. mor., n. d., folio (55) *Stocock,* £2 10s.
3709 Berks, Bucks, Surrey and Essex Pedigrees, by Wm. Berry,
hf. mor., 1837-30, folio (56) *Walford,* £3 10s.

3710 Berry (W.) Pedigrees of Berkshire Families, bds., 1837, folio
 (57) *Stocock,* £5
3711 Berry (W.) Pedigrees of Essex Families, bds., uncut, n. d.
 (1837), folio (58) *Arnold,* £3 10s.
3712 Berry (W.) Pedigrees of the Families in the County of
 Hants, bds., 1833, folio (59) *Arnold,* £3 10s.
3713 Berry (W.) Pedigrees of Hertfordshire Families, bds., n. d.
 (1837), folio (60) *Edwards,* £3 3s.
3714 Berry (W.) Pedigrees of the Families of the County of
 Sussex, bds., 1830, folio (61) *Walford,* £4 7s. 6d.
3715 Binding. Staat's Kalender, 1784, copy sent to George III.,
 worked silk binding, with initials and coronet in silk and
 spangles, in case, " G. R." on side, 8vo. (62) *Tregaskis,* £4
3716 Blore (E.) Monumental Remains, LARGE PAPER, India
 proofs, mor. ex., 1826, 4to. (64) *Rimell,* £1 3s.
3717 Bookplates. Examples of Irish Bookplates from the Burke
 Collection, with Supplement, limited issue, 2 vol., hf. bd.,
 1894, 4to. (65A) *Quaritch,* £1 8s.
3718 Bookplates. Griggs (W.) Armorial Bookplates, both series,
 2 vol., hf. mor., 1884-1892, 8vo. (65B) *Quaritch,* £4
3719 Bookplates. Journal of the Ex-Libris Society, from 1891 to
 1908, illustrations, 18 vol. in 199 parts, also General Index,
 4to. (66) *Dobell,* £1 10s.
3720 Botfield (B.) Memorials of the Families of De Boteville,
 Thynne and Botfield, with additions, rox., 1858, 4to. (71)
 Gray, £1 12s.
3721 Boyne (W.) Trade Tokens issued in the XVIIth Century,
 by Williamson, 2 vol., rox., 1889-91, 8vo. (75) *Maggs,* £2
3722 Brazazon Family. Genealogical History of the Family of
 Brazazon, LARGE PAPER, pedigrees, arms, views, etc., some
 on India paper, *Paris,* 1825—also a second copy, hf. cf.,
 together 2 vol., 4to. (76) *Stevens,* £3 3s.
3723 Bristol. The Little Red Book of Bristol, ed. by F. B. Brakley,
 plates, 2 vol., cl., g. t., 1900, 4to. (81) *Rimell,* £1 2s.
3724 British Archæological Society. Journal, illustrations, from
 the commencement, April, 1845 to September, 1908, being
 the Old Series, 47 vol., complete—New Series, vol. i. to
 xiv., part iii., in the orig. parts as issued, wanted Jan., 1870,
 Sept. and Dec., 1888, Dec., 1889, June, 1891 to Dec., 1896,
 being vol. i. and ii. of New Series, 8vo. (83B)
 Bailey, £4 12s. 6d.
3725 Bucks. Catholic Registers of Western Underwood, *Privately
 printed by F. A. Crisp,* vell., 1887, folio (86) *Rimell,* £1 1s.
3726 Burke (J. and Sir J. B.) General Armory, third ed., autograph
 letter inserted, 1844, 8vo. (92) *Hills,* £1 15s.
3727 Caesar (Sir Julius). Life, LARGE PAPER, ports., 1810, with
 Broadside relating to the case of John Higgins and Alice
 Cesar, 1703, inserted, russ. gt.—also another edition, ports.,
 bds., 1827, together 2 vol., 4to. (100) *Goss,* £1 4s.
3728 Camden (Sir W.) Britannia, best ed., plates, 4 vol., bds.,
 uncut, 1806, folio (104) *Jones,* £1 8s.
3729 Camden Society. Series from 1840 to 1868, 20 vol. various

—New Series, 13 vol., 1877-1901—Third Series, vol. i. to
xv., together 48 vol., 1900-1908 (105) *Harding*, £8 5s.
3730 Carr Family of Dunston Hill, co. Durham, History of,)y
Col. R. E. Carr, col. plates of arms, etc., 3 vol., 1893, imp.
4to. (107) *Walford*, £4 2s. 6d.
3731 Cheshire. Earwaker (J. P.) History of Sandbach, *Privately
printed*, 1890, 4to. (114) *Thorpe*, £1 3s.
3732 Cheshire. Ormerod (G.) History of the County Palatine and
City of Chester, plates, etc., LARGE PAPER, 3 vol.)ound in
6, mor., g. t., 1882, folio (115) *Bailey*, £5 5s.
3733 Cheshire Parish Registers, 6 vol., cl., 1891-6, 8vo. (117)
 Gray, £1 14s.
3734 Clarke (G. T.) Mediæval Military Architecture in England,
illustrations, 2 vol., orig. cl., 1884, 8vo. (122) *Rimell*, £1 3s.
3735 Clifford (A.) Collectanea Cliffordiana, rox., g. t., *Privately
printed*, 1817 (123) *Thorpe*, £1 1s.
3736 Cokayne (G. E.) Complete Baronetage, 5 vol., complete, vol.
i. hf. mor., the remainder in bds., 1902-6, 8vo. (125)
 Goss, £10 10s.
3737 Collectanea Topographica et Genealogica, ed. by J. B. Nichols,
8 vol., cl., 1834-43 (127) *Goss*, £3 5s.
3738 Collins (A.) Peerage of England, continued)y Sir Egerton
Brydges, 9 vol., cf., 1812 (128) *Goss*, £1 10s.
3739 Coppinger Family of County Cork, History of, ed. by W. A.
Copinger, pedigrees, etc. loosely inserted, 1884—Taafe
Family of Louth and Sligo, Memoirs, ports., *Privately
printed, Vienna*, 1856, together 2 vol., 8vo. (130)
 Walford, £2 10s.
3740 Cornwall. Fox Family. The Descendants of Francis Fox
of St. Germains, 1872—Short Genealogical Account of the
various Families of Fox in the West of England, 1864, 8vo.
(133) *Gray*, £2
3741 Cornwall. Parish Registers, ed. by Phillimore, etc., vol. i. to
viii. and vol. x., cl., 1900, 8vo. (136) *Guiness*, £3
3742 Cornwall Pedigrees. Vivian (J. L.) Visitation of Cornwall,
hf. mor., 1887, 8vo. (140) *Quaritch*, £1 17s. 6d.
3743 Coronation of King Edward VII. and Queen Alexandra,
Form and Order of the Service with the Music, edited by
Bridge, limited issue on Japanese vell., mor., arms and
tudor roses on sides, solid gold clasp, gilt leaves, 8vo. (141)
 Sawyer, £3 12s. 6d.
3744 Cotton (H.) Fasti Ecclesiæ Hibernicae, additions and index
)y Garstin, 5 vol., cl., 1860, 8vo. (143) *Guiness*, £2 5s.
3745 Crispe Family. Collections relating to the Family of Crispe,
4 vol., hf. vell., 1882-97, 8vo. (146) *Harding*, £1
3746 Creeny (W. F.) Facsimiles of Monumental Brasses on the
Continent, LARGE PAPER, hf. bd., 1884, folio (147)
 Parker, £1 5s.
3747 Croke (Sir A.) Genealogical History of the Croke Family,
commonly named Le Blount, 2 vol., bds., 1823, 4to. (148)
 Thorpe, £2 3s.

3748 Croston (J.) History of the Ancient Hall of Samlesɔury, illust., mor., 1871, folio (149) *Edwards,* £1 6s.
3749 Culpeper (Nich.) The English Physitian, port., cf., 1652, folio (150) *Rimell,* £2 14s.
3750 Cumɔerland Pedigrees. The Visitation of Cumɔerland, 1615, edited ɔy Fetherston, *Harleian Society,* 1872, 8vo. (153) *Thurloe,* £1 14s.
3751 Cumɔerland. Registers of Ulverston Parish Church, ɔy Bardsley and Ayre, hf. mor., 1886, thick 4to. (154) *Gray,* £2 10s.
3752 Cumɔerland and Westmorland Pedigrees. Visitations of 1615, 1666, ed. Foster (1880), 8vo. (155) *Thurloe,* £3
3753 Derɔyshire Archæological and Natural History Society. Journal, vol. i. to xxxi., from the commencement, Jan., 1879 to 1909, 27 vol. cl., rest unbd., 8vo. (159) *Hitchman,* £4 5s.
3754 Derɔyshire. Cox (J. C.) Notes on the Churches of Derɔyshire, plates, 4 vol., cl., 1875-79, roy. 8vo. (161) *Thorpe,* £1 14s.
3755 Dering Family. Genealogical Memoranda relating to the Family of Dering, by Haslewood, coats-of-arms, autograph letters of Edward Dering, 1801, inserted, vell., 1876, 8vo. (165) *Ellis,* £1 19s.
3756 Devonshire Pedigrees. Visitations of the County, 1531, 1564, 1620, with additions ɔy Lieut.-Col. Vivian, hf. mor., g. t., 1895, 8vo. (171) *Quaritch,* £3 5s.
3757 Devon and Cornwall. The Western Antiquary, or Devon and Cornwall Note Book, 1882-94, 12 vol., unbd., 8vo. (176) *Rimell,* £1 18s.
3758 Domesday Studies, edited ɔy Dove, 2 vol., 1888, cl., 4to. (181) *Parker,* £1 2s.
3759 Dorset. Hutchins (John). History and Antiquities of Dorset, 4 vol., mor., a few additions inserted, 1861-70, folio (182) *G. H. Brown,* £11 10s.
3760 Duckett (Sir G. F.) Charters and Records among the Archives of the Aɔɔey of Cluni, 2 vol., 1888—Visitations and Chapters General of Cluni, 1893—Penal Laws and Test Act, 1883, 2 copies, printed for suɔscriɔers, together 5 vol., orig. cl., 8vo. (187) *Harding,* £2 16s.
3761 Duket Family. Duckett (Sir G. F.) Duchetiana, or Historical and Genealogical Memoirs of the Family of Duket, hf. mor., 1874—Another copy, with ɔookplates inserted, hf. mor., 4to. (188) *Quaritch,* £2 4s.
3762 Durham Pedigrees. Heraldic Visitation of Durham in 1575, by Flower, ed. Philipon, bds., 1820, folio (193) *Harding,* £1 2s.
3763 Durham Pedigrees. Visitation of Durham in 1615, by St. George, bds., 1820, folio (195) *Stevens,* £2 10s.
3764 Durham and Northumɔerland Parish Register Society, vol. i. to xix., vol. i. hf. mor., rest in wrappers, 1898-1908, 8vo. (197) *Ellis,* £4
3765 East Anglian Notes and Queries, vol. i. to iv.—New

Series, vol. i. to ix., complete, and vol. x. to xiii. (wanted
some parts), 11 vol. hf. vell., remainder unbd., 8vo. (199)
Quaritch, £5 10s.

3766 Essex Archæological Society. Transactions, vol. i. to v.—
New Series, vol. i. to xi., 11 vol., rox., g. t., rest unbd., 1858-
1909, 8vo. (202) *Morley, £8* 10s.

3767 Essex. Bookingworth Registers, 1558-1785, one of 30 copies
privately printed by F. A. Crisp, vell., 1884 (203)
Walford, £1 17s. 6d.

3768 Essex. Bookingworth Sepulchral Memorials, Pedigrees,
Wills, etc., cuts of arms, one of 100 copies privately printed
by Crisp, vell., 1888 (204) *Quaritch, £1* 6s.

3769 Essex. History of, from a Late Survey, and Review of
Remarkable Events to 1771, copperplate views and maps,
6 vol., cf., 1771, 8vo. (206) *Edwards, £5*

3770 Essex. Kennedy (J.) History of the Parish of Leyton, LARGE
PAPER, hf. vell., 1894, folio (208) *Goss, £1* 2s.

3771 Essex. Morant (Philip). History and Antiquities of Essex,
map and plates, 2 vol., hf. cf., 1768, folio (209) *Arnold, £8*

3772 Essex. Parish Registers of Beaumont, Fyfield, Greensted,
Lambourne and Colchester, 5 vol., hf. vell., Crisp, 1890-99
(211) *Thorpe, £3* 17s. 6d.

3773 Essex Pedigrees. Visitation of the County, 1663-1668, by
Bysshe, ed. by Howard, mor. ex., gilt leaves, one of 6
special copies (issued at £2 12s. 6d.), 1888, 8vo. (212)
Rimell, £1 6s.

3774 Essex. South Weald. The First Book of the Registers of
St. Peter, 1539-1573, ed. by Hovenden, one of 34 copies,
hf. mor., g. t., 1889, imp. 8vo. (213) *Stevens, £1* 17s. 6d.

3775 Essex. South Weald. Registers of St. Peter's Church, 1539-
1573, ed. by Hovenden (34 copies printed), 10 copies (one
with error on title-page afterwards corrected), cl., 1889, 8vo.
(214) *Walford, £3* 12s. 6d.

3776 Essex. Stifford Parish Registers, *Privately printed by F. A.
Crisp*, vell., 1889, folio (215) *Quaritch, £1* 16s.

3777 Essex. Suckling (A.) Memorials of Essex, plates, LARGE
PAPER, hf. mor., 1845, folio (217) *Rimell, £2* 1s.

3778 Essex. Wright (T.) History and Topography of the County,
mostly India proof plates, 2 vol., hf. mor., 1836, 4to. (219)
Rimell, £1 17s.

3779 Fletcher (Phineas). Poems, ed. by A. B. Grosart, 4 vol., cl.,
Printed for private circulation, 1868, 8vo. (229) *Hill, £1* 6s.

3780 Fortescue Family. History, by Lord Clermont, ports., pedi-
grees, etc., Supplement and additions loosely inserted, rox.,
uncut, 1880, 4to. (230) *Rimell, £1* 1s.

3781 Fortescue Family. History, by Lord Clermont, second ed.,
with Supplement, LARGE PAPER, hf. mor., 1880, 4to. (231)
Rimell, £1 10s

3782 Foster (Joseph). Alumni Oxonienses, 8 vol.—Index Eccle-
siasticus, or Alphabetical Lists of Ecclesiastical Dignitaries,
together 9 vol., rox., g. t., 1887-1891, 4to. (232) *Ellis, £4* 10s.

3783 Foster (J.) Register of Admissions to Gray's Inn, 1521-1889, with the Register of Marriages in Gray's Inn Chapel, 1695-1754, hf. mor., *Privately printed for subscribers*, 1889, 4to. (233) *Gray, £1*

3784 Fragmenta Genealogica, edited ɔy Crisp, vol. i. to xii., hf. vell., 1889-1906, 8vo. (235) *Harding, £4* 17s. 6d.

3785 Genealogist (The), edited ɔy Dr. Marshall, etc., vol. i. to vii., and New Series, vol. i. to xxv., also Supplement—Parish Registers of Bermondsey, 1548-1609, 23 vol. cl. and 39 parts, 1877-1909, 8vo. (240) *Harding, £6* 10s.

3786 Gloucestershire. Bigland (R.) Historical, etc. Collections relating to the County, extra illustrated, arms emɔlazoned, 2 vol. in 1, cf., 1791-2, folio (245)—Sir T. Phillipps' Continuation of Bigland's Gloucester, in 9 parts, 1870-87—Fosbrooke (T. D.) History of the City of Gloucester, 1819, folio (246) *Quaritch, £20*

3787 Gloucestershire. Parish Registers, edited ɔy Phillimore, 12 vol., cl., 1896-1906, 8vo. (248) *Harding, £2*

3788 Gloucestershire. Parish Registers of Kempsford and Berkeley, ɔy Crisp, 2 vol., hf. vell., *Privately printed*, 1897, 8vo. (249) *Walford, £1*

3789 Gloucestershire Pedigrees. Visitation of 1569, *Privately printed by Sir T. Phillipps*, 1854, folio (250)
 Arnold, £1 10s.

3790 Gloucestershire. Notes and Queries, edited ɔy Beaver, Blacker and Phillimore, vol. i. to x. (June part), 3 vol. rox., g. t., rest unbd., 1881-1905, 8vo. (251) *Harding, £1* 6s.

3791 Gresham Family. Genealogy, by G. Leveson Gower, LARGE PAPER, interleaved, vell., 1883, 4to. (256) *Goss, £2* 10s.

3792 Griggs (W.) Illustrations of Armorial China, col. plates in six parts (no wrapper to part vi.), *Privately printed*, 1887, folio (258) *Rodman, £4*

3793 Grose (F.) Antiquities of England and Wales, first ed., views, complete with supplement, 6 vol., hf. russ., 1773-87, 4to. (259) *Arnold, £1* 15s.

3794 Guasco. Delle Ornatrici e de Loro Uffizj, engravings of antique comɔs and head-dresses, hf. mor., g. t., 1775, 4to. (260) *Arnold, £1* 6s.

3795 Haines (H.) Monumental Brasses, illustrations, 2 vol., cl., 1861, 8vo. (264) *Harding, £2*

3796 Hair-dressing. Duplessis (J.) Essai sur l' Art de la Frisure, 1760—L'Encyclopedie Perruquiere, plates, 1762—L'Encyclopedie Carcassiere ou Taɔleaux de Coiffures à la Mode, plates, 1763—Tissot. Traité de la Nature des Cheveux, 1776—Allemand. Le Parfait Ouvrage ou Essai sur la Coeffure, front., 1776, a collection on hairdressing, in 1 vol., mor. ex., 8vo. (265) *Rimell, £3*

3797 Hair-dressing. Recueil Général de Coeffures de differents Gouts, 1589-1778, suivi d'une Collection de Modes Françoise, 48 ports. shewing different styles of hair-dressing, extra plates inserted, continuing the fashions to 1799, title mounted, hf. mor., not suɔject to return, 1778, 8vo. (271)
 Edwards, £11 5s.

3798 Hair-dressing. Stewart (J.) Plocacosmos, or the Whole Art of Hair-dressing, front. and plates, bds., uncut, 1782, roy. 8vo. (272) *Rimell*, £1 7s. 6d.

3799 Hampshire Parish Registers, ed. ɔy W. P. W. Phillimore, 8 vol., cl., 1899-1906, 8vo. (281) *Thorpe*, £2 12s.

3800 Hampshire Pedigrees, ɔy Wm. Berry, hf. mor., 1833, folio (282) *Harding*, £1

3801 Hampshire Record Society. Puɔlications, 11 vol. (wanted 1893), 1889-1899, 8vo. (284) *G. H. Brown*, £2 10s.

3802 Hampshire. Woodward (B. B.) and Wilks (T. C.) History of Hampshire, plates (a few extra inserted), 3 vol. (1880), 4to. (285) *Jones*, £2 15s.

3803 Harleian Society. Puɔlications, complete set of the Visitations and Registers, cl., as issued, 92 vol., 1869-1908, 8vo. (288) *Thorpe*, £36
[Visitations, vol. i. to lvii., the Essex Visitation, interleaved and ɔound in 3 vol. ; and the London Visitation, 2 vol., interleaved and ɔound in 4. Registers, vol. i. to xxxii., 1877-1905.—*Catalogue.*]

3804 Hasted (E.) History of Kent, maps and plates, 4 vol., orig. cf., 1778-1799, folio (291) *Edwards*, £15 10s.

3805 Heath Family. Heathiana. Notes, Genealogical and Biographical, of the Family of Heath, hf. mor., 1881, 4to. (293) *Young*, £2

3806 Herald (The) and Genealogist, ed. by J. G. Nichols, 8 vol., hf. mor., g. t., 1863-74, 8vo. (294) *Bailey*, £2 12s. 6d.

3807 Hertfordshire. Aldenham Parish Registers, 1559-1659, ed. ɔy Brigg, cl., 1902, 8vo. (298) *Carter*, £1 8s.

3808 Hertfordshire. Cass (F. C.) East Barnet, South Mimms, Monken Hadley, 3 vol., hf. mor., 1880-1892, 4to. (299) *G. H. Brown*, £7

3809 Hertfordshire. Chauncy (Sir H.) Historical Antiquities of Hertfordshire, port., map and plates, also the rare list of plates, cf., 1700, folio (300) *G. H. Brown*, £1 1s.

3810 Hertfordshire. Chauncy (Sir H.) Historical Antiquities of Hertfordshire, douɔle-page plates, maps, etc., 2 vol., cf., 1826, 8vo. (301) *G. H. Brown*, £8 5s.

3811 Hertfordshire. Clutterɔuck (R.) History and Antiquities of the County of Hertford, map and plates, 3 vol., bds., uncut, 1815-27, folio (302) *Goss*, £5 5s.

3812 Hertfordshire Pedigrees. Collected ɔy Wm. Berry, printed in lithography (with additions), hf. mor., g. t. (1883), folio (306) *Rimell*, £3 7s. 6d.

3813 Herts. Genealogist and Antiquary, ed. by Brigg, 3 vol., hf. mor., 1895-1899—St. Alɔans Aɔɔey Parish Registers, transcriɔed ɔy Brigg, uniform, 1897, together 4 vol., 8vo. (307) *Goss*, £3 10s.

3814 Holme (R.) Academy of Armory, 49 plates, cf., 1701, folio (313) *Tregaskis*, £9 5s.

3815 Hotten (J. C.) The Original Lists of Emigrants to the American Plantations, 1874, 4to. (315) *Thorpe*, £1 13s.

3816 Howard (J. Jackson). Genealogical Collections illustrating the History of Roman Catholic Families of England, parts i. to iv., bds., 1892, folio (316) _Walford,_ £2 2s.
3817 Huguenot Society of London. Publications, vol. i. to xvii. in 26 parts, and 1 vol. cl., 1887-1905, 4to. (326) _Goss,_ £7 10s.
3818 Huguenot Society. Publications, fine paper copies, 14 vol. (vol. ix. missing), 1 vol. in cl. and 20 parts, 1890-98, 4to. (326A) _Arnold,_ £4 15s.
3819 Huguenot Society of London. Proceedings from the commencement in 1885, to vol. viii., part iii., 1907, 3 vol., hf. mor., remainder in parts, 4to. (327) _Maggs,_ £5 7s. 6d.
3820 Husenbeth (F. C.) Emblems of Saints, third ed., 1882, 8vo. (330) _Tregaskis,_ £2 10s.
3821 Index Library. Issued by the British Record Society, vol. i. to xxxv., 29 vol., rox., gt. tops, rest unbd., 1888-1908, 8vo. (332) _Bailey,_ £12 5s.
3822 Ireland. Association for the Preservation of the Memorials of the Dead in Ireland, Journal of, from vol. ii. to vol. vii., part i., with Indexes to vol. i. to iv., 29 parts, 1892-1909, 8vo. (335) _Hodges,_ £5
3823 Irish Book-plates, Examples of, from the Collections of Sir Bernard Burke, privately issued by his son, 100 copies done, and the supplementary volume of which only 30 were printed, together 2 vol., 1849, 4to. (340) _Quaritch,_ £1 7s.
3824 Irish Marriages. Index to the Marriages in Walker's Hibernian Magazine, 1771-1812, by Farrar, 2 vol., 1897, 8vo. (341) _Stevens,_ £2 10s.
3825 Irish Pedigrees. Visitation of Ireland, edited by Howard and Crisp, vol. i. to iv., 1897-1904, 8vo. (342) _Walford,_ £2 8s.
3826 Ireland (S.) Picturesque Views on the River Thames, aquatint plates, 2 vol., hf. mor., g. t., 1801-2, roy. 8vo. (343) _Goss,_ £1 8s.
3827 Jewish Historical Society. Transactions, 5 vol.—Publications, 3 vol., together 8 vol., 1893-1905, 8vo. (345) _Bailey,_ £1 6s.

Kent. Works relating to the County of Kent.

3828 Acts of Parliament, ranging from 1552 to 1816 (about 50), folio (353) _Thorpe,_ £3 10s.
3829 Amsinck (P.) Tunbridge Wells, etchings, russ. gt., 1810, 4to. (356) _Sotheran,_ £1
3830 Archæologia Cantiana, vol. i. to xxvii.—and extra vol., Testamenta Cantiana, 28 vol., cl., 1858-1906, 8vo. (357) _Jones,_ £8
3831 Archæologia Cantiana, LARGE PAPER, vol. i. to xxvii., 1858-1905, 8vo. (358) _Jones,_ £6 10s.
3832 Ayenbite (The) of Inwyt, in the dialect of Kent, by Dan Michel of Northgate, written in the year 1340, now first printed, ed. by Stevenson, rox., 1855, 8vo. (360) _Bain,_ £1 2s.
3833 Badeslade (T.) Thirty-six Views of Noblemen and Gentlemen's Seats, hf. mor., n. d., folio (361) _Rimell,_ £3 10s.

3834 Berry (W.) ·Kentish Genealogies, complete, bds., uncut, 1830, folio (365) *Walford,* £6 10s.
3835 Berry (W.) Pedigrees of the Families in the County of Kent, special copy, interleaved and ɔound in 2 vol., hf. mor., 1830, folio (366) *Daniell,* £7 15s.
3836 Birchington Parish Registers, *Privately printed by F. A. Crisp,* hf. vell., 1899, 8vo. (367A) *Gray,* £1 8s.
3837 Boys (W.) Collections for an History of Sandwich, maps and plates, LARGE PAPER, 2 vol., hf. russ., 1792, 4to. (369)
Arnold, £6 10s.
3838 Brayley (E. W.) Beauties of Kent, LARGE PAPER, extra illus-trated, including a series of plates by Ireland, Gilpin, etc., 5 vol., hf. mor., 1807, 8vo. (371) *Thorpe,* £5
3839 Canterɔury Cathedral. Register Booke of Christninges, Marriages and Burialls, ed. by Roɔert Hovenden, fine paper copy, mor. ex., 1878, 8vo. (382) *Bailey,* £1 1s.
3840 Canterɔury Marriage Licences, ed. by J. Meadows Cowper, thick paper copy, *Privately printed,* 6 vol., mor. ex., 1892-1906, 8vo. (392) *Harding,* £6 5s.
[Another set, in cloth, as issued, realised £4 10s.—ED.]
3841 Canterɔury. Registers of St. Alphages, St. Dunstans, St. Georges, St. Mary's, St. Pauls and St. Peters, ed. by J. Meadows Cowper, thick paper copies, 6 vol., mor. ex., 1887-1893, 4to. (395) *Walford,* £3 10s.
3842 Canterɔury Registers of the Wallon or Strangers Church in Canterɔury, ed. by Roɔert Hovenden, cl., g. t., 1891, and 4 copies unbd. (each in 3 parts), 4to. (403) *Goulden,* £2
[Forming vol. v. of the Huguenot Society's puɔlications. —*Catalogue.*]
3843 Canterɔury. Roll of the Freemen of the City, 1392-1800, by J. M. Cowper, thick paper copy, mor., g. t., 1903, 4to. (404)
Walford, £1 4s.
3844 Canterɔury. The Roll of the Freemen of the City of Canter-ɔury, 1392-1800, by J. M. Cowper, *Privately printed,* 1903—Intrantes : Admitted from 1392-1592, ed. ɔy J. M. Cowper, *Privately printed,* 1904, ɔoth mor. ex., 4to. (405)
Quaritch, £3 10s.
3845 Canterɔury, Somner (W.), Antiquities of, first ed., map and plan, old cf. (reɔacked), 1640, 4to. (406) *Goss,* £1 7s. 6d.
3846 Canterɔury Wills. Extracts from the Registers of the several Wills and Testaments proved, 1444-1731, MS. in 7 vol., hf. mor., sm. 4to. (411) *Rimell,* £7 15s.
3847 Chislet Parish Registers, 1538-1707, ed. by Roɔert Hovenden, fine paper copy, mor., g. t., 1887, 8vo. (414)
Quaritch, £1 14s.
3848 Chislet Parish Registers, 1538-1707, ed. ɔy Roɔert Hovenden, 1887—Maidstone Parish Church Registers, 1901—Beakes-ɔourne Parish Registers, 1896, 2 copies—Wymingeweld Parish Register (25 copies printed), 1898—Lee. St. Mar-garets Register, 1888—Kingston (Kent) Parish Registers, 1893, together 7 vol., 8vo. (420) *Walford,* £4 12s. 6d.
3849 Church Notes, MS. by Dr. Howard, with drawings and
XXIV. 18

ru))ings of·)rasses, etc., additional illustrations, engravings, old deeds, etc. loosely inserted, 5 vol., hf. mor. (1860), folio and 4to. (423) *Rimell, £6* 5s.

3850 Copies of Paintings on glass in Christ Church, Kilndown, by Eggert, col. plates, hf. mor. (1850), folio (426) *Winch, £3*

3851 Cotton (C.) History and Antiquities of the Church of St. Laurence, Thanet, maps, etc., 1895, 4to. (427)
Thorpe, £1 4s.

3852 Courtenay (Sir W.) Life and Extraordinary Adventures, plates, complete in 20 parts, 1838-9, 8vo. (428) *Bain, £3*

3853 Cowper (J. M.) The Memorial Inscriptions of the Cathedral Church of Canter)ury (one of 67 copies privately printed), mor., 1897, folio (429) *Quaritch, £3* 10s.

3854 Cozens (Z.) History of Kent, unpu)lished MS. of a)out 1,400 pages, in 2 vol., old hf. cf., *c.* 1800, 4to. (430)
Thorpe, £15 5s.

3855 Cozens (Z.) Tour through Thanet and other parts of East Kent, plates, hf. mor., 1793, 4to. (431)
Edwards, £2 17s. 6d.

3856 Cran)rook. A Brief Historical Account of Cran)rook, hf. mor., *Cranbrook*, 1789, 8vo. (432) *Sotheran, £2.*

3857 Crowquill. Guide to the Watering Places, by Alfred Crowquill, wrappers (1837), 8vo. (433) *Winch, £2*

3858 Deptford. Dunkin (A. J.) History of Deptford (200 copies printed), uncut, 1854, 8vo. (438) *Goss, £1* 17s. 6d.

3859 Dillon (J. J.) Hortus Elthamensis, 325 plates, LARGE PAPER, hf. cf., 1732, folio (441) *Quaritch, £3* 3s.

3860 Dover. The Old Mans Staffe. Two Sermons shewing the Onely Way to a comforta)le old Age. Preached in Saint Maries in Douer by John Reading, hf. mor., 1621, sm. 4to. (445) *Ellis, £1* 2s.

3861 Duncom)e (J.) History and Antiquities of Reculver and Herne, plates, hf. mor., 1784, 8vo. (451) *Daniell, £1* 10s.

3862 Dunkin (A. J.) History of Kent, 2 vol., cl., 70 copies printed, 1856-1858, 4to. (454) *Inglesden, £3* 5s.

3863 Dunkin (A. J.) History and Antiquities of Dartford, port., hf. mor., g. t., re-issue of 1846 edition, 8vo. (455) *Jones, £2*

3864 Erith. Extracts from the Registers of the Baptisms, etc. of the Parish Church, one of 25 copies printed for private circulation, hf. mor., 1879, folio (459) *B. F. Stevens, £4*
[The only Records now existing, the Registers having)een destroyed by fire in 1877, six months after these extracts were made.—*Catalogue.*]

3865 Furley (R.) Weald of Kent, autograph letters of the author inserted, 2 vol. in 3, cl., 1871-4, 8vo. (467) *Goss, £2* 2s.

3866 Glynne (Sir S. R.) Notes on the Churches of Kent, illustrations, and others added, MS. Index, cf. ex., 1877, 8vo. (471)
Tregaskis, £1 7s. 6d.

3867 Gravesend. Pocock's History of Gravesend and Milton, first ed., front., 1797, sm. 4to. (475) *Goss, £1* 8s.

3868 Greenwood (C.) Epitome of the County of Kent, plates, 2 vol., 1838, 4to. (476) *Arnold, £1* 5s.

3869 Greenwood (C.) Epitome of the History of Kent, LARGE PAPER, plates, 1838, 4to. (477) *Brown*, £1 5s.

3870 Harris (J.) History of Kent, with the map and view of Rochester, also additional illustrations, vol. i. (all pub.), cf., fine copy, 1719, folio (480) *Goss*, £7 10s.

3871 Harris (J.) History of Kent, extra illustrated, containing Badeslade's series of views and ports., hf. mor., 1719, folio (481) *Brown*, £6 15s.

3872 Hassell (J.) Views of Seats in Kent, ɔound in 1 vol., hf. mor., 1804, 4to. (488) *Spencer*, £2 10s.

3873 Hasted (E.) History of Kent, maps and views, 4 vol., hf. mor., 1778-99, folio (489) *Inglesden*, £19

3874 Hasted (E.) History of Kent, plates, etc., 12 vol., contemp. hf. cf., 1797-1801, 8vo. (490) *Bailey*, £3 3s.

3875 Hasted (E.) History of Kent. The Hundred of Blackheath, ed. by Blake, 1886, folio (491) *Arnold*, £1

3876 Hilder (Thomas, of Sandwich). Conjugall Counsell, port., cf., 1653, 8vo. (493) *Tregaskis*, £1 4s.

3877 Hops. Scot (Reynolde). A Perfite Platforme of a Hoppe Garden, black letter, cuts, last leaf repaired, had the preliminary ɔlank leaf, A.j., mor., g. e., Henrie Denham, 1576, 4to. (495) *Tregaskis*, £7

3878 Ireland (W. H.) New and Complete History of Kent, views from drawings by Sheppard and Gastineau, 4 vol., contemp. cf., 1828-30, 8vo. (500) *Brown*, £1 6s.

3879 Ireland (S.) Picturesque Views on the River Medway, LARGEST PAPER, plates, contemp. mor., g. e., 1793, folio (501) *Spencer*, £1 15s.

3880 Kilburne (R.) Survey of the County of Kent, last leaf defective, portion of a later edition added, cf., 1659, oɔlong 4to. (506) *Ellis*, £2 10s.

3881 Kentish Fayre (The), or The Parliament sold to their ɔest Worth (in new ɔoards), 1648, 4to. (510) *Dobell*, £1 2s. 6d.

3882 Kentish Garland (The), ed. by Julia de Vaynes, with notes and illustrations by Ebsworth, 2 vol., cl., g. t., 1881 (511) *Bain*, £1

3883 Kentish Note Book, 2 vol., hf. mor., 1891-4, 4to. (514) *Livett*, £4 5s.

3884 Kentish Pedigrees, ɔy Wm. Berry, hf. mor., 1830, folio (516) *Quaritch*, £5 5s.

3885 Kentish Tracts, Sermons, etc., several hundred, various, in 15 large parcels, ɔeing the entire contents of a catalogue issued by A. Russell Smith (518) *Ellis*, £28

3886 Lambarde (W.) Peramɔulation of Kent, first ed., black letter, col. map, cf., 1576, sm. 4to. (526) *Goss*, £6 10s.

3887 Larking (L. B.) The Domesday Book of Kent, hf. mor., 1869, folio (532) *Livett*, £1 11s.

3888 Lewis (John). History and Antiquities of Tenet, first ed., plates, bds., uncut, 1723, 4to. (533) *Daniell*, £2 15s.

3889 Lewis (J.) History and Antiquities of Tenet, port. and plates, cf., 1736, 4to. (534) *Rimell*, £7 10s.

18—2

[Believed to be the author's own copy, with short index
in his handwriting.—*Catalogue.*]

3890 Map of Kent on 25 large sheets, with Key, hf. cf., Laurie
and Whittle, 1794, folio (549) *Thorpe,* £2 12s.

3891 Markham (Gervase). The Inrichment of the Weald of Kent,
hf. mor., 1636, 4to. (555) *Arnold,* £1 2s. 6d.

3892 Marsham-Townshend (R.) Register of the Marshams of
Kent down to the end of 1902, 1905, folio (556)
Quaritch, £1 2s.

3893 Parsons (P.) Monuments and Painted Glass of upwards of
100 Churches in Kent, plates, cf., 1794, 4to. (573)
Bailey, £4 10s.

3894 Pedigrees. Philipot and Camden. Visitation of Kent,
1619-21, ed. by R. Hovenden, fine paper copy, mor. ex.,
Harleian Soc., 1898, roy. 8vo. (574) *Quaritch,* £1 12s. 6d.

3895 Pedigrees. Philipott (T.) Visitation, edited by Hovenden, cl.,
2 copies, *Harl. Soc.* (577) *Gray,* £1

3896 Pedigrees, from Visitation 1663-68, with notes by Dr.
Howard and R. Hovenden, 100 copies privately printed,
vell. bds., 1887, 8vo. (581) *Ellis,* £1 12s.

3897 Peter (J.) Treatise of Lewisham (but vulgarly called
Dulwich) Wells in Kent, cf., 1681, 12mo. (585) *Goss,* £2

3898 Philipott (T.) Villare Cantianum (map missing), cf., 1659,
folio (586) *Sotheran,* £1 2s.

3899 Philipott (T.) Villare Cantianum, second ed., view of Bromley
College, hf. mor., 1776, folio (587) *Sotheran,* £1 10s.

3900 [Rawlins (T.)] Tunbridge Wells, or a Day's Courtship, a
Comedy, folding front. by Faithorne, and Epilogue, hf. cf.,
1678, 4to. (599) *F. Sabin,* £4 15s.

3901 Registers of the French Church at Dover, privately printed
by F. A. Crisp, hf. vell., 1888, 8vo. (601) *Thorpe,* £1 4s.

3902 Sandwich. Boys (W.) History of Sandwich, plates, hf. cf.,
1792, 4to. (611) *Bain,* £5 10s.

3903 Scott (J. R.) Memorials of the Family of Scott of Scotts
Hall in the County of Kent, with an appendix of illustrative
documents, illustrations, cl., 1876, 4to. (612) *Avery,* £1 12s.

3904 Settle (E.) A Funeral Poem to the Memory of the Honoured
Clement Pettit, title in black borders (leaf defective), cf.,
Pettit arms on sides, 1717, sm. folio (613) *Ellis,* £2 7s. 6d.

3905 Smith (J. R.) Bibliotheca Cantiana, interleaved with MS.
additions by Smallfield and Hovenden, port. inserted, hf.
mor., 1837, 8vo. (617) *Levitt,* £4 2s. 6d.

3906 Smith (J. Roach). Antiquities of Richborough, presentation
copy with inscription, cl., 1850, 8vo. (618) *Gray,* £1

3907 Stoughton (T.) The Christian's Sacrifice, orig. vell. (the
copy given by the author to the Earl of Warwick, to whom
the book is dedicated) (630) *Ellis,* £1

3908 Thanet Views. Noel (Amelia). Six Original Water Colour
Drawings : View of Manston Court House—View from the
Battery at Broadstairs—View of Margate Pier—View of
Lord Holland's House, Kingsgate — View of Ramsgate
Pier—View of old Gate Dandelion, mor., 1797, sm. oblong

4to.—Col. etchings of the same, Princess Maria's copy, mor., 1797—Six further col. etchings of the series, Princess Augusta's copy, mor., 1797—Six further col. etchings, orig. grey covers, 1797 (2 copies), together 4 vol. etchings and one of drawings (637) *Rimell*, £21

3909 Thorpe (J.) Registrum Roffense, plates, hf. cf., uncut, 1769 —Custumale Roffense, port. and plates, hf. cf., uncut, 1788, together 2 vol., folio (640) *Bailey*, £4 5s.

3910 Web (E. A.) History of Chislehurst, maps, etc., 1899, 4to. (662) *Goss*, £1

3911 Lambarde (William). A Perambulation of Kent, with the Beacon Map, russ. ex., fine copy, 1596, 4to. (676) *Thorpe*, £3 17s. 6d.

3912 Lacroix (Paul). Science and Literature in the Middle Ages, col. plates, 1878—Military and Religious Life in the Middle Ages, col. plates (1878) — The Eighteenth Century, col. plates, all orig. hf. mor., 1876, 8vo. (677) *Clayton*, £3 7s. 6d.

3913 Lancashire. Chetham Society, including Vistitations of Lancashire, 1567, 1613, etc., 13 vol., 1857-76, 4to. (679) *Gray*, £2 7s. 6d.

3914 Lancashire. Foster (J.) Pedigrees of the County Families of England, vol. i., Lancashire, 1873, 4to. (683) *Gray*, £2

3915 Lancashire. Gregson's Portfolio of Fragments, engravings, etc., with additions, consisting of views and ports., including Dickenson's Countess of Sefton after Cosway, and a volume of proof impressions of the wood engravings, 3 vol., uncut, 1816-17, folio (684) *Rimell*, £5 10s.

3916 Lancashire. Gregson (Matthew). Portfolio of Fragments, second ed., cf., 1824, folio (685) *Rimell*, £3 3s.

3917 Lancashire. Parish Register Society. Publications, vol. i. to xxxiii., cl., 1898-1909, 8vo. (686) *Gray*, £5 5s.

3918 Lancashire and Cheshire Historic Society. Transactions, New Series, vol. i. to xxiii., 1888-1908, 8vo. (690) *Bailey*, £2 2s.

3919 Lancashire and Cheshire. Record Society for the Publication of Original Documents, vol. i. to lvi., 1879-1908, 8vo. (694) *Joseph*, £7

3920 Lathrop Family. Genealogical Memoir by Huntingdon, illust., 1884 — William Locke of Woburn, Genealogical Records, 1853, together 2 vol., 8vo. (696) *B. F. Stevens*, £2 2s.

3921 Leete (J.) The Family of Leete, second ed., hf. mor., 1906, 4to. (699) *Kingston*, £1 1s.

3922 Leicestershire Pedigrees and Royal Descents by Fletcher, ports., arms, etc., hf. mor., 1887, 8vo. (700) *Walford*, £2 5s.

3923 Leicestershire Pedigrees. Visitation of Leicester, 1619, ed. by Fetherston, *Harleian Society*, 1874, 8vo. (701) *Bailey*, £1

3924 Legros (Sieur). L'Art de la Coeffure des Dames Francoises avec des Estampes, with 20th supplements, col. plates of head-dresses and the double-page hunting plate, hf. mor. (1767-8), sm. 4to. (702) *Quaritch*, £18 10s.

3925 Letters and Papers, Foreign and Domestic, Henry VIII.,
vol. i. to vii., in 12 vol., 1862-1883, 8vo. (710)
Harding, £2 2s.
3926 Lincolnshire. Horncastle Parish Church Registers, 1908—
Horbling Parish Registers, 1653-1837—Monograph on the
Gainsborough Parish.Register, by Gurnhilt, 1890, 4to. (714)
Gray, £1
3927 Lincolnshire Notes and Queries, vol. i. to x., with 3 extra
vol.—Visitation of 1634, List of Brasses and Natural
History, 1898, 8 vol. hf. mor., g. t., rest unbound, 1889-1908,
8vo. (715) *Bailey,* £2 12s. 6d.
3928 Lincolnshire Parish Registers, edited by Phillimore, vol. i.,
cl., 1905—Register Book of the Parish Church of St. James,
Great Grimsby, 1538-1812, edited by Dr. Stephenson, cl.,
1889, 8vo. (718) *Gray,* £1 10s.
3929 Lincolnshire. Registers of Stubton, co. Lincoln, 1577-1628,
one of 12 copies privately printed by F. A. Crisp, 1883,
folio (719) *Gray,* £1 2s.
3930 Lincolnshire. Parish Registers of Sedgbrook, MS. transcript
of the originals, by Eedes, vell., 1883, folio (720)
Sotheran, £1 2s.
3931 Lodge (E.) Portraits, 12 vol., mor. ex., 1835, roy. 8vo. (724)
Howe, £5

London. Works relating to London.

3932 Aikin (J.) Environs of London, maps, plans and views, hf.
cf. (broken), Stockdale, 1811, 4to. (725) *Braun,* £1 12s.
3933 All Hallows, London Wall. Parish Registers, edited by
Robert Hovenden, LARGEST HANDMADE PAPER, vell., g. t.,
Privately printed at the Chiswick Press, 1878, imp. folio
(728) *Goss,* £5 10s.
3934 Annals of the Barber Surgeons of London, facsimiles, etc.,
hf. mor., g. t., 1890, 4to. (728) *Sutton,* £1 2s.
3935 Bishopsgate. St. Botolph's Registers, transcribed by Hallen,
with Index and vol. of Inscriptions, 3 vol., hf. mor., *Issued
to subscribers,* 1889, 4to. (734) *Goss,* £1 8s.
3936 Chancellor (E. B.) History and Antiquities of Richmond,
Kew, Petersham, etc., subscribers' copy, hf. rox., 1894, 4to.
(739) *Goss,* £1 10s.
3937 Clarke (C.) Architectura Ecclesiastica Londini. aquatint
plates, hf. mor., uncut, 1820, folio (742) *Spencer,* £4 5s.
3938 Clerkenwell. Register of all the Christenings, Mariages and
Burialles in the Parishe of St. James, Clerkenwell, ed. by
R. Hovenden, fine paper, 6 vol., mor. ex., *Harleian Soc.,*
1884-94, 8vo. (743) *Quaritch,* £5 5s.
3939 Clerkenwell. Registers of St. James' Parish Church, 1551-
1754, ed. by R. Hovenden, 6 vol., cl., *Harleian Soc.,* 1884-94,
8vo. (744) *Walford,* £3
3940 Clerkenwell. Storer and Cromwell. History of Clerkenwell,
LARGE PAPER, extra illustrated, bds., 1828 (746)
Rimell, £4 10s.

3941 Ellis (H.) History and Antiquities of St. Leonard, Shoreditch, extra map and plates and cuttings inserted, bds., 1798, 4to. (754) *Jones*, £3

3942 Ellis (H.) History of the Parish of Shoreditch, plates, hf. russ., uncut, 1798, 4to. (755) *Goss*, £2 7s. 6d.

3943 Faulkner (T.) Account of Fulham, LARGE PAPER, additional plates inserted, hf. cf., 1813, 8vo. (758) *Bailey*, £1 1s.

3944 Heath (Baron). Some Account of the Grocers Company, third ed., mor., 1869, 4to. (770) *Quaritch*, £1

3945 Howell (James). Londinopolis, front. and douɔle-page view, cf., 1657, folio (773) *Goss*, £2 15s.

3946 Hunter (H.) History of London and its Environs, plates, 2 vol., bds., 1811, 4to. (774) *Jones*, £3

3947 Livery Companies. Black (W. H.) History and Antiquities of the Company of Leathersellers, col. plates, etc., mor., g. t., *Printed for private circulation*, 1872 (779)
 Arnold, £1 17s. 6d.

3948 Livery Companies. Heath (J. B.) Some Account of the Grocers Company, third ed., mor., 1869 (781) *Quaritch*, £1

3949 Livery Companies. Young (S.) Annals of the Barɔer Surgeons of London, LARGE PAPER, illustrations (one of 60 copies), mor. ex., uncut, t. e. g., 1890, 4to. (783)
 Cornish, £1 5s.

3950 Lloyd (J. H.) History of Highgate, LARGE PAPER, hf. mor., 1888, 4to. (785) *Jones*, £2 2s.

3951 Lysons (D.) Environs of London, with Supplement, plates, 6 vol., hf. cf., 1796-1811, 4to. (787) *Jones*, £2 12s. 6d.

3952 Lysons (D.) Environs of London, LARGE PAPER, 21 extra plates ɔy Ellis, also a large numɔer of portraits, views, etc. inserted, 5 vol., hf. cf., 1810-11, 4to. (788) *Goss*, £8 10s.

3953 Malcolm (James P.) Londinum Redivivum, plates, 4 vol., uncut, 1803-7, 4to. (790) *Jones*, £1 7s. 6d.

3954 Malcolm (J. P.) One Hundred and Nineteen Views of London, with Memoir, bds., 1836, 4to. (791) *Goss*, £4

3955 Marriage Licenses, London and Canterɔury, extracted by Col. Chester, ed. by Armytage, 8 vol., *Harleian Society*, 1886-1892, 8vo. (792) *Carter*, £1 10s.

3956 Monumental Inscriptions. A numɔer of unpuɔlished MSS., by F. T. Cansick, some with pen and ink drawings, relating to the Burial Grounds of Highgate, St. Pancras Church, St. Giles-in-the-Fields, St. Mary's, Hornsey, etc., 4to. (793-804), realised each from £2 10s. to £7

3957 Parish Registers, ed. by Phillimore and Cokayne, vol. i. to iv., cl., 200 printed, issued to suɔscriɔers, 1900-1902, 8vo. (805)
 Gray, £1

3958 Parish Registers. All Hallows, London Wall, Registers, 1559-1675, one of 53 copies, LARGE PAPER, vell., g. t., *Privately printed at the Chiswick Press*, 1878, 4to. (806)
 Walford, £3

3959 Parish Registers. St. Dunstans, Stepney, 1568-1719, ed. ɔy Colyer Fergusson, 3 vol., cl., 4to. (806A) *Goss*, £3 5s.

3960 Parish Registers. Registers of All Hallows, London Wall, ɔy R. Hovenden, cl., 1878, 4to. (807) *Rimell, £3 3s.*
3961 Parish Registers. St. James, Clerkenwell, 1551-1754, 6 vol., *Harleian Society,* 1884-1894, 8vo. (811) *Harding, £2 10s.*
3962 Parish Registers. Registers of St. Paul's, Covent Garden, ed. ɔy W. H. Hunt, 4 vol., 1906-8, folio (820) *Walford, £1 16s.*
3963 Parton (John). Some Account of the Hospital and Parish of St. Giles-in-the-Fields, plates, LARGE PAPER, bds., 1822, folio (821) *Goss, £2 12s. 6d.*
3964 Pedigrees. Visitation of London, 1633-5, made ɔy H. St. George, ed. ɔy Dr. Howard and Col. Chester (*For the Harleian Society*), one of 4 copies retained after discovery of certain passage which made it advisaɔle to suppress this edition, presentation copy from Dr. Howard, hf. mor., 1878, 4to. (823) *Craig, £1 16s.*
3965 Pedigrees. Visitation of London, 1568, ed. ɔy Howard and Armytage, the first puɔlication of the Harleian Society, *Harleian Society,* 1869, 4to. (824) *Craig, £1*
3966 Pennant (T.) Some Account of London, extra illustrated and extended to 2 vol., containing 300 extra plates, 2 vol., russ., 1805, 4to. (828) *Jones, £8 5s.*
3967 Registers of All Hallows, London Wall, 1559-1675, transcriɔed by R. Hovenden, printed on vellum, 1878, 4to. (843) *Quaritch, £8*
3968 Shoreditch. Ellis (H.) History and Antiquities of the Parish of St. Leonard, plates, cf., 1798, 4to. (851) *Rimell, £1 8s.*
3969 Smith (J. T.) Antiquities of London, plates, mor. (ɔroken), 1791, folio (852) *Quaritch, £2 12s. 6d.*
3970 Smith (J. T.) Antiquities of Westminster, 246 engravings (some col.), LARGE PAPER, bds., uncut, 1807, 4to. (853) *Braun, £1 5s.*
3971 Stow (John). Survey of London and Westminster, maps and plates, 2 vol., russ., g.t., 1754, folio (858) *Rimell, £6 7s. 6d.*
3972 Tomɔs, Monuments, etc. Visiɔle in S. Pauls Cathedral and S. Faiths ɔeneath it previous to its Destruction ɔy Fire, A.D. 1666, by Major Payne Fisher, Poet Laureate to Oliver Cromwell, 1684, ed. ɔy Black and Morgan, rox., one of 30 copies, *Privately reprinted,* 1885, roy. 4to. (861) *Goss, £1 6s.*
3973 Visitation of London, 1633-5, ed. ɔy Howard and Chester, 2 vol., cl., *Harleian Soc.,* 1880-83, 8vo. (863) *Gray, £1*
3974 Wilkinson (R.) Londina Illustrata, 207 engravings, 2 vol., hf. mor., 1819-1825, folio (869) *Sotheran, £4*
3975 Woodɔurn (S.) Ecclesiastical Topography. A Collection of 100 Views of Churches in the Environs of London, LARGE PAPER, hf. russ., 1807-11, 4to. (870) *Braun, £2 12s. 6d.*

3976 Lysons (D.) Magna Britannia. Devonshire, 2 vol.—Cheshire, Cumɔerland, Derɔyshire, Cornwall, Beds., Bucks and Berks, Cambridge, 8 vol., 1810-11, 4to. (876) *F. Edwards, £5*

3977 Maire (H.) Arms and Pedigrees of various Roman Catholic Families (a copy of the Lawson MS. ɔy Eedes made for L. Hartley), hf. mor., from the Howard collection, folio (877)
Arnold, £6

3978 Marriage Licences, Allegations for, issued by the Dean and Chapter of Westminster, etc., extracted by Col. Chester and ed. ɔy Armytage, 8 vol., cl., *Harleian Society*, 1886-1890, 8vo. (882) *Arnold, £1 10s.*

3979 Masonic. Ars Quatuor Coronatorum, ɔeing the Transactions of the Coronati Lodge, vol. x. to xxi. (part ii.), 1897-1908—St. Johns Card, 1897 to 1907, 11, 46 parts, 4to. (885)
Thorpe, £1 10s.

3980 Meyrick (Sir S. R.) Heraldic Visitations of Wales, 2 vol., 1846, folio (890) *Bailey, £12 5s.*

3981 Middlesex. Harrow on the Hill Registers, 1558-1653, hf. cf., and another copy, unbd., 8vo. (892) *Braun, £1 14s.*

3982 Middlesex and Herts. Notes and Queries, 4 vol. in 2, hf. mor., 1895-98, 8vo. (893) *Carter, £1 12s.*

3983 Middlesex Monumental Inscriptions copied from the Remaining Stones in St. Mary's Church and Churchyard, Hendon, Middlesex, MS. ɔy Cansick, with the arms in pen and ink, hf. mor., 1884, 4to. (897) *Edwards, £2 10s.*
[Other MSS. of a similar kind ɔy Cansick realised from 26s. to £2 each.—ED.]

3984 Middlesex Pedigrees. Visitation of 1663, ed. ɔy Bysshe, bds., 1820, folio (904) *Quaritch, £1*

3985 Middlesex Pedigrees. Visitation of 1663, another copy, bds., 1820—Testamenta Lambethana, 1312-1636, extracted ɔy Ducarel, with Index, *Middlehill Press*, 1854, folio (905)
Quaritch, £4 10s.

3986 Middlesex. Staines Parish Register, 1644-1694, *Privately printed by Crisp*, hf. vell., 1886, folio (906)
Quaritch, £1 7s. 6d.

3987 Miscellanea Genealogica et Heraldica, ed. ɔy J. Howard, complete set from vol. i., 1868 to Third Series, vol. i., 1896, 12 vol., 8vo. (912) *Goss, £5 15s.*

3988 Monckton (D. H.) Genealogical History of the Family of Monckton, 50 plates, 1887, 4to. (895) *Gray, £1 17s. 6d.*

3989 Musgrave (Sir William). Oɔituary, ed. ɔy Armytage, 6 vol., *Harleian Society*, 1899-1901, 8vo. (914) *Goss, £1 15s.*

3990 Nicholson (W.) History of the Wars of the French Revolution, col. equestrian ports., hf. cf., 1816, 4to. (919)
Ward, £2 2s.

3991 Norfolk Archæology, vol. i. to xvii., part i., with General Index, vol. i.-x.—Norfolk Records, vol. i. and ii., etc., vol. i. to vi. cloth, vii. to x. hf. mor., rest in parts as issued, together 39 vol., 8vo. (922) *Robinson, £10*

3992 Norfolk. Farrer (E.) Church Heraldry of Norfolk, 4 vol., hf. mor., g. t., 1887, 8vo. (929) *Edwards, £3 3s.*

3993 Norfolk. Mason (R. H.) History of Norfolk, LARGE PAPER, 5 parts, 1882-4, folio (932) *Robinson, £2 4s.*

3994 Norfolk. Yarmouth. Palmer (C. J.) Perlustration of Great Yarmouth, plates, 3 vol., cl., 1872-5, 4to.(939) *Josephs,* £1 1s.

3995 Northamptonshire Notes and Queries, ed. ɔy Sweeting, 6 vol., hf. mor., 1886-1896, 8vo. (941) *Goss,* £2 10s.

3996 Northern Notes and Queries, ed. ɔy Cornelius Hallen and J. H. Stevenson, vol. i. to xvi., in 8 vol., hf. mor. ex., and 4 parts, 1888-1903, 8vo. (945) *Goss,* £5 10s.

3997 Notes and Queries, complete from vol. i., 1849 to 1903 (series i. to ix.), 108 vol., cl., hf. mor., hf. vell. and hf. cf.—and Indexes, 10 vol., cl. (duplicate of 9th) and parcel of unɔound parts, 4to. (946) *Sotheran,* £20

3998 Nottinghamshire Parish Registers, ed. ɔy Phillimore and Ward, 13 vol., cl., 1898-1906, 8vo. (950) *Harding,* £3

3999 Nottinghamshire Pedigrees. The Visitations of Nottingham, 1569 and 1614, ed. ɔy Marshall, *Harleian Society,* 1871, 8vo. (952) *Bailey,* £1 2s.

4000 Oliver (V. L.) History of the Island of Antigua, maps, etc., 3 vol., 1894-99, folio (953) *Gray,* £7

4001 Oxford. Historical Society. Puɔlications, from the commencement to 1909, 52 vol., cl. (portfolio of plans, vol. xxxviii., wanted), 1884-1909, 8vo. (957) *Parker,* £7

4002 Oxford. Magdalen College Register of Presidents, Fellows and other memɔers, ɔy Dr. Bloxham, 7 vol., and Index, 1853-1885, 8 vol., cl., 8vo. (958) *Stevens,* £4

4003 Oxfordshire. Dunkin (J.) History of Bullington and Ploughley, plates, 2 vol., hf. mor., 1823, 8vo. (964) *Jones,* £3

4004 Oxfordshire. Lee (F. G.) History of Thame Church, etc., plates, hf. mor., 1883, folio (965) *Parker,* £1 10s.

4005 Oxfordshire. Napier (H. A.) History of Swyncomɔe and Ewelme, plates, 1858—Coates (C.) History of Reading, hf. mor., 1802, 4to. (966) *Howe,* £3 12s. 6d.

4006 Oxfordshire Pedigrees. Visitations of the County of Oxford, 1566, 1574 and 1634, ed. ɔy Turner, *Harleian Society,* 1871, 8vo. (967) *Parker,* £1 17s. 6d.

4007 Papworth (J. W.) and Morant (A. W.) Ordinary of British Armorials, 2 vol., hf. mor., g. t., 1874, 8vo. (970) *Howe,* £8 10s.

4008 Parish Register Society. Puɔlications, from vol. i. to vol. lxi. (wanted part l.), sewed as puɔlished, 8vo. (975) *Josephs,* £8 8s.

4009 Parkyns (G. J.) Monastic and Baronial Remains, upwards of 100 plates, 2 vol., mor. ex., 1816, 8vo. (977) *Goss,* £1

4010 Parliaments of England. Lists of Memɔers, 1213-1800, with Indexes and Appendix, 3 vol., hf. cf., 1878-88, folio (978) *Goss,* £1 2s.

4011 Pedigrees of the Families of Cleaver and Peach, Finch, Fanshawe and Foster, 4 vol., hf. mor., 1872, etc., 8vo. (987) *Gray,* £1 18s.

4012 Pedigrees of the Families of Cole, Cotel, Cranmer, Cooke and Culcheth, 5 vol., hf. mor., 1873, etc., 8vo. (988) *Quaritch,* £1 4s.

4013 Pedigrees of the Families of Fanshawe, Palmer and Woodroffe, 3 vol., hf. mor., 1876, etc., 8vo. (989) *Gray*, £1 3s.

4014 Philips Family. Pedigree, with additional notes, arms emblazoned, bookplates, etc., hf. mor., 4to. (1006) *Thorpe*, £2

4015 Phillipps (Sir T.) Collectanea de Familiis, Diversis quibus Nomen est Phillipps. Wills et Wanborough, Court Rolls, etc., 3 vol., hf. mor., *Privately printed at Middle Hill*, additional matter, old deeds, etc. loosely inserted, 1839, 8vo. (1000) *Bailey*, £5 5s.

4016 Phillipps (Sir T.) Genealogia, *Privately printed*, 2 vol., hf. mor., 1840-1871, 8vo. (1001) *Maggs*, £6 10s.

4017 Phillipps (Sir T.) Genealogia, a Collection of Gloucester Wills and Welsh Pedigrees, *Privately printed at Middle Hill*, hf. mor., 1850, 8vo. (1002) *Maggs*, £6 10s.

4018 Phillipps (Sir T.) Visitatio Heraldica Comitatis Wiltoniae, A.D. 1623, 256 pages of pedigrees and title, hf. cf., g. t., *Privately printed at Middle Hill*, 1828, folio (1004) *Quaritch*, £3

4019 Pipe Roll Society. Publications, vol. i. to xxix., cl., as published, 1884-1908, 8vo. (1007) *Morley*, £17

4020 Reliquary (The), ed. by L. Jewitt, etc., 1860 to 1900, 30 vol. 8vo. and 6 4to., hf. mor., 1860-1900 (1012) *Morley*, £10 10s.

4021 Riestrop (J. B.) Armorial Général, 2 vol., hf. mor., 1884, 8vo. (1013) *Rimell*, £2 2s.

4022 Royal Historical Society. Transactions, and the original issue of vol. i. of First Series in 2 parts, 32 vol. cl. and 2 parts sewed, 1871-1907, 8vo. (1017) *E. George*, £4 15s.

4023 Rutland Pedigrees. The Visitation of Rutland, 1618-19, ed. by Armytage, *Harleian Society*, 1870, roy. 8vo. (1019) *Bailey*, £1 1s.

4024 Saint Paul's Ecclesiological Society. Transactions, vol. i. to vi., part iii., in the parts as issued, 1881-1908, 4to. (1020) *Watson*, £1 12s.

4025 Sanders (W. B.) Half Timbered Houses and Carved Oak Woodwork, hf. mor., 1894, folio (1022) *Josephs*, £1

4026 Scot (Reynolde). A Perfite Platforme of a Hoppe Garden, first ed., black letter, cuts in the text, with the blank preliminary leaf Ai., old hf. cf., 1574, sm. 4to. (1023) *Tregaskis*, £13

4027 Shakespeare. Plays and Poems, ed. by J. Payne Collier, 8 vol., mor. ex., with autograph letter of the editor, *Privately printed*, 1878, 4to. (1028) *Maggs*, £12 15s.

4028 Shakespeare. Series of Engravings, by Heath and Bartolozzi, from paintings by Stothard and others to illustrate Milton and Shakespeare, mor., 1818, folio (1029) *Howe*, £1 10s.

4029 Smith (C. Roach). Collectanea Antiqua, illustrations, complete set, 7 vol., hf. mor., 1848-80, 4to. (1036) *Jones*, £5 2s. 6d.

4030 Smith (J.) Memoirs of Wool, Woollen Manufactures and Trades, 2 vol., cf., 1726, 4to. (1037) *Ellis*, £1

4031 Somersetshire. Parish Registers, ed. ɔy Phillimore, 6 vol., cl., 1898-1905, 8vo. (1040) .*Harding,* £1 18s.
4032 Somersetshirè Wills, Aɔstracts of, edited from the MS. Collections of Rev. F. Brown, ɔy Crisp, 6 vol., *Privately printed,* 1887-1890, folio (1045) *Maggs,* £3 12s. 6d.
4033 Staffordshire Historical Collections, ed. ɔy the Wm. Salt Archæological Society, 18 vol.—New Series, vol. i. to xi., 29 vol. in 32, cl., as issued, 1880-1909 (1046)
 Walford, £13 10s.
4034 Staffordshire Parish Register Society, ed. ɔy Phillimore, 21 vol., hf. cl., 1901-1906, 8vo. (1047) *Harding,* £2 10s.
4035 Staffordshire Parish Registers. Walsall Parish Church Register Book, 1570-1649, transcriɔed ɔy Willmore, one of 75 copies, 1890, 8vo. (1048) *Gray,* £1 10s.
4036 Stewart (James). Plocacosmos, or the Whole Art of Hair Dressing, front. of Shakespeare's "Seven Ages" and port., bds., uncut, 1782, 8vo. (1052) *Rimell,* £2 2s.
4037 Suffolk. Blois. Arms and Genealogies of the Ancient Families of Suffolk, XVIIth Century Heraldic MS., in 4 vol., vell., covers, folio (1055) *Maggs,* £8 15s.
4038 Suffolk. Crisp (F. A.) Some Account of the Parish of Scrutton, LARGE PAPER, arms (col.), 1881, folio (1057)
 Jones, £1 2s.
4039 Suffolk. Gage (J.) History of Suffolk, Thingoe Hundred, map and plates, russ. ex., uncut, 1838, 4to. (1058)
 Arnold, £1 2s.
4040 Suffolk. Institute of Archæology and Natural History Proceedings, vol. i. to xiii., part ii., 1853-1908, and 2 extra parts—Feet of Fines and Ship-money Returns, 6 vol., hf. mor., 8vo. (1059) *Harding,* £5 5s.
4041 Suffolk. Long Melford, History of, ɔy Sir Wm. Parker, cl., 1873, 4to. (1061) *Bailey,* £1 7s.
4042 Suffolk. Calendar of Wills at Ipswich, 1444-1600, hf. vell., Crisp, 1895, folio (1064) *Quaritch,* £1 10s.
4043 Suffolk. Muskett (J. J.) Suffolk Manorial Families, hf. mor., 1894-1900, and vol. ii. in 10 parts, 1908 (limited to 250 copies), 1908, folio (1065) *Harding,* £1 18s.
4044 Suffolk. Parish Registers, Frostenden, Culpho and Chillesford, *Privately printed by F. A. Crisp,* hf. vell., together 3 vol., 1886-7, folio (1067) *Harding,* £1 6s.
4045 Suffolk. Parish Registers of St. Peters, Ipswich and Carlton, 2 vol., hf. vell., *Privately printed by F. A. Crisp,* 1896, folio (1068) *Quaritch,* £1 2s.
4046 Suffolk. Parish Registers of Kelsale, 1538 to 1812, one of 50 copies, *Privately printed by F. A. Crisp,* vell., 1887, folio (1069) *Arnold,* £2
4047 Suffolk. Parish Registers of Lowestoft, 1650-1812, 2 vol., hf. vell., *Privately printed by F. A. Crisp,* 1901-4, folio (1070)
 Walford, £1 2s.
4048 Suffolk. Parish Registers of Pakenham, one of 50 copies numɔered and signed, *Privately printed by F. A. Crisp,* vell., 1888, folio (1071) *Quaritch,* £1 16s.

4049 Suffolk. Parish Registers of Horringer, Ickworth, Rushbrook (with Jermyns and Darer's Annals), Little Saxham and Westow, 5 vol., cl., 1894-1903, sm. 4to. (1072) *Gray,* £1 18s.

4050 Suffolk. Parish Registers of Brundish, 1562-1785, one of 30 copies, *Privately printed by F. A. Crisp,* vell., 1885 (1073) *Gray,* £2

4051 Suffolk. Parish Registers of Tannington, 1539 to 1714, one of 15 copies, *Privately printed by F. A. Crisp,* 1885 (1074) *Gray,* £2

4052 Suffolk Pedigrees. The Visitation of Suffolk made by Wm. Hervey, 1561, ed. by Dr. Howard, 2 vol., LARGE PAPER, vol. i. cl., vol. ii. unbd., 1866, 8vo. (1076) *Quaritch,* £1 10s.

4053 Surrey. Archæological Collections, vol. i. to xxi., with extra vol. of Fines, 22 vol., 1858-1908, vol. viii. to xiv. in the 14 parts, with wrappers, rest cl., 8vo. (1086) *Jones,* £6

4054 Surrey. Aubrey (John). Natural History and Antiquities of Surrey, port. and plates, 5 vol., mor., g. e., autograph note of the author, addressed to Ashmole, inserted, 1719, 8vo. (1087) *Quaritch,* £8 5s.

4055 Surrey. Brayley (E. W.) History of Surrey, plates, 5 vol., hf. mor., 1850, 8vo. (1089) *Bailey,* £2 4s.

4056 Surrey. Catholic Registers of Woburn Lodge and Wey-bridge, 1750-1874, *Privately printed by F. A. Crisp,* 1888, folio (1090) *Arnold,* £1 8s.

4057 Surrey. Cracklow (C. T.) Lithographic Views of all the Churches and Chapels of Ease in Surrey, with descriptions, hf. mor. (1820), thick 4to. (1091) *Morley,* £7 10s.

4058 Surrey. Manning (O.) and Bray (W.) History of Surrey, plates (a few MS. additions, plates, etc. added), 3 vol., bds., uncut, 1804-14, folio (1098) *Wilkinson,* £17

4059 Surrey. Parish Registers, vol. i. to v., cl., 1903-1907, 8vo. (1102) *Walford,* £1 18s.

4060 Surrey Pedigrees. Visitations of Surrey, 1623, by Howard, hf. mor., n. d. (1108) *Ellis,* £1 6s.

4061 Surrey. Prosser (G. F.) Illustrations of the County of Surrey, LARGE PAPER, India proofs, mor., 1828, 4to. (1110) *Thorpe,* £2

4062 Surtees Society. Publications, vol. lxxxvi. to cxv., 30 vol., cl., 1889-1908, sm. 4to. (1116) *Bailey,* £7

4063 Sussex. Ansted and Combe. Portfolio of Sussex Views and Antiquities, mounted on cards in portfolio (pub. £3 3s.), 1894, folio (1118) *Potter,* £1

4064 Sussex. Archæological Collections, vol. i. to li., and Index to first 24, 52 vol., cl., 1848-1908, 8vo. (1119) *Andrews,* £15

4065 Sussex. Calendar of Sussex Wills, 5 parts, 1885-1901, 8vo. (1121) *Andrews,* £1 2s.

4066 Sussex. Elwes and Robinson. History of the Castles, Mansions and Manors of Western Sussex, hf. mor., 1876, 4to. (1124) *Robinson,* £1 1s.

4067 Sussex. Horsfield (T. W.) History of Sussex, map and plates, 2 vol., hf. roan, 1835, 4to. (1128) *Andrews,* £2

4068 Sussex. Lower (M. A.) Historical and Genealogical Notices
of the Pelham Family, with MS. additions, etc. inserted,
1873, 4to. (1131) *Andrews,* £1
4069 Sussex Pedigrees. Berry's Pedigrees of the Families of the
County of Sussex, MS. additions, hf mor., 1830, folio (1135)
Bailey, £3 15s.
4070 Sussex (Surrey ?). Prosser (G. F.) Select Illustrations of the
County, plates and vignettes, hf. cf., 1828, 4to. (1136)
Jones, £2 2s.
4071 Sussex. Record Society, vol. i. to iv., cl., 1902-1905, 8vo.
(1137) *Harding,* £2
4072 Topographer (The), for the year 1789, etc., plates, 4 vol., hf.
cf., with the very rare vol. v., *Printed by Sir T. Phillipps,*
bds.—also the Topographer, 1 vol., 4to., with 40 plates,
1791, 8vo. and 4to. (1147) *Ellis,* £1 17s. 6d.
4073 Transactions of the Royal Historical Society, vol. i. to x.—
New Series, vol. i. to xvi., duplicates of vol. ix. and xii., 28
vol., 1875-1902, 8vo· (1148) *Sotheran,* £4
4074 Turner Family. The Turner Genealogy, coats-of-arms, pedi-
grees, etc., *Privately printed,* 1884, 4to. (1151)
Harding, £1 2s.
4075 Ulster. Journal of Archæology, vol. i. to xiv. (part ii.), with
special vol. and some duplicates, 6 vol. hf. mor., rest unbd.,
1896-1908, 4to. (1154) *Maggs,* £8 15s.
4076 Visitation of England and Wales, ed. by Dr. Howard and
F. A. Crisp, vol. i. to xiv., 1893-1906—Notes on the Visita-
tions, vol. i. to vii., 1897-1907, together 21 vol., vell., as
issued, folio (1157) *Walford,* £15 5s.
4077 Walford (E.) Antiquarian Magazine and Bibliographer, vol. i.
to xii. (complete), 12 vol., hf. mor., 1882-1887, 8vo. (1162)
Jones, £1 10s.
4078 Warwickshire Antiquarian Magazine, cuts and plates, 8 parts
(all published), hf. mor., 1859-77, 4to. (1165)
Gray, £1 7s. 6d.
4079 Watson (J.) Memoirs of the Earls of Warren and Surrey,
ports. and plates, 2 vol. in 1, russ., 1782, 4to. (1170)
Harding, £2 2s.
4080 Whitaker (J. D.) History of Craven, third ed., plates, 1878,
4to. (1180) *Thomas,* £2
4081 Willis (Browne). Survey of the Cathedrals, bound in 2 vol.,
cf. ex., 1727-30, 4to. (1182) *Bailey,* £1 1s.
4082 Wilmer Family. Foster and Green. History of the Wilmer
Family, hf. mor., 1888, 8vo· (1183) *Quaritch,* £1
4083 Wood (Anthony à). Athenæ Oxonienses, with continuation
by Bliss, 4 vol., cf., 1813, 4to. (1190) *Bailey,* £1 7s.
4084 Wood Family. Genealogical, Heraldic and other Records,
col. plates of arms, etc., cl., *Privately printed,* 1886, 4to.
(1191) *Arnold,* £1 1s.
4085 Woodbridge Family. Mitchell (L.) The Woodbridge Record
of the Descendants of the Rev. John Woodbridge, of New-
bury, Mass., hf. mor., 1883, 4to. (1193)
B. F. Stevens, £1 15s.

4086 Worcester. Parish Book of St. Helens Church, Worcester, 1538-1812, y Wilson, 2 vol., hf. vell., 1900, folio (1199) *Harding*, £2 10s.

4087 Worcestershire. Catholic Registers of the City of Worcester, 1685 to 1837, one of 50 copies, vell., *Privately printed by F. A. Crisp* (1196) *Quaritch*, £1 2s.

4088 Worcestershire Historical Society. Publications, from the commencement in 1893 to 1905, 45 parts, wrappers, folio (1198) *Quaritch*, £4 5s.

4089 Worcestershire. Parish Register of Cropthorne, 1557-1717, y Crisp, hf. vell., 1896, folio (1200) *Quaritch*, £1

4090 Worcestershire. Parish Registers. Knightwick and Oddenham Parish Registers, 1538-1812, ed. by J. B. Wilson (52 printed), hf. vell., 1891, 4to. (1201) *Walford*, £2 17s. 6d.

4091 Worcestershire. Nash (T. R.) Collections for the History of Worcestershire, Index y Amphlett, 2 parts, LARGE PAPER, 1894-5, folio (1203) *F. Edwards*, £1 5s.

4092 Wright (Joseph). English Dialect Dictionary with Grammar, complete in the 30 parts in 18, 1896-1905, 4to. (1206) *Edwards*, £4 17s. 6d.

4093 Year Books of Probates from 1630, ed. by Matthews, vol. i. to iv. in parts, with duplicate, vol. i., cl., and extra part of Index Nominum, 1902-1908, 8vo. (1210) *Harding*, £2 16s.

4094 Yeatman (J. P.) History of the House of Arundel, hf. mor., 1882, folio (1211) *Walford*, £1 10s.

4095 Yorkshire Archæological Association. Record Series, vol. i. to xxxviii., cl., 1885-1907, 8vo. (1215) *Bailey*, £6 5s.

4096 Yorkshire. North Riding Record Society. Publications, vol. i. to ix., Old Series (complete)—and vol. i. to iv., New Series, 13 vol., cl., 1884-1907, 8vo. (1220) *Bailey*, £3 3s.

4097 Yorkshire. Parish Register Society. Publications, from 1899 to 1908, i. to xxxi. in 32 parts (1221) *Gray*, £3

4098 Yorkshire Parish Registers. Inglebye juxta Grenhow Register Booke, for Christnings, Weddings and Burials, since the yeare of Our Lord, 1539, by me John Blackburne, edited y Hawett, mor. (4 copies), 1889, 4to. (1226) *Arnold*, £2 17s. 6d.

4099 Yorkshire Pedigrees. Foster (J.) Pedigrees of the County Families of Yorkshire, 3 vol., 1874, 4to. (1240) *Walford*, £5 5s.

4100 Yorkshire. Stansfeld (John of Leeds). History of the Stansfeld or Stansfield Family in the Parish of Halifax, ports. and views, mor.,g. t.,1885, 8vo. (1242) *Quaritch*, £3 5s.

4101 Yorkshire Visitations, 1584-5 and 1612, edited by Foster, 1875 (1244) *Gray*, £1 10s.

4102 Yorkshire. Whit Kirk. Records of, y Platt and Morkhill, illusts., hf. mor., 1892, 4to. (1245) *Gray*, £1

(β) *Collection of Americana.*

4103 Lescarbot (Marc.) Histoire de la Nouvelle France, 4 maps, including the large "Figure de la Terre Neuve," orig. parchment, 1612, thick sm. 8vo. (1260) *Rayner*, £12 10s.

4104 America. Second Book Printed in America. An Oration
delivered)y the Rev. Samuel Whiting)efore Harvard
College in 1649, pamphlet, unbd., 16mo. (1262)
Rayner, £9 10s.
[One of the ancestors of the Whiting family has written
on top of first page, "Printed at Cam)ridge, 1649." It has
no t. p. or d., or p. . Examination of the type shows it to be
similar to that used in setting the "Whole Book of Psalms,"
Cam)ridge, Mass., 1644. The water-lines of its paper are
much closer together than those of paper used in later
years in Cambridge, and coincide with the paper in the
"Whole Book of Psalms."—*Catalogue.*]

4105 Esquemeling (J.) Histoire des Avanturiers qui se sont sig-
nalez dans Les Indes, engraved title, maps, etc., 2 vol. in 1,
vell., *Paris,* 1688 (1263) *Redway,* £2 4s.

4106 Mather (Increase). A/ Discourse,/ concerning/ the Su)ject
of Baptisme, 40 pages, and postscript 7 pages, entirely
uncut (small hole on pages 39, 40), grey wrappers, *Cambridge,*
printed by Samuel Green, 167.5, small 4to. (1264)
Rayner, £4 10s.

4107 Mather (Richard). A Modest and Brotherly Answer to Mr.
Charles Herle His Book against the Independency of
Churches, unbd., *London, printed for Henry Overton, in*
Popes Head Alley, 1644, sm. 4to. (1265) *Stevens,* £2 10s.

4108 Hooker (Thomas). A Survey of the Summe of Church-
Discipline, cf., 1648, 4to. (1266) *Johnson,* £2

4109 Theosophical Transactions of the Philadelphian Society,
Nos. i. and ii., with the music to the songs, cf., *Printed in*
London, 1697, 4to. (1267) *Rayner,* £3
[The first two Nos. of the Proceedings of the First
Quaker Society in America. This copy originally)elonged
to Christopher Marshall, and in a Latin sentence on)oth
titles he says that he "conceived the idea in London and
carried it to Philadelphia, where it was effected in 1697."
His grandson, Christopher Marshall, inherited this)ook.
He was the greatest Quaker of his time. They called him
the "fighting Quaker")ecause he advocated the American
Revolution, and expelled him from the Church.—*Cata-*
logue.]

4110 Keimer (S.) A Collection of One hundred Nota)le Things,
unbd. (wanted last leaf), *Philadelphia, printed and sold by*
S. Keimer, 1727, 4to. (1268) *Stevens,* £5

4111 Some Remarks on Mr. President Clap's History and Vindi-
cation of the Doctrines of the New England Churches,
127 pages (including title), uncut, *New Haven, printed by*
J. Parker & Company, 1757, 8vo. (1269) *Johnson,* £2 8s.

4112 Geographical Chart or Scheme Comprehending the most
important particulars relative to the Geography of N. and
S. America ()oundaries, produce, etc.), *Printed at Albany*
by John Barber, 1710 (1270) *Stevens,* £1 12s. 6d.

4113 Jeffereys (T.) An exact Chart of the River St. Laurence
(1775), 8vo. (1271) *Tregaskis,* £1 1s.

4114 Very Beginnings of the Episcopal Church in America. Journals of the First (*Philadelphia*, 1786)—Second (*Philadelphia*, 1785)—Third (*Philadelphia*, 1786)—Conventions of the Protestant Episcopal Church in the States of New York, New Jersey, Pennsylvania, etc., three pamphlets, contemp. paper covers—Dr. William Smith. Account of the Charitable Corporation for the Widows and Children of Clergymen of the Church of England in America, 1770, 8vo. (1273)
Johnson, £3

4115 American Indians. Surprising Account of the Captivity and Escape of Philip McDonald and Alexander McLeod of Virginia, unbd., *Henry Blake & Co., Keene, New Hampshire,* 1794, sm. 8vo. (1277) *Rayner, £14 10s.*

4116 American Indians. Withers (A. S.) Chronicles of Border Warfare, sheep, *Clarksburg, Va., published by Joseph Israel,* 1831, 8vo. (1278) *Maggs, £1 10s.*

4117 American Indians. Narrative of the Massacre, by the Savages, of the Wife and Children of Thomas Baldwin of Kentucky, cut on title, orig. wrappers, uncut, *New York,* 1836, 8vo. (1279) *Maggs, £1*

4118 American Indians. French-Huron Lexicon (270 pages MS.), by Father Jean Marie Chaumonot, Jesuit Missionary to the Huron tribe at Indian Lorette, near Quebec, Canada, an inheritance of the tribe, used and handed down from generation to generation, authenticated by Pere Prosper Vincent, a chief by Royal (tribal) descent, its last owner, its chirography authenticated as that of Chaumonot by comparison with his letters now in the Archives of Laval University, Quebec, unpublished, vell., written *circa* 1663, 4to. (1280) *Ellis, £190*

4119. American Indians. La Vie du R. P. Pierre Joseph Marie Chaumont de la Compagnie de Jesus, LARGE PAPER, presentation copy to the tribe, *Nouvelle York, Isle de Manale a la presse de J. M. Shea,* 1858, 8vo. (1281)
Rayner, £1

4120 Quebec. The original MS. "plot" of the top of the "Cape" at Quebec, on which the Chateau St. Louis stood—where the Chateau Froutenac now stands—as well as the Wolfe-Montcalm Monument, shows the amount of land occupied by each of those French Canadians then residing upon what is now the most aristocratic part of Quebec. This survey was executed at the behest of the "Intendant Bigot," by his architect, Maite Lamorille. It is approved in writing by "your Intendant Bigot" (1283) *Rayner, £27*
[This MS. marks the very near conquest of Canada, by the English, in 1759. It was executed in 1756. It was acquired from the Jesuit Abbe Tonquay by Sir James Lemoine, a well-known writer and authority on Canadian history.— *Catalogue.*]

SOTHEBY, WILKINSON & HODGE.

THE LIBRARY OF THE LATE REV. J. DUNCAN CRAIG, D.D., OF GLENAGARY, CO. DUBLIN.

(No. of Lots, 324 ; amount realised, £306 11s. 6d.)

4121 Almanach de Versailles, 1785, port. of Louis XVI., old French mor., arms of the Comte d' Artois, afterwards K. Charles X. (?), g. e. (Derome), *à Versailles chez Blaizot*, 1785, 8vo. (5) *Sotheran*, £4 12s.

4122 America. Book of Common Prayer, translated into the Mohawk language by Capt. Joseph Brant, plates (binding broken, spotted), 1787, 8vo. (6) *Tregaskis*, £6 10s.

4123 American Military Pocket Atlas. A Collection of Correct Maps of the British Colonies, etc., 6 folding maps, hf. bd., Sayer and Bennett, 1776, 8vo. (9) *Tregaskis*, £1 15s.

4124 Ariosto (Lud.) Orlando Furioso, engravings within ornamental borders, 4 vol., old cf. gt., *Venezia*, Ant. Zatta, 1772, 4to. (188) *Marinis*, 12s.

4125 Bacon (Lord). Remaines, *B. Alsop for L. Chapman*, 1648—Speech on Post Nati, 1641—Certaine Miscellany Works, edited by Wm. Rawley, *J. Haviland for H. Robinson*, 1629, in 1 vol., old cf., sm. 4to.—Letters written during the Reign of K. James I., hf. bd., uncut, B. Tooke, 1702, sm. 4to.—Essays, with the character of Q. Elizabeth, old cf., *E. Holt for H. Herringman*, 1701, 8vo., together 3 vol., 4to. and 8vo. (192) *Pickering*, £5 5s.

4126 Barrington (Sir J.) Historic Memoirs of Ireland, 2 vol., ports., hf. cf., 1835, roy. 4to. (193) *Halliday*, £1 18s

4127 Beaumont (A.) Travels through the Maritime Alps, front. and 27 tinted views, old cf. gt., arms of Geo. Cockburn, T. Bensley, 1795, folio 263) *Edwards*, 14s.

4128 Bentley (Rich., D.D.) Works, ed. by Rev. A. Dyce, 3 vol., cf. gt., F. Macpherson, 1836, 8vo. (17) *Bull*, 15s.

4129 Basque. Compendium Religionis Christianae quai ais un cuort Compilgiamaint de la Religiun Christianae tras H. Robarum (in the Basque tongue), orig. leather with clasps, *Stampa in Strada, tras Ludovicum C. Janet*, 1607 (25) *Quaritch*, 7s.

[Probably the earliest book printed in this Grison town by the first local printer. Cotton's earliest date is 1693.— *Catalogue.*]

4130 Bible (The Holy), King James's Version, blark lrttrr, first ed., with the " He " reading (wanted first title, dedication, the translators to the reader, and map, margins of genealogies mended, and wanted the title, 5 leaves in Revelations defective), has the N.T. title, and the body of the hook sound, R. Barker, 1611, folio (266) *Bull*, £2 12s.

4131 Biɔlia Hispanica. Biɔlia en Lengua Española, lít. goiḣ., douɔle columns, 44 lines, title within a singular woodcut ornamental ɔorder, with a ɔattleship in centre (title repaired, a few wormholes and stains in some leaves), old cf. (repaired), 12½ by 9 in. (Sunderland copy), *Estampada en Ferrara a Costa y depesa de Jeronimo de Vargas Español en primero de Marco de* 1553, folio (267) *Catlin, £30* [Second issue of the first Biɔle in Spanish printed for the Jews of Ferrara. This copy had the two leaves of "Taɔla de las Haphtharoth de todo el año."—*Catalogue.*]

4132 Biɔlia Hispanica. The "Ferrara" or Jews' Biɔle in Spanish, another copy, short (some plain margins mended, wanted the 2 leaves of "Haphtharoth," and last leaf of "Tabla"), vell., *Ferrara*, Jer. de Vargas, 1553, folio (268) *Tregaskis, £5 5s.*

4133 Biɔlia Hispanica. The "Ferrara" or Jews' Biɔle in Spanish, another copy (title and leaf of colophon mended, a few leaves stained, wanted the 2 leaves of "Haphtharoth"), old russ. gt. (Lord Carteret's copy), *Ferrara*, Jer. de Vargas, 1553, folio (269) *Catlin, £5 15s.*

4134 Breviarium et Missale Gothicum, Secundam Regulam B. Isidori, denuo Opera et impensa Card. F. A. Lorenzanae, port. and front., 2 vol., cf. (not uniform), *Matriti et Romae*, 1775-1804, folio (274) *Bull, £2 12s.*

4135 Brunet (J. C.) Manuel du Liɔraire. Supplément, par P. Deschamps et G. Brunet, 2 vol. in 1, hf. mor., t. e. g., *Paris*, Firmin-Didot, 1878-80, 8vo. (29) *Thin, £1 5s.*

4136 Bullet (J. B.) Mémoires sur la Langue Celtique, 3 vol., hf. cf., *Besançon*, Jo. Daclin, 1754-60, folio (275) *Barrow, £1 1s.*

4137 Caɔinet Choiseul. Recueil d'Estampes gravées d'après le Taɔleau du Caɔinet du Duc de Choiseul, par le Sieur de Basan, port. and 23 aes, old French cf., g. e., *Paris, chez l'Auteur*, 1771, 4to. (304) *Maggs, £3 3s.*

4138 Catlin (Geo.) North American Indian Chiefs, Wild Animals, Hunting Scenes, Buffalo Hunts, etc., 31 large lithographs, hf. bd., Day and Haghe, n. d., atlas folio (278) *Barrow, £9 5s.*

4139 Cent Nouvelles Nouvelles (Les), figures after Romain de Hooge, retouchées par B. Picart, 2 vol., old russ., *Cologne*, P. Gaillard, 1736, 8vo. (33) *Reader, 18s.*

4140 Denyse (Nicolaus). Opus super Sententias, lít. goiḣ., douɔle columns, ruɔricated (slightly wormed throughout), contemp. oak bds., stamped leather (half of upper cover wanted), *Rothomagi*, M. Morin (device at end), 1506, 8vo. (58) *Leighton, £1 16s.*

4141 De Rosset (Fr.) L'Admirable Histoire du Chevalier du Soleil, première édition, 8 vol., orig. vell., *Paris*, Jean Jouet, 1620-8, S. Thiboust, 1626, 8vo. (59) *Barrow, £1 1s.*

4142 Dictionarium Scoto-Celticum, a Dictionary of the Gaelic Language, 2 vol., cf. ex., *Edinb.*, Wm. Blackwood, 1828, 4to. (208) *J. Grant, £1 1s.*

4143 Du Cange (Dom.) Glossarium Mediae et Infimae Latinitatis cum Supplementis Integris D. P. Carpenterii, etc., 7 vol., cf. ex., *Paris,* Firmin Didot, 1840-50, 4to. (209) *Quaritch,* £11 15s

4144 Francisque-Michel. Les Écossais en France, Les Français en Écosse, LARGE PAPER, front., port. of Q. Mary of Scotland, coats-of-arms, etc., 2 vol., hf. mor., t. e. g., uncut, Trübner, 1862, 4to. (212) *Tregaskis,* £2 3s.

4145 Florian (M. de). Œuvres, augmentée de la Vie de l'Auteur de Guil. Tell, etc., port., and plates by Marillier, etc., 8 vol., cf., *Paris,* 1805, 8vo. (83) *Joseph,* 10s.

4146 Grose (F. R.) Antiquities of England and Wales, Scotland and Ireland, and Military Antiquities, plates, 14 vol., uniform old russ., 1784-1801, 4to. (215) *Hill,* £2 8s.

4147 Herrera (Antonio de). Historia General de los Hechos de los Castellanos, maps, 4 vol., vell., *Madrid,* N. Rodriguez, 1728-30, folio (290) *H. Stevens,* £3 12s.

4148 Huss (Joannes) et Hieronymus Pragensis. Historia et Monumenta, contemp. oak bds., stamped pigskin, *Norimbergae,* Jo. Montanus, 1558, folio (292) *Baker,* 18s.

4149 Jameson (Mrs.) History of Our Lord, illustrations, 2 vol., mor. ex., by Rivière, Longmans, 1864, 8vo. (113) *Lewine,* 13s.

4150 [Lewis (Thos., D.D.)] The Scourge in Vindication of the Church of England, orig. ed., old mor., with label inlaid, inscribed in gold letters "His Majesty King Geo. III., the Gift of I. D.," g. e., 1717, 8vo. (123) *Tregaskis,* £1

4151 Missale Romanum nunc denuo Urbani VIII. auctoritate recognitum, engravings and borders, old mor., g. e., *Lugd.,* P. Valfray, 1735, folio (302) *Andrews,* 12s.

4152 Mistral (Frédéric). Lou Tresor dou Felibrige, ou Dictionnaire Provençal-Français, 2 vol., hf. cf., *Aix-en-Provence, etc.* (1878), 4to. (239) *Quaritch,* £1 14s.

4153 Molière (J. B. P.) Œuvres, par M. Bret, port. and plates after Moreau, 6 vol., old French cf. gt., *Paris, Libraires Associés,* 1804, 8vo. (130) *Parsons,* £1 17s.

4154 Montaigne (M. de). Essais, port., 3 vol., old French mor., ornamental backs, g. e. (Padeloup), *Paris,* J. Servière et J. F. Bastien, 1793, 8vo. (132) *Leighton,* £1 16s.

4155 Montaigne (M. de). Livre des Essais, 2 parts in 1 vol., orig. cf., *à Lyon pour Gabriel la Grange,* 1593, 8vo. (133) *Maggs,* £2 2s.

4156 Montemayor (G. de). Diana of George of Montemayor, translated by Bartholomew Yong, first ed., title within woodcut border (coloured), old cf., *Printed by Edm. Bollifant impensis G. B.,* 1598, folio (303) *Tregaskis,* £5 17s. 6d.
[An interesting Shakespeare book, in prose and verse, said to have been partly translated by Sir Philip Sidney. It contains the original of Shakespeare's "Proteus and Julia" in the "Two Gentlemen of Verona."—*Catalogue.*]

4157 Morgan (L. H.) League of the Ho-Dé'-No-Sau-Nee, or Iroquois, first ed., map and col. plates, mor., richly gilt, g. e., *Rochester (U.S.A.),* 1851, 8vo. (134) *Tregaskis,* £2 3s.

4158 Nostradamus (Caesar de). L'Histoire et Chronique de Provence, engraved title and port., old cf., *à Lyon*, S. Rigaud, 1624, folio (307) *Picard*, 13s.

4159 Nostredame (Jean de). Le Vite delli piu celeɔri et antichi Primi Poeti Provenzali che fiorirno nel tempo delli Re' di Napoli, etc., prima édizione, mor. ex., *In Lione appresso d'Alesandro Marsilii*, 1575 (139) *Barrow*, £1 1s.

4160 Pallavicini (F.) Il Divortio Celeste, Il Corriero Svaligiato, Baccinata overo Battarella per le Api Barɔerine, etc., woodcut on titles, in 1 vol., vell., *Villafranca*, 1643-44, 8vo. (142) *May*, 12s.
[The collected tracts. For the last attack on Urɔan VIII. (Maffeo Barɔerini) the author was entrapped ɔy the Pope's orders and ɔeheaded.—*Catalogue.*]

4161 Paterson (J.) History of the Counties of Ayr and Wigton, woodcuts, 3 vol. in 5, *Edinb.*, 1863-66, 8vo. (144) *Maggs*, £1 7s.

4162 Playfair (Wm.) British Family Antiquity, LARGE PAPER (no charts), 9 vol., old mor. ex., T. Reynolds & Harvey Grace, 1809-11, roy. 4to. (244) . *Halliday*, £1 14s.

4163 Prayer. La Liturgie ou Formulaire des Prières Puɔliques, etc. selon l'usage de l'Eglise d'Irlande, puɔlished for the use of the French Huguenots who were refugees in Ireland, cf., *Dublin*, 1715, 8vo. (147) *Maggs*, £1 16s.

4164 Reuchlin (Jo.) De Arte Caɔalistica, editio prima, g.e., *Tubingae ex aed. Thomae Anshelmi Badensis*, 1514 [*Privilege on reverse of title dated* 1516], folio (317) *Leighton*, £1 9s.

4165 Ruɔens (P. P.) La Galérie du Palais de Luxemɔourg, 24 plates and port. of Ruɔens, old cf., *Paris, chez Duchange*, 1710, atlas folio (319) *Barrow*, £3 10s.

4166 Saxe (Maurice Comte de). Histoire de, par le Baron d'Espagnac, port., maps and plans, 2 vol., cf. gt., arms of Gen. Sir G. Cockɔurn, *Paris*, Philippe-Denys, 1775, 4to. (246) *Edwards*, 9s.

4167 Spanish. Martinez de Zuñiga (Fr. J.) Historia de las Islas Philipinas, vell., *Impreso in Sampaloc*, 1803—Oviedo y Baños (D. José de). Historia de la Conquista de Venezuela primera parte (title ɔacked), russ., *Caracas*, 1824—Thomas de Mercado (P. F.) Summa de Tratos y Contratos (cap. XIII. is headed "De los Camɔios que se usan de aqui a Indias"), vell., *En Sevilla*, H. Diaz, 1571, together 3 vol., sm. 4to. (250) *Quaritch*, £5

4168 Spenser (E.) The Faerie Queene, plates, 3 vol., hf. mor., 1751, 4to. (253) *Andrews*, 11s.

4169 Testamento Nuevo (El) de nuestro Senor y Salvador Jesu Christo, en romance Castellano (por Juan Perez), mor., g.e., by W. Pratt, *En Venecia en casa de Juan Philadelpho*, 1556, 8vo. (172) *Tregaskis*, £1 18s.

4170 Waller (Edmund). Poems to the Memory of this incomparaɔle Poet ɔy several hands, orig. ed., hf. bd., J. Knight and Fr. Saunders, 1688, sm. 4to.—The Petitioning Comet,

or a Brief Chronology of all the famous Comets and their
Events from the Birth of Christ, N. Thompson, 1681, and
other Satirical Pieces and Poems of the Reign of K. Charles
II., single leaves, 4 and 8 pages each (24 pieces sm. folio),
in 1 vol., together 2 vol., 4to. (259) *Quaritch*, £10

[FEBRUARY 14TH, 1910.]

SOTHEBY, WILKINSON & HODGE.

A COLLECTION OF BOOKS PRINTED IN OR RELATING TO
AMERICA, MANY OF THEM FORMERLY IN THE LIBRARY OF
CHRISTOPHER MARSHALL ("THE FIGHTING QUAKER," OF
PHILADELPHIA, PA.)

(No. of Lots, 268 ; amount realised, £322 8s.)

4171 Account of the Pelew Islands in the Western Part of the
Pacific Ocean, and the Shipwreck of the Antelope, wood-
cuts (stained), hf. bd., *Catskill*, M. Croswell, 1797, 8vo. (1)
Tregaskis, 6s.

4172 Ahiman Rezon abridged and digested as a help to all that
are, or would be Free and Accepted Masons (by William
Smith), front., sheep, *Philadelphia*, 1783, 8vo. (4)
Tregaskis, £1 7s.

4173 Allen (P.) History of the Expedition under the Command of
Captains Lewis and Clark to the Sources of the Missouri,
vol. ii., hf. cf., *Philadelphia*, 1814, 8vo. (5*) *H. Stevens*, 17s.

4174 Baker (D.) Yet one Warning more to Thee O England,
title shaved, bds., 1660, 4to. (255) *Tregaskis*, £1 5s.

4175 Barbarities of the Enemy Exposed in a Report of the Com-
mittee of the House of Representatives of the United
States, sheep, *Troy*, Francis Adancourt, 1813, 8vo. (12)
H. Stevens, 19s.

4176 Barber (J. W.) History and Antiquities of New Haven
(Conn.), col. plates and woodcuts, *New Haven*, 1831, 8vo.
(13) *H. Stevens*, 10s.

4177 Belknap (J.) The History of New Hampshire, 3 vol., map,
sheep, *Boston*, 1792, 8vo. (17) *H. Stevens*, 15s.

4178 Bulkeley (J.) and Cummins (J.) Voyage to the South Seas,
orig. cf., *Philadelphia*, *reprinted by James Chattin*, 1757
(24) 13s.
[With autograph signatures of Christopher Marshall,
"The Fighting Quaker."—*Catalogue*.]

4179 Campbell (J. W.) History of Virginia, orig. sheep, *Phila-
delphia*, Campbell and Carey, 1813, 8vo. (25)
H. Stevens, 14s.

4180 Canada. Nehiro-Iruniui Aiamihe Massinahigan (Catechism

in Iroquois), orig. sheep, *Uabistiguiatsh, Massinahitsetuau, Broun gaie Girmor,* 1767, 8vo. (29) *H. Stevens,* £7 5s.
 [One of the earliest ɔooks printed in Queɔec ɔy Brown and Gilmore, the first printers in Queɔec, who set up a press there in 1764. It was compiled ɔy Père J. B. La Brosse, an Indian.—*Catalogue.*]
4181 Canada. Aux citoyens et haɔitants des villes et des Campagnes de la Province de Queɔec (address issued ɔy the Committee of Reform), *Quebec,* 1785, 4to. (245*)
 H. Stevens, £3 12s. 6d.
4182 Canada. Champlain (Sieur de). Les Voyages, 7 maps (one defective), 3 plates and 12 engravings in the text, mor., g. e., *Paris,* 1613, 4to. (246) *H. Stevens,* £11 11s.
4183 Canada. Thèses de Mathematique, par MM. B. C. Panet, G. Perrault et C. Chauveaux, *Quebec,* 1775, 4to. (247)
 H. Stevens, £1 7s.
4184 Canada. Officium in Honorem Domini Nostri J. C. summi sacerdotis et omnium Sanctorum Sacerdotum ac Levitarum, fore-edge notes cut, hf. bd., the first ɔook puɔlished in Montreal, *Monti Regali,* F. Mesplet, 1776, 8vo. (30)
 Pearson, £7
4185 Canada. Réglement de la confrérie de l'adoration perpétuelle du S. Sacrement et de la ɔonne mort, orig. sheep, the second ɔook printed in Montreal, *Montreal,* F. Mesplet et C. Berger, 1776, 8vo. (32) *Pearson,* £12 5s.
4186 Canada. [St. Valier.] Relation des Missions de la Nouvelle France, par M. l'Évêque de Queɔec, orig. cf., *Paris,* 1688, 8vo. (33) *Chadenat,* £7 5s.
4187 Canada. [St. Valier.] Rituel du Diocese de Queɔec, puɔlié par l'ordre de Monseigneur l'Évêque de Queɔec, first 13 leaves inlaid and title defective, cf., *Paris,* S. Langlois, 1703, 8vo. (34) *Maggs,* £1 4s.
4188 Canada. Smith (Wm.) History of Canada, 2 vol., LARGE PAPER, uncut, *Quebec, printed for the Author by J. Neilson,* 1815, 8vo. (36) *Collam,* £9 10s.
 [Inserted is a pamphlet, "Oɔservations d'un catholique sur l'histoire du Canada par l'Honorable William Smith" (par Père McGuire), 1827.—*Catalogue.*]
4189 Canada. Walker (Sir Hovenden). A Journal, or full Account of the late Expedition to Canada, cf., 1720, 8vo. (38)
 J. Grant, £2 12s.
4190 Chalkley (Thomas). Journal, or Historical Account of the Life, etc. of Thomas Chalkley, first ed., cf., *Philadelphia,* B. Franklin and D. Hall, 1749, 8vo. (41) *Edwards,* £2
4191 Chauncy (C.) Sermon of Thanksgiving for the Reduction of Cape Breton, 1745, 8vo. (43) *Leon,* 16s.
4192 Christie (R.) Memoirs of the Administration of the Colonial Government of Lower Canada, *Quebec,* 1818—Extracts from the Votes of Proceedings of the American Continental Congress, held at Philadelphia on the 5th of Septemɔer, 1774, *ib.,* W. & T. Bradford, 1774, together 2 vol., 8vo. (44)
 H. Stevens, £1 6s.

4193 Clarke (Daniel). Proofs of the Corruption of Gen. James
Wilkinson, hf. bd. (cover wanted), *Philadelphia*, 1809, 8vo.
(49) *Leon, £1* 10s.
4194 Colman (B.) A Sermon at the Lecture in Boston after the
Funerals of . . . the Reverend Mr. William Brattle and
the Rev. Mr. Ebenezer Pemberton, unbd., *Boston, printed
by B. Green for Samuel Gerrish & Daniel Henchman,*
1717 (50) *Tregaskis,* 17s.
4195 Drake (D.) Natural and Statistical View, or Picture of
Cincinnati and the Miami Country, 2 maps (1 torn), orig.
sheep, *Cincinnati,* Looker & Wallace, 1815, 8vo. (63)
Quaritch, £1 8s.
4196 Estray (The). A Collection of Poems (with " Proem," by
H. W. Longfellow), orig. bds., *Boston,* 1847, 8vo. (66)
Maggs, 9s.
4197 Fox (George) and Burnyeat (J.) A New England Fire-Brand
Quenched, 2 parts in 1 vol., old cf., 1678-79, 4to. (262)
Yeats, £16 10s.
4198 Fox (George). The Secret Workes of a Cruel People made
manifest (cut close and imprint cut into), bds., 1659, 4to.
(259) *Coleman, £3* 15s.
4199 Fox (G.) An Epistle General to them who are of the Royal
Priest-hood and chosen generation, bds., T. Simmons, 1660
(260) *Coleman,* 10s.
4200 [Fox (G.)] An Answer to several New Laws and Orders
made by the Rulers of Boston in New England, *Printed in
the Year* 1678, 4to. (261) *H. Stevens, £3* 10s.
4201 Flint (Timothy). Biographical Memoir of Daniel Boone,
port. and woodcuts, *Cincinnati,* G. Conclin, 1836, 8vo. (68*)
B. F. Stevens, £1 17s.
4202 Franchere fils (G.) Relation d'un Voyage a la Côte du Nord
Ouest de l' Amérique Septentrionale, hf. cf., *Montreal,*
C. B. Pasteur, 1820, 8vo. (70) *H. Stevens, £4* 15s.
4203 Franklin (Dr. Benjamin). Life, written by himself (2 or 3
foot-lines shaved), hf. bd., *New York,* E. Duyckinck, 1813,
8vo. (71) *Hodgson,* 10s.
4204 Garden (Alex.) Anecdotes of the American Revolution,
second series, orig. bds., *Charleston,* 1828, 8vo. (76)
H. Stevens, 10s.
4205 Garrison (William Lloyd). Sonnets and other Poems, orig.
cl., *Boston,* 1843, 8vo. (77) *Tregaskis,* 12s.
4206 Gass (P.) Journal of Voyages and Travels . . . through the
interior Parts of North America, first ed., hf. sheep, *Pitts-
burgh,* Zadok Cramer, 1807, 8vo. (78) *H. Stevens, £3* 3s.
4207 Hall (David). A Mite into the Treasury, unbd., *Philadelphia,
reprinted by B. Franklin and D. Hall,* 1758, 8vo. (85)
H. Stevens, £1 4s.
4208 Hanson (Th.) The Prussian Evolutions in Actual Engage-
ments, plates, autograph signatures of Jno. McKinly, first
Governor of Delaware, hf. bd., uncut, *Philadelphia* (1776),
4to. (249) *Maggs, £1* 10s.
4209 Henry (J. J.) An Accurate and Interesting Account of the

Hardships and Sufferings of that Band of Heroes who traversed the Wilderness in the Campaign against Queɔec in 1775, sheep, *Lancaster*, Wm. Greer, 1812, 8vo. (90)
Edwards, £1 14s.

4210 History of the Seven Wise Masters of Rome, orig. pictured wooden bds. (mended), *Hudson (N. Y.)*, A. Stoddard, 1805, 8vo. (91)
Tregaskis, 9s.

4211 Holmes (A.) History of Camɔridge (Mass.), wrappers, uncut, *Boston*, 1801, 8vo. (93)
Maggs, 17s.

4212 Hutchins (T.) Historical Narrative and Topographical Description of Louisiana and West Florida, uncut, *Philadelphia*, 1784, 8vo. (98)
H. Stevens, £4 16s.

4213 Illinois in 1837, a Sketch descriptive of the Situation, Boundaries, etc. of· the State of Illinois, map, orig. bds., *Philadelphia*, 1837, 8vo. (99)
Quaritch, 16s.

4214 Imlay (G.) Topographical Description of the Western Territory of North America, 3 maps—The Discovery, etc. of Kentucky, by John Filson, map, 2 vol., orig. sheep, *New York*, 1793, 8vo. (101)
H. Stevens, £2

4215 Indians. Bartram (W.) Travels through North and South Carolina, etc., first ed., map and plates, autograph signatures of Jno. McKinley, first Governor of Delaware, orig. sheep, *Philadelphia*, James and Johnson, 1791, 8vo. (103)
Leon, £4 4s.

4216 Indians. Benezet (A.) Some Oɔservations on the Situation, etc. of the Indian Natives of this Continent, orig. wrappers, *Philadelphia*, J. Cruikshank, 1784, 8vo. (104)
H. Stevens, £1 1s.

4217 Indians. Butterfield (W.) History of Seneca County (stained), *Sandusky*, D. Campɔell, 1848, 8vo. (105)
Maggs, 9s.

4218 Indians. Bownas (Samuel). An Account of the Life, Travels and Christian Experiences of Samuel Bownas, sheep, *Philadelphia, reprinted by Wm. Dunlop*, 1759, 8vo. (106)
Ellis, 8s.

4219 Indians. The Captivity and Deliverance of Mr. John Williams and Mrs. Mary Rowlandson, orig. sheep, *Brookfield*, H. Brown, 1811, 8vo. (107)
Maggs, £1 10s.

4220 Indians. Darnell (E.) Journal containing an Account of the Hardships of those heroic Kentucky Volunteers and Regulars commanded by Genl. Winchester, orig. bds., *Philadelphia*, 1854, 8vo. (108*)
Quaritch, £1 12s.

4221 Indians. Colden (Hon. Cadw.) History of the Five Indian Nations of Canada, third ed., 2 vol., map, orig. cf., 1755, 8vo. (109)
H. Stevens, £1 14s.

4222 Indians. Davis (J.) Captain Smith and Princess Pocahontas, front., orig. bds., *Philadelphia*, 1805, 8vo. (109*)
Maggs, 14s.

4223 Indians. De Smet (P. J.) Letters and Sketches, plates, *Philadelphia*, 1843, 8vo. (110)
Leon, £1 12s.

4224 Indians. Gilɔert (Benj.) Narrative of the Captivity and Sufferings of Benjamin Gilɔert and his Family, orig. sheep, *Philadelphia*, 1848, 8vo. (111)
Quaritch, 15s.

4225 Indian Hubbard (Wm.) A ... of the In ... Wars
 in New England, sh... *Mass.*, ... 8vo.
 (112) H. ... 3s.

4226 Indians Hunter (J ... Customs ... ral
 India Tribes lo ... ssissipp ... 's.
 (brown), *Philad*... Quar ... s.

4227 Indians Johnston ... e of tl ... ts
 attending the C ... hnston, ... *w*
 York 1827, 8vo ... Qua ... 3s.

4228 Indian A Nar ... y of N ... n,
 orig. heep, W ... oner, 1 ... (6)
 £3.

4229 India ... itts ... er Li ... ew
 so ... *ita* ...) ... 12s.

4230 Indi ... l ... W ... ed),
 hf ... 13s.

4231 Indi ... d ... ning
 to ...)
 10s.

4232 Ind ... f th
 R ... 18
 8

4233 Jou
 N
 c

4234 La

4235 L

4236 I

4237 N

4238 Ma
 N
 tl ... *y.*
 7 ... s.

4239 Mat ... les
 in ... *ecti,*
 16 ... 17s.

4240 Moo ... and
 Su ... 2 10s.

4241 Moo ... 1744,
 8v ... 3 7s. 6d.

4242 urray (James). An Impartial Hiory of the Present War Min America, ports. and plates, vol. sheep, *Newcastle upon Tyne*, 1780, 8vo. (146) *H. Stevens, £1, 14s.*

4243 New York. The Picture of New Y k and Stranger's Guide to the Commercial Metropolis of e United States. plates, hf. bd., *New York*, 1828, 8vo. (146 *Quaritch, 16s.*

4244 Paine (Solomon). A Short View c the Difference between the Church of Christ and the Established Churches in the Colony of Connecticut (title-pag and last leaf torn and stained), autograph signature of aml. Robinson, Founder of Bennington, Vt., *Newport*, Jaes Franklin, 1752, 4to. (253) *H. Stevens, £1 2s.*

4245 Pietas et Gratulatio Collegii Cantabgiensis apud Novanglos, slip of errata, and autograph snature of Christopher Marshall "The Fighting Quake: hf. bd., *Boston*, *M 1es.*, J. Green and J. Russell, 1761, 4t (254) *H. Stevens, £1 14s.*

4246 Prayer. The Book of Common Præer, according to the Use of the Protestant Episcopal Chuh in the United States. The Second American Standarc Prayer Book. cf.. *New York*, H. Gaine, 1793 (151) *Maggs, £2 2s.*

4247 Public Good, being an Examinatic into the Claim of Virginia to the vacant Western Tertory. *Albany*, n. d., 1782, 8vo. (153) *H. Stevens, 13s.*

4248 Reminiscences of the French Wa with an account of the Life of Maj.-Gen. John Stark, rt., orig. bds., *Concord*, N. H. L. Roby, 1831, 8vo. (156) *Quaritch, £2 10s.*

4249 [Roosen (Gerhard).] Christliches Gemüths-Gesprach von dem geistlichen und seligmachenn Glauen, cf., *Ephratæ Typis Societatis anno* 1769, 8vo. 58) *H. Stevens, 11s.* [Ephrata, or Dunkard Town, Settlement of a German sect called Tunckers, situated in lncaster county, Pennsylvania.—*Catalogue.*]

4250 Sims (S.) A Sober Reply in Chrisan Love to a Paragraph in Jonathan Edwards' Discourse broadside), (*New Haven*, T. Green, 1741), folio (267) *B. F. Stevens, £1 8s.*

4251 Slavery. Clarke (Lewis). Narrave of the Sufferings of Lewis Clarke, *Boston*, D. H. Ela 1845, 8vo. (167) *Edwards, £1 5s.*

2 Smith (Samuel). History of the olony of Nova-Caesaria, or New Jersey, presentation cop from the author's son to John Darron, orig. sheep, *Burlinton, in New Jersey*, 1765, 8vo. (172) *H. Stevens, £3 3s.*

3 Smith (Wm.) The History of the Province of New York, front., autograph signature of "Enry Atkinson" (Quebec merchant and Officer in the War of 1812) on title, hf. cf., 1757, 4to. (254*) *Edwards, £14 5s.*

54 Stobo (Major Robert). Memoirs, olding plan, *Pittsburgh*, 1800, 8vo. (175) *Sicotte, £1 14s.*

55 [Steuen (F. W., Baron).] New ystem of Military Discipline, orig. bds., *Philadelphia*, 76, 8vo. (177) *Tregaskis, 11s.*

4225 Indians. Hu⊃⊃ard (Wm.) A Narrative of the Indian Wars
in New England, sheep, *Stockbridge, Mass.*, 1803, 8vo.
(112) *H. Stevens,* 13s..
4226 Indians. Hunter (J. D.) Manners and Customs of Several
Indian Tri⊃es located West of the Mississippi, orig. bds.
(⊃roken), *Philadelphia,* 1823, 8vo. (113) *Quaritch, £*1 12s.
4227 Indians. Johnston (Charles). Narrative of the Incidents
attending the Capture of Charles Johnston, uncut, *New
York,* 1827, 8vo. (114) *Quaritch, £*2 8s.
4228 Indians. A Narrative of the Captivity of Mrs. Johnson,
orig. sheep, *Windsor (Vt.)*, Alden Spooner, 1807, 8vo. (116)
 *Quaritch, £*3.
4229 Indians. [Pritts (J.)] Incidents of Border Life, plates (a few
soiled), *Lancaster (Pa.)*, 1841, 8vo. (117) *Hodgson, £*1 12s..
4230 Indians. Willett (W. M.) Scenes in the Wilderness (stained),
hf. cf., *New York,* 1845, 8vo. (118) *Quaritch,* 13s.
4231 Indians. Williams (J.) The Redeemed Captive returning
to Zion, front. and port., *Northampton,* 1853, 8vo. (119)
 Quaritch, 10s.
4232 Indians. Williams (S. W.) Biographical Memoir of the
Rev. John Williams, orig. bds., *Greenfield, Mass.*, 1837,
8vo. (120) *Quaritch,* 19s.
4233 Joutel (Capt.) Journal historique du dernier Voyage que feu
M. de La Sale fit dans le Golfe de Mexique, folding map,
old cf. gt., *Paris,* E. Robinot, 1713, 8vo. (129)
 *H. Stevens, £*4 14s.
4234 Las Casas (B. de). An Account of the first Voyages and
Discoveries made by the Spaniards in America, 2 plates
(one mounted, last leaf defective), cf., 1699, 8vo. (131)
 *H. Stevens, £*1 12s.
4235 Lee (D.) and Frost (J. H.) Ten Years in Oregon, map, *New
York,* 1844, 8vo. (132) *H. Stevens,* 16s.
4236 Le Page du Pratz. Histoire de la Louisiane, etc., 2 maps
and 40 plates, 3 vol., old French cf., *Paris,* 1758, 8vo. (133)
 *Edwards, £*2 9s.
4237 Mather (Increase). Gospel Order Revived, ⊃eing an Answer
to a ⊃ook lately set forth by the Rev. Mr. Increase Mather,
entituled The Order of the Gospel (headlines shaved), cf.
(New York), *Bradford,* 1700, 4to. (251)
 *H. Stevens, £*32 10s.
4238 Mather (I.) A Collection of some of the many offensive
Matters contained in a Pamphlet, entituled The Order of
the Gospel revived (by Increase Mather), *Boston, sold by
T. Green,* 1701, 12mo. (251*) *H. Stevens, £*2 10s.
4239 Mather (I.) De successu Evangelii apud Indos Occidentales
in Novâ-Angliâ, bds. from an early printed ⊃ook, *Ultrâjecti,*
1699, 8vo. (142) *Muller, £*1 17s.
4240 Moody (Lieut. James). Narrative of his Exertions and
Sufferings, hf. cf., 1783, 8vo. (143) *Leon, £*2 10s.
4241 Moore (Francis). Voyage to Georgia, hf. mor., t. e. g., 1744,
8vo. (145) *H. Stevens, £*3 7s. 6d..

4242 Murray (James). An Impartial History of the Present War in America, ports. and plates, vol. i., sheep, *Newcastle upon Tyne*, 1780, 8vo. (146) *H. Stevens*, £1 14s.

4243 New York. The Picture of New York and Stranger's Guide to the Commercial Metropolis of the United States, plates, hf. bd., *New York*, 1828, 8vo. (146*) *Quaritch*, 16s.

4244 Paine (Solomon). A Short View of the Difference between the Church of Christ and the Established Churches in the Colony of Connecticut (title-page and last leaf torn and stained), autograph signature of Saml. Robinson, Founder of Bennington, Vt., *Newport*, James Franklin, 1752, 4to. (253) *H. Stevens*, £1 2s.

4245 Pietas et Gratulatio Collegii Cantabrigiensis apud Novanglos, slip of errata, and autograph signature of Christopher Marshall "The Fighting Quaker," hf. bd., *Boston, Mass.*, J. Green and J. Russell, 1761, 4to. (254) *H. Stevens*, £1 14s.

4246 Prayer. The Book of Common Prayer, according to the Use of the Protestant Episcopal Church in the United States. The Second American Standard Prayer Book, cf., *New York*, H. Gaine, 1793 (151) *Maggs*, £2 2s.

4247 Public Good, being an Examination into the Claim of Virginia to the vacant Western Territory, *Albany*, n. d., 1782, 8vo. (153) *H. Stevens*, 13s.

4248 Reminiscences of the French War, with an account of the Life of Maj.-Gen. John Stark, port., orig. bds., *Concord*, N. H. L. Roby, 1831, 8vo. (156) *Quaritch*, £2 10s.

4249 [Roosen (Gerhard).] Christliches Gemüths-Gesprach von dem geistlichen und seligmachenden Glauben, cf., *Ephratae Typis Societatis anno* 1769, 8vo. (158) *H. Stevens*, 11s.
[Ephrata, or Dunkard Town, a Settlement of a German sect called Tunckers, situated in Lancaster county, Pennsylvania.—*Catalogue*.]

4250 Sims (S.) A Sober Reply in Christian Love to a Paragraph in Jonathan Edwards' Discourse (Broadside), (*New Haven*, T. Green, 1741), folio (267) *B. F. Stevens*, £1 8s.

4251 Slavery. Clarke (Lewis). Narrative of the Sufferings of Lewis Clarke, *Boston*, D. H. Ela, 1845, 8vo. (167) *Edwards*, £1 5s.

4252 Smith (Samuel). History of the Colony of Nova-Caesaria, or New Jersey, presentation copy from the author's son to John Darron, orig. sheep, *Burlington, in New Jersey*, 1765, 8vo. (172) *H. Stevens*, £3 3s.

4253 Smith (Wm.) The History of the Province of New York, front., autograph signature of "Henry Atkinson" (Quebec merchant and Officer in the War of 1812) on title, hf. cf., 1757, 4to. (254*) *Edwards*, £14 5s.

4254 Stobo (Major Robert). Memoirs, folding plan, *Pittsburgh*, 1800, 8vo. (175) *Sicotte*, £1 14s.

4255 [Steuben (F. W., Baron).] New System of Military Discipline, orig. bds., *Philadelphia*, 1776, 8vo. (177) *Tregaskis*, 11s.

4256 Stephenson (Marmaduke). A Call from Death to Life, bds.,
 T. Simmons, 1660, 4to. (264) *Yeates*, £2
4257 Sutcliff (R.) Travels in some parts of North America, front.,
 orig. bds., *Philadelphia*, 1812, 8vo. (179) *H. Stevens*, 10s.
4258 Taylor (S. W.) The Storming of Quebec, a Poem, sheep,
 Philadelphia, 1829, 8vo. (183) *Maggs*, 11s.
4259 Thomas (David). Travels through the Western Country,
 folding map, orig. sheep (cracked), *Auburn (N. Y.)*, David
 Rumsey, 1819, 8vo. (187) *H. Stevens*, £1 9s.
4260 Vermont Imprints. Flavel (J. A.) A Token for Mourners,
 orig. sheep, *Newbury, Vt.*, Nathaniel Coverly, 1796, 8vo.
 (198) *H. Stevens*, 11s.
4261 Vermont Imprints. Harmon (D. W.) Travels in the Inte-
 riour of North America, port. and map, *Andover*, Flagg
 and Gould, 1820, 8vo. (199) *Leon*, £4
4262 Vermont Imprints. Neilson (Ch.) Account of Burgoyne's
 Campaign and the Battles of Bemis's Heights, map,
 Albany (Vt.), J. Munsell, 1844, 8vo. (206) *Leon*, 10s.
4263 Vermont Imprints. Statutes of the State of Vermont, sheep,
 Bennington (Vt.), Anthony Haswell, 1791, 8vo. (215)
 B. F. Stevens, £1 1s.
4264 Vermont Imprints. Washington (G.) Farewell Address to
 the People of the United States, port., hf. bd., *Windsor
 (Vt.)*, T. M. Pomroy, 1812, 8vo. (219) *Coleman*, 12s.
4265 Washington (George). Letters to several of his friends in
 June and July, 1776, uncut, *Philadelphia, republished at the
 Federal Press*, 1795, 8vo. (226) *Ellis*, 9s.
4266 Washington (G.) Legacies of Washington, port., orig. sheep,
 Trenton, Sherman, Mershon and Thomas, 1800, 8vo. (227)
 Leon, 15s.
4267 Washington (G.) Political Legacies, port. by Rollinson after
 Savage inserted, sheep, *Boston*, 1800, 8vo. (229)
 Maggs, £1 8s.
4268 Washington (G.) Letters to Arthur Young and Sir J.
 Sinclair, port. by Rollinson, uncut, *Alexandria*, 1803, 8vo.
 (230) *H. Stevens*, 11s.
4269 Washington (G.) The Washingtoniana, port. by D. Edwin
 (stained), orig. sheep, front cover wanted, *Lancaster*, 1802,
 8vo. (231) *H. Stevens*, 13s.
4270 Washington (G.) Farewell Address to the People of the
 United States, port. by A. Reed, hf. bd., *New York*, 1809,
 8vo. (232) *Coleman*, 8s.
4271 Washington (G.) Farewell Address to the People of the
 United States, port. by A. Reed, hf. bd., *Greenfield*, 1812,
 8vo. (233) *Hodgson*, 13s.
4272 Washington (G.) Farewell Address to the People, on his
 retiring from Public Life, port., hf. cf., *Keene, N.H.*, 1812,
 8vo. (235) *Hodgson*, £1 2s.
4273 Williamson (Hugh). History of North Carolina, 2 vol., 2
 maps, orig. sheep, *Philadelphia*, 1812, 8vo. (244)
 H. Stevens, £1 12s.

4274 Yale College. By the Honourable Gurdon Saltonstall, Esq.,
Governour of His Majesty's Colony of Connecticut, A
Brief, Whereas upon a Representation made to the General
Assembly Holden at Hartford, the 11th day of May last, it
appeared that the want of a House for the Rector of Yale
College at New Haven was a great disadvantage to the
good Order and Education of the Students there, damaged
in folds (Broadside), *New London*, T. Green, 1721, folio
(268) *Coleman*, £3 5s.

*The following were sold by Messrs. Hodgson & Co.
on February 16th-18th :—*

4275 America. An Impartial History of the War in America,
folding map, 13 engraved ports., including Washington,
Hancock, Franklin and others (lower right-hand corner of
the map defective), old cf., R. Faulder, 1780, 8vo. (542)
£10 15s.

4276 Bibliotheca Lindesiana. Catalogue of English Ballads, hf.
vell., *Privately printed*, 1890—Catalogue of English Broad-
sides, 1505-1897, cl., t. e. g., *Privately printed*, 1898—Cata-
logue of Chinese Books and MSS. and Handlist of Oriental
MSS., 2 vol., cl., *Privately printed*, 1895-8—Catalogue of
English Newspapers, hf. roan, 1901, together 5 vol., sm.
4to. (96-7-8-9) £11 6s.

4277 Curtis's Botanical Magazine, col. plates (Nos. 1-4553). First
Series, 42 vol.—New Series, 11 vol.—The Rare Second
Series, 17 vol.—Third Series, vol. i. to vi., being the first 76
vol., hf. russ. (a few bindings defective), 1787-1850, 8vo.
(204) £26

4278 Dallaway (J.) and Cartwright (E.) History of the Western
Division of the County of Sussex, ports., views, etc. (a few
extra inserted), 3 vol., hf. russ., T. Bensley, etc., 1815-32-30,
imp. 4to. (282) £19

4279 Du Cange (C. du Fresne). Glossarium, 10 vol., hf. mor.,
Niort, 1883-7, 4to. (759) £11

4280 Evelyn (J.) Silva, port. by Bartolozzi and plates by J. Miller,
coloured copy, 2 vol. in 1, old mor., g. e., with a view of
Wotton, Surrey, on the fore-edge, *York*, 1786, 4to. (205) £23

4281 Prault's Italian Classics. Dante, 2 vol.—Boccaccio, 3 vol.—
Petrarch, 2 vol.—Ariosto, 4 vol.—Macchiavelli, 8 vol., etc.,
ports. and engraved titles by Moreau, 32 vol., old French
mor. ex., *Parigi*, M. Prault, 1768, 12mo. (496) £17 5s.

4282 [Smollett (T.)] The History and Adventures of an Atom, first
issue of the first ed., with the half-titles, 2 vol., orig. mottled
boards, cf. back, edges entirely uncut (7⅜in. by 4½in.),
*London, printed for Robinson and Roberts, No. 25, in Pater-
noster Row*, 1749 [for 1769], 8vo. (387) £63
[The fact that titles and half-titles are printed on paper of
a character different from that used in the body of the work

may be a factor worthy of consideration when the discrepancy in the dates is under consideration.—ED.]

4283 Sussex Archæological Collections, plates and woodcuts, from the commencement in 1848 to 1879, being vol. i. to xxix., with General Index to vol. i.-xxv., together 30 vol., cl., 1848-79, 8vo. (207)　　　　　£10 5s.

[FEBRUARY 17TH, 1910.]

SOTHEBY, WILKINSON & HODGE.

THE LIBRARY OF THE LATE MR. J. R. CARR-ELLISON (THE DUNSTON HILL LIBRARY) OF NEWCASTLE-ON-TYNE, AND ANOTHER PROPERTY.

(No. of Lots, 335 ; amount realised, £482 6s.)

(*a*) *The Dunston Hill Library.*

4284 Adam (R.) Ruins of the Palace of the Emperor Diocletian at Spalatro, 61 plates by Bartolozzi and others, hf russ., 1764, folio (153)　　　　　*Neumayer,* £1 10s.

4285 Ancient Laws and Institutes of England, edited by B. Thorpe, 2 vol., 1840—Anglo-Saxon Chronicle, edited with a Translation by B. Thorpe, facs., 2 vol., roxburghe, 1861, together 4 vol., 8vo. (5)　　　　　*Harding,* £2 14s.

4286 Archaeologia Æliana, new series, plates, vol. i.-xii., hf. cf. antique, t. e. g., *Newcastle-upon-Tyne,* 1857-87, 8vo. (6)　　　　　*Walford,* £4 17s. 6d.

4287 Ariosto (L.) Orlando Furioso, por Don Jeronymo de Urrea, woodcuts, cf., *Lyon,* G. Roville, 1550, folio (155)　　　　　*Maggs,* £1 1s.

4288 Aristophanes. Comoediae, editio princeps, 347 leaves (wanted one blank, one leaf in facsimile, and the last 6 leaves defective), hf. vell., *Venetiis, ap Aldum,* 1498, folio (156)　　　　　*Ellis,* £4 5s.

4289 Beaumont (F.) and Fletcher (J.) Fifty Comedies and Tragedies, port. of Fletcher by W. Marshall, sound copy in old cf., 1679, folio (160)　　　　　*Maggs,* £7 12s. 6d.

4290 Beckford (P.) Thoughts upon Hunting, front. by Bartolozzi, orig. bds., uncut, *Sarum,* 1782, 8vo. (91)　　　*Barnard,* £2 2s.

4291 Berwickshire Naturalists' Club. History of the Berwickshire Naturalists' Club, plates, in 11 vol. (vol. i. reprint), hf. cf. gt., *Alnwick,* 1849-87, 8vo. (10)　　　　　*Quaritch,* £8

4292 Bible (The Holy), ed. by J. Forshall and Sir F. Madden, 4 vol., *Oxford,* 1850, 8vo. (92)　　　　　*Hill,* £3 7s. 6d.

4293 Boiardo ed Ariosto. Orlando Innamorato ed Orlando Furioso, notes by A. Panizzi, port., 9 vol., hf. mor., t. e. g., by Hayday, W. Pickering, 1830-34, 8vo. (12)　　　　　*Edwards,* £2 2s.

4294 Budaeus (G.) De Asse et partibus eius lib. v., vell., *Venet.*,
in ædibus Aldi et And. Asulam, 1522, 8vo. (14) *Reuter*, 14s.
4295 Camden (Wm.) Britannia, enlarged by R. Gough, port.,
maps and plates, 4 vol., cf. (2 vol. broken), 1806, folio (164)
Carter, £1 6s.
4296 Cavanilles (A. J.) Observaciones sobre la Historia Natural
del Reynos de Valencia, maps and plates, 2 vol., hf. cf.,
uncut, *Madrid*, 1795-97, folio (165) *Wesley*, £1 2s.
4297 Churchill (J.) Collection of Voyages and Travels, 6 vol.,
maps and plates, hf. cf., 1744-46, folio (166) *Hill*, £3 11s.
4298 Chaucer (G.) Canterbury Tales, by Th. Tyrwhitt, 5 vol.,
front. (spotted), orig. cl., W. Pickering, 1830, 8vo. (20)
Edwards, £3
4299 Cicero. Rhetoricorum ad Herennium, lib. iv.—De Inventione,
lib. ii.—De Oratore, lib. iii., etc., *Venetiis, in ædibus Aldi*,
1514—Quintilianus Institutiones Oratoriae edente Andr.
Naugerio, first Aldine ed., *ib.*, 1514, in 1 vol., orig. Venetian
cf., 8vo. (21) *Tregaskis*, £1 15s.
4300 Cicero. Opera (cum scholiis nonnullis Pauli Manutii), *id est.*,
Orationes—Epistolae ad Familiares—Rhetorica—Epistolae
ad Atticum—Philosophia—Paediani Expositio in IIII. ora-
tiones contra C. Verrem, etc., together 10 vol., vell.,
Venetiis, ap. Aldus, 1522-44 (22) *Barnard*, £3 4s.
4301 Cicero. Opera, *id est.*, Philosophia—Epistolae ad Atticum—
Orationes—De Officiis—De Oratore—Rhetorica, together
9 vol., vell., *Venetiis, ap. Aldus*, 1523-69, 8vo. (23)
Barnard, £1 11s.
4302 Cleasby (R.) and Vigfússon (G.) Icelandic-English Dic-
tionary, 3 parts, as issued, *Oxford*, 1874, 4to. (104)
Hill, £1 15s.
4303 Couch (J.) History of the Fishes of the British Islands, 4
vol., 57 col. plates, 1877, imp. 8vo. (25) *Winter*, £1 16s.
4304 Crescentio (P. de). De Agricultura Istoriato, woodcuts
(slightly wormed), vell., *Venetia*, 1504, 4to. (107)
Leighton, £7
4305 Defoe (D.) Robinson Crusoe, 2 vol., LARGE PAPER, plates
by Stothard, hf. cf., Stockdale, 1804, 4to. (110)
Col. Ellison, £2 11s.
4306 Dugdale (Sir Wm.) Monasticon Anglicanum, by Caley, Ellis
and Bandinel, 6 vol. in 8, engravings, hf. mor., t. e. g., others
uncut, 1817-30, folio (172) *E. W. Reeves*, £23 10s.
4307 Edwards (S.) The New Botanic Garden, 2 vol., 133 col.
plates, old cf., g. e., 1812, 4to. (113) *Tregaskis*, £1 14s.
4308 Eddis (Wm.) Letters from America, cf., 1792, 8vo. (29)
Leon, £1 2s.
4309 Fielding (H.) Tom Jones, first ed., 6 vol., old cf., 1749, 8vo.
(30) *Sotheran*, £4 14s.
4310 Forrest (T.) A Voyage to New Guinea, port., 30 plates and
maps, cf., 1779, 4to. (116) *Ellis*, £1 2s.
4311 Froissart (Sir John). Histoire et Cronique, par Denis
Sauvage, 3 vol. in 2, vell., *Lyon*, J. de Tournes, 1559-61,
folio (174) *Tregaskis*, £2 2s.

4312 Froissart (Sir John). Chronicles, by T. Johnes, 12 vol. and atlas in 4to., cf. (worn), 1805, 8vo. (35) *Edwards*, £1
4313 Gould (John). Century of Birds from the Himalaya Mountains, 80 col. plates, hf. mor., t. e. g., 1832, folio (176)
 Wesley, £4 4s.
4314 Grose (F.) The Antiquities of England and Wales, 8 vol., 1783-87—The Antiquities of Ireland, 2 vol., 1791-97—The Antiquities of Scotland, 1797—Military Antiquities; 1801, together 14 vol., cf., 1784-1801, 4to. (118) *Reuter*, £2 6s.
4315 Gower (John). Confessio Amantis, ed. ɔy Dr. Reinhold Pauli, 3 vol., 1857, 8vo. (36) *Harding*, 14s.
4316 Hallam (H.) View of the State of Europe during the Middle Ages, 3 vol., 1856—Introduction to the Literature of Europe, 3 vol., 1854—Constitutional History of England, 3 vol., 1854, together 9 vol., cf. gt., 8vo. (37) *Fenwicke*, £3 10s.
4317 Hewitson (W. C.) British Oology, 2 vol., 155 col. plates, hf. cf., *Newcastle-upon-Tyne*, n. d., 8vo. (38)
 Quaritch, £3 6s.
4318 Heriot (G.) Travels through the Canadas, map and aquatint plates, cf., 1807, 4to. (121) *Ellis*, £1 14s.
4319 Hogarth Restored. The Whole Works, now re-engraved ɔy Thos. Cook, 111 plates, hf. bd., uncut, 1806, folio (179)
 Spencer, £3 8s.
4320 Horsley (J.) Britannia Romana, map and plates, cf., 1732, folio (181) *Bosanquet*, £2 6s.
4321 Howell (Ja.) Instructions for forreine Travell, first ed., front. by W. Hollar and port. of Prince Charles by Glover, name cut from title, orig. sheep, *T. B. for H. Mosley*, 1642, 8vo. (40) *Ridler*, 16s.
4322 Jacopone da Todi. Laude de lo contemplativo et extatico B. F. Jacopone, item alcune laude de S. Thomaso de Aquino, etc., lit. gotħ., douɔle columns, woodcuts, mor. ex., g. e., by Capé, *Venetiis, per Bernardinum Benalium*, 1514, 4to. (124) *Leighton*, £10 10s.
4323 Johnson (Samuel). Dictionary of the English Language, first ed., 2 vol., cf., 1755, folio (183) *Tregaskis*, £2 13s.
4324 Jones (W. D.) and Eardley-Wilmot (F.) Records of the Royal Military Academy, col. plates, *Woolwich*, 1851, 4to. (125) *Lewine*, £3 3s.
4325 Jonson (Ben). Works, with a Comedy called the New Inn, port. ɔy W. Elder, old cf., 1692, folio (184) *Reader*, £1 7s.
4326 King (E.) Munimenta Antiqua, 4 vol., plates, russ., g. e., 1799-1805, folio (186) *Ellison*, £1 8s.
4327 Lambarde (Wm.) Eirenarcha, or the Office of the Justices of Peace, in foure Bookes, black letter, *Companie of Stationers*, 1619—The Duties of Constaɔles, Borsholders, Tythingmen and such other lowe and lay Ministers of the Peace, black letter, *ib.*, 1606, in 1 vol., cf., 1606-19, 8vo. (48)
 Tregaskis, £1
4328 Lavater (J. C.) Essays on Physiognomy, by H. Hunter, 5 vol., illustrations, russ. gt., 1789-1810, 4to. (126)
 Edwards, £3 10s.

4329 McArthur (J.) The Army and Navy Gentleman's Companion, front. and 19 plates, cf., n. d. (1780), 4to. (130)
Barnard, £1 18s.

4330 Macartney (Earl of). Embassy from the King of Great Britain to the Emperor of China, by Sir G. Staunton, 2 vol. (and atlas of plates in folio), hf. mor., illustrations, cf., 1797, 4to. (131) *Maurice,* 6s.

4331 Maitland Club. Scalacronica, by Sir Thomas Gray of Heton, Introduction and Notes by J. Stevenson, hf. mor., uncut, *Edinburgh,* 1836, 4to. (132) *Ellis,* £1 1s.

4332 Malton (J.) A Picturesque and Descriptive View of the City of Dublin, city arms, 2 maps, 25 plates and key-plate, orig. bds., 1794, oblong folio (189) *Maggs,* £6 5s.

4333 Mayer (L.) Views in Palestine, 24 col. plates, hf. mor., folio (190) *Spencer,* £1 4s.

4334 Milton (J.) Paradise Lost, a Poem, first illustrated edition, port. by R. White and plates, cf. (rebacked), large copy, 1688, folio (193) *Ellison,* £1 11s.

4335 Milton (J.) Poetical Works, Bulmer's ed., 3 vol., ports. and plates, russ. gt., 1794-97, folio (194) *Mrs. Carr,* £1 8s.

4336 Natural History Society of Northumberland, Durham and Newcastle-upon-Tyne. Transactions, 2 vol., illustrations, hf. cf., t. e. g., *Newcastle,* 1831-38, 4to. (133) *Quaritch,* £1

4337 Naumann (J. A.) Naturgeschichte der Vögel Deutschlands, 13 vol., port. and 389 col. plates, russ., *Leipzig,* 1822-60, 8vo. (63) *Wesley,* £8 10s.

4338 Painter (W.) Palace of Pleasure, ed. by J. Haslewood, 3 vol., 1813, 4to. (135) *Bull,* £2 7s.

4339 Parkinson (John). Theatrum Botanicum, 1 vol. in 2, woodcuts, engraved title, last leaf of table and errata leaf mounted, and first leaf of table defective, old cf., Th. Cotes, 1640, folio (195) *Gordon,* £3 1s.

4340 Paruta (P.) Historia Venetiana, 2 vol., mor., g. e., with the Foscarini arms, *Venetia,* 1645, 4to. (136) *Ellison,* £1 5s.

4341 Piranesi (G. B.) Vasi, Candelabri, Cippi, Sarcofagi, Tripodi, Lucerne ed Ornamenti Antichi, 2 vol. in 1, 107 plates, hf. russ., 1778-91, oblong atlas folio (197) *Quaritch,* £6

4342 Ruskin (John). Seven Lamps of Architecture, first ed., orig. cl., 1849, imp. 8vo. (74) *Ellison,* £2 4s.

4343 Ruskin (J.) The Stones of Venice, 3 vol., 1873-74, 8vo. (75) *Ellison,* £1 6s.

4344 Sanson (N.) Atlas Nouveau, contenant toutes les parties du monde, maps col., hf. cf., *Amsterdam,* n. d., folio (203)
Carter, £5 5s.

4345 Savonarola (Hieronymo). Prediche raccolte per Ser Lorenzo Violi da la viva voce del Reverendo Padre Frata Hieronymo da Ferrara Giorno per Giorno mentre che e predicava, lit. rom., double columns, wanted the two preliminary leaves and with last leaf pasted down, contemp. MS. marginal notes, orig. stamped cf. (rebacked and repaired), *Firenze,* Lorenzo Vinuoli, 1496, 4to. (142) *Barnard,* £2 6s.

4346 Shakespeare. Boydell's Collection of Prints, 2 vol. in 1, 98 plates (including the "Seven Ages") and 2 vignettes, hf. russ., J. and J. Boydell, 1803, elephant folio (205)
Mrs. Carr, £14 10s.

4347 Stedman (J. G.) Expedition against the Revolted Negroes of Surinam, 2 vol., col. plates and maps, cf., 1806, 4to. (146)
Bain, £4

4348 Stukeley (W.) Itinerarium Curiosum, 100 plates, cf., 1724, folio (211)
Ellison, £1 2s.

4349 Thornton (R. J.) The Temple of Flora, col. port. of Linnaeus and col. plates, hf. cf., 1799, folio (214)
Maggs, £3 3s.

4350 Tyneside Naturalists' Field Club. Transactions, 1846-64, continued as Natural History Transactions of Northumberland and Durham, 1865-1888, together 15 vol., plates, hf. cf. gt., *Newcastle-upon-Tyne*, 1850-88, 8vo. (78)
Quaritch, £2 12s.

4351 Virgilius. Opera omnia, 5 vol. in 3, engraved throughout on one side of the leaf, engravings, mor. ex., *Apud J. L. de Boubers, Bruxellis*, n. d., 8vo. (79)
Ellison, £2 6s.

4352 Walpole (Horatio, Earl of Orford). Works, 5 vol., ports. and plates, hf. russ., 1798, 4to. (149)
Reuter, £1

4353 Young (A.) Travels through France, 2 vol., maps, cf., 1794, 4to. (152)
Hill, £2 4s.

(β) *Another Property.*

4354 Alfonso (King of Castile). Tabulae Astronomice divi Alfonsi Romanorum et Castilie Regis, rough cf., MS. additions (wanted 6 leaves), *Venet.*, 1492, 4to. (293) *Leighton*, £1 12s.

4355 Austen (Jane). Mansfield Park, first ed., 3 vol., cf. (no half-titles), 1814, 8vo. (224)
Hornstein, £2 8s.

4356 Bible. La Biblia Volgarizata, per Nicolo de Mallerini, engraved title and woodcuts, woodcut borders, vell. (a little wormed), *Venet.*, 1541, folio (320) *Leighton*, £2 4s.

4357 Chamberlaine (J.) Imitations of Original Designs in His Majesty's Collection by L. Da Vinci, the Caracci and others, plates, hf. mor., g. e., 1812, imp. folio (322)
Hill, £1 8s.

4358 Charles V. Pompa Coronationis, 39 plates (should be 40) by J. N. Hogenberg, the missing plate (30) supplied by a drawing (1619)—Pompa Funebris, 36 plates (should be 37) by J. and L. Duetecum, *Hagæ Comit.*, H. Hondius, 1619, in 1 vol., hf. bd., portions of some plates missing, 1619, folio (323)
Leighton, £6

4359 Diodorus Siculus. Bibliothecæ Historicæ libri u supersunt, Gr. et Lat. nova editio, etc., 11 vol., mor. ex., fine copy, *Bipont*, 1793-1807, 8vo. (240)
Edwards, £1 11s.

4360 Goldsmith (O.) The Good Natur'd Man, first ed., mor. ex., by Rivière, half-title in fac., 1768, 8vo. (243)
James, £6 17s. 6d.

4361 Homerus. Ilias et Odyssea, Batrachomyomachia et Hymni

Graecè, 2 vol., contemp. mor. (title to second vol. wrong), third ed. of Homer, from the Aldine Press, *Venet.*, Aldus et And. Asulanus, 1524, 8vo. (247) *Maggs*, £4 10s.

4362 Horatius. Opera æneis tabulis incidit Johannes Pine, second issue ("post est" corrected), 2 vol., engravings, contemp. mor., g. e., arms of "Musgrave de Edenhall," 1733-37, 8vo. (248) *Sotheran*, £7 10s.

4363 Livius (T.) Historiarum Libri, ed. by T. Hearne, LARGE PAPER, 6 vol., 2 folding plates, old mor., g. e., Sunderland Library, *Oxon.*, 1708, roy. 8vo. (253) *Sotheran*, £1 15s.

4364 Miniature Books. Kern der Nederlandsche Historie, plates, *Amst.*, 1753—Kern der Kerkelyke Historie, 2 vol., plates, *Dordregt*, 1755, together 3 vol. (size 2in. by 1¼in.), old cf., gilt tooling, in case, 1753-55 (264) *Maggs*, £2

4365 Miniature Books. Moreau (H.) La Souris Blanche (1⅝ by 1¼in.), illustrations, mor., *Paris*, 1895—Les Rondes de l'Enfance (1½in. by 1⅛in.), illustrations, *ib.*, 1895—Claretie (J.) Boum-Boum (1½in. by 1¼in.), illustrations, *ib.*, 1898 —Small Rain on the Tender Herb (1¼in. by 1in.), roan, g. e., n. d., together 4 vol. (265) *Tregaskis*, 14s.

4366 Newcastle (Duke of). The Country Captaine and the Varietie, Two Comedies, first ed., mor., g. e., by Rivière, 1649 (271) *Quaritch*, £6 10s.

4367 Scott (Michael). Tom Cringle's Log, first ed., 2 vol., orig. cl., 1833, 8vo. (283) *Edwards*, £1 13s.

4368 Scott (Sir W.) Tales of My Landlord, first ed., first series, 4 vol., with the half-titles, *Edinburgh*, 1816—The Abbot, first ed., 3 vol., 1820—Redgauntlet, first ed., 3 vol., 1824, together 10 vol., orig. bds., uncut, 8vo. *Hornstein*, £108
 [Realised on February 22nd at the sale of the contents of Bunny Hall, near Nottingham.—ED.]

4369 Smollett (T.) History and Adventures of an Atom, first ed., earliest issue, with the misprint of date (1749) in vol. ii., 2 vol., old hf. cf., 1769, 8vo. (286) *Hornstein*, £5

4370 Tarleton (Lieut.-Col.) History of the Campaigns in the Southern Provinces of North America, folding map and plans, cf., t. e. g., by Ramage, 1787, 4to. (313) *Dobell*, £3 10s.

4371 Valla (Laur.) De Linguæ Latinæ Elegantia, cf. (broken), *Paris*, 1491, 4to. (315) *Ellis*, £2 12s.

4372 Vida (M. H.) Opera Poetica, LARGE PAPER (so called, but there is no small paper), 4 vol., 3 ports. and vignettes, old English mor., g. e., not quite uniform, *Oxon.*, 1722-32, roy. 8vo. (288) *Quaritch*, £1

4373 Voltaire (M. A. de). Œuvres Complètes, LARGE PAPER, 70 vol., port. and plates by Moreau, old hf. cf. (some vol. spotted), *Société Littéraire Typographique*, 1785, roy. 8vo. (290) *Lewine*, £2 10s.

4374 Whittinton (Robert). Verborum præterita et supina, lit. goth., title within ornamental border, woodcut initials, mor., top and front margins cut into (stained), *Lond.*, Wynkyn de Worde, 1522, 4to. (318) *Andrews*, £2 14s.

CHRISTIE, MANSON & WOODS.

A PORTION OF THE LIBRARIES OF THE LATE SIR ARTHUR DOUGLAS BATEMAN SCOTT, BART., AND THE LATE LADY BATEMAN SCOTT, AND ANOTHER PROPERTY.

(No. of Lots, 296 ; amount realised, about £1,500.)

4375 Ackermann (R.) History of the University of Oxford [by W. Combe], col. plates, including the series of ports. of the Founders, 2 vol., russ. ex., 1814, 4to. (113) *Sawyer*, £15 10s.

4376 Ackermann (R.) History of the University of Cambridge [by W. Combe], col. plates, including the series of ports. of the Founders, 2 vol., russ. ex., 1815, 4to. (114) *Sawyer*, £17

4377 Ackermann (R.) History of the Colleges of Winchester, Eton, Westminster, etc., col. plates by Pugin and others, russ. ex., Ackermann, 1816, 4to. (115) *Quaritch*, £26 10s.

4378 Aikin (J.) Description of the Country round Manchester, 73 plates and folding maps, hf. cf., 1795, 4to. (116) 7s.

4379 Annales Archéologiques, par D. Ainé, from the commencement to 1860, plates, 20 vol., hf. cf., *Paris*, 1844-60, 4to. (117) *Picard*, £3 15s.

4380 Annales du Musée et de l'École Moderne des Beaux-Arts, par Landon, including the "Paysages" and Salons for 1808, 1810, 1812 and 1814, upwards of 1,800 outline engravings, 31 vol., bds., *Paris*, 1803-14, 8vo. (1) *Parsons*, £1 9s.

4381 Arabian Nights, trans. by Forster, proof plates by R. Smirke, LARGEST PAPER, 5 vol., mor. ex., Bulmer, 1802, 4to. (118) *Sotheran*, £10 10s.

4382 Ariosto (L.) Orlando Furioso, Baskerville's ed., engravings by Bartolozzi, Eisen and others, 4 vol., contemp. mor. ex., *Birmingham*, 1773, 8vo. (2) *Parsons*, £5 15s.

4383 Ballantyne's Novelists' Library, complete in 10 vol., cf. ex., 1821-25, 8vo. (3) *Joseph*, £3 5s.

4384 Beaumont (F.) and Fletcher (J.) Dramatick Works, ports. and plates, 10 vol., old cf., 1778, 8vo. (4) *Rimell*, £2 16s.

4385 Bentham (James). History and Antiquities of Ely Cathedral, with Appendix of Charters, 50 plates, cf. ex., *Cambridge*, 1771, 4to. (119) *Bain*, £2 14s.

4386 Bewick (T.) British Birds, first ed., on thick paper, 2 vol., russ. ex., *Newcastle*, 1797-1804—History of Quadrupeds, first ed., cf., *ib.*, 1790, 8vo. (5) *Bumpus*, £4

4387 Binding. Boissardus (J. J.) Romanæ Urbis Topographia et Antiquitates, Pars i.-iv., plates, old cf., inlaid floral corners, with port. in gold on front side, arms on reverse, *Francofurti, impensis Theodori de Bry*, 1597-8, folio (198) *Quaritch*, £18

4388 Blomefield (Francis). Essay towards a History of Norfolk, LARGE PAPER, port., plates and coats-of-arms, 11 vol., hf. cf. gt., W. Miller, 1805-10, 4to. (121) *Cubitt,* £9 10s.

4389 Binns (R. W.) Century of Potting in the City of Worcester, second ed., roxourghe, 1877, 8vo. (263) *Jackson,* £5 10s.

4390 Brogniart (A.) and Riocreux (D.) Description Méthodique . . . de Porcelain de Sèvres, col. plate, mor. ex., *Paris,* 1845, 4to. (124) £9 5s.

4391 Brunet (J. C.) Manuel de Libraire, 5 vol., mor. ex., *Paris,* 1842-4, 8vo. (11) *Rimell,* £2

4392 Burney (Frances). Camilla, first ed., hf. cf., 1796, 8vo. (13) *G. H. Brown,* £1 9s.

4393 Cahier (P. C.) · Mélanges d'Archéologie, etc., plates (some in gold and colours), 4 vol. in 2, hf. cf. ex., *Paris,* 1847-56, 4to. (126) *Lewine,* £6 5s.

4394 Campbell (John Lord). Lives of the Lord Chancellors, 7 vol. —Lives of the Chief Justices, 2 vol., together 9 vol., cf. ex., 1848-58, 8vo. (14) *Hatchard,* £4

4395 Cervantes (M. de). Don Quixote, by Mary Smirke, engravings by R. Smirke, 4 vol., cf. ex., Bulmer, 1818, 8vo. (15) *Bumpus,* £3 15s.

4396 Chappe d' Auteroche (L'Abbé). Voyage en Sibérie, plates after Moreau le jeune, etc., 2 vol. in 3 and 4to. atlas of plates, 4 vol., cf., *Paris,* De Bure père, 1768, 4to. (127) *Bumpus,* £3 7s. 6d.

4397 Chaucer (Geoffrey). Workes, fourth folio ed., 𝔟𝔩𝔞𝔠𝔨 𝔩𝔢𝔱𝔱𝔢𝔯, cuts and woodcut capitals, old cf. ex. (margin of title wormed, hole in 6 leaves and few margins stained), *Jhon Kyngston for Jhon Wight,* 1561, folio (205) *Maggs,* £8 5s.

4398 Chauncy (Sir Henry). Historical Antiquities of Hertfordshire, map, port. and plates, old cf., 1700, folio (206) *Brown,* £4

4399 Collinson (John). History of the County of Somerset, map and plates, 3 vol., old cf., *Bath,* 1791, 4to. (130) *Bain,* £7

4400 [Combe (W.)] Dance of Life, col. plates by Rowlandson, old cf., Ackermann, 1817, 8vo. (17) *Jones,* £6

4401 Cook (Capt.) Three Voyages Round the World, plates by Bartolozzi, etc., maps and charts, 8 vol.—also Folio Atlas of plates to the third Voyage, cf. and hf. cf., 1773-85, 4to. (131) *Quaritch,* £7 10s.

4402 Cox (Nicholas). The Gentleman's Recreation, second ed., plates, including the one of "Ancient Hunting Notes," old cf. (few headlines shorn), 1677, 8vo. (18) *Maggs,* £1 4s.

4403 Crébillon (P. J.) Œuvres, port. and plates after Marillier, 3 vol., French cf. ex., *Paris,* 1785 (19) *Sawyer,* £1 6s.

4404 Daniell (T. and W.) Picturesque Voyage to India, 50 col. views on cardboard, hf. russ. gt., Longman, 1810, folio (207) *Thorpe,* £4 5s.

4405 Defoe (Daniel). Robinson Crusoe, Stockdale's ed., plates after Stothard (foxed), 2 vol., contemp. mor. ex., 1790, 8vo. (21) *Quaritch,* £4

4406 Dennistoun (James). Memoirs of the Dukes of Urbino, views, ports. and map, 3 vol., cl., uncut, 1851, 8vo. (22) *Bain,* £4

4407 Dibdin (T. F.) Bibliotheca Spenceriana—Ædes Althorpianæ, 6 vol., hf. mor., 1814-22, 8vo. (23) *Parsons,* £5 5s.

4408 Dibdin (T. F.) Bibliographical Decameron, 3 vol., russ. ex., 1817, 8vo. (24) £5 10s.

4409 Dugdale (Sir W.) Antiquities of Warwickshire, ports., maps and plates by Hollar, 2 vol., cf. (rejacked), several orig. drawings inserted, 1730, folio (209) *Edwards,* £25

4410 Falconer (William). The Shipwreck, plates by Fittler, LARGE PAPER, contemp. mor. ex., 1804, 8vo. (28) *Maggs,* £1 4s.

4411 Froissart (Sir J.) Chronicles, by Thomas Johnes, woodcuts, and the series of illuminations from the MSS. in the British Museum and Bib. Royale, 2 vol., mor. ex., 1852, 8vo. (32) *Dancocks,* £9 10s.

4412 Froude (J. A.) History of England, Library ed., port., 12 vol., cl., uncut, 1856-70, 8vo. (33) *Sabin,* £2 15s.

4413 Froude (J. A.) History of England, Library ed., vol. i. to xi., cf. ex., 1870-75 (34) *Bain,* £6 10s.

4414 Fuller (T.) Worthies of England, first ed., port. by Loggan, cf., 1662, folio (216) *Dobell,* £2 18s.

4415 Giraldus Cambrensis. Itinerary of Archbishop Baldwin through Wales, trans. by Sir R. C. Hoare, maps and plates, 2 vol., russ. ex., 1806, 4to. (143) *Quaritch,* £2 8s.

4416 Gladstone (Right Hon. W. E.) Studies on Homer, 3 vol., cf. ex., *Oxford,* 1858, 8vo. (37) *Sotheran,* £1 12s.

4417 Granger (Rev. James). Richardson's Portraits illustrating Granger's History of England, LARGE PAPER, 310 ports. (mostly uncut), 2 vol., hf. cf., 1794-1800, 4to. (144) *Braun,* £3 7s. 6d.

4418 Grote (George). History of Greece, maps, 12 vol., cl., uncut, 1854-6, 8vo. (38) *Bain,* £4 5s.

4419 Hallam (Henry). Introduction to the Literature of Europe, 3 vol., 1843—Europe during the Middle Ages, 2 vol., 1841—Constitutional History of England, 2 vol., 1846, together 7 vol., cf. ex., 1841-6, 8vo. (39) *Hatchard,* £2 14s.

4420 Heideloff (N.) The Gallery of Fashion, vol. i. to vol. vi., in 3 vol., col. plates, russ. gt., 1794-99, 4to. (150) *Quaritch,* £56

4421 Hennepin (Lewis). New Discovery of a Vast Country in America, 2 parts in 1 vol., 2 folding maps and plates, orig. cf., 1698, 8vo. (41) *Quaritch,* £14

4422 Heures à lusage de Rōme, printed on paper, gotḥic letter, woodcut borders, astrological man, woodcuts and painted initials (few leaves wormed), old stamped binding, in case, *Ces psentes heures a lusage de Rōme feuēt acheuees le viii. jour de Mars* (1489) *pour Simon Vostre,* 8vo. (42) *Quaritch,* £47

4423 Heures à lusaige de Rōme, printed on vellum, gotḥic letter, front. representing "Déjanire en levée par le Centaure Nessus et secourue par Hercule," astrological man, 17 woodcuts, illuminated capitals and initials, and woodcut borders, mor., orig. cf. binding as sides, *Paris, Guil. Anabat pour Gillet et Germ. Hardouyn, s. d.* [*Almanack,* 1500-20], 8vo. (43) *Maggs,* £35

4424 Heures à lusaige de Romme, printed on paper, 𝔤𝔬𝔱𝔥𝔦𝔠 𝔩𝔢𝔱𝔱𝔢𝔯, woodcut ɔorders, astrological man, woodcuts and painted initials (Almanack 1488 to 1508), mor., *"Ces presentes heures a lusaige de Romme furèt acheuees le vi. jour de Mars, l'an Mil cccc.iiiixx. et xiv. sept pour Simon Vostre libraire demourant a Paris a la rue neuve nostre dame a leuseigne Sainct Jehan levangeliste,"* Paris, P. Pigouchet pour Simon Vostre, 8vo. (44) *Leighton, £36*

4425 Hewitt (John). Ancient Armour and Weapons, illustrations, 3 vol., cl., Parker, 1855-60, 8vo. (45) *Bain, £2 18s.*

4426 Hogarth (W.) Works, re-engraved by Cook, old hf. russ. (ɔroken), 1802, folio (222) *Amor, £4 10s.*

4427 Holɔein (Hans). Imitations of Original Drawings, pub. by John Chamberlaine, 83 ports., mostly on pink paper and many, including Holɔein and his wife, in colours, mor., 1792-1800, folio (223) *Quaritch, £33*

4428 Horæ Beatæ Mariæ Virginis, cum Calendario. Manuscript on 153 pages of vellum (7½ inches by 4⅞), 𝔤𝔬𝔱𝔥𝔦𝔠 𝔠𝔥𝔞𝔯𝔞𝔠𝔱𝔢𝔯, 13 full-page miniatures, the Calendar having 24 smaller miniatures, each page decorated, illuminated initials, mor. ex., *Sæc.* XIV., 8vo. (48) *Ellis, £68*

4429 Horæ Beatæ Mariæ Virginis, cum Calendario. Manuscript on vellum (5⅛ inches by 3¾), 𝔤𝔬𝔱𝔥𝔦𝔠 𝔠𝔥𝔞𝔯𝔞𝔠𝔱𝔢𝔯, 4 small miniatures, illuminated ɔorders (one containing arms), capitals, initials, etc., old cf., g. e., *Sæc.* XV., 8vo. (49) *Leighton, £34*

4430 Horatius. Opera, incidit Johannes Pyne, engraved throughout, list of suɔscriɔers to ɔoth volumes, 2 vol., cf. gt., 1733-7, 8vo. (51) *Hornstein, £3 15s.*

4431 Ireland (Samuel). Picturesque Views on the Thames, plates in aquatint, 2 vol., vell., g. e., 1792—Tour through Holland, etc., plates in aquatint, 2 vol., vell., g. e., 1790—Views on the Medway and Avon, plates in aquatint, 2 vol., cf., 1793-5, together 7 vol., 8vo. (52) *Spencer, £4 10s.*

4432 Johnson (Samuel). Materials for his Life, 20 humorous caricatures, orig. hf. ɔinding, E. Jackson, 1876—The Punishments of China, 22 col. plates, cl., 1801, 4to. (151) *Maggs, £5 5s.*

4433 Jones (Owen). Plans, Elevations, Sections and Details of the Alhamɔra, 102 plates, several finished in gold and colours, 2 vol., hf. mor., 1842-45, folio (227) *Amor, £9*

4434 Ladies Amusement (The), or whole Art of Japanning made Easy, second ed., 1,500 different designs on 200 copperplates of flowers, shells, etc., ɔy Pillemont and others, with directions, old cf, with ɔookplates of Lady Charlotte Schreiɔer and W. Edkins (wanted plate 78), R. Sayer, n.d., oɔlong 4to. (266) *Andrews, £9 15s.*

4435 Lavater (J. C.) Essays on Physiognomy, trans. ɔy H. Hunter, D.D., engravings, 3 vol. in 5, russ. ex., 1789-98, 4to. (155) *Joseph, £3 5s.*

4436 Le Sage (A. R.) Histoire de Gil Blas, LARGE PAPER, 24

proof plates ɔy R. Smirke, 4 vol., mor. ex., *Londres,* 1809,
4to. (157) *Sotheran, £9* 10s.
4437 Lingard (John). History of England, Liɔrary ed., port., 10
vol., cf. ex., 1849, 8vo. (58) *Sotheran, £3*
4438 London. Modern London, map and plates, the Itinerant
Traders of London coloured, 1805, 4to. (159) *Bain, £6* 5s.
4439 Manuscript. Instructions given by the Doge of Venice,
Pasquale Cicogña to Zan Batista Pasqualigo on appointing
him Podesta at Cresignana, manuscript in Italian on 170
leaves of vellum, mor., in box, dated 1593, 4to. (160)
Quaritch, £17
[An uncommon specimen of Venetian ɔinding of the
XVIth century, ɔoards carved out in the Oriental style, and
covered with gold tooling, the Lion of St. Mark impressed
on the oɔverse side, and the Pasqualigo arms on the
reverse. There is at the British Museum a volume ɔound
at Venice for Queen Elizaɔeth of England, in the same
style.—*Catalogue.*]
4440 Marguerite de Navarre. Les Nouvelles (l'Heptameron), plates
after Freudenɔerg, 3 vol., mor., g. e., *Berne,* 1792, 8vo. (62)
Sotheran, £14
4441 Molière (J. B. P. de). Œuvres, par M. Bret, plates after
Moreau, 6 vol., French cf. ex., *Paris,* 1788, 8vo. (64)
Sawyer, £5 10s.
4442 Moore (F.) Lepidoptera of Ceylon, 215 col. plates, 3 vol.,
mor. ex., 1880-87, 4to. (163) *Edwards, £11*
4443 Nagler (G. K.) Neues Allgemeines Künstler-Lexicon, 22
vol., cl., *München,* 1835-52, 8vo. (69) *Tregaskis, £12* 5s.
4444 Nash (T. R.) Collections for the History of Worcestershire,
mezzo. and other ports., etc., 2 vol., old russ. (ɔroken),
1781-2, folio (237) *Rimell, £8*
4445 Newgate Calendar (The), by A. Knapp and W. Baldwin,
plates and cuts, 4 vol. in 3, cl., 1824-28 (71) *Rimell, £2* 12s.
4446 Nichols (Jno.) Progresses and Processions of Q. Elizaɔeth,
plates, 3 vol., old cf., 1788-1807, 4to. (164)
Tregaskis, £2 17s. 6d.
4447 Owen (Hugh). Two Centuries of Ceramic Art in Bristol,
LARGE PAPER, additional illustrations and duplicate proof
impressions of many of the engravings, 1 vol. in 2 (author's
own copy), *Privately printed,* 1873, imp. 8vo. (268)
Amor, £8 5s.
4448 Owen (H.) Two Centuries of Ceramic Art in Bristol
(author's own copy), with the extra plates prepared for the
LARGE PAPER ED., and 2 ports. on vell., hf. mor. ex., *Pri-
vately printed,* 1873, 8vo. (269) *Amor, £8* 5s.
4449 Parker (J. H.) and Turner (T. H.) Domestic Architecture in
England, plates, 4 vol., cl., 1851-59, 8vo. (72)
Joseph, £2 10s.
4450 Paxton (Sir J.) Magazine of Botany, col. plates, complete
set, 16 vol., hf. mor., g. e., 1841-49, 8vo. (73)
Sotheran, £5 5s.
4451 Palladio (Andrea). Le Faɔɔriche e Disegni di, raccolti

illustrati da Ottavio Bertotte Scamozzi con la traduzione Francese, plates, 5 vol., hf. cf., *Vicenza*, 1776-85, folio (239) *Batsford*, £3 3s.

4452 Pitt (Moses). The English Atlas, vol. i., containing a description of the Places next the North Pole, as also of Muscovy, Poland, Sweden, Denmark, etc., vignette col. port. of Charles II. and 44 folding maps in gold and colours, mor. ex., ɔy Samuel Mearne, *Oxford*, 1680, folio (240) *Sotheran*, £12

4453 Pugin (A. W.) Glossary of Ecclesiastical Ornaments, 70 plates, in gold and colours, and woodcuts, mor. ex., 1844, 4to. (172) *Walford*, £3 10s.

4454 Pyne (W. H.) History of the Royal Residences, 100 col. plates, 3 vol., russ. ex., 1819, 4to. (173) *Bain*, £15

4455 Ralfe (J.) Naval Chronology of Great Britain, port. and col. plates, 3 vol., mor. ex., 1820, 8vo. (78) *Parsons*, £20 10s.

4456 Repton (H.) Oɔservations on Landscape Gardening, 1805— Theory and Practice of Landscape Gardening, 1816, 2 vol., port., col. and other plates, with movaɔle slips, russ. ex., 1805-16, 4to. (174) *Sotheran*, £20 10s.

4457 Reynolds (Sir Joshua). Catalogue Raisonné of his Engraved Works, ɔy Edward Hamilton, cl., 1884, imp. 8vo· (288) *Quaritch*, £4

4458 Ruggieri (Ferd.) Studio d'Architettura Civile, over 200 plates, 3 vol., russ. ex., arms on sides, *Firenze*, 1722-28, folio (246) *Edwards*, £4 10s.

4459 Salt (H.) Twenty-four Views in India, Ceylon, Aɔyssinia, Egypt, etc. (col. like drawings), orig. hf. ɔinding, 1809, folio (213) *Bain*, £6 5s.

4460 Selɔy (P. J.) Illustrations to British Ornithology. Land and Water Birds, 228 plates, containing 383 figures, 2 vol., hf. mor. (no text), *Edin.* [1833-34], folio (247) *Simpson*, £4 5s.

4461 Seroux d'Agincourt (G. B. L. G.) Histoire de l'Art par les Monumens, 325 plates, 6 vol., hf. mor., g. t., *Paris*, Trenttell et Wurtz, 1823, folio (248) *Joseph*, £1 10s.

4462 Shakespeare (William). Dramatic Works, Boydell's ed., 100 engravings, 9 vol., russ. ex., Bulmer, 1802, folio (249) *Grant*, £5 15s.

4463 Shakespeare (W.) Harding (S. and E.) Shakespeare Illustrated, LARGE PAPER, upwards of 150 proof plates, including the one of Jane Shore, russ. gt., 1793, 4to. (180) *Spencer*, £5 5s.

4464 Shaw (Rev. Steɔɔing). History and Antiquities of Staffordshire, LARGE PAPER, engravings (some coloured), with 14 orig. drawings of seats inserted, 2 vol., hf. cf., 1798-1801, folio (250) *Rimell*, £44

4465 Shaw (Geo.) and Nodder (F. P.) Naturalist's Miscellany, col. engravings, vol. i. to xvii. (should be 24 vol.), hf. mor., uncuₜ, 1790-1813, 8vo· (87) *Brown*, £1 8s.

4466 Sidmouth Scenery, ɔy the Rev. E. Butcher, engraved title with col. vignette, folding view and 22 other col. plates, cf. ex., *Sidmouth*, 1817, 8vo. (88) *Leighton*, £8

4467 Smollett (T.) Roderick Random, 6 folding plates in aquatint
by Rowlandson and others (one torn), 2 vol., cf. gt., 1792,
8vo. (90) *Rimell*, £4 10s.
4468 Sotheoy (S. Leigh). Principia Typographia, facs., 3 vol., hf.
roan, 1858, 4to. (184) *Maggs*, £4 15s.
4469 Stothard (C. A.) Monumental Effigies of Great Britain, 147
col. plates, LARGE PAPER, with the plates extra coloured,.
hf. mor., uncut, 1817, folio (251) *Daniell*, £1 16s.
4470 Strutt (Joseph). Dress and Habits of the People of England,
col. plates, 2 vol., old cf., 1796, 4to. (185) *Bain*, £3 5s.
4471 Stephens (J. L.) Travel in Central America, Chiapas and
Yucatan, 2 vol., 1842—Travel in Yucatan, 2 vol., 1843,.
together 4 vol., plates, cf. ex., *New York*, 1842-3, 8vo. (94)
Jackson, £1 10s.
4472 Tallemant des Reaux (G.) Les Historiettes, 9 vol., cf. ex.,.
Paris, Techener, 1854-60, 8vo. (98) *Hill*, £2 12s.
4473 Thomson (Jas.) The Seasons, printed in large type by
Bensley, engravings by Bartolozzi and Tomkins, contemp.
mor., g. e., 1797, folio (252) *Bumpus*, £6
4474 Throsby (J.) Select Views in Leicestershire, with Supple-
mentary Volume, port., map and plates, 2 vol., russ. ex.,.
Leicester, 1789-90, 4to. (187) *Hodge*, £2 4s.
4475 Virgilii Opera, plates oy Bartolozzi and others, LARGE PAPER,.
2 vol., contemp. mor. ex., *Lond. typis Bensley*, 1800, 8vo.
(103) *Sotheran*, £3 10s.
4476 Voltaire (F. M. A. de). Romans et Contes, port. after La
Tour, 13 vignettes by Monnet, and plates after Marillier,.
Martini, Monnet and Moreau, 3 vol., French cf. ex., *Bouillon*,.
aux dépens de la Société typographique, 1778, 8vo. (104)
Bumpus, £14
4477 Waagen (Dr.) Treasures of Art in Great Britain, with the
Supplement, 4 vol., orig. cl., uncut, 1854-7, 8vo. (105)
Bain, £1 10s.
4478 Willemin (N. X.) Monuments Français inédits, plates (many
coloured), 2 vol., mor. ex., *Paris*, Willemin, 1825-39, folio
(256) *Brown*, £4 15s.
4479 Williamson (Thomas). Oriental Field Sports, 40 col. plates,.
hf. mor. ex., Orme, 1807, oolong folio (257)
Quaritch, £12 10s.
4480 Wood (Anthony à). Athenæ Oxonienses, with the Fasti, 4
vol., hf. russ. ex., 1813-20, 4to. (192) *Edwards*, £2 6s.
4481 Yarrell (W.) British Birds, third ed., 3 vol., mor· ex., 1856,.
8vo. (112) *Sotheran*, £1 8s.

SOTHEBY, WILKINSON & HODGE.

THE BRITWELL COURT LIBRARY.

(No. of Lots, 452 ; amount realised, £1,085 4s. 6d.)

4482 Addison (Joseph). The Campaign, a Poem, first ed., hf. title, unbd., 1705, folio (167) *Tregaskis*, £2 4s.

4483 Arthur. The Most Ancient and Famous History 'of the Renowned Prince Arthur King of Britaine, black letter, 3 vol. in 1, fronts. (that to part iii. wanted), last 6 leaves supplied in MS., old cf., *W. Stansby for J. Bloome*, 1634, 4to. (80) *Dobell*, £3 5s.

4484 Ballads, Songs, etc. A Collection of two hundred single and double-sheet Humorous, Panegyrical, Political and Satyrical Ballads and Songs, chiefly of the later years of Charles II., 1680-1710, folio (170) *Pickering*, £32 10s.

4485 Barclay (John). Barclay, his Argenis, or the Loves of Poliarchus and Argenis, first ed., 2 leaves torn, cf., *G. P. for H. Seile*, 1625, folio (171) *Smedley*, £1 6s.

4486 Beaumont (Sir John). Bosworth Field (prefatory verses by Francis Beaumont, Ben Jonson, Mic. Drayton and others), pages 181-182 wanted, as in all copies, sheep, *Felix Kyngston for Henry Seile*, 1629, 8vo. (10) *Quaritch*, £3 10s.

4487 Belianis of Greece. The Famous and Delectable History of Don Bellianis of Greece, by Fr. Kirkman, 3 parts in 1, black letter (margins of a few leaves repaired), cf., 1673, 4to. (83) *Dobell*, £1 1s.

4488 Bibliotheca Heberiana. Catalogue of the Library of Richard Heber, 13 parts in 4 vol. (part xiii. unbd.), LARGE PAPER, except of part xiii., of which no large paper was issued, Sotheby and Son, 1834-37, 8vo. (13) *Picard*, 14s.

4489 Black Fryers. Elegia de admiranda clade centum Papistarum tempore concionis vespertinae habitae Londini juxta domum Legati Gallicani, anno 1623, Oct. 26, woodcut on title (headlines shaved), hf. cf., J. Marriot and J. Grismand, 1625, 8vo. (14) *Tregaskis*, £1 10s.

4490 Book Auction Catalogues. Bibliotheca Smithiana, *Sold by R. Chiswell*, 1682, title-page mounted—Bibliotheca Anglesiana, *Sold by T. Phillips*, 1686—Bibliotheca Massoviana, *Sold by E. Millington*, 1687—Catalogus Librorum Roberti Scott, *Sold by B. Walford*, 1687—Bibliotheca Illustriss., *Sold by T. Bentley and B. Walford*, 1687—Catalogus Librorum instructissimae Bibliothecae Nobilis cujusdam Scoto-Britanni, *Sold by B. Walford*, 1688, in 1 vol., cf., 4to. (86) *Maggs*, £3 18s.

4491 Brewer (Anth.) The Countrie Girle, a Comedie, 1647—The Lovesick King, an English Tragical History, 1655, first eds. (headlines shaved), 4to. (88) *Pickering,* £4 4s.

4492 Burne (Nicol). The Disputation concerning the Controversit Headdis of Religion, haldin in the Realme of Scotland the yeir of God (1580), betwix the praetendit Ministeris of the Kirk in Scotland and Nicol Burne, orig. ed. (blank corners of first 3 leaves mended and a few underlinings), old cf., *Imprented at Parise (Oct.* 1), 1581, 8vo. (18) *Quaritch,* £3

4493 Carion (John). The thre ookes of Cronicles, gathered by John Funcke, black letter (sig. G viii. defective), orig. cf. on oak bds., metal corners and centrepieces, *London,* Gwalter Lynne, 1550, 4to. (96) *Jordan,* £3 5s.

4494 Cicero. The Thre bookes of Tullyes offyces, trans. by Roberte Whytinton, italics and black letter on alternate pages (slightly stained and wormed), old hf. cf., *Imprinted by Wynkyn de Worde,* 1534, 8vo. (22) *Quaritch,* £12 5s.

4495 [Collins (Thomas).] The Penitent Publican, his Confession of Mouth, etc. [a Poem], (title-page and last leaf soiled), 3 leaves wanted catchwords, several passages underlined, hf. cf., Arthur Johnson, 1610, 4to. (103) *Tregaskis,* £3 3s.

4496 Cowley (Abraham). Naufragium Joculare, Comoedia, first ed., unbd., H. Seile, 1638, 8vo. (27) *Pickering,* 10s.

4497 Cupids Messenger, or, a trusty Friend stored with sundry sorts of serious, witty, pleasant, amorous and delightful Letters, black letter, hf. roan, *Printed for Miles Flesher,* n.d., 4to. (104) *Woodward,* £7 10s.

4498 Davies (John, of Hereford). Microcosmos. The Discovery of the Little World [in verse], first ed., sigs. F i. and iv. wanted, and wormed, hf. cf., *Oxford,* J. Barnes, 1603, 4to. (105) *Pickering,* £3

4499 Dekker (Thomas). The Wonder of a Kingdom, first ed., unbd., *R. Raworth for N. Vavasour,* 1636, 4to. (106) *Quaritch,* £9 15s.

4500 Drake (N.) Shakespeare and his Times, 2 vol., LARGE PAPER, uncut, 1817, 4to. (109) *Bull,* 15s.

4501 Dryden (John). Astraea Redux, a Poem on the Happy Restoration of Charles the Second, first ed., with preliminary leaf with arms of Charles II., unbd., *J. M. for Henry Herringman,* 1660, folio (178) *Pickering,* £15 5s.

4502 Dryden (J.) To His Sacred Majesty, a Panegyrick on his Coronation, first ed., unbd., Henry Herringman, 1661, folio (179) *Pickering,* £6

4503 Dryden (J.) To My Lord Chancellor, presented on New-years-day, first ed., unbd., Henry Herringman, 1662, folio (181) *Pickering,* £15 10s.

4504 Dryden (J.) Alexander's Feast, first ed., unbd., J. Tonson, 1697, folio (182) *Pickering,* £4 15s.

4505 Dryden (J.) Absalom and Achitophel, a Poem (title, To the Reader, and 32 pages), 1681—The Second Part of Absalom and Achitophel (title and 34 pages), stained, 1682, first eds.

—The Second Part, another copy, text cut into—[Buckingham (George Villiers Duke of).] Poetical Reflections on a late Poem entituled Absalom and Achitophel, 1682, unbd., folio (183) *Quaritch,* £10 5s.

4506 Dryden (J.) Of Dramatick Poesie, first ed., Henry Herringman, 1668, 4to. (110) *Woodward,* £12

4507 Dryden (J.) The Rival Ladies, a Tragi Comedy, 1664—Marriage a la Mode, a Comedy, 1673—Aureng-Zebe, a Tragedy (a few headlines shaved), 1676, first eds., 4to. (111) *Pickering,* £2 15s.

4508 Elizabeth (Queen). A Discoverie of the treasons practised and attempted against the Queenes Maiestie and the Realme, by Francis Throckmorton (title and a few leaves repaired), mor. ex., no place or printer's name, 1584, 4to. (117) *Pickering,* £7 10s.

4509 Elyot (Sir Thos.) Bibliotheca Eliotae. Eliotes Dictionary, by Thomas Cooper, black letter, woodcut border to title-page, contemp. cf. on oak bds. (damaged), T. Berthelet, 1552, folio (184) *Leighton,* £6

4510 European Magazine and London Review, 50 vol., ports. and plates, hf. bd., uncut, 1782-1806, 8vo. (34) *Sotheran,* £4 14s.

4511 Evelyn (John). A Panegyric to Charles the Second (16 pages), unbd. (1661), folio (185) *Pickering,* £3

4512 Foxe (John). Christ Jesus Triumphant. A fruitefull Treatise, etc., black letter, woodcut on verso of title, g. e., John Daye and Richard his Sonne, 1579, 8vo. (38) *Bull,* £1 17s.

4513 Fraunce (Abraham). The Countesse of Pembrokes Yvychurch, in 3 parts, with the Countesse of Pembrokes Emanuel, in 2 vol., woodcut borders to titles, part ii. of Yvychurch wanted sigs. G.2 and 3, part iii. wanted title, sigs. L 1, N.4 and Q.1 and 2, and corners of a few leaves mended, *T. Orwyn for W. Ponsonby,* 1591, 4to. (122) *Lamb,* £1 16s.

4514 Gardiner (R.) An Account of the Expedition to the West Indies, first ed., 2 maps, 1759, 4to. (123) *Maggs,* 10s.

4515 [Gay (John).] Wine, a Poem, first ed., 8 leaves, including title and errata, unbd., William Keble, 1708, folio (187) *Maggs,* £19 5s.

4516 Gay (J.) Rural Sports, a Poem inscribed to Mr. Pope, first ed. (title-page soiled), unbd., 1713, folio (188) £2 10s.

4517 Gay (J.) The Fan, a Poem in three Books, first ed., unbd., 1714, folio (189) *Pickering,* £4

4518 Gay (J.) An Epistle to her Grace Henrietta Duchess of Marlborough, first ed., unbd., 1722, folio (190) *Pickering,* £31 10s.

4519 [Gayton (Edm.)] Chartae Scriptae, or a New Game at Cards (marginal repairs obliterating headlines on pages 17 and 18), mor. ex., *Printed in the year* 1645, 4to. (124) *Tregaskis,* £1 17s.

4520 Goldsmith (Oliver). The Traveller, first ed., wanted half-title and leaf of advertisements, J. Newbery, 1765, 4to. (125) *Maggs,* £9 5s.

4521 Haddon (W.) Lucubrationes [et Poemata], 2 vol. in 1, old cf., wanted upper cover, W. Seres, 1567, 4to. (126) *Barnard*, £2

4522 Hall (Bishop Joseph). Virgidemiarum. The three last Bookes of byting Satyres (title-page damaged and sign. B i. inlaid), vell., *R. Bradocke for R. Dexter,* 1598, 8vo. (46)
Pickering, £4 4s.

4523 Hannay (Patrick). Two Elegies on the late death of our Soveraigne Queene Anne, wanted sigs. A. 2 and D 4, cf. ex., g. e., Nicholas Okes, 1619, 4to. (127) *Dobell,* 19s.

4524 Heywood (Tho.) Pleasant Dialogues and Dramas selected out of Lucian, Erasmus, Textor, Ovid, etc., first ed., cf., g. e., 1637, 8vo. (49) *Tregaskis,* £5

4525 Heywood (T.) The Generall History of Women, engraved title-page, printed title partly in MS., cf., 1657, 8vo. (50)
Sotheran, £2

4526 Huarte (J.) Examen de Ingenios. The Examination of men's Wits, Englished by R. C(arew), hf. cf., *Adam Islip for T. Adams,* 1616, 4to. (130) *Leighton,* £1 1s.

4527 [Isidorus Hispalensis (S.)] Here be the gathered Counsailes of Saincte Isidorie, black letter (16 leaves, including title), signature of William Herbert on title, mor. ex., by W. Pratt, *In aedibus Thomae Bertheleti,* 1534, 8vo. (54)
Bull, £4 2s. 6d.

4528 [Johnson (Dr. Samuel).] London, a Poem, first ed., unbd., R. Doddesley, 1738, folio (195) *Hatchard,* £3

4529 Jordan (Tho.) A Royal Arbor of Loyal Poesie, orig. ed., wanted signs. B vii., F i. and Aa iv., headlines cut, cf., *R. W. for Eliz. Andrews,* 1663, 8vo. (57) *Pickering,* £1

4530 Killigrew (Mrs. Anne). Poems [with prefatory Ode by John Dryden], first ed., mezzo. port. by I. Beckett, Samuel Lowndes, 1686, 4to. (131) *Leighton,* £8

4531 Lady's Magazine, or Entertaining Companion for the Fair Sex, 28 vol., plates, hf. cf., 1770-97, 8vo. (60) *Dobell,* £2 4s.

4532 Lamb (Charles). Album Verses, first ed., orig. bds., Moxon, 1830, 8vo. (62) *Dobell,* £1 18s.

4533 Lefevre (Raoul). The Recueill of the Histories of Troie, black letter, in 3 books, title to book i. in facsimile, and wanted sig. B. (6 leaves) and I 11., sig. Dd 11. in the second book damaged, sig. A. v. in the third book damaged, and wanted last leaf, hf. vell., Wyllyam Copland, 1553, folio (198)
Leighton, £7 5s.

4534 Lobineau (G. A.) Histoire de Bretagne, 2 vol., ports. and plates, hf. bd., uncut, *Paris,* F. Muguet, 1707, folio (200)
Picard, £1 8s.

4535 Lodge (Thomas). An Alarum against Usurers, black letter, pages 1-20 only (sigs. B to F in 4's), (sig. F. 4 defective, a fragment,) *T. Este for Sampson Clarke,* 1584, 4to. (137)
Quaritch, £1 10s.

4536 [Markham (Gervase).] Marie Magdalens Lamentations for the Losse of Her Master Jesus (a Poem), orig. ed., signs. A-H. 4 (H. 4 blank), A. 1 a blank wanted (title repaired,

some headlines cut into), mor. ex., *A. Islip for Edw. White*, 1601, 4to. (138) *Quaritch, £6* 15s.
[Only two other copies are known, one of which is in the Marsh Library at Dublin. Lowndes attributes the work to N. Breton.—*Catalogue.*]

4537 Marmyon (Shackerley). Hollands Leaguer, an excellent Comedy, 1632—A Fine Companion, acted before the King and Queene at White-Hall, a few lower lines cut, 1633— The Antiquary, a Comedy, 1641, first eds., in 1 vol., hf. cf., 4to. (139) *Quaritch, £15* 5s.

4538 Mary the Mother of Christ. The Song of Mary, the Mother of Christ, containing the story of His life and passion. The Teares of Christ in the garden, 20 leaves, finishing on sig. E. 4 (headlines cut and a few repairs), mor. gt., g. e., *E. Allde for W. Ferbrand*, 1601 (140) *Leighton, £3* 5s.
[The hymn on the Heavenly Jerusalem at the end is the source of the modern one beginning "Jerusalem, my Happy Home."—*Catalogue.*]

4539 Milton (John). Areopagitica, first ed., 22 leaves (including blank at end), uncut, and the greater part unopened, *Printed in the Yeare* 1644, 4to. (143) *Sabin, £63*

4540 Milton (J.) Paradise Lost, second ed., port. by W. Dolle, orig. cf., 1674, 8vo. (75) *Ellis, £2* 10s.

4541 Mirrour for Magistrates, ed. by Wm. Baldwyn, second ed. of part i., **black letter** (wanted title-page, 3 preliminary leaves and some leaves cut into), Thomas Marshe, 1563, 4to. (144) *Quaritch, £8* 5s.

4542 Mirrour for Magistrates, newly imprinted [ed. by Wm. Baldwin and J. Higgins], part i., **black letter**, title-page in MS. and mounted (wanted Epistle to the Reader, one leaf of contents supplied in MS., and a few marginal repairs), cf., *Henry Marsh, being the assigne of Thomas Marsh*, 1587, 4to. (147) *Pickering, £2* 10s.

4543 Mirrour of Princely deedes and Knighthood, wherin is shewed the Worthinesse of the Knight of the Sunne and his brother Rosicleer, translated by Margaret Tyler and H. P., the First Part, the Second Part of the First Booke, the Third Part of the First Booke, the Second Part, in 4 vol., **black letter** (title-page to the Third Part of the First Booke wanted, many leaves loose and repaired), etc., hf. cf., Thomas East, 1583-85, 4to. (149) *Ellis, £4*

4544 Montemayor (George of). Diana, translated by Bartholomew Yong, orig. ed., hf. cf., E. Bollifant, 1598, folio (201) *Leighton, £8*

4545 Neville (Alexander). De Furoribus Norfolciensium Ketto Duce, liber unus, Ejusdem Norvicus, first ed., title with coat-of-arms on reverse, hf. cf., *Excud. Henrici Binnemani Typographi*, 1575, 4to. (151) *Leighton*, 19s.

4546 Pallas Armata. The Gentleman's Armorie (with prefatory verses by R. Lovelace and others), 6 full-page woodcuts (slightly shaved), g. e., *I. D. for John Williams*, 1639, 8vo. (229 *Tregaskis, £12*

4547 Peryn (William). Thre godlye and notable Sermons, black letter, woodcut border to title, old cf., *John Herforde at the costes and charges of Roberte Toye*, n. d., 8vo. (234)
Bull, £4 17s. 6d.

4548 Pleasant Comedie (A), called The Two Merry Milke-Maids, or the Best Words weare the Garland, by J. C. (last leaf torn, pasted down and defective), hf. cf., *Bernard Alsop for Lawrence Chapman*, 1620, 4to. (297) *Quaritch, £14* 10s.

4549 Pope (Alex.) An Essay on Man, 4 parts (part i. wanted half-title and not uniform), J. Wilford, n. d. (1732-34)—Of Taste, 1731—Of the Use of Riches (no half-title), 1733—Of the Knowledge and Characters of Men, 1733—An Epistle to Dr. Arbuthnot, 1734—Of the Characters of Women, 1735 —The First Epistle of the First Book of Horace (no half-title), 1737—The Sixth Epistle of the First Book of Horace imitated, 1737—The First Epistle of the Second Book of Horace imitated, 1737—The Second Epistle of the Second Book of Horace imitated, 1737—Horace, his Ode to Venus, lib. iv., Ode i., imitated (no half-title), 1737—The Universal Prayer, 1738—One Thousand Seven Hundred and Thirty Eight, 2 parts, n. d. and 1738, first eds., unbd., together 17 pieces, folio (428) *Maggs, £7* 7s.

4550 Porcius (G.) Cynopithecomachia seu canum et pithecorum pugna, vell. gt., arms of Cardinal Barberini, *Romae*, 1638, 8vo. (249) *Barnard, £1* 13s.

4551 [Randolph (Thomas).] Aristippus, or The Joviall Philosopher, first ed. (wormed, title-page loose and damaged), hf. cf., *T. Harper for J. Marriot*, 1630, 4to. (349)
Pickering, £3 5s.

4552 Rawlinson (Thomas). Catalogue of Choice and Valuable Books, to be sold by Auction by T. Ballard, Bookseller, 8 various parts, some with prices, cf. and unbd., 1721-29, 8vo. (253) *Ellis, £2* 18s.

4553 Rich (Barnabe). A Path-Way to Military Practise, black letter (title-page soiled and defective), sig. E.4 wanted, and hole in last leaf, unbd., *John Charlewood for Robert Walley*, 1587, 4to. (350) *Pickering, £3* 18s.

4554 Roscommon (Earl of). An Essay on translated Verse [with prefatory poems by John Dryden and others], first ed., cf., Jacob Tonson, 1684, 4to. (351) *Ridge, £1*

4555 [Rushe (Anthonie).] A President for a Prince, black letter (title-page and last leaf wanted, and end leaf soiled), H. Denham, 1566, 4to. (352) *Barnard, £1* 6s.

4556 Sallustius. The Conspiracie of Cataline, trans. by Thomas Paynell, black letter, sigs. B to Y (end) in fours, John Waley, n. d. (1557) (353) *Hanney, £1*

4557 Scot (Reynolde). A Perfite platforme of a Hoppe Garden, black letter, with the rare leaf A. 1 and blank at end, woodcuts, Henrie Denham, 1576, 4to. (354) *Harding, £10*

4558 Settle (E.) Eusebia Triumphans, an Heroick Poem, first ed. (stained), fore and lower edges uncut, 1704, folio (433)
Wayman, £1

4559 Settle (E.) Euseɔia Triumphans, first ed., old cf., arms on sides (worn), 1704, folio (434) *Ellis*, £1 16s.

4560 Sidney (Sir Philip). The Countesse of Pemɔrokes Arcadia, title-page and a few leaves mended and defective, cf., R. Waldegrave, 1599, folio (435) *Pickering*, £3 14s.

4561 Skelton (John). Collyn Clout, 𝔟𝔩𝔞𝔠𝔨 𝔩𝔢𝔱𝔱𝔢𝔯 (wanted title-page and signs. D I. and D II., also sig. A ii. defective), *Imprynted by Anthony Kytson*, n. d., 8vo· (264) *Quaritch*, £2

4562 Skelton (J.) Heare after foloweth certain ɔokes compiled by Master Skelton, signs. A to B VII. only (15 leaves, containing Speake Parrot, the Death of ye noɔle Prince King Edward the Fourth, a Treatise of the Scottes, and part of Ware the hawke), woodcut ɔorder to title-page, *Imprynted by Jhon Day*, n. d., 8vo. (265) *Leighton*, £2

4563 Tauɔman (Mat.) An Heroick Poem to His Royal Highness the Duke of York (with music), unbd., 1682, folio (440) *Ellis*, 15s.

4564 Trade. Parker (H.) Of a Free Trade. A Discourse seriously recommending to our Nation the wonderfull ɔenefits of Trade, cut, 1648—[Carter (W.)] England's Interest by Trade Asserted, 1671—An Essay on the Rise of Corn, *Birmingham*, 1756, and 5 other Trade Pamphlets, 4to. (367) *Harding*, £8

4565 Udall (Nicolas). Floures for Latine spekyng, 𝔟𝔩𝔞𝔠𝔨 𝔩𝔢𝔱𝔱𝔢𝔯, marginal notes in a contemp. writing, orig. cf., T. Berthelet, 1553, 8vo. (275) *Quaritch*, £18 10s.

4566 Vegetius (Flavius). The Foure Bookes of Martiall Policy of Flavius Vegetius Renatus, first ed. of the first English translation (by Jno. Sadler), 𝔟𝔩𝔞𝔠𝔨 𝔩𝔢𝔱𝔱𝔢𝔯, woodcut ɔorder to title and 2 plates (should be 4), wormed, cf., Thomas Marshe, 1572, 4to. (370) *Hanney*, £1 12s.

4567 Vigo (John). The most excellent worckes of Chirurgery, 𝔟𝔩𝔞𝔠𝔨 𝔩𝔢𝔱𝔱𝔢𝔯, woodcut ɔorder to title-page (partly inked over), old cf., Edw. Whytchurch, 1550, folio (442) *Leighton*, £3 3s.

4568 Waller (E.) A Poem on St. James's Park, first ed., unbd. (stained), G. Bedel and Th. Collins, 1661, folio (447) *Maggs*, £11

[At the end appears the following notice: "The reader is desired to take notice, that a false copy of these verses on St. James's Park was surreptitiously and very imperfectly printed in one sheet, without the author's knowledge and consent, several lines ɔeing there left out."—*Catalogue*.]

4569 Waller (E.) Instructions to a Painter, for the drawing of the Posture and Progress of His Maties. Forces at Sea, etc., first ed., unbd., Henry Herringman, 1666, folio (448) *Tregaskis*, £5

4570 Waller (E.) To the King, upon His Majesties Happy Return, first ed., R. Marriot (1660)—To the King, upon His Majesties Happy Return, ɔy a Person of Honour, *J. M. for H. Herringman*, 1660, sewn together, folio (445) *Pickering*, £13

4571 [Ward (Edward).] Wine and Wisdom, 1710—The Field-Spy
—The Tipling Philosophers, 1719—The Delights of the
Bottle, 1720—The Merry Travellers and the Wandering
Spy, 2 parts, 1721-22—The Parish Gutt'lers, or the
Humours of a Select Vestry, 1722—The Dancing Devils,
or the Roaring Dragon, 1724—Apollo's Maggot in his
Cups, 1729—The Forgiving Husband and Adulteress Wife,
n. d.—Cervantes, Don Quixote, merrily translated into
Hudibrastic Verse by E. Ward, part i., port. of Ward, by
Van der Gucht, unbd., together 11 pieces, 8vo. (279)
 Dobell, £5 5s.
4572 Washington (George). A Circular Letter to His Excellency
William Greene, Esq., 1783—The Present State of Mary-
land, by the Delegates of the People, 1787—M'Lean (J.)
Notes of a Twenty-Five Years' Service in the Hudson's
Bay Territory, 2 vol., 1849, and 12 others, 8vo. (280)
 H. Stevens, £6 5s.
4573 Weaving. The Triumphant Weaver, or the Art of Weaving
discuss'd and Handled, woodcut on title-page (title mended),
cf. gt., *Printed for J. Deacon*, 1682, 4to. (375) *Harding*, £5
4574 Wolfius (J.) Lectionum memorabilium et reconditarum cen-
tenarii XVI., 3 vol. in 2, orig. and best ed., woodcuts, vell.,
mor. back, *Lavingae*, 1600-08, folio (452) *Bull*, £1

[FEBRUARY 24TH AND 25TH, 1910.]

PUTTICK & SIMPSON.

A MISCELLANEOUS COLLECTION.

(No. of Lots, 657 ; amount realised, £739 11s. 6d.)

4575 Ainsworth (W. H.) Windsor Castle, etchings and woodcuts
by G. Cruikshank and Tony Johannot, in the orig. 11 8vo.
parts, with wrappers, 1844, 8vo. (511) *Bumpus*, £4 5s.
4576 Ainsworth (W. H.) Jack Sheppard, first ed., port. and full-
page etchings by G. Cruikshank, 3 vol., cl., uncut, 1839, 8vo.
(512) *Lupton*, £3 15s.
4577 Albert Durer Revived, or Book of Drawing, Limning, Wash-
ing or Colouring of Maps and Prints, etc., plates, hf. mor.,
1685, folio (635) *Maggs*, £1 8s.
4578 Amours (Les) de Henri IV. roy de France avec ses Lettres,
presentation copy from Thos. Gray the Poet, with note on
fly-leaf, "Wm. Cole Coll Regal A.B. ex dono Tho. Gray
Coll Divi Petri Cantab., 1737," cf., *Cologne*, 1695, 8vo. (444)
 Dobell, £1
4579 Barbet (J.) Livre d'Architecture, dedie a Cardinal Richelieu,
plates, 1633, folio (647) *Batsford*, £1

4580 Bell (J. Munro). Chippendale, Sheraton and Hepplewhite Furniture Designs, cl., 259 plates, 1900, 4to. (241) *Thin*, £1 10s.

4581 Bible (Holy), engravings, old mor., elaborately tooled, *Printed by Robert Baskett*, 1756, 4to. (251) *Bull*, £1 3s.

4582 Bingham (Capt.) Letters and Despatches of the First Napoleon, 3 vol., cl., 1884, 8vo. (102) *Edwards*, £1

4583 Book of Common Prayer of Edward VI., 1549 and 1552—Elizabeth, 1559—James I., 1604—Charles I., 1637—Charles II., 1662, Pickering's facsimile reprints, 6 vol., mor. antique, gilt leaves, 1844-45, folio (641) *Sotheran*, £6 5s.

4584 Borrow (George). Word Book of the Romany, cl., 1874, 8vo. (159) *Bumpus*, £2 8s.

4585 Borrow (G.) Wild Wales, first ed., 3 vol., orig. cl., 1862, 8vo. (200) *Shepherd*, £3 6s.

4586 Bossuet (J. B.) Exposition of the Doctrine of the Catholique Church, translated into English by W. M., cf., *Printed at Paris*, 1672, 12mo. (347) *Barnard*, £1 17s. 6d.
[The French original was published in 1671. On fly-leaf is the inscription, "Apr. 7th, 1680, legatio Mri. Hobbes, Mro. Trafflere Coll. nov.," and on a blank leaf is a MS. index, probably by Thos. Hobbes, of Malmesbury.—*Catalogue.*]

4587 Brighton. Panoramic Coloured View of Brighton, about 60 feet long (damaged), Ackermann, 1833 (619) *Bumpus*, £11

4588 British Essayists (The), with Prefaces by Chalmers, 45 vol., hf. mor. (vol. xxxix. missing), 1817, 8vo. (63) *Bailey*, £1 14s.

4589 Brontë (Charlotte). Life and Works, Haworth ed., 7 vol., hf. mor., 1899-1900, 8vo. (321) *Tregaskis*, £1 8s.

4590 Bruce (J. C.) Lapidarum Septentrionale, illustrations, 5 parts, bds., 1875, folio (627) *Thurnham*, £4 10s.

4591 Buckingham (Duke of). Memoirs of the Courts and Cabinets of George III., ports., 4 vol., 1853-5—Memoirs of the Court of George IV., ports., 2 vol., 1859, cl., together 6 vol., 8vo. (99) *George*, £2 2s.

4592 Budge (E. A. W.) The Book of the Dead, Text Translation and Vocabulary, 3 vol., cl., 1895, 8vo. (435) *Edwards*, £1 1s.

4593 Burlington Fine Arts Club. Catalogue of Silversmiths' Work of European Origin, 1901, 4to. (278) *Schulze*, £6

4594 Burlington Fine Arts Club. Old Silver Work, by Gardner, 1903, 4to. (279) *Schulze*, £4 5s.

4595 Burns (Robert). Works, with Life by Cunningham, plates, 8 vol., cl., 1834, 8vo. (28) *Hill*, £1 12s.

4596 Burton (Captain Sir R. F.) Il Pentamerone, 2 vol., cl., 1893, 8vo. (481) *Peacock*, £1 18s.

4597 Burton (Captain Sir R. F.) The Carmina of Catullus, Englished into verse and prose (the prose portion and notes by Leonard Smithers), one of 12 copies on Japanese vell., *Printed for private subscribers*, 1894, 8vo. (443) *Barnard*, £1 1s.

4598 Burton (Wm.) History and Description of English Porcelain, col. plates, etc., cl., n. d., 8vo. (502) _Quaritch, £5_

4599 Byron (Lord). Works, 8 vol., mor. ex., Murray, 1827, 8vo. (30) _Sotheran, £1 2s._

4600 Cardanus (Hier.) De rerum Varitate liɔri xvii., bds., 1557, folio (629) _Lewis, £1 8s._

4601 Carroll (Lewis). Through the Looking-Glass, first ed., 40 illustrations by Tenniel, orig. cl., 1872, 8vo. (73) _Shepherd, £1 2s._

4602 Diaz del Castillo (Bernal). Historia Verdadera de la Conquista de la Nueva España, first ed., mor., _Madrid_, 1632, folio (625) _Stevens, £2 7s._

4603 Dickens (Charles). Master Humphrey's Clock, first ed., in the orig. 88 weekly numɔers, with wrappers as issued, 1840-41, 8vo. (396) _Spencer, £2 10s._

4604 Dickens (C.) Oliver Twist, ɔy "Boz," first ed., etchings by G. Cruikshank, including the "Fireside" plate, afterwards cancelled, 3 vol., cl., uncut, 1838, 8vo. (513) _Spencer, £3 10s._

4605 Dickens (C.) Works, Liɔrary ed., 30 vol., green cl., _Chapman and Hall, Piccadilly_, 8vo. (395) _Edwards, £6_

4606 Dickens (C.) Works, édition de luxe, 30 vol., hf. mor., 1881-82, 8vo. (390) _Rimell, £17_

4607 Dickens (C.) Works, Gadshill ed., by Andrew Lang, illustrations, 34 vol., cl., 1897-99, 8vo. (326) _Jacobs, £7 5s._

4608 Edwards (Sydenham). Cynographia Britannica, consisting of coloured engravings of the various ɔreeds of Dogs, 12 col. plates and 5 duplicates loosely inserted, hf. cf., uncut, 1800, folio (642) _Quaritch, £6 10s._

4609 Frankau (Julia). Eighteenth Century Colour Prints, col. front. and 52 plates, 1900, folio (639) _Camm, £3_

4610 Freeman (E. A.) History of Sicily, maps, 4 vol., cl., 1891-94, 8vo. (101) _Edwards, £2_

4611 Froude (J. A.) History of England, 12 vol., cl., 1862-70, 8vo. (68) _Sotheran, £2_

4612 Garnier (E.) The Soft Porcelain of Sèvres, 50 col. plates, 1892, folio (298) _Rimell, £2 17s. 6d._

4613 Gibbon (E.) Decline and Fall of the Roman Empire, 12 vol., cf., 1825, 8vo. (33) _Joseph, £1 10s._

4614 Glauɔer (J. R.) Philosophical Furnaces, or New Art of Distilling, set forth in English by J. F., hf. mor., g. t., 1651-2, 4to. (537) _Lewis, £1 6s._

4615 Goldsmith (Oliver). Miscellaneous Works, with Life, 6 vol., mor. ex., g. e., 1823, 8vo. (31) _Spencer, £1 8s._

4616 Green (J. R.) History of the English People, maps, 4 vol., cl., 1881, 8vo. (94) _Morie, £1 9s._

4617 Grote (G.) History of Greece, Liɔrary ed., 12 vol., cl., 1854-57, 8vo. (117) _Jones, £2 15s._

4618 Gurney (E.), Myers (F. W. H.) and Podmore (F.) Phantasms of the Living, 2 vol., cl., 1886, 8vo. (427) _Edwards, £1 18s._

4619 Havard (H.) Dictionnaire de l'Ameublement et de la Décoration, col. plates, 4 vol., bds., n. d., 4to. (265) _Hatchard, £3_

4620 Hayward (Ab.) Biographical and Critical Essays, 2 vol., cl., 1858, 8vo. (107) *Bailey*, £1

4621 Heppelwhite (A.) The Cabinet Maker and Upholsterer's Guide, third ed., 1794, reprint 1897, 4to. (270) *Quaritch*, £1 16s.

4622 Hogarth (W.) Works, by Trusler, 158 engravings by Cooke and Davenport, 2 vol., mor., 1824, 4to. (239) *Walford*, £1 9s.

4623 Howard (M.) Old London Silver, plates and marks, 1903, 4to. (262) *Batsford*, £1 16s.

4624 Hugo (Victor). Novels, complete and unabridged ed., 27 vol., cl., g. t., 8vo. (467) *Thornton*, £1 18s.

4625 James (R. N.) Painters and their Works, 3 vol., orig. cl., Upcott Gill, 1896-97, 8vo. (196) *Sotheran*, £2 7s. 6d.

4626 Jenkins (J.) Martial Achievements, 50 col. plates by Heath (including the arms of the Duke of Wellington), with descriptions, hf. mor., g. t., 1815, folio (285) *Joseph*, £3 10s.

4627 Jerrold (W. B.) Life of Napoleon III., port., 4 vol., cl., 1874-82, 8vo. (103) *George*, £1 14s.

4628 Jewitt (Llewelyn). Ceramic Art of Great Britain, 2,000 illustrations, 2 vol., 1878, 8vo. (185) *Hyam*, £1 4s.

4629 Kaye (Sir J. W.) and Malleson (G. B.) Histories of the Sepoy War and Indian Mutiny, 6 vol., cl., 1865-1880, 8vo. (98) *Grant*, £1 2s.

4630 Knights of the Garter. Les Noms, Surnomes, Qualitez, Armes et Blasons et tous les Princes, Seigneurs, etc. de l'Ordre & Milice de la Jartière, 350 woodcuts of arms, a contemporary note states that it was bound by Bojet, binder to Louis XIV. (sold not subject to return), cf., *Paris*, 1647, folio (612) *Barnard*, £1 12s.

4631 Laborde (J. B. de). Choix de Chansons, special copy, with 2 sets of plates, 3 vol. (1773, reprint), 1881, imp. 8vo. (466) *Bumpus*, £2 4s.

4632 La Fontaine (J. de). Fables Choisies, port. and vignettes, 2 vol., mor. ex., 1727-8, 8vo. (317) *Sotheran*, £2 2s.

4633 Lecky (W. E. H.) History of Rationalism in Europe, 2 vol., cl., 1866, 8vo. (100) *Hill*, £1 1s.

4634 Lewis (M.) and Clarke (Capt.) Expedition to the Sources of the Missouri, maps, 3 vol., cf., 1817 (448) *Leon*, £4

4635 Lindsay (Lord). Lives of the Lindsays, pedigrees, 3 vol., cl., *Wigan*, 1849, 8vo. (125) *Grant*, £1 8s.

4636 Louvet de Couvray (J. B.) Les Amours du Chevalier de Faublas, plates by Marillier, 4 vol., cf., 1798, 8vo. (148) *Menel*, £1 10s.

4637 Mackenzie (A.) Voyages from Montreal through America, to the Pacific Ocean, plates, bds., uncut, 1801, 8vo. (554) *Quaritch*, £1 14s.

4638 Major (R. H.) Notes upon Russia, by Baron Von Herberstein, 2 vol., cl., *Hakluyt Soc.*, 1851, 8vo. (437) *Barnard*, £1 4s.

4639 Mather (Increase). A Further / Account / of the / Tryals / of the / New-England Witches / to which is added / 𝕮𝖆𝖘𝖊𝖘

of **Conscience,** concerning Witchcrafts and Evil Spirits per/sonating men (some headlines and one marginal note shaved, and 2 leaves mended), advertisement leaf of "Books now in the Press" at end, cf. ex., ɔy Hayday, *London, printed for J. Dunton,* 1693, 4to. (574) *Tregaskis,* £6 10s.

4640 Muilman. History of Essex, by a Gentleman, plates, 6 vol., hf. cf. (ɔroken), 1771, 8vo. (18) *Harding,* £1 12s.

4641 Müther (R.) History of Modern Painting, illustrations, 3 vol., 1895-6, 8vo. (193) *Winter,* £1 7s.

4642 Naval Victories of Great Britain, a series of col. views from drawings by officers in the actions represented, 40 plates mounted like drawings (inscription on one plate cut into), hf. mor., Finch (1824), folio (643) *Sotheran,* £8

4643 Neale (J. P.) Views of the Seats of Noɔlemen and Gentlemen, ɔoth series, engravings, 11 vol., hf. mor., uncut, and MS. Index ɔound to match, together 12 vol., 1818-29, 8vo. (367) *Hill,* £4 2s. 6d.

4644 Nordenskiold (A. E.) Periplus, fac. of rare maps, etc., hf. mor., 1897, folio (622) *Hill,* £2 10s.

4645 Ogilɔy (John). Britannia, 100 maps, port., cf., 1698, folio (286) *Morgan,* £1 6s.

4646 Palser's Views of St. James Park, Hyde Park and the Serpentine, with Naval Review, 8 col. plates (without title), 1814, folio (644A) *Rimell,* £6 5s.

4647 Pepys (Samuel). Diary, ed. by Wheatley, ports. and illustrations, 8 vol., cl., 1893-1896, and Index, 1903, 8vo. (110) *G. H. Brown,* £4 10s.

4648 Percier (C.) et Fontaine (P. F. L.) Recueil de Décorations Interieures, plates, 1812, 4to. (277) *Batsford,* £1 12s.

4649 Percy (Bishop). Folio Manuscript Ballads and Romances, ed. by Hailes and Furnivall, 3 vol., hf. mor., 1867, 8vo. (74) *Hill,* £2 12s.

4650 Poole (W. F.) Index to Periodical Literature, third ed., ɔrought down to 1882, cl., 1885, 4to. (235) *Edwards,* £1 4s.

4651 Pope (Alex.) Works, ɔy Warton, 9 vol., cf. gt., 1822, 8vo. (24) *Joseph,* £1 2s.

4652 Racinet (A.) L'Ornement Polychrome, col. plates, hf. mor., n. d., folio (299) *Batsford,* £2 8s.

4653 Repton (H.) Theory and Practice of Landscape Gardening, port. (stained), col. and other plates with moveaɔle slips, hf. cf., 1805, 4to. (577) *Hatchard,* £6 15s.

4654 Rosenroth (C. K. von). Kaɔɔala Denudata—Liɔer Sohar Restitutus, together 3 vol., cf., 1684, 4to. (570) *Hill,* £3

4655 Rosicrucians. Andreas (A.) Mythologiæ Christianiæ, 1619 —Turris Baɔel sive Judiciorum de Fraternitate Rosaceæ-Crucis, 1619—Reipublicæ Christianopolitanæ descriptio, 1619—Memoralia Benevolentium, 1619, in 1 vol., cf. (the first tract wormed, not suɔject to return), 12mo. (140) *Shepherd,* £1 13s.

4656 Rouveyre (E.) Connaissances Necessaires à un Biɔliophile, plates and cuts, 10 vol., wrappers, Exemplare imprimé sur papier velin teinte, n. d., 8vo. (75) *Vyt,* £1

4657 Ryff (Gualtherus). Der Deutschen Apotecten, woodcut of an apothecary's shop and cuts of herɔs, etc., vellum tie, 1593, 8vo. (123) *Menel*, £1 10s.

4658 Scott (Sir Walter). The Pirate, first ed., 3 vol., uncut, 1822, 8vo· (449) *Jones*, £1 1s.

4659 Scott (Sir W.) The Fortunes of Nigel, first ed., 3 vol., uncut, 1822, 8vo. (450) *Jones*, £1 1s.

4660 Scott (Sir W.) Rob Roy, first ed., 3 vol., bds., uncut, 1818, 8vo· (514) *Lindsey*, £4 10s.

4661 Scott (Sir W.) Waverley Novels, Liɔrary ed., fronts. and vignette titles, 25 vol., cl., 1852-3, 8vo. (27) *G. H. Brown*, £2

4662 Scott (Sir W.) Waverley Novels, Fisher's ed., etchings ɔy G. Cruikshank, 48 vol., cl., 1836 (394) *Edwards*, £3 3s.

4663 Scrope (Wm.) Art of Deer-Stalking, first ed., tinted plates, hf. mor., 1838, 8vo· (202) *Grant*, £1 10s.

4664 Shelley (P. B.) An Address / to the / Irish People / ɔy Percy Bysshe Shelley / *Dublin*, 1812, Price 5d., Title and pp. 22, including the Postscript, orig. ed., unbd., 8vo. (516) *Sabin*, £75

4665 Small (J. W.) Scottish Woodwork of the XVIth and XVIIth Centuries, 100 plates, hf. mor., *Edinburgh*, 1878, folio (292) *Nield*, £1 1s.

4666 Sterne (Laurence). Works, with Life, 6 vol., old mor. ex., 1823, 8vo. (32) *Joseph*, £1 6s.

4667 Stevenson (R. L.) Oɔject of Pity, or the Man Haggard, presentation copy from the author, with autograph inscription to Mrs. Forsyth from "The Oɔject of Pity," viz., B. M. Haggard H.B.Ms. Land Commissioner for Samoa, 1894, *Imprinted at Amsterdam* (1892), 8vo. (363) *Shepherd*, £2 4s.

4668 Strickland (A.) Lives of the Queens of England, ports. and vignettes, 12 vol., cl., 1840-48, 8vo. (114) *Adam*, £2

4669 Turner (W.) The Ceramics of Swansea and Nantgarw, col. plates, 1897, 8vo. (189) *Hatchard*, £2 7s. 6d.

4670 Villon (F.) Poems, trans. ny John Payne, *Villon Society*, 1892, 8vo. (504) *Hatchard*, £1 3s.

4671 Voltaire (F. M. A. de). Works, trans. by Dr. Franklin and others, fronts., 35 vol., cf., 1761-9, 8vo. (392) *Maggs*, £3 17s. 6d.

4672 Walpole (H.) The Castle of Otranto, trans. by Marshall, Jeffery's ed., col. plates and ɔorders, mor., 1796, 8vo. (478) *Sotheran*, £1 18s.

4673 [Wither (Geo.)] Echoes from the Sixth Trumpet, reverɔerated by a Review of Neglected Rememɔrances, etc., the First Part (all puɔlished), orig. cf., *Imprinted in the year Chronogrammically expressed in this Seasonable Prayer,* LORD HAVE MERCIE VPON VS (1666), 8vo. (332) *Edwards*, £1 1s.

4674 Zarate (Augustin de). Historia del Descuɔrimiento y Conquista del Peru, mor., g. e., *Sevilla*, 1577, folio (656) *Quaritch*, £5

SOTHEBY, WILKINSON & HODGE.

THE REMAINING PORTION OF THE LIBRARY OF THE LATE
RIGHT HON. THE EARL OF SHEFFIELD.

(No. of Lots, 603; amount realised, £991 15s.)

———

[The sale of the first portion of this Library is very fully reported
in BOOK-PRICES CURRENT, Vol. xxii., pp. 44 *et seq.*—ED.]

———

4675 Agricultural Surveys of Great Britain and Ireland, by Arthur
Young, etc., plates, 27 vol., hf. cf. (some wormed), 1798-
1807, 8vo. (4) *J. Thin,* £1
4676 Ainslie and Mayer. Views in Turkey, in Europe and Asia,
col. plates, cf., g. e., 1801, imp. folio (236) *Rimell,* £1 6s.
4677 America. Abridgement of the Laws in Force and Use in
Her Majesty's Plantations of Virginia, Jamaica, Barbadoes,
Maryland, etc., cf., 1704, 8vo. (10) *H. Stevens,* £1 7s.
4678 America. Edwards (Brien). Thoughts respecting the Trade
of the West India Islands, 1784—Stevenson (J.) Address
to Brien Edwards containing Remarks on preceding, 1784
—Atkinson (R.) On the State of the Intercourse between
His Majesty's Sugar Colonies and the Dominions of the
United States, 1784—Champion (R.) Present Situation of
Great Britain and the United States, 1784, etc., in 1 vol., hf.
cf., 1784, 8vo. (11) *Pickering,* £2 2s.
4679 America. Letter from an American, containing Strictures on
Lord Sheffield's Pamphlet on the Commerce of the Ameri-
can States, 1784—Considerations on the Present Situation
of Great Britain and the United States, 1784—Edwards
(B.) Thoughts on the late Proceedings of Government
respecting the Trade of the West India Islands, 1784—
Long (E.) Free and Candid Review of a Tract entitled
"Observations on the Commerce of the American States,"
1784—Gibbes (Sir P.) Reflections on the Proclamation
relative to the Trade between the United States and the
West India Islands (1784)—Remarks on Lord Sheffield's
Observations on the Commerce of the American States, in
1 vol., some with MS. notes by Edward Gibbon, hf. cf., 1784,
8vo. (13) *Pickering,* £6 6s.
4680 Annual Register, from commencement to 1870, with 2 Indexes,
1758-1819, and 3 vol. of New Series, 1884-1886, together
119 vol., cf., hf. cf. and cl., 1758-1886, 8vo. (18)
 Bull, £5 17s. 6d.
4681 Arabian Nights, trans. by E. Forster, 5 vol., plates by Smirke
(spotted), mor. ex., g. e., 1802, roy. 8vo. (20)
 Parsons, £5 10s.

4682 Army List (Official), 28 vol., mor., g. e. (not quite uniform), 1780-1807, 8vo. (23) *Edwards, £6* 10s.

4683 Bible. Old and New Testaments, Macklin's ed., plates by Bartolozzi, etc., 6 vol., mor., g. e. (some leaves stained), 1800, imp. folio (247) *Hornstein, £3* 12s.

4684 Boyer (Abel). Political State of Great Britain, frontispieces (mounted), vol. i.-xlviii., in 46 vol., cf., 1711-34, 8vo. (48) *Harding,* 11s.
[Complete in 60 vol., 8vo., 1711-40.—ED.]

4685 Boyle (Rt. Hon. R.) Works, with Life of the Author by T. Birch, LARGE PAPER, port., 5 vol., russ., 1744, folio (248) *Blythe,* 15s.

4686 Buffon (M.) Histoire Naturelle, port. and col. plates, 76 vol., uncut, *Paris*, 1799-1808, 8vo. (52) *Reuter,* 13s.

4687 Byron (Lord). Works, port., 12 vol., cf., g. e., 1822-24, 8vo. (59) *Bull, £1*

4688 Charlotte (Queen). Translations from the German, in Prose and Verse, front., presentation copy to Mrs. Holroyd, with a note containing 2 autograph signatures of the Queen inserted, old binding, *Printed by E. Harding, Frogmore Lodge, Windsor,* 1812 (66) *Bain, £2* 2s.

4689 Collins (Arthur). English Baronetage, plates of coats-of-arms, 5 vol., cf., T. Wotton, 1741, 8vo. (69) *Mrs. Smith, £1* 1s.

4690 Collins (A). Peerage of England, plates, 9 vol., hf. russ., 1812, 8vo. (70) *Bain, £1* 18s.

4691 Combe (W.) First and Second Tours of Dr. Syntax, col. plates by Rowlandson, 2 vol., hf. cf. (some leaves loose), 1819-20, roy. 8vo. (71) *Abrahams, £3* 6s.

4692 Cook (Capt. J.) Three Voyages Round the World, 8 vol. and folio vol. of maps and plates (stained), together 9 vol., cf. gt., 1773-85, 4to. (195) *Ellis, £7* 5s.

4693 Curtis (Wm.) Flora Londinensis, with continuation by W. J. Hooker, col. plates, 4 vol., hf. cf. gt., 1777-1821, imp. folio (264) *Wesley, £6*

4694 Daily Gazetteer (The), from Wednesday, Sept. 19, 1739 to Monday, Feb. 15, 1742, in 1 vol., hf. cf., 1739-42, folio (266) *Edwards, £2*

4695 Dallaway (J.) History of the Western Division of the County of Sussex, plates, ports., etc., vol. ii. in 2 vol., uncut, 1830-32, folio (265) *Walford, £9*

4696 Dallaway (J.) Origin and Progress of Heraldry, plates (some col.), russ., *Gloucester,* R. Raikes, 1793, 4to. (200) *Ellis,* 13s.

4697 Daniel (W. B.) Rural Sports, with Supplement, plates, 3 vol., mor., g. e., 1801-2-13, roy. 8vo. (80) *Rimell, £4* 5s.

4698 Dodwell (Edward). Views in Greece, 30 col. plates, 2 vol. in 1, mor. ex., 1821, imp. folio (271) *Lewine, £2* 12s.

4699 Donovan (E.) Natural History of British Shells, 180 col. plates, 5 vol., mor., g. e., 1803-4, 8vo. (91) *Joseph, £1* 18s.

4700 Donovan (E.) Natural History of British Fishes, 120 col. plates, 5 vol. in 2, mor., 1802-8, 8vo. (92) *Maggs, £4*

4701 Donovan (E.) Natural History of British Insects, col. plates, vol. i.-xv., 15 vol., cf. gt., 1802-13, roy. 8vo. (93)
Quaritch, £2 15s.

4702 Duruy (G.) Memoirs of Barras, trans. ɔy C. E. Roche, ports. and plans, 4 vol., ɔuckram, uncut, 1895-96, 8vo. (99)
Hitchman, 12s.

4703 Encyclopædia Britannica, ninth edition and the supplementary vol. forming the tenth edition, maps and plates, together 35 vol., hf. mor., t. e. g., in revolving ɔookcase, 1875-1903, 4to. (207)
Joseph, £7 15s.

4704 Evelyn (J.) Sylva, notes ɔy A. Hunter, port. and plates, old mor. ex., *York,* 1776, 4to. (209)
Hatchard, £4 10s.

4705 Evening Post (The), a Periodical Paper, from Thursday, April 24 to Thursday, Oct. 2, 1729, puɔlished ɔy E. Berington, in 1 vol., hf. cf., 1729, folio (279) *Maggs, £2* 4s.

4706 Fielding (H.) Joseph Andrews, first ed., 2 vol., old cf., 1742, 8vo. (104)
Spencer, £9 15s.

4707 Flying Post (The), or The Post-Master, a Periodical Paper, various numɔers from 1697 to 1718, in 2 vol., some numɔers of the Post-Man included, hf. cf., 1697-1718, folio (281)
Edwards, £3 3s.

4708 France. Collection Universelle des Memoires Particuliers relatifs à l'Histoire de France, 67 vol., cf., 1785-91, 8vo. (114)
Peck, £1 5s.

4709 Franco (N.) Dialogi Piacevoli, woodcut initials, cf., *In Vinegia, Gab. Giolito de Ferrari,* 1545, 8vo. (116)
Leighton, 19s.

4710 Froissart (Sir John). Chronicles, trans. ɔy Johnes, 12 vol. in 6, hf. cf., 1805-6, 8vo. (118) *Hatchard, £1* 8s.

4711 Gay (John). The Beggar's Opera, with the music by Dr. Pepusch—Polly, an Opera, with the music, in 1 vol., hf. bd., Harrison and Co., n. d., oɔlong folio (283) *Maggs, £1* 1s.

4712 General Evening Post. A London Periodical Paper, from Septemɔer, 1739 to 1749, etc., in 6 vol., hf. cf., 1739-49, folio (285)
Maggs, £5 15s.

4713 Giambullari (P. F.) De'l Sito, Forma e Misure, dello Inferno di Dante, woodcuts, cf., *In Firenze,* 1544, 8vo. (123)
Leighton, £1

4714 Giɔɔon (Edward). Decline and Fall of the Roman Empire, first ed. (vol. i. is the third ed. and has the notes at the foot of the pages), port., 6 vol., mor. ex., 1777-88, 4to. (213)
Bain, £60
[This copy was specially prepared as a presentation copy to the Earl of Sheffield, and contains the following inscription in the author's autograph : "As a memorial of friendship and esteem the six volumes of this History are presented to the Right Honouraɔle John Lord Sheffield ɔy the author, E. Giɔɔon."—*Catalogue.*]

4715 Giɔɔon (E.) Miscellaneous Works, with Memoirs of his Life, Notes, etc. ɔy John Lord Sheffield, 2 vol. in 4, Lord Sheffield's proof copy, interleaved with MS. additions and

corrections, and some autograph letters and MSS. of Gi))on, Lord Sheffield, etc., 1796, 4to. (214) *Benson,* £12

4716 Gi))on (E.) Miscellaneous Works, with Life and Notes by Lord Sheffield, 3 vol., port. of author and port. of Lord Sheffield after Sir J. Reynolds, 1796-1815—Decline and Fall of the Roman Empire, vol. i., mor. ex., presentation copy from the author, 1776, together 4 vol., 4to. (215) *Tregaskis,* £6 5s.

4717 Gi))on (E.) Antiquities of the House of Brunswick (only a few copies of this part of the Miscellaneous Works printed for presents), mor., g. e., 1814, 4to. (216) *Bain,* £1 8s.

4718 Gi))on (E.) A Pocket Diary for the year 1776, with numerous entries in his autograph. On Fe)ruary 17th he notes, "The first Volume of my History of the decline and fall of the Roman Empire was pu)lished." Other entries record his journey to Bath, entertaining the Neckers to dinner, seeing Garrick as Lear and in other characters, writing the 1st Chapter of Vol. II. of his History, meeting with Burke and Reynolds, etc.—Receipt and Expenses, 1783-5, a)out 25 pages of entries in his autograph, and 2 others, one with receipt in his autograph, together 4 vol. (531) *Benson,* £38.

4719 Guillim (J.) Display of Heraldry, fifth ed., plates, old cf., 1679, folio (287) *Tregaskis,* £1 2s.

4720 Handel (G. F.) Songs in Messiah, an Oratorio—Samson, an Oratorio, set to Musick)y Mr. Handel, first eds., in 1 vol., hf. bd., Walsh, n. d., folio (293) 13s.

4721 Hargrave (F.) Complete Collection of State Trials and Proceedings for High Treason, etc., 11 vol., cf., 1776-81, etc., folio (294) *Harding,* £1

4722 Holinshed (R.) Chronicles of England, Scotland and Ireland, continued)y J. Hooker, etc., 6 vol., hf. cf., 1807-8, 4to. (230) *Edwards,* £6

4723 Horsfield (T. W.) History and Antiquities of Lewes, 2 vol., plates, cf., *Lewes,* 1824, 4to. (232) *Walford,* £1 6s.

4724 Hazlitt (W. C.) Collection of Old English Plays, fourth ed., 15 vol., 1874-76, 8vo. (148) *Hornstein,* £6 2s. 6d.

4725 Illustrated London News, from July, 1843 to June, 1908, inclusive, illustrations (some col.), 129 vol., 1843-1908, folio (298) *George,* £2

4726 Inghirami (Fr.) Monumenti Etruschi, o di Etrusco Nome, plates (many col. like the originals), 6 vol. in 9, 1821-26, 4to. (468) *Hunt,* £1 2s.

4727 Journal of the House of Lords, from 1509 to 1816, vol. i. to l. hf. cf., li.-liv., lxiii. and lxxv.-lxxix. unbd.—Index and Calendar, 5 vol., together 65 vol., v. y., folio (302) *Harding,* £5 10s.

4728 Journal of the House of Commons, 1547-1818, vol. i.-lxxiii. hf. cf., lxxiv.-lxxix. unbd.—Indexes, 6 vol., etc., together 93 vol., v. y., folio (303) *Sotheran,* £9.

4729 Journal of the House of Commons of Ireland, 1613-1794, vol.

i.-xxxi. (wanted 5 vol.), in 22 vol., cf., v. y.—Statutes of Ire-
land, 16 vol., with Index, cf., 1765-96, etc., folio (304)
Sotheran, £8
4730 L'Art de Vérifier les Dates, avec des Corrections et Anno-
tations par M. de Saint-Allais, 5 vol. (only), hf. vell., *Paris,*
1818-19, 4to. (475) *Bloomfield,* 14s.
4731 Lavater (J. G.) Essai sur la Physiognomie, LARGE PAPER,
ports. and illustrations, including a port. of Lord Sheffield
after Sir J. Reynolds (inserted), with autograph inscription
ɔy Lavater, and an autograph letter, 3 vol., russ., *La Haye,*
1781-86, 4to. (476) £1 10s.
4732 Lillywhite and Haygarth's Cricket Scores, from 1746 to 1878,
vol. i.-xiv., 14 vol., 1862-95, 8vo. (324) *Joseph,* £3 15s.
4733 Lodge (Edmund). Portraits, LARGE PAPER, ports., proofs on
India paper, vol. i.-iii., mor. ex., 1821-28, folio (310)
Edwards, £9
4734 London Journal (The), a Periodical Paper, No. lxxx.-cccii.,
Feb. 4, 1720 to May 8, 1725, in 1 vol., hf. cf., 1720-25, folio
(311) *Sotheran,* £5
4735 Luccock (J.) Nature and Properties of Wool, uncut, *Leeds,*
1805—Considerations upon the Present State of the Wool
Trade, 1781—Enquiry into the Nature and Qualities of
English Wools, 1782—Reflections on Present Low Price of
Coarse Wools, by J. Tucker, 1782—Sinclair (Sir John).
Address to the Society for the Improvement of British
Wool, *Edinb.,* 1791—View of the Bill for Preventing the
Illicit Exportation of British Wool and Live Sheep, 1787,
and others relating to Wool, etc., in 4 vol., hf. cf., 1781-91—
Sheffield (John Lord). Oɔservations on the Manufactures,
Trade and Present State of Ireland, port. inserted, cf., 1785,
etc., together 10 vol., 8vo. (332) *Pickering,* £5 5s.
4736 Mayer (L.) Views in Egypt and Palestine, col. plates, 2 vol.,
cf. gt., ɔorders on the sides, 1804-10, imp. folio (313)
Rimell, £2 2s.
4737 Middlesex Journal and Evening Advertiser for 1774 and
1776, in 2 vol., hf. cf., 1774-76, folio (314) *Edwards,* £2 10s.
4738 Molière (J. B. P.) Œuvres, par M. Bret, port. and plates ɔy
Moreau, 6 vol., cf., y. e., *Paris,* 1788, 8vo. (351)
Hatchard, £4 18s.
4739 Patrick (Symon, Bp. of Ely). Discourse concerning Prayer,
in 2 parts, contemp. mor., panelled and "au pointillé"
tooling on sides, g. e., 1705, 8vo. (368) *Bloomfield,* £1
4740 Phillip (A.) Voyage to Botany Bay, port., maps and plates,
hf. russ., 1790, 4to. (498) *Grant,* 18s.
4741 Pinkerton (John). Vitae Antiquae Sanctorum (Scoticorum)
cum Notis, etc., first ed., 2 maps, cf., J. Nichols, 1789, 8vo.
(373) *Harding,* 12s.
4742 Poets of Great Britain, complete from Chaucer to Churchill,
Bell's ed., ports. and fronts., complete set of 109 vol., cf. gt.,
Edinb., 1777-92, 8vo. (376) *Edwards,* £6 10s.
4743 Post Man (The) and Historical Account, etc., a Periodical
Paper, 1698-1729 (wanted 1717-1719), in 6 vol.—some

numȝers of the Flying Post and The Post Boy included,
hf. cf., uncut, 1698-1729, folio (560) *Ellis*, £8 15s.

4744 Post Boy (The), a Periodical Paper, and The Flying Post, or
The Post-Master, various numȝers, 1695-1727, in 2 vol., hf.
cf., uncut, 1695-1727, folio (559) *Dobell*, £1 12s.

4745 Punch, 1845-1872 and 1876-1879, illustrations, 35 vol., 1845-79,
4to. (503) *G. H. Brown*, £2 6s.

4764 Quarterly Review, from the commencement in 1809 to 1872,
with 6 Indexes, 132 vol. in 129 (wanted vol. iii. and iv.), hf.
cf., and some parts, 1809-72, 8vo. (382) *Sotheran*, £2 2s.

4765 Roȝerts (D.) Views in the Holy Land, Syria, Idumea,
Araȝia, Egypt and Nuȝia, plates, 3 vol., hf. mor., 1842-49,
atlas folio (570) *Joseph*, £1 2s.

4766 Roȝerts (Peter). Camȝrian Popular Antiquities, col. plates
by Havell, hf. bd., 1815, 8vo. (390) *Edwards*, £1 10s.

4767 Rotuli Parliamentarum et Petitiones et Placita in Parlia-
mento 1278 to 1503, 6 vol., hf. cf., and Index, vol. i., as
issued, n. d., folio (571) *Harding*, £3 18s.

4768 Royal Society of London. Philosophical Transactions, 1783
to 1859, plates, 65 vol. (some vol. wanted), hf. cf. and cf.,
1783-1859, 4to. (507) *Wesley*, £20

4769 St. James's Chronicle (The), or British Evening Post, July,
1769-August, 1779 (wanted 1774 and 1776), in 6 vol., hf. cf.,
1769-79, folio (574) *Edwards*, £2 5s.

4770 Shakespeare (W.) Dramatic Works, Boydell's ed., revised
by George Steevens, engravings after Smirke, Hamilton,
etc., 9 vol., russ., g. e. (some leaves in vol. i. stained and
some plates spotted), Bulmer, 1802, folio (577)
Hornstein, £2 15s.

4771 Sheffield (John Lord). Oȝservations on the Manufactures,
Trade and Present State of Ireland, 1785—Strictures on
the Necessity of inviolaȝly maintaining the Navigation and
Colonial System of Great Britain, 1806—Orders in Council
and the American Emȝargo, 1809—Oȝservations on Com-
merce, etc., American Exports and Imports, etc. (title
missing), n. d., author's proof copies, mostly interleaved
with numerous MS. alterations and corrections in the
author's handwriting, together 4 vol., 8vo. (410)
Maggs, £5 2s. 6d.

4772 Sowerȝy (J.) British Mineralogy, col. plates, 5 vol., hf. cf. gt.,
1804-17, roy. 8vo. (421) *Quaritch*, £5 10s.

4773 Sussex Weekly Advertiser, or Lewes Journal, from Octoȝer,
1769 to Decemȝer, 1818 (wanted 1812-13 and 1816-17), in
11 vol., hf. cf., 1769-1818, folio (590) *Edwards*, £6 5s.

4774 Tasso (Torq.) La Gierusalemme Liȝerata, engraved title and
20 plates, col. and illuminated ȝy a contemp. hand, illumi-
nated ȝorders, initials and tail-pieces, vell. (some leaves
repaired and stained and 2 defective), *In Genova*, 1590, folio
(591) *Lincoln*, £2 18s.

4775 Vivian (G.) Spanish Scenery, plates, 1838—Views in Madeira,
Egypt, India and the Oregon, plates (some col.), 1 vol., hf.
cf., n. d., etc., folio (597) *Spencer*, £7 15s.

4776 Voltaire (M. de). Collection Complette des Œuvres de Voltaire, port. and plates by Gravelot, 30 vol., cf. gt., *Geneve*, 1768-78, 4to. (522) *Merton, £7 5s.*

4777 Walpole (Horatio, Earl of Orford). Works, ports., plates, etc., 5 vol., hf. cf., 1798, 4to. (523) *Bull, £1 4s.*

4778 Washington (General). Letters to Arthur Young, containing particulars of the Rural Economy of the United States, etc., 1801—Sheffield (Lord). Letter on the Corn Laws, 1815— Young (Arthur). Enquiry into the Rise of Prices in Europe, 1815, and other Pamphlets (124) relating to Agriculture, Corn and the Corn Laws, Tythes, Wool, etc., in 11 vol., hf. cf., 8vo. (451) *Sotheran, £9 5s.*

4779 White (Gilbert). Natural History of Selborne, first ed., view of Selborne and other engravings, hf. cf. gt., 1789, 4to. (526) *Hornstein, £8*

4780 Wood (Ant. à). Athenae Oxonienses, by Philip Bliss, 4 vol., hf. russ., 1813-20, 4to. (527) *Tregaskis, £3 3s.*

4781 Young (Arthur). Tour through North of England, plates, 4 vol., cf., 1771—Farmer's Tour through East of England, plates, 4 vol., 1771—Farmer's Guide in Hiring and Stocking Farms, plates, 2 vol., cf., 1770—Six Weeks Tour, cf., 1769, together 11 vol., 8vo. (464) *Bain, £2 12s.*

[MARCH 9TH, 1910.]

SOTHEBY, WILKINSON & HODGE.

A COLLECTION OF BIBLES AND SERVICE BOOKS FORMED BY THE LATE DR. GEORGE S. WATSON, OF TUNBRIDGE WELLS.

(No. of Lots, 307 ; amount realised, £413 10s. 6d.)

[All the books in this catalogue were sold not subject to return on any account whatever ; almost all were more or less imperfect. —ED.]

(a) *Bibles.*

4782 Greek. Vetus Testamentum e Codice MS. Alexandrino fideliter descriptum cúm notis, cura et labore H. H. Baber, in 7 parts, hf. bd., uncut, R. and A. Taylor, 1816-28, imp. folio (3) *Leighton, £2 2s.*

4783 Greek. Novum Testamentum e Codice MS. Alexandrino descriptum a C. G. Woide, hf. mor., John Nichols, 1786, roy. folio (4) *Leighton, 11s.*

4784 Greek. [Codex Vaticanus.] Vetus Testamentum juxta septuaginta ex auctoritate Sixti v. Pont. Max. editum (edidit

Card. Caraffa), old French mor., g. e. (Derome), from the
Wodhull and Gennadius libraries, *Romae*, Fr. Zannettus,
1587, folio (5) *Leighton*, £2 2s.

4785 Latin. [Vulgate] cum Interpretationibus Hebraicorum Nomi-
num, lít. gotí. parva, double columns, 52 lines, with signs.
rubricated, capitals painted in blue and red (wanted leaf of
Register, had blank for a j and the blank before the
Gospels), [Copinger, No. 28,] vell., wide margins, *Venet.*,
Nic. Jenson, 1476, sm. folio (12) *Sotheran*, £9 15s.
[Jenson's first Latin Bible, and one of the earliest with
printed signatures.—*Catalogue.*]

4786 Latin. [Vulgate] Evangelia. Glossa Continua super quatuor
Evangelistas per Thomam de Aquino, lít. gotí., capitals
painted [Hain, *1332], contemp. Netherlands oak bds.,
leather, with small stamps, and legend, "Jhesus Maria,"
clasps [*Basil.*, 1476], large folio (13) *Leighton*, £5 5s.

4787 Latin. [Vulgate] cum Epistola Menardi Canonibus Eusebii
et Interpret. Hebr. Nom., lít. gotí., double columns, 51 and
53 lines, without signs. [contains "locus numerus librorum,"
one leaf, text ccccli. numbered leaves, Menard's Epistle,
Canons, Interpretations, 48 unnumbered leaves], text rubri-
cated, painted capitals in blue and red [Copinger, No. 41],
old vell., MS. covers (Coberger's Sixth Latin), *Nurem-
bergae*, Ant. Coberger, 1479, folio (14) *Bull*, £5 12s. 6d.

4788 Latin. [Vulgate] cum Prologis S. Hieronymi Locu Numeri
Librorum, Epistola Menardi et Canonibus Eusebii, lít. gotí.,
double columns, 51 lines, without signs., leaves numbered
in roman figures [Copinger, No. 48], illuminated initial on
first page of text, capitals painted (wanted "Interpre-
tationes"), orig. oak bds., half leather, clasps, good copy of
a rare edition, *Nurembergae*, A. Coberger, 1480, folio (15)
Hartland, £3 5s.

4789 Latin. [Vulgate] (with a Table of the Texts of the Bible and
the Rubric of the Proper Lessons, and "Interpretationes
Hebraicorum Nominum"), lít. gotí., double columns, illu-
minated initial with marginal decoration on first page,
painted capitals, the blank for a j containing a MS. index
[Copinger, No. 53], contemp. oak bds. and stamped pig-
skin, blanks at beginning and end, *s. l. aut n.*, 1481 [*Basil.*,
Jo. de Amerbach], sm. folio (16) *Bull*, £4 8s.
[The third of the "Fontibus ex Graecis" editions, with
several peculiarities of printing, etc. noted by Copinger.
The mark used for the diphthongs is not an "e," as
Copinger says, but a sort of *cedilla.*—*Catalogue.*]

4790 Latin. [Vulgate] (with Interpretation of Hebrew Names),
lít. gotí., double columns, 50 lines, with signs. [Copinger,
No. 60], painted initials (margins of first leaf mended, some
headings cut into), old cf., *Venet.*, F. Renner de Hailbrun,
1483, sm. 4to. (17) *Maggs*, £2 2s.

4791 Latin. [Vulgate] (with Register and Interpretations of
Hebrew Names), lít. gotí., double columns, 56 lines with
signs. (Copinger, No. 64), 2 illuminated initials, ornamental

pen-letters and painted capitals (wanted a j), vell. ɔack,
"*Fontibus ex Graecis,*" *etc., Venet., Jo. Herbert de Selgen-*
stadt, 1484, sm. 4to. (18) *Crawshaw, £1* 18s.
4792 Latin. [Vulgate] ɕum ɔostillis Nic. de Lyra, lít. gotf)., douɔle
 columns, with siǵns., 2 types, 72 and 73 lines to a full page,
 illuminated inițial at beginning of each vol., ruɔricated,
 capitals painteʹd, woodcuts in O. T. [Copinger, No. 102],
 4 vol., old oak bds., cf. (a few leaves wormed), [*Lugduni,*]
 Jo. Syber [1494], large folio (20) *Sotheran, £7* 7s.
4793 Biɔlia Latina. Copinger (W. A.) Incunaɔula Biɔlica,
 Quaritch, 1892, folio (22) *Quaritch, £2* 14s.
4794 Latin. [Vulgate.] Sixti V. jussu recognita, et Clementis
 VIII., Auctoritate edita, old French mor., au pointillé,
 "Jesus. Maria" in centres, g. e. (Du Seuil), *Paris. e Typ.*
 Reg., 1653, 4to. (30) *Tregaskis, £1* 7s.
4795 French. [Huguenot] avec deux Taɔles, orig. French oak
 bds., stamped leather (reɔacked), [*Genève,*] *L'Olivier de*
 Rob. Estienne, 1553, *le ix. Juiñ,* large folio (35)
 Tregaskis, £1 2s.
 [First edition of the Huguenot Biɔle puɔlished in French
 at Geneva by the Estiennes.—*Catalogue.*]
4796 French. [La Biɔle. Huguenot] avec Prières et Pseaumes
 en Vers, etc., old French mor., g. e., *à la Rochelle,* C.
 Hertman, 1616, 8vo. (38) *Tregaskis,* 16s.
4797 German. [Emser.] Das New Testamēt, Verteutscht durch
 H. Emser, lít. gotf)., woodcuts (title, next and last 2 leaves
 mended, stained), hf. bd., *Freyburg in Brysgaw,* Jo. Faɔer,
 1539, sm. 8vo. (39) *Tregaskis, £1*

English Bibles aad Testaments.

Originals arranged in chronological order as in Darlow
and Moule's Historical Catalogue.

4798 [New Testament. Wycliffe], now first printed from Lea
 Wilson's Sion Monastery MS., black letter, mor., ex., *Chis-*
 wick, Ch. Whittingham for Wm. Pickering, 1848, 4to. (41)
 Tregaskis, 15s.
4799 [New Testament, Tyndale's of 1525 or 1526], reproduced in
 fac. ɔy Fr. Fry, mor., ɔlind stamped antique ornaments,
 t. e. g., uncut, *Bristol, printed for the Editor,* 1862, 8vo. (42)
 Bull, £3 5s.
4800 [New Testament, Tyndale's]. A Biɔliographical Description
 of Tyndale's New Testaments from 1525-1566, ɔy Fr. Fry,
 port. and facs., uncut, t. e. g., Sotheran and Co., 1878, 4to.
 (43) *Dickinson, £1* 2s.
4801 [Coverdale] first ed., black letter, douɔle columns, 57 lines,
 with woodcuts (imperfect), ɔeginning with the woodcut title
 to "The Second Parte of the Old Testament," followed ɔy
 Judges, chap. i.-xxi. (wanted 2 leaves), Ruth, iv. Books of
 Kings, ii. Books of Chronicles, ii. Books of Esdras, Hester,
 Job (wanted title to the Part), the Psalter, Proverɔs, Eccle-
 siastes, Solomon's Song, the Prophets from Isaiah to

Malachi (title in fac.), Apocrypha (title in fac., fol. lxvii., lxxxi. and lxxxiii. defective), N. T. (wanted title, fol. xci. and cxi. fac., first title and 23 following leaves and map of Canaan supplied in fac.), [D. and M. 7,] modern mor., g. e. [*Zurich*, Chr. Froschover? 1535], sm. folio (44)

Tregaskis, £16
[The first edition of the Bible in English. This copy contains altogether 450 genuine leaves, most in sound condition.—*Catalogue.*]

4802 [Matthew's. Tindale and Coverdale] first ed., black letter, first title in fac. (wanted 14 of the preliminary leaves and leaf of colophon, some leaves mended), large cut of Adam and Eve in Eden before Genesis and cuts in the text [D. and M. 17], old cf. (broken), *R. Grafton and E. Whitchurch* (? *printed at Antwerp*), 1537, sm. folio (47)

Tregaskis, £17 10s.

4803 [Matthew's (Tindale's) Version] first ed., black letter (made-up copy, titles and all preliminary leaves and colophon in fac., some leaves supplied from a shorter copy, some margins cut into), old cf. [D. and M. 17], *Grafton and Whitchurch* (*Antwerp*), 1537 (48)

Bull, £5 5s.

4804 New Testament. [Coverdale, English and Latin] black letter and roman, Calendar in red and black (woodcut title mended, 3 leaves of the Calendar in fac., some leaves at end stained and margins mended, last leaf of Table in fac.), contemp. cf., stamped borders (repaired), (D. and M. 21,) *Prynted in Southwarke by James Nicolson*, 1538, sm. 4to. (49)

Quaritch, £10

4805 [Taverner] first ed., black letter, 66 lines, beginning with the 9th preliminary leaf (the first 8 being supplied in fac.), text complete to Colossians i., after which all is wanted except 8 original leaves (some leaves defective), [D. and M. 24,] *Jo. Byddell for Thos. Barthelet*, 1539, sm. folio (51)

Tregaskis, £2 10s.

4806 Fry (Fr.) Description of the Great Bible, 1539, and of Cranmer's Six Editions, 1540-41, and the Editions of the Authorised Version, 1611-1640, facs., hf. mor., Willis and Sotheran, 1865, folio (52)

Maggs, £4 10s.

4807 [The "Great" Version] fifth ed., black letter (imperfect), had only iii. and vi. of the preliminary leaves and wanted last leaf of Revelations and last leaf of the Table of Epistles and Gospels, also N. T. title (few leaves defective and headlines cut into), hf. bd. [R. Grafton and E. Whitchurche, 1541], folio (53)

Tregaskis, £3 11s.

4808 [The "Great" Version] first ed., black letter, double columns, 62 lines, engraved titles and woodcuts (general title and preliminary leaves in fac., first 3 leaves of Genesis, 4 leaves in Apocrypha and several leaves at end repaired), 2 different titles to Apocrypha (cut down), [D. and M. 25,] modern mor. ex., *R. Grafton and E. Whitchurch*, 1539, *fynisshed in Apryll*, large folio (54)

Bull, £5 5s.

4809 [The "Great" Version] second ed., black letter, all prelimi-

XXIV. **22**

nary leaves in fac., as well as titles and last leaf (several
leaves defective), uncut edges, loose in wooden covers [D.
and M. 30], R. Grafton, *April,* 1540, large folio (56)
Quaritch, £25 10s.

4810 [New Testament. Tyndale] black letter, long lines, 38 to a
full page, woodcuts (imperfect, but having "The Printer to
the Reader," with Almanack, 1549 to 1577, on reverse, 4
leaves of Calendar and "William Tindale unto the Christian
Reader" (8 leaves, the last defective), the vol. ending with
the second leaf of the Epistles of the O. T.), containing 376
leaves of text (some leaves stained and a leaf or two defec-
tive), [D. and M. 43,] J. Day and W. Seres, 1548, 12mo. (58)
*Tregaskis, £*1 16s.
[A rare edition, rarely found perfect, the first with notes
at the end of the chapters and the first with the wife-
)eating note to 1 Peter iii.—*Catalogue.*]

4811 [New Testament. Erasmus's Paraphrase] first ed., black letter
(first title in fac. and outer margins of several leaves
mended, title to vol. ii. mended), 2 vol., sides of orig.
stamped cf. on oak bds. (repaired), E. Whitchurche, 1548-49,
sm. folio (59) *Tregaskis, £*2 18s.

4812 Matthew's. [Tyndale's] black letter ("Bugges" reading in
Psalm xci. 5), (first title in fac., 2 leaves in Apocrypha
supplied from shorter copy, some leaves stained,) old cf.,
Wm Hyll and Thos. Reynalde, 1549, sm. folio (60)
*Tregaskis, £*3 3s.

4813 Matthew's. [Tyndale's] black letter, title and leaf of Kalendar
in fac., and 25 pages of preliminaries only (margins of
several leaves mended, leaves of Ta)le defective and
mended, and wanted nearly all the Revelations), [D. and
M. 48,] old cf., T. Raynalde and Wm. Hyll, 1549, sm. folio
(61) *Tregaskis, £*3 3s.

4814 [Matthew's. (Tyndale's) revised by Becke] black letter, wood-
cut titles and cuts in the text [with Ta)le of the Epistles
and Gospels after the use of Salis)ury], title and leaf of
Ta)le in fac. (some margins cut into and a few leaves
mended), [D. and M. 47,] cf., r. e., J. Day and Wm. Seres,
1549, sm. folio (62) *Tregaskis, £*3 6s.
[Hardly ever found complete. It has the reading
"Bugges" in Psalm xci. 5, and the wife-)eating note on
1 Peter iii.—*Catalogue.*]

4815 [The "Great" Version] black letter, first title in fac. (margins
of first 6 leaves and 17 leaves at end mended), short copy
[D. and M. 49], modern mor. ex., in a case, Edw. Whit-
churche, 1549, sm. folio (66) *Tregaskis, £*4 15s.
[A very fair copy, and apparently perfect apart from the
defects mentioned.—*Catalogue.*]

4816 [Coverdale] black letter, first leaf of Genesis and last 4 leaves
in fac. (several leaves mended and 3 defective), [D. and M.
55,] mor., blind stamped ornaments, g. e.,)y W. Pratt
[*London,* A. Hester], [*Zurich,* C. Froschover], 1550, 4to.
(71) *Bull, £*4 4s.

4817 [The "Great" Version] black letter (first title inlaid, margins
of several leaves mended and cropped), [D. and M. 56),
modern mor. antique, Edward Whytchurche, 1550, sm. 4to.
(73) *Tregaskis,* £2 2s.
4818 [New Testament. Latin-English. Erasmus and Tyndale]
(title in fac., wanted last leaf of Calendar), [D. and M. 58,]
old cf., *Thos. Gaultier pro J. C.*, 1550, 8vo. (75)
 Tregaskis, £1 16s.
4819 [Matthew's (Tyndale's)] black letter, first title and 3 leaves of
Calendar in fac. (margins of several leaves mended, wanted
large cut)efore Genesis), [D. and M. 64,] old russ., Thos.
Petyt and Nic. Hyll, 1551, sm. folio (77) *Tregaskis,* £2 2s.
4820 [Matthew's (Taverner and Tyndale's, revised by Becke)]
black letter, first title and preliminary leaves in fac., also the
last 3 leaves [D. and M. 66], old cf., with metal)osses
(re)acked), J. Daye, 1551, sm. folio (78) *Tregaskis,* £1 11s.
4821 [The "Great" Version] black letter, first title mounted, 2
leaves fac. (a few margins mended and shaved), [D. and M.
72,] modern mor.,)lind antique ornaments, g. e., Edw.
Whytchurche, 1553, sm. folio (83) *Bull,* £2 10s.
[The only folio Bi)le issued in the reign of Q. Mary, who
is said to have destroyed most of the impression.—*Cata-
logue.*]
4822 [The "Great" Version] with Apocrypha, black letter, 3 titles
within woodcut)orders (margins cut down and text
wormed), much of the text underlined in red [D. and M.
73], old cf., Richarde Grafton, 1553, sm. 4to. (85)
 Tregaskis, £2 6s.
4823 New Testament. Whittingham's Translation, with Calvin's
Epistle and a Ta)le, etc., roman letter (title in fac., a few
margins shaved), [D. and M. 76,] old cf., g. e., *Geneva,
printed by Conrad Bodius,* 1557, sm. 8vo. (87)
 Tregaskis, £2 4s.
[This is the first edition of Whittingham's N. T. printed
in roman letter, with verse divisions. It is quite distinct
from the versions of Beza and Tomson, and forms the first
critical English edition of the text.—*Catalogue.*]
4824 [Genevan or "Breeches"] first ed., roman letter, maps and
cuts (orig. title inlaid and the first 4 leaves in fac., 2 leaves
in Genesis mended and also the last leaves of ta)le), [D.
and M. 77,] modern cf., antique gilt tooling, g. e., *At
Geneva, printed by Rowland Hall,* 1560, 4to. (88)
 Bull, £10 15s.
4825 [Genevan or "Breeches"] roman letter, with woodcuts
(wanted first title, 4 maps, last leaf of ta)le, several leaves
defective and mended), [D. and M. 84,] hf. mor., *Printed at
Geneva,* 1562 (1561), sm. folio (90) *Barnard,* £1 6s.
[Second edition of the "Breeches" Bi)le.—*Catalogue.*]
4826 [The "Great" Version] black letter (first title and next 3
leaves in fac., margins of several leaves defective and
mended), [D. and M. 85,] modern cf., antique gilt orna-
ments, Richarde Harrison, 1562, folio (91) *Tregaskis,* £3

4827 [The "Great" Version] 𝔟𝔩𝔞𝔠𝔨 𝔩𝔢𝔱𝔱𝔢𝔯, titles in fac., except those
to the Third Part and Apocrypha, several other leaves in
fac., had 14 preliminary leaves only (several mended and
defective, wanted ta꜏le), [D. and M. 86,] old oaken bds.,
leather (wormed and repaired), *Rouen*, Rich. Carmarden,
1566, folio (93)　　　　　　　　*Tregaskis*, £2 12s.

4828 [The Bishops' Version] first ed., 𝔟𝔩𝔞𝔠𝔨 𝔩𝔢𝔱𝔱𝔢𝔯, woodcuts and
woodcut initials of classical su꜏jects (Leda and Swan, etc.),
(some margins mended, 2 of preliminary leaves and last
leaf of Ta꜏le in fac., some leaves mended and stained,)
large cut of Adam and Eve mounted [D. and M. 89], cf.
(mended), R. Jugge, 1568, folio (95)　　　*Tregaskis*, £2 8s.
[The first edition of the Bishops' Bi꜏le. It contains a
reference to Christopher Colum꜏us in the note to Psalm
xlv. 5.—*Catalogue*.]

4829 [The Bishops' Version] second ed., 𝔟𝔩𝔞𝔠𝔨 𝔩𝔢𝔱𝔱𝔢𝔯, engraved
title, containing port. of Q. Eliza꜏eth (damaged and re-
paired), ports. and arms of the Earl of Leicester and Lord
Burleigh, map, woodcut title to N. T., woodcuts and initials
of classical su꜏jects (Leda and Swan, etc.), contains 25
preliminary leaves (including title), (inner margins to
Genealogies mended, hole in last 2 leaves,) [D. and M. 96],
old cf., centre gilt ornaments and ties, R. Jugge, 1572, folio
(107)　　　　　　　　　　　　　　*Maggs*, £7 5s.

4830 [The Bishops' Version] third folio ed., 𝔟𝔩𝔞𝔠𝔨 𝔩𝔢𝔱𝔱𝔢𝔯 (wanted
first title), (supplied in fac., a few margins mended,) [D. and
M. 101], modern cf. ex., R. Jugge, 1574, folio (110)
　　　　　　　　　　　　　　　　Tregaskis, £2 4s.

4831 [New Testament. Genevan, ꜏y L. Tomson] roman letter,
map, old Anglo-Lyonnese cf., stamped with semis of
rosettes and corner and centre ornaments (repaired, some
margins of preliminary leaves mended), [D. and M. 125,]
Chr. Barker, 1580, sm. 8vo. (130)　　　　*Ellis*, £4 18s.

4832 [Roman Catholic Version] first ed. of the Rhemish Testa-
ment and Doway Bi꜏le, 3 vol., uniformly ꜏ound in 3 vol.,
old cf. gt., good copy, *Rhemes*, John Fogny, 1582—*Doway*,
L. Kellam, 1609-10, 4to. (131)　　　　*Tregaskis*, £1 8s.

4833 [Rhemes and Doway Version] second ed. of the N. T., first
ed. of the O. T., 3 vol., old cf. (uniform), *Antwerp*, D.
Vervliet, 1600—*Doway*, L. Kellam, 1609-10, sm. 4to. (155)
　　　　　　　　　　　　　　　　Bull, £1 1s.

4834 [Genevan or "Breeches"] roman letter, with Apocrypha,
Speed's Genealogies and two Ta꜏les (first title ꜏acked),
Edinb., And. Hart, 1610—Book of Common Prayer, R.
Barker, 1616 — Psalmes in Meeter by Sternhold and
Hopkins, *Stat. Co.*, 1609, in 1 vol., modern cf. (169)
　　　　　　　　　　　　　　　　Tregaskis, £1 9s.
[The second edition of the Bi꜏le printed in Scotland.
It has a metal map ꜏efore Gen. iii.—*Catalogue*.]

4835 [Authorised] first ed., 𝔟𝔩𝔞𝔠𝔨 𝔩𝔢𝔱𝔱𝔢𝔯, with "He" reading (wanted
general title, supplied in fac., first leaf of dedication

mended, all leaves from "Colossians" to end damaged, last leaf in fac.), cf. antique, R. Barker, 1611, folio (172)
Bull, £3 12s. 6d.

4836 [Authorised] first ed., black letter, with "She" reading (first title and last leaf of Revelation in fac., some preliminary leaves loose), [D. and M. 240,] old cf., R. Barker, 1611, folio (173)
Tregaskis, £3

4837 [Authorised] first ed., black letter, with "He" reading (wanted first title and first leaf of dedication, last leaf in fac.), [D. and M. 240,] old cf. gt., y. e., metal bosses, R. Barker, 1611, large folio (174)
Tregaskis, £4 5s.

4838 [Authorised] roman letter, clean and perfect (but some margins cut into), [D. and M. 243,] R. Barker, 1612—Book of Common Prayer, J. Bill and C. Barker, 1662—The Way to true Happiness, T. Pavier, 1610—Whole Book of Psalmes in meeter, *Stat. Co.*, 1612, in 1 vol., new cf. ex., 8vo. (179)
Barnard, £3
[The Bible is the first edition of the Authorised Version in octavo with the "He" reading in Ruth iii. 15.—*Catalogue.*]

4839 [Authorised] roman letter (with Apocrypha), engraved title by J. Payne [D. and M. 324], old English mor. sides, tooled au pointillé, *Cambridge University*, T. & J. Buck, 1629, sm. folio (201)
Leighton, £2
[The first edition of the Authorised Version printed at Cambridge. It appears to be the earliest edition in which the error in 1 Tim. iv. 16 (" Thy Doctrine ") occurs.—*Catalogue.*]

4840 [Authorised] roman letter [D. and M. 339], *R. Barker and Assignes of John Bill*, 1631-30—Booke of Common Prayer, *ib.*, 1630—Whole Booke of Psalmes in meter, *Stat. Co.*, 1631, in 1 vol., old Anglo-Lyonnese cf., arms of K. Charles I. in centres, and initials W. A. with ties, 8vo. (206)
Leighton, £4 10s.
[An interesting volume with entries of a branch of the Addison family, beginning with Benjamin Addison in 1659, and including "Joseph Addison," son of Benjamin (born 1673, died 1674), and ending with Martha Addison, died 1682. In the Metrical Psalms are entries of the "Robertson" family, 1682-1730.—*Catalogue.*]

4841 [Authorised] roman letter (wanted Apocrypha), engraved title by W. Hole, and woodcut title to N. T., old cf., silver armorial bearings (Marcus Trevor?) and clasps (repaired), *R. Barker & Assigns of Bill*, 1639-38 (*Metrical Psalms E. Griffin and J. Raworth for Stat. Co.*, 1638), folio (221)
Ellis, £1 14s.

4842 [Authorised] with Book of Common Prayer. Speed's Genealogies, and Psalms in Metre, map of Canaan, vignette of the Creation of Adam and Eve at the head of Genesis, woodcut titles (all dated 1640), orig. Anglo-Lyonnese cf., covered with semis of ermines, corner and centre orna-

ments, g. e., *R. Barker and Assignes of John Bill*, 1640,
8vo. (228) *Tregaskis*, £5 7s. 6d.
[A fine and perfect copy, and a well-preserved specimen
of old Lyonnese binding. It differs from D. and M. 438,
in having all the titles as well as the colophon dated 1640.
A written label inside cover reads : "This Bible is given to
Sarah Steele to be the constant companion and Guide of
her Life."—*Catalogue.*]

4843 [Authorised] frontispiece (title and next 6 leaves damaged,
some leaves stained), bound in 2 vol., old mor., the sides
covered with crowned monogram of W. M. R. representing
William III. and Q. Mary, with the large Royal arms of
England, lettered "Windsor Chapel," *Oxford, by the Uni-
versity-Printers*, 1701, imp. folio (253) *Leighton*, £12

4844 [Authorised] The "Vinegar" Bible, 2 vol., old English mor.,
gilt panel sides, cottage roof ornaments, and centre orna-
ments in red and blue, silk ties and gilt tassels, John
Baskett, 1717, imp. folio (259) *Tregaskis*, £2 8s.

4845 [Authorised] bound in 5 vol., old English mor., side borders
of floreate ornaments, *Cambridge, printed by John Basker-
ville*, 1763, imp. folio (264) *Leighton*, £2 12s.
[The fly-leaves in vol. i. are occupied by "A Genealogy
of the Family of Greenholme Co. Ayr, N.B. from 1390
from the ancient House of Nisbet of that Ilk Co. Berwick."
It has the old Nisbet ex-libris in each volume.—*Catalogue.*]

4846 [Authorised] pearl type, LARGE PAPER, 2 vol., old mor., richly
gilt, g. e., *Edinb.*, Sir D. Hunter Blair and J. Bruce, 1811,
8vo. (268) *Hopkins*, £2 4s.
[This edition is one of the two mentioned before the Bible
Patent Committee as more nearly approaching immaculate-
ness than any other in existence. Only 25 copies were
taken on large paper. [D. and M. 1020.]—*Catalogue.*]

(β) *Miscellaneous Books. Common Prayer.*

4847 Blundeville (Th.) The Fower Chiefyst Offices belonging to
Horsemanshippe, **black letter**, the four books complete
(title and several other leaves damaged by damp), old
cf. (rebacked), W. Seres, n. d. [1565], sm. 4to. (284)
 Tregaskis, £3 5s.

4848 Nattes (J. C.) Versailles, Paris and St. Denis, a Series of
Views from Drawings made on the spot, 40 aquatint col.
plates by J. Hill, hf. bd., W. Miller, n. d. (1805-9), roy. folio
(290) *Quaritch*, £45

4849 Parey (Ambrose). The Workes of that famous Chirurgion,
trans. by Tho. Johnson, engraved title by T. Cecill, and
woodcuts, old cf., R. Cotes, 1649, folio (291) *Maggs*, £1 1s.

4850 Plinius. The Naturall Historie of the World, trans. by
Philemon Holland, M.D., first ed., woodcut title, 2 vol. in 1,
russia, g. e. (cracked), *A. Islip impensis G. B.*, 1601, folio
(294) *Edwards*, £1 9s.

4851 Prayer. The Book of Common Prayer, etc., LARGE PAPER, front., old English mor., gilt tooled panel ornaments, with cottage roof designs, inlaid centre ornaments, silk ties and gilt tassels, g. e., with leather book-stamp of "Grantles" in covers, Mark Baskett, etc., 1766, folio (303) *Leighton*, £1

The following, the property of Sir Walter Gilbey, Bart., were sold at Cambridge House, Regent's Park, on March 9th, by Messrs. Knight, Frank and Rutley. All the books were well bound and in good condition.

4852 Sporting Magazine (The), complete from the commencement to 1870, plates, 156 vol., bound in hf. cf. gt., together with the index to the engravings and the names of the artists, privately printed by Sir Walter Gilbey in 1892, 1792-1892, 8vo. £378
 [*See* BOOK-PRICES CURRENT, Vol. xxiii., No. 8349, where a complete set, entirely uncut, is recorded as having realised £500.—ED.]

4853 New Sporting Magazine (The), from its commencement in 1831 to 1846, together 30 vol., with additional index, 8vo. £194 5s.
 [Another set, neither so well bound nor in such good condition, realised £78 15s.—ED.]

4854 Sporting Review (The), a Monthly Chronicle of the Turf, the Chase, etc., edited by "Craven" (Capt. J. W. Carleton), illustrations by H. Alken and others, from the commencement to 1846, 15 vol., 1839-46, 8vo. £44 2s.

4855 Annals of Sporting and Fancy Gazette, complete in 13 vol., including the scarce number 78 for June, 1828, in vol. xiii., and the two extra plates, "Hunting" and "Mare by Sore-heels," 1822-28, 8vo. £73 10s.

[MARCH 9TH AND 10TH, 1910.]

PUTTICK & SIMPSON.

A MISCELLANEOUS COLLECTION.

(No. of Lots, 618 ; amount realised, £538 18s. 6d.)

4856 A'Beckett (G. A.) Comic History of England, 20 col. etchings and woodcuts by John Leech, 2 vol.—Comic History of Rome, 10 col. etchings and woodcuts by the same, first eds., uniform hf. mor., g. t., specimen wrappers bound in, uncut, *Punch Office*, 1847-48, Bradbury, Evans & Co., n. d., 8vo. (496) *Hornstein*, £6

4857 Audubon (J. J.) and Bachman (J.) Viviparous Quadrupeds of North America, col. plates, in 2 vol. (no text, vol. ii. no title), hf. mor., 1845, elephant folio (607) *Spencer, £7 7s.*

4858 Barham (R. H.) Ingoldsby Legends, illustrations by G. Cruikshank and others, 3 vol., cl., 1855, 8vo. (79)
Reader, £1 3s.

4859 Barlandus (H.) Historia Hollandiæ et Icones, 35 engraved ports., old cf., floreate borders and centre-piece, 1584, 4to. (285) *Polygot, £1 1s.*

4860 Blunt (W. S.) Love Lyrics and Songs of Proteus, vell., *Kelmscott Press,* 1892, 8vo. (492) *Maggs, £3 15s.*

4861 Book of Common Prayer, old view of Walton Church, Isle of Wight, painted on fore-edge, mor., 1786, 12mo (495)
Tregaskis, £6 15s.

4862 Catlin (G.) O-Kee-Pa. A Religious Ceremony and other Customs of the Mandans, 13 col. illustrations, cl., *Trubner,* 1867, 8vo. (326) *Leon, £2 2s.*

4863 Cervantes (M.) Don Quixote, trans. from the original Spanish, 24 col. engravings by Clark, 4 vol., bds., uncut, 1819, 8vo. (478) *Bumpus, £5 10s.*

4864 Chaucer (Geoffrey). Poetical Works, Pickering's Aldine ed., 6 vol., orig. cl., 1852, 8vo. (444) *Roberts, £5 10s.*

4865 Cleland (J.) Memoirs of Fanny Hill (title torn), old cf., Griffiths, n. d. (17—), 8vo. (438) *Shepherd, £2 8s.*

4866 Dickens (Charles). Memoirs of Grimaldi, first ed., etchings by G. Cruikshank, 2 vol., fine copy in orig. salmon cloth, 1838, 8vo. (459) *Shepherd, £5*

4867 Dickens (C.) Gilbert's Illustrations to the Pickwick Papers, 32 plates, orig. impressions, hf. mor., g. t., n. d., 8vo. (450)
Shepherd, £2

4868 Fitzgerald (E.) Rubáiyát of Omar Khayyám, rox., 1872, sm. 4to. (487) *Spencer, £1 10s.*

4869 Fitzgerald (E.) Six Dramas of Calderon, freely translated, Pickering, 1853, 8vo. (488) *Quaritch, £2*

4870 Forlong (J. G. R.) Rivers of Life, maps and illustrations, 2 vol., cl., and Atlas, 1883, 4to. (570) *Edwards, £3 17s. 6d.*

4871 Frazer (J. G.) The Golden Bough, 3 vol., cl., 1900, 8vo. (484)
Sotheran, £2 10s.

4872 Gheyn (Jacob de). Exercise of Armes, 111 plates (title mounted), 2 plates inlaid (letterpress mended and defective), hf. mor., 1608, folio (585) *Reader, £1 14s.*

4873 Gray (Thomas). Poetical Works, Pickering's Aldine ed., port., 5 vol., cl., 1836-43, 8vo. (82) *Allison, £1 8s.*

4874 Grub (George). Ecclesiastical History of Scotland, 4 vol., cl., 1861, 8vo. (115) *Baker, £1 13s.*

4875 Haeckel (Ernst). The Evolution of Man, illustrations, 2 vol., cl., g. t., 1905, 8vo. (316) *Hill, £1*

4876 Heptameron Francais. Les Nouvelles de Marguerite Reine de Navarre, plates by Freudenberg, 3 vol., mor., tooled backs, *Berne, chez la Nouvelle Société typographique,* 1780-81, 8vo. (493) *Bumpus, £7 15s.*

4877 Hodgson (J. E.) Raroria, being Notes on Printed Books, MSS., Medals, etc., 3 vol., 1900, 4to. (240) *Maggs*, £1. 15s.

4878 Horatius. Carmina, etc., vell., gt., painted on sides with marriage of Cupid and Psyche, and Muses, with brilliantly painted view of Mountstuart on fore-edge, in case, *Birmingham*, Baskerville, 1762, 8vo. (494) *Bumpus*, £16 10s.

4879 La Fontaine (J. de). Contes et Nouvelles en Vers, plates after Eisen, tail-pieces and fleurons, 2 vol., mor., uncut, *Paris, chez Chevalier*, 1792, 8vo. (439) *Sotheran*, £2 10s.

4880 Lawrence Gallery. Engravings from the Choicest Works of Sir Thomas Lawrence, title and 50 ports., with descriptions (that to the port. of Lawrence torn across), publisher's hf. mor., 1835-44, folio (300A) *Edwards*, £23

4881 Lover (Samuel). Handy Andy, first ed., 24 etchings by the author, hf. cf., 1842, 8vo. (460) *Read*, £1 1s.

4882 Manning (O.) and Bray (W.) History and Antiquities of Surrey, plates, 3 vol., hf. mor. (stained), 1804-14, 4to. (284) *Brown*, £9 5s.

4883 Maxwell (W. H.) History of the Irish Rebellion, etchings by G. Cruikshank, hf. cf., 1845, 8vo. (80) *Maggs*, £1 10s.

4884 Mayo (J. H.) Medals and Decorations of the British Army and Navy, col. plates, 2 vol., cl., 1897, 8vo. (182) *Sutton*, £1

4885 Miniature Book. Plaisir et Gaité à Paris, plates, mor. (about ⅞ of an inch high), 1824 (486) *Bumpus*, £1 1s.

4886 Morris (Wm.) A Dream of John Ball, front. and border designed by Burne-Jones, vell., *Kelmscott Press*, 1892 (491) *Shepherd*, £2

4887 Notes and Queries, from the commencement to the 10th series, vol. ii. also with Indexes to First and Second and 4th to 9th Series, together 127 vol., indexes all cl., remainder various bindings, 1849 to 1909, 4to. (232) *Edwards*, £8 5s.

4888 Percy (Bp.) Folio Manuscript with the Loose and Humorous Songs, 4 vol., hf. cf., gt., 1867, 8vo. (121) *Hill*, £2 4s.

4889 Rawlinson (Sir G.) History of Herodotus, 4 vol., cl., 1862, 8vo. (150) *Allison*, £1 8s.

4890 Rickman (Thomas). Gothic Architecture, with additions by Parker, illustrations, 1862, 8vo. (130) *Maggs*, £1 1s.

4891 Sismondi (J. C. L. S. de). Histoire des Republiques Italiennes, 10 vol., vell., 1840, 8vo. (411A) *Hill*, £1 4s.

4892 Stevenson (R. L.) Child's Garden of Verses, first ed., publisher's cl., g. t., 1885, 8vo. (440) *Hornstein*, £2 17s. 6d.

4893 Stevenson (R. L.) Virginibus Puerisque, first ed., publisher's cl., 1881, 8vo. (441) *Shepherd*, £2 4s.

4894 Stevenson (R. L.) Treasure Island, first ed., orig. cl., 1883, 8vo. (442) *Bain*, £1 2s.

4895 Stevenson (R. L.) Silverado Squatters, 1883—Kidnapped, 1886—Merry Men, 1887, first eds.—Familiar Studies of Men and Books, 1886—Underwoods, 1887, all orig. cl., 8vo. (443) *Edwards*, £1 15s.

4896 Sturt (J.) The Orthodox Communicant, engraved throughout, head-pieces to each page, title, preface and 82 pages, with list of subscribers, old mor., gold borders, Sturt, 1721, 8vo. (437) *Maggs*, £1 7s.

4897 Vyner (R. T.) Notitia Venatica, first ed., orig. green cl., 1841, 8vo. (471) *Bumpus*, £2 11s.

4898 Wilde (Oscar). Intentions, first ed., presentation copy, with autograph inscription (name erased), "With the compliments of the author," 1891, 8vo. (489) *Edwards*, £2 10s.

[MARCH 10TH AND 11TH, 1910.]

SOTHEBY, WILKINSON & HODGE.

A Portion of the Library (Lots 1-67) of the late Mr. T. H. Longfield, of the Museum of Science and Art, Dublin, and other Properties.

(No. of Lots, 721 ; amount realised, £863 17s. 6d.)

4899 Abbot (J.) and Smith (J. E.) Lepidopterous Insects of Georgia (in English and French), 104 col. plates, 2 vol., hf. mor., g. e., 1797 (201) *Wesley*, £7

4900 Alford (Lady M.) Needlework as Art, plates and illustrations, 1886, roy. 8vo. (407) *Sotheran*, £1·1s.

4901 America. New and Further Discovery of the Isle of Pines in a Letter from Cornelius van Sloetton, . . . to a Friend of his in London, with a Relation of his Voyage to the East Indies, etc., first ed., 1688, 4to. (507) *West*, 14s.

4902 America. Map of North America from the French of D'Anville, with Back Settlements of Virginia and Course of Ohio Illustrated (margins torn).—Map of Discoveries by the Russians on the North-West Coast of America—Plan of the Environs of Quebec—Plan and Fortifications of Montreal—Map of Nova Scotia and Cape Britain—Plan of City and Harbour of Louisburg, and other maps and plans of America, in 1 vol., hf. bd. (broken), Jefferys, 1756-59, imp. folio (669) *H. Stevens*, £22 10s.

4903 Angelo (Dom.) The School of Fencing, 47 plates, text in English and French, hf. bd., S. Hooper, 1765, oblong folio (61) *Rimell*, £1 18s.

4904 [Argenville (D. d').] Abrégé de la Vie des plus fameux Peintres, unlettered proof front. after Boucher, and 254 ports. by Auber, etc., 4 vol., old French cf. gt., Paris, 1762, 8vo. (469) *Sands*, 14s.

4905 Bacon (Sir Francis). Essaies, sixth ed. (corner of last leaf torn, title soiled), hf. cf., *Printed for John Jaggard*, 1613, 8vo. (451) *Quaritch,* £12 10s.

4906 Beckford (Peter). Thoughts upon Hunting, front. by Barto-
lozzi, unlettered proof, and 2 plates, hf. cf., uncut, 1782, 4to..
(586) *Selby*, £1 15s.

4907 Beeverell (James). Les Délices de la Grande Brétagne,
orig. ed., maps and douᴊle-page views and costumes, 8 vol..
in 7, old cf., 1707, 8vo. (464) *Lacroix*, 15s..

4908 Belzoni (G.) Plates illustrative of the Researches and
Operations in Egypt and Nuᴊia, orig. ed., 44 col. plates,
orig. bds., with laᴊel, 1820, atlas folio (690)
Hiersmann, £1 1s.

4909 Biᴊle Cuts. The true and lyuely Historyke Portreatures of
the Woll Biᴊle, 194 woodcuts by Bernard Salomon, with
quatrains ᴊeneath each by Peter Derendel (small worm-
hole through some leaves, and some of the letters restored
in fac.), mor., g. e., *At Lyons, by Jean of Tournes*, 1553.
(632) *Ellis*, £4 4s..

4910 Biᴊlia, nu van nieuwe uyt D. M. Luthers Hoogduitse Byᴊel
in onze Nederlandsche Taale getrouwelyk overgezet,.
engravings ᴊy Romain de Hooghe, contemp. Dutch oak
ᴊoards, russ., centre gilt ornaments, ᴊrass corners and
clasps, *Amst.*, J. Lindenᴊerg, 1702, folio (67)
Halliday, £1 10s..

4911 Biᴊliotheca Sunderlandiana. Sale Catalogue of the Sunder-
land or Blenheim Liᴊrary, LARGE AND FINE PAPER COPY,
5 vol., with prices and names of purchasers, orig. covers,
uncut, 1881-3, imp. 8vo. (350) *Barnard*, £1 8s.

4912 Bree (C. R.) Birds of Europe, col. plates, 4 vol., hf. cf. gt.,
1859-63, 8vo. (167) *Quaritch*, £2 6s..

4913 British Zoology (The). Class i. Quadrupeds, ii. Birds, pub-
lished under the Inspection of the Cymmrodorion Society,.
107 col. plates, cf., 1766, folio (220) *Quaritch*, £5 5s.

4914 Bryce (J.) American Commonwealth, first ed., 3 vol., cl.,.
1888, 8vo. (388) *Hornstein*, £2 16s.

4915 Bruyn (Aᴊraham de). Haᴊits de Diverses Nations de
l'Europe, Asie, Afrique et Amérique, orig. ed., 57 plates,.
mounted on stout paper, in portfolio, 1581 (663)
Selby, £1 7s..

4916 Burke (J. and J. B.) Royal Families of England, Scotland
and Wales, port., 2 vol., cf., g. e., 1848-51, imp. 8vo. (417)
Edwards, £1 2s..

4917 Burke (J. and J. B.) Dictionary of the Landed Gentry, and
Supplement, 3 vol., cf., g. e., 1847-49, imp. 8vo. (418)
Harding, £1 7s.

4918 Buttes (Henry). Dyets Dry Dinner, first ed. (title defective,
outer margins of 3 leaves frayed), hf. cf., *Tho. Creede for
W. Wood*, 1599, 4to. (633) *Edwards*, £1 10s.

4919 Byron (Lord). Poetical Works, Liᴊrary ed., port., 6 vol., hf.
mor., 1879, 8vo. (393) *G. H. Brown*, £1 10s..

4920 Caᴊinet of Genius (The), exhiᴊiting Frontispieces and.
Characters adapted to the most popular Poems, etc., tinted
suᴊjects ᴊy S. Shelley and engraved views, old cf., C. Taylor,
1787, sm. 4to. (30) *Spencer*, £1 2s.

4921 Canaletti. Urɔis Venetiarum Prospectus celebriores ex Ant.
 Canal Taɔulis XXXVIII., aere expressi ab Ant. Visentini,
 34 plates (only), ɔesides engraved title and 2 ports., hf.
 russ., *Venet.,* Pasquali, 1742, oɔlong folio (63)
 Geoffray, £7 5s.
4922 Catesɔy (M.) Natural History of Carolina, 100 col. plates,
 descriptions in English and French, vol. i., cf. (reɔacked),
 1731, folio (203) *James,* £1 1s.
4923 Catullus, Tiɔullus et Propertius, Opera, Lucretii de Rerum
 Natura, liɔri vi., 2 vol., old mor., g. e., *Birmingham,* J.
 Baskerville, 1772-73, 8vo, (293) *Edwards,* 13s.
4924 Chapman (A.) and Buck (W. J.) Wild Spain. Records of
 Sport, 174 illustrations, cl., 1893, roy. 8vo· (222)
 G. H. Brown, £2 5s.
4925 Chaucer (G.) Poetical Works, with Memoir by Sir H.
 Nicolas, "Pickering's Aldine ed.," port., 6 vol., orig. cl.,
 Pickering, 1852, 8vo. (294) *Rimell,* £4 16s.
4926 Chesterfield (Earl of). Letters written to his Son, 2 vol., first
 ed., port., old cf., 1774, 4to. (578) *Andrews,* 14s.
4927 Corneille (Pierre). Théâtre, ɔest ed., unlettered proof front.
 and 34 plates after Gravelot, 12 vol., contemp. French cf.,
 1764, 8vo. (483) *Quaritch,* £1 5s.
4928 Couch (J.) Fishes of the British Islands, col. plates, 4 vol.,
 hf. cf. gt., 1862-65, 8vo. (165) *Hawkins,* £3 4s.
4929 Cries of Venice. Zompini (Gaetano). Le Arti che Vano
 per Via nella città di Venezia, LARGE PAPER, 60 plates, hf.
 bd., *Venez.,* 1785, imp. folio (60) *Sotheran,* £1 10s.
4930 Cunningham (P.) Story of Nell Gwyn, first ed., illustrations,
 orig. cl., 1852, 8vo· (366) *Abrahams,* £1·10s.
4931 Dante. La Divina Commedia, port. of Dante, plates and
 vignettes, 5 vol., *Venezia,* 1757-8, 4to. (589)
 Marinis, £1 5s.
 [Besides the "Prose e Rime Lirichie edite ed inedite di
 Dante" this copy contains the rare portrait of the Czarina
 Elizaɔetta Petrowna, as well as the "Guidizio degli antichi
 Poeti sopra la moderna Censura di Dante attriɔuiti in-
 giustamente a Virgilio Venezia, 1758," with front. and head
 and tail-pieces.—*Catalogue.*]
4932 D'Aumale (M. le Duc). Histoire des Princes de Condé, orig.
 ed., ports. and maps, uncut, 7 vol. (vol. i. and ii. hf. cf. gt.),
 1863-1892, 8vo. (468) *Andrews,* 14s.
4933 Descamps (J. B.) La Vie des Peintres Flamands, Allemands
 et Hollandois, orig. ed., unlettered proof frontispiece ɔy
 Leɔas, vignettes and ports. after Eisen, etc., 4 vol., old
 mor. gt. (vol. i. not uniform), *Paris,* 1753-64, 8vo. (482)
 Sands, £1 8s·
4934 Desmarest (A. G.) Histoire Naturelle des Tangaras, des
 Manakins et des Todiers, duplicate set of the 72 plates
 (plain, and coloured, by Pauline de Courcelles), hf roan,
 Paris, 1805, folio (217) *Edwards,* £3 3s.
4935 Dickens (C.) David Copperfield, 20 original parts as issued,
 with the advertisements, etc., 1849-50, 8vo. (290)
 J. Bumpus, £4 10s.

4936 Dickens (C.) Little Dorrit, 20 orig. parts as issued, with the advertisements, etc., 1855-57, 8vo. (291) *Shepherd,* £1 12s.

4937 Dickens (C.) Our Mutual Friend, 20 orig. parts as issued, with the advertisements, etc., 1864-65, 8vo. (292) *Spencer,* 16s.

4938 Dickens (C.) Posthumous Papers of the Pickwick Club, first ed., autograph letter of Dickens, 1 page 8vo. to Nugent Robinson, Esq., dated 12th Jan., 1869, relating to his illness in consequence of his readings, hf. mor. gt., Chapman and Hall, 1837, 8vo. (22) *Rimell,* £4 4s.

4939 Donovan (E.) Insects of India, ed. by J. O. Westwood, 58 col. plates, hf. cf. gt., 1842, 4to. (192) *Quaritch,* £1 8s.

4940 Donovan (E.) Insects of China, ed. by J. O. Westwood, 50 col. plates, hf. cf. gt., 1842, 4to. (193) *Quaritch,* £1 8s.

4941 Doré (Gustave). Histoire Dramatique, Pittoresque et Caricaturale de la Sainte Russie, illustrée de 500 gravures par Gustave Doré, orig. ed., printed on India paper on one side only, mor., orig. col. wrappers bound in, uncut, *Paris,* J. Bryainé, 1854, folio (653) *Lacroix,* £1 1s.

4942 Doves Press. Milton (John). Paradise Regain'd, Samson Agonistes and Poems, vell., *Hammersmith,* Cobden-Sanderson and E. Walker, 1905, sm. 4to. (88) *Edwards,* £2 2s.

4943 Doves Press. Milton. Paradise Regain'd, etc., another copy, printed upon vellum, vell., *Hammersmith,* Cobden-Sanderson and E. Walker, 1905, sm. 4to. (89) *Downing,* £7

4944 Drury (D.) Illustrations of Natural History (with French translation), 150 col. plates, 3 vol., hf. cf. gt., 1770-82, 4to. (195) *Quaritch,* £2 4s.

4945 Dunton (J.) Whipping-Post, or a Satyr upon Every Body with the Whoring-Pacquet, cf. (stained), 1706—Whipping-Tom, or a Rod for a Proud Lady, plates inserted, hf. mor., 1722, 8vo. (458) *Tregaskis,* 19s.

4946 Durfey (T.) Wit and Mirth, or Pills to Purge Melancholy, 6 vol. (one leaf imperfect vol. iv.), old cf., g.e., 1719-20, 8vo. (365) *Grayston,* £2 12s.

4947 East Anglian (The), or Notes and Queries on Subjects connected with Suffolk, Cambridge and Essex, 4 vol.—New Series, 7 vol., together 11 vol., vell., t. e. g., 1864-98, 8vo. (69) *Edwards,* £5 7s. 6d.

4948 Eden (Honble. Miss). Portraits of the Princes and People of India, 24 plates (col. and mounted like drawings), with descriptions, mor., Dickenson, 1844, atlas folio (107) *Quaritch,* £3 15s.

4949 Edwards (G.) Natural History of Birds, etc., 4 vol., 1802-3—Gleanings of Natural History, 3 vol., 1805-6, together 7 vol., col. plates, LARGE PAPER, hf. russ., folio (214) *Wesley,* £2 6s.

4950 Edwards (S.) Ornamental Flower Garden and Shrubbery, 288 col. plates, 4 vol., hf. mor., g. e., 1854, 8vo. (166) *Edwards,* £2 8s.

4951 Eragny Press. The Queen of the Fishes, by Margaret Rust,

illustrations in colours by Lucien Pissarro (150 copies
printed), vell:, *Epping*, L. Pissarro, 1894, 8vo. (86)
Downing, £2 2s.
4952 Eragny Press. Milton (John). Areopagitica, printed upon
vellum (8 copies so taken), prepared for ɔinding, *Printed at
the Eragny Press, Hammersmith*, 1903, sm. 4to. (87)
Downing, £1 12s.
4953 Erasmus. Éloge de la Folie, traduit par Victor Develay et
accompagné des Dessins de Hans Holɔein, papier de
Hollande (500 copies printed), woodcuts, extra illustrated
by the insertion of 18 ports. of Erasmus, including the one
by Blenswyk and 2 ɔy Hopfer, first state, 8 views of the
Erasmus Statue at Rotterdam in various tints, ports. of
More and Holɔein, and 13 orig. title-pages, mor. super ex.,
in case, *Paris*, 1876, 8vo. (432) *Young*, £4
4954 Esquemeling (John). Bucaniers of America, LARGE PAPER,
ports, etc., parts i.-iii., modern cf. ex., W. Crooke, 1684, 4to.
(125) £2 5s.
4955 Fagan (Louis). History of Engraving in England, in 3 port-·
folios, with clasps, 1893, folio (286) *Parsons*, £9 5s.
4956 Falda (G. B.) Le Fontane di Roma, 105 proof plates, hf.
russ., *Roma*, G. J. de Rossi, s. d., oɔlong folio (65)
Carter, £1 14s.
4957 Fauchet (Claude). Les Œuvres, first collected ed., port. of
the author, 2 vol., contemp. French cf. gt., with arms, *Paris*,
1610, 4to. (577) *Maggs*, £2 6s.
[The copy contains at end the three opuscula, viz.,
"Traicté des Libertez de l'Eglise Anglicane," "De la Ville
de Paris," and "Pour le couronnement du Roi Henri IIII.,"
numbering 24, 4 and 4 pages respectively.—*Catalogue.*]
4958 Fasciculus Temporum (auctore Wernero Rolewinck), lit. gotf.,
cut on reverse of title, small cuts in text (wanted last leaf),
orig. monastic oak bds., stamped pigskin, *Absque nota*
[*Colon.*, 1485 ?], folio (148) *Barnard*, £1 1s.
4959 Floral Magazine (The), by T. Moore and W. H. Dombrain,
10 vol.—New Series, vol. i. and ii., 656 col. plates, hf.
cf. gt. and hf. mor., 1861-73, roy. 8vo. and 4to. (162)
Wesley, £2
4960 Forlong (J. G. R.) Rivers of Life, maps, illustrations and
separate chart (a few autograph letters and· sketches
inserted), 3 vol., 1883, 4to. (119) *Edwards*, £4 12s. 6d.
4961 Fox (George) and Burnyeat (J.) A New England Fire-Brand
Quenched, 2 parts in 1 vol., old cf., 1678-79, 4to. (135)
Mahon, £7 10s.
4962 French Revolution. Taschenɔuch für die neuste Geschichte,
orig. ed., engraved title, 5 ports. and 44 plates, 2 col. plates
containing military costumes, folding plates of 3 aeronauts,
col. folding plate of the telegraph apparatus at the Louvre,
with the plate of the telegraphic alphaɔet, musical folding
plates of the "Marche des Marseillais," "Le Reveil du
Peuple contre les Terroristes," 4 vol., old cf., g. e., 1794-8,
8vo. (423) *Virgin*, £5

4963 Gray (R.) Birds of the West of Scotland, plates, cl., *Glasgow*,
1871, 8vo· (249) *Wheldon*, £1 6s.

4964 Greville Memoirs. Journal of the Reign of Queen Victoria,
from 1837 to 1860, first ed., 5 vol., 1885-87, 8vo· (421)
Quaritch, £2 10s.

4965 Guicciardini (Francesco). La Historia d'Italia, port., vig-
nettes and historiated letters, old Venetian mor., gilt backs
and ornaments, old ex-libris, "Joannis de Bizzaro," 2 vol.,
Vinegia, Gabriel Giolito de Ferrari, 1568, 4to. (551)
Barberi, £1 13s.

4966 Habington (William). Castara, third ed., in 3 parts, front. by
W. Marshall, mor., g. e., 1640, 8vo· (376) *Dobell*, £5 7s. 6d.

4967 Hamerton (P. G.) Etching and Etchers, first ed., illustra-
tions, hf. mor., 1868, imp. 8vo· (373) *Rimell*, £4 12s.

4968 Harvie-Brown (J. A.) and Buckley (T. E.) A Vertebrate
Fauna of the Moray Basin, illustrations, 2 vol., *Edinb.*, 1895
—A Vertebrate Fauna of Sutherland, Caithness and West
Cromarty, plates, *ib.*, 1887—A Vertebrate Fauna of the
Orkney Islands, plates, *ib.*, 1891—A Vertebrate Fauna of
the Outer Hebrides, map and plates, *ib.*, 1888—A Verte-
brate Fauna of Argyll and the Inner Hebrides, illustrations,
ib., 1892—Graham (H. D.) The Birds of Iona and Mull,
illustrations, *ib.*, 1892—Evans (A. H.) A Vertebrate Fauna
of the Shetland Islands, plates, *ib.*, 1899, together 8 vol.,
1887-99, 4to. (265-271) *Wesley*, £9

4969 Hewitson (W. C.) Illustrations of New Species of Exotic
Butterflies, over 300 col. plates, 5 vol., hf. cf. gt., 1851-76,
4to. (187) *Quaritch*, £9 15s.

4970 Hewitson (W. C.) Illustrations of Diurnal Lepidoptera, part
i., Lycænidæ, 89 col. plates, mor., g. e., 1863, 4to. (186)
Quaritch, £2 4s.

4971 Hickes (Capt. Wm.) Oxford Jests, refined and enlarged, being
a Collection of Witty Jests, Merry Tales, Pleasant Joques,
hf. title (mended), cf., g. e., 1671, 8vo· (370) £2 2s

4972 Hill (Robert). Sketches in Flanders and Holland, first ed.,
LARGE PAPER, 36 plates, including col. costumes, all proofs,
orig. bds., uncut, author's presentation copy, 1816, 4to. (501)
Edwards, £1 4s.

4973 Homer. Odyssey, printed at the University Press with the
Greek types designed by Robert Proctor, 225 copies printed,
uncut, *Oxford*, 1909, folio (677) *Quaritch*, £2 18s.

4974 Horatianus (Oct.) Rerum Medicarum, lib. iv.—Albucasis
[Opera Chirurgica], lib. iii., edidit Hermannus Comitis a
Nevenar, woodcuts, old cf., *Argent.*, Jo. Schottus, 1532,
folio (51) *Tregaskis*, £1 8s.

4975 Hughe (Wyllyam). The troubled man's medicine verye
profitable to be redde of al men, **black letter**, 2 parts in 1
vol., cf., g. e. (a few leaves repaired), *Prynted at London by
Ihon Herforde*, 1546, 8vo· (288) *Bull*, £3 3s.

4976 Hugo (Victor). Novels, complete and unabridged, illustra-
tions, 28 vol., cl., *Edinb.*, 1903, 8vo· (539) *Quaritch*, £2 18s.

4977 Hum_oldt (Alex. de). Political Essay on the Kingdom of
New Spain, translated by John Black, 4 vol., cf. (vol. i.
)roken), 1811, 8vo. (368) *Virgin,* £1 6s.
4978 Hume and Marshall. Game Birds of India, Burmah and
Ceylon, col. plates, 3 vol., all faults, *Calcutta* (1879-81), roy.
8vo. (298) *J. Bumpus,* £8 5s.
4979 Huth Li)rary. Catalogue of the Printed Books, etc. collected
)y Henry Huth (by Ellis and Hazlitt), 130 copies printed
for sale on hand-made paper, unlettered proof port. and 2
dou)le-page plates, hf. bd., 5 vol., t. e. g., uncut, 1880, 8vo.
(337) *Dobell,* £2 18s.
4980 Imitation de Jésus Christ, traduction de Michel de Marillac,
compositions, gravées à l'eau-forte par Léopold Flameng
(one of 100 num)ered copies " sur papier de chine "), plates
in two states, proofs)efore and with letters, mor., t. e. g., by
Dupré, in case, *Paris,* Quantin, 1878, 8vo. (355)
 Quaritch, £1 3s.
4981 Indagine (Jo.) Die Kunst der Chiromantzey, Physiognomey,
Natürlichen, Astrologey, lit. gotf)., woodcut head of Indagine
dated 1523, and woodcuts, *Straszburg,* Jo. Schott, 1523,
folio (147) *Dietrich,* £2 2s.
4982 James I. A Counterblaste to To)acco, first ed. (wanted title,
a few headlines shaved), hf. mor., t. e. g., 1604, 4to. (275)
 Quaritch, £4 8s.
4983 Knight (R. Payne). Worship of Priapus, plates, hf. mor.,
uncut, t. e. g., *Privately printed,* 1865 (*reprinted* 1894), 4to.
(118) *Halliday,* £2 4s.
4984 Knorr (G. W.) Délices des Yeux et de l'Ésprit, 190 col.
plates, 6 vol. in 2, hf. mor., t. e. g., *Nuremberg,* 1760-63, 4to.
(184) *Hill,* 16s.
4985 Knowsley Menagerie. Gleaning from the Menagerie and
Aviary at Knowsley Hall, Hoofed Quadrupeds, ed. by J. E.
Gray, 59 plates (some col.), *Privately printed, Knowsley,*
1846-50, folio (219) *Wheldon,* £1 12s.
4986 La Fontaine (J. de). Fa)les de, avec les dessins de Gustave
Doré, orig. ed., " exemplaire sur papier de Hollande très
fort," unlettered India proof port., plates on India paper
)y G. Doré, 2 vol., hf. mor., *Paris,* 1867, folio (715)
 Quaritch, £1 2s.
4987 Lam) (Chas.) Elia, first series, first ed., cf. ()roken), g. e.,
Taylor and Hessey, 1823, 8vo. (98) *Hornstein,* £4 2s. 6d.
4988 Lawes (Henry). Treasury of Musick, autographs on fly-leaf,
music throughout, engraved front. missing, old cf., *Wm.
Godbid for John Playford,* 1669, folio (644) *Ellis,* £3
4989 Lear (E.) Illustrations of the Family of Psittacidæ, 42 col.
plates, 1832, folio (199) *Wesley,* £2 10s.
4990 Le Petit (J. Fr.) La Grande Chronique Ancienne et Moderne
de Hollande, etc., ports. by C. Van Sichem, 2 vol., hf. vell.,
Dordrecht, Jaco) Canin, 1601, folio (54) *Dietrich,* 10s.
4991 Levaillant (F.) Histoire Naturelle des Oiseaux de Paradis et
des Rolliers, 112 col. plates, 2 vol., hf. mor. gt., *Paris,* 1806,
folio (215) *G. H. Brown,* £5

4992 Lever (Charles). Confessions of Con Cregan, first ed., plates ɔy Hablot K. Browne, 2 vol., hf. mor., t. e. g., uncut, Wm. S. Orr and Co., n. d. (1849), 8vo· (488) *Graystone*, £1

4993 Lewin (J. W.) Birds of New South Wales, 26 col. plates, 1822, folio (211) *Quaritch*, £3

4994 Lichtenɔerger (Jo.) Prognosticatio in Latino, lit. gotⱨ., 37 leaves, with signs. (4 leaves wanted, supplied in fac.), woodcuts, arms of Marie Augusta de Sulzɔach, wife of Chas. Ph. Th. of Sulzɔach, Count Palatine of the Rhine, etc., old cf., *"Datum in Vico Umbroso Subtus quercum Carpentuli Anno domini* mcccclxxxviii., *Kl. Aprilis,"* etc., sm. folio (55) *Quaritch*, £15 10s.

4995 Lowe (E. J.) Ferns, British and Exotic, 479 col. plates, 8 vol., hf. cf. gt., 1856-60, roy. 8vo. (163) *James*, 16s.

4996 Madeira. History of Madeira, 27 col. plates, hf. cf., g. e., 1821, imp. 8vo. (371) *Spencer*, £2 16s.

4997 Mahon (Lord). History of England, 1701-1783, Liɔrary ed., 8 vol., hf. cf. gt., J. Murray, 1839-54, 8vo. (105) *Rimell*, £1 12s.

4998 Marozzo (Achille). Opera Nova de l'Arte de l'Armi, full-page woodcuts of duelling, etc., hf. bd., no imprint [15—], sm. 4to. (24) *Quaritch*, £3 10s.

4999 Martinet (M.) Coloured Figures of Birds, over 1,000 col. plates (from Buffon), no text, 6 vol., old French mor., g. e., *circa* 1750, 4to. (197) *Edwards*, £6

5000 Massinger (P.) Plays, with Notes ɔy W. Gifford, second ed., 4 vol., cf., m. e., 1813, 8vo. (364) *Dobell*, £1 2s.

5001 Migeon (Gaston). L'Exposition Rétrospective de l'Art Décoratif Français, 1900, illustrations (many printed in colours), 10 parts in 2 portfolios, mor., with ties, *Paris*, Goupil, n. d. (*c.* 1890), folio (282) *Vyt*, £12 10s.

5002 Military Uniforms. Schema aller Uniform der K. K. Kriegsvölkern, front. and 135 col. plates, orig. bds., *Wien*, 1785, 8vo. (1) *Hornstein*, £22 10s.

5003 Milton (John). Works, in Verse and Prose, port., 8 vol., cf. gt., 1863, 8vo. (392) *Edwards*, £4 2s. 6d.

5004 Morris (B. R.) British Game Birds and Wildfowl, 60 col. plates, n. d., 4to. (185) *James*, 12s.

5005 Morris (F. O.) British Moths, col. plates, 4 vol., hf. cf. gt., 1861-70, 8vo. (164) *Wesley*, £1 13s.

5006 Naval Magazine, 13 numɔers, from the commencement in Decemɔer, 1798 to Decemɔer, 1799 (all puɔlished), col. flags, col. plate of Nelson's arms, etc., 1 vol., hf. cf., 1798-9, 8vo. (486) *Phillips*, £1 10s.

5007 Newcastle (Duchess of). Playes, no port., cf., g. e., ex-liɔris of Horace Walpole, 1662—Plays, never ɔefore printed, first ed., each play with separate pagination, front., cf., 1668, folio (676) *Ridge*, £4 16s.

5008 Newcastle (Duke of). Neu Erfundene Anweissung die Pferde Aɔzurichten, Der Vollkommene Bereuter ins Teutsche

XXIV. 23

Geöracht Von Jo. Ph. Bernauer (German and French), front. and engravings of horses and horsemanship, vell., *Nürnberg,* Jo. Ziegers, etc., 1700, folio (151)
Dietrich, £1 4s.

5009 Newes from France, a True Relation of the great losses which happened by the lamentaöle accident of fire in the Citie of Paris, Oct. 24, 1621, etc., hf. bd., 1621, 4to. (568)
Edwards, 16s.

5010 Nicolay (Nicolas de). Les Navigations et Voyages faicts en la Turquie, orig. ed., 60 full-page costumes, after Titian, old cf., 1576, 4to. (601) *Edwards,* £1 2s.

5011 Occult. The English Fortune-Tellers, containing several necessary questions resolved öy the aölest Antient Philosophers and Modern Astrologers, öy J. P., student in astrology, first ed., front. and 48 ports: and astrological signs and circles (some leaves mended), old cf., 1703, 4to. (583)
Llewellyn, £2 4s.

5012 Old Plays. Swetnam, the Woman-hater, arraigned öy Women, 1620—Pathomachia, or the Battell of Affections, Shadowed öy a Faigned Siedge of the Citie Pathopolis, 1620—The Costlie Whore, a Comicall Historie, 1633—The Tragedy of Nero, 1633—The Valiant Scot, by J. W. Gent, 1637—Love à la Mode, a Comedy, written by a Person of Honour, 1663, in 1 vol., mor., g. e. (a few headlines cut into), 1620-63, 4to. (567) *Dobell,* £21

5013 Ovidius. La Vita et Metamorphoses, figurato & aööreviato da Gaör. Symeoni, etc. (complete), woodcuts by Le Petit Bernard, mor. ex., *Lione,* Giov. di Tornes, 1559, 8vo. (8)
Tregaskis, £1 1s.

5014 Palestine Exploration Fund Puölications. Memoirs, 3 vol.— Name Lists—Special Papers—Fauna and Flora of Palestine —Jerusalem—Geology—General Index, together 9 vol., illustrations, and 2 hf. mor. portfolios containing the large map of Western Palestine and the separate plates, 1881-88, 4to. (605) *Bull,* £6 10s.

5015 Pallas (P. S.) Travels through the Southern Provinces of the Russian Empire, 20 col. foldihg views, unlettered proofs, 17 col. plates of costumes, col. vignettes, folding maps and col. plates of animals, etc., 2 vol., cf. gt., 1802-3, 4to. (508)
Selby, £1 1s.

5016 Palliser (Mrs.) History of Lace, first ed., illustrations, 1865, 8vo. (401) *Zaehnsdorf,* 16s.

5017 Perkins (C. C.) Tuscan Sculptors, illustrations, 2 vol., 1864— Italian Sculptors, illustrations, 1868, together 3 vol., orig. cl., 4to. (616) *Joseph,* £3 15s.

5018 Perry (G.) Conchology, 61 col. plates, mor., g. e., 1811, folio (200) *James,* 19s.

5019 Petitot (Jean). Les Emaux de Petitot du Musée Impérial du Louvre, ports., 2 vol., *Paris,* 1862, 4to. (263)
Hoffman, £1 14s.

5020 Playford (John). Select Musicall Ayres and Dialogues, engraving of viols on title and musical notation (wanted A 2),

mor. plain, g. e., *Lond., printed by T. H. for John Playford*, 1653, sm. folio (645) *Ellis, £3*

5021 Ra)elais (F.) Œuvres, édition variorum, augmentée de pièces inédites, etc., 2 ports. and 10 plates after Devéria, and the series of 120 grotesque figures for the "Songes Drolatiques" and the "Carte du Chinonais" (generally missing), some extra plates inserted, 10 vol., contemp. mor., uncut, *Paris*, 1823, 8vo. (485) *Lacroix, £1* 12s. [Vol. x. forms the rare Supplement)y Brunet, entitled, "Récherches)i)liographiques et critiques sur les Éditions Originales des Cinq Livres du Roman Satirique, de Ra)elais, . . . Paris, 1852."—*Catalogue.*]

5022 Ramsay (Sir J. H.) Lancaster and York, a Century of English History, maps and illustrations, 2 vol., *Oxford*, 1892, 8vo. (389) *Harding, £1*

5023 Repton (H.) Designs for the Pavilion at Brighton, col. front. and 13 col. views with the movea)le slips, and other illustrations, orig. hf. cf., with la)el, 1808, folio (692) *Edwards, £1* 3s.

5024 Rowfant Li)rary. Appendix Catalogue of Books and MSS. collected since the printing of the First Catalogue in 1886, by F. Locker-Lampson, front., 350 copies printed, rox., uncut, Chas. Whittingham, 1900, roy. 8vo. (103) *Dobell,* 16s.

5025 Ruskin (John). Modern Painters, 5 vol., 1873, imp. 8vo. (374) *J. Bumpus, £2* 4s.

5026 Ruxner (George). Thurnier-Buch, Von Anfang Ursachen und Herkommen der Thurnier in heyligen Römischen Reich Teutsches Nation, lit. goth., woodcuts, by Jost Amman, etc. (title defective, 2 leaves mended, some leaves stained), vell., *Frankf. à M.*, G. Ra)en, 1566, folio (150) *Hill, £1* 6s.

5027 S. (N.) Merry Jests concerning Popes, Monkes and Friers, trans. into French)y G. I. and into English by R(owland) W(illet), blatk letter, mor., gilt tooled (some headlines cut into, title and last leaf)acked), *Printed by G. Eld*, 1617, 8vo. (445) *Stout, £2* 16s.

5028 Shelley (S.) Beattie (Jas.) The Minstrel, etc., new ed., 6 orig. drawings in sepia by Samuel Shelley inserted, cf., C. Dilly, 1784, 8vo. (5) *Quaritch, £8*

5029 Silvayn (Alex.) The Orator, Englished)y L. P(yot), (*i.e.*, Anthony Munday), russ., title, index and last leaf in MS. (headlines cut into), A. Islip, 1596, 4to. (566) *C. & E. Brown, £3* 12s.

5030 Silver Binding. Dion Cassius. Dione Historico delle guerre & fatti de Romani, per N. Leoniceno, woodcuts,)ound in massive silver cover, the)ack and)orders of Italian ornaments, with an equestrian figure in centres in high relief, one clasp, *Vinegia*, N. d'Aristotile, 1533, sm. 4to. (120) *Dietrich, £3*

5031 Slater (Mrs. John). Little Princes, Anecdotes of Illustrious Children, col. illustrations, 1845, 8vo. (405) *Edwards, £1* 6s.

23—2

[Presentation copy from Queen Victoria, with the following inscription in her autograph : " A mon cher Cousin Le Comte de Paris, de son affectionée Cousine Victoria R."— *Catalogue.*]

5032 Smith (Wm.) History of Canada, from its Discovery to the Year 1791, 2 vol., LARGE PAPER, uncut (wanted folding sheet of census in vol. ii.), *Quebec,* J. Neilson, 1815 (108)
Mahon, £5
[Inserted is a pamphlet, " Observations d'un catholique sur l'histoire du Canada par l'Honorable William Smith" (par Père McGuire), 1827. John Neilson's copy, with his MS. notes and Wm. Brown's bookplate.—*Catalogue.*]

5033 Sowerby (J. E.) English Botany, 1,824 col. plates, 11 vol., hf. cf. gt., 1863-72, 8vo. (160) *Quaritch, £10 10s.*

5034 Stevenson (H.) and Southwell (T.) Birds of Norfolk, port. and plates, 3 vol., cl., 1866-90, 8vo. (248) *Edwards, £1 18s.*

5035 Stockholms Almanach Pa Aret 1773, uplagd af Kongl. Wenskaps-Academien och tryckt ho Henr. Jongt, in a silk pocket with outside silk and embroidered case with mirror, *Stockholm,* 1773, 64mo. (100) *Tregaskis, £1 8s.*

5036 Swift (J.) Travels, by Lemuel Gulliver, first ed., port. and maps, continuous pagination to each vol., cf., name on titles, 1726, 8vo. (369) *Tregaskis, £2 14s.*

5037 Terentius. Comediae commentario Guidonis Juvenalis, woodcuts of theatrical scenes (wanted title and colophon, leaf of dedication mended, some leaves stained and wormed), modern mor. [*Lugduni,* Jo. Trechsel, 1493], 4to. (26)
Leighton, £4 14s.

5038 Terentius, cum Directorio, Glosa interlineali et Commentariis Donato, Guidone, Ascensio, etc., lit. goth. and rom., woodcuts of theatrical scenes, some touched with colours (title packed, a few leaves wormed and soiled,) hf. cf., r. e., the first ed. of Terence with these woodcuts, *Argent.,* Jo. Grüninger, 1496, folio (47) *Quaritch, £5*

5039 Terentius cum quatuor Commentariis Videlicet Donati, Guidonis, Calphurnii & Ascensii, lit. rom., Italian outline woodcuts, the full-page one on reverse of title had a small hole in it (some leaves stained and shaved), modern cf., *Venetiis per Lazarum de Soardis,* 1499, folio (50)
Barnard, £3 3s.

5040 Terry (D.) British Theatrical Gallery, 20 character ports., 1825, folio (679) *C. & E. Brown,* 16s.

5041 Theurdannckh. Pfinzing (Melchior). Der aller-durchleuchtigste Ritter, oder Grossthaten, Abentheuer, etc. des Heldens Maximilian I. Imp., lit. goth., front. and 117 woodcuts by Hans Schaufflein, orig. German oak bds., stamped pigskin, *Augspurg,* M. Schultes, 1679, folio (145) *Edwards, £1 19s.*

5042 Theurdannckh. Another edition, in German, lit. goth., 123 woodcuts, orig. German oak bds., stamped pigskin, *Ulm,* M. Schultes, 1679, folio (146) *Hill,* 10s.

5043 Thomas Aquinas (S.) Super tertio libro Sententiarum Petri

Lombardi, **lit. gotħ.**, 68 lines, with signs., capitals painted, 2 illuminated initials in the taɔle, miniature of S. Thomas Aquinas, lower margins decorated, illuminated initial to each section, orig. monastic oak bds. and leather, stamped with fleur-de-lis and the word " Maria," metal clasp catches (ɔack slightly damaged), *Venet.*, H. Liechtenstein Coloniensis, 1490, folio (149) *Halliday*, £4 12s.

5044 Thornton (R. J.) Illustrations of the Sexual System of Linnaeus, ports. and plates, 3 parts in 2 vol., plain and col. cf., 1799-1807, atlas folio (207) *Wesley*, £4

5045 Thornton (R. J.) Temple of Flora, col. plates, mor., g. e., 1812, folio (154) *Wreathall*, £1 2s.

5046 Vale Press. Browne (Sir T.) Religio Medici, Urn Burial, Christian Morals and other Essays, printed upon vellum, prepared for ɔinding, Hacon and Ricketts, 1902, sm. folio (91) £1. 14s.

5047 Vale Press. Field (Michael). Julia Domna, a Play, printed upon vellum, vell., Hacon and Ricketts, 1903, sm. 4to. (92) *Dobell*, 16s.

5048 Vale Press. Field (Michael). The Race of Leaves, a Play, printed upon vellum, prepared for ɔinding, Hacon and Ricketts, 1901, sm. 4to. (93) *Dobell*, 10s.

5049 Vale Press. Danaë, a Poem, by T. Sturge Moore, printed upon vellum, vell., Hacon and Ricketts, 1903, sm. 4to. (94) *Dobell*, £1 3s.

5050 Vale Press. Paraɔles from the Gospels, 10 orig. woodcuts ɔy Ch. Ricketts, printed upon vellum, Hacon and Ricketts, 1903, sm. 4to. (95) *Edwards*, £1 1s.

5051 Vale Press. The Kinges Quhair, ed. ɔy R. Steele, printed upon vellum, vell., Hacon and Ricketts, 1903, sm. 4to. (96) *Downing*, £1

5052 Vale Press. Ecclesiastes, or the Preacher and the Song of Solomon, printed upon vellum, vell., Hacon and Ricketts, n. d., sm. folio (97) *Dobell*, 18s.

5053 Vecellio (Cesare). Haɔiti Antichi et Moderni, upwards of 500 plates of costumes, including those of America, from designs ɔy Titian, hf. vell., *Venetia*, 1598, 8vo. (470) *Lacroix*, £1 1s.

5054 Vegetius (Fl.) De Re Militari, woodcuts, paper covers, *Lutetiae, ap. Chr. Wechelum*, 1532, folio (152) *Edwards*, 18s.

5055 [Voltaire.] Questions sur les Miracles à Monsieur le Professeur Cl . . . par un Proposant—Autres Questions d'un Proposant à Mr. le Professeur en Théologie sur les Miracles —Réponse d'un Théologien au docte Proposant des autres Questions—Troisième Lettre du Proposant à Monsieur le Professeur en Théologie—Quatrième Lettre d'un Proposant à Mr. le Professeur et Remerciments à ses extrêmes ɔontés —Cinquième Lettre du Proposant à Monsieur N . . .— Parodie de la Troisème Lettre du Proposant addressée à un Philosophe—Sixième Lettre sur les Miracles—Septième Lettre de Mr. Covelle sur les Miracles—Huitième Lettre

sur les Miracles, in 1 vol., orig. ed., entirely uncut, 8vo.
(494) *A. Jones*, £1
[These tracts belong to the rarest of Voltaire's produc-
tions, and are rarely met with in so fine a condition.—
Catalogue.]
5056 [Wesley (S.)] Maggots, or Poems on Several Subjects, first
ed., front., cf., g. e. (a small piece torn off title, one leaf im-
perfect), *Printed for John Dunton*, 1685, 8vo. (377)
 Stout, £2 14s.
5057 Westwood (J. O.) British Moths and their Transformations,
124 col. plates, 2 vol., hf. cf. gt., 1857, 4to. (196)
 James, £1 1s.
5058 Wilkinson (J. G.) Manners and Customs of the Ancient
Egyptians, first ed., both series, 6 vol. (including the vol. of
plates), plates (col. and plain), uncut, 1837-41, 8vo. (495)
 Shepherd, 16s.
5059 Wilson (J.) Illustrations of Zoology, col. plates, hf. mor.,
g. e., 1831, folio (204) *James*, £1 5s.
5060 Winsor (Justin). Memorial History of Boston, Mass., illus-
trations, 4 vol., hf. cf., *Boston*, 1880, 4to. (558)
 Edwards, 16s.
5061 Wit and Drollery, Jovial Poems, cf. (a few headlines cut into),
Obadiah Blagrave, 1682, 8vo. (459) *Ridge*, £1 16s.
5062 Wolf (Johann) und Meyer (B.) Naturgeschichte der Vögel
Deutschlands (Text in German and French), 177 col. plates,
2 vol., hf. mor., *Nürnberg*, 1805, folio (216) *Wesley*, £4 6s.

[MARCH 16TH, 17TH AND 18TH, 1910.]

HODGSON & CO.

A MISCELLANEOUS COLLECTION.

(No. of Lots, 945 ; amount realised, £1,103 10s.)

5063 Albertus Magnus. De Animalibus, gothic letter, woodcut
initials, old Italian stamped cf., with small medallion heads
(repaired), *Venetiis*, 1519, folio (95) £4 5s.
[Sold on February 24th.—ED.]
5064 America. Map of the Trading Part of the West Indies,
including the Seat of War, col. in outline, with 10 engraved
views including New York and Boston, in margins (3ft 5in.
by 2ft.), R. Sayer [*ca.* 1776,] (271) *Leon*, £7 7s.
5065 America. Map of the Province of New York, with part of
Pensilvania and Quebec, by Major Holland and Governor
Pownall, col., with plan of New York City (4ft. 5in. by
1ft. 8½in.), 1776 (272) *Edwards*, £2 2s.

5066 America. Map of Theatre of War in North America, with Roads and Table of Distances, col. in outline, with Printed Account of the British Colonies at foot, R. Sayer, 1776 (273) *Leon,* £1 11s.

5067 America. [Dummer (J.)] A Letter to a Noble Lord concerning the Late Expedition to Canada, 1712—[Defoe (D.)] Essay on the South Sea Trade, 1712, etc. (3)—[Davenant]. New Dialogues on the Bank, East India Company, etc., vol. ii., 1710, in 1 vol., cf., 8vo. (44) *Leon,* £7

5068 Annual of the British School at Athens, Nos. 3 to 14, being Sessions 1896-7 to 1907-8, illustrations (some col.), 12 vol., sm. 4to. (468) £4 10s.

5069 Ars Moriendi. Kunst Wolzusterben . . . durch Adam Walasser in Truck verfertiget, full-page woodcuts, orig. stamped leather over oak bds., Dilingen, 1570, 8vo. (226) *Edwards,* £1 16s.

5070 Ashmole (E.) Order of the Garter, port. and folding plates by Hollar, etc., cf., 1672 (151) *Maggs,* £1 6s.

5071 Bale (J., Bishop of Ossory). The Actes of Englysh Votaryes: First Part, woodcut on first leaf (4 preliminary leaves and A-K in 8's, last blank), *Imprynted at London by Abraham Vele,* 1551—Second Part, (A-P in 8's, Q. 4 leaves), *Imprinted at London . . . and solde wythin Paule's Chayne,* 1551, in 1 vol., hf. mor. (207) *Tregaskis,* £2 12s.

5072 Balzac (H. de). La Comédie Humaine, Temple ed., ed. by G. Saintsbury, etched fronts. by W. Boucher, 40 vol., cl., t. e. g., 1901, 8vo. (403) £3 8s.

5073 Beacon (R.) Solon his Follie, or A Politique Discourse, a few contemp. MS. notes (wormed), vell., *At Oxford, printed by Joseph Barnes,* 1594, sm. 4to. (209) *Tregaskis,* £5

5074 Beardsley (A.) The Early Work of Aubrey Beardsley, Japan paper ed., illustrations, cl., t. e. g., 1899, 4to. (410)—The Later Work of Aubrey Beardsley, Japan paper ed., illustrations, cl., t. e. g., 1901, 4to. (411) £4 7s. 6d.

5075 Beaumont and Fletcher. Fifty Comedies and Tragedies, port., with verses beneath, by Marshall, cf. (worn), *J. Macock, for John Martyn, Henry Herringman, Richard Marriot,* 1679, folio (113) *Edwards,* £5 17s. 6d.

5076 Behn (Mrs. A.) Poems upon Several Occasions, first ed. (wormhole in inner margin), cf., R. and J. Tonson, 1684, 8vo. (132) *Pickering,* £1 11s.

5077 Black Letter Acts, temp. Charles II. to Queen Anne, relating to Burying in Woollen, Coynage, Clipped Money, Exportation of Corn and Leather, the Poor, Encouragement of Trade to America, etc. (100), in 1 vol., old cf., with contemp. MS. index, 1672-1717, folio (71) *Maggs,* £2

5078 Black Letter Acts, temp. Charles II. to William III., relating to the Prohibition of the Exportation of Corn and Wool, Trade to Russia and to Newfoundland, Inland Navigation, etc., in 2 vol., cf. and vell., 1678-99, folio (72) *Edwards,* £1 8s.

5079 Black Letter Acts, 12 Queen Anne to 9 George II., relating to the Bank of England, South Sea Scheme, Lotteries, etc., in 12 vol., old cf., 1714-35 (73)—Black Letter Acts, 10-13 George II., 2 vol., old cf., J. Baskett, 1736-40 (74)—Black ·Letter Acts, 14-28 George II., uniformly ɔound in 15 vol., old cf., 1740-55, folio (75) *Sotheran*, £8

5080 Blome (R.) Britannia, maps of each county, and plates of arms, cf., 1673, folio (149) £1

5081 Booke of Common Prayer (The), first ed. of Laud's ɔook, *Edinburgh,* R. Young, 1637—The Psalter, *Edinburgh,* 1636—The Psalmes in metre, with music, *London,* T. Harper, 1636, **black letter**, in 1 vol., cf., 1637-36, folio (161) *Edwards,* £5 7s. 6d.

5082 Bosman (W.) Description of the Coast of Guinea, folding map and plates of forts, cf., 1705, 8vo. (47) *Edwards,* 15s.

5083 Breviarium Bambergense [Hain, No. 3797], part ii. containing 387 leaves (imperfect), printed throughout in red and ɔlack, initial letters illuminated, one with floral ɔorder, with 14 pages of Supplementary Prayers in a contemp. hand, old cf., *Babenbergæ,* J. Sensenschmidt et H. Petzensteiner, 1484, 8vo. (229) *Barnard,* £3

5084 Brieger (J.) Flores Calvinistici decerpti ex Vita Roɔerti Dudlei, etc., mor., g. e., *Neapoli,* 1585, 12mo. (225) *Pearson,* £1 10s.

5085 Browning (R.) Poetical Works, complete ed., 17 vol., cl., Smith, Elder and Co., 1888-94, 8vo. (453) £2 14s.

5086 Burns (R.) Works, Liɔrary ed., port., plates and facs., 6 vol., cl., *Edin.,* 1877-79, imp. 8vo. (437) £1 6s.

5087 Burton (R.) Anatomy of Melancholy, engraved title in compartments ɔy Blon (with "The Argument of the Frontispiece"), cf., clean copy, 1676, folio (115) *Ridler,* £1 14s.

5088 Byron. The Poetical Works of the late Thomas Little, Esq. [*i.e.,* Thomas Moore], with the autograph of Edward Noel Long, "Olim Trin. Coll. nunc Colᵐ Gᵈˢ" on title, and a poem of 12 lines, commencing "Ah! memory! torture me no more. The present's all oercast," signed "Byron, May 18th, 1806," in the handwriting of Lord Byron, written on the front fly-leaf and inner cover, orig. bds., uncut, 1805, 8vo. (228) *Maggs,* £17 5s.
 [Moore ɔelieved these lines to be ɔy the poet, but subsequently corrected his mistake (*see* the Collected Edition of 1834, vol. i., page 85). Sold on Feɔruary 24th.—ED.]

5089 Calentinius (E.) Opuscula—Elegiæ, Epigrammaton Libellus, Satyra contra Poetas, etc., old mor., g. e., *Romæ,* J. de Belicken, 1503, 4to. (221) *Ellis,* £1 10s.

5090 Cicero. Marcus Tullius Ciceroes three Bookes of Duties, ɔy Nicolas Grimaldi, partly **black letter**, woodcut title, hf. cf., T. Este, 1596, 12mo. (206) *Tregaskis,* £1 4s.

5091 Coinage. A Review of the Universal Remedy for all Diseases incident to Coin. In a Letter to Mr. Locke, 1696, and Second Letter to Mr. Locke, 1696—Leigh (E.) An Essay upon Credit, 1715—Thoughts on our Silver Coin, 1718—

Letter to a Friend relating to Coin, 1718—An Account of all the Gold and Silver Coins ever used in England, 1718, and 3 other Tracts relating to the same, in 1 vol., cf., 8vo. (56) *Sotheran, £8* 5s.

5092 Cotgrave (R.) French-English Dictionary, with another in English and French, by R. Sherwood, 1 woodcut title, 2 parts in 1 vol., old cf., 1650, folio (292) *Sims, £1* 14s.

5093 Cracklow (C. T.) The Churches of Surrey, 158 litho plates, with Historical Notices (some text wanted), hf. mor., g. e., 1827, 4to. (263) *Adams, £5* 2s. 6d.

5094 Crowne (J.) Plays, viz., Juliana, a Tragi-comedy, 1671— Andromache, a Tragedy, translated by Crowne, 1675—The Ambitious Statesman, 1679—Henry the Sixth, 1681— Thyestes, 1681, and others (18), by the same, chiefly first eds. (a few headlines shaved and 4 titles missing), in 2 vol., cf., sm. 4to. (125) *Pickering, £1* 8s.

5095 D'Acugna (C.), Acarete (M.) and Grillet (M.) Voyages and Discoveries in South America, folding maps, 3 parts in 1 vol., cf., 1698, 8vo. (42) *Maggs, £2* 2s.

5096 Dampier (Capt. W.) Voyages round the World, folding maps and plates, 4 vol., cf., 1697-1705-1703-1709, 8vo. (41) *Edwards, £2* 6s.

5097 Dante Alighieri. La Divina Commedia, col. Comento di Christ. Landino, large woodcut to the Inferno and 99 woodcuts in the text, from an edition printed in 1491 (the 10 preliminary leaves wanted, w. a. f.), bds., *Venetia, per P. de Zunanne di Quarengii,* 1497, folio (275) *£8* 10s.

5098 Davenant (Sir W.) Two Excellent Plays. The Wits, a Comedy—The Platonick Lovers, a Tragi-Comedie, cf., 1665, 8vo. (118) *£2*

5099 Davenant (Sir W.) Works, first collected ed., engraved port. by Faithorne after Grenhill, cf., *Printed by T. N. for Henry Herringman,* 1673, folio (117) *Pickering, £3* 12s. 6d.

5100 Digges (Sir Dudley). The Compleat Ambassador, title by Faithorne containing ports. of Queen Elizabeth, Burleigh and Walsingham, old cf., 1655, folio (18) *£1*

5101 Donovan (E.) Natural History of the Insects of New Holland, New Zealand, etc., 41 col. plates, hf. mor., g. e., 1805, 4to. (564) *£10*

5102 Dryden (John). Miscellany Poems, with contributions by Dryden, Waller, Nat Lee, Addison, Earl of Rochester, etc., front., the 6 parts complete in 5 vol. (parts iii. to vi. first eds.), cf., *Printed for Jacob Tonson,* 1693-1708, 8vo. (122) *Dobell, £3*

5103 Elzevir. Livii Historiarum "quod extat," engraved title, mor., g. e., by Bedford, *Amst., D.* Elzevir, 1678, 12mo. (222) *Maggs, £1* 1s.

5104 Erasmus (Des.) Enchiridion Militis Christiani, contemp. cf., with escutcheon bearing the Tudor royal arms supported by dragon and hound, with binder's initials G. R., and inscription in border, the lower cover in 4 compartments,

each containing full-length figure of a Saint, in good con-
dition, *Argentorati*, J. Knobluch, 1524, 8vo. (230)
 Maggs, £6 6s.
5105 Fitzgerald (E.) Ruɔáiyát of Omar Khayyám, reprinted
 privately from the London edition, with an extract from
 the Calcutta Review (No. 59, March, 1856), a Note ɔy
 M. Garcin de Tassy, and a few additional Quatrains (limited
 to 50 copies), presentation copy from the editor, with
 inscription "Charles Austin, Esq., with kind regards from
 W. S., Feb. 1/64," orig. pink cl., label on upper cover,
 Madras, 1862, 8vo. (245) £16
 [The aɔove copy is of interest on account of its having
 ɔeen given by Dr. Whitley Stokes, who is understood to
 have ɔeen the editor of the vol. [*see* Col. Prideaux's Biɔlio-
 graphy of Fitzgerald]. The additional Quatrains have a
 few corrections apparently in the autograph of the editor.
 —*Catalogue.*]
5106 Fores's Sporting Notes and Sketches, illustrations ɔy Finch
 Mason and others, from 1884 to 1907, 24 vol., cl., g. e., 8vo.
 (133) *James*, £6 2s. 6d.
 [Sold on Feɔruary 24th.—ED.]
5107 Garcilaso de la Vega. Royal Commentaries of Peru, trans.
 by Rycaut, port. and plates, cf., 1688, folio (144)
 Maggs, £2 1s.
5108 Grose (F.) and Astle (F.) Antiquarian Repertory, ports. and
 engravings, 4 vol., hf. mor., 1807-9, roy. 4to. (262)
 Ryan, £1 5s.
5109 Hafiz. The Divan, written in the 14th century, trans. from
 the Persian ɔy H. W. Clarke, 2 vol., cl., 1891, 4to. (419)
 15s.
5110 Hale (T.) New Inventions relating to Building Ships, Pub-
 lick Taxes, etc., with Petty's Naval Philosophy, folding
 "Survey of the Thames," cf., 1691, 12mo. (200) *Maggs*, 16s.
5111 Harington (Sir J.) Orlando Furioso, engraved title, port.
 and engravings (a few leaves defective), cf., 1634, folio (112)
 Hill, £1 10s.
5112 Hastings (J.) Dictionary of the Biɔle, maps and cuts, 4 vol.,
 cl., 1906, imp. 8vo. (457) £2 1s.
5113 Hennepin (L.) A New Discovery of a Vast Country in
 America, etc., engraved front., 2 folding maps and 6 plates,
 2 parts in 1 vol., cf., 1698, 8vo. (40) *Edwards*, £16
5114 Hieronymi Epistolæ, opera ac studio Mariani Victorii Reatini,
 woodcut initials, 3 vol. in 4, cf. gt., with the Caraffa arms,
 Romæ, P. Manutius, 1565, folio (277) £1 1s.
5115 Hoɔɔes (T.) Leviathan, first ed. (4 leaves stained), old Eng-
 lish mor., g. e., 1651, folio (23) *Maggs*, £1 5s.
5116 Horæ Beatæ Mariæ Virginis ad usum Parisiense, a Fifteenth-
 Century MS., written by a French Scriɔe, on 170 leaves of
 vellum (6¾ in. ɔy 4⅝ in.), with Kalendar, containing 5
 miniatures of the evangelists, etc., 13 illuminations, occupy-
 ing three-quarters of the page (at the Penitential Psalms,
 David and Bathsheɔa—Office of the Dead, Job kneeling),

and 11 miniatures in the Memoriæ (including S. Geneviève),
an illuminated ɔorder on every page and several hundred
initial letters, heightened with gold, old cf., gilt and gauf-
fered edges (upper cover ɔroken) (227) *Hornstein,* £49

5117 Hortulus Animæ (cum Calendario), **gothic letter,** woodcuts,
every page within ɔorder, Clein's device at end, coloured
throughout by an early hand (ɔorders of a few leaves at
each end defective and one leaf wanted), vell., g. e., *Lug-
duni,* J. Clein, 1516, 8vo. (228) *Barnard,* £4 12s. 6d.

5118 Houghton (J.) Collection of Letters for the Improvement of
Husɔandry and Trade, from March 30th, 1692 to Sept. 18th,
1696 (ɔeing Nos. 1-216, or vol. i.-ix.), in 1 vol., old cf., folio
(51) *Leon,* £10

5119 House of Lords Journals (1509-1681), 13 vol.—Journals of the
House of Commons (1547-1772), 33 vol.—Indexes, 2 vol.—
Reports (1715-1773), 4 vol., together 52 vol., orig. hf. ɔind-
ing, uncut, folio (166) *Carter,* £1 2s.

5120 Joe Lisle's Play upon Words, 38 humorous col. plates, with
descriptions ɔeneath (no title), hf. cf., T. McLean, 1828,
oɔlong 8vo. (246) £1 11s.

5121 [Johnson (S.)] The Prince of Aɔissinia, first ed., 2 vol. in 1
(name on title of vol. i.), old cf., R. and J. Dodsley, 1759,
8vo. (194) *Edwards,* £4 4s.

5122 Jonson (Ben). Works, port. by Elder, cf., 1692, folio (114)
Edwards, £2 12s.

5123 Kæmpfer (E.) History of Japan, by Scheuchzer, maps and
plates, 2 vol., hf. mor., 1728, folio (279) *Myers,* £4 2s. 6d.
[Sold on Feɔruary 24th.—ED.]

5124 Killigrew (T.) Comedies and Tragedies, first ed., fine im-
pression of the port. of the author with his dog, by
Faithorne, contemp. cf., Henry Herringman, 1664, folio
(116) *Quaritch,* £29

5125 Kipling (R.) Works, Macmillan's pocket ed. on thin paper,
20 vol., leather, gt. ɔacks, t. e. g., 1909, fcap 8vo. (406)
Winter, £2 17s. 6d.

5126 Langley (Batty). Pomona, or the Fruit-Garden Illustrated,
plates, col. copy, cf., 1729, folio (283) £1 6s.

5127 Lery (J. de). Histoire d'un Voyage fait en la Terre du Bresil,
woodcuts (wormed), mor. ex., *Geneva,* E. Vignon, 1594,
12mo. (213) £2

5128 L'Estrange (Sir R.) A Collection of Tracts by Sir R.
L'Estrange, comprising A Caveat to the Cavaliers—A Dis-
course of the Fishery—Citt and Bumpkin, 2 parts—The
Shammer Shamm'd, and others by the same (46), in 4 vol.,
cf., 1660-82, sm. 4to. (34) *Pickering,* £2 12s. 6d.

5129 Ligon (R.) History of the Island of Barɔadoes, map, plates,
etc., orig. cf., 1673, folio (39) *Tregaskis,* £2 16s.

5130 Lowndes (W.) A Report containing an Essay for the Amend-
ment of Silver Coins, cf., C. Bill, Sept. 12th, 1695, 8vo. (55)
Tregaskis, £2

5131 Marcort (A.) Declaration de la Messe, **lettres batardes,** hf.
mor., 1544, 18mo. (218) £1 10s.

5132 [Marston (J.)] Tragedies and Comedies, first ed., with the orig. title-page, but the second issue of the plays (1 leaf defective and a few stained), cf., 1633, 8vo. (198)
Pickering, £4 10s.

5133 Milton (J.) A Brief History of Moscovia, first ed., contemp. sheep, 1682, 12mo. (199) *Tregaskis*, £2

5134 Milton (J.) Paradise Lost, first ed., seventh title-page and the seven leaves of argument (last leaf defective), (6¼in. ɔy 5⅜in.), old sheep, *Printed by S. Simmons, and are to be sold by T. Helder,* 1669, sm. 4to. (222) *Pickering*, £23
[Sold on February 24th.—ED.]

5135 Newcastle (Duke of). The Triumphant Widow, a Comedy— The Humorous Lovers, a Comedy, first eds., in 1 vol., cf., *J. M. for H. Herringman*, 1677, sm. 4to. (120)
Tregaskis, £3 2s. 6d.

5136 Newcastle (Duchess of). Plays, never ɔefore printed (forming the second volume and containing Five Plays), first ed., port. ɔy Van Schuppen, cf., 1668—Poems and Phancies (no port.), cf., 1664, together 2 vol., folio (119) *Maggs*, £5

5137 Ogilɔy (J.) Africa, douɔle-page engravings and folding map, cf., 1670, folio (142) *Maggs*, £1 11s.

5138 Ogilɔy (J.) Asia, folding map, charts and plates, cf., 1673, folio (143) *Maggs*, £1

5139 O'Shaughnessy (A. W. E.) An Epic of Women and other Poems, first ed., frontispiece, cl., 1870, 8vo. (418) £1

5140 Ovid. La Vita et Metamorfoseo d' Ovidio, figurato da M. Gaɔriello Symeoni, 188 woodcuts ɔy Little Bernard, mor. ex., inlaid, *Lione*, 1559, sm. 4to. (204) £2 17s. 6d.

5141 Oxford Printing. Master Bezaes Sermons upon the three first Chapters of the Canticle . . . trans. ɔy J. Harmar (title repaired), cf., m. e., *Oxford*, J. Barnes, 1587, 8vo. (208) *Dobell*, £1

5142 Paradin (Guillaume). Cronique de Savoye, cf., g. e., *Lyon*, Jean de Tournes, 1552, sm. folio (219) 16s.

5143 Paradin (G.) Continuation de l'Histoire de Nostre Temps, mor. ex., *Paris*, 1575, 12mo. (220) *Barnard*, 18s.

5144 Paré (Amɔroise). Œuvres, woodcut title and cuts of Natural History, Anatomy, Monstrosities, etc., old cf. (reɔacked), *Paris*, 1585, folio (270) *Sims*, £1 15s.

5145 Pater (W. H.) Studies in the History of the Renaissance, first ed., cl., 1873, 8vo. (416) *Edwards*, £2 8s.

5146 Political State of Great Britain, large map of the plantations and folding taɔles, from the commencement in 1711 to June, 1728, in 37 vol., and 14 vol. ɔetween 1729 and 1738, in 51 vol., cf., 1711-1738, 8vo. (80) *Maggs*, £11 15s.

5147 Pope (A.) Poetical Works, first collected ed., large folding port. by Vertue, cf., 1717, folio (442) 16s.

5148 Ptolemaei de Analemmate et Commandini de Horologiorum descriptione, diagrams, mor. ex., *Romæ*, P. Manutius, 1562, sm. 4to. (202) 17s.

5149 Queen Mary. A Collection of Poems on the Death of Queen Mary, ɔy Nahum Tate, Samuel Wesley, John Dennis, W.

Congreve, John Phillips, S. Strode and others, some first
eds., mostly within ɔlack ɔorders (34), front. (stained), in 1
vol., cf., 1695, folio—Lacrymæ Cantabrigienses in Obitum
Reginæ Mariæ, cf., *Cantabrigiæ*, 1695, sm. 4to. (130) £6 6s.
5150 Raɔelais (F.) Œuvres, 2 vol., mor., g. e. [Elzevir], 1669,
12mo. (216) *Ellis*, 18s.
5151 Riverside Natural History (The), ed. by J. S. Kingsley, plates
(some col.) and other illustrations, 6 vol., cl., 1888, imp. 8vo.
(241) £1 2s.
5152 Saint-Simon (Duc de). Mémoires Complèts et Authentiques,
21 vol., old cf., *Paris*, 1829-30, 8vo. (354) £1 19s.
5153 Sandford (F.) Genealogical History of the Kings of Portugal,
plate of emɔlems and coats-of-arms, old cf., g. e., 1662, folio
(177) 16s.
5154 Scott (Sir W.) Ivanhoe, first ed., 3 vol., orig. bds., with the
laɔels, edges untrimmed, *Edinburgh*, 1820, 8vo. (256)
 Maggs, £2 5s.
5155 Shakespeare Society. Puɔlications. Papers, 4 vol.—Fairy
Mythology—Registers of the Stationers' Company, 2 vol.—
Coventry Mysteries, and others, ed. ɔy J. P. Collier, J. O.
Halliwell, etc., 31 vol., cl., 1841-9, 8vo. (253) £2 18s.
5156 Sharp (T.) Dissertation on the Pageants, anciently per-
formed at Coventry, plates, uncut, *Coventry*, 1825, 4to. (264)
 17s.
5157 Smith (Capt. John). England's Improvement Reviv'd (Trade,
Sovereignty of the Seas, Fisheries, etc.), cf., *Printed for
the Author*, 1670, sm. 4to. (30) *Pickering*, £2
5158 Smith (Capt. J.) Generall Historie of Virginia, 2 folding
plates of "Ould Virginia" and "The Summer Ils," and the
large map of Virginia (but wanted the engraved title, the
map of New England and the 2 ports.), (11⅛ ɔy 7⅜ in.,)
orig. sheep [1627] (37) *Sabin*, £32
5159 South Sea Scheme. View of the Coasts and Islands of the
South Sea Company, first ed., large folding map of South
America ɔy Moll, cf., 1711 (45) *Ellis*, £2 10s.
5160 Stevens (Capt. J.) General History of Taxes, 1728—Gee.
The Trade of Great Britain, third ed., 1731—Cary. Dis-
course on Trade, 1745, together 3 vol., cf., 8vo. (33)
 Sotheran, £1 18s.
5161 [Swift (J.)] Travels into several Remote Nations of the
World, first ed., port. and maps, 4 parts in 2 vol., old cf., B.
Motte, 1726, 8vo. (193) *Hornstein*, £1 19s.
5162 Thackeray (W. M.) Works, Liɔrary ed., 22 vol., hf. mor.,
Smith, Elder [1869], 8vo. (254) *J. & E. Bumpus*, £6 7s. 6d.
5163 Trade. Rates payaɔle ɔy the Tariff of 1664 on all Goods
imported into or exported from France, 1714—The Assiento
Contract Consider'd, also the Advantages of the Trade of
Jamaica, 1714—Letter to the Honble A[rthur] M[oore],
1714—Memoirs of Count Tariff, 1713—Tryal of Count
Tariff, 1713—[Defoe (D.)] The Villany of Stock-Joɔɔers
detected, 1701 — Remarks upon the Bank of England,
second ed., 1706, and others (9), in 1 vol., cf. (59)
 Sotheran, £5

5164 Trade. [Defoe (D.)] General History of Trade, 4 parts,
June-September, 1713—Essay on the Treaty of Commerce
with France, 1713—Further Observations, with a folding
"Scheme of the Trade carried on between England and
France," 1713—Letter to Sir R[obert] H[arley] on the
Trade and Manufactures, 1713—The 8th and 9th Articles
of the Treaty of Commerce, 1713—[Fortrey (I..)] Eng-
land's Interest consider'd, 1713—Mun· (T.) England's
Treasure by Foreign Trade, 1713, and others (9), in 1 vol.,
cf., 8vo. (58) *Sotheran,* £9 10s.

5165 Valentia (G. Viscount). Voyages and Travels, plates and
maps, 3 vol., cf., 1809, 4to. (261) *James,* £1 1s.

5166 Weever (J.) Ancient Funerall Monuments, title in compart-
ments and woodcuts, cf., 1631, folio (148) *Ridler,* 16s.

5167 Wilde (Oscar). Poems, first ed., vell., t. e. g., David Bogue,
1881, 8vo. (257) *Shepherd,* £3 17s. 6d.

5168 Wilde (O.) The Sphinx, first ed. (limited to 200 copies),
vell. ex., Elkin Mathews and John Lane, 1894, sm. 4to. (258)
 Hatchard, £5 6s.

5169 Wilde (O.) Intentions, first ed., presentation copy, "To
Constance, with the Author's Love. April, '91," cl., uncut,
Osgood, M'Ilvaine and Co., 1891, 8vo. (259) £5 5s.

5170 Wilde (O.) Intentions, first ed., cl., uncut, Osgood, M'Ilvaine,
1891, 8vo. (260) £1 11s.

5171 Wilde (O.) Lady Windermere's Fan, first ed., vell. (binding
defective), 1893, 8vo. (407) £2 10s.

5172 Wilde (O.) The Picture of Dorian Gray, first ed., hf. vell.,
Ward, Lock and Co. (1891), 8vo. (408) £1 .7s.

5173 Wilde (O.) Works, first collected ed., Japanese vellum copy
(limited to 80 sets), 12 vol., vell. ex., Methuen and Co., 1908,
8vo. (409) £14

5174 [Wishart (G.)] History of the King's Affaires under the
Marquis of Montrose, port., russ., g. e., Haghe, 1648, 8vo.
(212) £1

5175 Wit at a Venture, or Clio's Privy Garden [including an Elegy
of the Death of Admiral Spragge and a curious reference to
"Cricket or Gauff"], russ. (first 9 leaves wormed), J. Edwin,
1674, 12mo. (197) *Dobell,* £3 10s.

5176 Wool, etc. Treatise of Wool and the Manufacture of it, 1685
—An Essay on Wool and Woollen Manufactures, 1693—
[Petty (Sir W.)] A Treatise of Taxes and Contributions,
1685—Reasons for a Registry [for Lands], shewing the
Great Benefits and Advantages, etc., 1678 — Reasons
against the same [being an Answer to the foregoing], 1678
—England's Interest, or a Discipline for Seamen, 1694, in
1 vol., cf. (some margins shaved), sm. 4to. (31)
 Leon, £4 10s.

SOTHEBY, WILKINSON & HODGE.

A MISCELLANEOUS COLLECTION.

(No. of Lots, 662 ; amount realised, £5,318 11s.)

5177 Ackermann (R.) History of the Colleges of Winchester, Eton and Westminster, etc., col. plates by Pugin, etc., orig. hf. russ., 1816, roy. 4to. (105) *Butt, £24*

5178 Ackermann (R.) Microcosm of London, col. plates by Pugin and Rowlandson, 3 vol., hf. cf. (1811), roy. 4to. (191) *Hornstein, £14 10s.*

5179 Adam (Rob.) Ruins of the Palace of the Emperor Diocletian at Spalatro, 61 plates, proofs, old English mor. ex., 1763, imp. folio (316) *Howell, £3 12s.*

5180 Addison (Joseph). Works, Baskerville's ed., port. and plates after Hayman, 4 vol., old French mor., line tooled (Derome), *Birmingham*, Baskerville and Tonson, 1761, 4to. (277) *Edwards, £5 17s. 6d.*

5181 Ælianus et Polybius. La Milice des Grecs et Romains, traduite en François du Grec, par Louys de Machault, engraved title by Jasper Isac, copperplate engravings of military operations, old cf., silk back, *Paris*, H. Drouart, 1616, folio (367) *Quaritch, £2 12s.*

5182 Æsopus. Fabulae, Graecè, 58 full-page woodcuts, old French mor., g. e. (Derome), *Venet.*, 1644, 8vo. (245) *Quaritch, £4 17s.*

5183 Ainsworth (W. Harrison). Jack Sheppard, first ed., port. and 27 plates by G. Cruikshank, 3 vol., cf. ex., 1839, 8vo. (178) *Cooper, £4*

5184 Akerman (J. Y.) Tales of Other Days, first ed., plates by G. Cruikshank, cf. ex., by Rivière and Son, 1830, 8vo. (176) *Moore, £1 4s.*

5185 Aldine Editions. Dante, Le Terze Rime, editio prima Aldina, old russ., g. e., *Venet.*, Aldus, 1502—Il Petrarca (title and last leaf soiled), old mor. gt., *ib.*, Eredi d'Aldo, 1533—Pontanus, Opera, 2 vol., old mor., g. e., *ib.*, Aldus, 1513—Justinus et Æmylius Probus, old mor., g. e., *ib.*, 1522—Caesaris Commentarii, etc., anchors painted, map, *ib.*, 1519—Valerius Maximus (margin of last leaf mended), *ib.*, 1502, mor., g. e., together 7 vol., 8vo. (259-261) *Quaritch, £14*

5186 Alken (H.) A Collection of Sporting Designs, 30 col. plates, hf. mor., g. e., *Collected and published by Thos. McLean*, n. d. (1827), folio (194) *Parsons, £6*

5187 Alken (H.) National Sports of Great Britain, orig. ed., front. and 50 col. plates, descriptions in English and French, orig. mor., g. e., T. McLean, 1821, folio (230) *Quaritch, £70*

5188 Alken (H.) National Sports of Great Britain, 50 col. engrav-
ings, orig. cl., T. McLean, 1825, imp. 8vo. (187)
B. F. Stevens, £13 5s.
5189 Alken (H.) A Series of Twelve Engravings, by John Zeitter,
after Henry Alken, to illustrate Cervantes' Don Quixote,
Tilt, 1831-2, folio (196) *Abrahams*, 19s.
5190 Allen (Thos.) History and Antiquities of London, West-
minster and Southwark, best ed., plates, 4 vol., hf. mor. ex.,
1827-8, 8vo. (2) *Edwards*, £1 3s.
5191 Amadis de Gaule [Livres I.-VII.] qui traicte de maintes
Adventures d'Armes & Amours, tant du Royaulme de la
Grand Bretaigne, que d'aultres Pays, par le Seigneur des
Essarts, Nicolas de Herberay, première éd. (à l'exception
du Premier Livre), woodcuts, the 7 books bound in 4 vol.,
old cf. gt., *Paris, Denis Janot (Pour Jean Longis) et Jeanne
de Marnef Veuve Janot*, 1544, 1541, 1542, 1543, 1545 and
1546, folio (363) £15 15s.
5192 America. Barbé-Marbois. Complot d'Arnold et de Sir Henry
Clinton contre les Etats-Unis de Amerique, ports. of Wash-
ington, Arnold, and plan of West Point, uncut in wrappers,
with label, presentation copy from the author, with inscrip-
tion, *Paris*, 1816, 8vo. (19) *Parsons*, £1 3s.
5193 America. The Book of Common Prayer, according to the
Use of the Protestant Episcopal Church in the United
States, mor., g. e., *Philadelphia, printed by Hall & Sellars*,
1791, 8vo. (20) *Ellis*, £1 10s.
[The second issue of the first standard Prayer Book for
the Episcopal Church in America.—*Catalogue*.]
5194 America. Laws of Maryland at Large, with proper Indexes,
now first collected into one compleat Body, with Charter
and English Translation, by Thomas Bacon, orig. sheep
(rebacked), *Annapolis*, 1765, folio (214) *Howell*, £2
[With the leaf of advertisement at end, missing in most
copies. Contains all the laws from 1637 to 1763, including
those relating to the Indians, tobacco, swearing, negroes,
etc.—*Catalogue*.]
5195 America. [Galloway (Joseph).] Tracts. A Candid Exam-
ination of the Mutual Claims of Great Britain and the
Colonies, J. Wilkie, 1780—Examination of Joseph Gallo-
way, Esq., late Speaker of the House of Assembly of
Pennsylvania, *ib.*—Letters to a Nobleman on the Conduct
of the War in the Middle Colonies, plan, *ib.*—Letter to
Viscount Howe on his Naval Conduct, *ib.*, 1779—Historical
and Political Reflexions on the American Rebellion, *ib.*,
1780—Cool Thoughts on the Consequences to Great Britain
of American Independence, *ib.*—Plain Truth, or a Letter
to the Author of Dispassionate Thoughts on the American
War, *ib.*, in 2 vol., old cf., green edges, 1779-80, 8vo. (266)
H. Stevens, £5 10s.
5196 America. Historical and Political Reflections on the Rise
and Progress of the American Rebellion (by Jos. Galloway),
G. Wilkie, 1780—Candid Examination of the Mutual

Claims of Great Britain and the Colonies (by the same),
ib.—Plain Truth to the Author of Dispassionate Thoughts
on the American War, *ib.*—Reply of His Majesty's Su)jects
the Principal Inhajitants of the Mosquito-Shore in America
to a Pamphlet intituled The Defence of Rob. Hodgson,
1780, and another, in 1 vol., hf. bd., 8vo. (267)
H. Stevens, £2 12s. 6d.

5197 America. Canada. Thoughts on the Canada Bill now
depending in Parliament, J. De)rett, 1791—Introduction
to the Ojservations made by the Judges of the Court of
Common Pleas for the District of Quebec upon the Investi-
gation into the Past Administration of Justice, J. Stockdale,
1790—Answer to the Introduction, *ib.*—Review of the
Government and Grievances of the Province of Que)ec,
ib., 1788—State of the Present Form of Government of the
Province of Que)ec, 1790, in 1 vol., hf. russ., 8vo. (268)
H. Stevens, £5 10s.

5198 American Maps. Mitchell (John). Map of the British and
French Dominions in North America, large folding sheet,
col., 1755—Maps of Canada, New York Island, Seat of
War in New England, Philadelphia, etc., 1777, etc., together
2 vol., atlas folio (374) *Quaritch, £30*

5199 America. Schryvens van Consideratie Vyt Londen. Door
een Lief-)e))er van desent Staat, Aldaar woonende, **blark
letter**, uncut, *Rotterdam*, 1653, 4to. (5) *B. F. Stevens, £1* 1s.

5200 America, etc. The Present State of North America, etc.,
part i. [)y John Huske] (all published), unbd., uncut, R. and
J. Dodsley, 1755—The Budget, inscri)ed to the Man who
thinks himself Minister, J. Almon, 1764—Merici Casauboni
Is. F. Vindicatio Patris, signature of J. Murray on title,
B. Norton, etc., 1624, together 3 vol., 4to. (292)
Leon, £3 18s.

5201 Analysis (The) of the Hunting Field ()y R. S. Surtees), first
ed., col. plates)y H. Alken, and woodcuts, orig. cl., g. e.,
R. Ackermann, 1846, 8vo. (44) *Parsons, £6* 5s.

5202 Annals of the Kingdom of Ireland, ed.)y John O'Donovan,
5 vol., orig. cl., uncut, *Dublin*, 1848-51, 4to. (104)
Edwards, £8 5s.

5203 Apperley (C. J.) Life of a Sportsman, first ed., 36 col. illus-
trations)y Henry Alken (4 of the plates as usual mounted),
cf. gt., g. e., R. Ackermann, 1842, 8vo. (45)
Hornstein, £15 15s.

5204 Ariosto (L.) Orlando Furioso, Baskerville's ed., port. and
plates after Eisen, etc. by Bartolozzi and others, 4 vol., old
English mor., g. e. (Roger Payne), *Birmingham*, G. Basker-
ville, 1773, roy. 8vo. (234) *Hatchard, £8*

5205 Auburey (Thos.) Travels through the Interior Parts of
America, maps and plates, 2 vol., old cf. gt., y. e., W. Lane,
1789, 8vo. (265) *H. Stevens, £2* 14s.

5206 Auctores Classici Graeci. Sophocles (2)—Æschylus (2)—
Euripides—Aristoteles—Aristophanes—Anacreon—Epic-

tetus—Theocritus, etc., Foulis's eds., together 15 vol., old
mor. gt., *Glasguae*, R. et A. Foulis, v. d., 12mo. (256)

Maggs, £1 19s.

5207 Auctores Classici Latini. Boethius—Horatius—Juvenal &
Persius—Lucretius — Minucius Felix — Phaedrus — Pom-
ponius Mela—Paterculus—Poetae Minores—Sallustius—
Terentius—Tibullus & Propertius, Foulis's eds., together
12 vol., old mor. gt., *Glasguae*, R. et A. Foulis, v. d., 12mo.
(257) *Barnard*, £2 14s.

5208 Auctores Classici. Tacitus (4)—Cæsar (3)—Plinius (2)—
Hippocrates (1), Foulis's eds., together 10 vol., old mor. gt.,
Glasguae, R. et A. Foulis, v. d., 12mo. (255) *Tregaskis*, £2

5209 Austen (Jane). Northanger Abbey—Persuasion, first ed., 4
vol., with half-titles to "Persuasion," orig. bds., uncut
(backs damaged), J. Murray, 1818, 8vo. (433)

Law Bros., £7 7s.

5210 Austin (Wm.) Certaine Devout, Godly and learned Medi-
tations, set forth after his decease by his deare wife and
executrix Mrs. Anne Austin, second ed., engraved front. in
12 compartments, one containing the head of the author, by
G. Glover (duplicates of the 12 compartmental cuts of the
title cut out and inserted throughout the vol.), mor. ex., R.
Meighen, 1637, sm. folio (421) *Ellis*, £1 11s.

5211 Bacon (F.) The History of the Reigne of King Henry the
Seventh, orig. cf., *London, printed by Io. Haviland, and are
to be sold by Phil. Stephens and Christopher Meredith*, 1628,
folio (213) *Glasse*, £6 5s.

[An hitherto unknown edition, of which there is no copy
in the British Museum, and no record in the printed cata-
logues of any of the great libraries, public or private. It
must have been suppressed for some reason, as the biblio-
graphers are not aware of any issue between the original of
1622 and the so-called second edition of 1629.—*Catalogue*.]

5212 Badeslade (Thos.) Chorographia Britanniae, maps by W. H.
Toms, col. by hand, old mor., gt. back and borders, g. e.,
W. H. Toms, 1742, obl. 4to. (285) *Rimell*, £1 19s.

5213 Bancroft (Bp. R.) A Briefe Discovery of the Vntrvthes and
slanders (against the trve Government of the Church of
Christ) contained in a Sermon, preached the 8. of Februarie
1588 (title stained), cf., *Secretly printed*, n. d. (1588), 4to.
(112) *Tregaskis*, 15s.

[This tract is addressed To the Godlie indifferent
Reader's judgment to discerne and zeal to embrace the
Truth, in which mention is made of a vile and scurrilous
pamphlet, "An Almond for a Parrott."—*Catalogue*.]

5214 Beaumont (Albanis). Travels through the Maritime Alps,
map, aquatinta and other plates, hf. mor., T. Bensley, 1795,
folio (197) *Colbrooke*, 13s.

5215 Beaumont (Fr.) and Fletcher (John). Comedies and Trage-
dies, first ed., port. by Marshall, mor., rough g. e. (two or
three leaves mended), 1647, folio (151) *Milton*, £20 10s.

5216 Beaumont (Fr.) and Fletcher (John). Fifty Comedies and
Tragedies, port. ɔy Wm. Marshall (ɔacked), old cf. gt.,
J. Macock for J. Martyn, etc., 1679, folio (351)
Ellis, £6 5s.
5217 Beauties (The) of the Isle of Thanet, and the Cinque Ports,
map and 106 plates, 2 vol., hf. mor. ex., 1830, 8vo. (59)
James, 13s.
5218 Beckett (G. A. à). Comic History of England, first ed., 20
col. plates and 240 woodcuts by John Leech, 2 vol., orig.
cl., *Punch Office,* 1847-8, 8vo. (60) *Spencer,* £2
5219 Beesley (A.) The History of Banɔury, 26 plates, cf. ex.,
uncut, ɔy F. Bedford, Nichols (1841), 8vo. (72)
Maggs, £1 5s.
5220 Behmen (Jacoɔ). Signatura Rerum, or The Signature of all
Things, first ed., orig. cf., 1651, 4to. (113) *Shepherd,* £1 1s.
5221 Bellasis (G. H.) Views in St. Helena, 6 col. plates by R.
Havell, with letterpress and list of suɔscriɔers (stained at
end), orig. wrappers, 1815, obl. roy. folio (198)
Quaritch, £1 15s.
5222 Bentham (James). History and Antiquities of the Cathedral
Church of Ely, with Supplement ɔy W. Stevenson, port.
and plates, 2 vol., uncut, 1812-17, 4to. (114) *Andrews,* 15s.
5223 Bertruccius Bononiensis Medicus. Nusquam antea im-
pressum Collectorium totius fere Medicine, etc., lit. golɧ.,
woodcut initials, contemp. English oak bds., leather, with
stamped panel in 2 compartments, containing the arms of
King Henry VIII. and the Tudor Rose supported ɔy
angels, the under cover having a single panel of the "Arma
Redemptoris Mundi," and the mark of the King's ɔinder,
John Reynes, clasp catches (slightly damaged), old signa-
ture and motto of "G. Digɔy" (? second Earl of Bristol),
Lugduni in aedibus Jac. Myt sumptu B. Trot, 1518, sm. 4to.
(406) *Quaritch,* £20
5224 Beverley (Robert). History of Virginia, second ed., front. and
14 plates reduced from De Bry, orig. cf., F. Fayram and J.
Clarke, etc., 1722, 8vo. (11) *H. Stevens,* £4 12s.
5225 Bewick (T.) British Land and Water Birds, 2 vol., LARGEST
THICK PAPER, russ., m. e., fine copy, inserted is Bewick's
engraved ɔill-head, dated 1805, and invoice receipted by J.
Bewick, *Newcastle,* 1805, imp. 8vo. (73) *Howell,* £2 18s.
5226 Biɔlia Sacra Latina Editionis Vulgatae, Anglo-Norman Sæc.
xiv. Manuscript on uterine vellum (550 leaves, 8 by 4 in.),
gotɧic letter, 52 lines to a full page, divisions in ɔlue and
red, ornamental pen-letters with marginal decorations,
small illuminated initial letters, a fine strap initial ɔefore
Genesis of the Works of Creation in very small medallions,
in xvth century Anglo-French oak bds. and stamped
leather, the ɔack in diagonals, the sides in involved orna-
mental scrolls, large rose and star-shaped designs in the
centre of upper cover, the under cover ɔeing covered with
punctuated scrolls in octagon compartments, clasps, *Sæc.*
xiv., 8vo. (423) *Quaritch,* £57
24—2

5227 Bishop (George). New England Judged [Part i.], [wanted
the Appendix,] *Printed for Rob. Wilson in St. Martins Le
Grand,* 1661—New England Judged, the Second Part,
Printed in the year 1667, 2 vol., orig. cf., 1661-67, 4to. (622)
H. Stevens, £7 10s.

5228 Blake (Wm.) Illustrations of the Book of Job, 22 engrav-
ings, orig. India proofs on LARGE PAPER, each plate within
a mount, *London, published as the Act directs, March 8,
1825, by William Blake, No. 3, Fountain Court, Strand,*
folio (449) *Robson, £22* 10s.

5229 Blake (Wm.) Illustrations of the Book of Job, orig. ed., 21
plates mounted on separate sheets, proof impressions on
India paper, 1825, roy. folio (450) *B. F. Stevens, £11*

5230 Blake (Wm.) Poetical Sketches, orig. ed. (contained title,
leaf of advertisement, and 70 pages of text), with the orig.
blanks at beginning and end, old mor. ex. (Roger Payne
period), *Printed in the year* 1783, 8vo. (448) *Edwards, £52*
 [The two front fly-leaves contained three MS. songs by
 Blake, not printed in the book, headed Songs by Mr. Blake,
 and entitled "Song 1st, by a Shepherd ; Song 2nd, by a
 Young Shepherd ; Song 3rd, by an Old Shepherd." A
 different version of the 2nd song, beginning "When the
 green woods laugh with the voice of joy," was included in
 the Songs of Innocence, but the other two songs were not
 published till B. M. Pickering's edition of the Poems, 1874.
 It is most probable that the MS. of the three songs is the
 handwriting of Mrs. Blake. On the title is an inscription,
 "from Mrs. Flaxman, May 15, 1784." Various MS. altera-
 tions have been made in the text, and on page 9 the words
 "I am" have been erased and replaced by the word
 "behold." The volume was sold in Heber's sale in 1834.
 It contained the earliest poems of Blake, composed between
 the 12th and 20th year of his age.—*Catalogue.*]

5231 Blake (W.) Working Cabinet of mahogany, 18½in. high,
16 in. long, and 8in. deep, a metal stamp of the crest of the
Butts family is fixed to the outside of the front, and their
coat-of-arms is painted inside, within are pigeon-holes and
small drawers, and beneath them a long drawer containing
Blake's working tools, a quantity of bismuth, etc., the
bottom forms a secret drawer, in which are some copper-
plates engraved by Blake, with others (including two
signed by T. Butts), probably executed by pupils under his
direction (446) *Tregaskis, £30* 10s.
 [The cabinet came into the possession of Thomas Butts,
 the artist's friend and patron, and it has remained in the
 Butts family ever since. About 30 years ago it was given
 to Aubrey Butts, a boy of about 14 years of age, who
 affixed the crest and painted on the coat-of-arms. The
 secret drawer had at some time been forced open with a
 chisel.—*Catalogue.*]

5232 Boethius (A. T. S.) De Philosophiae Consolatione, **lit.** semi-
goth., 137 leaves (3 blank), without marks, text rubricated,

capitals painted (first leaf of text defective), orig. oak bds.,
pigskin ɔack, *Impressum Nurenburgae per Ant. Koberger*,
1476, folio (87) *Leighton*, £4 8s.
[*See ante* No. 2573. Same copy returned for imperfec-
tions.—ED.]

5233 Booke of Common Prayer, etc., for the use of the Church of
Scotland, black letter, *Edinburgh*, R. Young, 1637-36—The
Psalms of David translated by King James (with musical
notes), black letter, *Lond., printed by Thos. Harper*, 1636, in
1 vol., old cf., sm. folio (358) *Hopkins*, £4 4s.

5234 Booth (Barton). Memoirs of Life of, first ed., port., 1733,
8vo. (124) *Wilson*, 10s.

5235 Boydell (J. and J.) History of the Thames, 76 engravings,
col. like drawings, 2 vol., orig. mor. gt., Bulmer, 1794-96,
roy. folio (211) *Butt*, £13

5236 Brabant. Die Nieuwe Chronijcke van Brabandt, lit. goth.,
woodcut head of Charles V. (coloured) on title, 76 ports. of
the Dukes of Braɔant, etc., with their armorial ɔearings,
large folding woodcut plan of Brussels (inlaid), and cuts in
the text, old Dutch cf. gt., *t'Antwerpen by Jan Mollijns*,
1565, sm. folio (453) *Maggs*, £2

5237 Brighton Cartoons, by Cipriani, a series of 12 col. engravings
after designs ɔy Cipriani, engraved ɔy Godɔy, etc. for the
Pavilion, comprising Sir Christ. Wren, Columɔus, Dante,
Ovid, Virgil, Bp. Bossuet, etc., folio (199) *Hyam*, £2 2s.

5238 British Poets. The Works of the English Poets, ɔy Dr.
Samuel Johnson, ɔest ed., 75 vol., old cf. gt., 1790, 8vo. (38)
Howell, £3

5239 [Browne (Sir Thos.)] A true and full coppy of that which
was most imperfectly and surreptitiously printed ɔefore
under the name of Religio Medici, *Printed for Andrew
Crooke*, 1645, title-page missing—Oɔservations vpon Religio
Medici, occasionally written by Sir Kenelme Digɔy, Knight,
*London, printed by F. L. for Lawrence Chapman and
Daniel Frere*, 1644, together in 1 vol., orig. cf., some leaves
in uncut state and ɔlanks at ɔeginning of ɔoth works,
1644-45, 8vo. (482) *Tregaskis*, £17
[Presentation copy from Sir Thomas Browne, with con-
temporary inscription on fly-leaf, "Roɔert Bendish ex dono
authoris."—*Catalogue*.]

5240 Browne (Sir Thos.) Hydriotaphia, Urne-Buriall, first ed.,
plates (but not the slip title sometimes found at end), and
the Stationer to the reader and list of ɔooks printed for H.
Brome, orig. cf., H. Brome, 1658, 8vo. (40) *Young*, £2 1s.

5241 Bruce (Jas.) Travels to Discover the Source of the Nile,
1768-1773, first ed., maps and plates, 5 vol., old cf., *Edinb.,
for G. & J. Robinson*, 1790, 4to. (278) *Bruce*, 9s.

5242 Bryant (W. C.) Poems, presentation copy from the author
with inscription, orig. cl. (*Privately printed, New York*,
1869), 8vo. (22) *B. F. Stevens*, £1 6s.

5243 Budaeus (Gul.) Commentarii Linguae Graecae (top margin
of title cut off), contemp. English cf., panel ɔorders, stamped

with portcullises, fleurs-de-lis and royal arms of England
(Henry VIII.), top and bottom of back torn off, sides
slightly rubbed, *Colon. Opera et impensa Jo. Soteris,* 1530,
folio (420) *Leighton,* £2 18s.

5244 Budaeus (G.) De Asse et Partibus Eius, lib. v., title within
woodcut border with "Prelum Ascensianum" in centre,
woodcut initials (wormed and some leaves stained), con-
temp. English oak bds., leather with panel stamps of
floreate ornaments (damaged), *Paris, in aedibus Ascensi-
anis,* 1514, folio (419) *Barnard,* £2 10s.

5245 Bulkeley (Peter, Fellow of S. John's College, Cambridge).
The Gospel-Covenant, preached in Concord in New-
England, first ed., old cf., *M. S. for B. Allen,* 1646, sm.
4to. (415) *Grant,* £1 16s.

5246 Bunbury (H.) Annals of Horsemanship and Academy for
Grown Horsemen, 29 humorous plates, 2 vol., orig. bds.,
uncut, Hooper and Wigstead, 1796, 4to. (272)
Abrahams, £1 16s.

5247 Burns (Robert). Bureau. An old mahogany bureau, with
sloping flap front, 3ft. 8½in. high, 3ft. 6in. long, and 1ft.
9½in. deep, containing three wide and two narrow drawers,
inside the flap are seven small drawers and pigeon-holes,
with the usual small cupboard in the centre, one of these
small drawers has one new handle, otherwise the bureau is
entirely in its original condition, it is oak-lined throughout
(445) *Quaritch,* £600
[This desk was used by Robert Burns at Ellisland and
Dumfries. It will be remembered that he took his farm at
the former place in 1788. "Tam o' Shanter," "Thou
Ling'ring Star," the "Elegy on Matthew Henderson," and
many of the poet's finest lyrics, including "Auld Lang
Syne," "Scots Wha Hae" and "A Red, Red Rose" were
published between 1789 and his death in 1796. It is pro-
bable that most, if not all of them, were written originally
at this desk. After 1796 the desk became the property of
Burns' widow ("Jean Armour"), and on her death in 1834
it was given by her trustees to her eldest son Robert, who
gave it to his youngest brother William Nicol, afterwards
colonel in the Indian Army, who in his turn gave it to his
niece, Annie Burns Burns, younger daughter of Colonel
Glencairn Burns, third son of the poet. In 1846 the two
brothers, Colonel William Nicol Burns and Colonel Glen-
cairn Burns, with the latter's daughter, Miss Annie Burns,
came to live at Cheltenham, where this desk was part of
the furniture of the house; it has never been out of the
possession of Miss Burns until now. It is particularly
mentioned in the "Minutes of the Trustees of Mrs. Burns,
April 1, 1834," the date of the funeral of Mrs. Burns.—
Catalogue.]

5248 Caesar. Caii Julii Caesaris et A. Hirtii de Rebus a Caesare
Gestis Commentarii, ex recens. S. Clarke, LARGE PAPER,
old mor. gt., *Glasguae,* R. et A. Foulis, 1750, folio (353)
Maggs, £1 14s.

5249 Camoens (D. Luys de). Os Lusiados, port. and engravings after F. Gerard, mor. super ex., finely ƿound, in case, *Paris,* Firmin Didot, 1817, 4to. (303) *Quaritch, £3*

5250 Cartwright (Edmund). Parochial Topography of the Rape of Bramƿer in Sussex (forming vol. ii. part the second of Dallaway's History of Sussex), ports., maps and plates, uncut, 1830, imp. 4to. (116) *W. Daniell, £2 10s.*

5251 Cathcart (Wm. Shaw). Disputatio Juridico, Digest. pro Derelicto, contemp. Scotch mor., gilt floreated ornaments, ƿronze flowered end leaves, in perfect state, *Edinb.,* Balfour and Smellie, 1776, 4to. (301) *Marks, £5*

5252 Caulfield (James). Calcographiana. The Printsellers' Chronicle and Collectors' Guide to Engraved British Portraits, port., hf. mor., 1814, 8vo. (34) *Parsons, 9s.*

5253 Cavendish (George). The Negotiations of Thomas Woolsey, first ed., port. of Woolsey ƿy Marshall (mended), cf. gt., W. Sheares, 1641, 4to. (117) *Maggs, £1 5s.*

5254 Cent Nouvelles Nouvelles, Les. Planches de Roman De Hooghe tirées à part du texte, 2 vol., old English mor., g. e., *Cologne, chez Pierre Gaillard,* 1701, 8vo. (239) *Withers, £3 18s.*

5255 Cervantes (M. de). El Ingenioso Hidalgo Don Quixote de la Mancha, compuesto por Miguel de Cervantes Saavedra, Dirigido al Duque de Beiar, etc., device on title, old vell. (18th cent.), r. e., the second issue of the first ed. of the first part of Don Quixote, with the Particular Privilege for the Kingdom of Portugal, dated 9 Feb., 1605. Perfect, except K I.-III., of which the ƿinder has cut off a portion of the lower ƿlank margins, "*Con privilegio de Castilla, Aragon y Portugal. En Madrid, por Juan de la Cuesta, Vendese en Casa de Francisco de Robles, librero del Rey Nro Senor,*" 1605, sm. 4to.—Segunda parte del Ingenioso Cavallero Don Quixote de la Mancha, device on title, old cf. gt., sprinkled edges, old ex-liƿris of Sir Peter Killigrew, of Arwenack, Cornwall, and John Bowle (a former editor of Don Quixote), the first ed. of the second part of Don Quixote, perfect and in clean state, with the four leaves of "Taƿla" and imprint at end, which Brunet does not mention, *Con privilegio en Madrid por Juan de la Cuesta, Vendese en Casa de Francisco de Robles,* 1615, sm. 4to. (311-12) *Quaritch, £250*

5256 Cervantes (M. de). El Ingenioso Hidalgo Don Quixote de la Mancha, Partes IV., first Brussels ed. (some top margins stained, wanted last leaf, the one ƿefore the last defective), hf. cf., *En Brusselas for Roger Velpius,* 1607, 8vo. (429) *Sotheran, £2*

5257 Cervantes (M. de). Segunda Parte del Ingenioso Cavallero Don Quixote de la Mancha, orig. vell., *En Barcelona en Casa de Seb. Matevat,* 1617, 8vo. (242) *Quaritch, £3 5s.*

5258 Cervantes (M. de). The Spirit of Don Quixote, 4 col. plates, cf. ex., Charles Tilt, 1831, 8vo. (175) *Howell, £1 14s.*

5259 Chalmers (Geo.) Political Annals of the Present United Colonies [Book i.], presentation copy to the Earl of Mans-

field, with inscription, hf. cf., *Printed for the. Authour*, 1780, 4to. (289) *Maggs*, £2 12s.

5260 Chariton. De Chaerea & Callirrhoe Amatoriarum Narrationum, liɔ. VIII., Gr. et Lat., J. J. Reiskius Vertit (cum Animadversionibus), LARGE PAPER, old mor., ornamental ɔorders, centre inlayings, g. e., *Amst.*, P. Mortier, 1750, 4to. (305) *Bruce*, £1

5261 Charles I. Book of Common Prayer, etc., 𝔟𝔩𝔞𝔯𝔨 𝔩𝔢𝔱𝔱𝔢𝔯, LARGE PAPER (wanted first title and leaf of preface damaged), engraving of S. Catherine of Siena ɔy P. Bertrand pasted in cover, old English mor., ornamental tooling and the crowned arms of William II., Prince of Orange, and Mary, sister of Charles I., and Princess Royal of England, *R. Barker & Assigns of Bill*, 1634, folio (223) *Bacon*, £60
 [An interesting copy, having ɔelonged to King Charles the First, with his signature, "Carolus R.," on the title-page of the Psalms, and may have ɔeen given by him to his ɔrother-in-law and sister for use in the Private Chapel during their stay in England. Bears also the signature of "John Hutton, M.D., 1714."—*Catalogue*.]

5262 Charles I. Eikon Basilike, front. (shaved), with the leaf, "The explanation of the Emɔleme," in verse, port. of the Prince of Wales at page 150—Papers that Passed at New-Castle, etc., separate title, orig. mor., crowned "C. R." on sides, g. e. (size 3⅝ by 2), *Reprinted in Regis Memoriam for J. Williams*, 1649 (33) *Tregaskis*, £1 11s.

5263 Chaucer (Geoffrey). Workes, 𝔟𝔩𝔞𝔯𝔨 𝔩𝔢𝔱𝔱𝔢𝔯, old cf. (title-page mended and a few wormholes at end), portion of first page in fac., Wyllyam Bonham (c. 1546) (152) *Maggs*, £12

5264 Chaucer (G.) Workes (ed. ɔy John Stow, first ed. second issue), 𝔟𝔩𝔞𝔯𝔨 𝔩𝔢𝔱𝔱𝔢𝔯, cuts in text (title and next 2 leaves mended, some headlines shaved), mor., g. e., *John Kyngston for John Wight*, 1561, folio (86) *Spencer*, £6 10s.
 [*See ante* No. 2608, same copy.—ED.]

5265 Chinese Plants with their Insects reckoned Medical among the People, 814 col. illustrations on several hundred leaves of native paper, descriptions in Chinese and English, native emɔroidered ɔinding in case [18—], oɔlong folio (339) *Maggs*, £16 15s.

5266 Chronicon Nurembergense, lít. 𝔤𝔬𝔱𝔥., first ed., woodcuts, with the ɔlank leaves and "Sarmacia," hf. bd., *Nurembergae*, Ant. Coɔerger, 1493, folio (328) *Schulze*, £24 10s.

5267 Clutterɔuck (Roɔt.) History of the County ɔf Hertford, maps and plates, open-letter impressions, 3 vol., hf. russ. ex., 1815-27, roy. folio (216) *Colbrooke*, £10

5268 Coelestes et Inferi, 27 full-page copperplate engravings and 16 vignettes, contemp. Italian mor., ornamental ɔorders, inlaid oval centres, g. e., end leaves of gold and silver threads, *Venetiis, Typis C. Palese*, 1771, 4to. (299) *Edwards*, £4 10s.

5269 Cook (Capt. Jas.) and King (Capt. Jas.) A Voyage to the Pacific Ocean (Cook's third voyage), 3 vol., old cf. gt., G. Nicol, 1784, 4to. (279) *H. Stevens*, £2 2s.

5270 Cory (W., of Eton). Ionica (Poems), first ed., orig. cl., Smith, Elder and Co., 1858, 8vo. (471) *B. F. Stevens*, 16s.

5271 Costumes of Switzerland, 74 col. engravings and lithographs by Gatine, etc. (no title), hf. mor., n. d., 4to. (286)
Rimell, £3

5272 Cotton (Clement). The Mirrour of Martyrs (title mended), woodcut front., mor. ex., *E. A. for R. Allot*, 1631, 8vo. (473)
Burgon, £1 6s.

5273 Cowley (Abr.) Poems—Miscellanies—The Mistress—Pindarique Odes—Davideis, first collected ed., old cf., H. Moseley, 1656—Wheler (Geo.) Journey into Greece, plates, old cf., W. Cademan, etc., 1682 (359) *Maggs*, £3

5274 Cowper (W.) and Newton (J.) Olney Hymns, first ed., with half title, orig. sheep, 1779, 8vo. (474) *J. Bumpus*, £1 12s.

5275 Crescentio (Piero). Il Libro della Agricultura, lit. rom., double columns, with signs., woodcut at commencement of text, commences with text on aj. [Proctor, 7128], (wanted 2 blanks and leaf of index, some leaves stained and loose,) contemp. oak bds., half leather, *Vicenza, per Meliardum de Basilea*, 1490, folio (418) *Leighton*, £4

5276 Cries of London, 30 plates, col. by hand, modern impressions, hf. mor., t. e. g. (*Published by Richard Phillips*, 1804), 4to. (189) *Parsons*, £1 17s.

5277 Cruikshank (G.) Points of Humour, both parts, orig. ed., 20 plates and woodcuts by Cruikshank, hf. cf., C. Baldwyn, 1823-4, 8vo. (515) *Karslake*, £1 15s.

5278 Cruikshank (G.) Fairy Library, Jack and the Bean Stalk, first ed., plates by Cruikshank, orig. pictorial cover, clean as new, Bogue, n. d., 8vo. (516) *J. Bumpus*, £1 6s.

5279 Cullum (Rev. Sir John). The History and Antiquities of Hawsted and Hardwick in the County of Suffolk, second ed., ports., pedigrees and plates, hf. mor. ex. (200 copies printed), 1813, roy. 4to. (107) *Colbrooke*, 19s.

5280 Dasent (A. Irwin). The History of St. James's Square, ports. and illustrations, and extra illustrated by the insertion of 90 views and portraits, mor. ex., t. e. g., others uncut, Macmillan, 1895, 8vo. (172) *Crossley*, £6

5281 Daniel (G.) Merrie England in the Olden Time, plates by John Leech, and woodcuts, 2 vol., extended to 4 vol. and extra illustrated with upwards of 500 portraits, prints, old advertisements. etc., 8 orig. drawings executed expressly for this copy, only 10 copies printed, from Geo. Daniel's library, and since rebound, cf. ex., t. e. g., others uncut, 1842, 8vo. (181) *Maggs*, £25 10s.

5282 Daniel (G.) Merrie England in the Olden Time, plates by John Leech, col. by hand, 2 vol., cf. ex., 1842, 8vo. (179)
Howell, £2 14s.

5283 Daniel (Samuel). Poeticall Essayes, mor., by Rivière (hole in last leaf, a few leaves inlaid, and stamp erased from title-page), *London, by P. Short for Simon Waterson*, 1599, 4to. (135) *Wilson*, £15 10s.

5284 Daniel (S.) The Civill Warres betweene the Howses of Lan-

caster and Yorke, engraved title ɔy Cookson, with port.,
mor., ɔy Rivière (title-page repaired), first complete ed.,
Printed at London by Simon Watersonne, 1609, 8vo. (136)
Mitford, £8

5285 Daniel (S.) Works, cf., from the liɔraries of Jas. Crossley
and Joseph Knight, *Printed for Simon Waterson*, 1602,
folio (153) *Tregaskis, £11 5s.*

5286 Daniell (William) and Ayton (R.) A Voyage round Great
Britain, col. views, 8 vol. in 4, hf. mor., g. e., 1814-25, imp.
4to. (190) *Parsons, £37*

5287 Defoe (D.) A Journal of the Plague Year, ɔy E. W. Brayley,
4 plates by G. Cruikshank, col. by hand, mor., inlaid skull
and cross-ɔones, t. e. g., 1839, 8vo. (177) *Maggs,* 15s.

5288 Des Barres (Col. J. F. W.) Charts of the Coasts and Har-
ɔours in the Gulph and River of St. Lawrence from Surveys
taken by Major Holland, 1765-68, 22 large folding charts
of the American coasts and harɔours—The Atlantic Nep-
tune, puɔlished for the use of the Royal Navy of Great
Britain, charts of American coasts, etc., together 4 vol., old
cf., 1778-9, narrow sup. imp. folio (372) *Quaritch, £84*
[These four volumes of charts, by the Surveyor-General
of the Coasts of America, are of rare occurrence.—*Cata-
logue.*]

5289 Diccionario de la Lengua Castellana, compuesto por la Real
Academia Española, 6 vol., orig. vell., *Madrid,* Fr. del
Hierro, 1726-39, folio (333) *Quaritch, £5 5s.*

5290 Dickens (C.) A Four-legged Oak Stool, with cane seat
(18½ in. square), from the room in which Charles Dickens
last wrote at his house in Gad's Hill, a framed Photograph
showing room with stool and two other Photographs (443)
Spencer, £10 10s.
[This stool was purchased at the sale of Charles Dickens'
effects at Gad's Hill ɔy Mr. E. Banes, July, 1870, and has
remained in his possession until the present time. Verified
by a letter from a lady who was at the sale with Mr. Banes
when he ɔought it.—*Catalogue.*]

5291 Dickens (C.) A mahogany Sloping Desk (1 ft. 9 in. long ɔy
2 ft. 1½ in. wide), with ɔrass plate affixed, containing the
following inscription : "This desk, constantly used by
Charles Dickens, was presented by him to James P. Davis
when he ɔought Tavistock House from the author in 1860,"
and an Autograph Letter from Charles Dickens, and
another from his daughter, Mamie Dickens, ɔoth relating
to the sale of Tavistock House (442) *Spencer, £13*
[This desk is ɔelieved to be the one Charles Dickens used
in his study, and upon which many of his novels were
written. At the death of Mr. Davis it passed into the
possession of his daughter, the present owner, Mrs. M.
Phipps-Jackson.—*Catalogue.*]

5292 Dickens (C.) Sketches ɔy "Boz," ɔoth series, first ed., and
second series, second ed., with the 2 extra plates, together
4 vol., plates by G. Cruikshank, mor. ex., t. e. g., others

uncut, with the advertisements and orig. dark-green and
pink cloth ɔinding ɔound in, John Macrone, 1836-37, 8vo.
(17) *Groome*, £25
 [Inserted in the first vol. is an autograph letter of John
 Forster (the ɔiographer of Dickens) to George Cattermole·
 . . . "Will you dine with me at the Cluɔ on Saturday? I
 have asked 'Boz,' who makes his first appearance there on
 that occasion."—*Catalogue*.]
5293 Dickens (C.) Sketches by "Boz," 40 plates by G. Cruik-·
 shank, hf. mor. ex., 1839, 8vo. (168) *Shepherd*, £2 8s.
5294 Dickens (C.) Overs (J.) Evenings of a Working Man,.
 Preface by C. Dickens, first ed., liɔrary stamp on half-title,.
 advertisement leaf at end, orig. cl., g. e., 1844, 8vo. (542)
 J. Bumpus, £1
5295 Domesday Book. [Vol. i.-ii.], orig. ed., 2 vol., old cf. gt., y. e.
 (no titles as puɔlished), 1783, folio (326) *Hughes*, £1 8s..
5296 Donne (Dr. J.) Poems, by J. D., title inlaid, old cf. (ɔack
 repaired), J. Marriot, 1633, 4to. (109) *Ellis*, £2 18s.
 [First ed., with the preliminary leaves found in but few·
 copies, viz., "The Printer to the Understanders," ɔesides·
 the usual prose epistle. On Y iii. is found the well-known
 epitaph on Shakespeare.—*Catalogue*.]
5297 Donne (Dr. J.) Poems, first 8vo. ed., port. by Marshall, with
 eight lines in verse inlaid, orig. cf., *Printed by M. F. for·
 John Marriott*, 1635 (547) *Ellis*, £3 16s.
5298 Dryden (J.). A Poem upon the Death of His Late Highness
 Oliver, Lord Protector, first ed., large copy, mor· ex., W
 Wilson, 1659, 4to. (111) *Maggs*, £1 15s.
5299 Dryden (J.) Britannia Rediviva, a Poem on the Birth of the·
 Prince, first ed., fine copy, J. Tonson, 1688, 4to. (97)
 Maggs, 10s..
5300 Dryden (J.) The Life of St. Ignatius, Founder of the Society·
 of Jesus, written in French by the Rev. Father Dom. Bou-
 hours, translated into English by a Person of Quality (John
 Dryden), first ed., orig. cf., with ɔlanks, *Printed by Henry·
 Hills, Printer to the King's most Excellent Majesty, for his
 Household and Chappell*, 1686 (578) *Tregaskis*, 10s.
 [On the fly-leaf is written, "To Mrs. Catherine Prue,"
 ɔelieved to be in the neat handwriting of Dryden. One of·
 the Roman ɔooks printed for James II.'s "Household and
 Chappell."—*Catalogue*.]
5301 Dryden (J.) The Tempest, first ed., hf. mor., 1670, 8vo. (137)
 Wilson, £2 10s.
5302 Dryden (J.) An Evening's Love, or the Mock Astrologer,.
 first ed., 1671—Cleomenes, the Spartan Heroe, first ed.,
 1692, 8vo· (138) *Ellis*, 17s.
5303 Dryden (J.) All for Love, or the World well Lost, first ed.,.
 hf. mor. (a few headlines shaved), 1678, 8vo. (139)
 Ellis, 15s.
5304 Durandus (Guliel.) Rationale Divinorum Officiorum, lit.
 𝔤𝔬𝔱𝔥., title within Holbeinesque ɔorder, with Fradin's device·
 in centre, ornamental woodcut initials, contemp. MS. notes·

(few leaves at end stained), contemp. English oak bds., leather, with panel stamps of wiverns and other grotesque ɔirds, etc., and mark of John Reynes, clasp catches (rather worn and damaged), *Lugduni, impressum Const. Fradin,* 1521, 4to. (409) *Leighton, £4* 4s.

5305 Dugdale (Sir W.) History of Imbanking and Draining, second ed., plates, cf. ex., 1772, folio (217) *Edwards, £2* 18s.

5306 Dugdale (Sir W.) Origines Juridiciales, third ed., ports. by Hollar, Loggan, White, etc. (two or three leaves repaired), hf. mor. ex., 1680, folio (224) *Walford, £1* 12s.

5307 Eden (Honble. Miss). Portraits of the Princes and People of India, 24 lithographs, col. and mounted like drawings, loose in cover, Dickenson and Son, 1844, atlas folio (329) *Edwards, £2* 6s.

5308 Eden (Sir F. M.) The State of the Poor, 3 vol., hf. russ., B. and J. White, 1797, 4to. (276) *Harding, £4* 4s.

5309 Edinɔurgh. Cries of Edinɔurgh Characteristically Represented, accompanied with Views of several principal Buildings of the City, 20 plates, orig. paper wrapper, *Edinb.,* L. Scott, 1803, 12mo. (572) *Hornstein, £2* 12s.

5310 Eliot (John). The Indian Grammar Begun, or an Essay to ɔring the Indian Language into Rules (portion of imprint on title and small pieces of signatures A 2, H 2, H 4, I, I 2 and I 3 repaired), mor., gilt centre medallion on upper cover, g. e., ɔy Rivière, *Cambridge (N.E.),* Marmaduke Johnson, 1666, 4to. (435) *Quaritch, £200*

5311 Erasmus. In Acta Apostolorum Paraphrasis nunc primum recens & nata et excusa, contemp. English ɔlack leather with stamped panels, the upper panel representing the Baptism of Christ by S. John the Baptist, the Deity and Dove in the clouds aɔove, with legend, "**Ḫic est filius meus Dilectus,**" the under panel representing St. George on horseɔack slaying the dragon, etc., ɔoth panels within ɔorders, with mark **𝕵 𝕽** joined by a lovers' knot [*see* Weale's "English Ruɔɔings," 168], the upper panel damaged), the stamps apparently first used *c.* 1520, *Basil. in Off. Jo. Frobenii,* 1524 (382) *Leighton, £8* 15s.

5312 Fane (Violet). Denzil Place, first ed., orig. cl., the Authoress' own copy, with her autograph on title, and several MS. notes and dates of the pieces, 1875, 8vo. (562) *Hornstein, £1* 18s.

5313 Femmes de Versailles (Les). Texte par Pierre de Nolhac, 32 ports., printed in colours (the complete works should have 50 ports.), text printed on Japanese vell., edition limited to 100 copies, in 5 flowered silk portfolios (puɔlished at 5,000 francs complete), *Paris,* Goupil, 1906-07, atlas folio (651) *Graves, £41*

5314 Forɔes (Jas.) Oriental Memoirs, port. and plates, the Natural History suɔjects col., 4 vol., old English mor., g. e. (ɔacks ruɔɔed), White and Cochrane, 1813, 4to. (274) *Edwards, £3* 16s.

5315 Foreign Field Sports, Fisheries, Sporting Anecdotes, etc., orig. ed., 110 col. plates by Howitt, Atkinson, etc., orig. hf. mor., g. e., E. Orme, n. d. (1814), roy. 4to. (588)
Maggs, £3 12s.

5316 Fuller (Thos.) Worthies of England, port., extra illustrated with 200 ports., views of cities, etc., and a series of maps, 2 vol., old russ., g. e., 1811, thick roy. 4to. (315)
Phillips, £5 17s. 6d.

5317 Fuller (Thos.) A Collection of Sermons, first ed., separate title and pagination to each part, orig. cf. (re)acked), J. Stafford, 1656, 8vo. (564) *Fuller, £2* 2s.

5318 Fur, Feather and Fin Series, ed. by A. E. T. Watson, illustrated, 10 vol., 1893-1903, 8vo. (164) *Tregaskis, £1* 4s.

5319 Gay (John). Fables [vol. i.], first ed., vignettes after Jas. Wootton and W. Kent, orig. cf., Tonson and Watts, 1727, 4to. (283) *Howell, £1* 1s.

5320 Gage (J.) History and Antiquities of Hengrave in Suffolk, ports. and plates, mor. ex., uncut, 1822, roy. 4to. (591)
Edwards, £2 14s.

5321 Gage (J.) History and Antiquities of Suffolk. Thingoe Hundred, LARGE PAPER, map, ports. and plates, uncut, 1838, imp. 4to. (592) *Burgon,* 16s.

5322 Galerie des Peintres Flamandes, Hollandais et Allemands, 201 proof plates, 3 vol., old russ. gt., uncut lower margins, *à Paris, chez l'Auteur, etc.*, 1792-6, folio (319) *Vyt, £6*

5323 Gerson (Jo.) Donatus Moralizatus—Epistola Abagari regis ad Jesum Christum—De Secundo Philosopho et eius pertinari Setentio, lit. goth. (13 leaves), long lines, 30 to a full page, with signs. (not in Hain or Procter), *Finit iste libellus jam primo Anno scz. dñi* MCCCCXCVIII. *Colonie impressus* (1498), 8vo. (534) *Leighton, £1* 9s.

5324 Goodwin (P.) The Mystery of Dreames, Historically Discoursed, orig. cf. (re)acked), 1658, 8vo. (565) *Shepherd,* 19s.

5325 Gould (John). Handbook of the Birds of Australia, 2 vol., orig. cl., 1865, 8vo. (566) *J. Bumpus, £1* 4s.

5326 Gregorius (S.) Omelie in duutschen, lit. goth. (lettres bâtardes), long lines, 24 to a full page [begins "Dit is die prologus of die Voersprake in sinte Gregorius Omelie in duutschen," ends "Opten xx. sonnendach Mathews"], without signs. but leaves numbered I.-CXCI. [? Hain, 7954], (119 leaves wanted), not subject to return, old cf. [*Ultrajecti,* Jo. Veldener, 1479?], sm. 4to. (314) *Leighton, £5* 5s.

5327 Grevillea, a Monthly Record of Cryptogamic Botany, ed. by M. C. Cooke, port. and col. and other plates, vol. i. to x., in 5 vol., hf. cf., m. e., 1872-81, 8vo. (183) *Quaritch, £1*

5328 Griffiths (A. F.) Bibliotheca Anglo-Poetica, the orig. corrected proof sheets, a large portion printed on one side only, with title and index, hf. cf., uncut, 1815 (479) *Tregaskis,* 16s.

5329 Guicciardini (Fr.) Histoire des Guerres d'Italie traduite par Hierosme Chomedy, nouvelle édition (augmentée), 2 vol., old French mor., elaborately tooled, double, g. e. (Padeloup), [*Genève,*] *Heritiers d'E. Vignon,* 1593, 8vo. (248)
Quaritch, £6 6s.

.5330 Hakluyt (R.) The Principal Navigations, Voyages, Traffiques and Discoveries of the English Nation, black letter, vol. i. (title cut down, inlaid and loose, first leaf of dedication shorter than the rest, wanted Voyage to Cadiz at end), old cf., portcullis, lion and rose on back, large gilt crowned Tudor rose at each corner and large royal arms (worn), G. Bishop, R. Newberie and R. Barker, 1599-1600, sm. folio (356) *Quaritch*, £26 10s.

5331 Hakluyt (R.) The Third and Last Volume of the Voyages, etc., first ed., black letter, old cf., centre gilt ornaments and initials L. D. S. (rebacked), G. Bishop, R. Newberie and R. Barker, 1600, folio (357) *H. Stevens*, £5

.5332 Hamilton (Lady Emma). Attitudes, drawn from Nature at Naples, 15 plates, parts i.-iii., orig. wrappers, Random and Stainbank, 1807, obl. 4to. (302) *Abrahams*, £1 11s.

.5333 Hammond (Dr. Henry). A Practical Catechisme, first ed., cf., with ex-libris of Wm. Cowper, *Oxford (no name)*, *printed in the yeare* 1645 (480) *Vaughan*, £1 1s.

5334 Harris (Dr. John). Complete Collection of Voyages and Travels, charts, maps and plates, 2 vol., old cf. gt., T. Osborne, etc., 1744-8, folio (347) *Grant*, £1

5335 Homerus. Ilias lib. XXIV., Graecé, contemp. oak bds., leather, stamped panels of grotesque animals, etc., *Lovanii*, Theodorus Martin Alostensis, 1523 (no date on title), sm. 4to. (403) *Barnard*, £2 12s.

5336 Homerus. Opera Omnia Graecé, editio princeps (cum Prefatione Latine Bern. Nerlii et Prefatione Graecé Demetrii Chalcondylae), (lower plain margin of Nerlius's Epistle cut off and supplied, outer margins of B iiii.-v. cut close), (12½ by 9in.), 19th century, mor., tooled back and sides, g. e., *Florentiae Sumptibus Bern. et Nerliorum*, 1488 (380) *Mahon*, £245

.5337 Horae Beatae Mariae Virginis ad usum Ecclesiae Romanae, French XVth century, illuminated manuscript on vellum (164 leaves, 7⅜ by 5¼in.), gothic letter, long lines, 15 to a full page, calendar in French in red and black, every page within a decorated margin, 13 illuminated arched miniatures within borders, old French mor., g. e., *Sæc.* XV. (early), square 8vo. (427) *Hornstein*, £76

.5338 Horæ Beatæ Mariæ Virginis ad Usum Romanum, Flemish XVth century, illuminated manuscript on vell. (144 leaves, 6¼ by 4¼ in.), gothic letter, long lines, 14 to a full page, with wide margins, full Calendar in French in blue, red and gold, red rubrics in French and Latin, text decorated throughout, numerous illuminated initials, 12 illuminated semi-arched miniatures (3 by 2½ in.), surrounded by borders, old French cf. gt., g. e., *Sæc.* XV. (428) *Ellis*, £54

.5339 Horae B.V.M. ad Usum Ecclesiae Parisiensis, cum Calendario, lit. goth. (lettres bâtardes), long lines, 30 to a full page, printed within woodcut borders, Vostre's large device on title, Skeleton Man, Stem of Jesse, Adoration of the Virgin, Death of Uriah in battle, Day of Judgement, etc.

(all these within borders), and 14 full-page woodcuts of the Passion without borders, apparently wanted last leaf, inner plain margins of first 2 leaves and last leaf guarded (a few leaves stained), new mor. ex., *Paris*, S. Vostre, s. a. [Almanack, 1515-1530], sm. 4to. (437) *Hess*, £6

5340 Horatius. [Opera], accedunt nunc D. Heinsii De Satyra Horatiana lib. II. et Notas, editio Elzeviriana prima, 3 vol. in 1, old French mor., au pointillé, centre and corner ornaments, leather and metal shell clasps (Le Gascon), *Lugd. Bat. ex off. Elzeviriana*, 1629, 12mo. (550)
C. Johnson, £5 5s.

5341 Houbraken and Vertue. Heads of Illustrious Persons, LARGE PAPER, 108 ports., 12 additional ports. inserted, 2 vol. in 1, old English mor. ex., J. and P. Knapton, 1743-51, imp. folio (318) *Rimell*, £16 5s.

5342 Hughes (Thos.) Tom Brown's School Days, illustrated by Arthur Hughes and Sydney P. Hall, orig. cl., very clean, 1889, 8vo. (461) *Maggs*, £4 2s.
[Presentation copy, with inscription on half-title, "Fanny Hughes, March, 1890," and attested as follows : "This was written by the Author, and is now given by his wife, Fanny Hughes, to Mary Hannah Hughes, on Jan. 12, 1898."—*Catalogue.*]

5343 Hunt (Leigh). The Town, first ed., 45 illustrations, 2 vol., orig. orange cl., clean copy, 1848, 8vo. (462)
Shepherd, £1 8s.

5344 Jeake (Saml.) Charters of the Cinque Ports, Two Ancient Towns, and their Members, translated into English, leaf at end of books printed by B. Lintot, old cf., B. Lintot, 1728, folio (228) *W. Daniell*, 18s.

5345 Johnson (S.) Irene, a Tragedy, first ed., with half title, and advertisement leaf at end, cf. ex., R. Dodsley, 1749, 8vo. (488) *Shepherd*, £1 16s.

5346 Johnson (S.) Dictionary, first ed., 2 vol., old cf., Knapton, etc., 1755, folio (348) *Tregaskis*, £4

5347 Johnson (S.) Life, by Boswell, ed. by Percy Fitz-Gerald, port., 3 vol., cf. ex., 1874, 8vo. (171) *Rimell*, £1 6s.

5348 [Johnson (S.)] The False Alarm, first ed., hf. bd., uncut, with the half title, "Written . . . upon the expulsion of Wilkes and the seating of his opponent Luttrel," 1770 (23) *Shepherd*, 10s.

5349 Jonson (Ben.) Works, port. by W. Elder, old cf., *T. Hodgkin for H. Herringman, etc.*, 1692, folio (350) *Howell*, £2

5350 Justinianus (Imp.) Corpus Juris Civilis, cum Annotationibus, etc., lit. got!)., 4 columns, red and black, Chevallon's device on title, woodcut before the text, ornamental initials (a few leaves at end wormed), new mor. antique, *Paris, ap. Claudium Chevallonium*, 1538, large folio (417)
Barnard, £1 8s.

5351 Keats (John). Lamia, Isabella, The Eve of St. Agnes, and other Poems, first ed., with half-title and 8 pages of advertisements at the end, beautifully clean, in the orig. bds.,

with printed label (slightly defective), *London, printed for
Taylor & Hessey, Fleet-street,* 1820, 8vo. (508) *Dobell,* £48

5352 Kelmscott Press. Chaucer (Geoffrey). Works, edited by
F. S. Ellis, specially bound in white stamped pigskin, the
sides covered with a blind tooled Morris design, g. e., uncut,
with clasps, by T. J. Cobden Sanderson, in box with lock
and key, *Hammersmith, printed by William Morris, May* 8,
1896 (232) *J. Bumpus,* £68
[With the autograph signatures of William Morris,
Burne-Jones, T. J. Cobden Sanderson and W. H. Hooper
mounted on separate tickets, loose in cover.—*Catalogue.*]

5353 Kelmscott Press. Morris (Wm.) The Story of the Glittering
Plain, woodcut border and ornamental initials (200 copies
printed), vell., uncut, with ties, *Hammersmith, printed by
William Morris, April* 4, 1891, sm. 4to. (231) *Panser,* £17
[Presentation copy of the first book issued from the
Kelmscott Press, with following inscription on fly-leaf, "To
Kate Faulkner from William Morris, May 30th, 1891."—
Catalogue.]

5354 Kemble (J. M.) The Saxons in England, revised by W. De
Gray Birch, 2 vol., uncut, Quaritch, 1876, 8vo. (184) *Hill,* £1

5355 Knorr (G. W.) Regnum Florae. Das Reich der Blumen
mit allen seinen Schönheiten, 148 plates (col. by hand), hf.
bd. (broken), *Nürnberg,* 1750, folio (346) *Foote,* £1

5356 Knox (John). The Copie of a Lettre delivered to the Ladie
Marie Regent of Scotland (28 leaves), (title soiled and
defective, 2 or 3 other leaves soiled,) *Geneva,* J. Poullain
and Antonie Rebul, 1558—The Appellation of John Knoxe
from the cruell and most unjust sentence pronounced
against him, first ed. (H 1 transposed, had portion of K 7
only and wanted K 8), (soiled,) *Printed at Geneva,* 1558, in
1 vol., old cf., 12mo. (431) *Holden,* £4

5357 La Bibliofilia. Rivista dell' arte antica in Libri, Stampe,
Manoscritti, Autografi e Legature, 1899-1906, 8vo. (533)
 Timbs, 14s.
[A long run of this periodical, with many hundreds of
illustrations in black and colours. It extends from, and
includes, the first vol. to No. 10, 1906.—*Catalogue.*]

5358 Lafontaine (J. de). Contes et Nouvelles en Vers, ré-
impression de l'Édition des Fermiers Généraux, plates and
vignettes after Eisen and Choffard (without letters), 2 vol.,
old French cf., Etruscan vases on backs, g. e., s. l., 1777,
8vo. (240) *Howell,* £4 6s.

5359 Lafontaine (J. de). Fables Choisies, mises en vers, grand
papier d'Hollande, front. containing port. of Lafontaine and
275 proof plates after J. B. Oudry, the plate, "Le Singe et
Léopard," before the letters, 4 vol., old French cf. gt., gilt
and painted edges, *Paris,* Desaint and Saillant, 1755-59,
imp. folio (324) *Quaritch,* £23

5360 La Guerinière (Fr. R. de). L' École de Cavalerie, engraved
title, with port. of the author inlaid on back, and plates,
old cf., *Paris,* J. Collombat, 1733, folio (342) *Foote,* £1 18s.

5361 Lambarde (Wm.) Eirenarcha, or the Office of the Justices of Peace, black letter (a few leaves wormed), old cf., *Stat. Co.*, 1619, 8vo. (244) *Ford*, £1 10s.

5362 Lamɔ (Charles and Mary). Tales from Shakespeare, first ed., with the 3 pages of advertisements, 20 copperplates ɔy W. Blake, 2 vol., orig. cf. (joints defective), *Printed for Thomas Hodgskin at the Juvenile Library, Hanway Street*, 1807, 8vo. (509) *Spencer*, £16

5363 Langhorne (Dr.) The Faɔles of Flora, first ed., illustrated ɔy Stothard, vell. ex., design in colours on each side, *E. & S. Harding, Pall Mall*, 1794, 8vo. (74) *Maggs*, £1 6s.

5364 Laud (Archɔp.) A Breviate of the Life of William Laud, Archɔishop of Canterɔury, by Wm. Prynne, front. of the Trial Scene ɔy Hollar (margin restored, last leaf ɔacked), cf. ex., *F. L., for Michaell Sparke at the Blew-Bible in Green-Arbour*, 1644, folio (218) *Colbrooke*, 19s.

5365 Laud (Archɔp.) A Speech delivered in the Starr Chamɔer, on Wednesday, the XIVth of June, 1637, at the censure of John Bastwick, Henry Burton and Wm. Prinn, first ed., with dedication, hf. mor., g. e., *Printed by Richard Badger*, 1637 (611) *Tregaskis*, 10s.
[The original edition, of which only 25 copies were issued with the dedication to King Charles, xi. pages.—*Catalogue.*]

5366 Lawrence (Mary). A Collection of Roses from Nature, 90 col. plates and front., old mor. gt., elegantly tooled, g. e., 1796, folio (349) *Wesley*, £66

5367 Le Brun (Ch.) La Grande Galerie de Versailles, éd. originale, grand papier, 52 proof plates, bds. (ɔroken), *Paris, Impr. Royale*, 1752, atlas folio (371) *Buckley*, £2 10s.

5368 Leslie (C. R.) and Taylor (Tom). Life and Times of Sir Joshua Reynolds, ports. and illustrations, 2 vol., orig. cl., 1865, 8vo. (48) *Barnet*, £1

5369 Lièvre (Ed.) Works of Art in the Collections of England, 50 plates, 500 copies printed, hf. mor., g. t., uncut, Holloway, n.d., imp. folio (219) *James*, £1

5370 Lilford (Lord). Coloured Figures of the Birds of the British Islands, first ed., plates in colours, text and illustrations, mounted on guards, 7 vol., hf. mor., t. e. g., R. H. Porter, 1885-97 (188) *Edwards*, £45

5371 Lilly (William). "Anti / Bos / sicon." [These words alone in large letters on title-page, woodcut of ɔear ɔaiting ɔy dogs on reverse.] The next page ɔegins "Aɔsolus Agrigentinus. Ad Lectorem," contains 24 leaves, signs. a-f, the same woodcut repeated on reverse of ɔ ii. and recto of d., ɔlack and roman letter, *Londini in aedibus Pynsonianis, An.* MDXXI.—Antibossicon / Guil. Hormani ad Guiliel- / mum Lilium. / Epistola Aldrisii ad Hor / mannum. / Epistola protovatis ad eun- / dem Hormannum. / Apologeticon Hormani ad / protovatam bisfarium. / lit. goth. and rom., title with the cut of ɔear-ɔaiting on reverse, the cut ɔeing

repeated on reverse of b iiii. and on separate leaf at end,
contains 36 leaves, signs. a-h in 4's, g having 8 leaves, the
leaf ending with an "Epigramma in Opera Whittintoniana,"
followed by the imprint as above, R. Pynson, 1521—Stulti-
fere Naves [cum prefatio J. B. Ascensii], (16 leaves,) De
Marnef's device on title and Kerver's on last leaf, 2 cuts in
text (wanted 4 leaves), *Paris, T. Kerver, anno hoc Jubilee
ad* XII. *Kal. Martias,* 1500—Erasmus. Scarabeus cum
Scholiis in quibus Graeca potissimum quae passim inserta
sunt exponuntur (28 leaves), lower margins uncut, *Lovanii,
Theodoricus Martinus Alost.,* 1517—A. Persii Satyrae, cut
of S. Jerome and lion in a library on reverse of last leaf,
Colon., in aed. Eucharii Cervicori, 1522—Lucianus Samos.
de Veris Narrationibus Commentarii duo festivissimi, etc.,
Gr. et Lat., *Basil., in aed. Valentini Curionis,* 1524—Vallae
(Laurentius). De Voluptate ac Vero Bono declamationes,
etc., prelum Ascensianum on title, and ornamental woodcut
initials, [*Paris*] *in aedibus Ascensianis,* 1512, in 1 vol.,
contemp. Cambridge leather binding, stamps of wiverns,
dragons and floreate designs, and mark of the binder,
Garret Godfrey (Von Graten), y. e. [*see* Weale's Bookbind-
ings in S. K. M.], sm. 4to. (408) *Quaritch,* £125

[The two Tracts of the "Anti-Bossicon" in this volume,
printed by Pynson in 1521, with the repetitions of the
satirical woodcut, are of the most extreme rarity. They
relate to the controversy between the two grammarians,
Lyly (the Latin master of Colet's School in St. Paul's),
Horman, his assistant, and R. Whitinton, the grammarian,
a number of whose treatises were printed by Pynson. [*See*
Brunet's full description under "Anti-Bossicon."] Two fly-
leaves from a XIVth Century Service Book, and inscription
on fly-leaf in front, "Roberte Digbye owethe this booke,
witnessed by ffrancis Hanley and manye other."—*Cata-
logue.*]

5372 Locke (John). Æsop's Fables in English and Latin Inter-
lineary, second ed., with (74) sculptures, orig. cf., 1723, 8vo.
(523) *Touswell,* £1 1s.

5373 L'Office de la Semaine Saincte, old French mor., decorated in
mosaics, inside dentelles, g. e., in the style of Padeloup,
with his ticket, in perfect preservation, *Paris,* J. F. Collom-
bat, 1750, 12mo. (426) *Sabin,* £33 10s.

5374 Lombardus (Petrus). Textus Magistri Sententiarum in
quatuor sectus libros partiales . . . [Item. quidam articulis
in Anglia & Exonia condemnati a doctoribus Sacrae Theo-
logiae Parisiensis], lit. goth., Queen Catharine of Arragon's
copy, contemp. English oak bds., leather, the upper cover
stamped with the large arms of the Queen, the under cover
having the arms of King Henry VIII., with supporters
of wivern and greyhound, y. e., clasp catches (slightly
damaged), probably bound by Thos. Berthelet, *Lugduni,*
Jo. Moylin, 1527, sm. 4to. (407) *Quaritch,* £55

5375 Marvell (Andrew). Miscellaneous Poems, first ed., with the

octagonal port., nearly always wanted, mor· ex., *Printed for Robt. Boulter at the Turks-Head in Cornhill*, 1681, folio (220) *Nowell, £6* 5s.

5376 Mathematicorum Veterum Athenaei, Bitonis Apollodori, Heronis, Philonis et aliorum Opera, Gr. et Lat., old cf., royal arms of France, *Paris, Typ. Reg.,* 1693, folio (343) *Wesley, £3*

5377 Mayer (Luigi). Views in Egypt and the Ottoman Empire (Caramania), 72 col. plates, 2 vol. in 1, hf. russ., R. Bowyer, 1801-3, imp. folio (317) *Howell, £1* 9s.

5378 Mélange of Humour (by D. T. Egerton), a collection of 45 (should be 50) col. engravings, orig. impressions (no title), hf mor., g. e., 1823, etc., folio (193) *Edwards, £2* 2s.

5379 "Memorias y Aniversarios, Calenda y Regla de Sant Benito"—Capitula Evangeliorum in Adventu Domini—Martyrologium—"Incipit Prologus regule eximii Patris ɔeatissimi Benedicti," etc., Spanish and Latin manuscript on vellum (222 leaves, 11 ɔy 7in.), 𝔤𝔬𝔱𝔥𝔦𝔠 𝔩𝔢𝔱𝔱𝔢𝔯, long lines, generally 24 to a full page, red ruɔrics, capitals painted, ornamental pen letters, 14 large initials in the Martyrology. old oaken bds., leather, *initio Sæc.* XIV.-XV. (451) *Quaritch, £160*
[The Chartulary of the Benedictine Monastery of St. Peter in Cardeña, near Burgos. A composite manuscript in various hands; the earliest date noted ɔeing 1170, and the latest 1502.—*Catalogue.*]

5380 Military Pageant. Beschreiɔung und Vorstellung de Solennen Stück-Schiessens, welches auf hohen oberherrlichen Befehl eines hochlöblichen Raths des Heil. Rom. Reichs Freyer Stadt Nurnɔerg in Jahr 1733 den 8. Junii, etc., 14 douɔle plates of military processions, etc., hf. vell., *Nürnberg,* 1734, folio (321) *Quaritch, £1* 1s.

5381 Milton (John). Paradise Regain'd, first ed., leaf of License and the leaf of Errata, mor. ex. (7 ɔy 4½ in.), *Printed by J. M. for John Starkey at the Mitre in Fleet-street, near Temple-Bar,* 1671 (525) *Maggs, £13*

5382 Miniature Books. Almanack. Calendar von dem Jahr 1797 bis auf 1805, each year printed on different col. paper, engravings, 9 vol., uniform leather with silver and painted ornaments, g. e. (3 by 2 in.), *Augsburg, verlegt von Jo: Peter Ebner,* 1797-1805 (389) *Quaritch, £6* 6s.

5383 Miniature Books. Dante, Divina Commedia, port. (the smallest edition of Dante ever printed, measuring 2 by 1¼ in.), mor., g. e., *Milano,* U. Hoepli, 1878—Le Rime de Petrarca, ports. and vignettes (the smallest edition ever printed), vell., t. e. g., uncut (2¼ by 1½ in.), *Venez.,* F. Ongania, 1879 —De Imitatione Christi, LARGE PAPER, uncut, front., cf. antique (3¼ by 2 in.), *Paris,* E. Tross, 1858 (390) *Lewine, £1* 11s.

5384 Miseries of Human Life, Sixteen Scenes from, by One of the Wretched (Jas. Beresford), 16 col. plates (one folding) and

col. vignette on title, orig. ɔinding with laɔel, 1806-7, oɔlong
4to. (629) · *Hornstein,* £2 2s.

5385 Missale Monasticum secundum morem & ritum Casinensis
congregationis, **lit. goth.** magna (first leaf of Canon mended,
pages 204-5 defective and some woodcuts cut into), mor.
ex., douɔlé, in case, *Venetiis, per Lucam Ant. de Giuntis
Florentinum,* 1506, XIII. *Kal' maias,* folio (88) *Ellis,* £20
[The same copy as that reported *ante* No. 2860, returned
for the imperfections stated.—ED.]

5386 Missale s'm. ordinē Carthusiensiuɜ | nouiter impressum . . at
end : In alma Ue | netorum Ciuitate . . sumptibus ac
expensis | Noɔilis viri domiai Luceantonii de giūta Floren-
tini impres | sum Anno . . quingētesimo nono supra | mil-
lesimum : Die. 5. aprilis . ., **lit. goth.**, square musical notes
on a stave of 4 lines, 20 full-page woodcuts and aɔout 400
small cuts, ornamental and figured initials (leaves of
Calendar stained and a few with holes damaging the text,
wanted ⊕i.-ii.), contemp. Venetian mor., gilt ornaments,
tooled clasps (ɔack repaired), *Venet.,* L. A. de Giunta, 1509,
8vo. (520) *Leighton,* £5 5s.

5387 Monstrelet (Enguerrand de). Chroniques, 3 vol. in 2 (stained),
old cf. gt., *Paris,* P. L'Huillier, 1572, folio (352)
Carte, £1 18s.

5388 Nash (J.) Mansions of England, orig. ed., the four series
complete, 104 plates (wanted No. 19 first series), col. and
mounted like drawings, loose in 4 orig. portfolios (with
descriptive text in 8vo.), 1839-49, atlas folio (85) £33
[*See ante* No. 2868, same copy.—ED.]

5389 Navy. A General Treatise of the Dominion of the Sea,
third ed., folding front. and plate of sea flags, etc., old cf.,
Executors of J. Nicholson, etc., n. d., 4to. (412) *Dobell,* 13s.

5390 Needlework Binding. The Holy Biɔle, R. Barker, 1638—
The Psalter, *Printed for the Societie of Stationers,* 1635—
The Whole Booke of Psalmes in English Meeter ɔy John
Sternhold, etc., *G. M., for the Companie of Stationers,* 1637,
in 1 vol., ɔound in ɔoards and white silk, with elaɔorate
ornaments in coloured threads of flowers and scrolls, and
a spread eagle in centres, g. e., ɔy the Nuns of Little
Gidding, well preserved, 1638-35, 8vo. (425)
Maggs, £22 10s.

5391 Newcastle (Duke of). La Methode Nouvelle de dresser les
Chevaux, traduit de l'Anglais, engraved title and plates,
including the plate of the ducal family, and equestrian
ports., old cf., *Anvers, chez Jacques Van Meurs,* 1658, folio
(344) *Tregaskis,* £4 4s.

5392 Newton (Sir Isaac). Opera quae extant Omnia, Commentariis
illustravit S. Horsley, D.D., etc., 5 vol., old cf. gt., Jo.
Nichols, 1779-85, 4to. (275) *Hill,* £5 15s.

5393 Nichols (John). History and Antiquities of the County of
Leicester, LARGE PAPER, maps, plates and ports., 4 vol.
in 8, orig. hf. cf., uncut (measures over 20 by 12in.), 1795-
1815, folio (222) *Halliday,* £96

[An apparently perfect and genuine su）scri）er's copy, including the West Goscote and Guthlaxton Hundreds, nearly all ）urnt at Nichols' fire, with proof plates. The "Guthlaxton Hundred" was reprinted on small paper only ; the "West Goscote" was not reprinted in any form.— *Catalogue.*]

5394 Nicolas (Sir Harris). History of the Battle of Agincourt, port. on India paper, col. plate of arms and maps, Spanish cf., inside ）orders, g. e., 1833, 8vo. (568) *Edwards*, 17s.

5395 Noli (Glam）.) Nuova Pianta di Roma, 18 dou）le plates, hf. russ., s. l., 1747, folio (322) *Rossi*, £1

5396 Nova Scotia. The Memorials of the English and French Commissaries concerning the Limits of Nova Scotia [vol. i.], map, unbd., uncut, 1755, 4to. (294) *H. Stevens*, £1 7s.

5397 Officium et Missae Sanctorum, etc. cum notis Musicis Secundum Romanum Curiam, musical manuscript on vellum (154 leaves, 17½in. by 13in.), roman letters, square musical notes on red 5-line staves, calligraphic and red painted initials, written ）y a Spanish scri）e, with 2 leaves of index in Spanish at the ）eginning of the MS. in a later hand, contemp. monastic oak bds. and leather, 74 small metal ）osses and cane and metal clasps, *Sæc.* XV.-XVI., large folio (440) *Hess*, £90

[This MS. contained 28 large initial miniatures of saints, 4 full-page paintings and a quarter-page painting, richly illuminated. Apart from these initial miniatures the MS. contained 4 very fine full-page illuminated paintings and a quarter-page painting (10in. ）y 6in.). All the decorations and illuminations are ）y an Italian copyist of the late Renaissance period.—*Catalogue.*] .

5398 Omar Khayyam. The Ru）áiyát [by Edward Fitz Gerald], first ed. (one misprint corrected in Fitz Gerald's autograph), orig. wrapper, as good as when first issued, Bernard Quaritch, 1859, 4to. (596) *Hornstein*, £51

[Of this, the ）est known of Fitz Gerald's works, 250 copies are said to have ）een printed, of which 200 were made a present to the pu）lisher. Accompanying the lot are two post-cards and short notes, etc. in the handwriting of Edward Fitz Gerald, also two water-colour seascapes, one taken at Lowestoft, in 1841, and ）oth signed "E. F. G."— *Catalogue.*]

5399 Oxford Almanacks from 1775 to 1820, with full margins, and post office stamp 1764 to 1774 (some of these have had the almanack cut away), engraved views of the colleges, etc., in 1 vol., old hf. mor., 1775-1820, imp. folio (207) *Butt*, £7

5400 Paleologus (Manuel Aug.) In Theodorum Fratrem Despotam Peloponnesi, Demetrii Cydonii Deliberativae, in Causa Subsidii Latinorum, etc., Gr. et Lat., edidit F. Fr. Combefis, old French mor., semis of fleur-de-lis, arms of Louis XIV. in centres, g. e., *Paris*, A. Bertier, 1647 (331) *Leighton*, £4 4s.

5401 Palladio (Andrea). Le Faɔɔriche, raccolti ed illustrati da
O. B. Scamozzi, plates, 4 vol. in 2, old cf., *Vicenza*, F.
Modena, 1776, folio (327) *Batsford*, £2 8s.
5402 Pérau (Aɔɔé). Déscription Historique de l'Hotel Royal des
Invalides, front. and 108 plates by Cochin, old French cf.,
with gilt fleur-de-lis, g. e., *Paris*, G. Desprez, 1756 (330)
Maggs, £3 13s.
5403 Parkinson (A.) Collectanea Anglo-Minoritica, or a Collection
of the Antiquities of the English Franciscans, with 2 leaves
of errata, and a leaf with Tho. Hearne's letter on the work,
4 plates (often wanted), mor. ex., *Printed by Thos. Smith*,
1726, 4to. (607) *Hodgkin*, £1 8s.
5404 Passerat (Jean). Recueil de ses Œuvres Poétiques, port.,
signature of (Sir) "Andrew Moray of Balvairdé emptus
Paris. 8 April 1608. 15 solid.," on title, orig. vell., *Paris*,
Cl. Morel, 1606, 8vo. (250) *Lewine*, £1 8s.
5405 Petrarca. Il Petrarcha con l'Espositione d'Aless. Vellutello
con molte altre cose . . . nuovamente da lui aggiunte,
woodcut map (a few leaves wormed), contemp. Venetian cf.,
"Il Petrarcha" in gold letters, and "Protha K." on under
cover, old gilt edges (ɔinding damaged), *In Vinegia*, B. de
Vidali, 1528 (241) *Clarke*, £3 13s.
[J. A. de Thou's copy, with his signature, "Jac. Aug.
Thuani," occurring three times in the ɔook.—*Catalogue*.]
5406 Piranesi (G. B.) Opere. Le Antichita Romane, 4 vol.—
Campus Martius—L'Antichita d'Albano—Magnificenza de'
Romani, together 7 vol., uniform hf. ɔinding, uncut, *Roma*,
1756-62, atlas folio (334) *Phillips*, £12
5407 Plague (The). A Forme of Common Prayer, together with
an Order of Fasting for the heavy Visitation upon many
places of this Kingdom, etc., black letter, hf. mor., Norton
and Bill, 1625, 4to. (608) *Quaritch*, £1 12s.
5408 Planche (J. R.) Cyclopaedia of Costume, col. plates and
numerous illustrations, 2 vol., hf. mor., g. t., 1876-9, 4to.
(606) *Godfrey*, £4 14s.
5409 Plautus. [Comediæ] ex fide atque auctoritate complurium
Librorum Manuscriptorum opera Dion. Lamɔini, old mor.,
arms and monogram, g. e. (worn), *Lut. ap. Jo. Macaeum*,
1577, folio (362) *Quaritch*, £3
5410 Playing Cards. A Pack of Engraved Pictorial Playing Cards
of the Popish Plot in King Charles II.'s Reign, 1678,
ɔacked with thick paper, in box, 1678 (51) *Maggs*, £1 8s.
5411 Plinius Secundus. Opera, old mor., gilt floreate ɔack, *Glas-
guae*, R. et A. Foulis, 1751, sm. 4to. (307) *Berkeley*, £1 8s.
5412 Poe (Edgar Allan). Tales, first ed., hf. mor., *New York*, 1845,
8vo. (18) *Tregaskis*, £1 4s.
5413 Pope (Alex.) Works, first collected quarto ed., 6 vol., Lintott,
etc., 1717, 1735, 1737, 1741 and 1807—Homer's Iliad and
Odyssey, first quarto ed., port. of Homer, 6 vol., *Bowyer
for Lintott*, 1715-20, together 12 vol., old English mor. gilt,
tooled, g. e. (Du Seuil), (vol. vi. of works in modern mor. to
match,) 1715-1807, 4to. (281) *Foote*, £10

5414 Pope (A.) Works, in prose and verse, first collected ed., folding port. (mended), 4 vol., cf., 1717-1741, 8vo. (144)
Rimell, £1

5415 Prayer. Booke of the Common Praier, black letter, title within woodcut border, with representation of the king in council at top, and device of Grafton at foot, preliminary leaves, including Calendar, in red and black, woodcut initials throughout (defect affecting a few letters of marginalia and two holes in another leaf), orig. stamped cf., back partly restored, *Londini, in officina Richardi Graftoni* . . . M.D.XLIX. *mense Martig,* (at end) . . . *mense Iunij,* M.D.XLIX. (1549) (653) *Quaritch,* £70
[The rarest of the early issues of Edward the Sixth's first Prayer Book. It has the singular royal order as to prices of the book in different bindings, just above the colophon on reverse of last leaf, and two folio leaves at the end, containing " The Forme of Prayer at the Healing when the King touches." These are printed in black letter, on one side of the paper only, and intended for insertion in those Prayer Books which did not originally contain this Form.—*Catalogue.*]

5416 Prayer. Book of Common Prayer, engraved throughout by John Sturt, with the " Circular Table," contemp. mor. ex., John Sturt, 1717, 8vo. (50) *Young,* £5 12s. 6d.

5417 Primaleon de Grece. L'Histoire de Primaleon de Grece, par François de Vernassal Quercinois [Premier Livre], première éd., woodcuts, orig. cf., *Paris,* Jan Longis, 1550, folio (361)
Quaritch, £10
[This vol. belonged in 1580 to a certain Sir George Moray (or Murray), who has scribbled some notes in Scotch and Latin on fly-leaves.—*Catalogue.*]

5418 Prior (James). Memoirs of the Life and Character of the Right Hon. Edmund Burke, second ed., illustrated with 125 additional ports., including a few views, 2 vol., hf. mor. ex., 1826, 8vo. (497) *Maggs,* £5 12s. 6d.

5419 Propert (J. L.) History of Miniature Art, 21 plates and illustrations of illuminated MSS., hf. cf., t. e. g., 1887, roy. 4to. (122) *Bury,* £7

5420 Ptolemaeus (Cl.) Geographiae libri octo, engraved title, port. of Mercator and 28 maps, col. by a contemp. hand, old cf., *Amst.,* Hondius, 1605, folio (341) *Edwards,* £4

5421 Pyne (W. H.) History of the Royal Residences, 100 engravings, facsimiles of original drawings by C. Wild, Cattermole, etc., 3 vol., hf. cf., m. e., 1819, roy. 4to. (192)
G. H. Brown, £5 10s.

5422 Pyne (W. H.) Somerset House Gazette and Literary Museum, by Ephraim Hardcastle, author of " Wine and Walnuts," first ed., 2 vol., hf. cf., 1824-5, 4to. (585) *Shepherd,* 13s.

5423 Raine (Rev. J.) History of North Durham, LARGE PAPER, port., map and plates, unbd., Nichols and Son, 1852, folio (200) *Walford,* £2 10s.

5424 Repton (H.) Sketches and Hints on Landscape Gardening, col. plates (some with moveaɔle slips), orig. bds., uncut, Boydell (1794), oɔlong 4to. (273) *Quaritch,* £6 6s.

5425 Révolution Française, ou Analyse Complette et Impartiale du Moniteur, mezzo. ports. and plates, 4 vol., old French cf., gt., m. e., *Paris, chez Girardin,* 1801-2, folio (320)
 Hatchard, £9 5s.

5426 Rolewincke (W.) Fasciculus Temporum, 𝔤𝔬𝔱𝔥𝔦𝔠 𝔩𝔢𝔱𝔱𝔢𝔯, diagrams and 51 woodcuts, col. ɔy hand, *Venetiis, Erhardus Ratdolt,* v. *Junii,* 1484, folio (201) *Barnard,* £1 10s.

5427 Romney (George). Life, ɔy William Hayley, ports. and plates, hf. mor., t. e. g., *Chichester,* 1809, 4to. (121) *Bury,* £5

5428 Roscoe (Thos.) German Novelists' Tales, 4 vol., cf. ex., uncut. 1826, 8vo. (554) *Howell,* £2

5429 Rothschild (Alfred de). A Description of the Works of Art forming the Collection of Alfred de Rothschild, 2 vol., vol. i. pictures, with 81 photographs, vol. ii. Sèvres china, furniture, etc., text only (plates wanted), unbd., *Compiled by C. Davis, New Bond St.,* 1884 (202) *James,* £2 14s.

5430 Rowlandson (T.) A complete series of Six Plates, under the title of " Masqueroniens," designed and etched ɔy Rowlandson, and finished and coloured in imitation of the original drawings, original grey wrapper, with pink laɔel, in hf. mor. covers, R. Ackermann, Aug. 15, 1800, oɔlong folio (650) *Hornstein,* £44 10s.
[" It is not very clear whether these symɔolical groupings, which are superior in execution to the average of Rowlandson's puɔlished works, were devised to be cut up for scrap-ɔooks, screens or wall-ɔorderings ; but they have ɔecome remarkaɔly scarce . . . and are rarely met with at the present time."—*Joseph Grego.* The heads are duɔɔed with names such as " Philosophorum," " Fancynina," " Epicurum," " Tally-ho ! rum," etc. Proɔaɔly the publisher's own copy.—*Catalogue.*]

5431 Rowlandson (T.) A complete set of Six Illustrations to Smollett's Roderick Random—(1) Lieut. Bowling pleading the cause of young Rory, (2) the Passengers from the Waggon arrive at the Inn, by Rowlandson, after G. M. Woodward, (3) Roderick's Examination at Surgeons' Hall, (4) Morgan offending the delicate organs of Captain Whiffle, by Stadler, after Collings, (5) Melopyn haranguing the Prisoners in the Fleet, (6) Captain Bowling introduced to Narcissa, ɔy Rowlandson, after Singleton, a series of col. aquatints, in orig. wrapper, in hf. mor. covers, R. Ackermann, May 12, 1800, oɔlong folio (649)
 Maggs, £25 10s.
[Of excessive rarity, ɔeing unknown even to Mr. Grego in this form, and no set recorded as having occurred for puɔlic sale during the past 25 years. It is a set picked ɔy the puɔlisher from his own collection, as evidenced ɔy his mark stamped on the first plate.—*Catalogue.*]

5432 Rowlandson (T.) Naples, and the Campagna Felice, first

ed., col. plates ɔy Rowlandson, hf. mor. ex., uncut, Acker-
mann, 1815, roy. 8vo. (559) *J. Bumpus, £3* 16s.
5433 Rowlandson (T.) Poetical Sketches of Scarɔorough, 21 plates
ɔy Rowlandson, hf. mor. ex., uncut, Ackermann, 1813, roy.
8vo. (555) *Howell, £3* 4s.
5434 Rowlandson (T.) The Grand Master, or Adventures of Qui
Hi? in Hindostan, first ed., folding col. front. and col.
plates ɔy Rowlandson, hf mor. ex., uncut, Tegg, 1816, roy.
8vo. (557) *J. Bumpus, £4* 17s. 6d.
5435 [St. Germain (Chr.)] Dyalogues in Englishe ɔetween a
Doctour of Divinitie and a Student of the Lawes of Eng-
land, **black letter**, R. Tottel, 1554—[Fitzherɔert (Sir A.)]
Natura Brevium in Englishe, **black letter**, *ib.*, 1557, in 1 vol.,
old cf., Tudor rose in centres and fleurs-de-lis at corners,
sm. 8vo. (383) *Leighton, £2* 16s.
5436 Sanson (N.) La France, L'Espagne, L'Italie, L'Allemagne,
et les Isles Britanniques, descrites en plusieurs Cartes, etc.,
50 col. maps, old cf., *Paris, chez l'Auteur*, 1651, folio (332)
Quaritch, £12 12s.
5437 Scotland. Confession of Faith of the Kirk of Scotland,
suɔscriɔed ɔy the Kings Majestie and his Household, in
the yeare of God 1580, no name, place or date (*Edinb.*,
1638)—Confessio Fidei Ecclesiae Scoticanae, woodcut on
title (*Edinb.*), *Anno Domini nostri*, 1638, fine copies in 1
vol., hf. mor., 4to. (633) *Holden, £2*
5438 Scott (Sir W.) The Doom of Devorgoil, Auchindrane, first
ed., uncut, 1830 — Halidon Hill, first ed., uncut, 1822,
together 2 vol., 8vo. (130) *B. F. Stevens,* 11s.
5439 Scrope (W.) Art of Deer Stalking, engravings and litho-
graphs after E. and C. Landseer and the author, new ed.,
mor. ex., g. e., J. Murray, 1839, imp. 8vo. (392)
Howell, £3 14s.
5440 Scrope (W.) Days and Nights of Salmon Fishing, first ed.,
lithographs and woodcuts, ɔy Haghe, T. Landseer and S.
Williams, orig. cl., uncut, 1843, roy. 8vo. (236)
Maggs, £5 2s. 6d.
5441 Seymour (R.) Humorous Sketches, comprising Ninety-two
Caricature Etchings illustrated in Prose ɔy R. B. Peake,
col. plates, mor. ex., g. e., Routledge, 1846, 8vo. (180)
Abrahams, £2
5442 Shakespeare (W.) Collection of Prints, from Pictures painted
for the purpose of illustrating the Dramatic Works of
Shakespeare, 99 plates, including ports. of George III. and
Queen Charlotte, and two vignettes on title-pages (wanted
to complete the series plate 48 in vol. ii., "Shakspeare
nursed by Tragedy and Comedy"), 2 vol., orig. hf. ɔinding
(damaged), J. and J. Boydell, 1803, atlas folio (233)
Joseph, £12
5443 Shakespeare (W.) Genuine Leaf, containing Ben Johnson's
verses "To the Reader," as prefixed to a rare issue of the
Third Folio Shakespeare, measures 11¾ ɔy 8½in. (1663)
(229) *Quaritch, £20*

[This ɔelongs to the earliest issue, ɔearing the date 1663
on the title-page. The later one of 1664 had the verses
printed ɔeneath the portrait.—*Catalogue.*]

5444 Shakespeare (W.) Dramatic Works, port., plates in three
states, 8 vol., mor. ex., ɔy F. Bedford, in his ɔest style, in
case, *Chiswick*, Whittingham, 1827, 32mo. (500)
Rimell, £7 2s. 6d.

5445 Shelley (Mary Wollstonecraft). Frankenstein, first ed., 3 vol.
in 1, old cf., Lackington, etc., 1818 (422) *Quaritch*, £35
[Mary Shelley's copy, with numerous corrections in her
hand for the second ed. ; inscription on fly-leaf, "Mrs.
Thomas from her friend the author Mary Shelley," and two
autograph letters of Mary Shelley to Mrs. Thomas ; also
a note relating to her acquaintanceship with the author on
fly-leaf.—*Catalogue.*]

5446 Shepard (Thos.) Theses Sabbaticae, or The Doctrine of the
Saɔɔath, mor. ex., *T. R. and E. M. for John Rothwell*, 1650,
8vo. (4) *B. F. Stevens*, £1 12s.

5447 Sheraton (T.) The Caɔinet-Maker and Upholsterer's Draw-
ing Book, second ed., with additional plates, *Printed for the
author*, 1794—Appendix to the Caɔinet-Maker and Up-
holsterer's Drawing-Book, *ib.*, 1796—An Accompaniment
to the Caɔinet-Maker and Upholsterer's Drawing Book,
ib. (1796), together 1 vol., plates, contemp. cf. gt., 1794-1796,
4to. (96) *Tregaskis*, £11 15s.
[The plates in the first appendix are numɔered and
arranged in a most erratic manner, and it is douɔtful
whether all are present ; sold with all faults.—*Catalogue.*]

5448 Sidney (Sir P.) The Countess of Pemɔroke's Arcadia,
eleventh ed., orig. cf., with 3 orig. ɔlanks, *H. Lloyd for
Wm. Du Gard*, 1662, folio (354) *Howell*, £1 6s.

5449 Slave Trade. Evidences ɔefore the House of Commons,
1789-91, 6 vol., 1825, folio (360) *James*, £1 13s.

5450 Slatyer (Wm., D.D.) Genethliacon, sive Stemma Jacoɔi,
Genealogia scilicet Regia Catholica, etc., 11 pages in verse
and 21 pages of pedigrees, cf. ex., G. Miller, 1630, folio (204)
Edwards, £1 1s.

5451 Smith (Ch. Hamilton). Selections of the Ancient Costume
of Great Britain and Ireland, 62 col. plates, including front.,
old mor., arms of Sir Simon R. B. Taylor, g. e., Colnaghi
and Co., 1814, roy. 4to. (310) *Maggs*, £3

5452 Smith (Adam). Wealth of Nations, first ed., 2 vol., old cf.
gt., W. Strahan, etc., 1776, 4to. (280) *Howell*, £2 12s.

5453 Smith (J. T.) Antiquities of London and its Environs, hf.
mor. ex., g. t., uncut (1791), 4to. (593) *Edwards*, £1 3s.

5454 Some (Roɔert). A Godly Treatise containing and deciding
certaine questions mooved of late in London and other
places, etc. After the ende of this Booke you shall finde
(separate title) A defence of such points as M. Penry hath
dealt against, and a Confutation of many grosse errours
ɔroched in M. Penries last Treatise, cf., g. e., *Imprinted at
London by G. B. Deputies to Christ. Barker*, 1588, 4to. (594)
Quaritch, £2 6s.

5455 Somner (Wm.) Antiquities of Canterɔury, second ed., with Appendix and Supplement, folding map, plans and plates ɔy Hollar, etc., Camɔridge cf. ex., fine copy, 1703, folio (654) *Harding*, £2 2s.
5456 Steele (Richard). The Christian Hero, first ed., autograph signature of Bolton Smith on title-page, orig. cf., Jacoḃ Tonson, 1701, 8vo. (24) *Tregaskis*, £8
5457 Steele (R.) The Conscious Lovers, a comedy, first ed., 1723, 8vo. (131) *Howell*, 8s.
5458 Sterne (L.) Tristram Shandy, vol. iii., iv., v., vi. and vii., first ed., front. ɔy Hogarth, and the half-titles to 3 vol. (only issued to these and to vol. ix.), 5 vol., orig. marɔled paper covers, uncut, R. and J. Dodsley, 1761-62-65, 8vo. (572) *Dobell*, £7 5s.
5459 Stothard (T.) Life of Thomas Stothard, R.A., with Personal Reminiscences ɔy Mrs. Bray, 1 vol. inlaid and extended into 3 vol. ɔy the insertion of 608 extra illustrations, mor., gilt ɔacks, g. e., 1851, folio (210) *Maggs*, £29
5460 Surtees (R. S.) "Ask Mamma," first ed., col. illustrations and woodcuts by Leech, orig. cl., 1858, 8vo. (46) *Quaritch*, £3 15s.
5461 Surtees (R. S.) Mr. Facey Romford's Hounds, first ed., col. illustrations and woodcuts by Leech and Browne, orig. cl., 1865, 8vo. (47) *Quaritch*, £6 4s.
5462 Surtees (R. S.) "Ask Mamma"—Mr. Sponge's Sporting Tour—Handley Cross—Plain or Ringlets—Mr. Romford's Hounds, 5 vol., col. plates and woodcuts, hf. mor., t. e. g:., n. d., 8vo. (174) *Taylor*, £5 15s.
5463 Suckling (Sir J.) Fragmenta Aurea, port. by Marshall (the top corner repaired, a few leaves shaved in the headlines), (6¾ by 4⅝in.), mor. ex., H. Moseley, 1648, 8vo. (575) *Edwards*, £4 10s.
5464 Swift (Jon.) Complete Collection of Genteel and Ingenious Conversation, by Simon Wagstaff, Esq., first ed., orig. cf., with leaf of advertisements, 1738, 8vo. (132) *Dobell*, 10s.
5465 Sydney (Sir H.) Letters and Memorials of State—Oliver's Usurpation, ɔy A. Collins, 2 vol., port. by Vertue, and MS. pedigree of the Sidney family inserted, hf. mor., 1746, folio (656) *Gibson*, £1 13s.
5466 Tasso (Bernardo). L' Amadigi, ornamental initials, old French mor., g. e. (Derome), "Biɔliotheca Lamoniana," *Venet.*, Fratelli Zoppini, 1583, 4to. (300) *Leighton*, £4 17s. 6d.
5467 Tasso (T.) La Gierusalemme Liɔerata, proof plates and vignettes after Gravelot, 2 vol., old French mor., g. e. (Derome), *Parigi*, Delalain, etc., 1771, 8vo. (238) *Edwards*, £7 5s.
5468 Tatham (R. E.) Genealogical Chart of the Family of Tatham, plate and large folding pedigree (12ft. long), mounted on linen, orig. bds., only a few copies privately printed, *Settle*, 1857, folio (657) *Walford*, £1

5469 Techener (J. et L.) Histoire de la Biobliophilie, Reliures recherchés sur les Bibliothèques des plus Célèores Amateurs, Armorial des Biobliophiles, 47 plates of ancient oindings, oound from parts with the wrappers, hf. mor. ex., *Paris*, Techener, 1861-4, imp. folio (636) *Maggs*, £3

5470 Terentius. Comoediae sex, old mor., diagonal olind lines on oack, panel frame sides, arms and devices of Henri II. of France and Diane de Poictiers, 2 silk ties, plain edges, *Venet. ex off. Erasmiana ap. V. Valgrisium*, 1546, 8vo. (424) *Barnard*, £8

5471 Testamentum (Novum) Graecè et Latinè, studio et industria Des. Erasmi Roterodami accurate editum (defect in last leaf), mor. ex., *Lipsiae, Typis Voeglianis* (1570), 8vo. (528) *Colbrooke*, 16s.

5472 Themistius. In Aristoteles Posteriora Physica, Anima, Memoria & Reminiscentia Somno & Vigilia, Insomniis, Diviniatione per Somnum, Herm. Baroare interprete, contemp. oaken bds., leather, stamped panels, *Basil.*, Jo. Walderus, 1533, sm. 4to. (402) *Leighton*, £2 6s.

5473 Thomson (Jas.) The Seasons, first collected ed. (the first appearance of " Autumn "), 4 engravings after W. Kent, oy N. Tardieu, orig. cf., *Printed in the year* 1730, 4to. (282) *Hughes*, £2 11s.

5474 Treitzsauerwein (Marx). Der Weisz Kunig, woodcuts oy Hans Burgkmair, from the original olocks, old cf. gt., *Wien*, Jo. Kurtzböchen, 1775, folio (365) *Leighton*, £7 10s.

5475 Trials for Adultery, from 1780 to the middle of 1797, vol. i. (oelieved to be all puolished), containing 17 trials (one leaf defective), illustrated with 31 plates by Dodd, Chalmers, etc., old cf., y. e., 1796, 8vo. (512) *Hornstein*, £10 15s.
[This is the extremely rare continuation to the 7 vol. edition which only contained the trials up to 1780. This was also issued as " The Cuckold's Chronicle," a copy of which was sold April, 1902, in Col. Hiooert's sale.—*Catalogue*.]

5476 Turner (T. H.) Domestic Architecture in England, in 2 parts, plates (some spotted), together 4 vol., orig. cl., *Oxford*, J. H. Parker, 1851-59, 8vo. (185) *Hornstein*, £2 11s.

5477 Uroanus (Bolzanius). Grammaticae Institutiones iterum per quā diligenter elaboratae, etc. Gr. et Lat., gothíc letter, small cut of Agnus Dei oelow, contemp. Camoridge oinding of leather, stamped with figures of dragons and other grotesque animals, oy Nicolas Spierinck of Camoridge (slightly worn and top of oack torn), *Venet.*, *Jo. de Tridino alias Tacuino*, 1512, sm. 4to. (398) *Ellis*, £8 5s.

5478 Veterinariae Medicinae liori duo, a Johanne Ruellio nunc vero Graeca lingua primum in lucem aediti, contemp. Italian leather with 8 medallion heads in panels, containing oinder's mark G. F. (or F. G.), (worn and under cover damaged), *Basil.*, Jo. Valderus, 1537, sm. 4to. (397) *Leighton*, £2 2s.

5479 Virgilius et Horatius, front. to Horace inserted, 2 vol., old
mor. gt., *Birmingham*, Jo. Baskerville, 1757-70, 4to. (313)
Withers, £2 18s.

5480 Voragine (Jacobus de). Sermones de Sanctis, lít. gotÿ., Italian
woodcut on title, large gothic initials, contemp. English
(Oxford?) oak bds., stamped leather (the stamp on the
upper cover erased), that on the under cover consisted of
a panel of five divisions containing ɔirds, animals and
ornaments, with inscription "datum fac michi manu," etc.,
but name illegiɔle (not in Weale), *Papie impressi cura ac
impensis Jacob. de Paucisdrapis de burgofrancho*, 1500 (*with
device*) (385) *Leighton*, £25
[The fly-leaves of the ɔinding are composed of two
original leaves of Mirk's Liɔer Festivalis printed in Oxford,
1486, in two types, one for the English and one for the
Latin texts. One of the leaves ɔears the signature g 11.—
Catalogue.]

5481 Waller (Edmund). Speech in Parliament at a Conference of
ɔoth Houses in the Painted Chamɔer, July 6, 1641, first
ed., uncut and unopened, 1641, 4to. (150) *Maggs*, £1 10s.

5482 Walpole. A Series of Portraits to Illustrate the Earl of
Orford's Catalogue of Royal and Noble Authors, 168 ports.
ɔy S. Harding, cf., *Harding, Pall Mall*, 1798-1803, 4to. (288)
Maurice, £3 18s.

5483 Walton and Cotton. The Complete Angler, seventh ed.,
ɔy Sir John Hawkins, ports., plates and vignettes, russ.,
g.e., Bagster, 1808, 8vo. (43) *Hornstein*, £1 1s.

5484 Walton and Cotton. The Complete Angler, ɔy John Major,
8 etchings in two states, woodcuts on India paper, J. C.
Nimmo and Bain, 1883, 8vo. (167) *James*, 13s.

5485 Walton and Cotton. The Compleat Angler, third ed., vig-
nette on title and cuts of fish (a few headlines shaved),
*J. G. for Rich. Marriot in St. Dunstans Churchyard, Fleet
Street*, 1661—[Cotton (Ch.)] The Compleat Angler, part ii.,
first ed. (title cut into, and wanted ɔlank for A j), R.
Marriott and Henry Brome, 1676—Venaɔles (Col. Rob.)
The Experienced Angler, fifth ed., front. and cuts (a few
side-notes cut into), *B. W. for B. Tooke*, 1683—Nobbes
(Roɔert). The Compleat Troller, first ed. (corner of B j
defective), *T. James for Th. Helder in Little Britain*, 1682,
in 1 vol., orig. cf., 8vo. (430) *Quaritch*, £32

5486 Watteau (Antoine). Figures de Différents Caractères de
Paysages et d'Études dessinées d'après Nature, engraved
throughout with port. of Watteau and 352 plates on 223
leaves, orig. impressions, 2 vol., old russ., g.e., *Paris, chez
Audran et Chéreau* (*c.* 1735-40), imp. folio (325)
Quaritch, £131

5487 Welsh New Testament. Testament Newydd ein Arglwydd
Jesu Christ, blark letter, title and calendar in red and
ɔlack, mor. ex., g.e., ɔy Rivière, *Henry Denham, at the
costes and charges of Humfrey Toy*, 1567 (436)
Howell, £180

[Very fine and perfect copy of the first edition of the
New Testament in Welsh, translated by William Salesbury,
assisted by Thomas Huatt and Richard Davies, Bishop
of St. David's. Collation : Title, 1 leaf ; Almanac and
Calendar, 7 leaves ; Dedication to Queen Elizabeth, in
English, 2 leaves ; Epistol. Richard Episc. Menew at y
Cembru, etc., 14 leaves ; text, folios 1-399 ; Tabul yr
Epistol, etc., 2 leaves.—*Catalogue.*]

5488 Wheatley (H. B.) Round about Piccadilly and Pall Mall,
extra illustrated and extended to 2 vol. by the addition of
autograph letters of T. Pennant and R. Glover, a document
with signature of H. Arbuthnot, and upwards of 170 ports.,
mor. ex., t. e. g., by Rivière, 1870, 8vo. (182) *Crossley*, £10

5489 Wheelwright (John). Mercurius Americanus, Mr. Welds, his
Antitype, or Massachusetts great Apologie examined (last
leaf torn), unbd., 1645, 4to. (434) *H. Stevens*, £8 10s.

5490 White (Rev. G.) Natural History of Selborne, first ed.,
plates, old cf., line tooled, *T. Bensley for B. White*, 1789,
4to. (284) *Gladstone*, £8 10s.

5491 Willement (Thos.) Facsimile of a Contemporary Roll with
the names and arms of the Sovereign, and of the Spiritual
and Temporal Peers who sat in Parliament on the 5th Feb.,
1515, 28 plates emblazoned by hand, mor. ex., g. t., uncut,
50 copies privately printed, 1829, oblong 4to. (605)
Quaritch, £3

5492 William III. Relation du Voyage de Sa Majesté Britannique
en Hollande, port. of William III. by Gunst, and 14 large
plates, some double, vell., fine copy, *La Haye, chez A. Leers*
1692, folio (637) *Leighton*, £2. 2s.

5493 Williams (R.) A Key into the Language of America, original
ed., orig. cf., book-stamp of "Robert Barclay of Urie in
the Kingdom of Scotland," *Printed by Gregory Dexter*,
1643 (432) *Low Bros.*, £94

5494 Wither (George). A Collection of Emblemes Ancient and
Modern, front. by W. Marshall, with the leaf "A preposition
of this frontispiece," in verse, printed title to each part,
port. and engravings, mor. ex., g. e., *Printed by A. M. for
Robert Allot*, 1635 (638) *Norton*, £13
[Extremely rare and believed to be one of the finest
copies known (measuring 11⅜ by 7 7⁄16 in.) Mr. Huth's copy,
considered the largest known, measured 11½ by 7½in., and
also wanted the pointers. It is a question whether they
were ever issued with the book. Two or three defects
made good, and the leaf of dial repaired and inlaid.—
Catalogue.]

5495 Wicquefort (A. de). Relation du Voyage d'Adam Olearius
en Moscovie, Tartarie et Perse, etc., maps, signature of
J. L. Mirabeau on title, 2 vol., old French cf. gt., arms of
Paulin Prondre de Guermante, *Paris*, Jean du Puis, 1666,
4to. (287) *Bruce*, 17s.

5496 Wollstonecraft (Mary). Thoughts on the Education of Daughters, mor. ex., uncut, 1787, 12mo. (464)
Quaritch, £1 16s.

5497 Wycherley (Wm.) Miscellaneous Poems, first ed., port. after Lely ɔy J. Smith, inlaid (ɔinding shaɔɔy), 1704, folio (640)
Maggs, £6 5s.

[APRIL 5TH AND 6TH, 1910.]

PUTTICK & SIMPSON.

THE LIBRARY OF THE LATE MR. W. H. RICHARDSON, OF LANSDOWNE PLACE, W.C., AND OTHER PROPERTIES.

(No. of Lots, 659 ; amount realised, £765 18s. 6d.)

5498 American Indians. Original MS. French-Huron Lexicon on 270 pages 4to., written *circa* 1663 ɔy Father Jean Marie Chaumonot, Jesuit Missionary to the Huron Triɔe at Indian Lorette, near Queɔec. An Inheritance of the Triɔe used and handed down from generation to generation. Authenticated ɔy Père Prosper Vincent, its last owner, orig. parchment covers (546) *Miller, £60* [*See ante* No. 4118 (ɔought in). This is the same manuscript, apparently again ɔought in.—ED.]

5499 American Indians. Surprising Account of the Captivity and Escape of Philip McDonald and Alexander McLeod of Virginia from the Chickkemogga Indians, 11 pages, including title, unbd., *Printed by Henry Blake & Co., Keene, New Hampshire,* 1794, sm. 8vo. (542) *H. Stevens, £13*

5500 Anthologie Satyrique. Repertoire des meilleures poésies et chansons joyeuses, 8 vol., hf. mor., g. e., 1876, 8vo. (492)
Cappell, £2 4s.

5501 Ashɔee (H. S.) Index Librorum Prohibitorum, 3 vol., hf. mor., 1877-85, 4to. (605) *Jones, £14*

5502 Baɔylonian and Oriental Record (The), vol. i. to viii., 8 vol., cl., 1886-1900, 8vo. (397) *Hill, £2* 5s.

5503 Barrett (F.) The Magus, or Celestial Intelligencer, hf. mor., 1801, 4to. (596) *Shepherd, £1* 12s.

5504 Beharistan (The), (Aɔode of Spring,) ɔy Jami, vell., 1887, 8vo. (483) *Hector, £1* 8s.

5505 Berry (W.) Pedigrees of Essex Families, bds., uncut, n. d., folio (301) *Walford, £3* 7s. 6d.

5506 Biɔliotheca Arcana. Seu catalogus librorum penetralium, by Speculator Morum, hf. mor., 1885, 8vo. (427)
Schultze, £1 15s.

5507 Black (W. H.) History and Antiquities of the Worshipful Company of Leathersellers, col. plates, etc., mor., g. e., *Printed for private circulation,* 1872, folio (307)
Allison, £1 2s.

5509 Blake (W.) Illustrations to the Book of Jòb, engraved title and 21 plates, proof impressions, inserted in folio guard-ɔook, with the orig. laɔel, March, 1826, 4to. (566)
Bumpus, £12

Blake (W.) Muir's Facsimile Reprints, in wrappers, as issued.
5510 There is no Natural Religion, No. 28 (568) *Sotheran,* £1 14s.
5511 Songs of Innocence, No. 14 (569)—Songs of Experience, No. 1 (570) *Edwards,* £6 10s.
5512 Milton, a poem in 2 ɔooks, No. 17 (571) *Sotheran,* £3
5513 The Book of Thel, No. 9 (572) *Edwards,* £1 15s.
5514 The Marriage of Heaven and Hell, No. 13 (573)
Edwards, £2
5515 Visions of the Daughters of Alɔion, No. 50 (574)
Quaritch, £2 4s.
5516 America, a Prophecy, No. 23 (575) *Edwards,* £1 15s.
5517 Jerusalem, No. 58 (576) *Dobell,* £1 2s.

5518 Blavatsky (H. P.) Isis Unveiled, 2 vol., cl., 1884, 8vo. (435)
Cappell, £1 18s.
5519 Blavatsky (H. P.) The Secret Doctrine, 2 vol., cl., 1888, 8vo. (436) *Shepherd,* £1 8s.
5520 Boys (W.) Collections for a History of Sandwich, maps and plates (one wanted), hf. cf., 1792, 4to. (264)
Thorp, £2 16s.
5521 Boys (W.) Sandwich, another copy, LARGE PAPER, 2 vol., hf. russ., 1792, 4to. (265) *Thorp,* £5 17s. 6d.
5522 Bunsen (C. C. J.) Egypt's Place in Universal History, complete set, with the Dictionary, 5 vol., 1848-67, hf. cf., 8vo. (463) *Sotheran,* £2 4s.
5523 Campɔell (R. A.) Phallic Worship, 200 illustrations, n. d., 8vo. (410) *Llewellyn,* £1 2s.
5524 Chaucer (Geoffrey). Poetical Works, Pickering's Aldine ed., 6 vol., cl., 1852, 8vo. (351) *Bumpus,* £5 2s. 6d.
5525 Cokayne (G. E.) Peerage of England, Scotland, Ireland and Great Britain, 8 vol., vol. i. to iv. hf. mor., vol. v. to viii. bds., 1887-98, 8vo. (159) *Walford,* £8 10s.
5526 Cokayne (G. E.) Complete Baronetage and Index, 5 vol., bds., 1900-06, 8vo. (160) *Harding,* £5 15s.
5527 Coleman (C.) The Mythology of the Hindus, illustrated, 1832, 4to. (598) *Hill,* £1 6s.
5528 Cottle (Joseph). Early Recollections, ports., 2 vol., cl., uncut, presentation copy, 1837, 8vo. (71) *Shepherd,* £1
5529 Cunningham (A.) The Bhilsa Topes, or Buddhist Monuments of Central India, illustrated, cl., 1854, 8vo. (477)
Edwards, £1 7s.
5530 Dabistan (The), or School of Manners, translated ɔy Shea and Troyer, 3 vol., cl., *Paris,* 1843, 8vo. (394)
Gardner, £1 14s.
5531 Davenport (John). Aphrodisiacs and Anti-aphrodisiacs, hf. bd., *Privately printed,* 1869, 8vo. (424) *Shepherd,* £1 3s.

5532 Davenport (J.) Curiositates Eroticae Physiologiae, hf. bd., *Privately printed*, 1875, 8vo. (425) *Shepherd*, £1 6s.

5533 Dee (Dr.) A True & Faithful Relation of what passed for many Years between Dr. John Dee and some Spirits, front. and plates, cf., 1659, folio (636) *Shepherd*, £3 12s.

5534 Dickens. Scenes from the Life of Nickleby Married, containing certain Remarkable Passages, Strange Adventures and Extraordinary Occurrences that befel the Nickleby Family, ed. by " Guess," full-page etchings by " Quiz," in the orig. 22 parts in 18, with all the wrappers, in case, John Williams, 1840, 8vo. (515) *Reynolds*, £16

5535 Drake (F. S.) The Indian Tribes of the United States, by H. R. Schoolcraft, ed. by Drake, plates (some col.), 2 vol., 1885, 4to. (608) *Carter*, £1 16s.

5536 Faber (G. S.) The Origin of Pagan Idolatry, plates, 3 vol., hf. cf., 1816, 4to. (580) *Bull*, £1 3s.

5537 Fergusson (J.) Tree and Serpent Worship, illustrated, hf. mor., 1868, 4to. (585) *Hill*, £4 12s. 6d.

5538 Fergusson (J.) Tree and Serpent Worship, second ed., plates, hf. mor., 1873, 4to. (586) *Quaritch*, £7 5s.

5539 Fergusson (J.) The Rock Cut Temples of India, hf. mor., with 8vo. volume of text, cl., 1845, folio (637) *Edwards*, £1 4s.

5540 Fergusson (J.) and Burgess (J.) The Cave Temples of India, illustrations, hf. mor., 1880, 4to. (589) *Hill*, £1 16s.

5541 Forberg (F. C.) Manual of Classical Erotology, vell., cl., *Printed for private circulation*, 1887, 8vo. (417) *Llewellyn*, £2 12s.

5542 Forlong (J. G. R.) Rivers of Life, 2 vol., with the scarce Chart, 3 vol., cl., 1883, 4to. (577) *Hill*, £5

5543 Foster (Joseph). Alumni Oxonienses, 1500-1886, 8 vol., hf. rox., 1887-91, 8vo. (156) *Quaritch*, £4

5544 Gloucestershire Pedigrees. Visitations of 1569, privately printed by Sir T. Phillipps, bds., 1854, folio (304) *Quaritch*, £1 2s.

5545 Greenwood (C.) Epitome of the County of Kent, plates, 2 vol., cl., 1838, 4to. (268) *Edwards*, £1 2s.

5546 Griggs (W.) Armorial China, plates in gold and colours, 6 parts in publisher's cl. case, *Privately printed*, 1887, 4to. (261) *Quaritch*, £2 12s. 6d.

5547 Hamilton (A.) Memoires du Comte de Grammont, ports. (a hundred copies printed), cf., *Imprimée à Strawberry Hill*, 1772, 4to. (623) *Shepherd*, £1 9s.

5548 Hamilton (Sir W.) and Knight (R. P.) The Worship of Priapus, ed. by Hargrave Jennings (100 printed), 1883, 8vo. (488) *Osler*, £3

5549 Hancarville (H. d'). Monumens de la vie Privée des douze Césars, plates, cf., 1780, 8vo. (490) *Thorp*, £2 6s.

5550 Hardy (R. S.) A Manual of Buddhism, 1853, 8vo. (390) *Sotheran*, £1 4s.

5551 Hardy (R. S.) Eastern Monachism, the origin, rites, etc. of the order of Mendicants, 1860, 8vo. (391) *Sotheran*, £1 2s.

5552 Her)ert (A.) Nimrod, a Discourse on certain Passages of
 History and Fa)le, complete set, 4 vol., 1828-9, 8vo. (480)
 Edwards, £4 4s.
5553 Higgins (Godfrey). The Celtic Druids, plates, cl., 1829, 4to.
 (581)- *Quaritch, £1 10s.*
5554 Higgins (G.) Anacalypsis, 2 vol., hf. russ., 1836, 4to. (582)
 Hill, £9 5s.
5555 Hooker (T., Pastor of the Church at Hartford). A Survey of
 the Summe of Church-Discipline, title stamped, old cf.,
 1648, 8vo. (529) *Johnson, £1 8s.*
5556 Inman (T.) Ancient Faiths em)odied in Ancient Names, 2
 vol., 1868-69—Ancient Faiths and Modern, 1876, 8vo. (468)
 Edwards, £2 13s.
5557 Jennings (Hargrave). Phallicism, with the series of illustra-
 tions, 1884, 8vo. (495) *Shepherd, £1 7s.*
5558 Knight (R. Payne). Le Culte de Priape, with all the plates,
 traduit par E. W., hf. mor., 1883, 8vo. (428) *Osler, £1 15s.*
5559 Leroux (P. J.) Dictionnaire Comique, 2 vol., cf., g. e., 1786,
 8vo. (109) *Bumpus, £1 10s.*
5560 Lescarbot (Marc.) Histoire de la Nouvelle France—Les
 Muses de la Nouvelle France,)est ed., with 3 maps, in-
 cluding the large "Figure de la Terre Neuve," and one
 map not)elonging to the work, orig. vell., 1612, 8vo. (543)
 Edwards, £8
5561 [Little (Thomas).] The Beauty, Marriage Ceremonies and
 Intercourse of the Sexes, plates, 4 vol., hf. russ., 1824, 8vo.
 (445) *Shepherd, £1 2s.*
5562 Locker (Frederick). London Lyrics (not pu)lished), rox.,
 g. t., John Wilson, 1868, 8vo. (519) 16s.
5563 London Singer's Magazine and Reciter's Al)um (The), col.
 port. of Mrs. Wood and cuts)y Cruikshank, etc., orig. bds.,
 Duncom)e, n. d., 8vo. (520) 15s.
5564 Lucifer, a Theosophical Magazine, vol. i. to xii., 12 vol., hf. cf.,
 1887-93, 4to. (592) *Shepherd, £3 2s. 6d.*
5565 Maire (H.) Arms and Pedigrees of various Roman Catholic
 Families (a copy of the Lawson MS.)y Eedes, made for
 L. Hartley), hf. mor., g. t., folio (303) *Quaritch, £4*
5566 Marlowe (Christopher). Works,)y Dyce, 3 vol., cl., Pickering,
 1850, 8vo. (513) *Bumpus, £5*
5567 Marryat (J.) History of Pottery and Porcelain, third ed.,
 col. plates, mor. ex., 1868, 8vo. (383) *Jackson, £1 10s.*
5568 Massey (Gerald). The Natural Genesis, 2 vol., 1883—A
 Book of the Beginnings, 2 vol., cl., 1881, 8vo. (466)
 Shepherd, £1 5s.
5569 Mitra (Rajendralala). Buddha Gayá. The Hermitage of
 Sakya Muni, illustration, 1878, 4to. (587)
 Edwards, £2 10s.
5570 Naples Museum. The Royal Museum at Naples, 60 full-page
 illustrations [Secret Museum], with notes)y Col. Fanin,
 rox., 1871, 8vo. (487) *Shepherd, £1*
5571 Nostradamus (M.) The Prophecies or Prognostications, with
 the front. containing 3 ports., hf. cf., 1672, folio (628)
 Hill, £1 12s.

5572 Peaks, Passes and Glaciers, ed. ɔy John Ball and E. S. Kennedy, maps, etc., ɔoth series, 3 vol., cl., 1859-1862, 8vo. (512) *Barnard,* £3

5573 Perfumed Garden (The) of the Sheik Nefzaoui, 1886, 8vo. (484) *Daly,* £2 16s.

5574 Priapeia, or Sportive Epigrams of Divers Poets on Priapus, bds., *Erotika Biblion Society,* 1888, 8vo. (423) *Shepherd,* £1 1s.

5575 Psychical Research Society. Proceedings, vol. i. to v., 1883-9, 8vo. (455) *E. George,* £1 8s.

5576 Ramɔler's Magazine (The), or the Annals of Gallantry, Glee, Pleasure and the Bon Ton, plates, 8 vol., 1783-90, hf. cf., rest unɔound—The Ramɔler's Magazine, or Fashionaɔle Companion, plates, vol. i., hf. cf., 1824, 8vo. (448) *Reuter,* £19 5s.

;577! Rawlinson (Sir George). The Five Great Monarchies of the Ancient Eastern World, 3 vol., 1871, 8vo. (385) *Edwards,* £1

;578! Renouf (Le Page). Egyptian Book of the Dead, 8 parts, 1893, 4to. (583) *Hill,* £2 2s.

;579! Sadi. The Gulistan, or Rose Garden of Sadi, vell., 1888, 8vo. (482) *Quaritch,* £1 8s.

;580! Schlangweit (E.) Buddhism in Tiɔet, with the folio volume of 20 plates, together 2 vol., 1863 (392) *Edwards,* £2 15s.

;581! Shakespeare (W.) Plays, Pickering's Diamond ed., 9 vol., mor., g. e., 1826, 8vo. (439) *Edwards,* £2 16s.

;582! Shakespeare (W.) Plays and Poems, ed. ɔy J. Payne Collier, 8 vol., hf. mor., g. t., 1878, 8vo. (102) *Hopkins,* £5 10s.

;583! Sellon (E.) Annotations on the Sacred Writings of the Hindus, hf. mor., 1865, 8vo. (405) *Grant,* £1 2s.

;584! [Shelley (P. B.)] St. Irvyne, or The Rosicrucian, first ed., mor. ex., *London, printed for J. J. Stockdale,* 1811, 8vo. (517) *Osler,* £28

;585! Shelley (P. B.) Prometheus Unɔound, first ed., mor. ex., g. t., Ollier, 1820, 8vo. (518) *Spencer,* £3 10s.

5586 Sibly (E.) New and Complete Illustration of the Occult Sciences, port., col. and other illustrations, 4 vol., cf., 1790, 4to. (221) *Shepherd,* £1 7s. 6d.

5587 Sleeman (W. H.) History of the Sect of Maharajas in Western India, cl., 1865, 8vo. (409) *Quaritch,* £1 10s.

5588 Sporting Anecdotes, Original and Select, including Character-istic Sketches of Eminent Persons who have appeared on the Turf, 16 illustrations ɔy Bewick, orig. bds., with laɔel, *Albion Press,* 1804, 8vo. (521) *Spencer,* £2

5589 Squier (E. G.) Serpent Symɔol and the Worship of the Reciprocal Principles of Nature in America, cl., 1851, 8vo. (402) *Sotheran,* £1 12s.

5590 Stanley (J. T.) Leonora, from the German of Burger, front. and vignette ɔy Blake, hf. mor. ex., uncut, 1796, 4to. (567) *Edwards,* £1 6s.

5591 Suffolk. Parish Registers of Kelsale, 1538-1812, one of 50

26—2

copies numbered and signed, privately printed by F. A.
Crisp (£5 5s.), vell., 1887, folio (312) *Quaritch*, £1 12s. 6d.

5592 Théophile (V.) Œuvres, contemp. French mor., with panels
lettered " A. Mr· Le Conte de Largovet," g. e., *Paris*, 1629,
8vo. (108) *Lewine*, £1 12s.

5593 Theosophist (The), conducted by Mdme. Blavatsky, vol. vii.
to xiv., 8 vol., hf. cf., 1886-93, 8vo. (396) *Gardner*, £1 2s.

5594 Thornton (R. J.) The Pastorals of Virgil, 230 illustrations
by Blake, Cruikshank, etc., 2 vol., mor., g. e., 1821, 8vo.
(441) *Edwards*, £1 18s.

5595 Veneres et Priapi, by H. d'Hancarville, text in French and
English, LARGE PAPER, plates, cf., *Lugd. Bat.*, n. d. (17—),
8vo. (432) *Jones*, £2 7s.

5596 Vishnu Parana (The). A System of Hindu Mythology and
Tradition, trans. by H. H. Wilson, 5 vol., cl. (not uniform),
1864-70, 8vo. (395) *Shepherd*, £1 11s.

5597 Walker (Sir Hovenden). Journal of the late Expedition to
Canada, old cf., 1720, 8vo. (179) *Stevens*, £2 10s.

5598 Webster (John). The Displaying of supposed Witchcraft,
cf., 1677, folio (629) *Fisher*, £1 4s.

5599 Whiting (D. S.) Oratio quam comitiis Cantabrigiensibus
Americanis, anno 1649, pamphlet of 16 pages, no title,
believed to be printed about the date of the Oration, at
Cambridge, Mass., the type and paper are similar to those
used for the whole Book of Psalms, unbd., 1644, 8vo. (538)
H. Stevens, £1 12s.

5600 Wilkes (John). An Essay on Woman, 1883 (reprint), 8vo.
(489) *Carpenter*, £1 10s.

5601 Withers (A. S.) Chronicles of Border Warfare (title defec-
tive), orig. sheep, *Clarksburg, Va.*, 1831, 8vo. (536)
H. Stevens, £1 5s.

5602 Yule (Col. H.) Mission to the Court of Ava, plates and map,
hf. cf., 1857, 4to. (578) *Bailey*, £1 5s.

[APRIL 6TH, 1910.]

SOTHEBY, WILKINSON & HODGE.

THE LIBRARY OF MR. ALFRED TRAPNELL, OF BOURNEMOUTH.

(No. of Lots, 195 ; amount realised, £963 11s. 6d.)

5603 Ackermann (R.) A History of the University of Cambridge,
col. plates, 2 vol., cf., R. Ackermann, 1815, 4to. (1)
Commin, £31

5604 Æneas Sylvius, Papa Pius II. Enee Silvii poete laureati de
duobus amantibus historia incipit, et Epistola Enee Silvii

ad Marianum, lit. goth., 40 leaves, without signs., autograph
signature of Jean de Tournes, marginal notes and MS.
dedication, old cf., *Absque ulla nota* [*Roma, circa* 1475], sm.
4to. (2) *Maggs, £4*

5605 Arcandam. The most excellent profitable and pleasaunt
Booke, to finde the Fatall destiny, constellation, com-
plexion and naturall inclination of every man and childe by
his birth, tourned out of French by Wm. Warde, black
letter (margins of last 5 leaves repaired, last leaf defective),
mor., g. e., T. Marshe, 1578, 12mo. (6) *Hatchard, £4* 18s.

5606 Arrivabene (P.) Opera devotissima continente le piissime
meditatione de la Passion de Christo (portion of title-page
wanted and last leaf defective), vell., *Mantua, per Fran-
cescho di Bruschi da Regio*, 1511, sm. 4to. (7) *Rossi,* 10s.

5607 Augustinus (S. Aurelius). Opuscula Varia, *id est.*, De spiritu
et littera, De Periculis et De Suffragiis, lit. goth., 39 leaves
[*Coloniae*, Ulric Zel, 1470]—Super orationum Dominicam,
De ebrietate cavenda, De Fuga Mulierum, De Continentia,
De contemptu mundi et De communi vita clericorum, lit.
goth., 32 leaves [*ib.*, 1467], in 1 vol., old cf., sm. 4to. (8)
Leighton, £6

5608 Ayres (Ph.) Emblems of Love, plates by S. Nicholls, orig.
bds., uncut, J. Osborn, n. d., 8vo. (9) *Dobell,* 11s.

5609 Bale (J.) The First Two Partes of the Actes or unchaste
examples of the Englyshe Votaryes, 2 parts in 1, black
letter (sig. H viii. of part ii. defective), old cf., J. Tysdale,
1560, 12mo. (10) *Dobell,* 16s.

5610 Bates (G.) The Troubles of England, engraved title by J.
Sturt, armorial bookplate of Sr. John Aubrey, of Lan-
trithyd, dated 1698, cf., 1685, 8vo. (11) *Young, £1* 1s.

5611 Beckford (W.) An Arabian Tale (Vathek), first ed., Robert
Southey's copy, with his autograph signature, "Keswick,
Jan. 3, 1811," and book-plate, hf. cf., 1786, 8vo. (13)
Commin, £2 2s.

5612 Becon (T.) The Governaunce of Vertue, black letter (a few
headlines shaved), cf., Jhon Daye (1549), 24mo. (14)
Bull, 10s.

5613 Bellianis of Greece. The Honour of Chivalry, or the famous
and delectable history of Don Bellianis of Greece, black
letter (title-page and some headlines cut), old cf., B. Alsop,
1650, sm. 4to. (15) *Ranshaw,* 16s.

5614 Berthorius seu Berchorius (Petrus). Liber biblie moralis
expositionum interpretationumque, historiarum ac figurarum
veteris novique testamenti, lit. goth., 266 leaves, double
columns, 50 lines, ornament to first leaf, and woodcut
capitals, smaller initials painted red, rubricated throughout,
orig. stamped vell., *Ulmae*, Johannes Zeiner de Reutlingen,
1474, folio (17) *Quaritch, £10* 5s.

5615 Boccaccio (G.) The Tragedies, gathered by Jhon Bochas, of
all such Princes as fell from theyr estates throughe the
Mutabilitie of Fortune, black letter, cut of Adam and Eve
on "Leaf I." and ornamental woodcut initials (a few small

wormholes), mor., g. e., by J. Clarke, *Imprinted by John Wayland (Day's device below)*, n. d. (1558), folio (20)

Dobell, £16 10s.

5616 Boethius. De consolatione philosophiae, cum commentario Thomae de Aquino, lit. goth., 186 leaves (should be 192, but wanted 6 preliminary leaves), russ. (re)acked), *Colonia,* H. Quentell, 1493, sm. 4to. (21) Dobell, £1 1s.

5617 Boethius. De consolatione philosophica, cum commentariis S. Thomae de Aquino, lit. goth., 102 num)ered leaves, woodcut initials, last leaf with device of Octavianus Scotus (mended, MS. marginal notes), hf. cf., *Venetiis,* Bonetus Locatellus, 1498, folio (22) *Barnard,* £1

5618 Boethius. Consolatio Philosophica, Disciplina Scholarum, etc., commentariis S. Thomae de Aquino, lit. goth., wood-cuts, old cf. gt. (*Lugd.*), Symon Vincent, 1521, sm. folio (23) *Young,* £1

5619 Bonaventura (S.) Directorium religiosorum, lit. goth., 16 leaves, device of Denis Roce on title, woodcut capitals, mor. ex., the sides tooled with an elegant Grolieresque design, dou)lé, g. e.,)y Lortic, *Parisiis,* Jo. Bar)ier, *s. a.* (1503), 12mo. (24) *Young,* £3 12s.

5620 Breen (A. van). De Nassau'sche Wapen-handelinge, van Schilt, Spies, Rappier, ende Targe, engraved title (mounted) and 47 plates, *La Haye,* 1618 — Maniement d'Armes, d'Arquebuses, Mousquetz et Piques, représenté par figures par Jacques de Gheyn, 117 plates, *Amsterdam,* 1608, in 1 vol., hf. cf., folio (25) *Dobell,* £6 5s.

5621 Bullein (Wm.) Bulwarke of Defence, black letter, woodcuts, old cf. (re)acked), T. Marshe, 1579, sm. folio (27)

Leighton, £5 5s.

5622 Bunyan (John). The Pilgrim's Progress, 2 parts in 1, port. and 21 plates)y J. Sturt, cf., 1727-28, 8vo. (28)

Young, £2 14s.

5623 [Burleigh (Cecil, Lord).] The Execution of Justice in England for maintenaunce of pu)lique and Christian Peace, black letter, 1583—A Declaration of the favoura)le dealing of her Maiesties Commissioners, black letter, 1583, in 1 vol., cf., sm. 4to. (29) *Quaritch,* £3 5s.

5624 Caesar. The eyght bookes of Caius Julius Caesar,)y Arthur Goldinge, black letter (wormhole through last 3 leaves), cf., raïsed panel on sides, Willyam Seres, 1565, 12mo. (31)

Quaritch, £4 8s.

5625 Camerarius (Jo.) Symbolorum et Emblematum ex animali-bus, quadrupedibus desumtorum, orig. ed., engravings, cf., *Noribergae,* P. Kaufmann, 1595, sm. 4to. (32)

Young, £1 5s.

5626 Caulfield (J.) Portraits, ports., 7 vol., hf. cf., 1813-20, 8vo. (34) *Bull,* £4

5627 Causes (The) of the Decay of Christian Piety,)y the author of the Whole Duty of Man, contemp. English mor., covered with floral tooling, g. e., 1694, 8vo. (35) *Tregaskis,* £7 15s.

5628 Cavalleriis (J. B. de). Romanorum Pontificum Effigies, 230
ports. of Popes, cf. gt., *Romae*, 1580, sm. 8vo. (36)
B. F. Stevens, £1 4s.

5629 Chrysostomus (Johannes). De dignitate sacerdotii, lit. gotђ.,
77 leaves (should be 78, but wanted last ɔlank), long lines,
27 to a full page, initials in red, hf. cf., from the liɔrary of
Cornelius Paine, *Absque ulla nota* (*sed Cologne, Ulrich Zel,*
1472), sm. 4to. (38) *Leighton*, £3 10s.

5630 Cicero. Orationes, per Philippum Beroaldum, lit. rom., vell.,
Bonon. Bened. Hectoris impressit, 1499, sm. folio (39)
Barnard, £1 1s.

5631 Coleridge (S. T.) Poems, second ed., to which are now added
Poems by Charles Lamɔ and Charles Lloyd, orig. bds.,
uncut, in case, *N. Biggs for J. Cottle, Bristol*, 1797, 12mo.
(40) *Spencer*, £5 5s.

5632 Coleridge (S. T.) Poems, second ed., another copy, mor. ex.,
douɔlé, g. e., ɔy Lortic, *N. Biggs for J. Cottle, Bristol*, 1797,
12mo. (41) *Young*, £4

5633 Coleridge. Schiller (F.) Wallenstein, a Drama, trans. ɔy
S. T. Coleridge, port., cf., 1800, 8vo. (43)
Hornstein, £3 16s.
[Presentation copy from Coleridge, with inscription,
" S. T. Coleridge to the Revd. Mr. Roskilly."—*Catalogue.*]

5634 Coronations. The Manner and Solemnitie of the Coronation
of K. Charles the Second at Manchester, ɔy W. Heawood,
and of the Coronation of K. George III. and Ọ. Charlotte
at Manchester, one of 4 copies printed on vellum, hf. bd.,
Manchester, 1861, imp. 8vo.—Account of the Ceremonies
oɔserved in the Coronations of the Kings and Queens of
England, 2 folding plates (one mounted) and woodcuts, and
2 extra folding plates inserted, cf., t. e. g., 1760, 4to. (44)
Hornstein, £1 1s.

5635 Coryat (Thomas). Coryat's Crudities, first ed., engraved
title, with port. of the author, and all the plates (those of
the Amphitheatre of Verona and the Heidelɔerg Tun
mounted), (errata leaf defective,) mor. ex., ɔy Zaehnsdorf,
W. S., 1611, 4to. (45) *Tregaskis*, £22 10s.

5636 Cottin (Mme.) Matilda, and Malek Adhel the Saracen, 4
vol. in 3 (last leaf defective), illustrated by the insertion of
74 engravings, orig. drawings, etc., vell., g. e., from the
liɔrary of the Earl of Harrington, 1816, sm. 8vo. (46)
Hornstein, £1 18s.

5637 Cousteau. Costalius (P.) Pegma, cum narrationibus philo-
sophicis, first ed., 94 woodcuts (marginal mendings to three
leaves and a few contemp. MS. notes), old mor. gt.
(reɔacked), *Lugduni*, M. Bonhomme, 1555, sm. 8vo. (47)
Ranshaw, 14s.

5638 Dante, con l' espositioni di C. Landino et d' A. Vellutello,
port. on title and woodcuts (last leaf defective), vell.,
Venetia, G. et M. Sessa, 1578, folio (52) *Leighton*, £1 11s.

5639 Diogenes Laertius. Vitae et sententiae translatae a Fratre
Amɔrosio ex recensione Benedicti Brognoli, editio princeps,

lit. rom., initials painted, oak bds., pigskin jack, with clasps, *Venetiis, per Nicolaum Jenson,* 1475, sm. folio (55)
Quaritch, £18

5640 Drayton (Michael). Poly-Olbion, 2 parts in 1, Part I. 10 unnumbered leaves + 304 pages—Part II. 5 leaves + 168 pages, engraved title-page to part i. (no printed title), port. of Prince Henry by Hole, and 30 maps, mor. ex., by Rivière, 1613-22, folio (57) *Leighton,* £10

5641 Emblems of Mortality, represented in upwards of fifty cuts, first ed., woodcuts by T. and J. Bewick, mor. ex., the sides elegantly tooled, t. e. g., T. Hodgson, 1789, sm. 8vo. (59)
Young, £2 2s.

5642 Esquemeling (J.) Bucaniers of America, maps and plates, cf. gt., 1699, 8vo. (61) *Rimell,* £2

5643 Estienne (H.) The Art of Making Devises, translated by T. Blount, title by W. Marshall and fine emblematic device (a few headlines shaved), hf. cf., 1646, sm. 4to. (62)
Dobell, 9s.

5644 Farmer (R.) Sathan Inthron'd in his Chair of Pestilence, port. of James Naylor inserted, hf. roan, 1657, sm. 4to. (64) *Bull,* 10s.

5645 Ferne (John). The Blazon of Gentrie, col. front. inserted, the coats-of-arms emblazoned (title-page defective and one leaf damaged), old cf. (rebacked), John Windet, 1586, sm. 4to. (66) *Ellis,* £3 6s.

5646 Fuchs (Leonhard). Commentaires tres excellens de l'Hystoire des Plantes, 520 woodcuts of plants, cf. ex., finely bound in imitation of a binding made for Henri II. and Diane de Poitiers, by M. Hagué, of Brussels, *Paris,* Jacques Gazeau, 1549, folio (68) *Young,* £13 15s.

5647 Fuchsius (L.) Plantarum Effigies, woodcut on each page, vell., *Lugduni, apud B. Arnoulletum,* 1552, 12mo. (69)
Quaritch, £1 18s.

5648 Gay (John). Trivia, or the Art of Walking the Streets of London, first ed., vignette on title-page, cf., g. e., by J. Larkins, Bernard Lintott, n. d. (1714), 8vo. (72)
Dobell, £2 4s.

5649 Gerarde (J.) Herball, title mounted, port. of Gerarde from the first edition (1597) inserted, and woodcuts, russ., A. Islip, 1636, folio (73) *Ellis,* £3 8s.

5650 Gethin (Grace, Lady). Reliquiae Gethinianae, with Verses by Wm. Congreve, and a Funeral Sermon, port. by W. Faithorne and folding mezzo. plate of the monument in Westminster Abbey, mor. ex., tooled design, g. e., by Lortic, 1703, sm. 4to. (74) *Leighton,* £3 10s.

5651 Goldsmith (O.) and Parnell (T.) Poems, illustrated by T. and J. Bewick, mor., tooled back and corners, g. e., W. Bulmer, 1795, 4to. (76) *Young,* £1 12s.

5652 Gower (J.) De Confessione Amantis, **black letter** (title repaired and mounted), port. of Gower inserted (wanted last leaf of table), russ., g. e., T. Berthelette, 1554, sm. folio (77) *Dobell,* £3 3s.

[Ro>ert Southey's copy, with his autograph signature, 1791, >ook-plate, and note in his handwriting : " This >ook once >elonged to Shenstone." J. W. Warter, Southey's son-in-law, has written the following note on the fly-leaf : "Southey purchased this >ook with the first guinea he ever had to spare. I purchased it at the sale of his li>rary for £4, and the auctioneer told me that had the fact >een known he had no dou>t but that it would have fetched £10. J. W. Warter."—*Catalogue.*]

5653 Grellman (H. M. G.) Dissertation on the Gipseys, 6 plates and music inserted, mor., g. e., Earl of Harrington's arms, 1787, 4to. (79) *Tregaskis, £1* 14s.

5654 Guevara (Anthony). The Diall of Princes, first ed., 𝔟𝔩𝔞𝔠𝔨 𝔩𝔢𝔱𝔱𝔢𝔯 (title mended, portion of folio 31 missing), russ. gt., John Waylande, 1557, sm. folio (82) *Edwards, £5* 12s. 6d.

5655 Guazzo (S.) The Civile Conversation, translated by G. Pettie and B. Young, 𝔟𝔩𝔞𝔠𝔨 𝔩𝔢𝔱𝔱𝔢𝔯 (title cut round and mounted), hf. cf., T. East, 1586, sm. 4to. (83) *Tregaskis, £5* 5s.

5656 Heroine Musqueteer (The), or the Female Warrier (a few headlines and lower lines cut into), J. Magnes, 1678—Kidd's Practical Hints for the Use of Young Carvers, illustrations, n. d., in 1 vol., mor. gt., crest of the Earl of Harrington on sides, 12mo. (84) *Leighton, £1* 10s.

5657 Homer. Iliad and Odyssey, >y W. Cowper, first ed., 2 vol., orig. bds., 1791, 4to. (88) *Maggs,* 17s.

5658 Homer. A Burlesque Translation of Homer [by Thos. Brydges], plates, 2 vol., cf., 1797, 8vo. (89) *Dobell,* 5s.

5659 Hooper (J.) A Declaracion of Christe and of His Offyce, 𝔤𝔬𝔱𝔥𝔦𝔠 and roman letter, cf. gt., *Prynted in Zurych by Augustyne Fries,* 1547, 12mo. (91) *Young, £3* 4s.

5660 Horae Beatae Mariae Virginis, Secundum Usum Romanum, illuminated Flemish manuscript on vell. (202 leaves, 7 by 4¾in.), 𝔤𝔬𝔱𝔥𝔦𝔠 𝔩𝔢𝔱𝔱𝔢𝔯, red and >lack, long lines, 15 to a full page, the greater num>er having outer margins painted and illuminated, 2 large initials with three-quarter >orders, 13 large miniatures of the usual su>jects, painted and illuminated, and 9 smaller miniatures, 4 leaves of Private Prayers at end in a later hand, russ., g. e., *Sæc.* xv. (94) *Hornstein, £78*

5661 Horae Beatae Mariae Virginis, Secundum Usum Romanum, illuminated manuscript on vell., by a French scri>e, 𝔤𝔬𝔱𝔥𝔦𝔠 𝔩𝔢𝔱𝔱𝔢𝔯 (92 leaves, 6⅞ by 4¾in.), long lines, 15 to a full page, each page with outer >orders painted and illuminated, 15 large miniatures painted and illuminated (that of the " Fall" somewhat damaged), Hymn and Ta>le, 2 leaves at end, in a later hand, old Lyonese cf., richly gilt, central lozenge enclosing the name Jacqueline du Pre, *Sæc.* xv., sm. 8vo. (95) *Young, £39* 10s.

5662 Horae B. V. M. cum Calendario, 𝔩𝔦𝔱. 𝔤𝔬𝔱𝔥., lettres bâtardes (80 leaves, signs. A-K in 8's), within >orders, woodcut of the astrological man on first leaf, uncoloured, but with surrounding figures coloured, 19 large woodcuts and 38

smaller cuts all coloured and illuminated, ornamental
initials, with Pigouchet's device of the naked savages on
last leaf, old. cf., with clasps, in box, *Paris*, P.
Pigouchet, 1493 [*Almanack* 1488-1508], sm. 4to. (99) *Sabin, £58*

5663 Horae B. V. M. ad Usum Romanum, cum Calendario, lit.
rom., red and black, printed upon vellum, within borders,
10 large woodcuts, all coloured and illuminated, contained
89 leaves only (should have 108), old cf. gt., with clasps,
Paris, Opera Thielmanni Kerver, 1501, *Id. Feb.*, sm. 8vo.
(100) *Dobell, £3* 15s.

5664 Horae B. V. M. cum Calendario, printed upon vellum, within
borders of Scriptural subjects, etc., Anabat's device on title
nearly obliterated, astrological man on reverse, and 19 full-
page cuts within borders, small capitals, initials and orna-
ments illuminated (first and last leaves damaged, and a few
borders cut), mor., blind tooled, *Paris, par Guillaume
Anabat Imprimeur . . . pour Gillet Hardouyn et Germain
Hardouyn* [*Almanack* 1507-20], 8vo. (101) *Commin, £5*

5665 Horae B. V. M. ad Usum Romanum, cum Calendario, lit.
goth., printed upon vellum, large printer's device with arms
(damaged), 13 full-page woodcuts and 32 smaller woodcuts,
all coloured and illuminated (wanted sig. E VI.), orig.
stamped cf. on oak boards, *Imprimees a Paris par Sim-
phorian Barbier* [*Almanack* 1516-27], sm. 8vo. (102)
Kimell, £8 10s.

5666 Horae B. V. M. cum Calendario, lit. goth., lettres bâtardes,
printed upon vellum, without borders, device on first leaf, 15
large woodcuts, within borders, 16 smaller woodcuts and 10
pages with borders, all coloured and illuminated, illumi-
nated ornamental letters, etc. (wanted signs. b III., d IV.,
f. VI., g V. and O I., old mor., g. e., *Imprimees a Paris par
Nycolas Hygman pour Guillaume Eustache*, 1517, *le* XX.
jour de Septembre, 8vo. (103) *Commin, £10* 10s.

5667 Horae B. V. M. cum Calendario, lit. goth., lettres bâtardes (79
leaves), printed upon vellum, without borders, device of
Hardouin on first leaf, cut of astrological man, with 4
smaller figures on second leaf, 13 large woodcuts within
borders, 4 marginal paintings and 16 smaller woodcuts,
all coloured and illuminated, watered silk on oak bds., in
case, *Imprimées a Paris par Gilles Hardouyn . . . pour
Germain Hardouyn* [*Almanack* 1518-25], sm. 8vo. (104)
Tregaskis, £15

5668 Horae B. V. M. cum Calendario, lit. goth., lettres bâtardes,
printed upon vellum, without borders, device on first leaf
and 19 large woodcuts, 4 full-page, all painted and illumi-
nated, ornamental letters and details (sign. e VII. defective),
old mor., g. e., *Imprimez a Paris pour Guillaume Eustace*,
1520, sm. 8vo. (105) *Edwards, £8* 17s. 6d.

5669 Horae Beatissimae Virginis Mariae ad Usum Romanum,
woodcuts and borders to each page, mor., g. e., *Antverpiae*,
C. Plantin, 1565, 12mo. (106) *Maggs, £3* 12s.

5670 Horae. Le Livre d'Heures de la Reine Anne de Bretagne
traduit du Latin par l'Abbé Delaunay, 2 vol., (i.) facsimile of
the original MS., 48 miniatures and borders, mor., bevelled
boards, with massive brass ornaments and clasps, (ii.) trans-
lation into French, and notes, hf. mor., in box, with clasps,
Paris, Curmer, 1861, 4to. (107) *Hill*, £13

5671 Horae Beatissime Virginis Marie ad legitimum Sarisburiensis
Ecclesie ritum, lit. 𝔤𝔬𝔱𝔥., printed in red and black on saffron
coloured paper, rubrics and many prayers in English, 224
leaves, within borders, woodcut of astrological man, 20
large woodcuts and smaller cuts (headlines of a few leaves
cut, 2 leaves mended and a few damaged), old cf., in box,
Impresse Parisius per Franciscum Regnault (with device),
1536, roy. 8vo. (108) *Barnard*, £17 5s.

5672 Horatius. Opera, aeneis tabulis incidit Johannes Pine, first
or "post est" ed., orig. flowered boards, uncut (backs
wanted), 2 vol., in 2 cases, with decorative and floral bor-
ders, by Lortic, 1733-37, roy. 8vo. (109) *Quaritch*, £19

5673 Horatius. Q. Horatii Flacci Emblemata, studio Othonis
Vaeni, orig. ed., 103 engravings, interleaved, with MS.
descriptions, in a contemp. hand, mor., g. e., doublé, with
the covers of the orig. stamped cf. binding, by Zaehnsdorf,
Antverpiae, H. Verdussen, 1607, 4to. (110) *Dobell*, £1 5s.

5674 Hortulus Anime, cum aliis ꝗplurimis orationibus pristine im-
pressioni super additis (cum Calendario), lit. 𝔤𝔬𝔱𝔥., wood-
cuts, 5 leaves, including 4 woodcuts in fac., orig. stamped
cf., with clasps, *Impensis Jo. Koberger, Civis Nurembergen
. . . Lugduni, arte et industria Jo. Clein*, 1511, 12mo. (111)
Ranshaw, £5

5675 Indagine (John). Briefe introduction unto the Art of Chiro-
mancy, etc., trans. by F. Withers, 𝔟𝔩𝔞𝔠𝔨 𝔩𝔢𝔱𝔱𝔢𝔯, diagrams,
modern cf., Thomas Purfoote, 1575, 12mo. (113)
Tregaskis, £2 10s.

5676 Isidorus. De summo bono, lit. 𝔤𝔬𝔱𝔥., 104 leaves, large "De
Marnef" device on title-page, capitals painted, vell., *Paris*,
s. a., 12mo. (114) *Barnard*, £2 2s.

5677 Joye (G.) The Exposycion of Daniel the Prophete, 𝔟𝔩𝔞𝔠𝔨
𝔩𝔢𝔱𝔱𝔢𝔯, mor., g. e., Thomas Raynalde, 1550, 12mo. (117)
Bull, £1 12s.

5678 Junius Medicus (Hadrianus). Emblemata, first ed., woodcuts,
decorative border to each page (a few leaves mended), cf.
gt., by Zaehnsdorf, *Antverpiae*, C. Plantin, 1565—Idem,
alia editio, mor., g. e., arms of the Earl of Harrington, *ib.*,
1575, 12mo. (118) *Tregaskis*, £1 16s.

5679 Juvenal (Guidone). Reformationis monastice vindicie seu
defensio, lit. 𝔤𝔬𝔱𝔥., 69 leaves, De Marnef's device on title-
page, mor. ex., sides tooled, "au pointillé," doublé, by
Lortic, *Paris*, J. Barbier et F. Foucher, 1503, 12mo. (119)
Young, £3 5s.

5680 Juvenal. Satyre, tradotto in terza rima per Georgio Sum-
maripa, 81 leaves (wanted the first, a blank, margins of a

few leaves mended and wormed), hf. cf., _Tarvisii_, Michaele
Manzolo, 1480, sm. folio (120) _Leighton_, £2 2s.
[First edition of Juvenal's Satires in Italian.—_Catalogue_.]
5681 Lamɔalle (Princess). Secret Memoirs of the Royal Family
of France, fronts., 3 plates inserted, 2 vol., 1826—Hautefort
(Marquis de). Memoirs, 1763, in 1 vol., mor., large scroll
ornament with crowned P in centre, on sides, g.e., from the
Earl of Harrington's liɔrary, 8vo. (122) _Hornstein_, £2 14s.
5682 Le Blanc (V.) The World Surveyed, cf., 1660, folio (123)
Edwards, 9s.
5683 Leigh (Gerard). The Accedens of Armorie, folding plate and
woodcut, coats-of-arms, old cf., R. Tottel, 1568, sm. 4to. (124)
Dobell, £2 5s.
5684 Literae Humaniores. The Comical Hotch Potch, or the
Alphaɔet turn'd Posture-Master, 24 col. plates, Bowles and
Carver, n.d.—The Man of Letters, or Pierrot's Alphaɔet, 24
col. plates, _ib._, n.d.—The Digits in the Fidgets, 10 col.
plates, _ib._, n.d., in 1 vol., mounted on ɔrown paper, cf.,
12mo. (125) _Hornstein_, £1 8s.
5685 Lucanus (M. A.) Pharsalia, italic type, ornamental initial to
each line (a few marginal repairs), mor., g.e., _Parrhisiis_,
per G. Lerouge, expensis Dion Roce (with device), 1512,
12mo. (126) _Maggs_, £2 12s.
5686 Lucan (M. A.) Pharsalia, Englished ɔy Thomas May (a few
headlines cut), old cf., in case, with emɔossed flowers on
sides, 1631, 12mo. (127) _Dobell_, £1
[Alexander Pope's copy, with his signature, "Alexan.
Pope," in a ɔoyish hand on fly-leaf.—_Catalogue_.]
5687 Lyra (Nicholas de). Le Premier [le second, le quart et le
cinquiesme] Volume des Exposicions, des Epistres et Evan-
giles de Quaresme [et de toute lannee], [translate par Pierré
Desray,] lit. gotḥ. (lettres bâtardes), woodcuts, parts i., ii.,
iv. and v. in 2 vol., vell., _Paris_, Antoine Verard, 1511-12,
sm. folio (128) _Leighton_, £10 10s.
5688 Meager (L.) The English Gardener, in 3 parts, 24 plates,
old cf., 1688, sm. 4to. (132) _Wesley_, £1 1s.
5689 Missale Benedictine Religionis Monachorum Cenobii Melli-
censis (cum Calendario), lit. gotḥ., red and ɔlack, Canon of
the Mass on 7 leaves of vell., full-page woodcut of the
Crucifixion col. and illuminated, large woodcut of Aɔraham
offering up Isaac, and large capitals painted and illumi-
nated (a few letters defective and marginal repairs), 7 leaves
of a contemp. MS. added, sheep, _Nuremberg_, _G. Stöchs de
Sulczpach_ (_c._ 1490), folio (133) _Hornstein_, £21 10s.
5690 Missale Saltzeburgensis noviter impressum ac emendatum,
lit. gotḥ. magna, red and ɔlack, woodcuts, orig. stamped
pigskin on oak bds., _Venetiis ex officina litteraria Petri
Liechtenstein Coloniensis_, 1515, 15 _Octob._, folio (134)
Bull, £12
5691 Modus Tenendi curiam Baronis, Th. Berthelet, 1540—Re-
turna Brevium, _ib._, 1534—Carta Feodi, _ib._, 1539—A True
Copy of the Ordinance made in the tyme of King Henry

the VI. to be o)served in the kinges Escheker, etc., *ib.*,
1540, all **black letter**, cf., mor.)ack, in case, 12mo. (135)
Young, £3 12s.

5692 Montenay (Georgette de). Livre d'Armoiries, engravings
(with verses in seven languages), vell., *Frankfort au Mayn,*
1619, sm. 8vo. (136) *Leighton,* £1 2s.

5693 Narrative (A) of the Proceedings of the British Fleet com-
manded by Admiral Sir John Jervis, K.C. in the late Action
with the Spanish Fleet off Cape St. Vincent's, 8 plans, old
cf., 1797, 4to. (138) *Tregaskis,* £2 14s.
[Originally in the possession of Lord Nelson, who gave it
to his)rother William, afterwards created Earl Nelson.
It had the following inscription in Earl Nelson's hand-
writing : "Wm. Nelson. The Gift of his Brother, Horatio,
Lord Viscount Nelson and Duke of Bronte, etc., etc., etc.,
1802."—*Catalogue.*]

5694 Nostradamus (M.) True Prophecies or Prognostications,
trans.)y Th. de Garencières, port., cf. gt., 1672, sm. folio
(140) *Hill,* £1 18s.

5695 Orthodox Communicant (The), engraved throughout with
vignettes,)orders and initial letters)y J. Sturt, contemp.
mor., g. e., J. Sturt, 1721, sm. 8vo. (141) *Young,* 16s.

5696 Pallavicini (M.) Devises et Em)lemes d'Amour, front. and
24 plates after F. d. Kaarsgite, hf. mor., t. e. g., *Amsterdam,*
1696, sm. 4to. (142) *Dobell,* 11s.

5697 Paulus de Sancta Maria. Scrutinium Scripturarum, **lit. goth.**,
217 leaves, of which two at the end are)lank, folio 72
()lank) cut out, 39 long lines to the page, without printed
signs., but some leaves having MS. signs., capitals in red
and yellow, uncut, old cf. (re)acked), *Strassburg,* Johann
Mentelin, s. a. [1471], folio (143) . *Edwards,* £9 15s.

5698 Periander (Aeg.) Noctuae speculum, omnes res memora-
)iles, variasque et admirabiles, woodcuts attri)uted to Jost
Amman, cf. gt., *Francofurti,* S. Feyrabendt et S. Huter,
1567, 12mo. (145) *Maggs,* £1 12s.
[A translation of Eulenspiegel into Latin elegiac verse.—
Catalogue.]

5699 Platina (B.) Vitae Summorum Pontificum, **lit. goth.**, 128
dou)le columns, without marks, capitals painted, MS. notes
in margins, oak bds., pigskin)ack, *Nuremberg,* A. Co)urger,
1481, folio (146) *Young,* £3

5700 Plinius Secundus. Historia Naturalis, li). XXXVII., **gothic
letter**, device of cat and mouse, woodcuts and initials, 2 vol.
in 1, vell., *Venet.,* M. Sessa et P. Serenae, 1525, sm. folio
(148) *Barnard,* £3 12s. 6d.

5701 Pontificale Romanum, emendatum diligentia R. P. Jaco)i de
Lutiis Epi. Caiacens. et D. Joannis Burckardi Capelle
S. D. N. Papae Ceremoniarum Majistri, **lit. goth.** magna,
dou)le columns, contained ccxxvi. leaves and leaf of errata
(wanted the 4 preliminary leaves), the first page of text has
an illuminated)order, 10 illuminated initials in the text (3.

figured), mor. ex., g. e., ɔy R. de Coverley, *Impressus Romae per Stephanus Planck*, 1497, xvi. *Aug.*, folio (149) £15 5s. [This copy sold for £5 in April, 1902. *See* BOOK-PRICES CURRENT, Vol. xvi., No. 4363.—ED.]

5702 Pontificale Romanum, lit. goth., full-page woodcut of the Crucifixion and smaller woodcuts (a few marginal mendings), old oak bds., leather ɔack, *Venetiis, apud Juntas*, 1561, folio (150) *Ranshaw*, £2 4s.

5703 Postellus (G.) De Rationibus Spiritu Sancti liɔ. II., cf., sides covered with painted scrolls, "Th. Maioli et Amicorum" on under cover, g. e. (ɔy M. Hagué, of Brussels), *Parisiis*, 1543, sm. 8vo. (152) *Young*, £3 10s.

5704 Postellus (G.) Sacrarum Apodixeon, seu Euclidis Christiani liɔ. II., mor., sides covered with painted scroll ornaments, large crowned F (Francis I.) in centre of upper cover, and the Royal arms of France, g. e. (ɔy M. Hagué, of Brussels), *Paris*, P. Gromorsus, 1543, sm. 8vo. (153) *Cash,* £4 8s.

5705 Prayer. Book of Common Prayer, black letter, title ɔy D. Loggan, mor., g. e., John Bill and Chr. Barker (1662), folio (154) *Commin*, £2 18s. [The "Sealed Book" of K. Charles II., and the editio princeps of the present Prayer Book.—*Catalogue.*]

5706 Prayer. The Book of Common Prayer printed at ye Theatre in Oxford, orig. fish-skin ɔinding, with arms of Sir Francis Godolphin, silver corner and clasp pieces, 1674, sm. 8vo. (155) *Tregaskis*, £2 16s.

5707 Prayer. Book of Common Prayer, engraved throughout by John Sturt (wanted the "Moveaɔle Circular Table"), contemp. mor., g. e., John Sturt, 1717, 8vo. (156) *Edwards*, £1 6s.

5708 Prayer. Book of Common Prayer, orig. plaited straw ɔinding, woven in different colours, ɔy Lady Kirkwall, 1806, 12mo. (157) *Tregaskis*, £4 [On the fly-leaf is the following inscription in Hester Lynch Piozzi's handwriting : "H. L. P. 1811. Given ɔy Dear Lady Kirkwall, made by her own hand."—*Catalogue.*]

5709 Psalterium Davidis, cum Canticis, Credo, Litaniis Sanctorum, etc., manuscript on vellum (197 leaves, 7¾ by 5⅜ in.), gothic letter, long lines, 24 to a full page, by a French scriɔe, first large initial painted and illuminated, 11 large initials illuminated, marginal decorations, smaller initials illuminated, and others in red and ɔlue, orig. cf. on oak bds., *Sæc.* XV., sm. 4to. (159) *Leighton*, £32 10s.

5710 Ptolomaeus. Liɔer quattuor tractatuum (Quadripartitum), lit. goth., 68 leaves, douɔle columns, capitals, pigskin ex., ɔy D. Cockerell, *Venetiis*, Erhard Ratdolt, 1484, sm. 4to. (160) *Young*, £6 5s.

5711 Quarles (Fr.) Emɔlemes, engravings, mor., g. e., 1663, 12mo. (161) *Edwards*, 18s.

5712 Ramesey (Wm.) Astrologia Restaurata, or Astrologie Restored, port. ɔy T. Cross, old cf. (ɔroken), 1653, sm. folio (162) *Lewine*, £1 10s.

5713 Regula Canonicorum Regularium per Hugonem de Sancto
Victore commentario declarata, lit. 𝔤𝔬𝔱𝔥., 44 leaves, title-
page (mended), mor. ex., the sides tooled, douꝫlé, g. e., ꝫy
Lortic, *Paris*, Gaspard Philippe, *s. a.* (1503), 12mo. (163)
Young, £4 10s.

5714 Reynolds (John). A Sermon upon part of the Prophesie of
Oꝫadiah, 𝔟𝔩𝔞𝔠𝔨 𝔩𝔢𝔱𝔱𝔢𝔯 (wanted sig. A i, and fore-edge notes
cut), cf., g. e., ꝫy Rivière, Thomas Dawson, 1584, 12mo.
(164) *Ellis*, 14s.

5715 Rolewinck (W.) Fasciculus Temporum, lit. 𝔤𝔬𝔱𝔥., 7 unnum-
ꝫered and 68 numꝫered leaves, woodcuts, hf. vell., *Venetiis*,
Erhardus Ratdolt, 1480, folio (165) *Barnard*, £1 16s.

5716 Rolewinck (W.) Fasciculus Temporum, lit. 𝔤𝔬𝔱𝔥., 7 unnum-
ꝫered and 64 numꝫered leaves, woodcuts (a few marginal
repairs), hf. vell., uncut, *Venetiis*, Erhardus Ratdolt, 1481,
folio (166) *Commin*, £2 4s.

5717 Sabellicus. Enneades abꝫ orꝫe condito ad inclinationem
Romani Imperii, lit. rom., title in red 𝔤𝔬𝔱𝔥𝔦𝔠, 14 preliminary
leaves, cccclxii. numꝫered leaves and one leaf Register
(wanted folios clxx. and clxxv.), woodcut initials, vell.,
*Venetiis, per Bernardinum et Mattheum Venetos, qui vulgo
dicuntur Li Albanesoti*, 1498, folio (167) *Commin*, £2 12s.

5718 Scarron. Whole Comical Works, translated ꝫy T. Brown
and others, plates, mor., g. e., from the Earl of Harrington's
liꝫrary, 1712, 8vo. (169) *Leighton*, £2 2s.

5719 Sedley (Sir Ch.) Works, 4 plates inserted, 2 vol. in 1, mor.,
g. e., arms of the Earl of Harrington, 1778, sm. 8vo. (170)
Leighton, £2 2s.

5720 Sherlock (Wm.) Practical Discourse concerning Death,
contemp. mor., richly gilt inlays and floral tooling, faintly
painted fore-edge, in good preservation, 1690, sm. 8vo. (172)
Delaine, £10

5721 Slatyer (W.) The History of Great Britanie (in verse), first
ed., leaf of imprint at end, old cf. gt. (reꝫacked), W. Stansꝫy
(1621), folio (173) *Delaine*, £5

5722 Stow (John). Survay of London, first ed., 𝔟𝔩𝔞𝔠𝔨 𝔩𝔢𝔱𝔱𝔢𝔯 (a few
marginal notes cut into), cf., John Wolfe, 1598, sm. 4to.
(175) *Edwards*, £2 16s.

5723 Straꝫo. Rerum Geographicarum liꝫri XVII. Latinè, lit. rom.,
217 leaves, long lines, 51 to a full page, marginal notes in a
contemp. hand, vell., uncut [*Venet., Vindelinus de Spira*],
1472, folio (176) *Leighton*, £15 10s.
[Very rare in this fine state ; the only indication of the
printer's name is contained in the following lines :—
" Nunc antenorei viden penates :
Impressos digitis Videlianis."—*Catalogue.*]

5724 Thomassin (S.) Recueil des Statues, Groupes, Fontaines,
Termes, Vases, etc. du Chateau et Parc de Versailles, plan
and 218 plates, hf. bd., uncut, *à la Haye*, 1723, 4to. (180)
Leighton, £1 12s.

5725 **Trade.** The Antiquity, Honor and Dignity of Trade, written

ɔy a Peer of England, LARGE PAPER, 6 ports. and extra
illustrated, hf. russ., 1813, 4to. (181) *Dobell,* £1 1s.
5726 Trithemius (Jo.) De Proprietate Monachorum, lit. gotɧ., 32
 leaves, woodcut capitals, mor. ex., douɔlé, ɔy Lortic, *Paris,*
 D. Roce, s. a. (1503), 12mo. (182) £7
5727 Tyndale (Wm.) The Paraɔle of the Wicked Manɪmon, black
 letter (a few headlines shaved), cf. ex., Wyllyam Hill, 1549,
 sm. 4to. (183) *Young,* £2 2s.
5728 Vigerius (Marcus). Decachordum Christianum Julio 11. Pont.
 Max. dicatum, 10 full-page and 33 small woodcuts (margins
 of 2 leaves inlaid and a few leaves wormed), orig. stamped
 Venetian cf., *Fani,* Hieron. Soncinus, 1507, folio (186)
 Young, £4 10s.
5729 Visscher (R.) Roemer Visschers Zinne-Poppen, alle verciert
 met Rijmen, en sommighe met Proze door zijn Dochter
 Anna Roemers, engravings, mor. ex., arms of the Earl of
 Harrington, *Amsterdam,* 1678, 12mo. (187)
 Leighton, £1 15s.
5730 Voltaire. The Maid of Orleans, by W. H. Ireland, 3 ports. of
 Joan of Arc (2 in colours), engraving from Sergent's Por-
 traits des Grands Hommes, 2 plates ɔy Moreau le Jeune
 and 1 ɔy Ramɔerg inserted, 2 vol. in 1, cf., g. e., arms of
 the Earl of Harrington, 1822, 8vo. (188) *Rimell,* £1 14s.
5731 Voragine (Jacoɔ de). Legenda Aurea, lit. gotɧ., woodcut
 initials (outer margin of title-page and last few leaves
 mended), text of last leaf mounted, cf. (reɔacked), *Impressa
 Lugduni per Magistrum Nicolaus de Benedictis,* 1505, sm.
 folio (189) *Commin,* £1 8s.
5732 Ward (Edward). The London Spy, orig. ed., separate titles,
 18 parts in 1 vol., old cf. (reɔacked), 1698-1700, folio (190)
 Gay, £2 14s.
5733 Westall (Richard, R.A.) A Day in Spring, and other Poems,
 plates by the author within gold lines, silk gilt, with water-
 colour sketches on covers, pale ɔlue silk linings and fly-
 leaves, and a water-colour painting on fore-edge, in case,
 1808, 8vo. (192) *J. Bumpus,* £9 5s.
5734 Wollstonecraft (Mary). Original Stories from Real Life, first
 ed., 6 plates by Wm. Blake, orig. sheep, J. Johnson, 1791,
 sm. 8vo. (194) *Edwards,* £1 1s.
5735 Worlde (The), or an Historicall Description of the most
 famous Kingdomes and Common-weales therein, ɔy J. R.,
 orig. vell., uncut, in box, with clasps, *E. Bollifant for J.
 Jaggard,* 1601, sm. 4to. (195) *Edwards,* £3

SOTHEBY, WILKINSON & HODGE.

THE LIBRARIES OF MR. S. MIDDLETON, OF DUBLIN, THE BARONESS VON COLBERG, OF ROME, AND OTHER PRO-PERTIES.

(No. of Lots, 707 ; amount realised, £1,195 7s. 0d.)

5736 Aesop. Faɔles, Stockdale's ed., 112 engravings ɔy Blake, etc., 2 vol., orig. bds., uncut, 1793, imp. 8vo. (555)
 Edwards, £5 10s.
5737 Alexander (W.) Dress and Manners of the Chinese, 50 col. engravings, with descriptions, uncut, 1814, roy. 4to. (319)
 Andrews, 17s.
5738 Alken (Henry). Tutor's Assistant, 6 col. plates, orig. bds., T. McLean, 1823, oɔlong folio (353) *J. Bumpus*, £4 8s.
5739 Allibone (S. A.) Dictionary of English Literature, with Supplement, 5 vol., *Philadelphia*, 1881-96—Beeton's Encyclopædia of Universal Information, maps and illustrations, 4 vol., n. d., imp. 8vo. (22) *Joseph*, £2 12s.
5740 Anderson (James). A Genealogical History of the House of Yvery, ports. ɔy Faɔer (two extra ones inserted), views, etc., 2 vol., contemp. mor., gilt gaufré edges, *Privately printed*, 1742, roy. 8vo. (199) *Edwards*, £11 15s.
 [This copy contained the "Epitome of the Work," which is frequently wanted.—*Catalogue.*]
5741 Anson (George). Voyage round the World, LARGE PAPER, 42 folding maps and plates, contemp. mor., g. e. (joints cracked), with the Gower arms, not suɔject to return, 1748, 4to. (596) *Blake*, £1
5742 Araɔian Nights Entertainments, translated by Sir R. F. Burton, ed. ɔy Smithers, illustrations ɔy Letchford, 12 vol., cl., t. e. g., 1894, roy. 8vo. (167) *A. Jackson*, £3 3s.
5743 Archæologia Cantiana, vol. i. to xviii. (vol. i. to iii. LARGE PAPER), illustrations, orig. cl., 1858-89, 8vo. (171)
 Thorp, £2 6s.
5744 Ariosto (L.) Orlando Furioso, ɔy Sir John Harington, illustrations ɔy Porro, orig. cf. (reɔacked), with the right plate to Canto xxxiiii., 1634, folio (355) £3 3s.
5745 Aristoteles. Decem liɔri Ethicorum (a few leaves stained and wormed), contemp. stamped cf., with design and initials "J. P." (Jehan Petit,) (repaired), *Parisiis, apud Joannem Paruum*, 1539, 8vo. (511) *Virgin*, £3 10s.
5746 Bacon (Sir F.) Works, ed. ɔy J. Spedding and others, port., 15 vol., mor., g. e., *New York*, 1872, 8vo. (30)
 Smedley, £4 4s.

5747 Barrocius (P.) De Modo Bene Moriendi, mor. gt. (Bozet), Jean Baptiste Col)ert's copy, with his arms and autograph, " Bi)liothecæ Colbertinæ," *Venet.*, 1531, 8vo. (181)
Virgin, £5 7s. 6d.

5748 Beaconsfield (Earl of). Novels and Tales, Hughenden ed., port., etc., 11 vol., 1881, 8vo. (66) *Zaehnsdorf*, £1 12s.

5749 Belcher (J.) and Macartney (M. E.) Later Renaissance Architecture in England, 170 large plates and 153 illustrations in the text, ed.)y J. Belcher and M. E. Macartney, in 6 portfolios, Batsford, 1901 (700) *Hill*, £4 10s.

5750 Bentham (G.) et Hooker (J. D.) Genera Plantarum, pencil-notes in margins, 3 vol., hf. cf., used copy, 1867-83, 8vo. (565) *Quaritch*, £4 15s.

5751 Bewick (T.) British Birds, first ed., 2 vol., orig. bds., uncut, with paper la)els, *Newcastle*, 1797-1804, 8vo. (562)
T. T. Gray, £3

5752 Bolton (James). Harmonia Ruralis, a Natural History of British Song Birds, 80 plates col. after nature, 2 vol., orig. hf.)inding, 1794-6, 4to. (457) *Edwards*, £1 4s.

5753 Borrow (Geo.) Wild Wales, first ed., 3 vol., orig. cl., 1862, 8vo. (552) *J. Bumpus*, £3 16s.

5754 Boswell (J.) Life of Johnson, including Johnsoniana,)y J. W. Croker, port. and plates, 10 vol., hf. mor., m. e., 1839, 8vo. (62) *Hornstein*, £1 15s.

5755 Boydell (J. and J.) History of the River Thames, 76 col. engravings and a folding map (a few plates and some leaves of text in vol. i. stained), 2 vol., orig. hf. cf., Bulmer, 1794-6, roy. folio (580) *Thorp*, £9 5s.

5756 Brassington (W. S.) Art of Book)inding, engravings in colour and monotints, LARGE PAPER, one of 50 copies, ornamented cl., t. e.g., 1894, 4to. (451) *Hatchard*, £1 15s.

5757 Brathwait (Richard). Ar't asleepe Hus)and? A Boulster Lecture, front.)y W. Marshall (wanted the print at page 246, a few leaves stained and 2 wanting), russ., *R. Bishop for R. B. or his Assigns*, 1640, 8vo. (197) *Banks*, £6 5s.

5758 Brehm (A. E.) Thierleben. Allgemeine Kunde des Thierreichs, col. plates and illustrations, 10 vol., hf. mor., *Leipzig*, 1882-83, imp. 8vo. (56) *Thorp*, £1 10s.

5759 Bridges (R.) Nero, an Historical Tragedy, first ed., hf. bd., uncut, 1885, 4to. (297) *Dobell*, 7s.

5760 British Essayists (The),)y L. T. Berguer, ports., 45 vol., cf., 1823, 8vo. (48) *Suckling*, £1 18s.

5761 British Novelists (The),)y Mrs. Barbauld, 50 vol., hf. bd., 1820, 8vo. (128) *Suckling*, £3 3s.

5762 Brontë (Charlotte). Shirley, first ed., 3 vol., orig. cl., 1849, 8vo. (384) *Edwards*, £1 12s.

5763 Brontë (C.) Life and Works, illustrations, 7 vol., hf. mor., t. e. g., 1882, 8vo. (23) *Suckling*, £1 4s.

5764 Browning (Ro)ert). Christmas Eve and Easter-Day, a Poem, first ed., orig. cl., 1850, 8vo. (215) *Menel*, 12s.

5765 Browning (R.) Paracelsus, first ed., with the advertisements, mor. ex., Effingham Wilson, 1835, 8vo. (512) *Thorp*, £3 5s.

5766 Burlington Fine Arts Club. Catalogue of a Collection of Silversmiths Work of European Origin, 120 plates, buck-ram, uncut, 1901, folio (343) *Hitchman, £4 6s.*

5767 Burney (Charles). General History of Music, engravings by Bartolozzi, 4 vol., cf. gt., 1776-89, 4to. (323) *Edwards, £2 10s.*

5768 Burns (Robert). Works, ed. by W. S. Douglas, Library ed., port., fronts. and vignettes, 6 vol., hf. mor., t. e. g., *Edinb.,* 1877-79, imp. 8vo. (53) *Joseph, £1 7s.*

5769 Burton (William). Description of Leicestershire, port. and engraved title by Delaram, map and engravings of arms, orig. cf., not subject to return (1622), folio (682) *Thorp, £2*

5770 Byron (Lord). The Bride of Abydos, 1813—Childe Harold's Pilgrimage, Canto III., 1816—Letter to ―――― (John Murray) on the Rev. W. L. Bowles' Strictures on the Life and Writings of Pope, 1821, first editions, orig. wrappers, uncut, together 3 pieces, 8vo. (551) *Spencer, £2 6s.*

5771 Byron (Lord). Letters and Journals, by Thomas Moore, ports. and plates after Turner, etc., 3 vol., hf. mor., t. e. g., 1832, 8vo. (16) *Young, £1 10s.*

5772 Byron (Lord). Works, by Moore, port. and fronts., 17 vol., hf. cf. gt., 1832-33, 8vo. (85) *Joseph, £1 6s.*

5773 Byron. Finden's Landscape Illustrations to the Life and Works of Lord Byron, LARGE PAPER, proof impressions, 24 parts, as issued, 1833-34, 4to. (288) *Archer, 16s.*

5774 Cabinet of Genius, aquatinta plates chiefly by S. Shelley, and views (soiled), 2 vol., orig. cf., 1787, 4to. (469) *Bloomfield, £3*

5775 Campion (Thos.) Works, ed. by A. H. Bullen, LARGE PAPER, one of 120 copies, mor. ex., *Chiswick Press, privately printed,* 1889, 8vo. (174) *Young, £1 8s.*

5776 Carlyle (T.) Works, éd. de luxe, one of 315 copies on parch-ment-linen paper, ports., etc., 20 vol., uncut, *Boston,* 1884, roy. 8vo. (32) *Kerr, £3 5s.*

5777 Chaffers (W.) Marks and Monograms, illustrations, 1886, imp. 8vo. (6) *Joseph, 17s.*

5778 Charles I., by Sir John Skelton, printed upon Japanese vellum, front. in colours, plates (in duplicate) and other illustrations, presentation copy to Andrew Lang, mor. super ex., doublé, Goupil, 1898, roy. 4to. (609) *Watts, £4 15s.*

5779 Chauncy (Sir Henry). Historical Antiquities of Hertford-shire, port. by Savage, map and plates, contemp. russ. gt., arms on upper side, not subject to return, 1700, folio (683) *Parsons, £5*

5780 Combe (William). Life of Napoleon, 30 col. engravings by Geo. Cruikshank (imprint of some of the plates cut off, a few leaves stained), orig. hf. cf., T. Tegg, 1815, 8vo. (568) *Spencer, £4 5s.*

5781 Common Prayer (Book of), engraved by John Sturt, borders, vignette drawings and 2 ports. (one shaved), 2 vol., mor. ex., in drop cases, 1717, 8vo. (198) *Leighton, £2 14s.*

5782 Common Prayer (Book of), contemp. mor., dentelle ɔorders,
g. e., *Birm.*, J. Baskerville, 1760, roy. 8vo. (232)
James, £1 6s.

5783 Conaeus (G.) Vita Mariae Stuartae Scotiae Reginae, etc.,
port. of the Queen (some leaves stained), mor., g. e., not
suɔject to return, *Wirceburgi,* 1624, 8vo. (528)
Stryte, £1 8s.

5784 Constaɔle (J.) Various Suɔjects of Landscape, engraved ɔy
David Lucas, engraved title and 25 plates, orig. wrapper
inserted, also a 3-page 4to. autograph letter of Constaɔle to
D. Colnaghi, mor. super ex., not suɔject to return (1830),
oɔlong folio (684) *Lecky,* £18

5785 Cook (T. A.) History of the English Turf, illustrations,
2 vol., ɔuckram, g. e., n. d., 4to. (309) *Thorp,* 10s.

5786 Coryat (Thomas). Coryats Crudities, first ed., engraved title
(shaved at top), plates, including whole-length port. of
Coryat with a Venetian courtezan, delineation of the
Amphitheatre of Verona (damaged and mounted), the
famous clock of Strasɔourg (cut into) and the Heidelɔurg
tun (cut into), (the leaf of Errata defective and some leaves
soiled,) mor. ex., not suɔject to return, 1611, 4to. (631)
Leighton, £16

5787 Darwin (C.) Descent of Man, 1883—Origin of Species, 1882
—Naturalist's Voyage, 1882, and other of his Works, in 14
vol., illustrations, hf. cf. gt., 1878-83, 8vo. (92)
Young, £3 5s.

5788 Davenport (Cyril). Mezzotints, illustrations, uncut, t. e. g.,
1904, roy. 8vo. (208) *Hyam,* 15s.

5789 Dickens (C.) Evenings of a Working Man, ɔy John Overs,
Preface ɔy Charles Dickens, title in ɔlue and red, orig. cl.,
1844, 8vo. (653) *Young,* 6s.

5790 Dickens (C.) Martin Chuzzlewit, first ed., illustrations ɔy
" Phiz," specimen wrapper ɔound up, cf. ex., with the trans-
posed "£" in the reward, on the engraved title, 1844, 8vo.
(654) *Young,* £1 12s.

5791 Dickens (C.) The Lamplighter, orig. wrapper ɔound up, cf.
ex., one of 250 copies, 1879, 8vo. (672) *Quaritch,* £2 2s.

5792 Dickens (C.) Sketches by " Boz," first ed., first series, 2 vol.,
J. Macrone, 1836—Second Series, first ed., *ib.*, 1837, hf.
mor., g. e., 8vo. (635) *F. H. Green,* £3 15s.
[The Second Series, ɔesides all the original plates, had
the two which appeared for the first time in the second
edition.—*Catalogue.*]

5793 Dickens (C.) Sketches of Young Ladies . . . by " Quiz," 6
illustrations ɔy " Phiz," 1837—Sketches of Young Gentle-
men, 6 illustrations ɔy " Phiz," 1838—Sketches of Young
Couples, 6 illustrations ɔy " Phiz," 1840, first eds., orig.
pictorial bds. (repaired), in case, 1837-40, 8vo. (643)
Hornstein, £2 11s.

5794 Dickens (C.) A Tale of Two Cities, first ed., illustrations by
H. K. Browne, wrapper ɔound up, cf. ex., 1859, 8vo. (663)
Parsons, £2 15s.

5795 Dickens (C.) Great Expectations, first ed. (half-titles wanted), 3 vol., cf. ex., 1861, 8vo. (664) *Edwards, £2* 2s.

5796 Dickens (C.) The Village Coquettes, first ed., in sheets (folded), in case, 1836, 8vo. (638) *Spencer, £3* 15s.

5797 Dickens (C.) Posthumous Papers of the Pickwick Club, first ed., 43 illustrations by R. Seymour and "Phiz," and the 2 suppressed plates by R. W. Buss, extra illustrated by the insertion of a series of illustrations by "Sam Weller" (T. Onwhyn), and the set of 40 plates called the "Pickwickians," by Alfred Crowquill, specimen wrapper bound up, cf. ex., g. e., 1837—Extra Illustrations, by Sir John Gilbert, hf. mor., t. e. g. (1847), together 2 vol., 8vo. (639) *Hornstein, £8* 7s.

5798 Dickens (C.) The Library of Fiction, illustrations by Seymour, Buss, etc., 2 vol., hf. mor., t. e. g., 1836-37, 8vo. (640) *Edwards, £1* 12s.

5799 Dickens (C.) Nicholas Nickleby, first ed., illustrations by "Phiz" and a port., extra illustrated by the insertion of 40 full-page etchings by T. Onwhyn, and the set of 24 ports. by Kenny Meadows, specimen wrapper bound up, cf. ex., g. e., by Tout, 1839—Extra Illustrations to the work, by Sir John Gilbert, hf. mor., t. e. g. (1847), together 2 vol., 8vo. (646) *Hornstein, £3*

5800 Dickens (C.) Loving Ballad of Lord Bateman, first ed., earliest issue, orig. pictorial cl., no advertisements at end, in case, 1839, 8vo. (647) *W. Brown, £4* 6s.

5801 Dickens (C.) Sergeant Bell and his Raree-Show, first ed., woodcuts by Cruikshank, etc., orig. cl., 1839, 8vo. (648) *Edwards,* 12s.

5802 Dickens (C.) Master Humphrey's Clock, first ed., illustrations by Geo. Cattermole and Hablot Browne, extra illustrated with the series of plates by Sibson, 3 vol., hf. mor., 1840-41, 8vo. (649) *Hornstein, £7*

5803 Dickens (C.) American Notes, first issue of the first ed. (with the first 8 pages wrongly numbered up to xvi.), orig. cl., uncut, 1842, 8vo. (650) *Sawyer,* 12s.

5804 Dickens (C.) The Pic Nic Papers, first ed., illustrations by Geo. Cruikshank, "Phiz," etc., 3 vol., orig. cl., 1841, 8vo. (651) *Zaehensdorf, £1* 18s.

5805 [D'Ouvilly (George Gerbier).] The False Favorit Disgrac'd, a Tragi-Comedy, never acted, first ed., mor. ex., g. e., 1657, 8vo. (513 *Sandley, £3* 10s.

5806 Dramatists of the Restoration, ed. by J. Maidment and W. H. Logan, LARGE PAPER, one of 150 copies, 14 vol. (Davenant 5 vol., Browne 4 vol., Wilson, Cokain, Tatham, Lacy, Marmion), buckram, uncut, 1872-79, 8vo. (172) *Sotheran, £3* 6s.

5807 Drayton (Michael). Poems, mor., g. e. (title soiled, some leaves repaired and some headlines cut close), 1613, 8vo. (178) *Ellis, £1* 6s.

5808 Dryden (John). An Ode, on the Death of Mr. Henry

Purcell, first ed., the music by Dr. Blow (the last leaf torn), uncut, *Printed by J. Heptinstall for Henry Playford*, 1696, folio (678) *Maggs*, £5 2s. 6d.

5809 Dryden (J.) Works, with Notes and Life ɔy Sir W. Scott, revised ɔy G. Saintsɔury, port., vol. i.-xiii., *Edinb.*, 1882-87, 8vo. (60) *G. H. Brown*, £3 10s.

5810 Duɔlin University Magazine (The), from the commencement to 1868, plates, 71 vol., hf. cf., not uniform, *Dublin*, 1833-68, 8vo. (37) *Sotheran*, £5

5811 D'Urfey (T.) Wit and Mirth, or Pills to Purge Melancholy, port., 6 vol., uncut, 1719-20 (reprint), 8vo. (194)
 A. Jackson, £1 14s.

5812 Duruy (V.) History of Rome, ed. ɔy J. P. Mahaffy, col. plates and illustrations, 16 vol., uncut, t. e. g., *Boston*, 1883-86, imp. 8vo. (38) *G. H. Brown*, £4 1s.

5813 Edgeworth (Maria). Tales and Novels, fronts., 18 vol., hf. cf. gt., 1832-33, 8vo. (65) *Edwards*, £2 11s.

5814 Edwards (George). Natural History of Uncommon Birds, col. engravings, 7 vol., mor., g. e., 1743-64, 4to. (604)
 Edwards, £5 15s.

5815 Egan (Pierce). Life of an Actor, first ed., col. plates ɔy T. Lane (imprint of a few cut into) and woodcuts by Thompson (several leaves soiled), mor. ex., not suɔject to return, 1825, 8vo. (524) *Hornstein*, £4

5816 Eisenɔerg (Baron d'). Description du Manège Moderne, première éd., engraved title and 59 plates, ɔy Bernard Picart, old cf., 1727, oɔlong folio (679) *Halliday*, £2

5817 [Evelyn (John).] Mundus Mulieɔris, or The Ladies' Dressing Room Unlock'd (verse), first ed., hf. bd., 1690, 4to. (607)
 Dobell, £1 15s.

5818 Fisher (Fitz-Payne). Irenodia gratulatoria, sive Oliveri Cromwelli Epinicion, 2 ports. of Oliver Cromwell (cut into), mor., g. e., 1652, 4to. (316) *Alum*, £1 16s.

5819 [Fitzgerald (Edward).] Polonius, first ed., mor., t. e. g., Pickering, 1852, 4to. (296) *Shepherd*, 18s.

5820 Fitzgerald (E.) Six Dramas of Calderon, first ed., orig. cl., Pickering, 1853, 8vo. (179) *Dobell*, £1 14s.

5821 Fitzgerald (E.) Readings in Craɔɔe. "Tales of the Hall," port. of Craɔɔe added, hf. vell., t. e. g., Quaritch, 1883, 8vo. (218) *Spencer*, 12s.

5822 Fortnum (C. D. E.) Maiolica of Italy, illustrations, ɔuckram, uncut, 1896, 4to. (303) *Hill*, 19s.

5823 Fox (George). The Great Mystery of the Great Whore unfolded, cf. (ɔroken), 1659-60, folio (359) *Taylor*, £1 6s.

5824 Freer (M. W.) Life of Marguerite D'Angoulême, 2 vol., 1854 —Life of Jeanne D'Albret, 2 vol., 1855—Elizaɔeth de Valois, 2 vol., 1857—Henry III. King of France, 3 vol., 1858—Reign of Henry IV., 2 vol., 1860—Henry IV. and Marie de Medici, 2 vol., 1861—Last Decade of a Glorious Reign, 2 vol., 1863—Married Life of Anne of Austria, 2 vol., 1864—Regency of Anne of Austria, 2 vol., 1866, first eds., together 19 vol., ports., hf. mor., t. e. g., 1854-66, 8vo. (63)
 Hornstein, £14 15s.

5825 Galerie du Palais du Luxembourg, peinte par Rubens, ports. and engravings by Vermeulen, Audran, etc. (inlaid), contemp. mor. gt., arms of the city of Paris, not subject to return, *Paris*, 1710, folio (687) *Hornstein*, £17

5826 Gay (John). Fables, "Stockdale's fine ed.," 2 vol., 70 engravings by Blake (some stained), orig. bds., uncut, 1793, 8vo. (390) *Edwards*, £3 5s.

5827 Gilchrist (Alex.) Life of Blake, 2 vol., cl., uncut, 1880, 8vo. (378) *Bain*, £2 4s.

5828 Goethe (J. W. von). Works, by John Oxenford, 10 vol., hf. cf., *Boston*, 1883, 8vo. (86) *Winter*, £1 9s.

5829 Gray (Dionis, of London, Goldsmith). The Storehouse of Breuitie in workes of Arithemetike, **black letter** (a few leaves water-stained and wormed), orig. cf., with stamp on sides, fly-leaves from early English printed books of poems and grammar, with early stationer's label "Arithmetick" attached, *Imprinted at London for William Norton and Jhon Harrison*, 1577, 8vo. (514) *Tregaskis*, £5 5s.

5830 Grote (George). History of Greece, bust and maps, 12 vol., cl., uncut, 1854-56, 8vo. (560) *T. T. Gray*, £3

5831 Grote (G.) History of Greece, port., maps and plans, 12 vol., hf. mor., g. e., 1869, 8vo. (67) *James*, £1 19s.

5832 Guizot (M.) History of France, by R. Black, illustrations, 8 vol., hf. mor., m. e., 1883, imp. 8vo. (25) *Hornstein*, £3 11s.

5833 Hamerton (P. G.) The Graphic Arts, illustrations, parchment, uncut, *New York*, 1882, folio (146) *Vyl*, 17s.

5834 Hamilton (A.) Memoirs of Grammont, ed. by Sir Walter Scott, port., plates, etc., India proofs, mor., uncut, t. e. g., 1889, imp. 8vo. (185) *Rimell*, £1 12s.

5835 Hawkins (Sir John). General History of Music, ports., musical notation and engravings, 5 vol., mor. ex., 1776, 4to. (324) *Thorp*, £4 4s.

5836 Hawthorne (Nathaniel). The Marble Faun, first ed., 2 vol., orig. cl., *Boston*, Ticknor and Fields, 1860, 8vo. (213) *Shepherd*, 11s.

5837 Hayti. Almanach Royal d'Hayti pour l'année 1815, présenté au Roi, par P. Roux, mor., g. e., *au Cap-Henry, chez P. Roux* (570) *J. Davis*, £1 1s.

5838 Heath (W.) Good Dinners, dressed by W. Heath, and served by T. McLean, 9 col. plates, orig. bds., T. McLean, 1824, oblong folio (354) *Hornstein*, £4 15s.

5839 Historical Narrative of those Momentous Events which have taken place in this Country [1816-23] (by R. Bowyer), col. plates by Dubourg and other illustrations, proofs, orig. bds., with label, 1823, folio (707) *Wilkinson*, £1 4s.

5840 Holmes (Oliver Wendell). Astraea, The Balance of Illusions, a Poem, first ed., orig. cl., *Boston*, Ticknor, Reed and Fields, 1850, 8vo. (212) *Spencer*, 13s.

5841 Hooker (J. D.) Flora of British India, complete in 24 parts (the first vol. in cl.), Reeve, 1875, 8vo. (558) *Quaritch*, £4 18s.

5842 [Hope (Sir Wm.)] The Fencing-Master's advice to his Scholar, *Edinb.*, 1692—The Gentleman's Jockey (folding plate torn and a few leaves stained), 1679—The Sailing and Fighting Instructions, or Signals, in the Royal Navy, the flags coloured, cf., n. d., together 3 vol., not subject to return, 8vo. (532) *Edwards*, £3 12s.

5843 Howitt (W.) Visits to Remarkable Places, both series, 1840-42—Rural Life of England, 1840—Rural and Domestic Life of Germany, 1842—Homes and Haunts of the most eminent British Poets, 2 vol., 1847, together 6 vol., illustrations, hf. mor., t. e. g., 1840-47, 8vo. (19) *Suckling*, £2 8s.

5844 Irving (Washington). Works, Hudson ed., illustrations, 27 vol., hf. cf., *New York*, n. d., 8vo. (59) *Suckling*, £3 3s.

5845 Jacquemart (A.) History of Furniture, illustrations, hf. mor., 1878, imp. 8vo. (9) *Ridler*, 14s.

5846 James I. Workes, first collected ed., port. by Passe and engraved title by Elstrack, vell., crest on the sides, 1616, folio (680) *Lecky*, £6 15s.

5847 Jami. Salámán and Absal, trans. by Edward Fitzgerald, front., mor., t. e. g., 1856, 4to. (294) *Quaritch*, £5

5848 Lamb (Charles). Tales from Shakespeare, first ed., copperplates by W. Blake, vol. ii., orig. hf. binding, 1807, 8vo. (553) *Fletcher*, £7

5849 Leland (T.) History of Ireland, 3 vol., mor., emblematical tooling, g. e., presentation copy, *Dublin*, 1773, 4to. (134)
 Sawyer, £1 4s.

5850 Litchfield (Fr.) Illustrated History of Furniture, illustrations, 1892, folio (375) *Thorp*, 10s.

5851 Lodge (E.) Portraits, ports., 12 vol. in 6, hf. mor., t. e. g., 1823-34, imp. 8vo. (15) *Suckling*, £2 18s.

5852 Loggan (Dav.) Oxonia Illustrata, plates, contemp. mor., g. e., not subject to return, *Oxoniae*, 1675, folio (686)
 Edwards, £10 5s.

5853 Macaulay (Lord). History of England, port., 5 vol., n. d.—Miscellaneous Works, 5 vol., hf. mor., t. e. g., 1880, together 10 vol., *New York*, 1880, 8vo. (64) *Joseph*, £1 5s.

5854 Madden (R. R.) Infirmities of Genius Illustrated, 2 vol., 1833 —Twelve-months Residence in the West Indies, 2 vol., 1835—Egypt and Mohammed Ali, 1841—The United Irishmen, 3 series, 7 vol., 1842-46—Shrines and Sepulchres of the Old and New World, 2 vol., 1851—Life and Martyrdom of Savonarola, 2 vol., 1853—Phantasmata, 2 vol., 1857, first eds., together 18 vol., illustrations, hf. mor., t. e. g. (some vol. stained), 1833-57, 8vo. (58) *Edwards*, £6 10s.

5855 Marco Polo. The Book of Ser Marco Polo, the Venetian, by Col. Henry Yule, maps and illustrations, 2 vol., buckram, uncut (presentation copy, "From the Author"), 1871, 8vo. (243) *Taylor*, £1 11s.

5856 Meehan (T.) Native Flowers and Ferns of the United States, col. plates, 2 vol., *Boston*, 1879-80, imp. 8vo. (26)
 Wesley, 14s.

5857 Menken (Adah Isaacs). Infelicia, first ed., port. and vignettes, with inscription, "To H. Eastlake, from A. C. Swinburne, Aug. 27/68," orig. cl., g. e., 1868, 8vo. (571)
J. Bumpus, £6 7s. 6d.

5858 Mercator. Minor Atlas. Historia Mundi, or Mercator's Atlas, ed. by J. Hondius, Englished by W. S. [William Saltonstall], maps, orig. cf., 1635, folio (696) *Thorp,* £2 7s.

5859 Mercure de France, May, 1730, contemp. French mor., g. e., arms of Marie Leckzinska, wife of Louis XVth, on sides, not subject to return, 1730, 8vo. (529) *Virgin,* £2 12s.

5860 [Mitford (John, R.N.)] Adventures of Johnny Newcome in the Navy, col. plates by Rowlandson (imprints of some of the plates cut into), orig. cl., not subject to return, 1818, 8vo. (525) *J. Bumpus,* £4 7s. 6d.

5861 Napoleon I. Histoire d'Hérodote, traduite du Grec, 9 vol., cf. gt., with the Gower arms, not subject to return, 1802, 8vo. (535) *Sawyer,* £10 10s.
[This copy of Herodotus formerly belonged to Napoleon at St. Helena. In the second volume, at pages 172, 179 and 180, are calculations, in his handwriting, in the margins.—*Catalogue.*]

5862 Napoleon III. Mémorial de Saint-Hélène, illustrations by Charlet, 2 vol., hf. cf. gt., in cases, not subect to return, 1842, roy. 8vo. (536) *Lacroix,* £2 10s.
[From the library of the Emperor of France, when Prince Louis Bonaparte ; his library was sold in London in 1842. MS. memorandum in vol. ii. Two autographs inserted.—*Catalogue.*]

5863 Needle-Work Binding. The Whole Book of Psalmes, by T. Sternhold, J. Hopkins and others, embroidered binding in silver and col. threads, full-length figures of male and female in costume of the period, gilt and gauffred edges, silk ties, by the Little Gidding Nuns, in case, *Cambridge,* Cantrell Legge, 1623, 32mo. (577) *Lecky,* £16 10s.

5864 Newcastle (Duke of). General System of Horsemanship, plates, 2 vol. in 1, cf. (injured), 1743, folio (156)
Thorp, £2 16s.

5865 New South Wales. The Private Journal of Robert Dawson, Esq., of Port Stephens, New South Wales, orig. manuscript (28 leaves unpublished), *Dated Port Stephens, N. S. W., July,* 1826, sm. folio (582) *Maggs,* £15 5s.

5866 Nieuhoff (Joan). Descriptio Legationis Batavicae, port., map and engravings, old cf., *Amst.,* 1668, folio (360)
Taylor, £1 10s.

5867 O'Connor (The). Chronicles of Eri, port., maps and plates, 2 vol., hf. mor., t. e. g., 1822, 8vo. (7) *James,* 12s.

5868 Old English Plays, new series, ed. by A. H. Bullen (Nabbes and Davenport), 3 vol., hf. parchment, uncut, 1887-90, 4to. (298) *Edwards,* £3 8s.

5869 Omar. Rubáiyát of Omar Khayyam (by Edward Fitzgerald), third ed., hf. bd., 1872, 4to. (295) *Spencer,* £2 2s.

5870 Omar. Rubáiyát of Omar Khayyam, trans. by J. H.

McCarthy, printed on Japanese vellum, one of 60 copies, mor., uncut, t. e. g., 1889, 8vo. (175) *B. F. Stevens*, £1 6s.

5871 Orme (E.) Historical Memento of the Public Rejoicing, in St. James's and Hyde Parks, in Celebration of the Glorious Peace of 1814, 6 col. plates by Clark and Dubourg, introduction by F. W. Blagdon, orig. hf. binding, 1814, 4to. (441)
J. Bumpus, £1 6s.

5872 Pascal (B.) Les Provinciales, mor., g. e., *Cologne*, P. de la Vallee, 1656-7, 8vo. (182) *James*, 16s.

5873 Percy Anecdotes (The), Original and Select, by Sholto and Percy, ports., 20 vol., hf. mor., n. d., 8vo. (87)
Edwards, £1 6s.

5874 Picturesque Tour through the Overland, 17 col. views and a map, orig. hf. binding, R. Ackermann, 1823, 8vo. (381)
Maggs, £2 2s.

5875 Poe (Edgar A.) Eureka, a Prose Poem, first ed., orig. cl. (damaged), *New York*, 1848, 8vo. (211) *Quaritch*, £1 8s.

5876 Poe (E. A.) Works, by R. H. Stoddard, one of 315 copies, port., fronts. and facs., 8 vol., uncut, t. e. g., *New York*, n. d., 8vo. (52) *Sawyer*, £3 3s.

5877 Prescott (W. H.) Works, ed. by J. F. Kirk, édition de luxe, one of 250 copies, ports., 15 vol., hf. bd., t. e. g., *Philadelphia*, n. d., roy. 8vo. (103) *Joseph*, £2

5878 Prime (W. C.) Pottery and Porcelain of all Times and Nations, illustrations, *New York*, 1878, roy. 8vo. (5)
Suckling, 16s.

5879 Propert (J. L.) History of Miniature Art, illustrations, uncut, 1887, roy. 4to. (439) *Forrester*, £5 15s.

5880 Racinet (M. A.) Le Costume Historique, LARGE PAPER, col. plates and illustrations, 6 vol. in 18 portfolios, *Paris*, n. d., folio (150) *Edwards*, £9 7s. 6d.

5881 Racinet (A.) Polychromatic Ornament, 100 plates in gold, silver and colours, with text, subscription ed., complete in 12 parts, Sotheran, 1873, folio (274) *Edwards*, £1 18s.

5882 Reaumur (R. A. de). Art de Faire Eclorre et d'Elever en toute saison des Oiseaux Domestiques, plates, 2 vol., contemp. French mor., g. e., arms of the Marquis du Tot, not subject to return, 1749, 8vo. (530) *Edwards*, £2 18s.

5883 Reinhardt (J.) Collection of Swiss Costumes, in miniature, 30 col. plates, orig. hf. binding, with paper label, n. d., 8vo. (383)
Parsons, £1 18s.

5884 Roadside Songs of Tuscany, trans. by F. Alexander, ed. by Ruskin, 20 illustrations, uncut, Orpington, 1885, 4to. (450)
Askew, £1 6s.

5885 Rocque (J.) New Survey of the Cities of London and Westminster, map in 8 large sheets, engraved and published by Pine and Tinney, in 1 vol., hf. bd., not subject to return, 1746, folio (685) *Thorp*, £6

5886 Roe (F.) Ancient Coffers and Cupboards, 2 col. and numerous other illustrations, buckram, uncut, t. e. g., 1902, 4to. (300) *Hill*, £1

5887 Rossetti (D. G.) Poems, LARGE PAPER, orig. bds., uncut, 1881, 8vo. (173) *Dobell,* £1 1s.
5888 Ruskin (John). The Stones of Venice, first ed., illustrations (some spotted), 3 vol., orig. cl., t. e. g., 1851-3, imp. 8vo. (544) *Zaehnsdorf,* £4 15s.
5889 Scott (Sir Walter). Waverley Novels, Library ed., ports. and plates, 25 vol., cf., g. e., *Edinb.,* 1852-53, 8vo. (47) *Hornstein,* £6 2s. 6d.
5890 Seeley (Prof. J. R.) Life and Times of Stein, ports., 3 vol., uncut, *Cambridge,* 1878, 8vo. (253) *Young,* £1
5891 Shakespeare (William). Works, by Nicholas Rowe, and Poems by C. Gildon, engraved front., with port. and plates, 7 vol., orig. cf. (rebacked), J. Tonson and E. Curll, 1709-10 (538) *Pickering,* £13
5892 Shakespeare (W.) Works, ed. by Staunton, édition de luxe, illustrations by Gilbert, on India paper, 15 vol., hf. mor., t. e. g., 1881, 4to. (133) *Thorp,* £3 12s.
5893 Shelley (P. B.) Queen Mab, first ed., roan, uncut, t. e. g. (margins stained, wanted title and dedication, imprint on last leaf cut away), 1813, 8vo. (177) *Spencer,* £5 10s.
5894 Shelley (P. B.) Works, by H. Buxton Forman, port., fronts., etc., 8 vol., hf. mor., 1880, 8vo. (54) *Sawyer,* £8 7s. 6d.
5895 Shoberl (Fr.) Picturesque Tour from Geneva to Milan, 36 col. views, by J. and J. Lory, hf. bd., R. Ackermann, 1820, 8vo. (380) *Swift,* £2
5896 Singleton (Esther). Furniture of our Forefathers, plates and woodcuts, 2 vol., hf. parchment, uncut, t. e. g., Batsford, 1901, 4to. (302) *Edwards,* £1 14s.
5897 Smith (C. Roach). Collectanea Antiqua, illustrations, vol. i. to vii., uncut, 1848-80, 8vo. (170) *Ebbs,* £3 12s.
5898 Smith (J. Chaloner). British Mezzotinto Portraits, fronts., 4 parts in 5 vol., uncut, 1878-83, 8vo. (389) *Parsons,* £16 5s.
5899 Society of French Aquarellists, ed. by Edward Strahan, plates on India paper, tinted plates and illustrations, in 8 portfolios, in velvet case, *Paris,* Goupil, 1883, folio (160) *Sawyer,* £2 12s.
5900 Spenser (Edm.) The Faerie Queene and other Works, woodcuts, cf. (broken), 1617, folio (348) *Edwards,* £2 6s.
5901 Spenser (E.) Works, ed. by J. Payne Collier, 5 vol., hf. mor., 1862, 8vo. (55) *G. H. Brown,* £3
5902 Sporting Magazine (The), from its commencement in October, 1792 to October, 1842, being vol. i. to c. (wanted vol. xc.), (vol. c. wanted the title-page,) together 99 vol., cf. gt., not uniform, not subject to return, 1792-1842, 8vo. (520) *Fox,* £58
5903 Surtees (R. S.) Analysis of the Hunting Field, first ed., 6 col. plates by H. Alken and woodcuts, orig. cl., g. e., R. Ackermann, 1846, oblong 8vo. (576) *J. Bumpus,* £17 15s.
5904 Swift (J.) Works, by Sir Walter Scott, port., 19 vol., *Edinb.,* 1814, 8vo. (68) *James,* £1 1s.
5905 Talleyrand (Prince de). Memoirs, by the Duc de Broglie, ports., 5 vol., uncut, 1891-2, 8vo. (254) *Hatchard,* £1 5s.

5906 Taunton (T. H.) Portraits of Celebrated Racehorses, plates
(4 extra ones added), 4 vol., hf. bd., uncut, t. e. g., 1887-88,
4to. (308) *Edwards*, £3 5s.
5907 Tennyson (Alfred, Lord). Poems, chiefly Lyrical, first ed.,
mor. super ex., E. Wilson, 1830, 8vo. (186) *Shepherd*, £4
5908 Tennyson (Alfred, Lord). Poems, mor. super ex., E. Moxon,
1833, 8vo. (187) · *Shepherd*, £4
5909 Thackeray (W. M.) Works, in 22 vol., hf. mor., uncut, t. e. g.,
1874-6, 8vo. (557) *Hornstein*, £6 15s.
5910 Thackeray (W. M.) The Snob, "conducted by Members of
the University," Nos. 3, 4, 5, 6 and 9, title and index, etc.,
Cambridge, 1829—The Gownsman, (formerly called) "The
Snob," now conducted by Members of the University, Nos.
13 to 17, title and index, etc., *ib.*, 1830—The Individual,
Nos. 1 to 15, printed on different coloured papers, 1836-37
—The Progress to B.A., a Poem, *Cambridge*, 1830—The
Fellow, No. xi., 1836—The Tripos, No. 1, n. d.—A few
more Words to Freshmen, by the Rev. T. T., *Cambridge*,
1841—Granta, a Fragment, by a Freshman, ed. by the
Rev. J. Snodgrass, M.A., 1841—The Cambridge Odes, by
Peter Persius, *Cambridge*, n. d.—The Snobs' Trip to Paris,
ib., n. d. (1830), bds., with paper label, in 1 vol., 8vo. (540)
Hornstein, £8 17s. 6d.
5911 Thomson (James). The Seasons, plates, a painting on the
fore-edge, vell. gt., g. e., in cloth case, not subject to return,
1788, 8vo. (526) *Tregaskis*, £2 10s.
5912 Toms (W.) Thirty-six New, Original and Practical Designs
for Chairs, plates, *Bath*, n. d., 4to. (610) *Ellis*, 7s.
5913 Tracts. Treatise concerning the Regulation of the Coyn of
England, by R. C. [Roger Cook], 1696—Proposal for the
Raising of the Silver Coin of England, considered, 1696—
Dialogue concerning the Falling of Guineas, uncut, 1696—
Papers concerning Clipt and Counterfeit Money, 1696—
Discourse upon Coins, by B. Davanzati, trans. by J. Toland,
1696—Letter concerning the Trade and Coin of England,
uncut, 1695—Essay for Regulating of the Coyn, 1696—
Proposals for Setling the East-India Trade, uncut, 1696,
together 13 tracts, not subject to return, 4to. (584)
Leon, £11 15s.
5914 Tracts. Geographical History of Nova Scotia . . . its Trade
. . . etc., 1749—Tryal of Sir Chaloner Ogle, before the
Chief Justice of Jamaica, 1743—Tabago, a Geographical
Description, folding map, n. d.—Tracts on the South-Sea
Company's Scheme, 1720, etc., together 8 pieces, the lot
sold not subject to return, 8vo. (545) *Leon*, £5
5915 Traité des Danses, auquel est amplement resolue la question,
asavoir s'il est permis aux Chrestiens de danser (attribué à
Lambert Daneau), old mor. ex., g. e., not subject to return,
François Estienne, 1579, 8vo. (527) *Edwards*, £1 12s.
5916 Tuer (A. W.) Bartolozzi and his Works, illustrations, 2 vol.,
parchment, uncut, t. e. g. (1881), 4to. (603)
Tregaskis, £2 4s.

5917 Virgil. The Pastorals of Virgil, by R. J. Thornton, 230 woodcuts, of which 17 were designed ɔy William Blake, 2 vol., orig. sheep, 1821, 8vo. (518) *Tregaskis*, £2 4s.

5918 Watts (Isaac). Hymns and Spiritual Songs, fourth ed., old cf. (front cover loose), 1714, 8vo. (554) *Fletcher*, 12s.

5919 White (Gilɔert). Natural History of Selɔorne, first ed., folding front. and plates, orig. cf. (damaged), 1789, 4to. (311) *Edwards*, £7

5920 Whitman (Alfred). Masters of Mezzotint, 60 illustrations, uncut, t. e. g., 1898, 4to. (313) *Rimell*, £2 12s.

5921 Whitman (Walt). Leaves of Grass, port., orig. cl., *Boston*, Thayer and Eldridge (1860-61), 8vo. (214) *Shepherd*, 11s.

5922 Wilkinson (J.) Select Views in Cumɔerland, Westmoreland and Lancashire, 48 plates, in 12 parts, wrappers, as issued, 1810, folio (345) *Suckling*, £1 6s.

5923 Williamson (E.) Les Meuɔles d'Art du Moɔilier National, 100 heliogravure plates by Dujardin, with descriptive text, in two portfolios, *Paris*, Baudry, n. d., folio (701) *Parsons*, £4 4s.

5924 Wither (George). Opoɔalsamum Anglicanum, an English Balme (in verse), first ed. (cut into), hf. mor., 1646, 4to. (611) *Leighton*, 11s.

[APRIL 14TH AND 15TH, 1910.]

PUTTICK & SIMPSON.

A MISCELLANEOUS COLLECTION.

(No. of Lots, 665 ; amount realised, £1,220 16s. 6d.)

5925 Angelo (H.) Treatise on the Utility and Advantages of Fencing, 47 plates ɔy Gwin—The Guards and Lessons of the Highland Broadsword, title and 6 plates by Rowlandson and mezzo. port. ɔy Ward of The Chevalier St. George, wrappers, 1799, presentation copy "With Mr. Angelo's respects," Angelo, 1817, oɔlong folio (651A) *Rimell*, £3 12s. 6d.

5926 Araɔian Nights, Lady Burton's ed., 6 vol., cl. ex., 1886, 8vo. (59) *Bickers*, £1 10s.

5927 Arnott and Wilson. The Petit Trianon Versailles, measured drawings and photographs of the entire building, 3 parts, hf. ɔuckram, 1907-8, folio (282) *Parsons*, £1 6s.

5928 Belcher (J.) and Macartney (M. E.) Later Renaissance Architecture in England, photographic and other plates, in the 6 hf. cl. portfolios as issued, 1901 (298) *Hill*, £4 15s.

5929 Bewick (Thomas). Works, Memorial ed., 5 vol., rox. gt., 1885-7, roy. 8vo. (56) *Bull*, £2 4s.

5930 Biɔlia Sacra Latina, editio vulgata, manuscript on vellum, 435 leaves (9 by 6¼ in.), 𝔤𝔬𝔱𝔥𝔦𝔠 𝔩𝔢𝔱𝔱𝔢𝔯, douɔle columns, 53 lines, ornamental initials, strap initial along the margin of first page, a very fine one along the margin of the first page of text with small miniatures representing the 6 days' work, and a crucifixion and several other historiated strap initials, decorative pen-work in ɔlue and red, red rubics, mor. ex., *Sæc.* XIII., sm. 4to. (612) *Hornstein*, £50
[A finely written and apparently perfect Codex, with decorations. Strap initials, which are treated in Latin. An inscription ɔy the scribe at the end of the Psalter reads : "Explicit Psalterium, que scripsit semp cu dno Vivat in celis daniel nomine felix."—*Catalogue.*]

5931 Biɔlia Sacra Vulgata, lit. 𝔤𝔬𝔱𝔥., in douɔle columns, with woodcut title and cut facing New Testament, old mor., tooled sides and ɔorders, *Paris, from the Press of T. Kerver*, 1534, 8vo. (52) *Leighton*, £3

5932 Birch (G. H.) London Churches of the XVIIth and XVIIIth Centuries, plates, hf. mor., g. t., 1896, folio (283)
Bain, £3 17s. 6d.

5933 Blake (Wm.) Songs of Innocence and Songs of Experience, Muir's facs. in colours of the eds. of 1789 and 1794, 2 vol., orig. wrappers, 4to. (211) *Bain*, £8 10s.

5934 Blaeu (J.) Le Theatre du Monde, quatrième partie, maps (Camden's Britannia), vell. gt., 1646, folio (312)
Carter, £1 16s.

5935 Blomfield (Reginald). A History of Renaissance Architecture in England, plates, 2 vol., hf. buckram, 1897, 8vo. (50) *Batsford*, £1 9s.

5936 Brindley and Weatherley. Ancient Sepulchral Monuments, plates, cl., 1887, folio (273) *Batsford*, £1 8s.

5937 Brown (T.) Works, ɔy Drake, port. and plates, 4 vol., mor. ex., 1730, 8vo. (204) *G. H. Brown*, £1 8s.

5938 Burlington Fine Arts Cluɔ. Catalogue of a Collection of European Enamels, plates, orig. ɔuckram, 1897, folio (280)
Quaritch, £5 15s.

5939 Burlington Magazine, from the commencement, 8 vol. in 36 numɔers, 1903-6, 4to. (241) *Philbrick*, £1 15s.

5940 Burne-Jones (Edward). A Record and Review, ɔy Malcolm Bell, plates, buckram, g. t., 1892, 4to. (237) *Lee*, £1 7s. 6d.

5941 Burton (Sir R. F.) Arabian Nights, by L. C. Smithers, thick paper issue, 12 vol., parchment, 1897, 8vo. (376)
Browning, £3 17s. 6d.

5942 Burton (Sir R. F.) Il Pentamerone, 2 vol., 1893, 8vo. (377A)
Jackson, £1 12s.

5943 Casanova (Jacques). Memoirs of Casanova, translated into English, 12 vol., *Privately printed*, 1894 (375) *Hector*, £9

5944 Caulfield (James). Portraits, 4 vol., mor., g. e., 1819-20, 8vo. (199) *Jones*, £1 18s.

5945 Cellini (Benvenuto). Treatises on Goldsmithing and Sculpture, plates, *Essex Press*, 1898, 4to. (224) *Longden*, £1

5946 Cochin. Collection de Vignettes, Fleurons et Culs-de Lampes

relatifs à Hénault's Histoire de France, 40 plates on hand-made Dutch paper, orig. bds., uncut, *Paris*, 1767, 4to. (544) *Batsford,* £3 17s. 6d.

5947 Coleridge (S. T.) Poems, 16 leaves, including title, orig. grey wrappers, apparently printed 1798, 8vo. (539) *Ellis,* £3 [Contains " Fears in Solitude," written during the alarm of an invasion ; " France, an Ode " ; " Frost at Midnight." *Printed by Law & Gilbert.—Catalogue.*]

5948 Costume of Yorkshire, 40 col. plates by Havell after Walker, 1814, folio (329) *Maggs,* £6

5949 Creeny (F.) A Book of Facsimiles, Monumental Brasses, photo lithos. by Griggs, 1884, folio (302) *Hill,* £1 2s.

5950 Dickens (Charles). Tale of Two Cities, first ed., etchings by H. K. Browne, orig. cl., 1859, 8vo. (540) *Ellis,* £2

5951 Dumas (F. G.) Illustrated Biographies of Modern Artists, 36 plates, with text and illustrations, in 4 portfolios, 1882 (325) *Export,* £1 8s.

5952 D'Urfey (Tom). Wit and Mirth, or Pills to Purge Melancholy, port., 6 vol., old mor., g. e., 1719-20, 8vo. (404) *Sotheran,* £4 8s.

5953 English Art in the Public Galleries of London, more than one hundred photogravures, one of 50 copies with plates printed on parchment (subscription £40), in 15 portfolios, 1888 (321) *Bailey,* £1 1s.

5954 Faulkner (T.) Historical Description of Chelsea, engravings, 2 vol., cf., 1829, 8vo. (118) *Smith,* £1

5955 Ford (E.) The Most Famous Delectable and Pleasant History of Parismus, black letter, woodcut ports., mor. ex., 1681, 8vo. (395) *Ellis,* £2 2s.

5956 Gerarde (John). Herball, title and woodcuts, fine copy, with the table at end, cf., 1633, folio (649) *Edwards,* £3 10s.

5957 Gould (J.) Birds of New Guinea, 5 vol., hf. mor. ex., 1875-88, folio (645) *Edwards,* £39

5958 Gould (J.) Birds of Great Britain, 5 vol., hf. mor. ex., 1873, folio (646) *White,* £34

5959 Grands Peintres, Français et Etrangers, plates, one of 25 copies printed with duplicate set of plates, on Japan paper, in 8 portfolios, 1884 (319) *Rimell,* £1

5960 Haden (Sir F. S.) Etudes à l'Eau-Forte, 25 etchings on China paper mounted on cardboards (with the plate of Fulham in two states) and 5 culs-de-lampe, par Phillippe Burty, hf. mor., portfolio, 1866 (317) *Keppell,* £173 5s.

5961 Havard (H.) Dictionnaire de L'Ameublement, col. and other plates, 4 vol., hf. mor., *Paris*, n. d., 4to. (220) *Longden,* £3

5962 Heptameron (The), or Tales and Novels of Marguerite, Queen of Navarre, by Arthur Machen, *Privately printed*, 1886, 8vo. (66) *Abrahams,* £1

5963 Higgins (Godfrey). The Celtic Druids, plates, cl., 1829, 4to. (261) *Dobell,* £1 15s.

5964 Hirsch. L'Art Pratique, illustrations, 6 vol., in loose cl. cases, 1879-84, 4to. (225) £1 6s.

5965 Hogg (R.) and Johnson (G. W.) The Wild Flowers of Great
Britain, 800 col. plates, 10 vol. (should be 11 vol., 1863-80)
hf. mor., 1863-78, 8vo. (409) *Bailey*, £4 4s.

5966 Hope (W. St. John). The Stall Plates of the Knights of
the Garter, 90 col. facs., in 8 parts, 1901, 4to. (236)
 Batsford, £1 17s. 6d.

5967 [Hortense (La Royne, Mère de L'Empereur Napoleon III.)]
Romances, Mises en Musique par S.M.L.R.H., engraved
port., in colours, ɔy Monsaldi, after Isaɔey, and 12 aquatint
plates, French mor., crowned "H." on sides, *Privately
printed* (1815), oɔlong 4to. (327) *Sabin*, £10 10s.
[*See* BOOK-PRICES CURRENT, Vol. xvii., No. 2885.—ED.]

5968 Johnson (Samuel). Dictionary, first ed., 2 vol., cf., 1755, folio
(326) *Hill*, £2 6s.

5969 Kay (J.) A Scrap Book, containing a collection of etched
ports., including Military, Law, Church, Medicine, Stage,
American, French, Sporting, Costume, etc., many proofs,
Kay's own Shop Show Book, folio (331) *Williams*, £8

5970 Kelmscott Press. Ruskin (John). The Nature of Gothic,
vell., tie, 1892, 8vo. (84) *Shepherd*, £1 8s.

5971 Kelmscott Press. Biɔlia Innocentium, ɔy J. W. Mackail,
vell., tie, 1892, 8vo. (85) *Shepherd*, £3

5972 Kelmscott Press. Utopia, by Sir Thomas More, revised ɔy
F. S. Ellis, vell., tie, 1893, 8vo. (86) *Philbrick*, £4

5973 Kelmscott Press. Psalmi Penitentiales, bds., 1894, 8vo. (87)
 Winter, £1 8s.

5974 Kelmscott Press. The Floure and The Leafe and the Boke
of Cupide God of Love, or The Cuckow and the Nightin-
gale, bds., 1896, sm. 4to. (88) *Lee*, £1 10s.

5975 Kelmscott Press. Cockerell (S. C.) Some German wood-
cuts of the fifteenth century, 35 reproductions, bds., 1897,
folio (89) *Lee*, £2 15s.

5976 Kelmscott Press. The Friendship of Amis and Amile, 1894,
sm. 8vo. (99) *Winter*, £1 8s.

5977 Kelmscott Press. The Wood ɔeyond the World, front. and
ɔorders, vell., tie, 1894, 8vo. (100) *Lee*, £3 5s.

5978 Kelmscott Press. The Earthly Paradise, 8 vol., vell., tie,
1896-7, 4to. (101) *Winter*, £9 15s.

5979 Kelmscott Press. Rossetti (D. G.) Ballads and Narrative,
Poems—Sonnets and Lyrical Poems, 2 vol., vell., 1893-4,
sm. 4to. (108) *Lee*, £6 15s.

5980 Kelmscott Press. Rossetti (D. G.) Hand and Soul, vell.,
1895, 12mo. (109) *Shepherd*, £1 8s.

5981 Kelmscott Press. Tennyson (Alfred, Lord). Maud, a Mono-
drama, vell., tie, 1893, 8vo. (115) *Lee*, £1 15s.

5982 Kelmscott Press. Recuyell of the Historyes of Troye, vell.,
vell., tie, 1892, folio (289) *Winter*, £5 10s.

5983 Kelmscott Press. The Water of the Wondrous Isles, vell.,
tie, 1897, folio (290) *Dobell*, £3 7s. 6d.

5984 Kelmscott Press. Life and Death of Jason, vell., tie, 1895,
folio (291) *Shepherd*, £4 17s. 6d.

5985 Kelmscott Press. The Well at the World's End, vell., tie, 1896, folio (292) *Lee, £3* 17s. 6d.
5986 Kelmscott Press. Sigurd the Volsung and the Fall of the Niɔlungs, vell., tie, 1898, folio (293) *Lee, £7* 5s.
5987 Kelmscott Press. Chaucer (Geoffrey). Works, ɔound ɔy Coɔden-Sanderson, in white pigskin, ɔlind tooled ɔorder, ornamented centre panel, gilt on the rough, metal clasps, 1896, folio (294) *Shepherd, £60*
5988 Kipling (Rudyard). Writings in Prose and Verse, édition de luxe, 20 vol., cl., 1897-1901, 8vo. (60) *Maggs, £11* 5s.
5989 Lecky (W. E. H.) History of European Morals, first ed., 2 vol., orig. cl., 1869, 8vo. (147) *Bain, £1* 16s.
5990 Legge (James). The Chinese Classics, vol. i. to v. in 8 vol., cl., 1861-72, 8vo. (175) *Hill, £4* 10s.
5991 Leonard. The Souvenirs of Leonard, ports., 2 vol., 1897, 8vo. (378) *Hatchard, £1* 8s.
5992 McKenny (T. L.) and Hall (J.) Indian Triɔes of North America, col. plates, 3 vol., hf. mor., g. e., *Philadelphia,* 1848, 4to. (415) *Edwards, £5*
5993 Malory (Sir T.) Birth, Life and Acts of King Arthur, as printed ɔy Caxton, 1485, now spelled in modern style, designs ɔy Auɔrey Beardsley, 2 vol., cl. ex., 1893-4, 4to. (212) *Lee, £4*
5994 Menpes (Mortimer). Etchings and Drypoints, Japanese, 40 col. plates, proofs signed in pencil, in 2 portfolios (318) *Scott, £11*
5995 Meyer (H. L.) Illustrations of British Land and Water Birds, col. plates of ɔirds and their eggs, 4 vol., hf. mor., n. d., 4to. (577) *Edwards, £15* 5s.
5996 Morris (W.) Earthly Paradise, first ed., 4 parts in 3 vol., cl., Ellis, 1868-1870, 8vo. (90) *Sherratt, £3* 5s.
5997 Morris (W.) Life and Death of Jason, first ed., cl., 1867, 8vo. (91) *Bain, £1* 10s.
5998 Morris (W.) Defence of Guenevere and other Poems, first ed., cl., 1858, 8vo. (92) *Bain, £1* 8s.
5999 Morris (W.) and Magnusson. The Saga Liɔrary, 5 vol., hf. mor., 1891-95, 8vo. (105) *Cohen, £1* 7s.
6000 Muntz (Eugené). Histoire de l'Art pendant La Renaissance, illustrations, 3 vol., mor., g. e., 1889-1895, 4to. (222) *Vyt, £4* 5s.
6001 Murphy (B. S.) English and Scottish Wrought Iron Work, plates, cl., 1904, folio (274) *Batsford, £1* 6s.
6002 National Gallery. One hundred and seven Photogravures from the Original Paintings in the National Gallery, introduction ɔy Arthur Strong, n. d., folio (314) *Parsons, £3* 7s. 6d.
6003 Neal (Daniel). History of New England, map, cf., 1747, 8vo. (124) *Walford, £1* 16s.
6004 Nicolas (Sir N. H.) History of the Orders of Knighthood, col. plates (many in silver and gold), 4 vol., cf. ex., 1842, 4to. (576) *Edwards, £4* 2s.

6005 Oakeshott (G. J.) Detail and Ornament of the Italian Renaissance, plates, cl., g. t., 1888, folio (277)
W. Brown, £1 12s.

6006 Oxford and Cambridge Magazine, cf. ex., 1856, 8vo. (543)
Hornstein, £5

6007 Pater (Walter). Works, 8 vol., art silk, 1900, 8vo. (67)
Bain, £11 10s.

6008 Pergolesi (M. A.) Book of Ornament, 60 plates (only), no title, not subject to return, 1777-85, folio (303)
Parsons, £2 17s. 6d.

6009 Picturesque Representation of the Dress and Manners of the English (by J. A. Atkinson), 50 col. plates, J. Murray, 1814, folio (330)
Adams, £1 17s.

6010 Plato. Works, trans. by Thomas Taylor, 5 vol., cf., 1804, 4to. (260)
Dobell, £2 6s.

6011 Prentice (A. N.) Renaissance Architecture and Ornament in Spain, plates, cf. ex. (1893), folio (275)
Edwards, £4

6012 Pyne (W. H.) Costume of Great Britain, 60 col. plates, W. Miller, 1804, folio (328)
Adams, £2 15s.

6013 Reade (Charles). Peg Woffington, first ed., orig. cl., 1853, 8vo. (538)
Maggs, £3 5s.

6014 Reeves (John). History of the Government of Newfoundland, new cf., 1793, 8vo. (125)
Maggs, £1 18s.

6015 Richardson (C. J.) Studies from Old English Mansions, the 4 series complete, 140 tinted plates (many col.), 4 vol., hf. mor., McLean, 1841-48, imp. folio (299) *Hatchard,* £8 10s.

6016 Robinson (Wm.) History of Hackney, map and plates, 2 vol., hf. mor., 1842, 8vo. (120)
Winter, £1 12s.

6017 Robinson (Wm.) History of Tottenham, map and plates, 2 vol., hf. cf., 1840, 8vo. (121)
Winter, £1 12s.

6018 Rowlandson (T.) Essay on the Art of Ingeniously Tormenting, col. front. and engravings by Woodward after Rowlandson, hf. cf., Tegg, 1808, 8vo. (426)
Abraham, £1 12s. 6d.

6019 Ruskin (John). Praeterita, 28 parts, 1885-89—Dilecta, 3 parts, 1886, 8vo. (81)
Lee, £1 8s.

6020 Ruskin (J.) Modern Painters, illustrations by Le Keux and the author, 5 vol., cl., vol. iii., iv. and v. first eds., 1857-1860, 8vo. (68)
Lee, £7

6021 Ruskin (J.) Stones of Venice, first ed., 3 vol., cl., 1851-53, 8vo. (69)
Lee, £3 5s.

6022 Sandby (Paul). Select Views in England, Scotland and Ireland, 150 plates, by Watts and Rooker, 2 vol., cf., 1783, oblong 4to. (234)
Hill, £1 18s.

6023 Savoy (The), ed. by Arthur Symons, complete in the original 8 parts, 1896, 4to. (561)
Export, £2 6s.

6024 Serly (Sebastian). Booke of Architecture, engravings (some margins repaired), cf., 1611, folio (286)
Lee, £4

6025 Shaw (H.) Specimens of Ancient Furniture, 74 plates, cl., Pickering, 1836, 4to. (217)
Lee, £1 10s.

6026 Shaw (H.) Handbook of Mediæval Alphabets and Devices, 37 tinted plates, orig. cl., 1853, imp. 8vo. (24)
Schultze, £1 3s.

6027 Shelley (P. B.) The Cenci, first ed., mor. ex., *Italy, printed for C. and J. Ollier*, 1819, 8vo. (542) *Ellis*, £11
6028 Sheraton (T.) Cabinet Maker's and Upholsterer's Drawing Book, plates, Batsford's re-issue of the 1802 ed., cl., 1895, 4to. (218) *Hill*, £2 18s.
6029 Smith (Dr. C.) The Ancient and Present State of the County and City of Cork, port. and plates, 2 vol., cf., 1815, 8vo. (129) *Maggs*, £1 4s.
6030 Stoddart (John). Local Scenery and Manners in Scotland, col. plates, 2 vol., hf. mor., g. t., uncut, 1801, 8vo. (197) *W. Brown*, £1 10s.
6031 Suckling (A.) History and Antiquities of the County of Suffolk, plates, 2 vol., bds., 1846-8, 4to. (578) *Rimell*, £6
6032 Symonds (J. A.) The Greek Poets, both series, first eds., 2 vol., orig. cl., 1873-6, 8vo. (112) *Lee*, £1
6033 Symonds (J. A.) Sketches of Italy and Greece, 1874—Italian Byways, 1883, first eds., orig. cl., 8vo. (113) *Lee*, £1 1s.
6034 Thackeray (W. M.) Book of Snobs, first ed., orig. covers (re-backed, corners defective), 1848, 4to. (541) *Ellis*, £2 10s.
6035 Thorpe (Benjamin). Northern Mythology, 3 vol., orig. bds., 1851, 8vo. (163) *Quaritch*, £1 10s.
6036 Tijou (J.) A New Book of Drawings, reproduced by J. S. Gardner, plates, hf. parchment, 1896, folio (281) *Quaritch*, £1 4s.
6037 Triggs (H. Inigo). Formal Gardens in England and Scotland, plates by Latham, hf. mor., g. t., 1902, folio (279) *Edwards*, £2 15s.
6038 Trollope (T. A.) History of the Commonwealth of Florence, 4 vol., orig. cl., 1865, 8vo. (171) *Hill*, £1 10s.
6039 Vacher (Sydney). Fifteenth Century Italian Ornament, chiefly taken from Brocades and Stuffs, plates in gold and colours, bds., 1886, folio (301) *Quaritch*, £1 2s.
6040 Van Yysendyck (J. J.) Specimens of Art connected with Architecture in the Netherlands, Heliotype plates, in 10 portfolios (subscription price 1,000 francs), 1880-89, folio (297) *Schultze*, £21
6041 Violet (Tho.) Narrative of Remarkable Proceedings concerning the Ships Samson, Salvador and George, and other Prize Ships depending in the High Court of Admiraltie—Answer of the Corporation of Moniers in the Mint at the Tower to two False Libels—Mysteries and Secrets of Trade and Mint Affairs, in 1 vol., mor., titles mounted and several leaves inlaid, 1653, folio (652) *Harding*, £2
6042 Westlake (N. H. J.) History of Design in Painted Glass, illustrations, 4 vol., cl., 1881-1894, 4to. (223) *Edwards*, £4

PUTTICK & SIMPSON.

THE MUSICAL LIBRARY OF THE LATE MR. F. G. EDWARDS,
EDITOR OF THE "MUSICAL TIMES," AND A PORTION OF
THE LIBRARY OF MR. S. BERGER, HON. SEC. OF THE
PHILHARMONIC SOCIETY.

(No. of Lots, 266 ; amount realised, £308 15s.)

6043 Bach Society. Works, 18 vol., various (107) *Speyer,* £4 5s.
6044 Boyce (Dr. W.) Cathedral Music, second ed., port., 3 vol.,
1788, folio (91) *Hunt,* £1 10s.
6045 British Museum. Catalogue of Manuscript Music, 3 vol.,
1906-8-9, 8vo. (34) *Bevan,* £1 14s.
6046 Burney (Dr.) History of Music, plates ɔy Bartolozzi, 4 vol.,
hf. cf., not uniform, 1776-82-89, 4to. (78) *Reeves,* £1 18s.
6047 Eitner (R.) Quellen-Lexikon. Biographie und Biɔliographie
üɔer die Musiker und Musikgelehrten, 10 vol. in 5, n. d.,
8vo. (26) *Graham,* £4
6048 Fétis (F. J.) Biographie Universelle des Musiciens, with the
Supplement, 10 vol. in 5, *Paris,* 1860-81, 8vo. (25)
Bevan, £3 10s.
6049 Fitzwilliam Virginal Book (The), ed. ɔy J. A. Fuller Maitland
and W. Barclay Squire, 2 vol., hf. mor. (100)
Novello, £2 17s. 6d.
6050 Grove (G.) Dictionary of Music and Musicians, 3 vol. and 4
parts, complete, 1880-89, 8vo. (250) £1 2s.
6051 Handel (G. F.) Suites de Pieces pour le Clavecin, premier
vol. (margin of page 58 damaged), *London, printed for the
author, and are to be had at Christopher Smith's at the
Hand and Musick-Book in Coventry Street, ye Upper-end
of ye Haymarket, and by R. Mears, Musical Instrument
Maker, in St. Paul's Churchyard* (1720)—Second vol.,
puɔlished ɔy John Walsh (1730), together 2 vol., 4to. (241)
Hill, £6
6052 Hill (W. H.) Stradivari, his Life and Work, col. plates, hf.
mor., 1902, 4to. (29) *Hill,* £3
6053 Jullien (A.) Richard Wagner, sa vie et ses Œuvres, plates,
Paris, 1886, sm. folio (28) £2 5s.
6054 Mendel (H.) Musikalisches Conversations-Lexikon, eine
Encyklopadie, with Supplement, 12 vol., 1870-83, 8vo.
(33) *Mackay,* £1 10s.
6055 Mendelssohn (M.) Elijah, Vocal Score, "proof copy with
some alterations in Mendelssohn's own hand" (93)
Maggs, £2 12s. 6d.
6056 Mendelssohn (M.) First ed., Book I., Songs without words,
Signed I. M. for M. B. (*Ignace Moscheles for Mendelssohn
Bartholdy*)—2nd Book, copies of Letters from William
Bartholomew to Mendelssohn on translation of "Elijah"
(213) *Maggs,* £2

6057 Mendelssohn (M.) Original Draft of Bartholomew's English
Version of the Libretto of Elijah, with pencilled notes in
Mendelssohn's hand—Word-book of the First Performance
of Elijah, 1846, etc. (231) *Quaritch, £4* 5s.

6058 Mendelssohn (M.) Lauda Sion, adapted by Bartholomew,
Original Score in Bartholomew's writing, signed, 51 pages
oblong 4to. (232) *Lee, £2*

6059 Mendelssohn (M.) Original MS. Score Sheets used by the
Soloists and others at the first performance of Mendels-
sohn's Oratorio Elijah at the Birmingham Festival, 1846,
time not permitting of copies with more complete accom-
paniments to be made, they are in Bartholomew's writing,
with occasional alterations in Mendelssohn's own hand—
Bartholomew's Full Score of the Oratorio in MS., etc. (233)
Quaritch, £9 5s.

6060 Musical Association. Proceedings, from the commencement
in 1874 to 1909, 31 vol. hf. cf., remainder bds., together 35
vol., 8vo. (14) *Quaritch, £5* 10s.

6061 Oxford History of Music (The), ed. by H. E. Wooldridge and
others, 6 vol., 8vo. (42) *Mackay, £3* 3s.

6062 Rossini (G.) Eight bars of music in his autograph, signed
(235) *Maggs, £2* 12s.

6063 Scarlatti (A.) L'Olympia Vendicante Opera, early manuscript,
vell., n. d., oblong folio (118) *Quaritch, £2* 12s. 6d.

6064 Spitta (Ph.) John Sebastian Bach, his Work and Influence
on the Music of Germany, trans. by Clara Bell and J. A.
Fuller Maitland, 3 vol., 1899, 8vo. (40) *Mackay, £1* 10s.

6065 Wagner (R.) Life, an authorised English version by Wm.
Ashton Ellis, of C. F. Glasenapp's "Das Leben Richard
Wagner's," 4 vol., 1900, 8vo. (43) *Mackay, £2* 5s.

6066 Wagner (R.) Prose Works, trans. by W. Ashton Ellis, vol.
v. to viii., n. d., 8vo. (44) *Mackay, £1* 6s.

[APRIL 21ST, 1910.]

SOTHEBY, WILKINSON & HODGE.

THE LIBRARY OF THE LATE MR. LIONEL BROUGH.

(No. of Lots (204-313), 109 ; amount realised for the books
only, £112 2s.)

[NOTE.—Most of the books in this collection were sold in parcels
for small sums. The sale of Mr. Brough's effects, which occupied
two days—April 20th and 21st—comprised old and modern en-
gravings, water-colour and other drawings, oil paintings, china,
theatrical relics and books, including those mentioned below.—ED.]

6067 A'Beckett (G. A.) Comic History of England, col. plates by
Leech, n. d.—Comic History of Rome, first ed., col. plates
by Leech, n. d., 8vo. (204) *Edwards, £1* 3s.

6068 Ackermann (R.) Microcosm of London, col. plates, 3 vol., hf. mor., uncut, t. e. g., 1808-10, roy. 4to. (270) *Terry*, £20

6069 Art Journal (The), 1849-1884, plates and illustrations, 36 vol., orig. cl., 1849-84, 4to. (271) *Joseph*, £2 4s.

6070 Brough (Lionel). Prompt Copies of Plays, with additions, annotations, etc. ɔy Lionel Brough, copies of parts, some in Lionel Brough's handwriting, several with his autograph signature, together 20 plays, 8vo. (210) *Croker*, 13s.

6071 Brough (Roɔert B.) Life of Sir John Falstaff, first ed., 20 plates ɔy G. Cruikshank, hf. mor., g. e., 1858, imp. 8vo. (211) *Maggs*, £2 14s.

6072 Claude le Lorrain. Liɔer Veritatis, ports. and plates ɔy Earlom, 3 vol., hf. mor., g. e., Boydell, n. d., folio (287) *Sydney*, £3

6073 [Collier (J.)] Tim Boɔɔin's Lancashire Dialect and Poems, plates ɔy G. Cruikshank, presentation copy to Lionel Brough, 1833—Laffan (Mrs. De Courcy). Poems, port., presentation copy to Lionel Brough, with inscription, 1907, together 2 vol., 8vo. (217) *Lewine*, 13s.

6074 Inchbald (Mrs.) Animal Magnetism, in Three Acts, trans. from the French Comedy, "Le Magnetisme Animal," orig. autograph manuscript in Mrs. Inchbald's handwriting, hf. bd., presentation copy to Lionel Brough, with inscription, "To Lal Brough, with the ɔest wishes of his friend, G. Lowne"—Autograph Alɔum, with autograph signatures of actors and actresses, 4to. (276) *Spencer*, £2 4s.

6075 Inchbald (Mrs.) The British Theatre, 25 vol., 1803-8—The Modern Theatre, 10 vol., 1811—Collection of Farces, 7 vol., 1815, together 42 vol., ports. and plates, russ., g. e. (ɔinding of a few vol. injured), 1803-15, 8vo. (245) *Maggs*, £1 8s.

6076 Ireland (S.) Miscellaneous Papers and Legal Instruments under the hand and seal of William Shakespeare (138 copies extant), facs., hf. cf., 1796—Studies from the Stage, col. plates (stained and imperfect), 1823, folio (299) *Dobell*, £1 1s.

6077 Malton (J.) Picturesque View of Duɔlin, hf. bd. (stained and spotted), 1794, oɔlong folio (301) *E. Massey*, £4 16s.

6078 Manuscript Play. That Heathen Chinee, as represented in the Extravaganza of Blueɔeard atte ye Gloɔe from Dec., 1874 to July 3rd, 1875, MS., with 12 water-colour drawings ɔy Edmund Greenhill, photographs of actors and actresses, etc., mor., g. e., Lionel Brough's copy, with his signature, 1875, 4to. (278) *Bloomfield*, £4 10s.

6079 Punch, or the London Charivari, from the commencement in 1841 to 1884, 86 vol., illustrations (covers loose of vol. viii.), 1841-84, 4to. (280) *Joseph*, £2 8s.

6080 Shakespeare (W.) Comedies, Histories and Tragedies, facsimile of the first folio of 1623, "The National Shakespeare," illustrations by Sir J. Noel Paton, 3 vol., mor., uncut, t. e. g., n. d., folio (308) *Horsley*, £3 5s.

6081 Train (The), a First Class Magazine, illustrations, 5 vol., hf.
cf., autograph note of Lionel Brough, 1856-58, 8vo. (264)
King, 11s.

6082 Tuer (A. W.) Bartolozzi and his Works, illustrations, 2 vol.,
vell., uncut, t. e. g. (1881), 4to. (283) *Edwards*, £1 16s.

On Monday, April 25th, Messrs. Sotheoy sold for £8,650 (*Sabin*)
the correspondence chiefly addressed to W. Blathwayt, Secretary
of State and Commissioner for Trade and Plantations, relative to
the American Colonies during the last quarter of the 17th century.
This correspondence comprised Lots 34-79 in the catalogue, and
was sold as one collection for the sum named. It included *inter
alia* the original draft of the famous grant made by Charles II. of
the Province of Pennsylvania to William Penn, dated 4th March,
1681. A collection of 13 manuscript and 35 printed maps of the
North American Colonies, *c.* 1670-90, realised £690; and an
extensive collection of documents and pamphlets on the state of
the North American and West Indian Colonies in the later years
of William III., £300. The maps are descrioed in the catalogue
as follows :—

6083 A Collection of Thirteen Manuscript and Thirty-five printed
Maps, illustrating chiefly the development of the British
Provinces of North America, during the period *c.* 1670-
1690, together with some relating to the West Indies, South
America, Africa and India, 15 are on vell., and the whole
collection is in excellent condition, having oeen preserved
in a large folio vol. in contemp. oinding. The manuscript
maps comprise : Newfoundland (21½in. oy 19in. on vell.)
The island is lettered "Terra nova," while the main land
of Laorador oears the name "Cambalv," but the place-
names and scale are in English. The geographical con-
figurations are of a type which does not conform to any
descrioed oy Harrisse in his exhaustive work, "Evolution
Cartographique de Terre-Neuve," col. and gilded in places
—Massachusetts, Connecticut, etc. (26in. by 22½in. on
vell.), [endorsed] "Merrimack River. This map was
exactly copied aoout 1678 from an original lent Sir Rooert
Southwell oy Mr. Stoughton and Mr. Buckley, two agents
from New England." Drawn in sepia; shows the New
England coast from Stratford (Conn.) to Kenebeck River.
The Connecticut River is shown inland with settlements
marked some distance aoove Hadley, while Merrimack
River is traced to a large lake with numerous islands
oeyond the oorders of Massachusetts. Lines across the
map denote the N. and S. limits of Massachusetts.
Boston, the haroour and the neighoouring towns, are
clearly defined—Long Island and New York (31in. by
22½in. on vell.) Shows the whole of Long Island, Staten
Island and New York Island, with part of the coasts of
New Jersey and Connecticut, on a scale of 4in. to the mile.
The coast lines and oorder are tinted, while the scale,

compass and quadrant are coloured, heightened here and there with gold. The map has no title, but a small inscription above the scale reads, "Long Iland siruaide by Robarth Ryder." This map is somewhat similar in style to the following, and may be by the same hand, but the workmanship of this is not so good.

Maryland, Virginia and Carolina. The following six maps on vell., all without titles, although of different sizes and on varying scales, seem to form a series. Judging from the style of the colouring, lettering, ornamentation and gilding, they are evidently the work of the same draughtsman, who has, however, only put his name on the last, "Made by James Lancaster, Anno Domi 1679." The maps of Maryland and Virginia are well detailed, and contain a very large number of English and Indian names. The four maps of Carolina, being principally confined to the coast line, are consequently less detailed inland—(1) Maryland (25½in. by 22in.) Shows the upper part of Chesapeake Bay and Susquehanna River, also Delaware Bay and River, all as far north as 40°. The Schuylkill River is marked, but as yet there is no sign of Pennsylvania or Philadelphia. (2) Virginia (24¾in. by 25¾in.) Shows the province from the borders of Carolina almost as far north as the Falls of Potomac River. (3) Carolina (18in. by 29½in.) From Hilton Head to Roanoke River. (4) Carolina (21in. by 24¼in.) From Cape Roman to Cape Hatteras. Has a small drawing of James Fort on Cape Fear River. (5) Carolina (25in. by 22in.) From St. Augustine to Cape Henry. (6) North Part of Carolina. Shows the Settlements on Albemarle River—Bermuda (42¾in. by 21¼in. on paper). A Mapp or Description of Sommer Islands somtime called Bermudas . . . surveighed by Mr. Richard Norwood, 1663, Thomas Clarke *fecit* 1678, coloured—Montserrat. Mountserra Island, 1673 (26½in. by 22½in. on vell.) Drawn in sepia, with the mountains and coast line in elevation all round, ornamented with designs of ships, mermaids and other mythological figures —Surinam River (16½in. by 20in. on paper)—Island and Port of Bombay (49in. by 21in. on vell.) Appears to be the work of the same draughtsman as the above mentioned maps of Maryland, Virginia and Carolina.

The printed maps include : World. A new Mapp of the World according to Mr. Edward Wright, commonly called Mercator's Projection, John Thornton — World drawn according to Mercator's Projection, Morden and Berry—A new Map of the English Plantations in America, Morden and Berry—Novi Belgii Novaeque Angliae nec non partis Virginiae Tabula multis in locis emendata a Hugo Allardt (with view of Nieuw Amsterdam), uncoloured—A Mapp of Virginia, Mary-Land, New-Jersey, New York and New England, John Thornton—New England, etc. A map of New England, New Yorke, New Jersey, Mary-Land and

Virginia, Morden and Berry, on vell., uncoloured, with another copy on paper partly outlined in colours, corresponding to a MS. key in the margin—New Jersey. A Mapp of New Jersey in America, ɔy John Seller and William Fisher (36½in. ɔy 16¾in., coloured), with inset view of New York, pasted to the lower margin is a printed slip (36½in. ɔy 5½in.), in four columns, with heading, "The Description of the Province of West-Jersey in America. As also Proposals to such as desire to have any Propriety therein," and imprint, "*London, printed for John Seller . . . and William Fisher . . .* 1677 "—Pennsylvania. A Map of some of the south and eastbounds of Pennsylvania in America ɔeing partly inhaɔited, Thornton and Seller, with printed description in four columns, on separate slip pasted to the ɔottom margin, no heading or imprint—Virginia. A Mapp of Virginia discouered to yᵉ Hills. "Domina Virginia Farrer Collegit." Are sold ɔy I. Stephenson, 1651, port. of Drake at the top—Carolina. A new map of the Country of Carolina, Joel Gascoyne and Roɔert Greene—Jamaica. Novissima et accuratissima Jamaicae descriptio per Johannem Ogiluium, 1671, on vell., with another copy (also on vell.) of a later issue, with title partly erased and altered in MS. to read "Jamaicae descriptio Auctior et emendatior," with new parishes and a large numɔer of places added in MS.—Jamaica. Taɔula Jamaicae Insulae per Edwd. Slaney, 1678, Will: Berry, on vell.—Jamaica. A New Mapp of Jamaica according to the last Survey, James Moxon, 1677, coloured. And many others of lesser interest, ɔy Sanson, Mariette, Janson, Seller, Thornton, etc. (82)

£690

[APRIL 28TH AND 29TH, 1910.]

HODGSON & CO.

THE SCIENTIFIC LIBRARY OF THE LATE PROFESSOR E. PERCEVAL WRIGHT (LOTS 276-592), AND OTHER PROPERTIES.

(No. of Lots, 592 ; amount realised, £1,350.)

6084 Ackermann (R.) History of the University of Oxford, col. engravings, including the academical costume, 2 vol., russ. (reɔacked), 1814, atlas 4to. (218) *Sawyer,* £10 5s.

6085 Ackermann (R.) History of the University of Camɔridge, col. engravings, including the academical costume, a few extra plates ɔy Harraden (India proofs) inserted, 2 vol., uniform with the preceding, 1815, atlas 4to. (219)
Leighton, £12 10s.

6086 Acts of the Privy Council of England, new series, ed. by
J. R. Dasent, from 1452 to 1597, being vol. i. to xxvii., cl.,
1890-1903, roy. 8vo. (168) *Sweet & Maxwell*, £7 5s.

6087 Agassiz (A.) Revision of the Echini, plates, 4 parts in 2 vol.
(the plates bound separately), hf. mor., t. e. g., 1872-4, 4to.
(533) £5 15s.

6088 Agassiz (L.) Nomenclator Zoologicus, interleaved, 2 vol.,
hf. mor., Solduri, 1842-6—Engelmann. Bibliotheca Zoolo-
gica et Entomologica, 4 vol., hf. mor., 1861-3, together 6
vol., 4to. (464) £1 16s.

6089 Allen (J. R.) Early Christian Monuments of Scotland, hf.
mor., t. e. g., *Edin.*, 1903, thick 4to. (306) *Hill*, £1 17s.

6090 Ambrosius Mediolanensis. Epistolæ et Varia Opuscula.
[Hain 898], early MS. notes in margins, Michael Wodhull's
copy, russ., *Mediolani*, L. Pachel, 1490, folio (235) £2 4s.

6091 Ames and Herbert. Typographical Antiquities, port. and
facs., 3 vol., old cf. (rebacked), 1785-90, 4to. (83) 18s.

6092 Anthropological Institute of Great Britain and Ireland.
Journal, from 1871 to 1896, being vol. i. to xxvi., part ii.,
with Index of Publications by Bloxam, 1843-91, plates, first
26 vol. hf. cf., remainder in 18 Nos., 1872-96, 8vo. (515)
Sotheran, £7 12s. 6d.

6093 Antiquary ('The), a Magazine devoted to the Study of the
Past, ed. by E. Walford, illustrations, complete from the
commencement to March, 1910, 49 vol., first 41 vol. in
uniform hf. cf., remainder in Nos., 1880-1910, 4to. (308)
Bailey, £2 14s.

6094 Aphrates. The Homilies of Aphrates the Persian Sage; ed.
by W. Wright, Syriac text, vol. i., cl., 1869, 4to. (32)
Wesley, £1 7s.

6095 Apostolic Fathers. S. Clement of Rome, S. Ignatius and
S. Polycarp, with introductions and notes by J. B. Light-
foot, 5 vol., cl., 1885-90, 8vo. (24) £1 19s.

6096 Ascham (Roger). Works, viz., The Scholemaster, 1579—
Toxophilus, woodcut border on title and initials (some
leaves scored by an early hand), T. Marshe, 1571—Report
and Discourse of the Affaires of Germany and the Emperor
Charles, J. Day, 1570, 𝔟𝔩𝔞𝔠𝔨 𝔩𝔢𝔱𝔱𝔢𝔯, in 1 vol., old stamped
cf., sm. 4to. (206) £15 5s.

6097 Beauties of England and Wales, 26 vol., hf. mor., 1801-18,
8vo. (155) £1 11s.

6098 Belfast. The Town Book of the Corporation, and Historical
Notices of Old Belfast, edition de luxe, maps and plates,
ed. by R. M. Young, 2 vol., cl., 1892-6, 4to. (414) £1

6099 Biblia (La) que es los Sacros Libros, transladada en Español
[known as the "Bear Bible"], woodcut on title, etc., mor.,
g. e., *Berne*, 1569, sm. 4to. (199) £1 2s.

6100 Biblia Sacra Polyglotta, Hebraicè, Chaldaicè et Graecè, de
mandato ac sumptibus Cardinalis D. F. Ximenis de Cis-
neros, woodcut arms in red on titles (3 leaves repaïred and
the margins of a few leaves stained), the "Complutensian

Polyglot," with the 6 leaves of Greek Preface to St. Paul's
Epistles, 6 vol., cf., *Compluti, Arnald Guil. de Brocario,*
1514-15-17, folio (237) *Quaritch, £59*
6101 Bibliotheca Rabbinica, eine Sammlung alter Midraschim ins
Deutsche übertragen von Dr. Aug. Wünsche, in 3 vol., hf.
bd., *Leipzig,* 1880-5, 8vo. (4) *Baker, £1* 10s.
6102 Blake (W.) Songs of Innocence, title and 26 col. plates,
printed on one side of the leaf only, *The Author and
Printer W. Blake,* 1789, also 2 coloured plates (The Little
Girl Lost and The Little Girl Found) from the "Songs of
Experience" [1794], in 1 vol., old russ., blind tooled sides,
gilt inner border, 8vo. (246) *Edwards, £47*
[The two sections of the "Songs of Innocence and
Experience," which Blake subsequently grouped together,
comprised 27 plates each. The above appears to be an
early copy, before the numbering of the plates. 7¼in. by
6⅛in.—*Catalogue.* Sold on April 21st.—ED.]
6103 Boccaccio (G.) Traité des Mesadventures de Personnages
Signalez, traduit par C. Witart, Nicolas Eve's device on title,
contemp. cf., g. e., *Paris,* 1578, 8vo. (197) *£1* 1s.
6104 Borlase (W. C.) The Dolmens of Ireland, 2 col. fronts. and
illustrations, 3 vol., cl. gt., 1897, imp. 8vo. (386)
Harding, £1 18s.
6105 Brant (Seb.) Stultifera Navis Mortalium, per Jacobum
Locher, woodcuts, hf. cf., *Basileæ,* 1572, 12mo. (191)
White, £1
6106 British Essayists (The), by A. Chalmers, ports., 38 vol. in 19,
hf. cf. gt., 1823, 8vo. (172) *Hornstein, £2* 2s.
6107 British Essayists, by J. Ferguson, ports., 40 vol., contemp.
mor., g. e., 1823, 8vo. (125) *Sawyer, £4*
6108 British Poets. Works of the English Poets, from Chaucer to
Cowper, 21 vol., old russ. ex. (rebacked), g. e., 1810, 8vo.
(126) *A. Jackson, £3* 10s.
6109 Bronn (H. G.) Thier-Reichs—Echinodermen, Nos. 1 to 77—
Coelenterata, Nos. 1 to 21, etc., in 36 parts, 1889-1908, 8vo.
(466) *£1* 18s.
6110 Brontë (Charlotte). Life, by Mrs. Gaskell, first ed., fronts., 2
vol., cl., uncut, 1857, 8vo. (336) *Edwards, £1* 4s.
6111 Brooks (W. K.) The Genus Salpa, col. plates, 2 vol., sewed,
Baltimore, 1893, 4to. (559) 15s.
6112 Buckley and Harvie-Brown. Vertebrate Fauna of the Orkney
Islands, plates, cl., t. e. g., 1891, 8vo. (505) *Buckley,* 16s.
6113 Buckton (G. B.) Monograph of the British Cicadæ, col.
plates, 2 vol., hf. cf., 1890-1, 8vo. (495) *Quaritch, £1* 8s.
6114 Buller (Sir W. L.) Birds of New Zealand, col. plates, 2 vol.
in 13 parts (without the Supplement), wrappers, *Published
by the Author,* 1887-8, 4to. (552) *Edwards, £3* 10s.
6115 Burke (E.) Works, 14 vol., cf. (rubbed), 1815-22, 8vo. (147)
Harding, 17s.
6116 Burke (E.) Works, 16 vol. in 8, 1826-7—Life by Prior, port.,
1839, together 9 vol., hf. mor. (rubbed), 8vo. (75)
Heffer, £1 4s.

6117 Butler (A. G.) Lepidoptera Exotica, 64 col. plates, hf. cf.,
t. e. g., 1874, 4to. (491) *Freidlander*, £2 12s. 6d.
6118 Carrigan (W.) History and Antiquities of the Diocese of
Ossory, maps and plates, 4 vol., cl., 1905, 4to. (419) 17s.
6119 Camp)ell (Ld.) Lives of the Lord Chancellors, Li)rary ed.,
8 vol.—Life of Lord Camp)ell,)y Mrs. Hardcastle, port.,
2 vol., together 10 vol., hf. mor., 1848-81, 8vo. (136)
Hill, £3 5s.
6120 Chapman and Buck. Wild Spain. Records of Sport, Natural
History, etc., map and plates, LARGE PAPER, cl., 1893, roy.
8vo. (513) *Buchanan*, £2 14s.
6121 Chaucer (G.) Works,)y John Urry, 2 full-page ports. and
equestrian vignette engravings—Glossary and Life of the
Author, cf., 1721, folio (252) £1 5s.
6122 Challenger Voyage. Report of the Scientific Results of the
Voyage of H.M.S. Challenger, 1873-76, complete set, viz.,
Narrative, 2 vol. in 3—Physics and Chemistry, 2 vol.—
Deep Sea Deposits—Zoology, 32 vol. in 40—Botany, 2 vol.
—Summary of Results, 2 vol., col. and other illustrations,
together 50 vol., cl., 1880-95, 4to. (426) *Maggs*, £36
6123 Chauncy (Sir H.) Historical Antiquities of Hertfordshire,
first ed., port., folding plates and pedigrees, with the list of
plates and including the 3 plates usually missing, mor.,
g. e.,)y Bedford, 1700, folio (240) *Daniel*, £11 5s.
6124 Child (F. J.) English and Scottish Ballads, 8 vol., fcap. hf.
mor., m. e., 1860-61, 8vo. (108*) £1 15s.
6125 Chwolsohn (D.) Die Ssabier und der Ssabismus, 2 vol., hf.
cf., *St. Petersburg*, 1856, roy. 8vo. (40) 19s.
6126 Cork Historical and Archæological Society. Journal, com-
plete set, from the commencement to 1909, illustrations, 18
vol., cl., 1892-1909, roy. 8vo. (393) £6 15s.
6127 Corpus Inscriptionum Semiticarum, plates, vol. i. and ii. in 4
parts, *Parisiis*, 1889-91, 4to. (56) £2 2s.
6128 Couch (J.) Fishes of the British Islands, col. plates, 4 vol.,
hf. mor., 1862-5, roy. 8vo. (482) *Quaritch*, £1 12s.
6129 Creighton (M.) Queen Eliza)eth, col. front. and illustrations,
orig. wrapper, uncut, Boussod, Valadon and Co., 1896, 4to.
(548) £7 7s.
6130 Cureton (W.) Remains of a very Ancient Recension of the
Four Gospels in Syriac, front., cl., 1858, 4to. (30)
Higham, £1 12s.
6131 Cureton (W.) Ancient Syriac Documents, cl., 1864, 4to. (31)
Dickinson, £1 5s.
6132 Daniell (T. and W.) Picturesque Voyage to India, 50 col.
plates ()inding)roken), 1810, 4to. (220) £3
6133 Darwin (C.) Animals and Plants under Domestication, 2
vol., 1868—Descent of Man, 2 vol., 1871, cuts, together 4
vol., cl., 8vo. (433) *Quaritch*, £1 1s.
6134 Darwin (C.) Origin of Species, "From the Author," 1860,
etc., cuts, 4 vol.—Life,)y his Son, first ed., ports., 3 vol.,
1887, together 7 vol., cl., 8vo. (434) *Quaritch*, £1 2s.

6135 Dekker (T.) The Magnificent Entertainment given to King James . . . upon the day of his Maiesties Triumphant Passage through London, ɔeing the 15 of March, 1603, old mor. ex. (some headlines cut away), *T. C. for Tho. Mun*, 1604, sm. 4to. (185) *Dobell*, £11

6136 [De Quincey (T.)] Confessions of an English Opium-Eater, first ed., with the hf. title and leaf of advertisements, bds. (repaired), uncut, 1822, 8vo. (181) £2 10s.

6137 Dodington (George Buɔɔ, Baron Melcomɔe, 1691-1762). Manuscript Diary, from March 8th, 1749 to Feɔruary 9th, 1761, written in 8 fcap. note-ɔooks, orig. marɔled paper or leather covers (591) £13
 [It is from this manuscript that the original edition of the Diary was puɔlished in 1784, under the editorship of Henry Penruddocke Wyndham, nephew of the Thomas Wyndham to whom Dodington left his papers. Many passages omitted are of consideraɔle interest, several relating to naval, military and other affairs in North America, Dodington having held during the period the post to treasurer of the Navy.—*Catalogue*. Sold on April 14th.—ED.]

6138 Doyle (J. E.) Official Baronage of England, illustrations, 3 vol., hf. mor., t. e. g., 1885, sm. 4to. (82) 19s.

6139 Duɔlin. Parish Register Society of Duɔlin, ed. ɔy J. Mills and others, vol. i. to vii., sewed, 1906-9, 8vo. (409) *Walford*, £1 6s.

6140 Dugdale (Sir W.) History of St. Paul's Cathedral, port. after Hollar and plates, hf. cf., 1818, folio (242) £2 2s.

6141 Dugdale (Sir W.) Monasticon Anglicanum, ɔy Caley, Ellis and Bandinel, engravings and ports., 8 vol., hf. cf., 1817-30, folio (241) *Wilkinson*, £16

6142 Dresser (H. E.) History of the Birds of Europe, col. plates, parts xlix. to lxxxiv. (parts lxxx.-lxxxiv. containing the final title-pages and contents), in 18 parts, sewed, 1876-81 (553) *Quaritch*, £4

6143 Dresser (H. E.) Monograph of the Meropidæ, 34 col. plates, in 5 parts, sewed, *Published by the Author*, 1884-6, 4to. (554) *Quaritch*, £2 12s.

6144 Dunraven (Earl of). Notes on Irish Architecture, photo plates, 2 vol., cl. ex., 1875-7, folio (382) £8 15s.

6145 Durandus (G.) Rationale Divinorum Officiorum, gothic letter (2 leaves defective and ɔinding reɔacked), old cf., 1512, folio (66) *Barnard*, £1

6146 Dürer (Albrecht). Passio Domini Nostri Christi. The Series of 15 Engravings on Copper, generally known as "The Passion in Copper," together with the plate of Peter and John at the Gate of the Temple, in all 16, loosely attached to cartridge paper and ɔound in a vol., mor. antique, 1509-12, 8vo. (193) £20

6147 Egan (Pierce). Life in London, col. plates ɔy I. R. and G. Cruikshank, with the 3 leaves of music (ɔinding ɔroken and plates soiled), 1821, roy. 8vo. (182) *Zaehnsdorf*, £5 2s. 6d.

6148 Egan (P.) Real Life in London, col. plates ɔy Alken and others, 2 vol., cf., 1823, 8vo. (183) £3 10s.
6149 Encyclopædia Britannica, ninth ed., with the additional volumes forming the tenth ed., maps and illustrations, 35 vol., hf. mor., t. e. g., 1875-1903, 4to. (231) £9
6150 English Dialect Dictionary, ed. ɔy Joseph Wright, with Supplement, Biɔliography and Grammar, 6 vol., complete in· 30 parts, sewed, 1896-1905, 4to. (549) £4 17s. 6d.
6151 Entomologist's Monthly Magazine, from the commencement to March, 1910, ɔeing Vol. i. to xlvi., in 24 vol., hf. cf. and 51 numɔers sewed, 1864-1910, 8vo. (497) *Bailey*, £3 5s.
6152 Euseɔius. Ecclesiastical History, in Syriac, ɔy Wright and McLean, cl., *Cambridge*, 1898, imp. 8vo.—Brockelmann. Lexicon Syriacum, hf. roan, 1895, roy. 8vo. (36) *Dickinson*, £1 7s.
6153 Evans (A. H.) Verteɔrate Fauna of the Shetland Islands, map and plates, cl., 1899, 8vo. (508) *Buckland*, 16s.
6154 Expositor (The), ed. ɔy W. R. Nicoll. Third Series, 10 vol. —Fourth Series, 10 vol.—Fifth Series, 10 vol. (wanted vol. viii.)—Sixth Series, 12 vol.—Seventh Series, vol. i. and ii., together 43 vol., cl., 1885-1906, 8vo. (1) £2
6155 Fergusson (J.) History of Architecture, third ed., plates and cuts, 5 vol., hf. roan, t. e. g., 1891-9, 8vo. (303) *Hill*, £2 7s.
6156 Fisher (Payne, Poet Laureate to Cromwell). Marston Moor, port., 1650—Irenodia, port., with Bradshaw's arms on title, 1652—Inauguratio Olivariana, arms (2 leaves cut into), 1655, orig. eds., in 1 vol., mor., 1650-4, sm. 4to. (202) £2 2s.
6157 Fitzgerald (E.) Ruɔáiyát of Omar Khayyám, fourth .ed., front., hf. roan, t. e. g., 1879, 8vo. (346) £1 6s.
6158 Fowler (W. W.) Coleoptera of the British Islands, col. plates, 5 vol., cl., 1887-91, imp. 8vo. (487) £12
6159 Freeman (E. A.) History of Sicily, maps, 3 vol., cl., *Oxford*, 1891-4, 8vo. (291) *Quaritch*, £2
6160 Freytag (G. W.) Lexicon Araɔico-Latinum, 4 vol. in 2, hf. mor., *Halis Saxonum*, 1830-7, 4to. (65) *Baker*, £1 4s.
6161 Fuerst (J.) Concordantiæ Hebraicæ atque Chaldaicæ, hf. mor., *Lipsiæ*, 1840, 4to. (52) 16s.
6162 Gardiner (S. R.) History of England, from the Accession of James I. in 1603 to 1660, complete set of the orig. Liɔrary eds., 17 vol., orig. cl., uncut, 1863-1903, 8vo. (166) [Sold on April 21st.—ED.] *Maggs*, £24 10s.
6163 Geɔhardt und Harnack. Texte und Untersuchungen zur Geschichte der Altchristlichen Literatur, vol. i. and ii. hf. cf., and 10 parts of vol. iii.-xiv., *Leipzig*, 1883-96, 8vo. (18) *Wesley*, £1 8s.
6164 Geiler (J.) Speculum Fatuorum, **gothic letter**, numerous three-quarter page woodcuts (first leaf wanted and a few leaves defective), cf. gt., *Argentorati*, 1511, sm. 4to. (192) *Barnard*, £2
6165 Gerson (J.) Incipit Tractatus venerabil. Magistri Joh: Gerson, Cancellarii Parisieñ de Meditacõe, **gothic letter**, 55 leaves,

27 lines to a page [Hain, No. 7628], initial letters in red, mor., g. e., Ulric Zell, n.d, sm. 4to. (194) *Ellis, £3* 6s.

6166 Gesenius (W.) Heɔrew and English Lexicon of the Old Testament, with Appendix, hf. cf., *Oxford,* 1906, sm. 4to. (9) *Dickinson, £1* 7s.

6167 Gilɔert (J. T.) History of the City of Duɔlin, map, 3 vol., cl., 1859, 8vo. (407) *Quaritch, £1* 12s.

6168 Gilɔert (J. T.) History of the Confederation and War in Ireland, 3 vol.—Documents relating to Ireland, ed. ɔy J. T. Gilɔert, plates and facs., LARGE PAPER (limited to 200 copies), 4 vol., hf. roan, 1882-93, sm. 4to. (403) *£2* 2s.

6169 Gilɔert (J.) and Churchill (G. C.) The Dolomite Mountains, col. plates, cl., uncut, 1864, 8vo. (366) *£1*

6170 Gildas, Nennius, etc. Historia Britonum, ed. C. Bertram, front. and map, old mor. ex., *Havniæ,* 1757, 8vo. (204) 15s.

6171 [Goldsmith (O.)] Vicar of Wakefield, first ed., 2 vol., old cf. (reɔacked), ɔookplate of T. Drake Tyrwhitt and contemp. autograph on fly-leaves, "T. Tyrwhitt, 1766" [Chaucerian Commentator (1730-1786)], *Salisbury, printed by B. Collins,* 1766, 8vo. (242) *Edwards, £67*
[A fairly tall copy, in clean condition, with the exception of the first and last leaves, the margins of which have ɔeen stained ɔy the leather of the ɔinding.—*Catalogue.* Sold on April 21st.—ED.]

6172 Gower (J.) Confessio Amantis, ed. ɔy R. Pauli, 3 vol., hf. cf., t. e. g., 1857, 8vo. (89) 16s.

6173 Graham (H. D.) Birds of Iona and Mull, cuts, cl., t. e. g., 1890, 8vo. (504) *Sotheran,* 18s.

6174 Guillemard (F. H.) The Cruise of the Marchesa to New Guinea, col. fronts. and illustrations ɔy Whymper, 2 vol., hf. mor., t. e. g., 1886, 8vo. (430) *Quaritch, £1* 8s.

6175 Guillim (J.) Display of Heraldrie, cuts of arms, col. throughout, and MS. Index, second ed., old cf., 1632, folio (240*) *Leighton,* 16s.

6176 Harvie-Brown (J. A.) and Buckley (T. E.) Verteɔrate Fauna of Sutherland, Caithness and West Cromarty, maps and plates, cl., t. e. g., 1887, 8vo. (502) *Quaritch, £2* 12s. 6d.

6177 Harvie-Brown (J. A.) and Buckley (T. E.) Verteɔrate Fauna of the Outer Heɔrides, maps and plates, cl., t. e. g., 1888, 8vo. (503) *Quaritch, £2* 12s. 6d.

6178 Harvie-Brown (J. A.) and Buckley (T. E.) Verteɔrate Fauna of Argyll and the Inner Heɔrides, maps and plates, cl., 1892, 8vo. (506) *Quaritch,* 13s.

6179 Harvie-Brown (J. A.) and Buckley (T. E.) Verteɔrate Fauna of the Moray Basin, maps and plates, 2 vol., cl., 1895, 8vo. (507) *Buckland, £1* 5s.

6180 Harvie-Brown (J. A.) and Macpherson. Verteɔrate Fauna of North-West Highlands and Skye, maps and plates, cl., 1904, 8vo. (509) *Buckland,* 18s.

6181 Harvie-Brown (J. A.) Fauna of the Tay Basin and Strathmoor, maps and plates, cl., 1906, 8vo. (510) *Sotheran,* 19s.

6182 Hatch and Redpath. Concordance to the Septuagint and

other Greek Versions of the Old Testament, with Supplement, in 8 parts, bds., *Oxford*, 1892-1906, 4to. (61)

Hill, £5 2s. 6d.

6183 Henderson and Hume. Lahore to Yārkand, col. plates of ɔirds ɔy Keulemans, cl., 1873, roy. 8vo. (363) *Quaritch*, 15s.

6184 Herculanum et Pompéi. Recueil des Peintures, Bronzes, Mosaiques, etc. gravés par H. Le Roux, Texte explicatif par M. L. Barrè, 8 vol. (including the Musée Secret), bds., *Paris*, 1870, imp. 8vo. (299) £4 7s. 6d.

6185 Hind (H. Y.) The Canadian Red River, and Assinniboine and Saskatchewan Expeditions, tinted plates and maps, 2 vol., cl., uncut, 1860, 8vo. (362) £1 13s.

6186 Hodgkin (T.) Italy and her Invaders, illustrations (some col.), 8 vol. in 9 (vol. i. to iv. second ed.), cl., *Oxford*, 1892-9, 8vo. (290) £5 12s. 6d.

6187 Holy Biɔle, from the Latin Vulgate ɔy John Wycliffe, ed. ɔy Forshall and Madden, 4 vol., cl., *Oxford*, 1850, roy. 4to. (229)

Edwards, £3

6188 Homilies. Opus preclarum Omnium Omeliarū et Postillaru Venerabiliū ac Egregiorū Doctor Gregorii, Augustini Hieronimi, Bede, etc. (cum Prologo Karoli Magni), 𝔤𝔬𝔱𝔥𝔦𝔠 𝔩𝔢𝔱𝔱𝔢𝔯, initials in red and ɔlue [Hain, 8790], (first 4 leaves damaged,) ɔound in a fragment of an antiphonarium, 1482, folio (233) £2 12s.

6189 Hook (W. F.) Lives of the Archɔishops of Canterɔury, with Index, presentation copy, 12 vol., 1860-75—Life of Dean Hook, ɔy Stephens, port., 2 vol., 1878, together 14 vol., hf. mor., 8vo. (137) *Leighton*, £3 5s.

6190 Hore (H. F.) History of the Town and County of Wexford, ed. ɔy P. H. Hore, illustrations, 4 vol., cl., 1901-4, 4to. (418)

£2 2s.

6191 Hudson (C. T.) and Gosse (P. H.) The Rotifera, col. plates, 6 parts, wrappers, 1886-89, imp. 8vo. (473) *Quaritch*, £2 7s.

6192 Iɔis (The), col. plates, the Fourth to the Ninth Series— General Index to the Eighth Series—Juɔilee Supplement to the Ninth Series, in 137 parts (part x. of the Seventh Series wanted and 2 parts of the Third Series), 1877-1910, 8vo. (498) *Porter*, £9 10s.

6193 Irish Manuscript Series. The Three Shafts of Death of Geoffrey Keating, ed., with Glossary, ɔy Atkinson, sewed, 1890, 8vo. (398*) £1 1s.

6194 Irish Naturalist (The), ed. by Carpenter and Praeger, plates, vol. i. to xiv. in 7 vol., hf. cf., and vol. xv. to xix., part ii., in numɔers (2 wanted), 1892-1910 (524) *Wesley*, £2

6195 Jewish Quarterly Review, from the commencement to 1906, ɔeing Vol. i. to xviii., 13 vol., cl., remainder in numɔers, 1889-1906, 8vo. (2) *George*, £5 10s.

6196 Johnson (S.) Works, with Parliamentary Deɔates, and Life ɔy Boswell, ports., 15 vol., hf. cf., *Oxford*, 1825-6, 8vo. (127)

£1 14s.

6197 Journal of Anatomy and Physiology, conducted ɔy G. M. Humphrey and others, plates, Vol. i. to iii., cl., 1867-9, and

Vol. xiii., part iii. to Vol. xxi., part i., in 31 numbers, 1879-86 —Journal of Physiology, ed. by M. Foster, plates, Vol. iii. to vii., etc., in 27 parts, 1879-87, 8vo. (442) *Wesley*, £5 17s.

6198 Jukes (J. B.) Narrative of the Surveying Voyage of H.M.S. Fly, plates, 2 vol., cl., 1847, 8vo. (429) 17s.

6199 Keats (J.) Lamia, Isabella, the Eve of St. Agnes and other Poems, first ed., with the half title and 4 leaves of advertisements at end, orig. bds., uncut, with label, Taylor and Hessey, 1820, 8vo. (245) *Quaritch*, £42 [Sold on April 21st.—ED.]

6200 Kemble (J. M.) Studies in the Archæology of the Northern Nations, plates (some col.), cl., 1863, 4to. (313) 15s.

6201 Kent (W.) Manual of the Infusoria, plates, 3 vol. in 6 parts, sewed, 1880-2, imp. 8vo. (474) *Quaritch*, £2 14s.

6202 Kermode (P. M. C.) Manx Crosses, plates, buckram gt., 1907 —Moore (A. W.) History of the Isle of Man, map, 2 vol., cl., together 3 vol., 1900, 8vo. (314) £1 16s.

6203 Kildare Archæological Society. Journal, plates and genealogies, vol. i. to iv., hf. cf., continued to vol. vi., No. 3, in 9 parts, sewed, 1895-1910, 8vo. (392) £1 16s.

6204 Kilkenny Archæological Society's Transactions, and Journal of the Royal Society of Antiquaries of Ireland. A complete set, from the commencement in 1849 to December, 1909 (including Index to the first 19 vol.), with 2 Antiquarian Handbooks, illustrations, together 39 vol., uniformly bound in hf. mor., t. e. g. (last 2 vol. in 8 parts), 1849-1909 (388) *Bailey*, £20 10s.

6205 Knight's Gallery of Portraits, 7 vol., cf., g. e., 1833-36, imp. 8vo. (121) *A. Jackson*, £1 5s.

6206 König (F. E.) Lehrgebäude und Syntax der Hebräischen Sprache, 3 vol., hf. cf., *Leipzig*, 1881-97, 8vo. (14) £1 2s.

6207 Lambarde (W.) APXAIONOMIA, sive de Priscis Anglorum Legibus libri, Anglo-Saxon text, MS. notes in margins, contemp. cf., blind stamped, gilt fleur-de-lys at corners, J. Day, 1568, sm. 4to. (205) £3 18s.

6208 Lane (E. W.) Arabic English-Lexicon, Book I., parts i. to viii., in 6 vol., cl., and 8 parts sewed, 1863-86, roy. 4to. (64) £2 15s.

6209 Langland (W.) The Vision of Pierce Plowman, second ed., **black letter** (3 leaves wormed), mor., g. e., *Imprinted . . . by Roberte Crowley*, 1550, sm. 4to. (186) *Hill*, £8

6210 Latimer. The fyrst [to the seventh] Sermon of Mayster Hughe Latimer which he preached . . . at Westmynster, 1548-1549, **black letter**, woodcut border on title and coat-of-arms of the Duchess of Suffolk on verso, mor., g. e., *London*, Jhon Daye and Wm. Seres, 1549, 12mo. (187) *Tregaskis*, £5

6211 Levy (Dr. J.) Chaldäisches Wörterbuch über die Targumim (binding broken), *Leipzig*, 1867-8—Buxtorf. Lexicon Chaldaicum, 2 vol. in 1, hf. mor., *ib.*, 1869, together 2 vol., imp. 8vo. (6) *Luzac*, £1 2s.

6212 Levy (Dr. J.) Neuhebräisches und Chaldäisches Wörterbuch, neɔst Beiträgen von H. L. Fleischer, 4 vol. in 2, hf. cf., m. e., *Leipzig*, 1876-89, imp. 8vo. (7)		£3 9s.
6213 Leyden Museum. Notes from the Royal Zoological Museum of the Netherlands, ed. ɔy Schlegel and Jentink, plates, Vol. i. to viii., in 17 parts, and 34 parts of Vol. ix. to xvii., 1879-96, 8vo. (467)		*Wheldon*, £1 6s.
6214 Liddell and Scott. Greek Lexicon, 8th edition, hf. mor., m. e., *Oxford*, 1897, 4to. (63)		*Baker*, £1 6s.
6215 Linnean Society of London. Journal. Zoology, from the commencement to Nov., 1909 (vol. i. to xxxi.), the first 10 vol. in 6, hf. cf., remainder in 142 numɔers (Nos. 155, 201 and 202 missing), 1857-1909, 8vo. (450)		£4 5s.
6216 Linnean Society. Transactions, Vol. xxii., parts ii. to iv.— Vol. xxiii., xxiv., parts ii. and iii.—Vol. xxv. to xxviii., xxix., parts i. to iii.—Vol. xxx., parts i. to iii.—and Index to Vol. i.-xxx., plates (some col.), 30 parts, sewed, 1856-75, 4to. (451)		*Wheldon*, £2 17s.
6217 Linnean Society. Transactions, Second Series. Zoology, Vol. i. to ix., 10 parts i. to viii., 11 parts i. to v.—and Vol. xii., plates, in 110 parts, sewed, 1875-1909, 4to. (452)		£4
6218 Macaulay (Lord). History of England, 5 vol., 1849-61— Essays, 3 vol., 1843, together 8 vol., cl., 8vo. (166)		*Sotheran*, 17s.
6219 Macaulay (Lord). History of England, 5 vol., 1849-61— Essays, 3 vol., cf. gt., 1884—Miscellaneous Writings, port., 2 vol., cf. gt., g. e., 1860, together 10 vol., 8vo. (148)		*Chaundy*, £1 15s.
6220 Macgiɔɔon (D.) and Ross (T.) Ecclesiastical Architecture of Scotland, illustrations, 3 vol., buckram, t. e. g., *Edinburgh*, 1896-7, 8vo. (305)		*Edwards*, £3 9s.
6221 Maclauchlan and Wilson. History of the Scottish Highlands, ed. by Keltie, plates, including the Tartans (col.), 2 vol., mor., g. e., 1875, roy. 8vo. (152)		£1 1s.
6222 Maris (Jacoɔ) [Dutch artist, 1839-99], ɔy Th. De Bock, 90 photogravures and a port., Japanese vellum copy (limited to 25 copies), vell. ex., *De la More Press*, n. d., folio (251)		£1 16s.
6223 Massorah (The), arranged ɔy Christian D. Ginsɔurg, 4 vol., bds., *Printed for subscribers*, 1880-1905, roy. folio (50)		*Baker*, £8 10s.
6224 Max Müller (F.) History of Ancient Sanskrit Literature, cl., 1859, 8vo. (42)		17s.
6225 Milne Edwards (H.) Leçons sur la Physiologie, etc., Vol. i. to ix., hf. cf., and 7 parts of, Vol. x.-xiv., *Paris*, 1857-80— Roɔin. Journal de l'Anatomie, plates, Vol. i. to vi., hf. cf., and vii. to ix. in numɔers, *ib.*, 1864-73, 8vo. (443)		*Wesley*, £8 5s.
6226 Monatsschrift für Geschichte des Judenthums, herausgegeɔen von Dr. Z. Frankel, fortgesetzt von Dr. Graetz und P. F. Frankl, from 1868 to 1887, 20 vol. in 13, hf. cf. and cl., *Breslau, etc.*, 1868-87, 8vo. (3)		£2 5s.

6227 Montagu (Lady M. W.) Letters and Works, ed. ɔy Lord
Wharncliffe, ports., 3 vol., hf. bd., 1837, 8vo. (144)
Edwards, 19s.
6228 Morphologisches Jahrbuch, herausgegeben von C. Gegenɔaur,
litho. plates, 42 parts of Vol. v. to xxiii. (vol. vii. to xi., xix.
and xx. complete), 1879-95, 8vo. (544) *Freidlow,* £3 10s.
6229 MS. A Fifteenth Century Flemish Service Book, written
throughout in a large gothic hand, on 224 leaves of thick
vellum, one historiated initial letter and 13 illuminated
ɔorders heightened with gold, musical notation, autograph
note ɔy Sir S. R. Meyrick at commencement, russ., with
ɔrass clasps, *Sæc.* xv., folio (232) £30
6230 Museum of Comparative Zoology at Harvard College.
Bulletin, plates, 72 numɔers of Vol. i. to vi., viii. to xiii.,
xvii. to xx., xxii., xxviii. to xxx. and xxxiii., *Cambridge,*
Mass., U.S.A., 1867-98, 8vo. (531) *Wesley,* £1 10s.
6231 Mydrasz Raɔa, 2 vol. in 1, hf cf., *Warszawa,* 1867—Talmud
Jerushalmi, Heɔrew text, hf. bd., together 2 vol., 4to. (51)
£1 5s.
6232 Napier (Sir W. F. P.) History of the Peninsular War, maps
and plans, 6 vol., cl., 1880, 8vo. (49) 17s.
6233 Naples. Fauna und Flora des Golfes von Neapel und der
Angrenzenden Meeres-Aɔschnitte, herausgegeɔen von der
Zoologischen Station zu Neapel, plates (some col.), Nos. 1
to 3, 5, 6, 9, part i., x., xi., in 2 parts, and xiii. to xxxiii. in
15 parts, together 24 parts, sewed, *Leipzig and Berlin,*
1880-96, 4to. (570) *Quaritch,* £22 10s.
6234 Nature, a Weekly Illustrated Journal of Science, Vol. i. to
xlvi., cl., and liii. to lxxv. in numɔers (a few missing), also
6 numɔers of Vol. lxxxii., 1870-1910, 8vo. (528) *Sotheran,* £4
6235 New English Dictionary on Historical Principles, ed. ɔy
J. A. H. Murray, Vol. i. to v. (A to K), hf. mor., *Oxford,* 1888-
1901, 4to. (550) *Harding,* £4 14s.
6236 North (R.) Lives of the Norths, ports., 3 vol., cf. gt., H.
Colɔurn, 1826, 8vo. (143) £1 11s.
6237 O'Curry (E.) On the Manners and Customs of the Ancient
Irish, 3 vol., hf. mor., 1873, 8vo. (372) *Quaritch,* £2 10s.
6238 O'Curry (E.) Lectures on the Manuscript Materials of
Ancient Irish History, facs., hf. mor., 1861, 8vo. (373)
Bailey, £1 10s.
6239 O'Donovan (J.) Irish Grammar (binding soiled), *Dublin,*
1845—Bourke. Irish Grammar with A.L.S., 1856—Coneys.
Irish Dictionary, 1849 (47) £1 2s.
6240 O'Hanlon (J.) Lives of the Irish Saints, cuts, Vol. i. to ix., hf.
cf. (ruɔɔed), and Vol. x., parts c. to cvi., 1875, etc., 8vo. (376)
Hill, £3 6s.
6241 Origenis Hexaplorum quæ supersunt, edidit F. Field, 2 vol.,
cl., *Oxonii,* 1875, 4to. (62) *Higham,* £2 17s.
6242 Owen (R.) Anatomy and Physiology of Vertebrates, 3 vol.,
1866-8—British Fossil Mammals and Birds, 1848—Palæ-
ontology, 1860—The Pearly Nautilus, 1832, and others ɔy
the same, cuts, together 10 vol., 8vo. (440) *Quaritch,* £1 2s.
29—2

6243 Palæographical Society. Facsimiles of Manuscripts and Inscriptions. Oriental Series, ed. by W. Wright, 100 plates, hf. bd., 1875-83, roy. folio (57) £6

6244 Palestine Exploration Fund. Quarterly Statements, from 1872 to 1908, with Index to 1865-1892, plates, in 21 vol., hf. roan, 8vo. (28) £1 1s.

6245 Parker (J. H.) Glossary of Architecture, plates, 3 vol., cf. gt. (ɔroken), 1850, 8vo. (156) 16s.

6246 Payne Smith (R.) Thesaurus Syriacus, 2 vol., vol. i. hf. cf. (ɔinding ɔroken) and vol. ii. in 6 parts, *Oxonii*, 1879-1901, 4to. (60) *Hill*, £7 15s.

6247 Pennant (T.) Some Account of London and Westminster, extra illustrated with ports., historical prints, etc., 2 vol., old russ. (ɔroken), 1805, folio (245) *A. Jackson*, £2 15s.

6248 Pentateuchus Samaritanus, edidit et varias Lectiones adscripsit H. Petermann, hf. cf., *Berlin*, 1872, 8vo. (12) *Higham*, 18s.

6249 Percy Society. Puɔlications, 30 vol. (vol. ii., xii. and xxix. missing), hf. mor., 1840-52, 8vo. (106) *Harding*, £4 17s. 6d.

6250 Petrie (G.) Ecclesiastical Architecture of Ireland, cuts, cf. ex., 1845, 4to. (378) £1 18s.

6251 Petrie (G.) Christian Inscriptions in the Irish Language, ed. ɔy M. Stokes, plates and facs., 2 vol. in 1, hf. cf., t. e. g., 1872-8, 4to. (379) *Quaritch*, £2 12s. 6d.

6252 Plato. The Dialogues of Plato, trans. ɔy B. Jowett, third ed., 5 vol., cl., *Oxford*, 1892, 8vo. (293) £2 15s.

6253 Playfair and Günther. Fishes of Zanziɔar, plates (some col.), cl., Van Voorst, 1866, 4to. (486) *Wesley*, 15s.

6254 Pragmatica Sanctio, edidit Cosme Guymier, 𝔤𝔬𝔱𝔥𝔦𝔠 𝔩𝔢𝔱𝔱𝔢𝔯, woodcut devices of Petit and Pigouchet on first and last leaves (small wormhole in a few leaves), vell., *Parisiis*, 1510, 8vo. (189) £1 5s.

6255 Prescott (W. H.) Works. The Reign of Ferdinand and Isaɔella, 3 vol.—Conquest of Mexico, 3 vol., Bentley, 1839-43—Conquest of Peru—Reign of Phillip II.—Charles V.—Miscellanies, Routledge, 1874-8, ports., together 14 vol., hf. mor. gt., 8vo. (150) £4 10s.

6256 Quarterly Journal of Microscopical Science, ed. ɔy Lankester and others, plates. First Series, 8 vol.—New Series, Vol. i. to xxxix., part iii., first 18 vol. hf. cf., remainder in 113 parts, 1853-96, 8vo. (480) *Wesley*, £32

6257 Raɔelais (F.) Works, trans. ɔy Urquhart and Motteux, plates ɔy Louis Chalon, 2 vol., cl., 1892, imp. 8vo. (323) 18s.

6258 Ray Society. Blackwall (J.) History of Spiders, col. plates, 2 parts, bds., *Ray Society*, 1861-4, folio (453) £2 2s.

6259 Ray Society. Allman (G. J.) Fresh-Water Polyzoa and Gymnoɔlastic Hydroids, 2 parts col. plates, 3 parts bds., 1871-2, folio (454) £1 5s.

6260 Ray Society. Buckton (G. B.) Monograph of the British Aphides, plates (some col.), 4 vol., cl., t. e. g., 1876-83 (461) *Freidlander*, £3 12s. 6d.

6261 Ray Society. Buckler (W.) Larvæ of British Butterflies and
Moths, ed. ɔy Stainton, col. plates, 9 vol., cl., t. e. g., 1886-
1901 (462) *Quaritch*, £6 10s.
6262 Ray Society. Brady. Monograph of the Copepoda, 3 vol.,
1878-80 — Boulenger (G. A.) Tailless Batrachians of
Europe, part i., plates, 4 vol., 1896 (463) £1 16s.
6263 Ray Society. Günther (Dr. A.) Reptiles of India—Flower
on the Cetacea—Parker on the Shoulder-Girdle in the
Verteɔrata, plates, together 3 parts, 1864-8, folio (457) 19s.
6264 Ray Society. Günther (Dr. A.) Reptiles of India—McIntosh.
British Annelids, in 2 parts, and one other, together 3
parts, bds., 1864-74, folio (458) *Dulau*, £1
6265 Records of the Past, ɔeing English Translations of Assyrian
and Egyptian Monuments, ed. ɔy S. Birch and A. H.
Sayce. First Series, 12 vol.—Second Series, 6 vol., to-
gether 18 vol., cl., 1875-92, 8vo. (26) *Dickinson*, £1 10s.
6266 Reliquary (The) and Illustrated Archæologist, ed. ɔy J. R.
Allen, New Series, vol. i. to xv., first 11 vol. hf. cf., re-
mainder in 16 numɔers, 1895-1909, 4to. (309) *George*, £1
6267 Roscoe's Novelist's Liɔrary. Le Sage (A. R.) Gil Blas,
plates ɔy G. C., 2 vol., cl., 1833, 8vo. (178)
Walford, £1 11s.
6268 Royal Duɔlin Society. Scientific Proceedings of the Royal
Duɔlin Society, plates (some col.), New Series, vol. i. to
vii., hf. bd., 1878-92, 8vo. (520) *Wheldon*, £1 3s.
6269 Royal Duɔlin Society. Scientific Transactions of the Royal
Duɔlin Society, plates, Second Series, vol. i. to v., and 3
parts of vol. vi., the first 3 vol. in 4, cl., etc., remainder in
in 29 parts, 1877-97, 8vo. (521) £1 5s.
6270 Royal Duɔlin Society. Journal of the Royal Duɔlin Society,
plates and maps, vol. i. to v., cl., 1858-70, and Liɔrary
Catalogue, 1860, 8vo. (522) *Wesley*, £1 5s.
6271 Royal Duɔlin Society. Journal, vol. i. to v., cl., 1858-70—
Scientific Transactions, 15 parts of vol. i. and iii., Second
Series, 1882-7, 4to. (523) *Wesley*, £1 7s.
6272 Royal Irish Academy. Transactions, vol. xviii., Antiquities
—Vol. xxiv., xxv. and xxvi., Science—Vol. xxvii., Polite
Literature and Antiquities—Vol. xxviii., Science—Vol. xxix.,
xxx. in 20 parts,—Vol. xxxi., parts i. to xiii.—Vol. xxxii.,
section B, parts iii. and iv., section C, parts i. to iii.—List
of Papers puɔlished in the Transactions, etc., 1786-1886,
plates, 6 vol. cl., remainder bds. and sewed, 1839-1905, 4to.
(395) £1 16s.
6273 Royal Irish Academy. Cunningham Memoirs, ɔy Casey,
Haddon, Mahaffy (the Flinders Petrie Papyri, in 5 parts),
and others, in 11 parts (ɔeing Nos. 1, 3 to 6, and 8 to 11),
plates and facs., bds., 1880-1905, 4to. (396) *Quaritch*, £3 6s.
6274 Royal Irish Academy. Proceedings, First Series, 10 vol., cl.
—Second Series, 6 vol., cl.—Third Series, vol. i. to iv., hf.
cf., and v. to vii., sewed, and 95 numɔers April, 1903 to
Feb., 1910, 8vo. (394) *Quaritch*, £3 5s.

6275 Royal Irish Academy. Todd Lecture Series, Vol. i., part i., and Vol. ii. to vi., etc., 2 vol. hf. mor., remainder sewed, 1884-95, and 3 others, 8vo. (398) £1

6276 Royal Microscopical Society. Journal, First Series, 3 vol.—Second Series, vol. i. to vi. (No. 43 missing), in 56 numbers and 2 other numbers, 1878-88, 8vo. (481) *Sotheran*, £1 18s.

6277 Royal Society. Report on the Eruption of Krakatoa and subsequent Phenomena, plates, cl., 1888, 4to. (230) 16s.

6278 Savonarola. Prediche nuovamente venute in Luce, woodcut on title, hf. cf., *Vinegia*, 1528, sm. 4to. (198) £1 15s.

6279 Schliemann (H.) Mycenæ, illustrations and maps, 1878—Tiryns, col. plates and other illustrations, 1886, 2 vol., cl., t. e. g., sm. 4to. (294) £1 3s.

6280 Schliemann (H.) Ilios. The City and Country of the Trojans—Troja, illustrations, 2 vol., cl., 1880-4, roy. 8vo. (295) £1 6s.

6281 Scientific Pamphlets. A Collection of Zoological and Natural History Pamphlets, both English and Foreign, classified under the following headings : Annelida, Molluscoidea, Scolecida, Insecta, Aves, Reptilia, Pisces, Mammalia, Geology, Palæontology, etc., contributed by Profs. Grube, Allman, Heller, Krause, Gray, Owen, Newton, Dana and others, plates and some presentation copies, in 16 vol., hf. cf., *ca.* 1840-70, 8vo. (546) £3 12s. 6d.

6282 Scott (Sir W.) Waverley Novels, fronts. and vignette titles, 48 vol., hf. cf., gilt backs, 1841, 8vo. (130) *Quaritch*, £2 12s.

6283 Shakespeare (W.) Mr. William Shakespeare's Comedies, Histories and Tragedies, the second impression, port. by Martin Droeshout on title, with the verses, "To the Reader," by Ben Jonson, opposite (the verses mounted, title and last leaf repaired, and a few words or letters in fac., 13⅛in. by 8½in.), mor. ex., *London, printed by Tho. Cotes for Robert Allot, and are to be sold at the signe of the Blacke Beare in Pauls Church-yard,* 1632, folio (239) *Hornstein,* £60

6284 Shakespeare (W.) Works, ed. by S. W. Singer, Chiswick Press Ed., port. and cuts, 10 vol., orig. bds., *Chiswick*, 1826, 8vo. (171) *Zaehnsdorf*, £5 7s. 6d.

6285 Shakespeare Illustrated by an Assemblage of Portraits and Views, 158 plates, 2 vol. in 1, old mor., g. e., S. and E. Harding, 1793, 8vo. (105) *Leighton*, £2 6s.

6286 Sheraton (T.) The Cabinet Maker and Upholsterers' Drawing Book, first ed., front. and 64 folding and other plates (plate 1 missing and a few misplaced, and stained), hf. bd., 1793, sm. 4to. (221) £5

6287 Siborne (W.) History of the Waterloo Campaign, second ed., plates, 2 vol., cl., 1844—Folio Atlas of Plans, hf. cf.—Waterloo Letters, plans, 1891, 8vo. (287) £1 1s.

6288 Sinigaglia (L.) Climbing Reminiscences of the Dolomites, trans. by Vialls, map and 39 plates, Japan paper ed. (limited to 30 copies), hf. mor., t. e. g., by Zaehnsdorf, 1896, 8vo. (367) £1 10s.

6289 Slade Collection. Catalogue of the Collection of Glass formed ɔy Felix Slade, Esq., plates (some col.) and other illustrations, presentation copy to Sir Digɔy Wyatt, hf. mor., t. e. g., *Printed for private distribution*, 1871, folio (250) *Edwards*, £3 17s. 6d.

6290 Smith (C.) History of Cork, folding maps and plates, 2 vol., hf. cf., 1815 (421) *Bailey*, 16s.

6291 Smith (G.) History of Assurɔanipal, front., cl., 1871, imp. 8vo. (29) 16s.

6292 Smith and Cheetham. Dictionary of Christian Antiquities, cuts, 2 vol., cl., 1875-80, 8vo. (23) 18s.

6293 [Smollett (T.)] The History and Adventures of an Atom, first ed., contemp. MS. key to the characters and places, 2 vol., orig. grey wrappers, entirely uncut (a few leaves frayed), *London, printed for Robinson & Roberts*, 1769 (1749 *sic*), 8vo. (184) *Dobell*, £12 5s.

6294 Smollett (T.) Miscellaneous Works, port., 6 vol., cf. (cracked), *Edinburgh*, 1817, 8vo. (129) £1 10s.

6295 Smyth (R. B.) The Aɔorigines of Victoria, illustrations, 2 vol., hf. bd., 1878, imp. 8vo. (160) £2 4s.

6296 Society of Antiquaries of London. Proceedings, from the commencement to 1895, 19 vol. in 17, hf. mor., 1849-95, 8vo. (310) *Quaritch*, £3

6297 Spencer (H.) Principles of Biology and Psychology, 2 vol., 1865-72—Autoɔiography, ɔy himself, port., 2 vol., 1904, together 4 vol., cl., 8vo. (438) £1 2s.

6298 Stokes (M.) Early Christian Architecture in Ireland—Six Months on the Apenines, etc., plates, 4 vol., 1878-95—Stokes (G. T.) Ireland and the Celtic Church, presentation copy, etc., 2 vol., 1886-9, together 6 vol., cl., 8vo. (380) *Quaritch*, £4 10s.

6299 Stokes (Whitley). Tripartite Life of St. Patrick, 2 vol., 1887, roy. 8vo.—Reeves. Ecclesiastical Antiquities of Down, Connor, etc., 1847, sm. 4to., together 3 vol. (46) £1 10s.

6300 Stradivari (Antonio). His Life and Work (1644-1737), ɔy W. H., A. F. and A. E. Hill, col. plates and other illustrations, hf. vell., t. e. g., 1902, 4to. (302) *Maggs*, £3 3s.

6301 Strickland and Melville. The Dodo and its Kindred, col. front. and plates, cl., 1848, 4to. (556) 15s.

6302 Symonds (J. A.) Life of Benvenuto Cellini, first ed., port., etchings by Laguillermie and reproductions, 2 vol., orig. ɔinding, t. e. g. (rubbed), 1888, roy. 8vo. (315) £5 7s. 6d.

6303 Symonds (J. A.) Life of Michelangelo Buonarroti, first ed., LARGE PAPER, port. and photo. etchings on Japan paper (limited to 112 copies), 2 vol., cl., uncut, 1893, imp. 8vo. (316) £3 17s. 6d.

6304 Symonds (J. A.) Memoirs of Count Carlo Gozzi, port. and etchings ɔy Lalauze, 2 vol., hf. cf., t. e. g. (ruɔɔed), 1890, roy. 8vo. (317) £1 9s.

6305 Terence in English, trans. ɔy R. Bernard, with the Latin Text, mor., g. e., 1641, sm. 4to. (203) 15s.

6306 Texts and Studies. Contriɔutions to Biɔlical and Patristic Literature, ed. by J. Armitage Roɔinson, facs., vol. i. to v. and vii., in 21 parts, sewed, *Cambridge*, 1893-1905, 8vo. (25)
Higham, £3 14s.

6307 Thackeray (W. M.) Vanity Fair, first ed., with the suppressed woodcut, hf. mor., t. e. g., 1848, 8vo. (131)
Leighton, £3

6308 Thackeray (W. M.) Pendennis—The Newcomes, first eds., 4 vol., hf. mor., t. e. g., 1849-55, 8vo. (132) *Leighton, £1* 10s.

6309 Thackeray (W. M.) The Virginians, 2 vol., uncut, 1858-9—Esmond, 3 vol., 1852, first eds., 5 vol., hf. mor., 8vo. (133)
Leighton, £1 7s.

6310 Thackeray (W. M.) Works, Biographical Ed., ɔy Mrs. Ritchie, illustrations, 13 vol., cl., t. e. g., 1898, 8vo. (338)
Brown, £1 7s.

6311 Thompson (W.) Natural History of Ireland, port., 4 vol., cl., 1849-56, 8vo. (519) *Wheldon, £1* 17s.

6312 Tracts and Treatises relating to Ireland (1613-58), with Index, 2 vol., cl., 1860-1, 8vo. (402) *Edwards, £1* 6s.

6313 Tuer (A. W.) History of the Horn Book, orig. ed., 2 vol., vell. gt., t. e. g., 1896, 4to. (350) *Maggs, £1* 16s.

6314 Turner (J. M. W.) Picturesque Views of England and Wales, ɔy H. E. Lloyd, LARGEST PAPER, 96 plates, artist's proofs, on India paper, 2 vol., mor. ex., 1838, imp. folio (243)
£25

6315 Ulster Journal of Archæology, litho plates and cuts, complete set, 8 vol., hf. cf. gt., 1853-62, sm. 4to. (391) *Bailey, £7*

6316 Vetus Testamentum Græce, ed. Tischendorf, 2 vol., hf. roan —Novum Testamentum Græce, with Prolegomena ɔy Gregory, 3 vol., hf. cf., together 5 vol., *Lipsiæ*, 1887-94, 8vo. (21) *Higham, £2* 10s.

6317 Villari (P.) The Two First Centuries of Florentine History, 2 vol.—Barɔarian Invasion of Italy, 2 vol.—Life of Machiavelli, 2 vol., together 6 vol., cl., 1892-1902, 8vo. (292)
£1 13s.

6318 Wallace (A. R.) Geographical Distriɔution of Animals, maps and plates, 2 vol., cl., 1876, 8vo. (435) *Hill, £1*

6319 Wallace (A. R.) Malay Archipelago, 2 vol.—Island Life—Tropical Nature, etc., plates, together 6 vol., cl., 1869-89, 8vo. (436) *Quaritch, £1* 3s.

6320 Walpole (H.) Letters, 6 vol., 1846—Letters to Sir H. Mann, ɔoth series, 7 vol., 1833-45—Letters to the Countess of Ossory, 2 vol., 1848, ports., together 15 vol., cf. gt. (ruɔɔed), 8vo. (145) *G. H. Brown, £2* 14s.

6321 Walpole (H.) Memoirs of the Reign of George II., 3 vol., 1846—Reign of George III., 4 vol., 1845, ports., together 7 vol., cf. (ruɔɔed), 8vo. (146) *Edwards, £3* 10s.

6322 Westwood (J. O.) Thesaurus Entomologicus Oxoniensis, 40 col. and other plates, hf. cf., t. e. g., 1874, 4to. (490)
Quaritch, £4 12s. 6d.

6323 Wilson (Capt. C. W.) Ordnance Survey of Jerusalem,

photo illustrations and facs., 2 vol., hf. mor., *Published by authority*, 1865, imp. folio (244) £1

6324 Winckler (H.) Altorientalische Forschungen, the first Two Series in 1 vol., hf. cf., and 6 parts of the Third Series, sewed, *Leipzig*, 1893-1906, 8vo. (19) *Wesley*, £1

6325 Winter and Wünsche. Die Jüdische Litteratur seit Abschluss des Kanons, 3 vol., sewed, *Trier*, 1894-6, 8vo. (15) £1 1s.

6326 Wright (W.) Arabic Grammar, third ed., 2 vol., 1896-8—Grammar of the Semitic Languages, 1890, 3 vol., cl., *Cambridge*, 8vo. (35) *Dickinson*, £1 3s.

6327 Wright (W.) Contributions to Apocryphal Literature, 1865—Apocryphal Acts of the Apostles, 2 vol., 1871, presentation copies, together 3 vol., cl., 8vo. (33) £1 7s.

6328 Zangemeister (C.) und Wattenbach (G.) Exempla Codicum Latinorum, 51 facs. in portfolio, *Heidelbergæ*, 1876 (59) £1 15s.

6329 Zeitschrift für Wissenschaftliche Zoologie, herausgegeben von Siebold, Kölliker und Ehlers, Vol. xxxii., part iii., to Vol. xlv., part ii.—Vol. liii., parts ii. to iv.—Vol. liv., parts iii. and iv.—Vol. lv. to lvii., plates, in 67 parts, sewed, *Leipzig*, 1879-94, 8vo. (542) *Freidlander*, £3 18s.

6330 Zeitschrift für Keilschriftforschung, 2 vol. in 1—Zeitschrift für Assyriologie, herausgegeben von Carl Bezold, plates, vol. i. to xxii., part iii., in 9 vol., cl., and 13 numbers and 2 parts of Seybold's Glossary (pages 41-128 and 144 to 449), 1884-1908, 8vo. (27) *Wesley*, £6 10s.

6331 Zoological Society (of) London. Proceedings, complete set, from the commencement to 1909, with Indexes from 1830 to 1900 (in 5 vol.), col. plates, the first 22 vol. in 28 (the plates to 1848-60 bound separately), hf. mor., remainder in 153 numbers, with Library Catalogue, etc., 4 vol., cl., 1830-1909, 8vo. (448) *Edwards*, £40

6332 Zoological Society. Transactions, plates (some col.), Vol. x. to xvii., xviii., parts i. to iii.—Vol. xix., parts i. to iii.—Index, vol. i.-x., in 81 parts, sewed, 1877-1909, 4to. (449) £3 9s.

6333 Zoological Record, ed. by Günther and others, vol. i. to xxxiii., cl., 1864-1896, 8vo. (446) *Quaritch*, £9 5s.

SOTHEBY, WILKINSON & HODGE.

THE LIBRARY OF THE LATE MRS. C. WYLIE, OF CHELSEA,
AND OTHER PROPERTIES.

(No. of Lots, 327 ; amount realised, £562 1s. 6d.)

6334 A'Kempis (Thomæ). De Imitatione Christi, old vell., in case
(125 mm.), *Lugduni, apud Joh. et Dan. Elzevirios, s. a.*
(281) *Thorp*, £1 8s.
6335 Album de Coiffures historiques, par Henri de Bysterveld,
orig. ed., 24 female ports. with various head-gears of
Louis XIII., Louis XV., Marie Antoinette and other
periods, from designs by Rigolet, printed in colours, orig.
cl., g. e., *Paris*, 1863, 8vo. (15) *Edwards*, 15s.
6336 America. Journal of the House of Assembly of Upper
Canada, from 31st day of Oct., 1832 to 13th day of Feb.,
1833—Journal of the Legislative Council of Upper Canada,
3rd Session of the 11th Provincial Parliament, 2 vol., hf.
cf., *York*, 1833, 8vo. (40) *Leon*, £1 5s.
6337 America. A Fair Representation of His Majesty's Right to
Nova Scotia or Acadia, briefly stated from the Memorials
of the English Commissaries, 64 pages, 1756—Remarks on
the French Memorials concerning the Limits of Arcadia,
etc., 110 pages, with 2 folding maps, 1756—The Progress
of the French in their Views of Universal Monarchy, 58
pages, 1756, and three other Pamphlets on Trade or Finan-
cial Matters, all uncut, in 1 vol., 8vo. (41)
H. Stevens, £6 10s.
6338 America. Map of the Province of New York with part of
Pensilvania and New England, from a Survey by Captain.
Montresor, folding map on linen, in case, 1775 (84)
Leon, £2 8s.
6339 America. The American Military Pocket Atlas, 6 large
folding maps, orig. hf. binding, 1776, 8vo. (38)
Carter, £1 16s.
6340 America. Journals of Major Robert Rogers containing an
Account of the several Excursions he made under the
Generals who commanded upon the Continent of North
America during the late War, etc., orig. cf., *Dublin*, 1765,
8vo. (39) *Sotheran*, £5 10s.
6341 America. Weld (Isaac). Travels through the States of
North America, maps and engravings, hf. mor., 1799, 4to.
(290) *Leon*, 15s.
6342 Andrews (H. C.) Monograph of the Genus Rosa, col. plates,
hf. cf., 1805, 4to. (67) *Thorp*, £3 3s.
6343 Annals of the Kingdom of Ireland, by the Four Masters,
trans. by John O'Donovan, second ed. (no index), 6 vol.,
orig. bds. (damaged), *Dublin*, 1856, 4to. (117)
Edwards, £6 5s.

6344 Araɔian Nights' Entertainments, by E. W. Lane, illustrations ɔy Harvey, 3 vol., cf. antique, 1839, roy. 8vo. (125)
Joseph, £1 17s.

6345 Araɔian Nights' Entertainments, ed. ɔy E. S. Lane-Poole, illustrations ɔy W. Harvey, 3 vol., 1865, roy. 8vo. (126)
Tregaskis, 18s.

6346 Balzac (H. de). Les Contes Drolatiques, first ed., with the 425 designs ɔy Doré, Francis Bedford's copy, with autograph letter inserted, mor. ex., g. e., *Paris*, 1855—Lettres à l'Étrangère (1833-1842), *ib.*, 1899, together 2 vol., 8vo. (28)
Hunt, £1 12s.

6347 Basan (F.) Recueil d'Estampes gravées d'apres les Taɔleaux du Caɔinet de Monsr. le Duc de Choiseul, port. and 128 plates, hf. bd., name on title, *Paris*, 1771, 4to. (80)
Reuter, 15s.

6348 Basan (F.) Taɔleaux du Caɔinet de Monsr. Poullain, engraved titles and 119 plates, hf. bd., *Paris*, 1781, 4to. (81)
Reuter, 16s.

6349 Basan (F.) Taɔleaux du Caɔinet de Monsr. Le Brun, hf. bd. (no title), *Paris* (1777-91), 4to. (82)
Reuter, 12s.

6350 Beibl Cyssegr-Lan sef yr hen Destament ar Newydd, Agyficithiad William Morgan, first ed. of the standard Welsh Biɔle, **black letter** (wanted title to Old Testament, several preliminary and other leaves damaged and imperfect, and many stained), old cf., *Llundain, gan Bonham Norton & John Bil*, 1620—A Portion (very imperfect at ɔeginning and end) of the first ed. of the Biɔle in Welsh, trans. ɔy W. Morgan, **black letter** (has the title to the New Testament), 1588, sold not suɔject to return, together 2 vol., folio (187)
Andrews, £3

6351 Biɔliographical Society. Illustrated Monographs, Nos. 5 and 7 to 15. Antoine Verard—Printing of Greek in the Fifteenth Century—Early Oxford Bindings—Earliest English Music Printing—Early Editions of the Roman de la Rose —A Census of Caxtons, etc., facs., uncut, together 10 vol., 1897-1909, 4to. (56)
Virgin, £4 6s.

6352 Butler (Rev. Alɔan). Lives of the Fathers, 12 vol., uncut, 1854, 8vo. (3)
Edwards, £2 2s.

6353 Byble (The). Matthewe's Emendation of Tyndale's Version, revised ɔy E. Becke, **black letter**, woodcuts (wanted title and some preliminary leaves, imperfect at end), old mor., g. e., not suɔject to return (John Daye and William Seres, 1549), folio (120)
J. Day, £4

6354 Byron (Lord). Fugitive Pieces, a facsimile reprint of the suppressed edition of 1806, vell. bds., *Printed for private circulation*, 1886, 4to.
Vane, £31

[Inserted is an A. L.'s. from Lord Byron, 3 pages, 4to., Venice, Octr. 15th, 1819, to his sister, Augusta Leigh. He wishes the produce of the Newstead sale to be invested in some other security than the funds, as he thinks the political situation very precarious, and continues that "if there is to be a scene in England you will proɔaɔly see me in England

in the next spring—but I have not decided on the part I
ought to take." . . . "To me it appears that you are on the
eve of a revolution—which wont be made with rose-water
however. If so I will be one. As Liston says, 'I love a
row.'" This letter is not printed in Prothero's edition.
There is also inserted a MS. copy of a Byron Poem.—
Catalogue. Sold on May 4th among a large and important
collection of historical manuscripts.—ED.]

6355 Camden (W.) Britannia, front. and large maps, with coats-
of-arms and figures, col. by hand, cf., *Amst., apud J.
Jansonium*, 1659, folio (123) *Maclehose*, £4

6356 Canada. Hawkins' Picture of Quebec, first ed., engraved
title, folding map and 11 views of Quebec by Sproule after
Russell, cf., *Quebec*, 1834, 8vo. (280) *Maggs*, £1 6s.

6357 Cervantes (M. de). Don Quixote, trans. by Smollett, engrav-
ings, 4 vol., orig. cf., *Dublin*, 1796, 8vo. (4) *Parsons*, £1 4s.

6358 Champion (Richard). Two Centuries of Ceramic Art in
Bristol, ports. and engravings, hf. bd., t. e. g., *Printed
privately*, 1873, imp. 8vo. (250) *Hyam*, £3 10s.

6359 Civil Engineers' Institution. Minutes of Proceedings, vol.
i.-cliv, with General Index—Vol. i.-xx., Subject Index—Vol.
i.-cxviii., Name Index—Vol. i.-lviii., Catalogue of Library,
Lectures, Charters, Lists of Numbers, etc., together 170
vol., hf. mor. and cl., 1842-1903, 8vo. (51) *Joseph*, £26

6360 Colonna. Hypnerotomachia Polophili, mor., doublé, by
Lortic, from the Sardou Library, *Venetiis in aedibus Aldi
Manutii*, 1499, folio (226) *Bartlett*, £28 10s.
 [The Priapus woodcut unmutilated ; errata leaf at end in
 facsimile.—*Catalogue*.]

6361 Cromwell (O.) Prohibition of Horse Racing, two black letter
proclamations on the above subject—
 (1) "By his Highness : A Proclamation prohibiting
Horse-Races for six Months," on top are the Parliamen-
tary arms with the initials "O. P." on either side, *Given at
Whitehall, the 24th day of February*, 1654 (57) *Maggs*, £5
 (2) "By the Protector, a Proclamation of his Highness
prohibiting Horse-Racing in England and Wales for eight
Months," at top, Cromwell's arms with inscription around,
Given at Westminster, 8th day of April, 1658 (57A)
 [Sold on May 4th.—ED.] *Quaritch*, £13

6362 Darwin (Charles). Descent of Man, first ed., illustrations, 2
vol., orig. cl., uncut, 1871, 8vo. (9) *Virgin*, 19s.

6363 Delille (Abbé de). Les Jardins, ou l'Art d'embellir les pay-
sages, Poème, first illustrated ed., Dutch paper, unlettered
proof plate after Cochin, contemp. French cf., g. e. (Derome),
Paris, 1782, 8vo. (16) *Hooker*, 7s.

6364 Dickens (Charles). Posthumous Papers of the Pickwick
Club, first ed., No. 1 to 10, with illustrations by Seymour
and "Phiz," the two plates by R. W. Buss, the notice of
the death of Seymour, and two addresses, orig. wrappers,
1836, 8vo. (286) *Bruton*, £36 10s.

6365 Dugdale (Sir W.) History of St. Paul's Cathedral, first ed.,
port. and plates ɔy Hollar (one cut into), cf., 1658, folio
(183) *Barnard*, 9s.
6366 Eikon Basiliké, folding frontispiece of the king kneeling, by
W. Marshall, with verses ɔeneath, contemp. ɔlack mor.,
g. e., with crown and monogram and death's-head ɔeneath
in memory of the king's murder, in case, *Reprinted in
R(egis) M(emoria)* [*W. Dugard, London*], 1648, 8vo. (31)
Harold, £51
[On reverse of title is the following inscription in the
autograph of Charles II.:—"A mon Cousin Le Comte de
la Gardee, Charles R. A la Haye ce 1ome de May 1649."
This edition was specially printed for gifts to friends of
Charles II. during his exile at the Hague.—*Catalogue.*
This copy formed part of a collection of important MSS.
sold by Messrs. Sotheɔy on May 4th.—Ed.]
6367 Evelyn (John). Memoirs, Diary, and Correspondence, ed.
by Bray and Upcott, ɔest ed., ports. and engravings
(spotted), 2 vol., hf. cf., 1819, 4to. (60) *Andrews*, 14s.
6368 Farington (Joseph). Views of the Lakes, 20 large plates
(stained), with descriptive text, uncut, 1789, oɔlong folio
(94) *Halliday*, 12s.
6369 Foreign Field Sports, with a Supplement of New South
Wales, 110 col. plates, mor., g. e., E. Orme, 1819, 4to. (112)
Thorp, £5
6370 French Revolution. Raɔaut (J. P.) Précis historique de la
Révolution Française, 6 plates ɔy Moreau, cf. gt., *Paris*,
Didot, 1819, 8vo. (18) *Dobell*, 8s.
6371 Going to Epsom Races : the Derby Day, col. Panoramic
View, 15 feet in length, comprising the Road, the Downs
and Race, in a cloth case (52) *Spencer*, £4 10s.

*Goupil's Historical Monographs, Japanese vellum paper copies,
with a duplicate set of the portraits and illustrations, all
in 4to., as issued :—*

6372 Prince Charles Edward, ɔy Andrew Lang, in case, 1900 (69)
Forster, £1 18s.
6373 Prince Charles Edward, another copy, in case, 1900 (70)
Kelly, £2 3s.
6374 Prince Charles Edward, another copy, in case, 1900 (71)
Forrester, £1 18s.
6375 Oliver Cromwell, ɔy S. R. Gardiner, 1899 (72)
Forrester, £1 14s.
6376 Charles II., by Osmund Airy, in case, 1901 (74)
Forrester, £1 11s.
6377 Henry VIII., by A. F. Pollard, fine paper, ports. and illustra-
tions, cf. ex., uncut, t. e. g., orig. wrappers inserted, 1902 (77)
G. H. Brown, £1 12s.

6378 Hakewell (James). History of Windsor and its Neighbour-
hood, engravings, hf. mor. ex., 1813, 4to. (63) *Moore*, 8s.

6379 Halliwell (J. O.) The Yorkshire Anthology (one of 110 copies), front., uncut, *Printed for private circulation*, 1851, 4to. (288) *Dobell*, 18s.

6380 Hickman (William). Sketches on the Nipisaguit, a River of New Brunswick, B. N. America, 8 col. lithographic plates and text, orig. cl., *Halifax and London*, 1860, 4to. (289) *James*, £2 8s.

6381 Hoare (Sir Richard Colt). The Ancient History of North and South Wiltshire, ports., maps and plates, 2 vol., in the orig. hf. russ., uncut, 1812-19, folio (319) *Thorp*, £3 15s.

6382 Holmes (Richard R.) Queen Victoria, col. front. and illustrations, orig. wrapper, uncut, 1897, 4to. (66) *A. Jackson*, 6s.

6383 Hooker (W. J.) Botanical Miscellany, illustrations (col. and plain), 3 vol., hf. mor. ex., 1830-33, 8vo. (26) *Wesley*, £3 5s.

6384 India. The Costumes of Hindostan, 60 col. engravings, with descriptions, by Solvyns, hf. mor. gt., 1804, 4to. (65) *Carter*, £1 5s.

6385 Jewitt (L.) Ceramic Art of Great Britain, illustrations, 2 vol., 1878, roy. 8vo. (128) *Carter*, £1 9s.

6386 Jollyvet (Evart). Fulmen in Aquilam, seu, Gustavi Magni . . . Heroico-Politicum Poema, orig. ed., front., old French mor. gt., *Paris*, M. Guillemot, 1633, 8vo. (17) *Hooker*, 7s.

6387 Jones (Sir W.) Works, with Supplemental volumes, port. (stained) and plates, together 8 vol., orig. russ., 1799-1801, 4to. (111) *J. Grant*, 15s.

6388 Kip (J.) Britannia Illustrata, 80 large plates (binding broken), 1707—Another collection of 80 views in perspective, and coats-of-arms, vol. ii. (binding broken), 1717, folio (184) *Braun*, £6

6389 Louis XVI. and Marie Antoinette. Procès des Bourbons, contenant des Details historiques sur la journée du 10 août 1792, . . . et la mort de Louis Charles, fils de Louis XVI., etc., six unlettered proof ports. and 3 plates, proofs before letters, 2 vol., hf. cf., 1798, 8vo. (270) *J. Bumpus*, £2

6390 Loudon (J. C.) Arboretum et Fruticetum Britannicum, second ed., the plates col., woodcuts in the text, 8 vol., orig. cl., Bohn, 1844, 8vo. (287) *Thorp*, £8 15s.

6391 Martinet (M.) Coloured Figures of Birds, over 1000 col. plates (10 missing, no text), 6 vol., old French mor., g. e., *circa* 1750, 4to. (211) *Parsons*, £6

6392 Mather (Cotton). Magnalia Christi Americana, orig. cf., 1702, folio (182) *Thorp*, £5

6393 Meteyard (E.) Life of Wedgwood, port. and illustrations, 2 vol., hf. mor., uncut, t. e. g., 1865, 8vo. (130) *Walford*, 18s.

6394 More (Sir T.) The Apologye of Syr Thomas More, Knyght, **black letter** (title defective and mounted, a few leaves stained), cf. gt., not subject to return, W. Rastell, 1533, 8vo. (109) *J. Day*, £7

6395 Nash (Treadway). Collections for the History of Worcestershire (without Supplement), map, ports., pedigrees and plates, 2 vol., orig. cf. (defective), 1781-82, folio (318) *G. H. Brown*, £6 2s. 6d.

6396 Naumann (J. A.) Naturgeschichte der Vögel Deutschlands, port. and 389 col. plates (pages 413-4 defective, also wanted one plate), 13 vol., russ., *Leipzig*, 1822-60, 8vo. (191)
Thorp, £2 16s.

6397 Newcastle (Marquis et Comte de). Methode et Invention Nouvelle de Dresser les Chevaux, seconde éd., large plates, orig. cf. (defective), *Londres*, 1737, folio (321)
Hornstein, £1 12s.

6398 Picturesque Guide to Bath, Bristol Hot-Wells, the River Avon and adjacent Country, col. aquatint plates, uncut, 1793, 4to. (61) *Hornstein*, £3 8s.

6399 Pope (A.) Poetical Works, 4 vol.—Milton. Paradise Lost and Regained, 2 vol.—Gay. Poems, with Beggar's Opera, 3 vol.—Young. Night Thoughts, 2 vol.—Dryden. Virgil, 3 vol.—Thomson. Seasons and Liberty, 2 vol.—Shenstone. Select Works in Prose and Verse—Garth. Poetical Works —Lyttleton. Poems—Aikinside. Pleasure of Imagination, together 20 vol., uniform contemp. English mor., *Glasgow*, Foulis, 1770-5, 8vo. (45) *Tregaskis*, £2 16s.

6400 Repton (Humphry). Observations on the Theory and Practice of Landscape Gardening, col. and other plates, moveable slips and a port. of Repton, orig. cf., 1803, 4to. (89)
W. Daniell, £5 10s.

6401 Reynolds (G. W. M.) Mysteries of the Court of London, illustrations, 8 vol., orig. cl., n. d., 8vo. (240)
G. H. Brown, £1 7s.

6402 Reynolds (G. W. M.) The Mysteries of London, illustrations, 4 vol., orig. cl., n. d., 8vo. (241) *Hill*, 11s.

6403 Rowlands (Henry). Mona Antiqua Restaurata. Antiquities of the Isle of Anglesey, engravings (some leaves stained), orig. cf., *Dublin*, 1723, 4to. (114) *Bull*, 10s.

6404 Scott (Sir Walter). Waverley Novels, "Abbotsford ed.," 12 vol., plates (spotted) and woodcuts, orig. cl., *Edin.*, 1842-47, imp. 8vo. (104) *J. Day*, £3 6s.

6405 Selden (John). Titles of Honor, port. and plates, cf., 1672, folio (68) *Tregaskis*, 7s.

6406 Shakespeare (William). Titus Andronicus (a portion only, consisting of 35 leaves), stained (1611)—Sherley (James). The Schoole of Complement, a Comedy (wanted title, imperfect, damaged and stained), (1631)—D'Avenant (Sir William). The Cruell Brother, a Tragedy, first ed. (headlines cut into, stained), 1630—Brewer (Anthony). Lingua, or the Combat of the Tongue (imperfect and stained), 1622 —Markham and Sampson (W.) The true Tragedy of Herod and Antipater (imperfect and stained), 1622, not subject to return, in 1 vol., old cf., 8vo. (23) *Dean*, £7

6407 Shakespeare (W.) Plays and Poems, ed. by Valpy, 171 illustrations, 15 vol., orig. cl., 1832-34, 8vo. (2)
Tyrrell, £1 5s.

6408 Smith (John). Catalogue Raisonné, complete in 9 parts, front., ports., uncut, 1829-42, 8vo. (24) *Eastwood*, £5

6409 Smollett (T.) Works, Memoirs ɔy Anderson, port., 6 vol., old cf. ex., *Edinb.*, 1806, 8vo. (27) *G. H. Brown*, 18s.
6410 Stewart (J.) Plocacosmos, or the Whole Art of Hairdressing, front. and plates, hf. vell., m. e., 1782 (131) *Dobell*, £1 11s.
6411 Strutt (Joseph). Sports and Pastimes of the People of England, engravings (coloured), russ., g. e., 1810, 4to. (59) *Bickers*, £2 10s.
6412 Trissino (G. G.) La Italia Liɔerata da Gotthi (Tomo i.), *Roma*, Dorici, 1547—(Tomo ii., iii.), *Venezia*, Tolomeo Janiculo, 1548, 3 vol. (woodcut at end of vol. iii. cut into), orig. ed., 4to. (214) £1 2s.
[Genuine orig. issues containing lines antagonistical to the Church of Rome, suppressed in later editions.—*Catalogue.*]
6413 Valois (de). Valesiana, ou, Les Pensées critiques, historiques et morales, et les Poésies latines de Monsieur de Valois, orig. ed., port. and 2 folding plates containing 16 headgears, old French cf. gt., *Paris*, 1694, 8vo. (19) *Hooker*, 11s.
6414 Waagen (D.) Treasures of Art in Great Britain, with the Supplement, ɔest ed., 4 vol., 1854-57, 8vo. (31) *Tregaskis*, £1 17s.
6415 Westwood (J. O.) Caɔinet of Oriental Entomology, col. plates, orig. cl., 1848, 4to. (64) *Wheldon*, £2 2s.

[MAY 5TH AND 6TH, 1910.]

SOTHEBY, WILKINSON & HODGE.

THE LIBRARY OF THE LATE MR. MONTAGU J. GUEST, OF THE ALBANY, AND OTHER PROPERTIES.

(No. of Lots, 703; amount realised, £1,152 18s.)

(*a*) *Mr. Guest's Library (Lots 1-392, amount £568 16s. 6d.)*

6416 Ackermann (R.) Repository of Arts, 14 vol.—New Series, 26 vol., together 40 vol., col. plates of costume, etc. (some missing), hf. cf., 1809-28, 8vo. (1) *Maggs*, £52
6417 Alken (Henry). Illustrations to Popular Songs, 43 col. plates, hf. bd. (spotted), 1825, oɔlong folio (340) *Rimell*, £4 2s. 6d.
6418 Alford (Lady M.) Needlework as Art, illustrations, 1886, roy. 8vo. (5) *Batsford*, £1 2s.
6419 America. Neptune Americo-Septentrional, contenant les Cotes, Iles et Bancs, les Baies, Ports, et Mouillages, et les Fondes des Mers de cette partie du Monde, maps of America, etc., old ɔinding (1780), atlas folio (341) *Edwards*, £3 18s.

6420 Amours des Dames Illustres de France, sous le Regne de
Louis XIV., front., 2 vol., mor., g. e., *Cologne* (1734), 8vo.
(7) *Edwards, £1 1s.*
6421 Angling. Halford (F. M.) Dry-Fly Fishing, illustrations,
uncut, t. e. g., 1889, imp. 8vo. (10) *Walford,* 14s.
6422 Baily's Magazine of Sports and Pastimes, ports., vol. i.-xxx.,
30 vol., hf. cf., 1860-77, 8vo. (21) *Howell, £1* 14s.
6423 Bellin (M.) Hydrographie Françoise, Recueil des Cartes
Marines, Générales et Particulières, col. plate of flags,
maps, including America, etc., 2 vol., old cf. (soiled), (1791,)
imp. folio (345) *Manley, £2* 8s.
6424 Berkeley (G. F.) My Life and Recollections, ports., 4 vol.,
hf. mor., t. e. g., 1865-66, 8vo. (26) *Rimell, £1* 14s.
6425 Bible, with Book of Common Prayer, Psalms in Meeter by
Sternhold and Hopkins, etc., ruled in red, contemp. mor.,
silver corners and clasps, M. W. on sides, Register of
Whiteway Family of Suddington, Bedford, 1687-92 on fly-
leaf, 1660-62, 8vo. (30) *Purchase, £1* 3s.
6426 British Museum. Catalogue of Playing and other Cards, by
W. H. Willshire, plates (some col.), 1876, imp. 8vo. (34)
Rimell, 7s.
6427 British Novelists (The), by Mrs. Barbauld, 50 vol., cf., 1820,
8vo. (36) *Maggs, £4* 14s.
6428 Chatterton (Thos.) Works, with Life, by G. Gregory—Mis-
cellaneous Poems (ed. by R. Southey and Cottle), fronts.,
3 vol., cf. gt., 1803, 8vo. (51) *Howell, £1* 10s.
6429 Coker (N.) Survey of Dorsetshire, maps and plates, cf., 1732,
folio (349) *Walford, £1* 4s.
6430 Combe (W.) Three Tours of Dr. Syntax, col. plates by T.
Rowlandson, 3 vol., hf. cf., n. d., roy. 8vo. (54)
G. H. Brown, £3 1s.
6431 Constant. Memoirs of Napoleon, etc., trans. by Percy
Pinkerton, port., 4 vol., 1896—Memoirs of Bertrand Barère,
trans. by De V. Payen-Payne, port., 4 vol., together 8 vol.,
1896, 8vo. (55) *Maggs, £3*
6432 Cosway (Richard). Catalogue Raisonné of his Engraved
Works, by F. B. Daniell, front., vell., 1890, 4to. (300)
Edwards, £1 1s.
6433 Covent Garden Magazine (The), or Amorous Repository,
plates, in 1 vol. and 4 parts, cf., uncut, 1772-74—The
Tickler, or Monthly Compendium of Good Things, 4 vol.,
hf. cf. (stained), 1819-22, 8vo. (58) *Rimell, £4* 4s.
6434 Cruikshank (G.) Comic Almanack, complete set, plates, in 5
vol., hf. bd., t. e. g., 1835-53, 8vo. (62) *Howell, £4* 5s.
6435 Cruikshank (G.) Catalogue of the Collection of the Works
of George Cruikshank, the property of Edwin Truman, sold
at Sotheby's May 7-12, 1906, LARGE PAPER, illustrations,
1906, imp. 8vo. (63) *Edwards,* 11s.
[For a report of the Truman sale *see* BOOK-PRICES
CURRENT, Vol. xx., page 537.—ED.]
6436 Curtis (C. B.) Flora Londinensis, col. plates, 3 vol. (should be
5 vol., 1817-28), uncut, 1817-26, folio (354) *Parsons, £3* 10s.
XXIV. 30

6437 Curtis (John). British Entomology, col. plates, 16 vol.,
1824-39, roy. 8vo. (65) *Edwards,* £12 5s.
6438 Daniel (W. B.) Rural Sports, with Supplement, plates
(spotted), 3 vol. in 4, hf. cf., 1801-13, roy. 8vo. (66) *Hill,* 15s.
6439 D'Avenant (Sir Wm.) Two Excellent Plays. The Wits, a
Comedie—The Platonick Lovers, a Tragi-Comedie, 1665—
Mayne (J.) The City Match, a Comœdy—The Amorous
Warre, a Tragi-Comœdy, *Oxford,* 1659, in 1 vol., old cf.,
1659-65, 8vo. (68) *Dobell,* £3
6440 Davenport (John). Aphrodisiacs and Anti-Aphrodisiacs,
illustrations, hf. mor., t. e. g., *Privately printed,* 1869, 4to.
(301) *Walford,* £1 1s.
6441 Dawe (G.) Life of Morland, port. and plates, hf. cf. gt.,
1807, 8vo. (69) *Tregaskis,* 10s.
6442 De Quincey (T.) Collected Writings, ed. by D. Masson,
with Index, front., 14 vol., *Edinb.,* 1889, 8vo. (70)
Quaritch, £1 2s.
6443 Du Barri (Mdme.) Memoirs, trans. by H. T. Riley, port., 4
vol., 1896—Talleyrand (C. M.) Memoirs by the Author of
"The Revolutionary Plutarch," port., 2 vol., 1895—Fouché
(Joseph). Memoirs, port., 2 vol., 1896, 500 copies printed
of each, H. S. Nichols, 1895-98, 8vo. (80) *Graystone,* £2 18s.
6444 Ducrest (Mme.) Memoirs of the Empress Josephine, port.,
2 vol., 1894—Miraṇeau (Count). Secret History of the
Court of Berlin, port., 2 vol., 1895—Secret History of the
Court and Caṇinet of St. Cloud, port., 2 vol., 1895, 500
copies printed of each, H. S. Nichols, 1894-95, 8vo. (81)
Graystone, £1 18s.
6445 Egan (P.) Life in London, first ed., col. plates by G. and R.
Cruikshank, cf., 1821, 8vo. (83) *Edwards,* £5 10s.
6446 Elegant Extracts, Prose, Verse and Epistles, vignettes, 18
vol., mor., g. e., name on titles, n. d. — New Elegant
Extracts, by R. A. Davenport, 6 vol., mor., g. e., *Chiswick,*
1827, 8vo. (84) *Maggs,* £1 18s.
6447 Evans (E.) Catalogue of a Collection of Engraved Portraits,
2 vol., n. d., 8vo. (85) *Tregaskis,* £1 6s.
6448 Evans (T.) Old Ballads, Historical and Narrative, front.,
4 vol., mor., g. e., 1810, 8vo. (87) *Hatchard,* 14s.
6449 Fergusson (James). History of Architecture, illustrations, 4
vol., hf. bd., 1874-76, 8vo. (89) *Rimell,* £1 4s.
6450 Fielding (H.) Works, ṇy A. Murphy, front., 12 vol., old cf.,
1766, 8vo. (90) *Zaehnsdorf,* £1 1s.
6451 Freemasons. Anderson (J.) Constitutions of the Antient
and Honouraṇle Fraternity of Free and Accepted Masons
(ṇinding ṇroken), port. and 2 leaves of MS. inserted, 1767,
8vo. (93) *W. Daniell,* £1 18s.
6452 Freemasons. Constitution of Freemasonry, or Ahiman Rezon,
revised ṇy Thomas Harper, front., hf. cf., presentation copy
ṇy Roṇt. Tho. Crucefix, 1813, 8vo. (95) *Dobell,* £1
6453 Freemasons. Constitutions of the Freemasons, front., old cf.,
presentation copy, *In the year of Masonry,* 5723 (1723), 4to.
(306) *Maggs,* £8

6454 Freemasons. Dermott (Laur.) Ahiman Rezon (binding broken, title cut off), 1756—Smith (Capt. G.) Use and Abuse of Free-Masonry, cf., 1783, 8vo. (97)
F. L. Gardner, £1 14s.

6455 Freemasons. Milledge (Z.) Historic Notes of All Souls' Lodge No. 170, Weymouth, illustrations, presentation copy to Montagu J. Guest, hf. mor., uncut, *Weymouth*, 1896, 8vo. (98)
Tregaskis, 11s.

6456 Freemasons. New Collection of Masonic Songs, with a General Charge to Masons, etc., *Poole*, n. d., 8vo. (99)
Milledge, £1 17s.

6457 Garner (T.) and Stratton (A.) Domestic Architecture of England during the Tudor Period, plates, etc., part i.-ii., 2 vol., subscriber's copy, n. d., imp. folio (357)
Edwards, £2 18s.

6458 Gibbon (E.) Decline and Fall of the Roman Empire, map, 7 vol., 1896-1900, 8vo. (106)
Hill, £1 1s.

6459 Gilbert (W. S.) "Bab" Ballads, first ed., illustrations by the author, orig. green cl., g. e., 1869, 8vo. (107)
Ellis, £2 8s.

6460 Goldsmith (Oliver). Life of Richard Nash, first ed., port., cf., 1762, 8vo. (108)
Howell, £1 16s.

6461 Goldsmith (O.) The Vicar of Wakefield, 24 col. plates by T. Rowlandson, hf. cf., 1817, roy. 8vo. (109)
Maggs, £9 5s.

6462 Goldsmith (O.) The Deserted Village, first ed., engraving on title (a few leaves defective and stained), 1770—Robinson (John). The Village Oppress'd, a Poem, dedicated to Dr. Goldsmith, 1771—Love Elegies, 1762—Howard (M.) The Conquest of Quebec, a Poem, *Oxford*, 1768—Hazard (J.) The Conquest of Quebec, a Poem, *ib.*, 1769, etc., in 1 vol., hf. cf., 1762-76, 4to. (311)
Maggs, £7

6463 Gotch (J. Alfred). Early Renaissance Architecture in England, plates and illustrations, 1901, imp. 8vo. (111)
Woodrow, 18s.

6464 Harding (E.) Portraits of the whole of the Royal Family, 21 ports., hf. cf., 1806, folio (360)
Parsons, £2 5s.

6465 Hawkins (E.) Medallic Illustrations of the History of Great Britain and Ireland, illustrations, 2 vol., *British Museum*, 1885, 8vo. (127)
Quaritch, £2

6466 Hervey (John Lord). Memoirs of the Reign of George the Second, first ed., front. (stained), 2 vol., cf. gt., 1848, 8vo. (132)
Edwards, £1 9s.

6467 Hone (William). Humorous and Satirical Tracts relating to Queen Caroline, her Trial, etc., woodcut illustrations by G. Cruikshank, etc., in 3 vol., hf. russ. (broken), 1817-20, 8vo. (135)
Dobell, £1 15s.

6468 Hume (D.) Treatise on Human Nature, 2 vol.—Essays, 2 vol., ed. by Green and Grose, together 4 vol., 1874-75, 8vo. (138)
Joseph, £1 4s.

6469 Hutchins (John). History and Antiquities of Dorset, map and plates, 4 vol., hf. cf., 1861-70, folio (363) *Edwards*, £6 10s.

6470 Inchbald (Mrs.) British Theatre, plates, 25 vol., 1808—
 Modern Theatre, 10 vol., 1811—Collection of Farces, 7
 vol., 1809, together 42 vol., cf., 1808-11, 8vo. (140)
 Quaritch, £2 16s.
6471 Jackson (C. J.) English Goldsmiths and their Marks, front.,
 buckram, uncut, t. e. g., 1905, 4to. (315) *Rimell, £1* 11s.
6472 Jacquemart (A.) History of Furniture, ed. by Mrs. B.
 Palliser, illustrations, 1878, imp. 8vo. (141) *Edwards,* 11s.
6473 James I. Secret History of the Court of James the First, by
 Sir W. Scott, front. and port., 2 vol., russ., *Edinb.*, 1811,
 8vo. (142) *Howell,* 16s.
6474 Jesse (J. H.) George Selwyn, ports., 4 vol., 1882, 8vo. (144)
 Hill, £1 4s.
6475 Jones' Diamond Poets and Classics, ports. and fronts., 51
 vol., cf., in glazed case, 1825-35, 8vo. (146) *Howell, £8* 10s.
6476 Lang (A.) The Blue Fairy Book, 1889—The Red Fairy
 Book, 1890—The Green Fairy Book, 1892, first eds., illus-
 trations, together 3 vol., 8vo. (157) *Maggs,* 19s.
6477 Langbaine (G.) Account of the English Dramatick Poets,
 first ed., good copy, with the rare "Errata" leaf, also
 another leaf with the title printed across, cf., *Oxford*, 1691,
 8vo. (159) *Tregaskis, £3* 3s.
6478 Leslie (C. R.) and Taylor (T.) Life and Times of Sir Joshua
 Reynolds, ports. and illustrations, 2 vol., 1865, 8vo. (162)
 Howell, £1 4s.
6479 Lièvre (Edouard). Musée Graphique pour l'Étude de l'Art
 dans toutes ses Applications, plates of furniture, etc. (some
 col.), mounted on cardboard, loose in 2 vol., hf. mor.,
 presentation copy, with autograph letter from J. Murray
 Scott, *Paris*, n. d., imp. folio (364) *Parsons, £2* 6s.
6480 Macaulay (Lord). Works, ed. by Lady Trevelyan, port., 8
 vol., 1866, 8vo. (170) *£1* 11s.
6481 Mayhew (H.) London Labour and London Poor, with the
 extra vol., illustrations, 4 vol., hf. mor., t. e. g., 1861-62, 8vo.
 (176) *Tregaskis,* 17s.
6482 Moore (T.) and Lindley (J.) Ferns of Great Britain and
 Ireland, nature-printed plates by Bradbury, hf. mor., g. e.,
 1857, imp. folio (365) *Quaritch,* 18s.
6483 Muller (F. Max). Chips from a German Workshop, 4 vol.,
 1880, 8vo. (186) *Howell,* 11s.
6484 Nightingale (J. E.) Church Plate of the County of Dorset,
 plates, hf. mor., t. e. g., presentation copy, *Salisbury*, 1889—
 Champion (R.) Two Centuries of Ceramic Art in Bristol,
 port. and 160 engravings, 1873, imp. 8vo. (188) *Maggs, £4*
6485 Plato. Dialogues, trans. by B. Jowett, 4 vol., *Oxford*, 1871—
 Index to Plato, by E. Abbott, *ib.*, 1875, together 5 vol., 8vo.
 (196) *Thin, £1* 14s.
6486 Poets. Works of the British Poets, by Thos. Park, with
 Supplement and Lives of the Poets by S. Johnson, plates,
 together 54 vol. in 51, cf. (vol. i. wormed), 1806-9, 8vo. (197)
 Hill, £2 8s.

6487 Pottery. Auscher (E. S.) History and Description of French. Porcelain, ed. by Burton, 24 col. plates, illustrations, etc., 1905, imp. 8vo. (199) *Edwards*, £1 9s.

6488 Pottery. Bemrose (Wm.) Longton Hall Porcelain, col.. plates and illustrations, 1906, imp. 8vo. (200) *Blest*, £1 14s.

6489 Pottery. Binns (W. Moore). The First Century of English Porcelain, col. plates and illustrations, 1906, 4to. (201) *Hyam*, £1

6490 Pottery. Burton (Wm.) History and Description of English Earthenware and Stoneware, col. plates and illustrations, 1904—Porcelain, a Sketch of its Nature, Art and Manufacture, 50 plates, 1906, 8vo. (202) *Quaritch*, £1 16s.

6491 Pottery. Chaffers (Wm.) Marks and Monograms, illustrations, 1870, imp. 8vo. (205) *Hill*, 11s.

6492 Pottery. Chaffers (Wm.) Marks and Monograms, by F. Litchfield, illuminations, 1903, imp. 8vo. (207) *Rev. — Wright*, £1 6s.

6493 Pottery. Chaffers (Wm.) The Keramic Gallery, illustrations (some col.), 1907, imp. 8vo. (208) *Blest*, £1 1s.

6494 Pottery. Crisp (F. A.) Armorial China, one of 150 copies, col. plates, hf. vell., uncut, t. e. g., *Privately printed*, 1907, 4to. (210) *Hyam*, £1 15s.

6495 Pottery. Jacquemart (A.) History of the Ceramic Art, illustrations, 1877, imp. 8vo. (213) *Quaritch*, £1 6s.

6496 Pottery. Jewitt (Ll.) Ceramic Art of Great Britain, 2 vol., illustrations, 1878, imp. 8vo. (214) *Quaritch*, £1 5s.

6497 Pottery. Litchfield (F.) Pottery and Porcelain, 7 col. plates, 150 illustrations, etc., 1900, imp. 8vo. (215) *Winter*, 9s.

6498 Pottery. Meteyard (E.) Life of Josiah Wedgwood, port. and illustrations, 2 vol., 1865, 8vo. (217) *Quaritch*, 18s.

6499 Pottery. Old English Porcelain, published by Stoner and Evans as a Souvenir, plates, 1909, 4to. (218) *Edwards*, 11s.

6500 Pottery. Rhead (G. W. and F. A.) Staffordshire Pots and Potters, 4 col. plates and other illustrations, 1906, imp. 8vo. (219) *Walford*, £1 1s.

6501 Pottery. Solon (M. L.) Old English Porcelain and its Manufactories, col. plates and other illustrations, 1903, roy. 8vo. (222) *Blest*, £2 2s.

6502 Pratt (Anne). Flowering Plants of Great Britain, 6 vol., col. plates, Warne, n. d., 8vo. (224) *Edwards*, £1 11s.

6503 Rider (C.) British Merlin, 1795—Royal Kalendar for 1796, 2 vol., contemp. mor., richly tooled, g. e., 1795-96, 8vo. (229) *Tregaskis*, 15s.

6504 Robinson (Fredk. S.) English Furniture, front. and 160 plates, cl., t. e. g., n. d., imp. 8vo. (232) *Hyam*, 16s.

6505 Rocque (J.) Plans of London, Westminster and Southwark, engraved plans on linen, reprinted 1878, imp. folio (371) *Edwards*, £1 6s.

6506 Roger-Miles (L.) Architecture, Décoration et Ameublement, pendant le Dix-Huitième Siècle—Comment Discerner les Styles du XVIII. au XIX. Siècle, 2 vol., together 3 vol., plates, and illustrations, *Paris*, n. d., 4to. (324) *Hill*, £1 8s.

6507 Royal Register (The), with Annotations by another hand, 9 vol., cf., with the names filled in (title of vol. ix. mounted), J. Bew, 1778-84, 8vo. (234) *Howell, £1 1s.*
6508 Schreider (Lady C.) Fans and Fan Leaves, plates, 2 vol., hf. mor., g. e., 1888-90, imp. folio (372) *Rimell, £2 18s.*
6509 Schreider (Lady C.) Playing Cards, plates, 3 vol., hf. mor., g. e., 1892-95, imp. folio (373) *Rimell, £5 2s. 6d.*
6510 Shakespeare (W.) Dramatic Works, by S. W. Singer, port. and woodcuts, 10 vol., cf. gt., *Chiswick*, 1826, 8vo. (245) *Edwards, £4 4s.*
6511 Sharp (T.) Catalogue of Provincial Copper Coins, etc. in the Collection of Sir George Chetwynd, port., plates, etc. inserted, 1834—Boyne (W.) Silver Tokens of Great Britain and Ireland, 7 plates, hf. bd., 1866, 4to. (325) *Yeates, £2*
6512 Sowerby (J.) English Botany, col. plates, 12 vol., hf. mor., t. e. g., 1877, imp. 8vo. (254) *Quaritch, £10 5s.*
6513 Spectator (The), 8 vol., 1797—The Tatler, 4 vol., 1797—The Guardian, 2 vol., 1797—The Adventurer, 3 vol., 1794, together 17 vol., Library ed., front. and vignettes, uniform in russ., 1794-97, 8vo. (256) *Rimell, £2*
6514 Stevens (Chas.) and Liebault (John). Maison Rustique, woodcuts, old cf., arms on sides, E. Bollifant, 1600, 4to. (328) *Ellis, £6 5s.*
6515 Sweet (R.) British Flower Garden, both series, col. plates, 7 vol., hf. cf., 1823-38, 8vo. (265) *Quaritch, £9 15s.*
6516 Vehse (E.) Memoirs of Court and Aristocracy of Austria, port., 2 vol., 1896—Memoirs of Madame la Marquise de Montespan, port., 2 vol., 1895—Secret Memoirs of the Court of St. Petersburg, port., 1895—Secret Memoirs of the Court of Louis XIV., port., 1895—Private Memoirs of Louis XV., port., 1895—Memoirs of Margaret de Valois, port., 1895, 500 copies printed of each, H. S. Nichols, 1895-96, 8vo. (274) *Rimell, £1 10s.*
6517 Virtuoso's Companion (The) and Coin Collector's Guide, front. and plates of coins, 8 vol., cf., 1795, 8vo. (276) *Maggs, £1 10s.*
6518 Wheatley (H. B.) London Past and Present, 3 vol., 1891, 8vo. (285) *Hatchard, £3 10s.*
6519 Whitman (A.) Print-Collector's Handbook, first ed., 80 illustrations, pencil notes, uncut, 1901, roy. 8vo. (286) *Pollard, £1 18s.*
6520 Wilkinson (R.) Londina Illustrata, plates, extra illustrated, 2 vol., hf. russ., 1819-25, imp. 4to. (336) *Graystone, £6*
6521 Wonderful Magazine and Marvellous Chronicle (The), plates, 5 vol., hf. cf., all faults, n. d., 8vo. (290) *Rimell, £1 5s.*

(β) *Other Properties.*

6522 Alford (Lady M.) Needlework as Art, illustrations, vell., uncut, t. e. g., 1886, folio (692) *Batsford, £1 14s.*
6523 Annals of Sporting and Fancy Gazette, with the rare No. 78 (June 1, 1828), col. plates by Alken, other illustrations by

Scott, etc. and ports., 13 vol., cf., g. e., the ɔacks symboli-
cally tooled, 1822-28, 8vo. (540) *Hornstein,* £58
6524 Anstis (J.) Register of the Most Noɔle Order of the Garter,
plates, 2 vol., old cf., 1724, folio (697) *Harding,* 12s.
6525 Armstrong (W. B.) The Bruces of Airth and their Cadets,
one of 105 copies, front., ɔuckram, uncut, *Edinb., pri-
vately printed,* 1892, 4to. (484) *Bolton,* 19s.
6526 Boswell (James). Life of Johnson, 3 vol., cf. ex., uncut, 1900
—Johnsoniana, or Supplement to Boswell, plates, cf. ex.,
1836, illustrated ɔy the insertion of 353 ports. and views,
and 6 autograph letters, including one of Dr. Johnson, 8vo.
(538) *Sawyer,* £15
6527 Bray (Mrs.) The Life of Thomas Stothard, R.A., extended to
3 vol., the text inlaid to folio size, and extra illustrated ɔy
the insertion of 614 engravings, some proofs ɔefore letters
and on India paper, mor. super ex., orig. cover ɔound up,
1851, folio (570) *E. Parsons,* £19 10s.
6528 British Portrait Painters and Engravers of the Eighteenth
Century, Biographical Notes ɔy Edmund Gosse (one of 100
numɔered copies on Japanese vell. paper), illustrations in
duplicate (some in colours), uncut, in case, Goupil and Co.,
1906, imp. 4to. (545) *Thorp,* £4 4s.
6529 Brough (R. B.) Life of Sir John Falstaff, first ed., in the
orig. 10 parts as issued, with the wrappers (part i. stained),
1857-58, roy. 8vo. (606) *Spencer,* £6
6530 Burke (J.) History of the Landed Gentry, ports. and coats-
of-arms, mor., g. e., presentation copy, 1837-38, 8vo. (396)
Walford, £1 8s.
6531 Burke (J. and J. B.) Encyclopædia of Heraldry, third ed.,
with Supplement, hf. mor., Bohn, n. d., roy. 8vo. (402)
Rimell, £1 4s.
6532 Burke (J. and J. B.) Extinct and Dormant Baronetcies,
coats-of-arms, hf. mor., 1838, 8vo. (403) *Hill,* 14s.
6533 Burke (Sir B.) Dormant and Extinct Peerages, plates of
arms, hf. mor., 1866, roy. 8vo. (404) *Thorp,* £2 16s.
6534 Burke (Sir B.) Royal Descents and Pedigrees of Founders'
Kin, pedigrees, hf. mor., g. e., 1858, roy. 8vo. (405)
Walford, 9s.
6535 Chatsworth Liɔrary, Catalogue of, compiled ɔy J. P. Lacaita,
LARGE PAPER, one of 50 copies, 4 vol., uncut, *Chiswick
Press,* 1879, folio (693) *Quaritch,* £2 2s.
6536 [Chatto (W. A.)] A Paper: Of Toɔacco, plates by "Phiz,"
hf. mor., 1839—[Hill (B. E.)] A Pinch—of Snuff, with
Review of Snuff, etc., by Dean Snift of Brazen-nose, plates
by Siɔson, hf. mor., 1840, together 2 vol., 1839-40, 8vo.
(585) *Hornstein,* 15s.
6537 Cokayne (George E.) Complete Peerage, 8 vol., vol. i. and
ii. hf. vell., the remainder as issued, 1887-98, 8vo. (475)
Thorp, £7 15s.
6538 Corolla Numismatica. Numismatic Essays in honour of
Barclay V. Head, port. and 18 plates, ɔuckram, t. e. g.,
1906, imp. 8vo. (409) *Quaritch,* 18s.

6539 Costello (Dudley). Holidays with Hoɔgoɔlins, first ed., illustrations ɔy G. Cruikshank, orig. cl., 1861, 8vo. (584)
Shepherd, 6s.

6540 Costume. Book of Historical Costumes, col. plates of costume, Cassell, n. d., folio (653) *Edwards,* £1 15s.

6541 Crane (Walter). Toy Books (5)—New Series, etc. (12), col. illustrations ɔy W. Crane, picture wrappers, 4to. (647)
Pickering, £3 18s.

6542 Cruikshank (G.) Basile (G.) The Pentamerone, trans. ɔy J. E. Taylor, first ed., illustrations, orig. cl., 1848, 8vo. (613)
Edwards, £1 14s.

6543 Cruikshank (The). The Comic Almanack, complete set, 1835-1853, illustrations, in parts and 2 vol. hf. mor., duplicate of 1851, together 14 vol. (614) *Spencer,* £8 5s.

6544 Cruikshank (G.) Bachelor's Own Book, first ed., 24 designs on 12 plates, orig. cover, 1844, oɔlong 8vo. (603)
Hornstein, £2 8s.

6545 Cruikshank (G.) Taɔle Book, ed. ɔy G. A. à'Beckett, first ed., illustrations ɔy G. Cruikshank, orig. cl., g. e., 1845, roy. 8vo. (607) *Cappes,* £3 10s.

6546 Cruikshank (G.) Fairy Liɔrary. Hop o' my Thumɔ, and the Seven League Boots, D. Bogue, n. d.—Jack and the Beanstalk, *ib.*, n. d.—Puss in Boots, Routledge and F. Arnold, n. d.—Cinderella and the Glass Slipper, D. Bogue, n. d., all first eds., in the orig. wrappers, fine copies, together 4 vol. (608) *Hornstein,* £12 10s.

6547 Cruikshank (G.) The Tooth-Ache, Imagined ɔy Horace Mayhew and Realized ɔy G. Cruikshank, 43 col. plates on folding sheet, and illustrated covers (ɔroken), D. Bogue, n. d., 8vo. (598) *Rimell,* £2

6548 Dante. Benvenuti de Rambaldis da Imola Commentum super Dantis Comœdiam, curante J. P. Lacaita, 5 vol., illustrations, *Florent.,* 1887, imp. 8vo. (476) *Maggs,* £1 3s.

6549 Dickens (C.) Child's History of England, first ed., front., 3 vol., orig. cl., 1852-3-4, 8vo. (639) *Spencer,* £1 18s.

6550 Dickens (C.) Christmas Books. Christmas Carol, first issue (with green end papers and "stave I."), 1843—The Chimes, 1845—Battle of Life, 1846—Cricket on the Hearth, 1846— Haunted Man, 1848, first eds., illustrations ɔy Leech, etc. (some col.), orig. cl., very good state, 8vo. (638)
J. Bumpus, £5 17s. 6d.

6551 Dickens (C.) Hard Times for these Times, first ed., 1854— Uncommercial Traveller, first ed., 1861, orig. cl., 8vo. (636)
Edwards, £2 5s.

6552 Dickens (C.) Memoirs of Grimaldi, edited by "Boz," first ed., illustrations ɔy G. Cruikshank, 2 vol., 1838, 8vo. (634)
Spencer, £4 5s.

6553 Duckëtt (Sir G. F.) Duchetiana, or Historical and Genealogical Memoirs of the Family of Duket, illustrations, hf. cf., presentation copy, 1874, 4to. (486) *Thurman,* £1 7s.

6554 Edmondson (J.) Historical and Genealogical Account of

the Family of Greville, etc., plates and pedigrees, hf. bd.,
uncut, 1766, roy. 8vo. (399) *Quaritch,* 9s.

6555 Foster (C. W.) History of the Wilmer Family, map, ports.,
etc., presentation copy, *Leeds, privately printed,* 1888, 4to.
(485) *Rimell,* £1 1s.

6556 France (Anatole). Vie de Jeanne d'Arc, facsimile plates in
gold and colours and other illustrations, one of 50 copies
on Japanese vellum paper, 4 vol., uncut, 1909, imp. 8vo.
(541) *Howell,* £5 5s.

Goupil's Historical Monographs, all in 4to.

6557 Mary Stuart, by John Skelton, ports. and illustrations, 1893
(548) *Edwards,* £3

6558 Queen Elizabeth, by Bp. Creighton, ports. and illustrations,
1896 (549) *Maggs,* £6 7s. 6d.

6559 Queen Victoria, by R. R. Holmes, ports. and illustrations,
1897 (550) *Maggs,* £1 1s.

6560 Charles I., by Sir John Skelton, ports. and facs., 1898 (551)
 Maggs, £2 2s.

6561 Oliver Cromwell, by S. R. Gardiner, ports., etc., 1899 (552)
 Maggs, £2 18s.

6562 Prince Charles Edward, by Andrew Lang, ports. and illustra-
tions, 1900 (553) *Maggs,* £2 2s.

6563 Charles II., by Osmund Airy, ports., 1901, (554)
 Maggs, £2 12s.

6564 Henry VIII., by A. F. Pollard, ports. and illustrations, 1902
(555) *Maggs,* £2 3s.

6565 The Electress Sophia, and the Hanoverian Succession, by
A. W. Ward, ports. and illustrations, 1903 (556)
 Maggs, £2 3s.

6566 James I. and VI., by T. F. Henderson, ports., 1904 (557)
 Maggs, £2 2s.

6567 Queen Anne, by Herbert Paul, ports. and illustrations, 1906
(558) *Maggs,* £2 2s.
[The above 11 lots were uniformly bound in cf. gt., uncut,
t. e. g., original wrappers inserted.—ED.]

6568 Henry VIII., by A. F. Pollard, fine paper, ports. and illustra-
tions, buckram, uncut, t. e. g., orig. wrapper bound up, 1902,
4to. (559) *Bain,* £2 2s.

6569 Oliver Cromwell, by S. R. Gardiner, ports., etc., orig.
wrapper, uncut, in case, 1899, 4to. (561) *Howell,* £1 12s.

6570 Prince Charles Edward, by Andrew Lang, uncut, in case,
Japanese vellum paper copy, with a duplicate set of ports.
and illustrations, 1900, 4to. (563) *Gilbert,* £1 10s.

6571 Gower (Lord Ronald S.) Sir Thomas Lawrence, LARGE
PAPER, duplicate series of 60 illustrations, one of 200
numbered copies, uncut, in case, Goupil and Co., 1900,
imp. 4to. (546) *Rimell,* £3 3s.

6572 Grego (J.) Rowlandson the Caricaturist, illustrations, 2 vol.,
hf. mor., 1880, 4to. (495) *Joseph,* £1 5s.

6573 Greuze (Jean-Baptiste). A Portfolio containing Ten Reproductions, printed from hand-coloured copper plates, executed ɔy F. Hanfstaengl, edition limited to 100 sets, 1906, folio (571) *J. Bumpus,* £5

6574 Hare (Aug. J. C.) Life and Letters of Baroness Bunsen, 2 vol., 1882—Walks in London, 2 vol., 1883—Southern Italy and Sicily, 1883—Cities of Northern Italy, 2 vol., 1884—Days near Rome, 2 vol., 1884—Memorials of a Quiet Life, with supplemental vol., 3 vol., 1876-84—Cities of Central Italy, 2 vol., 1884—Wanderings in Spain, 1885—Studies in Russia, 1885—Sketches in Holland and Scandinavia, 1885—Paris, 1887—Days near Paris, 1887—Walks in Rome, 2 vol., 1887—South Eastern, South Western and North Eastern France, 3 vol., 1890—Life and Letters of Maria Edgeworth, 2 vol., 1894—Story of Two Noꞁle Lives, 3 vol., 1893—Sussex, 1894, together 30 vol., ports., etc., uniform cf. ex., 1882-94, 8vo. (412) *Vincent,* £10 5s.

6575 Hogarth (William). Works, from the original plates, restored ɔy Heath (including "Before" and "After," in pocket at end), by John Nichols, hf. mor., g. e., Baldwin and Cradock, n. d., atlas folio (703) *Nattali,* £5
[A memorandum, inserted, states : "The impressions in the present copy are in the earliest state, after the plates had ꞁeen repaired ɔy James Heath, and many are proofs in the first state . . . Henry G. Bohn.—*Catalogue.*]

6576 Humphreys (H. Noel). History of the Art of Printing, first issue, 100 plates (some in colours), 1867, folio (654) *Edwards,* £1 18s.

6577 Hunt (Leigh). Jar of Honey from Mount Hyꞁla, first ed., illustrations ɔy R. Doyle, orig. fancy bds., g. e., fine copy, 1848, 8vo. (589) *Shepherd,* £1

6578 Jones (Owen). Alhamɔra, 102 plates (67 in gold and colours), 2 vol., hf. mor., g. e., *Published by Owen Jones,* 1842-45, folio (675) *Rimell,* £7 5s.

6579 Leslie (Col.) Historical Records of the Family of Leslie, 3 vol., *Edinb.,* 1869, 8vo. (398) *Quaritch,* 13s.

6580 Maitland (W.) History and Survey of London, plans and plates, 2 vol., old ɔinding, 1756, folio (696) *Andrews,* 12s.

6581 Master-Pieces of Dutch Art in English Collections, etchings ɔy P. J. Arundzen, artists' signed proofs, text by Dr. C. H. de Groot, complete in xii. parts (wrappers), in a portfolio, n. d. (573) *Howell,* £2 4s.

6582 Maxwell (Sir H.) History of the House of Douglas, col. plates and illustrations, 2 vol., 1902, 8vo. (397) *Thorp,* 7s.

6583 Mayhew (Aug.) Paved with Gold, first ed., illustrations ɔy H. K. Browne, in the 13 parts as issued, orig. wrappers and advertisements, 1857-58, 8vo. (621) *Spencer,* £2 4s.

6584 Mayhew (Henry). Adventures of Mr. and Mrs. Sandꞁoys, first ed., illustrations ɔy G. Cruikshank, in the orig. 8 parts as issued, with the wrappers and advertisements, 1851, 8vo. (622) *Zaehnsdorf,* £2 14s.

6585 Mayhew (Brothers). The Good Genius that turned everything into gold, first ed., illustrations ɔy G. Cruikshank, orig. cl., g. e. (1847), 8vo. (582) *Rimell*, 14s.
6586 Miller (Mrs. L. F.) A Day of Pleasure, 8 illustrations by H. K. Browne, orig. cl., 1853, 4to. (644) *Maggs*, 8s.
6587 Miscellanea Genealogica et Heraldica, New Series, vol. iv., 1884—Second Series, vol. iii.-v., 1888-93—Third Series, 5 vol., 1894-1902—Fourth Series, vol. i. and vol. ii., parts i.-iii., 1904-6, together 10 vol. and 3 parts, 4 vol. hf. cf., the remainder as issued, 1884-1906, imp. 8vo. (406)
Rimell, £1 14s.
6588 Mudford (William). Historical Account of the Campaign in the Netherlands, map, plans and col. plates ɔy Geo. Cruikshank and J. Rouse (several leaves stained), ɔuckram, uncut, 1817, 4to. (543) *Hornstein*, £15 10s.
6589 Nash (Joseph). Mansions of England in the Olden Time, with the orig. 104 illustrations, reduced and executed in lithography, by Samuel Stanesby, col. and mounted on cardɔoards, with vol. of Descriptive Text, together 5 vol., hf. mor., g. e., H. Sotheran and Co., 1869, folio (661)
Edwards, £11 15s.
6590 National Gallery (The) Portfolio, 80 plates, one of 105 copies, mor., t. e. g., 1901, folio (572) *Thorp*, £5 15s.
6591 Nelson (Lord). Letters to Lady Hamilton, with Supplement, 2 vol., hf. cf., 1814, 8vo. (425) *Howell*, 15s.
6592 Nordenskiöld (G.) The Cliff Dwellers of the Mesa Verde, South Western Colorado, their Pottery and Implements, trans. ɔy D. Lloyd Morgan, plates, *Stockholm*, 1893, folio (669) *Hill*, 16s.
6593 Parkinson (John). Paradisi in Sole Paradisus Terrestris, woodcut title and full-page woodcuts, orig. cf. (reɔacked), 1656, folio (568) *Ellis*, £7 5s.
6594 Petits Conteurs et Petits Poétes du XVIIIe Siècle, illustrations in 2 states, special signed copies, together 24 vol., hf. mor., t. e. g., *Paris*, Quantin, 1878, etc., 8vo. (539)
Lewine, £16 10s.
6595 Punch's Pocket Book for 1849 to 1860 (wanted 1856 and 1857), folding col. fronts. and plates ɔy Leech, 10 vol., roan with tuck, g. e., 1849-60, sm. 4to. (632) *Maggs*, £1 7s.
6596 Pyne (W. H.) History of the Royal Residences, 100 col. engravings, 3 vol., hf. mor., t. e. g. (specimen wrappers ɔound up at end), 1819, 4to. (542) *Edwards*, £17
6597 Ridlon (G. T.) History of the Ancient Ryedales and their Descendants in Normandy, Great Britain, Ireland and America, ports., plates, col. coats-of-arms, etc., cf. gt., g. e., *Manchester, N. H.*, 1884, roy. 8vo. (400) *Harding*, 16s.
6598 Roɔertson (Herɔert). Stemmata Roɔertson et Durdin, 48 copies printed, presentation copy, 1893-95, 4to. (526)
Quaritch, £2 6s.
6599 Rodwell (G. H.) Memoirs of an Umɔrella, first ed., 68 engravings by " Phiz," orig. cl. (1845), 4to. (645)
Shepherd, 7s.

6600 Ruskin (John). The King of the Golden River, first ed.,
 illustrations ɔy R. Doyle, orig. bds., g. e., 1851, 8vo. (630)
 Maggs, £5 2s. 6d.
6601 Seton (G.) The House of Moncrieff, one of 150 copies, col.
 plates, *Edinb., privately printed*, 1890, 4to. (523)
 Walford, £1 10s.
6602 Stodart (R. R.) Scottish Arms, reproduced in fac. (in
 colours), from contemporary manuscripts, LARGE PAPER,
 limited to 60 copies, hf. mor., uncut, t. e. g., *Edinb.*, W.
 Paterson, 1881, folio (662) *Howell, £4* 5s.
6603 Stourton Family. History of the Noɔle House of Stourton,
 of Stourton, Wilts, 100 copies printed, ports. and illustra-
 tions, 2 vol., mor., g. e., presentation copy, *Privately printed*,
 1899, 4to. (519) *Quaritch, £2* 18s.
6604 Thackeray (W. M.) The Kickleburys on the Rhine, first ed.,
 illustrations, orig. bds., clean copy, 1850, 8vo. (626)
 Spencer, £2
6605 Thackeray (W. M.) Mrs. Perkins's Ball, first ed., illustra-
 tions, orig. bds., ɔack gone, 1847, 8vo. (624) *Spencer, £1*
6606 Thackeray (W. M.) The Rose and the Ring, ɔy M. A.
 Titmarsh, first ed., illustrations, orig. bds., clean copy, 1855,
 8vo. (625) *Spencer, £4*
6607 Thackeray (W. M.) Reɔecca and Rowena, first ed., col.
 plates ɔy R. Doyle, orig. bds., g. e., clean copy, 1850, 8vo.
 (643) *Spencer, £2* 4s.
6608 Topsell (Edward). The Historie of Foure-Footed Beastes,
 engravings, orig. cf. (reɔacked), W. Jaggard, 1607, folio
 (567) *Quaritch, £13* 10s.
6609 Vacher (Sydney). Fifteenth Century Italian Ornament; 30
 large plates in colours, some heightened with gold, extra
 plate added, presentation copy, parchment cover gt., in case,
 Quaritch, 1886, folio (673) *Quaritch,* 15s.
6610 White (Gilɔert). Natural History and Antiquities of Sel-
 ɔorne, first ed., folding front. of the north-east view of Sel-
 ɔorne, and engravings (stained), orig. bds., uncut, 1789, 4to.
 (544) *Edwards, £17* 5s.
6611 White (J.) Journal of a Voyage to New South Wales, col.
 plates, uncut (title torn), 1790, 4to. (506) *Maggs, £1* 9s.
6612 Willoughɔy (Eliz. H. D.) Chronicles of the House of Wil-
 loughby de Eresby, ports., etc., hf. bd., 1896, folio (698)
 Quaritch, 14s.
6613 Willshire (W. H.) Introduction to the Study and Collection
 of Ancient Prints, second ed., 2 vol., plates, hf. bd., t. e. g.,
 1877, 8vo. (463) *Edwards, £1* 16s.
6614 Yeatman (J. P.) Early Genealogical History of the House of
 Arundel, front., etc., 1882, folio (699) *Walford,* 10s.

PUTTICK & SIMPSON.

A MISCELLANEOUS COLLECTION.

(No. of Lots, 617 ; amount realised, £898 9s.)

6615 Alken (H.) Alken's Scrap Book, col. plates, no title, cf., 1824,
4to. (290) *Murphy*, £4 15s.

6616 America. History of the War in America between Great
Britain and her Colonies from its commencement to 1778,
maps and list of the killed and wounded, 2 vol., cf., 1779-85,
8vo. (69) *H. Stevens*, £2 7s. 6d.

6617 Apperley (C. J.) Life of Mytton, col. etchings by Alken and
Rawlins, orig. green pictorial cl., g. e., Ackermann, 1851,
8vo. (200) *Bumpus*, £4 15s.

6618 Apperley (C. J.) Life of Mytton, first ed., 12 col. etchings by
H. Alken, no title, orig. cl., 1835, 8vo. (191) *Hornstein*, £4

6619 [Apperley (C. J.)] Life of a Sportsman, first ed., 36 col.
etchings by Henry Alken, orig. blue cl., g. e., 1842, 8vo.
(192) *Earl*, £32

6620 Army List of 1775 and 1848-9, together 2 vol., 8vo. (35)
Williams, £1 5s.

6621 [Ashbee (H. S.)] Index Librorum Prohibitorum, 1877—
Centuria Librorum Absconditorum, 1879—Catena Librorum
Tacendorum, 1885, 3 vol., rox. g. t., 4to. (255) *Thorp*, £13

6622 Barham (R. H.) Ingoldsby Legends, etchings by George
Cruikshank and others, 3 vol. (vol. ii. and iii. first eds.),
orig. cl., 1843-42-47, 8vo. (424) *Sotheran*, £4 7s. 6d.

6623 Barth (H.) Travels in North and Central Africa, tinted
plates, 5 vol., hf. mor., 1857-58, 8vo. (140) *Quaritch*, £1 10s.

6624 Baskerville Press. Virgilii Maronis Bucolica, Georgica et
Æneas, old mor., *Birminghamiae*, 1757, 4to. (266)
Leighton, £1 12s.

6625 Baskerville Press. Quintus Horatius Flaccus Opera, en-
graved front., mor., 1770, 4to. (267) *Hatchard*, £1 12s.

6626 Bewick (T.) History of British Birds, first ed., 2 vol., cf.,
1797-1804, demy 8vo. (405) *Thorp*, £1 1s.

6627 Billings (R. W.) Baronial and Ecclesiastical Antiquities of
Scotland, LARGE PAPER, plates on India paper, 4 vol.,
mor. ex., *Published by the Author*, n. d., 4to. (499)
Sotheran, £4 12s. 6d.

6628 Bruce (J.) Travels to Discover the Source of the Nile, plates,
5 vol., cf., 1790, 4to. (264) *Earl*, £1

6629 Butler (A. G.) Foreign Finches in Captivity, col. plates, in
10 parts, n. d., 4to. (248) *Hill*, £1 14s.

6630 Caldecott (J. W.) The Values of Old English Silver and
Sheffield Plate, plates, 1906, 4to. (243) *Millar*, £1 1s.

6631 Carey (David). Life in Paris, first ed., LARGE PAPER, 21
col. etchings ɔy G. Cruikshank, and woodcuts, mor., g. e.,
ɔy Zaehnsdorf, specimen wrapper ɔound in (no half title or
"Directions to Binder"), 1822, 8vo. (205) *Spencer,* £13

6632 Carlyle (T.) Works, Library ed., with Index, 34 vol., cl.,
1870-72, 8vo. (233) *Bain,* £16

6633 Cervantes (M.) Don Quixote, ɔy Jarvis, port. and plates, by
Stothard, 4 vol., mor., g. e., 1801, 8vo. (65)
 Bumpus, £4 11s.

6634 Cervantes (M.) Don Quixote, trans. ɔy C. Jarvis, 24 col.
engravings by Clark (one wanted in vol. ii.), 4 vol., bds.,
uncut, 1819, 8vo. (73) *G. H. Brown,* £4 12s. 6d

6635 Clarke (J. H.) Field Sports of the Native Inhaɔitants of New
South Wales, col. plates, orig. wrappers, 1813, 4to. (262)
 Maggs, £4 10s.

6636 Comɔe (W.) Tour of Dr. Syntax through London, col. etch-
ings, cl., uncut, with laɔel, 1820, 8vo. (190)
 Murphy, £1 7s. 6d.

6637 Comɔe (W.) Dr. Syntax in Paris, first ed., col. etchings ɔy
Williams, cf. ex., g. e., Wright, 1820, 8vo. (475) *Spencer,* £3

6638 Conway (Sir Martin). Great Masters, 1400-1800—Reproduc-
tions in Photogravure of the finest works of famous painters,
25 parts in cl. portfolio, 1903-4, folio (320) *Bailey,* £1 9s.

6639 D'Abrantes (Duchess). Memoirs of Napoleon, ports., 2 vol.,
cl., Bentley, 1836, 8vo. (135) *G. H. Brown,* £1 6s.

6640 Dickens (Charles). Nicholas Nickleɔy, first ed., port. and
etchings ɔy "Phiz," orig. cl., uncut, 1839, 8vo. (183)
 Karslake, £1

6641 Dickens (C.) Works, Library ed., illustrated by Cruikshank,
etc., 18 vol., hf. mor., g. t., 1858-59, 8vo. (53)
 F. Edwards, £2

6642 D'Imray (Comte). Bibliographie des Ouvrages relatifs a
L'Amour, hf. mor., t. e. g., 1871-3, 8vo. (82) *Reuter,* £1

6643 Donovan (E.) The Natural History of British Insects, 468
col. plates, 13 vol., bds., 1792-1813, 8vo. (356)
 G. H. Brown, £2 17s. 6d.

6644 D'Urfey (T.) Pills to Purge Melancholy, LARGE PAPER, 6
vol., bds., 1719 (reprint), 8vo. (252) *Hill,* £1 13s.

6645 Egan (Pierce). Life in London, first ed., col. etchings ɔy G.
and R. Cruikshank, no half title, mor. ex., 1821, 8vo. (201)
 F. Edwards, £4

6646 Egan (P.) Real Life in London, first ed., col. etchings by
Alken, Rowlandson and Dighton, 2 vol., mor. ex., 1821-22,
8vo. (202) *G. H. Brown,* £6

6647 Egan (P.) Finish to the Adventures of Tom, Jerry and
Logic, first ed., col. etchings and woodcuts ɔy R. Cruik-
shank, mor. ex., g. e.; Virtue, 1830, 8vo. (203)
 Hornstein, £12

6648 Egan (P.) Finish to the Adventures of Tom, Jerry and
Logic, col. plates ɔy R. Cruikshank, mor., g. t., Hotten,
n. d., 8vo. (204) *Hornstein,* £1 10s.

6649 Gardiner (S. R.) History of England, 2 vol., cl., very scarce, Hurst and Blackett, 1863—Prince Charles and the Spanish Marriage, 2 vol., cl., 1869—England under Buckingham, 2 vol., 1875—Personal Government of Charles I., 1877—Fall of the Monarchy, 3 vol., cl., 1882—History of the Great Civil War, 3 vol., cl., 1886-91—History of the Commonwealth and Protectorate, 3 vol., cl., and Supplement, 1897, together 16 vol., 8vo. (212-16) *Bumpus, £26*

6650 Geneste (J.) Some Account of the English Stage, 10 vol., cl., *Bath*, 1832, 8vo. (128) *F. Edwards, £7 15s.*

6651 Geyler (J.) Navicula, sive speculum Fatuorum, lit.. goth., woodcuts (some leaves wormed), old oak bds., partly covered with stamped pigskin, clasp, *Argent.*, 1511, 4to. (271) *Leighton, £2 12s. 6d.*

6652 Gibbon (E.) Roman Empire, 13 vol., cf., 1838-9, 8vo. (219) *Hill, £2 5s.*

6653 Gillray (Jas.) Works, from the original plates, including the volume of suppressed Caricatures, and the 8vo. Historical and Descriptive Account of the Caricatures, by Wright and Evans, Bohn, 1851, 3 vol., atlas folio, hf. mor. and 8vo. (615) *Sotheran, £3 3s.*

6654 Gray (T.) Works, ed. by Mitford, Pickering's Aldine ed., 4 vol., cl., 1836-43, 8vo. (124) *Hornstein, £1*

6655 Grose (F.) Antiquities of England and Wales, with the Supplement, LARGE PAPER, engravings, 8 vol., hf. cf., n. d., folio (611) *Sotheran, £1*

6656 Guillemard (F. H.) Cruise of the "Marchesa," maps, col. plates, etc., 2 vol., hf. mor., 1886, 8vo. (383) *Sotheran, £1 2s.*

6657 Hervey (Lord). Memoirs of the Reign of George the Second, fronts., 2 vol., cl., 1848, 8vo. (132) *Bain, £1 12s.*

6658 Hewitson (W. C.) Coloured Illustrations of the Eggs of British Birds, 2 vol., russ. (broken), Van Voorst, 1846, 8vo. (407) *Sotheran, £2 5s.*

6659 Hogarth (W.) Works, re-engraved by Cook, hf. mor., uncut, Stockdale, 1806, folio (614) *Sotheran, £3 12s. 6d.*

6660 Howard (M.) Old London Silver, plates, 1903, 4to. (242) *Batsford, £1 1s.*

6661 James (G. P. R.) Commissioner (The), etchings by "Phiz," in the original 14 parts in 13, with the illustrated wrappers (no back wrapper to last part), 1843, 8vo. (188) *Hornstein, £1 10s.*

6662 Jami. The Behâristan (Abode of Spring), a Literal Translation from the Persian, *Kama Shastra Society*, 1887, 8vo. (81) *Hector, £1 10s.*

6663 Kilburne (R.) Topographie of Kent, first ed., port. by Cross old cf., sound copy, 1659, 4to. (509) *Kilburn, £1*

6664 La Fontaine (J. de). Contes et Nouvelles en Vers, plates by Eisen (counterfeit of the Fermiers Generaux), 2 vol., cf., g. e., 1777, 8vo. (83) *Hatchard, £1 11s.*

6665 Lamb (Charles). Works, first collected ed., 2 vol., cl., uncut, Ollier, 1818, 8vo. (125) *F. Edwards, £3 5s.*

6666 Lavater (J. C.) Essays on Physiognomy, plates ɔy Holloway and Blake, and ports., including Washington, 5 vol., cf., g. e., 1789-98, 4to. (235) *Braun,* £2 5s.

6667 Le Brun (C.) La Grande Galerie de Versailles, 52 engravings ɔy Simoneau, etc., bds. (ɔroken), 1752, atlas folio (317) *Batsford,* £1 2s.

6668 Lever (Charles). The O'Donoghue, first ed., in the orig. 13 parts in 11, with wrappers (part i. defective), 1845, 8vo. (186) *Murphy,* £1 4s.

6669 Lever (C.) Our Mess, vol. ii. and iii., containing Tom Burke, etchings ɔy "Phiz," in the orig. 22 parts in 20, with the wrappers, not suɔject to return, 1841-4, 8vo. (187) *Murphy,* £1 7s. 6d.

6670 Livius. The Romane Historie Written, trans. by Philemon Holland, first ed., port. of Queen Elizaɔeth on ɔack of title, cf., Islip, 1600, folio (301) *Leighton,* £2

6671 Lory (G.) Voyage Pittoresque de L'Oberland Bernois, col. plates, hf. russ., 1822, folio (298) *F. Edwards,* £4 5s.

6672 Martial Achievements of Great Britain, 52 col. plates, hf. russ., Jenkins, 1815, 4to. (291) *Thorp,* £3 17s. 6d.

6673 Maxwell (W. H.) Fortunes of Hector O'Halloran, etchings ɔy Leech, in the orig. 13 parts with the wrappers, no ɔack wrapper to last part, Bentley, n. d., 8vo. (189) *Spencer,* £1 10s.

6674 Milton (John). Poetical Works, ed. ɔy Sir E. Brydges, fronts. and vignettes ɔy Turner, 6 vol., cl. (wanted vol. ii.), 1835, 8vo. (126) *Maggs,* £2 5s.

6675 Monmouth's Reɔellion. A List of the Names of the Reɔels that were executed at Lyme, Bridport, Weymouth, etc. (defective), 1686—London—Proceedings of the President and Governors for the Poor of the City of London, 1700—Overture for Preserving of Bread and Relieving the Poor. One Tax for all Taxes—Dr. Chamberlen's Proposal for a Land-Bank, and other XVIIth and XVIIIth century folio tracts and broadsides relating to Trade and Currency, in portfolio (604) *Leon,* £22

6676 Nerciat. Le Diaɔle au Corps, LARGE PAPER, 3 vol., mor. ex., 1865, imp. 8vo. (86) *Roberts,* £1 15s.

6677 Oliver (G.) History of the Town and Minster of Beverley, plates, LARGE PAPER, hf. cf., 1829, 4to. (494) *Sotheran,* £2

6678 Orme (E.) Historic Military and Naval Anecdotes, 40 col. plates, puɔlisher's hf. mor., with laɔel, 1819, 4to. (292) *Jones,* £4 15s.

6679 Pardoe (Miss). Court and Reign of Francis the First, first ed., fronts., 2 vol., cl., 1849, 8vo. (134) *F. Edwards,* £1 7s. 6d.

6680 Piranesi. Le Antichita Romane, 4 vol., 1756—Antichita d' Alɔani, Il Campo Marzio, 7 vol., hf. russ., uncut, *Roma,* 1756, etc., folio (316) *Hill,* £8

6681 Pratt (Anne). The Flowering Plants, Grasses, Sedges and Ferns of Great Britain, revised ɔy Step, 315 col. plates, 4 vol., hf. cf., n. d., 8vo. (404) *Josephs,* £1 10s.

6682 Punch, vol. i. to xxvii., orig.)rown cl., 1841-54, 4to. (247)
McIntosh, £2 10s.
6683 Purchas (S.)˙ Purchas his Pilgrimage, contemp. cf., 1614,
folio (296) *Harding,* £1 6s.
6684 Reynolds (G. W. M.) Mysteries of the Court of London, the
4 series complete, 8 vol.—Mysteries of London, 4 vol.,
illustrations, together 12 vol. cl., n. d. (470) *Bain,* £2 5s.
6685 Richardson (W.) Monastic Ruins of Yorkshire, large col.
lithos in imitation of water-colour drawings and numerous
engravings of plans, etc., su)scription copy, with the orna-
mental capitals coloured, 2 vol., hf. mor. (ru))ed and
)roken), 1843, imp. folio (613) *G. H. Brown,* £3 12s. 6d.
6686 Rowlandson (T.) Naples and the Campagna Felice ()y
Engel)ach), col. plates, hf. mor., 1815, 8vo. (184)
Bumpus, £2 10s.
6687 Ruskin (J.) Modern Painters, illustrations, 5 vol., hf. mor.,
g. e., 1851-60, 8vo. (29) *Harding,* £3 10s.
6688 Salvin (F. H.) and Brodrick (W.) Falconry in the British
Isles, col. plates, cl., Van Voorst, 1855, 8vo. (415)
Sotheran, £5 7s. 6d.
6689 Saville-Kent (W.)˙ The Naturalist in Australia, col. plates,
1897, 4to. (491) *Thorpe,* £1 8s.
6690 Scott (Sir W.) Waverley Novels, fronts. and vignettes, 48
vol., cl., 1854-7, 8vo. (232) *Earl,* £1 7s. 6d.
6691 Scrope (W.) Art of Deer Stalking, engravings, etc. after
Landseer, cl., 1839, 8vo. (413) *Sotheran,* £1 17s. 6d.
6692 Scrope (W.) Days and Nights of Salmon Fishing in the
Tweed, first ed., lithos., etc. after Landseer, orig. cl., 1843
(414) *Hornstein,* £6 5s.
6693 Shakespeare (W.) .Comedies, Histories and Tragedies ()y
E. Capell), 10 vol.—Also Prolusions, 1760, together 11 vol.,
old mor., g. e., Tonson, 1767-8, 8vo. (122) *Quaritch,* £3
6694 Shakespear's Works, including the Poems, with Life)y
Rowe, plates)y Du Guernier, 9 vol., old cf., Tonson, 1719,
8vo. (40) *Andrews,* £1
6695 Sower)y (Jas.) British Wild Flowers, col. plates, hf. mor.,
1863, 8vo. (416) *Weldon,* £1 14s.
6696 Sterne (Laurence). Works, port., 10 vol., cf., 1780, 8vo. (66)
Hill, £1
6697 Stevenson (H.) Birds of Norfolk, 3 vol., cl., 1866-90.—
Ba)ington (C.) Catalogue of the Birds of Suffolk, 1884-96,
together 4 vol., 8vo. (409) *Thorpe,* £2
6698 [Surtees (R. S.)] Analysis of the Hunting Field, first ed.,
col. etched title and 6 col. etchings by H. Alken, orig.
green pictorial cl., g. e., 1846, 8vo. (193) *F. Edwards,* £9
6699 [Surtees (R. S.)] Mr. Sponge's Sporting Tour, first ed., col.
etchings and woodcuts)y Leech, orig. cl., 1853, 8vo. (194)
Quaritch, £5 15s.
6700 [Surtees (R. S.)] Handley Cross or Mr. Jorrocks's Hunt,
first ed., full-page etchings and woodcuts)y John Leech,
orig. cl. (title short at foot), 1854, 8vo. (195)
Hornstein, £10 2s. 6d.

6701 [Surtees (R. S.)] "Ask Mamma," first ed., col. etchings and woodcuts ɔy Leech, orig. cl., 1858, 8vo. (196)
Bumpus, £4 12s. 6d.
6702 [Surtees (R. S.)] Plain or Ringlets, first ed., col. etchings and woodcuts ɔy Leech, orig. cl., 1860, 8vo. (197)
Spencer, £5 10s.
6703 Surtees (R. S.) Mr. Facey Romford's Hounds, first ed., col. etchings ɔy Leech, orig. cl., 1865, 8vo. (198)
Bumpus, £4 12s. 6d.
6704 Surtees (R. S.) Hillingdon Hall, 12 etchings ɔy Wildrake, Heath and Jellicoe, col. ɔy hand, orig. cl., 1888, 8vo. (199)
Quaritch, £3 15s.
6705 Talɔot (E. A.) Five Years' Residence in the Canadas, fronts., 2 vol., bds., 1824, 8vo. (68) *Grant,* £1 3s.
6706 Tennyson (A., Lord). In Memoriam, first ed., orig. cl., Moxon, 1850, 8vo. (451) *Shepherd,* £3 2s. 6d.
6707 The Whole Booke of Davids Psalmes, with apt notes to sing them withall, contemp. needlework ɔinding in silver wire and silks, 1611, 8vo. (480) *Quaritch,* £7 5s.
6708 Thornton (A.) Don Juan, and Don Juan in London, 31 col. etchings, 2 vol., orig. cf., 1821-1822, 8vo. (180)
Hornstein, £10 5s.
6709 Turner (Sharon). History of England, 12 vol., cf., 1839, 8vo. (217) *Earl,* £1 17s. 6d.
6710 Veneres uti Observantur in Gemmis Antiquis, plates, mor., g. e., *Lugd. Bat.,* n. d., 8vo. (84) *Menel,* £1 17s. 6d.
6711 Virgilius. Bucolica, Georgica et Æneis, mor., g. e., *Birminghamiæ, typis Johannis Baskerville,* 1769—Virgil, another ed., mor., *Edinburgh,* 1743, 8vo. (104) *Bain,* £1 14s.
6712 Walker (G.) Costume of Yorkshire, 40 col. engravings, orig. hf. mor., uncut, 1814, 4to. (497) *F. Edwards,* £6 7s. 6d.

[MAY 9TH AND THREE FOLLOWING DAYS, 1910.]

SOTHEBY, WILKINSON & HODGE.

THE LIBRARIES OF THE LATE MR. FRANCIS MARION CRAWFORD AND OF THE LATE MR. JOSEPH THOMPSON, OF WILMSLOW, CHESHIRE.

(No. of Lots, 1143; amount realised, £2,606 1s. 6d.)

(a) *Mr. Crawford's Library (Lots 1-400, realising £602 2s.)*

6713 America. The Charter granted by His Majesty, King Charles II., to the Governor and Company of the English Colony of Rhode-Island, and Providence-Plantations, in New-England, in America, inscription on fly-leaf: "The Gift of Samuel Ward to his honest and worthy Friend,

Thos. Hu)ɔart, S.W." (some leaves stained, four prelim-
leaves wrongly)ound up), limp vell., *Newport, Rhode
Island, printed by the Widow Franklin,* 1744, folio (363)
*Quaritch, £*10 5s.
[J. O. Austin's "Genealogical Dictionary of Rhode
Island," 1887, 4to., was included.—ED.]

6714 Anthologia Graeca, curavit Epigrammata in Codice Palatino
desiderata, et Annotationem Criticam adjecit Fr. Jacoɔs,
3 vol., hf. mor., *Lipsiae,* 1813-17, 8vo. (12) *Hunt, £*1 2s.

6715 Arnold (Dr. T.) Works. History of Rome,)oth series, the
Early History and the later Commonwealth, Sermons, etc.,
14 vol., hf. cf. gt., 1843-5, 8vo. (14) *Joseph,* 11s.

6716 Bacon (Francis). Works, by James Spedding and others,
port., 7 vol., uncut, 1877-79, 8vo. (16) *G. H. Brown, £*2 6s.

6717 Bancroft (George). History of the United States, ports.
(spotted), maps and illustrations, 6 vol., hf. cf: gt., *Boston,*
1854-74, 8vo. (18) *Sawyer,* 9s.

6718 Bartlett (John). Concordance to the Dramatic Works of
Shakespeare, 1896, 4to. (324) *Thorp,* 16s.

6719 Bartlett (J. R.) Explorations in Texas, map, plates and
woodcuts, 2 vol., hf. cf. gt., *New York,* 1854—Mayne (Com-
mander). Four Years in British Columɔia, map and illus-
trations, uncut, 1862, together 3 vol., 8vo. (19)
*Sotheran, £*1 8s.

6720 Bartsch (Adam). Le Peintre Graveur, plates, 21 vol. in 17,
hf. bd. (defective), *Leipzig,* 1854-21—Supplément, par R.
Weigel, vol. i. (all puɔlished), hf. bd., g. e., *ib.,* 1843, 8vo.
(20) *Quaritch, £*5 2s. 6d.

6721 Bianchini (Guiseppe). Delle Magnificenze di Roma, plates,
7 vol., vell., *Roma,* 1747-56, oɔlong folio (365) *Baker, £*1 2s.

6722 Biɔle (Holy), with the Apocrypha, and Annotations, plates,
russ., *Birm.,* John Baskerville, 1769, folio (366)
Crawshaw, 19s.

6723 Biographie Universelle, ancienne et moderne, 52 vol. cf.,
1811-28, 8vo. (23) *Barrow, £*1 6s.

6724 Blake (William). Life, by Gilchrist, illustrated chiefly on
India paper, 2 vol., cl., uncut, 1880, 8vo. (25)
*Edwards, £*2 4s.

6725 Blanc (Charles). L'Œuvre de Remɔrandt, 3 vol., with Atlas
of large plates, the etchings in the 4 vol. are in two states,
on Holland and Japan paper, hf. mor., uncut, t. e. g. (de-
fective), *Paris,* Quantin, 1880, folio (368) *Maggs, £*7 15s.

6726 Blavatsky (H. P.) Isis Unveiled, port., 2 vol., cl., *New York,*
1882 (26) *Barrow, £*1 12s.

6727 Bon Gaultier. Book of Ballads, first ed., illustrated by
Crowquill, Leech and Doyle, mor. ex., W. Blackwood, n.d.,
sq. 8vo. (27) *Sotheran,* 16s.

6728 British Poets, Pickering's orig. Aldine ed., by Sir Harris
Nicolas and others, ports. (stained), 52 vol., cf. gt., all
faults, Pickering, 1835, etc. (34) *Hornstein, £*13 10s.

6729 Brontë (Charlotte, Emily and Anne). Works, 12 vol., hf. cf.,
uncut, t. e. g., 1899-1901, 8vo. (36) *G. Harrison, £*2 8s.

31—2

6730 Browning (Rojert). Poetical Works, port., 16 vol., cl., uncut,
 1888-9, 8vo. (38) *Alison, £2 4s.*
6731 Brugsch-Bey (Dr. Henry). History of Egypt under the
 Pharaohs, jy P. Smith, second ed., maps and illustrations,
 2 vol., cl., uncut, 1881, 8vo. (39) *Sotheran, 13s.*
6732 Brunet (J. C.) Manuel du Libraire et de l'Amateur de
 Livres, cinquième éd., avec le Supplément, 2 vol. in 1,
 together 7 vol., hf. mor., uncut, 1860-80, 8vo. (40)
 Virgin, £10 12s. 6d.
6733 Calhoun (John C.) Works, 4 vol., hf. cf., *New York*, 1854-57,
 8vo. (49) *Maggs, 11s.*
6734 Carlyle (Thomas). Works, The Ashburton ed., port., 17 vol.,
 orig. cl., uncut, 1885-6, 8vo. (54) *Edwards, £4 6s.*
6735 Chesterfield (Earl). Letters, by Lord Mahon, port., 4 vol.,
 hf. cf. gt., 1845-53, 8vo. (57) *G. H. Brown, 19s.*
6736 Clark (J. W.) The Care of Books, illustrations, 1901—Kunz
 (G. F.) Gems and Precious Stones of North America, col.
 plates and engravings, presentation copy, 1892, together
 2 vol., imp. 8vo. (59) *Virgin, £1 16s.*
6737 Coleridge (S. T.) Works, ed. jy Hartley Coleridge and
 others, 19 vol., cf. gt., Pickering and Moxon, 1849-52, etc.,
 8vo. (60) *Maggs, £3 12s.*
6738 Contes et Nouvelles en Vers, par. Voltaire, Vergier, Perrault
 and others, vignette illustrations, 2 vol., hf. mor., uncut,
 t. e. g., *Genève*, 1804, 8vo. (61) *Tregaskis, £1 2s.*
6739 Cooper (J. Fenimore). Novels, new ed., 33 vol., hf. cf. gt.,
 1852, 8vo. (62) *A. Jackson, £1 11s.*
6740 Coppée (François). Œuvres complètes : Prose, Poésie, et
 Théâtre, together 10 vol., port. and plates, hf. mor., 1885,
 8vo. (63) *Bain, £1 16s.*
6741 Crawford (Francis Marion). Ave Roma Immortalis, éd. de
 luxe, map and illustrations, 2 vol., one of 150 copies,
 buckram, uncut, t. e. g., 1898, 8vo. (66) *Sotheran, £2 5s.*
6742 Crawford (F. M.) The Rulers of the South : Sicily, Calabria,
 Malta, LARGE PAPER, 100 illustrations, the full-page ones
 India proofs, 2 vol., one of 150 numbered copies, silk
 binding, uncut, t. e. g., 1900, 8vo. (67) *Sotheran, £1 12s.*
6743 D'Arblay (Madame). Diary and Letters [1778-1840], (ports.
 and titles stained), 7 vol., hf. cf. gt., 1854, 8vo. (70)
 Maggs, £1 10s.
6744 Daru (P.) Histoire de la République de Vénise, seconde
 édition, maps, 8 vol., hf. cf. gt., uncut, t. e. g., 1821, roy. 8vo.
 (71) *Baker, £1 5s.*
6745 De Mas Latrie (Comte de). Trésor de Chronologie d'Histoire
 et de Géographie, hf. vell., *Paris*, 1889, folio (374)
 Hill, £2 12s.
6746 De Quincey (Thomas). Works, port., 17 vol., hf. cf. gt., 1854,
 8vo. (74) *Hill, £1 16s.*
6747 Dibdin (Charles). Tour through almost the whole of Eng-
 land, aquatinta views and vignettes, 2 vol., hf. russ. (defec-
 tive), 1801-2, 4to. (330) *Thorp, 14s.*
6748 Dibdin (T. F.) Bibliotheca Spenceriana, 4 vol. — Aedes

Althorpianae, facs. of woodcuts, orig. impressions, together 6 vol. in 5, mor., g. e., 1814-22, imp. 8vo. (75)
Thorp, £4 2s. 6d.

6749 Dibdin (T. F.) Bibliomania, front. and illustrations, mor., g. e., Bohn, 1842, roy. 8vo. (76) *Sotheran*, £1 5s.

6750 Di Marzo (Gioacch.) Delle Belle Arti in Sicilia, illustrations, 4 vol., *Palermo*, 1858-64, imp. 8vo. (79) *B. F. Stevens*, £1 4s.

6751 Dodsley (Robert). Select Collection of Old English Plays, by W. C. Hazlitt, 15 vol., uncut, 1874-76, 8vo. (80)
Bain, £7 5s.

6752 Dramatists of the Restoration, ed. by J. Maidment and Logan, complete in 14 vol., uncut, 1872-79, 8vo. (81).
Edwards, £2 14s.

6753 Du Cange (C. D., Dom.) Glossarium Mediae et Infimae Latinitatis, plates, 7 vol., hf. cf., *Parisiis*, 1840-50, 4to. (331)
Picard, £11

6754 Dumas fils (Alexandre). Théâtre complêt, 8 vol., 1890— Théâtre complêt de Emile Augier, 7 vol., 1892, hf. mor. gt., t. e. g. (83) *Barrow*, £1 10s.

6755 Edwards (E.) Life of Sir Walter Raleigh, port. and facs., 2 vol., hf. mor., uncut, t. e. g., 1868, 8vo. (85) *Maggs*, 16s.

6756 Egypt Exploration Fund. Graeco-Roman Branch. The Oxyrhynchus Papyrie, in vi. parts, ed. by B. P. Grenfell and A. S. Hunt, plates and facs., 6 vol., 1898-1908, 4to. (332)
Hill, £3 13s.

6757 Fielding (Henry). Works, by Leslie Stephen, éd. de luxe, port. and illustrations on India paper, 10 vol., buckram, uncut, one of 250 numbered copies, 1882, imp. 8vo. (89)
Sawyer, £1 12s.

6758 Ford (John). Dramatic Works, ed. by W. Gifford, 2 vol., uncut, 1827, 8vo. (90) *A. Jackson*, 11s.

6759 Franklin (Benjamin). Works, with Notes and a Life of the Author, by Jared Sparks, ports., 10 vol., hf. cf. gt., *Boston*, 1840, 8vo. (93) *Sotheran*, £2

6760 Froissart (Sir John). Chronicles of England, etc., trans. by Thomas Johnes, engravings, 2 vol., uncut, 1839, imp. 8vo. (95) *Maggs*, £1 2s.

6761 Goncourt (Journal des) [1851-95], 9 vol., hf. vell., 1906, 8vo. (102) *Bain*, £1 3s.

6762 Granger (J.) Biographical History of England, illustrated with the ports. pub. by Richardson, 4 vol., russ. (broken), 1804-6, 8vo. (103) *Braun*, £1 19s.

6763 Green (J. R.) History of the English People, with 8 maps, 4 vol., 1878-80, 8vo. (104) *Maggs*, £1 12s.

6764 Gray (Thos.) Poems, first ed., hf. cf., large copy, first collected ed., *Glasgow*, R. and A. Foulis, 1768, 4to. (337)
B. F. Stevens, 10s.

6765 Hamilton (Alexander). Works, ed. by John C. Hamilton, 7 vol. (several leaves water-stained), hf. cf. gt., *New York*, 1851, 8vo. (114) *Maggs*, £1 4s.

6766 Hare (A. J. C.) The Story of Two Noble Lives, ports. and illustrations, 3 vol., orig. cl., 1893, 8vo. (116) *Sotheran*, 10s.

6767 Havard (Henry). Dictionnaire de l'Ameublement et de la Décoration, illustrations, some in colours, 4 vol., hf. mor., t. e. g., *Paris*, n. d., 4to. (339) *Quaritch*, £4 10s.

6768 Herodotus (History of), a new English Version, ed. by George Rawlinson, maps and illustrations, 4 vol., cf. gt., 1862, 8vo. (123) *Walford*, £2

6769 Hildreth (Richard). History of the United States, 6 vol., hf. cf. gt., *New York*, 1856, 8vo. (124) *Grant*, 14s.

6770 Hoffbauer (M. F.) Paris à travers les Ages, col. and other illustrations and plans, 2 vol., hf. vell., *Paris*, 1875-82, folio (383) *Rimell*, £3 3s.

6771 Hottenroth (Fed.) Historia General del Arte—Historia del Traji, col. and other illustrations, 2 vol., ornamental silk binding, g. e., *Barcelona*, 1893, 4to. (340) *Batsford*, £2 14s.

6772 Hugo (Victor). Œuvres complètes, "Édition Definitive d'après les Manuscrits Originaux," 48 vol., hf. mor., t. e. g., n. d., 8vo. (130) *Hornstein*, £16

6773 Hugo (V.) Œuvres, Poésie, 18 vol., 1880, etc.—Choses Vues, 1887, vell., t. e. g., uniform, 8vo. (131) *Bain*, £2

6774 Initials and Miniatures of the IXth, Xth and XIth Centuries, from the Mozarabic Manuscripts of Santo Domingo de Silos in the British Museum, with introduction by A. M Huntington, fac. reproduction in colours, t. e. g., 1904, imp. 4to. (384) *Edwards*, £2 18s.

6775 Irving (Washington). Works, engravings, 16 vol., hf. cf. gt., *New York*, 1854-55, 8vo. (136) *Sotheran*, £2 10s.

6776 Jefferson (Thomas). Writings, published from the original MSS., by H. A. Washington, port. and facs., 9 vol., hf. cf. gt., *New York*, 1854, 8vo. (142) *Maggs*, £1 5s.

6777 Jesse (J. H.) George Selwyn, ports., 2 vol., 1882, 8vo. (143) *Maggs*, £1 4s.

6778 Johnson (Dr. Samuel). Works, including Debates in Parliament, Oxford Classic ed., port. (stained), 11 vol., hf. cf. gt., *Oxford*, 1825, 8vo. (144) *Maggs*, £1 5s.

6779 Lamb (Charles). Works, port. (stained), 4 vol., hf. cf. gt., Moxon, 1850, 8vo. (150) *Maggs*, 12s.

6780 Lavisse (Ernest) et Rambaud (A.) Histoire Générale du IVe Siècle à nos jours, 12 vol., hf. mor., 1896-1901, 8vo. (154) *Hill*, £5 5s.

6781 Lear (Edward). Journals of a Landscape Painter in Albania, etc., uncut, 1851—Journals in Southern Calabria, etc., half mor., t. e. g., 1852—Journal in Corsica, uncut, 1870, tinted and other illustrations, imp. 8vo. (156) *Bain*, 15s.

6782 Legouvé (Ernest). Soixante Ans de Souvenirs, 4 vol., hf. mor., uncut, t. e. g., n. d., 8vo. (158) *Bain*, 12s.

6783 Lingard (John). History of England, fifth ed., port., 10 vol., hf. cf. gt., Dolman, 1849, 8vo. (159) *Baker*, £2 4s.

6784 Liber (Le). Pontificalis, par l'Abbé L. Duchesne, facs., 2 vol., hf. mor., t. e. g., 1886-92, 4to. (345) *Baker*, £8 5s.

6785 Litta (Pompeo). Famiglie Celebri Italiane, vol. i. to x., in hf. mor., t. e. g., and Nos. 1 to 39 (seconde série) in the orig. wrappers—A Series of Pedigrees, several thousand engrav-

ings of medals, sculptures, paintings, etc., the ports. coloured and coats-of-arms emblazoned, not subject to return, *Milano, etc.*, 1819-1908, folio (389) *Maggs*, £23 10s.

6786 Littré (E.) Dictionnaire de la Langue Française, avec le Supplément, 5 vol., hf. mor., 1882-83, 4to. (346)
Maggs, £2 10s.

6787 Mabillon (Johannes) de Re Diplomatica, cum Supplementa, editio tertia et nova, fac. plates, etc., 2 vol., vell., *Neapoli*, 1789, folio (390) *Harding*, £1 1s.

6788 Mau (August). Pompeii, its Life and Art, trans. by Professor Kelsey, illustrations, hf. bd., uncut, t. e. g., 1899, roy. 8vo. (173) *Edwards*, 10s.

6789 Maupassant (Guy de). Romans, Nouvelles, Voyages et Théâtre, 19 vol. vell. (1 vol. hf. vell.), 1894, 8vo. (174)
Bain, £2 12s.

6790 Mazzini (Guiseppe). Scritti, editi e inediti, 18 vol., hf. bd., *Milano*, 1897, 8vo. (176) *Hill*, £2 2s.

6791 Montaigne. Essays, trans. by Chas. Cotton, ed. by W. C. Hazlitt, port. and fronts., 3 vol., uncut, 1877, 8vo. (183)
Zaehnsdorf, £1 10s.

6792 Montagu (Lady M. W.) Letters and Works, ed. by Lord Wharncliffe, third ed., ports. (spotted), 2 vol., hf. cf. gt., 1861, 8vo. (184) *Rimell*, £1 7s.

6793 Moore (Thomas). Poetical Works, ports., fronts. and vignettes (spotted), 10 vol., cf. gt., m. e., 1853, 8vo. (185)
Maggs, £1 14s.

6794 Morley (John). Life of Gladstone, ports., 3 vol., uncut, t. e. g., 1903-5, 8vo. (187) *Bain*, £1 2s.

6795 Moroni (G.) Dizionario di Erudizione Storico-Ecclesiastica, 103 vol. in 53 vol., *Venezia*, 1840-61—Index to the work, 6 vol., *ib.*, 1878-9, together 59 vol., hf. vell., 1840-79, 8vo. (188) *Baker*, £4 4s.

6796 Museo (Real). Borbonico (descritto da Pistolesi) Atlante, e Tavole, plates, in 15 vol., hf. bd., *Napoli*, 1824-52, 4to. (351) *Baker*, 18s.

6797 Oliphant (Mrs.) The Makers of Florence and the Makers of Venice, extra illustrated with ports. and reproductions, 2 vol., uncut, t. e. g., uniform, 1891-2, 8vo. (200) *Hill*, £1 6s.

6798 Oliphant (Mrs.) The Makers of Modern Rome, illustrations, orig. cl., t. e. g., 1895, 8vo. (201) *Edwards*, 9s.

6799 Papinius (P. Statius). Opera, quae extant Joh. Bernartius ad Libros Veteres recensuit, contemp. French mor., covered with semis of fleurs-de-lis, arms in centres, surrounded by inscription : "Jo. Genest. Proton. Apos. Archid. Offic. Niver. 1614" (Clovis Eve), well preserved, *Antw.*, Martinus Nucius, 1607, 8vo. (208) *Edwards*, £5 10s.

6800 Passavant (J. D.) Le Peintre-Graveur, port. and monograms, 6 vol., hf. vell., *Leipsic*, 1860-4, 8vo. (211) *Bain*, £2 4s.

6801 Peel (Sir Robert). Speeches delivered in the Commons, with General Index, 4 vol., hf. cf. gt., 1853, 8vo. (213)
Walford, £2 2s.

6802 Pepys (Samuel). Diary, ɔy H. B. Wheatley, ports. and
illustrations, 8 vol., ɔuckram, uncut, t. e. g., 1893-6, 8vo. (214)
Shepherd, £2 11s.

6803 Plato. Dialogues, translated ɔy Prof. Jowett, second ed.,
5 vol., uncut, *Oxford*, 1875, 8vo. (219) *Bain*, £2 8s.

6804 Prescott (W. H.) Works. Ferdinand and Isaɔella, 3 vol.—
Conquest of Mexico, 3 vol.—Conquest of Peru, 2 vol.—
History of Philip the Second, 3 vol., together 11 vol.,
Liɔrary ed. (ports. and a few leaves stained), hf. cf. gt.,
1854-6, 8vo. (223) *Clementson*, £2 10s.

6805 Ralegh (Sir Walter). Works, ɔy Oldys and Birch, 8 vol., hf.
cf. gt., *Oxford*, 1829, 8vo. (225) *Bain*, £3 10s.

6806 Renan (Ernest). Histoire du Peuple d'Israel, 5 vol., 1887—
Vie de Jésus, 1893—Les Evangiles, 1877—Saint Paul,
1888, together 8 vol., vell., t. e. g., 8vo. (227) *Bain*, £1 18s.

6807 Reumont (Alfred von). Geschichte der Stadt Rom, 3 vol.,
hf. vell., *Berlin*, 1867, 8vo. (228) *Hunt*, £1 4s.

6808 Richardson (Samuel). Works, ɔy Mangin (port. and many
leaves stained), 19 vol., cf. (defective), 1811, 8vo. (231)
G. H. Brown, £2 8s.

6809 Romanin (S.) Storia Documentata di Venezia, 10 vol., hf.
vell., *Venezia*, 1853, 8vo. (237) *Picard*, £1 8s.

6810 Rose (H. J.) New General Biographical Dictionary, 12 vol.,
hf. cf., 1853, 8vo. (238) *Barrow*, 17s.

6811 Rousseau (J. J.) Collection complette des Œuvres, 34 vol.,
cf., g. e., 1782-89, 8vo. (240) *Edwards*, £1 13s.

6812 Roxɔurgh Cluɔ. The Old English Versions of the Gesta
Romanorum, ed. by Sir F. Madden, hf. mor., t. e. g., 1838,
4to. (355) *Bain*, £2 14s.

6813 Schmidt (Dr. A.) Shakespeare-Lexicon, 2 vol., hf. russ.,
1874, 8vo. (250) *Hill*, 12s.

6814 Shakespeare (William). Works, the Plays edited from the
Folio of MDCXXIII., ɔy Richard Grant White, 12 vol., hf.
bd., uncut, t. e. g., *Boston*, Little, Brown and Co., 1866, 8vo.
(260) *Grant*, £1 10s.

6815 Smith (Dr. W.) Dictionary of Greek and Roman Anti-
quities—Greek and Roman Biography and Mythology—
Greek and Roman Geography, together 6 vol., hf. bd. and
cl., 1842-78, 8vo. (267) *Joseph*, £1 3s.

6816 Sophocles. The Plays and Fragments, with Critical Notes,
etc., ɔy Prof. Jeɔɔ, in 7 parts, *Cambridge*, 1902, 8vo. (270)
Bain, £2 4s.

6817 Stevenson (Roɔert Louis). Novels and Tales, illustrations,
22 vol. (with a duplicate of vol. xviii.), together 23 vol.,
ɔuckram, uncut, t. e. g., *New York*, Scriɔner, 1894-98, 8vo.
(275) *Edwards*, £3 12s.

6818 Stirling (William). Annals of the Artists of Spain, first ed.,
ports. and illustrations, 3 vol., orig. cl., 1848, 8vo. (278)
Maggs, £2 8s.

6819 Stirling-Maxwell (Sir W.) Don John of Austria, .wood
engravings, 2 vol., uncut, 1883, imp. 8vo. (279) *Maggs*, 11s.

6820 Swift (Dean). Works, ɔy Sir Walter Scott, second ed., port., 19 vol., hf. cf., *Edinb.*, 1824, 8vo. (284) *Quaritch*, £7 5s.

6821 Tallemant des Reaux (G.) Historiettes, par MM. de Monmerqué et Paulin Paris, 6 vol., hf. mor., uncut, t. e. g., 1854-60, 8vo. (285) *Braun*, £1 11s.

6822 Taylor (T.) Two Orations of the Emperor Julian, trans. ɔy Thomas Taylor, hf. mor., t. e. g., 1793, 8vo. (289) *Edwards*, 13s.

6823 Taylor (T.) Five Books of Plotinus, 1794—Essay on the Mysteries of Eleusis, ɔy M. Ouvaroff, 1817—Dissertation on the Eleusinian and Bacchic Mysteries, *Amst.*, n. d., in 1 vol.—Jamblichus, 1831—Metamorphosis of Apuleius, 1821, and all trans. ɔy Thomas Taylor, hf. vell., 8vo. (290) *Edwards*, £2 8s.

6824 Thackeray (W. M.) Works, "The Biographical Ed.," illustrations and a port., 13 vol., hf. mor., t. e. g., 1902-4, 8vo. (294) *Thorp*, £3 14s.

6825 Viollet-le-Duc (E.) Dictionnaire Raisonné du Moɔilier Français, illustrations (some in colours), 6 vol., hf. mor., t. e. g. 1872-75, 8vo. (301) *Bain*, £6 5s.

6826 Viollet-le-Duc (E.) Dictionnaire Raisonné de l'Architecture Française, port. and illustrations, 10 vol., hf. mor., t. e. g., 1867-68, 8vo. (302) *Bain*, £10 5s.

6827 Voltaire. Collection complette des Œuvres, port., 57 vol., cf., *Lausanne*, 1780-81, 8vo. (303) *Barrow*, £2 4s.

6828 Voragine (Jacques de). La Légende Dorée, traduite par l'Abbé J. B. M. Roze, facs., orig. wrappers ɔound up, 3 vol., hf. mor., uncut, t. e. g., 1902, 8vo. (304) *Hunt*, 18s.

6829 Weɔster (Daniel). Works, ports. and illustrations, 6 vol., hf. cf. gt., m. e., *Boston*, 1854, 8vo. (311) *Rimell*, £1 1s.

6830 Weɔster (John). Dramatic Works, 4 vol., Pickering, 1830— Dramatic Works of Roɔert Greene, 2 vol., *ib.*, 1831, ed. ɔy the Rev. Alex. Dyce, orig. cl., together 6 vol., 8vo. (312) *Hornstein*, £6 7s. 6d.

6831 Williams (Professor (Monier). Sanskrit-English Dictionary, *Oxford*, 1872, 4to. (360) *Thin*, 16s.

(β) *Mr. Joseph Thompson's Library* (*Lots 401 to the end, realising £2,003 19s. 6d.*)

6832 Addison (J.) Works, port., 4 vol., russ., *Birmingham*, J. Baskerville, 1761, 4to. (524) *Edwards*, £1 1s.

6833 Aelfric Society. Puɔlications, Nos. i.-xiv., as issued, 1843-46, 8vo. (401) *B. F. Stevens*, £1 13s.

6834 Aldine Poets. Burns, 3 vol.—Collins—Cowper, 3 vol.—Pope, 3 vol.—Chaucer, 6 vol., together 16 vol., ports., W. Pickering, 1839-53, 8vo. (402) *Rimell*, £8 5s.

6835 Angelica (Fra), by Langton Douglas, illustrations, 1902, imp. 8vo. (404) *Power*, 9s.

6836 Araɔian Nights. The Book of the Thousand Nights and One Night, 9 vol.—Tales of the Araɔic, 3 vol.—Alaeddin

and the Enchanted Lamp, together 13 vol., trans. by John Payne, orig. parchment, *Villon Society*, 1882-89, 8vo. (409)

Hopkins, £10

6837 Armstrong (W.) Gainsborough and his Place in English Art, 62 photogravures and 10 lithographic facs. in colour, 1898, 4to. (530) *J. Bumpus, £7*

6838 Armstrong (W.) Sir Joshua Reynolds, 78 photogravures and 6 lithographic facs. in colour, 1900, 4to. (531)

Edwards, £2 11s.

6839 Articles agreed upon by the Clergie in Convocation at London in 1562, reprinted by his Majestie's commands, black letter, cf., g. e., *Printed for the benefit of the Common-wealth*, 1642, 4to. (532) *Thorp*, 13s.

·6840 Auscher (E. S.) A History and Description of French Porcelain, ed. by W. Burton, 24 col. plates and illustrations, 1905, 8vo. (416) *J. Bumpus*, 16s.

6841 Austen (Jane). Pride and Prejudice, LARGE PAPER, illustrations by Hugh Thomson, on India paper, 1894, imp. 8vo. (417) *Hill*, 11s.

6842 Bancroft (G.) History of the United States, ports., 10 vol. (vol. ix.-x. not uniform), *Boston*, 1854-60, *and London*, 1866-74, 8vo. (420) *Edwards, £1 18s.*

6843 Barham (R. H.) Ingoldsby Legends, plates by G. Cruikshank, 3 vol., blue cl., 1852, 8vo. (421) *Hornstein, £1 4s.*

6844 Baring-Gould (S.) Iceland, its Scenes and Sagas, first ed., map and plates (some col.), cf. gt., 1863, roy. 8vo. (422)

Sotheran, 16s.

6845 Bartlett (E.) A Monograph of the Weaver-Birds, col. plates, parts i.-v., *Maidstone*, 1888-89, 4to. (535)

Barnard, £1 1s.

6846 Basile (G. B.) Il Pentamerone, trans. by Sir R. Burton, 2 vol., LARGE PAPER, No. 44 of 165 copies, 1893, 8vo. (424)

Hill, £1 18s.

6847 Bell (Malcolm). Edward Burne-Jones, a Record and Review, plates and illustrations, 1892, 4to. (536) *Barnard, £1 16s.*

6848 Blackmore (R. D.) Lorna Doone, illustrations, mor., t. e. g., 1883, 4to. (540) *Maggs*, 18s.

6849 Blake (Wm.) Life, by Gilchrist, first ed., port. and facs., 2 vol., orig. cl., 1863, 8vo. (434) *Young, £1 3s.*

6850 Bonner (Edmund). A Profitable and Necessarye Doctrine, black letter (wanted last 3 leaves), russ., g. e., John Cawood, 1555, 4to. (542) *Bull, £1*

6851 Boswell (J.) Life of Johnson, including Boswell's Journal of a Tour to the Hebrides and Johnson's Diary of a Journey into North Wales, ed. by G. Birkbeck Hill, ports. and facs., 6 vol., roxburghe, *Oxford*, 1887, 8vo. (439) *Thorp, £1 18s.*

6852 Brandon (R. and J. A.) Analysis of Gothic Architecture, plates and illustrations, 2 vol., hf. roan (rubbed), 1858, 4to. (543) *Rimell, £1 1s.*

6853 Brodrick (W.) Falconers' Favourites, 6 col. plates, 1865, imp. folio (586) *Parsons, £2 4s.*

6854 Brown (H. F.) The Venetian Printing Press, 22 facs., Nimmo, 1891, 4to. (545) *Barnard,* 19s.
6855 Brown (Ford Madox). A Record of his Life and Work by Ford M. Hueffer, illustrations, 1896, 8vo. (445)
Rimell, £1 2s.
6856 Browning (E. B.) Poetical Works, ports. and illustrations, 6 vol., one of 125 copies on handmade paper, 1889-90, 8vo. (446) *Isaacs, £6*
6857 Browning (Robert). Poetical Works, port., 17 vol., one of 250 copies on handmade paper, 1888-94, 8vo. (447)
Isaacs, £17 5s.
6858 Browning (R.) The Ring and the Book, first ed., 4 vol., 1868-69, 8vo. (448) *Edwards,* 19s.
6859 Brownists. Barrowe (Henry) and Greenwood (Jo.) A Plaine Refutation of M. Giffard's Booke, intituled A short treatise gainst the Donatists of England, cf. gt., 1605, 4to. (546)
B. F. Stevens, £6 10s.
6860 Brownists. Giffard (G.) A Short Treatise against the Donatists of England, whome we call Brownists, **black letter** (title mounted and defective, dedication defective), hf. roan, John Windet, 1590, 4to. (548) *B. F. Stevens, £6* 5s.
6861 Brownists. Giffard (G.) A Plaine Declaration that our Brownists be full Donatists, **black letter**, unbd., *Printed for Toby Cooke,* 1590, 4to. (549) *B. F. Stevens, £6* 5s.
6862 Brownists. Giffard (J.) A Short Reply unto the last printed books of Henry Barrow and John Greenwood, **black letter** (title and last 2 leaves defective), uncut, *T. Orwin for T. Cooke,* 1591—Barrow (H.) and Greenwood (J.) A Collection of Certain Letters (imperfect), hf. mor., 1590, 4to. (550)
B. F. Stevens, £6 15s.
6863 Brownists. Hall (J.) A Common Apologie of the Church of England against the unjust Challenges of the Brownists, vell., 1610, 4to. (551) *B. F. Stevens, £1* 8s.
6864 Brownists. Hall (J.) A Common Apologie of the Church of England, 1610—Bernard (R.) Plaine Evidences. The Church of England is Apostolicall, 1610, in 1 vol., cf., y. e. (552) *B. F. Stevens, £4* 15s.
6865 Brownists. Jacob (H.) A Defence of the Churches and Ministery of Englande (title mended), *Middelburgh,* 1599—Fairlande (P.) The Recantation of a Brownist, **black letter** (title defective), 1606—The Brownists' Synagogue, or a late Discovery of their Conventicles, etc. (text cut into), 1641—Taylor (John, the Water Poet). The Anatomy of the Separatists, alias Brownists (title mended and 2 leaves defective)—Rathband (W.) A most grave and modest Confutation of the Errors of the Sect, commonly called Brownists or Separatists, 1644, in 1 vol., hf. mor., r. e., 4to. (553) *B. F. Stevens, £20*
6866 Brownists. Johnson (Francis). An Answer to Maister H. Jacob his Defence of the Churches and Ministery of England, **black letter** (a few headlines shaved), old mor., g. e., 1600, 4to. (554) *B F. Stevens, £7* 12s. 6d.

6867 Brownists. Johnson (Francis). Certayne Reasons and Arguments proving that it is not lawfull to heare or have any spirituall communion with the present Ministerie of the Church of England, hf. mor., 1608, 4to. (555)
B. F. Stevens, £4 5s.

6868 Brownists. Paget (J.) An Arrow against the Separation of the Brownists (wanted title-page), cf. gt., 1618, 4to. (556)
B. F. Stevens, £2 12s. 6d.

6869 Brownists. The Prophane Schisme of the Brownists or Separatists . . . discovered by C. Lawne, J. Fowler, C. Sanders and R. Bulward, hf. mor., 1612, 4to. (557)
B. F. Stevens, £6 5s.

6870 Brownists. [Robinson (J.)] An Apologie or Defence of such true Christians as are commonly (but unjustly) called Brownists, partly black letter, unbd., 1604, 4to. (558)
B. F. Stevens, £8 8s.

6871 Brownists. Robinson (J.) An Apologie, or Defence of such true Christians as are commonly (but unjustly) called Brownists (lower lines shaved), 1604, bookplate of Thomas Millington, 1703, on verso of title—Ainsworth (H.) Counterpoyson Considerations touching the poynts in difference between the godly ministers and people of the Church of England, and the seduced brethren of the Separation (a few catchwords cut), n. d., in 1 vol., old cf. (560)
Bull, £5

6872 Brownists. Robinson (J.) A Manumission to a Manuduction (headlines cut), 1615—Ainsworth (H.) An Animadversion to Mr. Richard Clyfton's Advertisement (headlines cut), *Amsterdam,* 1613, in 1 vol., cf. gt. (561)
B. F. Stevens, £7 12s. 6d.

6873 Brownists. Robinson (J.) A Defence of the Doctrine propounded by the Synode at Dort, against John Murton and his Associates (title mounted and headlines cut), cf. gt., 1624, 4to. (562)
Bull, £3 5s.

6874 Brownists. Streater (A.) A Letter sent to My Lord Mayor and his Venerable Brethren, by an Athist, no Papist, no Arminian, no Anabaptist, no Familist, no Separatist or Brownist, unbd., 1642, 4to. (563)
B. F. Stevens, £3 8s.

6875 Brownists. White (Th.) A Discoverie of Brownisme, hf. mor., 1605, 4to. (564)
B. F. Stevens, £10

6876 Buckley (T. E.) and Harvie-Brown (J. A.) A Vertebrate Fauna of the Orkney Islands, map and illustrations, *Edinburgh,* 1891, 4to. (565)
Forrester, £1 6s.

6877 Bullen (A. H.) Musa Proterva, autograph letter of editor inserted, *Privately printed,* 1889, 4to. (566)
Thorp, £1 6s.

6878 Buller (Sir W. L.) A History of the Birds of New Zealand, 2 vol., in 13 parts in 8, 1888—Supplement, in 2 vol., 1905, col. plates and other illustrations, 1888-1905, roy. 4to. (567)
Edwards, £11

6879 Bunsen (C. C. J.) Egypt's Place in Universal History, maps and plates, 5 vol., 1848-67, 8vo. (450)
Thorp, £2 16s.

6880 Bunyan (J.) The Pilgrim's Progress, 25 drawings on wood by G. Cruikshank, 1903, roy. 8vo. (451)
Barnard, 11s.

6881 Burlington Magazine for Connoisseurs, vol. i.-xiii. and xiv.,
part i. (Nos. 1-67), illustrations, as issued, 1903-8, 4to. (568)
Power, £2 10s.

6882 Burnet (Bp.) History of his Own Time, 6 vol., *Oxford,*
1833, 8vo. (453) *Power,* £1 8s.

6883 [Burrough (E.)] A Declaration of the Sad and Great Perse-
cution and Martyrdom of the People of God called Quakers
(title mended and a few headlines cut), hf. roan, 1660—The
Peoples Ancient and Just Liberties Asserted in the Tryal
of Wm. Penn and Wm. Mead, 2 parts, 1670—An Answer
to the Seditious and Scandalous Pamphlet entituled The
Tryal of W. Penn and W. Mead, 1671, in 1 vol., hf. russia,
4to. (570) *Barnard,* £6 5s.

6884 Burroughs (J.), Muir (J.) and Grinnell (G. B.) Alaska, 2 vol.,
col. plates and other illustrations, 1902, 4to. (571) *Hill,* 16s.

6885 Burns (Robert). Complete Works, ed. by W. S. Douglas,
port., 6 vol., *Edinb.,* W. Paterson, 1883, 8vo. (455)
H. Brown, 14s.

6886 Burton (J. H.) History of Scotland, Library ed., 9 vol.,
1853-70, 8vo. (457) *Sotheran,* £2 16s.

6887 Burton (R.) The Anatomy of Melancholy, front., 3 vol., hf.
vell., t. e. g., Nimmo, 1886, 8vo. (458) *Rimell,* £1 12s.

6888 Burton (Wm.) A History and Description of English
Porcelain, 24 col. plates and numerous illustrations, n. d.,
8vo. (461) *J. Bumpus,* £4 8s.

6889 Byron (Lord). Poetical and Prose Works, ed. by Coleridge
and Prothero, ports. and illustrations, 13 vol., 1898-1903,
8vo. (464) *Joseph,* £1 19s.

6890 Cambridge Modern History (The), planned by the late Lord
Acton, ed. by A. W. Ward and others, vol. i.-v., vii.-xi., 10
vol., *Cambridge,* 1902-09, 8vo. (468) *Hill,* £4 12s.

6891 Carlyle (T.) History of Frederick the Great, ports. and
plates, 10 vol.—Translations from the German, 3 vol.—Past
and Present—Sartor Resartus—Heroes and Hero Worship,
together 16 vol., Library ed., 8vo. (472) *J. Bumpus,* £3 3s.

6892 Cellini (Benvenuto). Life, first ed., port., 8 etchings and 18
illustrations, 2 vol., Nimmo, 1888, 4to. (574)
J. Bumpus, £5 7s. 6d.

6893 Century Dictionary (The), by W. D. Whitney, illustrations,
6 vol., hf. mor., *New York,* 1889, 4to. (575)
J. Bumpus, £3 10s.

6894 Cervantes (M. de). Don Quixote, trans. by J. Ormsby, map,
4 vol., 1885, 8vo. (474) *Walford,* 16s.

6895 Chaffers (Wm.) The Keramic Gallery, photographic plates
and woodcuts, 2 vol., 1872, roy. 8vo. (475) *Sotheran,* £2

6896 Chambers (R.) Domestic Annals of Scotland, woodcuts,
3 vol., cf. gt., *Edinburgh,* 1859-61, 8vo. (476) *Maggs,* £1

6897 Chaucer (Geoffrey). Works, ed. by W. W. Skeat, with
Supplement, port. and facs., 7 vol., *Oxford,* 1894-7, 8vo.
(479) *Hill,* £3 3s.

6898 Chetham Society. Publications, orig. series, 114 vol. with

2 vol. indexes, 116 vol. complete—New Series, vol. i.-lxv.,
together 181 vol., as issued, *Manchester,* 1844-1909, 4to.
(576) *Harding,* £13 5s.

6899 Choice Examples of Art Workmanship selected from the
Exhibition of Ancient and Mediæval Art at the Society of
Arts, drawn and engraved under the superintendence of
P. De La Motte, 60 coloured plates, mor. antique, g. e.,
1851, imp. 8vo. (481) *Barnard,* £1 1s.

6900 Cholmondeley-Pennell (H.) The Sporting Fish of Great
Britain, 16 lithographs in gold, silver and colours, hf. vell.,
1886, roy. 8vo. (482) *Young,* 14s.

6901 Church (A. J.) The Laureate's Country, LARGE PAPER, illus-
trations by E. Hull, 1891, folio (591) *Thorp,* 13s.

6902 Cleasby (R.) and Vigfusson (G.) An Icelandic English
Dictionary, with supplement, *Oxford,* 1874-76, 4to. (816)
Hill, £2 5s.

6903 Cotton (J.) The Powring out of the Seven Vials, or an
Exposition of the 16 Chapter of the Revelation, hf. roan,
1642, 4to. (819) *Bull,* 14s.

6904 Crealock (Lieut.-Gen. H. H.) Deer-Stalking in the High-
lands of Scotland, 40 full-page plates, illustrations in the
text, 1892, imp. 4to. (821) *J. Bumpus,* £14 15s.

6905 Creighton (M.) A History of the Papacy, Library ed.,
vol. i.-v., 1882-94, 8vo. (488) *Quaritch,* £3 5s.

6906 Creighton (M.) Queen Elizabeth, first ed., front. in colours,
plates and illustrations, *Boussod,* Valadon, 1896, 4to. (822)
Edwards, £7

6907 Croston (J.) A History of the Ancient Hall of Samlesbury,
200 copies privately printed, hf. mor., t. e. g., *Chiswick
Press,* 1871, folio (592) *Barnard,* 13s.

6908 Davison (F.) Poetical Rhapsody, ed. by A. H. Bullen, 2 vol.,
LARGE PAPER, as issued, 1890, 8vo. (500) *Sotheran,* 13s.

6909 Dawkins (W. Boyd). Cave Hunting, col. front. and wood-
cuts, autograph letter of author inserted, 1874, 8vo. (501)
Hayle, £2

6910 Dawkins (W. B.) Early Man in Britain, woodcuts, presenta-
tion copy, 1880, 8vo. (502) *Edwards,* £1 15s.

6911 Dennistoun (J.) Memoirs of the Dukes of Urbino, first ed.,
plates and illustrations, 3 vol., orig. cl., 1851, 8vo. (504)
Bain, £3 6s.

6912 De Quincey (T.) Selections Grave and Gay from Writings
published and unpublished, port., 14 vol., *Edinburgh,* 1853-
60, 8vo. (505) *Barnard,* 10s.

6913 Des Murs (O.) Iconographie Ornithologique, 72 col. plates,
hf. mor., t. e. g., *Paris,* 1849, roy. 4to. (824)
Maggs, £7 2s. 6d.

6914 Dibdin (Rev. T. F.) Bibliotheca Spenceriana, fac. woodcuts,
4 vol., mor., g. e., 1814-15—Aedes Althorpianae, plates, 2
vol., cf., 1822—Descriptive Catalogue of the Cassano
Library, russ. gt., 1823 (506) *Edwards,* £7 10s.

6915 Dickens (Ch.) Works, édition de luxe, plates on India paper,
30 vol., 1881-82, imp. 8vo. (507) *Zaehnsdorf,* £14 10s.

6916 Dilke (Lady). French Painters of the XVIIIth Century, plates and illustrations, 1899, imp. 8vo.—French Architects and Sculptors of the XVIIIth Century, plates and illustrations, 1900, imp. 8vo.—French Furniture and Decoration in the XVIIIth Century, plates and illustrations, 1901, imp. 8vo.— French Engravers and Draughtsmen of the XVIIIth Century, plates and illustrations, together 4 vol., 1902, imp. 8vo. (509-12) *Rimell, £3 10s.*

6917 Dixon (R. W.) History of the Church of England, 6 vol., 1878-1902, 8vo. (514) *Baker, £2 8s.*

6918 Dodson (Austin). Ballad of Beau Brocade, LARGE PAPER, 50 illustrations by Hugh Thompson on Japanese and India paper, 1892, roy. 8vo. (516) *Barnard, 13s.*

6919 Doyle (J. A.) The English in America, maps, 3 vol., 1882-87, 8vo. (517) *Thin, £1 10s.*

6920 Doyle (J. E.) A Chronicle of England, col. illustrations, mor., g. e., by Rivière, 1864, 4to. (827) *A. Jackson, £1 1s.*

6921 Dresser (H. E.) History of the Birds of Europe, col. plates, 8 vol., uncut, 1871-81, 4to. (828) *B. F. Stevens, £36*

6922 Dresser (H. E.) A Monograph of the Meropidae, or Family of the Bee-eaters, 34 col. plates, as issued, 5 parts (complete), 1884-86, roy. 4to. (829) *B. F. Stevens, £4*

6923 Duff (E. Gordon). Early English Printing, No. 111 of 300 copies, 40 plates, in portfolio, 1896, folio (593) *Quaritch, £1 1s.*

6924 Duruy (V.) History of Rome and the Roman People, ed. by J. P. Mahaffy, 590 wood engravings, 11 maps, 4 plans and 8 chromo-lithographs, 6 vol., 1883-86, imp. 8vo. (521) *Young, £3 6s.*

6925 Dutton Family. Memorials of the Duttons of Dutton in Cheshire, photographic illustrations and pedigrees, 1901 (830) *Barnard, £1 8s.*

6926 Edwards (Edwin). Old Inns, First Division, Eastern England, etched text and etchings, as issued, 1873, folio (594) *Thorp, £2 12s.*

6927 Edwards (Th.) The First and Second Part (and Third) of Gangraena (cut close and some lines shaved), in 1 vol., vell., 1646, 4to. (832) *Quaritch, £2 15s.*

6928 Elliot (D. G.) A Monograph of the Tetraoninae, or Family of the Grouse, 27 col. plates, as issued, 4 parts (complete), *New York*, 1864-65, folio (595) *Quaritch, £8*

6929 Elliot (D. G.) A Monograph of the Pittidae, or Family of Ant Thrushes, 31 col. plates, hf. mor., t. e. g., *New York*, 1867, folio (596) *Edwards, £5 2s. 6d.*

6930 Elliot (D. G.) Monograph of the Phasianidae, over 80 col. plates, as issued, 2 vol. in 6 parts, *New York*, 1870-72, folio (597) *B. F. Stevens, £47*

6931 Elliot (D. G.) A Monograph of the Paradiseidae, or Birds of Paradise, 37 col. plates, as issued, 7 parts (complete), 1873, folio (598) *Maggs, £6 15s.*

6932 Fergusson (J.) History of Architecture, illustrations, 4 vol., 1865-76, 8vo. (617) *Thin, £1 2s.*

6933 Fergusson (J.)　Rude Stone Monuments in all Countries, 234
　　　illustrations, 1872, 8vo. (618)　　　　　　　*Young*, 18s.
6934 Foss (E.)　The Judges of England, etc., 9 vol., cf. (broken),
　　　1848-64, 8vo. (623)　　　　　　　　*Harding*, £2 10s.
6935 Froude (J. A.)　History of England, Library ed., 12 vol.,
　　　1862-70, 8vo. (627)　　　　　　　*J. Bumpus*, £2 2s.
6936 Froude (J. A.)　The English in Ireland, first ed., 3 vol., 1872-
　　　74, 8vo. (628)　　　　　　　　*Zaehnsdorf*, £1 6s.
6937 Fuller Worthies Library, ed. by Rev. A. B. Grosart, complete
　　　set, 39 vol., LARGE PAPER, 24 vol. 8vo. cl. and 15 vol. 4to.
　　　roxburghe, *Privately printed*, 1868-72 (839)
　　　　　　　　　　　　　　　　　Edwards, £15 5s.
6938 Gardiner (S. R.)　Oliver Cromwell, front. in colours, plates
　　　and illustrations, Goupil, 1899, 4to. (840)　　*Bain*, £1 12s.
6939 Gardiner (S. R.)　History of the Great Civil War, first ed.,
　　　3 vol., 1886-91, 8vo. (632)　　　　　　*Hill*, £2 6s.
6940 Gardiner (S. R.)　History of the Commonwealth and Pro-
　　　tectorate, with Supplementary Chapter to vol. iii., first ed.,
　　　4 vol., 1894, 8vo. (633)　　　　　　*Hitchman*, £2 4s.
6941 Gaskell (Mrs.)　Works, Knutsford ed., port. and plates,
　　　8 vol., 1906, 8vo. (634)　　　　　　*Hawkins*, 16s.
6942 Gaskell (Mrs.)　Cranford, LARGE HANDMADE PAPER, orig.
　　　cl., 1891, imp. 8vo. (635)　　　　　　*Maggs*, 14s.
6943 Gell (Sir W.) and Gandy (J. P.)　Pompeiana, the Topography,
　　　Edifices and Ornaments of Pompeii, 2 vol., 1824—Pom-
　　　peiana, the Result of Excavations since 1819, plates and
　　　vignettes on India paper, 1832, together 4 vol., imp. 8vo.
　　　(638)　　　　　　　　　　　　　*Hunt*, 16s.
6944 Gibbon (E.)　Decline and Fall of the Roman Empire, map,
　　　6 vol., 1846, 8vo. (640)　　　　　　*Young*, 19s.
6945 Goldsmith (O.)　The Vicar of Wakefield, LARGE PAPER,
　　　illustrations by Hugh Thomson, 1890, imp. 8vo. (646)
　　　　　　　　　　　　　　　　　Maggs, £1 6s.
6946 Goldsmith (O.)　Vicar of Wakefield, port. on India paper,
　　　32 woodcuts by W. Mulready, and set of 12 plates, proofs,
　　　by Unwins inserted, mor. ex., t. e. g., by Rivière, 1843, 4to.
　　　(841)　　　　　　　　　　　　*J. Bumpus*, £4 6s.
6947 Gould (John).　A Century of Birds from the Himalaya
　　　Mountains, 80 col. plates, hf. mor., t. e. g., 1832, folio—
　　　Birds of Europe, 449 col. plates, 5 vol., mor., g. e., 1837,
　　　folio—A Monograph of the Trogonidae, or Family of Tro-
　　　gons, orig. ed., 36 col. plates, 1838, folio—A Monograph of
　　　the Odontophorinae, 32 col. plates, 3 parts (complete), as
　　　issued, 1844-50, folio — The Birds of Australia, with
　　　Supplementary Volume, nearly 700 col. plates, 8 vol., mor.
　　　ex., 1848-69, folio—A Monograph of the Trochilidae or
　　　Humming Birds, 360 col. plates, 5 vol. in 25 parts, 1849-61
　　　—Supplement, 22 col. plates, parts i. and ii., 1880-81,
　　　together 27 parts, as issued, folio—The Birds of Asia,
　　　nearly 500 col. plates, 7 vol. in 35 parts, as issued, 1850-83,
　　　folio—A Monograph of the Ramphastidae, orig. ed., 51
　　　col. plates, mor. ex., 1854, folio — The Birds of Great

Britain, nearly 370 col. plates, 5 vol. in 25 parts, as issued, 1862-73, folio—The Birds of New Guinea and the Papuan Islands, 320 col. plates, 5 vol. in 25 parts, as issued, 1875-88, folio (599-608) *Hornstein,* £370

6948 Gozzi (Count Carlo). Memoirs, trans. by J. A. Symonds, first ed., port. and 6 etchings by A. Lalauze, 2 vol., Nimmo, 1890, 4to. (842) *Hill,* £1 7s.

6949 Graham (H. D.) The Birds of Iona and Mull, illustrations, *Edinburgh,* 1890, 4to. (843) *B. F. Stevens,* 12s.

6950 Gray (G. R.) The Genera of Birds, illustrated by D. W. Mitchell, plates, col. and plain, 3 vol., hf. mor., t. e. g., 1849, folio (609) *Edwards,* £13 15s.

6951 Great Masters (The). Reproductions in photogravure from the Finest Works of the most Famous Painters, by Sir M. Conway, in parts in case, as issued, 1904, folio (863) *Edwards,* £2 4s.

6952 Greenaway (Kate). By M. H. Spielman and G. S. Layard, éd. de luxe, col. plates and other illustrations, 1905, 4to. (844) *James,* £4 18s.

6953 Grimole (A.) Deer Stalking and the Deer Forests of Scotland, illustrations by A. Thorourn and others, hf. vell., 1901, 4to. (845) *Hill,* 18s.

6954 Gruner (L.) The Terra-Cotta Architecture of North Italy, 48 plates in colours, and illustrations by F. Lose, hf. bd. as issued, 1867, roy. 4to. (846) *Hiersemann,* £3

6955 Gruner (L.) Specimens of Ornamental Art, 80 plates, many in colours (text in 4to.), hf. mor., g. e., 1850, imp. folio (864) *Quaritch,* £5

6956 Gruner (L.) Fresco Decorations and Stuccoes of Churches and Palaces in Italy, plates (plain and coloured), with text in 4to., hf. mor., g. e., 1854, roy. folio (865) *Batsford,* £4 8s.

6957 Haines (Rev. H.) Manual of Monumental Brasses, 200 illustrations, 2 vol., *Oxford,* 1861, 8vo. (661) *Harding,* £2 3s.

6958 Hamerton (P. G.) Etching and Etchers, first ed., 35 etchings, orig. hf. binding, g. e., Macmillan, 1868, roy. 8vo. (664) *B. F. Stevens,* £5

6959 Hamerton (P. G.) Etching and Etchers, third ed., etchings, roxburghe, 1880, folio (867) *Rimell,* £3 17s. 6d.

6960 Hamerton (P. G.) The Graphic Arts, LARGE PAPER, plates, 1882, folio (868) *Edwards,* £1 11s.

6961 Hamerton (P. G.) Landscape, LARGE PAPER, orig. etchings and illustrations, 1885, folio (869) *A. Jackson,* £1 14s.

6962 Harrison (F.) Annals of an Old Manor-House, Sutton Place, Guildford, illustrations, 1893, 4to. (849) *J. Bumpus,* £1 4s.

6963 Hart (G.) The Violin, its famous Makers, 24 plates, hf. mor., t. e. g., 1875, 4to. (850) *Maggs,* £1 2s.

6964 Harvie-Brown (J. A.) Travels of a Naturalist in Northern Europe, port., col. plates and other illustrations, and 4 maps, 2 vol., 4to. (851) *Barnard,* £1

6965 Harvie-Brown (J. A.) and Buckley (T. E.) A Vertebrate Fauna of Sutherland, Caithness and West Cromarty, map and plates, *Edinburgh,* 1887, 4to. (852) *Forrester,* £3

XXIV. 32

6966 Harvie-Brown (J. A.) and Buckley (T. E.) A Vertebrate Fauna of the Outer Hebrides, map and illustrations, *Edinburgh*, 1888, 4to. (853) *B. F. Stevens*, £2 16s.

6967 Harvie-Brown (J. A.) and Buckley (T. E.) A Vertebrate Fauna of Argyll and the Inner Hebrides, map and illustrations, *Edinburgh*, 1892, 4to. (854) *B. F. Stevens*, £1 8s.

6968 Hazlitt (W. Carew). History of the Venetian Republic, first ed., ports. and plates, 4 vol., orig. cl., 1860, 8vo. (673) *Rimell*, £1 19s.

6969 Henderson (T. F.) James I. and VI., front. in colours, plates and illustrations, Goupil, 1904, 4to. (855) *Bain*, £1 8s.

6970 Herkomer (H.) Etching and Mezzotint Engraving. Lectures delivered at Oxford, 13 plates, 1892, 4to. (856) *Barnard*, £2 4s.

6971 Helps (A.) The Spanish Conquest in America, maps, 4 vol., orig. cl., 1855-61, 8vo. (675) *J. Grant*, £2 1s.

6972 Herodotus. History, trans. by G. Rawlinson, maps and illustrations, 4 vol., 1862, 8vo. (676) *Sotheran*, £1 13s.

6973 Hervey (John, Lord). Memoirs of the Reign of George the Second, 2 fronts., 3 vol., 1884, 8vo. (677) *Edwards*, £1 5s.

6974 Hewitson (W. C.) Coloured Illustrations of the Eggs of British Birds, third ed., 145 col. plates, 2 vol., 1856, 8vo. (678) *B. F. Stevens*, £4 4s.

6975 Hewitt (John). Ancient Armour and Weapons in Europe, illustrations, 3 vol., 1855-60, 8vo. (679) *J. Bumpus*, £2 5s.

6976 Hichens (R.) Egypt and its Monuments. col. plates by J. Guérin, and photographs, 1908, imp. 8vo. (680) *Cash*, 14s.

6977 Hipkins (A. J.) and Gibb (W.) Musical Instruments, 50 plates in colours by W. Gibb, hf. mor., g. e., *Edinb.*, 1888, folio (870) *Thin*, £3

6978 Holmes (C. J.) Constable and his Influence on Landscape Painting, No. 110 of 350 copies, 72 photogravure plates, 1902, 4to. (860) *Barnard*, £1 14s.

6979 Hone (W.) The Every-Day Book and Table Book, orig. ed., illustrations by G. Cruikshank and others, 4 vol., cf., 1837-39, 8vo. (683) *Gaskell*, 17s.

6980 Hook (W. F.) Lives of the Archbishops of Canterbury, with Index, 12 vol., 1860-75, 8vo. (685) *Maggs*, £2 14s.

6981 Houghton (W.) British Fresh-Water Fishes, col. plates and engravings, 1884, 4to. (862) *B. F. Stevens*, 14s.

6982 Hunt (Leigh). The Town, first ed., 45 illustrations, 2 vol., orig. cl., 1848, 8vo. (691) *A. Jackson*, £1 1s.

6983 Jameson (Mrs.) Legends of the Madonna, etchings and woodcuts, mor. ex., 1857, 8vo. (701) *Thorp*, 9s.

6984 Jameson (Mrs.) The History of Our Lord, first ed., 2 vol., orig. cl., unopened, 1864, 8vo. (702) *Maggs*, £1 2s.

6985 Jesse (J. H.) English Historical Memoirs, nearly 200 etchings and photogravure plates on Japan paper, as issued, 30 vol., Nimmo, 1901, 8vo. (705) *Edwards*, £6 10s.

6986 John Rylands' Library, Manchester. Catalogue of the Printed Books and Manuscripts, 3 vol., mor., t. e. g., *Manchester*, 1899—Catalogue of English Printed Books to the

end of the year 1640 in the John Rylands' Library, mor., t. e. g., with monogram J. R., *ib.*, 1895, 4to. (1013)
Crawshaw, £2 14s.
6987 John Rylands' Library. The English Bibles in the John Rylands' Library, 1525 to 1640, preface by R. Lovett, 26 facs. and 39 engravings, mor., t. e. g., by Zaehnsdorf, *Printed for private circulation*, 1899, folio (871)
Leighton, £8
6988 Johnston (Sir H.) The Uganda Protectorate, 48 col. plates, 9 maps and other illustrations, 2 vol., 1902, 4to. (1014)
Edwards, 18s.
6989 Jones (Owen). Grammar of Ornament, 100 col. plates, hf. mor., g. e., 1856, roy. folio (873) *A. Jackson*, £3 3s.
6990 Jonson (Ben). Works, by W. Gifford, Appendices by Lieut.-Col. F. Cunningham, port., 9 vol., 1875, 8vo. (707) *Hill*, £4
6991 Joyce (Rev. J. G.) The Fairford Windows, col. plates, hf. mor., *Arundel Society*, 1872, folio (874) *Maggs*, £7 15s.
6992 Julian (J.). Dictionary of Hymnology, 1892, roy. 8vo. (708)
Thorp, 13s.
6993 Kelmscott Press. History of Reynard the Foxe, W. Morris, vell., 1892, folio (875) *B. F. Stevens*, £2 18s.
6994 Kelmscott Press. Chaucer (Geoffrey). Works, as issued, W. Morris, 1896, folio (876) *Parsons*, £45
6995 Kelmscott Press. Caxton (Wm.) The Golden Legend, 3 vol., 1892, 4to. (1015) *Edwards*, £6
6996 Kelmscott Press. Caxton (Wm.) Recuyell of the Historyes of Troy, 3 vol. in 2, vell., 1892, 4to. (1016)
Edwards, £6 10s.
6997 Kelmscott Press. Ruskin (John). The Nature of Gothic, vell., 1892, 4to. (1017) *B. F. Stevens*, £2 14s.
6998 Kemble (J. M.) Horae Ferales, ed. by R. G. Latham and A. W. Franks, plates (some in colours) and illustrations, 1863, 4to. (1018) *Hill*, 17s.
6999 [Langland (Wm.)] The Vision of Pierce Plowman, black letter, sm. 4to., each leaf inlaid and mounted to sm. folio size (wanted title-page, a few headlines defective), mor., g. e., Roberte Crowley, 1550, folio (877)
Barnard, £2 12s. 6d.
7000 Latham (Ch.) In English Homes, photographic illustrations, G. Newnes, 1904, folio (878) *Rimell*, £1 7s.
7001 Lecky (W. E. H.) History of England, Library ed., 8 vol., 1878-90, 8vo. (724) *Edwards*, £4 4s.
7002 Leighton (Lord). Life, Letters and Work, by Mrs. Russell Barrington, illustrations, 2 vol., 1906, 4to. (1020) *Bain*, 17s.
7003 Leland (C. G.) Etruscan Roman Remains in Popular Tradition, No. 10 of 100 copies on handmade paper, containing an original illustration by the author and his signature, illustrations, 1892, 4to. (1021) *Edwards*, 13s.
7004 Lilford (Lord). Notes on the Birds of Northamptonshire, map and illustrations, 2 vol., hf. mor., t. e. g., 1895, 4to. (1022) *Edwards*, £2 18s.
7005 Lilford (Lord). Coloured Figures of the Birds of the British

32—2

Islands, port., text and plates mounted, 7 vol., hf. mor., t. e; g., orig. suðscriðer's copy, 1885-97, roy. 8vo. (730)
Thorp, £47

7006 Linton (W. J.) The Masters of Wood Engraving, col. front., illustrations, the smaller on India paper, 1889, folio (879)
Maggs, £2 10s.

7007 Lloyd (L.) Field Sports of the North of Europe, second ed., illustrations, 2 vol., orig. cl., 1831, 8vo. (731) *A. Jackson*, 5s.

7008 Lloyd (L.) The Game Birds and Wild Fowl of Sweden and Norway, map, woodcuts and chromo illustrations, 1867, imp. 8vo. (732) *A. Jackson*, £1 1s.

7009 Lübke (W.) History of Sculpture, illustrations, 2 vol., 1872, roy. 8vo. (733) *Hill*, £1 9s.

7010 Macaulay (Lord). Works, ed. by Lady Trevelyan, Liðrary ed., port., 8 vol., 1871, 8vo. (736) *Maggs*, £1 9s.

7011 Macgillivray (W.) History of British Birds, plates and woodcuts, 5 vol., cf. gt., 1837-52, 8vo. (738) *Hitchman*, £4

7012 Macpherson (H. A.) A Verteðrate Fauna of Lakeland, col. plates, etchings and woodcuts, *Edinburgh*, 1892, 8vo. (741)
Thurman, 19s.

7013 Marryat (J.) History of Pottery and Porcelain, second ed., col. plates and woodcuts, mor., g. e., 1857, 8vo. (745)
Leighton, 15s.

7014 Marston (John). Works, ed. ðy A. H. Bullen, No. 99 of 200 copies, on LARGE PAPER, 3 vol., Nimmo, 1887, 8vo. (746)
B. F. Stevens, £3

7015 Martin Marprelate. A Dialogue wherein is plainly laid open the tyrannical dealing of L. Bishopps against God's Children, orig. ed., hf. mor., uncut, n. d. (1589), 8vo. (747)
Barnard, £3 17s. 6d.

7016 Martin Marprelate. Theses Martinianae, that is certaine demonstrative conclusions sette downe and collected (as it shoulde seeme) by that famous and renowmed (*sic*) Clarke, the reverend Martin Marprelate the great, orig. ed., hf. mor., *Printed by the assignes of Martin Junior, without any priviledge of the Catercaps*, n. d. (1589), 8vo. (748)
Barnard, £2 18s.

7017 Martin Marprelate. The Just Censure and reproofe of Martin Junior, orig. ed., hf. mor., n. d., 8vo. (749) *Bull*, £3 18s.

7018 Martin Marprelate. A Sacred Decretall, or Hue and Cry for his superlative Holinesse, Sir Symon Synod, woodcut on title, hf. roan, *Europe, printed by Martin Claw Clergy*, 1645, 4to. (1027) *Barnard*, £1 2s.

7019 Martin Marprelate. Marre Mar-Martin, or Marre-Martins medling, in a manner misliked (in verse), black letter, 3 leaves, hf. roan, n. d., 4to. (1028) *Ellis*, £5

7020 Massey (W.) History of England during the Reign of George the Third, 4 vol., cf. gt., 1855-63, 8vo. (753)
Hitchman, 19s.

7021 Mayer (A. M.) Sport with Gun and Rod in American Woods and Waters, plates on India paper and illustrations, 2 vol., roxðurghe, *Edinb.*, 1884, imp. 8vo. (755) *Maggs*, 19s.

7022 Meteyard (Eliza). Life of Josiah Wedgwood, first ed., illustrations, 2 vol., orig. cl., 1865, 8vo. (756) . *Hill*, 17s.

7023 Meyer (H. L.) Coloured Illustrations of British Birds and their Eggs, 422 col. plates, 7 vol., hf. mor., g. e., rubbed, 1857, 8vo. (757) *Edwards, £7* 7s. 6d.

7024 Meyrick (S. R.) A Critical Inquiry into Antient Armour, col. plates and initials, many heightened with gold, 3 vol., russ. (broken), 1824, folio (880) *Edwards, £3* 12s. 6d.

7025 Michel (É.) Rubens, his Life, his Work and his Time, 40 col. plates, 40 photogravures and 72 text illustrations, 2 vol., 1899, 4to. (1029) *Hill, £1* 6s.

7026 Michel (É.) Rembrandt, his Life, his Work and his Time, 67 plates and 250 text illustrations, 2 vol., 1894, 4to. (1030) *Young, £1* 5s.

7027 Millais (J. G.) Game Birds and Shooting Sketches, orig. ed., col. and autotype plates and illustrations, hf. roan, t. e. g., 1892, 4to. (1031) *Edwards, £5* 17s. 6d.

7028 Millais (J. G.) The Wildfowler in Scotland, 2 col. plates and other illustrations, 1901, 4to. (1032) *J. Bumpus, £1* 2s.

7029 Millais (J. G.) The Natural History of the British Surface Feeding Ducks, 6 photogravures, 41 col. plates and 25 other illustrations, 1902, 4to. (1033) *Sotheran, £4* 10s.

7030 Millais (J. G.) The Mammals of Great Britain and Ireland, 31 col. plates, 18 photogravures and 63 uncol. plates, 3 vol., 1904-06, 4to. (1034) *J. Bumpus, £11* 10s.

7031 Mills (C.) History of Chivalry, 2 vol., 1826—History of the Crusades, port. and map, 2 vol., 1828, together 4 vol., cf. gt., 8vo. (764) *A. Jackson, £1* 11s.

7032 Milman (H. H.) History of Latin Christianity, 9 vol., 1864— History of Christianity, 3 vol., 1863—History of the Jews, 3 vol., 1863, together 15 vol., blue cl., 8vo. (765) *Bull, £2* 7s.

7033 Milton (John). Areopagitica, first ed. (blank corner of title and blank leaf at end missing, and pencil notes), *Printed in the Yeare* 1644—and other Tracts (mostly imperfect), in 1 vol., hf. mor., 1642-48, 4to. (1035) *Ellis, £24*

7034 Milton (J.) Works in Verse and Prose, by the Rev. John Mitford, port., 8 vol., W. Pickering, 1851, 8vo. (766) *J. Bumpus, £8*

7035 Milton (J.) Poetical Works, by D. Masson, ports., 3 vol., 1874, 8vo. (767) *Power, £1* 11s.

7036 Milton. Masson (David). Life of John Milton, ports., 6 vol., *Cambridge*, 1859-80, 8vo. (768) *Edwards, £7* 5s.

7037 Molière (J. B. P. de). Dramatic Works, by H. Van Laun, port. and etchings by Ad. Lalauze, 6 vol., *Edinb.*, 1875-76 (771) *Maggs, £1* 14s.

7038 Montalembert (Count de). The Monks of the West, 7 vol., 1861-79, 8vo. (773) *Hill, £2* 16s.

7039 More (Sir Thomas). A Dyalogue, wheryn he treatyd dyvers maters as of the veneracyon and worshyp of ymags and relyques, **black letter**, mor. antique, with the leaf "Fawtes escaped in the pryntynge" (W. Rastell), 1530, folio (882) *Maggs, £11* 10s.

7040 Morris (Rev. F. O.) British Birds, col. plates, 6 vol., 1851-57,
　　　roy. 8vo. (778)　　　　　　　　*Edwards*, £4 2s. 6d.
7041 Morris (Rev. F. O.) Nests and Eggs of British Birds, col.
　　　plates, 3 vol., 1866-7, roy. 8vo. (779)　　*Edwards*, £1 7s.
7042 Motley (J. L.) Life and Death of John of Barneveld, first
　　　ed., illustrations, 2 vol., unopened, 1874, 8vo. (781)
　　　　　　　　　　　　　　　　　　　　　　Edwards, £1 4s.
7043 Müller (K. O.) History of the Literature of Ancient Greece,
　　　port., 3 vol., cf. gt., 1858, 8vo. (783)　　*Hunt*, £1 3s.
7044 Mure (W.) A Critical History of the Language and Litera-
　　　ture of Antient Greece, 5 vol., 1854-57, 8vo. (784)
　　　　　　　　　　　　　　　　　　　　　　Hunt, £1 6s.
7045 Müntz (E.) Leonardo da Vinci, Artist, Thinker and Man of
　　　Science, 48 plates and 252 text illustrations, 2 vol., 1898,
　　　4to. (1041)　　　　　　　　　　　　　*Hill*, £1 3s.
7046 Murray (A. H. Hallam). Sketches on the Old Road through
　　　France to Florence, No. 73 of 150 copies on handmade
　　　paper, col. plates and illustrations, hf. vell., 1904, 4to. (1042)
　　　　　　　　　　　　　　　　　　　　　　Young, 17s.
7047. Nash (Joseph). Mansions of England, four series, orig. ed.,.
　　　104 plates, col. and mounted in imitation of the orig.
　　　drawings, in 4 portfolios, 1839-49, roy. folio (884)
　　　　　　　　　　　　　　　　　　　　　　Edwards, £30
7048 New Testament (The), one of 250 copies on LARGE PAPER,
　　　illustrations after the Old Masters, hf. mor., Longman,
　　　.1864, 4to. (1046)　　　　　　　　　　*Rimell*, 10s.
7049 Northbrooke (J.) A briefe and pithie summe of the Christian
　　　Faith, **black letter** (a few headlines shaved), hf. cf., John
　　　Charlewood, 1582, 8vo. (789)　　　*Barnard*, £1 10s.
7050 Ormerod (G.) History of the County and City of Chester,
　　　LARGE PAPER, port., plates and illustrations, 3 vol. in 6, hf.
　　　mor., t. e. g., 1882, folio (886)　　　*Hitchman*, £4
7051 Palgrave (Sir F.) The History of Normandy and of Eng-
　　　land, 4 vol., 1851-64, 8vo. (795)　　　*Hill*, £1 16s.
7052 Palgrave (F. T.) The Rise and Progress of the English
　　　Commonwealth, fine paper, vol. i. in 2, cf., 1831-32, 4to.
　　　(1049)　　　　　　　　　　　　　*Barnard*, £1 16s.
7053 Palgrave (F. T.) The Golden Treasury of the best Songs
　　　and Lyrical Poems in the English Language, No. 441 of
　　　500 copies, on LARGE PAPER, hf. vell., 1890, 4to. (1050)
　　　　　　　　　　　　　　　　　　　　　　Schulze, £1 6s.
7054 Parker (J. H.) A Glossary of Terms used in Architecture,
　　　fifth ed., 1700, woodcuts, 3 vol., hf. mor. (rubbed), t. e. g.,
　　　Oxford, 1850, 8vo. (798)　　　　　　*Thorp*, £1 3s.
7055 Pattison (Mrs. Mark). The Renaissance of Art in France,
　　　plates, 2 vol., 1879, 8vo. (799)　　　*James*, £2 5s.
7056 Paul (Herbert). Queen Anne, front. in colours, plates and
　　　illustrations, Goupil, 1906, 4to. (1053)　*Bain*, £1 1s.
7057 Penley (Aaron). English School of Painting in Water-
　　　Colours, col. plates, 1871, folio (1116)　*Hunt*, £1 1s.
7058 Penri (J.) Th' Appellation of John Penri, unto the Highe
　　　Court of Parliament, from the bad and injurious dealing

of th' Archb. of Canterb. (headlines shaved), 1589—A defence of that which hath bin written in the questions of the ignorant ministerie, and the communicating with them (wanted title), n. d., in 1 vol., mor., g. e., ɔy Hammond, 8vo. (802) *Quaritch*, £16

7059 Penri (J.) A viewe of some part of such puɔlike wants and disorders as are in the service of God, within her Maiesties countrie of Wales, etc., mor. ex., g. e., n. d. (1588) (803) *Quaritch*, £15 15s.

7060 Penri (J.) An Humɔle Motion with Suɔmission to the Ll. of the Counsell concerning the necessity of Christ's Discipline in our Land (title mended, a few fore-edges cut), hf. mor., 1590, 4to. (1054) *Quaritch*, £6 6s.

7061 Pepys (S.) Diary and Correspondence, ports. and map, 4 vol., 1854, 8vo. (804) *Hill*, £1 3s.

7062 Percy (Bishop). Folio Manuscript. Ballads and Romances, ed. by J. W. Hales and F. J. Furnivall, Whatman paper,. 3 vol. in 5 parts, as issued, 1867-68, 8vo. (805) *Rimell*, £1 6s.

7063 Poets. The Works of the British Poets, ɔy T. Park, fronts., 36 vol., Sharpe, 1828, 8vo. (806) *Maggs*, £2 8s.

7064 Pollard (A. F.) Henry VIII., front. in colours, plates and illustrations, Goupil, 1902, 4to. (1055) *Bain*, £1 13s.

7065 Pontoppidan (E.) Natural History of Norway, LARGE PAPER, maps and plates, cf., 1755, folio (1119) *Thorp*, £1 17s.

7066 Prescott (W. H.) Biographical and Critical Miscellanies, 1845—Ferdinand and Isaɔella, 2 vol., 1851—Conquest of Mexico, 2 vol., 1855—Conquest of Peru, 2 vol., 1855— Charles V., 2 vol., 1857—Philip the Second, 3 vol., 1859-60, together 12 vol., Liɔrary eds., ports., ɔlue cl., 1845-60, 8vo. (810) *Maggs*, £6 12s. 6d.

7067 Prior (E. S.) A History of Gothic Art in England, illustrations, plans and diagrams, 1900, imp. 8vo. (887) *Edwards*, 19s.

7068 Quaritch (B.) A Collection of Facsimiles from Examples of Historic or Artistic Bookɔinding, col. facs. by W. Griggs, 1889—Examples of the Art of Book-Illumination, col. facs., many heightened with gold, 1889, together 2 vol., hf. mor., t. e. g., imp. 8vo. (889) *Edwards*, £8 5s.

7069 Rashdall (H.) The Universities of Europe in the Middle Ages, facs., 2 vol. in 3, *Oxford*, 1895, folio (891) *Thin*, £3 3s.

7070 Rawlinson (G.) The Five Great Monarchies of the Ancient Eastern World, maps and woodcuts, 4 vol., 1862-67—The Sixth Great Oriental Monarchy, col. front., maps and woodcuts, 1873—The Seventh Great Oriental Monarchy, col. front., map and illustrations, 1876, together 6 vol., 8vo. (892) *Quaritch*, £4 18s.

7071 Reade (Ch.) Peg Woffington, one of 200 copies on LARGE PAPER, illustrations by Hugh Thomson, 1899, imp. 8vo. (893) *B. F. Stevens*, 17s.

7072 Reed (T. B.) A History of the Old English Letter Foundries, plates and illustrations, roxourghe, 1887, 4to. (1059) *Hill,* 9s.

7073 Ricketts (C. S.) The Prado and its Masterpieces, one of 50 copies on Japanese paper, 54 photogravures, hf. mor. gt., t. e. g., 1903, 4to. (1062) *Hill,* £2

7074 Roman Empresses (The), or the History of the Lives and Secret Intrigues of the Wives of the Twelve Caesars, 2 vol., *Walpole Press,* 1899, 8vo. (897) *Hill,* £2 3s.

7075 Rossetti (D. G.) The Early Italian Poets, first ed., orig. cl., 1861, 8vo. (900) *Maggs,* £2 4s.

7076 Rothschild (Hon. W.) The Avifauna of Laysan and the Neighbouring Islands, col. and black plates, by Keulemans and Frohawk, and collotype photographs, 3 parts (complete), 1893-1900, roy. 4to. (1065) *B. F. Stevens,* £7 5s.

7077 Rule (W. H.) History of the Inquisition, ports. and plates, 2 vol., cf. gt., 1874, 8vo. (902) *Harding,* £1

7078 Ruskin (John). Modern Painters, plates, 5 vol., first eds. of vol. iii.-iv., 1857-60, roy. 8vo. (904) *Maggs,* £4 5s.

7079 Ruskin (J.) The Stones of Venice, 3 vol., 1874, imp. 8vo. (905) *Edwards,* £1 6s.

7080 Ruskin (J.) Examples of the Architecture of Venice, 15 plates, G. Allen, 1887, roy. folio (1124) *Thorp,* 13s.

7081 Saga Library (The), ed. by William Morris and Eirikr Magnússon, 6 vol., as issued, 1891-1905, 8vo. (912) *Hill,* £1 10s.

7082 St. John (Ch.) Natural History and Sport in Moray, illustrations, *Edinb.,* 1882, imp. 8vo. (913) *Hitchman,* £1 15s.

7083 Saint-Simon (Duc de). Memoirs, trans. by K. P. Wormeley, ports., 4 vol., hf. parchment, 1899, 8vo. (914) *Hill,* £2 4s.

7084 Salvin (F. H.) and Brodrick (W.) Falconry in the British Isles, first ed., col. plates (a few leaves soiled and torn), orig. cl., 1855, imp. 8vo. (915) *Edwards,* £4 2s. 6d.

7085 Sclater (P. L.) A Monograph of the Jacamars and Puff-Birds, 55 col. plates and illustrations, hf. mor., t. e. g., n. d., 4to. (1071) *Edwards,* £2 14s.

7086 Scott (Sir W.) Waverley Novels, "Abbotsford Edition," ports., plates and woodcuts, 12 vol., hf. mor. gt., *Edinb.,* 1842-47, roy. 8vo. (919) *Edwards,* £3 12s.

7087 Scrope (Wm.) Art of Deer -Stalking, first ed., plates and woodcuts, stamp on half-title and printed title, orig. cl., 1838, roy. 8vo. (922) *Edwards,* £3 12s.

7088 Scrope (Wm.) Days and Nights of Salmon Fishing in the Tweed, first ed., col. plates and woodcuts (1 plate loose), orig. cl., 1843, roy. 8vo. (923) *Maggs,* £4 6s.

7089 Seebohm (H.) History of British Birds, 3 vol., illustrations, 68 col. plates mounted on guards in separate vol., together 4 vol., hf. mor., t. e. g., 1883-5, 8vo. (925) *Edwards,* £4 10s.

7090 Seebohm (H.) The Geographical Distribution of the Charadriidae, 21 col. plates, illustrations, orig. cl., t. e. g., n. d. (1073) *Hill,* £2 15s.

7091 Seeley (J. R.) Life and Times of Stein, ports., 3 vol., *Cambridge,* 1878, 8vo. (927) *Harding,* 17s.

7092 Shakespeare (W.) Works, ɔy J. Payne Collier, port., 8 vol., hf. mor. gt., 1843-44, 8vo. (928) *Maggs*, £1 9s.
7093 Shakespeare (W.) Works, "The Camɔridge Shakespeare," ed. ɔy W. A. Wright, one of 500 copies on hand-made paper, 40 vol., 1893-95, imp. 8vo. (929)
J. Bumpus, £8 2s. 6d.
7094 Shakespeare. Schmidt (A.) Shakespeare Lexicon, 2 vol., 1874-75, imp. 8vo. (932) *Thin*, 15s.
7095 Sharpe (R. Bowdler) and Wyatt (C. W.) Monograph of the Hirundinidae, or Swallows, col. plates, 2 vol. in 11 parts, as issued, 1885-94, 4to. (1075) *Porter*, £4 14s.
7096 Shaw (H.) The Decorative Arts of the Middle Ages, 41 plates, some in colours, and heightened with gold, russ., g. e., W. Pickering, 1851, imp. 8vo. (934) *Thorp*, £2
7097 Shaw (H.) Dresses and Decorations of the Middle Ages, plates in col., and illustrations, 2 vol., roxɔurghe, 1858, 4to. (1079) *Thorp*, £2 10s.
7098 Shaw (H.) A Handɔook of the Art of Illumination, illustrations, hf. mor., g. e., 1866, folio (1125) *Barnard*, 17s.
7099 Shaw (H.) Illuminated Ornaments, descriptions by Sir F. Madden, col. facs., roxɔurghe, W. Pickering, 1833, 4to. (1076) *Barnard*, £2 2s.
7100 Shaw (H.) Specimens of Ancient Furniture, 74 plates (2 in col.), cf., g. e., W. Pickering, 1836, 4to. (1077)
Barnard, £1 4s.
7101 Shelley (Capt. G. E.) Monograph of the Nectariniidae, 121 plates, col. ɔy hand, hf. mor., t. e. g., 1876-80, 4to. (1080)
Edwards, £6
7102 Smith .(W.) and Wace (H.) Dictionary of Christian Biography, 4 vol., 1877-87, 8vo. (940) *Hunt*, £2 8s.
7103 Smollett (T.) Works, ed. ɔy G. Saintsɔury, No. 2 of 150 copies on handmade paper, port. and plates, 12 vol., 1895, 8vo. (941) *Young*, £1 5s.
7104 Solly (H. Neal). Memoir of the Life of David Cox, port. and plates, 1873, imp. 8vo. (942) *Sotheran*, £1
7105 Solon (M. L.) History of Old English Porcelain, plates, many col., 1903, 8vo. (943) *Hill*, £1 7s.
7106 Specimens of Royal, Fine and Historical Bookɔinding, selected from the Royal Liɔrary, Windsor Castle, ɔy R. R. Holmes, 152 plates in fac., 1893, roy. 4to. (1083)
Clegg, £3 4s.
7107 Spenser (Edmund). The Faerie Queene, ed. by T. J. Wise, illustrations by Walter Crane, in box, 6 vol., W. Allen, 1897, 4to. (1089) *Edwards*, £2 11s.
7108 Spenser Society. Puɔlications. First Series, vol. i.-xlv.— New Series, vol. i.-vi., with extra volume, together 52 vol., illustrations, 1867-94, 4to. and folio (1087)
A. Sutton, £13 10s.
7109 Spenser Society. Puɔlications. First Series, vol. xiii.-xxii., xxiv.-xxxix., with duplicate of vol. xxxi.—New Series, vol. v., together 28 vol., illustrations, 1872-92, 4to. and folio (1088)
Barnard, £2 12s.

7110 Spenser (Edmund). Works, ed.)y J. Payne Collier, 5 vol., 1862, 8vo. (946) *Edwards*, £2 5s.
7111 Stephens (G.) The Old-Northern Runic Monuments of Scandinavia and England, port. and facs., illustrations partly in gold and colours, 2 vol., hf. mor., t. e. g., 1866-68, folio (1127) *Bull*, £1 4s.
7112 Stevenson (H.) The Birds of Norfolk, plates (some col.), 3 vol., 1866-90, 8vo. (949) *Gladstone*, £2 12s.
7113 Stillmann (W. J.) Venus and Apollo in Painting and Sculpture, No. 220 of 555 copies on handmade paper, col. front. and plates, with duplicate set of the plates in portfolio, hf. vell., 1897, folio (1128) *Thorp*, £1 2s.
7114 Street (G. E.) Gothic Architecture in Spain, first ed., plates and woodcuts, fine copy, 1865, 8vo. (954) *Edwards*, £2 1s.
7115 Strong (S. A.) The Masterpieces in the Duke of Devonshire's Collection of Pictures, No. 2 of 330 copies printed, 60 photogravures, 1901, 4to. (1094) *Thorp*, £2 2s.
7116 Strutt (J.) Dress and Habits of the People of England, col. plates, 2 vol., hf. mor., 1842, 4to. (1095) *Hill*, £4 4s.
7117 [Surtees (R. S.)] "Ask Mamma," first ed., col. plates and woodcuts by J. Leech, orig. cl., 1858, 8vo. (957) *Maggs*, £4
7118 [Surtees (R. S.)] "Plain or Ringlets?" first ed., col. plates and woodcuts)y J. Leech, orig. cl., 1860, 8vo. (958) *James*, £5 15s.
7119 [Surtees (R. S.)] Hillingdon Hall, 12 illustrations by Wildrake, Heath and Jellicoe, col.)y hand, orig. cl., fine copy, 1888, 8vo. (959) *J. Bumpus*, £3 12s. 6d.
7120 Symonds (J. A.) The Life of Michelangelo Buonarroti, first ed., port. and 50 reproductions, 2 vol., Nimmo, 1893, 4to. (1097) *Edwards*, £2 2s.
7121 Temminck (C. J.) et Langier de Chartrouse. Nouveau Recueil de Planches Coloriées d'Oiseaux, 600 col. plates, 5 vol., hf. mor. ex., *Paris*, 1838, 4to. (1098) *Edwards*, £15 5s.
7122 Texier (C.) and Pullan (R. P.) Byzantine Architecture, 70 plates, woodcuts, 1864, folio (1130) *Edwards*, £3 10s.
7123 Thackeray (W. M.) Works, édition de luxe, ports. and plates on India paper, 24 vol., 1878-79, imp. 8vo. (962) *Young*, £14
7124 Thackeray (W. M.) Vanity Fair, first ed., woodcuts, including that of the Marquis of Steyne at page 336, hf. cf., 1848, 8vo. (963) *Edwards*, £2 8s.
7125 Thackeray (W. M.) The History of Henry Esmond, first ed., 3 vol., orig. cl., 1852, 8vo. (965) *Maggs*, £2 19s.
7126 Ticknor (G.) History of Spanish Literature, first ed., 3 vol., 1849, 8vo. (970) *Shepherd*, 19s.
7127 Trevelyan (Sir G. O.) The American Revolution, maps, 2 parts in 3 vol., 1899-1903, 8vo. (971) *Hill*, £1 6s.
7128 Trollope (T. A.) History of the Commonwealth of Florence, 4 vol., 1865, 8vo. (972) *Maggs*, £1 13s.
7129 Turbervile (G.) The Booke of Falconrie or Hawking, black letter, woodcuts (margins of title mended), russ., g. e., Th. Purfoot, 1611, 4to. (1101) *B. F. Stevens*, £7

7130 Turner and Ruskin, an Exposition of the Work of Turner from the Writings of Ruskin, ed. by F. Wedmore, édition de luxe, plates on India paper, duplicate set on Japan paper, in separate portfolio, 2 vol., 1900 (1133)
Thorp, £2 4s.

7131 Tymms (W. R.) and Wyatt (M. D.) The Art of Illuminating, col. and illuminated plates, 1860, folio (1134)
Quaritch, £1 12s.

7132 Venice. Streets and Canals in Venice (Calli e Canali in Venezia), photographic plates, *Venezia,* F. Ongania, 1893, folio (1135) *Edwards,* £1 16s.

7133 Viollet-le-Duc. Dictionnaire Raisonné de l'Architecture Française, illustrations, 10 vol., hf. mor., t. e. g., *Paris,* 1858-68, 8vo. (979) *Lewine,* £5 10s.

7134 Walton (I.) and Cotton (C.) The Complete Angler, "Major's Second Edition," ports. and plates on India paper, and woodcuts, russ. gt., 1824, 8vo. (986) *Barnard,* £1 2s.

7135 Walton (I.) and Cotton (C.) The Complete Angler, ed. by John Major, No. 111 of the "Extra Illustrated Edition," limited to 120 copies, etchings and woodcuts, mor. ex., by Zaehnsdorf, 1885, 4to. (1103) *Maggs,* £2 6s.

7136 Walton (I.) and Cotton (C.) The Compleat Angler, ed. by R. B. Marston, No. 119 of 250 copies of the édition de luxe, plates on India paper, 2 vol., mor., t. e. g., Walton and Cotton monogram on sides, 1888, 4to. (1104) *Dobell,* £2 4s.

7137 Walton (I.) and Cotton (C.) Complete Angler, by Sir H. Nicolas, ports. and vignettes on India paper, and extra illustrated by the insertion of 31 ports. and plates, 2 vol., mor. ex., emblematically tooled, g. e., W. Pickering, 1836, imp. 8vo. (987) *Barnard,* £12 10s.

7138 Walton (I.) and Cotton (C.) The Complete Angler, ed. by John Major, 2 ports. and 6 etchings, in two states, and woodcuts on India paper, Nimmo, 1883, 8vo. (988)
Young, 16s.

7139 Warburton (Eliot). Memoirs of Prince Rupert and the Cavaliers, first ed., ports., 3 vol., hf. cf. gt., 1849, 8vo. (989)
Hill, £1 8s.

7140 Weale (John). Divers Works of Early Masters in Christian Decoration, illustrations (some in colours), 2 vol., hf. mor., 1846, folio (1138) , *Batsford,* £2 12s.

7141 Westwood (J. O.) Fac-similes of the Miniatures and Ornaments of Anglo-Saxon and Irish Manuscripts, 53 col. plates, 1868, roy. folio (1140) *Quaritch,* £8 15s.

7142 Wheeler (J. T.) History of India, maps, 4 vol. in 5, 1867-81, 8vo. (993) *Edwards,* £2 18s.

7143 Wickes (C.) The Spires and Towers of the Mediæval Churches of England, plates, 3 vol. in 1, hf. mor., 1853-9, folio (1141) *Thorp,* £1 6s.

7144 Wilkinson (J. G.) Manners and Customs of the Ancient Egyptians, both series, illustrations, 6 vol., cf., 1837-41, 8vo. (998) *Shepherd,* 19s.

7145 Wilson (A.) and Bonaparte (C. L.) American Ornithology, port. and col. plates, 3 vol., hf. mor., t. e. g., 1832, 8vo. (999)
J. Bumpus, £4
7146 Winthrop (J.) History of New England, port., 2 vol., *Boston,* 1853, 8vo. (1002) *H. Stevens,* £1 3s.
7147 Wolley (J.) Ootheca Wolleyana, plates (col. and plain), as issued, 2 vol. in 4 parts, 1864-1907, 8vo. (1003) *Porter,* £5
7148 Wyatt (M. Digby). Specimens of Ornamental Art, Workmanship in Gold, Silver, Iron, Brass and Bronze, plates (plain and col.), 1852, folio (1142) *Thorp,* 14s.
7149 Wyclif Society. Publications. Wyclif's Latin Works, facs., vol. i.-xvii., 1882-93, 8vo. (1005) *Barnard,* £1 16s.
7150 Yarrell (Wm.) History of British Birds, 3 vol., and Supplement, 4 vol., 520 woodcuts, 1843-45, roy. 8vo. (1007)
Thorp, £1 13s.
7151 Yarrell (Wm.) History of British Birds, fourth ed., 564 woodcuts, 4 vol., 1871-85, 8vo. (1008) *Edwards,* £2 3s.
7152 Yarrell (Wm.) History of British Fishes, ed. by Sir J. Richardson, 522 woodcuts, 2 vol., 1859 (1009) *Edwards,* 13s.

[MAY 25TH, 26TH AND 27TH, 1910.]

HODGSON & CO.

A PORTION OF THE LIBRARY OF THE LATE PROFESSOR A. J. BUTLER, OF WEYBRIDGE, AND OTHER PROPERTIES.

(No. of Lots, 955 ; amount realised, £1,505.)

7153 Alken (H.) and Sala (G. A.) The Funeral Procession of the Duke of Wellington, a folding Panorama of the Procession, coloured, 66 feet long, in cover, with watered-silk linings, by Rivière, the orig. front cover preserved, in case [1852] (124) £5 5s.
7154 Alken (H.) Ideas, 42 plates, col. by hand, 11 parts, in portfolio, 1827 (re-issue) (306) £2 18s.
7155 Alken (H.) National Sports of Great Britain, orig. issue, title and 50 col. plates, descriptions in English and French, hf. cf. gt., Thomas M'Lean, 1821, folio (558) £52
7156 Angas (G. F.) South Australia Illustrated, 60 large col. plates, hf. mor., t. e. g., with the 10 pictorial wrappers bound in, M'Lean, 1847, folio (561) *Parsons,* £10 5s.
7157 Angeli Politiani Opera Omnia (Hain, No. 13218), contemp. MS. notes, vell., *Venetiis, in Ædibus Aldi Romani,* 1498, folio (826) £2 2s.
7158 Aquinas (Thomas de). Catena Aurea, **gothic letter**, 432 unnumbered leaves (Hain, No. 1331), 4 illuminated initial

letters, the small initials and paragraph marks in red and ɔlue, contemp. pigskin (ɔroken), *Nuremberg*, A. Coɔerger, 1475, folio (935) £5 5s.

7159 Archer (J. W.) Vestiges of Old London, 37 proof plates, LARGEST PAPER (5 copies so issued), mor. ex., 1851, folio (513) £2 10s.

7160 Armstrong (W.) Sir Joshua Reynolds, édition de luxe, 78 photogravures and 6 lithographic facs. in colour, duplicate set of the illustrations on India paper in portfolio, 2 vol., cl., 1900, folio (289) £3 10s.

7161 Armstrong (W.) Turner, plates, Japanese paper copy, duplicate set of the plates (350 copies issued), 2 vol., cl., 1902, folio (290) £2

7162 Auction Prices of Books, from the commencement of the English Book-Prices Current in 1886, and the American Book-Prices Current in 1894, to 1904, ed. by L. S. Livingston, limited ed., 4 vol., buckram, 1905, 8vo. (84) £3 4s.

7163 Auduɔon (J. J.) Birds of America, a selection of 88 plates, 24 of which are coloured (2 defective), unbd., 1827, douɔle elephant folio (599) £5 15s.

7164 Baker (G.) History of the County of Northampton, LARGE PAPER, plates on India paper, vol. i. (erasure on title), hf. russ., 1822-30, roy. folio (527) £1 14s.

7165 Barrozzio de Vignole (J.) Livre Nouveau ou Regles des Cinq Ordres d'Architecture, 107 plates (should be 109), with vignettes ɔeneath, elevations, altars, etc., after Cochin and others, cf., *Paris*, 1767, folio (880) £5 2s. 6d.

7166 Biɔliographical Society. Puɔlications, comprising the Illustrated Monographs, facsimiles, 15 parts, 4to.—Transactions, from the commencement in 1902 to Dec., 1908 (ɔeing vol. i. to ix.), in 14 parts, sm. 4to.—Hand-Lists of English Printers—Index to the Serapeum—English Plays and Masks—The English Book Trade, 1457-1557—Newton and Bentley Biɔliographies, etc., 17 vol. and parts, sewed, 1894-1909 (712) £6 15s.

7167 Bigland (R.) Collections relative to the County of Gloucester, with Fosbroke's City of Gloucester, plates, in 2 vol., hf. cf., 1791-1819, folio (520) £2 7s. 6d.

7168 Blomefield (F.) and Parkin (C.) History of the County of Norfolk, port. and plates, LARGE PAPER, extra illustrated by the insertion of 237 additional plates, arms emɔlazoned (the text in some volumes discoloured), 11 vol., hf. mor., t. e. g., 1805-10, roy. 4to. (540) £12

7169 Blondus (Flavius). Historiarum Romanarum Decades Tres (Hain, No. 3249), contemp. MS. notes in margins, vell., *Venetiis, per Thomam Alexandrium*, 1484, folio (822) £1 6s.

7170 Borlase (W.) Antiquities of Cornwall, map and plates, old cf., 1769—Oɔservations on the Islands of Scilly, map and folding plates, old cf., *Oxford*, 1756, folio (525) £2 4s.

7171 Brayɔrooke (R., Lord). History of Audley End, ports. and plates, cf. (reɔacked), 1836, 4to. (504) £1 4s.

7172 Brayley (E. W.), Nightingale and Brewer. London and Middlesex, plates, 4 vol. in 5, old mor., g. e., 1810-16, 8vo. (466) £2 6s.

7173 Bruin (G.) Civitates Orbis Terrarum, 240 engraved views and plans, the whole coloured throughout by an early hand, first 4 vol. old cf., *Coloniæ,* 1577, folio (577) *Barnard,* £4

7174 Burke (E.) Works, Library ed., port. after Reynolds, 12 vol., buckram, t. e. g., J. C. Nimmo, 1899, 8vo. (120) *J. Bumpus,* £4 10s.

7175 Burton (Sir R. F.) Il Pentamerone, 2 vol., cl., Henry and Co., 1893, 8vo. (66) £1 14s.

7176 Carlyle (T.) Collected Works, viz., French Revolution, 3 vol. (collected title to vol. i. defective)—Essays, 6 vol.—Hero Worship—Past and Present—Latter Day Pamphlets, 1870 —Life of Sterling—Frederick the Great, 10 vol.—Wilhelm Meister, 3 vol.—and Index, Library ed., together 27 vol., orig. cl., Chapman and Hall, 8vo. (119) *J. Bumpus,* £5 12s. 6d.

7177 Chauncy (Sir H.) Historical Antiquities of Hertfordshire, orig. ed., port. and engravings (as usual, wanted the three scarce plates), old cf. (rebacked), 1700, folio (518) £1 10s.

7178 Chemical Society. Journal, vol. xci. to xcvi., in 39 numbers, wrappers, 1907-9, 8vo. (369) £1 10s.

7179 Clarkson (C.) History and Antiquities of Richmond in the County of York, hf. mor., *Richmond,* 1821, 4to. (494) *Walford,* £1 12s.

7180 Cleasby (R.) and Vigfusson (C.) Icelandic-English Dictionary, hf. mor., *Oxford,* 1874, sm. 4to. (697) £1 16s.

7181 Colden (Hon. C.) History of the Five Indian Nations of Canada, folding map, contemp. cf., 1750, 8vo. (455) *Grant,* £1 14s.

7182 Collins (G.) Navigation by the Mariners Plain Scale new plain'd, diagrams, contemp. cf., 1659, sm. 4to. (870) *Quaritch,* £1 6s.

7183 Collins (Lieut.-Col.) Account of the English Colony in New South Wales, second ed., port. and plates, the Natural History coloured, cf. gt., 1804, 4to. (451) £1 11s.

7184 Collinson (J.) History of the County of Somerset, folding map and engravings, 3 vol., old cf. gt. (cracked), *Bath,* 1791, 4to. (487) *Bailey,* £3

7185 Condor (J.) Flowers of Japan, illustrations (some coloured), sewed, 1892, folio (606) *Quaritch,* £1 11s.

7186 Cook (Capt.) Three Voyages round the World, port., maps and plates, 8 vol., uniform old russ. gt., 1773-84, 4to. (506) *Quaritch,* £6 10s.

7187 Cornwall. Visitations of Cornwall, containing the Heralds' Visitations of 1530, 1573 and 1620, with additions by J. L. Vivian, cf., 1887, 4to. (542) £1 17s.

7188 Cox (David). Treatise on Landscape Painting, col. and other illustrations, 2 vol., cl., S. Fuller, 1814, oblong folio (595) *Maggs,* £3 3s.

7189 Dante. La Divina Commedia, ristàmpate per cura di G. G. Warren, Lord Vernon, facs. (limited to 100 copies), hf. roan, *Londra*, 1858, folio (719) £2 2s.

7190 Dante. La Divina Commedia, Comento di Christophoro Landino, fourth illustrated ed., woodcuts (4 preliminary leaves and last 2 leaves repaired), hf. bd., *Impresso in Vinegia, per Petro Cremonese*, 1491, folio (720) £4 15s.

7191 Dante. La Divina Commedia [Comento di Ch. Landino], one full-page and numerous small woodcuts, russ., *Venetia, per Bernardino Stagnino*, 1512, sm. 4to. (721) £5 12s. 6d.

7192 Dante. La Divina Commedia, con la nova Espositione di A. Vellutello, woodcuts, in 3 vol., hf. cf., *Vinegia*, F. Marcolini, 1544, sm. 4to. (723) £2 12s.

7193 Dart (J.) Westmonasterium, or History of St. Peter's, Westminster, plates, 2 vol., old cf. (rejacked), 1742, folio (515) £1

7194 Davis (J. B.) and Thurnam (J.) Crania Britannica, plates, 2 vol. in 1, hf. cf., 1865, folio (574) £1 15s.

7195 Dennistoun (J.) Memoirs of the Dukes of Urbino, plates, 3 vol., cl., 1909, 8vo. (812) £1 1s.

7196 Dent (Clinton). Above the Snow Line, cuts by Whymper, etc., orig. cl., 1885, 8vo. (668) £1 11s.

7197 Dial (The), ed. by Shannon and Ricketts, illustrations, 5 numbers (all published), autograph of R. Savage and a postcard from C. H. Shannon, relating to the publication, inserted, wrappers, 1889-97, 8vo. (152) £6 7s. 6d.

7198 Dickens (C.) Dombey and Son, in the orig. 20 numbers, with wrappers, 1846-8, 8vo. (892) £3 12s. 6d.

7199 Dilke (Lady). French Painters, Architects and Sculptors, Decoration and Furniture, and Engravers and Draughtsmen of the XVIIIth Century, illustrations, 4 vol., cl., t. e. g., 1899-1902, imp. 8vo. (250) *Sotheran*, £3 7s. 6d.

7200 Dodsley's Annual Register, from the commencement in 1758 to 1903, with Index, 1758-1819, together 147 vol., first 106 vol. hf. cf., the remaining 41 vol. orig. cl., with the exception of 2 volumes in sound condition, 8vo. (464) *Edwards*, £12 5s.

7201 Doves Press. The English Bible, ed. by F. H. Scrivener, 5 vol., vell., 1903-5, folio (195) *Edwards*, £5 7s. 6d.

7202 Dugdale (Sir W.) History of St. Paul's, second ed., LARGE PAPER, port. and plates by Hollar, old russ. gt. [? by Roger Payne], 1716 (514) £1 11s.

7203 Dugdale (Sir W.) Monasticon Anglicanum, by Caley, Ellis and Bandinel, port. and plates, 8 vol., hf. russ., t. e. g. (binding of vol. i. and iv. broken), 1846, folio (564) *Harding*, £11

7204 [Dulaney (Daniel).] Considerations on imposing Taxes in the British Colonies for the Purpose of raising a Revenue, orig. ed. (last 3 leaves defective), unbd., *North America, printed by a North American*, 1765, 8vo. (867) £1 5s.

7205 Dunbar (W.) Poems, ed. by D. Laing, with Supplement, 2 vol., hf. mor., t. e. g., *Edin.*, 1834-65, 8vo. (649) £1 17s.

7206 Eagle (The), a Magazine supported by Members of St. John's
College, from the commencement in 1858 to 1898, being
vol. i. to xx., part iv., in 117 numbers, sewn, *Cambridge*, 8vo.
(82) £2 10s.

7207 Edwards (J.) Exotic and British Flowers, 100 col. plates,
with descriptions, hf. mor., uncut, 1770, folio (601)
Quaritch, £1 12s.

7208 Egypt Exploration Fund. Tanis, 2 parts—Naukratis, 2 parts
—Deshasheh, by Flinders Petrie—Goshen—City of Onias
—Bubastis—Ahnas el Medineh—Temple of Deir el Bahari,
with 2 folio vol. of plates by E. Naville, being Memoirs
ii. to iv., vi. to viii., xi., xii. and xv., plates, together 10 vol.
4to. and 2 folio, bds., 1885-94 (593) £2 15s.

7209 Ellis (H.) History and Antiquities of St. Leonard's, Shore-
ditch, plates, extra-illustrated by the insertion of 6 engrav-
ings after Hollar, views and ports., and a plate of Lunardi's
balloon ascent in 1784, cf. gt., 1798, 4to. (472)
Walford, £2 8s.

7210 Elizabethan MS. Walsingham's Letter-Book, a contemp.
transcript of his letters written to or received from Queen
Elizabeth, Sir Wm. Cecil, Lord Burleigh, the Earl of
Leicester, and others between August, 1570 and November,
1572, on 224 leaves, bds., sm. folio (849) £11

7211 English Dialect Dictionary, ed. by Joseph Wright, with
Supplement, Bibliography and Grammar, 6 vol., cl., 1896-
1905, 8vo. (711) £5

7212 Entomological Society. Transactions, plates (some col.), 19
various complete vol. and 37 various parts, ranging from
the commencement in 1836 to 1901, 5 vol. hf. cf., 6 vol.
bds. and 76 numbers, 8vo. (375) £2 10s.

7213 Erskine (Mrs. Steuart). Beautiful Women in History and
Art, éd. de luxe, front. in two states and ports. (some in
colours), (175 copies,) cl., t. e. g., 1905, folio (296) £2 2s.

7214 Essex House Press. Shelley. Adonais—Keats. Eve of St.
Agnes—Gray. Elegy—Spenser. Epithalámion—Chaucer.
Flower and the Leaf—Milton. Comus—Burns. Tam o'
Shanter—Wordsworth. Ode on Immortality—Coleridge.
Ancient Mariner—Whitman (Walt). Hymn on the Death
of President Lincoln (limited eds.), printed on vell., to-
gether 10 vol., vell., 1900-3, 8vo. (198) £5 10s.

7215 Evelyn (J.) Memoirs, ed. by Bray, ports., 2 vol., hf. cf., uncut,
1819, 4to. (549) £1 5s.

7216 [Fielding (H.)] Joseph Andrews, first ed., 2 vol., contemp.
cf., with List of Books published by A. Millar in each vol.,
1742, folio (859) *Spencer*, £11 5s.

7217 Foster (J. J.) British Miniature Painters, ports., some on
Japanese paper, cl., t. e. g., 1898, folio (293) £1 10s.

7218 Foster (J. J.) Miniature Painters, British and Foreign, éd.
de luxe, col. fronts. and ports. on Japanese paper (175
copies printed), 2 vol., vell., t. e. g., 1903, folio (294) £3 5s.

7219 Foster (J. J.) The Stuarts, éd. de luxe, col. fronts., ports. on India paper, and etchings (175 copies printed), 2 vol., cl., t. e. g., 1902, folio (295) £2 10s.
7220 Gautier (T.) Works, trans. ɔy Prof. F. C. de Sumichrast, port. and plates, 24 vol., cl., 1906, 8vo. (72) £4 9s.
7221 Gilɔert (C. S.) Historical Survey of Cornwall, ports., plates and heraldic illustrations (title and a few pages of vol. i. stained), 2 vol., old cf., 1817-20, 4to. (541) £3
7222 Gould (J.) Monograph of the Ramphastidæ, col. plates, 2 vol. in 1; mor. ex., g. e., 1834-8, roy. folio (591)
Quaritch, £4 6s.

Goupil's Historical Monographs, each vol. illustrated with a col. front., numerous ports. and photogravure, 4to.

7223 Queen Elizaɔeth, by Mandell Creighton, orig. wrapper, Boussod, Valadon and Co., 1896 (260) £7
7224 Mary Stuart, by Sir John Skelton, first ed., wrapper, 1893 (261) £5
7225 Charles I., by Sir John Skelton, Japanese vell. copy, duplicate set of the plates, wrapper, in box, 1898 (262) £2 4s.
7226 Oliver Cromwell, ɔy S. R. Gardiner, Japanese vell. copy, duplicate set of the plates, wrapper, in box, 1899 (264)
£2 9s.
7227 Joséphine, Impératrice et Reine, par Frédéric Masson, Japanese vell. copy, duplicate set of plates, wrapper, in case, *Paris*, 1899 (266) £2 10s.
7228 Marie Antoinette, the Dauphine, from the French of Pierre de Nolhac, wrapper, n. d. (269) £1 18s.

7229 Gower (Lord Ronald). Sir Thomas Lawrence, col. front. and other illustrations, LARGE PAPER, duplicate set of the plates (200 copies so printed), wrappers, in cl. case, Goupil and Co., 1900, folio (288) £3 5s.
7230 Haddan (A. W.) and Stuɔɔs (W.) Councils and Documents relating to Great Britain and Ireland, 3 vol. (vol. ii. in 2 parts, part ii. sewn), cl., *Oxford*, 1869-78, 8vo. (92)
Harding, £2
7231 Haddon Hall Liɔrary. Hunting—Fly-Fishing—Wild Life in the Hampshire Highlands—Our Gardens—Our Forests—Bird Watching—Outdoor Games—Shooting, photogravure and other illustrations (some col.), fronts. in 2 states, éd. de luxe, together 8 vol., vell. ex., 1899-1902, 8vo. (216)
£4 7s. 6d.
7232 [Hardy (T.)] Desperate Remedies, first ed., 3 vol., orig. ɔrown cl., Tinsley Brothers, 1871, 8vo. (629) £17 15s.
7233 [Hardy (T.)] Under the Greenwood Tree, first ed., 2 vol., orig. cl. (loose), 1872, 8vo. (630) *Bailey*, £3 15s.
7234 Hardy (T.) Far from the Madding Crowd, illustrations, first ed., 2 vol., orig. cl., 1874, 8vo. (631) *Bumpus*, £5 12s. 6d.
7235 Hardy (T.) The Trumpet Major, first ed., 3 vol., orig. cl., 1880, 8vo. (633) £1

7236 Hardy (T.) A Laodicean, first ed., 3 vol., orig. cl., 1881, 8vo. (634) £2
7237 Hardy (T.) Two on a Tower, first ed., 3 vol., orig. cl., 1882, 8vo. (635) £2 16s.
7238 Hardy (T.) The Mayor of Casterbridge, first ed., 2 vol., orig. cl., 1886, 8vo. (636) £4
7239 Hardy (T.) The Woodlanders, first ed. (titles stamped), 3 vol., orig. cl., 1887, 8vo. (637) £1 11s.
7240 Harris (J.) Collection of Voyages and Travels, maps, ports. and plates, 2 vol., hf. cf. gt., 1744-8, folio (539) £1
7241 Harris (M.) Natural History of Moths and Butterflies, col. front. and 44 col. plates, LARGE PAPER, hf. cf., t. e. g., 1778, folio (602) £1 19s.
7242 Harvey (W. H.) Phycologia Britannica, LARGE PAPER, col. plates, 4 vol., cl., 1846-51, 8vo. (378) £3 5s.
7243 Harvey (W. H.) Phycologia Australica, 300 col. plates, 5 vol., cl., 1858-63, roy. 8vo. (379) £3 8s.
7244 Hasted (E.) History of Kent, orig. ed., engravings and maps, 4 vol., cf. gt. (rejacked), uncut, *Canterbury*, 1778-99, folio (507) *Quaritch*, £21
7245 Heath (W.) Military Costume of the British Cavalry, 16 col. plates, orig. pink bds., uncut, with the label, J. Watson, 1820, folio (557) *Robson*, £66
7246 Hedwig (J.) Species Muscorum Frondosorum, ed. a F. Schwaegrichen, col. plates, 5 vol., hf. cf., *Lipsiæ*, 1801-27, sm. 4to. (377) £1 18s.
7247 Hind (H. Y.) Explorations in the Interior of Labrador, col. plates, 2 vol., orig. cl., uncut, 1863, 8vo. (43) £1 14s.
7248 Hoare (Sir R. C.) Ancient History of Wiltshire, 2 ports. and engravings, etc., LARGE PAPER, 2 vol., russ. (broken), 1819-21, folio (524) £1 12s.
7249 Holmes (C. J.) Constable and his Influence on Landscape Painting, 77 photogravure plates, Japanese vell. copy (50 so printed), hf. mor., t. e. g., with a duplicate set of the illustrations in a cl. portfolio, 1902, folio (291) £2
7250 Horsfield (T. W.) History of Sussex, maps, ports., etc. (margins stained), 2 vol., hf. bd., *Lewes*, 1835, 4to. (486) £1 13s.
7251 Hutchins (J.) History of Dorsetshire, second ed., ports., plates, with a few additional ports. and plates inserted, including 2 water-colour drawings of Sir John and Lady Strangways, 4 vol., hf. mor., entirely uncut, 1796-1815, folio (522) £4 10s.
7252 Hutchinson (W.) History of Cumberland, map, pedigrees and plates, 2 vol., hf. cf., *Carlisle*, 1794, 4to. (492) £2 10s.
7253 Ihne (W.) History of Rome, English ed., 5 vol., cl., 1871-82, 8vo. (10) *Edwards*, £2 5s.
7254 Journal of Hellenic Studies, from the commencement to 1909, being vol. i. to xxix., in 54 parts, with the plates to vol. i.-viii. in 14 parts, in case, folio—Index, vol. ix.-xvi.— Supplementary Paper No. 1—Catalogue of Books, etc., together 78 parts, 1880-1909, 8vo. (696) £12 15s.

7255 Journal of Philology, ed. by W. G. Clark, etc., from the commencement to 1907, vol. i. to xxx., in 60 parts, 1868-1907, 8vo. (710) £7

7256 Keepsake (The), illustrations on India paper, from 1829 to 1836, LARGE PAPER, 8 vol., mor., g. e., 1829-36, 8vo. (652) £1 15s.

7257 King (D.) The Vale-Royal of England, map and plates, old cf., 1656, folio (529) £1 3s.

7258 La Fontaine (J. de). Tales and Novels, 85 engravings by Eisen, Japanese vell. paper (95 copies so printed), 2 vol., cl., t. e. g., *Paris*, 1884, 8vo. (218) £2 5s.

7259 Lewis (S.) History and Topography of St. Mary, Islington, extra-illustrated by the insertion of about 70 old views, ports., etc., cf. gt., 1842, 8vo. (470) *Bailey*, £2 5s.

7260 Loutherbourg (P. J. de). Scenery of England and Wales, 18 col. plates mounted as drawings, with descriptions, hf. bd., 1805, folio (590) £2 6s.

7261 Luxembourg Gallerie, engraved title, port. and 23 plates after Reubens by Nattier, old cf., *Paris*, 1710, atlas folio (598) *Scotti*, £2 15s.

7262 Lysons (S.) A Collection of Gloucestershire Antiquities, engravings, those of stained glass coloured, old russ. ex., g. e., 1791-1803, folio (521) £1 13s.

7263 Maitland (W.) History of London, plates, 2 vol., cf. (rebacked), 1772, folio (511) £2 2s.

7264 Malton (J.) View of the City of Dublin, coloured copy, hf. mor., t. e. g., 1792, oblong folio (560) £10

7265 Manning (Rev. O.) and Bray (W.) History and Antiquities of Surrey, views, ports., etc., with a facsimile copy of the Domesday on 13 plates, 3 vol., old russ. (rebacked), 1804-14, folio (509) *Thorp*, £12 12s.

7266 Mannskirsch (F. I.) Coloured Views of the Parks and Gardens of London, 8 col. plates, by H. Schutz (first 2 defective), mounted, mor., R. Ackermann, 1813, oblong folio (559) *Leighton*, £15 10s.

7267 Medina (Pierre de). L'Art de Navegar, woodcut diagrams (the folding map and first few leaves defective), vell., *Rouen*, 1577, sm. 4to. (868) *Sotheran*, £1 5s.

7268 Meredith (G.) Beauchamp's Career, first ed., 3 vol., orig. cl., 1876, 8vo. (638) £2 18s.

7269 Microscopical Society. Publications, viz., Transactions, New Series, 1853-1868, and Quarterly Journal of Microscopical Science, ed. by Lankester and Busk, 1853 to 1870, in 18 vol., hf. cf.—Monthly Microscopical Journal, ed. by H. Lawson, 1869 to 1877, 18 vol., hf. cf.—Journal of the Royal Microscopical Society, plates, from March, 1878 to Dec., 1908, in 193 numbers, including 6 star numbers, wrappers, together 36 vol., hf. cf., and 193 numbers, 8vo. (368) £8 10s.

7270 Miller (P.) Figures of the Plants described in the Gardener's Dictionary, 300 col. plates, and Text, in 3 vol., hf. mor., g. e., 1760, folio (600) *Quaritch*, £1 16s.

33—2

7271 Morant (P.) History and Antiquities of the County of Essex, orig. ed., maps and plates, 2 vol., old russ. (reacked), 1768, folio (516) *Quaritch,* £9 15s.

7272 Nash (T.) Collections for the History of Worcestershire, maps, ports. and plates, with the 13 facsimile pages of Domesday Book, as usual wanted the Supplement and plan of Worcester, but having Amphlett's Index, 2 vol. old russ. (reacked), the index hf. mor., 1781-1899, folio (526) £5 5s.

7273 Nuremberg Chronicle, editio princeps, 𝔤𝔬𝔱𝔥𝔦𝔠 𝔩𝔢𝔱𝔱𝔢𝔯, woodcuts by M. Wolgemuth and W. Pleydenwurff, with the 5 leaves, "De Sarmacia," and the blank leaves 259-261, large initials in red, some with marginal decorations, title in fac., cf. gt., in case, *Anthonius Koberger Nuremberge impressit,* 1493, folio (820) £40

7274 Ormerod (G.) History of Cheshire, orig. ed., port., plates, etc., LARGE PAPER, 3 vol., hf. mor., t. e. g., 1819, folio (563)
 £4 10s.

7275 Owen (H.) and Blakeway (J. B.) History of Shrewsbury, map, views, etc., 2 vol., old russ. ex., Harding and Lepard, 1825, 4to. (499) £3 10s.

7276 Oxley (J.) Journal of Two Expeditions into the Interior of New South Wales, maps and plates, hf. bd., uncut, 1820, 4to. (450) *Maggs,* £2 4s.

7277 Palmer (S.) St. Pancras, LARGE PAPER, illustrated by the insertion of upwards of 156 views, ports., etc., a few col., inlaid to size where necessary, extended to 2 vol., hf. mor., t. e. g., 1870, 8vo. (471) £3 5s.

7278 Petrarch. Opera del preclarissimo Poeta Miser Francesco Petrarcha . . . historiate per Miser Nicolo Perãzone, 𝔤𝔬𝔱𝔥𝔦𝔠 𝔩𝔢𝔱𝔱𝔢𝔯, 6 full-page woodcuts (a few leaves defective), hf. vell., *Venetiis,* B. de Zanis, 1508, folio (768) £3

7279 Pitt's English Atlas, ports., 2 mappe-mondes and numerous maps with engravings depicting costume, emblazoned coats-of-arms by a contemp. hand, 4 vol., old cf., *Oxford,* 1680, atlas folio (876) *Thorp,* £2 8s.

7280 Platina (B.) Vitæ Pontificum, 𝔤𝔬𝔱𝔥𝔦𝔠 𝔩𝔢𝔱𝔱𝔢𝔯 (Hain, No. 13,047), vell., *Nuremberge,* A. Koberger, 1481, folio (821) £1 14s.

7281 Proctor (R.) Bibliographical Essays, port. and facs., hf. mor., t. e. g., 1905, roy. 8vo. (713) £1 13s.

7282 Ptolemæus. Liber quadripartiti Ptholemei, ejusdem de Stellis, de Horis Planetarum, etc., 𝔤𝔬𝔱𝔥𝔦𝔠 𝔩𝔢𝔱𝔱𝔢𝔯 (Hain, No. 13,544), diagrams, initials coloured, British Museum Sale Duplicate 1787, and Wodhull copy, cf., *Venetiis,* B. Locatellus, 1493, folio (828) £1 7s.

7283 Purchas (S.) Hakluytus Posthumus, or Purchas his Pilgrimes, first issue of the first ed., folding maps and tables, autograph inscription, "Francis Butler, March 31, 1677, the five volumes cost 5l." (engraved title margined), 5 vol., mor. ex., by Rivière, *W. Stansby for H. Fetherstone* [1624], 1626, folio (578) £80
 [The above is a copy of the first issue with the title in vol. i. dated 1624, the "Note touching the Dutch," which

was amended in the second issue, the original headline, " Hollander's lying devices to disgrace the English " (page 704, vol. i.), and the many other leaves which, on account of their objectionable references to the Dutch, were afterwards reprinted or issued with printed slips. —*Catalogue.*]

7284 Ranke (L. von). History of England, 6 vol., cl. (rebound), *Oxford*, 1875, 8vo. (14) £1 12s.

7285 Royal Geographical Society. The Journal of the Royal Geographical Society of London, from the commencement to 1880 (being vol. i. to l.), with General Indexes to vol. i.-xl.—Library Catalogue, 55 vol., hf. cf. gt.—Proceedings, First Series, 22 vol.—New Series, vol. i. to iii., 1855-81, maps, 25 vol., hf. cf., together 80 vol., 1830-81 (40) £10 15s.

7286 Rudder (S.) History of Gloucestershire, map and folding plates, old russ. ex., *Cirencester*, 1779, folio (519) £5

7287 Shakespeare (W.) Works, ed. by T. Sturge Moore—Marlowe (C.) Doctor Faustus, decorations by Charles Ricketts, 40 vol., cl., 1900-3, 8vo. (175) £5 10s.

7288 Shakespeare (W.) Comedies, Histories and Tragedies, fac. of the first folio ed., by Sidney Lee, cf., with ties, *Oxford*, 1902, folio (308) £4 9s.

7289 Shaw (S.) History and Antiquities of Staffordshire, with the Appendix, folding map, plan of Wolverhampton, pedigrees, engravings and fac. of Domesday Book, 2 vol., contemp. cf. (cracked), J. Nichols, 1798-1801, folio (562) *Quaritch*, £10 10s.

7290 Shelley (P. B.) Poetical Works, ed. by Buxton Forman, best library ed., ports., 4 vol., orig. cl., 1876, 8vo. (73) £5 10s.

7291 Smith (J. T.) Antiquities of London and its Environs, contemp. mor. ex., g. e., 1791, folio (512) £2

7292 Smith (W.) History of Canada, presentation copy from the author, with the rare folding Census slip in vol. ii. (title and a few leaves water-stained), 2 vol., orig. bds., uncut, *Quebec*, John Neilson, 1815, 8vo. (454) *Maggs*, £6 12s. 6d.

7293 Songe du Veigier. Le songe du vergier qui parle de la Disputacion ou Clerc et du Chevalier, black letter, first leaf in fac., mor. ex., [*Lyon*] *imprimé par Jacques Maillet*, 1491, folio (936) £5

7294 South African Commercial Advertiser, from July, 1837 to 1849, 12 vol., hf. cf. (first 3 vol. wanted title-pages), *Cape Town*, 8vo. (448) *Edwards*, £9 15s.

7295 Speed (J.) Theatre of the Empire of Great Britaine, maps, surrounded by views of cities, costume, etc., cf., 1676, folio (576) £2 17s.

7296 Stevenson (R. L.) Letters, by Sidney Colvin, ports., 2 vol., 1899—Life, by Graham Balfour, port., 2 vol., 1901, first eds., together 4 vol., buckram, t. e. g., 8vo. (133) £1 19s.

7297 Stone (Mrs.) Chronicles of Fashion, first ed., ports., 2 vol., cl., uncut, 1845, 8vo. (408) £2 2s.

7298 Stow (J.) Survey of the Cities of London and Westminster, port., folding plan and plates, 2 vol., old cf. (rebacked), 1720, folio (510) £3 3s.

7299 Strang (W.) A Series of Thirty Etchings, illustrating sub-
jects from the writings of Rudyard Kipling, cl., 1901, folio
(302) £1 19s.
7300 [Surtees (R. S.)] Handley Cross, or Mr. Jorrocks's Hunt,
col. plates ɔy J. Leech (early issue), cl., n. d., 8vo. (76)
 £1 18s.
7301 [Surtees (R. S.)] "Ask Mamma," first ed., col. plates ɔy
Leech, cl., 1858, 8vo. (77) £4 2s. 6d.
7302 Thornton (R. J.) Temple of Flora, port. by Bartolozzi and
plates after Cosway and others, printed in colours, hf. mor.,
1799, atlas folio (592) *Wheldon*, £3 12s. 6d.
7303 Upcott (W.) Bibliographical Account of the Works relating
to Topography, LARGE PAPER, 3 vol., mor. ex., 1818, roy.
8vo. (484) *Edwards*, £2 8s.
7304 Van Dyck (A.) Le Cabinet des plus beaux Portraits de
plusieurs Princes et Princesses, des Hommes Illustres, etc.,
ports., 2 vol. in 1, old cf., *Anvers et La Haye*, 1728, folio
(597) £5
7305 Wallis (R.) London's Armoury accurately delineated, en-
graved throughout; old cf. (worn), 1677, folio (611)
 Quaritch, £10 10s.
7306 Walpole (H.) Letters, ports., 6 vol., 1840—Letters to Sir
Horace Mann, concluding series, ports., 4 vol., 1843-4,
together 10 vol., uniform cf. gt., 8vo. (389) £1 19s.
7307 Walpole (H.) Memoirs of the Reign of King George III.,
first ed., 4 vol., 1845—Journal of the same Reign, 1771-83,
2 vol., 1859, together 6 vol., cf. gt., 8vo. (391) £3 5s.
7308 Ward (H.) and Roberts (W.) George Romney, a Biographical
and Critical Essay, ports., Japanese paper copy, 2 vol., hf.
mor., t. e. g., 1904, 4to. (272) £2 14s.
7309 Whitaker (T. D.) History of the Town and Parish of Leeds,
including the whole of Thoresby's Ducatus Leodiensis, etc.,
plates, 2 vol., cf. gt., 1816, folio (533) £1 10s.
7310 Whitaker (T. D.) History of Whalley and Clitheroe, third
ed., map, port. and plates, LARGE PAPER, old mor. ex.,
1818, folio (534) £1 13s.
7311 White (G.) Natural History of Selborne, ed. ɔy Bowdler
Sharpe, illustrations, LARGE PAPER (limited to 160 copies),
signed by the Editor and artists, 2 vol., vell. ex., 1900, sm.
4to. (215) £3 17s. 6d.
7312 Williamson (G. C.) George Engleheart, Miniature Painter
to George III., éd. de luxe, with 10 miniatures, hand
painted (53 copies privately painted), art cl., 1902, folio
(297) £5 5s.

SOTHEBY, WILKINSON & HODGE.

A FURTHER PORTION OF THE LIBRARY OF MR. J. W. FORD,
OF WINCHMORE HILL AND ENFIELD OLD PARK.

(No. of Lots, 1239; amount realised, £3,160 10s. 6d.)

[NOTE.—The sales of the two portions of this Library already
disposed of are reported in BOOK-PRICES CURRENT, Vol. xvi.,
page 450, and Vol. xviii., page 462.—ED.]

7313 Acerbi (Jos.) Travels to the North Cape, port., map and
proof plates, 2 vol., hf. mor., t. e. g., uncut (Beckford copy),
Jos. Mawman, 1802, 4to. (1) *Quaritch*, £1 12s.

7314 Ackermann (R.) History of the University of Oxford, col.
views and ports., russ. super ex., R. Ackermann, 1814, roy.
4to. (2) *Quaritch*, £20

7315 Adams (Wm.) An Old English Potter, ed. by W. Turner,
LARGE PAPER, illustrations (50 printed), cl., t. e. g., Chapman
and Hall, 1894, large pot 4to. (3) *Rimell*, £1 3s.

7316 Addison (Jos.) Miscellaneous Works in Verse and Prose
(with "The Freeholder"), by Tickell, port. (an extra one
inserted), front. and plates, 5 vol., cf. ex., Tonson, 1765
(1758), 8vo. (4) *Maggs*, £1 6s.

7317 Ainsworth (W. H.) The Lancashire Witches, first ed., 3 vol.,
hf. mor., t. e. g., H. Colburn, 1849, 8vo. (6) *Young*, £1

7318 Almack (Edw.) Bibliography of Eikon Basilike, LARGE
PAPER, 150 copies printed, black cl., uncut, Blades, 1896,
4to. (12) *Hill*, £1 5s.

7319 America. Some Correspondence between the Governors
and Treasurers of the New England Company in London
and the Commissioners of the United Colonies in America,
ed. by J. W. Ford, 3 copies, black cl., uncut, t. e. g.,
Spottiswoode and Co., 1896, 8vo. (14) *Harding*, £1 10s.

7320 Annesley (Earl). Beautiful and Rare Trees and Plants at
Castlewellan, 70 illustrations, 300 copies printed, buckram,
t. e. g., "*Country Life*" *Office*, 1903, 4to. (18) *Wesley*, 16s.

7321 Antiquarian Repertory (The), by Fr. Grose, Thos. Astle, etc.,
plates, 4 vol. in 2, pigskin ex., J. Blyth and T. Evans, 1775-84,
4to. (20) *Rimell*, £1 4s.

7322 Arthington (Henry). The Seduction of Arthington by Hacket
especiallie (7 pages of verse at end), *R. B. for T. Man* (1592)
(date cut off)—Principall Points of Holy Profession touch-
ing these three estates of Mankind, in verse by H. A. G.,
Bright's copy, n. d. (1607), both in cf. gt., the latter having
old ex-libris of Thos. Arthington, Esq., of Arthington, Co.
Yorks., sm. 4to. (22) *Tregaskis*, £1 1s.

7323 Athenaeus. Les Quinze Livres des Deipnosophistes d'Athénée (par l'Abbé de Marolles), port., old French mor., gilt ɔack, g. e. (Derome), *Paris*, J. Langlois, 1680, 4to. (24)
Leighton, £3 5s.

7324 Austen (Jane). Novels. Emma, first ed., 3 vol., J. Murray, 1816—Northanger Aɔɔey, first ed., 4 vol., *ib.*, 1818—Pride and Prejudice, third ed., 2 vol., T. Egerton, 1817—Sense and Sensiɔility, second ed., 3 vol., *ib.*, 1813—Mansfield Park, second ed., 3 vol., J. Murray, 1816, together 15 vol., orig. cf. gt., post 8vo. (29) *Spencer*, £5 15s.

7325 Austen (Ralphe). A Treatise of Fruit Trees, second ed., front., orig. cf., *Oxford*, H. Hall, 1657, sm. 4to. (30)
Leighton, £1 10s.

7326 Bacon (Lord). Works, ɔy Basil Montague, port., 16 vol. in 17, mor., g. e. (C. Lewis), W. Pickering, 1825-34, 8vo. (32)
Edwards, £8 5s.

7327 Bacon (Lord). Historie of the Raigne of King Henry the Seventh, first ed., port. by John Payne, old cf., *W. Stansby for M. Lownes, etc.*, 1622, sm. folio (33) *Smedley*, £4

7328 Bacon (Lord). Sylva Sylvarum, by Wm. Rawley (second ed., with "New Atlantis"), port. ɔy T. Cecil, orig. cf., *J. Haviland for Wm. Lee*, 1635, sm. folio (34) *Smedley*, £1 3s.

7329 Bacon (Lord). Of the Advancement and Proficience of Learning, port. by Wm. Marshall, orig. cf., good copy, *Oxford, L. Lichfield for R. Young, etc.*, 1640, sm. folio (35)
Quaritch, £4 12s.

7330 Badminton Liɔrary. Coursing and Falconry—Archery, LARGE PAPER, illustrations, 2 vol., hf. bd., t. e. g., Longmans, 1892-94, cr. 4to. (36) *Porter*, £1

7331 Baines (Edw.) History of the County of Lancaster, LARGE PAPER, port., map, pedigrees and views on India paper, 4 vol., mor. ex., fine copy, Fisher, 1836, roy. 4to. (38)
J. Bumpus, £7 10s.

7332 Barclay (Roɔert). An Apology for the True Christian Divinity, first ed., old cf., 1676, sm. 4to. (41) *Young*, 15s.

7333 Baring-Gould (S.) Old Country Life, illustrations, LARGE PAPER, 125 copies printed, art cl., Methuen, 1890, cr. 4to. (42) *Young*, 16s.

7334 Barrett (C. R. B.) Essex. Highways, Byways and Waterways, Whatman paper, illustrations ɔy the author, 120 copies printed, 2 vol., white cl., uncut, Lawrence and Bullen, 1892-3, sm. 4to. (43) *J. Bumpus*, 15s.

7335 Barrow (Dr. Isaac). Works, fifth ed., fine paper, port. by Loggan, 3 vol. in 2, mor., g. e., Theodore Williams's copy, arms and monogram on sides, A. Millar, etc., 1741, folio (45) *Ellis*, £1

7336 Barrow (John). Travels in China—Travels into the Interior of Southern Africa, col. plates, 3 vol., russ. ex., Cadell and Davies, 1804-6, 4to. (46) *Young*, £2 18s.

7337 Barrow (J.) Voyage to Cochin China, chart and col. plates, MS. notes by W. Beckford, hf. mor., t. e. g., Cadell and Davies, 1806, 4to. (47) *Maggs*, £2 2s.

7338 Beaumont (Fr.) and Fletcher (John). Works, first octavo
collected ed., LARGE PAPER, 2 ports. by Vertue and 52
plates ɔy Boitard, 2 mezzo. ports. inserted, 7 vol., old russ.,
Fontaine copy, with device of an elephant, J. Tonson, 1711,
imp. 8vo. (52) *Maggs*, £4 7s. 6d.
7339 Beckford (Wm.) Biographical Memoirs of Extraordinary
Painters, orig. ed., old mor., g. e., fine copy (Beckford's
own), J. Roɔson, 1780—Russell (Lord John). Essay on
the History of the English Government, hf. mor., Long-
man, 1821, together 2 vol., sm. 8vo. (53) *Clements*, £2 3s.
7340 [Beckford (Wm.)] An Araɔian Tale (Vathek), first. ed. in
English, mor., g. e., J. Johnson, 1786, 8vo. (54)
 Hatchard, £3 5s.
7341 Bedwell (Thos.) Mesolabium Archtectonicum, with The
Tournament of Tottenham (by Gilɔert Pilkington), and a
Briefe Description of the Towne of Tottenham Highe
Crosse, mor., *J. Norton for Wm. Garrett*, 1631, sm. 4to.
(57) *Tregaskis*, £6
7342 Beeverell (J.) Les Délices de la grand Bretagne, 240 views,
without text, ɔound in a vol., hf. mor., g. e., *Leide*, P. Van
der Aa, 1707, square 8vo. (58) *Quaritch*, £5 10s.
7343 Belcher (John) and Macartney (M. E.) Later Renaissance
Architecture in England, 170 plates, in 6 parts, Batsford,
1901, roy. fol. (60) *Edwards*, £4 6s.
7344 Bemrose (Wm.) Bow, Chelsea and Derɔy Porcelain, illus-
trations, ɔuckram, uncut, Bemrose, 1898, sup. imp. 8vo.
(65) *Hiersemann*, £3 11s.
7345 Beresford (Jas.) Miseries of Human Life, eighth ed., col.
plates ɔy J. A. Atkinson, 2 vol., mor., g. e., W. Miller, 1806-7,
sm. 8vo. (68) *Quaritch*, £3 15s.
7346 Berkeley (Hon. Grantley F.) The English Sportsman in the
Western Prairies, 10 illustrations, orig. cl., Hurst and
Blackett, 1861, imp. 8vo. (69) *Hill*, 9s.
7347 Berry (Wm.) History of Guernsey, map and plates, russ.,
Longman, 1815, 4to. (70) *Rimell*, 18s.
7348 Berry (Wm.) Encyclopaedia Heraldica, plates, 3 vol., orig.
bds., *Published for the Author*, 1828, 4to. (71)
 Rimell, £1 1s.
7349 Bewick (Thos.) A General History of Quadrupeds, second
ed., royal paper, mor. ex., *Newcastle*, S. Hodgson, etc.,
1791, roy. 8vo. (72) *Sotheran*, £3 3s.
7350 Bewick (Thos.) History of British Birds, first ed., royal
paper, cuts (a few in vol. ii. foxed), 2 vol., mor., g. e., with
arms (C. Lewis), MS. notes by Wm. Beckford on flyleaf,
Newcastle, Hodgson and Walker for Beilby and Bewick,
1797-1804, roy. 8vo. (73) *Hatchard*, £9 5s.
7351 Bewick (Thos.) Figures of British Land Birds, to which are
added a few foreign ɔirds, taken separately on 133 pages
on one side of the paper only, suppressed vignette of a
pigstye at end, and 4 pages in duplicate (500 copies printed,
many destroyed ɔy Bewick), hf. mor., t. e. g., uncut, *New-
castle*, Hodgson, Beilby and Bewick, 1800, imp. 8vo. (74)
 Brewer, £2 2s.

7352 Bewick (Thos.) History of British Birds, fifth ed., with supplements, imperial paper, 2 vol., mor. super ex., *Newcastle, E. Walker for T. Bewick*, 1821, imp. 8vo. (75)
J. Bumpus, £5 5s.

7353 Bewick (Thos.) Figures of Quadrupeds (second ed.), birds and vignettes, upwards of 1,000 woodcuts taken on separate quarto leaves, mostly without lettering, autograph of T. Bewick and a thumb-mark receipt, 2 vol., mor. ex., *Newcastle-upon-Tyne*, 1825, 4to. (76) *Brewer, £2 12s.*
[Only 100 copies of the " Quadrupeds " were printed in this form, and both vol. came direct from Miss Bewick, and had her receipt.—*Catalogue.*]

7354 Billings (Commodore Jos.) An Account of a Geographical and Astronomical Expedition to the Northern Parts of Russia, map and proof plates (some in 2 states), mor. ex., tooled inside borders (Staggemeir), MS. notes by Wm. Beckford, Cadell and Davies, 1802, 4to. (79)
H. Stevens, £3 18s.

7355 Bingley (Rev. W.) A Tour Round North Wales, views in aquatinta by J. Alken, 2 vol., mor., g. e., by Hering, with ticket, E. Williams, 1800, 8vo. (80) *Quaritch, £1 12s.*

7356 Birch (G. H.) London Churches of the XVIIth and XVIIIth Centuries, 64 plates and other illustrations, hf. mor., Batsford, 1896, imp. folio (82) *Rimell, £3 19s.*

7357 Blackburn (Henry). Travelling in Spain, 1866 — The Pyrenees, 1867—Artists and Arabs, 1868—Normandy Picturesque, 1869—Art in the Mountains, 1870, illustrations, 5 vol., cf. ex., m. e.—Breton Folk, illustrated by R. Caldecott, hf. mor. ex., t. e. g., cr. 4to., 1880, together 6 vol., S. Low, 1866-80, 8vo. (86) *Maggs, £2 2s.*

7358 Blackstone (Wm.) Commentaries, first ed., 4 vol., vell. super ex., g. e. (Kalthoeber), *Oxford*, 1765-9, 4to. (89)
Edwards, £1 5s.

7359 Bock (Carl). Head-Hunters of Borneo, second ed., map, 30 col. plates and other illustrations, cl., S. Low, 1882, imp. 8vo. (94) *Thin, 16s.*

7360 Bodger (John). Chart of the Beautiful Fishery of Whittlesea Mere, Co. Huntingdon, etc., folding chart (1ft. 7in. by 2ft. 2½in.), printed upon satin, old mor., 1786, sm. 4to. (95)
Quaritch, £15

7361 Bolton (Jas.) History of Funguses growing about Halifax, vol. i.-ii., and Appendix, containing 135 col. plates, 1788-91 —Filices Britannicae, and History of British Ferns, part ii., 14 col. plates, 1790, in 2 vol., old russ. and cf., g. e., 4to. (97) *J. Bumpus, £2 16s.*

7362 Bond (Jer.) Gothic Architecture in England, 1,254 illustrations, cl., t. e. g., Batsford, 1905, imp. 8vo. (98)
Joseph, £1 1s.

7363 Books about Books, 6 vol., orig. cl., Kegan Paul, 1893-4, 8vo. (100) *Hill, £1 3s.*

7364 Borlase (Wm.) Observations on the Antiquities of Cornwall,

etc., orig. ed., maps and plates, autograph letter of R. Gough, MS. notes and ex-liɔris inserted, cf. gt., *Oxford*, W. Jackson, 1754, folio (101) *Tregaskis, £2* 4s.

7365 Borlase (W. C.) The Dolmens of Ireland, 4 maps, 800 illustrations, including 2 col. plates, 3 vol., cl., t. e. g., uncut, Chapman and Hall, 1897, imp. 8vo. (103) *Edwards, £*1 8s.

7366 Boswell (Jas.) Life of Johnson, first ed., port. after Reynolds, 2 vol., hf. cf. gt., C. Dilly, 1791, 4to. (104) *Maggs, £*4 10s.

7367 Bougainville (L. A. de). Voyage autour du Monde par la Frégate du Roi La Boudeuse et la flote l'Etoile, fine paper, maps and charts, mor. ex., by C. Kalthoeber, with ticket (Beckford), *Paris*, Saillant et Nyon, 1771, 4to. (105) *Quaritch, £*4 18s.

7368 Boutell (Chas.) Heraldry, third ed., 975 illustrations, hf. mor., g. e., by R. de Coverly, R. Bentley, 1864, 8vo. (107) *Harding*, 14s.

7369 Bowdich (T. E.) Mission from Cape Coast Castle to Ashantee, folding col. plates and map, etc., cf. ex. (C. Lewis), 4 pages of MS. notes by Wm. Beckford, J. Murray, 1819, 4to. (109) *Quaritch, £*3 7s. 6d.

7370 Bowen, Kitchen and others. Large English Atlas, and 3 general maps of England, Scotland and Ireland, 47 large col. maps, hf. bd., R. Sayer, 1777, atlas folio (110) *Quaritch, £*1 9s.

7371 Boyle (Hon. Rob.) Works, by T. Birch, port., 5 vol., old cf. gt., A. Millar, 1744, folio (111) *Sotheran, £*1 12s.

7372 Boyle (Capt. Rob.) Voyages and Adventures in Several Parts of the World, second ed., front., old cf., A. Millar, 1728—A New History of Jamaica, second ed., 1 map (that of Jamaica wanted), cf. ex., 1740, together 2 vol., 8vo. (113) *H. Stevens, £*1

7373 Boyne (Wm.) Trade Tokens, illustrations, 2 vol., 250 copies printed, roxɔurghe, uncut, t. e. g., E. Stock, 1889-91, 8vo. (114) *Hill, £*1 16s.

7374 Brandt (Gerard). History of the Reformation, front. and ports. by G. Vertue, 4 vol., old cf., *T. Wool for J. Childe*, 1720-23, folio (118) *Hill*, 17s

7375 Bree (C. R.) History of the Birds of Europe, col. plates, 4 vol., orig. cl., Groomɔridge, 1866 (63), sup. imp. 8vo. (119) *Sotheran, £*1 12s.

7376 Brenchley (Julius L.) Cruise of H.M.S. Curaçoa, map and illustrations, cl., uncut, Longmans, 1873, sup. imp. 8vo. (120) *Quaritch, £*2 16s.

7377 Brewer (J. S.) The Reign of Henry VIII., port., 2 vol., orig. cl., uncut, J. Murray, 1884, 8vo. (121) *Quaritch, £*2 18s.

7378 British Essayists. Tatler—Spectator (with the 2 extra vol.)—Guardian — Englishman — Lover — Freethinker — Medleys, orig. collected eds., LARGE PAPER, 23 vol., uniform pigskin gt. (from Edward Moore's liɔrary), Chas. Lillie, etc., 1710-25, roy. 8vo. (124) *Quaritch, £*12 10s.

7379 British Novelists (The), by Mrs. Barbauld, 50 vol., cf. ex. (C. Lewis), Rivington, etc., 1810, 12mo. (125) *Quaritch, £*13 5s.

7380 British Numismatic Journal (The) and Proceedings of the
British Numismatic Society, plates, 4 vol., buckram, uncut,
t. e. g., 1905-8, cr. 4to. (126) *Quaritch*, £1 14s.
7381 British Poets, Spenser to Churchill, Bell's ed., ports. and
fronts., 60 vol., old mor., *Edinb.*, *Apollo Press*, 1778-9, 12mo.
(127) *Quaritch*, £7 15s.
7382 British Poets, by Sam. Johnson, and Index, ports., 68 vol.
(wanted vol. xlv.), old cf. gt., *J. Nichols for C. Bathurst and
others*, 1779-81, 12mo. (128) *Quaritch*, £6 10s.
7383 Britton (John). Architectural Antiquities of Great Britain,
orig. ed., plates, 5 vol., old russ. ex., m. e., Longman, etc.,
1807-26, 4to. (129) *Young*, £2 6s.
7384 Britton (J.) and Pugin (A.) Illustrations of the Public Build-
ings of London, LARGEST PAPER, India proof plates, 2 vol.,
orig. bds., uncut, t. e. g., J. Taylor, etc., 1825, 4to. (131)
Quaritch, £1 5s.
7385 Brontë (Charlotte). Jane Eyre, first ed., 3 vol., orig. cl., with
the original preface, dedication to Thackeray and review
extracts from the second ed. inserted, Smith, Elder and
Co., 1847, 8vo. (132) *Quaritch*, £28
7386 Brontë (Anne and Emily). Wuthering Heights—Agnes Grey,
first ed., 3 vol., orig. bds., uncut, T. C. Newby, 1847, cr. 8vo.
(133) *Quaritch*, £48
7387 Broughton (T. D.) Letters written in a Mahratta Camp, 10
col. engravings etched by J. A. Atkinson, hf. mor. gt., MS.
notes by Wm. Beckford, J. Murray, 1813, 4to. (135)
Maggs, £2 2s.
7388 Broughton (W. R.) Voyage of Discovery to the North Pacific
in his Majesty's Sloop Providence, maps, charts and plates,
hf. mor., t. e. g., uncut, 2 pages of MS. notes by Wm.
Beckford, Cadell and Davies, 1804, 4to. (136)
Quaritch, £5 15s.
7389 Brown (Horatio F.) The Venetian Printing Press, 22 facs.,
265 copies for sale in England, buckram, uncut, Nimmo,
1891, cr. 4to. (138) *Hill*, 14s.
7390 Brown (Jas.) and Nisbet (John). The Forester, sixth ed.,
woodcuts, 2 vol., hf. roan, t. e. g., Blackwood, 1894, imp.
8vo. (139) *Hill*, 14s.
7391 Brown (J.) and Nisbet (J.) The Forester, etc. (a later edition
by J. Nisbet), woodcuts, 2 vol., hf. roan, t. e. g., Blackwood,
1905, imp. 8vo. (140) *Thin*, £1 4s.
7392 Browne (Sir Thos.) Works, LARGE PAPER, port. and plates,
4 vol., mor. super ex., Wm. Pickering, 1835-6, imp. 8vo.
(142) *Maggs*, £5 17s. 6d.
7393 Browne (Sir T.) Posthumous Works, LARGE PAPER, port.
and plates, russ., g. e., 1712, imp. 8vo. (143) *Maggs*, £2 6s.
7394 Buckingham (John Sheffield, Duke of). Works, LARGE AND
THICK PAPER, port. by Vertue, plan of monument and
vignettes, 2 vol., old English mor., g. e. (from the Fountaine
sale), John Barber, Alderman of London, 1723, 4to. (147)
J. Bumpus, £4 6s.
7395 Buckingham (J. S.) Travels in Palestine, port., map and

plates, cf. ex., g. e., 2½ pages of MS. notes ɔy Wm. Beckford, Longman, 1821, 4to. (148) *Dobell*, 12s.

7396 Bullen (A. H.) Lyrics from Elizaɔethan Dramatists and Song Books, 3 vol., Nimmo, 1887-8-9—Davison (F. and W.) Poetical Rhapsody, ed. ɔy A. H. Bullen, 2 vol., G. Bell, 1890, together 5 vol., ɔuckram, t. e. g., 8vo. (153)
Young, £1 5s.

7397 Bullock (W.) Six Months' Residence and Travels in Mexico, map and plates (some col.), cf. ex. (C. Lewis), 4 pages of MS. notes by Wm. Beckford, J. Murray, 1824, 8vo. (154)
Maggs, £1

7398 Bunyan (John). Pilgrim's Progress, 22nd ed., port. and 21 engravings by Sturt, orig. cf., J. Clarke, etc., 1727-8, 8vo. (155) *Young*, 17s.

7399 Burckhardt (J. L.) Notes on the Bedouins and Wahábys, mor. ex. (C. Lewis), (Beckford,) Colɔurn and Bentley, 1830, 4to. (158) £2

7400 Burke (Sir B.) Extinct Peerages, coats-of-arms, Harrison, 1883, roy. 8vo. (161) . *Quaritch*, £4 12s.

7401 Burke (Edm.) Works, LARGE PAPER, 8 vol. (should be 16), old russ., Rivington, 1801-27, roy. 8vo. (162)
B. F. Stevens, £1 5s.

7402 Burke (J. B.) Heraldic Illustrations, pedigrees, etc. (and Illuminated Supplement), 4 vol., orig. cl., Hurst and Blackett, 1853—E. Churton, 1851, imp. 8vo. (163)
Walford, £2

7403; Burke (J. B.) A Visitation of the Seats and Arms of the Noɔlemen and Gentlemen of Great Britain and Ireland, ɔoth series, lithograph views and coats-of-arms, etc., 3 vol., cl., H. Colɔurn, etc., 1852-54, imp. 8vo. (164)
Hitchman, £1 4s.

7404; Burnaɔy (Rev. Anth.) Travels through the Middle Settlements in North America, third ed., fine paper, map and tinted plates, mor. ex., by C. Kalthoeber, with ticket, MS. notes by Wm. Beckford, T. Payne, 1798, 4to. (166)
Quaritch, £5 5s.

7405 Burnet (Bp. G.) History of the Reformation, second ed. (with Supplement), front., 3 vol., old English mor., g. e., R. Chiswell and J. Chiswell, 1679-81-1715, sm. folio (168)
Maggs, £3 3s.

7406 Burney (Frances). Diary and Letters, orig. issue, ports., 7 vol., cl., uncut, H. Colɔurn, 1843-6, 8vo. (169) *Young*, £3 3s.

7407 Burt (Capt. Edw.) Letters from a Gentleman in the North of Scotland, first ed., plates, 2 vol., cf. gt., S. Birt, 1754, 8vo. (170) *Dobell*, £1 12s.

7408 Burton (Robert). Anatomy of Melancholy, fourth ed., orig. cf., *Oxford, printed for H. Cripps*, 1632 [the last figure altered to an 8], sm. folio (173) *Quaritch*, £4 18s.

7409 Butler (Sam.) Hudiɔras, port. and folding plates by Hogarth, mezzo port. of Butler inserted, 2 vol., mor. ex., *Cambridge, J. Bentham for W. Tunys, etc.*, 1744, 8vo. (176)
Quaritch, £2 12s.

7410 Buxton (E. N.) Short Stalks, or Hunting Camps, North, South, East and West, map and illustrations, 2 vol., picture buckram, uncut, E. Stanford, 1892-8, 4to. (177) *Hill*, 17s.

7411 Byron (Lord). Works, by Thos. Moore, port. and fronts., 17 vol., orig. cl., J. Murray, 1832-3, post 8vo. (178)
Quaritch, £1 14s.

7412 Caldecott (Randolph). A Personal Memoir of his early Art Career, 172 illustrations, cl., t. e. g., S. Low, 1886, sm. 4to. (179) *Young*, 11s.

7413 Camden (Wm.) Britannia, port., maps and engravings, 3 vol., old russ., J. Nichols, 1789, folio (182) *Ellis*, 17s.

7414 Canaletti (Ant.) Urbis Venetiarum Prospectus Celebriores tabulis XXXVIII. aere expressa ab Ant. Visentini, front., 2 ports. and 38 oblong views, proofs, old cf. gt. (Beckford copy), *Venet.*, J. B. Pasquali, 1742, obl. folio (184)
Quaritch, £7 7s.

7415 Canning Case. Canning's Farthing Post, cheap book ed. (260 pages), with 2 woodcut ports., hf. mor., g. e., *Printed by T. Jones, near Billingsgate*, n. d., sm. 4to. (187) *Ellis*, 14s.
[Lots 185-192 inclusive comprised a collection of books and pamphlets relating to the case of Elizabeth Canning, who, in 1753, declared that she had been attacked by two men in Moorfields, robbed, stunned and finally dragged to a house on the Hertfordshire Road. She was convicted of perjury on May 30th, 1754, and sentenced to seven years' transportation. *See* Howell's "State Trials," ed. 1813, Vol. xix.—ED.]

7416 Cartwright (Capt. George). Journal of Transactions, etc. during a Sixteen Years' Residence on the Coast of Labrador, LARGEST PAPER, maps and port. (the latter in 3 states), 3 vol., mor. ex., by C. Kalthoeber, with ticket (the Beckford copy), *Newark*, Allan and Ridge, 1792, roy. 4to. (195)
H. Stevens, £13 5s.

7417 Cary's Improved Map of England and Wales, 65 folded sheets in 8 slip cases, hf. russ., C. L. J. Cary, 1832, sup. imp. 8vo. (196) *H. Stevens*, £1 8s

7418 Catalogue of the Harleian, Lansdowne and Cottonian MSS. in the British Museum, 6 vol. in 3, hf. mor., 1802-19, folio (200) *Quaritch*, £1 19s.

7419 Catalogues. White Knight's Library, sold by Auction by Mr. Evans, interleaved, prices written, mor. super ex. (C. Lewis), Beckford copy, 1819, 8vo. (203) *Quaritch*, £2 4s.

7420 Catalogus Codicum Manuscriptorum Bibliothecae Bodleianae, Partis quintae fasiculi v. Confecit Gulielmus D. Macray, 5 vol., cl., uncut, *Oxon.*, 1862-93, 4to. (204)
Quaritch, £1 5s.

7421 Catlin (George). Manners, Customs and Condition of the North American Indians, 400 illustrations, 2 vol., orig. cl., uncut, *Published by the Author*, 1841, imp. 8vo. (205)
Maggs, £1 10s.

7422 Cavendish (Geo.) Life of Card. Wolsey, by S. W. Singer, ports., etc., 2 vol., cf. ex., *Chiswick*, 1825, roy. 8vo. (206)
Maggs, £2 2s.

7423 Cervantes (M. de). Don Quixote, by Chas. Jarvis, plates by Vandergucht and Hogarth, 2 vol., old russ., J. and R. Tonson and R. Dodsley, 1742, 4to. (207) *J. Bumpus*, £2

7424 Chancellor (F.) Ancient Sepulchral Monuments of Essex, nearly 200 illustrations, cl., t. e. g., uncut, *Printed for the Author by C. F. Kell*, 1890, folio (214) *Edwards*, £1 12s.

7425 Chap Books and Folk-Lore Tracts, ed. by G. L. Gomme and H. B. Wheatley, woodcuts, 5 vol., bds., uncut, *Villon Society*, 1885, pott 4to. (215) *Hill*, £1 1s.

7426 Chaplain. Fifty Small Original and Elegant Views of Churches, engraved by H. Roberts, old cf., with clasp [1750, etc.], obl. 8vo. (217) *Edwards*, £4 12s.

7427 Chappell (Lieut. Edw.) Narrative of Voyages of H.M.S. Rosamond to Hudson's Bay, Newfoundland, etc., maps and plates, 2 vol., russ. super ex., 4 pages of MS. notes by Wm. Beckford, J. Mawman, 1817-18, 8vo. (220) *Maggs*, £2 11s.

7428 Chardin (Sir John). Travels into Persia, port., map and folding plates, russ. ex. (C. Hering), C. Bateman, 1691, sm. folio (221) *Quaritch*, £2

7429 Chauncy (Sir Henry). Historical Antiquities of Hertfordshire, orig. ed., port. by G. Savage and plates by Drapentier, etc. (including the three plates sometimes wanted), pigskin ex., by Clarke and Bedford, B. Griffin, etc., 1700, folio (224) *Quaritch*, £10

7430 Chesterfield (Earl of). Letters to his Son, sixth ed., port., 4 vol., mor., g. e., J. Dodsley, 1775, 8vo. (225) *Quaritch*, £2 10s.

7431 Child (Prof. Francis J.) English and Scottish Popular Ballads, orig. ed. of 1000 copies, 10 vol., mor. ex., t. e. g., uncut (vol. x. unbd.), *Boston (Mass.)*, Houghton and Co., 1882-98, 4to. (228) *Quaritch*, £11 15s.

7432 Children's Books. History of Little Goody Two-Shoes (by Goldsmith?), fifth ed., plates, Newbery and Carnan, 1768— The British Champion, or Honour Rewarded, cuts, *York*, n. d.—Mother Shipton's Legacy, cuts, *ib.*, 1797, orig. col. bds., 16mo. (230) *Quaritch*, £5 5s.

7433 Clive (Robert Lord). Life, by Sir John Malcolm, LARGE PAPER, port. and maps, 3 vol., cf. gt., Sir R. Peel's copy, J. Murray, 1836, imp. 8vo. (236) *Grant*, £1 1s.

7434 Clutterbuck (Rob.) History and Antiquities of Hertfordshire, orig. ed., map and five views, 3 vol., russ. ex., Nichols, 1815-27, folio (238) *J. Bumpus*, £11 10s.

7435 Cockburn (John). Journey Over Land from the Gulf of Honduras to the Great South Sea, map, cf. ex., uncut, by Rivière, C. Rivington, 1735, 8vo. (242) *Stevenson*, £1 7s.

7436 Coleridge (S. T.) Literary Remains, ed. by H. H. Coleridge, 4 vol., orig. cl., W. Pickering, 1836-9, 8vo. (246) *Young*, £1 9s.

7437 Collins (Arthur). The Peerage of England, eighth ed., with Supplement by Longmate, coats-of-arms, 9 vol., old cf. gt., Geo. Strahan, etc., 1779-84, 8vo. (247) *Maggs*, £1 10s.

7438 Columna (Fr. de). Hypnerotomachia Poliphili, reprint of the

orig. ed. of 1499 (limited to 350 copies on handmade paper),
mor., g. e., Methuen and Co., 1905, sm. folio (249)
Edwards, £2 12s.

7439 Congreve (Wm.) Works, Baskerville's ed., port. and plates,
3 vol., old mor., g. e., Holland House copy, *Birm.*, *J.
Baskerville for J. L. R. Tonson*, 1761, imp. 8vo. (251)
Quaritch, £12 10s.

7440 Constaɔle (John, R.A.) Memoirs of his Life, by C. R.
Leslie, second ed., port. (2 orig. pencil sketches ɔy Con-
staɔle and autograph inserted), mor. ex., Longman, 1845,
sm. 4to. (254) *Tregaskis*, £1 14s.

7441 Cooke (Capt. Edw.) Voyage to the South Sea and Round
the World, maps and plates, 2 vol., orig. cf., B. Lintot, etc.,
1712, 8vo. (255) *H. Stevens*, £3 15s.

7442 Cook and Vancouver. Voyages. Atlas of Maps and Plates,
66 proof plates and 14 maps, hf. bd., 1780, atlas folio (256)
H. Stevens, £5 17s. 6d.

7443 Cornman (F.) Some Olde London Shope Signes and Streete
Taɔlets, printed in colours and script characters, 30 copies
taken, ɔoth series, 2 vol., hf. mor., uncut, *Privately printed*,
1891-94, 4to. (258) *Hatchard*, £1 2s.

7444 Cornwall (Visitations of). Comprising the Heralds' Visita-
tions of 1530, 1573 and 1620, with Additions ɔy Lieut.-Col.
J. L. Vivian, rox., *Exeter*, W. Pollard, 1887, 4to. (259)
Bridger, £1 18s.

7445 Coryat (Thos.) Crudities, reprinted from the edition of 1611,
front. and plates, 3 vol., mor. super ex., uncut, by F. Bed-
ford, large copy (query large paper), (Col. Hiɔɔert's), W.
Cater, etc., 1776, roy. 8vo. (260) *Ellis*, £7 15s.

7446 Costume of China (The), ɔy Wm. Alexander, 48 col. engrav-
ings, russ. gt., W. Miller, 1805, 4to. (263)
J. Bumpus, £1 18s.

7447 Coxe (Archd. Wm.) Travels in Switzerland, third ed., LARGE
PAPER, maps and plates, 2 vol., mor. ex., ɔy C. Kalthoeber,
with ticket, T. Cadell, 1794—Additions to the Travels in
Switzerland, LARGE PAPER, 2 parts in 1 vol. (only a few
copies printed), map, duplicate proof views and unpuɔlished
drawings, hf. mor., t. e. g., 1802, together 3 vol., 8vo. (268)
Maggs, £1 10s.

7448 Coxe (Archd. Wm.) Account of the Russian Discoveries
ɔetween Asia and America, maps, russ., g. e., Beckford
copy, *J. Nicholls for T. Cadell*, 1780, 4to. (269)
Quaritch, £1 7s.

7449 Croker (T. Crofton). Fairy Legends and Traditions of the
South of Ireland, orig. ed., illustrations by W. H. Brooke,
the three series complete, 3 vol., cf. gt., J. Murray, 1826-28,
sm. 8vo. (274) *Bain*, £2

7450 Cruikshank (G.) Peter Schlemihl, 8 illustrations, cf. gt., g. e.,
G. and W. B. Whittaker, 1824, cr. 8vo. (277) *Curtis*, £2 5s.

7451 Cumɔerland and Westmoreland Antiquarian and Arch-
æological Society. Transactions, vol. viii., ix., xi., xii.,
xiii., xiv., part ii., xv., xvi.—New Series, vol. i.-vii., with

Tract Series, No. 2—The Old Manorial Halls of West-moreland and Cumberland, by M. W. Taylor, *Kendal*, 1892, 8 vol. cl. and 17 parts, 1885-1907, 8vo. (278)
Carlton, £5 2s. 6d.

7452 Curtis (John). British Entomology, 770 col. plates, autograph letter of the author inserted, 8 vol., hf. mor. ex., *Printed for the Author*, 1823-40, imp. 8vo. (282) *J. Bumpus*, £16 10s.

7453 Curtis (Wm.) Flora Londinensis, col. plates, 4 vol. (the fourth vol. with descriptions by W. G. Hooker), russ. ex., 1777-1821, roy. folio—Flora Londinensis, New Series, by W. J. Hooker, col. plates, Nos. 25-36, *G. Graves, Peckham*, 1828, folio—Hooker (Wm.) Paradisus Londinensis, col. figures of plants, 70 plates, vol. i. (only), hf. mor., 1805, 4to. (283-4) *J. Bumpus*, £21

7454 Dallaway (Jas.) Science of Heraldry in England, plates (some in colours), russ. ex., by Kalthoeber, with ticket (the Beckford copy), *Gloucester*, *R. Raikes for T. Cadell*, 1793, 4to. (287) *Clements*, £1 13s.

7455 Dalrymple (A.) Voyages and Discoveries in the South Pacific, fine paper, maps and plates (some in two states), mor. ex. (Staggemeier), the Beckford copy, *Printed for the Author*, 1769-71, 4to. (288) *Edwards*, £4 18s.

7456 Dalrymple (A.) Voyages and Discoveries in the South Pacific, maps and plates, 2 vol., old cf., m. e., *Printed for the Author*, 1770-1, 4to. (289) *Edwards*, £2 8s.

7457 Dampier (Capt. Wm.) Voyages, maps and plates, 4 vol., russ., g. e., J. and J. Knapton, 1729, 8vo. (290) *Ellis*, £5 5s.

7458 Darwin (Dr. Erasmus). The Botanic Garden, a Poem, orig. ed., plates, 2 ports. of the author inserted, 2 vol. in 1, mor., g. e. (Kalthoeber, with ticket), J. Johnson, 1791, 4to. (293)
Young, 14s.

7459 Dasent (Sir G. W.) Story of Burnt Njal, first ed., maps and plans, 2 vol., green picture cl., *Edinb.*, Edmondstone and Douglas, 1861, 8vo. (294) *Quaritch*, £1 10s.

7460 [D'Aulnoy (Mme.)] Relation d'un Voyage d'Espagne, première éd., 3 vol., old French mor., gilt floreate backs (Derome), De Bure's copy, *Paris*, Veuve Claude Barbin, 1699, 12mo. (295) *Quaritch*, £7

7461 Dawkins (W. Boyd). Cave Hunting, illustrations, 1874—Brun (D.) Cave Dwellers of Southern Tunisia, 1898, together 2 vol., 8vo. (298) *Leon*, £1 18s.

7462 Dawson (Dr. Thos.) Memoirs of St. George and of the most noble Order of the Garter, port. of George II. robed and Seal of the Order, g. e. (C. Lewis), Beckford copy, H. Clements, 1714, 8vo. (299) *Dobell*, 16s.

7463 Defoe (Dan.) Novels and Miscellaneous Works, by Sir W. Scott, port., 20 vol., orig. cl., uncut, *Oxford, Talboys for T. Tegg*, 1840-41, post 8vo. (301) *Quaritch*, £9 15s.

7464 Defoe (D.) Life and Adventures of Robinson Crusoe, fifth ed., front. (port. inserted), W. Taylor, 1720—The Farther Adventures of Robinson Crusoe, second ed., map,

XXIV. 34

ib., 1719—Serious Reflections, first ed., folding front., *ib.*, 1720, together 3 vol., old cf., plain edges, 8vo. (303)
Edwards, £2 2s.

7465 De la Motraye (A.) Voyages en Europe, Asie & Afrique, maps and engravings, many ɔy Wm. Hogarth, 3 vol., old French cf. (Padeloup), *La Haye*, T. Johnson, etc., 1727-32, (306) *Quaritch*, £2

7466 Delany (Mrs.) [Mary Granville.] Autoɔiography and Correspondence, edited ɔy Lady Llanover, ɔoth series, ports. and plates, 6 vol., orig. cl., uncut, R. Bentley, 1861-2, 8vo. (307) *Bain*, £4 1s.

7467 Dennis (Geo.) Cities and Cemeteries of Etruria, third ed., maps, plans and illustrations, 2 vol., cl., J. Murray, 1883, 8vo. (310) *Thorp*, 10s.

7468 Dennistoun (Jas.) Memoirs of the Dukes of Urɔino, first ed., illustrations, 3 vol., orig. ɔlue cl., Longman, 1851, 8vo. (311) *Hill*, £3 8s.

7469 Des Jardins (Mlle.) Carmente, Histoire Grecque, première ed., 2 vol., old French mor., g. (Padeloup), *Paris*, Claude Barɔin, 1668, sm. 8vo. (313) *Maggs*, £4 10s.

7470 Diaz del Castillo (Capt. Bernal). The True History of the Conquest of Mexico, trans. ɔy M. Keatinge, plan of Mexico, cf. ex. (C. Lewis), J. Wright, 1800, 4to. (315)
Harding, £2 10s.

7471 Dictionary of National Biography, with Supplement and vol. of Errata, 67 vol., cl., Smith, Elder and Co., 1885-1904, 8vo. (317) *Tregaskis*, £25 10s.

7472 Dillon (Jo. Jac.) Hortus Elthamensis, plates, old russ. gt., *Sumptibus Auctoris*, 2 vol., 1732, folio (318) *Wesley*, £1

7473 Dillon (J. T.) Travels through Spain, second ed., port. of Charles III., map and plates, russ. ex. (Staggemeier), MS. note by Wm. Beckford, R. Baldwin, 1782, 4to. (319)
Young, £1 8s.

7474 Disraeli (Benj.) Novels and other Writings, viz., Vivian Grey, new edition—Voyage of Captain Popanilla, two editions, one with Maclise's plates—Contarini Fleming, second ed.—Syɔil, second ed., all first editions (except otherwise noted), together 25 vol., uniform hf. mor., t. e. g., 1876-64, 8vo. (320) *Quaritch*, £7

7475 Disraeli (I.) Calamities and Quarrels of Authors, Literary Character and Curiosities of Literature, 13 vol., uniform cf. ex., 1812-24, cr. 8vo. (322) *B. F. Stevens*, £4 19s.

7476 Dixon (Capt. Geo.) Voyage Round the World, LARGE AND FINE PAPER, maps and proof plates, those of birds coloured, mor. ex., by C. Kalthoeber (Beckford copy), Geo. Goulding, 1789, 4to. (324) *H. Stevens*, £4

7477 Dodge (Col. R. Irving). The Hunting Grounds of the Great West—Our Wild Indians, ports., maps and illustrations, 2 vol., uniform hf. mor., t. e. g., 1877-83, 8vo. (326)
H. Stevens, £1 10s.

7478 Dodwell (Edw.) Classical and Topographical Tour through Greece, map and India proof plates (only 6 copies printed),

2 vol., mor. super ex. (C. Lewis), 5 pages of MS. notes ɔy
Wm. Beckford, Rodwell and Martin, 1818, 4to. (328)
Edwards, £2 4s.

7479 Drummond (Wm., of Hawthornden). History of Scotland,
ports. of the author and of the five Jameses, Kings of Scot-
land, by R. Gaywood, orig. cf., H. Hills, etc., 1655, 8vo.
folio (332) *Leighton,* £3 12s.

7480 Dryden (John). Works, ɔy Sir Walter Scott, LARGE PAPER,
port., 18 vol., russ. super ex., ɔy J. Clarke (Hiɔɔert's copy),
W. Miller, 1808, imp. 8vo. (333) *Sotheran,* £12

7481 Du Chaillu (P. B.) The Viking Age — Early History,
Manners and Customs of the Ancestors of the English-
speaking Nations, illustrations, 2 vol., cl., uncut, J. Murray,
1889, 8vo. (335) *Edwards,* £1 2s.

7482 Dugdale (Sir Wm.) History of Emɔanking and Drayning,
first ed., with the 5 scarce leaves following the Preface,
"To the Reader," maps, etc., old russ., floreate ornaments,
sides ɔeautifully tooled, g. e. (Roger Payne), *Printed by
Alice Warren,* 1662, folio (337) *Quaritch,* £41

7483 Dance (George). Collection of Portraits sketched from the
Life, engraved by Wm. Daniell, 72 ports., 2 vol. in 1, hf.
russ., Longman, etc., 1808-14, roy. folio (338)
Tregaskis, £2 18s.

7484 Eddis (Wm.) Letters from America, russ. ex., ɔy C. Kal-
thoeber, with ticket (Beckford copy), *Printed for the Author
by C. Dilly,* 1792, 8vo. (343) *H. Stevens,* £2 2s.

7485 Edgeworth (Maria). Tales and Novels, front. and vignettes,
triplicate set, 2 proofs on India paper, 18 vol., orig. cl.,
Baldwin and Cradock, 1832-33, post 8vo. (344)
Quaritch, £6

7486 Edwards (Bryan). History of the British Colonies in the
West Indies, first ed., maps, etc., 2 vol., old cf. ex., ɔy C.
Kalthoeber, with ticket, J. Stockdale, 1793, 4to. (347)
Ellis, £1 7s.

7487 Ehret (G. D.) Original Coloured Drawings of Plants, some
with their Butterflies, 18 large drawings, hf. mor. gt. (Beck-
ford sale), 1754-67, folio (349) *Quaritch,* £18 10s.

7488 Elegant Extracts, 18 vol., mor. ex., g. e., J. Sharpe, n. d.,
12mo. (350) *Quaritch,* £6 12s. 6d.

7489 Elphinstone (Hon. Mountstuart). Account of the Kingdom
of Cauɔul, maps and col. plates of costume, russ. ex. (C.
Lewis), 2 pages of MS. notes by Wm. Beckford, Longman,
1815, 4to. (353) *Young,* £1 14s.

7490 Elton (Chas.) Origin of English History, maps, white cl.,
uncut, B. Quaritch, 1882—Catalogue of a Portion of the
Liɔrary of Chas. I. Elton and Mary Augusta Elton, facs.,
rox., uncut, t. e. g., *ib.*, 1891, together 2 vol., roy. 8vo. (355)
Quaritch, £2 18s.

7491 Enfield (Wm.) Essay towards the History of Liverpool,
second ed., map, chart and views, old cf., J. Johnson, 1774,
sm. folio (358) *Tregaskis,* 18s.

7492 English, Irish and Scots Compendium, or Rudiments of

34—2

Honour, coats-of-arms, 5 vol., old mor., g. e., 1753, etc.,
12mo. (360) *Quaritch*, £3 3s.
7493 Erdeswicke (S.) Survey of Staffordshire, LARGE PAPER, port.,
extra illustrated with 27 orig. pencil sketches ɔy J. P. Neale,
52 sepia drawings ɔy Anne Harwood, wife of the editor,
ports. and views from the "Gentleman's Magazine," etc.,
cl., uncut, J. B. Nichols, 1844, sup. imp. 8vo. (361)
 Rimell, £14
7494 Evelyn (John). Kalendarium Hortense, tenth ed., front., old
English mor., g. e., R. Scot, etc., 1706, sm. 8vo. (365)
 Fairfax, £1 18s.
7495 Evelyn (J.) Sylva, fourth ed., port. after Nanteuil, orig. cf.,
R. Scott, etc., 1706, folio (366) *Tregaskis*, £2
[Presentation copy from John Evelyn, the author's
nephew, to Sir T. Rawlinson, Lord Mayor of London, with
inscription. Wm. Morris's copy.—*Catalogue.*]
7496 Evelyn (J.) Sylva, reprint of the fourth ed. (500 copies
printed), port., extra plates inserted, 2 vol. ɔound in 3, hf.
mor. super ex., ɔy Rivière, A. Douɔleday, 1908, imp. 8vo.
(367) *Maggs*, £1 13s.
7497 Evelyn (J.) Memoirs, ports. in 2 states, additional port. ɔy
Bartolozzi (unlettered proof) and proof plates, 2 vol., russ.
ex. (C. Lewis), 7 pages of MS. notes by Wm. Beckford, H.
Colɔurn, 1818, 4to. (368) *Maggs*, £10 15s.
7498 Evelyn (J.) De la Quintinye (M. de la). The Compleat
Gard'ner, port. and plates, orig. cf., M. Gillyflower, etc., 1693,
sm. folio (369) *Quaritch*, £4 12s.
7499 Fairfax Correspondence. Reign of K. Charles I. and the
Civil War, ed. by G. W. Johnson and Rob. Bell, ports., 4
vol., orig. cl., R. Bentley, 1848-9, 8vo. (374) *Young*, £1 4s.
7500 Farmer (J.) History of Waltham Aɔɔey, first ed., folding
views, old mor., g. e. (Gosford copy), 1735, 8vo. (377)
 Harding, £1 6s.
7501 Farquhar (Geo.) Works, eighth ed., 2 vol., russ. ex., Knapton,
etc., 1742, sm. 8vo. (378) *Maggs*, £1 10s.
7502 Fénélon (F. S. de la Mothe). Les Aventures de Télémaque,
LARGE PAPER, port. and 24 plates, proofs ɔefore letters (200
copies printed), 4 vol., old French mor., g. e. (Bozerian),
Paris, de l'Imprimerie de P. Didot l'Aîné, 1796, sm. 8vo.
(382) *Quaritch*, £18
7503 Ferrar (John). View of Ancient and Modern Duɔlin, view of
Custom House, 1796—Tour from Duɔlin to London in
1795, tinted allegorical plate, in 1 vol., old cf. ex., by Kal-
thoeber, with ticket (Beckford copy), 8vo. (385) *Maggs*, £2 6s.
7504 Ferrarius (J. B.) De Florum Cultura liɔ. IV., full-page
engravings ɔy F. F. Greuter (top margins of pages 41-44
repaired), mor., g. e., ɔy Kalthoeber, with ticket, *Romae*, St.
Paulinus, 1633, sm. 8vo. (386) *Quaritch*, £7 2s. 6d.
7505 Field (Thos. W.) Essay towards an Indian Biɔliography,
orig. cl., uncut (presentation copy), *New York*, 1873, 8vo.
(388) *Edwards*, £1 2s.
7506 Fielding (Henry). Works, by A. Murphy, port. ɔy Hogarth,

Rowlandson's illustrations to "Tom Jones" and "Amelia" inserted from another ed., 8 vol., cf. super ex., Strahan and others, 1771, 8vo. (389) *Quaritch, £6*

7507 Fitzclarence (Lieut.-Col. G.) Journal of a Route across India to England, map, plans and col. plates of military costume, etc., cf. ex. (C. Lewis), 3 pages of MS. notes by Wm. Beckford, J. Murray, 1819, 4to. (393) *Maggs, £1 16s.*

7508 Fitzgerald (Edw.) Rubáiyát of Omar Khayyám, mor. ex., emblematic ornaments, double, g. e., finely bound, Macmillan and Co., 1895, 8vo. (394) *Tregaskis, £1 17s.*

7509 Fitzgerald (E.) Letters and Literary Remains (edition limited to 775 copies), port. and front., 7 vol., red silk, uncut, Macmillan, 1902-3, 8vo. (395) *Young, £2 16s.*

7510 Folkard (H. C.) The Wild-Fowler, plates, orig. cl., Piper, etc., 1859, 8vo. (401) *Quaritch, 14s.*

7511 Folkes (Martin). Tables of English Silver and Gold Coins, with Supplement, 67 plates, russ. ex., *Soc. Ant.*, 1763 (402) *Hill, 10s.*

7512 Forbes (Prof. Edw.) and Hanley (S.) History of British Mollusca, plates, LARGE PAPER, 4 vol., cl., Van Voorst, 1853, roy. 8vo. (405) *Hill, 10s.*

7513 Forbes (Jas.) Oriental Memoirs, port. and plates, those of Natural History col., 4 vol., russ., g. e., White and Co., 1813, 4to. (407) *J. Bumpus, £2 12s.*

7514 Ford (Edw.) and Hodson (Geo. H.) History of Enfield, printed on hand-made paper (only 2 copies so printed), and extra illustrated, 2 vol., mor. super ex., with the orig. copperplates and wood-blocks, *Printed (privately) by J. H. Meyers*, 1873, 8vo. (408) *Sotheran, £8*

7515 Ford (Richard). Designe for bringing a Navigable River from Rickmansworth to St. Gyles in the Fields, map, J. Clarke, 1641—An Answer to Mr. Ford's Booke, map, *ib.*, in 1 vol., hf. mor. (Comerford's copy), sm. 4to. (410) *Edwards, £2 16s.*

7516 Forrest (Capt. Thos.) Voyage to New Guinea and the Moluccas, with a Vocabulary of the Magindano Tongue, port., maps and plates, old cf. gt. (Beckford copy, J. Robson, etc., 1779, 4to. (413) *Edwards, £1 12s.*

7517 Forster (Geo.) Voyage Round the World, 2 vol., 1777—Observations made during a Voyage round the World, 1778—History of the Voyages and Discoveries made in the North, 1786—Journey from Bengal to England, 2 vol. in 1, 1798, maps, together 5 vol., mor. ex., by C. Kalthoeber, with tickets (the Beckford copy), White, Robinson and others, 1777-98, 4to.(414) *Quaritch, £8*

7518 Fortis (Abbé A.) Travels into Dalmatia, 20 folding copperplates, old cf. gt. (Kalthoeber), J. Robson, 1778, 4to. (417) *Ellis, 15s.*

7519 Fortnum (C. Drury E.) Maiolica, a Historical Treatise on the Glazed and Enamelled Earthenwares of Italy, illustrations, cl., uncut, t. e. g., *Oxford, Clarendon Press*, 1896, cr. 4to. (418) *Quaritch, £1 3s.*

7520 Fougasses (Thos. de). Historie of the State of Venice, eng-
lished by W. Shute, orig. cf., with orig. ɔlanks, G. Eld and
W. Stansɔy, 1612, folio (420) *Quaritch, £5*
7521 Foxe (John). Acts and Monuments, ninth ed., port. ɔy Sturt
and engravings, 3 vol., cf. gt., *Stat. Co.,* 1684, folio (421)
Harding, £1 10s.
7522 Francklin (W.) History of the Reign of Shah-Aulum, the
present Emperor of Hindostaun, map and ports., russ. ex.,
by C. Kalthoeber, with ticket, *Printed for the Author,* 1798,
4to. (422) *Edwards, £1* 6s.
7523! Free-Thinker (The), first collected ed., LARGE PAPER, 3 vol.,
old English mor., g. e., *Printed in the year* 1722-23, roy. 8vo.
(424) *Ellis, £2*
7524! Freshfield (D. W.) Exploration of the Caucasus, illustra-
tions in autotype by Vittorio Sèlla, 2 vol., ɔuckram, t. e. g.,
uncut, Edw. Arnold, 1896, sup. imp. 8vo. (425) *Thin, £1* 3s.
7525! Frezier (A. F.) Relation du Voyage de la Mer du Sud aux
Côtes du Cɔily et du Pérou, fine paper, maps and plates,
old cf. ex., g. e. (Kalthoeber), *Paris,* J. G. Nyon, etc., 1716,
4to. (426) *Maggs, £1* 11s.
7526 Fuller (Dr. Thos.) Worthies of England (and Wales), first
ed. (with reprint of the Alphaɔetical Index), port. ɔy D.
Loggan, old russ., gilt tooling, g. e., by Roger Payne, with a
characteristic note of the ɔinder, to Thos. Payne, the ɔook-
seller for whom it was reɔound [he says, "It is the finest
large copy without stains or spots that I have ever seen"],
from the Fonthill sale (Beckford), *Printed by J. G., W. L.
& W. G.,* 1662, folio (430) *Quaritch, £110*
7527 Fuller (Dr. Thos.) The Holy and Profane State, first ed.,
front. and Prince of Wales's feathers, and ports. by Marshall,
orig. cf., *Cambridge,* R. Daniel, 1642, sm. folio (431)
Tregaskis, £1 3s.
7528 Gainsɔorough (Thos.) Collection of Prints illustrative of
English Scenery, 61 plates in aquatint and ɔlack and
white, by W. F. Wells and J. Laporte (title and leaf of
dedication mended), hf. mor., H. R. Young, 1819, roy. folio
(433) *Young, £1* 14s.
7529 Galt (John). Voyages and Travels, plates, hf. mor., g. e., 2
pages of MS. notes ɔy Wm. Beckford, Cadell and Davies,
1812, 4to. (436) *Maggs,* 18s.
7530 Garcilasso de la Vega (El Ynca). Histoire des Yncas Rois
du Perou (avec) l'Histoire de la Conquête de la Floride
(par F. Bandouin et P. Richelet), grand papier (50 copies
printed), engravings ɔy B. Picart, 2 vol., old russ. ex. (the
Beckford copy), *Amst.,* J. F. Bernard, 1737, 4to. (437)
Quaritch, £4
7531 Gardening. The Century Book of Gardening, on toned paper,
illustrations, hf. mor. ex., t. e. g., uncut, n. d., 4to. (441)
Sotheran, £1 10s.
7532 Gay (John). Trivia, first ed., LARGE AND THICK PAPER,
vignettes, orig. cf. (Fountaine copy), B. Lintott, n. d., roy.
8vo. (442) *Pickering, £5* 5s.

7533 Gell (Sir W.) and Gandy. Pompeiana, plates, proofs and etchings on India paper, LARGE PAPER, 2 vol., mor. ex., by C. Lewis, 1817-19, 8vo. (444) *Edwards*, £2 12s.

7534 Gell (Sir W.) Pompeiana, the Result of Excavations since 1819, plates, proofs and etchings on India paper, 2 vol., LARGE PAPER, mor. ex., by C. Lewis, 1832, 8vo. (445) *Rimell*, £1 12s.

7535 Gentleman's Magazine Library, ed. by G. L. Gomme, 30 vol., buckram, uncut, E. Stock, v. d., 8vo. (446) *Harding*, £3 4s.

7536 Goguet (A. Y. de). Origin of Laws, Arts and Sciences, trans. from the French (by D. Thompson), plates, 3 vol., mor., g. e., *Edin.*, *printed for the translator*, 1761, 8vo. (456) *Thorp*, £1

7537 Goldicutt (John). Specimens of Ancient Decorations from Pompeii, LARGE PAPER, India proof plates and a duplicate set in colours, russ. ex. (C. Lewis), Rodwell and Martin, 1826, 4to. (457) *J. Bumpus*, £1 1s.

7538 Goldsmith (Oliver). Works, ed. by Cunningham, fronts., 4 vol., orig. blue cl., J. Murray, 1854, 8vo. (458) *Quaritch*, £2 6s.

7539 Goldsmith (O.) Miscellaneous Works, 6 vol., cf. ex., by F. Bedford, J. Murray, 1837, 8vo. (459) *Quaritch*, £5 17s. 6d.

7540 Gotch (J. Alfred). Architecture of the Renaissance in England, 145 plates and 180 illustrations in the text, 2 vol., hf. mor., t. e. g., B. T. Batsford, 1894, imp. folio (464) *W. Brown*, £6 2s. 6d.

7541 Gough (Richard). History and Antiquities of Pleshy, Co. Essex, fine paper (25 copies printed), old russ., g. e., J. Nichols and Son, 1803, 4to. (467) *Edwards*, £1 16s.

7542 Gough (R.) Sepulchral Monuments in Great Britain, orig. ed., plates, 3 vol. in 5, hf. russ., uncut, t. e. g., J. Nichols, 1786-96, imp. folio (468) *Rimell*, £11 10s.

7543 Graham (Maria). Journal of a Residence in India, *Edinb.*, 1812—Journal of a Voyage to Brazil and Residence, 1821-23, Longman, 1824—Journal of a Residence in Chile in 1822, *ib.*, 1824, together 3 vol., MS. notes by Wm. Beckford, cf. ex. (C. Lewis), 4to. (469) *H. Stevens*, £2 12s.

7544 Graves (Geo.) British Ornithology, 144 col. plates, 3 vol., hf. mor., t. e. g., 1821, imp. 8vo. (472) *Wesley*, £3 12s. 6d.

7545 Graves (Rev. John). History of Cleveland, Co. York, first ed., front. and views, etc., old russ., g. e., *Carlisle*, 1808, 4to. (473) *Edwards*, £1 4s.

7546 Gray (Thos.) Designs by Mr. R. Bentley for Six Poems by Mr. T. Gray, J. Dodsley, 1753—Odes by Mr. Gray, first ed., *Strawberry Hill*, *for R. & J. Dodsley*, 1757—To Mr. Gray on his Odes (by David Garrick), a single leaf, *Printed at Strawberry Hill*, n. d.—Ode on the Pleasure arising from Vicissitude left unfinished by Mr. Gray and since completed (3 leaves), *ib.*—Ode Written upon the Death of Mr. Gray (4 leaves), *ib.*, in 1 vol., russ. ex., g. e., by Chas. Lewis, sm. folio (475) *Hornstein*, £50
[An interesting volume, in which are inserted 2 autograph

notes of Gray, 2 autograph notes of Horace Walpole, 20
proof portraits of Gray, portrait of Bentley, etc.—*Cata-
logue.*]
7547 Gray (T.) Odes [Progress of Prosy and the Bard], first ed.
(with fly title), mor., arms of Lord Vernon, *Printed at
Strawberry Hill for R. & J. Dodsley,* 1757, sm. 4to. (477)
Ellis, £7 10s.
7548 Gray (T.) Poems, port. by W. Doughty, 4 vol., old mor.,
g. e. (Roger Payne), (G. Daniel's copy,) *York,* A. Ward,
etc., 1778, cr. 8vo. (478) *Hatchard,* £5 5s.
7549 Green (Wm.) Sixty Views of the English Lakes, printed in
col., mor. ex., *Published at Ambleside by W. Green,* 1815,
imp. 4to. (481) *Quaritch,* £8 15s.
7550 Greenwell (Wm.) and Rolleston (G.) British Barrows, cl.,
Oxford, Clarendon Press, 1877—Wood-Martin (W. G.)
The Lake Dwellings of Ireland, illustrations, cl., uncut,
t. e. g., *Dublin and London,* 1886, imp. 8vo. (482)
Edwards, £1 16s.
7551 Grey (Geo.) Journals of Two Expeditions of Discovery in
Australia, 1837-9, maps and plates, 2 vol., orig. cl., T. and
W. Boone, 1841, 8vo. (483) *Young,* £1 2s.
7552 Grose (Fr.) Antiquities of England and Wales, Ireland and
Scotland, with Supplement—The Military Antiquities—
Darell (W.) History of Dover Castle, 1786, orig. eds.,
LARGE PAPER, proof plates, together 13 vol., old russ. ex.,
S. Hooper, etc., 1773-91, roy. 4to. (486) *Edwards,* £4
7553 Grote (George). History of Greece, 1854-6—Plato and other
Companions of Sokrates, 1867, Library eds., 15 vol., cf. ex.,
by F. Bedford, fine set (Col. Hibbert's), J. Murray, 8vo.
(488) *Quaritch,* £8 15s.
7554 Guliffe (Jas. A.) Italy and its Inhabitants, 2 vol., cf. ex. (C.
Lewis), 9 pages of MS. notes by Wm. Beckford, J. Murray,
1820, 8vo. (490) *Edwards,* £1
7555 Hacke (Capt. Wm.) Collection of Original Voyages (Cowley,
Sharp, Wood and Roberts), maps, old cf., J. Knapton, 1699,
8vo. (493) *Ellis,* £2 2s.
7556 Hall (Capt. Basil). Account of a Voyage of Discovery to
the West Coast of Corea and the Great Loo-Choo Island,
charts and col. plates, MS. notes by Wm. Beckford, orig.
bds., uncut, J. Murray, 1818, 4to. (496) *Quaritch,* £2 14s.
7557 Hall (Rev. Jas.) Travels in Scotland by an Unusual Route,
map and views, 2 vol., hf. mor., t. e. g., uncut, 3 pages of
MS. notes by Wm. Beckford, J. Johnson, 1807, roy. 8vo.
(498) *Thorp,* £1 14s.
7558 Hall (Rev. Jas.) Travels throughout Ireland, map, 2 vol., cf.,
g. e., 10 pages of MS. notes by Wm. Beckford, R. P. Moore,
etc., 1813, 8vo. (499) *Maggs,* £1 10s.
7559 Hamilton (Count A.) Memoirs of Count Grammont, second
ed., ports., 3 vol., hf. mor., uncut, J. White, etc., 1809, 8vo.
(500) *J. Bumpus,* £3 10s.
7560 Hamilton (Sir Wm.) Campi Phlegraei, map and 59 plates,
col. by hand, 3 vol. in 1 (including Supplement), Italian

vell., gilt ornaments, inlaid, g. e., fine ɔinding, *Naples*,
1776-79, folio (501) *Edwards*, £6

7561 Hanway (Jonas). A Sentimental History of Chimney
Sweepers, 2 plates, old mor., g. e., Dodsley, 1785, sm. 8vo.
(503) *Quaritch*, £4 8s.

7562 Hanway (J.) . On Solitude in Imprisonment of Malefactors,
etc., old mor., rich ɔorders and ornaments, g. e. (perhaps
ɔound for George, Prince of Wales, afterwards George IV.),
J. Bew, 1776, 8vo. (504) *Ellis*, £2 10s.

7563 Harington (Sir John). Nugæ Antiquæ, 3 vol., old mor. ex.
(Roger Payne), ex-liɔris of Horace Walpole in each vol.,
J. Dodsley, etc., 1779, post 8vo. (505) *Quaritch*, £5

7564 Harris (Moses). The Aurelian, LARGE PAPER, orig. ed.,
front. and 44 col. plates, russia gilt (ɔroken), *J. Edwards
for the Author*, 1766, folio (509) *Wesley*, £1 18s.

7565 Harting (J. E.) Biɔliotheca Accipitraria, col. front., rox.,
t. e. g., B. Quaritch, 1891, 8vo. (514) *Porter*, 12s.

7566 Hartshorne (A.) Old English Glasses, illustrations, art cl.,
hf. vell., t. e. g., uncut, E. Arnold, 1897, roy. 4to. (516)
Tregaskis, £1 18s.

7567 Harvie-Browne (J. A.), etc. A Verteɔrate Fauna of Scotland :
Sutherland, Caithness and West Cromarty, Inner and
Outer Heɔrides and Argyll, Orkney Islands, Moray
Basin, North-West Highlands and Skye, Shetland
Islands, Tay Basin and Strathmore, plates, 9 vol., cl.,
t. e. g., uncut, *Edinb.*, D. Douglas, 1887-1906, pott 4to.
(517) *Gladstone*, £12 5s.

7568 Hawkins (Sir Richard). The Oɔservations of, in his Voyage
into the South Sea, anno domini 1593, orig. ed., ex-liɔris of
Sir Thomas Hanmer, 1707, on reverse of title, orig. cf.,
J. D. for John Jaggard, 1622, sm. folio (521) *Ellis*, £7 5s.

7569 Hayes (Wm.) Portraits of Birds, from the Menagerie of
Osterley Park, 94 col. plates, cf. gt., 1794, 4to. (522)
Edwards, £1 5s.

7570 Hayward (A.) Biographical and Critical Essays, orig.
liɔrary ed., 5 vol., cf. ex., m. e., Longman, 1858-74, 8vo.
(523) *Hill*, £3 17s. 6d.

7571 Hazlitt (W. Carew). History of the Venetian Repuɔlic, map
and ports., 4 vol., cf. ex., ɔy F. Bedford, Smith, Elder
and Co., 1860, 8vo. (525) *Maggs*, £2 18s.

7572 Hazlitt (W. C.) Tenures of Land, new ed., LARGE PAPER,
bds., uncut, Reeves and Turner, 1874, imp. 8vo. (526)
Harding, 15s.

7573 Hearne (Sam.) Journey from Prince of Wales's Fort in
Hudson's Bay to the Northern Ocean, LARGE AND FINE
PAPER, map and proof views, mor. ex., by C. Kalthoeber,
with ticket, fine copy (Beckford), Strahan and Cadell, 1795,
4to. (527) *Leighton*, £6 15s.

7574 Hearne (Thos.) Reliquiæ Hernianæ, LARGE PAPER, port. of
Hearne, another portrait and autograph note inserted, and
two autograph letters of Dr. Bliss to Archdeacon Cotton, 50

copies printed, 2 vol., mor. super ex., by Rivière (Harleian style), *Oxford, for the Editor*, 1857, imp. 8vo. (529)
Parsons, £2

7575 Heath (Rob.) Account of the Islands of Scilly, draught and plates, 5 extra inserted, cf. ex. (Rivière), R. Man)y, etc., 1750, 8vo. (530) *Maggs, £1 7s.*

7576 Helps (Sir Arthur). The Spanish Conquest in America, 4 vol., cl., uncut, J. W. Parker, 1855-61, 8vo. (531)
Hatchard, £2

7577 Henderson (E)enezer). Iceland, map and plates, 2 vol., russ., g. e. (C. Lewis), 6 pages of MS. notes)y Wm. Beckford, *Edinb.*, Oliphant, etc., 1818, 8vo. (532) *Ellis, £1 10s.*

7578 Her)ert (Geo.) Works, port., 2 vol., mor. super ex., W· Pickering, 1853, roy. 8vo. (534) *J. Bumpus, £3*

7579 Herefordshire Pomona (The). Coloured Figures and Descriptions, ed.)y R. Hogg and H. G. Bull, 76 col. plates and woodcuts, 2 vol., mor. super ex., by Rivière, *Hereford*, Jakeman and Carver, etc., 1876-85, imp. 4to. (536)
Parsons, £8 15s.

7580 Herkomer (Sir H.) Etching and Mezzotint Engraving. Lectures delivered at Oxford, etched examples,)uckram, uncut, Macmillan, 1892, 4to. (537) *W. Brown, £1 15s.*

7581 Hibbert (Sam., M.D., etc.) Description of the Shetland Islands, geological map and plates, russ., g. e. (C. Lewis), (Sir R. Peel's copy), *Edinb.*, A. Consta)le, 1822, 4to. (544)
Thin, £1 6s.

7582 Historical MSS. Commission Reports, 131 vol., 1883-1909—Historical MSS. Commission Reports (Blue Books), 16 vol., 1870-74, together 147 vol., large 8vo. and folio (549-550)
Harding, £6 10s.

7583 Hoare (Sir R. C.) Journal of a Tour in Ireland, LARGE AND THICK PAPER, 25 copies printed, front., russ. ex. (the author's own copy), W. Miller, 1807, imp. 8vo. (552)
Thorp, £1 15s.

7584 Hoare (Sir R. C.) "Foreign Tours." Original MS. Journals of Tours in France, Italy, Sicily and Malta, Switzerland, Germany, etc., 1785-90, 9 vol., russ. gt. (from the Stourhead Li)rary), 1785-90, 4to. (553) *Hiersemann, £5*

7585 Hodges (Wm., R.A.) Travels in India, proof plates, LARGE PAPER, mor. super ex.,)y Kalthoeber, with ticket (from the Fonthill Li)rary), *Printed for the Author*, 1793, 4to. (554)
Leighton, £4 10s.

7586 Hogarth (Wm.) Anecdotes, written)y himself, illustrated with 44 plates, mor., g. e., J. B. Nichols, 1833, 8vo. (557)
Bain, £1 3s.

7587 Hogarth Illustrated, by John Ireland, second ed., with Supplement, port. and small engravings, 3 vol., russ. ex., J. and J. Boydell, etc., 1791-8, imp. 8vo. (558) *Hill, £1*

7588 Hogarth Moralized, by the Rev. Dr. Trusler, proof plates, mor. ex. (Hering), J. Major, 1831, 8vo. (559) *Bain, £2 8s.*

7589 Holland (H.) Travels in the Ionian Isles, Al)ania, etc.,

map and views, proofs of the latter in duplicate, 4 pages of notes by Wm. Beckford, russ. ex. (C. Lewis), Longman, 1815, 4to. (561) *Edwards, £1* 1s.

7590 Hooker (W. J.) Journal of a Tour in Iceland, second ed., LARGE PAPER, map and chart, col. front. and folding plates, 2 vol., russ. ex. (C. Lewis), Longman, 1813, imp. 8vo. (565) *Young, £1* 1s.

7591 Houbraken and Vertue. Heads of Illustrious Persons of Great Britain, by Thos. Birch, 108 ports., 2 vol. in 1, old russ. ex., J. and P. Knapton, 1747-52, folio (568) *Maggs, £10* 5s.

7592 Household Book of the Fifth Earl of Northumberland, begun A.D. 1512 (preface by Bp. Percy), old mor., g. e. [*Privately printed*], 1770, 8vo. (569) *Ellis, £1* 6s.

7593 Hughes (Rev. T. S.) Travels in Sicily, Greece and Albania, maps, etc., 2 vol., cf., g. e. (C. Lewis), 5 pages of MS. notes by Wm. Beckford, J. Mawman, 1820, 4to. (570) *Maggs, £1* 5s.

7594 Huish (Marcus B.) Samplers and Tapestry, Embroideries, etc., illustrations (limited to 600 copies), art buckram, t. e. g., Longmans, etc., 1900, sm. 4to. (572) *Quaritch, £1* 9s.

7595 Hunter (Capt. John). An Historical Journal of the Transactions at Port Jackson and Norfolk Island, port., maps, etc., cf. ex., J. Stockdale, 1793, 8vo. (576) *Edwards, £1* 4s.

7596 Hutchinson (Wm.) History of Cumberland, maps and views, etc., 2 vol., old mor., with the Hoare arms (the Stourhead copy), *Carlisle,* F. Jollie, 1794, 4to. (579) *J. Bumpus, £10* 10s.

7597 Hutton (Wm.) Voyage to Africa, maps and col. plates, hf. mor., g. e., 4 pages of MS. notes by Wm. Beckford, Longman, 1821, 8vo. (580) *Young, £1* 2s.

7598 Ides (E. Ysbrandts). Travels from Moscow Overland to China, front., folding map and plates, old russ. ex., W. Freeman, etc., 1706, sm. 4to. (581) *Young, £2* 2s.

7599 Ives (Edw.) Voyage from England to India, chart, maps, etc., tree cf. ex. (Kalthoeber), flyleaf filled with MS. notes by Wm. Beckford, E. and C. Dilly, 1773, 4to. (588) *Edwards, £1* 3s.

7600 Jackson (Georgina F.) Shropshire Word Book and Folklore, in the 6 orig. parts, uncut, *Issued to Subscribers only, Trübner, etc.,* 1879-86, 4to. (590) *Edwards, £1* 6s.

7601 Jackson (Jas. Grey). Account of the Empire of Morocco, second ed., miniature port. by Scriven, maps and engravings, that of the chameleon coloured, MS. note by Wm. Beckford, hf. mor., t. e. g., *Printed for the Author,* 1812, 4to. (591) *J. Bumpus, £1* 10s.

7602 Janson (C. W.) The Stranger in America, tinted views, hf. mor., t. e. g., uncut, Jas. Cundel, 1807, 4to. (597) *Sotheran, £3* 6s.

7603 Jefferies (Richard). Hodge and his Masters, 2 vol., 1880— Greene Ferne Farm, 1880—Bevis, the Study of a Boy, 3

vol., 1882—Nature near London, 1883—The Dewy Morn, 2 vol., 1884—Red Deer, 1884—Amaryllis at the Fair, 1887 —Field and Hedgerow, 1889—The Toilers of the Field, 1892, all first eds.—Besant. Eulogy, 1888, all in orig. cl., together 14 vol., cr. 8vo. (599)　　　　　*Thorp*, £5 15s.

7604 Jesse (J. H.) Literary and Historical Memorials of London— London and its Celebrities, orig. eds., front. and plans, 4 vol., orig. blue cl., R. Bentley, 1847-50, 8vo. (601)
Edwards, £4 10s.

7605 Jesse (J. H.) Memoirs of the Court of England during the Reign of the Stuarts, orig. ed., front., 4 vol., orig. cl., R. Bentley, 1840, 8vo. (602)　　　*J. Bumpus*, £3 17s. 6d.

7606 Johnson (Lieut.-Col. J.) Journey from India to England through Persia, etc., plates (col. and plain), cf. ex., by C. Smith, 1½ pages of MS. notes by Wm. Beckford, Longman, 1818, 4to. (604)　　　　　*Ellis*, £1 9s.

7607 Johnson (Dr. S.) Dictionary, first ed., 2 vol., orig. cf., *W. Strahan for J. & P. Knapton, etc.*, 1755, folio (606)
Bull, £3 5s.

7608 Jonson (Ben). Works, by W. Gifford, port., 9 vol., cf. ex., G. and W. Nicol, etc., 1816, 8vo. (612)　　*Young*, £5 17s. 6d.

7609 Junius. Letters, LARGE PAPER, 3 vol., cf. ex. (C. Lewis), *G. Woodfall for Rivington and others*, 1812, imp. 8vo. (615)
Maggs, £2 6s.

7610 Kahn (Peter). Travels into North America, second ed., map and plates, 2 vol., old cf. gt., T. Lowndes, 1772, 8vo. (617)
H. Stevens, £2 14s.

7611 Kane (E. Kent). Arctic Explorations in Search of Sir John Franklin, port., map and illustrations, 2 vol., mor. ex., *Philadelphia, etc.*, 1857, 8vo. (618)　　*Quaritch*, £1 7s.

7612 Keatinge (M.) Travels in Europe and Africa, plates, hf. russ., g. e., 2 pages of MS. notes by Wm. Beckford, H. Colburn, 1816, 4to. (619)　　　　　*Thorp*, £1 1s.

7613 Keats (John). Poems, port., red rubrics, 2 vol., white cl. ex., uncut, *Printed by C. Whittingham & Co. for G. Bell*, 1904, pott 4to. (620)　　　　　*Quaritch*, 19s.

7614 Keller (Ferd.) The Lake Dwellings of Switzerland, illustrations, 2 vol., cl., uncut, Longmans, 1878, roy. 8vo. (622)
Edwards, £1 9s.

7615 Keppel (Capt. the Hon. Geo.) Journey from India to England by Bussorah, Bagdad, the Ruins of Babylon, etc., map, col. plates and woodcuts, mor., g. e. (C. Lewis), 3 pages of MS. notes by Wm. Beckford, H. Colburn, 1827, 4to. (625)　　　　　*Quaritch*, £2 2s.

7616 King (Capt. P. P.), Fitzroy (R.) and Darwin (Chas.) Surveying Voyages of H.M.Ss. Adventure and Beagle, maps and plates, 4 vol., orig. cl., H. Colburn, 1839, roy. 8vo. (629)
Young, £2

7617 Kingsley (Ch.) The Water-Babies, new ed., 100 illustrations by Linley Sambourne, mor. ex., by Rivière, Macmillan, 1886, pott 4to. (630)　　　　　*Kemble*, £2 4s.

7618 Kirkpatrick (W.) An Account of the Kingdom of Nepaul, LARGE PAPER, map and plates, douɔle set of plates, lettered and unlettered proofs, hf. mor., uncut, t. e. g., MS. notes ɔy Wm. Beckford, W. Miller, 1811, 4to. (632)
Edwards, £1 11s.

7619 Klaproth (Julius von). Travels in the Caucasus and Georgia, hf. mor., g. e. (C. Lewis), 2 pages of MS. notes ɔy Wm. Beckford, H. Colɔurn, 1814, 4to. (633)
Thorp, £1

7620 Knight (Chas.) Gallery of Portraits, orig. issue, 168 ports., 7 vol., mor., g. e., C. Knight, 1833-36, sup. imp. 8vo. (635)
Edwards, £2 4s.

7621 Koran (The), trans. by George Sale, first ed., old mor., g. e. (Roger Payne), *C. Akers for J. Wilcox*, 1734, 4to. (639)
Hatchard, £3 16s.

7622 Koster (H.) Travels in Brazil, map, plan and 8 col. plates, cf. ex. (C. Lewis), MS. notes by Wm. Beckford, Longman, 1816, 4to. (640)
J. Bumpus, £3

7623 Krasheninnicoff (S.) History of Kamtschatka, trans. by Jas. Grieve, M.D., map and plates, russ. ex., ɔy C. Kalthoeber, *Glocester, printed by R. Raikes for T. Jeffreys*, 1764, 4to. (641)
Young, £1 10s.

7624 Krusenstern (Capt. A. J. von). Voyage Round the World, trans. by R. B. Hoppner, map and 2 col. plates ɔy J. A. Atkinson, 2 vol. in 1, mor. ex. (C. Lewis), 2½ pages of MS. notes ɔy Wm. Beckford, J. Murray, 1813, 4to. (642)
Quaritch, £6 6s.

7625 La Bedoyere (M. de). Voyage en Savoie et dans le Midi de la France, fine paper, French mor., gilt tooled, g. e., ɔy P. Rosa (Beckford), *Paris*, Giquet, etc., 1807, 8vo. (643)
Quaritch, £3 12s. 6d.

7626 Laing (Sam.) The Heimskringla, second ed., maps, 210 copies printed for sale in England, 4 vol., picture cl., t. e. g., J. C. Nimmo, 1889, 8vo. (646)
Edwards, £2 4s.

7627 Lamɔert (A. B.) A Description of the Genus Pinus, port. and 72 col. plates, 2 vol., hf. mor., g. e., *Wandsworth*, Weddell, 1832, sm. 4to. (648)
J. Bumpus, £5 17s. 6d.

7628 Landor (W. S.) Pericles and Aspasia, first ed., 2 vol., orig. bds., Saunders and Ottley, 1836, 8vo. (651)
Ellis, £1 10s.

7629 Lane-Poole (Stanley). The Art of the Saracens in Egypt, LARGE PAPER, 108 woodcuts, ɔuckram, uncut, 1886, sup. imp. 8vo. (653)
Quaritch, £1 8s.

7630 Langsdorff (G. H. von). Voyages and Travels in Various Parts of the World, port., maps and plates, 2 vol. in 1, mor. ex. (C. Lewis), MS. notes by Wm. Beckford, H. Colɔurn, 1813-14, 4to. (656)
Quaritch, £8 5s.

7631 La Rochefoucault Liancourt (Duke de). Travels through the United States of North America, etc., second ed., 3 maps, taɔles, etc., 4 vol., hf. mor., R. Phillips, etc., 1800, 8vo. (657)
Grant, £2 2s.

7632 Lawson (Wm.) A New Orchard and Garden, woodcuts, hf. cf., H. Sawbridge, 1683, sm. 4to. (662)
Hatchard, £1 3s.

7633 Le Blanc (Vincent). Voyages fameux aux quatre Parties du
 Monde, old cf. ex., G. Clousier, 1649, sm. 4to. (663)
 Ellis, £1 18s.
7634 Le Blanc (V.) The World Surveyed, trans. ɔy Francis
 Brooke, port., orig. cf., J. Starkey, 1660, sm. folio (664)
 Tregaskis, £1 16s.
7635 Leland (John). Itinerary, ed. ɔy Thos. Hearne, second ed.,
 LARGE PAPER (50 copies printed), MS. note ɔy Horace
 Walpole (?), 9 vol., hf. bd., uncut, *Oxford*, 1744-5, imp. 8vo.
 (669) *Thorp*, £3 3s.
7636 Lewin (W.) The Papilios of Great Britain, vol. i. (all pub-
 lished), 46 col. plates, text in English and French, cf. gt.,
 F. Johnson, 1795, 4to. (679) *Wheldon*, £1 7s.
7637 Lewis (George). A Series of Groups, illustrating the
 Physiognomy, Manners and Character of the People of
 France and Germany (to illustrate Dibdin's Tour), LARGE
 PAPER, 60 India proof plates, russ. ex. (C. Lewis), *Pub-
 lished for the Author by J. & A. Arch*, 1823, 4to. (680)
 Edwards, £1 4s.
7638 Lilford (Lord). Coloured Figures of the Birds of the British
 Islands, col. plates, port., etc., orig. issue, 36 parts (wanted
 parts vi.-vii.), R. H. Porter, 1885-97, roy. 8vo. (683)
 J. Bumpus, £24 10s.
7639 Lilford (Lord) On Birds, a Collection of Informal and Un-
 puɔlished Writings, illustrated by A. Thorɔurn, ɔuckram,
 uncut, Hutchinson, 1903, pott 4to. (684) *Pole*, £1 1s.
7640 Lindsay (Lord). Lives of the Lindsays, pedigree, etc., 3 vol.,
 orig. ɔlue cl., uncut, J. Murray, 1849, 8vo. (686)
 Harding, £1 5s.
7641 Lingard (Dr. John). History of England, fifth ed., port., 10
 vol., russ. ex., C. Dolman, 1849, 8vo. (687) *Edwards*, £3
7642 Link (H. F.) Travels in Portugal and through France and
 Spain, trans. by John Hinchley, mor. ex. (Staggemeier),
 MS. notes ɔy Wm. Beckford, Longman, 1801, 8vo. (688)
 Edwards, £1 3s.
7643 Lloyd (David). Memoires of the Lives, Actions, Sufferings
 and Deaths of Those Noɔle, Reverend and Excellent Per-
 sonages that suffered in our late intestine Wars, front.
 containing port. of Charles I., surrounded by 18 other
 heads, old russ. gt., *Printed for S. Speed, etc.*, 1668, sm.
 . folio (690) *Young*, £1 4s.
7644 Lloyd (L.) Scandinavian Adventures, illustrations, 2 vol.,
 orig. green cl., uncut, R. Bentley, 1854, imp. 8vo. (691)
 Pole, £1 6s.
7645 Locke (John). Works, third ed., 3 vol., old mor., g. e., arms
 of Trinity College, Duɔlin, prize copy, A. Bettesworth, etc.,
 1727, sm. folio (692) *Ellis*, £1 12s.
7646 Long (J.) Voyages and Travels of an Indian Interpreter
 and Trader, map of Canada, mor., g. e., by C. Kalthoeber,
 with his ticket, *Printed for the Author*, 1791, 4to. (701)
 H. Stevens, £7
7647 Loskiel (G. H.) History of the Mission of the United

Brethren among the Indians of North America, folding map, cf., g. e., arms of Theodore Williams (C. Lewis), *Printed for the Brethren's Society*, 1794, 8vo. (703)
H. Stevens, £1 8s.

7648 Lucas (N. I.) Dictionary of English and German, and German-English, 4 vol., russ. ex., *Bremen*, C. Schünemann, 1854-1868, sup. imp. 8vo. (705) *James*, £1

7649 Lukis (W. C.) Prehistoric Stone Monuments of the British Isles : Cornwall, plates, uncut, *Society of Antiquaries*, 1885, folio (707) *Hill*, 17s.

7650 Lyon (Capt. G. F.) Travels in Northern Africa, map, col. plates and woodcuts, cf. ex., g. e. (C. Lewis), MS. notes >y Wm. Beckford, J. Murray, 1821, 4to. (709)
J. Bumpus, £1 11s.

7651 Lysons (Rev. D.) Environs of London, orig. ed., LARGE PAPER, maps and plates (some col. like drawings), 6 vol., hf. russ. gt., Cadell and Davies, 1792-1800, roy. 4to. (708)
Quaritch, £10 10s.

7652 Mackenzie (Sir G. S.) Travels in Iceland, maps and col. plates, proofs (mounted), mor. ex. (C. Lewis), MS. notes >y Wm. Beckford, *Edinb.*, A. Constable, 1811, 4to. (716)
Quaritch, £4 4s.

7653 Macquoid (Percy). History of English Furniture, plates in colours and other illustrations, 4 vol., >uckram, uncut, Lawrence and Bullen, 1904-8, folio (723) *A. D. Gardner*, £6

7654 Magnus (Olaus). Historia de Gentibus Septentrionalibus, woodcuts, old cf. gt., *Romae*, J. M. de Viottis, 1555, sm. 4to. (726) *Quaritch*, £5

7655 Maitland (Wm.) History of London, plan and plates, LARGE PAPER, old mor., arms of George II., S. Richardson, 1739, roy. folio (729) *Ellis*, £2 10s.

7656 Malcolm (Col. Sir J.) History of Persia, LARGE PAPER, map and proof plates in various states, 2 vol., russ. super ex. (C. Lewis), (>roken,) the Beckford copy, J. Murray, 1815, imp. 4to. (731) *F. C. Carter*, £1 10s.

7657 Malkin (B. Heath). Scenery, Antiquities and Biography of South Wales, 1803, map and tinted views, hf. mor. ex., MS. notes >y Wm. Beckford, Longman, 1804, 4to. (732)
Quaritch, £2 4s.

7658 Manning (Rev. O.) and Bray (Wm.) History of Surrey, orig. ed., map and views, 3 vol., russ. ex., J. White, 1804-14, folio (735) *Bull*, £20

7659 Marco Polo. Travels in the Thirteenth Century, trans. >y Wm. Marsden, LARGE PAPER, hf. mor., g. e. (C. Lewis), *Printed for the Author*, 1818, 4to. (737) *Young*, £1 10s.

7660 Marlowe (Christopher). Works, >y the Rev. A. Dyce, on hand-made paper, 3 vol., orig. cl., with la>els, W. Pickering, 1850, cr. 8vo. (740) *Quaritch*, £5 17s. 6d.

7661 Marvell (Andrew). Poems and Satires, ed. by G. A. Aitken, LARGE PAPER, 200 printed, 2 impressions of the port., 2 vol., hf. mor., t. e. g., Lawrence and Bullen, 1892—Shen-

stone (Wm.) Poetical Works, plates ɔy T. Stothard, 2
vol., old mor. ex., T. Cadell, etc., 1798, sm. 8vo. (747)
 Maggs, £11 15s.
7662 Massinger (Philip). Plays, by W. Gifford, second ed., port.,
4 vol., cf. ex., ɔy C. Kalthoeber, with ticket, G. and W.
Nicol, etc., 1813, 8vo. (751) *Young,* £2 10s.
7663 Mathison (G. F.) Narrative of a Visit to Brazil, Chili, Peru
and the Sandwich Islands, col. plates and chart, hf. mor.,
g. e., 5 pages of MS. notes by Wm. Beckford, C. Knight,
1825, 8vo. (754) *Edwards,* £1 2s.
7664 Maundrell (H.) Journey from Aleppo to Jerusalem, plates,
old mor., g. e. (Roger Payne), *Oxford, printed at the Theatre,*
1740, 8vo. (755) *Maggs,* £1
7665 Mawe (John). Travels in the Interior of Brazil, plates, cf.
ex., g. e. (C. Lewis), MS. notes ɔy Wm. Beckford, Long-
man, 1812, 4to. (756) *Maggs,* £1 4s.
7666 Maxwell (W. H.) Wild Sports of the West—Highlands and
Islands (a Sequel to the aɔove), 4 vol., cf. ex., by F. Bedford,
Bentley and Routledge, 1832-52, 8vo. (757) *Bain,* £4
7667 Meager (Leonard). The English Gardener, orig. ed., 24
plates, old cf., P. Parker, 1670, sm. 4to. (758) *Bain,* £2 18s.
7668 Meares (John). Voyages from China to the Northwest Coast
of America, fine paper, port., maps and proof plates, mor.
ex., by C. Kalthoeber, with ticket (Beckford), *Printed at the
Logographic Press by Jo. Walter,* 1790, 4to. (759)
 Quaritch, £7 10s.
7669 Mexia (Pedro). Treasurie of Auncient and Moderne Times
(ɔy Thos. Milles), orig. cf., gilt ornaments, W. Jaggard,
1613, folio (762) *Quaritch,* £5
7670 Michaux (F. Andrew). North American Sylva, 150 col.
plates, 3 vol., mor., t. e. g., ɔy C. Hering, *Philadelphia, by
T. Dobson, etc. (printed in Paris),* 1817-19, imp. 8vo. (763)
 Edwards, £10 10s.
7671 Middleton (Thos.) Works, by Dyce, port., 5 vol., russ. super
ex., ɔy F. Bedford, E. Lumley, 1840, 8vo. (767)
 Sotheran, £7
7672 Miers (John). Travels in Chile and La Plata, maps and
plates, 2 vol., cf. gt., 5 pages of MS. notes by Wm. Beckford,
Baldwin, etc., 1826, 8vo. (768) *Edwards,* £1 10s.
7673 Millais (J. G.) British Deer and their Horns, col. front. and
185 text and full-page illustrations on toned paper, picture
ɔuckram, uncut, Sotheran, 1897, folio (770)
 B. F. Stevens, £2 13s.
7674 Milton (John). Poetical Works, 2 vol., old French mor., gilt
ɔacks, g. e. (Derome), *Birm., J. Baskerville for J. & R.
Tonson,* 1760, imp. 8vo. (774) *Quaritch,* £13 10s.
7675 Milton (J.) Paradise Lost—Paradise Regained, and other
Works, 2 vol., old cf. gt., *Birm., J. Baskerville for J. & R.
Tonson,* 1758-59, imp. 8vo. (776) *Bain,* £3
7676 Mitford (Mary Russell). Our Village, fourth ed.—Belford
Regis, first ed., together 7 vol., uniform hf. mor., t. e. g.,
uncut, Whittaker and Bentley, 1828-35, cr. 8vo. (780)
 Edwards, £1 18s.

7677 Molière (J. B. P. de). Œuvres, par M. Bret (with the starred leaves), port. and plates after J. M. Moreau, 6 vol., old French cf. ex. (Padeloup), *Paris, Libraires Associes,* 1773, 8vo. (782) *Quaritch,* £38

7678 Mollien (M. G.) Travels in the Interior of Africa, map and plates, cf. ex. (C. Lewis), 2 pages of MS. notes by Wm. Beckford, H. Colburn, 1820, 4to. (783) *Edwards,* £1 8s.

7679 Monk (Geo.) Duke of Albemarle. Life, from an original MS. of Thos. Skinner, LARGE PAPER, port. and plate inserted, mor., g. e., arms of Hon. K. Fitzgibbon (C. Lewis), fine copy, *W. Bowyer for the Editor,* 1723, roy. 8vo. (785) *Ellis,* £1 6s.

7680 Montaigne (M. de). Essays, by Chas. Cotton, first ed., 3 vol., old mor., ornamental backs and sides, g. e. (repaired), T. Basset, 1693, 8vo. (789) *Quaritch,* £8 5s.

7681 Morant (Philip). History of Essex, orig. ed., maps and plates, including the plate of Audley End in vol. ii., 2 vol., old russ. gt., fine copy, T. Osborne, etc., 1768, folio (790) *Edwards,* £12 15s.

7682 More (Sir Thos.) Life, by M. T. M(ore), LARGE PAPER, port. by G. Vertue, old cf., g. e. (Fountaine copy), J. Woodman and D. Lyon, 1726, imp. 8vo. (792) *Maggs,* £1 12s.

7683 More (Sir T.) Life, by Wm. Roper (ed. by S. W. Singer), port., mor. ex., by Rivière, *Chiswick,* C. Whittingham, 1817, post 8vo. (793) *Bain,* £1 10s.

7684 Morier (Jas.) Journey (and a Second Journey) through Persia, Armenia and Asia Minor to Constantinople, maps and plates, 2 vol., mor. super ex. (C. Lewis), 7 pages of notes by Wm. Beckford, Longman, 1812-18, 4to. (798) *Quaritch,* £5 10s.

7685 Mortimer (Lieut. G.) Observations and Remarks during a Voyage to the North-West Coast of America, etc., plans and plates, hf mor., *Printed for the Author,* 1791, 4to. (799) *Maggs,* £5 10s.

7686 Moss (Fletcher). Pilgrimages to Old Homes (First, Third and Fourth Books), 1903-8—Folk-Lore, 1898, photographic illustrations, 4 vol., buckram, uncut, t. e. g., *Published by the Author from his Home, The Old Parsonage, Didsbury,* 1893-1908, imp. 8vo. (801) *Montagu,* £2 4s.

7687 Muirhead (Geo.) The Birds of Berwickshire, map and woodcuts, 2 vol., cl., uncut, *Edinb.,* D. Douglas, 1889, 8vo. (803) *Wheldon,* £1

7688 Munro (Dr. Robert). Lake-Dwellings of Europe, plates, cl., Cassell, 1890, imp. 8vo. (805) *Hill,* 15s.

7689 Murphy (J. C.) Travels in Portugal—A General View of the State of Portugal, plates, 2 vol., mor. super ex., by C. Kalthoeber, with ticket (Beckford), Strahan and Cadell, 1795-98, 4to. (806) *Young,* £6 12s. 6d.

7690 Murray (A. H. Hallam). Sketches on the Old Road through France to Florence, 48 col. plates and illustrations in the text, 150 copies printed on hand-made paper, mor., t. e. g., uncut, J. Murray, 1904, large pott 4to. (807) *James,* £1 8s.

7691 Narborough (Sir John), Tasman (Capt.), Wood (Capt. J.) and Marten (Frederick). An Account of Several Late Voyages and Discoveries to the South and North, towards the Straits of Magellan, etc., maps and plates, old cf., S. Smith and B. Walford, 1694, 8vo. (813) *Quaritch,* £2 8s.

7692 National MSS. (Facsimiles of), from William the Conqueror to Queen Anne, photozincographed by Col. Sir H. James, 4 vol., cl., *Southampton, Ordnance Survey Office,* 1865-68, folio (815) *Quaritch,* £1 16s.

7693 Nelson (T. H.) The Birds of Yorkshire, photographic illustrations, 2 vol., cl., A. Brown and Sons, 1907, 8vo. (818) *B. F. Stevens,* £1 2s.

7694 Noehden (G. H.) Specimens of Ancient Coins of Magna Graecia and Sicily, 20 India proof plates, russ. ex. (C. Lewis), S. Prowett, 1824-6, imp. 4to. (826) *James,* 14s.

7695 Nodder (Fred. P.) Flora Rustica, by Thos. Martyn, 144 col. plates, hf. mor. ex., by R. de Coverley, *Printed for J. Harding,* n. d., 8vo. (827) *Quaritch,* £1 11s.

7696 Norden (John). Speculum Britanniae : Description of Middlesex and Hertfordshire, maps with coats-of-arms, old mor., g. e., D. Browne, etc., 1723, sm. 4to. (828) *Quaritch,* £2 2s.

7697 Norfolk and Norwich Naturalists' Society. Transactions, 1869-94, illustrations, 5 vol., hf. mor., t. e. g., *Norwich,* Fletcher and Son, 1874-94, 8vo. (829) *Porter,* £1 10s.

7698 Nowell (Alex.) Life, by R. Churton, port. and plates, mor., g. e., 2 pages of MS. notes by Wm. Beckford, *Oxford,* 1809, 8vo. (832) *Bain,* £1 2s.

7699 Nugent (Dr. T.) Travels through Germany, port., map and views, 2 vol., old English mor., g. e. (Lord Shelburne's copy, with ex-libris), E. and C. Dilly, 1768, 8vo. (833) *Quaritch,* £2 6s.

7700 Olina (G. P.) Uccelliera, overo Discorso della Natura e proprieta di diversi Uccelli e in particolare di que' che Cantano, engravings by Tempesta and Villamena, vell., *Roma,* A. Fei, 1622, sm. 4to. (835) *Edwards,* £2 4s.

7701 Ormerod (Geo.) History of Cheshire, orig. ed., port., map, etc., 3 vol., mor. ex., by Clarke and Bedford, with cancelled pages 99-108, in Northwich Hundred in vol. iii., Lackington, etc., 1819, folio (838) *Bain,* £12

7702 Ossian (Poems of), port. and plates, 2 vol., LARGE AND FINE PAPER, mor. ex., Lackington, etc., 1806, cr. 8vo.—Another ed., 2 vol., mor. ex., 12mo., Cadell and Davies, together 4 vol. (841) *Quaritch,* £5

7703 Ouseley (Sir Wm.) Travels in Various Countries, more particularly Persia, maps, plates, etc., 3 vol., mor. super ex. (C. Lewis), 6 pages of MS. notes by Wm. Beckford and 3 autograph letters of the author, Rodwell and Martin, 1819-22, 4to. (843) *Quaritch,* £9

7704 Outhier (M.) Journal d'un Voyage du Nord, LARGE PAPER, maps and plates, mor. ex., by C. Kalthoeber, with ticket, fine copy (Beckford), *Paris,* Piget et Durand, 1744, 4to. (844) *Edwards,* £1 16s.

7705 [Owen (Robert).] A New View of Society, or Essays (4) on the Principle of the Formation of the Human Character and the Application of this Principle to Practice, the 4 Essays in 1 vol., first eds., mor. ex., presentation copy, R. Taylor, etc., 1813-14, imp. 8vo. (846) *Leon*, £2 10s.

7706 Pananti (Signor). Narrative of a Residence in Algiers, ɔy Edw. Blaquiere, maps and col. view, cf. ex. (C. Lewis), 2 pages of MS. notes ɔy Wm. Beckford, H. Colɔurn, 1818, 4to. (853) *Ellis*, £1 7s.

7707 Park (Mungo). Travels in the Interior Districts of Africa and Journal of a Mission to Africa in 1805, port. and maps, 2 vol., cf. ex., Nicol and Murray, 1799-1815, 4to. (854) *Young*, £1 13s.

7708 Parkinson (John). Theatrum Botanicum, orig. ed., front. in compartments by W. Marshall and many hundred woodcuts, old russ., g. e. (Clarke), T. Cotes, 1640, folio (856) *Barrett*, £11

7709 Parkinson (Sydney). Journal of a Voyage to the South Seas in H.M.S. Endeavour, LARGE PAPER, port., maps and plates, old cf. gt., *Printed for Stanfield Parkinson*, 1773, imp. 4to. (857) *Edwards*, £1 16s.

7710 Parkman (Fr.) Historical Works [France and England in North America, etc.], 12 vol., 10 in hf. mor. and 2 cl., uncut, t. e. g., *Boston (Mass.)*, Little and Co. and Macmillan, 1887-92, 8vo. (858) *Grant*, £3 3s.

7711 Paterson (Lieut. Wm.) Narrative of Four Journeys into the Country of the Hottentots and Caffraria, fine paper, map and 17 col. plates, mor. ex., ɔy C. Kalthoeber, with ticket (the Beckford copy), J. Johnson, 1789, 4to. (860) *Quaritch*, £5 12s. 6d.

7712 Payne-Gallwey (Sir Ralph). Book of Duck Decoys, col. plates and woodcuts, cl., Van Voorst, 1886, sm. 4to. (863) *Quaritch*, 16s.

7713 Payne-Gallwey (Sir R.) The Crossɔow, Mediaeval and Modern, 220 illustrations, ɔuckram, t. e. g., uncut, Longmans, 1903, roy. 4to. (864) *Quaritch*, £2

7714 Peacock (T. Love). Various Works, viz., The Genius of the Thames, T. Hookham, 1810—Headlong Hall, *ib.*, 1816—Melincourt, 3 vol., *ib.*, 1817—Rhododaphne, *ib.*, 1818—Misfortunes of Elphin, *ib.*, 1829, all first eds., together 7 vol., uniform cf. gt., 8vo. (866) *Maggs*, £1 18s.

7715 Pennant (Thos.) Works, viz., Journey from Chester to London—Tour in Wales—Tour in Scotland—History of Whiteford and Holywell (with Literary Life)—Tour from Downing to Alston Moor and Alston Moor to Harrogate and Brimham Crags—London to Isle of Wight, orig. eds., ports. and plates, 10 vol., russ. gt., 1776-1801, 4to. (874) *Bull*, £3 3s.

7716 Pennant (T.) Tunstall (Marmaduke), of Wycliffe, Co. York, manuscript notes to Pennant's Natural History, with a printed memoir and port., 4 vol., hf. russ., by Rivière, *Sæc.* xviii., sm. 4to. (875) *Maggs*, £15 5s.

35—2

7717 Percy (Bp. Thos.) Folio Manuscript, ed. ɔy Hales and
Furnivall, on Whatman's riɔɔed paper, 250 copies printed,
4 vol. ɔound in 7, mor. super ex., ɔy Rivière, *Trübner, etc.,*
1867-68, extra demy 8vo. (877) *Quaritch,* £10 5s.
7718 Phipps (Capt. Constantine John). A Voyage towards the
North Pole, charts and proof plates, mor. ex. (Kalthoeber),
J. Nourse, 1774, 4to. (881) *Quaritch,* £3
7719 Pinkerton (John). Voyages and Travels, maps and plates, 17
vol., cf. gt., Longman, 1808-14, 4to. (885) *Edwards,* £6 5s.
7720 Pinto (F. Mendez). Voyage and Adventures in Ethiopia,
China, China Tartaria, etc., by H. Cogan (a few margins
wormed), large dated ex-liɔris of Sir T. Hanmer, 1707,
orig. cf., *J. Macock for H. Herringman,* 1663, sm. folio (888)
Ellis, £3
7721 Plinius. The Historie of the World, ɔy Philemon Holland,
first ed., 2 vol. in 1, orig. cf., centre gilt ornament and
initials " R.B.," A. Islip, 1601, folio (892)
Quaritch, £4 17s. 6d.
7722 Plinius. The Letters of Pliny the Younger (translated), by
John, Earl of Orrery, LARGE PAPER, 2 vol., mor. ex. (C.
Lewis), *Dublin,* G. Faulkner, 1751, 8vo. (893) *Thorp,* £1
7723 Plot (Dr. Rob.) Natural History of Oxfordshire, LARGE
PAPER, proof plates, orig. mor., floreate ornaments, g. e.
(Mearne), ex-libris of Ch. Chauncey (from the Beckford
sale), (reɔacked,) *Oxford,* 1677, folio (894)
J. Bumpus, £5 5s.
7724 Plot (Dr. R.) Natural History of Staffordshire, orig. ed.,
LARGE PAPER, armorial map and plates, with the slip of
arms usually wanted, MS. list of views and ports. of Plot ɔy
Harding (loose), old English mor., g. e., fine copy, *Oxford,*
at the Theatre, 1686, folio (895) *Somers,* £11
7725 Poiret (Aɔɔé). Voyage en Barɔarie, fine paper, 2 vol., old
mor., g. e., ɔy Kalthoeber, with ticket, *Paris,* J. B. F. Née,
1789, 8vo. (898) *Ellis,* £1 1s.
7726 Pope (Alex.) Works, complete, by Warɔurton (with a 6th
vol. containing pieces of Poetry and Collection of Letters),
ports. (3 added), 6 vol., old russ. gt. (Wodhull copy),
Bathurst, Johnson, etc., 1766-1807, 4to. (899) *Rimell,* £3 3s.
7727 Pope (A.) Works, first folio ed., old cf., *W. Bowyer for B.
Lintott,* 1717, folio (900) *Lewine,* 17s.
7728 Pope (A.) A Set of Illustrations to Du Roveray's Edition of
Pope's Works and Homer, 84 plates, including ports., after
Fuseti, Smirke, Stothard, etc., proofs, some in 2 states,
mor. ex. (C. Lewis), Du Roveray, 1804-5, roy. 8vo. (902)
J. Bumpus, £4 12s.
7729 Porter (Sir R. K.) Travels in Georgia, Persia, etc., fine
paper, engravings, the portrait of the Shah of Persia
duplicated, 2 vol., mor. ex. (C. Lewis), 6 pages of MS. notes
ɔy Wm. Beckford, Longman, 1821-2, 4to. (906)
Quaritch, £5 5s.
7730 Portlock (Capt. Nath.) and Dixon (Capt.) A Voyage round
the World, LARGE PAPER, port. and plates in two states

(one plate missing), the natural history subjects coloured and plain, mor. ex., by C. Kalthoeber, with ticket (Beckford), J. Stockdale, 1789, 4to. (908) *Quaritch*, £7 15s.

7731 Pottinger (Lieut. H.) Travels in Beloochistan and Scinde, map and col. front., 2 pages of MS. notes by Wm. Beckford, hf. mor., g. e., Longman, 1816, 4to. (910)
Maggs, £1 11s.

7732 Prayer. Pickering's Reprints of the Common Prayers of 1549, 1552, 1559, 1604 and 1637, and the Victoria Prayer-Book, 7 vol., vell. gilt, uncut, W. Pickering, 1844-45, folio (912) *Thorp*, £4 12s. 6d.

7733 Prayer (Book of Common), contemp. mor., floreate back, g. e. (John Ludford's ex-libris), *Cambridge*, J. Baskerville, 1762, imp. 8vo. (913) *Edwards*, £5 10s.

7734 Prescott (W. A.) Historical Works. Ferdinand and Isabella, Charles V., Philip II. and Conquest of Mexico and Peru, Library eds., ports. and maps, etc., 10 vol., cf. ex., by Rivière, Bentley and Routledge, 1851-57, 8vo. (915)
Edwards, £2 15s.

7735 Priest (Wm.) Travels in the United States of America, col. front. of "Peter Brown's Armes," by Rye and Smith, hf. mor., g. e., M.S. notes on flyleaf by Wm. Beckford, J. Johnson, 1802, 8vo. (918) *Grant*, £1 19s.

7736 Prior (Matthew). Poems on Several Occasions, LARGE PAPER, front. after L. Cheron, old English mor., g. e., J. Tonson, 1718, roy. folio (919) *Rimell*, 17s.

7737 Quakers. Croese (Gerard). General History of the Quakers, orig. ed., cf. ex., John Dunton, 1696, cr. 8vo. (927)
James, £1 10s.

7738 Quaritch (Bernard). General Catalogue, with Supplements, complete set on LARGE PAPER, 17. vol., hf. mor., t. e. g., 1887-98, sup. imp. 8vo. (931) *Quaritch*, £18 10s.

7739 Raleigh (Sir Walter). Works, by Oldys and Birch, 8 vol., cf. ex., *Oxford University Press*, 1829, 8vo. (934)
Quaritch, £5 12s. 6d.

7740 Ralfe (P. G.) Birds of the Isle of Man, photographic illustrations, *Edinb.*, 1905 — Saxby (H. L.) The Birds of Shetland, tinted plates, *ib.*, Maclachlan, 1874, 8vo. (935)
Grant, £1 9s.

7741 Rashleigh (Ph.) Specimens of British Minerals, specimens, col. and plain, old cf. ex., W. Bulmer, 1797-1802, 4to. (936)
Tregaskis, £3

7742 Rawlinson (Prof. G.) The Seven Great Oriental Monarchies —History of Ancient Egypt—Memoir of Sir Henry Creswicke Rawlinson, ports., maps and illustrations, together 10 vol., orig. cl., uncut, Murray and Longmans, 1862-98, 8vo. (939) *Quaritch*, £6 6s.

7743 Ray (John). Travels through the Low Countries, second ed., plates, 2 vol., old English mor., ornamental borders, g. e., fine copy, with Chas. Chauncey's ex-libris, *J. Hughes for O. Payne, etc.*, 1738, 8vo. (941) *Ellis*, £1 5s.

7744 Renefort (Souchu de). Relation du Premier Voyage de la

Compagnie des Indes Orientales, en l'Isle de Madagascar,
first ed., vell., *Paris*, Jean de la Tourette, 1668, sm. 8vo.
(943) *Ellis*, £1 10s.
7745 Repton (H. and J. H.) Theory and Practice of Landscape
Gardening, col. plates, some with moveaple slips, russ. ex.,
J. Bensley for J. Taylor, 1816, roy. 4to. (945)
 Bain, £10 15s.
7746 Reresby (Sir John). Travels and Memoirs, LARGE PAPER,
40 ports. and views, several additional ports. and plates
inserted, including 5 orig. drawings ɔy W. Beɔnes the
sculptor and John Smith, russ. ex. (C. Lewis), (the Beck-
ford copy), E. Jeffery, etc., 1813, imp. 8vo. (946) *Maggs*, £9
7747 Ritson (Jos.) A Select Collection of English Songs, first ed.,
front. and vignettes, 3 vol., mor. super ex., J. Johnson,
1783, cr. 8vo. (950) *Quaritch*, £4
7748 Ritson (Jos.) Roɔin Hood, a Collection of all the Ancient
Poems, Songs and Ballads now extant, first ed., woodcuts,
2 vol., mor. ex. (Roger Payne), T. Egerton, etc., 1795, cr.
8vo. (952) *Maggs*, £4 8s.
7749 Rivers (Lieut.-Gen. Pitt). Excavations of Cranborn Chase
—King John's House—The Development and Distriɔution
of Primitive Locks and Keys—Antique Works of Art
from Benin, illustrations, together 8 vol., cl., uncut, t. e. g.,
Privately printed, 1887-1900, 4to. (955)
 Quaritch, £4 7s. 6d.
7750 Roɔy (John). Traditions of Lancashire, ɔoth series, first
eds., LARGE PAPER, duplicate set of the plates, etchings
and proofs, 4 vol., cf. ex., Longman, 1829-31, imp. 8vo.
(962) *Maggs*, £2 2s.
7751 Rocque (J.) Topographical Survey of the County of Berks,
in 18 sheets, orig. ed., hf. bd., J. Dixwell, 1761, imp. folio
(965) *Edwards*, £3 17s. 6d.
7752 Roe (Fred). Ancient Coffers and Cupɔoards, 2 col. plates
and other illustrations, ɔuckram, gt., uncut, Methuen, 1902,
4to. (967) *R. D. Gardner*, £1 6s.
7753 Ronalds (Hugh). Pyrus Malus Brentfordiensis, 42 plates,
representing col. specimens, hf. mor. ex., Longman, 1831,
4to. (970) *Quaritch*, £3 3s.
7754 Roth (H. Ling). The Natives of Sarawak and British North
Borneo, 550 illustrations, 2 vol., cl., t. e. g., Truslove and
Hanson, 1896, sup. imp. 8vo. (971) *James*, 14s.
7755 Roxburgh (Wm.) Plants of the Coast of Coromandel, 298
col. plates and text, unbd., not suɔject to return, 1795-1819,
atlas folio (973) *Wheldon*, £7
7756 [Rutland (Duke of).] Journal of Three Years' Travels
through different Parts of Great Britain, LARGE PAPER, 25
copies printed, mor. ex., *Printed by J. Brettell*, 1805, imp.
8vo. (977) *Young*, £1 2s.
7757 Rye House Plot. A True Account and Declaration of the
Horrid Conspiracy against the late King, LARGE PAPER,
plan of Rye House, old mor., ornamental ɔack, g. e., *In the
Savoy, printed by Thos. Newcomb*, 1685, folio (980)
 Tregaskis, £2 8s.

7758 Salmon (N.) History and Antiquities of Essex, rùss. gt., N.
Bowyer, 1740, folio (985) *Bain, £3* 4s.
7759 Salmon (N.) History of Hertfordshire, map, old cf., Sutherland arms, *Printed* 1728, folio (986) *Bain, £1* 16s.
7760 Sanders (W. Bliss). Examples of Carved Oak Woodwork
(with the Sequel), 55 illustrations in photo-lithography, 2
vol., cl., B. Quaritch, 1883-94, folio (987) *Quaritch, £1* 14s.
7761 Sandwich (Edward Montagu, Earl of). Voyage round the
Mediterranean, with Memoirs by John Cooke, port., chart of
voyage and plates, old mor. gt., by Kalthoeber, with ticket,
Cadell and Davies, 1799, 4to. (988) *Ellis, £1* 14s.
7762 Saville-Kent (W.) The Great Barrier-Reef of Australia, map
and photographic illustrations, picture buckram, t. e. g.,
Allen and Co. (1893), roy. 4to. (990) *James, £1* 2s.
7763 Scheffer (John). History of Lapland, front., map and wood-
cuts, orig. cf., *At the Theater in Oxford*, 1674, sm. folio (991)
Young, £1 17s.
7764 Schliemann (Dr. Henry). Mycenae—Ilios—Troja—Tiryns,
illustrations, 4 vol., cl., uncut, t. e. g., J. Murray, 1875-86,
imp. 8vo. (993) *Rimell, £1* 18s.
7765 Seebohm (Henry). Coloured Figures of the Eggs of British
Birds, ed. by R. B. Sharpe, col. figures, cl. gt., *Sheffield*,
Pawson and Brailsford, 1896, imp. 8vo. (1003)
Weir, £1 10s.
7766 Seebohm (H.) History of British Birds, col. illustrations, 68
illustrations in the text and 68 plates of eggs in separate
vol., 4 vol., hf. mor., t. e. g., by Rivière, *Published for the
Author by R. H. Porter*, 1883, imp. 8vo. (1004)
Edwards, £4 18s.
7767 Seely (John B.) The Wonders of Elora, plates, duplicate set
on India paper, mor. ex. (C. Lewis), Whittaker, 1824, 8vo.
(1005) *Young, £1* 19s.
["The Duplicate Plates were presented to me by the
Author, W. B." [Note by Wm. Beckford on fly-leaf.]—
Catalogue.]
7768 Shaftesbury (Anthony, Earl of). Characteristics of Men,
Manners, Opinions, Times, fourth ed., LARGE PAPER, port.
and vignettes, mezzo. port. by Nattes (cut down) inserted, 3
vol., mor., g. e., by C. Kalthoeber, with ticket, *Printed in
the year* 1727, roy. 8vo. (1008) *J. Bumpus, £3* 18s.
7769 Shakespeare (Wm.) Plays, by Johnson, Steevens and Reed
(with Ayscough's Index), LARGE PAPER, 22 vol., cf., g. e.,
Nichols and Son and Tegg, 1813 (1827), roy. 8vo. (1009)
Maggs, £1 15s.
7770 Shelley (P. B.) Poetical Works, ed. by Mrs. Shelley, port., 4
vol., orig. cl., E. Moxon, 1839, post 8vo. (1018)
J. Bumpus, £3 3s.
7771 Shelvocke (Capt. Geo.) Voyage round the World, map and
plates, orig. cf., J. Senex, etc., 1726, 8vo. (1020)
Bain, £1 1s.
7772 Shirley (Jas.) Dramatic Works and Poems, by Wm. Gifford,
port., 6 vol., russ. super ex., J. Murray, 1833, 8vo. (1022)
Edwards, £5 10s.

7773 Sidney (Sir Philip). Miscellaneous Works, by Wm. Gray, mor. super ex., quotation from Cowper printed in gilt letters on upper cover, g. e. (C. Lewis), (E. V. Utterson's copy,) _Oxford_, Talboys, 1829, cr. 8vo. (1023) _Quaritch_, £2 4s.

7774 Simpson (F.) Ancient Baptismal Fonts, 40 plates ɔy R. Roɔerts, mor., g. e., ɔy Bauzonnet, S. Prowett, 1828, 4to. (1025) _Quaritch_, £1 5s.

7775 Singer (S. W.) Early English Poets, ed. by Singer, ports., 9 vol., hf. mor., t. e. g., uncut, _Chiswick, printed by C. Whittingham for R. Triphook_, 1817-24, cr. 8vo. (1026) _Quaritch_, £4 12s.

7776 Smith (Dr. Adam). Wealth of Nations, first ed., 2 vol., old cf. ex., Strahan and Cadell, 1776, 4to. (1031) _Bain_, £5

7777 Smith (Horace and Jas.) Rejected Addresses, first ed., cf. ex., ɔy W. Pratt, John Miller, 1812, sm. 8vo. (1032) _Bain_, £1 9s.

7778 Smith (J. T.) The Cries of London, port. of the author, 30 plates, cf. ex., ɔy Zaehnsdorf, J. B. Nichols, 1839, 4to. (1034) _Rimell_, £1 12s.

7779 Smith (J. T.) Antient Topography of London, col. front. and 33 plates, russ. ex., _Published by the Proprietor_, 1815, roy. 4to. (1037) _Young_, £2 8s.

7780 Smith (Capt. John). Works, ed. by Edw. Arɔer (limited Liɔrary ed.), 25 copies on Whatman paper, port., maps, etc., 2 vol., mor. ex., _E. Arber, Birmingham_, 1884, sm. 4to. (1038) _Young_, £3

7781 Smollett (Dr. T.) Works, by John Moore, port., 8 vol., mor. sup. ex., ɔy Rivière, Cadell and Davies, etc., 1797, 8vo. (1039) _Quaritch_, £9 17s. 6d.

7782 Snelgrave (Capt. Wm.) A New Account of Guinea and the Slave-Trade, map, old cf. gt., ɔy Kalthoeber, with ticket, _J. Wren, Fleet St._, 1734, 8vo. (1042) _Ellis_, £1 6s.

7783 Solon (L. M.) The Art of the Old English Potter, 50 plates, art cl., uncut, Bemrose and Sons, 1883, folio (1044) _Hiersemann_, £2 6s.

7784 Somerville (Wm.) The Chase, woodcuts by T. and J. Bewick, mor., g. e. (C. Lewis), W. Bulmer, 1802, sm. 4to. (1045) _J. Bumpus_, £2 11s.

7785 South Sea Buɔɔle. Acts of Parliament relating to the Mississippi Scheme, 22 separate acts ɔound in 1 vol., hf. cf., sm. folio (1046) _Edwards_, £1 10s.

7786 South Sea Buɔɔle. Inventories of the Lands, Tenements and Hereditaments, etc. of the Governors the Directors of the South Sea Company, 2 vol., old cf., J. Tonson, etc., 1721, folio (1047) _Hiersemann_, £1 17s.

7787 Sowerɔy (Jas.) English Botany, second ed., col. plates, 12 vol., cf. gt., m. e., 1832-46, 8vo. (1052) _Edwards_, £5 15s.

7788 Sparks (Jared). Life of Gouverneur Morris, port., 3 vol., cf. gt., _Boston_, Gray and Bowen, 1832, 8vo. (1053) _James_, £1 2s.

7789 Sparrman (Dr. And.) Voyage to the Cape of Good Hope, etc., trans. from the Swedish, map and plates, front. to vol. i.

in 2 states, 2 vol., mor., g. e. (Kalthoeber), Robinson, 1785,
4to. (1054) *Edwards,* £3 17s. 6d.

7790 Sprigge (Joshua). Anglia Rediviva, front., equestrian port.
by W. Marshall and folding plate of the Battle of Nazeby,
orig. cf., *R. W. for John Partridge,* 1647, sm. folio (1057)
Young, £4 18s.

7791 Statutes. In this Volume are Conteyned the Statutes from
the time of Kinge Henrye the thirde, unto the Firste Yeare
of the reygne of King Henry the VIII., black letter, orna-
mental initials, orig. cf. (no colophon), *Anno Domini,* 1577
(1061) *Young,* £2 2s.

7792 Stedman (Capt. J. G.) Narrative of a Five Years' Expedition
against the Revolted Negroes of Surinam, LARGE AND
FINE PAPER, maps and plates, engraved by Wm. Blake,
Bartolozzi, etc., several in 2 proof states, those of Natural
History subjects plain and col., 2 vol., mor. ex., by C.
Kalthoeber, with ticket, J. Johnson, 1796, 4to. (1063)
Quaritch, £10 15s.
[The Beckford copy. As several of the plates are inlaid,
the lot was sold not subject to return.—ED.]

7793 Steele and Addison. [The Tatler.] The Lucubrations of
Isaac Bickerstaff, Esq., first collected ed., LARGE AND
THICK PAPER, 4 vol., old mor., g. e. (Du Seuil), *Charles
Lillie, Perfumer, Beaufort Buildings, Strand, etc.,* 1710-11
(1064) *Ellis,* £4

7794 Stevenson (W. B.) Narrative of Twenty Years' Residence
in South America, front., 3 vol., hf. russ., g. e. (C. Lewis), 7
pages of MS. notes by W. Beckford, Hurst and Co., 1828—
James (Edwin). Account of an Expedition from Pittsburgh
to the Rocky Mountains, maps and plates, 3 vol., hf. russ.,
g. e. (C. Lewis), 1823, together 6 vol., 8vo. (1068)
Quaritch, £9 17s. 6d.

7795 Stow (John). Survey of London, sixth ed., folding maps and
views, 2 vol., old russ., g. e., W. Innys, etc., 1754-5, folio
(1069) *Edwards,* £4 17s. 6d.

7796 Strawberry Hill. A Description of the Villa of Horace
Walpole at Strawberry Hill, front. and plan, 100 copies
printed, mor., g. e., *Strawberry Hill, by Thos. Kirgate,*
1774, sm. 4to. (1070) *Maggs,* £3 5s.

7797 Strawberry Hill. Catalogue of Books, Poems, Tracts and
small detached Pieces, printed at Horace Walpole's private
press at Strawberry Hill, by Thos. Kirgate, 20 copies
printed, port. of Walpole, 2 ports. of Kirgate, 2 plates of
the printing house and farm, ex-libris of Strawberry Hill,
etc. inserted, mor., by Rivière, J. Barker, 1810, sm. 4to.
(1071) *Maggs,* £8 5s.

7798 Strawberry Hill. Catalogue of the Valuable and Curious
Collection by Mr. Thos. Kirgate, Printer to Horace Walpole
at Strawberry Hill, 6 copies printed, prices and purchasers'
names written, port. by Birrell, and an etched port. after
G. Edwards inserted, mor. super ex., 1810—Robins (Geo.)

Sale Catalogue of the Contents of Straw)erry Hill, illus-
trated with ports. and cuts, 1842, sm. 4to. (1072)

Maggs, £3 15s.

7799 Strutt (Jos.) Manners, Customs, etc. of the Inha)itants of
England, orig. ed., 157 tinted plates, 3 vol., russ., g. e., B.
White, 1775—W. Shropshire, 1776, 4to. (1074) *Bull,* £3 3s.

7800 Strutt (Jos.) Sports and Pastimes, new ed., Index)y Wm.
Hone, LARGE PAPER, title in)lue and woodcuts col.)y
hand, mor. ex., *Printed for W. Reeves, Westminster,* 1830,
imp. 8vo. (1076) *J. Bumpus,* £3 18s.

7801 Suckling (Sir John). Works, LARGE PAPER, old russ.
(Fountaine copy, with elephants), J. Tonson, 1709, imp. 8vo.
(1079) *Hatchard,* £2

7802 Swan (Rev. Chas.) Journal of a Voyage up the Mediterranean,
etc., 2 vol., cf. gt., 7 pages of MS. notes)y Wm. Beckford,
Rivington, 1826, 8vo. (1082) *Maggs,* 17s.

7803 Sweet (Rob.) The British War)lers, 6 col. plates, hf. mor.,
t. e. g., *Published for the Author,* 1823, imp. 8vo. (1083)

Quaritch, 12s.

7804 Swift (Dean). Works,)y Thos. Sheridan, 2 ports., 17 vol.,
old cf., gt., C. Bathurst, etc., 1784, 8vo. (1084)

Young, £3 5s.

7805 Swin)urne (H.) Travels through Spain, LARGE PAPER, map
and plates, russ. ex. (Beckford copy), P. Elmsly, 1779, 4to.
(1085) *James,* 16s.

7806 Symes (Major M.) An Account of an Em)assy to the
Kingdom of Ava, LARGE PAPER, map and proof plates,
mor. super ex. (the Beckford copy), G. and W. Nicol, etc.,
1800, roy. 4to. (1086) *Young,* £3

7807 Tales of Irish Life (by Whitty), 6 designs by G. Cruikshank,
with a duplicate set on India paper, 2 vol., hf. mor., g. e.
(C. Lewis), J. Ro)ins and Co., 1824, post 8vo. (1089)

Maggs, £3 14s.

7808 Tavernier (J. B.) Collections of Travels through Turkey into
Persia and the East Indies—Bernier (F.) History of the
Empire of the Mogul, maps and plates, 2 vol., old cf.,
1678-84, sm. folio (1090) *Quaritch,* £2 8s.

7809 Taylor (Bp. J.) and Cave (Dr. Wm.) Antiquitates Christianae,
ninth ed., port. and engravings, old mor., g. e., *J. Leake for
J. Meredith,* 1703, folio (1091) *James,* £1 2s.

7810 Thoms (W. J.) Early Prose Romances, orig. ed., 3 vol., hf.
mor., t. e. g., W. Pickering, 1828, post 8vo. (1098)

Quaritch, £1 10s.

7811 Thomson (Jas.) Works, by P. Murdoch, 2 ports. and plates
after Wale, etc., 4 extra plates inserted, including a coloured
print of "Spring" by Bartolozzi (cut close), "Celadon and
Amelia," after Angelica Kauffman)y Bartolozzi, and 2)y
W. W. White, 2 vol., old russ. ex. (Wodhull copy, with
arms), A. Millar, 1762, 4to. (1100) *E. Parsons,* £2 16s.

7812 Thores)y (Ralph). Ducatus Leodiensis, orig. ed., port., map
and views, the arms em)lazoned, modern proof port. of

author inserted, old mor., g. e. (Roger Payne), M. Atkins,
etc., 1715, sm. folio (1103) *Edwards*, £3 5s.

7813 Triggs (H. Inigo). Formal Gardens in England and Scot-
land, 72 plates and 53 reproduced from photos., in 3
portfolios, Batsford, 1902 (1111) *Hill*, £2 4s.

7814 Tudor Translations, ed. by W. E. Henley: Florio, Mon-
taigne — Shelton, Don Quixote — Hoby, Castiglione's
Courtier—Berners, Froissart, together 14 vol., cl., uncut,
D. Nutt, 1896-1903, 8vo. (1114) *Bain*, £12 5s.

7815 Tully (R.) Ten Years' Residence at Tripoli in Africa, map
and col. plates (3 pages of MS. notes by Wm. Beckford),
mor. ex., H. Colburn, 1816, 4to. (1115) *J. Bumpus*, £2 10s.

7816 Turner (J. H.) and Parker (J. H.) Domestic Architecture in
England, illustrations, 4 vol., mor. super ex., *Oxford*,
Parker, 1851-59, 8vo. (1117) *Young*, £3 12s. 6d.

7817 Turner (Wm.) The Ceramics of Swansea and Nantgarw,
col. plates, buckram, t. e. g., Bemrose, 1897, pott 4to. (1119)
E. Parsons, £2 2s.

7818 Tusser (Thos.) Five Hundred Points of Good Husbandry,
by Wm. Mavor, LARGE PAPER, front., mor. super ex., by
Leighton, Lackington and Co., 1812, sm. 4to. (1120)
Swann, £2

7819 Valentia (Geo. Viscount). Voyages and Travels to India,
Ceylon, the Red Sea, Abyssinia and Egypt, LARGE PAPER,
plates, proofs and a set of the etchings, mor. ex., W.
Millar, 1809, imp. 4to. (1124) *Edwards*, £4 17s. 6d.

7820 Verney Memoirs. Memoirs of the Verney Family, ports., 4
vol., cl., with arms, t. e. g., Longmans, 1892-9, 8vo. (1128)
Bain, £3 10s.

7821 Views. Prospects of the Great Canal of Venice, etc., after
Antonio Canale, views in Naples, Rome, Paris, Vienna,
Holland, etc., 142 views in 1 vol., old cf., *Published by John
Bowles in Cornhill*, n. d., obl. folio (1130) *Quaritch*, £5 5s.

7822 Views of Seats of the Nobility and Gentry, 64 engravings by
W. Watts, proofs, mor. ex. (C. Lewis), *W. Watts, Chelsea*,
1779, obl. 4to. (1131) *Quaritch*, £1 15s.

7823 Views of Seats of the Nobility and Gentry, engraved by W.-
Watts, 84 plates, old cf., *W. Watts, Chelsea*, 1779, obl. 4to.
(1134) *Quaritch*, 14s.

7824 Views of Seats of the Nobility and Gentry in Great Britain
and Wales, 63 engravings by W. Angus, with descriptions,
some proofs before numbers, mor. ex. (C. Lewis), *W.
Angus, Islington*, 1787, obl. 4to. (1132) *Quaritch*, £2 6s.

7825 Views of the principal Seats of the Nobility and Gentry in
England and Wales, 109 plates (one wanted), mor. ex.,
Harrison and Co., n. d., obl. 4to. (1133) *Quaritch*, £2

7826 Vitruvius Britannicus, or the British Architect, with the New
Vitruvius Britannicus by Geo. Richardson, plates, 6 vol.,
mor. ex., 1717-1810, imp. folio (1136) *Quaritch*, £13 15s.

7827 Waddington (Geo.) Journal of a Visit to some Parts of
Ethiopia, maps, plans and plates, russ. ex., 2 pages of MS.
notes by William Beckford, J. Murray, 1822, 4to. (1139)
Edwards, £1 13s.

7828 Wallace (A. Russell). Narrative of Travels on the Amazon and Rio Negro, map and illustrations, Reeve and Co., 1853 —Tropical Nature and other Essays, Macmillan, 1878— Island Life, charts, *ib.*, 1880, together 3 vol., 8vo. (1142)
Thorp, £2 5s.

7829 Waller (Edm.) Poems, eighth ed., port. of the author and ports. of ladies (2 extra inserted), cf. ex., J. Tonson, 1711, 8vo. (1143)
Maggs, £1 8s.

7830 Walpole (Horace). Works, viz., Reigns of George II. and III. — Correspondence — Letters to Mann, Mason and Orrery, ports., 21 vol., mor. super ex., Colourn and Bentley, 1843-51, 8vo. (1144)
J. Bumpus, £27 10s.

7831 Walpole (H.) A Description of the Villa of Mr. Horace Walpole at Strawberry Hill, LARGE PAPER, port., front. and 27 proof views and plans inserted, hf. mor., t. e. g., *Strawberry Hill*, Thos. Kirgate, 1784, 4to. (1145) *Maggs, £3 5s.*

7832 Walpole (H.) A Description of the Villa of Horace Walpole at Strawberry Hill, LARGE PAPER, front., vignette, 22 proof plates and ports. inserted, orig. blue wrapper, uncut, *Strawberry Hill*, T. Kirgate, 1774, 4to. (1146) *Maggs, £1 1s.*

7833 Walpole (H.) The Mysterious Mother, a Tragedy, copy in MS.—Abstract of the Will of Horace Walpole, 1793— Damer (Mrs.) MS. Catalogue of the Books, Poems, Tracts and Detached Pieces printed at Strawberry Hill—Sixty Detached Pieces, *Printed at the Private Press at Strawberry Hill* (1147)
Tregaskis, £25 10s.

7834 Walpole (H.) Fugitive Pieces in Verse and Prose, first ed., 200 copies printed, vignette of Strawberry Hill on title, old mor., gilt ornaments, g. e., by Kalthoeber, with ticket, *Printed at Strawberry Hill*, 1758, 8vo. (1149)
Maggs, £3 12s.

7835 Walton (Izaak). Lives of Donne, Wotton, Hooker and Sanderson, Major's ed., LARGE PAPER, proof plates, mor. ex., by Hering, J. Magor, 1825, 8vo. (1151) *Young, £2 10s.*

7836 Walton and Cotton. The Complete Angler, India proof plates by Stothard and Inskipp, 2 vol., mor. super ex., W. Pickering, 1836, sup. imp. 8vo. (1152) *Edwards, £10 15s.*

7837 Warourton (Eliot). Memoirs of Prince Rupert and the Cavaliers, ports., 3 vol., orig. red cl., 1849, 8vo. (1155)
Hatchard, £1 10s.

7838 Warourton (R. E. E.) Hunting Songs and Ballads, illustrated, roxourghe, uncut, W. Pickering, 1846, sm. 4to. (1158)
J. Bumpus, £2 10s.

7839 Ward (Rowland). Horn Measurements and Weights of the Great Game of the World, woodcuts, cl., R. Ward, 1892, roy. 8vo. (1160)
Gladstone, 15s.

7840 Ware (Isaac). Complete Body of Architecture, plates, old russ. ex., J. Rivington, etc., 1768, folio (1162)
Quaritch, £2 2s.

7841 Ware (Jas.) The Historie of Ireland, signature of the Earl of Anglesey on title, March 9, 1670, MS. notes in margins, orig. cf., *Dublin, Societie of Stationers*, 1705, folio (1163)
Quaritch, £5

7842 Waring (E. Scott). Tour to Sheeraz by the Route of Kazroon and Feerozabad, LARGE PAPER, front., hf. mor. gt., t. e. g., 2 pages of MS. notes by Wm. Beckford, Cadell and Davies, 1807, 4to. (1164) *Edwards*, £1 9s.

7843 Warner (Rich.) Walks through Wales and the Western Counties of England—Excursions from Bath—Tour through the Northern Counties of England and Borders of Scotland—Tour through Cornwall, plates, together 7 vol., cf. ex. (the last-named hf. cf.), by C. Kalthoeber, mostly with MS. notes by Wm. Beckford, 1798-1809, 8vo. (1166)
Edwards, £2 18s.

7844 Watkins (W. Thompson). Roman Lancashire, map and illustrations, *Liverpool*, 1883, 8vo. (1170) *Walford*, 16s.

7845 Watson (P. W.) Dendrologia Britannica, 172 col. plates, 2 vol., mor. super ex., *Printed for the Author*, 1825, roy. 8vo. (1171) *Bain*, £5 7s. 6d.

7846 Weld (Isaac). Travels through North America and Canada, maps, charts and plates, mor. ex., by C. Kalthoeber, MS. notes by Wm. Beckford, J. Stockdale, 1799, 4to. (1174)
Quaritch, £3 7s. 6d.

7847 Whitaker (T. D.) History and Antiquities of Craven, second ed., LARGE PAPER, maps and plates, plain and col., with the plates from the first ed. inserted, russ. ex. (C. Lewis) (from the Beckford sale), J. Nichols and Son, 1812, folio (1179) *Edwards*, £5 10s.

7848 Whitaker (T. D.) History of Whalley, first ed., map, plates and pedigrees, russ. ex. (cracked), (Beckford copy), Blackburn, Hemingway and Crook, 1801, 4to. (1180)
Blackburn, £1 1s.

7849 White (Rev. G.) Works in Natural History, containing the Natural History of Selborne, etc., with a Calendar and Observations by W. Markwick, first collected ed., front. and plates (2 col.), 2 vol., hf. mor. ex., J. White, 1802, 8vo. (1181) *Hatchard*, £1 6s.

7850 White (Rev. G.) Natural History of Selborne, first ed., folding view and plates, mor. super ex., B. White and Son, 1789, 4to. (1182) *J. Bumpus*, £20

7851 White (John). Journal of a Voyage to New South Wales, fine paper, 65 col. plates, mor. ex., by Kalthoeber (Beckford), J. Debrett, 1790, 4to. (1186) *J. Bumpus*, £4 6s.

7852 White (Capt. W.) Journal of a Voyage in the Lion extra Indiaman from Madras to Colombo, plate, hf. mor., t. e. g., MS. notes by Wm. Beckford, J. Stockdale, 1800, 4to. (1187)
Edwards, £1 2s.

7853 Whitehead (John). Exploration of Mount Kina Balu, North Borneo, col. plates and illustrations, 500 copies printed, cl. gt., Gurney and Jackson, 1893, folio (1188) *Hiersemann*, 16s.

7854 Whymper (Edw.) Scrambles amongst the Alps, maps and illustrations, cl., uncut, J. Murray, 1871, roy. 8vo. (1191)
Askew, 12s.

7855 Whymper (Edw.) Travels amongst the Great Andes, with

Supplementary Appendix and Maps, illustrations, 3 vol.,
hf. mor., t. e. g., uncut, J. Murray, 1892-97, roy. 8vo. (1192)
Askew, 14s.
7856 Wilkes (Benj.) English Moths and Butterflies, 120 copper-
plate engravings, col., russ. ex., B. White (1773), 4to. (1194)
Edwards, £1 18s.
7857 Wilkes (John). The North Briton, No. i.-xlvi. (complete), with
Notes and Continuation, 3 vol., hf. bd., uncut, W. Bingley,
1769-(70), folio (1195) *Young*, £1 12s.
7858 Wilkinson (Sir Gardner). Manners and Customs of the
Ancient Egyptians, third ed., 600 plates and woodcuts,
5 vol., mor. ex., J. Murray, 1847, 8vo. (1197) *James*, £1 19s.
7859 Willement (Thos.) Regal Heraldry. The Armorial Insignia
of the Kings and Queens of England, emblazoned arms
and other engravings, cf. ex. (C. Lewis), 1821, 4to. (1198)
Harding, £1 5s.
7860 Willis (Rob.) Architectural History of the University of
Cambridge and the Colleges of Cambridge and Eton,
plans, 4 vol., cl. bds., uncut, *Cambridge University Press*,
1886, sup. imp. 8vo. (1200) *Hill*, £3
7861 Willughby (Fr.) Ornithology in three Books, by John Ray,
78 engravings, russ., g. e., *A. C. for John Martyn*, 1678,
folio (1201) *Maggs*, £3 3s.
7862 Wilson (Capt. Jas.) Missionary Voyage to the Southern
Pacific, fine paper, maps, charts and proof views, mor. ex.,
by Kalthoeber, with ticket, MS. notes by Wm. Beckford,
T. Chapman, 1799, 4to. (1205) *Edwards*, £2 4s.
7863 Wingfield. Muniments of the Ancient Saxon Family of
Wingfield, illustrations, cl., uncut, t. e. g., *Privately printed*,
1894, folio (1210) *Quaritch*, £2 10s.
7864 Wolley (John) and Newton (Alfred). Ootheca Wolleyana,
port., col. plates and views, 2 vol., cl., t. e. g. (*Privately
printed, sold by R. H. Porter*), 1864-1907, imp. 8vo. (1214)
Quaritch, £5
7865 Woodville (Dr. Wm.) Medical Botany, col. plates, port.
inserted, 5 vol., russ. gt., W. Phillips and J. Bohn, 1832,
sm. 4to. (1220) *Young*, £1 16s.
7866 Woodward (Rev. John). Treatise on Heraldry, emblazoned
armorial plates, 2 vol., cl. gt., uncut, t. e. g., *Edinb.*,
Johnston, 1892, 8vo. (1221) *Harding*, £2 16s.
7867 Woolhope Naturalists' Field Club. Transactions, 1856-1902,
col. and other plates, 18 vol., cl., *Hereford*, 1857-1903 (1222)
Hitchman, £2 4s.
7868 Wooster (David). Alpine Plants, 88 col. plates, 2 vol., hf.
mor. gt., G. Bell, 1872-4, sup. imp. 8vo. (1223)
J. Bumpus, 18s.
7869 Wroath (Rt. Hon. Lady Mary). The Countesse of Mont-
gomeries Uranja, engraved title by S. Pass (margins cut
close), russ. ex., by F. Bedford, John Marriott and John
Grismand, 1621, sm. folio (1227) *Quaritch*, £6
 [A curious pastoral romance, interspersed with poetry,
written by the daughter of the Earl of Leicester and niece

of Sir P. Sidney, in imitation of her uncle's "Countess of
Pemjroke's Arcadia." At the end, 48 pages of sonnets and
songs, entitled "Pamphilia to Amphilanthus." The romance
is incomplete, ending with the word "and," but is all
printed.—*Catalogue.*]

7870 Wynne (J. H.) History of the British Empire in America,
map, 2 vol., old russ. gt., ex-lijris of John Mytton, W.
Richardson, etc., 1770, 8vo. (1229) *H. Stevens,* £2 6s.

7871 Yarrell (Wm.) History of British Birds, LARGEST PAPER
(with supplements), Van Voorst, 1843-56 — History of
British Fishes, LARGEST PAPER (with supplements), 3 vol.,
ib., 1836-60—Bell (Thos.) History of British Quadrupeds,
LARGEST PAPER, *ib.*, 1837, woodcuts, together 6 vol., hf.
mor. super ex., 1837-60, sup. imp. 8vo. (1230) *Swann,* £15

7872 Yarrell (Wm.) British Birds, fourth ed., woodcuts, 4 vol., cl.,
Van Voorst, 1871-85, 8vo. (1232) *Edwards,* £1 11s.

7873 Young (Arthur). Northern, Southern and Eastern Tours,
Farmer's Letters and Rural Economy, plates, 12 vol., old
cf. gt., W. Strahan, etc., 1771-73, 8vo. (1234) *Young,* £5

7874 Zurla (Ao. D. Placido). Di Marco Polo e degli altri Viaggia-
tori Veneziani piu illustri, 4 maps, 2 vol., hf. vell., G. G.
Fuchs, 1818, 4to. (1238) *H. Stevens,* 8s.

[JUNE 1ST AND 2ND, 1910.]

PUTTICK & SIMPSON.

A MISCELLANEOUS COLLECTION.

(No. of Lots, 603 ; amount realised, £895 19s. 6d.)

7875 Æsop's Fajles, with Life of the Author, 112 plates, 2 vol.
(jinding jroken), Stockdale, 1793, 8vo. (384)
F. Edwards, £2 12s. 6d.

7876 Alken (H.) Sporting Scrap-Book, orig. issue, 50 col. plates,
no title, orig. hf. mor., with lajel (1824), 4to. (257) *Payne,* £7

7877 America. Bill for making more effectual Provision for the
Government of Quejec, unbd., 1774, folio (571)
H. Stevens, £1 2s.

7878 [Apperley (C. J.)] Life of John Mytton, col. etchings jy
Alken and Rawlins, jrown pictorial cl., g. e., Ackermann,
1851, 8vo. (192) *Payne,* £5.17s. 6d.

7879 Artist's Repository and Drawing Magazine, plates in jlack
and red, 4 vol., cf. gt., 1785, 8vo. (114) *Adams,* £1 10s.

7880 Aspin (J.) Naval and Military Exploits, 34 col. plates, orig.
cf. (title and some plates soiled), 1820, 8vo. (197)
Wingfield, £3

7881 Baxter (G.) Pictorial Al)um, or Ca)inet of Paintings for the year 1831, 11 designs in oil colours, orig. mor., g. e., 1837, 4to. (568) *Allan*, £3 15s.

7882 Bi)le (Holy). Conteyning the Olde Testament and the Newe (Bishops' Version, 15th ed.), black letter, title within woodcut)orders, cf., Barker, 1588, folio (582) *Cogswell*, £2

7883 Book-Illuminations of the Middle Ages. Blake's Drawings to Milton's Comus, etc., facsimiles in gold and colours, mor. ex., orig. covers preserved, Quaritch, 1889, 4to. (509) *Quaritch*, £5 15s.

7884 Bright (T.) A Treatise of Melancholy, hf. cf., 1613, 12mo. (342) *Pickering*, £2 14s.

7885 Brontë (Charlotte). Shirley, first ed., 3 vol., orig. cl., 1849, 8vo. (207) *Shepherd*, £1 10s.

7886 Browning (Ro)ert). Paracelsus, first ed., bds., uncut (no)ack), 1835, 8vo. (193) *Zaehnsdorf*, £4 5s.

7887 Burton (Capt. Sir R. F.) Ara)ian Nights, with the Supplemental Nights, 16 vol., hf. mor., g. t., port. inserted with autograph, *Benares, printed by the Kamashastra Soc. for private subscribers*, 1885-6 (378) *Quaritch*, £24

7888 Certaine Sermons appoynted)y the Quenes Maiesty to be declared and read by al Parsons, Vicars and Curates everi Sunday. With the Second Tome of Homilies to be read in euery Parishe Church, black letter, in 1 vol., contemp. cf., Richard Jugge and John Cawood, 1563, 4to. (482) *Bull*, £2

7889 Chaucer (G.) Workes (wanted title, had the separate titles to the Caunterburie Tales and the Romaunt of the Rose), black letter, Jhon Kyngston, cf., w. a. f., 1561, folio (580) *Pearson*, £6 5s.

7890 Chaucer (G.) Canter)ury Tales,)y Tyrwhitt, 5 vol., bds., uncut, 1830, 8vo. (145) *Allison*, £3 3s.

7891 Com)e (W.) Johnny Quae Genus, col. etchings)y Rowlandson, bds., uncut, 1822, 8vo. (189) *J. Bumpus*, £4 17s. 6d.

7892 Com)e (W.) Tour of Dr. Syntax in Search of the Picturesque, col. etchings)y Rowlandson, hf. cf., 1812, 8vo. (187) *Parsons*, £1 5s.

7893 Coronation of Queen Victoria, col. panorama of the procession (20 feet long), folding in cl. case, Tyas (1837), (438) *Andrews*, £1 4s.

7894 Couts (J.) Practical Guide for the Tailor's Cutting-Room, col. and other plates of male attire (some)y H. K. Browne), hf. cf. (1840), 4to. (458) *Maggs*, £1

7895 Daniell (T. and W.) Picturesque Voyage to India, 50 col. plates on card)oard in imitation of water-colour drawings ()roken)inding), 1810-16, folio (589) *Hornstein*, £2 7s. 6d.

7896 Dickens (Charles). The Uncommercial Traveller, first ed., cl., 1861, 8vo. (453) *Spencer*, £1 15s.

7897 Egan (Pierce). Life in London, first ed., 36 full-page etchings by G. and R. Cruikshank, cf. ex., 1821, 8vo. (190) *J. Bumpus*, £4

7898 Foreign Field Sports, 100 col. plates from drawings)y

Howitt, Atkinson, etc., including the New South Wales
Supplement, publishers' hf. mor., 1814, 4to. (523)
Andrews, £4

7899 Fox (George). Journal or Historical Account of the Life
and Travels of that Ancient Servant of Christ, first ed.
(with the errors of pagination and uncancelled page of
Ellen Fretwell's narrative), orig. cf., 1694, folio (291)
Clark, £2 2s.

7900 Free-Masons' Magazine, ports. and plates, 10 vol., contemp.
hf. cf., 1793-98, 8vo. (149)　　*Pickering, £4*

7901 Froude (J. A.) History of England, Library ed., 12 vol., hf.
cf., 1867-70, 8vo. (135)　　*E. George, £2 15s.*

7902 Gardiner (S. R.) History of the Commonwealth and Pro-
tectorate, 3 vol., hf. mor., 1894, 8vo. (134)　　*E. George, £2*

7903 Gibbon (E.) Decline and Fall of the Roman Empire, port.,
8 vol., cf., 1828, 8vo. (137)　　*J. Bumpus, £1 15s.*

7904 Gibbons (T.) The Hidden Life of a Christian, the poet
Cowper's copy, with autograph on title, 1756, 8vo. (447A)
Hornstein, £3

7905 [Goldsmith (Oliver).] The Vicar of Wakefield, first American
ed., 2 vol. in 1, sheep, *Philadelphia*, 1772, 8vo. (449)
Pearson, £3

7906 Gould (John). The Mammals of Australia, col. plates, 3 vol.,
mor. ex., 1863, folio (283)　　*F. Edwards, £20 10s.*

7907 Hamerton (P. G.) Etching and Etchers, first ed., orig. hf.
mor., 1868, 8vo. (455)　　*Maggs, £4 12s. 6d.*

7908 Hamerton (P. G.) The Portfolio Monographs, illustrations,
7 vol., cl., g. t., 1894-98, 8vo. (17)　　*Adams, £1 4s.*

7909 Hooker (Thos.) A Survey of the Summe of Church Dis-
cipline, old cf., 1648, 4to. (533)　　*Leon, £1 5s.*

7910 Hughes-Hughes (A.) Catalogue of Manuscript Music in the
British Museum, 3 vol., cl., 1906-9, 8vo. (170)
Reeves, £1 17s. 6d.

7911 Humphreys (H. N.) Illuminated Illustrations of Froissart,
2 vol., orig. hf. mor., g.t., Smith, 1844-45, 4to. (508) *Hill, £8*

7912 Jefferys (T.) West Indian Atlas and Description, engraved
title and 88 plates, contemp. hf. cf., 1807, folio (572)
F. Edwards, £1 6s.

7913 Keats (John). Lamia, Isabella, The Eve of St. Agnes and
other Poems, first ed., contemp. cf., tall copy with hf. title,
1820, 8vo. (442)　　*Hornstein, £15 15s.*

7914 La Fontaine (J. de). Fables, avec figures gravées par Simon
de Coigny, 6 vol., mor. ex., *Paris*, 1796, 8vo. (30)
Hatchard, £4 7s. 6d.

7915 Lamb (Charles). Specimens of English Dramatic Poets, first
ed., hf. cf., 1808, 8vo. (208)　　*F. Edwards, £1 4s.*

7916 Lecky (W. E. H.) History of England in the Eighteenth
Century, library ed., 8 vol., hf. mor., g. t., 1878, 8vo. (130)
Hill, £4 5s.

7917 Lecky (W. E. H.) European Morals, 2 vol., hf. mor., g. t.,
1869, 8vo. (131)　　*Jackson, £1 3s.*

7918 Lecky (W. E. H.) Rationalism in Europe, 2 vol., hf. mor., g. t., 1866, 8vo. (132) *Jackson*, £1 16s.
7919 Lecky (W. E. H.) Democracy and Liberty, 2 vol., hf. mor., g. t., 1876, 8vo. (133) *Hill*, £1 10s.
7920 Leech (John). Follies of the Year, col. etchings, with notes by Shirley Brooks, publisher's hf. mor., 1844-64, oblong 4to. (258) *Payne*, £1 10s.
7921 Lewis (M. G.) Tales of Wonder, LARGE PAPER, 2 vol., mor. ex., Bulmer, 1801, 8vo. (23) *J. Bumpus*, £1 15s.
7922 Lloyd (Charles). The Duke D'Ormond, first ed., presentation copy, with inscription, bds., uncut, 1822, 8vo. (209) *Hornstein*, £1 10s.
7923 Loskiel (G. H.) History of the Mission of the United Brethren among the Indians in North America, map, cf., 1794, 8vo. (397) *F. Edwards*, £1 3s.
7924 Madeira, History of, with 27 col. engravings, hf. cf., Ackermann, 1821, 8vo. (456) *Spencer*, £2 8s.
7925 Mayo (J. H.) Medals and Decorations of the British Army and Navy, col. plates and illustrations, 2 vol., cl., g. t., 1897, 8vo. (66) *Adams*, £1 1s.
7926 Modern London, being the History and Present State of the British Metropolis, map, plates and the series of 31 col. "Cries" (old colouring), cf., 1804, 4to. (529) *F. Edwards*, £2 2s.
7927 Newcastle (Comte de). Methode et Invention Nouvelle de Dresser les Chevaux, engravings of horsemanship by Diepenbeke, mor. (rubbed), 1757, folio (573) *Hornstein*, £2
7928 Peaks, Passes and Glaciers, ed. by John Ball and E. S. Kennedy, 3 vol., cl., 1859-62, 8vo. (454) *F. Edwards*, £3 2s. 6d.
7929 Pepys (Samuel). Diary, by Lord Braybrooke, ed. by Wheatley, with Index volume and Supplement, "Pepysiana," together 10 vol., cl., 1893-99, 8vo. (143) *Quaritch*, £5 15s.
7930 Pepys (S.) Memoires relating to the State of the Royal Navy, first ed., port. by White, contemp. cf., 1690, 8vo. (448) *Shepherd*, £4 2s. 6d.
7931 Real Life in London, first ed., col. prints by Alken, Rowlandson, etc., 2 vol., cf. ex., 1821-1822, 8vo. (191) *Payne*, £4
7932 Reid (G. W.) Descriptive Catalogue of the Works of George Cruikshank, 313 illustrations, 135 copies printed, 3 vol., rox., g. t., 1871, 4to. (464) *Quaritch*, £9 10s.
7933 Rowlandson (T.) Tour of Dr. Syntax in Search of the Picturesque, col. plates, cf., 1815, 8vo. (31) *Davis*, £1 4s.
7934 Ruding (R.) Annals of the Coinage of Great Britain and its Dependencies, plates, 3 vol., hf. cf., 1840, 4to. (461) *Hornstein*, £2
7935 Ruskin (John), Works of, library ed., ed. by Cook and Wedderburn, 38 vol., vol. i. to xxxvii. cl. (vol. xxxviii. will be delivered when published), 1903-9, 8vo. (377) *B. F. Stevens*, £22

7936 Scott (Sir Walter). Waverley Novels, by Andrew Lang, Border ed., etchings, 48 vol., cl., g. t., 1893-94, 8vo. (375)
Times, £7 10s.

7937 Shakespeare (W.) Plays and Poems, Valpy's pictorial ed., 15 vol., Valpy, 1832-33, 8vo. (57) *F. Edwards*, £2 2s.

7938 Smith (Adam). Wealth of Nations, first ed., 2 vol., cf. gt., 1776, 4to. (247) *Maggs*, £2 12s.

7939 Smith (Captaine John). The Generall Historie of Virginia, New England and the Summer Isles, engraved title, folding plate, map of the Summer Isles and map of New England (defective), 1632—Also the true Travels, Adventures and Observations of Captaine John Smith, with the folding plate, 1630, contemp. cf., not suject to return, 1632-30, folio (281) *Sabin*, £43

7940 Sparrman (Dr. A.) Voyage to the Cape of Good Hope, plates, 2 vol., cf., 1786, 4to. (249) *Maggs*, £1 9s.

7941 Stevenson (R. L.) A Child's Garden of Verses, first ed., orig. cl., 1885, 8vo. (451) *Shepherd*, £3 2s. 6d.

7942 Sturt (John). Common Prayer and Sacraments, engraved throughout on 166 pages, within ornamental border, old mor., g. e., 1717, 8vo. (173) *F. Edwards*, £1 3s.

7943 [Surtees (R. S.)] Handley-Cross, or Mr. Jorrocks' Hunt, first ed., col. etchings by John Leech, mor. ex., 1854, 8vo. (184)
Parsons, £4 5s.

7944 [Surtees (R. S.)] Mr. Sponge's Sporting Tour, first ed., etchings by John Leech, cf. ex., 1853, 8vo. (185) *Parsons*, £5

7945 [Surtees (R. S.)] "Ask Mamma," col. etchings by John Leech, cf. ex., 1858, 8vo. (186) *Parsons*, £3 10s.

7946 [Surtees (R. S.)] Plain or Ringlets, first ed., col. etchings by John Leech, orig. pictorial cl., uncut, 1860, 8vo. (196)
Spencer, £4 10s.

7947 Swinourne (A. C.) Atalanta in Calydon, first ed., white cl., uncut, 1865, 4to. (210) *Maggs*, £6 15s.

7948 Tennyson (A. Lord). Five Lines of the Original MS. of "The Princess," enclosed in a letter from Palgrave to Mrs. Fox (551) *Zaehnsdorf*, £16

7949 Thackeray (W. M.) Vanity Fair, parts i., ii., iii. and vi., in the orig. yellow wrappers, correctly numbered and dated, 1847, 8vo. (444) *Spencer*, £10

7950 Thackeray (W. M.) Flore et Zephyr, Ballet Mythologique par Theophile Wagstaffe, 8 tinted plates (no title) in sunk mounts, mor. guard-book, 1836, folio (591) *Hornstein*, £37

7951 Tod (Lt.-Col. Jas.) Annals and Antiquities of Rajast'han, plates, 2 vol., cf. (broken), 1829, 4to. (230) *Bumpus*, £10

7952 Turner (J. M. W.) Liber Studiorum, reproduced in autotype, mor. ex., 1871, 4to. (471) *Hill*, £1 18s.

7953 Walton and Cotton. The Complete Angler, plates, LARGE PAPER, cf. ex., 1808, 8vo. (99) *Hatchard*, £1 10s.

7954 Wordsworth (W.) Poetical Works, port., 7 vol., cf. ex., Moxon, 1846, 8vo. (118) *Maggs*, £2

36—2

SOTHEBY, WILKINSON & HODGE.

The Library of Mr. Elliot Stock.

(No. of Lots, 301 ; amount realised, £639 12s.)

7955 Austin (S.) Austins Urania, or The Heavenly Muse, a Poem, first ed., hf. cf., *F. K. for R. Allot and H. Seile*, 1629, 8vo. (4) *Tregaskis, £2* 5s.

7956 Bacon (Sir F.) The Twoo Bookes of the proficience and advancement of Learning, first ed. (wormed and a few headlines shaved), cf., H. Tomes, 1605, 4to. (206) *Maggs, £12* 10s.

7957 Bacon (Sir F.) Charge, touching Duells, 1614—Considerations touching a Warre with Spaine, 1629—Learned Reading upon the Statute of Uses, 1642—His Apologie in certaine Imputations concerning the late Earle of Essex, 1642—Letter of Advice written to the Duke of Buckingham, autograph signature of Ambrose Thelwall on title, 1661—Defoe (D.) Francis, Lord Bacon, or the Case of Private and National Corruption and Bribery impartially considered, 1721, etc., in 1 vol., cf.—Original Letters and Memoirs, published by R. Stephens, port., cf., 1736, together 2 vol., 4to. (207) *Smedley, £6*

7958 Bacon (Sir F.) Instauratio Magna (Novum Organum), first ed., engraved title by S. Pass, old cf., J. Bill, 1620, folio (279) *Maggs, £17* 10s.

7959 Bacon (Sir F.) Sylva Sylvarum, port. and front., orig. cf., 1631, folio (280) *Maggs, £1* 2s.

7960 [Barham (Rev. R. H.)] Ingoldsby Legends, first ed., port. and plates by G. Cruikshank and J. Leech, 3 vol., hf. mor., t. e. g., others uncut, Bentley, 1840-42-47, 8vo. (7) *Bayle, £11* 5s.

7961 Beaumont (F.) and Fletcher (J.) Comedies and Tragedies, first ed., port. by W. Marshall, 1647—The Wild Goose-chase, 1652 [? leaf of licence missing.—ED.], in 1 vol., old cf. (rebacked), folio (281) *Hornstein, £26* 10s.

7962 Birrell (A.) Essays about Men, Women and Books, LARGE PAPER, 8 autograph letters of the author inserted, 1894, 4to. (212) *Dobell, £1* 1s.

7963 Birrell (A.) Essays about Men, Women and Books, the final proofs, with author's corrections, and 2 autograph letters inserted, rox., 1894 (12) *James, £1* 18s.

7964 Birrell (A.) Res Judicatae, author's proofs, with many alterations and corrections, 3 autograph letters inserted, rox., 1892 (11) *James, £1* 6s.

7965 Birrell (A.) Obiter Dicta, first ed., with copies in MS. of two sets of verses, not published in the book, 1884—The same,

fifth ed., with verse, "The Author to his Book," on an autograph letter from the author, 1885—The same, Second Series, the author's revised proofs, with autograph letter and notes inserted, 1887—The same, proof sheets with corrections, 3 autograph letters of author and caricature plate inserted, together 4 vol., 8vo. (13) *Maggs*, £6 2s. 6d.

7966 Blades (Wm.) The Enemies of Books, first ed., plates, autograph letter of author inserted, 1880, 8vo. (14) *James*, £1 1s.

7967 Blades (Wm.) The Enemies of Books, illustrations by L. Gunnis and H. E. Butler, with all the orig. pen-and-ink and wash drawings, 1896, 4to. (216) *Parsons*, £1 12s.

7968 Blake (Wm.) Silver Drops, or Serious Things, orig. ed., 4 plates, cf., g. e., by Rivière, n. d., 8vo. (16) *Dobell*, £1 17s.

7969 Boswell (J.) Life of Johnson, first ed., 2 vol., port., cf., 1791, 4to. (220) *Bain*, £3

7970 Boyle (M. L.) Biographical Catalogue of the Portraits at Longleat, 1881—Biographical Catalogue of the Portraits at Weston, 1888, *Privately printed* (221)
Dr. Williamson, £1 17s.

7971 Boyle (M. L.) Biographical Catalogue of the Portraits at Panshanger, 1885—Biographical Catalogue of the Portraits at Longleat, 1881—Tavistock (A. M.) and Russell (E. M. S.) Biographical Catalogue of the Pictures at Woburn Abbey, vol. i., 1890, *Privately printed* (222) *Bain*, £1 4s.

7972 British Musical Miscellany (The), engraved throughout, fronts., 6 vol. in 3, hf. cf. gt., n. d., 4to. (223) *Edwards*, £1

7973 Brontë (Sisters). Works, viz., Poems, by Currer, Ellis and Acton Bell (Smith, Elder), 1846—Jane Eyre, 3 vol., 1847—Wuthering Heights and Agnes Grey, 3 vol., 1847—The Tenant of Wildfell Hall, 3 vol., 1848—Shirley, 3 vol., 1849 —Villette, 3 vol., 1853—The Professor, 2 vol., 1857, together 18 vol., first eds. (the "Poems" belonged to the second issue of the first edition), polished oak boards, t. e. g., others uncut, not subject to return in respect to half titles (19) *Dobell*, £55

[The oak boards in which these volumes were bound were made from a beam out of the Old Chapter Coffee House in Paternoster Row, demolished some years back, where Charlotte Brontë stayed during her first visit to London.—*Catalogue.*]

7974 Brontë (Sisters). Poems, by Currer, Ellis and Acton Bell, first ed., second issue, Smith, Elder, 1846 (20) *Dobell*, 18s.

7975 Brooke (Sir Fulk Greville, Lord). Remains, being Poems of Monarchy and Religion, first ed., cf. (rebacked), *T. N. for H. Herringman*, 1670, 8vo. (21) *Dobell*, £1 2s.

7976 [Browne (Sir Thos.)] Religio Medici, title by Marshall (mounted) and pages 160, cf., g. e., by F. Bedford, *Printed for Andrew Crooke*, 1642 (22) *Tregaskis*, £6

[One of the first two surreptitious editions, but containing the truer reading on page 108 : "How much we stand in need of the precept of S. Paul," instead of "how little," as in subsequent authorised editions.—*Catalogue.*]

7977 Browning (Eliza)eth Barrett). Poems, 2 vol., first ed., name on titles, orig. cl., E. Moxon, 1844, 8vo. (23) *Allen,* 15s.
7978 Browning (Ro)ert). Paracelsus, first ed., orig. bds. ()roken and wanted)ack), 1835, 8vo. (28) *Spencer,* £1 8s.
7979 Browning (R.) Strafford, first ed., un)ound and unopened, 1837, 8vo. (29) *Spencer,* 10s.
7980 Browning (R.) Sordello, first ed., Moxon, 1840, 8vo. (30) *Dobell,* £1 15s.
7981 Browning (R.) Men and Women, first ed., 2 vol., orig. cl., 1855, 8vo. (31) *Maggs,* 19s.
7982 Bunyan (John). Pilgrim's Progress, second part, first ed. (wanted frontispiece and 2 cuts, several lines of text cut into, and a few leaves repaired and in fac.), mor., g. e.,)y Rivière, not su)ject to return, Nathaniel Ponder, 1684, 8vo. (34) *Edwards,* £1 1s.
7983 Bunyan (J.) Pilgrim's Progress, second part, second ed. plate)etween pages 52 and 53, but wanted front. and another plate, also pages 59-62, orig. sheep, Nathaniel Ponder, 1687 (35) *H. Green,* £1 10s.
7984 [Burton (R.)] Anatomy of Melancholy, first ed., mor. ex., g. e.,)y F. Bedford, *Oxford,* J. Lichfield and J. Short, 1621, 4to. (225) *Quaritch,* £37
7985 Butler (S.) Hudi)ras, The First Part, hf. cf., *Printed by J. G. for R. Marriot,* 1663, 12mo.—The Second Part, hf. cf., *Printed by T. R. for John Martyn and J. Allestry,* 1664, 12mo.—The Third and Last Part, sheep, *Printed for Simon Miller,* 1678, sm. 8vo., first eds., together 3 vol. (39) *Dobell,* £3 4s.
7986 Byron (Lord). Hours of Idleness, first ed. (name cut from title), hf. cf., *Newark,* 1807, 8vo. (41) *Allen,* £1 10s.
7987 Byron (Lord). English Bards and Scotch Reviewers, first ed., watermark 1805, uncut, J. Cawthorn (1809), 8vo. (42) *Dobell,* £1 16s.
7988 Chaucer (G.) Workes, by Tho. Speght, black letter, plate "The Progenie of Geffrey Chaucer" (title-page cut and mounted), old hf. cf., A. Islip, 1598, folio (283) *Maggs,* £2 8s.
7989 Cocker (Edw.) Cocker's Arithmetick, first ed., port. (mounted, and a few headlines shaved), leaf of advertisements at end, mor., g. e., 1678, 8vo. (51) *Leighton,* £6
7990 Cocker (E.) Decimal Arithmetic, first ed. (a few headlines shaved and wormed at end), mor., g. e., *Printed for Tho. Passinger at the Three Bibles on London Bridge,* 1685 (53) *Tregaskis,* 10s.
7991 Coleridge (S. T.) Poems on Various Su)jects, first ed., modern covers, 1796, 8vo. (54) *Maggs,* £1 3s.
7992 Coleridge (S. T.) Poems, second ed., to which are now added Poems)y Charles Lam) and Charles Lloyd, cf., *N. Biggs for J. Cottle,* 1797, 8vo. (55) *Maggs,* 14s.
7993 Cotton (Ch.) Poems on several Occasions, first ed., port. inserted, cf., 1689, 8vo. (64) *Maggs,* 16s.

7994 Cowper (Wm.) The Task and Poems, first eds., 2 vol. in 1, no half-title to vol. i., but with the half-title to vol. ii. (date cut off title of The Task), cf., 1782-85, 8vo. (66)
Spencer, £2
[Presentation copy from Cowper to the Rev. Thomas Scott, with inscription on half-title of vol. ii.—*Catalogue.*]

7995 Cowper (Wm.) Poems and The Task, first eds., 2 vol. (wanted hf. titles), cf. gt., 1782-85, 8vo. (68) *Dobell, £1 3s.*

7996 Cowper (Wm.) and Newton (John). Olney Hymns, first ed., orig. sheep, 1779, 8vo. (69) *Leighton, 14s.*

7997 Davenant (Sir Wm.) Works, first ed., port. by W. Faithorne, old cf., 1673, folio (284) *Edwards, £3 18s.*

7998 Donne (J.) Poems, with Elegies on the Author's Death, first ed. (wanted port.), vell., *M. F. for John Marriott,* 1633, 4to. (233) *Dobell, £12 5s.*

7999 Dryden (John). Absalom and Achitophel (title, To the Reader, and 32 pages), first ed. (stained), 1681, folio (286)
Hood, £1 6s.

8000 Dryden (J.) Annus Mirabilis, the Year of Wonders, 1666, an Historical Poem, first ed., sheep, H. Herringman, 1667, 8vo. (76) *Maggs, £3*

8001 Euclides. Liber Elementorum in Artem Geometriam, lit. goth. (Hain, *6693), ornamental border to first page (coloured), ornamental initials, all coloured, diagrams and MS. marginal notes, cf., g. e., *Venetiis, per Erhardum Ratdolt,* 1482, folio (289) *Leighton, £10*
[Editio Princeps, and the first book printed with mathematical diagrams. A few wormholes.—*Catalogue.*]

8002 Fletcher (P.) The Purple Island, or The Isle of Man, first ed., with leaf at end, " To my deare friend, the Spencer of this age," by Fr. Quarles (pages 97-100 wanted, as usual), cf., *Cambridge,* 1633, 4to. (240) *Ellis, £4 14s.*

8003 Germ (The). Facsimile Reprint, in parts as issued, in box, 1901 (81) *Edwards, £1 11s.*
[With this copy are included the original manuscript of W. M. Rossetti's Preface (on 25 4to. sheets), proofs of the illustrations, etc. and autograph letters of Ford Madox Brown (2), Coventry Patmore, etc.—*Catalogue.*]

8004 Gray (T.) Poems, first collected ed., old cf. gt., J. Dodsley, 1768, 8vo. (85) *Ellis, £1 8s.*

8005 Herbert (George). The Temple, second ed. (first published), (title-page and last two leaves mended,) mor. ex., by F. Bedford, *Cambridge,* T. Buck and R. Daniel, 1633, 8vo. (88)
Maggs, £9 15s.

8006 Herbert (G.) Remains, first ed., mor., g. e., Timothy Garthwait, 1652, 8vo. (89) *Maggs, £3 3s.*

8007 [Johnson (S.)] The Prince of Abissinia, first ed., 2 vol., cf. antique, 1759, 8vo. (98) *Zaehnsdorf, £4 4s.*

8008 Johnson (S.) Prayers and Meditations, Preface by A. Birrell, with the original manuscript of Mr. Birrell's Preface, on five sheets 4to., n. d. (99) *Tregaskis, £1 1s.*

8009 Jonson (Ben). Works [vol. i.], first ed. (wanted port., title by

Hole cut round and mounted, and a few marginal repairs),
cf., *g. e.*, ɔy W. Pratt, W. Stansɔy, 1616, folio (291)
Spencer, £12 15s.

8010 Keats (John). Endymion, first ed., with 5-line errata slip and
erratum leaf, cf., Taylor and Hessey, 1818, 8vo. (100)
B. F. Stevens, £14 10s.

8011 [Keɔle (J.)] The Christian Year, first ed., 2 vol., cf., *Oxford,*
1827, 8vo. (101) *Tregaskis,* 10s.

8012 Lamɔ (Charles). John Woodvil, first ed., orig. bds., 1802,
8vo. (103) *Spencer,* £8

8013 Lamɔ (C.) Works, first collected ed., 2 vol., orig. cl., 1818,
8vo. (104) *Maggs,* £3 4s.

8014 Lamɔ (C.) Elia, Essays which have appeared, etc., first ed.,
cf., arms on cover, Taylor and Hessey, 1823, 8vo. (105)
E. G. Allen, £1 10s.

8015 Lamɔ (C.) Alɔum Verses, first ed., cf. gt., ɔy Rivière, E.
Moxon, 1830, 8vo. (106) *Edwards,* £1 8s.

8016 Landor (W. S.) Poemata et Inscriptiones, cf., 1847, 8vo. (107)
Spencer, 10s.
[Presentation copy, with inscription in Landor's hand-
writing : "Walter Landor to Edward Twisleton, May 15,
1863."—*Catalogue.*]

8017 Layard (G. S.) Tennyson and his Pre-Raphaelite Illustrators,
LARGE PAPER, illustrations, with autograph letters of
Christina G. Rossetti, W. M. Rossetti (4), J. H. Round (3)
and G. S. Layard (2) inserted, rox., 1894, 4to. (251)
Edwards, 19s.

8018 Meredith (George). Modern Love and Poems of the English
Roadside, first ed., name on half title, orig. cl., 1862 (112)
Spencer, £1 18s.

8019 Milton (John). Paradise Lost, first ed., seventh title-page,
with 5-line " Printer to the Reader " (a few headlines, catch-
words and marginal numɔers shaved, and hole through
sig. L 3), cf., *g. e.*, *S. Simmons for T. Helder,* 1669, 4to. (252)
Dobell, £3 3s.

8020 Milton (J.) Poems, first ed. (wanted port. by Marshall, head
numɔers of 2 pages cut and names on title), orig. sheep
(6⅛in. ɔy 3¾in.), *Ruth Raworth for H. Moseley,* 1645, 8vo.
(115) *Maggs,* £21 10s.

8021 Milton (J.) Paradise Regain'd, first ed., "License" leaf and
errata (a few headlines shaved), cf., *Printed by J. M. for
John Starkey,* 1671, 8vo. (117) *Edwards,* £3 10s.

8022 North (Francis Dudley Lord). A Forest of Varieties, separate
title-pages, sheep, R. Cotes, 1645, folio (293)
Leighton, £1 10s.

8023 Pope (Alex.) An Essay on Man, 4 parts in 1 (part i. wanted
half title), J. Wilford, n. d. (1732-34)—Of the Knowledge
and Characters of Men, 1733—The First Satire of the
Second Book of Horace imitated, 1733 (2 copies)—An
Epistle from Mr. Pope to Dr. Arɔuthnot, 1734—One
Thousand Seven Hundred and Thirty Eight, 2 parts, 1738

—The First Epistle of the Second Book of Horace imitated, uncut, 1737—Another copy—The Second Epistle of the Second Book of Horace imitated, uncut, 1737—Another copy—The Sixth Epistle of the First Book of Horace, n. d. —Sober Advice from Horace to the Young Gentlemen about Town, n. d.—Characters : an Epistle to Alex. Pope and Mr. Whitehead, 1739—Milton's Epistle to Pollio, translated from the Latin, with notes, 1740, first eds., 15 pieces (295) *Parsons, £8* 15s.

8024 Prior (Matt.) Poems on Several Occasions, first authorized ed., front., cf., g. e., by W. Pratt, J. Tonson, 1709, 8vo. (125) *Leighton,* 13s.

8025 Quarles (Fr.) A Feast for Wormes, *F. Kyngston for R. Moore,* 1620—Pentalogia, or the Quintessence of Meditation, *ib.,* 1620—Hadassa, or the History of Queene Ester, R. Moore, 1621—Job Militant, with Meditations, *F. Kyngston for G. Winder,* 1624, first eds., in 1 vol., hf. russ., 4to. (259) *Dobell, £5* 10s.

8026 Quarles (Fr.) Emblemes, first ed., engravings by W. Marshall and W. Simpson (2 or 3 leaves shaved), loose, prepared for binding, 1635, 8vo. (129) *Radcliffe, £6* 5s.

8027 Quarles (Fr.) Emblemes, first ed., engravings by W. Marshall and W. Simpson, port. of Quarles inserted (3 leaves defective and soiled), mor., g. e., 1635, 8vo. (130) *Radcliffe, £4*

8028 Roberts (W.) Book Hunter in London, with the original pen-and-ink drawings inserted (in sheets), 1895, 4to. (260) *Edwards, £2* 6s.

8029 Scott (W. Bell). A Poet's Harvest Home, with 42 autograph letters of the author, and an original "Rondeau" signed Richard F. Littledale, 1882, 8vo. (140) *Edwards, £1* 16s.

8030 Shelley (Percy B.) The Revolt of Islam, first ed., orig. bds., C. and J. Ollier, 1818, 8vo. (143) *B. F. Stevens, £11* 5s.

8031 Shelley (P. B.) Laon and Cythna, first ed. (wanted hf. title), hf. cf., 1818, 8vo. (144) *Spencer, £10* 10s.

8032 Shelley (P. B.) Rosalind and Helen, first ed. (wanted hf. title), binder's bds., C. and J. Ollier, 1819, 8vo. (145) *Edwards, £2* 12s.

8033 Spenser (Edm.) The Faerie Queene, first ed. of Part ii. and second of Part i., title page to Part i. in fac., 2 vol. in 1, old cf., g. e., W. Ponsonbie, 1596, 4to. (266) *Leighton, £9* 10s.
[On inner cover are the autograph signatures of "C. Wesley ex Æde Xti 1734" and "Sally Wesley, 1776."— *Catalogue.*]

8034 Spenser (Edm.) The Faerie Queene, engraved title (mounted and defective), old cf., *H. L. for M. Lowne,* 1611, folio (297) *Leighton, £2* 6s.

8035 Sterne (Laurence). Sentimental Journey, LARGE PAPER, with list of subscribers and advertisement, 2 vol. in 1 (no half title to vol. ii.), hf. cf., 1768, 8vo. (160) *Hornstein, £6* 15s.

8036 Swift (Jonathan). Gulliver's Travels, first ed., continuous pagination, port. and maps, 2 vol., cf. (rebacked), B. Motte, 1726, 8vo. (162) *Spencer*, £1 15s.

8037 Taylor (Jer.) Rule and Exercises of Holy Living, first ed. (a few headlines shaved), mor., g. e., R. Royston, 1650, 8vo. (166) *Edwards*, £3 5s.

8038 Taylor (Jer.) Rule and Exercises of Holy Dying, first ed., folding plate (slightly damaged), cf. (rebacked), R. Royston, 1651, 8vo. (167) *Edwards*, £1 10s.

8039 [Tennyson (A. and C.)] Poems, by Two Brothers, first ed., orig. bds., unopened, fine copy, 1827, 8vo. (169)
 J. Bumpus, £39

8040 Tennyson (Alfred). Poems, chiefly Lyrical, first ed., leaf of errata, binder's bds., 1830, 8vo. (170) *Allen*, £1 14s.

8041 Tennyson (A.) Poems, first ed., binder's bds., 1833, 8vo. (171) *Allen*, £1 18s.

8042 Tennyson (A.) Poems, 2 vol., binder's bds., 1842, 8vo. (172)
 Quaritch, £3 8s.

8043 Tennyson (A.) Poems, 2 vol., orig. bds., 1842, 8vo. (173)
 Hornstein, £2 2s.

8044 Tennyson (A.) The Princess, first ed., 1847, 8vo. (174)
 Zaehnsdorf, £1 1s.

8045 Tennyson (Lord). In Memoriam, first issue of the first ed., with the misprints on pages 2 and 198 (oil stained in upper margin), orig. cl., E. Moxon, 1850, 8vo. (175)
 Zaehnsdorf, £2 10s.

8046 Tennyson (Lord). In Memoriam, first issue of first ed., inscription on title, orig. cl., 1850, 8vo. (176)
 Zaehnsdorf, £2 8s.

8047 Thomson (J.) A Poem, Sacred to the Memory of Sir Isaac Newton, first ed., 1727, folio (299) *Maggs*, £1 2s.

8048 Walton (Izaack). Life of George Herbert, first ed., port. by R. White, cf., *T. Newcomb for R. Marriott*, 1670, 8vo. (186)
 Maggs, £1 10s.

8049 Washbourne (Th.) Divine Poems, first ed., mor., g. e., H. Moseley, 1654, 8vo. (189) *Dobell*, £2 7s. 6d.

8050 Wesley (S.) History of the Old and New Testament attempted in Verse, engravings by G. Sturt, 3 vol., contemp. mor., g. e., 1704-16, 8vo. (194) *Edwards*, 17s.

8051 Wither (George). Psalmes of David translated into Lyrick-Verse, first ed. (title page loose and a few headlines shaved), sheep, *Imprinted in the Neatherlands*, 1632 (197)
 B. F. Stevens, 19s.

8052 Wordsworth (Wm.) Poems, first ed., 2 vol., hf. bd., 1807, 8vo. (199) *Spencer*, £1 4s.

8053 Wordsworth (W.) and Coleridge (S. T.) Lyrical Ballads, first ed., uncut, 1798, 8vo. (202) *Maggs*, £34 10s.

8054 Wycherley (W.) Miscellany Poems, first ed., port. by T. Smith after Lely, old cf., 1704, folio (300) *Maggs*, £8 15s.

8055 British Mezzotinto Portraits described, by J. C. Smith, with many additions and corrections in MS. by the late Mr. Alfred Whitman, 4 vol. (interleaved copy), 1878-84, 8vo. (19)

Agnew, £430 10s.

[Sold by Messrs. Christie, Manson and Woods on June 6th. This particular copy was exceptionally important, as a large number of undescribed "states" were catalogued and described.—ED.]

[JUNE 6TH AND THREE FOLLOWING DAYS, 1910.]

SOTHEBY, WILKINSON & HODGE.

A FURTHER PORTION OF THE LARGE COLLECTION OF MANU-SCRIPTS AND AUTOGRAPH LETTERS OF THE LATE SIR THOMAS PHILLIPPS, BART.

(No. of Lots, 908 ; amount realised, £5,959 11s. 6d.)

[NOTE.—This sale comprised the fourteenth portion of the MSS. of the late Sir Thomas Phillipps, which, including the amount obtained on this occasion, has so far realised the total sum of £51,031 6s. A reference to the thirteenth sale will be found in BOOK-PRICES CURRENT, Vol. xxii., page 580, and as the same conditions prevail now as they did then it is not necessary to further explain the reasons why a full report is not given. Now, as then, however, a few of the principal manuscripts may be referred to. The highest individual sum obtained was £520 (*Fairfax Murray*) for the original treaty dated August 8th, 1381, by virtue of which the war of Chioggia (Chiozza) between the Venetians and Genoese was brought to a conclusion on terms exceedingly unfavourable to the former Power. This treaty was written on 15 sheets of vellum, with signatures attached. A manuscript of the 12th century, on vellum, giving the text of the Venerable Bede's "Ecclesiastica Historia Gentis Anglorum," quoted as Codex A in the "Monumenta Historica Britannica," realised £91 (*Quaritch*); Boccaccio's *Teseida Poema*, a MS. of the 15th century, with large initial letters and a decorated border, £102 (*Quaritch*); the original Household Book of Accounts of Eleanor, daughter of Edward II., on her journey to Verlie for her marriage with Reginald Earl of Gelders, on vellum, £47 ; and many other important documents as set forth and fully described in the catalogue. —ED.]

SOTHEBY, WILKINSON & HODGE.

The Library of the late Mr. John Ellman Brown, of Shoreham, Sussex, and other Properties.

(No. of Lots, 327 ; amount realised, £573 10s.)

(a) *Mr. Brown's Library.*

8056 Alciatus (Andreas). Emblemata, title (mended) and wood-
cuts, mor., *Patavii*, P. Tozzius, 1618, 8vo. (6) *Ellis*, 10s.

8057 Annalia Dubrensia. Upon the Yeerely Celebration of Mr.
Robert Dover's Olimpick Games upon Cotswold-Hills
[Poems by Drayton, Jonson, Basse, Shackerley, Marmion,
etc.], orig. ed. (wanted front.), hf. cf., *R. Raworth for M.
Walbancke*, 1636, sm. 4to. (216) *Bloomfield*, £1 17s.

8058 Bible (Holy). Authorized Version, the "Wicked Bible" (see
Exodus, chapt. xx., verse 14), (soiled, side-notes cut into,
imperfect at end), old mor., R. Barker and J. Bill, 1631,
8vo. (13) *Page*, £1 19s.

8059 Bisse (James, M.A. Oxon.) Two Sermons preached, the one
at Paules Crosse the eight of Jan., 1580, the other at
Christe Churche in London the same day (marginal notes
shaved), cf. ex., Thos. Woodcocke, 1581, 8vo. (15)
Edwards, 12s.

8060 Boswell (James). Life of Johnson, first ed., port. by J. Heath,
2 vol., orig. hf. russ., 1791, 4to. (221) *Rimell*, £3
[Portion of a MS. Memorial for James Johnston, 1766,
endorsed : "This was the first Paper drawn by me as an
Advocate," signed "James Boswell."—*Catalogue.*]

8061 Breviarium ad Usum Cisterciensis Ordinis, printed upon
vellum, lit. goth., red and black, borders of 2 leaves and
several initials illuminated (wanted the Psalter [76 leaves],
also folio 190 in second part and the whole of the third
part), velvet binding, *Paris* (*De Marnef's device on title*), *in
Vico Sancti Jacobi*, 1512, sm. 8vo. (23) *Barnard*, £7 5s.

8062 Brighton. Panoramic View of Brighton (15 feet in length), in
colours, in the orig. boarded cover, Ackermann, 1833—
Another Panoramic View of Brighton, tinted, in the orig.
cl. cover, n. d. (223) *Rimell*, £5

8063 Brighton. [Lee (William).] Ancient and Modern History of
Lewes and Brighthelmstone, 4 water-colour views inserted,
russ., g. e., with a view of Lewes church, etc. (in duplicate)
on the sides, *Lewes*, 1795, 8vo. (25) *Rimell*, £1 18s.

8064 Browning (Robert). Christmas-Eve and Easter-Day, a Poem,
first ed., orig. cl., 1850, 8vo. (33) *Page*, 16s.

8065 Byron (Lord). Poetical Works, 6 vol., port., cf. gt., 1855, 8vo.
(35) *Thorp*, 14s.

8066 Carlyle (Thomas). The French Revolution, first ed., 3 vol., orig. bds., with labels, 1837, 8vo. (37) *Sotheran, £4* 12s.

8067 Carpenter (John, Bp. of Exeter). Rememmer Lot's Wife. Two Godly and fruitfull Sermons, orig. ed., 𝔟𝔩𝔞𝔠𝔨 𝔩𝔢𝔱𝔱𝔢𝔯, mor., g.e., Thos. Orwin, 1588, 8vo. (40) *Bull, £1*

8068 Chaffers (W.) Marks and Monograms on Pottery and Porcelain, fourth ed., with 3,000 potters' marks and illustrations, uncut, t.e.g., 1874, 8vo. (42) *Page,* 10s.

8069 Charles I. A Groane at the Funerall of that Incomparable and Glorious Monarch Charles the First, by J. B. (in verse), (title and 3 leaves,) title backed, 1649—A Deepe Groane fetched at the Funerall of Charles the First, written by D. H. K. (in verse, the same poem with alterations as the above), *ib.* (date cut off)—An Elegie, etc. on the Execution of K. Charles I. (7 leaves, no title), [1649,] 3 pieces in 2 vol., hf. bd., sm. 4to. (225) *Thorp, £1* 13s.

8070 Curtis (Rich., Bp. of Chichester). A Sermon Preached before the Queene's Majestie at Greenwiche the 14. day of March, 1573, orig. ed., 𝔟𝔩𝔞𝔠𝔨 𝔩𝔢𝔱𝔱𝔢𝔯 (title mended), modern cf. ex., H. Bynneman, 1574, 8vo. (54) *Thorp,* 12s.

8071 Day (Angel). The English Secretarie, 𝔟𝔩𝔞𝔠𝔨 𝔩𝔢𝔱𝔱𝔢𝔯 (title and next leaf mended, corners of a few leaves frayed and a few headlines cut into), hf. mor., *R. J. for C. Burbie,* 1595, sm. 4to. (227) *Bloomfield,* 13s.

8072 De Quincey (T.) Confessions of an English Opium-Eater, first ed., cf., uncut, t.e.g., 1822, 8vo. (59) *Hornstein, £4* 17s. 6d.

8073 De Quincey (T.) Klosterheim, or the Masque, first ed., orig. bds., with the label, 1832, 8vo. (60) *Page,* 13s.

8074 Dickens (C.) Great Expectations, first ed. (wanted the half titles, several leaves soiled), 3 vol., cf., t.e.g., 1861, 8vo. (78) *Spencer, £2* 10s.

8075 Drant (Thos., B.D.) Two Sermons Preached, the one at S. Maries Spittle on Tuesday in Easter Week, 1570, the other at the Court of Windsor the Sunday after Twelfth day, 1569, orig. ed., 𝔟𝔩𝔞𝔠𝔨 𝔩𝔢𝔱𝔱𝔢𝔯, hf. bd., John Daye (1570), 8vo. (82) *Bull,* 17s.

8076 Evelyn (John) and Pepys (Samuel). Diaries and Correspondence, ports., 9 vol., uncut, 1850-54, 8vo. (88) *Sotheran, £2* 8s.

8077 Excursions in Essex, Kent, Norfolk, Suffolk, Surrey, Sussex and Ireland, plates (some spotted) and maps, together 11 vol., mor., g.e., 1818-22, 8vo. (89) *Rimell, £3* 7s. 6d.

8078 Fisher (Jonathan). Description of the Lakes of Killarney, 12 col. aquatint plates, hf. bd., *Dublin* (date erased), oblong folio (262) *J. Bumpus, £4* 4s.

8079 Froude (J. A.) History of England, 12 vol., cf. gt., 1856-70, 8vo. (94) *Joseph, £2* 2s.

8080 Froude (J. A.) The English in Ireland, 3 vol., uncut, 1872-4, 8vo. (95) *J. Bumpus, £1* 1s.

8081 Froude (J. A.) The Divorce of Catharine of Aragon, 1891— The Spanish Story of the Armada, etc., 1892—Short Studies

on Great Subjects, the 4 series, 4 vol., 1868-83, uncut,
together 6 vol., 8vo. (97) _Edwards_, £7 18s.
8082 Froude (J. A.) Shadow of the Clouds, by Zeta, 1847, orig.
cl., 8vo. (93) _Quaritch_, 19s.
[This was Froude's first printed work.—ED.]
8083 Grafton (R.) Abridgement of the Chronicles of England,
black letter, old cf., R. Tottell, 1572, 8vo. (100) _Harding_, 16s.
8084 Grand Architectural Panorama of London : Regent Street to
Westminster Abbey, 20 feet in length—New Houses of
Parliament to Greenwich Hospital, 18 feet in length, 1849,
in 2 cl. cases (101) _Batsford_, £1 6s.
8085 Hall (Mr. and Mrs. S. C.) Ireland, its Scenery, etc., illustra-
tions (some spotted), maps and woodcuts, 3 vol., mor.,
g. e., How and Parsons, 1841-43, 8vo. (103)
Edwards, £1 3s.
8086 Hall (Mr. and Mrs. S. C.) Ireland, a new ed., plates (some
spotted), maps and woodcuts, 3 vol., cf., g. e., Hall, Virtue
and Co., n. d., 8vo. (104) _Page_, 17s.
8087 Hamilton (Lady Anne). Secret History of the Court of
England, 2 vol. in 1 (suppressed), hf. mor., 1832—Authentic
Records of the Court of England, col. front., hf. cf., 1832,
8vo. (106) _Quaritch_, £2 14s.
8088 Hissey (J. J.) An Old-Fashioned Journey through England
and Wales, 1884—A Drive through England, 1885—On the
Box Seat, 1886—A Holiday on the Road, 1887—Tour in a
Phaeton, 1889—Across England in a Dog-Cart, 1891, first
eds., maps and illustrations, orig. cl. (108)
Edwards, £5 15s.
8089 Horæ B. V. M. ad Usum Ecclesiæ Ambiananensis, cum
Calendario. " Ces psentes heures a lusaige de Amien tout
au lōg sans reqre ont este faictes pour Simō Vostre Libraire,
demourant a Paris en la rue neuve nostre dame," etc., lit.
goth. (bâtardes), printed upon vellum within woodcut bor-
ders of Biblical subjects, Dance of Death (long series),
hunting and rustic scenes, etc., 20 full-page woodcuts, all
col. by hand and heightened in gold, contained 140 leaves,
signs. A-R and + in 8's, D having 4 leaves only, apparently
perfect, unless a colophon is wanted, old French mor., gilt
tooling, etc. (fatiguée), (Clovis Eve,) _Paris, P. Pigouchet
for S. Vostre, s. a._ [_Almanack_ 1502-1520], 8vo. (114)
Leighton, £31
8090 Kettridge (Wm.) Original MS., containing numerous tech-
nical and other details connected with the Navy, temp.
Charles II., 166 leaves, with ornaments, and a port. drawn
in sepia, old English mor. gt., with initials " W. K.," g. e.,
1675, 8vo. (123) _Claude_, £7
8091 Kitchin (John). Le Court Leete et Court Baron, **black letter**,
contemp. MS. notes, modern cf., R. Tottell, 1581, 8vo. (124)
Betts, £1 10s.
8092 Ladies' Diary (The), or Woman's Almanack for the year
1760, being Leap Year, an engraved London Almanack for

the same year inserted, orig. drawings on fly-leaves, contemp. mor., gilt floreate ornaments, etc., silver clasp, *A. Wilde for the Stat. Co.*, 1760, 8vo. (126) *Leighton*, £2 4s.

8093 Lamb (Charles). Adventures of Ulysses, front. and engraved title by Corbould, orig. cl., *Published at the Juvenile Library*, n. d. (127) *Thorp*, £1 18s.

8094 Larke (John). The Boke of Wisdome, black letter, woodcut initials, title in MS. (next leaf defective, some leaves soiled), hf. russ., *Imprinted in Fletestreate by Thos. Colwell*, 1565 (?), 8vo. (128) *Barnard*, 18s.

8095 Lever (Charles). The O'Donoghue, first ed., orig. cl., 1845, 8vo. (132) *J. Bumpus*, 15s.

8096 Lever (C.) The Daltons, first ed., illustrations by "Phiz" (stained), 2 vol., orig. cl., 1852, 8vo. (133) *Thorp*, 18s.

8097 Magna Charta. The Great Charter called ī latyn Magna Carta, with divers Olde Statutes whose titles appere in the next leafe, newly Correctyd (trans. by George Ferrers), black letter, contemp. signature of Wm. Kyngsmyll on title, contemp. cf., stamped with initials "M. D." (either the binder's initials or date 1500), (repaired,) *Imprynted in Flete Strete by Elizabeth, Widow of Robert Redman*, n. d., 8vo. (140) *Thorp*, £4 7s. 6d.

8098 Morris (F. O.) British Birds, col. plates, 6 vol., cf. gt., 1851-57, 8vo. (148) *Barnard*, £2 12s.

8099 Morris (F. O.) British Butterflies, 71 col. plates, hf. cf., 1853, 8vo. (149) *Page*, 12s.

8100 Morris (F. O.) Nests and Eggs of British Birds, col. plates, 3 vol., hf. cf. gt., 1853-6, 8vo. (150) *Page*, £1 3s.

8101 Morris (F. O.) British Moths, col. plates, 4 vol., 1872, 8vo. (151) *Page*, £1

8102 Oulton (W. C.) Picture of Margate and its Vicinity, map and 20 views by J. J. Shury, extra illustrated by the insertion of 15 col. and other plates, 1820—Views of Ramsgate, by H. Moses, 1817, cf., in 1 vol., 8vo. (157) *Rimell*, £4 14s.

8103 Sharp (Thomas). Pageants, or Dramatic Mysteries, anciently performed at Coventry, LARGE PAPER (one of 50 copies), plates on India paper, orig. cl., *Coventry*, 1825, 4to. (238) *Walford*, 17s.

8104 Shaw (Henry). Decorative Arts of the Middle Ages, illustrations (some in col.), heightened with gold and silver, embossed mor., g. e., Pickering, 1851, imp. 8vo. (169) *Rimell*, £1 9s.

8105 Stow (John). Annales, black letter (bottom margin mended), old cf., arms of King Charles I. (rebacked), R. Meighen, 1631, folio (265) *Ellis*, £1 12s.

8106 Sussex Archæological Collections, vol. i. to lii., and General Index to vol. i. to xxv., plates (some spotted) and woodcuts, together 53 vol., orig. cl., 1848-1909, 8vo. (177) *Edwards*, £14

8107 Sussex. Borrer (William). The Birds of Sussex, col. plates, uncut, R. H. Porter, 1891, 8vo. (181) *Page*, 12s.

8108 Sussex. Dallaway (James). The Parochial Topography of
the Rape of Bramʒer, 250 copies printed, 1830—The Rape
of Arundel, with additions·by E. Cartwright, 1832, maps,
engravings and ports., together 2 vol., orig. cf. and bds.,
uncut, 4to. (247)　　　　　　*W. J. Smith*, £7 17s. 6d.
8109 Sussex. Hay (Alex.) History of Chichester, LARGE PAPER,
illustrated ʒy the insertion of 80 ports., views, etc., hf. bd.
(ʒroken), uncut, *Chichester*, 1804, roy. 8vo. (185)
　　　　　　　　　　　　　　Bloomfield, £2 12s.
8110 Sussex. Horsfield .(T.· W.) History and Antiquities of
Lewes, plan, views and pedigrees, 2 vol., hf. cf., 1824-27,
4to. (249)　　　　　　　　　*Bloomfield*, £1 6s.
8111 Sussex. Horsfield (T. W.) History of Sussex, ports. and
views (several stained), woodcuts and maps, 2 vol., hf. bd.,
Lewes, 1835, 4to. (250)　　　　　　*W. J. Smith*, £2
8112 Sussex. Hussey (Arthur). Notes on the Churches of Kent,
Sussex and Surrey, plates, extra illustrated with aʒout 200
illustrations, extended to 3 vol., hf. mor., t. e. g., 1852, 8vo.
(188)　　　　　　　　　　　　*Ellis*, £3 12s.
8113 Sussex. Lower (M. A.) Compendious History of Sussex,
illustrations, several views, cuttings, etc. inserted, 2 vol.,
hf. mor., *Lewes*, 1870, 8vo. (191)　　　　*Edwards*, £1 8s.
8114 Sussex. Parry (J. D.) Account of the Coast of Sussex,
map and plates, several old and modern views inserted, hf.
mor., t. e. g., 1833, 8vo. (192)　　　　*Bloomfield*, 18s.
8115 Thackeray (W. M.) Vanity Fair, cf. ex., 1848, 8vo. (203)
　　　　　　　　　　　　　　Lewine, £1 16s.
8116 Thackeray (W. M.) Doctor Birch and his Young Friends,
first ed., plates (uncol.), cf. ex., 1849, 8vo. (204)
　　　　　　　　　　　　　　Bloomfield, 17s.
8117 Thackeray (W. M.) Mrs. Perkins's Ball, illustrations (col.),
hf. mor., n. d., 8vo. (205)　　　　　　　*Tite*, 18s.

(β) *Other Properties*.

8118 Aʒʒot (J.) and Smith (Sir J. E.) Natural History of the
Lepidopterous Insects of Georgia, 106 col. plates, 2 vol.,
mor., g. e., 1797, roy. folio (310)　　　*Quaritch*, £6 15s.
8119 Byron. Finden's Landscape Illustrations to the Life and
Works of Byron, LARGE PAPER, proofs, 24 parts, 1832-34,
4to. (306)　　　　　　　　　　*Curtis*, 19s.
8120 Coryat (Thomas). Coryat's Crudities, first ed., plates (those
of the Amphitheatre of Verona and the Heidelʒerg Tun
mounted), (errata leaf and 3 other leaves defective), mor.
ex., ʒy Zaehnsdorf, W. S., 1611, 4to. (283) *Pickering*, £15
8121 Curtis (William). Botanical Magazine, 122 vol., Two Indexes,
2 vol., together 124 vol. in 103, port. and col. plates, vol. i.
to lxxiv. cf., remainder in cl., 1787-1896, 8vo. (274)
　　　　　　　　　　　　　　Wesley, £10 15s.
8122 Eden (Miss). Portraits of the Princes and People of India,
24 lithographic plates on cardʒoard (some spotted), 1844,
imp. folio (319)　　　　　　　　*Edwards*, £1 1s.

8123 Guercino. Imitations of Original Drawings by Guercino. ports. and plates by Bartolozzi, etc., 2 vol. in 1, hf. bd, (spotted), n. d., imp. folio (309) *Thorp*, £1 1s.

8124 Harris (Moses). The Aurelian, 46 col. plates (binding broken), 1778, folio (311) *Wheldon*, £1 1s.

8125 Horae B. V. M. cum Calendario, lit. goth., lettres bâtardes (79 leaves), printed upon vellum, without borders, cut of astrological man with four smaller figures on second leaf, 13 large woodcuts, 4 marginal paintings and 16 smaller woodcuts, all col. and illuminated (folio 24 missing), watered silk on oak bds., mor. case, *Imprimées a Paris par Gilles Hardouyn . . . pour Germain Hardouyn* [*Almanack* 1518-25], 8vo. (276) *Andrews*, £7 7s.

8126 Missale Saltzeburgensis noviter impressum ac emendatum, lit. goth. magna, woodcuts, including a full-page one at the beginning of the Canon of the Mass (wanted sign. A), orig. stamped pigskin, *Venetiis ex officina litteraria Petri Liechtenstein Coloniensis*, 1515, 15 *Octob.*, folio (285) *Edwards*, £7 5s.

8127 Ottley (W. Y.) Italian School of Design, facs., hf. bd., 1823, imp. folio (324) *Bloomfield*, £1 5s.

8128 Purey-Cust (A. P.) Heraldry of York Minster, illustrations, 2 vol., uncut, t. e. g., *Leeds*, 1890-96, folio (321) *Harding*, £1 10s.

8129 Recueil d'Estampes d'après les plus beaux Tableaux, etc. qui sont en France dans le Cabinet du Roy, etc., 177 plates, 2 vol., russ., *Paris*, 1729-42, imp. folio (317) *Maggs*, £6 5s.

8130 Revised Reports (The). A Republication of such Cases in the English Courts of Common Law and Equity from 1785 to 1858, as are still of Practical Utility, 111 vol., hf. bd., 1891-1910, 8vo. (270) *Harding*, £19 10s.

8131 Richardson (C. J.) Studies from Old English Mansions, four series, plates, in 4 vol., hf. mor., 1841-48, imp. folio (326) *Hill*, £6 10s.

8132 Wellington (Duke of). Victories of the, LARGE PAPER, col. plates after R. Westall, uncut, 1819, folio (312) *Hornstein*, £3 12s.

8133 Westwood (J. O.) Palaeographia Sacra Pictoria, facs. of illuminated manuscripts, etc., hf. mor., 1843-45, 4to. (304) *A. Jackson*, £2 2s.

SOTHEBY, WILKINSON & HODGE.

A MISCELLANEOUS COLLECTION.

(No. of Lots, 359 ; amount realised, £549 0s. 6d.)

———

8134 Ackermann (R.) Repository of Arts, First Series, 14 vol.,
1809-15—Third Series, vol. i. to xii., 1823-28, ports., cos-
tumes (coloured), designs, etc., additional plates inserted,
together 26 vol., hf. cf. gt., 1809-28, 8vo. (173)
Hornstein, £30
8135 Arnold (M.) Saint Brandan, orig. wrapper, 1867, 8vo. (109)
Quaritch, £2 4s.
8136 Arnold (M.) Geist's Grave, first ed., orig. wrapper, 1881, 8vo.
(110) *Quaritch*, £1 12s.
8137 Artist's Repository and Drawing Magazine, 11 ports., printed
in red, and numerous plates in red by Bartolozzi, etc., 4
vol., old cf., 1785-6, 8vo. (32) *Thomas*, £1 14s.
8138 Beaumont and Fletcher. Works, ɔy Henry Weɔer, 14 vol.,
bds., *Edin.*, 1812, 8vo. (144) *Brown*, £3 8s.
8139 Biɔlia Sacra Polyglotta, ed. B. Waltonus, port. by Lomɔard,
engraved title, 6 vol., rough cf., *London*, 1657, folio (29)
Baker, £2 12s.
8140 Blake (W.) The Complaint, by Edward Young, orig. im-
pressions of the engravings, by Blake, hf. cf., uncut, 1797,
roy. 4to. (314) *Edwards*, £7 7s.
8141 Blake (W.) The Grave, by Roɔert Blair, port. and 12 etch-
ings by L. Schiavonetti, from the inventions of Blake (a
few spotted), hf mor., t. e. g., 1808, imp. 4to. (315)
Dobell, £1 13s.
8142 Book (The) of Ballads, ed. ɔy Bon Gaultier, first ed., illus-
trated by Alfred Crowquill, orig. cl., g. e., Orr and Co., 1845,
8vo. (185) *Haughton*, £1 10s.
8143 Brown (Ford Madox). A Record of his Life and Work, ɔy
Ford M. Hueffer, reproductions, ornamented cl., t. e. g.,
1896, 8vo. (203) *Bumpus*, 17s.
8144 Burns (Roɔert). Letters addressed to Clarinda, port. ɔy
Tieɔout, orig. bds., uncut, *Philadelphia*, 1809, 8vo. (236)
Maggs, £1 6s.
8145 Chapman (F. R.) Sacrist Rolls of Ely, illustrations, 2 vol.,
ɔuckram, t. e. g., *Privately printed, Cambridge*, 1907, 8vo.
(3) *Heffer*, 15s.
8146 Chaucer (Geoffrey). Works, ɔy T. Speight, black letter, port.
of Chaucer, surrounded ɔy pedigree and coats-of-arms,
russ., g. e., sound copy, 1687, folio (352) *Hornstein*, £2 16s.
8147 Cleveland (Duchess of). The Battle Aɔɔey Roll, plan, etc.,
3 vol., ɔuckram, r. e., 1889, 4to. (302) *Maggs*, £2 2s.

8148 Constable (John). Memoirs, ɔy C. R. Leslie, R.A., port. and plates, hf. bd., uncut, 1843, folio (354) *Rimell*, £6 15s.

8149 Constable (J.) Various Suɔjects of Landscape, characteristic of English Scenery, engraved ɔy David Lucas, 3 parts only, orig. impressions of the plates, wrappers, uncut (one missing), with inscription, " Mrs. John Fisher, with Mr. Constaɔle's kind regards," *Published by Mr. Constable*, 1830, folio (355) *Rimell*, £4 12s.

8150 Dandies' (The) Rout, by a Young Lady of Distinction, aged eleven years, 16 col. engravings, ɔy R. Cruikshank, orig. wrapper, 1820, 8vo. (105) *Shepherd*, 18s.

8151 Defoe (Daniel). Roɔinson Crusoe, "John Major's ed.," engravings by Geo. Cruikshank (fronts. stained), 2 vol., orig. cl., with laɔels, 1831, 8vo. (169) *Manning*, £2 12s.

8152 Dickens (Charles). Domɔey and Son, in the orig. 20 numɔers, wrappers (repaired), 1846-48, 8vo. (165) *Dobell*, £2

8153 Dickens (C.) David Copperfield, in the orig. 20 numbers, wrappers, in case, 1849-50, 8vo. (166) *Shepherd*, £4 17s. 6d.

8154 Dickens (C.) Humphrey's Clock, in the orig. 88 numɔers, with all the illustrated wrappers, 1840-41, imp. 8vo. (163)
Maggs, £4 8s.

8155 Dickens (C.) Little Dorrit, in the orig. 20 numbers, wrappers (last defective, ɔacks repaired), in case, 1855-57, 8vo. (168)
Shepherd, £1 6s.

8156 Dickens (C.) The Loving Ballad of Lord Bateman, first ed., earliest issue (*see* Stanza V., illustrated by George Cruikshank), cf. ex., g. e., orig. pictorial cl. cover, ɔound up with the advertisements at end, C. Tilt, 1839, 32mo. (176)
Shepherd, £4 2s. 6d.

8157 Dickens (C.) Nicholas Nickleɔy, in the orig. 20 Nos., wrappers (ɔacks repaired), in case, 1838-39, 8vo. (161)
Shepherd, £4 7s. 6d.

8158 Dickens (C.) Posthumous Papers of the Pickwick Cluɔ, the orig. 20 Nos., with Dickens's Address in No. xv. and Puɔlishers' Notice in No. xviii., a few of the plates worn impressions, orig. pictorial wrappers (repaired), in a case, 1836-7, 8vo. (158) *Spencer*, £12

8159 Dickens. Pickwick Papers, first ed., with the two plates by R. W. Buss (inlaid), port. of Dickens and a specimen wrapper inserted, hf. mor., t. e. g., 1837, 8vo. (159)
Manning, £5 5s.

8160 Du Cange (C. Du Fresne Dom). Glossarium ad Scriptores mediae et infimae Latinitatis, front., 6 vol., cf., *Paris*, 1733-36, folio (18) *Heffer*, £1 16s.

8161 Dunɔar (William). Poems, ɔy David Laing, 2 vol., cf. gt., *Edin.*, 1834, 8vo. (241) *Thin*, £1 10s.

8162 East Indies. An East-India Colation, written by C. F(arewell), orig. sheep, 1633, 8vo. (101) *James*, £1 2s.

8163 Egan (Pierce). Life in London, first ed., 36 col. plates, woodcuts by J. R. and G. Cruikshank, uncut, orig. illustrated bds. (the ɔack missing), Sherwood, Neely and Jones, 1821, 8vo. (121) *Hornstein*, £15 5s.

8164 Erasmus (Desid.) Opera Omnia, port., engraved title, etc.,
9 vol. in 11, old cf., *Lugd. Bat.*, 1703-6, folio (21)
Luzac, £7 10s.
8165 Fajian (R.) The Chronicle of Fajyan, black letter, engraved
title (jacked), russ., g. e., *Printed by John Reynes*, 1542,
folio (348)　　　　　*Sotheran*, £3
8166 France. Constitution Française, La, présentée au Roi, par
l'Assemblée Nationale, le 3 Septemjre, 1791, 20 oval mezzo.
ports., jy Fiesinger, *Dijon*, 1791, 8vo. (104) *Sotheran*, £6

Fraser (Sir William). Scottish Family Histories.

8167 Haddington. Memorials of the Earls of Haddington, illus-
trations and facs., 2 vol., cl., mor. jacks, t. e. g., *Edin.*,
1889, 4to. (307)　　　　　*Hopkins*, £1
8168 Melvilles and Leslies. The Melvilles, Earls of Melville,
and the Leslies, Earls of Leven, ports., illustrations, etc.,
3 vol., cl., mor. jacks, t. e. g., *Edin.*, 1890, 4to. (308)
Hopkins, £1 15s.
8169 Annandale. The Annandale Family Book of the Johnstones,
ports., charters, etc., 2 vol., cl., mor. jacks, t. e. g., *Edin.*,
1894, 4to. (309)　　　　　*Hopkins*, £1 5s.
8170 Elphinstone. The Elphinstone Family Book, ports., illus-
trations, seals, etc., 2 vol., cl., mor. jacks, t. e. g., *Edin.*,
1897, 4to. (310)　　　　　*Hopkins*, £1

8171 Froude (J. A.) Short Studies on Great Sujjects, series one
to three, 3 vol., uncut, 1868-77, 8vo. (142) *Hornstein*, £4 6s.
8172 Gazette de France, orig. ed., Nos. 1 to 57 in 1 vol., old vell.,
1633-4, 4to. (276)　　　　　*Quaritch*, £2 12s.
[This Gazette was patronised jy Richelieu, and
numjered King Louis XIII. of France among its con-
tributors.—*Catalogue.*]
8173 Goldsmith (Oliver). The Vicar of Wakefield, first ed., with
the 32 illustrations by Mulready, cf., arajesque design in
colours on the sides and jack, g. e., Van Voorst, 1843, 8vo.
(197)　　　　　*Spencer*, £3 3s.
8174 Greene (Rojert). Dramatic Works, by Alex. Dyce, 2 vol.,
orig. cl., Pickering, 1831, 8vo. (242)　　*Quaritch*, £1 12s.
8175 Hawthorne (Nathaniel). Mosses from an Old Manse, in two
parts, first ed. (2 leaves stained), *New York*, 1846—The
Scarlet Letter, first issue of the first ed., with the word
"reduplicate" on page 21, afterwards altered to "resusci-
tate," *Boston*, 1850, orig. cl., 8vo. (221)　　*Maggs*, £3
8176 Hujjard (W.) A Narrative of the Troujles with the Indians
in New-England (wanted the map, some lower margins cut
into, a hole through several pages), unbd., not sujject to
return, *Boston*, John Foster, 1677, 4to. (299)
H. Stevens, £10 5s.
8177 Ireland (W. H.) Life of Napoleon, col. folding plates by
Geo. Cruikshank, etc. (soiled copy), 4 vol., hf. cf., J.
Cumjerland, 1828, 8vo. (106)　　*Hornstein*, £14 5s.

8178 Lam (Charles). Elia, oth series (first American ed., of which the second volume antedated the first English ed. of the second series by five years), (many leaves stained,) 2 vol., orig. bds., *Philadelphia,* 1828, 8vo. (234)
Dobell, £2 12s.

8179 Lam (C.) Satan in Search of a Wife, first ed., woodcuts, mor., Moxon, 1831, 8vo. (184) *Houghton,* £1

8180 Lam (C.) Tales from Shakespeare, third ed., plates by W. Blake, 2 vol., cf. gt., 1816, 8vo. (183) *Houghton,* £3 5s.

8181 Lilly (William). An Astrologicall Prediction of the Occurrances in England, first ed., woodcuts, unbd., 1648, 4to. (246) *Shepherd,* 11s.

8182 Lodge (Edmund). Portraits, ports. (a few spotted), 10 vol., hf. mor., t. e. g., 1849-50, imp. 8vo. (172) *Manning,* £5 5s.

8183 London (W.) Catalogue of the most vendile Books in England, with a Supplement, prefixed is an Introduction by a Bookseller at Newcastle-on-Tyne, cf., *Printed in the year* 1658, 4to. (13) *Quaritch,* £2 13s.

8184 Longfellow (H. W.) The Song of Hiawatha, *Boston,* 1855— The Courtship of Miles Standish and other Poems, *ib.,* 1858, first eds., orig. cl., 8vo. (216) *Lord Kesteven,* £1 14s.

8185 Longfellow (H. W.) The Golden Legend, first ed., orig. cl., 1851, 8vo. (215) *Sotheran,* £1 7s.

8186 Lover (Samuel). The Irish Penny Magazine, illustrations y Samuel Lover, vol. i., comprising 52 weekly numers, orig. wrappers, uncut, *Dublin,* 1833 (96) *Hornstein,* £1 4s.
[The only volume pulished, and very scarce in uncut state.—*Catalogue.*]

8187 Mandeville. Lier p̄us cuio auctor fert johānes de mādeville . . . agit de divers patriis regioniz princiis, et insul Turchia armenia maiore et miōre, egipto, etc., gothic letter, initialled in red and lue, modern cf., *Venet.,* circa 1480, 4to. (311) *Honebrook,* £9 10s.
[This is the edition in 61 leaves, 33 lines to a page, which Panzer elieved to have een printed by Thierry Martens at Alost, but which was undoutedly produced at Venice.—*Catalogue.*]

8188 McArthur (John). The Army and Navy Gentleman's Companion, folding plates, orig. bds., uncut, 1784, 4to. (317)
Carble, £1

8189 Military Costumes. Records of the Royal Military Academy, first ed., engraved title and plates, and military costumes, all printed in colours, orig. cl., *Woolwich,* 1851, folio (342)
Thomas, £2 2s.

8190 Nelson. Broadside (Large) or Poster. Britannia Triumphant, announcing the decisive and glorious Victory of Trafalgar, Oct., 1805, giving the composition of the rival forces, names of commanders, etc., in an oak frame, folio (357) *Crichton,* £6

8191 Newspapers. Mercurius Aulicus, 83 numers not consecutive, but includes No. 1, 1642-45—Modern Intelligencer, 26 numers (various), 1645-49—Mercurius Politicus, 47 num-

ɔers (various)—A Perfect Diurnall of some Passages in Parliament, 103 numɔers (various), 1643-49—Mercurius Puɔlicus, 26 numɔers (various), 1660-61—The Kingdomes Intelligencer, 11 numɔers, 1661—Mercurius Eleuticus, 5 numɔers, 1648—Weekly Intelligencer of the Commonwealth, 4 numɔers, 1659—The Weekly Account, May 14, 1645—Weekly Post, 2 numɔers, 1659—Perfect Passages of each Dayes Proceedings, 7 numɔers, 1645—The Loyal Protestant, 71 numɔers (various), 1681-82 (folio)

*Quaritch, £*31

8192 Pallas (P. S.) Travels through the Southern Provinces of the Russian Empire, 20 col. folding views, unlettered proofs, 17 col. plates, folding maps, col. vignettes and facs., 2 vol., 1802-3, 4to. (248) *Hornstein, £*2 2s.

8193 Perrault (Charles). Les Contes des Fées, deuxième édition, par Ch. Giraud, LARGE PAPER, proof port. and vignettes, cf. gt., *Lyon*, 1865, 8vo. (198) *Houghton, £*1

8194 Pinkerton (John). Voyages and Travels, with Index, plates, 17 vol., cf., 1808-14, 4to. (8) *Edwards, £*1 10s.

8195 Pistofilo (Bonaventura). Il Torneo, engraved title, port. and copperplates of men in armour, by Coriolano (on pages 121 and 122 is Music for the Drums), hf. cf., t.e.g., *Bologna*, 1627, 4to. (318) *Menel, £*1 14s.

8196 [Porteus (Beilby).] A ɔrief Account of Three Favourite Country Residences, Fulham, Hunton and Sundridge, 20 copies privately printed, 6 tinted views, hf. cf., g.e., 1806, 8vo. (36) *Philips, £*1 12s.

[The author's own copy, with note in his handwriting: "A ɔrief description of three favourite Country Residences . . . It is my earnest desire that this little Book may never be made puɔlic nor reprinted. B. L., Aug. 11, 1807." This copy passed to Hannah More, who has written ɔeneath: "Given to Miss Mary and Margaret Roɔerts by Hannah More, Jan. 1827. This little Narrative was written by one of the most ɔeloved, amiaɔle, and attached Friends H. More ever had or can have."—*Catalogue.*]

8197 Psalms. A New Version of the Psalms of David, by N. Brady and N. Tate, first ed., cf., *Company of Stationers*, 1696, 8vo. (5) *Pickering, £*1 6s.

8198 Rapin (Le P. R.) Of Gardens, a Latin Poem, Englished by Mr. Gardiner, front. by S. Gribelin, and 4 folding plates of ornamental gardens, old cf., *London*, 1706, 8vo. (44) *Thomas,* 19s.

8199 Rogers (Samuel). Italy, earliest issue, with the vignettes after Turner and Stothard, proofs ɔefore letters (vignettes on pages 88 and 91 reversed), mor., g.e., 1830, 8vo. (194) *Hornstein, £*4 4s.

8200 Rogers (S.) Poems, proof vignettes after Turner and Stothard, mor., g.e., 1834, 8vo. (195) *Hornstein, £*4

8201 Ruskin (J.) The Queens' Gardens, a Lecture delivered at the Town Hall, Manchester, Dec. 14, 1864, uncut, *Manchester*, 1864, 8vo. (113) *Gibbs, £*3 3s.

8202 Ruskin (J.) Leoni, a Legend of Italy, first ed., orig. wrapper, *Privately printed*, 1868, 8vo. (114) *Maggs*, £1 2s.

8203 Ruskin (J.) Samuel Prout, *Printed for private circulation*, orig. wrapper, *Oxford*, 1870, 8vo. (115) *Maggs*, 13s.

8204 Ruskin (J.) The Nature and Authority of Miracle (*For private distribution*), uncut, 1873, 8vo. (116) *Maggs*, £1 1s.

8205 Ruskin (J.) Ruskin's Romance, reprinted from a New England Newspaper, orig. wrapper, uncut, 1889, 8vo. (117) *Burke*, £1 2s.

8206 Sanderson (Rojert). Episcopacy not prejudicial to Regal Power, first ed., title in red and jlack, port. by W. Hollar, 1668, old cf., 1673, 8vo. (37) *Herbert*, £1 1s.

8207 Shakespeare (William). Plays and Poems, from the jest London editions, with Notes, jy Dr. Samuel Johnson, Glossary and Life, "first American ed.," the port., engraved jy R. Field, is the first port. of Shakespeare engraved in America, 8 vol., orig. sheep (damaged), and not uniform, *Philadelphia*, 1795-6, 8vo. (245) *Jaggard*, £5 12s.

8208 Shenstone (W.) The School-Mistress, a Poem, first ed., with the rare Index, hf. mor. (stained), 1742, 8vo. (70) *Power*, £4 6s.

8209 Stevenson (Rojert Louis). On the Thermal Influence of Forests, first ed., orig. wrapper, *Edinburgh*, 1873, 8vo. (107) *Shepherd*, £1 11s.

8210 Stevenson (R. L.) Some College Memories, first ed., orig. wrapper, *Edinburgh*, 1886, 8vo. (108) *Burke*, £2 4s.

8211 Swift (Dean). Works, by Hawkesworth, 24 vol., orig. cf., 1765-75, 8vo. (122) *Hornstein*, £2 13s.

8212 Tennyson (Alfred, Lord). The Lover's Tale (one of 50 copies), *Printed for private circulation*, unbd., uncut, 1875, 8vo. (112) *Burke*, £1 1s.

8213 Thackeray (W. M.) The Orphan of Pimlico, illustrations in two states, plain and in colours, cf. ex., uncut, t. e. g., jy Tout, orig. wrapper jound up, 1876, 4to. (316) *Hornstein*, £6 2s. 6d.

8214 Thackeray (W. M.) The Paris Sketch Book, first ed., designs by the author, on copper and wood, 2 vol., orig. cl. (a few leaves stained), J. Macrone, 1840, 8vo. (231) *Hornstein*, £4 5s.

8215 Thackeray (W. M.) Mrs. Perkins's Ball, col. illustrations, orig. pink bds. (soiled and repaired), g. e., 1847, sm. 4to. (192) *Parsons*, £2 8s.

8216 Thackeray (W. M.) The Kickleburys on the Rhine, first ed., illustrations, col., orig. pink bds. (soiled, jack missing), g. e., 1850, 8vo. (193) *Edwards*, £1 10s.

8217 Thackeray (W. M.) The Yellowplush Correspondence, first ed., orig. bds., *Philadelphia*, 1838, 8vo. (227) *Edwards*, £6 5s.

[A twelve-page introduction was contemplated when the work was sent to press, and this explains why the pagination commences on page "13."—*Catalogue*.]

8218 Thackeray. Bevan (Samuel). Sand and Canvas, col. copy,
hf. mor., t. e. g., 1849, 8vo. (180) *Manning,* £2 2s.
8219 Thackeray. Etchings ɔy the late W. M. Thackeray, while at
Camɔridge, illustrative of University Life, etc., now first
puɔlished from the orig. plates, etchings in two states, plain
and col., hf. mor., t. e. g., 1878, 8vo. (181) *Houghton,* £1 3s.
8220 Waller (Edmund). Poems, first genuine ed. (margins stained),
with autograph signature "Edmund Waller, 1850," orig. cf.
(rebacked), *J. N. for Hu. Mosley,* 1645, 8vo. (123)
Dobell, £6 7s. 6d.
8221 Walton and Cotton. The Complete Angler, Major's first ed.,
ports., plates by Wale and Nash and woodcuts, mor., g. e.,
1823, 8vo. (170) *Edwards,* £2 2s.
8222 Whitman. With Walt Whitman in Camden [March 28—
Octoɔer 31, 1888], ɔy Horace Trauɔel, first ed., port., facs.
and other illustrations, 2 vol., orig. cl., t. e. g., *Boston,* 1906,
and New York, 1908, 8vo. (208) *Richardson,* 15s.
8223 Wilkins (David). Concilia Magnae Britanniae et Hiberniae,
4 vol., cf. (reɔacked), 1737, folio (26) *Harding,* £18 5s.
8224 Yates. Mr. Thackeray, Mr. Yates and the Garrick Cluɔ),
the Correspondence and Facts, stated ɔy Edmund Yates,
unbd., *Printed for private circulation,* 1859, 8vo. (120)
Spencer, £3 5s.

[JUNE 16TH AND 17TH, 1910.]

SOTHEBY, WILKINSON & HODGE.

A MISCELLANEOUS COLLECTION.

(No. of Lots, 502 ; amount realised, £5,893 6s.)

8225 Aɔailard. Lettres d'Abailard et d'Héloïse, par J. Fr. Bastien,
printed on vellum, with two drawings in colours also on
vellum, 2 vol. in 3, old French mor. ex., by Derome le
Jeune, with his ticket dated 1785, *Paris,* 1782 (334)
Isaacs, £48
8226 Ælianus. Æliani Variæ Historiæ liɔri XIIII. (Græcè et
Latinè), cf., g. e., tooled sides, arms of the Ville de Mont-
auɔan, *Genevæ,* 1630, 8vo. (263) *Shore,* £4 6s.
8227 Aerostation. Saint-Fond (Fangas de). Description des
Expériences de la Machine Aérostatique de MM. de
Montgolfier, orig. ed., front. of the Montgolfier ɔalloon
ascending from Versailles, 19 Sept., 1783, and 9 other
plates, orig. hf. ɔinding, *Paris, chez Cuchet,* 1783, 8vo. (1)
Martin, £2 18s.
8228 Aerostation. L'Art de Voyager dans les Airs, ou Les Ballons,
suivant le méthode de MM. de Montgolfier, & suivant les

procédés de MM. Charles et Ro)ert, 3 plates of)alloons, hf. bd., *Paris, chez les Libraires*, 1784, 8vo. (2)

IV. Brown, £1 18s.

8229 Ainsworth (W. H.) Rookwood, fourth and first illustrated ed., illustrations)y G. Cruikshank, mor. ex., J. Macrone, 1836, 8vo. (19) *IV. Brown,* £5 5s.

8230 Ainsworth (W. H.) Jack Sheppard, first octavo ed., illustrations by G. Cruikshank, with a dou)le set of the plates (one plain and the other col.), mor. ex., dou)lé, 1840, 8vo. (53)

Spencer, £3

8231 Ainsworth (W. H.) The Miser's Daughter, third and first 8vo. ed., illustrations)y G. Cruikshank, orig. cl., 1848, 8vo. (78) *Pitcher,* £3 3s.

8232 Ainsworth (W. H.) The Original Holograph Manuscript of his novel, "The Good Old Times," covering 400 pages 4to., dated Sept. 13th, 1876, mor. (387) *Quaritch,* £40

8233 Alken. Funeral Procession of the Duke of Wellington, a panoramic sheet, 60 ft. long, by Henry Alken and George Augustus Sala, 1853 (237) *Spencer,* £6 15s.

[This sheet was the one coloured by the artists as a model from which all the other copies were taken. It is accompanied by the original finished drawing of the funeral car, signed by)oth artists.—*Catalogue.*]

8234 Almanach Royal, Année M.DCC.LVII. Contenant les Naissances des Princes et Princesses de l'Europe. Les Archevêsques, Evêq. Cardinaux & Abbez Commendataires, etc., 6 vol., old French mor., richly tooled, g. e., from the li)rary of Micault d'Harvelay, Conseiller au Parlement de Dijon and Secretary to Louis XV., with his arms, *Paris, chez le Breton,* 1757, 1771, 1774-77, 8vo. (9) *Maggs,* £39

[These volumes)ear three different examples of the arms of Micault d'Harvelay : 1, the ordinary example (as mentioned)y Guigard in his "Nouvel Armorial") ; 2, that in which the insignia are reduced ; and 3, that in which the arms of his wife are conspicuous.—*Catalogue.*]

8235 Almanach Royal, année M.DCC.LXXVIII., mor. ex.,)ound for Madame Adelaide, daughter of Louis XV., with her arms (the escutcheon)eing a mosaic of)lack mor., upon which the fleurs-de-lis of France are stamped in gold), fleurs-delis at the corners and impressed on the)ack, *Paris,* 1778, 8vo. (260) *Shore,* £8 5s.

8236 America. A Declaration of the State of the Colonie and Affaires in Virginia, woodcut of the Great Seal of James I. on title, and on verso of last leaf woodcut of the seal of the Council for Virginia, pp. 11—A Note of the Shipping, Men and Provisions sent to Virginia by the Treasurer and Company in the Yeere 1619, pp. 8—The Names of the Adventurers, with their several sums adventured, paid to Sir Thomas Smith, Knight, late Treasurer of the Company for Virginia, pp. 30, and)lank leaf—Names of the Adventurers with the sums paid by Order to Sir Baptist Hicks, Knight, pp. 4—Orders and Constitutions, partly collected

out of his Majesties Letters Patent, partly ordained ɔy the
Counseil and Company of Virginia, Anno 1619 and 1620,
pp. 39—A Declaration of the Supplies intended to be sent
to Virginia in this year 1620. By his Majesties Counseil for
Virginia, 18 Julii, 1620, pp. 9-16, mor. ex., 1620, 4to. (431)
 Ridler, £33
8237 America. A Fair Representation of His Majesty's Right to
Nova-Scotia or Acadie, 1756—Remarks on the French
Memorials concerning the Limits of Acadia (Nova-Scotia),
with the two maps, 1756, unbd., sm. 4to. (394)
 B. F. Stevens, £6 2s. 6d.
8238 America. A Broadsheet, headed "Die Sabbathi 23 Januarii,
1646," ɔegins "Whereas the severall Plantations in Vir-
ginia, Bermudas, Barɔados and other places of America
have ɔeen much beneficiall to this Kingdome . . ." (piece
torn from inner margin making two letters defective),
Printed for John Wright, 1646, folio (494)
 B. F. Stevens, £2 14s.
8239 America. A Supplement to the Negros' and Indians'
Advocate, by M. G. (wormed), *Printed by J. D.,* 1681—
Rogers (Nathaniel, now in New England). A Letter,
Discovering the Cause of God's Continuing Wrath against
the Nation, 1644, ɔoth unbd., 4to. (163)
 B. F. Stevens, £2 6s.
8240 America. A Letter to a Memɔer of the P————t of
G——t B————n, occasioned by the Priviledge granted ɔy
the French King to Mr. Crozat, unbd., *Printed for J. Baker,
at the Black-Boy in Paternoster-Row,* 1713 *(price 6d.)*
(309) *Sabin,* £39 10s.
[Of the utmost rarity. It consists of 44 pages, including
a half-title. It entirely relates to the then almost unknown
country designated under the name of "Louisiana."—
Catalogue.]
8241 America. Constitutions des Treize États-Unis de l'Amérique,
port. of Benjamin Franklin by Martinet, mor., ɔound for
Marie Josephine (Comtesse de Provence), Consort of
Louis XVIII., with her arms, *Philadelphia and Paris,* 1783,
8vo. (393) *Quaritch,* £35
8242 Anecdotes de la Cour de Philippe-Auguste, à Paris, Chez la
veuve Pissot, au ɔout du Pont-Neuf, Quai de Conti, à la
Croix d'Or, 6 vol., mor., ɔound for Marie Josephine Louise
de Savoie, Comtesse de Provence (consort of Louis XVIII.),
with her arms, 1738, 8vo. (297) *Quaritch,* £29
8243 Apparel. A Briefe Examination for the tyme of a Certaine
declaration lately put in print in the name of Certaine
Ministers in London refusyng to weare the apparell, etc.,
black letter and roman, cf. (corners of 4 leaves mended),
R. Jugge (1566), sm. 4to. (382) *Ellis,* £2
8244 Ashendene Press. Lo Paradiso di Dante Alighieri, reprinted
from the ed. of Venice, 1491, with woodcuts, printed upon
vellum, vell., *Shelley House, Chelsea, printed by St. John
and Cicely Hornby,* 1905, 8vo. (77) *Edwards,* £5 5s.

8245 Bacon (Francis). Sylva Sylvarum, first ed., orig. cf. (re)acked),
*Printed by F. H. for William Lee at the Turks Head in
Fleet Street, next to the Miter,* 1627, folio (231) *Russell,* £5

8246 Bacon (Francis). Three Speeches concerning the Post-Nati,
first ed., unbd., 1641, 4to. (174) *W. Brown,* £1 5s.

8247 Bar)our (John). The Acts and Life of the most Victorious
Conqueror Ro)ert Bruce King of Scotland, 𝔟𝔩𝔞𝔠𝔨 𝔩𝔢𝔱𝔱𝔢𝔯,
mor., g. e., *Edinb.,* And. Anderson, 1670, 8vo. (38)
W. Brown, £4

8248 Baruffaldi (Girolamo). Comentario Istorico-Erudito all'
Inscrizione eretta nel Almo Studio di Ferrara l' Anno 1704,
mor.,)ound for Pope Clement XI., with his arms, *Ferrara,*
1704, 4to. (412) *Borrow,* £3

8249 Baudot de Juilly. Histoire de Philippe Auguste, 2 vol., mor.
ex.,)ound for Mme. Adelaide, daughter of Louis XV., with
her arms, *Paris,* Nyon, 1745, 8vo. (305) *Leighton,* £4

8250 Beaumont (Francis). A Preparative to Studie, or The Virtue
of Sack, first ed., unbd., 1641, 8vo. (386) *Maggs,* £2

8251 Beaumont (Fr.) and Fletcher (John). Comedies and Trage-
dies, first collected ed., port. of Fletcher by Marshall, with
the first edition of The Wild-Goose Chase (the inner mar-
gin of the latter mended), mor. ex., *H. Robinson for H.
Moseley,* 1647-52 (445) *Edwards,* £20 10s.

8252 Beaumont (John). Treatise of Spirits, front., cf. ex., g. e.,)y
F. Bedford, 1705, 8vo. (85) *Pitcher,* 18s.

8253 Bede (C.) The Adventures and further Adventures of Mr.
Verdant Green—Mr. Verdant Green married and done for,
first eds., illustrations, 3 vol., cf. ex., with the orig. wrap-
pers, by Rivière, 1853-4-7, 8vo. (50) *Shore,* £4 5s.

8254 Bernardus (D. A))as Clarevallensis). Epistolae cum aliis
Tractatibus et Ta)ula, 𝔩𝔦𝔱. 𝔤𝔬𝔱𝔥. (Hain, *2870), unbd., large
copy, *absque ulla nota* [*Argent., Eggestein,* 147-], folio
(246) *Ellis,* £3 10s.

8255 Bewick (Thos.) Fa)les of Æsop, first ed., with thum)-
mark receipt, orig. bds., with la)el, *Newcastle, E. Walker
for T. Bewick and Son,* 1818, 8vo. (75) *Maggs,* £3 3s.

8256 Bi)le. The Byble, 𝔟𝔩𝔞𝔠𝔨 𝔩𝔢𝔱𝔱𝔢𝔯, dou)le columns, Calendar,
titles in woodcut compartments, woodcuts in the text (a
few margins repaired), modern mor., g. e.,)y Rivière, John
Day and Wm. Seres, 1549, sm. folio (249) *Leighton,* £10 5s.
[A reprint of Matthew's Bi)le of 1537, revised by Edm.
Becke. Tyndale's Prologue to Jonah is reprinted for the
first time in this edition. It has the readings Bugges and
Triacle, and the Wife-Beating note to 1 Peter iii. Wanted
the)lank for A a a 8 in part 3.—*Catalogue.*]

8257 Bi)le (Holy). Authorised Version, engraved title, Hills and
Field, 1660—The Whole Book of Psalms in Metre)y
Sternhold and Hopkins, *A. M. for Stat. Co.,* 1655, in 1 vol.,
old tortoiseshell)inding, perforated silver clasps, corners
and hinges, 1660-(55), 8vo. (47) *Leighton,* £1 1s.

8258 Bi)lia Sacra Latina, Editionis Vulgatae, cum Prologis S.
Hieronymi, 𝔩𝔦𝔱. 𝔤𝔬𝔱𝔥., chiefly 61 lines (Hain, *3079), woodcut

initial of the saint, some woodcut initials col. by hand, and
painted capitals, old oaken bds., stamped pigskin (wormed,
but generally a good copy), *Ulmae,* Jo. Zainer, 1480, folio
(466) *Stretton,* £195
 [A contemp. MS. note on folio 3 shows that the Bible in
1489 . belonged to the ·Monastery of SS. Dionysius and
Juliana in Schefflar.—*Catalogue.*]

8259 Blagrave (John). The Art of Dyalling in two parts, woodcut
diagrams, cf. gt. (title soiled), *N. O. for S. Waterson,* 1609,
sm. 4to. (398) *Maggs,* £1 1s.

8260 Boccace (Jean). Le Decameron ·(traduit par Le Maçon),
engraved titles, port., 110 plates and vignettes after Eisen,
Gravelot, Boucher, etc., many "avec le paraphe," also the
set of title and 20 plates of "Estampes Galantes" by
Gravelot, "grand papier de Hollande," 5 vol., contemp.
mor. ex. (Derome), *Londres (Paris),* 1757-61, 8vo. (335)
 Edwards, £116

8261 Boccaccio (G.) Il Decamerone, LARGE PAPER, mor., bound
for Louis Philippe Joseph Duc d'Orléans (" Egalité"), with
his arms, floral border on the sides and fleurons in the
panels, 1729 (296) *Sabin,* £13 5s.

8262 Boccaccio (G.) Cy commence le Prologue du liure de Jehan
Bocace, des Nobles hommes et femmes traslate de Latin en
François par Laurens du Prémier fait, manuscript on 418
leaves, illustrated with 8 paintings and several illuminated
letters, orig. oak bds., *Sæc.* XV. (488) *Grafton,* £30
 [A French MS. written on paper, the first leaf (which is
of vellum) is ornamented with a painting (7½in. by 6¾in.);
there are seven other paintings.—*Catalogue.*]

8263 Boethius (A. M. L.) De Consolatione Philosophiae, port.,
mor. ex., with fleur-de-lys, dots, etc. irregularly placed, g. e.,
Lugd. Bat., 1671, 8vo. (276) *Leighton,* £5

8264 Book-Prices Current, from December, 1886 to July, 1905 (vol.
i. to xix.), and Index to the first 10 volumes (1887 to 1896),
buckram, t. e. g. (1 vol. in parts, together 20 vol., 1886-1905,
8vo. (82) *Hornstein,* £8

8265 Bossewell (John). Workes of Armorie, first ed., black letter
and roman, cuts, arms, etc. (a few leaves stained and
guarded, some margins wormed), old cf., R. Tottell, 1572,
sm. 4to. (392) *Baud,* £1 16s.

8266 Boulay (Edmond de). Enterrement Très-Excellent de Très-
Haut et Très-Illustre Prince Claude Lorraine, Duc de
Guyse & d'Aumale, Pair de France, etc., wood engravings,
old French mor., g. e., *Paris,* 1620, 8vo. (21) *Barr,* £2

8267 Boullay (B.) Le Tailleur Sincere, contenant les moyens pour
bien pratiquer toutes sortes de pièces d'ouvrage pour les
habits d'hommes, & la quantité des estoffes qu'il y doit
entrir en chaque espece, etc., port. and engraved dedication
to Jean Baptiste Colbert, woodcuts illustrative of the tailor's
art, orig. vell., 1671, folio (217) *B. F. Stevens,* £10

8268 Boutell (Rev. Chas.) Monumental Brasses and Slabs—The

Monumental Brasses of England, plates, 2 vol., russ. ex., by Clarke and Bedford, G. Bell, 1847-9, roy. 8vo. (110)
Pitcher, £2 10s.

8269 Browne (Sir Thos.) Works, first collected ed., port. by R. White, old cf., T. Basset, etc., 1686, folio (220)
Edwards, £1 16s.

8270 Bryan (M.) Dictionary of Painters and Engravers, inlaid on imp. 4to. paper and extra illustrated by the insertion of about 1,800 examples of the artists, ancient and modern, in etching, mezzotint, line, stipple and aquatint, in various sizes, 8vo. to folio, extended to 21 vol., cf., borders of gold, *Printed for the Illustrator*, n. d., imp. 4to. (223A)
B. F. Stevens, £40

8271 Burne (Nicol). The Disputation concerning the Controversit Headdis of Religion, orig. ed., mor. ex., by F. Bedford, *Imprinted at Parise, the first day of October*, 1581, 8vo. (113)
Martin, £3 15s.

8272 Burns (Robert). The Original Holograph Manuscript Draft of his Letter to William Pitt, entitled the "Address of the Scottish Distillers," 3 full pages, this "Address" is printed in the "Works" of the poet, published by Paterson, of Edinburgh, 1879, but differs considerably from the printed version, large folio (321)
Trebmal, £190

8273 Burns (R.) Poems, port. after Nasmyth, mor. ex., uncut, *Edinb.*, 1787, 8vo. (318)
Maggs, £15 5s.
[A fine copy, with the original rough edges. The misprint of "Boxburghe" for (the Duke of) "Roxburghe" in the List of Subscribers. The subscription leaf was cancelled. —*Catalogue.*]

8274 Burns (R.) Poems, second ed., presentation copy, with inscription in the poet's writing, "To Mr. Andrew Aiken, as a mark of affectionate esteem, from the author," orig. cf. (broken, and pages 109-110 torn), *Edinb.*, 1787, 8vo. (317)
Spencer, £81

8275 Burns (R.) Catalogue of Five Hundred Celebrated Authors of Great Britain, now living, orig. bds., uncut, contains the first biography of Robert Burns, 1788, 8vo. (319) *McInnes*, £2

8276 Byron (Lord). Don Juan, first complete ed., 6 vol. in 3, cf. ex., t. e. g., other edges entirely uncut, by Bedford, 1819-24 (27) *Maggs*, £4 12s. 6d.
[A remarkably fine copy. Vol. i. is second edition, vol. ii.-vi. first editions.—*Catalogue.*]

8277 Byron (Lord). Monody on the Death of the Right Honourable R. B. Sheridan, first ed., cf. ex., 1816, 8vo. (269)
Parratt, £1

8278 C. (L. W.) A very perfect Discourse and Order how to know the Age of a Horse, first ed., black letter, woodcut, unbd., *Imprinted at London by W. W. for Thomas Pauier*, 1610, 4to. (403) *Quaritch*, £5 5s.

8279 Cabeus (Nicolas). Philosophia Magnetica, diagrams in text, mor., broad border of fleur-de-lys, the dedication copy to Louis XIII., *Cologne*, 1629, folio (228) *Maggs*, £10

8280 Campꜣell (Thomas). Poet, The Original Holograph Manuscript of his "Pelham's Widow," covering 173 pages, mor., 4to. (327) *Gunston*, £8

8281 Carlo Magno. Festa Teatrale in Occasione della Nascita del Delfino, engraved ꜣorders, plates, vell., richly tooled, ꜣound for Louis XV., with ꜣorders of fleurs-de-lis and arms, n. d., folio (230) *Leighton*, £4

8282 Carlton (Richard). Madrigals to Five Voyces (Cantus, Quintus, Altus, Tenor, Bassus), first ed. (wormholes in ꜣlank fore-margin), modern cf., *Printed by Thomas Morley*, 1601, 4to. (419) *Quaritch*, £54

8283 Cassiodorus. Ecclesiastice & Tripartite Hystorie, lít. gotð. (Hain, *4572), capitals painted, unbd., "ex-liꜣris M. Martini Pfeifferi Parochi Cadenensis," *Absque nota* [*Argent., M. Flach*, 14—], folio (242) *Barnard*, £1 10s.

8284 Cent Nouvelles Nouvelles (Les), plates ꜣy Romain de Hooghe, in the detached state, 2 vol., cf., g. e., *à Cologne* [*Amsterdam*] *chez Pierre Gaillard*, 1701 (337) *Ellis*, £2 6s.

8285 Cervantes (M. de). Don Quixote, port. and proof plates, fine copy, on LARGE PAPER, 7 vol., cf., *Paris*, 1814, 8vo. (69) *Maggs*, £3 12s. 6d.

8286 Charles VII. Histoire de Charles VII., Roy de France, par J. Chartier, J. Le Bouvier dît Berry Roi des Armes, M. de Concy et autres Autheurs, LARGE PAPER, ports. by Grignon and Langot, mor., richly tooled, with the king's arms, *Paris*, 1661 (478) *Ryder*, £7

[The dedication copy to Louis XIV. A fine example of Antoine Ruette's ꜣinding ; he was appointed "Relieur du Roy" in 1644.—*Catalogue*.]

8287 Charron (P.) Of Wisdom, three bookes, written in French, trans. ꜣy Samson Lennard, first ed., engraved title-page by William Hole, orig. vell., *Printed for Edward Blount and Will Aspley* (1612), (434) *Leighton*, £2 2s.

[The genuine first issue of this famous classic, containing the suppressed dedication to Henry Prince of Wales.—*Catalogue*.]

8288 C[hoderlos] de L[aclos]. Les Liaisons dangereuses, front. and 13 plates, after Fragonard, Monet and Gerard, 2 vol., mor. ex., *Londres* [*Paris*], 1796, 8vo. (338) *Isaacs*, £16 10s.

8289 Chronicon Nurembergense, lít. gotð., woodcuts, col. ꜣy a contemp. hand, contemp. German oak bds., stamped pigskin with metal clasps (rebacked russ., ꜣinding wormed), *Nurembergae*, A. Coꜣerger, 1493, large folio (224) *Hornstein*, £10 10s.

[The first edition (measuring 18¼ ꜣy 13in.), wanted folio cclxii. and the 3 ꜣlank leaves, folio clxix. damaged.—*Catalogue*.]

8290 Coleridge (S. T.) Poems, first ed. (commences on sheet B), old cf., in case [*Lond.*, 1796], 8vo. (252) *Black*, £1 10s.

[Mary Hutchinson's (afterwards Mrs. Wordsworth) copy, with a MS. poem ꜣeginning "Low was Our Pretty Cot,"

said to be in the handwriting of her sister Joanna, and
marginal notes (some cut into), probably by S. T. Coleridge.
—*Catalogue.*]

8291 Congreve (William). Incognita, or Love and Duty Recon-
cil'd, first ed., orig. cf. gt., *Printed for Peter Buck, at the
sign of the Temple, near Temple Bar in Fleet Street,* 1692,
8vo. (278) *Shore,* £7

8292 Cooper (Thos., Bp. of Lincoln). A briefe exposition of Such
Chapters of the Olde Testament as usually are redde, **black
letter**, old English mor., ornamental borders, g. e., *H.
Denham for R. Newbery,* 1573, sm. 4to. (201)
Leighton, £5 2s. 6d.

8293 Coote (Edw.) The English School-Master, orig. ed., old cf.,
A. Maxwell, etc. for the Company of Stationers, 1684, sm.
4to. (399) *Quaritch,* £4 4s.

8294 Crozat Gallery. Recueil d'Estampes d'après les plus beaux
Tableaux qui sont dans le Cabinet du Roy (par P. J.
Mariette), first ed., 2 vol., old cf., *Paris,* 1729-42, folio (207)
Quaritch, £6 10s.

8295 Dante. Le Terze Rime, first initial illuminated and initials
" K. C." below (some plain margins at end stained), vell.,
Venet. in aed Aldi, 1502 (299) *Tregaskis,* £6 5s.
[First Aldine edition, the first of Dante in portable form
and the first book with the anchor from the Aldine Press.—
Catalogue.]

8296 D'Arfeville (Nicolay). Navigation du Roy Jaques Cinquiesme
du nom, autour de son Royaume et Isles Hebrides et
Orchades, folding map of Scotland and plate, orig. vell.,
Paris, 1583, 4to. (197) *Restell,* £34

8297 Davies (J.) Letters of Affaires, Love and Courtship, port.,
orig. sheep, 1657, 8vo. (268) *Parratt,* £4 15s.
[This has a peculiar interest as presenting, beneath the
port. of Voiture, eight lines by Lovelace which are not found
in his Lucasta.—*Catalogue.*]

8298 Discours prononcés dans la Séance publique tenue par la
Classe de la Langue et de la Littérature Françaises de
l'Institut de France le 13 août de l'an 1806, pour la recep-
tion de M. Dam, mor., bound for Napoleon I., with his
arms, *Paris,* 1806, 4to. (146) *Gunston,* £6 15s.

8299 Drayton (Michael). Polyolbion, first ed. of both parts
together, port. of Prince Henry with spear (no printed
titles and no title to part ii.), 30 maps, orig. cf., *Printed for
M. Lownes, J. Brown, etc.,* n. d. (1613-22) (446)
Maggs, £7 10s.

8300 Dumesnil (Pierre). Jeanne d'Arc, ou la France Sauvée,
poëme en douze chants, mor., tooled in the romantic style,
the dedication copy to Louis XVIII., with his arms and
fleurs-de-lis, *Paris,* 1818 (81) *Edwards,* £12
[First ed., signed by the author, bound for the King by
Bradel.—*Catalogue.*]

8301 Edgeworth (Maria). Practical Education and Early Lessons,
3 vol., uncut, presentation copies to her sister Harriet, with

autograph letter and inscriptions on title, *Boston (Mass.),*
1823-5, 8vo. (64) *G. H. Brown,* £2

8302 Eliza)eth (Queen). Injunctions given by the Queenes
Majestie Anno Domini 1559—Articles to be enquired in
the Visitation in the first yeare of the raigne . . of Q.
Eliza)eth, **blarft letter**, first eds., 2 woodcut titles, Chr.
Barker, 1559, in 1 vol., old cf., sm. 4to. (379) *Bagley,* £2 14s.

8303 Ellis (Henry). A Voyage to Hudson's Bay, first ed., maps
and plates, contemp. mor. ex.,)y Dérome le Jeune, with his
ticket, 1748, 8vo. (286) *Parsons,* £4 17s. 6d.

8304 Elyot (Sir Thos.) The Boke named the Governour (third
ed.), **blarft letter**, title with date 1534, old cf., Thos. Berthelet,
1537, 8vo. (261) *Quaritch,* £3 3s.

8305 Erasmus. An Exhortacyon to the Dylygent study of Scrip-
ture, **blarft letter**, the last leaf occupied with the arms of
Westminster and the printer's mark (stains in margins),
unbd., Ro)ert Wyer, n. d. (*c.* 1532), 12mo. (294)
 Leighton, £9 15s.

8306 Fa)les Nouvelles dédiées à Madame La Dauphine, manu-
script of the xviii. century, covering 206 pages, mor.,)ound
for Marie Joseph de Saxe, with her arms and fleurs-de-lis
(*circa* 1750) (405) *Isaacs,* £15 10s.
[This volume is cited in "Les Femmes Bi)liophiles,"
vol. ii., page 103.—*Catalogue.*]

8307 Fasciculus Florum, or a Nosegay of Flowers, translated out
of the Gardens of severall Poets (in verse), old cf., 1636,
8vo. (37) *Maggs,* £3

8308 Fénelon (F.) Les Avantures de Télémaque, front., port.,
plates and vignettes, hf. cf., *Amst.,* 1734, 4to. (107)
 W. Brown, £1 12s.

8309 Ferriol (Bartholome). Reglas Utiles para los Aficionados a
danzar, Provechoso Divertimiento de los que gustan tocar
instrumentos, woodcuts of dancers, cf. gt., *Capoa,* 1745, 8vo.
(292) *Warren,* £3 12s.

8310 Field (John). A Caveat for Parson Howlet, concerning his
untimely flighte, and Scriching in the cleare day lighte of
the Gospell (a few headlines shaved), cf. (broken), R.
Waldegrave, 1581, 8vo. (282) *Ellis,* £1 8s.

8311 Florio (John). A Worlde of Wordes (hole in page 117, and
inkstains on pages 227, 290 and 356), old cf. (xviith Cen-
tury), gt., with the cypher of John Evelyn, in gold on sides
and in panels, and with his autograph inscription on fly-
leaf ()ack defective), *London,* 1598, folio (497)
 B. F. Stevens, £35
[From the li)rary of John Evelyn.—Ed.]

8312 Fuller (Dr. Thos.) A Triple Reconciler, first ed., mor., g. e.,
W. Bentley for W. Shears, 1654—Mixt Contemplations in
Better Times, first ed., mor., g. e., *R. D. for J. Williams,*
1660, together 2 vol., 8vo. (32) *Pettie,* £1 1s.

8313 Furgole (J. B.) Commentaire de l'Ordnance de Louis XV.
sur les Su)stitutions, mor. ex.,)ound for Ga)riel de Sartine,
lieutenant de police, with his arms, *Paris,* 1767, 4to. (200)
 Leighton, £8 5s.

8314 Furniture and Decoration. Livre de Plusieurs Cheminées Nouvelles de plus à la mode, 12 plates, n. d.—Recueil des plus jeaux Portails de plusieurs Eglises de Paris à 1600, P. Cottart fecit, 12 plates—Nouveau Livre d'Autels invente et grave par J. Dolivar, 6 plates, 1690—Livre de Divers Morceau d'Orfeurerie pour enrichir les Ornemens Dautelles, Nouvellement invente et grave par Jean le Pautre, 5 plates, n. d.—Grotesques et Moresques à la Moderne, par J. le Pautre, 6 plates, n. d.—Montans de trophees d'armes à l'antique, dessinés par J. le Pautre, 6 plates, 1659— Differents Morceaux d'Ornements à la Romaine pour servir aux Frises et Corniches, inventées par J. le Pautre, 6 plates, n. d.—Fontaines ou Jets d'Eau à la Moderne, par le Potre, 6 plates, n. d.—Ironwork Gates and Banisters, by M. Haste, 6 plates, n. d.—Designs for Ceilings, 9 plates, n. d.—Designs of Military Trophies and Armour, Renatus Boyvinus Andegavensis Faciebat, 12 plates, 1575-6, jound in 1 vol., old vell., 1575, etc., folio (223) *Batsford*, £8
[James Adam's (the celebrated architect) copy, with his bookplate and several drawings, probably by him.—*Catalogue*.]

8315 Gautier (Théophile). Le Tombeau de, first ed., port., hf. parchment, orig. wrapper bound up, 1873, 4to. (106)
Lovelace, £1 11s.

8316 Gibbons (Orlando). The First Set of Madrigals and Mottets of 5 Parts [Cantus, Altus, Tenor, Bassus, Quintus], first ed., modern cf., *Printed by Thomas Snodham*, 1612, 4to. (384)
B. F. Stevens, £43 10s.

8317 Goldsmith (Oliver). History of England, first ed., 2 vol., old mor. ex., arms of the Earl of Harrington, 1764, 8vo. (29) *Ellis*, £1

8318 Goldsmith (O.) The Haunch of Venison, first ed., head after H. Bunbury, cf. ex., with the half-title, 1776, 8vo. (55)
Spencer, £27

8319 Gould (John). Monograph of the Trochilidae, or Humming-Birds, with 360 col. plates, 5 vol. in the original 25 parts, illustrated limp boards, 1849-61, folio (449) *Sotheran*, £15

8320 Granger and Noble. Biographical History of England, LARGE PAPER, the text of Noble's continuation, inlaid on folio paper, interleaved and extra illustrated by the insertion of upwards of 1200 rare and curious portraits, in mezzotint, stipple and line, of various sizes, 8vo. to folio, extended to 21 vol. folio, cf., gilt backs, and Index vol., hf. cf. gt., *Printed for the Illustrator*, n. d. (223B) *B. F. Stevens*, £35

8321 Gruau (Louys). Nouvelle invention de chasse. Pour prendre et oster les loups de la France, six folding plates, mor. ex., g. e., *Paris*, Pierre Chevalier, 1613 (62) *Quaritch*, £8 5s.

8322 Grüner (L.) The Green Vaults, Dresden, illustrations (in colours) and ports., hf. mor., *Dresden Meinhold*, 1862, folio (213) *Quaritch*, £1 5s.

8323 Guischet (P.) Ars Ratiocinandi Lepida multarum Imaginum Festivitate contexta et in Cartiludium redacta, plates of

XXIV. 38

Tarot cards, mor., g. e. (Padeloup), from the Beckford sale, *Salmurii*, 1650, 4to. (166) *Gunston, £6* 5s.

8324 Gunston (Daniel). Jemmy Twitcher's Jests, cf. ex., *Glasgow*, 1798, 8vo. (93) *Shepherd,* 19s.

8325 Hart (John). An Orthographie, conteyning the due order and reason, howe to write or paint thimage of mannes voice, old cf., W. Seres, 1569, 8vo. (54) *Barr, £6*
[The author was Chester Herald, and his book, which was reprinted by Isaac Pitman in 1850, is the earliest English work on the subject, and contains also the first suggestion of the phonograph. A fine copy (with uncut leaves).—*Catalogue.*]

8326 Hazlitt (William). The Eloquence of the British Senate, first ed., 2 vol., mor., g. e., with water-colour drawing under the gilt on the fore-edge of each volume, by Edwards, of Halifax, Taylor and Hessey, 1808, 8vo. (295) *Rimell, £13* 5s.

8327 Hemmerlin (Felix). Varie Oblectationis Opuscula et Tractatus, lit. goth., long lines, 47 to a full page, with signs., woodcut figure of the author on title (wormed), vell., *Absque nota* [*Strasb., Jo. Reinhardt*, 1497 ?], sm. folio (470) *Wallace, £1* 18s.

8328 Hendley (T. H.) Ulwar and its Art Treasures, chromos, etc., hf. bd., W. Griggs, 1888, folio (214) *Batsford, £1* 4s.

8329 Herodianus. Herodiani Historiæ sui Temporis Libri VIII. ex Graece quondam in Linguam Latinam conversae ab Angelo Politiano, mor., g. e., bound for Antonius Drout, with device, "Ex dono. D. Antonii. Druot., 1658," the three fleurs-de-lis of France, escutcheon and arms, *Londini, excudebat Thom. Harper, impensis Samuelis Browne*, 1639, 8vo. (258) *Edwards, £4* 18s.

8330 Higden (Ranulph). Polycronycon, Englished by John de Trevisa, with continuation to 1460 by W. Caxton, black letter, large woodcut of St. George and the Dragon on title and last leaf, autograph and MS. notes of Thomas Brooke, russ. ex., by Roger Payne, *Imprented in Southwerke by my Peter Treveris at ye expences of John Reynes*, 1527, folio (496) *Grafton, £36*

8331 Hooy (Thos.) The Courtier of Counte Baldessar Castilio, black letter, modern mor. ex., g. e., T. Creede, 1603, sm. 4to. (409) *Ridler, £2* 8s.

8332 Hogg (James). The Ettrick Shepherd, two Original Holograph Manuscripts, his "Wat Pringle o' the Yair," covering 14 closely-written pages, folio, and his "Julia McKenzie," covering 7 pages, folio, 21 pages in all, mor. (326) *McInnes, £24*

8333 Homerus. Opera Omnia Graecè, éditio princeps, with the blank leaf before the text, 2 vol., modern mor., g. e., arms on sides, *Florentiæ Sumptibus Bern. et Nerii Nerliorum*, 1488, folio (493) *Watts, £245*

8334 Horsemanship. The Horsemanship of England, most particularly relating to the Breeding and Training of the Running-Horse, a Poem, cf., 1682, 8vo. (366) *Quaritch, £10* 15s.

8335 Humfrey (Laurence, D.D.) The Nobles, or of Nobilitye, first ed., 𝔟𝔩𝔞𝔠𝔨 𝔩𝔢𝔱𝔱𝔢𝔯, modern mor., g. e., *Imprinted in Flete-Strete by T. Marshe*, 1563, 8vo. (267) *Ellis*, £1 6s.

8336 Il Cortegiano del Conte Baldassarre Castiglione, Riueduto e coretto da Antonio Ciccarelli, mor.,)ound for Charles de Bour)on (Duc de Vendôme, Cardinal Arch)ishop of Rouen), with his arms, *Venice*, 1584, 8vo. (71) *Leighton*, £5 10s.
[The Cardinal, who died in 1590, was the first of the Bour)ons who took to this plain)inding of modern style, which De Thou had already)egun.—*Catalogue.*]

8337 Incuna)ula Typographica. A Collection of Thirty Original Specimen Leaves of the Productions of the First Continental Printers, including 3 leaves (3 pages) of an early Block-Book of the Bi)lia Pauperum—A Leaf from the 42-line Bible, Guten)erg, 1450-55, and others, a list of which is set out in the catalogue, folio, with written descriptions, hf. mor. (142) *Cotton*, £295

8338 Incuna)ula Typographica. A Collection of Thirty-one Original Specimen Leaves, with a few Fragments, of the Early Productions of the First Continental Printers, including Fust and Schoeffer (Psalter, 1457, etc.), many from missals and printed upon vellum, mounted on cartridge paper, in a case, mor., with)rass clasps (143)
Quaritch, £56

8339 Ingpen (Wm.) The Secrets of Num)ers according to Theologicall, etc. Computation, hf. cf., *H. Lowns for J. Parker*, 1624, sm. 4to. (400) *Ridler*, £1 16s.

8340 Johnson and Boswell. A Journey to the Western Islands of Scotland, *London, printed for W. Strahan and T. Cadell*, MDCCLXXV.—The Journal of a Tour to the He)rides, by James Boswell, *London, Henry Baldwin for Charles Dilly, in the Poultry*, MDCCLXXXV., together 2 vol., mor., g. t., uncut, 1775-85, 8vo. (328) *Tregaskis*, £20 10s.

8341 Jonson (Ben). Works, first collected ed., port. by Vaughan (inlaid, engraved title by Hole)acked, last leaf of vol. i. mended, but text intact), 2 vol., old cf., R. Meighen, 1616-40 (443) *Dobell*, £22

8342 Junius (Francis). The Painting of the Ancients, LARGE PAPER, orig. red velvet, *Printed by Richard Hodgkinsonne*, 1638, sm. folio (424) *Passant*, £3 5s.

8343 Kirk (Ro)ert). Secret Commonwealth (100 copies only reprinted), contemp. mor. ex., presentation copy from Sir Walter Scott, with signed inscription on fly-leaf, *Edinb.*, J. Ballantyne and Co., 1815, 4to. (148) *W. Brown*, £4

8344 La Cham)re (Sr. de). Nouvelles O)servations et Conjectures sur l'Iris, vignette on title and diagrams, mor., pro)a)ly)ound by Le Gascon for Anne of Austria, Queen of Louis XIII., *Avec Privilege du Roy à Paris, chez Pierre Rocolet, imprimeur du Roy, au Palais, en la gallerie des Prisonniers, aux armes de la Ville*, M.DC.XXXXX. (1650) (401)
Leighton, £15 10s.

8345 La Chau et Le Blond. Description des principalles pierres

38—2

gravées du Ca)inet de S. A. S. Monseigneur le Duc d'Orléans, front., containing port. of the Duke of Orleans by Saint Au)in, after Cochin, 178 plates and numerous vignettes by Saint Au)in, also 5 of the 8 additional "planches spintriennes")y Saint Au)in, 2 vol., old French mor., g. e., *Paris*, 1780-84, 8vo. (339) *Wilmerding*, £10 10s.

8346 La Fontaine (Jean de). Contes et Nouvelles en vers, engravings by Romain de Hooghe, 2 vol. in 1, mor. (plain), g. e., *Amsterdam*, 1685 (340) *Hatchard*, £1 16s.

8347 La Fontaine (J. de). Contes et Nouvelles en vers, Fermiers Généraux ed., ports. of La Fontaine and Eisen by Ficquet, vignettes by Choffard, and the series of plates by Eisen, those of the "Cas de Conscience" and "Dia)le de Papefiguière" découvertes, 2 vol., contemp. mor., g. e., *Amsterdam (Paris,* Bar)ou), 1762 (341) *Quaritch,* £51

8348 La Serre (Sr. de). Histoire de l'Entrée de la Reyne Mère du Roy tres Chrestien (Anne of Austria) dans les Provinces Unies des Pays Bas, plates, old mor. gt., *Londres*, 1639 (248) *Ellis,* £3 12s.

8349 Latimer (Bp. Hugh). Frutefull Sermons, **black letter**, with full-page cut of Latimer preaching)efore King Edward VI., ornamental initials, etc. (title mended), modern mor. ex., J. Daye, 1571, sm. 4to. (415) *Ellis,* £1 6s.

8350 La Trau (Olivier de). Discours de l'Ordre, milice et religion du St. Esprit, port. of Marie de Medicis, by Vorsterman, *Paris*, 1629—Bref Discours sur la différence des croix d'or, des chevaliers des deux Ordres du roy et des chevaliers hospitaliers de l'Ordre du St. Esprit, *ib.*, 1629—Compendio delli privileggi concessi da diversi Pontifici all' archihospitale di S. Spirito in Sassia di Roma, Viter)o, 1584—Sommaire des privilèges, etc. (traduction française de l'ouvrage précédent), Viter)e, 1584, in 1 vol., mor.,)ound for Louis XIII., covered with semis of fleurs-de-lis, *Paris*, Viter)e, 1584-1629 (383) *Boswell,* £5 10s.

8351 Leti (G.) Il Nipotismo di Roma o vero Relatione delle raggioni che muovono i Pontefici, all' aggrandimento de' Nipoti, 2 vol., mor.,)ound for Jeanne Antoinette Poisson, Marquise de Pompadour, with her arms, 1667, 8vo. (284) *Wilmerding,* £12

8352 Lever (Raphe). Arte of Reason rightly termed Witcraft, **black letter**, cf., g. e., *Imprinted by H. Bynneman*, 1573, 8vo. (265) *Shore,* £5 5s.

8353 Linocerius (G.) Natalis Comitis Mythologiae, sive explicationis Fabularum li)ri decem, mor., arms of the "Ville de Montau)an," *Excudebat Samuel Crispinus*, 1611, 8vo. (49) *Handley,* £7

8354 Livingstone (W.) The Conflict in Conscience of a Dear Christian named Bessie Clerkson, unbd., *Glasgow*, 1681, 8vo. (279) *W. Brown,* £1 10s.

8355 Louvet de Couvray (J. B.) Les Amours du Chevalier de Faublas, 8 plates)y Adam, Larcher, etc. after Collin, 4

vol., cf., g. e., ɔy Rivière, *Paris, chez Ambrose Tardieu,*
1821, 8vo. (342) *Sotheran,* £2 5s.
8356 L(ynton) [A(nthony).] Newes of the Complement of the Art
of Navigation, cf. ex., F. Kyngston, 1609, 4to. (205)
 B. F. Stevens, £11 15s.
8357 Mackintosh (Sir James). The Original Holograph Manu-
script of his History of England, covering over 1,000 4to.
pages, 4 vol., mor. ex. (408) *Farrant,* £5
8358 Maimbourg (L. de). Histoire du Pontificat de S. Gregoire le
Grand, front., 4 vignettes, the vignette to the dedication
containing the arms of Louis XIV., 5 initials and 3 culs-de-
lampe, mor., dedication copy to Louis XIV., with his arms
(not guaranteed), a LARGE PAPER COPY, *Paris,* 1686 (402)
 Borrow, £5 10s.
8359 Maleɔranche (N.) Recherche de la Verité, port., 2 vol.,
contemp. mor., g. e. (Derome), with arms, *Amst.,* 1688, 8vo.
(103) *Parsons,* £3 14s.
8360 Mansel (J.) La Fleur des Histoires, manuscript of the
fifteenth century, on 256 leaves of vellum, written and illu-
minated for John de Montmorency, Lord of Nivelles, who
died in 1477, ornamented with a painting (measuring 7¾
by 7½in.), the arms of Montmorency emɔlazoned in the
ɔottom margin, small illuminated initials, hf. vell. (*circa*
1450), folio (495) *Leighton,* £43
8361 [Markham (Jarvis, *i.e.* Gervase). A Most Exact, Ready and
Plaine Discourse, how to trayne and teach Horses to
Amɔle, first ed., woodcut on title and two others on pages
16 and 19 (a little stained), unbd., *At London, printed by
G. E. for Edward Blount,* 1605, sm. 4to. (418)
 Quaritch, £16 16s.
8362 Markham (Gervase). How to Chuse, Ride, Trayne and
Dyet, ɔoth Hunting-Horses and Running Horses, black
letter, woodcuts (some leaves stained), unbd., *Printed by
E. A. for E. White,* 1606, sm. 4to. (367) *Quaritch,* £6
8363 Marescotti. Vita della Veneraɔile Serva di Deo suor
Giacinta Marescotti (dedicated to Cardinal Marescotti,
with his arms and port. of the Nun), mor., sides covered in
floreate scrolls, ɔound for Cardinal Alɔani, afterwards
Pope Clement XI., with his arms, *Roma,* 1695, 4to. (411)
 Borrow, £6
8364 Marguérite de Navarre. L'Heptameron des Nouvelles,
with a set of 73 plates after Longueil inserted (from the
Berne edition of 1780-81), 3 vol., mor., douɔlé, g. e., *Paris,*
1853-4, 8vo. (343) *Sotheran,* £7 10s.
8365 Marmontel (M.) Contes Moraux, port. ɔy St. Auɔin after
Cochin, engraved titles by Duclos after Gravelot, and 23
plates by Longueil, etc. after Gravelot, J. J. de Bure's copy,
with his inscription dated 1825, 3 vol., old French mor. ex.,
à Paris, chez J. Merlin, 1765 (344) *Quaritch,* £49
8366 Martialis. Epigrammata, lit. goll. (Hain, 8599; Proctor,
4573), old cf. (Sunderland copy), *Absque ulla nota* [*Parma,*
1478?], sm. 4to. (187) *Leighton,* £7 5s.

8367 Maxwell (James). · Carolanna, that is to say, a Poeme in Honour of Our King James, Queen Anne and Prince Charles, old mor. ex., very fine copy, *Imprinted by Edw. All-de* (1619), 4to. (191) *Maggs, £6*

8368 Metal Binding. Missale Romanum, nunc denuo Urɔani VIII., auctoritate recognitum cum Calendario, full-page copperplate engraving; and engraved ɔorders ɔy C. Galle, old massive ɔrass ɔinding, cut in ornamental scrolls in high relief, the interstices filled with a red enamel substance, a ducal crown aɔove a coat-of-arms in centres, insides cut in outline with figures, *Antw. ex off. Plantin. B. Moreti,* 1663, folio (502) *Quaritch, £39*

8369 Milton (John). Defensio pro populo Anglicano, LARGE PAPER, orig. cf., *Typis Du Gardianis,* A.D. 1651 (475) *Sabin, £48*
[Presentation copy from the author, with autograph inscription on title : " Ex donatione Autoris Londini, mense Augusti A° 1651." An inscription on fly-leaf reads : "Hocce Exemplar pretiosius Autographo ipsius Joannis Miltoni."— *Catalogue.*]

8370 Milton (J.) Paradise Lost, 2 vol., contemp. mor., gilt ɔacks, g. e., *Birmingham,* J. Baskerville, 1759, 8vo. (277) *Bain, £9*

8371 Milton (J.) Tetrachordon, first ed. (holes in pages 37 and 98, and wanted final ɔlank leaf), original issue, with the Errata at foot of last page), unbd., *Printed in the yeare* 1645, 4to. (199) *Quaritch, £6*

8372 Missale ad Usum Sarum, a Fragment of 10 leaves printed upon vellum, containing the Missa pro defunctis and· the Canon Missae, the latter having the fine full-page woodcut of the Crucifixion, Pynson, 1500, folio (141) *Quaritch, £10 10s.*

8373 " Missale Mixtum secundum Consuetudinem Ecclesiae Toletanae " (Toledo), eight leaves (14¼ ɔy 10½in.), painted and illuminated Toletan Missal, on vellum, commencing with ruɔric, the first page within decorated ɔorder, initial miniature of the Ascension of Christ, a Cardinal's arms (Toledo?) in lower margin, etc., very fine specimens of Spanish illuminating art of the XVIth Century, *Sæc.* xv., folio (501) *Quaritch, £103*

8374 Molinier (Emile) et Marcou (Frantz). Exposition Rétrospective de l'Art Français des Origines à 1800—Musée du Louvre—Le Moɔilier Français du XVIIe et du XVIIIe siècle — La Collection Wallace—Meuɔles et Oɔjets d'Art Français du XVII. et du XVIII. siècle—Marx (Roger). Exposition Centennale de l'Art Français, 1800-1900, 400 heliotype plates and numerous engravings in the text, together 4 vol., hf. mor. ex., t. e. g., other edges uncut, by Zaehnsdorf, *Paris,* Emile Levy, n. d., 4to. (423) *Passant, £9 15s.*

8375 Montaigne (M. de). Essayes, ɔy John Florio, first ed. (short copy, defects in the 2 leaves of Errata at end), old cf., *V. Sims for E. Blount,* 1603, sm. folio (140) *Maggs, £32*

8376 More (John). A Taɔle from the Beginning of the World to

This Day, wherein is declared in what year of the world everything was done ɔoth in the Scriptures mentioned and also in profane matters, orig. vell., *Cambridge*, 1593, 8vo. (314) *Shore*, £10 10s.

[Manuscript Commonplace Book of Spanish interest, formed from an interleaved copy of a rare Elizaɔethan volume, and comprising memoranda ɔetween the years 1492 and 1621. The owner and annotator has taken the chronological record down to his own time, which includes the early English relations with Virginia and other parts of America.—*Catalogue.*]

8377 More (Sir Thos.) Woorkes, first collected ed., **black letter** (with the Youthful Poems and leaf of printers' errors), contemp. English cf., centre gilt ornament, one clasp, end leaves of a xivth century MS., Cawood, Waly and Tottell, 1557, sm. folio (462) *Dobell*, £20

8378 Morley (Thomas). The First Booke of Balletts to Five Voyces (Cantus, Altus, Tenor, Quintus, Bassus, the five parts complete), first ed., old cf. (reɔacked), with Tudor rose, Thomas Este, 1595, 4to. (404) *B. F. Stevens*, £48

8379 Naps upon Parnassus, a Sleepy Muse nipt and pincht though not awakened, title mounted (leaf defective and hole in another), hf. russ., *Printed by express order from the Wits for N. Brook at the Angel in Cornhill*, 1658, 8vo. (25) *Tregaskis*, £1 15s.

8380 New Testament (The), *R. Barker and Assignes of John Bill*, 1637—The Whole Book of Psalms in English Meter by Sternhold and Hopkins, *Stat. Co.*, 1638, ɔound dos-à-dos in emɔroidered needlework of coloured threads, g. e., good condition, 12mo. (72) *Leighton*, £7 10s.

8381 Norden (John). The Laɔyrinth of Man's Life, mor. ex., 1614, 4to. (440) *Gunston*, £7

8382 Norden (J.) Vicissitudo Rerum, an Elegiacall Poeme, mor. ex., 1600, 4to. (439) *Shore*, £3

[A poem in 157 stanzas of seven lines each, on 24 leaves, the last leaf ɔlank.—*Catalogue.*]

8383 Nostradamus (Michael). True Prophecies or Prognostications, port., old cf., Jo. Salusbury, 1685, folio (219) *Shepherd*, 19s.

8384 Orleans (Père d'). Histoire des Révolutions d'Angleterre, ports. and maps, 4 vol., mor., ɔound for Mme. Victoire Louise Marie Thérèse, second daughter of Louis XV., with her arms, *Paris*, 1750, 8vo. (306) *Quaritch*, £14 15s.

[Three of the volumes contain the ɔookplate of Mme. Victoire engraved by Baron.—*Catalogue.*]

8385 Ovid's Invective, or Curse against Iɔis, faithfully and familiarly translated into English verse, by J. Jones, old cf., 1658, 8vo. (43) *Maggs*, £3 3s.

[The present copy is the author's presentation copy to his friend Thomas Vickers, with a signed inscription in prose and verse of twelve lines in the author's autograph. From the collections of Thomas Park and Richard Heɔer. —*Catalogue.*]

8386 Paris. Views in Paris, 20 etchings)y Thomas Girtin, aquatinted)y Lewis, etc., hf. mor., *London,* 1803, 4to. (182)
Hornstein, £11 15s.
8387 Patrick (St.) Vida y Purgatori de S. Patricio por el Doctor Juan Perez de Montalvan, orig. stamped cf., *Madrid,* 1635, 8vo. (291) *Shore,* £1 16s.
8388 Penn (William). A collection of Ports., Documents and miscellaneous Relics catalogued under the title of "Penn Family Heirlooms" (352) *Parry,* £310
[A descriptive account of these relics is given in the Catalogue.—ED.]
8389 Petity (L'a))é de). Etrennes Françoises, 2 plates of arms, 5 plates by Saint Au)in and one by Gravelot, mor., *Paris,* 1766, 4to. (154) *Parsons,* £8
8390 Petrarca con l' Espositione d' Allessandro Vellutello, printed on)lue paper, ruled in red, mor.,)ound for Madame de Pompadour, with her arms, *Vinegia,* 1541, 8vo. (288)
Sabin, £15
8391 Pettus (Sir John). Volatiles from the History of Adam and Eve, old English mor., g. e., Harleian, 1674 (35)
Barber, 11s.
8392 Picard. Dégré du Méridan entre Paris et Amiens determiné par la Messire de M. Picard, 2 vignettes by Cochin and 8 folding plates by Dheulland, mor.,)ound for Louis XV., with his arms and fleur-de-lis, *Paris,* 1740, 8vo. (287)
Field, £7
8393 Pièces pour une Harpe et une Flute, à Mr. le Duc et à Mme. La Comtesse de Guines, original musical manuscript, old French mor., floreate)orders, with monogram of the Countess de Guines [17—], folio (218) *Leighton,* £10
8394 Piozzi (Hester Lynch). British Synonymy, 2 vol., orig. cf., 1794, 8vo. (271) *Shore,* £1 6s.
[First edition. Inserted is an autograph letter of the authoress (written when Mrs. Thrale) relative to Dr. Charles Burney.—*Catalogue.*]
8395 Playford (Henry). The Dancing Master, engraved title, musical notation, orig. cf., fine copy, 1698, 8vo. (28)
Quaritch, £6 5s.
8396 Playford (John). A Breif Introduction to the Skill of Musick, engraving of the)ass-viol opposite to page 65, woodcut of a violin on page 78, orig. sheep, 1658, 8vo. (304)
Ellis, £23 10s.
[According to Lowndes there is an earlier edition (1655), but this is dou)tful. Lowndes appears to be incorrect in describing a portrait, as the earliest known one appears only in the third edition of this work issued in 1660.—*Catalogue.*]
8397 Planche à tracer Générale de l'Installation de Louis Philippe Joseph d'Orléans, en qualité de grand maître de l'Ordre Royal de la Franc Maçonnerie en France, mor.,)ound for Louis-Philippe d'Orléans (Égalité), with his arms, and the autograph signature of Hue de Breval et Baron de Tous-

saint, together with the seal of the Grand-Orient of France,
s. l. n. d. (*Paris*, 1773), 4to. (149) *Edwards*, £6 2s. 6d.

8398 Plinius (Caius Secundus). Historia Naturalis li>ri XXXVII.,
lit. rom., long lines, 50 to a full page, without marks, ruled
in red and >lue, >orders of first pages of text illuminated,
37 decorated scoll initials, painted capitals, new russ. ex.,
Impressum Venetiis per Nicolaum Jenson Gallicum, 1472,
folio (139) *Leighton*, £46

8399 Plotinus. Opera cum Vita, interprete Latine Marsilio Ficino,
editio princeps (Hain, *13121), hf. mor., *Florentiae*, Ant.
Miscominus, 1492, folio (467) *Ellis*, £2 12s.

8400 Poliphile. Hypnerotomachie, ou Discours du Songe de Poli-
phile, wood engravings (including the Worship of Priapus),
mor. ex., *Paris, pour Jacques Kerver*, 1561 (235)
 Leighton, £8 15s.

8401 Politianus (A.) Omnia Opera, *Colophon*, *Venetiis in aedibus
Aldi Romani mense Julio* M.IID. (1498)—Impetravimus ab
Illustrissimo Senatu Veneto in hoc li>ro idem quod in aliis
nostris, 2 vol., orig. cf., folio (247) *Gunston*, £8 10s.
[A fine copy with the capitals painted throughout. The
present example was commissioned by George of Dal>erg
(Camerarius of Worms), and his arms are illuminated on
the recto of A 4.—*Catalogue.*]

8402 Pollanus (V.) [*i.e.* Philpot (John).] Vera Expositio Disputa-
tionis Instituta mandato Mariae Reginae Angl. Franc. &
Hibern., etc., modern mor. gt., *Impressa Romae, Coram
Castello S. Angeli ad Signum S. Petri*, 1554 (281)
 Martin, £1

8403 Porcelain. Leeds Pottery, Designs of Sundry Articles of
Queen's or Cream Coloured Earthenware, plates, orig.
sheep, *Leeds*, 1794, 4to. (181) *Parsons*, £9 5s.

8404 Prayer. A Brieff discours off the trou>les be>onne at
Franckford in Germany Anno Domini 1554 Abowte the
Booke off off (*sic*) Common Prayer, etc., first ed., **black
letter** (title >acked, some leaves damp-stained), modern
mor., g. e. [*Zurich*], 1575, sm. 4to. (374) *Savile*, £3

8405 Prayer Book and "Memorial" Manuscript. Written and
illuminated by a Parisian artist towards the end of the
fifteenth century, >ound in red velvet, with John Ruskin's
ex-li>ris inside the cover and MS. notes on the fly-leaves,
8vo. (310) *Fulwell*, £105
[This is a choice example of what French writers mean
by calling the later monastic and lay illuminatings "l'art de
babouiner," or playing the monkey. Upwards of 100
different illuminated borders and a large num>er of initials,
some containing painted >irds, others ornaments.—*Cata-
logue.*]

8406 Psalms. I Sette Salmi Penitentiali imitati in Rime dall'
Excellentiss. Dott. Agostino Agostini, titles and Calendar
in red and >lack, 12 wood engravings and 16 full-page
copperplates, mor., uncut, vell. fly-leaves, by Simier, *In
Anversa*, 1595, 8vo. (254) *Wallace*, £3 10s.

8407 Psalms. Kitâ› âl-Zouhour âbèlaby li Dâoud êluéby, mor., dou›lé, by Bozerian, 1753, 8vo. (36) *Maggs*, £1 14s.
[Printed entirely in Ara›ic characters by the monks of the Monastery of St. Jean Baptiste de Chouyr au Mont Liban.—*Catalogue.*]

8408 Pugh (Edward). Cam›ria Depicta, 71 col. plates, orig. bds. (repaired), uncut, 1816, 4to. (183) *Pitcher,* £4

8409 Purcell (Henry). Orpheus Britannicus, first ed., 2 ports. ›y R. White, 2 ›ooks in 1 vol., old cf. (›roken), *J. Heptinstal for H. Playford*, 1698-1702, folio (221) *Leighton,* £1 14s.

8410 Purchas his Pilgrimes, in five Bookes, 4 vol. (vol. i. wanted the engraved title and the folding sheet map of the Mogul Empire, by Elstracke), 1625-26—Purchas his Pilgrimage, fourth ed., 1626, maps, including the rare folding one of Virginia, ›y Capt. John Smith (imperfect and mended), plates and woodcuts (stained in places), together 5 vol., cf. (›roken), 1625-6, folio (460) *Quaritch,* £12

8411 Purchas (Samuel). Purchas his Pilgrimage, third ed., orig. cf., centre ornaments, ex-li›ris of the Hon. John Verney of Alexton in cover, presentation copy from Purchas to the Lord Chief Baron Sir Ro›ert Heath, with long Latin inscription on reverse of title, *W. Stansby for N. Fetherstone*, 1617—Haklu›tus Posthumus, or Purchas his Pilgrimes (vol. i.-iv.), with the fine engraved title in compartments (dated 1624), including Smith's Map of Virginia, by Hole, dated 1606, in vol. iv. (vol. i. wanted Alpha›etical Ta›le, 4 leaves, and Ta›le to the last four ›ooks, in the first part, 12 leaves including imprint; vol. ii. wanted Alpha›etical Ta›le and imprint, 20 leaves; vol. iii. wanted Alpha›etical Ta›le with imprint, 34 leaves; and vol. iv. wanted Alpha›etical Ta›le, 20 leaves), orig. cf., gilt ornaments, old ex-li›ris of John Verney of Alexton and John Peyto Verney, *W. Stansby for Henrie Fetherstone*, 1624-5-5 (452) *Quaritch,* £101
[Presentation copy from the author to Lord Chief Justice Heath, with inscription. This copy sold for £250 in July, 1908. *See* BOOK-PRICES CURRENT, Vol. xxii., No. 9145.—ED.]

8412 Ra›elais (F.) Romance of Gargantua and Pantagruel, trans. by Sir Thomas Urquhart, front., mor. ex., *Edinb.*, 1838 (162) *Kinley,* £2 4s.

8413 Rastell (John). A Treatise intitled Beware of M. Jewel, orig. ed., blaɛk letter (title ›acked), old cf., W. Her›ert's copy, *Antw.*, Jo. Fouler, 1566, 8vo. (33) *H. Stevens,* £1 18s.

8414 Ravisius (J.) Epitheta Joannis Ravisii Textoris Nivernensis, Qui›us accesserunt De Prosodia li›ri IIII., quos Epithetorum præposuimus operi, etc., mor., richly gilt, with arms of the Ville de Montau›an, *Lugduni*, 1607, 8vo. (272) *Leighton,* £5

8415 Remarka›le Trials and Interesting Memoirs of the most noted Criminals, 2 vol., cf. ex., 1765, 8vo. (92) *Maggs,* £3

8416 Reresby (Sir John). Travels and Memoirs, LARGE PAPER,
. illustrated with 40 ports. and col. views, old cf., g. e.
(rejacked), E. Jeffery, Esq., 1812, imp. 8vo. (111)
Hornstein, £1 12s.

8417 Richelieu (Cardinal). Traite qui contient la Methode la plus
Facile et la plus Asseurée pour Convertir ceux qui se sont
Séparez de l'Église, port. of Richelieu, mor.,)ound for
Louis XIV., with his arms, *à Paris, chez Sébastien Cramoisy
Imprimeur ordinaire du Roy, & de la Reyne Régente; et
Gabriel Cramoisy, rue sainct Jacques, aux Cicognes,* MDC. LI.
Avec Approbation et Privilége, 1651, folio (473)
Maggs, £6 17s. 6d.

8418 Rider. British Merlin, mor. ex., crowned monogram of
George III., 2 silver ornaments, each with monogram
G. R., steel clasps, g. e., 1764, 8vo. (257) *Leighton,* £2 14s.

8419 Rojerts (James). The Sportsman's Pocket Companion, first
ed., 40 plates representing horses, old cf., n. d. (? 1760)
(298) *Leighton,* £8 10s.
[This is one of the rare original issues, not the later and
inferior edition done ajout 1820.—*Catalogue.*]

8420 Sacro Busto (Johannes de). Opus sphaericum (wanted
sig. A 1), 3 large woodcuts and numerous woodcut diagrams
in the text, *Parisiis,* Guido Mercator, 1498, folio (484)
Leighton, £5

8421 Sanson. Carte et Description de l'Italie dédiée et presentée
à Monseigneur l'Eminentissime Cardinal Mazarin par son
très humjle Serviteur N. Sanson d'Abbeville, Geographe
du Roy, maps of the different provinces of Italy, after
Sanson jy Tavernier and Plaets, mor., the dedication copy
to Cardinal Mazarin, with his arms, *Paris,* 1648, folio (500)
Ryder, £9
[It was specially)ound and the title specially en-
graved for presentation to Cardinal Mazarin. Each map
has the title set forth in manuscript, most projajly in
Sanson's autograph, as a special mark of respect to the
Cardinal. Bound up at the end is : "Tajle Alphajétique
de Toutes les Villes grandes, moyennes, et petites et autre
places, qui sont de quelque consideration dans la Carte de
l'Italie," Paris, 1648.—*Catalogue.*]

8422 Savile (Capt. Henry). A Lijel of Spanish Lies, mor. ex.,
g. e. (2 letters at page 46 in fac.), 1596, 4to. (371)
Shore, £4 4s.
[This tract is reprinted in Hakluyt's "Principal Navi-
gations," 1600 (vol. iii.). Only five copies appear to be
known.—*Catalogue.*]

8423 Scott (Sir W.) The Life of John Dryden, russ. ex., 1808, 4to.
(325) *W. Brown,* £30
[One of but 50 copies printed (for presents only) on large
and thick paper. This copy is extra-illustrated with nume-
rous fine portraits.—*Catalogue.*]

8424 Scott (Sir W.) Novels and Tales, 24 vol., mor., g. e., fine set,
Edinb., 1821-22, 8vo. (12) *Parsons,* £2 2s.

8425 Scott (Sir W.) The Original Holograph MS. of his "Ro-
mance," dated 1824, comprising 40 closely-written pages
entirely in Scott's autograph, as well as 22 pages which
contain interpolations and additions, also in his autograph,
there are 11 pages of extracts and quotations in some
other hand, 73 pages in all, russ. ex., 1824, 4to. (324)
Sabin, £195
[Quite complete, and differing greatly from the printed
text.—*Catalogue.*]
8426 Scott (Sir W.) Catalogue of the Library at Abbotsford
(compiled by J. G. Cochrane), hf. mor., uncut, *Edinb.*, 1838,
8vo. (323) *McInnes*, £6 15s.
[Mr. Cochrane's personal copy (with manuscript addi-
tions), printed on one side of the paper only. Inserted is a
long autograph letter from Sir Walter Scott, covering 3
pages, 4to., and dated Edinburgh, 13 March, 1812, relative
to the building of Abbotsford.—*Catalogue.*]
8427 Seneca. A Frutefull Worke of Lucius Annæus Senecæ called
The Myrrour or Glasse of Manners and Wysedome, trans.
by Robert Whyttyngton, Poet Laureate, black letter, unbd.,
Wyllyam Myddylton, *anno* 1547, 8vo. (302)
Leighton, £7 7s.
8428 Seneca. The Remedyes agaynst all Casuall Chaunces . . .
trans. by Robert Whyttynton, Poet Laureat, black letter
(last leaf stained), unbd., Wyllyam Myddylton, 1547, 8vo.
(285) *Tregaskis*, £7 15s.
8429 Shakespeare (William). Mr. William Shakspear's Comedies,
Histories and Tragedies, the fourth ed., port. by Droeshout,
russ., g. e. (14¼ in. by 8¾ in.), from the Tempsford Hall
Library, *Printed for H. Herringman, E. Brewster and R.
Bentley*, 1685 (444) *Hornstein*, £51
8430 Shakespeare (W.) Hamlet (text of some leaves defective,
title and margins of most of the leaves repaired), sold not
subject to return, mor. super ex., *R. Young for John
Smethwicke*, 1637, sm. 4to. (108) *Pickering*, £20 10s.
8431 Shakespeare (W.) Poems/ on/ Several Occasions,/ front. by
Hulett, old sheep, an edition of the Poems hitherto not
noted by the Shakespeare bibliographers, *Sold by A.
Murden, R. Newton, etc.*, n. d. [*c.* 1750-60], 8vo. (6)
Quaritch, £3 3s.
8432 Shakespeare (W.) Dramatic Works, India proof engravings,
8 vol., mor. super ex., g. e., by Bedford, in case, *Chiswick*,
n. d., 8vo. (83) *Maggs*, £8 15s.
8433 Sheraton (Thos.) The Cabinet Maker and Upholsterer's
Drawing-Book, orig. ed., front. and plates, old cf., 1793,
4to. (420) *Maggs*, £15
8434 Sheridan (R. B.) The School for Scandal, the orig. manu-
script (apparently not in Sheridan's handwriting), with a
note from Sheridan, signed, submitting the same for the
approbation of the Lord Chamberlain (361) *Quaritch*, £75
[The MS. comprises about 137 pages 4to., russia, blind-
tooled with the Chetwynd arms on the front and back

covers. Some of the pages are slightly scorched at the
edges, but repaired and protected. Portraits of Sheridan
and Mrs. Abington added. The genuineness of the MS.
is established by a number of letters and extracts, all of
which are bound with it.—*Catalogue.*]
8435 Shirley (William). A Letter from the Governor of Massa-
chusets Bay to his Grace the Duke of Newcastle, unbd.,
1746, 8vo. (289) *Leon, £3*
8436 Sidney (Sir Philip). The Countesse of Pembroke's Arcadia
[really sixth ed., with 2 unpaged leaves, one between pages
332-3 and one between pages 482-3], old cf., *H. L. for S.
Waterson*, 1613, folio (480) *Pickering, £2*
8437 Smith (Samuel). History of the Colony of Nova Caesaria, or
New-Jersey, orig. cf., *Burlington, in New Jersey*, 1765, 8vo.
(20) *Lightfoot, £6* 10s.
8438 Smollett (T.) The Adventures of Telemachus, trans. from
the French of Fénélon, first ed., 2 vol., cf. ex., uncut, 1776,
8vo. (308) *Meredith, £10* 5s.
8439 Smollett (T.) History and Adventures of an Atom, first ed.,
2 vol., orig. hf. binding, Robinson and Roberts, 1769 (1749
sic), 8vo. (65) *Leighton, £1* 6s.
8440 Smollett (T.) Roderick Random, first ed., 2 vol., cf., g. e., by
Rivière and Sons, 1748, 12mo. (70) *Hornstein, £6* 5s.
8441 Spenser (Edmund). Faerie Queene, second ed. of vol. i.,
first ed. of vol. ii. (corners of several leaves repaired, a
portion of top margin of A2 in facsimile, some wormholes
in margins, top margin of last leaf cut into, headline of R5
in vol. ii. and some others cut very close, headline of pages
299-300 cut into), not subject to return, 2 vol., new mor.
gt., r. e., *Printed for William Ponsonby*, 1596, sm. 4to. (152)
B. F. Stevens, £25 10s.
8442 Squittino delle discolpe de' pochi Vescovi renitenti a ricevere
la costituzione Unigentus . . . opera Stefano Abbate della
concezione, mor., bound for Pope Clement XI., with his
arms, *Cologne*, 1719, 4to. (413) *Borrow, £3*
8443 Statham (N.) Abridgement of English Law Cases down to
the end of the reign of Henry VI., in Norman French, on
reverse of second leaf, "Per me. R. pynson," on reverse of
last leaf printer's device, old cf. (1490), folio (479) *Field, £60*
[The first English law book. It is an open question
whether this extraordinarily rare book was printed in
London by Pynson, or for him in Rouen by his former
master, Le Tailleur; the probability is that it was printed
on French paper in London by Pynson himself.—*Cata-
logue.*]
8444 Statutes of the most Honourable Order of the Bath, elaborately
bound in old mor., book-mark of silver filigree-work and
silk, and pink silk tiers with tassels, g. e., 1744, 4to. (206)
Hindley, £4
8445 Suckling (Sir John). Last Remains, port. by Wm. Marshall,
cf., g. e., by F. Bedford, H. Moseley, 1659, 8vo. (24)
Maggs, £4

8446 Taylor (John, the Water-Poet). A Common Whore with all these Graces Graced [in verse], first ed. (title and headlines cut into), mor. ex., g. e., *At London, printed for Henry Gosson*, 1622 (346) *Dobell, £3* 6s.

8447 Terentius (P.) Comoediæ, mor., g. e. (Derome), *Birmingham*, J. Baskerville, 1772, 4to. (372) *Bain, £4*

8448 Testament (The New). Rhemes Version, first ed., woodcut initials and ornaments (title mended), mor. ex., ɔy F. Bedford, *Printed at Rhemes by John Fogny*, 1582, 4to. (414) *Dobell, £4* 4s.

8449 Thackeray (W. M.) Comic Tales and Sketches, first ed., 2 vol., orig. cl. (one ɔack damaged), 1841 (307) *Spencer, £9* [Inserted in vol. ii. are the plates by George Cruikshank to illustrate "The Fatal Boots" from the Comic Almanack, 1839.—*Catalogue.*]

8450 Thames. The Panorama of the Thames from London to Richmond, coloured, measuring 55½ ft. and folding into orig. cl. case, with laɔels, Samuel Leigh (183-) (441) *Lightfoot, £6* 5s.

8451 Throckmorton (F.) A Discoverie of the treasons practised and attempted against the Queenes Majestie, original ed. (title and next leaf mended), cf., *n. p. or n.*, 1584, sm. 4to. (389) *£1* 10s.

8452 Thucydides. History of the Warre betwene the Peloponnesians and the Athenians, by Thos. Nicolls, first ed. of the first English translation of Thucydides, 𝔟𝔩𝔞𝔠𝔨 𝔩𝔢𝔱𝔱𝔢𝔯, woodcut title (cut close und margins repaired), modern cf., with leaf of errata (J. Wayland), *Imprinted the* xxv*th day of July a thousand fyve hundredde and fyfty* (1550) (461) *Borrow, £3* 3s.

8453 Tuccaro de l'Abruzzo (A.) Trois Dialogues de l'Exercise de Sauter et Voltiger en l'Air, 38 woodcuts of vaulting, etc., orig. limp vell., *Paris*, 1599, 4to. (147) *Gunston, £5*

8454 Turner (J. M. W.) Liɔer Studiorum, front. and 70 plates, some in first and other early states (margins of a few spotted), hf. mor., 1812-19, folio (448) *W. Ward, £130*

8455 Two Leaves of an old German Manuscript on vellum, ɔeing a Poem on the Life and Death of the Virgin Mary, written in douɔle columns of 41 lines, with painted and illuminated pictures of the Death of the Virgin and her Funeral Procession, *Sæc.* xv., folio (144) *Leighton, £30*

8456 Tymms and Wyatt. Art of Illuminating, illustrations in lithography, cl. ex., Day and Son, 1860, 4to. (159) *Rimell, £1* 14s.

8457 Virgilius. Pub. Virgilii Maronis Mauri Servii Honorati Grammatici Commentarii, cf., ɔound for Louis XIV., with his arms, *Geneva*, 1636, folio (226) *Gunston, £7*

8458 Voltaire. La Pucelle d'Orléans, printed on vellum, with a set of plates after Moreau, etc., proofs ɔefore letters inserted, 2 vol., old mor., g. e., by Bozerian, 1786, 8vo. (348) *Isaacs, £49*

8459 Voltaire. La Pucelle d'Orléans, port. of Jeanne d'Arc by

Gaucher and 20 plates after Monsiau, Le Barⲟier, Maril-
lier, etc., old French mor., g. e., *à Paris, Rue S. André-des-
Arcs, No.* 46, *an* VII. [1799] (349) *Parsons, £3* 6s.
8460 Waller (Edmund). The Works of Edmond Waller, Esquire,
first ed., orig. sheep, *Printed for Thomas Walkley,* 1645,
8vo. (301) *Pickering, £60*
 [The first issue, having the ornamental ⲟorder around
title.—*Catalogue.*]
8461 Wallace. The Life and Acts of the most famous and valiant
Champion Sir William Wallace [in verse], 𝔟𝔩𝔞𝔠𝔨 𝔩𝔢𝔱𝔱𝔢𝔯 (last
leaf defective), orig. vell., *Edinburgh, printed by Gedeon
Lithgow,* 1648, 8vo. (259) *Quaritch, £13*
8462 Wallace. The Life and Acts of the most famous and valiant
Champion, Sir William Wallace (in verse), 𝔟𝔩𝔞𝔠𝔨 𝔩𝔢𝔱𝔱𝔢𝔯, orig.
sheep, *Glasgow,* R. Sanders, 1685, 8vo. (42)
 Skene, £5 7s. 6d.
 [Supposed to have ⲟeen translated into Scottish metre
by Blind Harry, the minstrel.—*Catalogue.*]
8463 Wallace. The Acts and Deeds of Sir William Wallace,
Knight of Ellerslie, with Arnaldi Blair Relationes, LARGE
PAPER, orig. bds., uncut, *Edinb.,* 1758, 4to. (438)
 Shore, £3 5s.
8464 Walpole (Horace). The Castle of Otranto, sixth ed., LARGE
PAPER, front., vell. ex., gilt etruscan ornaments, with a
painting. of the Castle of Otranto on fore-edge (Edwards
of Halifax), *Parma, printed by Bodoni for J. Edwards,*
1791, imp. 8vo. (45) *Lovelace, £10* 2s. 6d.
8465 Walton (Izaak). Lives of Dr. John Donne, Sir Henry
Wotton, Mr. Richard Hooker, Mr. George Herⲟert and
Dr. R. Sanderson, LARGE PAPER, proof ports. on India
paper, cf. gt., John Major, 1825, 8vo. (11) *W. Brown, £1* 10s.
8466 Warner (Wm.) Alⲟions England, cf., g. e., *Printed for G. P.
and Sold by R. Moore in Fleet St.,* 1612, sm. 4to. (416)
 Dobell, £1
8467 Watts (Isaac). Hymns and Spiritual Songs, in Three Books,
first ed., contemp. mor., *Printed by J. Humfreys for John
Lawrence, at the Angel in the Poultrey,* 1707, 8vo. (303)
 Maggs, £20 10s.
8468 Wharton (Sir George). Ephemeris, or a Diary Astronomicall,
port. of Wharton by Faithorne, orig. sheep, with clasps,
1655, 8vo. (273) *Shore, £2* 4s.
8469 Whistler (J. McNeill). Gentle Art of Making Enemies, first
ed., orig. bds., uncut, 1890, 4to. (105) *Edwards, £1* 9s.
8470 White (Gilⲟert). Natural History of Selⲟorne, folding front.
and a vignette, after Grimm, by Lerpiniere, on second
title, and plates, orig. bds., uncut, *Printed by T. Bensley
for B. White and Son, at Horace's Head, Fleet Street,*
M.DCC.LXXXIX., 8vo. (363) *Borrow, £38*
 [Inserted is a holograph letter (signed) of White, 3 pages
4to., addressed to Sir Joseph Banks, dated from Selⲟorne,
near Alton, Hants, April 21, 1768, relating to the flora and
fauna of Selⲟorne.—*Catalogue.*]

8471 Whittington (R.) A Frutefull Worke of Lucius Anneus
Seneca named the forme and Rule of Honest Lyvynge,
𝔟𝔩𝔞𝔠𝔨 𝔩𝔢𝔱𝔱𝔢𝔯, large and clean copy, unbd., *Imprinted in
Fletestrete by Wyllyam Mydylton*, 1546 (79)
Quaritch, £10 10s.
[Only two other copies appear to be known, one in the
British Museum and the other in the Bodleian.—*Cata-
logue.*]

8472 Wilbye (John). The First Set of English Madrigals to 3, 4,
5 and 6 Voices (Cantus, Altus, Tenor, Quintus, Sextus,
Bassus), the six parts, orig. eds., old cf. (reɔacked), with
the Tudor rose surmounted ɔy a crown, *Printed by Thomas
Este*, 1598, 8vo. (365) *Quaritch*, £51
[The collation of the aɔove copy is most unusual, and is
as follows : Cantus, A 2 leaves, B to E in fours, the last leaf
ɔeing a ɔlank ; altus, A 2 leaves, B to E in fours, the last
leaf ɔeing a ɔlank ; tenor, A 2 leaves, B to D in fours ;
quintus, A 2 leaves, B and C 4 leaves each, D 1 leaf ; sextus,
A 2 leaves, B 4 leaves ; ɔassus, A 2 leaves, B to E in fours,
the last leaf ɔeing a ɔlank ; in all 85 leaves, including the
3 ɔlanks. The "Dedication to Sir Charles Cavendish" is
prefixed here to all the divisions.—*Catalogue.*]

8473 Witchcraft. A Tryal of Witches at the Assizes Held at Bury
St. Edmonds for the County of Suffolk, on the tenth day
of March, 1664, ɔefore Sir Matthew Hale, Kt., vell., 1682,
8vo. (15) *Rimell*, £1 9s.

8474 Witchcraft. A Full Confutation of Witchcraft, more particu-
larly of the Depositions Against Jane Wenham, Lately
Condemned for a Witch, at Hertford, in a Letter from a
Physician in Hertfordshire to his Friend in London, vell.,
1712, 8vo. (16) *Maggs*, £1 9s.

8475 Witchcraft. Wenham (Jane). The Impossiɔility of Witch-
craft, in which the Depositions against Jane Wenham are
Confuted and Expos'd, vell., 1712, 8vo. (17) *Maggs*, £1 9s.

8476 Witchcraft. Wenham (Jane). A Full and Impartial Account
of the Discovery of Sorcery and Witchcraft, Practis'd ɔy
Jane Wenham of Walkherne in Hertfordshire, the Pro-
ceedings against her, also her Trial . . ., vell., 1712, 8vo.
(18) *Maggs*, £1 11s.

8477 Wolfius (Jo. Chr.) Biɔliotheca Hebraea, front., mor., ɔound
for Prince Eugene of Savoy, with his arms, *Hamburgi &
Lipsiae, impensis Christiani Liebezeit, Anno* R.S. M.DCC.XV.
(158) *Quaritch*, £6

8478 Wortley (Francis). Characters and Elegies, first ed., cf. ex.,
Printed in the year CI I CXLVI. (1646), 4to. (164)
Hindley, £3 16s.

SOTHEBY, WILKINSON & HODGE.

THE LIBRARY OF MR. J. GARDINER MUIR, OF THRAPSTON, HAMPSHIRE, AND OTHER PROPERTIES.

(No. of Lots, 1034 ; amount realised, £1,960 7s. 6d.)

(a) Mr. Muir's Library.

8479 A'Beckett (G. A.) The Comic History of England and Comic History of Rome, col. plates and woodcuts by J. Leech, 2 vol., hf. mor., t. e. g., n. d., 8vo. (1)
Hornstein, £1 13s.

8480 Ackermann (R.) Microcosm of London, col. plates by Rowlandson and Pugin, 3 vol., hf. mor. (1811), 4to. (316)
Edwards, £13 15s.

8481 Album de la Gazette des Beaux-Arts, 3 series, 150 plates, hf. mor., g. e., *Paris*, 1866-74, folio (453)
Reader, £2 10s.

8482 Alford (Lady M.) Needlework as Art, illustrations, hf. mor., t. e. g., 1886, 4to. (320)
Joseph, £1 13s.

8483 Alison (Sir A.) History of Europe, ports., 23 vol., cf. gt., 1854-60, 8vo. (6)
Hopkins, £4

8484 Analysis of the Hunting Field, by R. S. Surtees, first. ed., 6 col. plates by H. Alken and woodcuts, orig. cl., edges unopened, R. Ackermann, 1846, 8vo. (8)
Young, £10 15s.

8485 Annual Register (The), with Index Volume to years 1758 to 1819, together 152 vol., cf. gt. (not quite uniform and 2 vol. broken), 1758-1908, 8vo. (11)
Sotheran, £13 5s.

8486 Apperley (C. J.) The Life of a Sportman, 38 col. plates by H. Alken, 1874, roy. 8vo. (13)
Sotheran, £4

8487 Arabian Nights (The), trans. by E. Forster, plates by R. Smirke, 5 vol., russ., 1802, roy. 8vo. (14)
Hornstein, £2 8s.

8488 Ariosto (L.) Orlando Furioso [by T. H. Croker], 2 vol., contemp. mor., g. e., 1755, 4to. (322)
Edwards, £1 3s.

8489 [Ashbee (H. S.)] Index Librorum Prohibitorum, front.— Centuria Librorum Absconditorum, front., together 2 vol., hf. mor., *Privately printed*, 1877-79, 4to. (323)
Edwards, £7 2s. 6d.

8490 Austen (Jane). Pride and Prejudice, name on titles, 3 vol., 1813—Emma, 3 vol., 1816, first eds., hf. cf. (not returnable if half titles wanted), 8vo. (20)
Thorp, £11 5s.

8491 Babington (Lieut.-Col.) Records of the Fife Fox Hounds, ports., 1883, 4to. (324)
W. Brown, £1 2s.

8492 Bacon (Francis). Works, port., 10 vol., russ. gt., 1819, 8vo. (21)
Rimell, £2 12s.

8493 Badminton Library (The) of Sports and Pastimes, illustrations, 28 vol., hf. mor., t. e. g., 1891-96, 8vo. (22)
G. H. Brown, £7

8494 Baily's Magazine of Sports and Pastimes, ports. and illustrations, vol. i.-xcii., hf. cf., emblematically tooled (last 2 vol. unbound), 1860-1909, 8vo. (23) *G. H. Brown*, £6 6s.
8495 Baker (G.) History of the County of Northampton, LARGE PAPER, maps and plates, proof, 2 vol., cf. gt. (vol. i. loose), 1822-30, folio (456) *Sotheran*, £8 5s.
8496 Balzac (H. de). Scènes of Parisian Life, etchings, 11 vol., L. Smithers, 1897, 8vo. (26) *Joseph*, £2 8s.
8497 Bardon (D'andré). Costume des Anciens Peuples, plates, 3 vol., contemp. French mor., g. e., *Paris*, 1772, 4to. (327)
Edwards, £4 2s. 6d.
8498 Barth (H.) Travels and Discoveries in North and Central Africa, maps, plates and illustrations, 5 vol., 1857-58, 8vo. (27) *Edwards*, £1 12s.
8499 Beaconsfield (Earl of). Novels and Tales, 11 vol., hf. cf. gt., 1881, 8vo. (28) *Hornstein*, £2 12s.
8500 Beaumont (F.) and Fletcher (J.) Dramatic Works, ports. and plates, 10 vol., cf., 1778, 8vo. (29) *G. H. Brown*, £2 16s.
8501 Beauties of England and Wales, plates, 18 vol. in 26, cf., 1801-18, 8vo. (30) *Thorp*, £2 6s.
8502 Bell's British Theatre, engravings (all col. by hand and sized), 20 vol., cf., 1776-78, 8vo. (32) *Hornstein*, £4 15s.
8503 Biographical Mirrour (The), ports., 2 vol. in 1, hf. russ., Harding, 1795-98, 4to. (333) *A. Jackson*, £3 5s.
8504 Blore (Th.) History of Rutland, plates, russ. gt., by J. Wright, Stanford, 1811, folio (459) *Edwards*, £3 12s.
8505 Boccaccio (G.) The Decameron, by John Payne, 3 vol., vell. gt., *Villon Society*, 1886, 4to. (335) *Hill*, £3 3s.
8506 Bolingbroke (Henry St. John, Visct.) Works, port., 11 vol., cf. gt., 1754-83, 8vo. (45) *Edwards*, 17s.
8507 Bridges (J.) The History of Northamptonshire, port., maps and plates, 2 vol., cf., *Oxford*, 1791, folio (462) *Walford*, £5
8508 Brulliot (F.) Dictionnaire des monogrammes, 3 vol. in 1, cf. gt., *Munich*, 1832-34, 4to. (336) *Hunt*, £1 1s.
8509 Bryan (M.) Dictionary of Painters and Engravers, 2 vol., hf. cf. gt., 1893-95, imp. 8vo. (51*) *Rimell*, £2 9s.
8510 Burke (E.) Works, 16 vol., cf. gt., 1826, 8vo. (52)
G. H. Brown, £5 12s. 6d.
8511 Burns (R.) Poems, first Edinburgh ed., with misprints, port. by Beugo, hf. cf., *Edinb.*, 1787, 8vo. (56) *Spencer*, £1 18s.
8512 Burton (Richard F.) Goa and the Blue Mountains, 1851— Scinde, or the Unhappy Valley, second ed., 2 vol., 1851— Pilgrimage to El-Medinah and Meccah, 3 vol., 1855—First Footsteps in East Africa, 1856—The City of the Saints, 1861 — Abeokuta and the Cameroon Mountains, 2 vol., 1863—The Prairie Traveller, 1863—The Nile Basin, 1864 —Mission to Gelele, second ed., 2 vol., 1864—A Pictorial Pilgrimage to Mecca and Medina, 1865—Wit and Wisdom from West Africa, 1865—Explorations of the Highlands of Brazil, 2 vol., 1869—Letters from the Battle Fields of Paraguay, 1870—Vickram and the Vampire, 1870—Zanzibar, 2 vol., 1872—Lacerda's Journey to Cazembie, 1873—Ultima

Thule, 2 vol., 1875—The Gold Mines of Midian, 1878—
The Land of Midian (Revisited), 2 vol., 1879—Drake
(C. T. T.) Unexplored Syria, 2 vol., 1872—Cameron (V. L.)
To the Gold Coast for Gold, 2 vol., 1883—Early Private
and Public Life, by F. Hitchman, 2 vol., 1887, together 34
vol., maps and plates, hf. mor. gt.., 8vo. (58)
Young, £22 10s.
[All first editions, unless otherwise mentioned.—ED.]

8513 Burton (R. F.) Pilgrimage to El Medinah and Meccah, first
ed., map and plates, 3 vol., orig. cl., 1855, 8vo. (59)
Hill, £2 5s.

8514 Carlyle (Thomas). Collected Works, Library ed., ports. and
plates, 30 vol.—Translations from the German, 3 vol.,
together 33 vol., hf. cf. gt., 1869-71, 8vo. (64)
Hornstein, £14 10s.

8515 Chambers (R.) Domestic Annals of Scotland, 3 vol., cf.,
t. e. g., *Edinb.*, 1874, 8vo. (67) 19s.

8516 Collins (A.) Peerage of England, coats-of-arms, 9 vol., cf.,
1812, 8vo. (73) *Bain, £1 14s.*

8517 Costume. Raccolta di 30 Costumi con altretante Vedute le
più interessanti della Città di Milano, 30 col. plates, orig.
bds., *Milano*, n. d. (*ca.* 1800), 4to. (347) *B. F. Stevens, £3*

8518 Daniel (W. B.) Rural Sports, illustrations, 4 vol., hf. cf.,
1801-12, 8vo. (85) *Thorp, 19s.*

8519 Dante Alighieri, Divine Comedy, trans. by H. W. Longfellow,
3 vol., cf. gt., 1867, roy. 8vo. (87) *Hornstein, £2*

8520 Day (F.) The Fishes of Great Britain and Ireland, plates, 2
vol., 1880-84, imp. 8vo. (89) *Quaritch, £3 6s.*

8521 Defoe (D.) Novels and Miscellaneous Works, with Sir
Walter Scott's notes, port., 20 vol., cf. gt., *Oxford*, D. A.
Talboys, 1840, 8vo. (90) *Hornstein, £13*

8522 Diogenes Laertius. De Vitis, Dogmatis et Apophthegmatis
eorum qui in Philosophia claruerunt lib. X., cum anno-
tationibus Henr. Stephani, 2 vol., mor., g. e., by Roger
Payne, *Paris*, H. Stephanus, 1570 (94) *Bloomfield, £1 7s.*

8523 Dryden (John). Works, by Walter Scott, port., 18 vol., russ.
gt., 1808, 8vo. (100) *G. H. Brown, £6 5s.*

8524 Dryden (J.) Fables, LARGE PAPER, proof plates by Lady
Diana Beauclerc, hf. cf. gt., uncut, T. Bensley, 1797, folio
(473) *Edwards, £1 19s.*

8525 Edgeworth (Maria). Tales and Novels, 18 vol., cf. gt.,
1832-33, 8vo. (104) *Hornstein, £5 2s. 6d.*

8526 Eliot (George). Works, Cabinet ed., 20 vol., cf. gt., n. d., 8vo.
(105) *G. H. Brown, £6*

8527 Fénélon (F.) Les Aventures de Télémaque, plates after C.
Monnet, 2 vol., mor., g. e., *Paris*, 1785, 4to. (361)
Edwards, £4 10s.

8528 Fielding (H.) Works, by A. Murphy, port., 8 vol., cf., 1771,
8vo. (111) *Edwards, £2 8s.*

8529 Fielding (H.) History of Tom Jones, first ed., 6 vol., old cf.,
1749, 8vo. (112) *Rimell, £4*

39—2

8569 Molière (J. P. de). Œuvres, par M. Bret, port. and plates by Moreau le jeune, with the "star" leaves 66-67 and 80-81 in vol. 16 vol., contemp. French cf., g. e., *Paris*, 1773, 8vo.
 (205) *J. Bumpus*, £34 10s.

8570 Milton (J. The Tenure of Kings and Magistrates, first ed. (2 head-lines and one catchword cut), hf. cf., M. Simmons, 1649, 8. (404) *Dobell*, £1 2s.

8571 Neville, Henry). The Isle of Pines, hf. roan, 1668, 8vo. (216) *Edwards*, £1 15s.

8572 Newton (Isaac). Opera quae exstant omnia, 5 vol., cf. gt, 1779-85, 4to. (408) *Wesley*, £

8573 Pardo (Julia). Louis the Fourteenth and the Court of France, 3 vol., 1886 — Court and Reign of Francis the First, 3 vol., 1887 — Life of Marie de Medicis, 3 vol., 18mo, together 9 vol., ports. and illustrations, cf. gt., 8vo. (219) *Hornstein*, £8 19.

8574 Pepys (S.) Diary and Correspondence, by Lord Braybrooke, 6 vol. Bickers, 1875-9, 8vo. (223) *Edwards*, £

8575 Piroli (M. A). Original Designs of Vases, Figures, Pedestals, Friezes, etc., engraved title and 66 plus medallions engraved by Bartolozzi after ... and (one plate defective and a few margins ...

... Jowett, 4 vol.,

... Dialogues trans. by B. ...

... by C. Cowden Clarke, ...

... The British Poets, ... (251)

... Works, by ... Masson and others, ...

... and Memoirs, LARGE ... russ. gt., 1853, ...

... Works, by S. ... printed titles, ...

... 3 vol., 1820-36 ...

... Reynolds, vol. ...

... together 4 ...

8586 Saint-Simon (Duc de). Mémoires par F. Laurent, 20 vol.,
hf. cf. gt., *Paris*, 1818-30, 8vo. (24) *Edwards*, £3 16s.
8587 Scarron (P.) Œuvres, port. and bnts., 7 vol., mor., g. e.,
Amsterdam, J. Wetstein, 1752, 8v. (248) *Hill*, £3 7s.
8588 [Scott (Sir W.)] Waverley, first ei (wanted half titles), 3
vol., hf. roan, 1814, 8vo. (251) *Hornstein*, £13 15s.
8589 Sévigné (Mme. de). Lettres à sa fie et à ses amis, par Ph.
A. Grouvelle, ports., 8 vol., hf. cf. t., *Paris*, 1806, 8vo. (261)
Rimell, £1 9s.
8590 Shakespeare (Wm.) Works, ed. b\Sir Th. Hanmer, plates,
with the ports. and plates from Shakespeare illustrated,
published by Harding in 1793, inerted, 6 vol., mor., g. e.,
Oxford, 1744, 4to. (425) *Quaritch*, £16 10s.
8591 Smollett (T.) Miscellaneous Work >y R. Anderson, port.,
6 vol., cf., *Edinb.*, 1811, 8vo. (275) *G. H. Brown*, £2
8592 Sparrman (A.) Voyage to the Cap of Good Hope, maps
and plates, 2 vol. in 1, cf., 1785, 4t (426) *Hill*, £1 9s.
!593 Stedman (C.) The History of the .merican War, maps, 2
vol., mor. gt., crest and monogran 1794, 4to. (429)
H. Stevens, £3 10s.
;94 Sterne (Laurence). Works, port. ad plates, 10 vol., cf. gt.,
1780, 8vo. (283) *Walpole*, £1
95 Stud Book (The General), containg Pedigrees of Race
Horses, etc. to the year 1900, 19 vl. (with duplicate of vol.
i.), 20 vol. cf., 2 supplements to vl. xix. in cl., 1869-1903,
8vo. (286) *Hornstein*, £8
5 [Surtees (R. S.)] Jorrocks' Jaunts ad Jollities, 16 col. plates
by H. Alken, 1869, roy. 8vo. (287) *Bloomfield*, £2 4s.
· Swift (J.) Works, >y J. Nichols, pa., 19 vol., cf. gt., 1808,
8vo. (289) *Edwards*, £5
Taunton (T. H.) Portraits of Celebated Racehorses, 4 vol.,
rox., 1887-8, 4to. (434) *Edwards*, £4
Tennyson (Alfred Lord). Works, pa., 9 vol., hf. cf., t. e. g.,
1891-96, 8vo. (292) *Hornstein*, £1 16s.
Throsby (J.) Select Views in Leicstershire, with Supple-
mentary Volume, plates, 2 vol., 1ss., *Leicester*, 1789-90,
4to. (437) *Rimell*, £1 15s.
'ouchstone· (S. F.) History of Clebrated English and
French Thorough-Bred Stallions ad French Mares, trans.
>y C. B. Pitman, col. illustrations, 390, o>long folio (522)
Hill, £1 4s.
1er (A. W.) Bartolozzi and his Wcks, illustrations, 2 vol.,
/ell., 1881, 4to. (330) *Dobell*, £1 16s.
itch (J. H.) A Traveller's Not' >r Notes of a Tour
hrough India, etc., map, plates a istrations, *Privately*
rinted, 1896, 4to. (439) *Wheldon*, £1
'lis (R.) London's Armory accu, delineated, presen-
tion copy to Sir John Robinsot of ye Tower of
~don, with his arms and crest, · , imp. 4to. (440)
dwards, £13 5s.
'T.) Anecdotes of Painting 'and, ports. and

8530 Florio (J.) Worlde of Wordes (title mended and signature of Will. Roöinson), hf. cf., *A. Hatfield for E. Blount,* 1598, folio (478) *Maggs,* £3 3s.

8531 Freeman (G. E.) and Salvin (F. H.) Falconry, illustrations, orig. cl., 1859, 8vo. (116) *J. Bumpus,* 19s.

8532 Froude (J. A.) History of England, Library ed., 12 vol., 1862-70, 8vo. (119) *Edwards,* £2 6s.

8533 Garnier (E.) The Soft Porcelain of Sèvres, 50 col. plates, hf. cf., t. e. g., Nimmo, 1892, folio (483) *Batsford,* £2 2s.

8534 Gay (John). Faöles, first ed., vignettes, front. and plates by Gravelot, 2 vol., old cf. gt., 1727-38, 4to. (363) *Maggs,* £11

8535 Genlis (Mme. la Comtesse de). Mémoires sur le dix huitième siècle et la Révolution Française, 10 vol., hf. cf. gt., *Paris,* 1825, 8vo. (124) *Sotheran,* £1 6s.

8536 Gold Coast. The Golden Coast, or a Description of Guinney (title-page mounted and defective, one leaf douätful), hf. cf., *Printed for S. Speed,* 1665, 4to. (368) *Edwards,* £1 11s.

8537 Gould (John). Birds of Great Britain, nearly 370 col. plates, 5 vol., vell., t. e. g., 1873, folio (485) *Thorp,* £43

8538 Grimöle (A.) Deer Stalking, 1886—Shooting and Salmon Fishing, 1892—Highland Sport, 1894—The Salmon Rivers of Scotland, 4 vol., 1900, autograph letter of author inserted, together 7 vol., hf. parchment, 4to. (371) *Walford,* £3

8539 Harper (C. G.) The Brighton Road—The Dover Road— The Portsmouth Road, first eds., illustrations, 3 vol., hf. mor., t. e. g., 1892-95, 8vo. (140) *B. F. Stevens,* £1 16s.

8540 Harris (S.) Old Coaching Days—The Coaching Age, first eds., illustrations by J. Sturgess, 2 vol., hf. mor., t. e. g., 1882-85, 8vo. (141) *Edwards,* £2 4s.

8541 Hartshorne (C. H.) Salopia Antiqua, plates, presentation copy, hf. mor., t. e. g., 1841, 8vo. (142) *B. F. Stevens,* £1 1s.

8542 Hissey (J. J.) An Old Fashioned Journey, 1884—A Drive through England, 1885—On the Box Seat, 1886—A Holiday on the Road, 1887—A Tour in a Phaeton, 1889—Across England in a Dog Cart, 1891—Through Ten English Counties, 1894—On Southern English Roads, 1896, together 8 vol., first eds., illustrations, hf. mor., t. e. g., 8vo. (145) *Edwards,* £8 15s.

8543 Johnson (Sam.) Works, by A. Murphy, port., 12 vol., cf. gt., 1823, 8vo. (158) *James,* £1 13s.

8544 Joly (G.) Mémoires, 2 vol., contemp. French mor., g. e., arms of Louis XV., *Rotterdam,* 1738, 8vo. (161) *Streeton,* £5 12s. 6d.

8545 Kerr (R.) Collection of Voyages and Travels, maps and charts, 18 vol., cf., 1824, 8vo. (165) *James,* £3 8s.

8546 King (Capt. P.) and Fitz Roy (R.) Narrative of the Surveying Voyages of H.M. Ships Adventure and Beagle, maps and plates, 4 vol., 1839-40, 8vo. (166) *Hill,* £1 16s.

8547 Knox (R.) An Historical Relation of the Island of Ceylon, port. by R. White, map and plates, cf. (öroken), 1681, folio (498) *Thorp,* £3 17s. 6d.

8548 La Pérouse (J. F. G. de). Voyage autour du monde, port.

and plates, 4 vol. and Atlas in folio, together 5 vol., hf. russ., *Paris*, 1797, 4to. (385) *Quaritch, £2* 12s.

8549 Latham (J.) A General Synopsis of Birds, with Supplement and Index Ornithologicus, col. plates, 10 vol., russ., with joints, 1781-90, 4to. (386) *Wesley, £2* 14s.

8550 Leland (J.) Itinerary, by T. Hearne, illustrations, 9 vol. in 5, cf. gt., *Oxford*, 1768-70, 8vo. (171) *Quaritch, £2* 14s.

8551 Le Sage (A. R.) Gil Blas, plates after Bornet, 4 vol., cf., *Paris*, 1795, 8vo. (174) *Bloomfield, £2* 14s.

8552 Liechtenstein (Princess). Holland House, first ed., illustrations, 1874, 8vo. (177) *A. Jackson, £1* 4s.

8553 Locke (John). Works, port., 10 vol., cf., 1812, 8vo. (180)
James, £1 19s.

8554 Locke (J.) Works, 10 vol., russ. gt., 1823, 8vo. (181)
James, £3

8555 Lydekker (R.) Deer of all Lands, 24 col. plates and other illustrations, 1898, 4to. (392) *Wheldon, £3* 7s. 6d.

8556 Lysons (D. and S.) Magna Britannia, maps and plates, 6 vol., russ. gt., 1806-22, 4to. (394) *Batsford, £3*

8557 Macaulay (Lord). Works, ed. by Lady Trevelyan, port., 8 vol., cf. ex., 1875, 8vo. (182) *Rimell, £2* 18s.

8558 Macgibbon (D.) and Ross (T.) The Castellated and Domestic Architecture of Scotland, illustrations, 5 vol., hf. cf., t. e. g., *Edinb.*, 1887-92, 8vo. (185) *W. Brown, £7* 2s. 6d.

8559 McIan (R. R.) Clans of the Scottish Highlands, 72 col. plates and 2 illuminated title-pages in 73 oak and gold frames, glazed, 2 vol. of text in 1 vol., mor. ex., Ackermann, 1845-47 (500) *Grant, £8*

8560 McKenney (T. L.) History of the Indian Tribes of North America, 100 ports. col. by hand, 3 vol., *Philadelphia*, 1870, 4to. (396) *Hill, £3* 12s.

8561 Macpherson (D.) Annals of Commerce, Manufactures, Fisheries and Navigation, 4 vol., hf. cf. gt., 1805, 4to. (397)
Hill, £2 4s.

8562 Malet (Capt.) Annals of the Road, col. plates (front. loose), 1876, 8vo. (189) *Streeton, £1* 10s.

8563 Mayer (L.) Views in Egypt, 48 col. plates, hf. russ., 1801, folio (503) *Karslake, £1* 6s.

8564 Marryat (Capt.) Novels, ed. by R. Brimley Johnson, ports. and etchings, 22 vol., hf. mor., t. e. g., J. M. Dent, 1896, 8vo. (194) *Rimell, £4* 15s.

8565 Michaux (F. A.) North American Sylva, 156 col. plates, 2 vol., hf. cf., t. e. g., *Paris*, 1819, imp. 8vo. (200)
Wesley, £7 15s.

8566 Mill (J.) History of British India, maps, 9 vol., 1840-48, 8vo. (201) *Edwards*, 16s.

8567 Millais (J. G.) Game Birds and Shooting Sketches, orig. ed., port. of Bewick by Sir J. Millais, col. plates, hf. roan, t. e. g., 1892, imp. 4to. (401) *B. F. Stevens, £6* 2s. 6d.

8568 Millais (J. G.) British Deer and their Horns, LARGE PAPER, coloured plates and other illustrations, hf. mor., t. e. g., 1897, imp. 4to. (402) *Hill, £2* 17s.

8569 Molière (J. B. P. de). Œuvres, par M. Bret, port. and plates
　　　ɔy Moreau le jeune, with the "star" leaves 66-67 and 80-81
　　　in vol. i., 6 vol., contemp. French cf., g. e., *Paris*, 1773, 8vo.
　　　(205)　　　　　　　　　　　　　*J. Bumpus*, £34 10s.
8570 Milton (J.) The Tenure of Kings and Magistrates, first ed.
　　　(2 headlines and one catchword cut), hf. cf., M. Simmons,
　　　1649, 4to. (404)　　　　　　　　*Dobell*, £1 2s.
8571 Neville (Henry). The Isle of Pines, hf. roan, 1668, 8vo.
　　　(216)　　　　　　　　　　　　*Edwards*, £1 15s.
8572 Newton (Isaac). Opera quae exstant omnia, 5 vol., cf. gt.,
　　　1779-85, 4to. (408)　　　　　　　*Wesley*, £7
8573 Pardoe (Julia). Louis the Fourteenth and the Court of
　　　France, 3 vol., 1886 — Court and Reign of Francis the
　　　First, 3 vol., 1887—Life of Marie de Medicis, 3 vol., 1890,
　　　together 9 vol., ports. and illustrations, cf. gt., 8vo. (219)
　　　　　　　　　　　　　　　　Hornstein, £8 15s.
8574 Pepys (S.) Diary and Correspondence, by Lord Brayɔrooke,
　　　ports., 6 vol., Bickers, 1875-79, 8vo. (223) *Edwards*, £2 6s.
8575 Pergolesi (M. A.) Original Designs of Vases, Figures,
　　　Medallions, Friezes, etc., engraved title and 66 plates,
　　　including 7 medallions engraved ɔy Bartolozzi after Cip-
　　　riani (one plate defective and a few margins mended), hf.
　　　cf., 1777-92, folio (508)　　　　　　*Mathias*, £7
8576 Plato. Dialogues, trans. ɔy B. Jowett, 4 vol., *Oxford*, 1871,
　　　8vo. (226)　　　　　　　　　　*Hill*, £1 16s.
8577 Poets. The British Poets, ɔy C. Cowden Clarke; ports., 36
　　　vol., hf. cf. gt., *Edinb.*, 1868, 8vo. (231)　*Walpole*, £1 11s.
8578 Pope (Alex.) Works, ɔy J. Warton and others, 2 ports.,
　　　9 vol., cf., 1797, 8vo. (232)　　　*Hornstein*, £1 5s.
8579 Reresby (Sir J.) Travels and Memoirs, LARGE PAPER, 40
　　　ports. and plates, some in colours, russ. gt., 1813, imp. 8vo.
　　　(237)　　　　　　　　　　　　*Thorp*, £2 10s.
8580 Reynolds (Sir Joshua). Graphic Works, by S. W. Reynolds,
　　　298 ports. and fancy suɔjects (wanted titles, but with later
　　　titles and indexes inserted), 3 vol., 1820-36—Engravings
　　　from the Works of Sir Joshua Reynolds, vol. iv., 59 plates,
　　　Molteno and Graves, 1835, etc., together 4 vol., hf. cf. gt.,
　　　folio (513)　　　　　　　　　　*Parsons*, £28 10s.
8581 Richardson (S.) Works. Pamela, 4 vol.—Clarissa, 7 vol.—
　　　Sir Charles Grandison, 6 vol., together 17 vol., cf., 1742-54,
　　　8vo. (240)　　　　　　　　　*Quaritch*, £4 10s.
8582 Richardson (S.) Correspondence, by A. L. Barbauld, ports.,
　　　col. plates and facs., 6 vol., hf. cf., t. e. g., 1804, 8vo. (241)
　　　　　　　　　　　　　　　　James, £2 14s.
8583 Rogers (S.) Poems, 2 vol., presentation copy "To Lady
　　　Alɔreda Elizaɔeth Wentworth Fitzwilliam from her sincere
　　　friend Samuel Rogers, Sept. 19th, 1851," mor., g. e., ɔy
　　　Hayday, 1845, 8vo. (242)　　　　*Sawyer*, £3 3s.
8584 Rousseau (J. J.) Œuvres, plates, 11 vol., old cf., arms on
　　　ɔacks, *Amsterdam*, 1762-69, 8vo. (243)　*Rimell*, £4 10s.
8585 Royal Gallery of British Art, 48 engravings, hf. mor., Hogarth,
　　　n. d., atlas folio (515)　　　　　*Richardson*, £1 6s.

8586 Saint-Simon (Duc de). Mémoires, par F. Laurent, 20 vol., hf. cf. gt., *Paris,* 1818-30, 8vo. (246)　　*Edwards,* £3 16s.
8587 Scarron (P.) Œuvres, port. and fronts., 7 vol., mor., g. e., *Amsterdam,* J. Wetstein, 1752, 8vo. (248)　　*Hill,* £3 7s.
8588 [Scott (Sir W.)] Waverley, first ed. (wanted half titles), 3 vol., hf. roan, 1814, 8vo. (251)　　*Hornstein,* £13 15s.
8589 Sévigné (Mme. de). Lettres à sa fille et à ses amis, par Ph. A. Grouvelle, ports., 8 vol., hf. cf. gt., *Paris,* 1806, 8vo. (261)　　*Rimell,* £1 9s.
8590 Shakespeare (Wm.) Works, ed. by Sir Th. Hanmer, plates, with the ports. and plates from Shakespeare illustrated, published by Harding in 1793, inserted, 6 vol., mor., g. e., *Oxford,* 1744, 4to. (425)　　*Quaritch,* £16 10s.
8591 Smollett (T.) Miscellaneous Works, by R. Anderson, port., 6 vol., cf., *Edinb.,* 1811, 8vo. (275)　　*G. H. Brown,* £2
8592 Sparrman (A.) Voyage to the Cape of Good Hope, maps and plates, 2 vol. in 1, cf., 1785, 4to. (426)　　*Hill,* £1 9s.
8593 Stedman (C.) The History of the American War, maps, 2 vol., mor. gt., crest and monogram, 1794, 4to. (429)　　*H. Stevens,* £3 10s.
8594 Sterne (Laurence). Works, port. and plates, 10 vol., cf. gt., 1780, 8vo. (283)　　*Walpole,* £1
8595 Stud Book (The General), containing Pedigrees of Race Horses, etc. to the year 1900, 19 vol. (with duplicate of vol. i.), 20 vol. cf., 2 supplements to vol. xix. in cl., 1869-1903, 8vo. (286)　　*Hornstein,* £8
8596 [Surtees (R. S.)] Jorrocks' Jaunts and Jollities, 16 col. plates by H. Alken, 1869, roy. 8vo. (287)　　*Bloomfield,* £2 4s.
8597 Swift (J.) Works, by J. Nichols, port., 19 vol., cf. gt., 1808, 8vo. (289)　　*Edwards,* £5
8598 Taunton (T. H.) Portraits of Celebrated Racehorses, 4 vol., rox., 1887-8, 4to. (434)　　*Edwards,* £4
8599 Tennyson (Alfred Lord). Works, port., 9 vol., hf. cf., t. e. g., 1891-96, 8vo. (292)　　*Hornstein,* £1 16s.
8600 Throsby (J.) Select Views in Leicestershire, with Supplementary Volume, plates, 2 vol., russ., *Leicester,* 1789-90, 4to. (437)　　*Rimell,* £1 15s.
8601 Touchstone (S. F.) History of Celebrated English and French Thorough-Bred Stallions and French Mares, trans. by C. B. Pitman, col. illustrations, 1890, oblong folio (522)　　*Hill,* £1 4s.
8602 Tuer (A. W.) Bartolozzi and his Works, illustrations, 2 vol., vell., 1881, 4to. (330)　　*Dobell,* £1 16s.
8603 Veitch (J. H.) A Traveller's Notes, or Notes of a Tour through India, etc., map, plates and illustrations, *Privately printed,* 1896, 4to. (439)　　*Wheldon,* £1
8604 Wallis (R.) London's Armory accurately delineated, presentation copy to Sir John Robinson, Lieut. of ye Tower of London, with his arms and crest, cf., 1677, imp. 4to. (440)　　*Edwards,* £13 5s.
8605 Walpole (H.) Anecdotes of Painting in England, ports. and

plates, 5 vol., cf., *Strawberry Hill*, T. Kirgate, 1765-71,
4to. (442)　　　　　　　　　　　　　*Rimell*, £2 6s.
8606 Walpole (H.) Letters, ed. by Peter Cunningham, Library
ed., ports., 9 vol., orig. cl., 1857-59, 8vo. (302)
Edwards, £6 10s.
8607 Washington (George). Life, port., map and plates, 5 vol.,
1804-07, 8vo. (307)　　　　　　　*B. F. Stevens*, £2 3s.
8608 Wood (W.) Index Entomologicus, with Supplement by J. O.
Westwood, cf., g. e., 1854, 8vo. (311)　　*Edwards*, £1 18s.
8609 Woodward (John) and Burnett (G.) A Treatise on Heraldry,
col. coats-of-arms, 2 vol., 1892, 8vo. (312)　　*Bain*, £2 12s.
8610 Wouvermens (P.) Œuvres, par J. Moyreau, port. and 60
plates, hf. cf., *Paris*, 1737, atlas folio (523)　*Little*, £8 15s.
8611 Yule (Capt. H.) A Narrative of the Mission to the Court of
Ava, plates and illustrations, 1858, 4to. (452)
Edwards, £1 1s.

(β) *Other Properties.*

8612 Arnold (Matthew). Works, édition de luxe, port., 15 vol.,
orig. art silk, Macmillan, 1903-4, 8vo. (641)　*Hill*, £4 5s.
8613 Ashendene Press. The Song of Songs which is Solomon's,
printed on vellum, first two leaves with painted and illu-
minated orders, initials in gold and colours, mor., St. John
Hornoy, 1902, 8vo. (643)　　　　*Cockerell*, £7 15s.
8614 Augustinus (S. Aurelius). Opera Omnia, LARGE PAPER, vol.
ix., mor., arms of Gabriel du Puget, *Basil.*, 1529, folio (614)
Bloomfield, £2 10s.
8615 Biblia. La Bible, translatez en Francoys, **lit. gotɧ.** (lettres
bâtardes), (outer margins of first two leaves mended,) mor.
ex., *Achever dimprimer en la Ville et Conte de Neuchastel
par Pierre de Wingh dict Pirot Picard lan* 1535, IIIIe *de
Juing*, folio (799)　　　　　　*Quaritch*, £23 10s.
[The first edition of the Bible in French for the Reformed
Church of Geneva, by P. Olivetan and John Calvin.—*Cata-
logue.*]
8616 Blavatsky (H. P.) The Secret Doctrine, 2 vol., cl., 1888, roy.
8vo. (646)　　　　　　　　　　*James*, £1 12s.
8617 Book of the Dead. Facsimiles of the Papyri of Hunefer,
Anhai, Kerāsher and Netchemet, with transcripts, trans-
lations, etc. by E. A. Wallis Budge, hf. mor., 1899, roy. folio
(800)　　　　　　　　　　　　　*Thin*, £1 5s.
8618 British Museum. Illuminated Manuscripts in the British
Museum, by G. F. Warner, 4 series, 60 plates, in portfolios
as issued, 1899-1903, 4to. (735)　*Edwards*, £6 7s. 6d.
8619 Bryan's Dictionary of Painters and Engravers, illustrations,
5 vol., 1903-05, 4to. (738)　　　*C. Jackson*, £3 16s.
8620 Bulwer-Lytton (Sir E.) The Pilgrims of the Rhine, LARGEST
PAPER, proof engravings, mor., g. e., 1834, imp. 8vo. (651)
James, £1
8621 Burlington Fine Arts Club. Exhibition of Bookbindings,
113 col. plates, mor. ex., with clasps, 1891, roy. 4to. (739)
Barnard, £8 15s.

8622 Byrne (Wm.) Britannia Depicta, hf. mor., 1806, 4to. (740)
James, £1 3s.

8623 Cambridge University Press. Facsimiles of Early English Treatises printed by Caxton and Wynkyn de Worde (only 250 of each printed), 12 vol., hf. vell., *Cambridge*, 1905-07, roy. 8vo. (653) *J. Bumpus*, £3 8s.

8624 Cardiff Records, being Materials for a History of the County Borough, ed. by J. H. Matthews, map and illustrations, 5 vol., rox., 1898-1905, 4to. (742) *Barnard*, £3 3s.

8625 Carmina Gadelica. Hymns and Incantations orally collected in the Highlands and Islands of Scotland, trans. by Alex. Carmichael, port., 2 vol., *Edinb.*, 1900, 4to. (741)
Mackay, £3 3s.

8626 Cipriani (G. B.) A Collection of Prints after his Sketches and Drawings, by Earlom, port. of Cipriani and 50 plates, unbd., J. and J. Boydell, 1789, folio (629)
Bloomfield, £8 10s.

8627 Creighton (M.) Queen Elizabeth, first ed., one of 200 copies on Japanese paper, with duplicate set of the plates, in box, *Boussod*, Valadon, 1896, 4to. (747) *Barnard*, £11

8628 Crisp (F. A.) Armorial China, 150 copies printed, col. plates, hf. vell., *Privately printed*, 1907, 4to. (748)
B. F. Stevens, £2 12s.

8629 Curtis (W.) Flora Londinensis, plates, 2 vol., hf. russ., 1777-98, roy. folio (1016) *Klincksieck*, £2 6s.

8630 Cust (L.) Notes on the Authentic Portraits of Mary Queen of Scots, ports., vell. gilt (2 copies), 1903, imp. 8vo. (656)
Kimell, £1 6s.

8631 De Vinne Press. Poem of the Cid, by A. M. Huntington, edition de luxe, 100 copies printed, port. and plates, 3 vol., vell., *New York*, 1897, folio (802) *B. F. Stevens*, £2 18s.

8632 Doves Press. The English Bible, ed. by the Rev. F. H. Scrivener, 5 vol., vell., T. J. Cobden-Sanderson and E. Walker, 1903-05, folio (803) *Cannon*, £7 15s.

8633 Dundas (Robert). Disputatio de Officio Adsessorum, contemp. mor., the sides tooled, Dutch end papers, g. e., fine specimen of Scotch binding, *Edinburgi*, T. Ruddimann, 1731, 4to. (598) *W. Brown*, £2 18s.

8634 Dürer Society. Publications, the Ten Series complete, with Introductory Notes by Campbell Dodgson, facs. on cardboard mounts, in portfolios, 1898-1908, roy. folio (1029)
J. Bumpus, £19

8635 Gay (John). Fables, first ed., 2 vol. in 1, mor., by Rivière, g. e., 1727-38, 8vo. (886) *Moore*, £9

8636 Hearn (Lafcadio). Japanese Fairy Tales, col. illustrations, 4 vol., *Tokyo* (1902), 12mo. and 16mo. (884) *Moore*, £1 1s.

8637 Herford (Oliver). The Rubaiyat of a Persian Kitten, illustrations, mor. ex., 1905, 8vo. (673) *Cannon*, £2 6s.

8638 Herodotus. A World of Wonders, first ed., the first complete edition of Herodotus in English, cf., *Imprinted for John Norton*, 1607, folio (632) *Bloomfield*, £3 10s.

8639 Kelmscott Press. Chaucer (Geoffrey). Works, edited by

F. S. Ellis, one of 13 copies printed on vellum, illustrations
and decorations by Sir E. Burne-Jones, as issued, *Ham-
mersmith*, W. Morris, 1896, folio (811) *Barnard*, £285
8640 Lady Meux Manuscript No. 1. The Lives of Maэâ' Sêyôn
and Gaэra Krêstôs, the Ethiopian Texts, ed. by E. A.
Wallis Budge, 300 copies printed, 92 col. plates эy W.
Griggs and 33 illustrations, mor., 1898, 4to. (771)
Edwards, £2 4s.
8641 Millais (J. G.) Game Birds and Shooting Sketches, first ed.,
port. of T. Bewick and col. plates, hf. mor., t. e. g., 1892,
folio (1017) *B. F. Stevens*, £6
8642 Millar (Alex.) Disputatio Juridica, contemp. mor., lozenge-
shaped ornaments on the sides, g. e., fine specimen of
Scotch эinding, *Edinburgi*, 1773, 4to. (599)
W. Brown, £2 18s.
8643 Moryson (Fynes). An Itinerary, maps, 4 vol., *Glasgow*,
J. Mac Lehose, 1907-08, 8vo. (691) *Hill*, £1 11s.
8644 Naval Chronicle, complete from its commencement in 1799
to 1818, ports., engravings and charts, 40 vol., hf. bd.
(damaged), 1799-1818, 8vo. (936) *Edwards*, £7 7s. 6d.
8645 Novum Testamentum, Graece et Latine (Erasmus), woodcuts,
initial letters and эorders (one cut into), vell., *Basil.*, J.
Froэenius, 1519, folio (620) *Bull*, £2 8s.
8646 Novum Testamentum, Graece et Latine (Erasmus), initial
letters and other ornamentation, ancient MS. notes, old oak
bds., pigskin (damaged), clasps, *Basil.*, J. Froэenius, 1522,
folio (621) *Bull*, £1 6s.
8647 Pausanias. Description of Greece, trans. by J. G. Frazer,
maps and illustrations, 6 vol., 1898, 8vo. (697)
Sotheran, £4 13s.
8648 Shakespeare (William). "The Bankside Shakespeare," ed.
by Appleton Morgan, 20 vol., *New York Shakespeare
Society*, 1888-92, 8vo. (710) *Edwards*, £1 16s.
8649 Shakespeare (W.) Works, Stratford Town ed., No. 3 of 12
copies printed entirely on vellum, ports., 10 vol., limp vell.,
in эoxes, *Shakespeare Head Press, Stratford-on-Avon*,
1904-06 (711) *J. Bumpus*, £33
8650 Tozzetti (Gio. T.) Notizie degli aggrandimenti delle Scienze
Fisiche Accaduti in Toscana, 3 vol., dedication copy to the
Grand Duke of Tuscany, with his arms, contemp. mor.,
g. e., *Firenze*, 1780, 4to. (596) *Tregaskis*, £2 6s.
8651 Turner (Dawson). Fuci, 258 col. plates of marine plants,
4 vol., hf. russ., uncut, 1808-19, 4to. (1015) *Edwards*, £3 7s.
8652 Victoria History of the Counties of England, ed. эy H. A.
Douэleday, plates and maps, 50 vol., 1900-08, sm. folio
(820) *Harding*, £28 10s.
8653 Worsley (Sir R.) Museum Worsleyanum, orig. ed., one of
100 copies privately printed, presentation copy to N. Mar-
chant, the engraver of the plates (some stained), 2 vol.,
mor. ex., g. e., 1794, imp. folio (611) *Edwards*, £1 6s.

PUTTICK & SIMPSON.

A MISCELLANEOUS COLLECTION.

(No. of Lots, 653 ; amount realised, £663 19s. 6d.)

8654 Adam (R. and J.) Works in Architecture, orig. issue, 8o (complete with 105) engravings by Bartolozzi (wanted plate 5, in part v., vol. i.), Vol. i. and ii. (should be 3 vol.), 2 vol., 1773-1779, atlas folio (626) *Bumpus*, £17 10s.

8655 Alley (G., Bp. of Exeter). The Poore Man's Library, 𝔟𝔩𝔞𝔠𝔨 𝔩𝔢𝔱𝔱𝔢𝔯, old stamped leather, *London, printed by John Daye*, 1571, folio (173) *Lewine*, £1

8656 Apperley (C. J.) Life of John Mytton, 18 col. illustrations by H. Alken and T. J. Rawlins, orig. green cl., g. e., 1837, 8vo. (503) *Bumpus*, £6 15s.

8657 Basilii Opera Omnia. Græco-Latina, 3 vol., old mor., g. e., *Paris*, 1618, folio (218) *Maggs*, £1 10s.

8658 Bible (Holy), 𝔟𝔩𝔞𝔠𝔨 𝔩𝔢𝔱𝔱𝔢𝔯, title mounted, fore-edge painted with Scriptural subject, 1613, folio (270) *Leighton*, £1 16s.

8659 Bible (Holy), with Book of Common Prayer, Apocrypha and Booke of Psalms in English Meeter, old mor., Barker, 1616, folio (274) *Weston*, £1 6s.

8660 Bible (Holy), Genevan or Breeches Version with Apocrypha (title repaired), cf., 1576, folio (257) *Bull*, £1 10s.

8661 Bible (Holy) and Book of Common Prayer, old mor., silver corners, painting of the Good Shepherd on fore-edge, *Oxford*, John Baskett, 1738, folio (272) *Leighton*, £1 8s.

8662 Biblia Latina. Editio Vulgata (cum prologus Ambrosiae), 𝔩𝔦𝔱. 𝔤𝔬𝔱𝔥., double columns, painted initials and large strap initial illuminated on first page, 2 vol., mor. covered bds., *Nurnberg, Ant. Koberg*, 1479, folio (256) *Maggs*, £5 15s.

8663 Biblia Latina. Cum Postilla Domini Hugonis Cardinalis, 𝔩𝔦𝔱. 𝔤𝔬𝔱𝔥., double columns, with gloss., 4 vol., old stamped leather covered bds., *Ant. Koberger, Nurmberg*, 1498, folio (261) *Bidwell*, £1 15s.

8664 Biblia Latina, 𝔩𝔦𝔱. 𝔤𝔬𝔱𝔥., double columns, woodcut title and woodcuts, stamped leather covered bds., *Impressa Lugduni*, 1522, folio (258) *Bidwell*, £1 4s.

8665 Biblia Latina (cum restituta Hebraicorum, Nominum interpretatione), double columns, *Paris*, 1528, folio (266) *Andrews*, 19s.

8666 Buffon (M. de). Œuvres Complètes, port., col. and other plates, 13 vol., mor., g. e., *Paris*, 1777, 8vo. (83) *Maggs*, £1 2s.

8667 Burney (Dr. Charles). General History of Music, port. and plates by Bartolozzi and others, 4 vol., hf. mor., g. e., 1776-89, 4to. (570) *Chappell*, £1 18s.

F. S. Ellis, ce of 13 copies printed on vellum, illustrations
and decoratns by Sir E. Burne-Jones, as issued, *Ham-
mersmith*, W Morris, 1896, folio (811) *Barnard*, £285
8640 Lady Meux Mnuscript No. 1. The Lives of Maȝâ' Sẽyôn
and Gaȝra ‹rẽstôs, the Ethiopian Texts, ed. ȝy E. A.
Wallis Budg, 300 copies printed, 92 col. plates ȝy W.
Griggs and ȝ illustrations, mor., 1898, 4to. (771)
Edwards, £2 4s.
8641 Millais (J. G.) Game Birds and Shooting Sketches, first ed.,
port. of T. ewick and col. plates, hf. mor., t. e. g., 1892,
folio (1017) *B. F. Stevens*, £6
8642 Millar (Alex.) Disputatio Juridica, contemp. mor., lozenge-
shaped ornaents on the sides, g. e., fine specimen of
Scotch bindbg, *Edinburgi*, 1773, 4to. (599)
W. Brown, £2 18s.
8643 Moryson (Fyrs). An Itinerary, maps, 4 vol., *Glasgow*,
J. Mac Leh<e, 1907-08, 8vo. (691) *Hill*, £1 11s.
8644 Naval Chronie, complete from its commencement in 1799
to 1818, pas., engravings and charts, 40 vol., hf. bd.
(damaged), '99-1818, 8vo. (936) *Edwards*, £7 7s. 6d.
8645 Novum Testaentum, Graece et Latine (Erasmus), woodcuts,
initial letter and ȝorders (one cut into), vell., *Basil.*, J.
Froȝenius, 119, folio (620) *Bull*, £2 8s.
8646 Novum Testaentum, Graece et Latine (Erasmus), initial
letters and mer ornamentation, ancient MS. notes, old oak
bds., pigskii(damaged), clasps, *Basil.*, J. Froȝenius, 1522,
folio (621) *Bull*, £1 6s.
8647 Pausanias. Lscription of Greece, trans. by J. G. Frazer,
maps and ilstrations, 6 vol., 1898, 8vo. (697)
Sotheran, £4 13s.
8648 Shakespeare (Villiam). "The Bankside Shakespeare," ed.
by Appleto Morgan, 20 vol., *New York Shakespeare
Society*, 188:92, 8vo. (710) *Edwards*, £1 16s.
8649 Shakespeare (V.) Works, Stratford Town ed., No. 3 of 12
copies printd entirely on vellum, ports., 10 vol., limp vell.,
in ȝoxes, hakespeare Head Press, *Stratford-on-Avon*,
1904-06 (711 *J. Bumpus*, £33
8650 Tozzetti (Gio.v.) Notizie degli aggrandimenti delle Scienze
Fisiche Accduti in Toscana, 3 vol., dedication copy to the
Grand Duk of Tuscany, with his arms, contemp. mor.,
g. e., *Firenz* 1780, 4to. (596) *Tregaskis*, £2 6s.
8651 Turner (Dawɔn). Fuci, 258 col. plates of marine plants,
4 vol., hf. rus., uncut, 1808-19, 4to. (1015) *Edwards*, £3 7s.
8652 Victoria Histry of the Counties of England, ed. ȝy H. A.
Doubleday, plates and maps, 50 vol., 1900-08, sm. folio
(820) *Harding*, £28 10s.
8653 Worsley (Sir ɩ.) Museum Worsleyanum, orig. ed., one of
100 copies rivately printed, presentation copy to N. Mar-
chant, the sgraver of the plates (some stained), 2 vol.,
mor. ex., g.., 1794, imp. folio (611) *Edwards*, £1 6s.

PUTTICK &

A MISCELLANEOUS

(No. of Lots, 653 ; amount

8654 Adam (R. and J.) Works
(complete with 105) engra
plate 5, in part v., vol. i.), Vol.
vol., 1773-1779, atlas folio (626)

8655 Alley (G., Bp. of Exeter). The Poo
lrttrr, old stamped leather, Londo
1571, folio (173)

8656 Apperley (C. J.) Life of John Mytt
H. Alken and T. J. Rawlins, orig.
(503)

8657 Basilii Opera Omnia. Græco-Latin
Paris, 1618, folio (218)

8658 Bible (Holy), black lrttrr, title m
with Scriptural subject, 1613, foli(270)

8659 Bible (Holy), with Book of Comme Prayer,
Booke of Psalms in English Mee, old mo
folio (274)

8660 Bible (Holy), Genevan or Breeche-Ve
(title repaired, cf., 1576, folio (25)

8661 Bible (Holy) and Book of Comme Prayer, old
corners, painting of the Good Shepherd
Oxford, John Baskett, 1738, folio

8662 Biblia Latina. Ed
lit. goth., doubl
initial illumin
Nurnberg, Ant.

8663 Biblia Latina. Cum Postil
lit. goth., double columns, w
leather covered bds., Ant. Kobe
(261)

8664 Biblia Latina, lit. goth., double col
woodcuts, stamped leather cover bds.,
1522, folio (258)

8665 Biblia Latina (cum restituta Hebucorum,
pretatione), double columns, Par 1528, foli

8666 Buffon (M. de). Œuvres Complè, port., col
plates, 13 vol., mor., g.e., Paris, 177, 8vo.

8667 Burney (Dr. Charles). General Htory of Music, po
plates by Bartolozzi and others 4 vol., hf. mor
1776-89, 4to. (570

8668 Clayton (John). Ancient Timɔer Edifices of England, tinted
plates, hf. mor., 1846, folio (621) *Bumpus*, £2 2s.

8669 Coney (J.) Ecclesiastical Edifices of the Olden Time, plates,
2 vol., hf. mor., 1842, folio (620) *Batsford*, £1 7s.

8670 Cruikshank. The Holiday Grammar, by Alfred Crowquill,
first ed., front. and 6 plates by G. Cruikshank, orig. printed
wrappers, 1825, 4to. (569) *Hornstein*, £31 10s.
[Apparently the same copy which ɔelonged to Mr. Edwin
Truman, who seems to have ɔought it many years ago for
3s. *See* BOOK-PRICES CURRENT, Vol. xx., No. 5913.—ED.]

8671 Dante. La Commedia, col commento di Chr. Landino, russ.,
ɔlind tooled, *In Venegia*, 1484, 8vo. (109) *Barnard*, £2 10s.

8672 Dante. L'Enfer, avec les dessins de Gustave Doré, mor. ex.,
douɔlé, in mor. box, velvet lined, 1867, folio (158)
Maggs, £2 6s.

8673 Fischɔach (F.) Ornament of Textile Faɔrics, 160 col. plates,
with English Translation of the Text, in cl. portfolio, 1882
(627) *Quaritch*, £4

8674 Fraser (J. B.) Views in the Himala Mountains, 20 col. plates,
old hf. cf. (ɔroken), Rodwell, 1820, elephant folio (638)
G. H. Brown, £3

8675 Giles (H. A.) Chinese-English Dictionary, 1892, 4to. (521)
Quaritch, £1 8s.

8676 Home Counties Magazine, 11 vol., hf. parchment, 1899-1909,
8vo. (450) *Bell*, £2 2s.

8677 Homerus. Ilias et Odyssea, Grecè cum commentariis Eusta-
thei, 4 vol., cf., g. e., Syston Park copy, *Romæ*, 1550, folio
(201) *Leighton*, £1 5s.

8678 Houghton Gallery. A Set of Prints engraved after the most
Capital Paintings in the Collection of The Empress of
Russia, 130 engravings by Earlom, Valentine Green, etc.,
2 vol., mor., g. e., Boydell, 1788, atlas folio (639)
Sanderson, £25

8679 Leonardus de Utinus. Sermones, lit. goth., douɔle columns,
illuminated initial, *Venetiis*, 1473, 8vo. (105) *Reader*, £2 16s.

8680 Liechtenstein (Princess Marie). Holland House, illustrations,
2 vol., cl. ex., 1874, 8vo. (407) *Jackson*, £1

8681 Licio (R. de). Sermones Quadragesimale, lit. goth., long
lines, painted capitals, mor. (*Schoeffer Mentz*, 1465), folio
(232) *Reuter*, £2 2s.

8682 Ligon (R.) A History of the Island of Barbadoes, map, old
cf. 1673, folio (593) *Wesley*, £1 10s.

8683 Lysons (D.) The Environs of London, with Supplement,
and the Middlesex Parishes, plates, 6 vol., cf., 1792-6, 8vo.
(49) *Cohen*, £1 8s.

8684 Maclean (John). History of the Deanery of Trigg Minor in
Cornwall, maps, col. plates, etc., 3 vol. in 14 parts, 1873-9,
4to. (558) *Walford*, £2 4s.

8685 Mayhew (H.) Adventures of Mr. and Mrs. Sandboys, first
ed., folding plates by George Cruikshank, cl., Bogue (1851),
8vo. (491) *Zaehnsdorf*, £1

8686 Mexia (P.) History of all the Roman Emperors, Englished by W. T(raheron), medallion ports., cf., 1604, folio (154)
Maggs, £1

8687 Salt (H.) Twenty-Four Views. St. Helena, The Cape, India, Ceylon, Abysinnia and Egypt, col. plates by Havell, orig. hf. russ. (broken), Miller, 1809, folio (637)
G. H. Brown, £2 15s.

8688 Sandford (F.) History of the Coronation of James II., plates, cf., 1687, folio (632)
Ellis, £1

8689 Scrope (W.) Days and Nights of Salmon Fishing, first ed., illustrations by T. Landseer, L. Haghe and others, orig. cl., 1843, 8vo. (424)
Bumpus, £4

8690 Sette of Odd Volumes. Year Bokes and other Publications of, about 80 vol. and parts, some duplicates, *Printed for private circulation*, 1895 etc., 8vo. (473)
Bailey, £4 15s.

8691 Shakespeare (W.) Works, "Cambridge Edition," ed. by Clark, Glover and Aldis Wright, 9 vol., 1863-6, 8vo. (383)
Joseph, £1 10s.

8692 Sloane (Sir Hans). Voyage to the Islands of Barbadoes, Jamaica, etc., plates, 2 vol., russ., 1707-25, folio (597)
Edwards, £2

8693 Suetonius. History of Twelve Cæsars, trans. by Philemon Holland, 2 vol., Tudor translations, 1899, 8vo. (370)
Hill, £1 2s.

8694 Thackeray (W. M.) The Newcomes, illustrated by R. Doyle, in the orig. 24 parts in 23, with the wrappers, 1853-55, 8vo. (498)
Spencer, £2 15s.

8695 Turner Gallery (The). A series of sixty Engravings from the principal Works of J. M. W. Turner, with Memoir and Text by Wornum, LARGE PAPER, port. and 60 India proof plates, hf. mor., g. e., 1875, folio (640)
Bumpus, £2 2s.

8696 Valerius Maximus. Factorum et Dictorum Memorabilium Opus, first leaf with illuminated border, old hf. cf., 1482, folio (174)
Leighton, £1 8s.

8697 Van Dyck. Icones Principum Virorum Doctorum, etc., 125 etched ports., mounted in 2 folio guard books, 1646-9 (320)
Gutekunst, £35

8698 Vincentius Bellovacensis. Opera Scilicet Liber Gratiæ, etc., lit. goth., double columns, strap initial and painted capitals, old oak bds., *Basil.*, Jo. Amerbach, 1481, folio (226)
Reuter, £2 4s.

8699 Williamson. Oriental Field Sports, 40 col. plates, LARGE PAPER, 2 vol., mor. ex., Young, 1819, oblong 4to. (505)
Parsons, £3 7s. 6d.

8700 Wilson (Harriette). Memoirs written by herself, 4 vol., hf. cf., Stockdale, n. d., 8vo. (387)
Hornstein, £1 6s.

8701 Wouvermans (P.) Œuvres, gravées d'après ses meilleurs Tableaux, 61 engravings, orig. cf., 1737, folio (321)
Parsons, £6 5s.

The following were also sold by Messrs. Puttick & Simpson on June 28th. They were catalogued among a number of musical instruments :—

8702 Baring-Gould (S.) English Minstrelsie, with notes and historical introductions, ports., etc., 8 vol., 8vo. (243)
Curry, £1 12s.

8703 Burney (Dr.) A General History of Music, port. and plates, 4 vol., 1776-89, 4to. (189) *Williams,* £1 12s.

8704 Descartes (R.) Musicæ Compendium. Excellent Compendium of Musick, Thomas Harper, 1653, sm. 4to. (173)
Barber, £1 1s.

8705 Mace (Thos.) Musick's Monument, port., *London, printed by T. Ratcliffe and N. Thompson,* 1676, folio (194)
Ellis, £7 10s.

8706 Morley (Thomas). A Plaine and Easie Introduction to Practical Musicke, *Imprinted at London by Humfrey Lownes,* old cf., 1608, folio (193) *Maggs,* £6 15s.

8707 Salmon (Thos.) An Essay to the Advancement of Musick, front., *London, printed by J. Macock, and are to be sold by John Car, at the Middle Temple Gate,* 1672—Bound in the same volume is, Locke (Matthew). The Present Practice of Musick vindicated, *London, printed for N. Brooke at the Angel in Cornhill, and J. Playford near the Temple Church,* 1673, 12mo. (175) *Ellis,* £3 19s.

[JUNE 28TH, 1910.]

SOTHEBY, WILKINSON & HODGE.

A PORTION OF THE LIBRARY OF THE LATE MR. THOMAS GRAY, OF DOWANHILL, GLASGOW.

(No. of Lots, 239; amount realised, £2,928 5s.)

8708 Alanvs. De Parabolis. Alias Doctrinale altum/ cum luculenta Glosarum expositione, lit. gotí. (2 types), (16 leaves including title), De Worde's Caxton device on title, modern cf., *Impressus . . . per Wynandum de Worde, etc., Anno Dom.* MCCCCCX. *Die* XIX. *Marcii* (1510), sm. 4to. (185)
Leighton, £9
[Lowndes has this work under Hales (for Ales), but Brunet gives Alain, of Lille, in Flanders, as the writer.— *Catalogue.*]

8709 Albertus Magnus. Compendium Theologicae Veritatis, lit. gotí. (Hain, *439), old port. of Albertus inserted, vell., *Venet.,* Christ. Arnoldus Alemannus, 1476, sm. 4to. (179)
Ellis, £3

8710 Al)in (E.) Natural History of Birds, 306 engravings, col.)y hand, 3 vol., old cf. gt., 1731-38, 4to. (137) *Quaritch*, £2 2s.

8711 Aldus. Index in C. Plinii Hist. Nat. li)ris locupletior, & castigatior, sides of orig. cf.)inding, with arms and devices of Francis I. of France, g. e. (re)acked and repaired), *Venet.*, 1538, 8vo. (85) *Quaritch*, £10 5s.

8712 America. New England's Crisis, or a Brief Narrative of New England's Lamenta)le Estate at present, compar'd with the former (but few) Years of Prosperity, Poetically descri)ed)y a Well-wisher to his Country (16 leaves), modern mor. gt., uncut, *Boston (Mass.)*, *printed and sold by John Foster over against the Signe of the Dove*, 1676 (46) *Quaritch*, £195
[Not apparently recorded. No trace of the sale of a copy can be found. John Foster was the first printer in Boston, in 1674.—*Catalogue.*]

8713 America. Sewall (Samuel, Sometime Fellow of Harvard Colledge). Phaenomena quaedam Apocalyptica ad aspectum Novi Or)is configurata, or some few Lines towards a Description of the New Heaven as it makes to those who stand upon the New Earth Massachu, orig. ed. (34 leaves including title), *Massachuset, Boston, printed by Bartholomew Green and John Allen, and are to be sold by Richard Wilkins*, 1697—Proposals touching the Accomplishment of Prophesies hum)ly Offered, first ed. (8 leaves including title), *ib.*, 1713, large copies, in 1 vol., hf. cf., sm. 4to. (177) *B. F. Stevens*, £13 5s.

8714 America. New Englands Plantation, or a Short and True Description of the Commodities and Discommodities of that Countrey (11 leaves, including title), *T. C. and R. C. for Michael Sparkes at the Signe of the Blew Bible in Greene Arbor in the Little Old Bailey*, 1630—A True Relation of the late Battell fought in New England)etween the English and the Salvages (14 leaves, including title), *Printed by M. P. for Nath. Butter and J. Bellamie*, 1637—Eliot (John). A Late and Further Manifestation of the Progress of the Gospel amongst the Indians in New England, first ed. (16 leaves, including title), (last 2 leaves defective,) *Printed by M. S.*, 1655—A Brief Narrative of the Progress of the Gospel amongst the Indians in New-England (6 leaves, including title), *Printed for John Allen*, 1671—Lederer (John). Discoveries in three several Marches from Virginia to the West of Carolina, trans. by Sir Wm. Tal)ot, orig. ed., with the rare map (18 leaves, including leaf of license on title), (lower plain margins repaired, some headlines cut into,) *J. C. for S. Heyrick*, 1672, in 1 vol., hf. cf., sm. 4to. (178) *B. F. Stevens*, £510

8715 Angelus (Joannes). Astrola)ium Planum in ta)ulis Ascendens continens, editio prima (Hain, *1100), woodcuts and initials, modern cf., *Aug. Vind. Erhart Ratdolt*, 1488, sm. 4to. (180) *Leighton*, £4 10s.

8716 Appianus. Romanae Historiae liber, Traductio latiné per P.
Candidum, lit. rom., long lines, 31 to a full page, with signs.
(part i., containing signs. A-O only, commencing on a ii.),
first page of text surrounded by woodcut scroll border and
several scroll initials in text, old Scotch mor., inlaid, outer
border of birds and ornaments, g. e., a fine specimen of
18th century Scotch binding, *Venet. per B. Pictorem &*
Erhardum Ratdolt una cum Petro Loslein de Langencen
Correctore ac Socio, 1477, sm. folio (235) *Leighton, £5*

8717 Aquinas (Thomas). Problemata Questionum primi Senten-
tiarum Fratris Thome de Aquino, lit. gotf., double columns,
40 lines, with signs., orig. oak bds., leather, with clasps,
Coloniae, H. Quentell, 1480, sm. folio (232) *Ellis, £5 5s.*

8718 Bartholomeus Anglicus [Glanvilla]. De Proprietatibus Rerum,
lit. gotf. parva (Hain, *2499 ; Proctor, 7452), (first 2 leaves
mended, wanted last leaf of Table,) *Absque ulla nota*
[*Basil.*, B. Ruppel, 14—] (238) *Leighton, £3 10s.*

8719 Belon (Pierre). L'Histoire de la Nature des Oyseaux, éd.
originale, cuts in the text, signature of "Lafond Laferte"
on title, old cf., *Paris*, G. Cavellat, 1555, folio (210)
Gladstone, £3

8720 Bewick (Thos.) Fables of Æsop and others, second ed.,
woodcuts, with the thumb-mark receipt, mor., t. e. g., *New-*
castle, E. Walker for T. Bewick & Son, 1823 (5)
Edwards, £1 5s.

8721 Bewick (T.) British Birds, first ed., before alterations or
advertisement on last leaf, royal paper, *Newcastle, Hodgson*
and Walker for Beilby and Bewick, etc., 1797-1804—History
of Quadrupeds, fifth ed., royal paper, *ib.*, 1807, together 3
vol., uniform mor. ex., by Ramage, 1797-1807, 8vo. (3)
Hopkins, £6

8722 Bible (Holy), Genevan or "Breeches" Version, black letter, 2
woodcut titles (some margins shaved close), mor., g. e.,
"Perfect and correct copy—J. Fry" (*see* MS. note), R.
Barker, 1608, 4to. (95) *Tregaskis, £1*

8723 Biblia [Sacra Latina, Editio Vulgata cum prologis S.
Hieronymi], lit. gotf., initials painted (Hain, *3122), (several
leaves wormed,) cf., with metal clasps, *Argentine impressum*
(*s. n. impressoris*), 1497, sm. folio (228) *Young, £3 15s.*

8724 Bligh (Capt. Wm.) A Voyage to the South Sea in H.M.S.
the Bounty, port. and charts, cf., G. Nicol, 1792—Narrative
of the Mutiny of the Bounty (separate), charts, hf. bd., *ib.*,
1790, together 2 vol., 4to. (116) *Maggs, £1 12s.*

8725 Block Book Alphabet. An Original Block Book Grotesque
Alphabet (Dutch), 24 letters and 6 leaves of ribbon letters,
the letter A dated 1464, mounted upon thick new paper
(some worn and defective, and mended), in a vol., modern
cf., *Sæc.* XV., sm. 4to. (191) *Quaritch, £1,520*
[Only two other copies are known, one in the British
Museum Library and the other at Basle.—ED.]

8726 Blondus (Flavius). De Roma Instaurata et Italia Illustrata,
lit. gotf. (Hain, *3243), rubricated throughout, painted

initials, modern mor., g.e., *Impressum Veronae per Boninum de Boniniis de Ragusia,* 1481, sm. folio (231) *Young,* £3 5s..

8727 Boccaccio (Jo.) Genealogiae, cum demonstrationibus in formis arborum designatis, woodcut initials (wormed), old cf., *Venet. Manfredus de Strevo de Monteferrato,* 1497, sm. folio (229) . *Leighton,* £1 14s.

8728 Bonifacius VIII., Papa, Sexti Liori Decretalium Opus, lit. gotḟ. et rom., 4 columns, first page of text with decorated order in gold and colours, with illuminated initial and emolazoned coat-of-arms oelow, capitals painted (Hain, 3597), modern cf., *Romae, impressum per Udalricum Gallum almanum alias han ex ingelstat,* 1478, folio (239) *Leighton,* £11

8729 Bonifacius Papa VIII. Lioer Sextus Decretalium, lit. gotḟ., 4 columns, printed in red and olack, painted initials, two illuminated (some leaves wormed), modern mor. ex., *Nurembergae,* 1486, sm. folio (233) *Edwards,* £3 5s.

8730 Bradford (John). The Copye of a letter sent by John Bradforth to the right honoraole lordes the Erles of Arundel, Daroie, Shrewsburye and Pemoroke, orig. ed. [2 leaves in verse at end], roman letter, very oadly printed, modern cf., *n. p. d. or n.* (1555), 8vo. (75) *Ellis,* 16s.

8731 Browne (Patrick, M.D.) Civil and Natural History of Jamaica, 49 engravings, hf. cf., B. White, 1789, folio (212) *H. Stevens,* £1 1s.

8732 Bruce (J. C.) The Roman Wall, third ed., plates, hf. mor., uncut, Longmans, 1867, 4to. (98) *Young,* £2 18s.

8733 Burns (Edw.) The Coinage of Scotland, LARGE PAPER, 45 copies printed, 78 plates, 3 vol., hf. mor., t. e. g., *Edinb.,* Black, 1887, roy. 4to. (146) *Thin,* £1 9s.

8734 Cassiodorus. Cassiodori Senatoris Viri dei de regimine ecclesie primitive hystoria tripartita, lit. gotḟ., douole columns, 54 lines, device on title, aosque nota—[Eusebii]. Hystoria Ecclesiastica (per Godfredum Boussardum exactissime correcta et emendata), lit. gotḟ., douole columns, 47 lines, device on title, *Impressa Parisii per Petrum Levet expensis Johannis de Côbetes,* 1497, in 1 vol., old russ. gt. (a few wormholes and stains), sm. 4to. (187) *Leighton,* £5

8735 Churchyard (Thos.) A Lamentaole and Pitifull Description of the Wofull Warres in Flaunders, orig. ed., blaƈk lettrr, 2 leaves of a Poem, "To the Worlde," in roman letters at end (a few headlines shaved), hf. cf., Ralph Newberie, 1578, sm. 4to. (162) *Wingate,* £9 5s.

8736 Complete Midwife's Practice Enlarged (The), port. of Mme. Louyes Bourgeois, midwife to the Queen of France, and plates (stained), new cf., *Obadiah Blagrave in S. Pauls,* 1680, 8vo. (55) *Leighton,* £4 4s.

8737 Consobrinus (Johannes). Tractatus de Justitia Communitativa et arte Campsoria seu Cambis, lit. gotḟ., long lines, 27 to a full page, with signs., Mercator's device on title and cut on reverse of last leaf, hf. bd., *Impressus Parisius per*

XXIV. 40

Guidonem Mercatoris in Campo Gaillardi 1494 *di* VI.
Septembris, 8vo. (90) *Baer*, £4 4s.

8738 [Cuɔa (Jacoɔus de).] (H)Ortus Sanitatis, **lit. goth.**, douɔle columns, woodcut title and woodcuts in the text (the leaves of Taɔle stained and wormed, and the last 3 defective), russ., g. e., *s. l. et n.*, 1517, sm. folio (224) *Quaritch*, £7

8739 Davies (Wm.) A True Relation of the Travailes and most Miseraɔle Captivitie, **black letter** (19 leaves), (title and other leaves soiled,) hf. bd., N. Bourne, 1614, sm. 4to. (174)
Llewellyn, £2 2s.

8740 Declaration (A) of the Causes which Mooved the Chiefe Commanders of the Navie of the Queene of England in their Voyage and Expedition for Portingal to take and Arrest . . . certaine Shippes of Corne and other Provisions of Warre (12 leaves), *Deputies of Chr. Barker*, 1589 —True Coppie of a Discourse Written by a Gentleman Employed in the late Voyage of Spaine and Portingale, **black letter** (32 leaves, the last ɔlank), *Thos. Woodcok in Paules Churchyard*, 1589—Nixon (A.) The Warres of Swethland, **black letter**, N. Butter, 1609, three rare tracts, in 1 vol., hf. cf., sm. 4to. (164) *Bradley*, £12 15s.

8741 Dixon (Capt. G.) Voyage round the World, maps, charts and plates, old cf., G. Goulding, 1789, 4to. (114)
Maggs, £1 1s.

8742 Donne (John). Poems, first ed., hf. bd., *M. F. for J. Marriott*, 1633, sm. 4to. (161) *Dobell*, £2 18s.

8743 [Du Buisson (M.)] Le Taɔleau de la Volupté, Poëme, éd. originale, 4 plates, 4 vignettes and 4 tailpieces, after Eisen, by Longueil (stained), hf. cf., *à Cythère au Temple du Plaisir*, 1771, 8vo. (82) *Edwards*, £2 2s.

8744 Elyot (Sir Thomas). The Castel of Helth, **black letter**, modern cf., g. e., *In aed. Th. Bertheleti typis impress.* (1541), sm. 4to. (171) *Sawyer*, £10

8745 Erasmus. De Immensa Dei Misericordia [trans. by Gentian Hervet], **black letter** (some marginal notes cut into), modern cf., Tho. Berth.(elet), 1547, 8vo. (78) *Ellis*, £1 11s.

8746 Fenton (Edw.) Certaine Secrete Wonders of Nature, orig. ed., **black letter**, title ɔacked, woodcuts, contemp. MS. notes, signature on title, modern cf., *H. Bynneman in Knight-rider Street*, 1569, sm. 4to. (155) *Wingate*, £7 15s.

8747 Frampton (John). Joyfull Newes out of the Newe Founde Worlde (ɔy N. Monardus), first ed., **black letter**, woodcuts and woodcut initials (title and next few leaves stained, hole in folio 91), modern cf., *Willyam Norton in Pauls Churchyard*, 1577, sm. 4to. (175) *Sawyer*, £8 15s.

8748 Frampton (J.) A Discourse of the Navigation which the Portugalls doo make to the Realmes and Provinces of the East Partes of the Worlde (ɔy Bernard de Escalante), orig. ed., **black letter**, woodcut initials, hf. cf., *Thos. Dawson, Three Cranes in the Vintree*, 1579 (176) *Tregaskis*, £6 10s.

8749 Goldsmith and Parnell. Poems, printed by W. Bulmer,

plates and vignettes by T. and J. Bewick, mor. ex., t. e. g., uncut, W. Bulmer and Co., 1804, 4to. (101)

B. F. Stevens, £1 4s.

8750 Gower (John). De Confessione Amantis, **black letter** (title and first 2 leaves of text somewhat dulled), modern mor., g. e., Thos. Berthelet, 1532, sm. folio (222) *Maggs,* £10
 [The second ed. of Gower's Poem in English. Contained 8 preliminary leaves and 191 numbered folios. It had the blank at end completing the last signature.—*Catalogue.*]

8751 Gualter (Rodolph.) An hundred threescore and fiftene Homelyes or Sermons, **black** and roman **letter**, initials of classical and other subjects, sides of contemp. English oak boards and leather with stamps of crowned roses, etc. (rebacked), John Daye, 1572, folio (223) *Bull,* £1 7s.

8752 Henry VIII. Literarum, quibus invictissimus Princeps Henricus Octavus rex Angliae et Franciae, Dns. Hybernie, ac fidei defensor respondit, ad quandam epistolam Martini Lutheri, ad se missā et ipsius Lutherane quoq; Epistole exemplum, lit. rom., title within woodcut border, with Pynson's mark below, modern cf., *In aedibus Pysonianis,* A.D. 1526, *secunda Decembris* (79) *Quaritch,* £38

8753 Herbert (Sir Thos.) A Relation of some Yeares Travaile into Afrique, etc., first ed., engraved title by Marshall and copperplates, old cf., W. Stansby and J. Bloome, 1634, sm. folio (220) *Wingate,* £2 15s.

8754 Hollands Leaguer, or an Historical Discourse of the Life and Actions of Dona Britanica Hollandia the Arch-Mistris of the Wicked Women of Eutopia (by S. Marmion), front. (last leaf defective and mended, two or three headlines shaved), modern cf., *A. M. for Rich. Barnes,* 1632, sm. 4to. (169) *Wingate,* £1

8755 Hooper (John, Bp. of Gloucester and Martyr). An Oversight and deliberacion upon the holy Prophete Jonas, orig. ed., **black letter** (leaf and leaf of errata mended), modern mor., g. e., *n. p. or n.,* 1550, 8vo. (72) *Bull,* 14s.

8756 Hutten (Ulric von). De Morbo Gallico : Of the Wood Called Guaiacum, **black letter**, modern cf., *In Officina Thomae Bertheleti Regii impressoris,* 1540, sm. 4to. (165) *Leighton,* £17 5s.

8757 Jardine (Sir Wm.) Natural History of Humming Birds, LARGE PAPER, ports. and 65 col. plates and woodcuts, 2 vol., mor., t. e. g., uncut, *Edinb.,* W. H. Lizars, 1840, 8vo. (15) *Edwards,* £2 6s.

8758 Jerrold (Douglas). Mrs. Caudle's Curtain Lectures, first ed., illustrated by Chas. Keene, printed on light blue paper, mor. ex., Bradbury & Evans, 1866, 4to. (96) *Spencer,* £1 10s.

8759 Joannes de Aurbach, Vicarius Bambergensis. Summa de Sacramentis, **lit. goth.**, long lines, 35 to a full page (49 leaves without marks), text rubricated (Hain *2124, Proctor 1522), cf. antique, *Impressus in Urbe Augustensi per Ginther Zeiner de Reutlingen,* 1469, folio (237) *Ellis,* £50

40—2

8760 Knorr (G. W.) Les Délices de l'Esprit, col. figures, 6 parts
in 3 vol., old French mor., g. e., *Nuremberg*, 1764-73, 4to.
(125) *Edwards*, £1 18s.

8761 Lambert (P.) The Successe of Swaggering, Swearing,
Dicing, Drunkenness and Whoring, described in the life
and downefall of Peter Lambert, black letter, 10 leaves,
(soiled), hf. cf., *Printed for John Busbie the elder* (1610),
sm. 4to. (168) *Edwards*, £2 7s.

8762 London. The Lamentacyon of a Christē agaīst the Citye of
London, for some certaine greate Vyces used therī, black
letter (title mended), modern cf., *Imprited t ye yere of Our
Lord* 1548 (*n. p. or n.*) (76) *Maggs*, £1 6s.
[This invective against the Londoners in Henry VIII.'s
time by an early English Reformer was first printed at
Nuremberg in 1545.—*Catalogue.*]

8763 Lowe (Peter). A Discourse of the Whole Art of Chirurgerie,
third ed., black letter, woodcuts, arms of James Hamilton
Earl of Abercorn on reverse of title, cf., g. e., Thos. Purfoot,
1634, sm. 4to. (166) *Leighton*, £3 10s.

8764 Martyn (Thos.) The Universal Conchologist, 22 plates, con-
taining many col. figures, text in English and French, old
cf., g. e., *Sold by T. Martyn at his House, in Great Marl-
borough St.*, 1789, roy. 4to. (139) *Maggs*, £2 18s.

8765 Mayhew (Bros.) The Greatest Plague of Life—Whom to
Marry, Cruikshank's plates, D. Bogue, n. d.—The Image of
his Father, illustrations by "Phiz," hf. mor., H. G. Bohn,
1851, first eds., 3 vol., uniform hf. mor., t. e. g., 8vo. (37)
Streeton, £1 19s.

8766 Mela (Pomponius). De Situ Orbis, lit. rom. (48 leaves), long
lines (Hain, *11017), woodcut initials, the first illuminated,
old French mor. gt., doublures, g. e. (some margins shaved),
Venet., Fr. Renner de Hailbrun, 1478, sm. 4to. (183)
Quaritch, £9

8767 Museum Tradescantianum. A Collection of Rarities pre-
served at South Lambeth neer London by John Tradescant,
orig. ed., front. and 2 portraits by Hollar, orig. cf. (broken),
J. Grismond for N. Brooke, 1656, 8vo. (66) *Quaritch*, £3 5s.

8768 Napier of Merchiston (John). A Plaine Discovery of the
Whole Revelation of Saint John, first ed., woodcut title,
arms of K. James VI. on reverse, hf. russ., *Edinburgh*, Rob.
Waldegrave, 1593, sm. 4to. (167) *Sotheran*, £1 4s.

8769 Nyder (Joannes). Consolatorium timoratæ Conscientiæ [et
Tractatus de Contractibus Mercatorum], lit. goth. (152
leaves, the last blank), [Proctor, 43-4,] text rubricated,
capitals painted (2 leaves Table to the first Treatise in
contemp. MS.), modern cf., *Absque nota [sed Colon., U.
Zel, c.* 1470], sm. 4to. (188) *Maggs*, £5 12s. 6d.

8770 Old Book Collector's Miscellany (The), ed. by Chas. Hindley,
LARGE PAPER, 3 vol., cf. ex., t. e. g., uncut, Reeves and
Turner, 1871-73, 4to. (93) *Sawyer*, £1 14s.

8771 Parkinson (Sydney). Voyage to the South Seas in H.M.S.

Endeavour, LARGE PAPER, port., map and 29 engravings, old cf. gt., C. Dilly, 1784, roy. 4to. (113) *Edwards, £2* 2s.

8772 Paterson (Ninian). Epigrammatum liɔri octo, orig. ed., modern cf. gt., *Edinb.*, T. Brown and J. Glen, 1678, 8vo. (68) *B. F. Stevens,* 17s.

8773 Paynell (Thos.) Regimen Sanitatis Salerni, **black letter**, title within woodcut ɔorder, with sig. of Humphrey Huntley, old cf., Abr. Vele, 1557, 8vo. (77) *Quaritch, £7*

8774 Peniteas Cito libellus iste nuncupatur, tractans Cōpendiose de Penetētia et eius circumstantiis ac vitam peccatis depravatam emendare cupiētibus multum utilis et necessarius, **lit. goth.** (2 types), long lines (14 leaves, signs. **a-b** 6), woodcut on title and reverse, *Impressi Londoñ. per Wynandū de Worde in Vico Anglice Nūcupato (the Fletestrete) ad Signum Solis Commorantem, s. a.*—[Whittinton (Robert).] De Octo Partiɔus Orationis, **lit. goth.** (2 types), (13 leaves, commencing on **a** ii), [Wynkyn's Caxton device of sun, 2 planets and 20 stars, etc. on reverse of last leaf,] *In œdibus Winandi de Worde Vicesimo primo supra sesqui millesimū nostre salutis anno Idibus Julii,* 1521, ɔoth clean copies, in 1 vol., modern cf., sm. 4to. (182) *Quaritch, £27*

8775 Peniteas Cito. [Libellus de Modo Confitendi & Penetendi], **lit. goth.**, long lines, 43 to a full page, large cut of Penitents confessing on fly-leaf, and device of John Koelhoff on reverse of last leaf (apparently not in Hain or Proctor), contains 22 leaves, signs. a-b 4, in sixes, hf. cf., *Coloniae,* Jo. Koelhoff, 1489, sm. 4to. (181) *Leighton, £3*

8776 Perry (Geo.) Conchology, 61 col. plates, col. mor. ex., W. Miller (1811), folio (200) *Edwards, £1* 18s.

8777 Persius (A. F.) Satyrae cum Comment. Bart. Frontii, lit. rom. (28 leaves, with signs.), [Hain, *12724,] hf. cf., *Venet.,* D. de Bertochis, etc., 1484, sm. folio (234) *Maggs, £9* 15s.

8778 Physiognomical Portraits. One Hundred Distinguished Characters from Undouɔted Originals, LARGE PAPER, text in English and French, 2 vol., hf. bd., uncut, J Major, 1824, sup. imp. 8vo. (109) *Lewine,* 14s.

8779 Plinius Secundus. The Historie of the World, by Philemon Holland, first ed. (ɔoth titles ɔacked), 2 vol., modern cf., A. Islip, 1601, folio (204) *Quaritch, £2*

8780 Recorde (Roɔert). The Castle of Knowledge, first ed., cuts in the text, cf., r. e.,·*Imprinted by Reginalde Wolfe,* 1556, sm. folio (219) *Tregaskis, £4* 5s.

8781 Rondelet (Guillaume). L'Histoire entière des Poissons, éd. originale, woodcut figures, 2 vol. in 1, old cf., *a Lion par Mace Bonhome,* 1558, sm. folio (209) *Leighton, £1* 14s.

8782 Sabellicus (Ant.) De Venetis Magistratibus, editio prima, lit. rom. (26 leaves), hf. mor., *Venet.,* Ant. de Strata Cremonense, 1488, sm. 4to. (184) *Barnard, £1* 14s.

8783 Sacro-Busto (Joannes de). Sphaerae Mundi Compendium, lit. rom., long lines, woodcut on reverse of title, woodcut diagrams (some col.), etc. and ornamental initials (48

leaves), (Hain, *14114), *Impressum Venetiis per Magistrum
Gullielmum de Tridino de Monteferrato,* 1491—Magistri
Gerardi Cremonēsis Theorica Planetarum, lit. gotf)., long
lines (12 leaves), no formal title, without signs., woodcut
diagrams (some col.), *In Venezia per Magistrum Adam de
. Rotteuil,* 1478—"Libellus Ysagogicus Abdilazi. i. servi
gloriosi dei. q̄. dr. Alchabitius ad magesteriū judiciorum
Astrorum ; interpretatus a Joanē Hispalese," lit. gotf)., long
lines (32 leaves), [Hain, *616,] woodcut initials (no formal
title), *Venetiis, impressus per Erhardum Ratdolt Augus-
tensis,* 1482, in 1 vol., vell., sm. 4to. (186) *Quaritch,* £10

8784 Salicétus (Nic.) Liber Meditationum ac Orationum devo-
tarum qui Anthidotarius Animae dicitur cum tabula
insertus, lit. gotf). (Hain, *14161), title cut down and
mounted (some headlines shaved), text rubricated, modern
cf., *Argent.,* Jo. Reynardus al's Grüninger, 1493, 8vo. (89)
Leighton, £4 12s.

8785 Sallustius. Belli Catalinarii et Jugurthini Historiæ, lit. rom.
(51 leaves, a j, a blank, wanted), (Hain, *14211,) first page
decorated, old russ. ex., *Venet.,* B. de Tortis, 1481, sm. folio
(230) *Maggs,* £2 16s.

8786 Say (Thos.) American Conchology, 40 col. plates, hf. mor.,
t. e. g., *New-Harmony, Indiana,* 1830, roy. 8vo. (11)
Edwards, £1 13s.

8787 Scory (John, Bp. of Chichester). An Epistle written unto all
the faythfull that be in Pryson in Englande, black letter,
orig. ed. (some margins cut into), modern cf., *n.p. or n.
(Waterford), anno* 1555—[Bale (John).] The Acquital or
Purification of the most Catholyke Christian Prince
Edwarde the VI. Kyng of Englande, orig. ed., black letter,
modern cf., *Imprinted at Waterford the 7. daye of November*
1555, together 2 vol., 8vo. (70) *Tregaskis,* £3 3s.
[The Dedication to the Nobilitie, etc. of England has the
name of John Olde, according to Lowndes a pseudonym of
John Bale. This and Scory's tract are both in the same
type, and the imprint is regarded by Cotton as fictitious.
Both works appear in Mackellar's sale in 1899.—*Cata-
logue.*]

8788 Scriptores Rei Rusticae. Opera Agricolationum ; Columellae ;
Varronis ; Catonisq. necnon Palladii ; cum exscriptionibus
& commentariis D. Philippi Beroaldi, ornamental initials
and printer's device at end, inscription on title, "Res Pauli
& Francisci Volaterrani et Amicorum," old cf., *Impressa
Reggii impensis Francisci Mazali Regiensis,* 1499, sm. folio
(206) . *Leighton,* £2 14s.

8789 Sepp (Jan Christian). Beschouwing der Wonderen Gods, in
de Minstgeachte Schepzelen of Nederlandsche Insecten,
col. plates, complete in 8 vol., hf. mor. ex., t. e. g., uncut,
Amsterdam, J. C. Sepp en Zoon, 1725-1860, 4to. (120)
Quaritch, £10 5s

8790 Sleidan (J.) A Famous Chronicle of Oure time called Sleidanes

Commentaries, trans. by Jhon Daus, etc., first ed., **black letter**, old signatures of "Alex. Gordone" and "Wm. Steuart," old cf., *J. Daye for A. Veale and N. England*, 1560, folio (216) *Edwards, £2* 10s.

8791 Sloane (Hans, M.D.) A Voyage to the Islands Madera, Barοados, Nieves, S. Christopher's and Jamaica, orig. ed., maps and plates (inner margins guarded), 2 vol., old russ. gt. (οroken), *B. M. for the Author*, 1707-25, folio (211) *Maggs, £5* 10s.

8792 Smith (Dr. Miles). A learned and godly Sermon preached at Worcester at an Assize, orig. ed., vell., *Oxford*, J. Barnes, 1602, 8vo. (74) *Tregaskis,* 10s.

8793 Somerville (Wm.) Hobbinol, Field Sports and the Bowling Green, printed by W. Bulmer, woodcut vignettes after Thurston, hf. mor. gt., R. Ackermann, 1813, 4to. (100) *Maggs, £1* 1s.

8794 Sowerοy (G. B.) Genera of Recent and Fossil Shells, 264 col. plates, 2 vol., mor. ex., G. B. Sowerοy, 1820-25, 8vo. (8) *Young, £2* 4s.

8795 Sowerοy (G. B.) The Conchological Illustrations, 200 plates, containing many hundred col. figures, mor. ex., *Sowerby, Gt. Russell St.,* 1841, 8vo. (9) *Wesley, £1* 14s.

8796 Sparrman (Dr. And.) Voyage to the Cape of Good Hope, map and plates, 2 vol., old cf., G. and J. Roοinson, 1786, 4to. (115) *Edwards, £1* 10s.

8797 Sterne (L.) Works, port. and vignettes by Thurston, 4 vol., old cf., *Trade Ed.,* 1808, 8vo. (26) *Young, £1* 8s.

8798 Three Kings of Cologne. The Moost Excellent treatise of the thre Kynges of Coleyne, **black letter**, long lines, 28 to a full page, 40 leaves, signs. **a-ff** 6 in 8's, E having 6 leaves only, woodcut of the Offerings of the Magi οelow title and one of the Crucifixion on reverse, Wynkyn de Worde's floriated Caxton device on reverse of last leaf (wormholes in several leaves), modern mor., g. e., "*Emprynted at Westmester by Wynkyn the Worde,*" n. d. (*c.* 1499), sm. 4to. (159) *Quaritch, £110*
[A large clean and perfect copy of this rare edition, measuring close on 8 by 5¼ in.—*Catalogue.*]

8799 Topsell (Edw.) History of Four-footed Beasts and Serpents, woodcuts, old cf., E. Cotes, etc., 1658, folio (213) *Madan, £8* 5s.

8800 Topsell (E.) The Historie of Serpents, or the Second Booke of Living Creatures, first ed., woodcuts (corners of title and next leaf mended, several leaves stained), old cf., W. Jaggard, 1608, folio (214) *Edwards, £4* 5s.

8801 Walpole (Horace). Castle of Otranto, sixth ed., LARGE AND FINE PAPER, 2 proof impressions of the view of the Castle, hf. mor., *Parma, printed by Bodoni for J. Edwards*, 1791, imp. 8vo. (34) *B. F. Stevens, £1* 12s.

8802 Zoological Journal (The), with the supplementary plates, col. plates, 6 vol. (all puοlished), hf. mor., t. e. g., 1825-35, 8vo. (17) *Wesley, £1* 1s.

8803 Zoology of the Voyage of H.M.S. Samarang, under Capt. Sir
E. Belcher, by J. E. Gray and others, ed. by A. Adams, 55
plates (col. and plain), hf. cf., Reeves and Benham, 1850,
4to. (140) *Quaritch,* £2 6s.

[JUNE 28TH, 29TH AND 30TH, 1910.]

HODGSON & CO.

A MISCELLANEOUS COLLECTION.

(No. of Lots, 966 ; amount realised, about £1,100.)

8804 America. A Relation of Maryland (6⅜in. by 5⅜in., wanted
the map), [*see* Sabin,] (the first blank leaf and some inner
margins wormed), *September the* 8, *Anno Dom.* 1635—
Bound up with it : A Journal of the Proceedings of the
English Army in the West-Indies, by I. S., an Eye-
Witnesse (headlines cut into), 1655—Bruton (W.) Newes
from the East Indies, whole-page woodcut (margins
shaved), 1638—Life of Tamerlane the Great, 1653, and 2
others relating to the East India Company (margins cut
into), 1664, together (6), in 1 vol., contemp. sheep, sm. 4to.
(553) *H. Stevens,* £31
8805 America. MS. Memoirs of Major Robert Stobo of the
Virginia Regiment from about the time of the French
encroachments on Virginia in 1754 to the Siege of Quebec
in 1759—a part of the regiment advanced "with Major
Washington at their head"—Genl Braddock and
Amherst, and stating that Major Stobo "pointed out the
place to land [at Quebec], where afterwards they did and
were successful," written on 85 pages, orig. wrapper
[1760], sm. 4to. (560] *H. Stevens,* £7
8806 America. An Impartial History of the War in America
between Great Britain and her Colonies, folding map and
13 ports., including George Washington, cf. (rebacked),
1780, 8vo. (561) *Edwards,* £10
8807 Ancestor (The), a Quarterly Review of Family History,
Heraldry, etc., 12 vol., bds., with Indexes, in 3 parts,
sewed, 1902-5, imp. 8vo. (54) 15s.
8808 [Apperley (C. J.)] Life of Mytton, third ed., col. plates by
Alken and Rawlins, orig. cl., g. e., 1851, 8vo. (188)
Spencer, £5
8809 Architecture. The Dictionary of Architecture issued by the
Architectural Publication Society, illustrations, 8 vol. in 4,
hf. mor. gt., *Printed by T. Harris,* 1887, etc., folio (308)
£3 10s.
8810 Baird, Brewer and Ridgway. History of North American

Birds. Land Birds, 3 vol.—Water Birds, 2 vol., illustrations, together 5 vol., cl., t. e. g., *Boston*, 1874-84, sm. 4to. (264) *Wesley*, £3 5s.
8811 Boccaccio (G.) The Decameron, trans. by J. Payne, plates by Louis Chalon, Japanese vellum copy (limited to 125), 2 vol., cl., uncut, 1893, imp. 8vo. (80) *Edwards*, £2 9s.
8812 Book-Prices Current. Index for the second Decade, 1897-1906, by W. Jaggard, buckram, 1909, 8vo. (486) £1 2s.
8813 Brandt (Sebastian). The Ship of Fooles, by Alexander Barclay, black letter, woodcuts (first leaf repaired and last leaf defective), cf., g. e., by Larkins, *Imprinted at London by J. Cawood*, 1570, folio (610) *Edwards*, £8 5s.
8814 Brunet (J. C.) Manuel du Libraire, 6 vol., hf. mor. (rubbed), *Paris*, 1860-65, 8vo. (370) *Scotti*, £6 10s.
8815 [Burton (R.)] Anatomy of Melancholy, first ed., with the 4 leaves containing "The Conclusion of the Author to the Reader" ("Errata" wanted, and top corner of title repaired, 7½in. by 5½in.), cf. (rebacked and joints cracked), *Oxford, John Lichfield and J. Short for H. Cripps*, 1621, sm. 4to. (348) *Leighton*, £24 10s.
8816 Burton (W.) English Earthenware and Stoneware, 24 col. plates, cl., t. e. g., 1904, 8vo. (71) 15s.
8817 Byron (Lord). Works. Poetry, with a Bibliography, ed. by E. H. Coleridge, 7 vol.—Letters and Journals, ed. by R. E. Prothero, 6 vol., ports. and plates, éd. de luxe (limited to 250 copies), together 13 vol., hf. roan, t. e. g., 1898, 8vo. (87) *Tickell*, £3 18s.
8818 Chaucer (G.) The Workes of Geffray Chaucer [the second ed. with Wm. Thynne's prologue], black letter, woodcuts and initial letters (8 and 355 leaves), old cf., with autograph, "Sr. Charles Lee of Billsly, Warwicks," on title, *Imprynted at London by Robart Toye* [1542], folio (608) *Maggs*, £13
8819 Chaucer (G.) Works, ed. by W. W. Skeat, fac. fronts., 6 vol., buckram gilt, *Oxford*, 1894-97, 8vo. (105) *Tickell*, £3 2s.
8820 Churchyarde (T.) The Bathes of Bathes Ayde. Wonderfull and most excellent agaynst very many Sicknesses, black letter, 2 folding tables, 2 parts stitched together, unbd., *T. East for W. Jones*, 1572, sm. 4to. (531) *Maggs*, £7 15s.
8821 Cockton (H.) Valentine Vox, first ed., plates by T. Onwhyn, cl., uncut, 1840, 8vo. (197) *Spencer*, £1 5s.
8822 [Combe (W.)] Life of Napoleon, 30 aquatint plates by G. Cruikshank, hf. cf., T. Tegg, 1817, roy. 8vo. (160) *Hornstein*, £2 19s.
8823 Cyclopædia of Engineering, ed. by L. Derr and others, illustrations, 4 vol., hf. mor., *Chicago*, 1904, 8vo. (68) 16s.
8824 Dawe (G.) The Life of Morland, Notes by J. J. Foster, éd. de luxe, port. and plates, with a duplicate set of the plates col., mor., the upper cover inset with 29 hand-painted miniatures (in circles) taken from works by the artist, also a miniature picture at each corner, mor. inner borders, t. e. g., in case, by Rivière, Dickinsons, 1904, 4to. (597) [Sold on June 22nd.—ED.] *Edwards*, £17 10s.

8825 Defoe (D.) Ro)inson Crusoe, plates)y Geo. Cruikshank,
2 vol., hf. mor., t. e. g.,)y Rivière, J. Major, 1831, 8vo. (200)
Buckland, £1 17s.
8826 Dickens (C.) More Hints on Etiquette, first ed., cuts by
G. Cruikshank, hf. mor., g. e., 1838, 24mo. (202)
Spencer, £1 2s.
8827 Dickens (C.) The Loving Ballad of Lord Bateman, first ed.,
plates by G. Cruikshank (stained), cl., *C. Tilt, Fleet Street
and Constantinople,* 1839, sq. 24mo. (203) *Spencer,* £3
8828 Dickens (C.) Sketches of Young Couples, first ed., 6 etchings
)y " Phiz," orig. picture bds., 1840, 8vo. (204)
Sotheran, £3 5s.
8829 Dugdale (Sir W.) Monasticon Anglicanum, by Caley, Ellis
and Bandinel, engravings, 8 vol.—History of St. Paul's,
with Life by Ellis, ports. and plates by Finden after Hollar,
1818, together 9 vol., cf. gt. (cracked), 1817-30, folio (615)
Walford, £12 5s.
8830 Encyclopædia of Sport (The), photogravures and cuts, 2 vol.,
hf. mor., 1897-8, imp. 8vo. (111) 18s.
8831 Fielding (H.) Works, port. and fronts. by Rooker, 10 vol.,
old cf. (worn and one cover missing), 1784, 8vo. (106)
£1 19s.
8832 Froude (J. A.) History of England from the Fall of Wolsey
to the Defeat of the Spanish Armada, Library ed., 12 vol.,
cl., uncut, 1870-75, 8vo. (116) £2 12s.
8833 Gay (John). Fa)les, vignettes by Blake and others, 2 vol.,
old cf. gt., J. Stockdale, 1793, imp. 8vo. (253)
Edwards, £2 13s.
8834 Giovanni (Ser). The Pecorone, trans. by W. G. Waters,
illustrations by E. R. Hughes, Japanese vell. copy (limited
to 210), hf. vell., 1897, imp. 8vo. (82) *Tickell,* £1 11s.
8835 Goldsmith (O.) The Vicar of Wakefield, 24 col. plates by
Rowlandson, orig. cl., uncut, Ackermann, 1823, 8vo. (186)
Dobell, £7 15s.
8836 Grove (Sir G.) Dictionary of Music, ed. by Fuller Maitland,
with Index, 4 vol., cl., t. e. g., 1902, 8vo. (76) *Heffer,* £1 8s.
8837 Hain (L.) Repertorium Bibliographicum, orig. ed., 4 vol., cl.,
Stuttgart, 1826-38, 8vo. (371) *Quaritch,* £6 15s.
8838 Hassell (J.) Picturesques Rides and Walks, col. plates,
2 vol., cf. (re)acked), 1817-18, 12mo. (185) *Edwards,* £4
8839 Hazlitt (W.) Collected Works, ed. by Waller and Glover,
fronts., 13 vol. (vol. iv. wanted), cl., t. e. g., 1902-6, 8vo. (78)
£1 18s.
8840 International Li)rary of Famous Literature, 20 vol., hf. mor.,
t. e. g., E. Lloyd, 8vo. (110) £1
8841 Jonson (Ben). Workes (port. by Houbraken inserted in place
of that by Vaughan), Will. Stans)y, 1616—The Second
Volume (general title mounted and margins of last 4 leaves
cut into), Richard Meighen, 1640, first collected ed., 2 vol.,
cf., sm. folio (609) *Maggs,* £15
8842 Jonson (B.) Works, ed. by Cunningham, Li)rary ed., port.,
9 vol., cl., uncut, 1875, 8vo. (249) *Hill & Sons,* £3 7s. 6d.

8843 Kelmscott Press. Morris (W.) The Defence of Guenevere, vell., with silk ties, 1892, 8vo. (213) *Buckland*, £2 14s.

8844 Kelmscott Press. Poems of Samuel Taylor Coleridge, vell., 1896, 8vo. (214) *Shepherd*, £1 17s.

8845 Kingsley (C.) Collected Works, uniform ed., port., 29 vol., cl., Macmillan, 1892-1900, 8vo. (208) *Winter*, £1 10s.

8846 Lamb (C.) John Woodvil, first ed., presentation copy, with autograph inscription on fly-leaf, "G. Darley, Esq., with the writer's respects," orig. pink bds., uncut (one cover broken), G. and J. Robinson, 1802, 8vo. (538) *Spencer*, £26

8847 Lamb (C. and M.) Tales from Shakespeare, LARGE PAPER, col. illustrations by A. Rackham, with an additional plate, buckram tie, t. e. g., 1909, imp. 8vo. (88) 15s.

8848 Leech (J. H.) Butterflies from China, Japan and Corea, 43 col. plates, with Descriptive Text, 3 vol., hf. mor., with the wrappers bound in, t. e. g., R. H. Porter, 1892-4, 4to. (303) [Sold on June 21st.—ED.] *Hitchman*, £4 11s.

8849 Le Sage (A. R.) Works, trans. by Smollett and ed. by Saintsbury, LARGE PAPER (limited to 100 copies), etchings by R. de Los Rios, 6 vol., cl., Nimmo, 1881, 8vo. (79)
 Tickell, £1 12s.

8850 Lory (G.) Voyage Pittoresque de Genève à Milan, second ed., 35 col. plates (but without the "Tableau Général"), wrapper, in orig. portfolio as issued, *Bâle*, 1819 (292)
 Spencer, £14 5s.

8851 Lydekker (R.) Royal Natural History, illustrations (some col.), 6 vol., cl., g. e., 1893-4, roy. 8vo. (112) £1 15s.

8852 Macaulay (Lord). Complete Works, ports., LARGE PAPER (limited to 250 copies), 12 vol., cl., t. e. g., 1898, 8vo. (77)
 Hitchman, £2 16s.

8853 Masuccio. The Novellino, trans. by W. G. Waters, illustrations by E. R. Hughes, Japanese vell. copy (limited to 210), 2 vol., hf. vell., 1895, imp. 8vo. (83) *Edwards*, £1 17s.

8854 Menpes (M.) World's Children, 1903—War Impressions, 1901, col. plates, together 2 vol., hf. mor., t. e. g., 8vo. (94) 17s.

8855 Montaigne (M. de). Essayes, trans. by Florio, introduction by T. Seccombe, ports., 3 vol., hf. cl. gt., 1908, 8vo. (93) 19s.

8856 Motley (J. L.) Works, new Library ed., ports., 9 vol., buckram, t. e. g., 1904, 8vo. (114) £1 9s.

8857 Murray. Handbooks to the English Cathedrals, first eds., plates, 6 vol., cl. gt., 1861-9, 8vo. (30) *Edwards*, £1

8858 Nicholson (W.) History of the Wars occasioned by the French Revolution, equestrian ports., col. copy, old cf. (rebacked), 1816, 4to. (297) *Karslake*, £1 3s.

8859 Pratt (A.) Flowering Plants and Ferns of Great Britain, col. plates, 6 vol., cl., g. e., S.P.C.K., 8vo. (63) *Hill*, £1 3s.

8860 Radcliffe (E. P. Delmé). The Noble Science, first ed., plates and cuts, cf. gt., R. Ackermann, 1839, 8vo. (157) 14s.

8861 Salt (H.) Twenty-four Coloured Views in St. Helena, the Cape, India, Ceylon, Abyssinia and Egypt, by R. Havell, with leaf of dedication, but no text, hf. mor., g. e., W. Miller, 1809, elephant folio (414) *Edwards*, £3 10s.

8862 Shakespeare (W.) The Chiswick Shakespeare, ed. ɔy John Dennis, illustrations ɔy Byam Shaw, Japanese vell. ed. (limited to 200 copies), 39 vol., cl. gt., vell. ɔacks, 1902, 8vo. (86) *Tickell,* £1 16s.

8863 Shakespeare (W.) Seven Ages of Man, title and 7 plates, engraved by W. Bromley after T. Stothard, col. copy, wrapper, 1799, 4to. (298) *Spencer,* £1 3s.

8864 Shelley (P. B.) The Revolt of Islam, hf. mor., 1818, 8vo. (220) *Edwards,* £1 14s.

8865 Shelley (P. B.) Queen Mab, with the Stanzas to Harriet, bds., uncut, R. Carlile, 1822, 8vo. (219) 15s.

8866 Smith (A.) Christopher Tadpole, first ed., port. and plates by Leech, cl., uncut, 1848, 8vo. (198) *Edwards,* £2

8867 Solon (M. L.) Old English Porcelain, plates, cl., t. e. g., 1903, 8vo. (69) £1 1s.

8868 Sowerɔy (J.) English Botany, third ed., col. plates, 11 vol., cl., t. e. g., R. Hardwicke, 1863-72, roy. 8vo. (263) *Quaritch,* £8 10s.

8869 Strang (W.) The Doings of Death, 12 etchings in portfolio, *Essex House Press,* 1901, folio (306) £1 1s.

8870 Straparola. The Nights, trans. ɔy W. G. Waters, illustrations by E. R. Hughes, Japanese vell. copy (limited to 210), 2 vol., hf. vell., 1894, imp. 8vo. (81) *Edwards,* £1 16s.

8871 Swift (J.) Gulliver's Travels, LARGE PAPER, col. illustrations by Rackham, ɔuckram, 1909, imp. 8vo. (246) 14s.

8872 Thackeray (W. M.) The Kicklebury's on the Rhine, first ed., plates, col. copy, orig. bds., g. e., 1850, 8vo. (159) *Spencer,* £3 15s.

8873 Thackeray (W. M.) Works, fronts., 12 vol., hf. mor., 1874, 8vo. (210) *Chaundy,* £1 13s.

8874 Trollope (A.) Chronicles of Barsetshire, fronts., 8 vol., cl., gt., Chapman and Hall, 1889-93, 8vo. (209) *Sotheran,* £1 6s.

8875 Villon Society. The Poems of Hafiz of Shiraz, trans. ɔy John Payne, 3 vol., mor. ex., *Privately printed,* 1901, 8vo. (223) *Edwards,* £3 15s.

8876 Wales. Views in North Wales, 20 col. plates, with descriptions, hf. bd., 1823, obl. 4to. (293) *Parsons,* £3 7s. 6d.

8877 Whitaker (T. D.) History of Richmondshire, LARGE PAPER, India proof plates after Turner, and other illustrations, pedigrees, etc., 2 vol., hf. mor. (ruɔɔed), g. e., 1823, folio (307) £6 15s.

8878 Wilde (O.) A Woman of No Importance, first ed., cl., uncut, 1894, 8vo. (167) *Spencer,* £1

8879 Wilson (T.) The Rule of Reason, R. Grafton, 1553—The Arte of Rhetorique, J. Kingston, 1562—A ɔook called the Foundacion of Rhetorike (last leaf repaired), 1563, all printed in black letter (some margins cut into), in 1 vol., russ., sm. 4to. (532) *Tregaskis,* £3 3s.

SOTHEBY, WILKINSON & HODGE.

The Library of the late Mr. T. W. Waller, of Westbourne Street, W.

(No. of Lots, 241 ; amount realised—exclusive of a large collection of Musical and Dramatic Autograph Letters, Caricatures and Prints—£1,447 18s.)

8880 Ackermann (R.) Microcosm of London, col. plates by Rowlandson and Pugin, 3 vol., russ. (2 vol. repaired and one broken), (1811,) 4to. (73) *Dobell*, £12

8881 Angelo (Henry). Reminiscences, 68 plates, 2 vol., 1904, imp. 8vo. (1) *Forrester*, £1 8s.

8882 [Apperley (C. J.)] Life of Mytton, second ed., 18 col. plates (one leaf torn), hf. cf., R. Ackermann, 1837, 8vo. (2) *Maggs*, £7 5s.

8883 Apperley (C. J.) Life of a Sportsman, first ed., 36 col. plates by H. Alken (a few, as usual, mounted), mor. ex., 1842, 8vo. (3) *Young*, £20

8884 Artists' Repository (The) and Drawing Magazine, plates, 5 vol., cf., 1784-94, 8vo. (4) *Lewine*, £2

8885 Auscher (E. S.) History of French Porcelain, 24 col. plates and other illustrations, 1905, roy. 8vo. (5) *Quaritch*, £1 1s.

8886 Blake (William). Songs of Innocence (No. 24)—Songs of Experience (No. 11), 2 vol. in 1, reproduced in fac. by Wm. Muir, col. by hand, mor., t. e. g., by Rivière, orig. blue wrappers bound in, 1884-85 (78)—Milton, a Poem, fac. at Edmonton, anno 1886, by Wm. Muir and others, col. by hand, mor., t. e. g., by Rivière, orig. blue wrappers bound in, 1885 (79)—There is no Natural Religion (No. 12), 1886 —The Marriage of Heaven and Hell (No. 3)—The Gates of Paradise (No. 15), 1888, 3 vol. in 1, reproduced in fac. by Wm. Muir, etc., mor. ex., t. e. g., by Rivière, orig. blue wrappers bound in, 1886-88 (80)—The Book of Thel (No. 26)—Visions of the Daughters of Albion (No. 31)—The First Book of Urizen (No. 2), 3 vol. in 1, reproduced in fac. by Wm. Muir, etc., col. by hand, mor., t. e. g., by Rivière, orig. blue wrappers bound in, 1888, etc., 4to. (81)—Europe, a Prophecy, 1794 (No. 11, 1887)—America, a Prophecy, 1793 (No. 3, 1887)—The Song of Los, 1795 (No. 9, 1890)— Little Tom the Sailor (broadside sheet), in 1 vol., reproduced in fac. by Wm. Muir and others, col. by hand, mor. ex., by Rivière, orig. blue wrappers bound in (180) *Edwards*, £57

8887 Boccace (Jean). Le Decameron [traduit par le Macon], port., engraved titles, plates and vignettes by Gravelot, Eisen, Cochin and Boucher, 10 extra plates inserted, 5 vol., contemp. French mor., g. e., *Londres* [*Paris*], 1757-61, 8vo. (8) *Parsons*, £56

8888 Browne (H. K., "Phiz"). Life and Labours, by D. C. Thomson, LARGE PAPER, proof port. and 130 illustrations, extra illustrated by the insertion of 43 ports. and plates, and 23 orig. drawings by H. K. Browne, mor. ex., with the orig. brown cl. cover, g. e., by Morrell, 1884, 4to. (85)
Sawyer, £23

8889 Burlington Fine Arts Club. Exhibition of Portrait Miniatures, 36 plates, 1889, imp. 4to. (86) *Quaritch*, £10 10s.

8890 Burlington Fine Arts Club. Catalogue of a Collection of European Enamels, 72 plates in photogravure (3 col.), 1897, imp. 4to. (87) *Quaritch*, £6 5s.

8891 Burlington Fine Arts Club. Exhibition of a Collection of Silversmiths' Work of European Origin, 120 plates, 1901, imp. 4to. (88) *Batsford*, £4 8s.

8892 Burlington Fine Arts Club. Exhibition of English Mezzotint Portraits, 30 plates, 1902, imp. 4to. (89) *Pollard*, £3 4s.

8893 Burton (Wm.) History of English Porcelain, 24 plates in colours, etc. and other illustrations (1902), roy. 8vo. (9)
Bumpus, £3 12s.

8894 Byron (Lord). Letters and Journals, by Thomas Moore, 2 vol. extended to 4 (with special title-page to each vol.) by the insertion of over 150 ports. and illustrations, and 140 views, mor. ex., t. e. g., 1830, 4to. (90) *E. Carr*, £9

8895 Caldecott (J. W.) Values of Old English Silver and Sheffield Plate, 87 plates, 1906, 4to. (91) *Edwards*, £1 3s.

8896 Campbell (T.) Poetical Works, inlaid to folio size and extended to 2 vol. by the insertion of 88 very carefully selected ports. ; fancy subjects by Bartolozzi, Cosway, Wheatley and others (some in proof states) ; a duplicate set of the illustrations to the work, artist's proofs before the plates were cut on folio paper ; and other important and valuable prints. Inserted are also an autograph letter of Robert Burns to James Candlish, and other autograph letters by T. Campbell, J. M. W. Turner, etc., mor. super ex., Moxon, 1837, folio (182) *W. Brown*, £88

8897 Catalogues of the Society of Artists of Great Britain, from its commencement in 1760 to its close in 1791, inlaid to royal 4to., and very extensively illustrated with about 230 orig. drawings and sketches, about 450 engravings, etc., some mezzotints, several in proof states, and about 60 autograph letters, title-pages, descriptive lists, etc., printed on vellum, bound in 6 vol., mor. ex. (93) *Maggs*, £38

8898 Catalogues of the Free Society of Artists, from its commencement in 1760 to its close in 1783 (those for 1780 and 1781 in MS.), inlaid to royal quarto, and very carefully illustrated by the late Mr. E. B. Jupp, with about 120 orig. drawings and sketches, numerous autograph letters and documents, and nearly 200 mezzotint and other engravings, some proofs, the title-pages, descriptive list of the illustrations to each vol., etc., printed on vellum, bound in 4 vol., mor. ex. (92)
Maggs, £46

8899 Chambers (R.) Book of Days, 2 vol. extended to 12 (with

special title-page to each volume) by the insertion of
hundreds of ports., views, etc., hf. mor., t. e. g., 1879, 8vo.
(17) *Dobell*, £9 10s.

8900 Claude Le Lorrain. Liber Veritatis, 3 ports. and 300 plates,
engraved by R. Earlom, orig. impressions, proofs, 3 vol.,
vol. i. and ii. hf. mor., uncut, by Zaehnsdorf, vol. iii. mor.,
g. e., 1777-1819, folio (185) *Lewine*, £3 15s.

8901 Copper Plate Magazine (The), or Monthly Treasure for the
Admirers of the Imitative Arts, ports. and plates, hf. mor.,
G. Kearsly, 1778, 4to. (97) *James*, £1 11s.

8902 Cuckold's Chronicle (The), being Select Trials for Adultery,
Incest, Imbecility, Ravishment, etc., plates, 2 vol., cf., g. e.,
by Rivière, 1793, 8vo. (24) *Hornstein*, £6 15s.

8903 Dickens (Charles). Works, éd. de luxe, plates on India
paper, 30 vol., hf. mor., t. e. g., by Rivière, 1881-82, imp.
8vo. (25) *Hill*, £20 10s.

8904 Dickens (C.) Memoirs of Joseph Grimaldi, first ed., 2 vol.,
inlaid and extended to 4 vol. folio (with specially printed
titles dated 1883), and extra illustrated with water-colour
drawings, ports., play-bills, orig. songs sung by Grimaldi,
with music, autograph letters of Charles Dickens and
others, and many other valuable illustrations, mor. super
ex., by Tout, 1838 (188) *Dobell*, £41

8905 Dilke (Lady). French Painters of the XVIIIth Century,
plates, 1899 — French Furniture and Decoration in the
XVIIIth Century, plates, 1901, super imp. 8vo. (27)
Parsons, £1 13s.

8906 Dorat (Cl.) Fables Nouvelles, fronts., engraved title and
vignettes by Marillier, 3 ports. of Dorat inserted, 2 vol.
in 1, mor. ex., *A La Haye et se trouve à Paris*, 1773, 8vo.
(30) *Maggs*, £18 10s.

8907 Dorat (Cl.) Les Baisers, précédés du Mois de Mai, first ed.,
LARGE PAPER, front., plate and vignettes by Eisen and
Marillier, mor. ex., by Belz-Niedrée, *A La Haye et se trouve
à Paris*, 1770, 8vo. (29) *Bumpus*, £29 10s.

8908 Doran (Dr.) "Their Majesties' Servants," ed. by R. W.
Lowe, 50 ports. and other illustrations, ports. in duplicate,
one on Japanese, the other on plate paper, as India proofs,
3 vol., hf. mor., t. e. g., by Rivière, 1888, roy. 8vo. (28)
Hornstein, £2 10s.

8909 [Duclos.] Les Confessions du Comte de ***, sixième éd.,
7 plates after Desrais, mor. ex., by Rivière, *Amsterdam*,
1783, 8vo. (31) *Bumpus*, £4 12s. 6d.

8910 Egan (Pierce). Finish to the Adventures of Tom, Jerry and
Logic, first ed., 36 col. plates and woodcuts by R. Cruik-
shank, cf., 1830, 8vo. (32) *Hornstein*, £19

8911 Etching Club. Etch'd Thoughts, India paper proof etchings,
Etching Club, 1844, folio (192) *James*, £1 3s.

8912 Etching Club. Goldsmith. Deserted Village, 1841—Songs
of Shakespeare, 1843—Gray. Elegy, 1847—Milton. L'Alle-
gro, 1849, illustrations by Members of the Etching Club, as
issued, together 4 vol., folio (193) *Maggs*, 18s.

8913 Etching Clu⊃ (The Junior). Passages from Modern English Poets, 47 etchings, hf. bd. (⊃roken), 1862, folio (196)
Maggs, £2

8914 Fields (J. L.) Yesterdays with Authors, extra illustrated by the insertion of several hundred autograph letters, ports., etc. of persons referred to in the ⊃ook, and other interesting matter, inlaid and extended to 2 vol., mor. super ex., 4to. (199)
Maggs, £47

8915 Foster (J. J.) Miniature Painters, éd. royale (45 copies only), 40 of the miniatures col. by hand in imitation of the originals, and with 15 extra plates (3 of which are in colours) specially executed for Mr. T. W. Waller, 2 vol., vell., with ties, 1903, folio (200)
Heighan, £19

8916 Fox (Right Hon. C. J.) A History of the Early Part of the Reign of James II., LARGE PAPER, extended into 2 vol. by the insertion of a⊃out 170 mezzotint and other engravings, an A. L. s. by C. J. Fox, etc., mor. super ex., the interiors of the covers with gold tooling, with monogram of Frederick Earl of Bessborough, to whom these 2 volumes originally ⊃elonged, ⊃y Charles Lewis, *London,* 1808, 4to. (105)
Bumpus, £30 10s.

8917 Frankau (Julia). Eighteenth Century Colour Prints, coloured copperplates, 1900 (201)—Eighteenth Century Colour Prints, 52 pictures printed in monochrome and one in colours, with extra portfolio, containing 50 proof plates, printed in colours on India paper, together 2 vol., one cl. and portfolio in hf. mor. ex., 1900, folio (202)
Rimell, £8

8918 Frankau (J.) John Raphael Smith, his Life and Works, 30 photogravures, separate volume in royal folio, containing 50 examples of stipple, mezzotints, paintings and drawings, printed in colours and monochrome, cl. and folio in hf. mor. ex., 1902 (34)
Edwards, £8 5s.

8919 Frankau (J.) Ward (William and James). Their Lives and Works, 1 vol. 8vo. text, with 30 photogravures and a port. containing 40 large plates, the stipples in colour, the mezzotints in monochrome, as issued, 1904, folio (235)
Rimell, £6 10s.

8920 French Art from Watteau to Prud'hon, ed. by J. J. Foster, éd. royale (limited to 35 copies), text and plates on Japan vell., with 45 plates col. ⊃y hand (30 of these plates are extra and appear only in this edition), 3 vol., vell. (pu⊃lished at 120 guineas net), Dickinsons, 1905-07, folio (203) *Forrester,* £15

8921 Garnier (E.) The Soft Porcelain of Sèvres, 50 col. plates, 1892, folio (205)
W. Brown, £2 12s.

8922 Goya y Lucientes (F.) El Arte de lidiar los Toros, 33 plates of ⊃ull fighting, hf. roan, n. d., o⊃long folio (208)
Baer & Co., £12 5s.

8923 Gruyer (F. A.) La Peinture au Chateau de Chantilly, plates, 2 vol., hf. mor. ex., ⊃y Rivière, *Paris,* 1896-98, 4to. (115)
Maggs, £4 15s.

8924 Hamerton (P. G.) Etching and Etchers, first ed., inlaid to folio size and extended to 6 vol. ⊃y the insertion of a⊃out

350 additional etchings, some in proof states, also ports. of
the artists, etc., mor. ex., 1868, folio (209) *Edwards, £26*
8925 Hamilton (Lady Anne). Secret History of the Court of Eng-
land, orig. ed., illustrated ɔy the insertion of 169 ports., 2
vol., mor., t. e. g., W. H. Stevenson, 1832, 8vo. (38)
Bumpus, £8
8926 Havard (H.) Dictionnaire de l'Ameublement, plates (many
in colours) and illustrations, 4 vol., hf. mor. ex., by Rivière,
Paris, n. d., 4to. (119) *W. Brown, £5 2s. 6d.*
8927 Herkomer (Hubert). Etching and Mezzotint Engraving, 13
plates, hf. mor., t. e. g., 1892, 4to. (121) *Young, £2*
8928 Hoppner (John, R.A.), by Wm. McKay and W. Roɔerts,
front. in colours and ports., 1909, imp. 4to. (125)
Rimell, £4 2s. 6d.
8929 Jackson (C. J.) English Goldsmiths and their Marks, front.
and facsimile marks, 1905, 4to. (126) *Forrester, £1 8s.*
8930 La Borde (B. de). Choix de Chansons mises en musique,
plates ɔy Moreau le jeune and others, words and music
engraved throughout by Moria and Mlle. Vendome (the
front. to vol. ii. containing the profile port. of Marie
Antoinette, instead of that of La Borde), 4 vol., mor., g. e.,
ɔy Mercier, Sr. de Cuzin, *Paris,* 1773, roy. 8vo. (41)
Maggs, £102
8931 La Fontaine (Jean de). Contes et Nouvelles en vers, Édition
des Fermiers Généraux, ports. of La Fontaine, Eisen and
Choffard, 80 plates by Eisen and 57 vignettes by Choffard,
with the vignettes in duplicate (separate proofs), and 24
additional plates designed for the work but rejected,
including "Le Cas de Conscience" and "Le Diaɔle de
Papefiguière," "couvert et découvert," 2 vol., mor. ex.,
elegantly tooled, in cases, *Amsterdam (Paris),* 1762, 8vo.
(40) *Bumpus, £81*
8932 Lane (Theodore). Biographical Sketch of the Life of the late
Mr. Theodore Lane (by Pierce Egan), each leaf inlaid to
4to. size and illustrated by the insertion of 14 ports. of
contemp. characters, an autograph letter of Pierce Egan, 7
character ports. of actors (col.), 27 col. plates, the original
manuscript, 10 pages folio of "The Naturalist," a poem by
William Comɔe, with autograph letter of the same, and 3
orig. water-colour drawings by Theodore Lane to illustrate
the poem, etc., mor. ex., g. e., ɔy Rivière (*ca.* 1840), 4to. (127)
Dobell, £17 10s.
8933 Moffatt (H. C.) Old Oxford Plate, 96 plates, 1906, 4to. (133)
G. R. Harding, £2 6s.
8934 Molinier (E.) Musée du Louvre. Le Moɔilier Français, in
2 parts, 100 plates (some in col.), as issued, *Paris,* n. d.,
folio (221) *G. R. Harding, £5*
8935 Montesquieu (C. de). Le Temple de Gnide, front., engraved
title and 9 plates, engraved ɔy N. Le Mire, text engraved
throughout, mor. ex., ɔy Zaehnsdorf, *Paris,* 1772, 8vo. (45)
Bumpus, £5 10s.
8936 Mudford (Wm.) An Historical Account of the Campaign in
XXIV. 41

the Netherlands, 28 col. plates by Geo. Cruikshank and J.
Rouse, plan and map, with 8 col. plates, by J. H. Clark, to
illustrate Sir W. Scott's poem, "The Battle of Waterloo,"
inserted, elaborately bound in mor. ex., with monogram of
Frederick, Earl of Bessborough, double, fore-edge painting
of the River Thames by J. Harris, 1817, 4to. (134)
　　　　　　　　　　　　　　　　　　Sotheran, £43
8937 Nolhac (Pierre de). J. M. Nattier, Peintre de la Cour de
Louis XV., Exemplaire sur Papier de Rives, plates (some
in colours) and illustrations, *Paris,* Goupil, 1905, 4to. (136)
　　　　　　　　　　　　　　　　　　Bluizot, £10
8938 Ovid. Les Métamorphoses (M. l'Abbé Banier), 145 plates
after Eisen, etc. and 30 vignettes by Choffard, 4 vol., mor.
ex., by Rivière, *Paris,* 1767-71,·4to. (137)　　*Quaritch,* £28
8939 Pennell (J.) Pen Drawing and Pen Draughtsmen, illustra-
tions, hf. mor., t. e. g., by Rivière, 1889, roy. 4to. (139)
　　　　　　　　　　　　　　　　　　James, £1 13s.
8940 Propert (J. L.) History of Miniature Art, plates, vell. gilt,
Macmillan, 1887, folio (226)　　　　　*James,* £5 17s. 6d.
8941 Redford (G.) Art Sales, 2 autograph letters of author in-
serted, 2 vol., 1888, 4to. (145)　　　　　　£5 10s.
8942 Rogers (S.) Italy, a Poem, and Poems, vignettes after
Turner and Stothard, 2 vol., mor., g. e., 1830-34, 8vo. (52)
　　　　　　　　　　　　　　　　　　Maggs, £2
8943 Romney (George). Life, by Wm. Hayley, ports. and plates,
mor., g. e. (rubbed), *Chichester,* 1809, 4to. (149)
　　　　　　　　　　　　　　　　　　Pollard, £7 5s.
8944 Rossetti (Dante Gabriel). An Illustrated Memorial of his
Art and Life, by H. C. Marillier, LARGE PAPER, port. and
plates on Japanese paper, and illustrations, mor. ex., uncut,
by D. Cockerell, 1899, folio (227)　　　　*Young,* £5 5s.
8945 Scott (W. H.) British Field Sports, LARGE PAPER, plates
and vignettes, russ., 1818, 8vo. (61)　　　*E. Carr,* £3 3s.
8946 Sheridan (R. B.), Memoirs of the Life of, by Th. Moore, 2
vol. extended to 4 by the insertion of 292 ports. and plates,
autograph signatures and documents, etc., cf., t. e. g., by
Tout, 1827, 8vo. (62)　　　　　　　　*Dobell,* £8 5s.
8947 Singleton (Esther). The Furniture of Our Forefathers, plates,
with descriptions by R. Sturgis, 2 vol., 1901, 4to. (156)
　　　　　　　　　　　　　　　　　　Rimell, £1 12s.
8948 Smith (J. C.) British Mezzotinto Portraits, 125 ports., 4 vol.,
hf. mor., t. e. g., by Rivière, 1884, roy. 8vo. (63)　　　£23
8949 Thackeray (W. M.) Works, édition de luxe, port. and plates
on India paper, 24 vol., hf. mor., t. e. g., by Rivière, 1878-79,
imp. 8vo. (65)　　　　　　　　　　*Rimell,* £20 10s.
8950 The Tavern Hunter, 1702—The Delights of the Bottle, or the
Compleat Vintner, 1721—Club Life of London, the portion
relating to old London Taverns—A Series of Newspaper
Articles, entitled "Licensed Victuallers, their Manners and
their Parlours," and other printed matter referring to the
same subject, uniformly mounted and bound in 3 vol., and
extensively illustrated, mor. ex., 4to. (160) · *Dobell,* £15 10s.

8951 Thomson (D. C.) The Barbizon School of Painters, LARGE
PAPER, plates and illustrations on Japanese paper, 1890,
4to. (161) *Maggs, £3* 10s.

8952 Turner, by Sir Walter Armstrong, No. 11 of 350 copies on
Japanese paper, plates and vignettes in two states, 2 vol.,
mor. ex., by Rivière, T. Agnew and Sons, 1902, folio (230)
Rimell, £5 5s.

8953 Van Dyck (Anthony). An Historical Study of his Life and
Works, by Lionel Cust, plates, 1900, folio (231)
James, £2 2s.

8954 Virgil. Works, translated into English verse by J. Dryden,
100 plates, cf., g. e., 1697, folio (232) *Bloomfield, £1*

8955 Virgilius. Bucolica, Georgica et Aeneis, Didot's ed., on
vellum paper, plates by Gérard and Girodet, proofs before
letters (wanted 2 plates in the "Bucolica"), mor., g. e., by
Bozerian, *Paris,* 1798, folio (233) *Dobell, £1* 1s.

8956 Walpole (Horace). Works, with Letters and Memoirs of the
last ten years of the Reign of George the Second, ports.
and plates, extra illustrated by the insertion of 550 ports.
and plates, 9 vol., hf. cf., 1798-1825, 4to. (164)
Maggs, £12 10s.

8957 Walton (Izaak) and Cotton (Charles). The Complete Angler,
by Sir H. Nicolas, ports., plates and vignettes, 2 vol., hf.
mor., t. e. g., W. Pickering, 1836, imp. 8vo. (69)
E. Carr, £9 5s.

8958 [Westmacott (C. M.)] The English Spy, first ed., col. plates
by R. Cruikshank, 2 vol., hf. mor., t. e. g., by Morrell,
1825-26, 8vo. (70) *Hornstein, £22* 10s.

8959 Whitman (A.) Nineteenth Century Mezzotinters : Samuel
Wm. Reynolds, No. 48 of 50 copies on LARGE HAND-MADE
PAPER, plates on Japanese paper, hf. vell., 1903, folio (239)
James, £1 9s.

8960 Whitman (A.) Nineteenth Century Mezzotinters : Chas.
Turner, No. 36 of 50 copies on LARGE HAND-MADE PAPER,
plates on Japanese paper, hf. vell., 1907, folio (240)
James, £1 10s.

8961 Whitman (A.) Masters of Mezzotint, No. 3 of 50 copies
on LARGE HAND-MADE PAPER, plates on Japanese paper,
hf. vell., 1898, folio (238) *Brewer, £5* 7s. 6d.

8962 Wilkie (Sir David) and Geddes (Andrew). Etchings, by
David Laing, hf. mor., t. e. g., *Edinb.,* 1875, folio (241)
Rimell, £2 8s.

SOTHEBY, WILKINSON & HODGE.

ILLUSTRATED SPORTING AND OTHER BOOKS FROM THE LIBRARIES OF MR. C. DITTER, OF FRANKFORT-ON-THE-MAIN ; COLONEL HARGREAVES, OF PUTNEY HEATH ; AND THE LATE SIR DANIEL COOPER.

No. of Lots, 236 ; amount realised, £4,102 5s. 6d.)

(*a*) *A Portion of Mr. C. Ditter's Library.*

8963 Shakespeare (Wm.) Works, éd. de luxe of the Cambridge ed. (one of 500 copies on hand-made paper), 40 vol., hf. mor., t. e. g., 1893-95, imp. 8vo. (2) *Quaritch*, £15

8964 Cervantes (M. de). Don Quixote, trans. by T. Shelton, 3 vol., hf. mor., t. e. g., 1900, 8vo. (13) *Quaritch*, £1 6s.

8965 Derbyshire Archæological and Natural History Society. Journal, from the commencement to 1897, plates, etc., 19 vol. in 10, hf. cf., 1879-97, 8vo. (14) *Thorp*, £2 6s.

8966 Wiltshire Archæological and Natural History Magazine, from the commencement to June, 1900, plates, etc., 30 vol. and 1 part, hf. cf. gt., 1854-1900 (15)—Abstracts of Wiltshire Inquisitiones Post Mortem, ed. by Fry, parts i.-vii., 1893-98—Catalogue of the Library of the Wiltshire Archæological and Natural History Society, 5 parts, 1894-98 (16) *Quaritch*, £10

8967 Wiltshire. The Beauties of Wiltshire displayed, plates, 3 vol., mor., g. e., 1801, 8vo. (17) *Quaritch*, £1 6s.

8968 Park (J. J.) Topography and Natural History of Hampstead, plates and map, hf. cf., 1814, roy. 8vo. (18) *Tregaskis*, £1 2s.

8969 Haddon Hall Library. Hunting by J. Otho Paget, and Shooting by A. I. Shand, 150 copies printed on handmade paper, vell., uncut, 1900-2, 8vo. (30) *Maggs*, 12s.

8970 Pepys (S.) Diary, ed. by H. B. Wheatley, with Index and Pepysiana, ports., etc., 10 vol., hf. mor., t. e. g., 1893-99, 8vo. (34) *Edwards*, £7

8971 Sowerby (J.) Mineral Conchology, with Index and Supplement, col. plates, 7 vol. (vol. vii. wanted title), hf. mor., t. e. g., 1812-29, roy. 8vo. (35) *Quaritch*, £12

8972 Lytton (Lord). Novels, Library ed., 48 vol., 1860—Poetical and Dramatic Works, 5 vol., 1852, uniform in buckram, t. e. g., 1852-95, 8vo. (36) *Latham*, £18 18s.

8973 Memorials of the Counties of England. Old Derbyshire, 1907—Old Norfolk, 1908—Old Dorset, 1907—Old Warwickshire, 1908—Old Hampshire, 1906—Old Somerset, 1906, together 6 vol., illustrations, 1906-8, 8vo. (38) *Thorp*, £1 14s.

8974 Harper (Charles G.) The Marches of Wales, 1894—The
Dover Road, 1895—Portsmouth Road, 1895—Exeter Road,
1899—Bath Road, 1899—Great North Road, 2 vol., 1901—
Norwich Road, 1901—Cambridge, Ely and King's Lynn
Roads, 1902—Holyhead Road, 2 vol., 1902—Newmarket,
Bury, Thetford and Cromer Roads, 1904—Oxford, Glouces-
ter and Milford Haven Roads, 2 vol., 1905—Hastings Road,
1906—Brighton Road, 1906, together 16 vol., illustrations,
buckram and cl., uncut, 1894-1906, 8vo. (40)
Quaritch, £7 10s.

8975 Hutchinson (Wm.) History and Antiquities of Cumberland,
map and plates, 2 vol., cf., *Carlisle,* 1794, 4to. (41)
Walford, £1 16s.

(β) *From the Library of Colonel Hargreaves.*

8976 Sporting Magazine (The), complete from the commencement
in 1792 to 1870, 156 vol., orig. wrappers bound up (the title-
page of vol. clvi. was never issued, but the vol. has a
specially etched title-page inserted), cf. extra, the edges
totally uncut, by Root and Son, 1792-1870—Gilbey (W.)
Index of Engravings in the Sporting Magazine from the
year 1792 to 1870, mor. ex., 1892, together 127 vol.—Sporting
Magazine (New). First Series, 19 vol., 1831-40 ; New
Series, vol. i. to vi., 1841-43, together 25 vol., mor. ex., uncut,
1831-43—Sportsman (The), 2 vol., 1833-34 (no titles) ; The
Sportsman and Veterinary Recorder, 3 vol., 1835-36 ; The
Sportsman (New Series), 6 vol., 1836-39 ; Second Series,
15 vol., 1839-46, together 26 vol., plates, cf. ex., 1833-46—
Sporting Review (The), a Monthly Chronicle of the Turf,
ed. by " Craven," plates and woodcuts, vol. i.-xviii., cf. ex.,
t. e. g., 1839-47 (56) *Quaritch, £920*
[The New Sporting Magazine, The Sportsman and The
Sporting Review were taken over and absorbed by The
Sporting Magazine. The above is the finest set hitherto
offered for sale.—*Catalogue.*]

8977 Annals of Sporting and Fancy Gazette, col. plates by Alken
and other illustrations, 13 vol., with the last number (No. 78)
for June, 1828, orig. hf. cf., uncut, 1822-28, 8vo. (57)
Quaritch, £90

8978 Turf Herald (The), or Annual Racing Calendar, from 1824 to
1827 (no title-pages), orig. hf. cf., uncut, symbolically tooled,
together 4 vol., 8vo. (58) *Quaritch, £20* 10s.

8979 Fores. Sporting Notes and Sketches, vol. i.-xix., hf. mor.,
uncut, t. e. g., symbolically tooled, 1884-1902, 8vo. (59)
Edwards, £3 3s.

8980 Racing Calendar for 1751, by John Pond—Historical List of
Horse-Matches Run, 1752 to 1768, by Reginald Heber—
Horse-Matches, 1769 and 1770, by B. Walker—The Racing
Calendar Abridged [1709-1750], in 1 vol., together 21 vol.,
cf., g. e. (the last vol. uncut), t. e. g., 8vo. (60)
Quaritch, £17 10s.

8981 Encyclopædia of Sport, 2 vol. in 4, orig. pictorial wrappers
ɔound up, hf. mor., uncut, 1897-8, imp. 8vo. (61)
A. D. Gardner, £3

8982 Brinkley (Capt. F.) Japan, its History, Arts and Literature,
éd. de luxe, on Japanese vell. paper (limited to 35 numɔered
copies for the United Kingdom), 12 vol., white ɔuckram,
uncut, t. e. g., 1903-4, 8vo. (66) *Spencer,* £13 5s.

8983 Matrimonial Ladder, or such things are, 23 col. plates, drawn
ɔy M. E(gerton), orig. bds., leather ɔack, with paper laɔel,
T. McLean, 1825, 8vo. (69) *Quaritch,* £5 15s.

8984 Thornton (Colonel). A Sporting Tour through various parts
of France, port. and plates, 2 vol., orig. bds., uncut, with the
paper laɔels, 1806, 4to. (72) *Quaritch,* £2 15s.

8985 Sportsman's Magazine (The), ed. ɔy Miles's Boy, engravings,
7 vol. in 6 (all puɔlished), mor., t. e. g., 1845-48, 4to. (74)
Hornstein, £18 15s.

8986 Thornton (Dr.) Temple of Flora, front. and col. plates of
flowers, hf. russ., 1812, 4to. (87) *Leighton,* 13s.

8987 Shakespeare (Wm.) Mr. William Shakespeares/ Comedies,/
Histories &/ Tragedies/, port. on title (repaired, but text
intact), with verses opposite (remargined, but text un-
impaired, a small portion of two margins in text repaired,
13in. by 8⅛in.), old mor. ex. (Roger Payne), *Printed by
Isaac Jaggard and Ed. Blount,* 1623 ; (at end) *Printed at
the charges of W. Jaggard, Ed. Blount, J. Smithweeke and
W. Aspley,* 1623 (88) *Quaritch,* £2,000
[This is the same copy which realised £2,400 in May,
1907. *See* BOOK-PRICES CURRENT, Vol. xxi., No. 6189.—
ED.]

8988 Historical Portraiture of Leading Events in the Life of Ali
Pacha, Vizier of Epirus, surnamed the "Lion," 6 col. plates
ɔy G. Hunt, mor. ex., T. M'Lean, 1823, folio (89)
Leighton, £2 6s.

8989 Costume of Yorkshire, 40 col. engravings, with descriptions in
English and French, bds., uncut, with laɔel, 1814, folio (90)
Maggs, £6 15s.

8990 Oxford. A few Recollections of Oxford, 12 large col. litho-
graphic plates (the margins of a few mended, no title), hf.
cf., with the paper label, *Oxford,* n. d., folio (92)
Quaritch, £20 10s.

(γ) *A Portion of the late Sir Daniel Cooper's Library.*

8991 Cracks of the Day. Pictorial Gallery of English Race
Horses, ed. ɔy Wildrake, engravings, cf. gt., Bohn, 1844,
8vo. (98) *Harrison,* £3 7s. 6d.

8992 Cracks of the Day, first ed., engravings, cf. ex., by Rivière
and Son, R. Ackermann, n. d. (1841), roy. 8vo. (102)
Wilkinson, £3 10s.

8993 Morland (T. H.) Genealogy of the English Race Horse,
front., cf. gt., 1810, 8vo. (109) *Edwards,* £1 1s.

8994 Carleton (J. W.) The Sporting Sketch Book, first ed., 11

engravings after Alken, Herring, etc., mor. super ex., 1842, 8vo. (110) *Quaritch*, £4 2s. 6d.

8995 Hinds (John). The Grooms' Oracle, col. front. by Alken, cf. ex., uncut, 1829, 8vo. (111) *Edwards*, 19s.

8996 Life of a Fox (The), written by himself, illustrations ɔy Thomas Smith, hf. mor. gt., uncut, t. e. g., 1843, 8vo. (112) *Hornstein*, £3

8997 Chifney (Samuel). Genius Genuine, hf. mor. (top margin of hf. title cut), 1804, 8vo. (113) *Quaritch*, £1 19s.

8998 Touchstone (S. F.) La Race Pure en France, col. front. and plates, hf. mor., t. e. g., 1895, imp. 8vo. (115) *Wilkinson*, £1 18s.

8999 Fournier (Paul) et Curot (Ed.) Le Pur Sang, Hygiène, Lois Naturelles, etc., 26 illustrations, hf. mor., uncut, t. e. g., 1906, roy. 8vo. (116) *Wilkins*, £2 6s.

9000 Horse-Racing, its History, hf. cf. gt., 1863, 8vo. (117) *Harrison*, £1 18s.

9001 Axe (Prof. J. W.) The Horse, its Treatment in Health and Disease, illustrations, some in col., 9 vol., 1905, 8vo. (120) *Edwards*, £1 5s.

9002 Pick (W.) and Johnson (R.) The Turf Register, hf. cf. gt., *York*, 1803-67, 8vo. (122) *Quaritch*, £1 16s.

9003 Roɔerts (J. and H.) The Sportman's Pocket Companion, head and tail pieces, engraved throughout (some leaves stained), mor. ex., uncut, t. e. g., n. d. (1760), 8vo. (123) *Quaritch*, £5 17s. 6d.

9004 Scott (W. H.) British Field Sports, plates, chiefly by J. Scott, and woodcuts, hf. mor., t. e. g., 1818, 8vo. (125) *Quaritch*, £3

9005 Dixon (H. H., "The Druid"). The Post and the Paddock (1856)—Silk and Scarlet, ports. (spotted), 1859—Scott and Seɔright, ports., 1862—Field and Fern, North and South, ports., 1865—Saddle and Sirloin (part North), ports., 1870, together 6 vol., hf. mor., t. e. g., uniform, 8vo. (131) *Hornstein*, £3 14s.

9006 Mills (John). Life of a Foxhound, first ed., port. and illustrations, nearly uncut copy, hf. mor., t. e. g. (ɔack symbolically tooled), 1848, 8vo. (135) — Life of a Racehorse, woodcuts, orig. wrapper ɔound up, hf. cf., t. e. g., by Rivière and Son, 1854—Too Fast to Last, hf. mor., t. e. g., n. d. (136)—The Flyers of the Hunt, first ed., col. illustrations ɔy Leech, front of the orig. cl. cover ɔound up, hf. mor., t. e. g., ɔack symɔolically tooled, 1859, 8vo. (137)—Life of a Racehorse, illustrated, front of orig. cl. cover ɔound up, hf. mor., t. e. g., 1861—Staɔle Secrets, i us ra ons, front of orig. cover ɔound up, hf. mor., t. e. g. 1863t(ɔacks symɔolically tooled), 8vo. (138) *Quaritch*, £12 5s.

9007 Jardine (Sir W.) Naturalists' Liɔrary, complete, col. plates and woodcuts, 40 vol., hf. mor., m. e., *Edinb.*, 1833-43, 8vo. (139) *Edwards*, £3 15s.

9008 [Apperley (C. J.)] Remarks on the Condition of Hunters, first ed., cf. ex., uncut, t. e. g., 1831, 8vo. (143) *Hornstein*, £1 10s.

8981 Encyclopædia of Nimrod's Hunting Tours, 1835—Nimrod's
)ound u hf. r', 1838, uniform cf. gt., 8vo. (144)
J. Bumpus, £4 12s.

8982 Brinkley (q⌐/. C.) Coloured Illustrations of the Eggs of
éd. de lⁱrds, third ed., 2 vol., uncut, Van Voorst, 1856,
copies ʃ *J. Bumpus, £4* 4s.
uncut. y H. B.) London, Past and Present, 3 vol., uncut,

8983 Matrir'₁ 8ι (154) *Hatchard, £3*
by alianStud Book, from the Earliest Accounts to the
τ',ar 19ɔ, by A. and W. C. Yuille, 7 vol., hf. mor.,

8984 T¹*Melbouɪ e*, 1878-1901, 8vo. (170) *Quaritch, £5* 5s.
' The Ausalasian" Turf Register and Sporting Calendar
[1865 to 908], (wanted 1904 and 1907,) together 41 vol., 24

8ɔ⌐ vol. in ɔr., the remainder in cl., as puɔlished, *Melbourne*,
1866-19ς, 8vo. (172) *Quaritch, £21*

9014 Stud Book(The) of New South Wales, ed. by F. B. Price,
etc., vol.. to iii., hf. mor., *Sydney*, 1859-73, 8vo. (173)
Barton, £4

9015 American tud Book (The), ed. ɔy S. D. Bruce, vol. i. to vi.,
New Yɔk, 1873-94—Vol. vii. and viii., puɔlished by the
Jockey (ub, *ib.*, 1898-1902, hf. cf. gt., 1873-1902, 8vo. (174)
Wilkinson, £4 4s.

⌐ɔ16 Stud Book(General), containing Pedigrees of Race Horses,
etc. to tⁱ year 1904, inclusive, hf. mor. gt. (vol. xv. in bds.),
together ᴐ̃ vol. (first ed. of vol. i. to xx., with the exception
of vol. i which is second ed.), 1791-1905—Supplements,
1791-19c (ᵼ6), cl. and wrappers, together 42 vol., 8vo. (176)
Quaritch, £15 5s.
ʃThis ɛt **included the** earlier volumes—Introduction,
ɪ ; Sˑd Book, with **Supplement**, 2 vol., 1793 and 1800;
; ɪˑ8, with Supplement, 2 vol., 1808 and 1814.—*Cata-*
]
ˑˑndar. By John Cheney, 1727-50, 24 vol., cf. gt. ;
ıl Heber, 1751-68, 18 vol., cf. gt. (with duplicates
to vii. in old cf.) ; by Tuting and Fawconer, 1769
ɪ 1775, 5 vol., cf. gt. ; **Plates**, Matches, etc. run
ıɪket, from 1728, from **the** vols. of Cheney, etc.,
ıs by W. Pick, of **York**, cf. gt. [1728-73]; by
ɜ to 1908, cf., together 188 vol., 1727-1908,
Hornstein, £35
Régistre des Chévaux de Pur Sang,
⌐1-98, 8vo. (180) *Wilkinson, £5* 10s.
st 31, 1833 to December, 1834, being
ınted the title), and Jan., 1835 to
ɪ woodcuts, bound in 18 vol., hf.
8vo. (183) *Hornstein, £28* 10s.
ɪ Pastimes, ports. and illustra-
and 5 numbers (various) of
ı) *Edwards, £11*
'e commencement in 1792
m. e., uniform, 1792-1870

—Gilbey (W.) Index of Engravings, from the year 1792
to 1870, cf., uncut, t. e. g., 1892, 8vo. 86) *Hornstein*, £125

9022 Grimble (Augustus). Deer Stalking, lustrations, mor., g. e.,
1886, 4to. (198) *Quaritch*, £3

9023 Taunton (T. H.) Portraits of Celebræd Racehorses, plates,
4 vol., hf. mor., uncut, t. e. g., 1887-84to. (203)
 Edwards, £3 12s.

9024 Tweedie (Major-General W.) The Aabian Horse, illustra-
tions and a map, orig. cl., uncut, 18ς, 4to. (205)
 Hatchard, £1 16s.
[A copy on large paper realised £ 8s., hf. mor.—ED.]

9025 Hayes (Capt. M. H.) The Points of tł Horse, illustrated ɔy
77 reproductions of photographs an 205 drawings, chiefly
ɔy J. H. O. Brown, hf. mor., t. e. g., 393, 4to. (208)
 Mills, £1 5s.

9026 Millais (J. G.) Game Birds and Shoong Sketches, plates in
col. and other illustrations, hf. mor t. e. g., 1892, imp. 4to.
(219) *Quaritch*, £6 5s.

9027 Millais (J. G.) A Breath from the Velt, illustrations by the
author and front. ɔy Sir J. E. Mlais, R.A., ɔuckram,
uncut, t. e. g., 1895, imp. 4to. (220) *Edwards*, £3 6s.

9028 Millais (J. G.) British Deer and thei Horns, "special ed."
(one ɔf dred numɔered and sɲed copies), 185 text
and f e illustrations, hf. mor.ɟ. e. g., 1897, imp. 4to.
(22 *Edwards*, £1 13s.

Mill) The Wildfowler in Sɔland, front. after Sir
is, 2 col. plates and other lustrations, hf. parch-
ut, 1901, 4to. (222) *Hornstein*, £2

) Natural History of the Fitish Surface-Feeding
RGE PAPER (one of 600 numbered copies), photo-
col. plates and other illusttions, orig. cl., uncut,
4to. (223) *Quaritch*, £5

G.) The Mammals of Gre: Britain and Ireland,
ures, col. plates and oth illustrations, 3 vol.,
uncut, 1904, imp. 4to. (224 *J. Bumpus*, £9 10s.

gazine. India Proof Impessions of 788 of the
the Sporting Magazine, iɾluding the engraved
e volumes, 20 sets so issui, on 4to. paper, in 4
ses, ɔook form, 1793-1824226) *Hornstein*, £96

I.) Life of Napoleon, pɫtes in col. and other
s, 4 vol., ornamental cl., urut, t. e. g., *New York*,
(227) *Andrews*, £2 5s.

Liɔrary (The), LARGE PAꓱR, illustrations, com-
iɲ 28 vol., hf. mor., t. e. g., ʒ85-96, 4to. (228)
 Quaritch, £16 10s.

ʒir Edwin, R.A.) Workꞓ Liɔrary ed., plates,
ore letters, on India papeɪmor. gt., g. e., *Henry
d Company*, n. d., folio (22ɩ *Young*, £4 10s.

Brood Mares ɔelonging ɔ the Royal Stud at
ɳ Court, ɔy C. W., large plæ:s, with text, hf. mor.,
ʒ37, folio (231) *Maggs*, £3 3s.

9009 Apperley (C. J. ...Nimrod's Hunting Tours, 1835—Nimrod's
 Northern T... 183... cf. gt., 8vo. (144)
 J. Bumpus, £4 12s.

9010 Hewitson (W. ...) ...strations of the Eggs of
 British B... irds.thi... uncut, Van Voorst, 1856,
 8vo. 15... *J. Bumpus,* £4 4s.

9011 Wheatle...y (H. B... ...ent, 3 vol., uncut,
 8vo. (15) *Hatchard,* £3

9012 ...n Stud B... accounts to the
 ...oo, b... vol., hf. mor.,
 ...ne, 188-... *Quaritch,* £5 5s.

901... ...tralasn... ...rting Calendar
 ...908 (w... ether 41 vol., 24
 ...or., te... ed, *Melbourne,*
 ...8vo (1... *Quaritch,* £21

9014 ...(Tb) ...by F. B. Price,
 ...toi... 8vo. (173)
 Barton,

9015 ...vol. i. to
 ...ished by
 ...8vo. (...son, £...

9016 S... ...ace Ho... ...in
 ...he exc...ppl...8...

—Gilbey (W.) Index of Engravings, fro the year 1792 to 1870, cf., uncut, t. e. g., 1892, 8vo. (186) *Hornstein*, £125

9022 Grimble (Augustus). Deer Stalking, illustrtions, mor., g. e., 1886, 4to. (198) *Quaritch*, £3

9023 Taunton (T. H.) Portraits of Cele)rated Rcehorses, plates, 4 vol., hf. mor., uncut, t. e. g., 1887-8, 4to. 203)
dwards, £3 12s.

9024 Tweedie (Major-General W.) The Ara)ia Horse, illustrations and a map, orig. cl., uncut, 1894, 4t((205)
litchard, £1 16s.
[A copy on large paper realised £2 8s.)f. mor.—ED.]

9025 Hayes (Capt. M. H.) The Points of the Hoe, illustrated)y 77 reproductions of photographs and 205lrawings, chiefly)y J. H. O. Brown, hf. mor., t. e. g., 1893, to. (208)
Mills, £1 5s.

9026 Millais (J. G.) Game Birds and Shooting Setches, plates in col. and other illustrations, hf. mor., t. e.., 1892, imp. 4to. (219) *Quaritch*, £6 5s.

9027 Millais (J. G.) A Breath from the Veldt, ilstrations by the author and front. by Sir J. E. Millais.R.A.,)uckram, uncut, t. e. g., 1895, imp. 4to. (220) *Edwards*, £3 6s.

9028 Millais (J. G.) British Deer and their Hois, "special ed." (one of a hundred num)ered and signecopies), 185 text and full-page illustrations, hf. mor., t. e. ¿ 1897, imp. 4to. (221) *ltwards*, £1 13s.

9029 Millais (J. G.) The Wildfowler in Scotlan front. after Sir J. E. Millais, 2 col. plates and other illustrtions, hf. parchment, uncut, 1901, 4to. (222) *Hornstein*, £2

9030 Millais (J. G.) Natural History of the BritisSurface-Feeding Ducks, LARGE PAPER (one of 600 numbe)d copies), photogravures, col. plates and other illustration orig. cl., uncut, 1902, imp. 4to. (223) *Quaritch*, £5

9031 Millais (J. G.) The Mammals of Great Brain and Ireland, photogravures, col. plates and other illtrations, 3 vol.,)uckram, uncut, 1904, imp. 4to. (224) *J.3umpus*, £9 10s.

9032 Sporting Magazine. India Proof Impressias of 788 of the Plates to the Sporting Magazine, includg the engraved titles to the volumes, 20 sets so issued, or4to. paper, in 4 hf. mor. cases,)ook form, 1793-1824 (226) *Hornstein*, £96

)33 Sloane (W. M.) Life of Napoleon, plates 1 col. and other illustrations, 4 vol., ornamental cl., uncut, e. g., *New York*, 1896, 4to. (227) *1ndrews*, £2 5s.

34 Badminton Li)rary (The), LARGE PAPER, lustrations, complete set, in 28 vol., hf. mor., t. e. g., 1885-6, 4to. (228) *Qaritch*, £16 10s.

5 Landseer (Sir Edwin, R.A.) Works, Lifary ed., plates, proofs)efore letters, on India paper, moigt., g. e., *Henry Graves and Company*, n. d., folio (229) *Young*, £4 10s.

• Portraits of Brood Mares)elonging to th Royal Stud at Hampton Court, by C. W., large plates, xth text, hf. mor., t. e. g., 1837, folio (231) *Maggs*, £3 3s.

9009 Apperley (C. J.) Nimrod's Hunting Tours, 1835—Nimrod's Northern Tour, 1838, uniform cf. gt., 8vo. (144)
 J. Bumpus, £4 12s.

9010 Hewitson (W. C.) Coloured Illustrations of the Eggs of British Birds, third ed., 2 vol., uncut, Van Voorst, 1856, 8vo. (153)
 J. Bumpus, £4 4s.

9011 Wheatley (H. B.) London, Past and Present, 3 vol., uncut, 1891, 8vo. (154)
 Hatchard, £3

9012 Australian Stud Book, from the Earliest Accounts to the year 1900, by A. and W. C. Yuille, 7 vol., hf. mor., *Melbourne,* 1878-1901, 8vo. (170) *Quaritch,* £5 5s.

9013 "The Australasian" Turf Register and Sporting Calendar [1865 to 1908], (wanted 1904 and 1907,) together 41 vol., 24 vol. in mor., the remainder in cl., as published, *Melbourne,* 1866-1908, 8vo. (172) *Quaritch,* £21

9014 Stud Book (The) of New South Wales, ed. by F. B. Price, etc., vol. i. to iii., hf. mor., *Sydney,* 1859-73, 8vo. (173)
 Barton, £4

9015 American Stud Book (The), ed. by S. D. Bruce, vol. i. to vi., *New York,* 1873-94—Vol. vii. and viii., published by the Jockey Club, *ib.,* 1898-1902, hf. cf. gt., 1873-1902, 8vo. (174)
 Wilkinson, £4 4s.

9016 Stud Book (General), containing Pedigrees of Race Horses, etc. to the year 1904, inclusive, hf. mor. gt. (vol. xv. in bds.), together 26 vol. (first ed. of vol. i. to xx., with the exception of vol. i., which is second ed.), 1791-1905—Supplements, 1791-1908 (16), cl. and wrappers, together 42 vol., 8vo. (176)
 Quaritch, £15 5s.
 [This set included the earlier volumes—Introduction, 1791 ; Stud Book, with Supplement, 2 vol., 1793 and 1800 ; 1803 ; 1808, with Supplement, 2 vol., 1808 and 1814.—*Catalogue.*]

9017 Racing Calendar. By John Cheney, 1727-50, 24 vol., cf. gt. ; by Reginal Heber, 1751-68, 18 vol., cf. gt. (with duplicates of vol. iv. to vii. in old cf.) ; by Tuting and Fawconer, 1769 to 1772 and 1775, 5 vol., cf. gt. ; Plates, Matches, etc. run for at Newmarket, from 1728, from the vols. of Cheney, etc., with corrections by W. Pick, of York, cf. gt. [1728-73] ; by Weatherby, 1773 to 1908, cf., together 188 vol., 1727-1908, 8vo. (179) *Hornstein,* £35

9018 Stud Book Français. Régistre des Chévaux de Pur Sang, 12 vol., hf. cf. gt., 1851-98, 8vo. (180) *Wilkinson,* £5 10s.

9019 Sportsman (The), August 31, 1833 to December, 1834, being vol. i. and ii. (vol. i. wanted the title), and Jan., 1835 to to Dec., 1842, plates and woodcuts, bound in 18 vol., hf. mor., uncut, t. e. g., 1833-42, 8vo. (183) *Hornstein,* £28 10s.

9020 Baily's Magazine of Sports and Pastimes, ports. and illustrations, vol. i.-lxxxix., hf. cf. gt., and 5 numbers (various) of vol. xc-xci., 1860-1909, 8vo. (184) *Edwards,* £11

9021 Sporting Magazine (The), from the commencement in 1792 to 1870, plates, 156 vol., hf. mor., m. e., uniform, 1792-1870

—Gilbey (W.) Index of Engravings, from the year 1792 to 1870, cf., uncut, t. e. g., 1892, 8vo. (186) *Hornstein*, £125

9022 Grimble (Augustus). Deer Stalking, illustrations, mor., g. e., 1886, 4to. (198) *Quaritch*, £3

9023 Taunton (T. H.) Portraits of Celebrated Racehorses, plates, 4 vol., hf. mor., uncut, t. e. g., 1887-8, 4to. (203) *Edwards*, £3 12s.

9024 Tweedie (Major-General W.) The Arabian Horse, illustrations and a map, orig. cl., uncut, 1894, 4to. (205) *Hatchard*, £1 16s.
[A copy on large paper realised £2 8s., hf. mor.—ED.]

9025 Hayes (Capt. M. H.) The Points of the Horse, illustrated by 77 reproductions of photographs and 205 drawings, chiefly by J. H. O. Brown, hf. mor., t. e. g., 1893, 4to. (208) *Mills*, £1 5s.

9026 Millais (J. G.) Game Birds and Shooting Sketches, plates in col. and other illustrations, hf. mor., t. e. g., 1892, imp. 4to. (219) *Quaritch*, £6 5s.

9027 Millais (J. G.) A Breath from the Veldt, illustrations by the author and front. by Sir J. E. Millais, R.A., buckram, uncut, t. e. g., 1895, imp. 4to. (220) *Edwards*, £3 6s.

9028 Millais (J. G.) British Deer and their Horns, "special ed." (one of a hundred numbered and signed copies), 185 text and full-page illustrations, hf. mor., t. e. g., 1897, imp. 4to. (221) *Edwards*, £1 13s.

9029 Millais (J. G.) The Wildfowler in Scotland, front. after Sir J. E. Millais, 2 col. plates and other illustrations, hf. parchment, uncut, 1901, 4to. (222) *Hornstein*, £2

9030 Millais (J. G.) Natural History of the British Surface-Feeding Ducks, LARGE PAPER (one of 600 numbered copies), photogravures, col. plates and other illustrations, orig. cl., uncut, 1902, imp. 4to. (223) *Quaritch*, £5

9031 Millais (J. G.) The Mammals of Great Britain and Ireland, photogravures, col. plates and other illustrations, 3 vol., buckram, uncut, 1904, imp. 4to. (224) *J. Bumpus*, £9 10s.

9032 Sporting Magazine. India Proof Impressions of 788 of the Plates to the Sporting Magazine, including the engraved titles to the volumes, 20 sets so issued, on 4to. paper, in 4 hf. mor. cases, book form, 1793-1824 (226) *Hornstein*, £96

9033 Sloane (W. M.) Life of Napoleon, plates in col. and other illustrations, 4 vol., ornamental cl., uncut, t. e. g., *New York*, 1896, 4to. (227) *Andrews*, £2 5s.

9034 Badminton Library (The), LARGE PAPER, illustrations, complete set, in 28 vol., hf. mor., t. e. g., 1885-96, 4to. (228) *Quaritch*, £16 10s.

9035 Landseer (Sir Edwin, R.A.) Works, Library ed., plates, proofs before letters, on India paper, mor. gt., g. e., *Henry Graves and Company*, n. d., folio (229) *Young*, £4 10s.

9036 Portraits of Brood Mares belonging to the Royal Stud at Hampton Court, by C. W., large plates, with text, hf. mor., t. e. g., 1837, folio (231) *Maggs*, £3 3s.

9037 Crealock (Lieut.-Gen. H. H.) Deer Stalking in the High-
lands, édition de luxe, 40 full-page plates and numerous
illustrations in the text, cl., uncut, t. e. g., 1892, folio (232)
J. Bumpus, £12 15s.
9038 Touchstone (S. F.) History of Celebrated English and
French Thorough-bred Stallions, plates and vignettes col.
by hand, hf. mor., t. e. g., Nimmo, 1890, obl. folio (233)
Wilkinson, £1 2s.

*The following formed part of a Miscellaneous Collection sold at
Sotheby's on June 30th and July 1st:—*

9039 America. Neptune Americo-Septentrional contenant les
Côtes, Îles et Bancs, etc., des Mers de cette Partie du
Monde, maps and plans, old cf., 1778-80, atlas folio (686)
Quaritch, £5 2s. 6d.
9040 Blow (Dr. John). Amphion Anglicus, first ed., port. by White,
old cf., 1700, folio (617) *Dobell*, £3
9041 Boisserée Gallery. Gallery of the Old German Masters, 120
plates, mounted on drawing paper, 2 vol., hf. mor., g. e.,
Stuttgart and München, 1821-30, elephant folio (644)
Spencer, £9
9042 Daniel (H. A.) Thesaurus Hymnologicus, 5 vol. in 2, hf. bd.,
Lipsiae, 1855-56, 8vo. (311) *Hill*, £3 16s.
9043 [Dodgson (C. L.)] Sylvie and Bruno, first ed., presentation
copy from Lewis Carroll, "The Bishop of Lincoln with the
affte. regards of the Author, Dec. 12, 1889," 1889—Sylvie
and Bruno Concluded, first ed., presentation copy in author's
autograph, 1893, together 2 vol., 8vo. (271)
Edwards, £9 10s.
9044 Early English Text Society. Publications, Nos. 1-93, as
issued, 1864-89, 8vo. (56) *Harding*, £7
9045 English Dialect Society. Publications, Nos. 1-80 (all pub-
lished), as issued, 1873-96, 8vo. (121) *Grant*, £6 5s.
9046 Gaimard (P.) Voyage en Islande et au Groenland, sur la
Corvette La Recherche, 6 vol. roy. 8vo. plates, and 2 vol.
folio of maps and plates, some col., hf. mor., t. e. g., *Paris,*
1838-52 (701) *Wesley*, £7
9047 Holland (H.) Herwologia Anglica, title mounted, 65 ports.
and 2 monuments (that of Q. Elizabeth mounted), by C.
Passe and others (wanted "Post Prefatio"), n. d. (1620),
folio (507) *Edwards*, £6 5s.
9048 Montaigne (M. de). Essayes, by John Florio, first ed., with
the 2 leaves of errata (the second defective), old cf., *Val.
Sims for E. Blount*, 1603, folio (373) *Edwards*, £28 10s.
9049 Rembrandt. L'Œuvre Complet de Rembrandt, par E.
Dutuit, Holland paper, plates, with duplicate set on Japanese
paper, and the etchings by Flameng, 6 vol., in parts as
issued, *Paris*, 1881-85, folio (734) *Jenner*, £15
9050 Rembrandt. L'Œuvres Complets de Rembrandt, par M.
Eugène Dutuit, one of 500 copies, ports. and illustrations,
3 vol., hf. mor., t. e. g., *Paris*, 1883-85, folio (621)
Jenner, £12 10s.

9051 Schlegel et Wulverhorst. Traité de Fauconnerie, col. plates, hf. mor., *Leiden et Dusseldorf,* 1844-53, atlas folio (665)
Wesley, £9 10s.

9052 Smollett (T.) Adventures of an Atom, first ed., 2 vol., cf., 1749 (for 1769), 8vo. (95) *Spencer,* £8 5s.

9053 Stephanus (H.) Thesaurus Græcæ Linguæ, 8 vol. in 9, vell., g. e., *Paris,* 1831-65, folio (616) *Neumayer,* £12

9054 Voyage Autour du Monde sur la Corvette La Bonite Commandée par M. Vaillant, 14 vol. roy. 8vo. and 3 folio vol. of plates, those of zoology col., hf. mor., t. e. g., *Paris,* 1841-52, folio (700) *Edwards,* £18

[JULY 12TH AND 13TH, 1910.]

SOTHEBY, WILKINSON & HODGE.

THE LIBRARIES OF THE LATE MR. GEO. FENTON SMITH, OF PUTNEY HILL, S.W.; OF MR. R. MOWBRAY HOWARD, OF FARNHAM; AND OTHER PROPERTIES.

(No. of Lots, 644 ; amount realised, £1,133 7s.)

(*a*) *Mr. Fenton Smith's Library.*

9055 A'Becket (G. A.) Comic History of England, 20 col. etchings and 240 woodcuts, 2 vol., *Punch Office,* 1847-48—Comic History of Rome, 10 col. plates and 140 woodcuts, Bradbury and Evans, n. d., together 3 vol., first eds., cf., g. e., 8vo. (1)
Maggs, £5 5s.

9056 Ackermann (R.) Repository of Arts. First Series, 14 vol.— Second Series, 14 vol. (wanted vol. v.)—Third Series, 12 vol., col. plates, together 39 vol., hf. cf., 1809-28, 8vo. (2)
Hornstein, £42 10s.

9057 Bacon (Sir Francis). Essaies (wanted blank leaf A 1, head-lines cut into), mor. ex., by Rivière, *I. D. for Elizabeth Jaggard,* 1624, 8vo. (6) *Maggs,* £3 8s.

9058 Bale (John). A brefe Chronycle concerning the examination and death of Sir John Oldecastell, black letter (title-page and a few margins repaired), mor., g. e., Anthony Scoloker and Wyllyam Seres (1548), 8vo. (7) *Tregaskis,* £2 16s.

9059 Behn (Mrs. Aphra). Plays, port. (a few headlines shaved), 4 vol., cf., g. e., 1724, 8vo. (8) *Hill,* £4 4s.

9060 [Barker (M. H.)] Greenwich Hospital, 12 plates by G. Cruikshank, in two states, one on India paper plain, the other col., hf. mor., t. e. g., J. Robins and Co., 1826, 4to. (142) *Spencer,* £5 5s.

9061 Berners (Dame Juliana). The Book containing the Treatises of Hawking, Hunting, Coat Armour, Fishing, as printed by

Wynkyn de Worde in 1486, reproduced in fac. ɔy Haslewood, mor., t. e. g., ɔy Tout, 1810, 8vo. (144)

Tregaskis, £1 18s.

9062 Biɔle (The Holy), port. of Charles II. and plates, H. Hills, 1660—Book of Common Prayer, port. of Charles I., 1660, in 1 vol., mor., silver corner-pieces, clasps, and centre medallions with monogram " E. H.," 8vo. (14)

Tregaskis, £4 2s. 6d.

[Originally the property of Elizaɔeth Hamilton, wife of James Hamilton, eldest son of the Hon. Sir George Hamilton, and the elder Hamilton of De Grammont's " Memoirs."—*Catalogue.*]

9063 Book of Common Prayer, LARGE PAPER (title repaired), orig. mor., sides covered with design of leafy ornamentation, inlaid panel and centre ornament, crowned monogram of Charles II. several times repeated, g. e. (repaired), ɔy F. Bedford, 1680, folio (187) *W. Daniell,* £21 10s.

9064 Burns (Roɔert). Poems, chiefly in the Scottish dialect, first ed. (title page mended and last leaf in facsimile), sheep, *Kilmarnock,* John Wilson, 1786 (16) *Spencer,* £107

[William Paterson's copy, with his autograph signature on fly-leaf: "William Paterson Merchant of Old Cumnock and Mauchline, married Miss Morton one of the 'Six Belles of Mauchline' celeɔrated ɔy Burns in his poem under that title" (Scott Douglas' Life of Burns).—*Catalogue.*]

9065 Burns (R.) Poems, first Edinɔurgh ed., port. by Beugo, hf. cf., *Edinb.,* 1787, 8vo. (17) *Hopkins,* £4

9066 Burns (R.) Poems, first London ed., port. by Beugo, uncut, 1787, 8vo. (19) *Hopkins,* £8 15s.

9067 Byron (Lord). Hours of Idleness, first ed., cf., g. e., *Newark,* 1807, 8vo. (25) *Hopkins,* £3 10s.

9068 Calvin (John). Thre Notaɔle Sermones, Englished ɔy William Warde, black letter, cf., g. e., Rouland Hall, 1562, 8vo. (27) *Johnson,* £3 3s.

9069 Cellini (Benvenuto). Life, by J. A. Symonds, No. 74 of 100 copies on LARGE PAPER, 8 etchings by F. Laguillermie on India paper and 18 illustrations, 2 vol., Nimmo, 1888, imp. 8vo. (28) *Hopkins,* £9

9070 Dodsley (R.) Select Faɔles of Esop, front. and plates, cf., g. e., *Birmingham,* J. Baskerville, 1761 (56) *Rimell,* £1 12s.

["To the Revᵈ Mʳ Spence, from the Author ;" note on fly-leaf in Dodsley's handwriting.—*Catalogue.*]

9071 Dodsley (R.) Œconomy of Human Life, LARGEST PAPER, vignettes ɔy Harding, mor., g. e., 1795, imp. 8vo. (57) *Hill,* 14s.

9072 Evelyn (John). Memoirs, ed. by Wm. Bray, port. and plates, 5 vol., cf., t. e. g., H. Colɔurn, 1827, 8vo. (60) *Edwards,* £2 6s.

9073 Fleming (A.) The Footepath to Felicitie, black letter, each page within woodcut ɔorders, mor., Peter Short, 1602, 8vo. (64) *Ellis,* £1 10s.

9074 Froissart (Sir John). Chronicles, trans. by T. Johnes, illustrations, with the illuminations from the MS. Froissarts in the British Museum and elsewhere inserted, mor., g. e., W. Smith, 1848, 8vo. (65) *Edwards, £7* 15s.

9075 Gay (John). Trivia, first ed., thick paper, cf., t. e. g., B. Lintott, n. d., 8vo. (67) *Rimell, £1* 18s.

9076 Goldsmith (O.) Works, ed. by Peter Cunningham, port. and vignettes, 4 vol., cf. gt., 1854, 8vo. (68) *Hornstein, £2* 4s.

9077 Goldsmith (O.) The Vicar of Wakefield, 32 illustrations by Mulready, mor. ex., by Rivière, Van Voorst, 1843, 8vo. (69) *Edwards, £2* 10s.

9078 Hamilton (Count A.) Memoirs of Grammont, 76 ports., mor., g. e., S. and E. Harding, 1793, 4to. (152) *Hopkins, £8* 5s.

9079 Hassell (J.) Picturesque Rides and Walks, LARGE PAPER, 120 col. plates, 2 vol., mor., g. e., by Rivière, 1817-18, 8vo. (72) *Rimell, £5* 12s. 6d.

9080 Hole (Dean). A Little Tour in Ireland, first ed., col. front. and woodcuts by John Leech, orig. cl., Bradbury and Evans, 1859, 8vo. (75) *Slocock, £1* 11s.

9081 Jacquemart (A.) History of the Ceramic Art, plates, 1877, imp. 8vo. (83) *Power, £1* 6s.

9082 [Johnson (Samuel).] The Prince of Abissinia (Rasselas), first ed., 2 vol., mor. ex., by F. Bedford, 1759, 8vo. (84) *Hopkins, £8* 15s.

9083 [Keble (Rev. J.)] The Christian Year, first ed., 2 vol., *Oxford*, 1827, 8vo. (85) *Rimell, £1*

9084 Kent (Countess of). A Choice Manuall, or Rare and Select Secrets in Physick and Chirurgery, mor., g. e., by Rivière, H. Mortlock, 1708, 8vo. (86) *Edwards, £1* 11s.

9085 Lacroix (P.) The Art, Manners and Customs, Science and Literature, and Military and Religious Life in the Middle Ages and during the Renaissance Period—The Eighteenth Century, France, 1700-1789, col. and illuminated plates, and woodcuts, together 5 vol., 1874-78, imp. 8vo. (87) *Rimell, £4* 2s.

9086 Lamb (Charles and Mary). Tales from Shakespear, second ed., plates by Wm. Blake, 2 vol., cf., g. e., M. J. Godwin, 1810, 8vo. (88) *Dobell, £1* 16s.

9087 Landscape Annual, 1830-39, LARGE PAPER, engravings on India paper, 10 vol., mor., g. e., R. Jennings, 1830-39, 8vo. (89) *A. Jackson, £2* 4s.

9088 Malcolm (J. P.) Londinum Redivivum, extra illustrated by the insertion of over 580 ports. and plates, 4 vol., hf. mor., t. e. g., 1802-7, 4to. (157) *Dobell, £6* 5s.

9089 Monardus (Nicholas). Joyfull Newes Out of the New-found Worlde, . . . Englished by John Frampton, black letter, woodcuts, old cf., E. Allde, 1596, 4to. (158) *Tregaskis, £11*

9090 More (Sir Thomas). The Commonwealth of Utopia, engraved title, with port. of More by Wm. Marshall, cf. gt., by Rivière, B. Alsop and T. Fawcet, 1639, 8vo. (96) *Edwards, £2* 14s.

9091 Origen. An Homilie of Marye Magdalene, declaring her fervent love and Zele towards Christ, 𝔟𝔩𝔞𝔠𝔨 𝔩𝔢𝔱𝔱𝔢𝔯 (title page mended), cf., g. e., ɔy W. Pratt, Reginalde Wolfe, 1565, 8vo. (98) *Ellis*, £4 5s.

9092 [Saint-Pierre (B. de).] Paul and Mary, an Indian Story [trans. by D. Malthus], first ed. of Paul and Virginia in English, 2 vol., cf. ex., J. Dodsley, 1789, 8vo. (108)
Tregaskis, £2 10s.

9093 Scott (Sir W.) Waverley Novels, fronts., 25 vol., cf. gt., *Edinburgh*, A. and C. Black, 1852-53, 8vo. (109)
Edwards, £6 10s.

9094 Stow (John). Survey of London and Westminster, ed. ɔy J. Strype, maps and woodcuts, 2 vol., mor. ex., g. e., by Mansell, 1720, folio (190) *Tregaskis*, £5 7s. 6d.

9095 Smith (J. C.) British Mezzotinto Portraits, ports., 4 vol. in 5, 1878-83, imp. 8vo. (113) *E. Parsons*, £9

9096 Strawɔerry Hill Press. Chamɔers (Anna, Countess Temple), Poems, mor. ex., 1764, 4to. (168) *Maggs*, £1 18s.

9097 Strawɔerry Hill Press. Cherɔury (Edward, Lord Herɔert of). Life, written ɔy himself, port. and genealogical taɔle, cf., 1764, 4to. (169) *Edwards*, £4

9098 Strawɔerry Hill Press. Walpole (Hon. T.) Letter to the Governor and Committee of the Bank of England, mor. ex., 1781, 4to. (170) *Pickering*, £2 2s.

9099 Strawɔerry Hill Press. Description of the Villa of Mr. Horace Walpole at Strawɔerry Hill, 27 plates, mor. ex., 1784, 4to. (171) *Maggs*, £2 12s.

9100 Strawɔerry Hill Press. More (Hannah). Bishop Bonner's Ghost, mor., g. e., 1789, 4to. (172) *Edwards*, 10s.

9101 Sterne (L.) A Sentimental Journey, first ed., 2 vol., cf., g. e., T. Becket and P. A. De Hondt, 1768, 8vo. (115)
Hopkins, £7 15s.

9102 Strawɔerry Hill Press. Hentzner (Paul). A Journey into England in the Year MDXCVIII. (220 copies printed), cf., 1757, 8vo. (116) *Ellis*, 14s.

9103 Strawɔerry Hill Press. Spence (Rev. Mr.) A Parallel, in the Manner of Plutarch, mor. ex., 1758, 8vo. (117) *Maggs*, 16s.

9104 Strawɔerry Hill Press. Walpole (Horace). Catalogue of the Royal and Noɔle Authors of England, front., 2 vol., cf., 1758, 8vo. (118) *Maggs*, £1 3s.

9105 Strawɔerry Hill Press. Walpole (Horace). A Letter to the Editor of the Miscellanies of Thomas Chatterton, inter-leaved, view of Chatterton's tomɔ, port. of Sir William Canynge and autograph note (third person) to Mr. Bull from Horace Walpole inserted, mor., g. e., ɔookplate of Richd. Bull of Ongar, 1779, 8vo. (119) *Dobell*, £2 4s.

9106 Strawɔerry Hill Press. Whitworth (Charles Lord). An Account of Russia, mor. ex., 1758, 8vo. (120) *Dobell*, 14s.

9107 Strawɔerry Hill Press. Gray (Thomas). Odes, first ed., cf., . g. e., by F. Bedford, 1757, 4to. (165) *Edwards*, £4 6s.

9108 Strawɔerry Hill Press. Miscellaneous Antiquities, mor. ex., ɔy Rivière, 1772, 4to. (166) *Ellis*, 19s.

9109 Strawberry Hill Press. Walpole (H.) Anecdotes of Paint-
ing, orig. ed., ports. and plates, 5 vol., mor. ex., by Rivière,
1762-71, 4to. (167) *Hopkins,* £8 15s.

9110 Taylor (Jeremy). A Choice Manual, port., contemp. English
mor., elaborate gold tooling, g. e., 1671, 8vo. (123)
Tregaskis, £5 12s. 6d.
[This copy belonged to Charlotte Jemima Henrietta
Maria Boyle, alias Fitzroy, daughter of Charles II., and
has her autograph signature, "C. Paston" (she married
Sir Robert Paston, created Earl of Yarmouth), and notes in
her handwriting.—*Catalogue.*]

9111 Universal Harmony, or the Gentleman and Ladies' Social
Companion, engraved throughout, front. and vignettes,
mor. ex., by Rivière, J. Newbery, 1746, 4to. (176)
Edwards, £6 15s.

9112 Vives (L.) A Very Fruteful and Pleasant Booke called the
Instruction of a christen woman, by R. Hyrde, **black letter,**
woodcut border (partly in facsimile) to title, mor. ex.,
Henry Wykes, 1557, 4to. (178) *Bull,* £2 10s.

9113 Walpole (Horace). Letters, extra illustrated by the insertion
of 285 ports., a private etching and 18 views, 9 vol., cf. ex.,
1857-59, 8vo. (128) *Edwards,* £21 10s.

9114 Walton (I.) and Cotton (C.) The Complete Angler, Major's
first ed., LARGE PAPER, ports. and plates on India paper,
mor. ex., John Major, 1823, 8vo. (129) *Hornstein,* £2 4s.

9115 Wheatley (H. B.) Round about Piccadilly and Pall Mall,
1 vol. extended to 2 by the insertion of about 90 ports. and
58 views, cf., t. e. g., 1870, 8vo. (131) *Leighton,* £4 12s. 6d.

9116 Whole Duty of Man (The), front. and engraved title, mor.
ex., covered with scroll and floreate tooling (top of back
damaged), 1673, 8vo. (135) *Edwards,* £10

(β) *Mr. R. Mowbray Howard's Library.*

9117 Carver (J.) Travels through the Interior Parts of North
America, LARGE PAPER, folding maps and plates, hf. cf.,
1778, 8vo. (346) *H. Stevens,* £1 15s.

9118 Chastellux (Marquis de). Travels in North America, trans.
from the French, maps and plates, 2 vol., cf., 1787, 8vo.
(347) *H. Stevens,* £1 12s.

9119 Clavigero (F. S.) History of Mexico, trans. by Charles
Cullen, maps and plates, 2 vol., cf., 1787, 4to. (408) *Hill,* £2

9120 Coryat (T.) Coryat's Crudities, reprinted from the edition of
1611, plates, 3 vol., cf. gt., fine copy, 1776, 8vo. (344)
Young, £4 15s.

9121 Dalrymple (Alex.) Voyages and Discoveries in the South
Pacific, folding maps and plates, 2 vol. in 1, cf., y. e., *Printed
for the author,* 1770, 4to. (411) *Barton,* £5 5s.

9122 Dampier (Capt. Wm.) New Voyage Round the World,
maps and plates, 4 vol. (top of title to vol. iii. cut off), cf.,
1703-7, 8vo. (355) *Edwards,* £2

9123 Dixon (Capt. G.) Voyage Round the World, maps, plans and plates, cf., 1789, 4to. (405) *Harding*, 16s.

9124 Douglass (William). Summary Historical and Political of the British Settlements in North America, map, 2 vol., cf., 1760, 8vo. (356) *Leon*, £3 6s.

9125 Graham (J. A.) Descriptive Sketch of the Present State of Vermont, port., cf., 1797, 8vo. (357) *W. Brown*, £1

9126 Hawkins (Sir Richard). Observations in his Voyage into the South Sea, first ed., old cf. gt., 1622, folio (433)
 Parsons, £7 17s. 6d.

9127 Hennepin (F. Louis). New Discovery of a vast Country in America, 2 folding maps and engravings, 2 parts in 1 vol., old cf., 1699, 8vo. (345) *Sabin*, £14 10s.

9128 Hearne (S.) Journey to the Northern Ocean, maps and plates, cf., 1795, 4to. (404) *Leon*, £3 15s.

9129 Jefferys (Thos.) History of the French Dominions in North and South America, folding maps and plans, 2 parts in 1 vol., cf., 1760, folio (430) *Maggs*, £6 17s. 6d.

9130 Long (J.) Voyages of an Indian Trader, folding map, uncut, 1791, 4to. (410) *Leon*, £3 12s.

9131 Mackenzie (Alex.) Voyages to the Frozen and Pacific Oceans, port. and folding maps, cf. gt., 1801, 4to. (406) *Ellis*, £1 19s.

9132 Meares (John). Voyages from China, port., maps (one mended) and plates, orig. bds., uncut, 1790—Dixon (G.) Remarks on the Voyages of John Meares, uncut (first leaves stained), 1790, together 2 vol., 4to. (375)
 Leon, £12 5s.

9133 Ogilby (John). America, front., maps and plates, old cf., 1671, folio (425) *Cooper*, £7

9134 Rochefoucault Liancourt (Duke de la). Travels through the United States, maps, 2 vol., cf., 1799, 4to. (407)
 Harding, £2 10s.

9135 Vancouver (Capt. G.) Voyage of Discovery to the North Pacific, etc., plates, 3 vol., cf., 1798, 4to. (372)
 H. Stevens, £4 7s. 6d.

9136 Vega (G. de la). Royal Commentaries of Peru, first English ed., by Sir P. Rycaut, port. and plates, old cf., 1688, folio (424*) *Edwards*, £1 14s.

9137 Wren (C.) Parentalia, or Memoirs of the Family of the Wrens, mezzo. port. by Faber, and other ports. and plates, cf., 1750, folio (426) *Tregaskis*, £4 5s.

(γ) *Other Properties.*

9138 America. Plan of the City and Suburbs of Philadelphia, by A. P. Folie, engraved by R. Scot and S. Allardice (25½ in. by 26½ in.), mounted in 20 squares on linen, *Philadelphia*, 1794, folio (296) *H. Stevens*, £3 3s.

9139 America. Stobo (Major Robert, of the Virginia Regiment). Memoirs, folding plan, *Pittsburgh*, 1854, 8vo. (233)
 Edwards, £1 6s.

9140 Canada. [St. Vallier.] Relation des Missions de la Nouvelle France, par M. Évêque de Quebec (title washed), orig. cf., *Paris*, 1688, 8vo. (604) *Leon, £5 5s.*

9141 Cooke (W. B. and G.) Views on the Thames, 1 vol. 8vo. and folio vol. of plates, India proofs, mor., g. e., 1822 (452)
Hill, £2 8s.

9142 Dante. The Vision, or Hell, Purgatory and Paradise, trans. by H. F. Cary, 3 vol., cf. gt., 1819, 8vo. (587)
Quaritch, £2 4s.

9143 Gradus ad Cantabrigiam, or new University Guide, col. plates, orig. bds., uncut, 1824, 8vo. (585) *Edwards, £1 1s.*

9144 Isis (The), series v., vol. ii., to series ix., vol. iv., part xiii., together 25 vol. and 2 parts, including the Jubilee Supplement, ports. and col. plates, in parts, 1885-1910, 8vo. (246)
Ross, £9

9145 Malcolm (J. P.) Manners and Customs of London, engravings and col. plates of costume, 2 vol., cf., 1808, 4to. (520)
Rimell, £1 1s.

9146 Norden (John). Speculum Britanniae. Description of Middlesex and Hartfordshire, maps, etc., mor., g. e., 1723, 4to. (539) *Bain, £2 8s.*

9147 Papworth (John B.) Select Views of London, 76 col. plates, hf. mor., g. e., R. Ackermann, 1816, imp. 8vo. (451)
Leighton, £17 15s.

9148 Percy Society Publications (The), complete set, 30 vol., hf. mor., t. e. g., 1840-52, 8vo. (193) *Heffer, £11 5s.*

9149 Short Introduction of Grammar (Latine) generally to be used, compiled and set foorth, etc., partly black letter, woodcut title, 1599 — Brevissima Institutio seu Ratio Grammatices Cognoscendae, woodcut title, etc., 1596, in 1 vol., cf., crest with initials "E. V.," 1596-97, 8vo. (586)
Johnson, £3 3s.

9150 Zoological Society of London. Proceedings from 1885 to 1909, part iii., with Indexes, 1881-1900, col. plates and illustrations, as issued, together 24 vol. and 5 parts, 1885-1909, 8vo. (247) *Ross, £10*

SOTHEBY, WILKINSON & HODGE.

THE LIBRARIES OF THE LATE SURGEON-GENERAL ROBERT ROUSE, OF REIGATE, AND OF THE REV. STOPFORD A. BROOKE.

(No. of Lots, 957 ; amount realised, £1,897 5s. 6d.)

(a) *Surgeon-General Rouse's Library.*

9151 Ainger (A.) Charles Lamb, front., extra illustrated with 51 ports., hf. mor., t. e. g., 1882, 8vo. (2) *Young*, £2 2s.

9152 Anacréon, Sapho, Bion et Moschus, par M. M *** C ** (Moutonnet de Clairfond), 2 engravings, 12 vignettes and 13 culs-de-lampe, after Eisen, old French cf., g. e., *à Paphos et à Paris par Le Boucher*, 1773-74, roy. 8vo. (6)
Maggs, £12

9153 Anandria, ou Confessions de Mademoiselle Sapho avec la Clef, grand papier d'Hollande, 3 impressions of the front., tirage à petit nombre, mor., t. e. g., uncut, *Lesbos*, 1778-(1866), imp. 8vo. (10) *Reuter*, £1 18s.

9154 Arabian Nights, trans. by John Payne (one of 500 copies), 9 vol., vell., uncut, t. e. g., *Villon Society*, 1882, 8vo. (19)— Tales from the Arabic of the Breslau and Calcutta (1814-18) editions, trans. by John Payne, 3 vol., vell., uncut, t. e. g., *ib.*, 1884, 8vo. (20) *Hopkins*, £10 12s. 6d.

9155 Arabian Nights. One Hundred Illustrations to Sir R. Burton's translation, by S. L. Wood, proofs before letters (250 copies printed), in a portfolio, n. d. (21) *Dobell*, £1

9156 Aretino (P.) Capricciosi & Piacevoli Ragionamenti, old English mor., g. e., *Stampata in Cosmopoli* [*Amst., Elzevier*], 1660, post 8vo. (23) *Scotti*, £2

9157 Ariosto (L.) Orlando Furioso, port. and 46 plates by Bartolozzi, etc., 4 vol., old cf., g. e. (worn), *Birmingham*, J. Baskerville, 1773, roy. 8vo. (25) *Scotti*, £3 2s. 6d.

9158 Ashbee (H. S.) Index Librorum Prohibitorum—Centuria Librorum Absconditorum—Catena Librorum Tacendorum —Notes on Curious and Uncommon Books (250 copies printed), fronts., etc., together 3 vol., hf. mor., t. e. g., 1877-85, 4to. (28) *Hitchman*, £9 9s.

9159 Asselineau (Ch.) Bibliographie Romantique. Catalogue anecdotique et pittoresque des Éditions Originales des Œuvres de V. Hugo, etc., seconde éd., papier vergé, eau-forte par Bracquemont, front., port. of Gautier, on Japanese paper, 4 ports. and 21 extra plates inserted, hf. mor. ex., uncut, *Paris*, P. Rouquette, 1872, 4to. (29) *Young*, £1 16s.

9160 Athenaeus. Œuvres d'Athenée, ou le Banquet des Savans, traduit par Lefeoure de Villebrune, 34 engravings, 5 vol., hf. cf., *Paris, chez Lamy, Impr. de Monsieur*, 1791, 4to. (30)
Maggs, £1 6s.

9161 Baffo (Giorgio). Raccolta Universale delle Opere (en dialecta Venetiana), port., 4 vol., uncut, *Cosmopoli*, 1789, 8vo. (34)
Scotti, £1 12s.

9162 Baffo (G.) Poésies Complètes en dialecte Vénitien, papier d'Hollande tiré à 100 exemplaires, 2 impressions of the port., 4 vol., hf. mor., t. e. g., uncut, *Paris*, J. Liseux, 1884, imp. 8vo. (35)
Carrington, £3 12s. 6d.

9163 Bandello (M.) Novels, trans. by John Payne, 6 vol., vell., uncut, t. e. g., *Villon Society*, 1890, 4to. (41)
Quaritch, £4 18s.

9164 Basan (Fr.) Dictionnaire des Graveurs, seconde éd., 50 plates, 2 vol., hf. russ. gt., *Paris, chez l'auteur, etc.*, 1789, 8vo. (45)
Maggs, £3 4s.

9165 Baudelaire (Chas.) Les Epaves, première éd., front. de Félicien Rops, in 2 states, papier vergé d'Hollande, 250 exemplaires, hf. mor., t. e. g., *Amst.*, 1866, cr. 8vo. (48)
Quaritch, £2 10s.

9166 Bayle (Pierre). Dictionnaire Historique et Critique, 16 vol., hf. mor., t. e. g., uncut, fine paper, *Paris*, Desoer, 1820, 8vo. (50)
Hunt, £2 18s.
[Another set on ordinary paper realised 15s., hf. cf. gt.— ED.]

9167 Beaumarchais (P. A. de). La Folle Journée, Comédie, éd. originale, 5 plates by Malapeau (the fifth plate by Roi), old French mor., g. e. (Derome), *au Palais Royal, chez Ruault à Paris de l'Impr. de Ph. D. Pierres*, 1785, 8vo. (52)
Meule, £6 2s. 6d.

9168 Béranger (P. J. de). Chansons, avec des vignettes (97) de Devéria (gravés sur oois par Thompson) et des (40) dessins coloriés d'Henri Monnier, port., 2 vol., hf. mor. ex., t. e. g., uncut, *Paris, Baudoin frères*, 1828, roy. 8vo. (57)
Lewine, £5 5s.

9169 Bibliophile Français (Le). Gazette Illustrée des Amateurs de Livres d'Estampes, reproductions of old woodcuts, etc., 7 vol., uncut, *Paris, Libraire Bachelin-Deflorenne*, 1868-73, sup. imp. 8vo. (71)
Hunt, £1 12s.

9170 Bibliothèque Elzevirienne. Histoire Amoureuse des Gaules, Dictionnaire des Précieuses Nuits de Straparoles, Morlini, Journal de Restif de la Bretonne, Gualtier Garguille et Catalogue Raisonné, 12 vol., cl., uncut, *Paris*, Jannet, etc., 1858-70, sm. 8vo. (75)
Hunt, £1 2s.

9171 Boccaccio (G.) Il Decamerone (texte Italien), papier d'Hollande, port., 5 engraved titles, 110 plates and 97 culs-de-lampe, 5 vol., old French cf., g. e., *Londra (Paris)*, 1757, 8vo. (80)
Isaacs, £17 10s.
[Earliest impressions of the plates with Paraphe on back of each, and the list of plates in vol. v. signed C. M.— Catalogue.]

42—2

9172 Boccaccio (G.) Nouvelles de Jean Boccace, Traduction li⊃re, ornée de la vie de Boccace, etc. par Mira⊃eau, dessins de Marillier, 4 vol., old French cf. gt., *Paris, chez L. Duprat*, 1802, 8vo. (83) *Edwards, £2* 11s.

9173 Burton (Rich. F.) The Book of the Sword, illustrations, 1884, imp. 8vo. (100) *Young, £1* 3s.

9174 Ca⊃inet de Lampsaque (Le), 101 plates, 2 vol., old cf. gt., *à Paphos*, 1784, 12mo. (106) *Maggs, £4*

9175 Ca⊃inet Satyrique (Le) ou Recueil de Vers Piquans & Gaillards, 2 vol., old French mor., g. e., by Derome, with his ticket dated 1786, *Au Mont Parnasse de l'imprimerie de Messer Apollon l'anné Satyrique, s. d. (c.* 1785), sm. 8vo. (107) *Hatchard, £6*

9176 Cavendish (G.) Life of Cardinal Wolsey, ed. by S. W. Singer, port., 2 vol., cf. gt., *Chiswick*, 1825, 8vo. (123) *Young, £2* 5s.

9177 Cent Nouvelles Nouvelles (Les), première édition, front. and vignettes ⊃y Romain de Hooghe, 2 vol., old French mor., g. e. (Padeloup), *Cologne*, P. Gaillard, 1701, sm. 8vo. (125) *Bumpus, £10* 15s.

9178 Cervantes. Don Quixote. A set of Coypel's Illustrations to Don Quixote, vignette and 31 engravings by Picart, etc., proof impressions, ⊃ound in a vol., mor. ex., t. e. g., uncut, by Rivière, 1744, etc., 4to. (127) *Maggs, £6* 17s. 6d.

9179 Chansonnier Historique du XVIII. Siècle, par Émile Raunié, ports. par Rousselle, exemplaire papier de Chine, tirage à 50 ex., avec deux suites des ports., 8 vol., hf. mor., t. e. g., uncut, *Paris*, Quantin, 1879-84, 8vo. (131) *Young, £3*

9180 Chants et Chansons Populaires de la France, illustrée d'après les Dessins de MM. E. de Beaumont, Meissonier, etc., 3 vol., hf. mor., g. e., *Paris*, Garnier, 1848, imp. 8vo. (133) *Maggs, £2* 6s.

9181 Choderlos de Laclos (A. F.) Les Liaisons Dangereuses, 2 fronts. and 13 plates, 2 vol., cf. gt., *Londres (Paris)*, 1796, 8vo. (135) *Rimell, £5* 15s.

9182 Ci⊃⊃er (Colley). Apology for his Life, ed. by R. W. Lowe, LARGE PAPER, one of 305 copies, ports., in two states, uncut, 1889, imp. 8vo. (136) *Dobell, £1* 2s.

9183 Cohen (Henry). Guide de l'Amateur de Livres à Gravures du XVIII. Siècle, 5e édition, hf. mor., t. e. g., uncut, *Paris*, P. Roquette, 1886, imp. 8vo. (137) *Quaritch, £3* 15s.

9184 Com⊃e (W.) Three Tours of Dr. Syntax, first eds., 3 vol., cf. gt., g. e., ⊃y Tout, 1812-21, roy. 8vo. (144) *Young, £19*

9185 [Coqueley de Chausse-Pierre.] Le Roué Vertueux, Poëme en Prose, séconde éd., 4 plates and 2 fleurons, cf. gt., *à Lauzanne (Paris)*, 1770, 8vo. (146) *H. Jones, £3* 17s. 6d.

9186 De Favre. Les Quatre Heures de la Toilette des Dames, Poëme en quatre Chants, première éd., front., vignette, 4 plates and 4 tailpieces after Leclerc, orig. hf. vell., *Paris*, J. F. Bastien, 1779, sm. 4to. (194) *Edwards, £7*

9187 Désfontaines (A⊃⊃é). Les Bains de Diane, première éd., 3 plates after Marillier, *à Paris*, J. P. Costard, 1770—Dorat

(Cl. J.) Les Baisers, première éd., front., vignette and tail-piece after Eisen, *à La Haye et à Paris, chez S. Jorry, etc.*, 1770, in 1 vol., old French cf., g. e., 8vo. (196)
Rimell, £8 10s.

9188 Desforges (P. J. B. Choudard). Le Poète, ou Mémoires d'un Homme de Lettres, 5 ports. and front., 5 vol., hf. mor., t. e. g., uncut, *Paris*, É. Baœuf, 1819, post 8vo. (208)
Reuter, £1 2s.

9189 Dictionnaire des Antiquités Grecques et Romaines, rédigé sous la Direction de MM. Ch. Daremberg, Edm. Saglio et Edm. Pattier [A— Quorum Bonorum], illustrations, 6 vol., hf. mor., and 5 fascicules, *Paris*, Hachette, 1877-1907, 4to. (219)
Scotti, £7 7s. 6d.

9190 Diderot (Denis). Les Bijoux Indiscrets, première éd., front., vignettes on titles and 6 plates, 2 vol., old cf., *au Monomotapa, s. d. (Paris*, 1748), sm. 8vo. (220)
Sotheran, £1

9191 Diderot (D.) La Religieuse, nouvelle éd., port. and 4 plates, proofs before letters, 2 vol., old French cf., g. e., *Paris, De Roy, etc., an* VII. (1799), 8vo. (221)
Quaritch, £2

9192 Dorat (C. J.) Irza et Marsis, ou l'Isle Merveilleuse, Poëme, séconde éd., LARGE PAPER, front., 3 engravings, 2 vignettes and 2 culs-de-lampe after Eisen, orig. paper bds., uncut, *La Haye et à Paris, chez De Lalain*, 1769, imp. 8vo. (227)
Isaacs, £1 18s.

9193 Du Buisson (B. C.) Le Tableau de la Volupté, front., 4 plates and 6 vignettes after Eisen, old cf., *à Cythère (Paris)*, 1771, cr. 8vo. (231)
Rimell, £8 10s.

9194 Dumas (A.) Les Trois Mousquetaires, compositions de Maurice Leloir, édition de grand luxe, 2 vol., hf. mor. ex., *Paris*, C. Lévy, 1894, 4to. (234)
Isaacs, £1 5s.

9195 Dumas (A.) La Dame de Monsoreau, compositions de Maurice Leloir, édition de grand luxe, 2 vol., hf. mor. ex., *Paris*, C. Lévy, 1903, 4to. (235)
Isaacs, £1

9196 Duval (Jacques). Traité des Hermaphrodits, etc., papier vergé, tiré à 400 exemplaires, hf. mor., t. e. g., uncut, *Paris*, J. Liseux, 1880, 8vo. (236)
Lewine, £1 16s.

9197 English Catalogue of Books, from 1835 to 1905 and 1908, 8 vol., hf. mor. and cl., 1835-1908, roy. 8vo. (245)
Thin, £5 10s.

9198 Galanteries des Rois de France (Les), 3 engraved titles, front. and 5 plates (not signed), 3 vol., old French cf. ex., t. e. g., uncut, *Cologne*, P. Marteau, *s. d. (vers* 1750), sm. 8vo. (271)
Sotheran, £2 2s.

9199 Gavarni. Le Carnival et Le Carnival à Paris, 73 col. plates, *Paris*, Aubert—Album des Fourberies de Femmes, etc., 29 col. plates, *ib.*—Masques et Visages, 30 lithographs, *ib.*— Paris, Le Matin et Le Soir, 37 lithographs, *ib.*, together 5 vol., 4to. (276)
Meulencere, £10 10s.

9200 Gessner (Salomon). Œuvres Complettes, exemplaire sur papier bleu, port., fronts. and 14 plates after Marillier, some dated 1779, 3 vol., mor. super ex., by Rivière, *s. l. n. d.* [*Paris*, Cazin, 1782 (?)], 12mo. (280)
Edwards, £5 17s. 6d.

9201 Goldsmith (O.) Vicar of Wakefield, 24 col. plates ɔy Row-
landson, cf., g. e., ɔy Rivière, 1817, roy. 8vo. (290)
Bain, £14 10s.
9202 Grego (J.) Reminiscences of Captain Gronow, illustrations
in duplicate (some col.), uncut, t. e. g., 1889, imp. 8vo. (308)
Bain, £2 8s.
9203 Grego (J.) Rowlandson the Caricaturist, 400 illustrations, 2
vol., hf. mor., t. e. g., 1880, 4to. (309) *Shepherd*, £1 1s.
9204 Hamilton (A.) Memoires du Comte de Grammont, 72 ports.
(par S. Harding, etc.), old mor., g. e. (Roger Payne), *à
Londres, chez Edwards* (1795), 4to. (315) *Young*, £7 5s.
9205 Hakluyt Society. Cathay and the Way Thither, trans. by
Col. H. Yule, front. and maps, 2 vol., 1866, 8vo. (316)
Quaritch, £7
9206 Hood (T.) Whims and Oddities, ɔoth series, first ed., wood-
cuts, 2 vol., uncut, 1826-27, 8vo. (326) *Maggs*, £1 5s.
9207 Hossein-Khan (M. G.) Seir Mutagharin, or View of Modern
Times, 3 vol. in 4, hf. cf. (wormed), *Calcutta*, 1789, 4to. (331)
Edwards, £3 3s.
9208 Hume and Marshall. Game Birds of India, Burmah and
Ceylon, col. plates, 3 vol., orig. cl., *Calcutta* 1879-81, roy. 8vo.
(334) *Edwards*, £10 12s. 6d.
9209 Jesse (J. H.) George Selwyn and his Contemporaries, first
ed., ports., 4 vol., orig. cl., fine copy, 1843-44, 8vo. (346)
Quaritch, £7
9210 Jesse (J. H.) Life of George Brummell, col. ports., 2 vol.,
uncut, 1886, 8vo. (347) *Bain*, £2 2s.
9211 Johnson (Chas.) Chrysal, or the Adventures of a Guinea,
first ed., 4 vol., cf., 1760-65, 8vo. (348) *Bain*, £1 2s.
9212 Journal of Sentimental Travels in the Southern Provinces of
France, first ed., col. plates ɔy Rowlandson, cf., g. e., by F.
Bedford, 1821, roy. 8vo. (350) *Bain*, £8 5s.

Kelmscott Press Publications.

9213 Ruskin (John). Nature of the Gothic, vell., uncut, 1892, sm.
4to. (357) *Young*, £1 14s.
9214 Morris (Wm.) News from Nowhere, vell., uncut, 1892, sm.
4to. (358) *Hare*, £2 14s.
9215 Order of Chivalry (The), ed. by F. S. Ellis, vell., uncut, 1893,
sm. 4to. (359) *Shepherd*, £2 12s.
9216 More (Sir Thos.) Utopia, vell., uncut, 1893, sm. 4to. (360)
Young, £3
9217 Tennyson (Alfred Lord). Maud, vell., uncut, 1893, sm. 4to.
(361) *Young*, £1 18s.
9218 Friendship of Amis and Amile, orig. bds., uncut, 1894, 12mo.
(362) *Shepherd*, £1 1s.
9219 Tale of the Emperor Coustans, orig. bds., uncut, 1894, 12mo.
(363) *Young*, £1 2s.
9220 Rossetti (D. G.) Hand and Soul, vell., uncut, 1894, 12mo.
(364) *Shepherd*, £1
9221 Syr Perecyvelle of Gales, orig. bds., uncut, 1895, sm. 4to. (365)
Shepherd, £1 11s.

9222 Morris (Wm.) Child Christopher and Goldilind the Fair, printed on vellum, 2 vol., orig. bds., uncut, 1895, 12mo. (366)
Edwards, £6 2s. 6d.

9223 Morris (Wm.) Child Christopher, 2 vol., orig. bds., uncut, 1895, 12mo. (367) *Young*, £1 12s.

9224 Herrick (Rob.) Poems, vell., uncut, 1895, sm. 4to. (368)
Shepherd, £4 2s. 6d.

9225 Siré Degrevaunt (reprinted from the Thornton MS.), orig. bds., uncut, 1896, sm. 4to. (369) *Young*, £1 6s.

9226 Laudes Beatae Mariae Virginis, ed. by S. C. Cockerell, orig. bds., uncut, 1896, sm. 4to. (370) *Young*, £1 12s.

9227 Floure and the Leafe (The), orig. bds., uncut, 1896, sm. 4to. (371) *James*, £1 7s.

9228 Romance of Syr Isambrace, orig bds., uncut, 1897 (372)
Young, £1 3s.

9229 Morris (Wm.) Love is Enough, vell., uncut, 1897, folio (373)
Edwards, £5 15s.

9230 Cockerell (S. C.) A Note by William Morris on his Aims in founding the Kelmscott Press, orig. bds., uncut, 1898, sm. 4to. (374) *Young*, £2 14s.

9231 Kitton (F. G.) Charles Dickens, oy pen and pencil, ports. and illustrations, India proofs, in parts as issued, 1889-90, folio (377) *Young*, £2 16s.

9232 Kryptalia, Recueil de Documents pour servir à l'Étude des Traditions Populaires, 11 vol., cl., uncut, *Heilbronn, Henninge frères, etc.*, 1883-1907, sm. 8vo. (381)
Meuleneere, £5 10s.

9233 Lafontaine. Contes et Nouvelles en Vers, front. and vignettes by Romain de Hooghe, first ed. with these designs, 2 vol. in 1, mor. ex., by Chamoolle-Duru, *Amst.*, H. Desoordes, 1685, cr. 8vo. (388) *Quaritch*, £7 15s.

9234 Lafontaine. Contes et Nouvelles en Vers, front. by Le Bas, vignettes on titles, vignette of La Fontaine écrivant, and 69 vignettes after Cochin (not signed), 2 vol., mor. ex., by F. Bedford, *Amst. (Paris*, David Jeune), 1745, cr. 8vo. (389)
Quaritch, £5

9235 Lafontaine. Contes et Nouvelles en Vers, port. and 24 plates after Desrais, 2 vol., mor. ex., by Lortic, with ticket, *à Londres (Paris*, Cazin), 1780, 12mo. (390) *H. Smith*, £7

9236 Lafontaine. Contes et Nouvelles en Vers, Didot's small type ed., fine paper, 75 proof plates, 6 découvertes and 17 extra plates inserted, 2 vol., orig. bds., uncut, *Paris, Impr. de P. Didot, aîné, l'an iii.* (1795), cr. 8vo. (391)
Quaritch, £18 5s.

9237 Lafontaine. Contes et Nouvelles, avec illustrations de Fragonard, réimpression de l'Édition de Didot 1795, exemplaires sur papier fait des manufactures impériales du Japon, vignettes en deux états et les planches quelques-uns en quatre et quelques-uns en deux états, 2 vol., hf. mor., t. e. g., uncut, *Paris*, Lemonnyer, 1883, thick 4to. (392)
Mrs. Rouse, £6 2s. 6d.

9238 La Harpe. Tangu et Félime, Poëme en IV. Chants, grand papier vélin, 4 plates after Marillier, mor. ex., uncut, ɔy Rivière, *Paris, chez Pissot* (1780), 8vo. (398)
　　　　　　　　　　　　　　　　　H. Smith, £4 10s.

9239 Larwood and Hotten. History of Signɔoards, LARGE PAPER, col. front. and illustrations, 1867, 4to. (412)　*Hatchard,* £1

9240 Lever (C.) Tales of the Trains, first ed., illustrations by "Phiz," orig. cl., g. e., 1845, 8vo. (431)　*Bumpus,* £2 19s.

9241 Lever (C.) Nuts and Nutcrackers, first ed., illustrations by "Phiz," orig. cl., g. e., 1845, 8vo. (432)　*Quaritch,* £1 2s.

9242 Longus. Les Amours Pastorales de Daphnis et Chloé, LARGE PAPER, front. by Audran, 28 plates of the Regent Philippe d'Orléans by Audran, plate of "Les Petits Pieds" (ɔefore letters) and vignettes after Cochin, old French cf., g. e., *s. l. ou n.* (*Paris*), 1745, sm. 4to. (444)　*Hatchard,* £4 2s. 6d.

9243 Lucan. La Pharsale de Lucain, traduite en François par Marmontel, 10 plates after H. Gravelot, 2 vol., old French mor., g. e., fine copy, *Paris, chez Merlin,* 1766, 8vo. (448)
　　　　　　　　　　　　　　　　　Isaacs, £4 7s. 6d.

9244 Lucretius. Della Natura delle Cose liɔri sei, tradotti in Italiano da Aless. Marchetti, papier de Hollande, fronts., vignettes and 6 plates ɔy Le Mire, etc., 2 vol., old French mor., full gilt ɔacks, g. e. (Derome), *Amst.* (*Paris*), *a Spese dell' Editore,* 1754, roy. 8vo. (450)　*Isaacs,* £28 10s.

9245 Marguerite de Navarre. Contes et Nouvelles, vignettes by Romain de Hooghe, 2 vol., vell. gt., *Amst.,* G. Gallet, 1698, sm. 8vo. (461)　　　　　　　　*Dobell,* £1 4s.

9246 Marguerite de Navarre. L'Heptameron, réimpression de l'édition de Berne 1780, sur papier de Hollande, planches et vignettes d'après Freudenɔerg et Dunker, 3 vol., mor. super ex., ɔy Lortic, *Berne,* 1780 [*Paris,* 18—?], 8vo. (463)
　　　　　　　　　　　　　　　　　Sotheran, £9 5s.

9247 Marryat (Capt.) The Pirate and the Three Cutters, first ed., LARGE PAPER, 20 engravings on India paper, ɔy Stanfield, 1836, imp. 8vo. (470)　　　　*Bumpus,* £1 16s.

9248 Martialis. Epigrammatum Liɔri, vignettes after Eisen, 2 vol., old French mor., g. e. (Derome), *Lut. Par.,* J. Barɔou, 1754, cr. 8vo. (471)　　　　　　　　*Bain,* £2 18s.

9249 Meursius (Jo.) Elegantiae Latini Sermonis, 2 vol. in 1, old French mor., g. e. (Derome), *Lugd. Bat. ex typis Elzevirianis,* 1757, 8vo. (482)　　　　*Scotti,* £2 4s.

9250 Molière. A Series of Illustrations to Molière (édition Bret, 1773), after Moreau le Jeune, by Duclos, Simonet, Née, De Ghent, Le Veau, 33 plates and a port. after Mignard par Cathelin, orig. impressions (tirage à part), old French cf., g. e. (*Paris,* 1773), imp. 8vo. (493)　*Isaacs,* £22 10s.

9251 Monselet (Chas.) Les Ouɔliés et les Dédaignées Figures Littéraires de la fin du 18e Siècle, première éd., papier vergé, 15 orig. ports. and designs in colours, signed "A. Baudet Bauderval del," inserted, 2 vol., orig. bds., uncut, *Alençon,* Poulet-Malassis, 1857, cr. 8vo. (498)
　　　　　　　　　　　　　　　　　Rimell, £8 2s. 6d.

9252 Montesquieu (C. S.) Le Temple de Gnide, éd. originale, engraved throughout on 68 leaves with port., engraved title and 9 engravings after Eisen, old cf., *Paris, chez Le Mire*, 1772, 4to. (502) *Isaacs, £*13 15s.

9253 Nodier (Chas.) Le Dernier Chapître de mon Roman, nouvelle éd., illustrée de trente compositions (en couleur) par L. Morin, papier vélin, hf. cf. gt., *Paris*, L. Conquet, 1895, roy. 8vo. (519) *Rimell, £*4 5s.

9254 Ovid. Les Metamorphoses d'Ovide, 140 engravings and a vignette after Boucher, Moreau, Eisen, Monnet, Gravelot, etc. (sans texte), old English mor., g. e. [*Paris*, 1767-71], 4to. (526) *Baer, £*24 10s.

9255 Pardoe (Miss). Louis the Fourteenth and the Court of France, first ed., 3 vol., illustrations, 1847, 8vo. (528)
 *Hornstein, £*3 15s.

9256 Pardoe (Miss). Court and Reign of Francis the First, first ed., ports., 2 vol., 1849, 8vo. (529) *Graystone, £*2 18s.

9257 Pardoe (Miss). Life of Marie de Medicis, first ed., ports., 3 vol., 1852, 8vo. (530) *Edwards, £*1 15s.

9258 Pepys (S.) Diary and Correspondence, by H. B. Wheatley, with Index and Pepysiana, LARGE PAPER, one of 250 copies, ports., 10 vol., hf. vell., uncut, 1893-99, 8vo. (537)
 *Askew, £*14

9259 [Pezay (Marquis de).] Zélis au Bain : Lettre d'Alciabade à Glicere, etc., plates and vignettes after Eisen, old cf. gt., *Genève*, 1766, 8vo. (546) *Edwards, £*3 3s.

9260 Plaisirs de l'Amour (Les), ou Recueil de Contes, Histoires et Poëmes Galants, LARGE PAPER, front. and 18 plates (not signed), 3 vol. in 1, hf. cf., *chez Apollon au Mont Parnasse, (Paris, Cazin*, 1782), sm. 8vo. (548) *Sotheran, £*3 3s.

9261 Poetical Magazine, dedicated to the Lovers of the Muse, by R. Ackermann, col. illustrations by Rowlandson, etc., 4 vol., uncut, 1809-10, 8vo. (552) *Hornstein, £*10 10s.

9262 Prinsep (J.) Essays on Indian Antiquities, illustrations, 2 vol., 1858, 8vo. (560) *Edwards, £*2 15s.

9263 Prydden (Sarah). The Genuine History of Mrs. Sarah Prydden, usually called Sally Salisbury, and her Gallants, cf., g. e., by Pratt, 1723, 8vo. (562) *Sotheran, £*1 18s.

9264 Racine (Jean). Œuvres, port. by Daullé, 12 plates and numerous vignettes by De Seve, 3 vol., old French cf. gt., *Paris*, 1760, 4to. (572) *Isaacs, £*3 7s. 6d.

9265 Ramblers' Magazine (The), plates, vol. i.-ii., 2 vol., hf. mor., t. e. g., n. d., 8vo. (574) *Thorp, £*3

9266 Recueil de Divers Petits Sujets Agréables d'après Eisen et autres Maîtres, 60 small engravings, chiefly ovals, on 58 leaves, after Eisen and others, by B. Picart, hf. mor., *Se Vend à Paris chez Basan, s. d.* [17—], 8vo. (577)
 *Maggs, £*3 3s.

9267 Recueil des Meilleurs Contes en Vers, par Lafontaine, et autres, 116 vignettes, unsigned, 4 vol., mor. super ex., by F. Bedford, *Londres (Paris*, Cazin), 1778, 12mo. (578)
 *Sotheran, £*8 10s.

9268 Restif de la Bretonne. Le Paysan Perverti, première éd. (no plates), 4 vol., old cf. gt., *Imprimé à la Haye*, 1776—La Paysane Pervertie, première éd., 38 plates after Binet, etc., 4 vol., old hf. cf., *à la Haie et à Paris chés la Veuve Duchesne*, 1784, sm. 8vo. (586) *Reuter, £2* 12s.

9269 Restif de la Bretonne. Le Nouvel Abeilard, ou Lettres de deux Amans, première éd., front. and 9 plates ("Gravé par Mme. Ponce"), 4 vol., mor. ex., by Champolle-Duru, *à Neuchatel et à Paris chez la Veuve Duchesne*, 1778, sm. 8vo. (589) *Quaritch, £7*

9270 Restif de la Bretonne. La Vie de Mon Père, première éd., vignette port. on each title, 2 fronts. and 12 plates (not signed), printed upon bluish paper, 2 parts in 1 vol., mor. ex. (some margins uncut), by Champolle-Duru, *à Neufchatel et à Paris chez Belin*, 1779, sm. 8vo. (590) *Edwards, £2* 1s.

9271 Restif de la Bretonne. La Malédiction Paternelle, première éd., 3 vol., mor. ex., by Champolle-Duru, *Imprimé à Leipsick par Buschel et se trouve à Paris chéz la Veuve Duchesne*, 1780, sm. 8vo. (591) *Reuter, £1* 16s.

9272 Restif de la Bretonne. La Dernière Avanture d'un Homme à Quarante-cinq ans, première éd., 5 plates after Binet, 2 vol. in 1, mor. ex., by Champolle-Duru, *Genève, et à Paris chez Regnault*, 1783, cr. 8vo. (592) *Leighton, £5* 5s.

9273 Restif de la Bretonne. La Prévention Nationale, première éd., 10 plates (not signed), 3 vol., orig. hf. binding, *à La Haie et à Paris chés Regnault*, 1784, sm. 8vo. (593) *Dobell, £1* 3s.

9274 Restif de la Bretonne. Tableaux de la Bonne Compagnie, première éd., 16 plates by Moreau le Jeune (reduced), 2 vol., mor. ex., uncut, by Rivière, *Paris*, 1787, sm. 8vo. (594) *Leighton, £9*

9275 Restif de la Bretonne. Les Parisiennes, première éd., 20 plates (not signed), 4 vol., bds., uncut, *à Neufchâtel et à Paris chés Guillot*, 1787, sm. 8vo. (595) *Dobell, £5* 5s.

9276 Restif de la Bretonne. Les Nuits de Paris, première éd., 18 plates after Binet (not signed), the 16 parts complete in 8 vol., old cf. gt., *à Londres et à Paris*, 1788-94, sm. 8vo. (596) *Maggs, £4* 12s.

9277 Restif de la Bretonne. Le Drame de la Vie, première éd., 4to. port. of Restif by Berthet, 5 vol., mor. ex., by Champolle-Duru, *Paris, chez la V. Duchèsne et Mérigot*, 1793, sm. 8vo. (599) *Reuter, £3* 3s.

9278 Restif de la Bretonne. Tableaux de la Vie et les Moeurs du dix-huitième siècle, 17 figures en taille douce d'après Moreau et Freudeberg, 2 vol., hf. mor., t. e. g., uncut, *Neuwied sur le Rhine et Strasborg, chez J. G. Treuttel, s. d.* (1787), 12mo. (600) *H. Smith, £5*

9279 Rochester, Roscommon, Dorset (Earls of). Works, port. (one plate wanted), 2 vol. in 1, mor. ex., 1774, 8vo. (603) *Young, £5*

9280 Roscoe (T.) Novelists' Library, complete set, illustrations by G. Cruikshank, etc., 19 vol. (one vol. wanted general title), orig. cl., 1831-33, 8vo. (605) *Spencer, £5* 5s.

9281 Rops (Félicien). Catalogue Descriptif et Analytique de l'Œuvre Gravé, papier vélin, illustrations, 3 vol., hf. mor., t. e. g., uncut, *Brux. et Paris*, 1891-93-95, sup. imp. 8vo. (606) *Neumayer*, £5

9282 Smollett (T.) Ferdinand Count Fathom, first ed., 2 vol., contemp. cf., 1753, 8vo. (637) *Maggs*, £3 7s. 6d.

9283 Smollett (T.) Peregrine Pickle, first ed., 4 vol., cf., 1751, 8vo. (639) *Bain*, £5 5s.

9284 Sterne (L.) Tristram Shandy, first ed. (except vol. i.-ii. which are second ed.), 9 vol., cf. ex., autograph signature of author in vol. v., vii. and ix., 1760-67, 8vo. (644) *Bain*, £5 10s.

9285 Sterne (L.) Sentimental Journey, first ed., 2 vol., cf. ex., with the half-titles and list of subscribers so often wanted, 1768, 8vo. (645) *Hopkins*, £8

9286 Stone (Mrs.) Chronicles of Fashion, ports., 2 vol., orig. cl., 1845, 8vo. (648) *Rimell*, £2 18s.

9287 Swift (J.) Complete Collection of Genteel and Ingenious Conversation, in three Dialogues, by Simon Wagstaffe, first ed., cf., 1738, 8vo. (655) *Donnithorn*, £1 13s.

9288 Terentius. Comoediae Sex, thick paper, fronts. and vignettes after Gravelot, 2 vol., old French mor., g. e. (Derome), *Lut. Par. N. Le Loup, etc.*, 1753, sm. 8vo. (667) *Isaacs*, £4 14s.

9289 Tibullus. Élégies de Tibulle, par Mirabeau l'aîné, port. of Mirabeau and 14 plates after Borel, 3 vol., hf. cf., uncut, *à Tours et à Paris, l'an* 3 (1795), 8vo. (678) *Dobell*, £3

9290 Voltaire. Candide, ou l'Optimisme, LARGE PAPER, 2 parts in 1 vol., mor., inside dentelles, by Petit, entirely uncut, *s. l.*, 1775, sm. 8vo. (701) *Bain*, £1 4s.

9291 Voltaire. Romans, L'Ingenu, Princesse de Babylone, Lettres d'Amabed, Zadig et Candide, eaux-fortes de Laguillermie, grand papier de Hollande, 5 vol., hf. mor. ex., t. e. g., uncut, *Paris*, Jouaust, 1878, 8vo. (702) *Sotheran*, £2

9292 Voltaire. La Pucelle d'Orléans, 20 plates (not signed), attributed to Gravelot, old French mor., ornamental back and borders, g. e., the first edition acknowledged by the author, *s. l.* (*Genève*), 1762, 8vo. (703) *Edwards*, £6

9293 Voltaire. La Pucelle d'Orléans, 21 vignettes after Duplessis-Bertaux, 2 vol. in 1, mor. ex., by F. Bedford, *à Londres* (*Paris*, Cazin), 1780 (704) *Sotheran*, £4 17s. 6d.

9294 Voltaire. La Pucelle d'Orléans, LARGE PAPER, front. and proof vignettes, 2 vol. in 1, russ. ex., *à Londres* (*Paris*, Cazin), 1780, cr. 8vo. (705) *Bumpus*, £7 5s.

9295 Voltaire. La Pucelle d'Orléans, Stereotype d'Herhan, port. and 21 plates after Moreau le Jeune, old mor., g. e., *Paris*, Frères Mame, 1808, 8vo. (706) *Sotheran*, £2

9296 Voltaire. La Pucelle d'Orléans, Stereotype d'Herhan, port. by Delvaux and 21 engravings after J. B. Moreau, hf. mor., t. e. g., uncut, *Paris*, Renouard, 1816, 8vo. (707) *Sotheran*, £2 8s.

9297 Walker (A.) Analysis and Classification of Beauty in Woman, first ed., plates, India proofs, parchment, uncut, 1836, roy. 8vo. (710) *Dobell*, £1 5s.

(β) *The Property of the Rev. Stopford A. Brooke.*

9298 Allingham (Wm.) The Music Master and Two Series of
Day and Night Songs, first ed., 7 designs, one by D. G.
Rossetti, hf. cf., t. e. g., 1855, 8vo. (728) *Quaritch,* £1 8s.

9299 Alpine Journal (The), maps, plates and plans, vol. i.-xiv., hf.
mor., t. e. g., orig. wrappers bound in, 1864-89, 8vo. (729)
Edwards, £13

9300 Arnold (Matthew). Strayed Reveller, and other Poems, first
ed., orig. cl., uncut, 1849, 8vo. (731) *Quaritch,* £3

9301 Arnold (M.) Saint Brandan, first ed., orig. wrappers, 1867,
8vo. (733) *Quaritch,* £2

9302 Beckford (P.) Thoughts on Fox and Hare Hunting, plates
by Scott, orig. bds., uncut, 1810, 8vo. (743) *Bain,* £2 12s.

9303 Bewick (T.) General History of Quadrupeds, first ed., royal
paper, orig. bds., uncut, fine copy, *Newcastle-upon-Tyne,*
1790, roy. 8vo. (744) *Hornstein,* £10 5s.

9304 Bewick (T.) History of British Birds, first ed., 2 vol., cf.,
g. e., *Newcastle,* 1797-1804, 8vo. (745) *Bain,* £2 18s.

9305 Bewick (T.) Select Fables, imperial paper, port. mounted,
clean uncut copy in later bds., *Newcastle,* 1820, imp. 8vo.
(747) *Power,* £6

9306 Blake (W.) Life, by A. Gilchrist, ports. and illustrations, 2
vol., 1880, 8vo. (753) *Bumpus,* £2 4s.

9307 Browning (E. B. and R.) Two Poems (Plea for Ragged
Schools of London, and The Twins), first ed., hf. mor.,
orig. wrappers bound in, 1854, 8vo. (760) *Spencer,* £2 2s.

9308 Browning (R.) Poetical Works (one of 250 copies on hand-
made paper), 17 vol., buckram, uncut, 1888, 8vo. (762)
Maggs, £21 5s.

9309 Clio and Euterpe, or British Harmony, front. and vignettes,
4 vol. in 1, hf. mor., m. e., not subject to return, n. d., 8vo.
(771) *Edwards,* £2 5s.

9310 [Cory (W. J.)] Ionica, first ed., uncut, a few MS. corrections,
1858, 8vo. (775) *Bain,* £1 10s.

9311 FitzGerald (Edward). Six Dramas of Calderon, first ed.,
orig. cl., uncut, Pickering, 1853, 8vo. (778)
Quaritch, £3 10s.

9312 FitzGerald (E.) Salámán and Absál, first ed., front., hf.
mor., t. e. g., 1856, sm. 4to. (779) *Quaritch,* £5 10s.

9313 FitzGerald (E.) Euphranor, a Dialogue on Youth, first ed.,
orig. cl., Pickering, 1851, 8vo. (780) *Maggs,* £1 10s.

9314 FitzGerald (E.) Two Dramas from Calderon, first ed., orig.
grey wrappers, 1865, 8vo. (781) *Quaritch,* £4 5s.

9315 FitzGerald (E.) Rubáiyát of Omar Khayyám, front., hf. bd.,
t. e. g., Quaritch, 1879 (782) *Maggs,* £2 12s.

9316 FitzGerald (E.) The Downfall and Death of King Œdipus,
a Drama, first ed., 50 copies printed, blue wrapper (1880-1),
8vo. (783) *Quariich,* £4 5s.

9317 FitzGerald (E.) Euphranor, a May-day Conversation at
Cambridge, "'Tis Forty Years Since," 50 copies printed,
hf. mor., g. e. (1882), 8vo. (784) *Spencer,* 14s.

9318 Germ (The), orig. issue, etchings, the four parts complete, uncut, with the wrappers, in a case, Aylott and Jones, 1850, 8vo. (788) *Sabin, £51*

9319 Huth Library (The), edited by A. Grosart. Greene (R.) Complete Works, and Life, 15 vol., 1881-86—Nashe (T.) Complete Works, 6 vol., 1883-84—Harvey (G.) Works, 3 vol., 1884—Dekker (T.) Non-Dramatic Works, 5 vol., 1884-86, together 29 vol., uncut, 1881-86, 8vo. (792) *Quaritch, £20 10s.*

9320 Keats (J.) Poetical and Prose Works, ed. by H. Buxton Forman, with the Supplement, ports., etc., 5 vol., buckram, uncut, 1883-90, 8vo. (793) *Hornstein, £8 5s.*

9321 Layamons Brut, or Chronicle of Britain, by Sir Frederic Madden, facs., 3 vol., hf. mor., t. e. g., 1847, roy. 8vo. (794). *Thin, £2 10s.*

9322 Lang (A.) Blue Fairy Book, first ed., LARGE PAPER, illustrations, orig. bds., uncut, 1889, imp. 8vo. (796) *Donnithorn, £1*

9323 Lang (A.) Red Fairy Book, first ed., LARGE PAPER, illustrations, orig. bds., uncut, 1890, imp. 8vo. (797) *Donnithorn, £1*

9324 Lang (A.) Green Fairy Book, first ed., LARGE PAPER, illustrations, orig. bds., uncut, 1892, imp. 8vo. (798) *Donnithorn, £1*

9325 Lang (A.) Yellow Fairy Book, first ed., LARGE PAPER, illustrations, orig. bds., uncut, 1894, imp. 8vo. (799) *Donnithorn, 12s.*

9326 Morris (Wm.) The Earthly Paradise, first ed., one of 25 copies on LARGE PAPER, 4 parts in 6 vol., orig. bds., uncut, 1868-70, 8vo. (804) *Bumpus, £9*

9327 Morris (W.) The Æneids of Virgil, first ed., LARGE PAPER, 1 vol. in 2, orig. bds., uncut, 1876, 8vo. (805) *Maggs, £1 6s.*

9328 Morris (W.) Sigurd the Völsung, first ed., LARGE PAPER, orig. bds., uncut and unopened, 1877, 8vo. (806) *Shepherd, £1 18s.*

9329 Morris (W.) Life and Death of Jason, LARGE PAPER, orig. bds., uncut, 1882, 8vo. (807) *Maggs, £1 18s.*

9330 Morris (W.) News from Nowhere, LARGE PAPER, hf. parchment, uncut, 1891, 8vo. (808) *Shepherd, £1 2s.*

9331 Morris (W.) and Magnússon (E.) Three Northern Love Stories, first ed., LARGE PAPER, orig. bds., uncut, 1875, 8vo (809) *Hornstein, £3 10s.*

9332 Morris (W.) and Magnússon (E.) Story of Grettir the Strong, first ed., LARGE PAPER, orig. bds., uncut, 1869, 8vo. (810) *Hornstein, £2 8s.*

9333 Pater (W.) Essays from the "Guardian," first ed., orig. bds., uncut, *Printed for private circulation*, 1896, 8vo. (811) *Quaritch, £6 15s.*

9334 Peaks, Passes and Glaciers, both series, first eds., col. plates and illustrations, 3 vol., hf. mor., t. e. g., 1859-62, 8vo. (812) *Young, £3 7s. 6d.*

9335 Rossetti (C. G.) Verses (written between the ages of twelve

and sixteen), mor., t. e. g., by Rivière, with the cancelled
leaf inserted (torn), *Privately printed at G. Polidori's, No.
15, Park Village East, Regent's Park, London,* 1847, 8vo.
(815) *Ellis,* £6 15s.
9336 Rossetti (C. G.) Goblin Market and other Poems, first ed., 2
designs by D. G. Rossetti, mor. ex., autograph letter of
author inserted, *Cambridge,* 1862, 8vo. (816) *Pyke,* £2 12s.
9337 Rossetti (D. G.) Verses (At the Fall of the Leaf and After
the French Liberation of Italy), (one of a few copies on
vellum,) orig. wrappers bound in, vell., *Privately printed,*
1881, 8vo. (817) *Bumpus,* £7
9338 Rossetti (D. G.) Poems, LARGE PAPER, orig. bds., uncut,
1881, 8vo. (818) *Ellis,* £1 14s.
9339 Rossetti (D. G.) Ballads and Sonnets, first ed. (one of 25
copies printed on LARGE PAPER), orig. bds., uncut, 1881,
8vo. (819) *Spencer,* £20
[Inserted are the original autograph manuscripts of two
sonnets, "The Day Dream" and " Proserpina," by Rossetti,
and a rare lithograph " Juliette," the only one ever executed
by Rossetti.—*Catalogue.*]
9340 Rossetti (D. G.) Collected Works, ed. by W. M. Rossetti,
LARGE PAPER (25 copies printed), 2 vol. in 4, orig. bds.,
uncut, 1886, 8vo. (820) *Hornstein,* £5 10s.
9341 Saga Library (The), LARGE PAPER (one of 125 copies), 6
vol., hf. mor., t. e. g., 1891-1905, roy. 8vo. (824)
Shepherd, £3 12s. 6d.
9342 Shakespeare. Facsimile of the Early Quarto Editions of
Shakespeare's Plays and Poems, ed. by F. J. Furnivall,
complete set, 43 vol., hf. roan, 1880-91, 8vo. (825)
Edwards, £9 5s.
9343 Shelley (P. B.) Poetical and Prose Works, ed. by H. Buxton
Forman, ports., etc., 8 vol., orig. cl., 1876-80, 8vo. (830)
Dobell, £10 5s.
9344 Shelley (P. B.) Letters to Jane Clairmont, *Privately printed,*
vell., uncut, not for sale, 1889, 8vo. (831) *Dobell,* 9s.
9345 Shelley (P. B.) Letters to Elizabeth Kitchener (not for sale),
printed on vell., 2 vol., vell., uncut, *Privately printed,* 1890,
8vo. (832) *Dobell,* £1 10s.
9346 Shelley (P. B.) Letters to William Godwin (not for sale), 2
vol., vell., uncut, *Privately printed,* 1891, 8vo. (833)
Dobell, 7s.
9347 Swinburne (A. C.) Cleopatra, first ed., vell., uncut, wrappers
preserved, 1866, 8vo. (836) *Bumpus,* £3 6s.
9348 Swinburne (A. C.) The Jubilee MDCCCLXXXVII., vell.,
uncut, orig. wrappers preserved, 1887 — The Question
MDCCCLXXXVII., a Poem, vell., uncut, orig. wrappers pre-
served, 1887, 8vo. (839) *Quaritch,* £15
9349 Swinburne (A. C.) Sequence of Sonnets on the Death of
Robert Browning, vell., uncut, orig. wrappers preserved,
1890, 8vo. (840) *Quaritch,* £7 5s.
9350 Wordsworth (W.) Peter Bell, first ed., front., hf. mor., t. e. g.,
1819, 8vo. (850) *Spencer,* £1 12s.

9351 FitzGerald (Edward). Ruɔáiyát of Omar Kháyyám, first
ed., 250 copies printed, hf. mor., t. e. g., Quaritch, 1859, 4to.
(864) *Quaritch,* £35
9352 FitzGerald (E.) Ruɔáiyát of Omar Kháyyám, second ed.,
hf. mor., t. e. g., part of orig. wrapper preserved, Quaritch,
1868, 4to. (865) *Quaritch,* £8 10s.
9353 FitzGerald (E.) Ruɔáiyát of Omar Kháyyám, third ed.,
orig. hf. rox., uncut, Quaritch, 1872, 4to. (866)
Maggs, £4 2s. 6d.
9354 FitzGerald (E.) Agamemnon, a Tragedy, first ed., orig. hf.
rox., uncut, Quaritch, 1876, 4to. (869) *Maggs,* £2 6s.
9355 Grolier Cluɔ. Bury (Richard de). The Philobiblon, gothic
letter, 3 vol., vell., uncut, in cases, 1889, 4to. (873)
Tregaskis, £7 10s.
9356 Hayley (Wm.) Life of George Romney, ports. and plates,
uncut, *Chichester,* 1809, 4to. (874) *Ellis,* £6 5s.
9357 Painter (W.) The Palace of Pleasure, ed. by Joseph Jacoɔs
(one of 550 copies), 3 vol., 1890, 4to. (886) *Quaritch,* £2 5s.
9358 Rossetti (Gaɔriel, Junior). Sir Hugh the Heron, first ed.,
mor., t. e. g., *G. Polidori's Private Press,* 15, *Park Village
East, Regent's Park,* 1843 (891) *Bumpus,* £20
9359 Stevenson (R. L.) Ticonderoga, LARGE PAPER (50 copies
printed), vell., uncut, *Printed for the author,* 1887, 4to. (902)
Spencer, £3 5s.
9360 Swinɔurne (A. C.) Atalanta in Calydon, first ed., in the orig.
white cl., as issued, with design on cover by D. G. Rossetti,
Moxon, 1865, 4to. (904) *Dobell,* £6 15s.
9361 Swinɔurne (A. C.) Grace Darling, parchment, uncut, 1893,
4to. (906) *Bumpus,* £3 10s.
9362 Chaucer (G.) Workes, edited by T. Speght, black letter,
engraved title and plate of the progenie of Chaucer, cf.,
G. Bishop, 1598, folio (920) *Young,* £4 18s.
9363 Gainsɔorough (T.) Engravings from the Works of, 125
plates, India proofs, hf. mor., t. e. g., Graves, n. d., roy. folio
(928) *Bumpus,* £7 15s.
9364 Gonse (Louis). L'Art Japonais, vell. paper, illustrations,
some col., 2 vol., silk ɔinding, uncut, *Paris,* Quantin, 1883,
folio (933) *Edwards,* £7 7s. 6d.
9365 Hamerton (P. G.) Etching and Etchers, third ed., illustra-
tions, hf. mor., uncut, 1880, folio (934) *Young,* £3 12s.
9366 Kelmscott Press. Chaucer (Geoffrey). Works, hf. holland,
uncut, *May 8th,* 1896, folio (939) *Young,* £48 10s.
9367 Lory (G.) Voyage Pittoresque de Gèneve à Milan, col.
plates, mor., g. e., Bâle, 1819, roy. folio (942) *Spencer,* £9
9368 Strang (Wm.) The Earth Fiend, a Ballad (one of 150
copies), etchings by the author, proofs on Japanese paper,
ɔuckram, uncut, t. e. g., 1892, folio (951) *Parsons,* £1 3s.
9369 Vacher (S.) Fifteenth Century Italian Ornament, col. plates
of ɔrocades, stuffs, etc. in case, 1886, folio (953)
Rimell, £1 8s.
9370 Vale Press. The Dial, edited by C. S. Ricketts and C. H.

Shannon, parts i.-v., illustrations, orig. wrappers, uncut (part
. i. buckram), 1889-97, folio (954) *Shepherd*, £3 10s.
9371 Venice. Vedute di Vinegia, engravings, at the end of the
volume are 12 orig. drawings by Canaletti, hf. vell. (1782),
oblong folio (955) *Parsons*, £5 10s.
9372 Whitaker (T. D.) History of Richmondshire, engravings, 2
vol., cf., g. e., 1823, folio (957) *Young*, £9 15s.

*The following were sold by Messrs. Puttick & Simpson
on July 14th and 15th :—*

9373 [Austen (Jane).] Emma, first ed., 3 vol., bds., uncut (vol. i.
wanted pages 2 to 7 and 17 to 22), with the half titles,
London, printed for John Murray, 1816, 8vo. (391)
Quaritch, £7 10s.
[Vol. i. and ii. printed by Roworth, vol. iii. by Moyse.—
Catalogue.]
9374 Buller (Sir W. L.) Birds of New Zealand, with the Supple-
ment, col. plates, 4 vol., hf. mor., 1888-1905, roy. 4to. (625)
Edwards, £12 15s.
9375 Cruikshank (G.) Phrenological Illustrations, 6 plates in the
orig. covers, presentation copy to Leigh Hunt, with auto-
graph inscription, 1826, folio (38) *Shepherd*, £1 9s.
9376 Historians' History of the World, 25 vol., mor., in oak book-
case, 1907, 8vo. (439) *Edwards*, £7 15s.
9377 Household Furniture in Genteel Taste by a Society of Up-
holsterers, Cabinet Makers, etc., 350 designs on 120 copper-
plates (in the Chippendale and Sheraton styles), the orig. 3
parts in 1 vol., old cf. (n. d. (1762), 8vo. (400)
Taplin, £8 8s.
9378 Ihne (W.) History of Rome, 5 vol., cl., 1871-82, 8vo. (372)
Hill, £2 10s.
9379 Ruskin (John). Portion of the original MS. of "Stones of
Venice," "Notes on Christianity," 7 pages folio, in Ruskin's
writing, also parts of "A Joy for Ever," etc., on 7 pages, all
in Ruskin's writing (579) *Spencer*, £10
9380 Scrope (W.) Art of Deer Stalking, 1838—Days and Nights
of Salmon Fishing, 1843, both first eds., orig. cl., 8vo. (459)
Hornstein, £11
9381 Surtees (R. S.) Ask Mamma, col. etchings by Leech, in the
orig. 13 parts (part xiii. no front wrapper, some others
wrongly numbered), 1858, 8vo. (164) *Shepherd*, £4 17s. 6d.
9382 Surtees (R. S.) Handley Cross, or Mr. Jorrocks' Hunt, col.
etchings by John Leech, and woodcuts, orig. pictorial cl.,
advertisements at end of vol., dated 1861, 1854, 8vo. (461)
Curtis, £7 5s.
9383 Woodward (G. M.) Caricature Magazine, vol. iii. and v.,
containing col. caricatures by Rowlandson, Cruikshank and
others, 2 vol., orig. hf. mor., 1821, oblong folio (639)
Edwards, £12 10s.

SOTHEBY, WILKINSON & HODGE.

THE LIBRARY OF MR. J. A. RUSTON, OF MONK'S MANOR,
LINCOLN, AND OTHER PROPERTIES.

(No. of Lots, 346 ; amount realised, £7,559 5s.)

———

(a) *Mr. Ruston's Library (nearly all the books had the owner's
ex-libris by C. W. Sherborne).*

9384 Agricola (Geo.) De Re Metallica, woodcuts, old red velvet
binding, g. e., with 2 leaves Fust and Schoeffer's First Latin
Psalter on vell., in large 𝔤𝔬𝔱𝔥𝔦𝔠 𝔩𝔢𝔱𝔱𝔢𝔯, 20 lines as fly-leaves,
Basil., Jo. Frozen, 1561, folio (114) *Quaritch,* £38 10s.
9385 Aldin (Eleazar). Natural History of Butterflies and Moths,
100 col. plates, 4to. size inlaid on folio paper, with a folio
engraved front. not belonging to the work, old mor. richly
gilt, arms of John V., King of Portugal, edges painted with
the Braganza arms (1720), imp. folio (101) *Isaacs,* £3
9386 Annae Comnenae Porphyrogenitae Alexias, sive de Rebus ab
Alexio Imperatore lib. XV., e Bibl. Barbarini, LARGE PAPER,
old French mor., with royal arms of France (Louis XIV.),
g. e., *Paris, e Typ. Reg.,* 1651, folio (113)
 E. Parsons, £6 10s.
9387 Ashmole (Elias). Institution, Laws and Ceremonies of the
Order of the Garter, orig. ed., LARGE PAPER, port. of
Charles II. by Sherwin (inlaid) and plates, modern mor. ex.,
J. Macock for N. Brooke, 1672, folio (96) *Young,* £4 8s.
9388 Burckhardt (J. L.) Travels in Nubia, port., maps and illus-
trations, mor., ornamental back, g. e. (C. Lewis), with the
Prince of Wales's feathers (George IV.), J. Murray, 1819,
4to. (40) *Ellis,* £2 6s.
9389 Chippendale (Thos.) The Gentleman and Cabinet-maker's
Director, orig. ed., 161 plates (plate 25 repeated), uncut copy,
in orig. hf. binding (top cover broken), *Printed for the
Author and Sold at his House in St. Martin's Lane,* 1754
(100) *Hatchard,* £19 10s.
9390 Dodd (Rev. Dr. Wm.) An Account of the Rise, Progress and
Present State of the Magdalen Charity, second ed., LARGE
PAPER, Queen Charlotte's copy, mor. ex., crowned wreath
bearing the inscription "Her Majesty Queen Charlotte
Patroness 1765," *Printed by W. Fallen for the Charity,* 1763,
8vo. (1) *Dobell,* £2 10s.
9391 Dugdale (Sir Wm.) Antiquities of Warwickshire, second ed.,
port., maps and views, 2 vol., old russ. gt., Osborne and
Longman, 1730, roy. folio (91) *Hitchman,* £10
9392 Eusebius. Chronicon id est Temporum Breviarium ab

Hieronymo latine fecit, lit. rom., red and ɔlack, woodcut
initials, modern pigskin, g. e., *Venetiis impressus per Er-
hardum Ratdolt Augustensis*, 1483, sm. 4to. (30)
Quaritch, £5 5s.

9393 Evelyn (John). Memoirs, ed. by Bray, first ed., port. and
plates, King William IV.'s copy, 2 vol., russ., g. e., with the
Royal arms, H. Colɔurn, 1818, 4to. (39) *Maggs, £6 10s.*

9394 Fialetti (Odoard). Briefve Histoire de l'Institution de toutes
les Religions, 72 engravings, with vignette shields, some
with arms, old Italian (15th century) mor., arms of Pope
Pius VI. (Broschi) and other quarterings painted in heraldic
colours, *Paris*, A. Menier, 1658, roy. 8vo. (7) *Tregaskis, £4*

9395 Foxe (John). Actes and Monuments, fourth tyme puɔlished,
𝔟𝔩𝔞𝔠𝔨 𝔩𝔢𝔱𝔱𝔢𝔯, woodcuts with separate cuts of the poisoning of
K. John, the ɔurning of Ridley and Latimer, and of the
ɔones of Bucer, 2 vol. in 1, sides of orig. English oak bds.,
stamped leather (reɔacked), fine copy of the last edition of
Foxe's Book of Martyrs revised ɔy the author, J. Daye,
1583, folio (103) *Maggs, £4 14s.*

9396 Gould (John). A Monograph of the Trochilidae, orig. issue,
360 col. plates, 5 vol., russ. ex., 1861, imp. folio (76)
Quaritch, £16 10s.

9397 Gould (J.) Birds of Great Britain, orig. issue, 367 col. plates,
5 vol., hf. mor., g. e., 1873, imp. 8vo. (77) *Nattali, £35*

9398 Gould (J.) Monograph of the Ramphastidae, orig. issue, 51
col. plates, russ. ex., 1854, imp. folio (78) *Quaritch, £4*

9399 Gould (J.) Monograph of the Odontophorinae, orig. issue,
32 col. plates, hf. mor., g. e., 1850, imp. folio (79)
Edwards, £5 5s·

9400 Gould (J.) A Century of Birds from the Himalaya Moun-
tains, orig. issue, 80 col. plates, hf. mor., t. e. g., 1832, imp.
8vo. (80) *Edwards, £2*

9401 Gwynn (Edward). Medulla Parliamentalis, original manu-
script, written on 356 leaves, the title within a well-
decorated ɔorder of floreate scrolls in colours, with the
arms and name of Edward Gwynn, Fellow of the Middle
Temple, contemp. English mor., covered with elaɔorate
gilt semis of stars and planets, "Edward Gwynn" stamped
in gold letters on ɔoth covers (Phillipps' MSS. 8922), 1622,
folio (107) *Quaritch, £71*

9402 Hamilton (Count A.) Memoirs of Count Grammont, 76
ports., old mor. ex., S. and E. Harding (1793), 4to. (35)
Quaritch, £7

9403 Horae B. V. M. ad usum Romanum, 𝔩𝔦𝔱. 𝔤𝔬𝔱𝔥., long lines, 33 to
a full page, printed upon vellum, within woodcut ɔorders,
20 full-page woodcuts and smaller woodcuts, capitals and
ornaments illuminated, contains 72 leaves, signs. a=i in 8's,
ɔeginning with the Calendar on a ii., modern mor., g. e.,
s. l. d. ou n. [*Paris*, P. Pigouchet, 1498?], sm. 4to. (31)
Leighton, £15 10s.

9404 Joanna Valesia Franciae Regina. Sacra Rituum Congre-
gatione Celsitudine Regia Card. Ducis Eboracensis Ponente

Bituricen, etc., LARGE PAPER, port., old French mor., ornamental ꝛorders, inlaid, the royal arms of France (Louis XVI.), g. e., *Romae, e Typ. Rev Cam. Apost.*, 1774, folio (111) *Quaritch, £35*

Kelmscott Press Publications.

9405 Morris (Wm.) A Dream of John Ball, vell., with ties, 1892, sm. 4to. (14) *Shepherd, £1* 1s.

· 9406 Caxton (Wm.) The Golden Legend, hf. ꝛuckram, uncut, 1892, large 4to. (15) *Shepherd, £5* 17s. 6d.

9407 Caxton (Wm.) The Recuyell of the Histories of Troye, 2 vol., vell., with ties, 1892, large 4to. (16) *Quaritch, £5* 5s.

9408 Caxton (Wm.) Historye of Reynard the Foxe, vell., with ties, 1892, sm. folio (17) *Shepherd, £2* 9s.

9409 Order of Chivalry (The) and the Ordination of Knighthood, vell., with ties, 1893, sm. 4to. (18) *Quaritch, £2* 15s.

9410 Godfrey of Boloyne and the Conquest of Jerusalem (The History of), printed upon vellum (6 copies taken), pigskin ꝛinding, ꝛy Leighton, 1893, sm. folio (19)
Leighton, £30 10s.

9411 Tennyson (Alfred, Lord). Maud, vell., with ties, 1893, sm. 4to. (20) *Quaritch, £2*

9412 Morris (Wm.) The Wood ꝛeyond the World, first ed., vell., with ties, 1894, sm. 4to. (21) *Quaritch, £3*

9413 Psalmi Penitentiales, uncut, 1894, sm. 4to. (22) *Shepherd,* 10s.

9414 Beowulf (The Tale of), vell., uncut, with ties (upper cover ink-stained), 1895, sm. folio (23) *Edwards, £2* 2s.

9415 Morris (Wm.) The Earthly Paradise, 8 vol., vell., with ties, 1897, sm. 4to. (24) *Shepherd, £7*

9416 Chaucer (Geoffrey). Works, ꝛlue bds., ꝛuckram ꝛack, uncut, 1896, large folio (25) *"Times" Book Club, £50*

9417 Chaucer (G.) Works, another copy, oak bds., hf. white pigskin, with ꝛlind stamps, uncut, 1896 (26) *Leighton, £50*

9418 Laudes Beatae Mariae Virginis (with the slip of the Rev. E. S. Dewick's note), uncut, 1896, 4to. (27) *Young, £1* 13s.

9419 Floure and The Leaf (The), uncut, 1896, sm. 4to. (28)
B. F. Stevens, £1 12s.

9420 Vallance (Aymer). The Art of William Morris, port. of Morris inserted, ꝛuckram, uncut, *Chiswick Press*, G. Bell, 1897, folio (29) *Maggs, £4* 10s.

9421 Liꝛer Evangeliorum et Liꝛer Epistolarum Festorum Annalium ac Solennium ad usum Ecclesiae Collegiatae Sancti Honorati, Anno Domini 1705, manuscript on vell. (80 leaves, 13½ ꝛy 9¾ in.), roman letters, within ꝛorders of natural flowers and floreate scrolls, the text adorned throughout and painted, and heightened in gold, in 2 vol., velvet, 1705, folio (117) *Quaritch, £46*

9422 Lodge (Edm.) Portraits, orig. ed., 240 ports., 4 vol., mor. ex., arms on sides and Grendon Hall stamp on titles, Lackington, Harding and Lepard, etc., 1821-34, folio (73)
Hopkins, £14 5s.

9423 Mendoça (R. P. Juan Gonçales de). Histoire du Grand
Royaume de la Chine, première éd., old mor., gilt rosettes
and fleurs-de-lis on ıack, with monogram G. R., large oval
laurel wreaths in centres (Clovis Eve, style of the Marguerite
de Valois ıindings), (repaired), *Paris,* Jeremie Perier, 1588,
8vo. (8) *Maggs, £9* 5s.
9424 Moseley (Dr. Benj.) Treatise on Tropical Diseases, pre-
sentation copy from the author to H.R.H. the Duke of
York, with inscription, mor., the Duke's crest and orna-
ments, g. e. (Roger Payne), T. Cadell, 1789, 8vo. (6)
 Leighton, £3 3s.
9425 Ocampo (Florian de). Los Quatro Liıros Primeros de la
Cronica general de España, primera ediçion, lít. 𝔤𝔬𝔱𝔥.,
modern mor. ex., g. e., by Belz-Niedrée, in case, *en Camora
por Juan Picardo,* 1543, xv. *Dec.,* folio (115) *Leighton, £*10
9426 Office de la Semaine Sainte, selon le Messel & Breviaire
Romain, engravings, old French mor., covered with semis
of fleurs-de-lis and crowned device of Maria Theresa of
Austria, Queen of Louis XIV., with royal arms of France,
g. e. (Boyer), *Paris,* A. Soubron, 1659 (12)
 Leighton, £6 10s.
9427 Office de la Semaine Sainte, Latin et François, nouvelle éd.,
engravings, old French mor. tooled au pointillé, arms of
Louis XVI., g. e., *Paris,* 1708, 8vo. (11)
 E. Parsons, £4 10s.
9428 O'Neill (H.) Illustrations of the Sculptured Crosses of
Ancient Ireland, 36 lithographs, hf. mor. gt., H. O'Neill,
1857, imp. folio (64) *Quaritch, £15* 10s.
9429 Ovid. Les Metamorphoses de la Traduction de l'Abbé
Banier, première éd., 141 plates after Eisen, etc., 4 vol., cf.
ex., by C. Cross, ıinder to the Queen, ıookplate of Anna
Damer by Agnes Berry, dated 1793, in each volume, *Paris,*
Hochereau, 1767-71, 4to. (33) *Quaritch, £19* 10s.
9430 Prodromo della Nuova Enciclopedia Italiana, ports. of the
Arch-Dukes Leopold and Ferdinand of Austria, with arms
on title, and 2 plates, old Italian cf., gilt ornaments, inlaid,
with the large painted arms of Leopold Grand Duke of
Tuscany, g. e. (worn), *Siena,* 1779, 4to. (56)
 Leighton, £2 5s.
9431 Quaritch (B.) Examples of the Art of Book-Illumination,
113 reproductions, the 12 parts complete, with wrappers, in
1 vol., mor. ex., by Zaehnsdorf, B. Quaritch, 1889-92, 4to.
(34) *Quaritch, £4* 16s.
9432 Richelieu (Card. de). Les Principaux Poincts de la Foy
Catholique, front., old French mor., crowned fleur-de-lis,
royal arms of France (Louis XIV.), *Paris, de l'Imprimérie
Royale du Louvre,* 1642, folio (108) *Warren, £6*
9433 Russell (Lord John). Life of William Lord Russell, port.,
King William IV.'s copy, russ., g. e., with large royal arms,
Longman, 1819, 4to. (36) *Nattali, £2* 2s.
9434 Selden (John). A Brief Discourse touching the Office of
Lord Chancellor, by (Sir) Wm. Dugdale, an engraving of

Lord Bacon's monument inserted, mor. ex., monogram
"T.W.," W. Lee, 1671, sm. folio (106) *Maggs*, £3

9435 Serpos (Marchese Giov.) Dissertazione Polemico-Critica
sopra due Dubbi di Coscienza concernenti gli Armeni Cat-
tolici inediti dell' Impero Ottomano, plate, old Italian mor.,
sides covered with floreate ornaments, arms of Ferdinand
I., King of Naples, g. e., *Venez.*, C. Palese, 1783, 4to. (57)
 Edwards, £5

9436 Shaw (Henry). Dresses and Decorations of the Middle Ages,
illustrations in colours and woodcuts, 2 vol., hf. mor. ex., W.
Pickering, 1843, 4to. (38) *Maggs*, £3 3s.

9437 Silvestre (J. B.) Universal Palaeography, by Sir F. Madden,
300 plates in colours, 2 vol., hf. mor. gt. (no text), H. G.
Bohn, 1850, imp. folio (65) *Quaritch*, £8

9438 Stone (Edm., F.R.S.) Analise des Infiniments Petits, plates,
old French mor., royal arms of France (Louis XV.), *Paris*,
·J. M. Gandouin, 1735, 4to. (37) *Maggs*, £3 18s.

9439 Stuart (John). Sculptured Stones of Scotland, 269 plates,
some with extra tints (one of 3 copies), and an extra volume
containing unpublished drawings of Sculptured Stones, by
A. Gibb, F.S.A. Scot., with MS. descriptions, 3 vol., two in
mor. and one hf. mor., *Aberdeen, Spalding Club,* 1856-67,
etc., folio (71) *Quaritch*, £8 15s.

9440 Taylor (Bp. Jer.) Rule and Exercises of Holy Living and
Dying, fronts., 2 vol. in 1, old English mor. ex., covered in
elaborate gilt tooling, *R. Norton for R. Royston*, 1676, 8vo.
(5) *Leighton*, £5

9441 Theocritus, Moschus, Bion, et Simmia, Graeco-Latini, con la
Buccolico di Virgilio Latino-Graeca, LARGE AND FINE
PAPER, 2 vol., old French mor., g. e., dedication copy to
Ferdinand Infanta of Spain, afterwards King Ferdinand I.,
with the royal arms, *Parma*, Stamp. Reale, 1780, 4to (55)
 E. Parsons, £5 17s. 6d.

9442 Turner (J. M. W.) Liber Studiorum, orig. issue, 71 plates
(with title), all in first or second states, with uncut margins,
loosely inserted in two wooden cases, with locks and key,
Published by J. M. W. Turner, May 23, 1812-19, atlas
folio (89) *W. Ward*, £190

9443 Worlidge (T.) A Select Collection of Drawings from Curious
Antique Gems, orig. ed., LARGE PAPER, port., 181 plates,
col. by hand, without text, title within double gold borders,
special copy, only a few taken for particular patrons, 2 vol.,
mor., gilt ornamental borders, with inlayings, g. e., from
Maskell Wm. Peace's (of Wigan) library, *Printed by Dryden
Leach for M. Worlidge*, 1768, 4to. (43) *Edwards*, £8

(β) *Ancient Manuscripts from the Abbatial Library of Waltham
Holy Cross, and the Monastic Library of St. Edmundsbury,
the property of Mr. George Holt Wilson.*

9444 Dionysius Areopagita. De Coelesti Hierarchiae, translata
de Greco in Latinam per R. de Chesney, manuscript on
vellum, English. XIIIth Century. (188 leaves, 8¼ in. by

6in.), 𝔤𝔬𝔱𝔥𝔦𝔠 𝔩𝔢𝔱𝔱𝔢𝔯, commentary in a small charter hand,
some marginal notes, ruled, text ru᠎ricated, small painted
capitals, 2 initials illuminated, orig. monastic oak bds.,
Sæc. XIII., sm. 4to. (155) *Maggs,* £38
 [Translation of Dionysius's " De Hierarchia" by Ro᠎ert
de Chesney, Bp. of Lincoln (d. 1166). There are 22 ᠎lank
leaves and 4 leaves occupied ᠎y a monastic treatise in
contemporary cursive characters. From Waltham A᠎᠎ey.
—*Catalogue.*]

9445 Cassiodorus (Magnus Aurelius). Li᠎er Variarum Formu-
larum, manuscript on vellum (88 leaves), 𝔤𝔬𝔱𝔥𝔦𝔠 𝔩𝔢𝔱𝔱𝔢𝔯, long
lines, 34 to a full page, ornamental pen-letters, *Sæc.* XIII.—
Seneca (L. Annaeus). De Beneficiis (9 leaves), 𝔤𝔬𝔱𝔥𝔦𝔠 𝔩𝔢𝔱𝔱𝔢𝔯,
long lines, 34 to a full page, with a painted and illuminated
strap initial extending the whole length of the margin, on
first page, ornamental pen-letters, *Sæc.* XIII.—Senecae de
Remediis fortuitorum (2 leaves only), illuminated initial,
capitals painted, *Sæc.* XIII.— Seneca Ludus de Morte
Claudii (4 leaves), illuminated initial head of the Emperor,
ornamental pen-letters, *Sæc.* XIII.—Senecae XIIII. li᠎er
Moralium Epistolarum ad Lucilium (61 leaves), long lines,
34 to a full page, the first having illuminated initial " R,"
painted capitals, *Sæc.* XIII.—Senecae de Remediis Fortui-
torum (the complete work), written on thick vellum in a
different hand from the rest of the MS., 𝔤𝔬𝔱𝔥𝔦𝔠 𝔩𝔢𝔱𝔱𝔢𝔯, long
lines, 34 to a full page (62 leaves), *Sæc.* XIII., in 1 vol.,
contemp. monastic oak bds., with orig. leather ᠎ook mark,
sm. 4to. (156) *Quaritch,* £80
 [The writing and illuminations are very fine specimens
of XIIIth century English work. The last four leaves of
Cassiodorus's Treatise have ᠎een separated and placed at
the end of the volume. The front cover has the mark

 See
 " WALTHAM ⟂ CXXIX. Al. Ca."
 Crucis.

and the first page of text *Walthā* ✠. The leaves measure
9 in. by 6 in.—*Catalogue.*]

9446 Bi᠎lia Sacra Latina. Editio Vulgata cum Prologis S.
Hieronymi, manuscript on vellum, English. XII-XIIIth
Century (215 leaves, 12½ ᠎y 9in.), written in contracted
minuscules, 50 lines, ru᠎ricated throughout, large orna-
mental initials, orig. monastic oak bds., pigskin, *Sæc.* XII.-
XIII., sm. folio (157) *Quaritch,* £67
 [A Codex of the Latin Vulgate, complete from Genesis
to Apocalypse, followed ᠎y Ecclesiastes and Song of Solo-
mon on 5 pages at end. At the ᠎eginning of the MS. is
" Opusculum Magistri Johannis Salesburiensis Carnotensis
Episcopi ad Comitem Henricum de divine pagine auctori-
bus" et " Prologus dni Willi A᠎᠎atis. Theodorice in S.
Bernardi de Corpore et Sanguine domini " (8 leaves) ; and
at the end, " Li᠎er Beati Anselmi qd. Cur Deus Homo

Vocat," 15 pages written in a contemp. hand, 3 columns to a page. On the first page occurs the following inscription : "Liʒer est ecce Sce Crucis de Walthm quem qt fraudulenter alienatur vel hūc titulū deleūt anathema sit. Amen." Two pieces of mended leaves are sewn together with the original green and yellow threads.—*Catalogue.*]

9447 Hieronymus (S.) Explanationes in Jeremiam Prophetam liʒ. VI., et super Ezechielem Prophetam liʒ. VI., etc., manuscript on vellum (158 leaves, 14in. by 10in.), 𝔤𝔬𝔱𝔥𝔦𝔠 𝔩𝔢𝔱𝔱𝔢𝔯, douʒle columns, 41 lines, painted scroll initial at head of each prophet, and numerous painted capitals, orig. monastic oak bds., pigskin with strap clasp, and orig. iron chain, *Sæc.* XIII., folio (158) *Quaritch,* £101
[Originally in the Monastic Liʒrary of St. Edmundsbury. It has the Contents written on the front cover, headed "Liʒ Stī Edmi in quo Continent"; and on reverse of last leaf, "& intercedente ʒeato Edmundo rege & martyre tuo. ad hostium nos defende," etc., and a contemporary signature of "Johs̄. Bury" on cover and in fly-leaf.—*Catalogue.*]

9448 Augustinus (S. Aurelius). Opuscula Varia, Contra Epistolas Juliani et aliorum de Heresi Pelagianorum—Sermo Arrianorum, etc., manuscript on vellum (344 leaves, 12½in. by 8½in.), 𝔤𝔬𝔱𝔥𝔦𝔠 𝔩𝔢𝔱𝔱𝔢𝔯, douʒle columns, 40 lines, by an English scriʒe, painted ornamental letters, 2 vol., orig. monastic oak bds. and pigskin, with strap and metal clasps and one link of the orig. iron chain and catch, *Sæc.* XIII., sm. folio (159) *Quaritch,* £51
[The last two volumes are from the Monastic Liʒrary of Bury St. Edmunds, and have the inscription in each volume "Lib. Monachorum Scti Edmundi," with the case marks. There are some early Eñglish scriʒʒlings on fly-leaves.—*Catalogue.*]

(γ) *The following were from the library of the late Rev. John Gott, D.D., Bishop of Truro. They were bought in at the sale held on March 20th and 21st, 1908. See* BOOK-PRICES CURRENT, *Vol. xxii., pp.* 345 *et seq.*

9449 Defoe (D.) Roʒinson Crusoe, as puʒlished in "The Original London Post, or Heathcot's Intelligencer," ʒeing a Collection of the Freshest Advices Foreign and Domestick, from Oct. 7, 1719 to Oct. 19, 1720 (Nos. 125-289), ʒound in 1 vol., old cf. (reʒacked, No. 257 in fac., also first numʒer torn and defective), 1719-20, sm. folio (282) *Ellis,* £50
[Bought in at £115 in 1908. *See* BOOK-PRICES CURRENT, Vol. xxii., No. 5001.—ED.]

9450 Missale Romanum ex Decreto SS. Conc. Tridentini restitutum additis Missis Sanctorum, ab Innocentio X. et Alexandro VI., P. M. ordinatis, engravings by Picart, etc., red velvet, richly emʒroidered (one plate missing, front. mounted and some leaves damaged), *Romæ,* 1662, folio (283) *Quaritch,* £5
[Bought in at £7 5s. in 1908. *See* BOOK-PRICES CURRENT, Vol. xxii., No. 5073.—ED.]

9451 Prayer. K. Edward VI. Whitchurche's Second Issue. The
Booke of the Common Praier, **black letter**, modern mor.,
g. e. (a number of leaves water-stained and some others
mended), (it did not contain the " Price Leaf" at end), 1549,
sm. folio (284) *Barnard*, £30
 [Bought in at £40 in 1908. *See* BOOK-PRICES CURRENT,
Vol. xxii., No. 5089.—ED.]
9452 Prayer. K. Edward VI. Whitchurche's Second Prayer
Book, woodcut initials ($10\frac{3}{16}$ by $6\frac{11}{16}$ in.), mor. ex. (title and
last leaf in fac., also last leaf but one mended and a portion
restored in fac.), 1552, folio (285) *Barnard*, £28
 [Bought in at £48 in 1908. *See* BOOK-PRICES CURRENT,
Vol. xxii., No. 5095.—ED.]
9453 Prayer. K. Edward VI. Whitchurch's Quarto Edition of
the Second Prayer Book, **black letter**, woodcut initials, mor.
antique, g. e. (title damaged, margined, and in part fac., 6
preliminary leaves in fac. and a few others mended), *Lon-
dini, in officina Edovardi Whitchurche* [1552] (286)
 Barnard, £25
 [Bought in at £49 in 1908. *See* BOOK-PRICES CURRENT,
Vol. xxii., No. 5097.—ED.]
9454 Prayer. K. James I. The Booke of Common Prayer, wood-
cut initials, mor. ex., g. e., by F. Bedford, Robert Barker,
1604, sm. 4to. (287) *Ellis*, £15
 [Bought in at £21 in 1908. *See* BOOK-PRICES CURRENT,
Vol. xxii., No. 5102.—ED.]
9455 Prayer. K. Charles I. The Booke of Common Prayer, and
The Psalmes of King David, trans. by King James [in
Metre], **black letter**, with music, orig. cf., metal clasps,
Edinb., Robert Young, 1637-6; *London*, Thomas Harper,
1636 (288) *Hopkins*, £15
 [Bought in at £19 10s. in 1908. *See* BOOK-PRICES
CURRENT, Vol. xxii., No. 5107.—ED.]
9456 Prayer. K. Charles I. Another copy, mor. antique, g. e.,
Edinb., R. Young, 1637-6, sm. folio (289) *Tregaskis*, £6
 [Bought in at £8 8s. in 1908. *See* BOOK-PRICES CUR-
RENT, Vol. xxii., No. 5108.—ED.]
9457 Prayer. K. Charles I. The Booke of Common Prayer,
black letter, woodcut initials, mor. antique ex. (title mended
and some marginal notes cut into), *Robert Barker and the
Assignes of John Bill*, 1639, sm. folio (290)
 Barnard, £3 15s.
 [Bought in at £4 5s. in 1908. *See* BOOK-PRICES CUR-
RENT, Vol. xxii., No. 5110.—ED.]
9458 Prayer. A Collection of Seven Forms of Prayer and Thanks-
giving set forth by Royal Authority, 1638-65, **black letter**,
1 vol., yellow mor., a scarce collection, from the library of
Philip Bliss, with bookplate of Henry Francis Lyte, author
of "Abide with me," 1638-65, sm. 4to. (293) *Maggs*, £3 10s.
 [Bought in at £5 5s. in 1908. *See* BOOK-PRICES CUR-
RENT, Vol. xxii., No. 5121.—ED.]
9459 Prayer. A Collection of Twenty-one rare Forms of Prayer,

black letter, in 1 vol., mor. antique, g. e., by F. Bedford, 1693-1716, sm. 4to. (294) *Milton*, £5
 [A complete list of these special forms of Prayer is given in the Catalogue. Bought in at £8 5s. in 1898. *See* Book-Prices Current, Vol. xxii., No. 5125.—Ed.]

9460 Shakespeare (Wm.) Merchant of Venice, first ed., mor. ex., by C. Lewis, J. Roberts, 1600, sm. 4to. (296) *Lauder*, £155
 [This copy is, but for the bottom corner of the title being facsimile, and a small hole in sign. B 1 (defacing one letter on each side), in faultless condition, clean and with very good margins, measuring 7⅛ by 5⁷⁄₁₆ inches. The work contains signatures A-K in fours, or 40 leaves in all, without pagination. Bought in at £290 in 1898. *See* Book-Prices Current, Vol. xxii., No. 5147.—Ed.]

9461 Shakespeare (Wm.) Mr. William/ Shakespeares/ Comedies,/ Histories, &/ Tragedies./ Published according to the True Originall Copies./ [Droeshout port.], *London/ Printed by Isaac Iaggard, and Ed. Blount*, 1623./ [At end :] *Printed at the Charges of W. Jaggard, Ed. Blount, I. Smethweeke/ and W. Aspley*, 1623 (297) *Quaritch*, £1,800
 [Size 12¼ by 7⅞ inches. Ben Jonson's verses guarded, one corner of title in fac., the others and a few leaves mended, last leaf edged, and 4 letters restored in fac.— *Catalogue.*]

9462 Shakespeare (Wm.) Mr. William/ Shakespeares/ Comedies,/ Histories and/ Tragedies./ Published according to the true Originall Copies./ The second Impression./ [Droeshout port.], *London/ Printed by Tho. Cotes for Robert Allot, and are to be sold at the signe/ of the Blacke Beare in Paules Church-yard,* 1632./ [At end :] *Thomas Cotes for John Smethwick, William Aspley, Richard Hawkins, Richard Meighen and Robert Allot,* 1632 (298)
Newman, £210
 [Size 13⁷⁄₁₆ by 8¹¹⁄₁₆ inches. Title and verses guarded, the penultimate page edged, and last leaf mended and portions of rulings restored in fac.—*Catalogue.*]

9463 Shakespeare (Wm.) Mr. William/ Shakespear's/ Comedies, Histories and Tragedies./ Published according to the true Original Copies./ The third Impression,/ [blank space], *London,/ Printed for Philip Chetwinde,* 1663/ (299)
W. Dawson, £850
 [Size 13½ by 8⅝ inches. Ben Jonson's verses opposite title in large type, title guarded and top margined. verses guarded and bottom margined, and dedication and last leaf guarded. Rare issue, bearing the 1663 imprint, and as originally issued without the port. and the seven spurious plays. The above copy has, however, these latter inserted. —*Catalogue.*]

9464 Shakespeare (Wm.) Mr. William Shakespear's/ Comedies,/ Histories/ and/ Tragedies./ Published according to the true Original Copies./ Unto which is added, Seven/ Plays./ The Fourth Edition,/ [woodcut ornament], *London,/ printed*

*for H. Herringman, E. Brewster and R. Bentley, at the
Anchor in the/ New Exchange, the Crane in St. Pauls
Church-Yard, and in/ Russel-Street, Covent-Garden.* 1685/.
(300) *W. Dawson,* £76
 [Size 14in. by 9in., in matchless condition.—*Catalogue.*
 See Book-Prices Current, Vol. xxii., Nos. 5141-5144.
 On that occasion these four folios were offered for sale in
 one lot and withdrawn at £3,850.—Ed.]

9465 Spenser (Edmund). Complaints, LARGE PAPER, printed on
 thicker paper, mor. antique, by Hayday, uncut (wanting
 l. A 2 ["The Printer to the Reader"], title and last leaf
 margined, and some corners mended), 8in. by 5¾in., *Printed
 for William Ponsonbie,* 1591, sm. 4to. (301) *Hayes,* £42
 [Bought in at £97 in 1908. *See* Book-Prices Current,
 Vol. xxii., No. 5160.—Ed.]

(β) *Other Properties.*

9466 Agas (Ralph). Bedfordshire. A Surveigh there, of the
 Manor of Tuddington, by Radulph Agas, Anno Dom. 1581,
 in wooden case (324) *Vernon,* £5
 [Original map on parchment (damaged) of the Manor of
 Toddington, Beds., measuring 11ft. 4in. by 8ft. 4in., on
 rollers, by Ralph Agas. At the right hand top corner is
 "Sealed and delivered (being first duely stampt) in the
 presence of Martha Johnson and R. Longford."—*Cata-
 logue.*]

9467 Behmen (Jacob). A Series of Illustrations, consisting of a
 Port. and twenty-five Allegorical Engravings, some with
 movable slips, some in col., from Wm. Law's Edition of
 the Works of Behmen, "The Teutonic Philosopher" (1768,
 etc.), 4to. (244) *Miss Walker,* £5 5s.

9468 Bible (Holy), Authorised Version, "Vinegar" edition, LARGE
 PAPER, 2 vol., old mor., rich panelled sides, g.e., fine copy,
 with birth register of the Speke family from 1800, *Oxford,*
 J. Baskett, 1717, sup. imp. folio (314) *Edwards,* £4 6s.

9469 Biblia Sacra Hebraica. Manuscript on vell., written at
 Damascus in 1496 (493 leaves, 7⅜ in. by 5¼ in.), bound in
 tortoiseshell, with silver hinges, clasps and studded frame
 and centre ornaments, with silver nails forming a verse
 from a Psalm, old gilt gauffred edges, in case, *Sæc.* xv., sm.
 4to. (261) *Maggs,* £52
 [Brought from Constantinople by the late Chief Rabbi,
 Dr. Louis Loewe, in 1846. This Bible is written in exactly
 the same style as that in the library of Raphael Ferkhi at
 Damascus.—*Catalogue.*]

9470 Biblia Sacra Latina, lit. gotf)., two types, double columns,
 Italian outline cuts, two cuts of Noah's ark, full-page cut of
 the tabernacle, and others, all in the O. T., painted capitals
 in red and blue (A j a blank wanting), [Hain, *3168], 4 vol.,
 hf. vell., rough edges, *Venetiis, Opere & Sumptibus Octa-
 viani Scoti* (with device in red), 1489, folio (306)
 Leighton, £15 10s.

9471 Boccaccio (Giovanni). Il Decamerone, port., plates and vignettes after Gravelot, 5 vol., old French cf. ex., *Londres* (*Paris*, Bar)ou), 1757, 8vo. (130) *Young*, £13 15s.

9472 Breviarium Secundum Consuetudinem Cathedralis Ecclesiae Magdeburgensis, lit. gotf)., dou)le columns, 50 lines, with signs. (margins of 10 leaves defective), had leaf of man-datum in front, and)lank for ℭ ℭ 10 [Hain, 3856],)order of first page illuminated, contemp. German oak bds., pigskin, metal)osses and clasps, *Nurnberg, Factore Georgio Stuchs de Sulzpach*, 1491, folio (305) *Barnard*, £5

9473 Bridges (Ro)ert). Poems, first ed., orig. cl. bds., uncut, B. M. Pickering, 1873, 8vo. (199) *Paton*, £2 6s.

9474 Bridges (R.) Prometheus the Fire Giver, first ed., 100 copies printed, orig. bds., uncut, *Oxford, H. Daniel's Private Press*, 1883, sm. 4to. (205) *Carless*, £1 8s.

9475 Bridges (R.) Shorter Poems, Five Books, orig. ed., in 5 parts, with index and fly-leaves, 100 copies printed, orig. wrappers, uncut, 1894, sm. 4to. (208) *Dobell*, £1 12s.

9476 Bi)le (Holy). Authorised Version, contemp. Scotch)inding in mor., ornamental)ack, sides covered in rich gilt tooling, g. e., fine specimen, well preserved, *Edinburgh, printed by James Watson, opposite to the Lucken-Booths*, 1716, 12mo. (171) *W. Brown*, £6 10s.

9477 Buck (Sam. and Nath.) Antiquities or Venera)le Remains of Castles, etc. in England and Wales, 477 views, including 81 large folding views, with the mezzo. plate of the two)rothers and separate mezzos. of each by Houston, 2 extra views of Worksop Manor inserted (no general titles), 4 vol., mor. super ex., 1732, etc., imp. folio (315) *Rimell*, £35

9478 Burns (Ro)ert). Poems, orig. Kilmarnock ed. (wanted all)efore page 11, pages 203-6, some leaves stained and a few torn), orig. hf.)inding, [*Kilmarnock, printed by John Wilson*, 1786] (221) *Hornstein*, £26 10s.

[The property of Mr. Douglas Crichton. "This copy of Burns' Poems was presented to Mrs. Provost Whigham of Sauquhar by the Immortal Author Ro)ert Burns." At end are six lines written by Burns on a pane of glass at the Queens)ury Arms Inn, Sauquhar. Accompanying the lot are a letter of Ro)ert Burns, the poet's son, relating to the poet's funeral, dated Sept. 30th, 1863, and a notification of the death of the poet's wife in 1834; and a letter from Mary Carlyle Aitken, acknowledging the receipt by her uncle, Thos. Carlyle, of an Anostocricia, 1870.—*Catalogue.*]

9479 Byron (Lord). The Bride of A)ydos, first ed., with a printed slip of errata, orig. wrapper, uncut, with)lanks, *T. Davison for J. Murray*, 1813 (211) *B. F. Stevens*, £42 10s.

[One of the rarest of Byron's earlier pieces. The slip of errata is, it is said, only found in this copy and that in the British Museum. It corrects line 300, Canto I., and supplies an omission to Canto II., page 47, after line 449. A type-written letter to the owner from Mr. John Murray, the pu)lisher (1909), shows that he had not known of the slip. —*Catalogue.*]

9480 [Columna (Fr. de).] Hypnerotomachia Poliphili, editio prin-
ceps et Aldina, woodcuts from designs by Giovanni Bellino,
the priapus unmutilated (two defects in title and a small
hole in next leaf), 2 original planks at end, old vell. sides,
cf. back, rough edges, fine state, *Venet. in aedibus Aldi
Manutii* 1499 *mense Dec.*, sm. folio (154) *Sotheran*, £145

9481 Daniel (Rev. W. B.) Rural Sports, plates in two states,
plain and col., 3 vol., old mor., packs covered in rich gilt
ornaments, g. e., 1807, roy. 8vo. (195) *Quaritch*, £13

9482 Du Rosoi (B. F.) Les Sens, Poëme en Six Chants, première
éd., LARGE PAPER, 7 plates, 6 vignettes and 2 tail-pieces by
de Longueil, mor. plain, doublé, gilt ornamental borders,
t. e. g., uncut, by Brocas, *à Londres (Paris)*, 1766, roy. 8vo.
(224) *Sotheran*, £8

9483 Evangelia Quatuor, Secundum Mathaeum, Marcum Lucam
et Johannem, editio vulgata, ancient MS. on vellum (159
leaves, 11 in. by 9 in.), roman letters, double columns, old
French mor. (18th century), *Sæc.* XII., 4to. (303)
 Quaritch, £260
[An important and interesting Codex of the Four Gospels.
On the reverse of page 4 is a large Roman arched miniature
of the Evangelist Matthew, on the opposite page the title
of the Gospel in uncials, with contractions, the letters LI
[before (ber)] forming strap initials of a peculiar character.
Seven leaves at the end are occupied by a "Breviarium de
Anni Circuli," followed by two leaves containing an account
of localities in Jerusalem mentioned in the text. This
Codex appears to be of Lombardic work. Formerly in the
possession of C. Kendall Bushe, Chief Justice of King's
Bench in Ireland, etc., b. 1767, d. 1843.—*Catalogue.*]

9484 Gould (John). Birds of Great Britain, 367 col. plates, original
subscriber's copy, with general titles, lists of plates, intro-
duction, etc., complete in the 25 orig. parts, picture bds.,
Published by the Author, 1862-73, imp. folio (142)
 Young, £29

9485 Graduale Romanum, de Tempore et Sanctis, lit. rom. magna,
musical notes on red staves, printed upon vellum, title in
compartments, partly coloured, 2 col. initials, full-page
engraving of the Annunciation partly col., initial delicately
col. of David playing the harp, an emblazoned coat-of-arms
(az. 3 wheat-sheaves, or) at beginning of text, woodblock
initials, oak bds., leather, stamped ornamental sides (re-
paired and rebacked), all faults, *Antwerpiae ex Off. Plantin
ap. Jo. Moretus*, 1599, imp. folio (304) *Maggs*, £34 10s.
[A fine book, finely printed, of which only a very small
number could have been taken off on vellum for special
patrons of the printer, one of whom is probably indicated
in this copy by the emblazoned coat-of-arms in the large
initial.—*Catalogue.*]

9486 Harte (Bret). The Jay of Mariposa, orig. autograph manu-
script on 24 pages 4to., signed in full (1897) (262)
 Walpole, £15

9487 Harte (B.) The Convalescence of Mr. Jack Hamlin, orig.
autograph manuscript on 26 pages 4to. (1899) (263)
Walpole, £13

9488 Harte (B.) A Niece of Jack Hamlin, orig. autograph manu-
script on 31 pages 4to., signed in full and dated " London,
21 Feby., '93 " (264) *Walpole, £21*

9489 Harte (B.) Lines to a Portrait, a Poem in seven stanzas of
six lines each, orig. autograph manuscript on 3 pages 4to.
(1897) (265) *Edwards, £4 4s.*

9490 Hartlib (Sam.) The Reformed Commonwealth of Bees, with
the Reformed Virginian Silkworm, etc., orig. ed., woodcuts,
old cf., G. Calvert, 1655, sm. 4to. (243) *Tregaskis, £2*

9491 Horae Beatae Mariae Virginis ad Usum et Secundum
Consuetudinem Ecclesiae Sarisburiensis, English. Illu-
minated manuscript on vell. (242 leaves, 9 by 6½in.), gothic
letter, long lines, 16 to a full page, 43 large miniatures (5½
by 4in.) within borders, the opposite page of text within a
border of similar character, 11 smaller miniatures (3 by
2¾in.), ornamental pen-letters and decorative details, old
red velvet (18th century), in slip case, *Sæc.* XV.-XVI., thick
sm. 4to. (119) *Leighton, £580*
[A very fine and interesting English manuscript, said to
have been executed in King Henry VII.'s time for the
young Prince Henry, afterwards Henry VIII. A very
lengthy descriptive account of the decorations is given in
the catalogue.—ED.]

9492 Indulgence of Pope Innocent VI., *c.* 1352, English MS. roll
on vellum, 5 ft. long by 6 in. wide, gothic letter, red and
black, 103 lines of text, within painted border, 2 coats-of-
arms and 3 paintings of Christ and Crucifixion implements,
etc. (some details worn), mounted in a black and gold
frame, glazed, *c.* 1352, folio (313) *Quaritch, £115*
[MS. in English and Latin. It begins ' O Man unkynde /
Bere in thy mynde / My Paynes smerte. / And ye shall
fynde / me treu and kynde / lo here my herte.*l'*—*Catalogue.*]

9493 Keats (John). Endymion, first ed., with the leaf of " Erratum,"
orig. cf., Taylor and Hessey, 1818, 8vo. (197)
B. F. Stevens, £11 10s.

9494 London. The Gigantic History of the Two Famous Giants
and other Curiosities in the Guildhall, London, and The
Curiosities of the Tower of London, cuts, 4 miniature
volumes, 2¼ in. by 1½ in., cf. ex., *Printed for Thos. Bore-
man, Bookseller near the two giants in Guildhall, price 4d.,*
1740-41 (190) *James, £3 7s.*

9495 Meredith (George). Poems, first ed., with the slip of errata,
orig. cl., J. W. Parker and Son, n. d. (1851), 8vo. (198)
Hornstein, £21 15s.

9496 Metastasio (Ab. Pietro). Opere, LARGE AND FINE PAPER,
port. and 35 plates after Cipriani, etc., and 2 extra plates to
Terence, proofs, 12 vol., mor., g. e. (Roger Payne), *Parigi,
Vedova Herissant,* 1780-82, 4to. (138) *Isaacs, £12 5s.*

9497 Omar Khayyám. Rubáiyát, trans. [by Edward FitzGerald],

first ed., unbd. (wanted the orig. ɔrown paper covers),
Bernard Quaritch, 1859, sm. 4to. (276) *Quaritch*, £38
9498 Psalms. The Whole Booke of Davids Psalmes, orig. needle-
work ɔinding in silver and col. threads representing King
David on one cover and Queen Bathsheɔa on the other,
with roses, etc., gilt and gauffred edges, well preserved,
Printed by T. C. for the Company of Stationers, 1635, 12mo.
(220) *E. Parsons*, £6
9499 Shakespeare (Wm.) Mr. William Shakespeare's Comedies,
Histories and Tragedies, puɔlished according to the True
Originall Copies, first folio ed. (title, verses and last leaf
facsimile, many leaves remargined, corner of ggi mended,
sold not suɔject to return), hf. ɔound, I. Iaggard and E.
Blount, 1623, folio (242) *Quaritch*, £600
 [Although wanting the 3 leaves mentioned aɔove, the
 text is perfect, except a few letters in the last leaf but one,
 and the majority of the leaves, including the 7 preliminary
 ones, are sound and good, 12¾ in. by 8¼ in.—*Catalogue*.]
9500 Shakespeare (Wm.) Mr. William Shakespeare's Comedies,
Histories and Tragedies, the second impression (title with
port. torn and soiled, the verses pasted on the ɔack, leaf of
dedication defective, stained throughout, numerous MS.
notes and erasures, wanted pages 417-419 in Cymɔeline
and leaf with imprint, the 2 last leaves of Cymɔeline in
the vol. defective, sold not suɔject to return), old cf., T.
Cotes for R. Allot, 1632 (331) *Quaritch*, £20 10s.
 [An interesting MS. note pasted on fly-leaf says : "This
 ɔook ɔelonged to Queen Elizaɔeth [of Bohemia], only
 daughter of King James I., given to her Majesty by the
 Countess of Angus, etc., . . . it was ɔought Octoɔer 10,
 1729, price 4s.—O tempora, O Mores !"—*Catalogue*.]
9501 Shakespeare (Wm.) Mr. William Shakespear's Comedies,
Histories and Tragedies, the fourth ed. (wanted port., mar-
gins wormed, 14 by 8¼ in., 8 fac. preliminary leaves to the
first folio inserted), modern cf., Herringman, Brewster and
Bentley, 1685, folio (332) *Rimell*, £9
9502 Shakespeare (Wm.) Poems,/ port. by Wm. Marshall, with
verses ɔeneath (margins of which are cut close and inlaid),
modern mor. ex., *Printed by Thos. Cotes and . . . sold by
John Benson dwelling in St. Dunstans Churchyard*, 1640
(118) *Maggs*, £106
 [The portrait is apparently a later impression without the
 words "W. M. Sculpsit" ɔelow."—*Catalogue*.]
9503 Sketches in Oxford, 12 col. lithographs, hf. bd., *Published
by J. Ryman, Oxford*, n. d. [182-], obl. folio (330)
 Hornstein, £11 5s.
9504 Smith (Wm.) History of the Province of New York, first
ed., orig. impression of the South View of Oswego on Lake
Ontario by J. Mynde, large copy (?large paper cut down),
T. Wilcox, 1757—Kirby (Joshua). Dr. Brook Taylor's
Method of Perspective mady easy, second ed., 50 copper-
plates, *Ipswich, for the Author*, 1755, in 1 vol., hf. bd., 4to.
(133) *Quaritch*, £20 10s.

9505 Smith (Capt. John). Generall Historie of Virginia, first ed., orig. engraved title by John Barra (cut close and inlaid), orig. maps of Virginia by Wm. Hole (top margin cut into, with mended defect at top), "Ould Virginia," with compartments of events in Smith's life ; the Summer Ils, with forts in compartments ; and New England, with port. of Smith ɔy S. Pass (the leaf of preface defective and mended, wanted port. of the Duchess of Richmond), russ. ex., ɔy F. Bedford, *H. D. and J. H. for Michael Sparkes,* 1624, sm. folio (120) *Dobell,* £48

9506 Testamentum Novum Graecum, woodcut ornaments and initials, old French mor., au pointillé, g. e. (Le Gascon), (ɔack damaged,) *Lutetiae in officina Roberti Stephani,* 1569, 8vo. (165) *Cobb,* £10 15s.

9507 Venetia. Representations des Palais, Batimens célèɔres, Places, Mascarades et autres Beautés Singulières de la Ville de Vénise, LARGE PAPER, 2 engraved titles, view of Venice and 117 folding plates (no text), old russ. gt., *Leide,* C. Haak, 1762, imp. folio (144) *Quaritch,* £5

9508 Wycherley (Wm.) Miscellany Poems, ɔrilliant (though short) impression of the mezzo. port. after Lely by T. Smith, old cf. gt., C. Brome, etc., 1704, folio (139)
E. Parsons, £9 15s.

[JULY 26TH, 1910.]

SOTHEBY, WILKINSON & HODGE.

A MISCELLANEOUS COLLECTION.

(No. of Lots, 228 ; amount realised, £2,091 3s.)

9509 Ackermann (R.) A History of the University of Camɔridge, LARGE PAPER, col. plates and ports., 2 vol., hf. mor., t. e. g., 1815, imp. 4to. (9) *G. H. Brown,* £20 5s.

9510 Æsop. Faɔles of Æsop, Stockdale's ed., 112 plates by Blake, etc., margins of titles, hand-painted medallions of Jove, Juno, Mercury and Ceres· on the sides, and 2 finely-executed paintings on the fore-edges, 2 vol., mor. super ex., g. e., 1793, roy. 8vo. (76) *Edwards,* £40

9511 Bacon. Vitae Philosophorum scriptoribus Diogene Laertio, Eunapio Sardiano, Hesychio Illustrio, with inscription, "Francis Bacon's Booke," on title (cut into), cf., *Lugd. Bat.,* 1596, 8vo. (51) *Maggs,* £5

9512 Barlow (F.) Nouvaux Livre d'Oyseaux, 40 plates, old cf. gt., 1673, folio (38) *Quaritch,* £6 15s.

9513 Boswell (James). Life of Johnson, LL.D., first ed., port., 2 vol., cf., 1791, 4to. (10) *Ellis,* £3 8s.

9514 Bree (C. R.) Birds of Europe, col. plates, 4 vol. orig. cl.,
 Groomɔridge, 1863, 8vo. (89) *Phillips,* £2 2s.
9515 Burns (Roɔert). A. L. s, 3 pages 4to., to Mrs. Dunlop, dated
 Jan. 5, 1792 (should be 1793) (173) *Hornstein,* £235
 [This letter was sent with two other sheets, written on
 Dec. 31, 1792 and Jan. 2, 1793 respectively, hence its
 unconventional opening : "You see my hurried life,
 Madam, I can only command starts of time." Mrs.
 Dunlop had recently given Burns a cocoanut cup, which
 had long ɔeen an heirloom in her family, and the poet
 refers to the gift : "Your cup, my dear Madam, arrived
 safe. I had two worthy fellows dining with me the other
 day, when I, with great formality, produced my whigme-
 leerie (fantastic) cup, and told them that it had ɔeen a
 family piece among the descendants of Sir William
 Wallace. This roused such an enthusiasm that they
 insisted on ɔumpering the punch round in it ; and ɔy and
 by, never did your great ancestor lay a Southron more
 compleatly to rest, than for a time did your cup my two
 friends." (*See* "Roɔert Burns and Mrs. Dunlop," ɔy W.
 Wallace, 1898, p. 376, where, however, the letter is not
 given in full.)—*Catalogue.*]
9516 Byron (Lord). The Siege of Corinth, orig. autograph MS.
 on 50 pages (32 pages folio, 18 pages 4to.), all inlaid to size
 and ɔound up with the printed text in morocco, with gilt
 scroll work on the sides (joints damaged), dated January
 30, 1815 (198) *Sabin,* £760
 [This MS. differs in many respects from the version
 puɔlished in 1816, which was printed from a transcript in
 Lady Byron's handwriting. It ɔegins at line 46, the first
 45 lines, which are introductory, having ɔeen sent to Murray
 some time afterwards, and not puɔlished till 1830. There
 are also very many textual differences.—*Catalogue.*]
9517 [Crawhall (J.)] The Compleatest Angling Booke that ever
 was writ, only 30 copies printed, woodcuts, etchings and
 col. illustrations, presentation copy to " Mr. George Rutland,
 with the author's compts.," hf. mor., t. e. g., *Imprynted by
 and for ye Authour,* 1859, 4to. (111) *Maggs,* £10 5s.
9518 Dresser (Henry E.) and Sharpe (R. B.) A History of the
 Birds of Europe, complete in 84 parts, with Index (parts i.
 to xii. in 1 vol., cl., uncut, the remainder in the orig. wrap-
 pers, uncut), col. plates, 1871-1881, roy. 4to. (108)
 G. H. Brown, £29
9519 Fox (George), Stuɔs (John) and Furley (B.) A Battle Door
 for Teachers and Professors to learn Singular and Plural ;
 You to Many, and Thou to One ; Singular, One, Thou ;
 Plural, Many, You, name on title, orig. sheep, 1660, folio
 (206) *Bailey,* £6 5s.
 [This copy contains the full collation of 114 leaves, as
 given by Hazlitt. It includes the errata leaf, with an
 original impression of the slip, "more errors espied since,"
 issued subsequently, and pasted in. On the verso of the

last leaf is pasted a very rare slip relating to the Pope's
pride in using "You to One." One leaf has the catchword
torn off.—*Catalogue.*]

9520 [Froude (J. A.)] Shadows of the Clouds, by Zeta, first ed.,
orig. cl., J. Ollivier, 1847, 8vo. (7) *Sotheran*, £1 1s.

9521 Kininger (V. G.) Abbildung der Neuen Adjustirung der K.
K. Armee, aquat. port. of Ferdinand Karl, and 46 large
plates, in colours, of Infantry and Cavalry, by J. C. Mans-
feld, orig. hf. russ. (the back lettered "Emperie Uniforms"),
Wien, n. d., folio (228) £77

9522 Lilford (Lord). Coloured Figures of the Birds of the British
Islands, 7 vol., second ed., plates in colours, text and
illustrations mounted on guards. mor., t. e. g., R. H. Porter,
1891-1897, 8vo. (79) *Hatchard*, £48
[Another copy, in the 36 parts, realised £40 (Lot 92).—
ED.]

9523 Mudford (Wm.) Historical Account of the Campaign in the
Netherlands, 28 col. plates by G. Cruikshank and J. Rouse,
large map and plan, mor. ex., by Rivière, H. Colburn,
1817, 4to. (125) *Nattali*, £13 5s.

9524 Naval Architects. Transactions of the Institution of Naval
Architects, vol. i.-l. (wanted vol. x. and xlvi.), with Index
to vol. i.-xxi., and International Congress Number, 1897,
together 50 vol., plates, 1860-1908, 4to. (123) *Sotheran*, £10

9525 [Phillips (Richard).] Modern London (front., title, plan and
some leaves spotted), at the end of the work is the series of
coloured illustrations, representing the Itinerant Traders of
London, bds., 1804, 4to. (102) *W. Daniell*, £2 10s.

9526 Palaeontographical Society. Publications, plates and illus-
trations, in 31 vol., 20 vol. in hf. cf., 6 in bds., cloth back
and unbound, 1848-82, 4to. (110) *Boot*, £4 17s. 6d.

9527 Playford (John). The Musical Companion, in Two Books
(wanted a leaf at end), orig. cf., sold not subject to return,
1673, obl. 4to. (103) *Ellis*, £1 18s.

9528 Pope (Alex.) The Rape of the Lock, in 5 cantos (first ed. in
this form), LARGE PAPER, plates by L. Du Guernier, orig.
cf., long MS. note on first fly-leaf (? Pope's writing), B.
Lintott, 1714, 8vo. (74) *Dobell*, £24 10s.

9529 Prayer. A Booke of Christian Prayers, black letter, within
woodcut borders, after Dürer and Holbein, port. of Q.
Elizabeth praying (outer margin of title mended), old russ.,
g. e., *R. Yardley and P. Short, for the Assignes of John
Day*, 1590, sm. 4to. (129) *Edwards*, £5 15s.
[The fourth edition of Q. Elizabeth's Book of Private
Prayers.— *Catalogue.*]

9530 [Primer of Salisbury use, wyth many Prayers and Goodly
Pyctures in the Kalendar], black letter, rubricated, with
many woodcuts, old cf. [*Paris, wythyn the House of Thyl-
man Kerver*, 1533?], 16mo. (199) *Barnard*, £13
[Wanted signatures A 1, A 8, CC 8, DD 8 leaves and the
last leaf. Collation of a perfect copy, A to Z in 8's, A A to
H H in 8's?—*Catalogue.*]

9531 Rider's British Merlin, for 1797, mor., elaɔorately tooled, 2
 circular silver ornaments on each side, steel clasps, with
 pencil fastener, g. e., 1797, 8vo. (77) *Edwards,* £1 11s.
9532 Smith (J. C.) British Mezzotint Portraits, 4 vol. in 5, with
 extra vol. containing 125 ports., together 6 vol., 1878-83,
 roy. 8vo. (2) *Rimell,* £15
9533 Sterne (Laurence). Tristram Shandy, 9 vol., vol. i.-ii., no
 place or printer's name, 1760 ; vol. iii.-ix., first eds., front.
 to vol. iii., autograph signature of Sterne in vol. vii., orig.
 cf., 1760-67, 8vo. (71) *Quaritch,* £17 10s.
9534 Swan (John). Speculum Mundi, first ed., engraved title ɔy
 W. Marshall, cf., *Cambridge,* 1635, 4to. (14)
 Parsons, £1 12s.
9535 Swinɔurne (A. C.) Atalanta in Calydon, first ed., with inscrip-
 tion, " From the author. This was Mrs. Procter's copy till
 1888," orig. cl., E. Moxon, 1865, 4to. (128) *J. Bumpus,* £8
9536 Swinɔurne (A. C.) Poems and Ballads, inscription on titlé,
 " B. W. Procter, from A. C. Swinɔurne. St. Clair-Baddeley,
 1888," orig. cl., uncut, J. C. Hotten, 1866, 8vo. (47)
 Hornstein, £6 10s.
9537 Tennyson (Alfred Lord). Auto. Verses s. six lines, Oct. 2,
 Cheltenham, with addressed envelope to Mrs. Keily, ports.
 and cuttings (140) *Maggs,* £6 15s.

THE EAGLE.

He clasps the crag with hooked hands,
 Close to the sun in lonely lands,
Ring'd with the azure world, he stands.

The wrinkled sea ɔeneath him crawls,
 He watches from his mountain walls,
And like a thunderɔolt he falls.
 —A. TENNYSON.

9538 Wilde (Oscar). The Decay of Lying, the orig. MS., 54
 leaves, in the handwriting of Oscar Wilde, signed ɔy the
 author, mor., sm. folio (94) *Hornstein,* £111
9539 Wilde (Oscar). Salomé, Drame en un Acte, orig. wrapper
 ɔound up, ex-liɔris of Frank Richardson inside cover,
 ɔuckram, t. e. g., *Paris,* 1893, 8vo. (97) *Hatchard,* £2 15s.

SOTHEBY, WILKINSON & HODGE.

A MISCELLANEOUS COLLECTION.

(No. of Lots, 1151 ; amount realised, £1,551 19s. 6d.)

9540 Aeschylus. Tragoediae VII., contemp. mor., fully gilt ɔack, centre medallions on sides, first complete ed. according to Brunet (*Lut.*) *ex off. H. Stephani*, 1557, 4to. (1009)
Parsons, £6 9s.

9541 Alpine Journal (The), illustrations and plans, vol. i.-xxv. and Index to vol. i.-xv., vol. i.-xix. in cl., remainder as issued, 1864-99, 8vo. (280) *Sawyer, £24*

9542 Bacon (Sir Fr.) Instauratio Magna, first ed., engraved title by S. Pass (lower ɔlank corner repaired), hf. cf., J. Bill, 1620, folio (250) *Maggs, £12 15s.*

9543 Biɔle in Welsh. The Old and New Testaments, trans. by Bps. Morgan and Davies, Thos. Salesɔury and Thos. Huet, first ed. of the first translation of the whole Biɔle in Welsh (imperfect, ɔeginning on B 3 [Gen. xxii., 10] and ending on Y y y y IIII.), (1st Epistle of John C 2,) (many leaves wanted and many defective), old cf., *Deputies of R. Barker*, 1588, folio (1137) *Fenwick, £10*

9544 Blake. Illustrations of the Book of Job, in 21 plates (proofs) and an engraved title (a few of the plates spotted), orig. bds., with the laɔel, *Published by the Author and Mr. J. Linnell, March*, 1826 (1146) *Maggs, £11*
[Inscription on side : "This copy of proofs, presented to G. Wythes, Esq., ɔy John Linnell, Decr., 1863."—*Catalogue.*]

9545 Campɔell (C.) Vitruvius Britannicus, plates, 5 vol., hf. cf., 1715-71, imp. folio (210) *Loftie, £7 10s.*

9546 Catho Moralizatus alias Speculam regiminis quo ad utriusque Hominis Reformationem (ed. Phil de Pergamo), lit. goth., full-page woodcut, small woodcut and woodcut initials, old ɔinding (wormed), *Lugduni*, Joh. de Vingle, 1497, folio (776) *Leighton, £5 2s. 6d.*

9547 Chalkhill (John). Thealma and Clearchus (ed. and the preface written ɔy Izaak Walton), first ed., mor. super ex., by Rivière and Son, Benj. Tooke, 1683, 8vo. (879)
Russell, £5 17s. 6d.

9548 Dallaway (J.) and Cartwright (E.) History of the Western Division of Sussex. Chichester and Arundel by Dallaway, Bramɔer by Cartwright, 2 vol. in 3, orig. ed., ports. and plates, vol. i. and ii., part I, in cf., vol. ii, part 2, uncut, arms and crests in vol. ii., part 2, fully emɔlazoned, Bensley, 1815-30 (1064) *Parsons, £21 5s.*

9549 Douglas (R.) Peerage of Scotland, first ed., coats-of-arms,
cf., *Edinb.*, 1764, folio (748) *Thorp*, £7 15s.
[This copy is from the Auchinleck library and contains
the following note in the autograph of James Boswell:
"James Boswell, Edinburgh, 1780, a present from Mr.
Thomas Matthew, one of the clerks in the Post Office."—
—*Catalogue.*]

9550 Elizabeth (Queen). Funeral Procession of Queen Elizabeth,
from a Drawing of the Time, supposed to be by the hand
of William Camden, then Clarencieux King at Arms, which
was in the possession of John Wilmot, Esq., and by him
deposited in the British Museum, col. panoramic engraving,
29 ft. by 9 in., *Soc. of Antiquaries*, 1791 (697)
 Thorp, £5 10s.

9551 [Glasse (Mrs.)] The Art of Cookery made plain and easy,
first ed., small hole through end pages, cf., *Printed for the
author*, 1747, folio (1074) *Maggs*, £12

9552 Goya y Lucientes (F.) Caprichos, orig. ed., 80 plates (in-
cluding portrait), a few damaged and stained, Spanish cf.,
Madrid, n. d. (*ca.* 1799), folio (1022) *Edwards*, £12 15s.

9553 Hannay (Patrick). Philomela, The Nightingale, Sheretine,
and Mariana . . . Songs and Sonnets, engraved title, con-
taining port. by C. Pass (shaved and mounted), the Dedi-
cation, Commendatory Verses and 2 leaves of music in fac.
(several leaves soiled and stained), mor. super. ex., by
Rivière and Son, *Printed for Nathaniel Butter*, 1622, 8vo.
(878) *Pickering*, £13
[Only six other copies in existence, four of which are in
the British Museum, the Bodleian, the Britwell and the
Huth libraries.—*Catalogue.*]

9554 Hilton (Walter). Scala Perfectionis (Englished): the Ladder
of Perfection, 𝔟𝔩𝔞𝔠𝔨 𝔩𝔢𝔱𝔱𝔢𝔯, wanting sheet A (many margins
repaired, and other imperfections), hf. roan (? Julian Notary,
1507), folio (254) *Barnard*, £6

9555 [Lathy (T. P.)] The Angler, a Poem, first ed.; one of 25
copies on LARGE AND THICK PAPER, port. on India paper
and woodcuts, mor. ex., emblems in blind and gold, in-
cluding ports. of Walton and Cotton, etc., g. e., with angling
bookplate of T. Gosden, 1819, 8vo. (1086) *Maggs*, £16

9556 Mercator, or Commerce Retrieved, being Considerations on
the State of the British Trade, etc. [ed. by Daniel Defoe],
Nos. 1, Tuesday, May 26, 1713, to 181, Tuesday, July 20,
1714 (complete), each number with stamp (No. 147 slightly
defective), in 1 vol., cf., 1713-14, folio (578) *Pickering*, £51

9557 Meyrick (Sir S. R.) Critical Inquiry into Antient Armour,
second ed., plates illuminated, 3 vol., hf. mor., g. e., Bohn,
1842, roy. 4to. (177) *Heffer*, £5 7s. 6d.

9558 Milton (J.) A Brief History of Moscovia, first ed., name on
title, hf. mor., M. Flesher, 1682, 8vo. (432) *Maggs*, £7 5s.

9559 Milton. Paradise Lost, first ed., eighth title page (marginal
repairs and one leaf defective), cf., S. Simmons, 1669, 4to.
(526) *Ellis*, £15 5s.

9560 Molière. Œuvres, nouvelle édition, port. after Ch. Coypel, plates after Boucher ɔy L. Cars, and vignettes, 6 vol., orig. cf. (reɔacked), g. e., 1734, 4to. (193) *Major Elliot*, £10 10s.

9561 Montesquieu (C. de). Le Temple de Gnide, LARGE PAPER, front., engraved title and 8 plates ɔy N. Le Mire, contemp. cf., g. e., *Paris*, 1772, 4to. (246) *Maggs*, £25 10s.

9562 Moore (A. W.) The Alps in 1864, orig. ed., plates, orig. cl., *Privately printed*, 1867, 8vo. (281) *Berney*, £5

9563 Omar Khayyám. Ruɔáiyát, trans. [ɔy Edward FitzGerald], first ed., orig. wrapper (soiled), Bernard Quaritch, 1859, sm. 4to. (1049) *Maggs*, £49

9564 [Pope (Alex.)] The Dunciad, first ed. (Issue C. of Thom's List), owi front., W. J. Thom's copy, hf. roan, *Dublin printed; London, reprinted for A. Dodd*, 1728, 8vo. (503) *Maggs*, £10 15s.

9565 Preston (Thomas). A Lamentaɔle Tragedie, mixed full of plesant mirth, containing the life of Cambises King of Percia, **blark lrttr**, 24 leaves, of which 4 are in fac. (sheet B), mor. super ex. (one headline shaved), *Imprinted at London by Edward Allde*, n. d. (1043) *Russell*, £26 10s.

9566 Rossetti (D. G.) Ballads and Sonnets, 1881, some orig. proof sheets of his King's Tragedy and Rose Mary, with some verses not included in first ed., some MS. corrections in the handwriting of Rossetti and the pattern cover in cl. gt., 8vo. (675) *Spencer*, £5

9567 Shakspeare (W.) Plays and Poems, by E. Malone, port., 21 vol., cf., 1821, 8vo. (939) *Bain*, £7 5s.

9568 Spenser (Ed.) The Faerie Queene, first folio ed. (small hole in sign. A 6), old cf., *H. L. for Mathew Lowne*, 1609, folio (1021) *Dobell*, £5

9569 Studio (The), illustrations, vol. i. to xlii., and Index [vol. i.-xxi.], cl., index in wrapper, 1903-8, 4to. (1042) *Edwards*, £5 2s. 6d.

9570 Symonds (J. A.) Renaissance in Italy, first ed. (wanted port.), 7 vol., orig. cl., 1875-86, 8vo. (923) *Hornstein*, £17 5s.

9571 Walpole (Horace). Letters, ports., 9 vol., cf. gt., 1857-59, 8vo. (881) *Bumpus*, £5 17s. 6d.

The following were sold by Messrs. Puttick & Simpson on July 28th and 29th:—

9572 Augustinus (S.) Operum Partes XI. [cum Expositione Psalmorum et Epitome operum], woodcut of St. Augustine, 11 vol., old cf., with circular and diagonal stamps (reɔacked), *Basil et Colon, Amerbach et Froben*, 1497-1506, *Colon, Novesanus*, 1549, folio (241) *Ellis*, £7

9573 Budge (E. A. W.) Life and Exploits of Alexander the Great, ɔeing a series of Ethiopic Texts (250 copies printed for private circulation), 2 vol., hf. mor., g. e., 1896, 8vo. (92) *Sotheran*, £2 5s.

9574 Cicero (M. T.) Opera, 11 vol., old French mor. ex., *Venetiis,*
 apud Aldi Filios, 1540-50, 8vo. (40)
 F. Edwards, £3 17s. 6d.
9575 Davenant (Sir William). Gondibert, first ed., orig. cf., 1651,
 4to. (405) *Ellis,* £1 7s. 6d.
9576 Goldsmith (Oliver). She Stoops to Conquer, first ed., with
 half title and epilogue (title repaired, portion of two letters
 wanted), cf. ex., 1773, 8vo. (311) *Spencer,* £2
9577 Hartlib (Samuel). His Legacy of Husbandry, old cf., 1655,
 4to. (161) *F. Edwards,* £3
9578 Herefordshire Pomona, containing Original Figures and
 Descriptions of the most esteemed kinds of Apples and
 Pears, col. plates and illustrations, 2 vol., mor., g. e., 1876-
 1885, folio (230) *Nield,* £7 5s.
9579 Ladies Losse ('The) at the Adventures of Five Hours, or the
 Shifting of the Naile (in verse), hf. cf., 1661, 4to. (406)
 Barnard, £1 16s.
9580 Lery (Jean de). Histoire d'un Voyage fait en la terre du
 Bresil, engravings, mor., g. e., 1594, 8vo. (160)
 Sotheran, £3
9581 Magna Carta. The Great Charter called in latyn Magna
 Carta (trans. into English by George Ferrers), black letter,
 mor., g. e., 𝕴𝖒𝖕𝖗𝖞𝖓𝖙𝖊𝖉 at 𝕷𝖔𝖓𝖉𝖔𝖓 in 𝕻𝖆𝖚𝖑𝖊𝖘 𝕮𝖍𝖚𝖗𝖈𝖍 𝕻𝖊𝖗𝖉𝖊 at
 𝖙𝖍𝖊 𝖘𝖎𝖌𝖓 𝖔𝖋 𝖙𝖍𝖊 𝕸𝖆𝖗𝖞𝖉𝖊𝖓'𝖘 𝕳𝖊𝖊𝖉 𝖇𝖞 𝕮𝖍𝖔𝖒𝖆𝖘 𝕻𝖊𝖙𝖞𝖙, 1542, 8vo.
 (37) *Maggs,* £1 10s.
9582 Redouté (P. J.) Les Roses, LARGE PAPER (a few plates and
 text missing), 3 vol. in 1, hf. bd. (w. a. f.), folio (495)
 Murray, £12
9583 Temple (Major). Eight Views of the Mauritius, Sixteen
 Views in the Persian Gulf, 24 col. plates, hf. mor., g. e.,
 1811, folio (497) *Edwards,* £6
9584 Thuanus. [De Thou (Jacques Auguste).] Historiarum sui
 temporis, Libri CXXXVIII., LARGE AND THICK PAPER COPY,
 first ed., 5 vol. in 4, mor. gt., in all probability by Clovis
 Eve about 1620 for the De Thou library, stamp containing
 the arms of J. A. De Thou and his second wife, Gasparde
 de Chastre, on sides, 1620, folio (526) *Sabin,* £12

SUBJECT AND GENERAL INDEX
IN ONE ALPHABET.

NOTE.—An asterisk placed against any number indicates that the entry referred to is annotated.—ED.

———✳———

Index.

52—2

Elliot Stock, 62, Paternoster Row, London, E.C.

CPSIA information can be obtained
at www.ICGtesting.com
Printed in the USA
BVHW080127211118
533619BV00015B/2531/P